# ART
## of the 20th Century

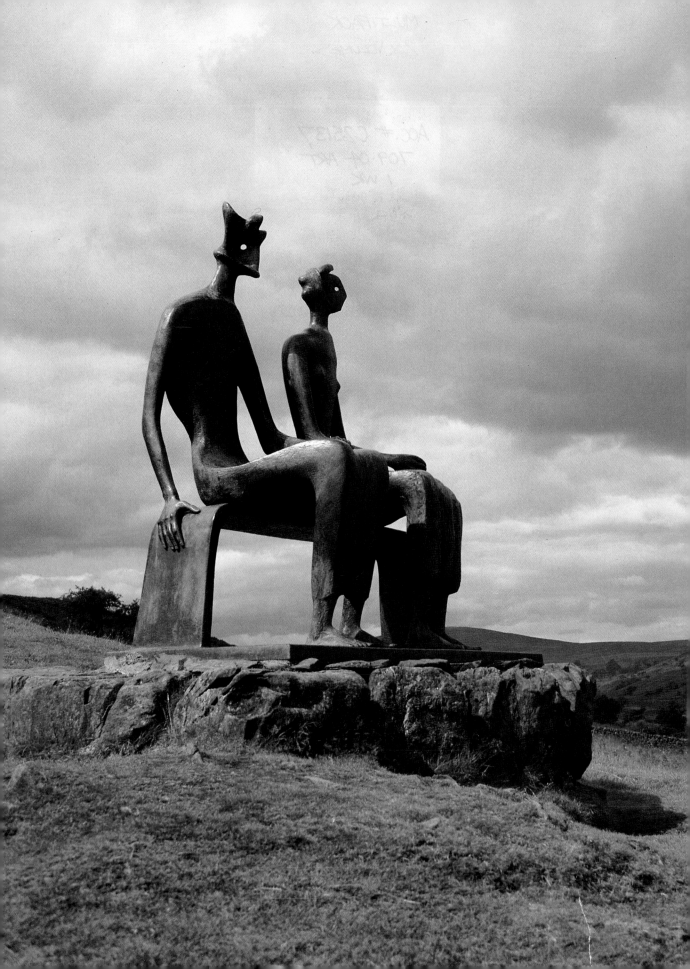

Ruhrberg · Schneckenburger · Fricke · Honnef

# ART
## of the 20th Century

*Edited by Ingo F. Walther*

**Volume II**

## SCULPTURE

*by Manfred Schneckenburger*

## NEW MEDIA

*by Christiane Fricke*

## PHOTOGRAPHY

*by Klaus Honnef*

**Manfred Schneckenburger,** born 1938 in Stuttgart. Studied German, journalism, history and art history at Tübingen and Munich. 1969 doctorate in art history from Tübingen; 1973-1975 director of the Cologne Kunsthalle; 1975-1977 and 1985-1988 artistic director of documenta 6 and 8; 1978-1981 lecturer in 20th century art at Bochum university. Since 1988 professor of art and public affairs at the Kunstakademie Münster, of which he was also Principal from 1995-2003. Numerous publications on 20th century art, in particular sculpture.

**Christiane Fricke**, born 1958 in Cologne. Studied art history, archaeology and German in Würzburg and Rome. 1996 doctorate in art history from Bonn. Since 1984 freelance writer. Numerous publications on cinema, video and contemporary art, including a monograph on the "Television Gallery" presenter Gerry Schum.

**Klaus Honnef**, born 1939 in Tilsit. Studied history and sociology in Cologne. 1965-1970 arts editor at the *Aachener Nachrichten* newspaper; 1970-1975 head of the Westfälischer Kunstverein; since 1974 head of the "Alternating Exhibitions" department at the Rheinisches Landesmuseum Bonn. Co-curator of documenta 5 and 6; 1981-2004 professor of Theory of Photography in Kassel, followed by a lectureship at the Bergische Universität, Wuppertal. Numerous publications on contemporary art. Curator of important exhibitions, most recently on the history of photography. Honnef has published *Contemporary Art* and a monograph on Andy Warhol with TASCHEN.

*Back cover and slipcase:*
**Duane Hanson**
Supermarket Lady, 1969
Painted fibreglass, polyester and clothing,
shopping cart with product packs
Figure: c. 166 x 70 x 70 cm
Aachen, Ludwig Forum für Internationale Kunst
© VG Bild-Kunst, Bonn 2005

*Illustration page 402:*
**Henry Moore**
King and Queen, 1952/53
Bronze; height: 170 cm
Glenkiln, Shawhead, Dumfriesshire
(Scotland), Collection W.J. Keswick

To stay informed about upcoming TASCHEN
titles, please request our magazine at www.taschen.com
or write to TASCHEN America, 6671 Sunset Boulevard,
Suite 1508, USA-Los Angeles, CA 90028,
Fax: +1-323-463.4442. We will be happy to send
you a free copy of our magazine which is filled with
information about all of our books.

© 2005 TASCHEN GmbH
Hohenzollernring 53, D–50672 Köln
**www.taschen.com**

Original edition:
© 1998 Benedikt Taschen Verlag GmbH
© 2005 for the illustrations: VG Bild-Kunst, Bonn,
the artists and the heirs of the artists
Edited by Ingo F. Walther, Alling
Project management: Juliane Steinbrecher, Cologne
Translation: John William Gabriel, Worpswede;
Ishbel Flett, Frankfurt; Fiona Elliott, Edinburgh;
Frances Wharton, Cologne
Cover design: Angelika Taschen, Cologne

Printed in India
ISBN 3–8228–4089–0

# Contents

## Sculpture
*by Manfred Schneckenburger*

# New Media

Non-Traditional Forms of Artistic Expression
*by Christiane Fricke*

# Photography

*by Klaus Honnef*

# Lexicon of Artists
*by Ingo F. Walther*

# Metamorphoses of Modern Sculpture

When the 19th century German critic and philosopher Johann Gottfried von Herder described painting as illusory dream and sculpture as harsh reality, he coined a definition that still held true as the 19th century drew to a close. Yet within less than a hundred years, it had been swept aside so radically that it was no longer valid even as a guideline or general rule of thumb. Indeed, when Joseph Beuys described sculpture as thought, he actually placed three-dimensional art in a sphere of intellectual reflection closely related to the realm of the dream. In the course of those one hundred years, the very concept of sculpture was reconsidered, redefined and reworked more profoundly than it had ever been in all the millennia before. It was a century in which painting, in spite of all its new directions, still remained painting. It was also a century in which the classical distinctions between the sculpturality of hewn stone or wood and the plasticity of the composite object became blurred to the point where these very distinctions were themselves questioned. In fact, nothing less than the crisis of identity itself had become the true productive principle behind the extension of the term "sculpture".

Let us chart this path that leads in an endless circle from volume to space to object to situation to concept and back again – from the archaic block to what Julio González called the "marriage of volume and space", across ever more distant deserts, skies and spaces, using ever different materials and media in ever different combinations. In 1968, the American sculptor Carl Andre summed up this development with the extraordinarily bold assertion that, whereas sculptors were once interested in the sword sheath of the Statue of Liberty on Bedloes Island, they eventually took an interest in Eiffel's reinforcing framework structure, and finally came to be interested in Bedloes Island itself. In other words, it is but a hop, a skip and a jump from outer shell to inner structure to topographical situation.

The much-vaunted expansion of art was first and foremost an expansion of sculpture. Before exploding into tangible reality after 1960, this had taken place between 1906 and 1916 as an implosion in the minds of a few revolutionary artists. Roughly speaking, its most concentrated generative phases can be pin-pointed between 1906 and 1916 and between 1960 and 1970. Though there were certainly some important caesura and watersheds in the interim periods, it was during these phases that the fundamental paradigms were established. Bearing this in mind, we can adopt an approach that differs somewhat from previous linear examinations of the history of modern sculpture. After all, every generation re-invents the past and writes its own history. With the notable exception of Rosalind Krauss' brilliant case study, all the major historiographies to date were published before the fundamental

changes of the 60s. Carola Giedion-Welcker, Michel Seuphor, Eduard Trier and Ulrich Gertz saw 20th century sculpture moving along two tracks, the gap between them ever widening. The double-doored propylaeum from which they branched out was the work of Auguste Rodin and Aristide Maillol respectively: Rodin melted form in space, merging the two and furrowing them with light, while Maillol condensed volumes and rounded forms, consolidating them tectonically. From here, the path leads on the one side towards an analytically crystalline handling of space and on the other side towards a dense, closed block. Naum Gabo and Constantin Brancusi spring to mind.

Instead of examining these two directions of development, let us consider the history of 20th century sculpture in the light of two generative phases. Rodin, whose mature work spans the entire period of the first phase, may be regarded as a central figure in the beginnings of modern sculpture. He introduced an unruly element, and his unfettered extroversion of sculptural plasticity was countered in 1907 by the radically compressed and almost block-like introversion that informed the work of André Derain, Brancusi and Picasso in their quest to re-create sculpture out of the elemental form of the material. Yet, just two years later, Picasso's *Head of a Woman* and Matisse's series of *Jeannette* busts actually adopted Rodin's furrowed surfaces. Thus, both countering and emulating the omnipresent Rodin contributed to the development of modern sculpture. Seen from this angle, the line of descent from Maillol becomes secondary, while Rodin's artistic heritage is marked by the ascendance of a complex and experimental avant-garde.

Does the history of sculpture, and of art in general, reflect political and social history? Are world wars and economic slumps, the fall of empires and the rise of the nation state reflected in the art of the 20th century? Is art the expression of historic and social relations, just as it is, for Marxist theorists, the superstructure of class interests? Or does it develop along its own lines, with all the biographical breaks, distractions and asides that this entails? This essay does without the usual introductory sketch of the general historical and cultural climate of the day and, in doing so, isolates sculpture from its broader contemporary context.

Yet this certainly does not mean it is entrapped within some ivory tower. On the contrary; as an independent expression of the period in which it is created, a sculpture necessarily embodies the conflicts, caesura and hopes of its time. Wherever the contemporary context is specifically addressed in the work or where an explanation is necessary in order to understand the sculpture more clearly, this will be taken into account, as for example, in the case of the Russian Constructivists.

> "Art has its tradition, but it is a visual heritage. The artist's language is the memory from sight. Art is made from dreams, and visions, and things not known, and least of all from things that can be said. It comes from the inside of who you are when you face yourself. It is an inner declaration of purpose, it is a factor which determines artist identity."
> DAVID SMITH

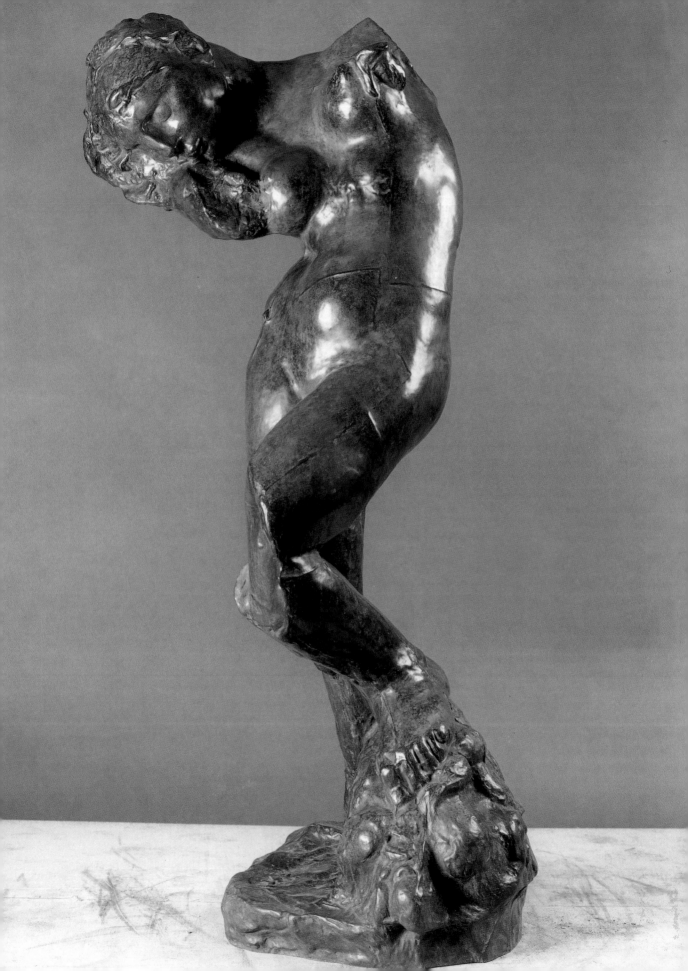

# Between Tradition and Modernity

## Rodin: Perfection and Experiment

In the past, Rodin's modernity tended to be linked primarily to Impressionism. The sculptor Rodin was more or less the same age as the painters Claude Monet, Alfred Sisley, Pierre-Auguste Renoir and Paul Cézanne. His tendency to apply the principle of sketchiness, and the way he moulded and furrowed the surface of his works in a fluid and vibrant play of light and shadow, certainly marks him as a contemporary of the Impressionists. Yet the label does not suit him. For Rodin, though he adopted much of the Impressionist formal syntax, also clung to all that the true Impressionists were only too eager to jettison. He drew upon mythology and literature, invoking heroism and passion – in short, he represented the shadow of tragedy and pessimism that darkened the face of the century. Even the fleeting and transitory vitality of his sculptures is not impressionistically motivated. Nothing in them reflects the atmosphere, the sun, the passing of clouds, or the influence of the outer world. Instead, they visualise the inner forces of the soul seeking outward expression in a writhing, threshing, swelling flow of physical rhetoric.

Rodin, in other words, is more aptly regarded as the heir and executor of the fertile French Romantic movement. He was the only artist to channel the pathos and passion of Théodore Géricault and Eugène Delacroix, of Victor Hugo, Théophile Gautier, Charles Baudelaire and even the exuberant joie de vivre and detailed realism of Honoré de Balzac into a cosmos of physicality. As a portrayer of the human form, Rodin was a true apprentice of the sculptural tradition that embraces the art of Ancient Greece, the Gothic cathedral, Donatello, Michelangelo and Gianlorenzo Bernini. He transported this tradition, by his truly modern approach, into the realms of psychological subtlety, and he did so, like Thomas Mann, without contradicting the archetypal. In this respect, he was the last – and as a sculptor the only – exponent of the 19th century penchant for perfection with all the triumphs and failures that entails, and with a taste for the great, cyclical life work.

Rodin's *Gates of Hell*, the alpha and omega of his œuvre, ranks alongside the great cycles such as Balzac's *Comédie humaine*, Richard Wagner's *Ring der Nibelungen*, Edouard Manet's planned panorama of "modern life" and Emile Zola's *Les Rougon-Macquart*. It is a work

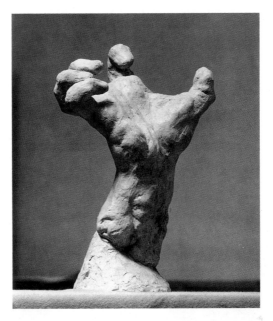

**Auguste Rodin**
The Mighty Hand (Right Hand),
before 1910 (?)
Plaster, 46.7 x 31.4 x 19.2 cm
San Francisco (CA), The Fine Arts
of San Francisco, Spreckels
Collection

in which Rodin's romantic vision is condensed just as his keenly realistic powers of observation are condensed in his *Burghers of Calais*.

Nevertheless, Rodin's sculpture (pp. 408–411), for all its affinity to great literature from Dante to Baudelaire, has nothing of the consumptive pallor of Salon art's sickly love of literature. He is a sculptor through and through. The high-minded reformist efforts of Adolf von Hildebrand, who sought to impose neo-classicist forms in a bid to discipline the nascent neo-baroque and the naturalistic panopticum, are anathema to him. The terms he used – "modelé", "profile" or "drawing from all sides" – sum up what was important to him: the vitality of the swelling, furrowed bodies and limbs with their pools and trails of light and shadow, the significance of various "fertile" angles which alternate to create a fluid, organic movement, the inclusion of the surrounding space and intermediate spaces as an integral part of the sculpture. Rodin's *Burghers of Calais* are a masterpiece of this "mouvement en l'air".

Though his work may have represented the culmination of 19th century sculpture and the essence of 19th century thought, Rodin untiringly challenged the boundaries of his era at the same time, anticipating in

**Auguste Rodin**
The Inner Voice, 1896/97
Bronze, 146 x 59 x 45 cm
Paris, Musée Rodin

many ways the art of the 20th century. In its dynamic diagonality, his *Balzac* (ill. below) soars like a vast and rocky reef, foreshadowing Brancusi. For the young revolutionaries of the new century who were to become the founding fathers of modern sculpture, Rodin was not only the hero of yesteryear, but also the omnipresent challenge.

It should be mentioned at this point that earlier histories of modern sculpture insisted upon the anticipatory role of certain painter-sculptors, most notably Géricault and Honoré Daumier, who created miniature, sketch-like studies modelled by hand, taking abstraction and expressive exaggeration to the point of caricature, and Edgar Degas, whose *Little Fourteen-Year-Old Dancer*, embellished with real horse-hair and tulle not

only points the way towards the readymade, but also prepares for the gestural inclusion of surrounding space. Most of their sculptures, however, were to remain in the studio or were destined, like the work of Degas, to shock the public simply because they failed to pander to clichéd contemporary notions of beauty. Only Paul Gauguin, who charged his work with complex borrowings from Breton folk art and from Indonesian and Polynesian imagery, regenerating sculpture in the spirit of *taille directe*, was to have a direct impact on Modernism. In 1906, Picasso and André Derain visited an exhibition of his work in Paris and drew their far-reaching conclusions. Yet it was Rodin alone who sparked the flame of modern sculpture. No later sculptor can ignore him.

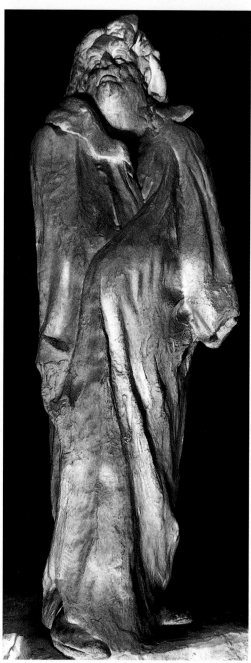

**Auguste Rodin**
Head of Balzac (Study for the
Monument to Balzac), 1897
Plaster. Paris, Musée Rodin

**Auguste Rodin**
Monument to Balzac, 1897
Plaster, 300 x 120 x 120 cm
Paris, Musée Rodin

The patriarch of Meudon knew this full well when he referred to himself as a bridge between the shores of the past and the present.

Fame came late in the day to the ever-controversial Rodin. What was it, then, that made him so important? It was certainly not the powerful influence he had on a number of sculptors who clung to the human image in the 20th century and thereby relegated themselves to the role of a nobly contemplative or expressive rearguard – Rodin's student and lover Camille Claudel, Charles Despiau and Antoine Bourdelle, the Germans Hans Albiker, Bernhard Hoetger and Georg Kolbe, the Norwegian Gustav Vigeland. There was no school of Rodin in the narrower sense, for this restless and obsessively experimental searcher never established a formal canon.

It was the "contradicatory filiations", as J. A. Schmoll alias Eisenwerth described them, that led to Modernism, and they did so by a far more direct route. These were artists who broke away from Rodin, yet continued to look back nonetheless, as though seeking the

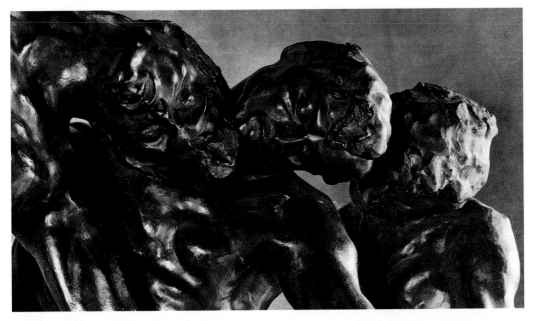

**Auguste Rodin**
The Three Shades (detail from the
Gates of Hell), 1880
Bronze, 635 x 400 x 85 cm (total size)
Paris, Musée Rodin

*"When a good sculptor models
human bodies, he not only portrays
the muscles, but also the life that
courses through them ... indeed,
more than the life ... the force that
formed them and gave them grace or
strength, charm or unfettered joy."*
AUGUSTE RODIN

reassuring safety of distance. The swelling curves and
ruggedly gouged surfaces with their ridges and furrows
drenched in pools of light and shadow, liberated
younger sculptors to pursue abstraction. The break-
down of traditional narrative patterns and accepted
compositional hierarchies in Rodin's *Gates of Hell* sub-
verted the hegemony of central perspective. Though his
work did not go so far towards a new formal order as
that of Cézanne, it nevertheless had important repercus-
sions in terms of changing the ways of seeing that had
prevailed for centuries. Above all, Rodin appears as the
mediator between the Romantic aesthetic of the frag-
mentary and the modern principle of montage. As a
modeller who had his assistants transpose his plaster
casts into larger and smaller formats, Rodin stood with
both feet firmly in the 19th century. This sculptor, who
kept a large collection of plaster arms, hands, legs, feet
and torsi, arranged by size (like a "typecase of body
parts", according to Werner Spies), actually lived to see
the advent of the montage. His figural assemblages of
plaster casts of various origins paved the way for Expres-
sionist and Cubist fragmentation.

Rodin's modernism did not simply prepare the
ground for the next generation, but led on deep into the
20th century. The very aspects of his work that met with
incomprehension among his contemporaries are those
in which we can discern this tremendous far-sighted-
ness. Whether Frank Popper was right in claiming that
excessive instability, fluidity, and the dissolution of firm
sculptural forms already announced the advent of
Futurism and kinetic art, is beside the point. Today, the
*Burghers of Calais* would appear to herald the dawn of a
new age more clearly. In an earlier design, Rodin had
envisaged mounting them on a shallow plinth without a
pedestal, almost level with the ground. It is precisely this
fact that made them so controversial in Calais, until an
inconspicuous place was found for them. Rodin had

undermined the classical monument, but by taking his
bronze figures down from their pedestal and allowing
them to intrude into the real space that they share with
the observer, foreshadowed some of the fundamental
changes in sculpture from the 1960s onwards. Alberto
Giacometti's so-called space sculptures marked a fur-
ther milestone on this road.

By the time Rodin died in 1917, the next generation
had already begun to ring in changes and had achieved
a breakthrough on many fronts – some by building on
the achievements of Rodin, and some by turning against
him. However logical it may seem to pass directly from
here to the dramatically accelerated revolution of mod-
ern sculpture, we would do well to take a look first at
some of the less spectacular modifications that took
place within the progress of tradition.

### Maillol and the Vitality of Classicism

Aristide Maillol, born in 1861 in the south of France,
updated the classical tradition, lending it a valid moder-
nity. His masterpiece, the seated female figure, *The
Mediterranean* (p. 412) echoes the eastern metopes of the
Temple of Zeus at Olympia. The limbs seem to frame
and structure the body, with supports and loads in har-
monious balance, reinforced by only a few diagonals.
The tectonic structure is in total harmony with the
organic modelling and gentle undulations of the limbs.
It is a work that combines the architectural with the
anatomic. The fact that Maillol was capable of power-
fully heightening his expressive portrayal of the human
body is evident in his study for a monument to the social
revolutionary Louis-Auguste Blanqui. It is a torso whose
(fragmented) arms seem bound as they lift the entire
twisting body. From the 1920s onwards, even in the work
of Maillol, the heroic ideal, as opposed to a classically
balanced one, tended to be reduced to a cult of the body
beautiful, healthy and strong.

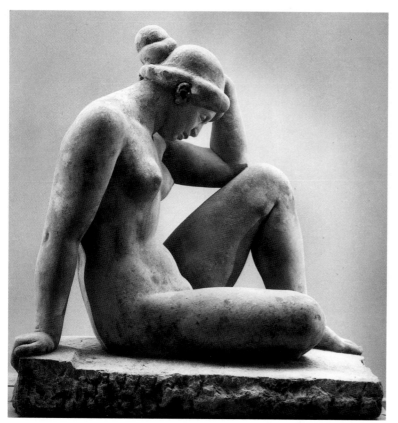

and elegance on a grand scale, and to imbue them with a blossoming and erotic sensuality. Maillol was a sculptor through and through. He cast off the shadow of Rodin by returning to the classical origins of sculpture, and remained in Rodin's shadow for the same reason. He was a step ahead of Hildebrand, that other counterpoint to Rodin, in the sense that his sculptures did not radiate any noble, historically founded theory of relief nor any artificial order of foreground and background levels. They captured the vitality and strength of the female body through their stringency of form, lending it an anonymous and purely sculptural existence and linking it in elementary coordinates of space without robbing it of vitality and development.

## Barlach: Expressive Robed Figures

Ernst Barlach and Wilhelm Lehmbruck are regarded as typically German sculptors, though both of them found their greatest inspiration outside Germany – Barlach on a visit to Russia in 1907 and Lehmbruck during his stay in Paris from 1910 onwards. As the sculptural revolution

**Aristide Maillol**
The Mediterranean, 1901
Bronze; height: 103 cm
Winterthur, Oskar Reinhart
Collection

*"There is something to be learned from Rodin ... nevertheless I felt an inner need to return to more stable and closed forms. Freed from the small psychological details, forms can be shaped to the sculptural qualities of a work all the more."*
ARISTIDE MAILLOL

Maillol is often regarded as an artist diametrically opposed to Rodin. That is true to a certain extent. While Rodin's figures are centrifugally oriented and embrace the space in which they stand, the works of Maillol are bound to their corporeal volume and remain within a firm tectonic framework. Rodin tended to create groups and complex, eccentric interweavings, while Maillol limited his sculptures to a single monumental figure. Rodin scored the surface, breaking it open and bathing it in streams of light, while Maillol rounded the limbs to a firm and magnificently sensual organism, lending the body volume and gravity, paring forms down to compact entities with clearly contoured silhouettes. They were opposites indeed.

Whether or not this makes Maillol a second founder of modern sculpture, comparable to Rodin, remains a moot point. Can he be said to stand at the beginning of a path which, irrespective of all changes of direction and paradigm, eventually leads to Brancusi and from there to such sculptors as Fritz Wotruba and Ulrich Rückriem – sculptors who work with forms of solid plasticity?

In retrospect, it might be more appropriate to regard Maillol as the last great master in the classical tradition; as a sculptor of calm and potent images, who rejected Neo-classicist restrictions and turned his back on the 19th century tendency towards psychology, narrative, genre scenes and rhetorical kitsch. His strength and his historical contribution – following Rodin's intermittently crisis-ridden destruction of plasticity – lie in his capacity to endow his figures with structural simplicity

**Aristide Maillol**
Ile de France, 1925
Bronze; height: 166.5 cm
Cologne, Museum Ludwig

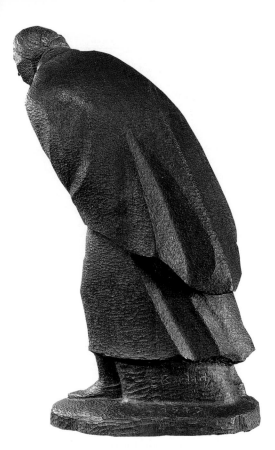

Barlach's work. His *Man Drawing a Sword* (ill. below) has a base that all but disappears under the great dome of the mantle: a taut and tensely strung outer shell that clenches with a solidly compacted inner form. The body of the *Old Woman with a Stick* (ill. left) is curved inwards, like a dent within the intractable surrounding space. The cloak lies like a shield around the figure. In this, Barlach moves among the avant-garde without sharing the mould-breaking radicalism or incisive analysis of Umberto Boccioni or Alexander Archipenko. His retreat to the provincial town of Güstrow was not a retreat from artistic urbanity.

It has been written of Barlach that he did not develop much further after visiting Russia. Yet the outer and inner energy of his figures did undergo a distinct transformation. His early beggars, peasants and herdsmen have an air of dullness and oppression, the elementary and laconic formal syntax reflecting their elementary and essential needs in the face of bourgeois conventions. After 1910, with war looming, an aggressive pathos broke out in the figures of the *Berserker*, the *Man Drawing a Sword* and *The Avenger*, the folds of their robes drawn into rushing lines charged with tension. The fury of war (based on drawings of the demise of Saul and the *Nibelungenlied*) is expressed in flashes of powerful mass dynamics. It was not until his later work, most notably his frieze for the Church of St. Katharinen in Lübeck

**Ernst Barlach**
Old Woman with a Stick, 1913
Walnut, 84 x 47 x 50 cm
Aachen, Niescher
Collection

**Ernst Barlach**
Man Drawing a Sword, 1911
Wood, 75 x 61 x 28 cm
Hamburg, Barlach Haus

swept Paris, Milan and Moscow, both these artists continued to work in the figural mode. Both formulated an expressionistic contribution to this period of change, for both of them were "modernists", yet the touchstone of their modernism was and remains the human image as an image of humanity. In this respect, both Barlach and Lehmbruck continued to exert an influence on the figurative tendency in German sculpture well beyond mid-century. Indeed, in terms of emotive expression, the work of Lehmbruck was an essential benchmark for Beuys. Barlach's work has been all but obscured by its popularity. Because of this, he is all too easily associated with a certain rather dubious and very German sense of import, cosy clichés and arts and crafts stylisation. His distinctively dialetic handling of gravity and elevation can, at times, seem heavy-handed and hackneyed. Yet Barlach's wooden sculptures were very much part of a wider European context at the time, particularly in the formative years around 1910.

One of the foremost undertakings between 1906 and 1910 lay in a return to the elementary forms of stone and wood, and the block-like compression of the figure. Derain, Picasso and Brancusi made the greatest inroads in this respect. At the time, Barlach, too, was cutting and reducing seated figures to a cuboid form whose stereometric ideal is reminiscent of ancient Egyptian block statues. A highly charged relationship between outer form and inner core emerges from the exploration of concave and convex undulations of volume in the robed figure that forms the contours and boundaries of

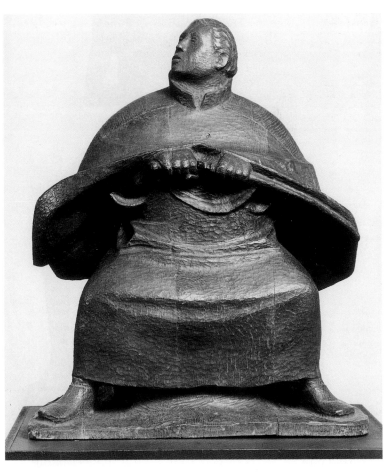

**Wilhelm Lehmbruck**
Kneeling Woman, 1911
Bronze, 178 x 71 x 141 cm
Duisburg, Wilhelm Lehmbruck
Museum

and in his *Fries of the Listeners,* originally planned for a Beethoven monument, that Barlach was to achieve the spiritual purity that is uncorporeal under flowing robes and which can be compared to High Gothic mystic figures.

## Lehmbruck: Structure and Spirituality

Lehmbruck's mature sculptural œuvre (pp. 414 f) was created in less than a decade. The son of a miner from Duisburg, Lehmbruck initially took as his role model the worker hero Constantin Meunier and, from 1908 – by the time he moved to Paris, at the latest – he quickly found a footing among the international avant-garde. From then on, each step marked a clear and conscious development. In the revolutionary climate of the Paris art world during the second decade of the century, Lehmbruck, though fully aware of the many innovations, continued to treat the naked human body as a metaphor for existence and spirituality. He remained,

**Wilhelm Lehmbruck**
Standing Youth, 1913
Bronze, 228 x 78 x 62 cm
Duisburg, Wilhelm Lehmbruck
Museum

like Brancusi, unaffected by the new Cubist formal syntax, finding his own unconditional response to the progressive central problem of the decade. Unlike Henri Gaudier-Brzeska or Jacob Epstein, he brooked no compromise, seeking instead to render the structural perfection of the body as a sign of human suffering. As early as 1912, at the Sonderbund exhibition in Cologne, Hans Hildebrandt described his *Kneeling Woman* (ill. above) as a "symbol of expressionism". There is more to this than an ambivalent epithet – it defines the characteristic traits of a work that unites formal stringency with extreme psychological and spiritual intensity.

The tall and earthy *Standing Woman* with its sensually harmonious body rhythm marks the close of his early phase in 1910. It was Lehmbruck's magisterial response to Maillol. Created one year later, his *Kneeling Woman* marks a decisive break. Its extreme elongation echoes an imagined body build rather than a natural one, situated somewhere between the tectonic and the organic. In short, it is a masterpiece of what Werner Haftmann described as the "secret Gothic" to which the Expressionist generation subscribed, as did Amedeo Modigliani and Derain, albeit without the slightest outburst of emotion, full of grace, tenderness, sensibility and gestural contemplation.

The *Standing Youth* of 1913 (ill. left) is the first work to go beyond the architectural into the fragile and vulnerable. The torso and one leg form a pillar buttressed by the other slightly outstretched leg. This pose channels the surrounding space into a geometric inner contour with an emphasis on the vertical. Tormented hands lead over angular elbows to a stern and brooding physiognomy. The figure of this young man still guides the surrounding space along his slender body. By contrast, Lehm-

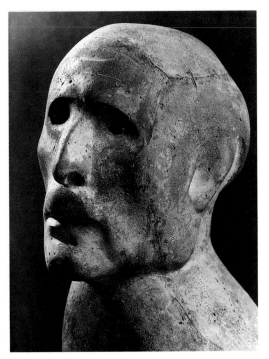

**Bernhard Heiliger**
Portrait of Karl Hofer, 1950
Cement; height: 44 cm
Mannheim, Städtische Kunsthalle
Mannheim

tury art. He rejected the cloying over-ornamentation, the formal rhetoric and anecdotal eclecticism of the fin de siècle in favour of pure form, believed in the primacy of the visual over the haptic and pursued a sculptural portrayal of distance. Yet in spite of the ideas posited in his widely read book *Das Problem der Form* (The Problem of Form in the Visual Arts) which was published in German in 1893 and appeared in English translation in 1907, all this led down a dead-end road, rather than opening new doors. The purity of contour of the *Amazons* by Louis Tuaillon, the harsh virility of the *Charioteer* by Hermann Hahn, both of them students of Hildebrand, may be immaculate, but they are hadly part of the progressive mainstream.

Unlike the artistic renewal based on classical antiquity, the stylised human image of Jugendstil or art nouveau had little resonance beyond the turn of the century. Figures were blended with the cantilena of curving floral forms or integrated as an architectural element in buildings. Even that masterpiece of art nouveau sculpture, the *Fountain of Kneeling Figures* (1898) by the Belgian sculptor George Minne was an integral part of Henry van de Velde's Folkwang Museum in Hagen. Gracefully

**Wilhelm Lehmbruck**
Seated Youth, 1918
Cast stone, 103.5 x 77 x 115 cm
Frankfurt am Main, Städelsches
Kunstinstitut und Städtische
Galerie

bruck's *The Fallen* created in the war years 1915–1916 and his *Seated Youth* of 1918 (ill. right) embrace the surrounding space with the structural armature of their limbs. They are no less containers of space than the contemporary sculptures of the innovative Archipenko, and yet they remain symbols of human mourning, despair and loneliness. In their sculptural condensation of tragedy, they are thus valid corporeal signs of their century.

## Image-Makers from Hildebrand to Marini

It was Brancusi, Picasso, Boccioni, Duchamp-Villon, Archipenko and a handful of others who staked out the boundaries of human imagery in the early 20th century. Yet alongside the clearly defined breaks with tradition there was also a broad-based, moderate, conservative modernism that retained the human image and the human body intact, no matter how simplified, stylised or even abstracted it might be. These sculptors took the 19th century tasks of architectural decoration, statue and portraiture one step further. Utterly convincing as images located between psychology and abstraction are the heads done by Bernhard Heiliger in the 50s (ill above). Nazi Germany denounced a few of these sculptors "degenerate", while others betrayed their classical ideals to the "racially healthy" notions of an athletic typology propagated by the Nazis. Gerhard Marcks, a sculptor of artistic and personal integrity, took the former path, while his teacher Georg Kolbe followed the latter.

The strict Munich classicism of Adolf von Hildebrand is generally regarded as a point of departure. Some earlier art historians even acclaim him as an artist whose work was seminal to modernism. Yet his true achievement lay more in putting the 19th century behind him than in preparing the ground for 20th cen-

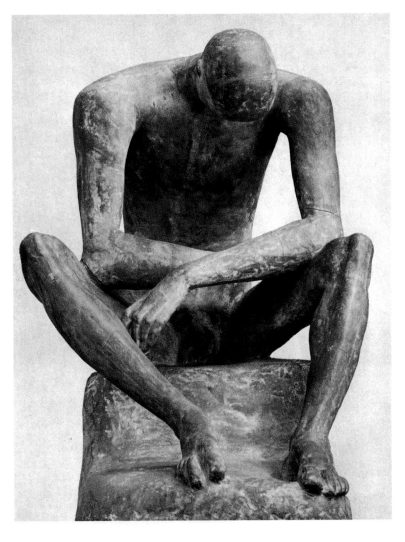

angled and slender, uniting plants and pillars with a smoothly dynamic energy of line, the quintuple repetition robs the kneeling figures of all individuality. Although Lehmbruck and Maillol (for instance the latter's *Young Cyclist*) both adopted the concept of the standardised figural type their approach did not constitute a direct route to Modernism either.

The strongest influences were generated in the field of tension between Rodin and Maillol. These two artists represented opposite poles of the artistic spectrum until well into the 20th century, with dynamic and sweeping physical gestures on the one hand and on the other hand a tectonically fixed body structure. It was not unusual for their successors to begin with an affinity to Rodin, only to move closer to the example of Maillol. Antoine Bourdelle, the most successful and independent Rodin student in France, adopted his teacher's dissolution of form only to reintegrate it within the stricter order of a bold and raw baroque style. Bourdelle, who accepted a number of official commissions and created several monuments for the Third Republic, was a prolific artist whose output tended increasingly towards the colossal and the oversized. His was a prodigious talent on the verge of Modernism that found a firm footing in pomp and circumstance. By contrast, another important Rodin assistant, Charles Despiau created languid and calmly composed female nudes that echœd the work of Maillol in a distinctly academic mode.

Was it by a mere quirk of biography that the genera-

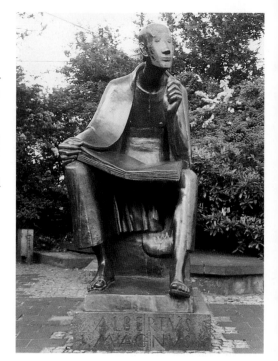

**Gerhard Marcks**
Albertus Magnus, 1955
Bronze; height: 260 cm
Cologne, University

tion of artists born between 1880 and 1890, including Gerhard Marcks and Ewald Mataré, did not go to Paris? The work of both these artists was firmly rooted in German Expressionism, with Marcks following in the footsteps of Barlach yet imbuing the latter's ecstatic robed figures with an archaic calm. In 1928, he visited Greece, and his travels there inspired him to turn once more to the nude and to sensitive portrayals of young men and women. After 1945, he was the representative German sculptor, unsullied by the Third Reich. His seated figure of *Albertus Magnus* (ill. above) in front of Cologne University structures the body into planar areas, gathering space and condensing it as though within a shell that opens out towards its audience. The right hand is leafing through the book that forms a base, the left hand is raised in a gesture of explanation, and above them the head of the scholar rises from the curve of the collar with the finely intellectual mien of the learned man. It is one of the few successful examples of a post-war monument.

Ewald Mataré became known in the 20s for his heraldically abstracted animal figures. Their smooth, laconic Ur-form and haptic sensuality reminiscent of Brancusi were to stimulate the early work of Mataré's student Beuys. His human figures, including numerous works commissioned by the Catholic church, are not always free from formalised stylisation.

In Italy, the anthropocentric and classical line was stronger than it was in other centres of art. Even the tempestuous winged hero by the revolutionary futurist Boccioni is – rather aptly, given the tone of his manifesto – reminiscent of the figures that grace the bonnet of a car, but also recall the Nike of Samothrace and the metamorphosis of Bernini's *Daphne*. Indeed, until the turning point of 1960, all of Italian sculpture focused

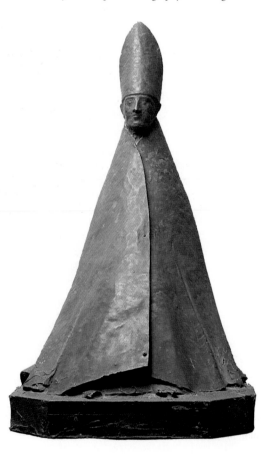

**Giacomo Manzù**
Cardinal, c. 1955
Bronze, 103 x 56 x 56.5 cm
Milan, Civico Museo d'Arte
Contemporanea

on the modernisation of an openly perceived classical antiquity that reached from Crete to Greece and from Etruria to Rome. The most influential post-futurist sculptor, Arturo Martini failed in the end to solve the problem of the eclectically inconsistent dichotomy between archaic abstraction and realism in the portrayal of nudity. Even such successful artists as Giacomo Manzù (p. 416), Marcello Mascherini and Emilio Greco, all major prizewinners at Italian biennials, were repeatedly torn between the overweening modernism and allpowerful tradition that occasionally played precisely the same role that Rodin and Maillol played elsewhere.

Is the Italian sculptor Marino Marini to be counted amongst the more conservative "guardians" of the human image? Or do his acrobats and dancers, his round-bodied, broad-hipped, fertile and yet graceful garden nymphs, his *Pomonas* and his many variations on the obsessively reiterated theme of horse and rider already go beyond all academic modernisms and classicistic reminiscences? Marini was unquestionably the greatest Italian sculptor of his generation, and the only one of European standing to consciously address his Mediterranean, Etruscan and Ancient Greek heritage. His portrait busts and heads of Manuel Gasser, Mies van der Rohe and others mediate effortlessly between archaic simplification and lifelike vivacity. His *Pomonas* are utterly enchanting; the perfect plasticity of their rounded bodies making the ample, sensual bodies of Renoir's women seem clearly contoured.

The first of his *Horse and Rider* sculptures was produced around 1940. Marini translated the ancient motif of the hero triumphant, taking it beyond all empty monumentality into a modern formal syntax. At first, man and horse seemed to merge in a balanced and harmonious orthogonal or diagonal. But then the power of the motif won through, increasingly expressing a gloomy world-view in stark contrast to the carefree vitality of his dancers and nymphs. In the course of the 50s, horse and rider merged to a single, colossal block charged with tension (ill. right); falling heroes that tell of defeat rather than victory, of catastrophe rather than triumph. Instead of painting them with the pale, earthy tones of Etruria and scoring them with sweeping gestures, the surfaces seemed to take on the character of eroded stone, of fossilised remains. Finally the horse itself disintegrates. According to his biographer Sam Hunter, Marini saw the world with increasingly pessimistic eyes after the war. Was this the reason for the transformation, or was it entirely motivated by artistic considerations alone? Was it an irrevocable sense of tragedy that drove Marini's equestrian motif from an almost clownishly lighthearted harmony to the agony of anatomic fragmentation? Does the repeated use of the title *Miracolo* suggest something of the miracle on the road to Damascus, in which the fall is concomitant with the promise of salvation? Marini's mastery of form, in all its emblematic compactness, is as accomplished as the relaxed gait of any classical equestrian statue.

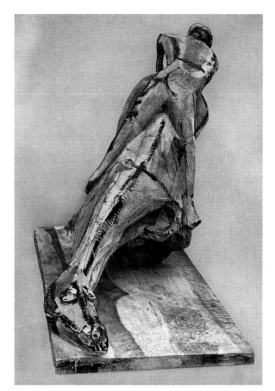

*Both illustrations:*
**Marino Marini**
Miracolo, 1955
Painted wood, 116 x 165.5 x 77 cm
Private collection

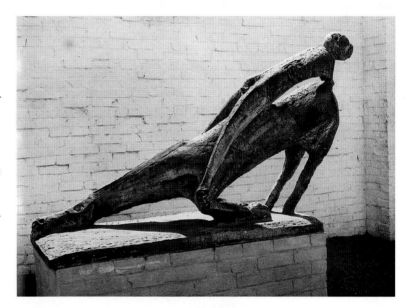

Wherever there are strong role models, pretentious mannerism is not far behind. The Norwegian artist Gustav Vigeland, who visited Rodin's studio in 1892, echoed the writhing mass of bodies of Rodin's *Gates of Hell* in his obelisk in Oslo's Frogner Park and, in doing so, unwittingly parodied them to the point of monstrous gigantomania. The American artist Gaston Lachaise, a naturalized French citizen, created wasp-waisted, musclebound figures that took Maillol's female nudes to the verge of caricature. His national fame as America's leading sculptor in the first half of the century was soon to fade.

# Abstraction and Cubism's Sound Shift

## Spatial Dimension

The revolution in modern sculpture initially centred on the human image. Indeed, at first it was such traditional subjects as the bust, the head and the nude that were revolutionized in an almost uninterrupted chain of progression from 1906 to 1916. Brancusi, Picasso, Boccioni, Duchamp-Villon, Archipenko and Naum Gabo liberated the human figure from its traditional conventions, breaking down the organic context and charging it with a new and tension-laden syntax, and transforming anatomy into autonomy.

For decades, the approach to modern sculpture was dominated by the spatial dimension. However, before the surrounding space penetrated the sculpture, streaming through it and hollowing it, the genre returned once more to its original form, the block. As though seeking to secure its fundamental stance, the invasion of space was preceded by a return to the block-like archetype or the rough-hewn trunk. There was a tendency to include elements of "primitive" art in which European artists at that time were taking a keen interest.

For thousands of years, and in spite of all the exuberant sweeping and spiralling and hollowing of the Baroque and Mannerist periods, the plasticity of three-dimensional volume had remained. Every sculpture was, at core, a solid mass. Now it was worked by hands that modelled, sculpted and constructed. The hollow spaces that penetrated and permeated that solid mass were no longer mere areas of emptiness between tangible forms, but were themselves forms of equal validity. Concave hollows complemented convex swellings. There was no longer a clear-cut boundary between the epidermis and the surrounding space. Either the surrounding space itself encroached upon the sculpture with a vitality of its own that broke and distorted the continuum of the sculpture; or the sculpture opened out to embrace the surrounding space in which it was situated. The many ways in which sculpture and space merged, analytically systematic or expressively dynamic, was the great generative issue of the period. The spectrum ranges from Archipenko and Boccioni to Lehmbruck and Jacques Lipchitz.

There was a second and even more radical break with tradition that constituted nothing less than the emancipation of the still life as a subject in sculpture.

Relegated for centuries to the realm of painting alone, guitars, bottles and glasses now came under scrutiny in the aesthetic laboratory of the sculptor. Through the reconstruction of their spatiality they entered the third dimension. Tentatively at first, as though sounding out the dialogue with this particular art form, Picasso and Braque included elements of everyday reality in their pictures – a scrap of wallpaper or newspaper, a piece of imitation basketweave, became touchstones of aesthetic integration, conjuring up references to a wall, a table or a chair.

The consequences were far-reaching indeed. However closely Picasso may have linked such references to an aesthetic and formally determined artistic syntax, this seemingly minor development was the thin end of the wedge that opened the floodgates, sweeping such utterly different artists as Boccioni and Tatlin into the world of the *objets trouvés* and the culture of materials within the space of just two years – not to mention the more or less contemporary appearance of Marcel Duchamp's readymade. A new sculptural possibility – the object – was born.

All these developments, interactions and independent innovations between 1906 and 1916 were promoted by formal analysis or craftsmanship and underpinned by the latest scientific, philosophical or esoteric theories. The incision was deeper and the changes more far-reaching than ever before. It was more than just a question of a new form, new structures, proportions, expressive energies – in short, a new "style". By the end of the decade, sculpture was exploring hitherto unknown worlds of pre-historic, African and Oceanic art, and was looking to everyday life in search of new sources. From then on, sculpture could be a structure of metal, glass, plaster, cardboard, wire or an abstract gesture. It started being receptive, at first only in theory, to new media such as light, movement, sound and electricity. It expanded its concept (seen from today's vantage point) so far that an industrially manufactured bottle-rack could suddenly become a cornerstone in the history of sculpture. It also forged ahead in directions that were not to be accepted on a wider scale for decades, including, for example, kinetic art.

Important forces and catalysts tend to be concentrated within a few specific places and their repercus-

*"The empty spaces must have as much significance as the volumes in a sculpture. Sculpture involves first and foremost taking possession of a space, a space bounded by forms. There are some who make sculptures without a sense of space, which is why their figures have no character at all."*
HENRI LAURENS

**Henri Laurens**
Clown, 1915
Painted wood, 51.5 x 29.5 x 22.5 cm
Duisburg, Wilhelm Lehmbruck
Museum

sions spread out from there. This was true of Florence in the 15th century just as it was of Paris in the early 20th century. The emergence of modern sculpture between 1906 and 1913 took place almost entirely in Paris. It was in Paris that Picasso invented his collages and *papiers collés*. It was in Paris that Duchamp declared the first readymade. Paris was the city where Rodin was still working, the city to which the future pioneers of art flocked from as far afield as Barcelona, Tîrgu Jiu, Moscow, Smolensk and Kiev. Paris was the cradle of the Italian Futurist movement.

Yet from 1913 onwards, other forces began to emerge in resistance to the hegemony of Paris (though not necessarily that of France). From Rome and Milan, Boccioni added a distinctly Italian touch to progressive sculpture. The Russians in particular, already an important source of innovative ideas in Paris, made Moscow an eastern counterpoint. Wherever sculpture eschewed these centres of influence and sought its regeneration directly from purportedly "primitive" sources – as did the Expressionists of the German group Brücke – it ended up within the confines of a narrowly defined and barren modernism.

**Paul Gauguin**
"Soyez amoureuses, vous serez hereuses" (Be in Love, You Will Be Happy), 1889
Painted wood relief, 95 x 75 cm
Boston (MA), Museum of Fine Arts, Arthur Tracy Cabot Fund

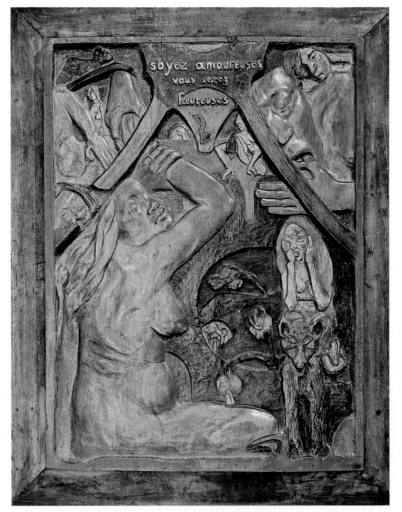

## Primitivism: a New Ideal

A key aspect of modern sculpture in its early stages was the discovery of tribal art. Shortly after the turn of the century, it was not, strictly speaking, a new discovery. After all, the ethnographic museums of Paris, London, Berlin and Dresden already possessed vast collections of masks, ancestral figures and totem poles from Africa, Oceania and Indoamerica. What was new was the way in which artists now regarded the aesthetic qualities of these objects. What was also new was the misplaced adulation of the primordial, natural and primitive qualities projected onto the highly conventionalised art of "indigenous peoples".

Admittedly, the allure of Roussean simplicity and Nietzschean barbarism and the appeal of the primordial and the instinctive, of vitality, youth and strength already informed the spirit of the time. It was only now, however, that these found an echo in the long-disparaged "fetishes" of an exotic art. Only now did "primitive" art come to be regarded as a fountain of youth at which a jaded European art might sup, having found in art nouveau, despite its charming embellishments, only the superficiality of stylisation. Only now was tribal art seen as the cure-all for an academically exhausted Graeco-Roman tradition. The rhythmic proportions of African wooden sculptures, their figures standing firmly on legs set parallel and slightly bent at the knee, offered an alternative to the classical contrapposto. Under the influence of the masks, a bold new formulation of the human face began to appear. Above all, however, the technique of *taille directe*, involving directly sculpting and carving out of the wood or stone, gained impetus against the surface effects of "smeared modelling" and the pointing machine, going even further than the over-intellectualised reforms posited by Hildebrand and Joseph Bernard.

The sculptor Henri Gaudier-Brzeska stated in 1914 that the sculpture he admired most was the work of master craftsmen, in which every inch of the surface had been chiselled, every blow of the hammer involved physical and intellectual effort, and in which there was no longer any arbitrary transposition of a design into some material or other. *Taille directe* and an appreciation of material properties that went beyond the choice of "appropriate material" called for by Gottfried Semper and the Jugendstil artists were the most advanced achievements of sculpture around 1910.

A reduction to block or pole was another innovation to be learned. Not that all such works were based on an African or Oceanic model. Brancusi's *Kiss* of 1908 (p. 425), for example, translates Rodin's extroversion of the fleeting moment into a solid Ur-form. On the other hand, not every source of inspiration meant reduction. Picasso, who in 1912 drew a parallel between the protruding cylindrical eyes of a West African Wobe mask and the resonator of a guitar, was taking a formal analytical approach rather than a primitivist one. Even Lipchitz, Henri Laurens and Ossip Zadkine, who modelled their cubist figures with short legs, long torsos and large

heads according to African proportions, turned against the formal canon of classical antiquity without seeking regression. In this respect they differed fundamentally from the founding father of all primitivist movements – Paul Gauguin.

"The Greeks are the great mistake. We have to go back beyond the horses of the Parthenon to the rocking-horse of our childhood," wrote Gauguin, underlining the biogenetic theory of Ernst Haeckel, which was prevalent around the end of the 19th century. Haeckel maintained that the development of human civilisation from pre-history to modern times echoed the development of the individual from child to adult. "Indigenous peoples" were, accordingly, still at the "childhood" stage. How easy for the colonialists to declare such children incapable of reasoned thought and responsibilty. And what motivation for Gauguin to seek the paradise of his own childhood among the "savages"! In 1894 he finally travelled to the South Seas to capture images of Tahitian women by the most progressive symphonies of line and colour that European painting had to offer. His sculptures of clay and wood, on the other hand, possess that savage, barbarian edge that he associated with the primordial. Even the ceramics he produced in Brittany before his first voyage to Tahiti in 1891 recall his childhood in exotic Peru. His self-portrait in the form of a tobacco pot is reminiscent of the moulded portrait pots of the pre-Columbian Mochica civilization – a compressed block bearing the facial traits of Gauguin, thumb in mouth like an infant.

His wood relief *Soyez amoureuses et vous serez heureuses* (ill. left) shows the same infantile regression, with its elements of childhood and early civilization, Peru and the dreamed-of South Seas. Under the thumb-sucking self-portrait a Peruvian mummy from the Musée de l'Homme flows into an embryonic position. On Tahiti and Hiva Ova Gauguin carved Polynesian deities in relief on a solid, cylindrical form in the style of the Marquesan Tikis. He also portrayed idols in Buddha-like positions with oversized heads and inserted cannibalistic filed teeth and Marquesan tattoos (ill right). In adopting the idol he updated a sculptural archetype which, in Europe, had been relegated to the field of folk art for more than a thousand years. This marked the beginning of a long line of idols, totems and fetishes that were to be leitmotifs of surrealist art and of 1950s American sculpture.

In 1906, three years after Gauguin's death on the Marquesas islands, a major memorial exhibition was mounted in Paris. It marked a fulcrum point between Post-Impressionism and the young avant-garde that included Picasso, Brancusi and Matisse. The following year, Picasso carved a number of rough and simple pole figures, their limbs barely articulated and closely bound to their bodies. Following Gauguin, Picasso reduced the type of sign-covered and precisely structured Marquesa Tikis to a massive primary style whose most distinctive feature is its solidity and idol-like rigidity.

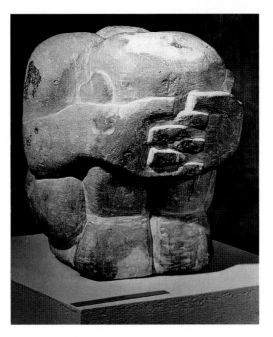

"One must seize nature in her economy, her course, her imaginative process. In other words, one must adapt her style, putting oneself in the interior of this style instead of trying to recopy the effects, the externals."
ANDRÉ DERAIN

**André Derain**
Crouching Figure, 1907
Stone; height: 33 cm
Vienna, Museum moderner Kunst

That same year, André Derain created his *Crouching Figure* (ill. above) with only a few markings in the stone, knees drawn up, head in hands, hands clasped like angular brackets. Here, the block is a cuboid formal principle that integrates the human figure. Rigid concentration on the primordial form of the limestone and the tangible core is turned against the fluidity of Rodin's visual sensations and spans an arc to Aztec figures of divinity and Egyptian block statues. The extreme radicalisation and sublimation of this principle was achieved in the autumn of 1907 with Brancusi's *Kiss*, which was presumably created under the influence of Derain. It uses the block to portray the duality and oneness of man and woman, and may be regarded as the manifesto of Brancusi the sculptor as opposed to Rodin the modeller. It is a seminal work of modern sculpture and can be seen as the very foundation of its renewal on the basis of elementary forms and *taille directe*. Generation by generation, the early work of Henry Moore, Fritz Wotruba and Ulrich Rückriem firmly established this approach and translated it into the language of the 20th century.

Although, according to Epstein, Brancusi actually destroyed some of his sculptures which he felt were all too "African", his interest in this aspect was evident from 1913 onwards. Wherever the material used is wood and is cut along the grain, the work has a distinctly African feel. In 1913, Brancusi created his first wood sculpture, *The First Step*. The axial rounding of the body, the egg-shaped head, the triangular mouth drawn upwards, and the sharply undercut eyebrows would appear to be based on a Bambara figure in the Musée de l'Homme.

In 1914, Brancusi destroyed the body, leaving only the head intact with the title *The First Cry*. A bronze version translated the African influence into the harder medium of brightly polished metal and pared the form

**Paul Gauguin**
Idol with Mussels, 1892
Ironwood and other materials
Heigth: 27 cm, diameter: 14 cm
Paris, Musée d'Orsay

down to that of the primordial egg, which was to remain the symbolic basic figure of Brancusi's sculptural œuvre from then on. Haeckel's biogenetic theory of the correlation between the first step or first cry of a child and alleged early tribal history proved an invariably fruitful comparison in the field of sculpture.

From 1909 the Italian artist Amedeo Modigliani had a studio beside Brancusi's in the rue Montparnasse. An impassioned sculptor, ill health and lack of money had obliged him to turn to painting instead. Of his sculptures, 23 *Heads* and two *Caryatids* have survived. Their relationship to architectural works remains to be clarified. Were they intended, for example, to adorn the portals of an envisaged temple?

Modigliani, eight years younger than Brancusi, had very probably become aware of African sculptures before the two artists met and became friends. What fascinated him was not so much their crude and elementary aspects as their refined sophistication and even elegant stylisation. In his paintings he would combine this with individuality and psychological analysis. The limestone *Heads* (ill. right) he created between 1909–1914 show the same extreme elongation, smooth roundness, graphic scoring, narrow bridge-like nose and isolated round mouth of the masks of the West African Baule, Guro and neighbouring tribes. Modigliani pares down the traits of the masks into unpretentious, expressionless faces in which nothing has been left to chance, reducing

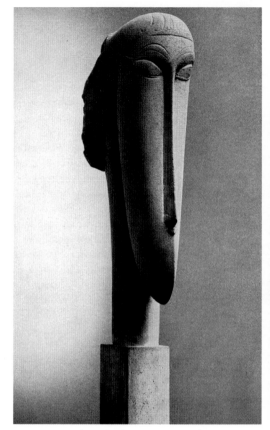

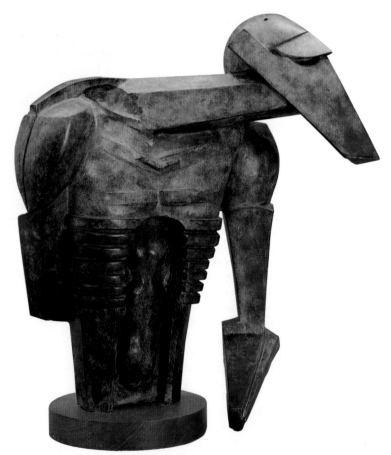

them to pure symmetrical axiality, strengthening their vertical rhythm and placing the head on a cuboid base to stabilise the sweeping curve. This marks a bold development towards the enigmatic in comparison to Brancusi's 1907 *Head of a Girl* which, together with the African masks, foreshadows Modigliani's *Heads*.

In the years running up to the first world war, there was hardly a single progressive sculptor in Paris who ignored "primitive" art, and few indeed who would admit to having been corrupted by the classicism of Rodin's modelling. Yet their motivations differed widely. Picasso and Brancusi made no attempt at the impossibility of identifying fully with it. Freundlich worked in a studio alongside Picasso's in the Bateau-Lavoir for a few months in 1908 and spent most of 1910–1914 in Paris. The rugged architectonic syntax of his *New Man* (1912) in all its monumentality is derived from the huge Easter Island heads and is his distinctive contribution to a primitivist concept of man with a cosmic dimension. In 1937 his sculpture was shown on the cover of the catalogue of the Nazi exhibition of "Entartete Kunst" to illustrate the epitome of "degenerate art".

Others used tribal art as a syncretic escape from their own era. Instead of addressing the conceptual principle, they used it as a source of form and exotic aura. Through their sculpture they sought a freer, wilder, more sensual intensity of life. Jacob Epstein, who visited Paris repeatedly from 1902 onwards, and who became a friend of

Modigliani and Brancusi, unerringly selected and interpreted the sexual aspects of African and Oceanic art in a short-lived, early phase between 1913 and 1915. Sex, pregnancy and birth were presented as phallic visual worlds, while a marble Venus of African proportions set on copulating pigeons demonstrated a new ideal of beauty. Yet even his brilliantly monstrous *Rock Drill* (ill. left) does have a distinct leaning towards Vorticism, which was then the specifically English variation of Futurism, Cubism, Expressionism and Machine Art. After the first world war, Epstein's rough, realistic colossal figures and his dramatic, tension-charged, Rodinesque portrait busts brought him fame and notoriety as a publicly commissioned artist in England.

It is said of his young French friend Henri Gaudier-Brzeska that he wanted to "go native" like Gauguin on a Pacific island and that he had even considered having a 10 cm rod pierced through his nose. He, too, sought new vitality and strong emotive expression in the art of indigenous peoples. It is for this reason that the dynamic Oceanic sculptures appealed to him more than the stringent tectonic approach of African art. From 1911–1914 he worked in England, and it was there, most

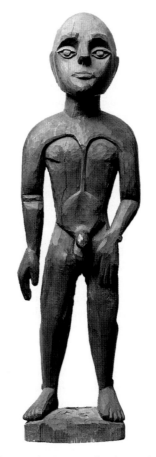

**Ernst Ludwig Kirchner**
Male Nude (Adam), before 1923
Poplar wood, stained brown and
burned, 169.6 x 40 x 31 cm
Stuttgart, Staatsgalereie Stuttgart

*"Sculptural energy is the mountain. Sculptural feeling is the appreciation of masses in relation. Sculptural ability is the defining of these masses by planes."*
HENRI GAUDIER-BRZESKA

notably in the British Museum, that this prodigious and highly talented young artist overcame the "conventional Rodin-Maillol mélange" of his early period. His œuvre as we know it was begun in 1913.

The *Red Stone Dancer* (ill. left) with its maelstrom of arms and hands whirling around a triangular face still has distinct Vorticist leanings, for all its solid force. In 1914, Gaudier-Brzeska created a *Hierarchical Head* of Ezra Pound, who greatly admired the *Dancer*. Its monumentality, forceful verticality and angularity reminiscent of the Easter Island heads merge with a contemporary tendency towards abstract planes and sharp angles. The sculptor fell in action in 1915, before he had quite abandoned the vibrant eclecticism of his youth. He left behind a small œuvre that is paradigmatic of primitivism.

In Dresden, too, the Expressionist artists of the Brücke group approached life through art. They "discovered" the carved wooden beams of the Palau islands and the figures from Cameroon around 1906 (and not, as Kirchner claimed, in 1903) in the ethnographic museum of Dresden. The impact on their work is evident by 1909. Painters and graphic artists, they also carved objects for their own studios. Their sculptures created an exotic atmosphere and homely echo of the paradisical summers spent working and relaxing on the Moritzburg Lakes.

From 1918 onwards, Ernst Ludwig Kirchner began furnishing his farmhouse in Davos with items he had

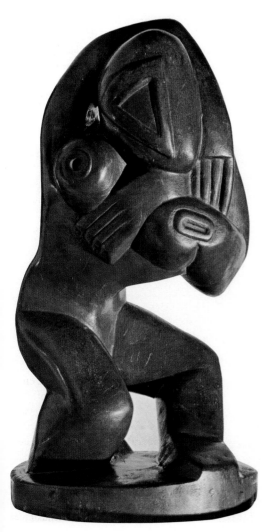

**Henri Gaudier-Brzeska**
Red Stone Dancer, 1913
Waxed stone, 43 x 23 x 23 cm
London, Tate Gallery

fashioned and carved in Swiss pine, including a bed, mirror frames, a fireplace, some of them borrowing from the iconography of Cameroon house posts and chieftains' chairs. European peasant art and African tribal art were meant to evoke a primordial and natural ambience for this nervous and highly-strung artist. In this respect, the carvings of the Brücke artists were intended for their own personal use and had little impact on the history of modern sculpture as such.

Nevertheless, Kirchner, Heckel and Schmidt-Rottluff did lend some weight to their sculptural œuvre. Kirchner, especially, who is known to have produced more than a hundred carved works (ill. left) repeatedly remarked on the significance of *taille directe* woodcarving for the creative process. In a letter to Gustav Schiefler in 1911, he wrote "... it is a sensual pleasure when, blow by blow, more of the sculpture grows out of the trunk. In every trunk there is a figure; it just has to be peeled out." This corresponds almost exactly with remarks made by Michelangelo on the way he related to the block of marble he was working. It is one of the most fundamental experiences of the sculptor, as opposed to the modeller, and one that influenced Kirchner's Swiss followers Hermann Scherer and Albert Müller. Half a century later the painters Georg Baselitz and Markus Lüppertz were to return to Kirchner's heavy figural style.

Of all the Brücke artists, it was Karl Schmidt-Rottluff in particular who looked to sculpture in his search for a means of expressing the spirit of his age. His *Heads*, all of which were produced during the first world war, found

their precursors in Carl Einstein's 1915 publication *Die Negerplastik* (Negro Sculpture). They heighten the concave structure of Fang reliquary figures from Gabon into an excited and ecstatic formal language. Whether or not the wooden figure of the *Worker Wearing a Cap* (ill. below left) is derived directly from a Congolese chieftain figure, the dignity of the crouching figure of authority is turned into its very opposite, and the cut edges of the amputated thighs emphasise the helpless isolation of the torso, while the open hand suggests, all the more poignantly in 1920, the begging of the warwounded. The African seated figure is linked with a leading theme of Expressionist humanity. Karl Einstein's harsh verdict that "Exoticism intoxicated the Saxon primitives for their lack of visual imagination" certainly does not apply in this case.

## Brancusi: Being and Form

For the Romanian artist Brancusi, primitivism was only one side of the coin. In his work, African influences merge with the heritage of Romanian folk art. It is a heritage that Brancusi, who arrived in Paris in 1904, having walked all the way from Bucharest via Vienna, was to carry with him always. African art, on the other hand, was a source he used sparingly. Between 1913 and 1923 he carved and sculpted wooden figures that were almost ungainly, additive, bizarre, bound and notched. They evoked a dissonant counterworld to the purity of form that predominates in his œuvre. Such titles as *Adam and Eve*, *The Prodigal Son* (p. 425), *Chimera* or *Witch* indicate that we are dealing here with an animalistic, grotesque,

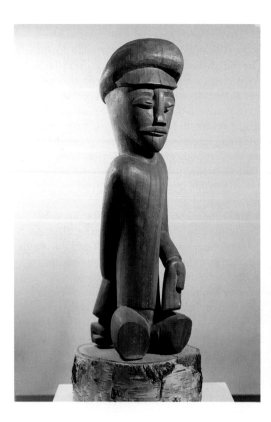

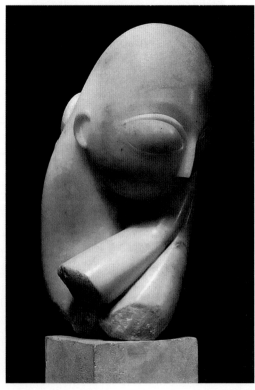

**Karl Schmidt-Rottluff**
Worker Wearing a Cap, 1920
Wood; height: 66 cm
Berlin, Brücke-Museum

**Constantin Brancusi**
Mlle Pogany, 1912
Marble; height: 44.5 cm;
stone base: 15.4 cm
Philadelphia, Philadelphia
Museum of Art, Gift of Mrs.
Rodolphe Meyer de Schauensee

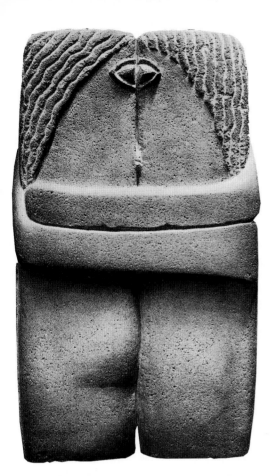

Werner Hofmann described as the "purism of modern sculpture" but set an example for the minimalist serial art of the 1960s.

Yet the art historian's eye does not fully capture the essence of Brancusi's work. Perhaps it would not even be going to far to say that his work is primarily the mystical experience of the world, sensual wisdom of form that is transformed into the spritual. He unerringly and painstakingly seeks an increasingly pure and perfect body of form that is transcendental in its immaculate finish. This has nothing to do with abstraction or even with stylisation, for, as Brancusi himself stated, "my work is aimed above all at realism. I seek the inner, hidden reality, the inner essence of things in their own unchanging nature." Revealing the essence – this is what Brancusi spent almost half a century trying to do. His way of thinking in this respect is close to Eastern philosophy. The architect Alvar Aalto saw Brancusi as the "hyphen linking Europe and Asia". For years, Brancusi

dark and even demonic world, from which Brancusi was to withdraw in 1922. With few exceptions, these works in wood were never cast in bronze, a material that would have dissolved their materiality through reflection. When Max Ernst gave the older artist a wooden arm of African origin, Brancusi threw it over the fence like some menacing fetish. There was no room left in his spiritual universe for the dangerous vitality of magically charged African sculpture.

Brancusi's star lit a different path. He began by making vivaciously academic busts and sensitively modelled children's heads in the manner of Rodin or Medardo Rosso. The turning point came in 1907. It was the year in which Picasso painted his epoch-making *Demoiselles d'Avignon* (pp. 68, 69) and the year in which Brancusi created his own incunabulae of modernism. The *Head of a Girl* (now lost) was his first sculpture directly hewn in stone. The extreme simplicity of the figure *Prayer* vindicated its own scuptural existence. The historical watershed can be identified most clearly between Brancusi's *The Kiss* (ill. above) and the romantically exalted *Kiss* created twenty years earlier by Rodin. Romanian-born Brancusi surmounted Graeco-Roman tradition with his programmatic return to the stone and the block, arriving almost directly at the emblematically abbreviated sculptural sign. At the same time, he established the only independent counter-position to the Cubist fragmentation of form. He thus founded not only what

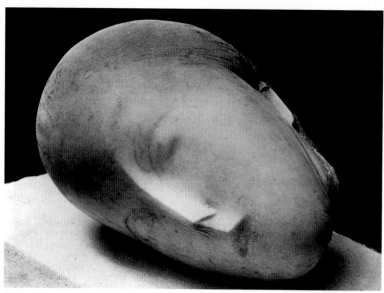

**Constantin Brancusi**
Sleeping Muse, c. 1912 (?)
Marble, 27 x 30 x 17 cm. Paris, Musée National
d'Art Moderne, Centre Georges Pompidou

**Constantin Brancusi**
The Gate of the Kiss, 1937/38
Stone, 513 x 654 x 169 cm
Tîrgu Jiu (Romania)

kept the autobiography of the 11th-century Tibetan ascetic Jetsun Milaresa under his pillow. Yet, as a sculptor, he remained far removed from the esoteric mysticism of some of his interpreters.

The block, the cylinder and the pyramid make up Brancusi's elementary vocabulary. By 1909 at the latest, however, he had found his most important archetypal form, the elongated sphere. It was not the definitive and unchangeable ideal of the sphere, but the moving and changeable ovoid – Goethe's "vitally developing form", Ezra Pound's "general key to form, not only Brancusi's, but form as such".

Out of the conventional marble *Sleep* he developed his *Sleeping Muse* in 1909. It is the original image of the reclining head which he translated into a bronze version in 1910, culminating in the very zenith of formal clarity and purity in an alabaster version of 1917 (ill. left). In his *Beginning of the World* the ovoid form melts beyond all physiognomic connection with the cosmic egg of which the Upanishadi speak. The *First Cry* links it again with its "African" counterworld that is, after all, more than just diametrically opposed. By 1910 it had entered the body of the fairytale bird *Maestra* – the forerunner of all Brancuis birds, through to the metaphors of flight and boundless elevation in space. Head, bird, swan, fish and seal – all variations on the living Ur-form that is contained within the ovoid, or egg.

No other sculptor of the 20th century turned again and again to the same motifs the way Brancusi did, obsessively and patiently varying the same motif in polished bronze, in white, black, yellow or blue marble, or in alabaster. It was not, as he himself stated, a question of doing the same sculpture again, but of moving on. However clearly his reductive, essential style may have been distilled by 1909, and however obvious it may have remained with minor changes, Brancusi kept moving on. Moving on towards the ever more perfect form, until the well-groomed, large-eyed head of his 1912 *Mlle Pogany* became, in the bronze version of 1931, a sheer dome over a fan of soaring arches (p. 424 below right). Moving on until the *Maestra* bird of 1910 became an ever more slender spindle, flashing in its verticality like a soaring bird, the very essence of flight condensed within a single feather.

Constantin Brancusi once told Carola Giedion-Welcker that "All my life I have sought the essence of flight. Flight, pure joy!" Which explains the mirroring dematerialisation, first in the shimmer of marble, then in the lucid reflexes of polished bronze that refract the surrounding space like a vision. A photo by Brancusi of a "bird in space" dissolves the sculpture into kinetic variations. In the end, he places bronze sculptures on blank steel sheets so that their optical echo fluctuates reciprocally.

The Tîrgu-Jiu ensemble, a war memorial, monumentalises this tendency. The decisive factor is the order. It begins with the *Table of Silence* and its twelve

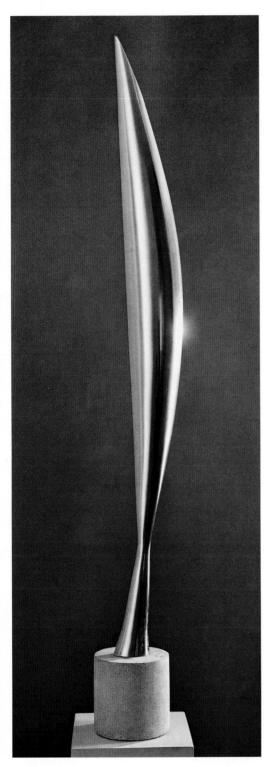

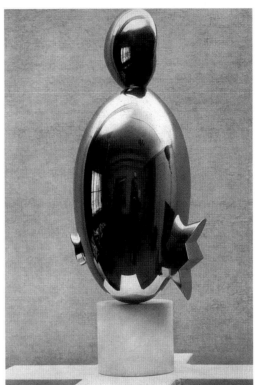

**Constantin Brancusi**
Blonde Negress, 1926
Polished bronze, 38.5 x 14 x 18 cm
San Francisco (CA), San Francisco
Museum of Modern Art

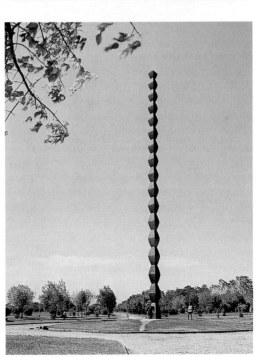

**Constantin Brancusi**
Bird in Space, 1928
Polished bronze; height: 137.2 cm,
circumference: 9.5 – 37.7 cm
New York, The Museum of
Modern Art

*Left:*
**Constantin Brancusi**
Endless Column, 1937
Cast iron; height: 29.35 m
Tîrgu Jiu (Romania)

massive stone seats as satellites forming a circle of calmly poised equilibrium. It continues with the *Gate of the Kiss* (ill. left) representing the rite of passage to a higher plane of reality and ends where there is no end – in the *Endless Column* (ill. above) of stacked pyramids which, for Brancusi, touch the heavens. Ira Klein was reminded of a stairway to heaven and recognised in it a transitory quality as meta-operator to an infinite cosmos. Other researchers see in it, more simply, a derivation from Rumanian balustrade pillars. American minimal artists adopted the principle of seriality pragmatically, without any cosmic ambition. Today, Brancusi stands for both – the mystic and the sculptor who inspired emotive faith and artistic strategy.

*"I have turned to sculpture when I
was tired of painting. For a change
of medium. But I approached sculp-
ture as a painter, not as a sculptor.
Sculpture does not say the same as
painting. Painting does not say the
same as music. These are parallel
paths, but they should not be
mixed."* <span style="font-variant:small-caps">Henri Matisse</span>

## Matisse: Modelled Space

The painter Henri Matisse, unlike the painters Gauguin
and Picasso, played only a brief role in the historical
development of sculpture. His bronze statuettes and
heads after 1900 reflect the motifs and formal problems
of the painter. In short, their bronze outer skin reflect-
ing the contours of an inner dynamism had distinct
leanings towards the work of Rodin. But then Matisse
created a few sculptures of enormous spatial astuteness
which placed him at the cutting edge of the artistic
avant-garde for a number of years. By 1907, his sculpture
had become Fauvist, as evidenced by the sheer force of
his *Reclining Nude* with its twisted, distorted, ex-centric
anatomy. From the strong upward and outward thrust of
the pelvis, structured by the upper torso and limbs, the
entire body writhes and stretches in a purely sculptural
rhythm, going far beyond the photograph on which it is
based (though the artist does adhere to it closely). Here,
distortion becomes a means of expression and decora-
tion alike, both of which are central concepts in the
work of Matisse.

Two years later, he was to pare down the harmo-
niously curved statuette *La Serpentine* (ill. above right)
with its Hellenistically influenced pose, to a torso and
limbs of almost identical proportion. The volume is
extended to a linear figure which underlines the inner
space between support, body, bend of arm in much the
same way that it draws out the arabesques of the con-
tour. In this work, Matisse introduces what is to be the

major theme of the following decade: the permeation of
the body with space.

In 1910/11 he then modelled the first of his four heads
of *Jeanette* with a fifth, his boldest of all, following in
1913. They mark a departure from the Rodinesque true-
to-life portrait, and a move towards the kind of free
transformation and asymmetrical distortion of the phys-
iognomic topography that does not even stop at rough
incisions in the skull (ill. above left). Masses become
sculptural energies which Matisse cloaks, shifts, merges
or enhances. It is a freedom that echoes the spirit of
Picasso's 1909 *Head of a Woman*, albeit without even
seeking the latter's early Cubist systematic facetting. In
the important series of heads by Picasso, Brancusi,
Duchamp-Villon, Modigliani and Boccioni that mark
the beginning of modern sculpture, Matisse's *Jeanette
I–V* command a key position.

## Picasso the Groundbreaker

It would undoubtedly be wrong to regard such sculptors
as Maillol, Barlach or Lehmbruck merely as followers-
on. Their sculptures possess a formal stringency that sets
them apart clearly from the art of the 19th century, even
without any radical process of abstraction. Nevertheless,
the revolution of modern sculpture breaks through in
other areas as well. The most far-reaching development
set in before 1910, almost as a by-product of painting.
Indeed, the major stimuli are to found concentrated in
the work of a painter who was to return to his easel in

1914 for another fifteen years, only to turn once more to sculpture around 1930 to take his art in a new direction yet again. That artist was Pablo Picasso.

The focal point was still the omnipresent Rodin. With his *Monument to Balzac* he had shown how a head can be forged out of hollows, mounds and furrows and how the artist's hand could model it until it took on on its own potent sculptural life. In 1909, Picasso created a *Head of a Woman* (ill. below), presumably his mistress Fernande Olivier. From a sinewy neck the furrowed physiognomy spirals upwards to the softly rounded pillows of her hair. A number of individual particles of form structure the head into concave and convex areas. The alternation of light and shadow thus takes on a rough regularity. The modelling follows neither bone structure nor epidermis, being built up instead of sharply angled sculptural curves and incisions. The same sweeping curve can indicate an eyebrow, a cheekbone or a nose. Convex areas – forehead cheeks, throat – seem concave. It is the position alone that leads the eye back time and time again from ambiguity to unequivocality. This is a tension that will later influence Cubist sculpture.

What had happened? Picasso subjected the head to an alternation of convex and concave forms. He did not stylise it or heighten it expressively, but consolidated form instead within its own early Cubist system. Instead

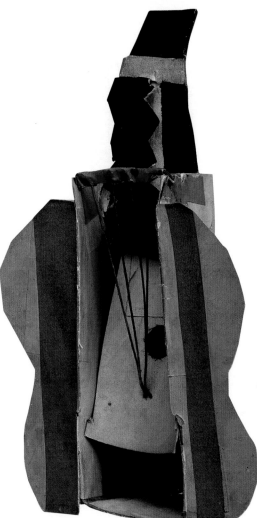

*"Cubism is neither a mustard seed not a foetus, but an art in which the main issue is form, and once a form has been created it is there and it lives its own life."* PABLO PICASSO

of imitating form, he recreated it. It is this freedom that explains the significance of the work, which Werner Spies has claimed to be as important to modern sculpture as the epoch-making *Demoiselles d'Avignon* (pp. 68, 69).

All things said and done, however, the *Head of a Woman* was still the product of traditional modelling techniques. Although it stands at the beginning of a new sculptural emancipation, it can also be seen as the conclusion of Picasso's early bronze-cast sculptures. Three years later, in 1912/13, following a phase of intensive painterly exploration, Picasso constructed a guitar out of layers of sheet metal, creating a *bricollage* rather than a picture. The resonator is not a depression, but a protrusion (originally a stovepipe) in the form of a cylinder. Seen from the front, it can be read as a resonator. The negative and positive forms are merely reversed. Other guitar reliefs vary the strings and the resonator board, have zigzag folds or play with the appeal of variously coloured cardboard (ill. above). The unified surface of the image is surmounted, as is the imitative or imaginative modelling of mass.

Rarely has such a seemingly marginal innovation had such a major impact. What was intended as a

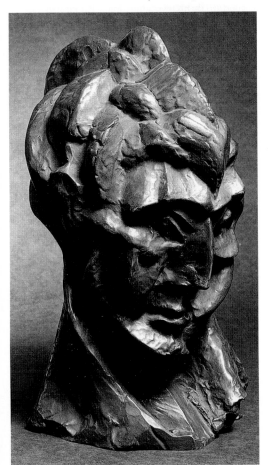

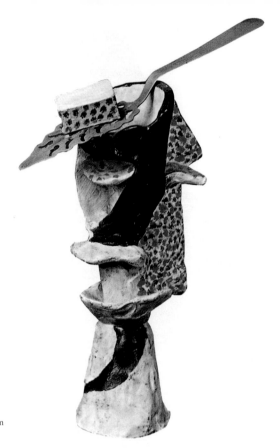

**Pablo Picasso**
Glass of Absinthe, 1914
Painted bronze after a wax
maquette with silver absinthe
spoon, 21.5 x 16.5 x 8.5 cm
New York, The Museum of
Modern Art, Gift of Mrs. Bertram
Smith

figures, standing and reclining, prior to 1906/07, with
their elongated, snaking limbs, remained demonstra-
tively distinctive extremes of modelling that seemed to
be both a continuation and a correction of Rodin at one
and the same time. Even the older Medardo Rosso, who
made the wax surfaces of his scenes and heads receptive
to the oscillations of the surrounding space and the sub-
tle dissolution of form, was to all intents and purposes a
modeller. The task of inextricably merging figure and
space was the issue of the day. Yet it was the Cubist frag-
mentation of form that first gave artists the tools with
which to do so.

Another seminal innovation by Picasso (and Braque)
has almost the intimacy of chamber music. With their
*papiers collés* and their implantation of real objects such
as oilcloth, basketweave or turned wood, they shattered
the material unity of the picture in 1912. Quotes from the
studio environment replaced pure depiction. It was a
cautious step towards the material world, for it still
remained within the scope of a formal artistic unit. It
was Duchamp who first opened the floodgates for the
century's deluge of object citations.

Picasso, however, had prepared the ground. In 1914,
he made six casts of his *Glass of Absinthe* in bronze from
wax models (ill. left) and painted each of them differ-
ently. He then placed a real absinthe spoon, an everyday
object, on each of them, as a pointer towards the world
beyond art. By his own admission, what Picasso was
interested in here was "the relationship between the real
spoon and the modelled glass". This interest is at the
basis of all assembled and combined sculptures, assem-
blages and collages that combine art with fragments of
reality. Picasso stands at the beginning of a rapidly
spreading line in which the artefact and the *factum bru-
tum* come together. He thus stands at the beginning of a
new and fundamental freedom in the field of sculpture.

The genius of Picasso thus condensed the most
advanced problems of sculpture within a period of just
four years. He made seemingly nonchalant contribu-
tions that were adopted, developed and expanded. Not
all sculptors took them up, however. Brancusi contin-
ued to pursue his own path, while Lehmbruck clung to
tradition. Yet most artists, even the strongest talents,
realised that sculpture was undergoing what Werner
Hofmann described as a "sound shift" from which a new
language would emerge. Picasso himself did not actually
use that language. Its most verbose and eloquent propo-
nents, innovators and poets were others.

### Archipenko: Emancipation of Empty Form
The Russian artist Alexander Archipenko arrived in Paris
in 1908 at the age of twenty. From 1910 onwards he
worked at developing his own style of stereometrically
simplified physical volumes, upwardly spiralling figures
incorporating the wedges, acute angles and crystalline
breaks out of the Cubist inventory and involving some
Mannerist borrowings. In 1912 Archipenko recognised
his true theme to be the interaction between volume and

critical correction of painting, as a studio experiment,
proved to be a new foundation for sculpture. At one fell
swoop, the centuries-old distinction between a sculp-
ture created by adding clay or plaster and a work of plas-
tic art created by removing stone had become redun-
dant. When space, volume and three-dimensionality are
made up of planes and surfaces, the modelling hand and
the chisel are no longer needed. Admittedly, this did not
mean that the organic swell of the corporeally rounded
or the cubically hewn volume disappeared completely.
From here on in, however, the new principle would con-
tinue to front developments time and time again, in the
work of such diverse artists as Gabo and González,
Anthony Caro and Richard Serra. Picasso himself was to
heighten his sheet-cut sculptures to the point of monu-
mental silhouettes.

The intervention of painting did not end here.
Beginning in 1909/10, Picasso and Braque opened up the
unified surface of the painting, fragmenting it and splin-
tering it in their cubist works. What remained legible of
the subject matter in their portraits and still lifes was
spatially embedded in rhythmic layers and permeated by
space. When sculptors such as Archipenko and Boc-
cioni began creating voids in their figures and integrat-
ing the surrounding space, activating it and charging it
with its own sculptural energy, they used the cubistically
broken surface of the picture as their magic formula.

The art historical aim of going beyond the compact
core figure had already been formulated by Henri
Matisse years before. Yet his sweepingly gestural female

**Alexander Archipenko**
Walking Woman, 1912
Bronze; height: 67.5 cm
New York, Perls Galleries

space. With that, he became one of the most important of European sculptors for a number of years, shifting the focus of Picasso's casual pointers from the no-man's land between painting and sculpture to the very centre of plastic art and systematically exploring individual aspects of it.

It would be unfair to regard Archipenko's later tendency towards decorative synthesis and his academic approach to his own innovations as in any way diluting the force of his contribution to modern sculpture. He forged ahead in his *recherche des formes* at a very early stage and with the utmost radicality. No other sculptor, with the possible exception of Boccioni, took such an absolutist approach to the question of space, which was the key issue of the decade. No other artist drove the interaction of volume and space so distinctively in the direction of the expressive, lyrical, dynamic and statuary. The fact that some of his work, even that produced at the height of his creative powers, appears almost didactic and schematic to us today, lies to some extent in the fact that it was rapidly emulated by a large following on a broad basis, even in the field of applied arts.

Nevertheless, some important sculptures remain. In his *Dance* (1912) a vibrantly soaring inner space is framed by the arabesque of the couple. In his famous *Boxing Match* (1914) the boxers are reduced to colliding, clenched wedges. Muscles are replaced by the flow of

**Rudolf Belling**
Triad, 1919
Bronze, 91 x 73 x 80 cm
Saarbrücken, Saarland-Museum
Saarbrücken

**Alexander Archipenko**
Marching Soldier, 1917
Bronze; height: 116.8 cm
Private collection

**Alexander Archipenko**
Médrano II, 1913
Painted sheet metal, wood, glass and painted oilcloth, 126.6 x 51.5 x 31.7 cm
New York, Solomon R. Guggenheim Museum

## Boccioni and the Futurist Vision

Boccioni's sculptural œuvre is exceptional. It stands out even among the work of the many pioneering artists prior to 1914. As a thirty-year-old artist who had devoted his energies to the boundlessly ambitious Manifesto of Futurist Painters (p. 86), presenting one programmatic work after another within the space of just two years, he now turned his attention to the revolution of sculpture. In April 1912 his Manifesto of Futurist Sculpture was published. Between the summer of 1912 and the spring of 1914 he created no fewer than fourteen sculptures in a period of intensive and concentrated work. Five of them have survived, seven are known only from photographs. Each one directly addressed the issues of the day in the field of sculpture and each one offers some fundamental

rhythmic energies. The volumetric masses follow the lines of movement. In this, Archipenko takes an enormous step towards the kind of expressive plastic art that Rudolf Belling emancipated completely from its anthropomorphic context in 1919 with his *Triad* (p. 431 below).

Apart from these sculptures which heighten the stylistic means of Cubism to the point of the expressive and energetic, as of 1912 there was also a tendency towards the formation of concave and convex curves, an aesthetics of the void by which, according to Heinz Fuchs, "plasticity of form is rendered tangible through its matrix". Archipenko developed his own theory of complementary forms based on the maxim that each empty space produces its imaginary counter-image. His theory is boldly illustrated by his 1912 *Walking Woman* (p. 431) in which, for the first time, he simply presents the head as a negative form. Another far-reaching conclusion that Archipenko drew in 1912 from Picasso's *Constructions* (or perhaps it was a conclusion he reached entirely independently) can be found in his *Médranos* – puppet-like figures made of wood, glass metal, wire, spheres, cones, cylinders, discs, activated by polychromatic painting. Here, too, Archipenko was the first to fully exploit the possibilties of montage, uniting formal stringency with irresistible wit.

contribution towards clarifying the ongoing discourse in that field. Some of them articulated a new formal language for sculpture that was to have repercussions far into the future. Whereas Picasso, almost the same age, re-founded sculpture within painting, Boccioni set out systematically to explore a new route of his own.

From the autumn of 1911 he acknowledged the priority of Cubism. At the same time, he was aware of the extent to which the generation and permeation of Cubist form could serve his own purposes. His criticism was aimed at the studio as ivory tower, cloistered from the industrial, urban, exhilarating modern world that he felt should inform paintings and sculptures alike. In his manifesto he therefore announced that figure and ground should go together (the Cubists had shown the way) and that the entire environment should penetrate the sculpture. He was strengthened in his resolve by another Italian artist, the subtly Impressionistic Medardo Rosso, who had gone further than Rodin in imbuing his street scenes and garden scenes with an atmospheric setting that seemed like a fragile material in its own right, peopling them with chatting groups, bus passengers or readers. Described by Joris-Karl Huysmans as a "Sculpteur de la vie moderne", Rosso lived in Paris from 1889, where he captured fleeting moments of urban genre scenes, children's heads, movement and light. Boccioni admired the continuity of volume and space in his small-scale sculptures, and it certainly suited him to find his own endeavours reflected in the work of a fellow Italian. It was a spark of life in an ossified tradition.

Rosso's rapid and improvisational lightness was, however, an aspect that appealed rather less to this rigorous "engineer of light". In the autumn of 1912, in his first assemblage *Head + House + Light*, Boccioni combined a real balcony railing as a sign of the city with the convulsive half-figure of his mother. Soon afterwards, in *Fusion of Head and Window* (p. 434 above), he crowned the plaster head with elements of a real window-frame and inserted a piece of horsehair and a glass eye. These were precursors of the readymades that Duchamp was to introduce just one year later. Uwe Schneede is right in describing these assemblages – which survive today only in photographs – as modern art's first sculptures of

**Medardo Rosso**
Golden Head, 1886
Wax over plaster; height: 58.4 cm
Private collection

*"The human face is no longer a shell, an immobile form, for nothing is immobile and everything is part of the hurried and manifold improvisations of the universe."*
MEDARDO ROSSO

**Medardo Rosso**
Conversation in a Garden, c. 1896
Plaster, 35 x 66.5 x 41 cm
Barzio, Museo Medardo Rosso

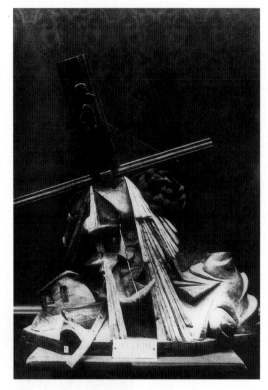

**Umberto Boccioni**
Fusion of Head and Window
Plaster (destroyed). Photograph
Milan, private collection

In a different way, the sculpture *Development of a Bottle in Space* (ill. below) bears the traits of a manifesto in practice. The still life was very much a Cubist domain. Boccioni's arrangement of table, plate, bottle and glass corrects them, as it were, on their own territory. Like all the Futurists, he rejected all that was static and harmoniously calm in favour of speed, movement and departure as metaphors for progress and modernity. In this *Weltbild* time becomes a visible dimension of space. This explains why the fragments rotate around the vertical core of a bottle, why the interior is sliced open, allowing us to see how concave and convex forms, hollows and shells curve within each other, gliding and interacting. This also explains why the frontally fixed bottle appears as an object in motion. The sculpture is the model of a world in which "absolute motion" – the frontal, upright, movement-triggering bottle – and "relative motion" – the circling fragments – are inextricably linked with one another.

Boccioni was not satisfied with this counter-design to the Cubist still life. The Italian in him still sought the great classical human form, even though this Futurist iconoclast considered a racing car more beautiful than the Nike of Samothrace. Is not the dynamically forward-rushing figure – *Unique Forms of Continuity in Space* (ill. right) – with its flame-like, wing-like, elongated muscles, ball-bearing joints, protruding and receding components – a synthesis of Nike, racing car and some future monster? Is this not a sculptural icon on the eve of the Great War whose pathos-laden faith in the machine era was soon to turn to horror?

Was this human whirlwind still too anatomical and not cosmic enough for the other great Futurist, Giacomo

montaged material. In his manifesto, Boccioni (who was killed in action in 1916) took this bold approach one step further: "We reject the exclusive use of a single material. …We maintain that even twenty different materials can be used in a single work to achieve pictorial emotion … glass, wood, board, iron, cement, horsehair, leather, fabric, mirror, electric light etc."

**Umberto Boccioni**
Development of a Bottle in Space,
1912/13
Bronze, 38.1 x 60.3 x 32.7 cm
Milan, Civica Galleria d'Arte
Moderna

*Page 435:*
**Umberto Boccioni**
Unique Forms of Continuity
in Space, 1913
Bronze, 112.2 x 88.5 x 40 cm
London, Tate Gallery

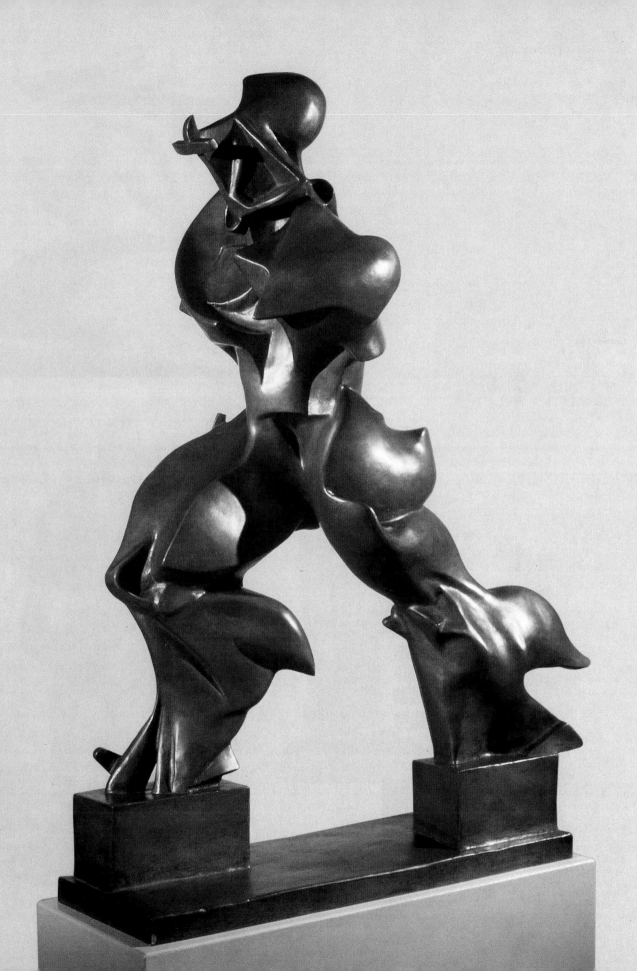

Balla? Is Balla's manifesto, *The Futurist Reconstruction of the Universe*, written in 1915 together with Fortunato Depero, actually addressing Boccioni in stating that "We shall find the abstract equivalent for all forms and elements of the universe. Then we shall combine them in sculptural constructions according to the moods of our inspiration"? Does his 1915 sculpture *Boccioni's Fist* (ill. right) in red-painted board, later cast in bronze, fulfil that statement of intent?

Preliminary drawings document step by step how the abstraction and reduction of the final version was developed out of a running figure with fist alternately extended and drawn back. Yet at the same time, the curves and glistening lines are entirely at one with Balla's *Line of Speed* sculptures derived from cars, aircraft, swallows in flight or stellar orbits. Whereas Boccioni anchors the feet of his figures in heavy blocks, Balla's *Fist* seems to leap up as though on a spring. It thus marks an early milestone on the path towards an abstract and sign-laden sculpture.

In contrast to such effusions, the colourful sculptures of Fortunato Depero (ill. below) seem calm without being static. They are, in contrast, coolly balanced

**Giacomo Balla**
Boccioni's Fist, 1915 – 1917
(Reconstruction 1956 – 1958)
Painted bronze, 80 x 76.2 x 25.5 cm

**Fortunato Depero**
Construction of a Girl, 1917
Varnished wood, 41 x 21 x 14 cm
Rovereto, Museo Fortunato
Depero

**Raymond Duchamp-Villon**
Seated Female Figure, 1914/15
Bronze, gildes, 73 x 22 x 29 cm
Cologne, Museum Ludwig,
Ludwig Collection

"It is impossible to satisfy the demands of today's art with the means of the past alone. We want to include in sculpture the things that sculpture would never have accepted before. Will we fail or will sculpture fail in this?"
RAYMOND DUCHAMP-VILLON

**Raymond Duchamp-Villon**
Horse, 1914
Bronze, 150 x 97 x 153 cm
Antwerpen, Openluchtmuseum
voor Beeldhouwkunst Middelheim

and lead the additive structure, the colority and naive charm of children's toys into the world of modern sculpture.

### Duchamp-Villon and the Mechanisation of Man

Cubism's sound shift had laced the figure into a rhythmic-geometric corset. Cuts, breaks and planes regulated the figure. Taken one step further, geometry became the expressive vocabulary that set the Cubist particles in motion or swept them along. The most frequently voiced criticism of Cubism was levelled at its static nature: it was the most modern form of perception, and yet it did not breathe the stormy spirit of modernity. It studied the world in the laboratory of art, while the world went on living beyond the confines of such still life studies. It undertook fundamental analysis, but applied its findings indiscriminately to man and form. Raymond Duchamp-Villon, brother of Marcel Duchamp, also started out leaning towards Rodin. In 1910 he discovered Cubism and, soon afterwards, the work of Archipenko. In the work of Duchamp-Villon, however, the compositional approach of these artists never tends towards rhythmic planarity, never pushes

aside sculptural dynamics and invariably retains a tendency towards the psychological and physiognomical, which many sculptors at that time were abandoning. This is what makes him such a significant portraitist. The heads of *Baudelaire* (1910), *Maggy* (1911) and *Professor Gosset* (1918) not only illustrate a progressive increase in abstraction, stereometry and furrowing, but also a heightened intensity in the captivating gaze of eyes staring from deep hollows, graduating from the unemotive distance of *Baudelaire* to the idol-like drama of *Maggy* and the monumental division of the Gosset head into a convex forehead and nose and a concave lower face.

His Cubist analysis culminated in the various versions of *The Horse* which Duchamp-Villon created between 1914 and 1918 (ill. above), with obvious borrowings from Archipenko. The *Horse* is made up of straight lines, curves, spirals, hollows and arches. It is a demonic hybrid of gyrating mechanics and animal nature, pistons and organs thrown together in a synthesis of pure sculptural energy. Duchamp-Villon died in 1918 as a result of war-related physical exhaustion. He was arguably the most important sculptor to have become a victim of the first world war.

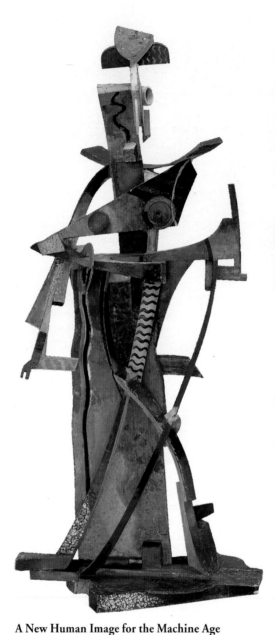

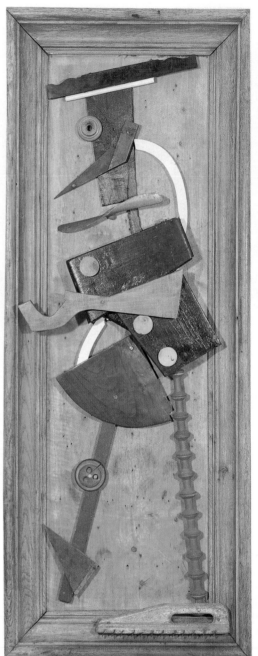

**Vladimir Baranov-Rossiné**
Symphony Number 1, 1913
Multi-coloured wood, painted
board and ground eggshell,
161.1 x 72.2 x 63.4 cm
New York, The Museum of
Modern Art, Katia Granoff Fonds

**Vladimir Baranov-Rossiné**
Counter-Relief, c. 1913
Assemblage; wood and other
materials, 131 x 46 cm
Private collection

*"This is the sinister armoured figure
of today and tomorrow. Nothing
human, only the terrible Franken-
stein's monster into which we have
transformed ourselves."*
JACOB EPSTEIN

### A New Human Image for the Machine Age

From 1912 the human image changed, above all in sculp-
ture. In contrast to the Graeco-Latin tradition, it con-
densed visions of synthesis of man, machine and
mechanics. The spectrum ranges from Archipenko's
witty *Médranos* to the violent pathos and grotesque
deformation of organic contours in Boccioni's flaming
giants of steel who vie with the aircraft and the auto-
mobile. This was Filippo Tommaso Marinetti's vision
of the mechanical superman resisting the shock of
omnipresent speed.

In 1913 Jacob Epstein began his visored, robotic *Rock
Drill* (p. 422). It was originally mounted on a drill base
whose function was transferred in the final, more con-

densed, version to the machine-like right arm. On its
chest, between ribs of armoured steel, it retained its own
(more human?) heirs: armoured knight, miner and
demon of progress in one. In 1914, Raymond Duchamp-
Villon's *Horse* merged the anatomy of the horse (Boc-
cioni's symbol of the emergent city) with the turning,
spiralling components of a machine. Without rider,
without legible movement, this is an independent crea-
ture in which the spiralling energy of a new and vital
creature is condensed. Albert Elsen pointed out cor-
rectly that these metaphors were created beyond the
scope of classical mythological convention and that they
euphorically glorify man and the extension of his powers
by mechanical means.

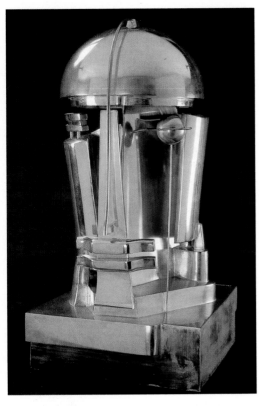

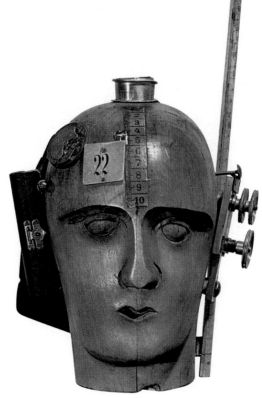

**Rudolf Belling**
Sculpture 23, 1923
Bronze, partly silvered,
41.5 x 21.5 x 23.5 cm
Kaiserslautern, Pfalzgalerie
Kaiserslautern

**Raoul Hausmann**
Mechanical Head (The Spirit of
our Times), 1919/20
Wood, leather, aluminium, brass,
and board, 32.5 x 21 x 20 cm
Paris, Musée National d'Art
Moderne, Centre Georges
Pompidou

Even Alexander Archipenko's *Médranos* (based on a Paris circus) of 1913 are light-hearted puppets somewhere between a child's plaything and a wooden robot, ideal figures of a mechanically controllable, eternally contented population of marionettes. Vladimir Baranov-Rossiné's famous *Symphony Number 1* (p. 438 left) of multi-coloured wood, painted board and crushed eggshells seems to provide an ironic response in a musical figure of abstract forms with the rhythm of broken melody lines and dissonant chords. In 1921, the Dadaist Raoul Hausmann codified the prevailing *Zeitgeist* in his *Mechanical Head* (ill. above right) with tape measure, clock, camera components, number-plate and typographic cylinder. The spirit of the day was metric. In 1923, the brass construction of Rudolf Belling's *Sculpture 23* (ill. above left) combined the rigidity of the mask with technical traits – note the skull as planetarium.

## From Cubism to the Myth of Nature: Lipchitz, Laurens, Zadkine

The Eastern Europe contribution comes from Russia, Lithuania and the Danube monarchy. Oto Gutfreund, a Czech, works for a time in Paris and is one of the first to make use of Picasso's early Cubist example (ill. right). The Hungarian Joseph Csáky (p. 442 right) develops this in a geometric, stream-lined Synthetic Cubism. Jacques Lipchitz (pp. 440, 441) was the most impassioned and versatile of these pioneering artists. In 1913, at the age of twenty, he arrived in Paris from Vilnau (Lithuania) for the second time. The influence of Cubism tautened the serpentine curves of his unruly figures, adding an angu-

*"The sculptor realises an imaginary portrayal within a real space and halts the flow of events by means of spatial materialisation."*
OTO GUTFREUND

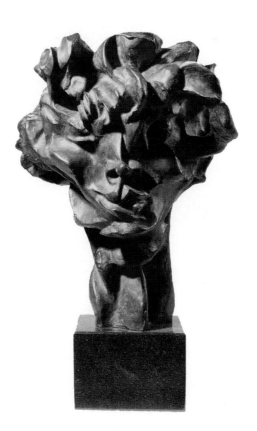

**Oto Gutfreund**
Viky (Cubist Head),
c. 1911–1913
Bronze; height: 33 cm
Private collection

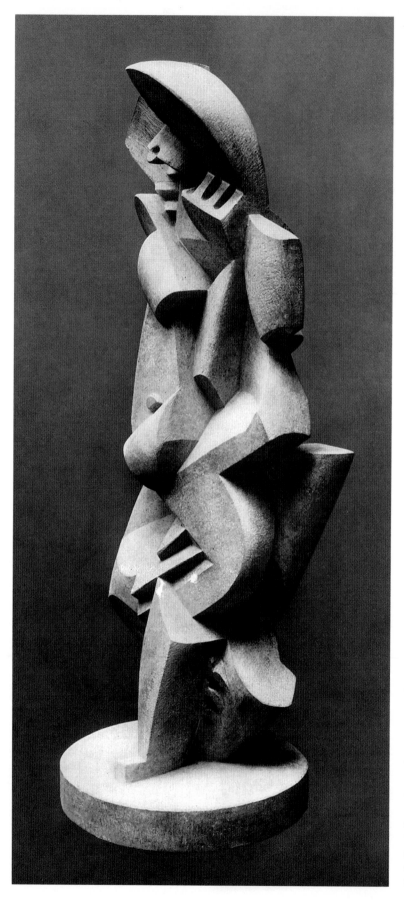

larity of structure to their axial symmetry. Interwoven, rhizomatic forms draw the surrounding space into the torsos and limbs of his sculptures. Yet just one year later, more radical solutions began to take hold. Picasso's step towards planar structure formed the basis for architectonically graduated and almost flat figures in which vertical lines predominate. Then Boccioni, Duchamp-Villon and Juan Gris presented a more nuanced grammar. From 1917 onwards the figures were fugue-like compositions of interactive straight and curved, concave and convex lines in which the axis zig-zigs angularly around a solid core.

Guitar players, dancers, bathers allowed the artist to explore the possibilities of rhythmic movement in harmony with organic and crystalline forms. In the 20s Lipchitz condensed this synthesis into emblematically reduced corporeal signs of concentrated energy. Abstract and later increasingly organic furrows converged in a broad and heavy flow. The rhythm slowed to one of fettered expression – the climax of a genuinely Cubist sculpture going far beyond any formalistic pattern.

After 1925 Lipchitz turned away from Cubism. The flow of organic growth processes took the place of analytic breakdown, just as it had before Cubist intervention. Formal structures took on a duality that gave them a symbolic force generated entirely from their own sculptural originality. The *Large Figure* with its magically staring cylinder eyes is more like an idol, a heavy-set progression of paired forms united beneath the sheltering horizontal oval of the head. Transitions between human, animal and plant forms in such subjects as *Mother and Child* or *The Couple* lead the motifs back to an archetypal foundation. Instead of the formal exercises with guitar-playing harlequins, he now began to address the existential themes that were to occupy him for half a century. These included such fundamental human issues as the polarities of gender, fertility and conflict, as reflected in Jewish and classical mythology.

In the 30s, Lipchitz created undulating figures of baroque exuberance. During the second world war, the harrowing awareness of Jewish persecution changed his figures into monstrous, torn creatures. Surreal cage-bars devoured the surrounding space with sharpened teeth. After the war, this latent pathos was heightened into a sweeping stylistic credo whose drama was sublimated in the pathos of form.

At the same time, of all the sculptors to have passed through Cubism, Lipchitz is the only one to have intervened a second time in the history of sculpture. His Cubist works had already been exceptional for the sheer audacity of their entirely abstract treatment of space. From 1928 onwards he repeatedly condensed the volume of his *Musicians* or *Heads* into narrow bands and serpentines that draw almost signature arabesques in space: scripturally dissolved corporeal signs whose sweeping eccentricity anticipated the metal sculptures of González. For the focal issue of the second decade,

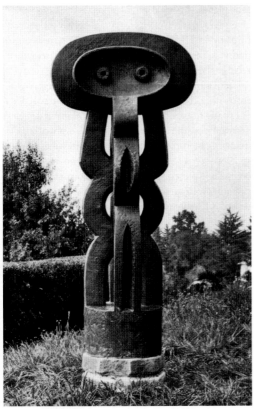

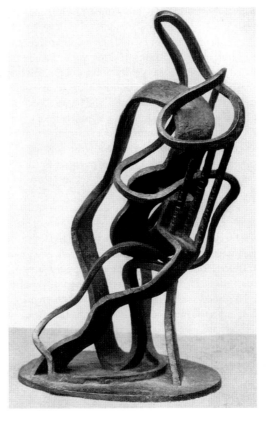

*Page 440:*
**Jacques Lipchitz**
Bather III, 1917
Stone; height: 71 cm
Merion (PA), Barnes Foundation

**Jacques Lipchitz**
Figure, 1926–1930
Bronze, 210 x 100 x 100 cm
New York, The Museum of
Modern Art

**Jacques Lipchitz**
Woman with Guitar, 1927
Bronze; height: 35 cm
Private collection

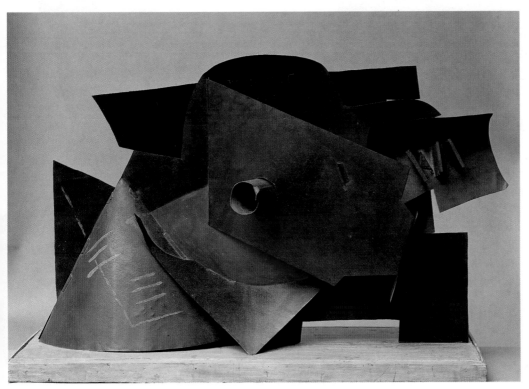

*"I suddenly discovered that volume
in sculpture is created by light and
shadow. Volume is light. In a
smoothly rounded or curvilinear
sculpture the light washes over the
surface and may even diminish or
destroy the sense of volume, the sense
of the third dimension. When the
forms of the sculpture are angular,
when the surface is broken by deep
interpenetrations and contrasts,
light can work to bring out the truly
sculptural qualities."*
JACQUES LIPCHITZ

**Henri Laurens**
Guitar, 1914
Sheet iron, painted; height: 44 cm
Cologne, Museum Ludwig,
Ludwig Collection

namely the flow of space into volume, Lipchitz once again provided an essential solution.

The French sculptor Henri Laurens (pp. 418 and 443) had been a friend of Braque since 1911, yet he did not join the sculptural avant-garde until 1914 or 1915. His first constructions – two wooden clowns of 1915 (p. 418) – are derived from the conically worked and fragile *Médranos* of Archipenko. Yet the search for classical harmony and the sensual vitality of Laurens' work was soon to turn away from hybrid balancing acts and abstract symmetries. He did not radicalise formal elements so much as transpose them into balanced and gracefully bizarre compositions.

Up to 1919 he produced the most persuasive sculptural counterpart to Cubist painting in the form of his still lifes with musical instruments, bottles and fruits, as well as figures and heads resembling vertically elongated still lifes. Picasso's cylindrical, protruding guitar aperture became a leitmotif in what may be regarded as a late echo of the African Grebe mask that had such a remarkable impact on modern sculpture. During this phase, for all his contrasting planarity, crystalline angles, overlapping planes, rhythmic modulations and tension-charged layering, Laurens remained heavily influenced by painting. His constructions, surely the purest contribution to the sculpture of Synthetic Cubism, remained reliefs to be viewed from one angle only.

Yet Laurens, a sculptor through and through, went still further, moving away from material contrasts, planarity and frontality. By 1917 he was working in stone, and exploring the block as an integral sculptural core that was structured, but not dissected, by cubes, angles, spheres or waves. These new sculptures possessed a compelling presence. The simplification of Cubist rhythms created a solid physicality (or vice versa) which, though still adhering to Cubist techniques, became increasingly rounded, mobile and ex-centric in the course of the 30s.

This new, post-Cubist Laurens was one of the greatest and most distinctive portrayers of the female form in modern art. The sheer vitality of his *Hommage à la femme* is surpassed only by Picasso. In the 1930s he transposed massive volumes and moving bodies into serene, playful, dance-like motion. From now on, Laurens pre-

**Ossip Zadkine**
Mother and Child (Forms and Light), 1918
Marble, 58.4 x 50 x 16.7 cm
Washington, Hirshhorn Museum and Sculpture Garden, Smithsonian Institution

**Joseph Csáky**
Head, 1914
Stone, 39 x 20 x 21.5 cm
Paris, Musée National d'Art Moderne, Centre Georges Pompidou

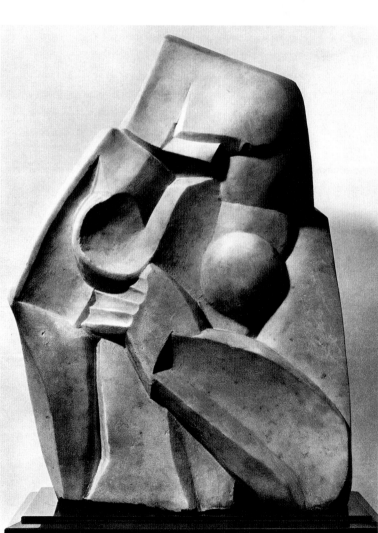

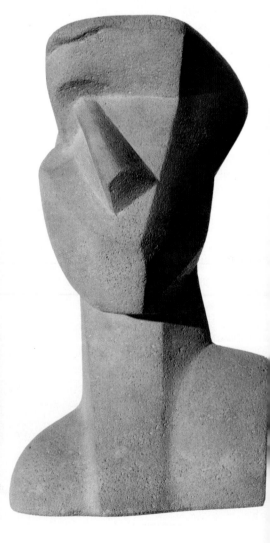

ferred to work in bronze, a material more versatile and vibrant than solid stone. His stretching, writhing, gesticulating bathers and nymphs are swept and flooded by space – voluptuous and graceful goddesses of fertility awakened from the stony sleep of their ancient Mediterranean tradition and brought to life with melodiously vibrant curves. They unite vitality and the immutability of mythical being.

The young Russian Ossip Zadkine (p. 442 and ill. below) arrived in Paris in 1909. He was, by nature, not so much an analytical artist as a sculptor of the elementary, a lyricist and expressionist. This approach brought him at a very early stage to the block-like form and it also explained why he returned time and time again to the wooden trunk as the solid basis for his figures. With hindsight, he would appear to be the only genuine wood sculptor, apart from Barlach, that classical Modernism produced. It is in this medium that we find his purest and most forceful works. They are soaring, closely contoured figural poles in which the anatomy is carved and notched as though from the outside, yet subtly modelled. His female figures are imbued with a quiet grace and sensuality that bring the wood to life. Does this make Zadkine a noble traditionalist emancipated from the classical ideal?

Even the Cubist semi-figures created around 1920 retain their solid core. Even where Zadkine rigidly encloses the body in a formal framework, geometrically

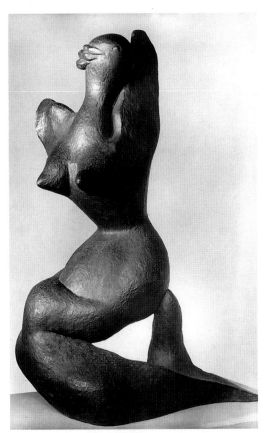

*"Even when I depict a movement, I am looking for stability. This movement does not disturb the calm impression that my statue should give."*
HENRI LAURENS

**Henri Laurens**
Siren, 1945
Bronze, 117 x 77 cm
Mannheim, Städtische Kunsthalle Mannheim

angled and concavely hollowed, he is merely marking the surface. Breaks, angles, corners, distortions, serve to consolidate and heighten emotional expression. What his externalised version of Cubism lacks in structural depth, it gains in force of expression and emotion. It is therefore only logical that Zadkine should have been one of the first to move on after 1920 in the direction of a more curvilinear, organic art. Yet in doing so, he took with him the Cubist freedom of combining viewpoints, and of offsetting the convex with the concave (the Archipenko paradigm).

Around 1930, apart from his nudes, he began producing deeply furrowed, baroquely moving and staggered groups with sculpted contours – an overstrained and dichotomous eclecticism whose ambition dissolves in a plethora of sweeping forms. The Rotterdam memorial *The Destroyed City* (ill. left) is the outstanding work of his mature œuvre. This fragmented, angular giant of pain is one massive lament, and the encroaching space a yawning wound. A work that unites once more the experience of Cubism and Expressionism, it is a rare example of modernism meaningfully exploring war.

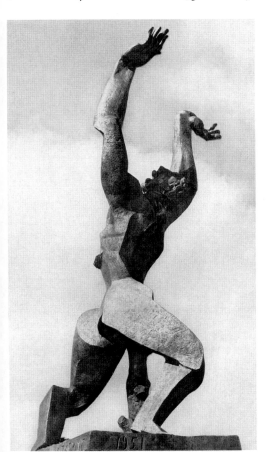

**Ossip Zadkine**
The Destroyed City. Monument for Rotterdam, 1948–1953
Bronze; height: 6.5 m
Rotterdam, Schiedamse Dijk

# Constructing the World

## Russia: Monuments and the Culture of Materials

Until the mid 20s, the revolution in the plastic arts was concentrated predominantly in the melting-pot that was Paris. Boccioni, of course, was an exception. Even Lipchitz, Laurens, Zadkine, Gutfreund and Csáky were sons of Cubism rather than its founding fathers. The next seminal influence was to emerge in Mosow rather than Paris. It was here that developments in the field since 1914/15 (some of them passionately nationalistic) took on a dynamism of their own. It was here, especially given the fact that the first world war severed contacts with Paris, that new stategies and paradigms became established. It was here, too that the formal history of modern sculpture finally merged with the profound social and political changes wrought by the 1917 October Revolution.

The term Constructivism has become widely accepted in referring to broad areas of Russian art between 1915 and 1925. Strictly speaking, however, a rapid succession of diverse movements had mushroomed in Moscow under the *nom de guerre* of Futurism. They ranged from the craftsmanship of Tatlin's so-called culture of materials to the esoterically cosmic Suprematism of Malevich and the Productivism of industrially manufactured consumer goods. Tatlin's emphasis on "real materials in real space" contrasts starkly with the idealistic flights of Malevich, El Lissitzky and Gabo. The actual Constructivists in the historically correct sense of the term numbered no more than twenty young artists and theoreticians who created a "constructivist working group" at the Moscow Institute of Artistic Culture (Inkhuk) and who exhibited together in May 1922. They coined the term. For the sake of simplicity, we shall use this term.

This fertile artistic and intellectual scene of painters, architects and critics rushed from one "ism" to the next. Not one of their spokesmen had actually trained as a sculptor originally. For most of them, reliefs, sculptures and objects were merely an intermezzo between painting and sculpture, stage design and revolutionary design. This is what distinguishes their work from the continuity of the œuvre produced by the Russian emigré artists in Paris. And yet, in a broader sense, they created sculptures more radical than any other developments at the time. What they saw as fundamental research, as a preparation for more useful products – buildings, propaganda kiosks, versatile furnishings – are early highlights in an abstract and thoroughly structural, conceptually organised sculpture. The Russian artists of the period taught sculpture to float, like a weightless and yet painstakingly devised choreography in a space without gravity. It was the art of aviators with boundless faith in revolutionary progress and the ability to compensate a real technological deficit.

In 1920, Gabo stated in his *Realistic Manifesto*: "The plumbline in our hand, eyes precise as a ruler, a mind as finely tuned as a compass, we construct our work as the universe constructs its own, as the engineer builds his bridges, as the mathematician his formulae of orbits." Wherever the optics of mathematical and technically rational construction, linear structure and the precision of engineering appear to regulate modern sculpture, they can be traced back to Russia. Much was destroyed after the advent of Stalinism and restructured in the spirit of doctrinaire realism, and is known today only from photographs or in the form of reconstructions. Nevertheless, the surviving material is still enough to recapitulate an enormously influential moment in recent art history.

**Vladimir Tatlin**
Model for the Monument to the Third International, 1919
Wood, steel and glass,
420 x 300 cm
Photo of original state. Formerly Moscow (destroyed)

**Vladimir Tatlin**
Model for a Monument to the Third International, 1919
(Reconstruction 1979)
Wood, steel and glass, 420 x 300 cm
Paris, Musée National d'Art Moderne, Centre Georges Pompidou

**Vladimir Tatlin**
"Letatlin" Flying Machine, 1932
Reconstruction by Jürgen Steger,
Kassel 1991
Frankfurt am Main, Lufthistorische
Gesellschaft am Flughafen
Frankfurt am Main

## Tatlin: Counter-Relief, Monument and Flying Machine

Vladimir Tatlin (pp. 444–447) stands at the very beginning of modern Russian sculpture, for the Russians in Paris followed the path of western art. He is a father figure, just as Malevich (pp. 160 f) is in painting. Of course, Tatlin visited Paris, but his legendary meeting with Picasso did not take place until February 1914, although it is often assumed to have been earlier. As a result, this progressive painter returned to Moscow as a constructor of reliefs. His critical response consists in a series of assemblages of metal, wood, plaster, board, asphalt and putty, created in a feverishly prolific output from 1914 onwards, soon to take the form of his freely suspended *Corner Reliefs*.

The superficial similarity of his early work to the still lifes of Picasso is deceptive. Tatlin did not seek to bridge a gap between portrayal and reality, and soon abandoned any associative references to a bottle, a newspaper or a guitar. He developed the reliefs directly from the *faktura* (a key word in Russian modernism) of the materials, their living language and specific characteristics such as colour, brilliance, structure, weight, firmness, elasticity. He called for the prerequisites of form to be sought in the material itself. Accordingly, Tatlin set about bending sheet metal, modelling plaster, breaking glass and tautening wire. He explored and staged, contrasted, composed and constructed every material according to its natural qualities.

The way this former seaman handled wood, tar, knots and bolts has more in common with the craft of the boatbuilder than with the traditional techniques of sculpture. He is as far removed from Picasso's border-crossing painting as he is from Boccioni's merging of man and city. His work rejects even the last vestige of quotation and illusion, positing sculpture as a perfect entity and as a structure complete within itself. These reliefs with their alternating elements of tension, curvature and anchoring, with their matt and reflecting surfaces, with their subtly elaborated haptic appeal and their traces of use challenge us, as El Lissitzky put it in a 1922 lecture on Tatlin, to "focus our eyes on the sense of touch".

Tatlin himself regarded his "culture of materials" as being in the tradition of the brightly coloured Russian icons, illustrated news sheets and shop signs, as opposed to the illusionist tradition of western art. His friend the poet Victor Chlebnikov had already explored the physical presence of words as opposed to their semantic meaning.

**Vladimir Tatlin**
Blue Counter-Relief, c. 1914
Various woods, metal, leather,
chalk and distemper on wood
panel, 79.5 x 44 x 7.3 cm
Berlin, Berlinische Galerie
(on loan from private collction)

Tatlin was one of the first to unconditionally acknowledge the October Revolution after 1917 and to re-direct his creative powers accordingly. His model for a *Monument to the Third International* (competition entry) is a vast utopian vision located somewhere between architecture and apparatus, a cross between a government building, a social organism and an emphatic symbol of progress (pp. 444 f). If built, it would be a 300 metre high spiral framework of steel incorporating a cylinder, a cone and a cube. These three components were to house the parliament, the executive and the headqurters for information and propaganda respectively, reflecting the actual decision-making process in the young Soviet Republic. It was planned by Tatlin, that each component was to revolve on its own axis at different speeds: the parliament housed in the cylinder once a year, the executive housed in the cone once a month and, at the very top, the office of information and propaganda housed in the cube once a day, thus placing the political instances within a larger cosmic cycle. Unrealistic as this bold design may have appeared in 1920, it heralded art's claim to have a hand in shaping the new society.

### Rodchenko and the Inkhuk Constructivists
The collaboration between artists and revolutionaries was not to be taken for granted at first. After the events

Even so, it would be rather one-sided to emphasise only the inherent expressive power of the material. Hubertus Gaßner quite rightly casts doubt upon the assumption that Tatlin regarded the properties of the material itself as absolute. The sweep of the arc and the elasticity of the curve oscillate with the rhythm of a living process of growth – the very opposite of that "great white god, the straight line" (Alexander Samayalin) worshipped by the younger, technology-loving Inkhuk Constructivists. Tatlin externalised the "inner constitution" of materials rather than reshaping it with ruler and compass. Even his *Letatlin* flying machine (p. 446 above) is based on an organically rhythmic concept of flying rather than a mechanical understanding of it. The notion of Tatlin as a "machine artist" is thus based on a misconception. His work demonstrates the biodynamic energies of the materials as well as their structural qualities.

Real materials are situated in real space. Herein lies an essential innovation, recognised by his Russian contemporaries. Picasso's *Guitar* and Boccioni's *Bottle* still function within their own restricted space. The bottle stands on a pedestal. Tatlin's *Corner Reliefs* (ill right and above), by contrast, are mounted on a taut wire across a corner like bizarre flying machines, and balanced around a gravitational core. They do not draw the space towards them, but depend on it instead. They do not link space to any ideal axis, but take it as it is. Their tensile strength corresponds with the corner. Thus, Tatlin distances himself more clearly than his contemporaries from the tradition of sculpture on a plinth.

**Alexander Rodchenko**
Hanging Construction No. 12, 1919
Painted plywood and wire,
83.5 x 58.5 x 43.3 cm
The George Costakis Collection
(Art Co. Ltd.)

cal" revolution. At first, painting was called into question. Influential theoreticians railed against the Suprematist works of Malevich, proclaiming that it was not idealism, but the "material object" produced by the worker that was the aim of art. This triggered a move towards the tangible, three-dimensional object in which technical and aesthetic polish were to be substituted for industry.

Tatlin, though he continued to have faith in art, provided a catalyst with his *Monument*. By 1920/21 an increasing number of avant-garde artists had begun to adopt the new line. In Moscow the Inkhuk group, from which Productivist Art was later to emerge, discussed and analysed the relationship between composition and construction. The die, once cast, fell in favour of Constructivism – a term we shall now examine more closely.

Alexander Rodchenko (ill. left) was their leading theoretician. Having demonstrated once more what Varvara Stepanova described as "nothing but painting" with his all-black paintings in 1919, he announced in an essay on *The Line* towards the end of that same year "Colour has died in black ... Let the brushstroke now die too!" The next step led from linear composition to the linearity of structure in real space. This took place at the end of 1919, when he joined the Association for the Synthesis of Painting, Sculpture and Architecture. Rodchenko now began designing ex-centrically balanced propaganda kiosks as his contribution to the Bolshevik revolution. Between late 1920 and early 1921, he created six hanging cardboard constructions comprising geometric figures such as the circle, triangle, hexagon, cut inwards concentrically. These were translations from the second dimension into the third dimension, anti-individual, reproducible entities which followed their immanent geometric logic entirely, allowing mass and materiality to dissolve into supple movement and light reflexes.

Here, Rodchenko intensified the sense of weightlessness that epitomised Russia's early contribution to modernism. Some may see in it the first mobiles. Other sculptures, asymmetrically suspended as in a tower building, explore the combinatory possibilities of geo-

of October 1917, the victorious Bolsheviks were just as suspicious of bourgeois relics of autonomy in art as the artistic avant-garde were of attacks on their autonomy. What would be the role of the artist under the future government of the proletariat? Would he be needed at all? The turn-around came as the result of a serious crisis of legitimation and dragged on until 1920. It was only then that a new understanding of the artist's role filtered through, reflecting the turnaround from political revolution to an emphatically propagated industrial "electri-

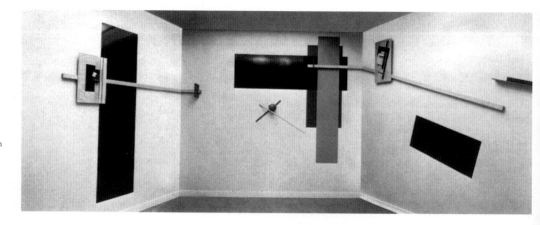

**El Lissitzky**
Proun-Room for the Great Berlin
Art Exhibition, 1923
(Reconstruction 1965)
Wood, colour-varnished,
320 x 365 x 365 cm
Eindhoven, Stedelijk Van Abbe
Museum

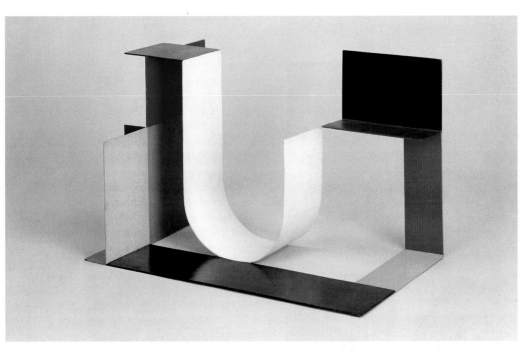

**Katarzyna Kobro**
Spatial Composition, 1929
Welded and painted steel,
40 x 40 x 64 cm
Lódz, Muzeum Sztuki

*"Construction is the modern
requirement for organization and
utilitarian use of material."*
ALEXANDER RODCHENKO

metric modules. Only Karl Ioganson, who was also a member of Inkhuk, achieved a similarly rigorous and absolutely logical systematic construction with his variable hybrids of steel bars and steel rope. His (no longer extant) *Studies in Equilibrium* are among the most radical experiments and most conclusive results in this laboratory phase of Productivist Art: ideal sculptures of power lines and study models for useful, versatile items in one.

Other Inkhuk members were less interested in a useable invention than in technical appearance. The brothers Vladimir and Georgi Stenberg, for example, when they were barely twenty years old, were creating mechanical, framelike structures reminiscent of elegantly propped apparatus, cranes or signal masts. Constantin Medunezki transposed Tatlin's aesthetics of materials into a technologically informed and gestural spatial context. For most of these young artists however, the exploration of sculpture was no more than a brief interlude before moving on to successful careers designing stage sets, trade-fair stands, industrial design and typography.

## "Transit Stations Between Painting and Architecture"

Did this, for a time at least in Russia, spell the end of modern sculpture, whose history as we know it has so often been synonymous with a history of its autonomy? From 1922 onwards the concept of Constructivist sculpture was imported by emigré artists such as Katarzyna Kobro, Naum Gabo and Antoine Pevsner to Warsaw, Paris, London and America, where it continued to develop outside the Soviet Union. Nevertheless, even in Moscow, a number of remarkable developments continued to take place. The outstanding achievements were

almost invariably situated in the forcefield of painting, sculpture and architecture, an area El Lissitzky described as "transit stations between painting and architecture". Gabo, referring to his work up to 1924, spoke of an "endeavour to unite the sculptural and the architectural elements".

No wonder the bizarre agitatory propaganda kiosks, speakers' tribunes, trade-fair stands, Socialist parade decorations which are also of interest as sculptural works, were generally created by painters and graphic artists such as Rodchenko and Gustav Klucis or architects such as Natan Altmann and the Vasnin brothers. They created their own type of architectural sculpture which Siah Armajani was to adopt and develop some fifty years later.

Even the painter Malevich, at times a keen rival of Tatlin, had left one problem unanswered. If the non-figurative world of his Suprematist paintings consists of rectangles, triangles, squares, crosses and circles, what happens when their purely planar geometry is transposed into three dimensions? What happens when their abstract forms are adopted in keeping with the spirit and ideology of the times and applied to some practical purpose such as architecture? In 1919 Malevich confronted the painter, graphic designer and trained architect El Lissitzky with this problem.

That same year, Lissitzky started work on his *Proun* paintings (meaning, roughly, "project for confirmation of the new") which he continued until 1924 (p. 168). They are axiometrically designed views of imagined cities, floating, soaring urban situations, housing blocks, squares and streets, interacting levels in dynamic diagonality devoid of all earthbound qualities – as though Malevich's forms had become three-dimensional.

*"Proun begins on the plane, proceeds
to the spatial model and from there
to the construction of all the objects
of life in general. In this respect, the
Proun goes beyond the painting and
its artists on the one hand, and
beyond the machine and the engineer on the other hand, and passes to
structuring the space and breaking it
down by the elements of all dimensions, and builds a new, versatile yet
uniform figure of nature."*
EL LISSITZKY

**Antoine Pevsner**
Portrait of Marcel Duchamp, 1926
Celluloid on copper, 94.3 x 65.1 cm
New Haven (CT), Yale University
Art Gallery

a concept for sculpture based on the work of Malevich. Her suspended compositions in fibreglass, wood and metal lend the Suprematist vocabulary a floating lyricism and transparency. Her *Spatial Sculptures* and *Spatial Compositions* (p. 449) activate and modulate the surrounding space, lending it rhythm with its simple flat or curved planes.

Though the notion that "sculpture penetrates space and space penetrates sculpture" was no longer a new insight by the 1920s, never before had it been realised so fundamentally, so naturally or so harmoniously. By adopting the Golden Section and the mathematical sequence of Fibonacci numbers (3, 5, 8, 13 etc.) and through the tense equilibrium of planar and linear relations, restricted to primary colours or black and white, her sculptures – for all their architectural foundations – are amongst the purest of autonomous works produced by Constructivism. It is interesting to note that they were not produced in Russia, but after her emigration to Poland.

**The Constructivist International**

1921–1922 were years of fundamental change for Russian Constructivism. The Productivist artists became organised and disappeared into production companies and the New Economic Policy (NFC) opened up the Soviet Union to the west, with the People's Commissariat for Education holding a huge exhibition of some 600 works, including the work of all the major Constructivists, which went on tour to Berlin. The Productivist idea became increasingly dogmatic. The brothers Naum Gabo and Antoine Pevsner turned their backs on Moscow's political pressure and emigrated.

In 1923 Lissitzky installed a "demonstration room" at the Große Berliner Kunstausstellung where his *Prouns* invade the surrounding space in the form of spheres, cubes and bars, providing the most conclusive example of a Constructivist environment (p. 448). The famous *Cloud Hangars* project he designed in 1924 as an urban highrise development for eight Moscow sites is relatively conventional by comparison and almost represents a step backwards compared to the visionary complexity of his *Proun* works.

The *Prouns* also forge a link with Malevich's own three-dimensional studies. Although he was not actually a sculptor, he considered the actual physical presence of a work important enough to create at least seventy *Architectones* between the years 1922 and 1929. These are vertically or horizontally staggered, cubistically angled dream buildings akin to cathedrals or broad-based, boldly cantilevered office tracts. They can be understood as immaculate intellectual models of a "non-figurative" universe within a material world. Perhaps they also represented a tentative step towards the ideology of the day, which called for applied ideas. They were certainly never intended to be realised. Soon afterwards, the leading Polish avant-garde artist and theoretician Vladislav Strzemiński (ill. right) reduced the fugue-like wealth "unistically" to a few massive, distinctly directed blocks which he also called *Architectones*.

Strzemiński's Russian-born wife Katarzyna Kobro, who settled in Poland in 1924, was one of the rare examples of a genuine sculptor among the many painters and architects of the Constructivist movement. She devised

**Vladislav Strzemiński**
Suprematist Architecton, 1923
(Reconstruction 1979)
Painted wood, 39 x 36 x 36 cm
Paris, private collection

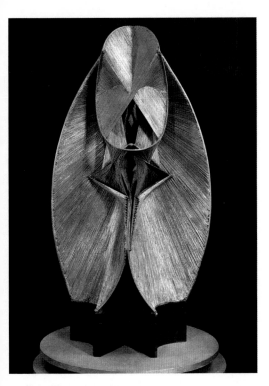

## Gabo and Pevsner: Crystalline Development

Naum Gabo and his brother Antoine Pevsner are regarded as the fathers of Constructivist sculpture. They were the only artists of the founding generation to make the new sculptural design their life work. Both of them spent their youth in Paris and were of course subjected to the prevailing artistic climate of Cubism. Both of them worked on the *Realistic Manifesto* (though Gabo played a more active role) which was published, as the result of a misunderstanding (the authorities believing it to be in praise of "realism"), by the State Printing House in Moscow on August 5, 1920. It confidently relativises the significance of Cubism and Futurism, and addresses the problems involved. "Realistic" means "space and time are the only forms in which life is built and therefore art must also be constructed in these forms ... We know that everything has its own specific quality: chair, table, lamp, telephone, book, house, person ... they are all entire worlds with their own rhythms, their own orbits. This is why, we in creating remove ... all that is accidental and local, leaving only the reality of the constant rhythm of the forces in them."

Up to this point, Boccioni would have had no qualms about signing such a manifesto. It concludes,

**Antoine Pevsner**
Spectral Vision, 1959
Bronze and oxydized copper,
110 x 58 x 36 cm
Private collection

**Antoine Pevsner**
Construction, 1938
Copper, 64 x 51 cm
Basel, private collection

In Berlin, El Lissitzky, who constantly sought to link up the various movements in Moscow, Berlin, Weimar, Hanover and Holland, published the magazine *Gegenstand* in collaboration with Ilya Ehrenburg. Responses and parallels became evident. In Holland in 1917, the De Stijl group was formed. In Weimar and Dessau, the Bauhaus had outgrown its early Expressionistic pathos and had begun to adopt a more Constructivist line. The experimental media artist Moholy-Nagy arrived in Germany from Hungary. From now on, Constructivism finally branched out from its specifically Russian beginnings to become an international movement with many different directions and variations.

What was it that made this movement so attractive in the interwar years? After the catastrophe of the nation states' turbulent catharsis, venting enormous emotional pressure in the apocalyptic scenes and anarchistic idylls of the Expressionists, and after the ecstatic confession of the Self, this new design for a rationally lucid, supranational, supraindividual art – and, for that matter, society as well – banished many fears and anxieties.

The Constructivism of the 20s was optimistic. It was a downpayment on a better future, the horizon of Utopia. It was not the aesthetic religion of simple, straight-forward reason, but was polarised between the industrial prototypes of the Bauhaus and the mystical spirituality of Malevich and Mondrian. In formal terms, it sought universally applicable principles, a general key that could be varied from image to sculpture, to design and building. For this reason, sculpture is just one facet of the spectrum and is frequently situated as an open genre between architecture, apparatus, scientific and mathematical model.

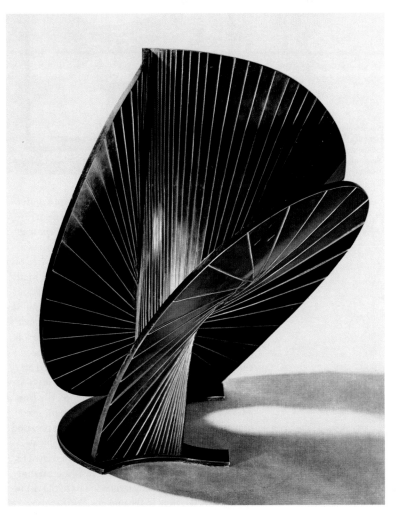

however, "We renounce volume as a pictorial and plastic form of space ... we take four planes and construct with them the same volume as of four tons of mass. Thus we bring back to sculpture the line as a direction and in it we affirm depth as the one form of space ... We affirm in these arts a new element, the kinetic rhythms, as the basic forms of our perception of real time."

The programme they posited may seem to us more idealistic than realistic, for what does idealism in art mean if not cleansing it of all that is "accidental" to the point of sheer transcendence of space and time. Pevsner worked on implementing this programme from 1915 onwards and, by 1920, in an act of elementary border-crossing, he had staked out the most extreme point of

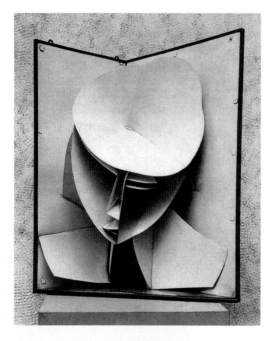

**Naum Gabo**
Head of a Woman, c. 1917–1920
Celluloid and metal, 62 x 49 cm
New York, The Museum of
Modern Art

all: a steel spring set in motion with the aid of a motor, transforming its physical mass into traces of form in space. It is almost like a prototype of the concept that Gabo was to continue to explore for more than half a century. Pevsner, originally a painter, finally crossed over to sculpture in 1924. For both these brothers, the Manifesto was to remain the Magna Carta of their art.

In 1937, Gabo illustrated a sentence of the Manifesto in the form of a diagram. He drew a closed cube made of four planes, from which he constructed "the same volume as of four tons of mass". He then drew an open cube without side walls and showed it intersected by two diagonal planes: an inner framework whose point of intersection forms the heart of the structure. His *Head of a Woman* (ill. above) of 1917–1920 is based on the same principle. Strip-like segments of cardboard or plywood radiate from a central axis, creating rhythmically segmented hollow spaces. It is a cellular system related to Picasso's 1909 *Head of a Woman* and clearly illustrating the step from the externally facetted mass to the visible constructive skeleton. In the mid-20s, Pevsner also

**Naum Gabo**
Column, 1923
(Replica 1975)
Plexiglas, wood, metal, and glass,
105.3 x 73.6 x 73.6 cm
Humblebæk (Denmark), Louisiana
Museum of Modern Art

created his closely related *Portrait of Marcel Duchamp* (p. 450 above).

Gabo's early *Heads* and arched bodies demonstrate his approach with didactic clarity, like demonstration models of a new sculptural theory. Yet it was not long before he began to move away from the human figure. In keeping with the spirit of the times, his *Column* of 1923 (ill. right) and other works of the early 1920s are situated somewhere between architectural concept, monument, apparatus and sculpture. The development of this sculpture around a vertical core remains fully transparent. Herein lies its ideal reality, whereas Tatlin's *Tower* addresses a real social place, however remote, rotating within real time. The transparent material plexiglass corresponds to the transparent structure.

In the 30s, the angular, additive and apparative disappeared from his sculptures. The central axis became the fulcrum point for curved wings, and the spatial interaction became more complex and polyphanous. Nylon threads or slender wires were spanned over the rounded plexiglass planes or metal frames. Lines were bundled to create light energy, refracting and breaking on angles. At the same time, the entire volume remained transparent: a multi-dimensional harp of light as an oscillating spatial entity whose lyricsim is a far remove from Pevsner's more rugged tone.

In terms of process and external structure, the work of the two brothers bears an astonishing similarity. Both build up the volume increasingly freely and openly out of curvilinear planes. Both use points of intersection as focal points of energy. Yet whereas Gabo uses transparency, Pevsner seeks a harshly metallic contrast. And whereas Gabo works his sculpture in gentle visual torsions and rotations, Pevsner captures them in rigid frontality. Whereas Gabo captures the central axis and plays around it, Pevsner lifts it through symmetrical lines of radiation in which the magical enchantment of fetishes is evident. Whereas Gabo has the light glide softly over curves, Pevsner closes a nest of light and shadow impenetrably into the inner life of the structure. Is this a case of the lyrical temperament versus the dramatic temperament? At any rate, together with the confident fundamentalism of Katarzyna Kobro, they indicate the expressive range of the Constructivist approach.

## Bauhaus and De Stijl: New Media and Experimentation

Remarkable as it may seem, the two most important European Constructivist movements – Bauhaus and De Stijl – produced few sculptors. They did not follow Russian art in turning away from painting towards the "object" around 1920. At the Bauhaus, initiated in 1919 with Expressionist pathos by the architect Walter Gropius, painting was very much to the fore. Admittedly, Gropius himself created a major early work of abstract monumental sculpture in his 1920 *Memorial to the Fallen of March* and even the painter Oskar

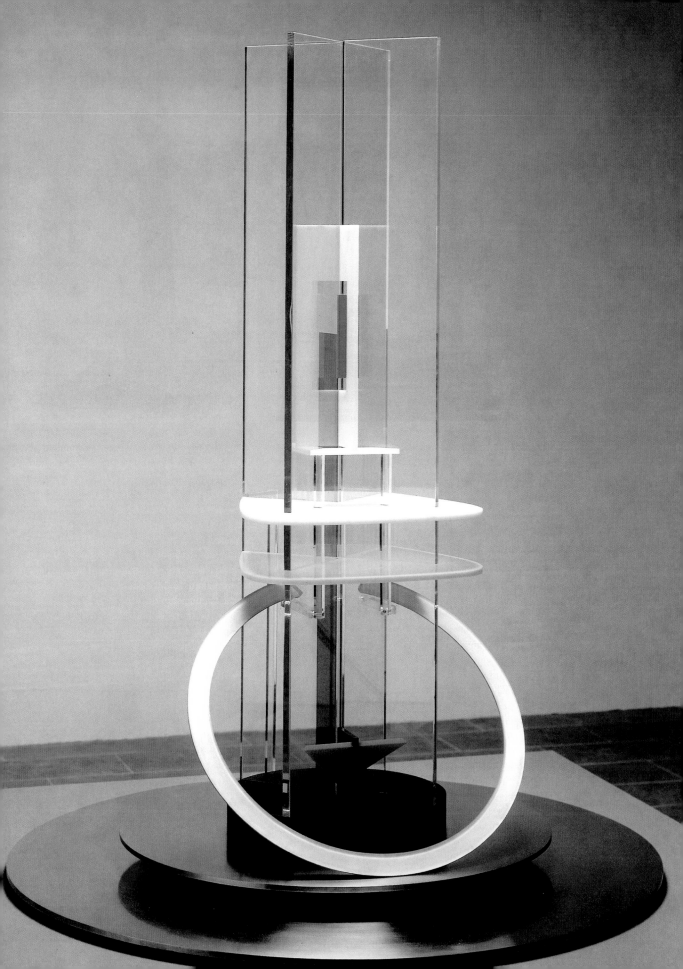

**László Moholy-Nagy**
Light-Space Modulator, 1930
(Replik 1970)
Metal and plastic, electric motor,
151 x 70 x 70 cm
Cambridge (MA), Busch-Reisinger
Museum

**László Moholy-Nagy**
Nickel Construction, 1921
Nickel-plated iron, welded,
35.6 x 17.5 x 23.8 cm
New York, The Museum of
Modern Art, Gift of Mrs. Sibyl
Moholy-Nagy

*"Because light is a spatial-temporal
problem, the mere accentuation of
the question of light brings us into
the field of a new spatial awareness
that cannot yet be fully analysed.
We can, however, find a word to
describe it: floating."*
LÁSLÓ MOHOLY-NAGY

Schlemmer gave his ideal human figure a sculptural profile.

On the whole, however, sculpture was very much a secondary concern at the Bauhaus, even though – or perhaps because – it played an important role as a fundamental part of the Basic Course. Exercises addressing the "nature of materials" focused on texture, structure, hardness, elasticity, transparency etc. were aimed at strengthening a sense of touch and spatial awareness. The titles of student papers occasionally read like a list of options on current or future developments in sculpture: material combinations, cuboid composition, haptic panels, floating sculpture, studies in equilibrium. Most, however, got no further than the experimental stage, serving merely to sensitise without actually resulting in any historic contribution to sculpture.

The great exceptiomn was the Hungarian artist László Moholy-Nagy. In 1923, at the age of 28, he took over from Johannes Itten as head of the Basic Course and was also put in charge of the metal workshop. Originally a painter (p. 178), he became the first modern multi-media artist, working in light sculpture, design, photography, film, typography, stage design and theory as component parts of a new social vision. His communicative spirit extended the concept of sculpture to include motion and openness, redefining the relationship between space, time, material and light, and emancipating mechanical apparatus to the point of art. He was the eternal forerunner, restless experimentor and enthusiastic researcher in the optical media of light and transparency whether he was developing photograms or,

in the early 1920s, creating his glittering sculptures out of combinations of wood, glass, steel, zinc and nickel alloys.

In 1930, after eight years of experimentation, he exhibited his *Light-Space Modulator* (ill. above left) in Paris. It was a 120 cm high apparatus of perforated and translucent discs, bars and glass spirals, which cast the brightness of 140 lightbulbs and five spotlights on the wall in an abstract theatrical display of shifting light and shadow, a drama in three acts with three tempi – calm, delayed, counter-movement.

It was the key to Moholy-Nagy's entire œuvre, his *Vision in Motion*, to quote the title of his subsequent publication. He not only referred to it in his scenarios

**Georges Vantongerloo**
Construction in the Sphere, 1918
Blue painted wood, 18 x 12 x 12 cm
Private collection

stringent rationalisation, whose *Construction in the Sphere* took modern sculpture to new heights of geometric ideality in 1917. The point of departure is still a seated female figure, systematically transposed onto a sphere, a cone, or a pyramid. Although Vantongerloo moved away from De Stijl after 1922, proportioning (and naming) his minimalist layered blocks according to mathematical formulae, he remained true to the orthogonal equilibrium of the De Stijl aesthetic.

In his later work after 1945 he drew sweeping curvilinear wires in the air and then moved towards undulating and organically intertwined entities of plexiglass, Medusas of light, transformations of colour. An œuvre that had remained within the strictest methodical bounds for a full two decades finally ended in lyrical abstraction. At the same time, Max Bill was taking Vantongerloo's methodical approach one step further in the direction of Concrete Art.

**Georges Vantongerloo**
Spatial Sculpture
(y = ax3–bx2 + cx), 1935
Nickel silver; height: 38.5 cm
Basel, Öffentliche Kunstsammlung Basel, Kunstmuseum, Emanuel Hoffmann-Stiftung

*"Through their relationship to one another, volumes convey to us a sense of space and through their distance from one another they convey a sense of time."*

GEORGES VANTONGERLOO

for Alexander Korda's film *The City of the Future* in stage sets and trade-fair designs – on the horizon appeared fountains of light and electric motion, "entertainment at fairs and heightened tension in the theatre". Moholy-Nagy was not only a pioneer of light kinetics, but also anticipated, with delight, the blurring of borders between "high" and "low" art.

In 1928 the left-wing ideology of the new Bauhaus director prompted Moholy-Nagy to leave. In 1934 he emigrated via Amsterdam to London, where he created the first of his *Space Modulators* – curved sheets of plexiglass whose shifting points suggest changing spatial curvature. After 1940, by which time he was living in Chicago and running his own School of Design, he bent the plexiglass into floating, transparent, interconnected tubes with an aura of gliding light: a counterpole to the technoid world of his work twenty years before. The arch-Constructivist Gabo moved in a similar direction at the time.

Fundamental research of a different kind was undertaken by Georges Vantongerloo, the only sculptor of the Dutch De Stijl movement. Instead of trawling the visual media, he pursued a mathematical fundamentalism whose "objective truth" he saw as the basis of art. Although Gerrit Rietveld's famous chair and the axial architectural sections by Theo van Doesburg do focus on Constructivist three-dimensionality, Vantongerloo stands alone as a sculptor and as a rigorous adherent of

**Georges Vantongerloo**
Construction from an Oval, 1918
Mahogany, painted blue, yellow and red, 16.5 x 6.5 x 6.5 cm
Private collection

**Max Bill**
Endless Torsion, 1953–1956
Bronze, 125 x 125 x 80 cm
Antwerpen, Openluchtmuseum
voor Beeldhouwkunst Middelheim

*"The mathematical approach in today's art is not actually mathematics. It is the design of rhythms and relationships, of laws with an individual origin, just as mathematics originates in the individual thinking of pioneering mathematicians."*
                    MAX BILL

### Abstraction-Création and Concrete Art

Paris had been the undisputed centre of the avant-garde since the artistic demise of Russia and Germany under their totalitarian regimes. With the German occupation of Paris, that centre moved to London, and later to New York. In Paris, the painers Auguste Herbin (p. 220), Jean Hélion (p. 304) and František Kupka (pp. 81 f), and the sculptors Vantongerloo (as vice-president), Hans Arp (pp. 120, 480 f) and others founded the international Abstraction-Création group in 1931. They channeled a wide variety of non-figurative trends, especially the late Cubists, the De Stijl followers and Constructivist emigrés such as Gabo and Pevsner. Abstraction-Création thus stood primarily for an art of basic geometric forms and interactions. Although this meant that their stance was predominantly a counterpoint to Surrealism, there were still a number of personal and artistic links with that movement.

By 1934 the group had some 50 members and 410 loosely associated friends from England to Paris and from Zurich to Italy, Germany and Poland. Its six year-books, published between 1932 and 1936, contained illustrations of works by such diverse artists as Arp, Calder, Freundlich, Gabo and Moholy-Nagy, covering a broad spectrum of non-figurative art whose creative autonomy was a powerful counterblast to totalitarianism. In terms of art history, this collective movement can be quite easily broken down into its component parts.

Abstraction refers to the progressive reduction of the mimesis of nature. Création refers to an elementary geometric order that is not derived from nature. The concept of Création was taken furthest by the Swiss artist Max Bill (p. 222). Following the approach of Theo van Doesburg, Bill called for the pure expression of van Doesburg's concept of "concrete art" in every field. As a member of the Züricher Konkreten group, he created a bastion of consistently rational, mathematically grounded "cold" art that was to have international influence after 1945.

Sculpture was only one aspect of the work by this Bauhaus student, architect, painter, designer, exhibition organiser and theoretician (ill. above and below). In the mid-1930s he constructed lightweight frames within which the inner and outer contours of cubes permeate each other, or stacked triangles and rectangles into airy, gravity-defying towers. At the same time, his *Endless Loop* marked the beginning of a lifelong fascination with the principle of the Mœbius strip and its finite-infinite flow. His sculptures show that rational relationships and visual logic, including mathematical formulae, can harbour dynamic streams and topological mysteries. Bill was a master of such transformation.

In 1933, the English painter and sculptor Ben Nicholson and his wife Barbara Hepworth both became members. In a brief phase from the end of that year until 1936, Nicholson created white reliefs cut out of flat circles and rectangles of cardboard. In 1937, together with Gabo, he published his book *Cercle*. It was a swansong to the Constructivist idea that had made such an impact in Eastern Europe twenty years before, and which, at its zenith, had touched Germany and Holland, had been formalised in Paris on a broad front and was now fermenting once more at the very fringes of Europe in the fragile cardboard reliefs by Nicholson.

**Max Bill**
Units of Three Identical
Volumes, 1961
Chromium-plated brass,
26 x 43 x 32 cm
Napa (CA), Hess Collection

# From Readymade to Surrealist Object

## Duchamp: Creation through Negation

In retracing the progress of art history, it is tempting to regard the step from Picasso or Boccioni to Duchamp as no more than the logical consequence of early object art. Picasso incorporates fragments of basketweave or newspaper into his pictures. Boccioni inserts half a window-frame. Duchamp mounts the front wheel of a bicycle on a kitchen stool. But that would be telling the story the wrong way.

After all, Duchamp neither based his readymades on the work of any precursors nor did he seek to set object art in motion. On the contrary, he was looking for a way out of art. Bicycle wheel, bottle-rack and urinal were all valedictions to accepted mores of aesthetics, style and taste – a negation that was to be transformed by subsequent generations into an fascinated and resounding Yes. And so Duchamp, with his readymades and kinetic objects, unwittingly made a seminal contribution to the historiography of modern sculpture by opening up a new dimension in aesthetic consciousness. This is why it is these that are of primary interest to us here, as opposed to his *Large Glass* (p. 458).

Over the years, there have been a number of explanations have been offered for the advent of the readymade in art. The interpretation offered here makes no claim to being the only valid one. In the brief period between 1906 and 1913 the face of art was changed as never before. Narrative symbolism, anatomical correctness, sculptural modelling, unity of material – all these givens were called into question. Surely a sceptic or even a cynic would feel compelled to ask "What is art?" "What makes it art?" "Who is an artist?" Duchamp answered these questions – not as a theoretician, but by means of tongue-in-cheek demonstration. He formulated his objections to painting and its "retinal" approach in an aphoristic object. The *Bicycle Wheel* on a stool (ill. above) that heralded a series of readymades in 1913 maintains that art is a question of definition, an agreed term. The artist himself, his autobiography, his feelings, have nothing to do with it. Art is what is placed on a plinth rather than on a department store shelf. In the end, art is in the eye of the beholder.

Of course, this effrontery against the aura of art contained more than a pinch of nihilism and amounted to a rejection of the Romantic notion of the creative artist, a

**Marcel Duchamp**
Bicycle Wheel, 1913
(Replica 1964)
Readymade; bicycle wheel mounted on a stool; height: 132 cm, diameter: 64.8 cm
Milan, Arturo Schwarz Collection

notion that was soon to be renounced by the Russian Constructivists as well. These objects are by no means mysterious things whose enigma is meant to torment us. Nor do they represent "life" as the art of the 60s did. They pose questions – critical and subversive questions about the condition of art itself.

Whether or not Duchamp saw things this way right from the start remains a moot point. The early readymades in his studio met with little response. The *Bottle-Rack* appeared for the first time at Charles Ratton's 1936 "Surréaliste d'objets" exhibition in Paris. The final definition was probably coined in retrospect when Dadaists and Surrealists took it up. It was now up to Duchamp to underpin the declaration. In doing so he occasionally over-stylised the abrupt break with his earlier art. Does not the wheel with its slender spokes recall the rollers of the *Chocolate Grinder* (p. 130) spanned as threads? Does not the round kitchen stool under the bicycle wheel recall the table on which the grinder stands? Is it really a radical break in protest against all older art, or is it the demonstrative replacement of painting by the principle of the readymade?

**Marcel Duchamp**
The Bride Stripped Bare by Her
Bachelors, Even (The Large Glass),
c. 1915–1923
Oil, varnish, lead foil, lead wire and
dust on two glass plates mounted
with aluminium, wood and steel
frames, 272.5 x 175.8 cm
Philadelphia, Philadelphia
Museum of Art, Bequest of
Katherine S. Dreier

**Marcel Duchamp**
Fountain, 1917
(Replica 1964)
Readymade; porcelain urinal,
61 x 48 x 36 cm
Milan, Galleria Schwarz

follow the other path, as did the Surrealists and, in other directions, Pop Art, Nouveau Réalisme, Kinetic Art, Process Art.

In 1921 Duchamp created an assemblage entitled *Why not Sneeze, Rrose Sélavy?* (p. 460) for the sister of a friend. It is what he calls an *objet assisté*: a birdcage painted white and filled with marble cubes in imitation of sugar-lumps or ice cubes, cuttle-bone (for the missing canary) and a thermometer. The nonchalant title, containing Duchamp's female pseudonym, is mirrored downwards. The relationship between the various items remains enigmatic. Lautréamont's famous phrase of 1864 "beautiful as the chance encounter of an umbrella and a sewing machine on a dissecting table" could well have motivated Duchamp long before André Breton discovered it for the Surrealists.

The cage evades any logical, narrative metaphorical interpretation. Even the pun *Rrose Sélavy* (Eros, c'est la vie?) is indicative of an underlying sexual promise that cannot be fulfilled. The marble imitations are a variation on the old illusionism of painting and recall Picasso's *Glass of Absinthe*. In Duchamp's work we recognise them by feeling and tasting them, by their weight and coolness (the thermometer?) rather than visually – a programmatic piece of non-retinal art. Here we find the object theatre of absurdity that was to be the starting point for so many Surrealist objects featuring cages, animal bones or measuring instruments which were to appear ten years later in the work of Giacometti and many Surrealist followers.

### The Shock of Dada: Man Ray and Schwitters

Although Duchamp could not be classified as belonging to any particular movement, he did for a time have close links to the anarchist revolt known as Dada; that frenzied rebellion against the insanity of war and genocide, instrumental logic and arms production, nationalist policy and petty bourgeois narrow-mindedness that spread out from its beginnings in Zurich in 1916 to take hold quickly in Cologne, Berlin, Hanover and New York. The Dadaist contribution to sculpture went hand in hand with a wealth of nonsense poetry, shock readings, noise music, chaotic manifestos and typographies, satirical photo-montages. Nevertheless, there are two object artists who would have been unthinkable without the liberating blow of Dadaism which toppled the hierarchy of values. Man Ray followed directly in the footsteps of Duchamp. Kurt Schwitters sublimated Dada's shock therapy by aestheticising and lyricising the heritage of the Cubist *papiers collés* and constructions and the diversity of the "modern" materials proclaimed by Boccioni.

The American-born artist Man Ray was perhaps the only student Duchamp ever had. Originally a painter, he founded a branch of Dada in New York in 1919 together with Duchamp and Francis Picabia. His early *objets assistés* which languished for so long in the shadow of his work as an innovative Surrealist photographer have since

Even the famous *Fountain* (ill right), a urinal turned at an angle of ninety degrees, is not entirely devoid of associations with previous art. Are not these symmetrical, centred, concave-convex forms a parody or a perhaps even a rehabilitation of classical composition? Do not these soft curves and rounded forms evoke associations with the female body? The urinal is signed "R. Mutt, 1917": Is this pure cynicism or does it betray a more gentle irony that reaffirms the concept of art rather than trashing it?

Duchamp pursued this path to its logical conclusion, staking out its extremes. Within these boundaries there are only individual strategies, combinations or a new interpretation of the object. Duchamp points out the first path himself before withdrawing almost entirely from production to scepticism. The Dadaists chose to

**Marcel Duchamp**
Why not Sneeze, Rrose Sélavy?,
1921
Readymade; 152 marble cubes in
the form of sugar-cubes with
thermometer and cuttle-bone in a
birdcage, 10.5 x 16.5 x 21 cm
Philadelphia, Philadelphia
Museum of Art, Louise and Walter
Arensberg Collection

**Marcel Duchamp**
Rotary Glass Plates, 1920
Five painted glass plates that rotate
around a metal axis and appear to
be a single circle when viewed at a
distance of one meter,
120.6 x 184 cm and 99 x 14 cm
(glass plate). New Haven (CT),
Yale University Art Gallery

**Man Ray**
Emak Bakia, 1927
(Reconstruction 1970)
Wood and horsehair; height: 46 cm
Private collection

*Page 461:*
**Kurt Schwitters**
Hanover Merzbau, c. 1933
Hanover, Sprengel Museum
Hannover

become icons of object art. They reduce the laconic hermeticism of Duchamp's readymade to a legible common denominator, and loosen it into a visual enigma, expressive and proto-surrealist. Emotions and associations are provoked by contradiction.

Man Ray's 1921 *Gift* is an upended iron with 13 nails, rising like a Gothic-arched monument. The metal surface that normally glides warmly over soft fabric is presented here as an object of brute aggression. The Surrealists referred to such works as *objets desagréables*. By contrast, his *Emak Bakia* of 1927 (ill. right) features a blonde ponytail emerging from the convoluted arm of a double bass: silky, flowing hair, in which the anthropomorphous suggestion of strings blends with a visual, haptic metaphor for the softly flowing sound of the instrument.

In his 1923 *Self-Destructive Object* a cut-out photo of an eye swings to and fro, pinned to the end of a metronome needle by a paperclip. It is the eye of God before the triangle of the Trinity. The stringently regulated world of measured time, the eternal Father, in short, the rational and determined world of strict laws and obligations, the counterworld to that of improvisation, association or chance – is undermined by this absurd combination and thrown offbeat, out of time. It is a Dada polemic for the freedom of creativity and anarchism, something which has become firmly established in the optical consciousness of our century.

Man Ray anticipated much that was to shape Surrealist sculpture ten years later: approximations between apparatus and the anthropomorphous, the aggressive, menacing, dissecting cruelty of the anatomic cut, floating and oscillating. Indeed, in comparison to his controversially epigrammatic objects, much of Surrealist art seems pretentious in its shallow pursuit of banal eroticism.

Their work could hardly be more different. Yet Man Ray and Kurt Schwitters both developed their œuvre on

the basis of the same starting point around 1920: the *objet trouvé.* The fact that these two artists took such very different paths indicates just how ambiguous the concept was in the first place.

Schwitters, however, did far more than preparing the ground for other artists. His early material reliefs possess their own distinctive chromatism, and their own atmosphere. His *MERZ* pictures (the title is derived from Com*merz*- und Darlehnsbank) update the Cubist *papiers collés* by adding a Futurist dynamism and by

**Kurt Schwitters**
Relief, 1923
Collage of various materials on
wood, 35.5 x 30 cm
Cologne, Museum Ludwig

*"I nailed pictures so that, alongside
the painterly effect, there would also
be a sculptural relievo effect. This
was done to blur the borders of artis-
tic genres."* KURT SCHWITTERS

plaster (p. 461). Behind the stalactite cladding are
posters bearing witness to political and social aspects,
relics of the everyday, garbage. The whole, according to
Harald Szeemann, is a monomanic "cross between
cathedral, cave, castle and ivory tower of its creator." For
decades, the *Merzbau* stood on the fringes of art history,
until, in the 60s, like El Lissitzky's *Proun-room* of 1923
or Duchamp's surreal staging of the 1938 Surrealist
exhibition, it became a milestone on the road towards a
new genre of art known as environment.

Russian artists like Ivan Puni (p. 163), Olga Rozanova
(p. 167) or Ivan Kliun (p. 164), who, like Schwitters, cre-
ated provocative sculptural montages around 1920,
either produced very few such works or else these works
are barely documented. Much was lost or destroyed,
including the filigree wire constructions created in 1917
by Marcel Janco (p. 121) in Zurich, the cradle of
Dadaism. Johannes Baargeld's Cologne assemblages of
garbage that cocked a snook at bourgeois values are also
lost. Hans Arp, although he had been creating his bio-
morphic, curvilinear layered reliefs since 1916, assembled
rotting pieces of painted wood on boards for his 1920/21
*Trousseaux*. Here, we find decay, waste and shoddy mate-
rial representing a rough and tongue-in-cheek objection
to the supposedly noble principles of art, using the
cheap, throwaway materials that were to be adopted
forty years later by the neo-Dadaists and Nouveaux
Réalistes. The strangest fancies of all, however, were
conjured up by the Surrealists in Paris.

## The Surrealist Object

Although André Breton proposed producing dreamt-of
objects as early as 1924, it was not until 1930 that Salvador
Dalí actually did so. Surrealism, which calculatedly
explored the world of dream, chance, free association
and *écriture automatique*, was originally more a literary
movement than an artistic one. Sculpture was at first far
removed from it. How were the strategies of chance and
automatic writing, the messages of dreams and the dis-
mantling of rational control to find expression in sculp-
ture? Was not sculpture inextricably linked with a form
of conscious action and handling?

It was not until Surrealism itself underwent a change
around 1930, and precisely painted reality was laid over
the abyss of the psyche as a thin veil of illusion, with
painters such as Dalí (pp. 143–145) and René Magritte
(pp. 146 f) mirroring the surreal in the real and trawling
the depths of the subconscious to come up with icono-
graphies as bizarre as they were precise, that Surrealism
became tangible enough for what Dalí called "surreal
objects with a symbolic function". The year 1931 marked
the turning point.

The "surrealist object" was Surrealism's specific con-
tribution to sculpture. What distinguishes it from *objets
trouvés* and the *objets assistés*, apart from the fact that it
foreshadowed them? Duchamp's readymades deny the
emotion, the signature of the artist and the autobiogra-
phy, eschewing his aesthetic intervention.

taking the step from the political Berlin Dada to the aes-
thetic (pp. 126 f). They have all the melancholy bright-
ness of flowers growing on wasteland, romanticising
and darkening the painted-over realities of everyday life
– posters, tickets, brochures, newspaper clippings, wire
mesh, pieces of wood. Although these are, strictly speak-
ing, reliefs, and although the no longer extant *Schwitters
Column* or *Merzbau* included actual sculptures, such as
the *Lust Gallows* and the *Culture Pump*, Schwitters' work
has, on the whole, a closer affinity to painting than to
sculpture. Even after he turned to the principles of Con-
structivism after 1923, and adopted more organic and
natural forms following his emigration in 1937, the laws
of planarity remained more important to Schwitters
than three-dimensionality.

There is, however, one exception. The *Merzbau*, or
*Schwitters Column*, which was his life's work, and which
he started anew three times: in Hanover in 1918
(destroyed in a bomb attack in 1943), then in Norway,
and finally in England. What began in the form of a col-
umn in his studio soon grew into a Dadaist votive
chapel, a labyrinth of grottoes in which found objects
and his own smaller sculptures were placed. On pho-
tographs dating from 1933 one can already see the devel-
oped constructive version of whitewashed wood and

**Salvador Dalí**
Telephone-Homard, c. 1936
Assemblage, 18 x 12.5 x 30.5 cm
Private collection

Breton, who was familiar with the writings of Freud, took a very different approach in probing the subconscious. While including chance or excluding reflection and calculation, he did not withdraw from the work itself. In his 1928 novel *Nadja*, Breton describes strolling aimlessly along the Boulevard Bonne-Nouvelle without knowing why, but in the firm conviction that "it will happen here". An inspiration? An encounter? A find – an *objet trouvé?* The chance encounter to which Breton refers makes no distinction between the author and his work. Instead, it is the principle of chance from which the work emerges in the first place, revealing the truth that lurks within our subconscious energies, drawing it from the depths of the libido. Chance, according to Breton, is the undercurrent beneath all rational planning and vision. It does not exclude the person, but drives the individual to the fore, in a profound sense, unveiling their clandestine imaginings and extreme wishes.

The Surrealists certainly mystified this "objective" chance in their choice of objects, adorning even the most astutely calculated found objects with the magical air of archaeological treasures from the very womb of the earth. Nevertheless, this sense of touching the environment with the divining rod of psychic inner worlds was to prove productive for sculpture. It psychologised, eroticised and charged Duchamp's readymade. Wherever these *objets* appeared, they adopted the full potency of Lautréamont's disparate metaphor.

Sigmund Freud paved the way for them. Given that they were generally exploring clandestine and suppressed desires, a tendency towards issues that are sexual or pathological, is almost to be expected. The forbidden, censored depths and taboos in which lust is linked to violence, pain and loathing, are brought to the fore. Giacometti's huge, penetrating, thorn-like *Disagreeable*

*Object,* and his *Caught Hand* enmeshed in some strange instrument of torture, are extreme expressions of this. Meret Oppenheim's famous *Fur-Lined Teacup Object* (ill. below) with its worldly-wise play on appeal, disgust, oral eroticism and refusal, evokes a typically ambivalent mood. Kurt Seligman offered a variation featuring a soup tureen covered in white hen feathers. Dalí (ill. above) worked drawers into a plaster cast of the *Venus de Milo,* following the curves of her body, adorned with furry handles. Even the lyrically narrative Joan Miró juggled evocatively with female limbs and suspended spherical objects. The Surrealist sculpture of the 30s was imbued with a pan-sexual obsession involving every possible leitmotif – cage, concealment, doll – and was

**Meret Oppenheim**
The Fur-Lined Teacup Object
(Le Déjeuner en Fourrure), 1936
Fur-lined spoon, saucer and
teacup; cup 10.9, saucer 23.7,
spoon 20.2 cm; height: 7.3 cm
New York, The Museum of
Modern Art

**Joseph Cornell**
Hotel de l'Océan, 1959/60
Wooden box, clay pipe, children's
block, postage stamp, several paper
clippings from unknown sources,
four brass rings on metal rod,
metal sun, 21.5 x 36 x 10.2 cm
Cologne, Museum Ludwig

**Joseph Cornell**
Portrait. From the Series "Medici
Slot Machine", 1942
Various materials, 35.5 x 28 x 9.5 cm
Private collection

even evident in the occasional sculpture by Magritte, Victor Brauner, Yves Tanguy, Marcel Jean, Oscar Dominguez and William Freedie.

In 1936 Ratton provided an overview at his Paris gallery. The exhibition "Surréaliste d'objets" added fuel to the flames. Artists scoured the flea-markets and bric-a-brac shops. Subsequent classics such as Duchamp's *Bottle-Rack* and his *Why not Sneeze* ensemble stood in showcases alongside sculptures by Max Ernst, Hopi Indian ceremonial dolls and a motley assortment of other objects. The exhibition was the intimate, small-scale climax of Surrealist object art, just as, two years later the "International Surrealist Exhibition" at the Galerie des Beaux-Arts was to become the triumphant swansong of the entire Parisian Surrealist scene. Once again, on the eve of war, Breton and his followers pulled out all the stops. Duchamp was the driving force behind the staging of grand operas that were a milestone in the development of environment art. As in the theatre, the individual areas were divided up into technical, lighting, props and sound, with each artist taking charge of one such area. The central obsessions or fads of the Surrealist visual world were parades in a grotesque display of mannequins covered in snails, spoon costumes, fantastic headgear, cages, body fragments.

Duchamp transformed the central hall into a uterine grotto with 1200 sacks of coal on the ceiling, a carpet of leaves on the floor, a pool with water-lilies, a coal-fired brazier (Bohemians in winter!) and a huge love-bed. To the aroma of Brazilian coffee, Prussian military marches resounded from a female-shaped gramophone. One year later, the Germans marched into Paris. The Surrealists emigrated to New York.

Soon afterwards, an entire generation of sculptors were caught in the wake of Surrealism. At times, it blends with the edges of the Constructivist movement, represented by Piet Mondrian (pp. 169–171) who had been in New York since 1940. This explains why it is not the Surrealist object that predominates, but the fully modelled, and often bronze-cast, sculptures. Remarkably, it was not the emigrant artists who had the strongest influence, but Giacometti, who lived far away in France. David Hare, Seymour Lipton, Louise Bourgeois, Ibram Lassov, Theodore Roszak, the Brancusi student Isamu Noguchi, and the early David Smith all have in common, albeit with differing emphases, cage-like grids and frames containing aggressively angular or biomorphically vegetable inner forms. American Indian influences added a vague totemism. In the end, like so much in Paris, this remained an externalised and second-hand Surrealism.

Only the American Joseph Cornell (ill. left), working in self-imposed isolation, succeeded in creating an authentic variation on Surrealist combination. His *Boxes* eschew the histrionics of cruelty. On the contrary, as in a *Wunderkammer* of disparate objects, they celebrate a complex conglomeration of familiar and unfamiliar things: bric-a-brac and nostalgic souvenirs of art, music,

theatre, literature, nature. They contain ballet photographs, star postcards, maps, bird-feathers. The viewer is invited to manipulate them in the manner of a board-game, creating an aleatory context. The past, the present, the now of the viewer, abstraction and objects all interweave, and forms correspond beyond any degree of reality. Each box is a pœtic metaphor of memory, in which submerged reminiscences meet current projections. This is one of the most charming, precise and complex enrichments of the *objet assisté*.

## Giacometti: Staging Psychological Terror

The Surrealists pursued the production of *objets* like a cult on the verge of becoming a fashion. When Giacometti created his *Invisible Object* in 1934, presenting an idol-like female figure with hands embracing empty space like a vessel – did the title turn ironically, or even polemically, against the "object"-obsession of his friends? Giacometti himself was the only artist who actually continued to create truly Surrealist sculptures for half a decade. Although, in keeping with Breton's doctrine, he insisted upon the subconscious, medial emergence of these sculptures, mystification did not hinder their precise formal realisation. In this respect

**Alberto Giacometti**
The Palace at 4 A. M., 1932/33
Wood, glass, wire, and string,
63.5 x 71.7 x 40 cm
New York, The Museum of
Modern Art

Giacometti took the spatial breakthroughs, concave hollows and convex curves of late Cubist sculpture one step further and re-interpreted them. He used Cubist frameworks to give his sculptures a clear spatial definition. Even his "sculpture-as-board-game" works were to

have a direct influence on the emergence of horizontal, landscape-oriented rather than anthropomorphic sculpture in the 60s and 70s.

From 1925 onwards, as a result of the influence of Cubism and "primitive" art, Giacometti moved towards a more strongly abstractive syntax influenced by Laurens and Lipchitz. With his "flat sculptures", most of them radically simplified *Heads*, he left Cubism behind him in 1927/28. The transition to Surrealism was fluid. It was not Giacometti who discovered Surrealism, but the Surrealists who discovered Giacometti. Was this new horizon already evident in the hierarchically towering and radically abbreviated idol of the *Reclining Woman* of 1926? Or did it not emerge until the injurious, aggressive figural signs of 1929 in which the act of love escalates into the murderous thrust of a dagger?

From 1930 onwards the central motif of man and woman becomes one of deadly copulation, an animal-insectoid gender struggle in which spindle (body), sphere (head), hacked ovaries or leaves interact. On several occasions, the merciless struggle is gridded by the bars of a cage: taboo zones are opened voyeuristically. His *Woman with her Throat Cut* lies directly on the floor, as though disembowelled, dissected, boned; remains that recall the battle of the scorpions in Luis Buñuel's film *L'Age d'or*. Duchamp's erotic fantasies of bachelor images are echoed in the anatomic interweavings, and Picasso's 1930 designs for monuments in the frame-like structures.

Giacometti's famous *Suspended Ball* of 1939 (ill. left) originally modelled in plaster, then painstakingly carved in wood by a carpenter, is a flagship of Surrealist sculpture, with its ambivalent crossing of male and female

**Alberto Giacometti**
Suspended Ball, 1930/31
Plaster and metal, 61 x 36 x 33.5 cm
Basel, Öffentliche Kunstsammlung,
Depositum im Kunstmuseum Basel,
Alberto Giacometti Stiftung

**Alberto Giacometti**
The Surrealistic Table, 1933
Bronze, 143 x 103 x 43 cm
Paris, Musée National d'Art
Moderne, Centre Georges
Pompidou

*"Whatever I look at, everything goes beyond me and astonishes me and I myself do not know exactly what I see. It is too complex. One simply has to try to copy the visible in order to take stock of what one sees."*
ALBERTO GIACOMETTI

human excess. Giacometti's crass revelation of cruelty does not aim to shock, but to present existential images of a polarised totality. In his *Board-Games* (1931–1932) he abstracts this theme from all the lurid extroversion of the psychological and transposes them to tracks in the ground plane of the board. A ball that will never reach its destination, figure circles of man and woman flank a row of graves and bomb craters. These are conclusive, concrete variations on the old topos of "the game of life", just as other sculptures address the topos of "the theatre of life".

The most enigmatic image of all is the model-like framework entitled *The Palace at 4 A.M.* (p. 465 above) which merges elements from the stage at the Meyerhold Theatre, Giotto's *Annunciation* and autobiographical elements. The work of art becomes a "stage of ideas" (R. Hohl), on which the primordial drama of life, love and death are coded with dream. The programmatic sculpture *Surrealistic Table* (ill. left) presents the tabletop as a stage tableau above which the half-veiled bust of a woman presides over a crystalline tetrahedron and a realistic model of a hand. Her veil floats under the table, which stands on four differently styled legs. In place of tormenting excess we find a mysterious ensemble somewhere between portraiture and still life.

Was Giacometti thinking here of his own artistic path, with friendly reference to the works of Magritte, Léger and Brancusi? Does the tetrahedron – a head, perhaps – indicate a style of semiotic abstraction? Does the hand suggest more realistic possibilities? Does the half-veiled head refer to a break between familiar and older and unknown future work? Towards the end of 1934 Giacometti, filled with doubts about the potential of sculpture, said he wished that he could succeed in making just one head. Breton retorted that everyone knew what a head was. Giacometti was moving away from Surrealism. He returned to the study of models.

### The Spectre of Surrealism

Giacometti was not the only one to place himself at a distance from the coquettishly provocative aspect of the *objets surréalistes*. Towards the end of the 40s, confidence in the projection of unaltered objects as quotations and the magic of the disparate had begun to wane. Too much had ended up in what amounted to little more than an artistic freakshow. Instead of Breton's literary-minded obsession with the object, the need for the author's shaping hand began to surface again. This does not mean that the Surrealist impulse ground to a halt, yet two of its leading painters turned to sculpture which concealed the object within the sculpture.

Max Ernst spent the summer of 1934 with Giacometti in the Italian mountain resort of Maiola near Stampa. In a riverbed, the two friends found large stones, weathered by the glacial flow, whose ovoid form inspired Max Ernst to make relief engravings like the scratching of newly hatched chicks. This was the first time he had transposed his ubiquitous bird motif into

specifics: a segmented sphere is suspended over the comb of a curved spindle form, the ball and the edge are close, stimulating each other without actually touching or gliding into one another in a tantalizing sexual stimulation. The sculpture embodies at one and the same time the sexual act and injury, erogenous zones and wound, forced touch and fear of touch, libido and destructive drive. The framework and the interim level present this as though on a stage, in a theatre of cruelty, but also in a prison from which there is no escape. We ourselves provide the impulse for the act of failure and are thus included in it. The movement is also a physiological potential.

In his magisterial Giacometti monograph, Reinhold Hohl has shown that the work not only exploits ambivalent sexual projections, but that gender polarity, torture, and futility reveal the depths of a (pessimistic?) view of humankind. The ultimate pain, as in André Malraux' novel *La Voie Royale* of the same period, becomes the touchstone of ultimate human reality. Here, we find ourselves sailing dangerously close to the abyss of anti-

the three-dimensional mode of a sculpture based on nature. During the following winter, he plastered and modelled eight sculptures containing objects of everyday use (his *Moon Asparagus* for example uses stacked flowerpots, and his *Œdipus* features sand-buckets). In 1960 he went one step further and had them cast in bronze.

Wherever Max Ernst worked from 1944 onwards, he surrounded himself with mural reliefs and figures. There were phases (1934/1935, 1944, 1948, 1967) when he created hybrid creatures that were a cross between plants, animals and humans, adding a new and grotesque species to the surrealist world of metamorphic transitions. The largest and most complex of these composite sculptures is his cast concrete *Capricorne* (ill. right) which Ernst installed in front of his house in the bizarre Arizona landscape in 1948. It is a "family portrait" featuring his wife Dorothea Tanning and the two dogs, with the man as a ruler enthroned in the guise of Capricorn and the woman as a gracefully elongated nymph with a fish-like head-dress, blending many motifs from collages and pictures, evoking the archetypal, and recalling Hopi ceremonial dolls and other Indian art. A powerful synthesis of the found and the modelled, it is one of the most stunning transformations of the Surrealist visual imagination.

Joan Miró also found and invented his own world by drawing from the wellspring of his richly associative and thoroughly pictorial imagination (ill left). He, too, combined found objects, stones, flotsam, craftsmen's tools with modelled parts and then merged the whole in a bronze cast. Herein lies an essential difference to the direct appeal of the objets trouvés. Above all, however, from 1944 onwards, he created his works in a primarily intuitive act of modelling in plaster or clay, diametrically opposed to the detached formal syntax of Max Ernst. From 1953–1956 he worked increasingly closely with his friend, the potter Artigas. Out of the unusual terracotta mixtures, oxydations and firings, he created a major series of maternal, grotesque, monstrous women and birds of childlike intensity and formal decisiveness. From 1966 onwards the sculptures began to take on monumental dimensions, particularly in his work for the Fondation Maeght at St Paul de Vence. Miró created rounded and angular variations on body volumes with a sheer enjoyment of biomorphic growth reminiscent of Ancient Mediterranean goddesses. His sculptures as a whole constitute an important œuvre in their own right and, as such, go far beyond the mere exploratory forays of a painter working in another genre.

**Max Ernst**
Capricorne, 1948–1964
Bronze, 240 x 205 x 130 cm
Destroyed; fragments: USA,
private collection

*"Sculpture is created in an embrace, by two hands, as in love. It is the simplest and most original art. I do not have to force myself or really push myself to it. It does not demand the same concentration or effort as painting."* MAX ERNST

**Joan Miró**
Figure, 1968
Painted bronze, 165 x 60 x 100 cm
Private collection

# New Materials: Iron and Steel

Around 1930, a new material entered the realms of sculpture: iron and its alloy, steel. Although sculptures and liturgical instruments had been made of cast iron in Classical Antiquity and the Middle Ages, iron came to be regarded during the industrial era of the 19th century as a cheap substitute for expensive bronze. As such, it was relegated to use in the field of decorative arts, and it was only in the world of civil engineering that it took on a new and functionally aesthetic character. Yet suddenly, around 1930, iron and steel became the preferred material of the avant-garde. Picasso (who had already experimented with sheet metal in his *Guitar* reliefs), González, Calder, and later David Smith, Anthony Caro and Eduardo Chillida, all placed this base metal at the forefront of progressive art. Iron, the more archaic of the two, tended to represent a timeless, pre-industrial view of the world, whereas steel was seen as a modern material redolent of the utopian spirit of a technologically advancing world.

Admittedly, most of these sculptures can also be regarded as representing the later stages of Expressionism, Constructivism or Surrealism, but the new material did create its own language, making a distinctive mark on the second third of the century. Used to express a number of styles, it may not have shaped a style of its own, but it did generate a new aesthetic approach that embraced a number of new developments.

Above all, iron and steel proved the perfect vehicle for two major themes in modern sculpture. Though neither of these themes was particularly new, they were channeled in different directions during this period. One involved the interaction of volume and space, positive and negative, which Lipchitz had been exploring in his *Transparencies* with their extreme spatial breakthroughs since 1926. The other was the principle of montage and collage involving the juxtaposition of found objects, garbage and commonplace utensils in a tradition that can be traced directly from Boccioni to Tatlin to Schwitters.

## Picasso's Discovery of the Metal Montage

In 1928, Picasso began experimenting with small figures made of wire. These were extremely simplified abstractions, reduced to pure contours. Condensation and open space balance each other out. Daniel-Henry Kahnweiler described these wire constructions as "drawings in space". The larger versions, especially, also pose a technical challenge in terms of construction, joints and seams. For this reason, Picasso called upon his fellow Catalonian Julio González, who had lived in Paris since 1900 and who was an outstanding metalsmith and craftsman. González taught Picasso to handle an oxyacetylene welding torch and, in turn, learned from Picasso a new freedom and decisiveness in his artistic ambitions, which, for almost three decades, had been distributed vaguely between painting, sculpture and applied art. Picasso freed the artist within the craftsman and cured him of the notion that sculpture in iron was work, while painting was art.

Until 1932, these two friends worked closely together, mainly in Picasso's studio at Boisgeloup. It was a collaboration that was to crystallise into one of the most felicitous moments of modern sculpture. Whatever assemblages Picasso later created in diverse materials were based on that collaboration. On the other hand, Picasso also acted as a catalyst on the work of González, liberating the powers that were to make him, in the following twelve months, the founding father of modern iron sculpture, described by David Smith as "the master welder". Even the ornamentally decorative work of another Catalonian artist in Paris, Pablo Gargallo (p. 474), with its boldly sweeping concave and convex curves, paled by comparison.

Encouraged by González, Picasso made his mark a second time on the history of sculpture. His purist metal wire constructions developed in the course of 1929/30 into a series of bizarre and unprecedented life-sized figures and heads based entirely on sculptural concepts, as opposed to the principles of drawing or painting. Such assemblages as the white-painted *Woman in a Garden* (p. 470 above left) and the *Head of a Woman* (p. 470 above right) are works of extraordinary wit and newfound imaginative freedom, a far cry indeed from the tense and at times tormented associative eroticism of the contemporary Surrealist objects.

Scrap-yards, storerooms and kitchens served as a source of found objects which were adventurously welded, soldered and bolted together, cut out or driven in iron. According to Picasso, "We roared with laughter as we did that." Everything is disparate and is as close to

**Alexander Calder**
Le Hallebardier, 1971
Red painted iron; height: 800 cm
Hanover, Kurt-Schwitters-Platz
(Sprengel Museum Hannover)

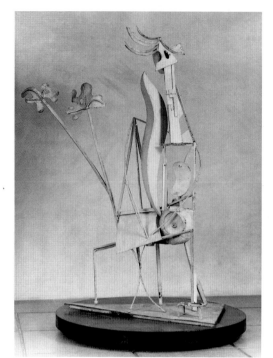

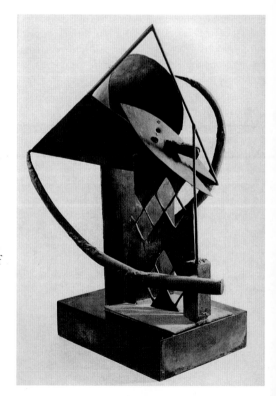

**Pablo Picasso**
Woman in a Garden, 1929/30
Iron, soldered and painted white,
206 x 117 x 85 cm
Paris, Musée Picasso

**Pablo Picasso**
Head of a Woman, 1929/30
Iron, sheet metal, colander and
springs, painted, 100 x 37 x 59 cm
Paris, Musée Picasso

Art Brut as it is to Surrealism. Fragments of iron form a body, a kitchen sieve a head, springs become hair, nails eyes, while two cast-iron rhododendron blossoms mark the transition to the world of plants, creating a semi-abstract figure.

The views are as diverse as the materials. All the components can be read, depending on the angle from which they are viewed, as head, body, or hair. Picasso deliberately used these transformations, playing with them and charging the object with ambivalence (as he had previously done in his Cubist collages) as both object and autonomous form. It is this double reading, in particular, that distinguishes his work from that of Boccioni and the early Russian assemblage artists such as Vladimir Baranov-Rossiné (p. 438). At the same time, he goes one step further in the interaction of volume and space. Panels, bars, kitchen utensils are not even extremely reduced volumes, but entities that rebuild, embrace and envelop space. And while Picasso was soon to turn again to sculptural mass and swelling volume, González was to continue in his consistent exploration of these themes.

### González: Founding Father of Iron Sculpture
In 1900, González and his family moved from Barcelona to Paris. Apart from a few Cubist touches, and in spite of his friendship with Brancusi, the emergence of Modernism had little influence on his work until well into the 20s. In 1928, under the influence of African art, he caught up on some lost ground, creating Cubistically stylised masks and ornamentally cut sihouettes of copper or repoussé iron. He curved and bent sheet metal out of the plane, opening up interim spaces, creating layers and bridges. It was not until 1930, however, that

his œuvre as we know it was begun. Just how much he owed to the liberating influence of Picasso remains a matter of speculation.

For the groundbreaking sculptures of the *Little Dancer* and *Don Quixote* (both 1929/30), at any rate, no precursors can be found in the œuvre of Picasso. They are derived entirely from the tradition of wrought iron. The limbs still recall the metal ingots and bear the traces

**Julio González**
Harlequin, 1927–1930
Wrought iron, 43 x 30 x 30 cm
Paris, private collection

of hammer, pincers and welding torch. Even at this early stage, González went beyond the bounds of Cubism to handle space "like a newly acquired material" equal to iron, as he himself claimed. The upper body of the melancholy knight is curved entirely out of air. The Catalonian in Paris took the path towards iron sculpture entirely on his own initiative and by his own strength.

Occasionally, especially after 1935, he continued to use the solid density of form that characterised his earlier works. His famous *Montserrat* created in 1935/36 for the Spanish pavilion at the World Fair appears to be armour-plated. It stands full square against the surrounding space, epitomising the stance of the individual in resistance. Even the thirty-odd heads (mainly in stone) and the figures wrought out of metal sheets present their closed form and their hardness as though in resistance. They tear, they erode, but they do not open up. Their resistance against penetration by the surrounding space lends a sense of resistance as such. Resistance, perhaps, against the Falangist terror of the Civil War?

The main thrust of his work, however, addressed the problem of gesturally embracing space. This central challenge inspired sculptures which, together with Giacometti's surrealist objects, were among the most influential innovations of the 30s. It began almost without warning in 1930, with the *Harlequin* (p. 470 below), a sculpture that sweeps into its surroundings with broad curves and jutting triangle, and draws them back into its innermost parts. All in all, it is a sketchy abbreviation made up of soldered-together iron pieces. A protruding

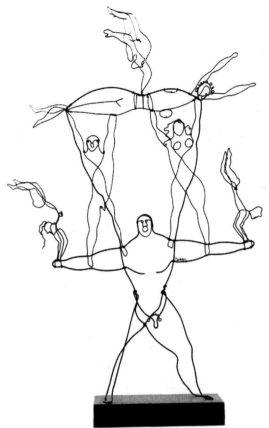

**Alexander Calder**
The Brass Family, 1929
Brass wire, 162 x 104 x 22 cm
New York, Whitney Museum of American Art, Gift of the Artist

rectangle is the stabilising element, replacing the upper body, while lozenge shapes recall the costume, and the face is a mere cut-out lying at an angle within the semi-transparent triangle that suggests the hat. A funnel forms the isolated head, and bow-like arcs suggest spindly arms. The precarious balance between transparent and non-transparent parts that meet and seem to fall apart, the abrupt discontinuity in the change of views, make this the perfect example of an open sculpture in the round. In 1932/33 the *Head* also known as the *Tunnel* (ill. left) interprets the inclusion of space as an exclusion of light. Not even in the work of Lipchitz and Picasso is there any parallel for such a complete turnaround of sculptural concepts.

From here on in, masterpiece was followed by masterpiece. The wild and fragmented conglomerate, *Woman Combing her Hair* of 1931 was followed two years later by a depiction of the same motif. This time the motif was taken up in a balanced and angular composition of verticals, arcs, protrusions and sweeping hair. In the mid 30s, González went a step further in his simplification of forms, in the spirit of Picasso's "drawings in space", by paring the complex equilibrium down to the dynamically stretched and dance-like movement of a single line. Picasso's geometric construction burst into vibrantly gesticulating eccentricity with verticals binding the body's framework, while curved lines contour and follow the upper bodies, heads, imaginary volumes.

González by now had mastered a wide range of rhythms and expressions within the scope of his actual

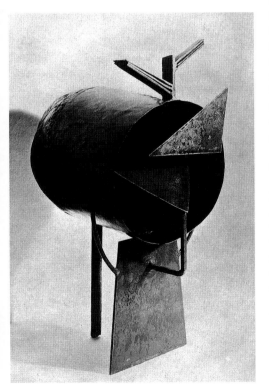

*"Great art is not made by drawing perfect circles and squares with a compass and ruler; really new things are directly inspired by nature and executed with love and honesty."*
JULIO GONZÁLEZ

**Julio González**
Head known as "The Tunnel", 1932/33
Iron, 46 x 22 x 40 cm
London, Tate Gallery

**Julio González**
Cactus Man I, 1939
Wrought iron, 65.5 x 27.5 x 15.5 cm
Paris, private collection

metalsmithing background, from the statuary verticalism of the *Grande Maternité* to the floating ecstacies of the dancers and the accomplished blend of the structural and the biomorphic, cubes and curves, warrior and plant in his peasant-cum-mercenary *Cactus Man* (ill. left). His work covered a spectrum from the graphic linearity of bars to the frenzied gestural movement of welded wrought-iron components, to the solid structure into which complementary spaces are inserted. Any inspiration he may have taken from the pictures by Magnelli (p. 220) or Miró (pp. 150 ff) are subordinate to his own authentic language. While they may influence individual aspects, they have no bearing on the overall form.

### Calder and the Poetry of the Mobile

Can Alexander Calder be properly added to a list of sculptors in metal, after González? Would it not be more appropriate to place him (almost) at the beginning of the Kinetic Art movement that emerged in the 1950s and 1960s. After all, the fragile choreography of his mobiles surely belongs within the context of moving and changeable art. Following the theoretical farsightedness of the Futurists, Rodchenko's suspended reliefs and Gabo's vibrating steel springs, Calder made mobility and mutability his aesthetic *leitbild* in which he recognised an inherent poetry and universal symbolism. In this respect, he is very much a part of that complex of modern sculpture described by Rosalind Krauss as "mechanical ballets".

A different categorisation would thus be possible. Strictly historically, however, Calder is an artist of the same period and the same context as González, and both arrived at their own formal language at almost the same time. Both came into contact around 1930 with the key Parisian influences of Surrealism and late Constructivism. Both go beyond the boundaries of these movements. Both were not originally sculptors and were therefore freer in their approach to a new medium. Calder soon restricted his work to steel, lending it the same lightness, malleability and compositional flexibility that González gave to iron.

A trained engineer, he came to Paris from Philadelphia in 1926. He began making witty and whimsical wire sculptures (p. 471), lines drawn in the air, unaware of the experiments being carried out in the same field by Jean Cocteau, Picasso and Arp – a parthenogenesis of three dimensionality out of drawing. Calder touched the pulse of art in his time. When he exhibited his miniature circus of wire, animals and weightless acrobats as linear sculptures of arabesque wit and stunning caricature, the doors of the avant-garde studios were open to him. However, it was his visit to Mondrian in 1931 that gave his sculpture the decisive boost, turning it into a series of moving, suspended Mondrians, their component parts balanced and turning in mutual dependency like the stars of the universe. The influence of Magnelli, Arp and above all Miró soon toned down

"Symmetry and order do not make a composition. It's the apparent accident to regularity which the artist contrls by which he makes or mars a work." ALEXANDER CALDER

**Alexander Calder**
Four Red Systems (Mobile), 1960
Painted metal and wire,
195 x 180 x 180 cm
Humblebæk (Denmark), Louisiana
Museum of Modern Art,
Ny Carlsbergfondet

his initial geometric stringency, adding a playful touch of energetic motion and organic curves far better suited to Calder's artistic temperament.

His most important contribution to modern sculpture was and has remained the mobile (ill. above). His achievement lies not least in the speed and determination with which he solved the aesthetic problems of this new genre, developing a valid, and for his followers dangerously accessible, lyricism. It makes all earlier kinetic art seem like some peripheral preparatory experiment. Soon, Calder was to abandon the motor drive as well as the geometric circles and rectangles he had derived from Mondrian. He adopted Magnelli's dynamic contours and Miró's leafy forms, threaded them onto slender iron wires and suspended them in counterweight against heavier, slower-moving slabs. The breath of air became the element of change. Outline, size, metal thickness, length and thickness of arms all affect the ponderation by which the mobile develops its full scope. The move-

ment describes virtual volumes – yet how much richer, more contemplative and more natural this seems than Gabo's whirring spindle of 1920.

Calder's stabiles (the term was coined by Hans Arp) are frequently regarded as being diametrically opposed to his mobiles, which Duchamp termed as such. Indeed, they soar with force and presence, in contrast to the mobiles, which gently cut the air, gliding through it smoothly. Elephants instead of floating fish, birds and blossoms. Yet these massive, humorously biomorphic, zoomorphic steel colossuses of brilliant red seem to push away from the ground, stretching out their slender arms, tentacles, crests and arcs, leading around and through the sculpture itself. Their monumentality goes hand in hand with dance-like lightness. It is for this reason that the large stabiles, which form the focal point of Calder's mature work, form a perfect contrast to urban architecture. They are among the few paradigmatic examples of urban art (p. 468).

**Pablo Gargallo**
Prophet, 1933
Bronze; height: 235 cm
Private collection

**Eduardo Chillida**
Gudari (Warrior), 1974/75
Steel, 185 x 146 x 107 cm
Berlin, Staatliche Museen zu
Berlin – Preußischer
Kulturbesitz, Nationalgalerie

## With Hammer and Cutter

In the 19th century, iron and steel were the materials used by innovative engineers for their bold new projects. After 1950 their distinctive aesthetics spread throughout the world of sculpture in the form of free-standing, sweeping, asymmetrical sculptures, wire "drawings in space" and axially aligned metal slabs. The metal was wrought and hammered, cut and welded. Wherever the traces, notches and scars of the hammer, the cutter or the welding torch were to be found, wherever the tension of iron and steel made its mark on the conceptual, compositional and gestural aspect of the work, these sculptors were a group apart. Those who assembled sculptures, seeking their materials in scrap-yards and spare parts stores are also part of that group.

The ground was prepared by González, at times by Picasso and to some extent by Pablo Gargallo – three Spanish artists in Paris whose work married the ancient Spanish craft of the smith with the spirit of Modernism. Gargallo's masks of iron and copper sheeting marked the beginning around 1910. Yet even his large figures after 1930 still leaned heavily towards a theatrically elegant stylisation (ill. right). In 1930, González had already demonstrated with his *Don Quixote* how a figure can

consist fundamentally of a void embraced by iron. The void as opposed to volume was to become a key word for the Basque artist Eduardo Chillida (ill. left and right) who rejected stone and figurative sculpture in Paris, to start from scratch in 1951 as an apprentice to the village smith of Hernani. Like no other 20th century sculptor, he revealed the dynamism and malleable resistance of iron. From 1954 to 1966 he created seventeen versions of the *Dream Anvil* that is a *leitmotif* throughout his œuvre. The anvil seems to bite into the wood in a sculptural abstraction that pays homage to the mythical yet still contemporary craft of the metalsmith.

The steles that Chillida dedicated to Pablo Neruda, Manuel Millares, Salvador Allende and others from the 60s onwards were also derived from the anvil motif. At that time, the bars were more massively rounded and angled, and the negative form was modelled almost violently into many-fingered interweavings. Undulations seem to trap their inherent power. In 1977 Chillida developed his famous *Combs of the Wind* to gigantic proportions. The three sculptures defy the spray, waves and wind on a rocky outcrop by San Sebastián. After 1973 this Basque sculptor also worked in alabaster and terracotta. Outwardly, these works clench together in a block. The walls reflect the light and draw the mystery of the space into the interior.

Instead of working in raw iron, the Swiss artist Bernhard Luginbühl (p. 475 above right). has been assembling industrially manufactured structural elements and

machine parts like components in a gigantic metal building block set since 1954. In the 60s, bolted girders, nuts, propellors and turbine fragments were mutated into animal silhouettes – a frog, a bulldog, a giraffe, an elephant – of grotesquely powerful expressiveness. The largest sculptures address the myths of work and futility, with spheres rolling up and down as though in some mechanised Sisyphean labour – an absurd technical procedure of the kind that Luginbühl's compatriot, friend and occasional collaborator Tinguely also stages.

Whether iron wires draw bold lines in the air, as in the work of the American artist Ibram Lassow or the Swiss artist Walter Bodmer, whether iron sheets can be shifted on an axis to work expressively against one another, as in the work of the Italian artist Berto Lardera (ill. above left) or whether, in the merging of Constructivist and Surreal roots, they aggressively besiege, dissect and spear the space as in the work of the Danish artist Robert Jacobsen (ill. below) the material itself invariably intervenes massively in the creative act.

**Berto Lardera**
Colloquio 8, 1959/60
Iron; height: 280 cm
Private collection

**Bernhard Luginbühl**
Small Cyclops, 1967
Iron, red painted, 292 x 485 x 300 cm
Hamburg, Hamburger Kunsthalle

**Eduardo Chillida**
Comb of the Wind XVII, 1990
Steel, 230 x 189 x 120 cm
Collection of the Artist

**Robert Jacobsen**
Sculpture, 1956
Iron, 74 x 57 x 40.5 cm
Clas Anshelm Collection

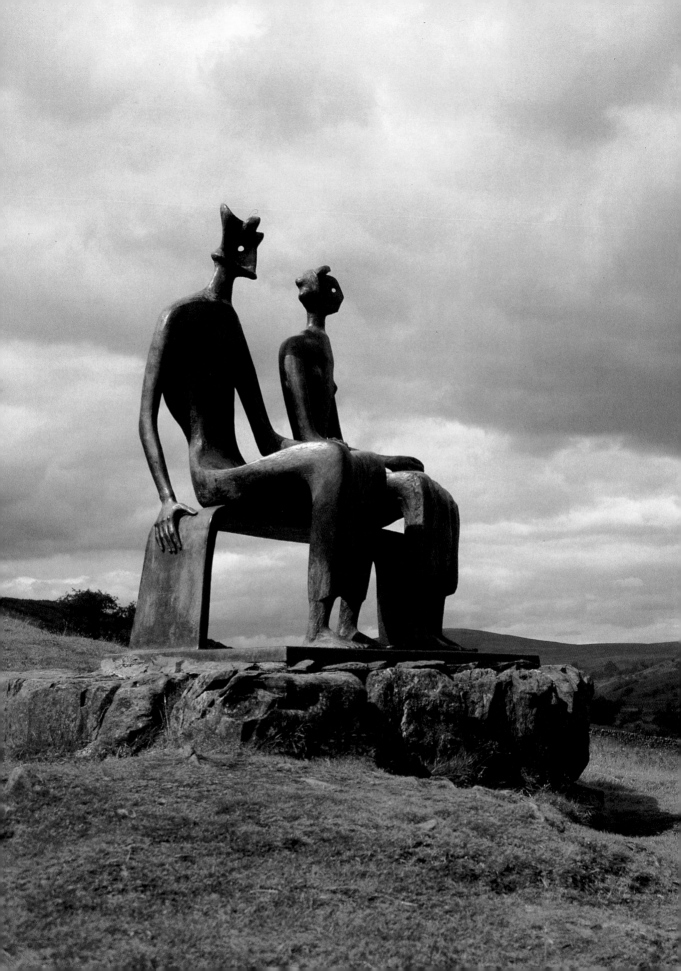

# Biomorphic Sculptures – A Vitalistic Counterposition

### "Like Nature"

The Constructivist world design shimmers on the horizon of modern technology with all the brilliance of a social utopia. Gabo and Pevsner wax lyrical in their manifestos on the plumbline, the rule and the compass, on the craft of the engineer, on mathematics, and on the linear structures and arcs upon which the universe is built. By the 1930s, this design had fallen prey to the histrionics of power and the philistine reactionary ideas of totalitarian regimes in Eastern and Central Europe. Almost simultaneously, an alternative design emerged – with neither manifesto nor programme, with cross-references to Surrealism, but without Surrealism's abysses and labyrinths of paranoia. It was an approach to art that did not seek to build and construct rationally, but to emulate the germinal forces of nature and be shaped by the erosive forces of the elements. "Like nature" became a fundamental aesthetic slogan of modernism, taking on its greatest resonance in the work of Paul Klee (pp. 119 ff).

Among sculptors it was adopted primarily by Hans Arp and Henry Moore. According to Arp, "We do not seek to imitate nature ... we want to create, as the plant creates its fruit, and not to imitate." According to Moore himself, "I am most deeply interested in the human figure, but I have discovered laws of form and rhythm in studying natural forms such as pebbles, rocks, bones, trees and plants." Sculpture became receptive to analogies of growth, its powers, structures and laws. This did not lead to the formation of any group or "style", but to a broad-based movement that was to spawn many others.

Its origins lay in Rodin's fluidity of form and in the organic morphology of Art Nouveau and Jugendstil. In 1914, the young sculptor Gaudier-Brzeska collected material for an essay on "The necessity of organic forms". Brancusi's ovoid form contains the essence of all life. Around 1930 the Constructivist founding father Tatlin actually based his *Letatlin* flying machine on the flight of birds, following an organically rhythmic, biodynamic principle rather than a mechanical one. The Surrealist influence came from Yves Tanguy (pp. 140, 142), whose fluid metamorphoses languish and melt on metaphysical beaches. Signs of a breakthrough became increasingly evident. At Boisgeloup, around 1930, Picasso created fertility idols of purely sculptural corporeality with

**Karl Hartung**
Composition VIII, 1948
Limewood; heigth: 33.5 cm
Private collection

ample, expansive limbs. Arp invented creatures of concentrated naturalness, in which stone, plants, animals and torsos are vividly united. Moore translated the inspiration of rocks, mountains, bones and branches into sculpture with dramatic effect.

From the 30s the tendency towards the organic spread rapidly. In Germany, under the influence of Brancusi and Arp, Karl Hartung (ill. above) opened up his abstract sculptures to include gouges, tears and surging protrusions. In France, Henri Etienne-Martin (p. 478 above left) evoked the chtonic origins of architecture with his formations of imaginary labyrinhtian habitations (*Demeures*). Alicia Penalba (p. 478 below) who was born in Buenos Aires, modelled lush, tropical plant symbols of eroticism out of clay.

It is quite remarkable that biomorphic sculpture – a term actually coined in 1936 by Alfred H. Barr – should have emerged so late. Goethe's *Theory of metamorphoses* had already prepared the ground after 1800. Novalis had linked art and poetry with the building plans of Nature. In 1907 Henri Bergson had published his credo *Creative development* and proclaimed *élan vital* to be an all-per-

**Henry Moore**
King and Queen, 1952/53
Bronze; height: 170 cm
Glenkiln, Shawhead, Dumfriesshire (Scotland), Collection
W. J. Keswick

**Henri Etienne-Martin**
Dwelling No. 3, 1960
Plaster, 250 x 500 x 225 cm
Private collection

**Pablo Picasso**
Figure (Maquette for a Monument
to Apollinaire), 1928
Iron wire and sheet metal,
50.5 x 18.5 x 40.8 cm
Paris, Musée Picasso

vading energy, tantamount to the flow of life and intuition against the rigid deformations of reason and the inflexible mimesis of the world. According to Bergson, evolutionary processes and artistic creativity, the forces of nature and creative impetus all rise from the same source. No wonder artists from the futurists to Paul Klee looked to the theories of Bergson, that lyrically inspired philosopher, to underpin their work.

In 1917 the biologist d'Arcy Wentworth Thompson published two volumes tracing the link between "growth and form" and explored the visible laws of growth governing bone structure, rhizomes, shells etc. – obvious reflections can be found two decdes later in the work of

Moore. In this way, a more conservative direction in biology and the philosophy of life fed a more vitalistic trend in sculpture, a third way alongside the constructivist idea and the surrealist object. The English art historian Herbert Read saw in this a "genetic principle" of Modernism in which natural forms merge with vitalistic abstraction.

## Picasso's Work at Boisgeloup
Picasso, meanwhile, had once again set about transforming opposites into aesthetic extremes. In 1928 he bent and knotted his wire constructions in space (ill. above). At around the same time he modelled a *Head of*

**Alicia Penalba**
Grande Ailée (Winged Figure),
1960–1963
Bronze, patina, 105 x 195 x 95 cm
Private collection

**Alicia Penalba**
Field with Wings. Sculpture for
St. Gallen Business College
(detail), 1962/63. Concrete
St. Gallen, Handelshochschule

abundantly hypertrophic work paid homage to an archetype of sculptural design that was diametrically opposed to the Constructivist world design. In creating it, Picasso gave expression to a *Weltbild* that has its own horizon in modern sculpture.

### Arp: Dada Heads and Organic Concretions

The work of Hans Arp (pp. 480 f) is the very epitome of biomorphic sculpture. He made his sculptures into metaphors of the demiurgic act in analogy to nature as no other artist had done before him. And, like no other, he united sheer sculptural form with the very essence of organic growth. In doing so he played through the entire evolutionary hierarchy from mineral to flora, fauna and the human body in a bid to show that no hierarchy exists and the same powers work through everything. He dreamt the "cosmic dream of unity and transformation with burlesque undertones" (C. Giedion-Welcker). "Out of a swelling heavenly fleece a leaf rises. The leaf turns into a vase, a huge navel appears. The navel has become a sun, an immeasurable source, the original source of the world."

*a Woman* (ill. above) in plaster to be cast in bronze. The difference between the two could harldy be greater. While one involves the reduction of form to a framework of slender rods, the other is a massive arch of firmfooted, elephantine proportion with a hypertrophic corporeal superstructure from which a broad head protrudes. What appears as physical deformation holds the balance between mass and void, volume and interior space.

At his large studio in Boisgeloup to the north of Paris, Picasso continued in 1931 to work on these exuberant female bodies, reclining and standing, whose heavy and unwieldy components were joined to form an ungainly and yet arabsequely curving dancelike torsion. In modelling his Ancient Mediterranean fertility goddesses, he made plaster a material of growth and life. While such transformations do have certain affinities with Surrealism, Picasso approached them entirely from the stance of autonomous sculpture, applying a convulsive gravity and inversion of form that were not only entirely foreign to Surrealism, but also to Cubism. In doing so, he produced some of the greatest and most influential volumetric sculptures of the 20th century.

Important as the subsequent developments of the principles of material collage, *objet trouvé* and print might have been, no matter how consistent his variously angled views of Sylvette in sheet metal and no matter how impressive the step towards urbanity with huge planar sculptures of concrete, this exaggeratedly organic,

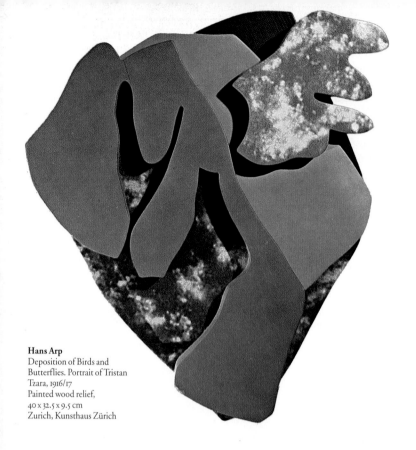

**Hans Arp**
Deposition of Birds and
Butterflies. Portrait of Tristan
Tzara, 1916/17
Painted wood relief,
40 x 32.5 x 9.5 cm
Zurich, Kunsthaus Zürich

The Strasbourg artist began as a painter indebted to expressionism and the Blauer Reiter group. In 1916 the young, eloquent poet and artist joined the founders of Dada Zurich who met at the Cabaret Voltaire. At that time, he was sawing and cutting his first polychromatic wooden reliefs *(Portrait of Tristan Tzara;* ill. left) with overlapping contours – a pictorial alphabet that draws its own conclusions from Picasso's planar montages with hieroglyphs of moustache, gendarme's cap, fork, navel, mirror, fried egg etc., and whose witty juxtaposition echoes the punning of his poetry. In the course of the 20s his offbeat approach focused on fluidly amoebic ovals with sweeping outlines.

Arp repeatedly stressed the aleatory principle behind these early reliefs in which forms seem to swim against each other. Yet for Arp, the law of chance did not mean the same as it did for Duchamp in his strategy of indifference or his surrealist receptiveness to the projections of the self. Rather than a withdrawal from artistic design, it indicated complete devotion to the unconscious, anonymous process, a "gift of the muses" or (citing Novalis) "the touch of a higher being" – a kind of first cause that creates "pure life". Behind this is a romantic concept of art and the artist which, in the work of Arp, loses all that is shapeless and trailing, and "concretises" itself in firmly outlined entities.

By 1929, Arp was making the rounded sculptures in marble, plaster or bronze that he called "concretions" and wished to have installed in modest locations in forests, mountains, in the countryside (ill. below). Initially, around the same time as Giacometti's board-

**Hans Arp**
Head with Three Annoying
Objects, 1932
Plaster, 23 x 33 cm
Private collection

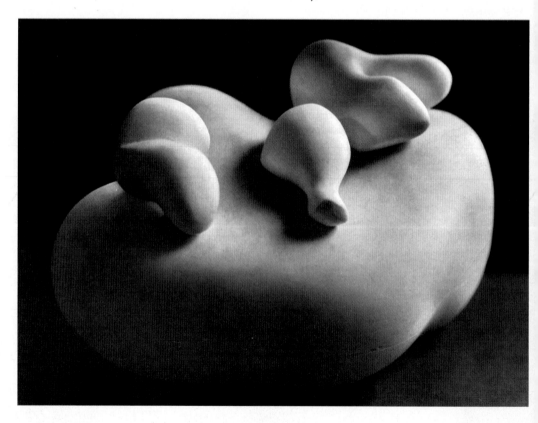

*Page 481:*
**Hans Arp**
Female Torso, 1953
(after a plaster model of 1930)
White marble, 88 x 34 x 27 cm
Cologne, Museum Ludwig,
Haubrich Collection

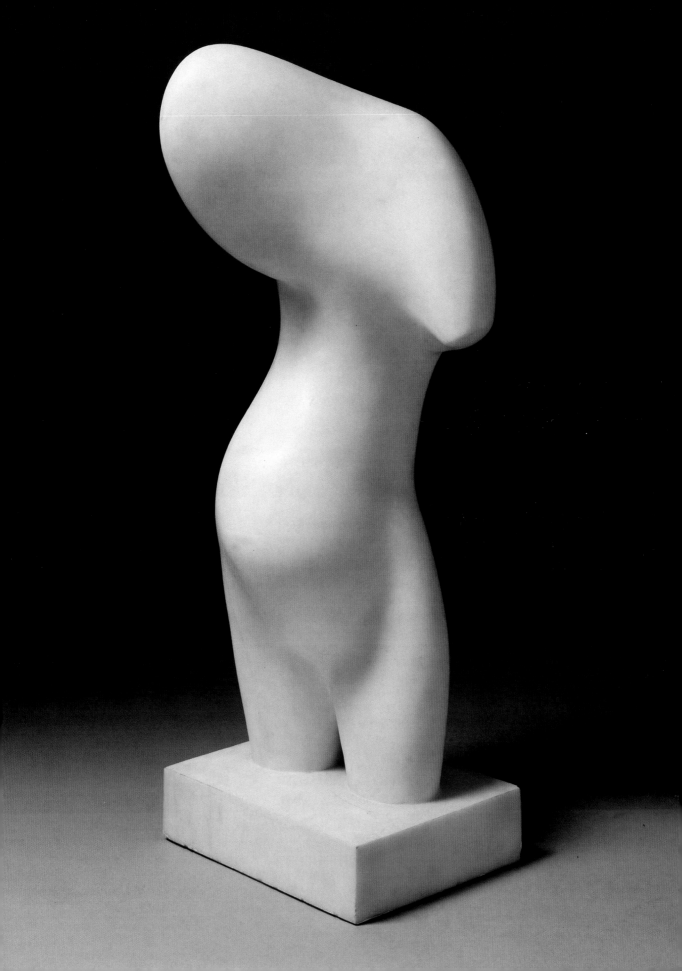

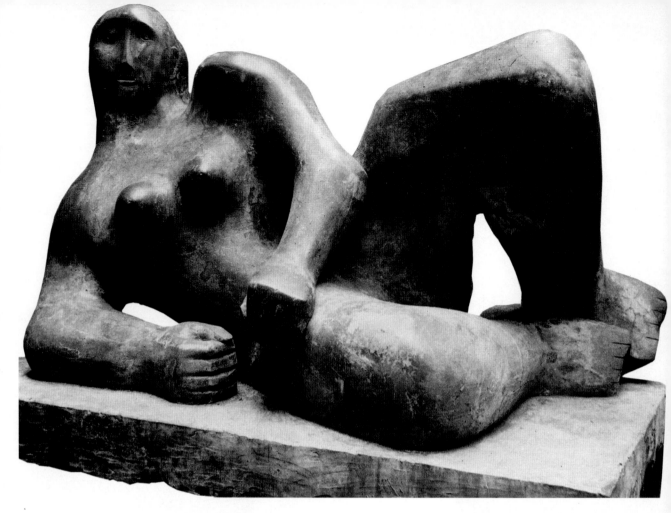

**Henry Moore**
Reclining Figure, 1932
Carved reinforced concrete;
width: 110 cm
St. Louis (MO), City Art Musem
of St. Louis

*"This is what the sculptor must do.
He must strive continually to think
of, and use, form in its full spatial
completeness. He gets the solid shape,
as it were, inside his head – he
thinks of it, whatever its size, as if he
were holding it completely enclosed
in the hollow of his hand. He men-
tally visualizes a complex form 'from
all round' itself; he knows while he
looks at one side what the other side
is like; he identifies himself with its
center of gravity, its mass, its weight;
he realizes its volume, as the space
that the shape displaces in the air."*
HENRY MOORE

games, he placed smaller forms like spores on the larger
fruit. In turn, his works became more torso-like, and he
subsequently developed a uniformly vibrant syntax of
condensed and inverted organic forms. The dense sculp-
tural quality of these works was as far from the frag-
mented metamorphoses of the Surrealists as it was from
the geometric orders that prevailed in the work of the
Abstraction-Création group. In the mid-30s, Arp dis-
tanced from both these movements.

What extraordinary richness there is in simplicity.
Germination, budding and blossoming, growth and
fusion, hardening, coagulation, curvature, complexity;
anorganic stone and smooth bronze are vitalised as
though from within, the skin pulsates like a membrane
moved by inner forces, juices and rhythms, full and
round-fingered. Life is fruitfulness or cell division, all in
the sense of the vitalistic biology that Arp rendered visi-
ble once more as natural piety in a late triumph. With
the onset of war, his sculptures seemed to soar higher,
stretching upwards like laconic signs, rising out of the
broad still lifes of fruits and the earthbound stones to
address the animal and the human. Yet still they
retained their aspect of plant-like growth. After the war,
his work took on a smooth verticalism. Protrusions were
cropped as though pruned with a knife, without cutting
off the life force itself. The base also began to play a part

in the structural rhythm. In his late work, the semiotic
aspect was consolidated in his freestanding cut-out
reliefs. Growth became part of the picture. Is this a sum-
ming-up or a heraldic stylisation – even schematisation
– of his life's work?

## Moore: the Landscape of the Body

The work of Henry Moore cannot be described as bio-
morphic sculpture with the same conclusiveness as that
of Arp. The human figure features far too prominently
in his work for that. The tectonic and constructive basis
is too powerful, the influences of non-European cul-
tures – Sumerian, Egyptian, American, African, oceanic
– far too strong. What is more, though he adopted key
formal aspects of modern sculpture in a repertoire so
varied that he was occasionally accused of eclecticism,
he never actually touched upon its most important revo-
lutionary breakthrough, the critical destruction of the
medium and the rejection of material unity. On the con-
trary, Moore carefully cultivated the notion of "appro-
priate material", probing the block of stone, gliding
along the annual rings and the grain of the wood, pursu-
ing the lively, abrupt mobility of bronze.

Though most of his formal motifs were not his own
invention, he was the quickest to close the gap on what
had been missing in British sculpture since the prema-

ture death of Gaudier-Brzeska. He not only adopted and varied the repertoire of the modernists, but translated it into the language of the true sculptor. He reconciled modernism with classical sculpture and was strong enough, or uncomplicated enough, not to falter under this heavy burden in what W. Spies has described as his "sculptural conservatory".

The early work, before 1930, still heavily emphasised the solid block and the technique of *taille directe* in the tradition of Derain and Brancusi. In 1924, Moore merged Mother and Child to create a towering bastion of almost brutal intimacy. In 1929, the famous Toltec rain-god Chacmool inspired the Ur-form of his *Reclining Figures*. On the immobile basis of leg and arm rest a knee and an elbow level with the head. They do not break out of the block. In this way, the two essential archetypes in Moore's work – the Mother and Child and the reclining Earth Goddess (according to Erich Neumann) are already fully present in his early work. Neumann, a psychoanalyst, has explored the interaction between interior and exterior form, shell and core, and has traced the biomorphic trait of the sculptures and examined their symbolism. Later, the theme of the family was added. Individual, semi-abstract motifs such as surrealistically hermaphrodite idols or the cage-like instrumentalisation of a space with the aid of slender wires were to remain on the periphery of this central trinity.

In 1930, a new development began. The next *Reclining Figure* lost its massive frontality, offering views from several angles, allowing hollows to enter. This tendency

**Henry Moore**
Head, 1937
Hopston-woodstone; height: 54 cm
New York, private collection

continued throughout the 30s until, by the end of the decade, he was creating figures that were slender, hollowed and bounded by the positioning of the limbs. From here on, Moore's *Reclining Figures* rose and fell in a rhythm of hills and dales. Moore himself claimed that it was possible to express something non-human, such as landscape, through the human figure. And indeed, his many *Reclining Figures*, right up to the dual and tripartite

**Henry Moore**
Reclining Figure No. 5 (Seagram), 1963/64
Bronze, 240 x 360 x 180 cm
Humblebæk (Denmark), Louisiana Museum of Modern Art, Ny Carlsbergfondet

**Henry Moore**
Reclining Figure, 1959–1964
Elmwood; length: 229 cm
Much, Hadham, Estate of
Henry Moore

monumental sculptures of the 60s (p. 483), do suggest mountains, cliffs and precipices. A precise imagination reworks natural processes: "Pebbles show the grinding, scrubbing treatment of stone and possess fundamental aspects of asymmetry. Rocks show a hacking, hitting treatment of stone ... bones have a wonderful structural power and hard formal tension ... trees illustrate the principles of growth and the power of joints with smooth transitions ...". Such was the wellspring from which Moore drew his concepts of form. It was a (sculpturally consolidated) awareness of nature anchored in the English romantic tradition.

In the 30s, Moore adopted the innovations of the early pioneers. Archipenko had been the first to lend autonomy to breaks and apertures. Picasso and Arp had led the way in organically fluid deformation. Anatomy had been inverted into the plasma of inner and outer forms. Body and interior spaces oscillated in a melodious or dramatically heightened equilibrium. In the war years and the immediate postwar era, his figures took on a doughy roundness that gently embraced the motif of the family. Moore avoided the pitfalls of an all too obviously schematic approach in the early 50s by calling upon the expressive energies of the demonic, the menacing and the tragic. The cylinder-eyes of his *Helmet Head 2* stare out through a narrow slit, and the mythical majesty of his *King and Queen* (p. 476) is heightened to a tragicomic cross between Pan and Don Quixote. His *Warrior with a Shield* is a mutilated and dramatic torso evoking resistance, while his *Three Standing Figures* seem like gnarled skeletons of the Fates.

After 1959, Moore was to break down his *Reclining Figures* repeatedly into two or three pieces, not in order to fragment them, but in order to let the interruption – the interim space – breathe as part of the whole. In an architectural context (for example, in front of the New York Lincoln Center) the landscape metaphor is set against an urban background. From now on, Moore was master of the entire spectrum, and rose to become the leading sculptor of his generation, surpassed only by Giacometti.

**Growth and Construction**

The biomorphic and the constructive are not mutually exclusive. Indeed, they seem to attract each other constantly. Even in the post-cubist work of the pioneering artists, we can often find organic tendencies. Lipchitz created baroque metamorphic transitions as bi-polar symbols of fertility. Laurens' nereids possess an ample-bodied roundness in keeping with the new-found awareness of nature. For all the predominance of geometry, the links are clearest in the melting pot of Abstraction-Création. In 1933, Barbara Hepworth and her husband Ben Nicholson joined the group. Otto Freundlich was one of the first members. Different as their work may have been, both Hepworth and Freundlich helped to consolidate the biomorphic tendencies of the 1930s.

Hepworth (ill. right), a sculptor from Yorkshire, England, has often been compared with her compatriot Henry Moore. Like Moore, she began with solidly block-like heads, then went on to foreshadow Moore's *Leitmotif* of the hollow core, and passed through various

phases influenced by Brancusi and Arp, though leaving aside the Surrealists, before arriving at the geometric clarity of her multi-faceted and asymmetrically vitalist forms. She used strings drawn taut over concave hollows to create classical solutions in an œuvre that echoes a spectrum from Gabo to Arp, from elementarily stereometric works to totem-like steles set in the landscape and, finally, sculptures that recall shells or weathered stones. The cool lyricism and finely tuned formalism of her œuvre sets it apart from the dramatic intensity of Moore.

By looking now at the work of the German painter and sculptor Otto Freundlich, we can appreciate the full scope of the polarity between growth and construction. Yet he does not really fit in here. Freundlich was always a maverick, somewhere between abstraction, architecture and mineral analogy. A contemporary of Picasso and the German Expressionists, he arrived in Paris in 1908, finally settling there in 1924. As a painter, he worked geometrically, with coloristic modulations (p. 221). As a sculptor, he began in an expressionistic, primitivistic style and went on to create a small but ambitious œuvre that anticipates social utopianism in the spirit of classical modernism.

Freundlich's masterwork, *Ascension* (ill. below) is the model of a "social process involving the coalition of independent individual forms into a living community."

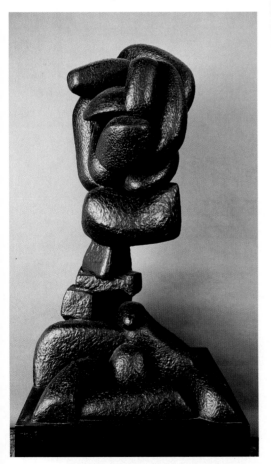

A bronzecast of dynamically super-imposed chunks of stone in three phases: a pyramidal base on which a narrow angular link-piece rests, forming a bridge to a broad, top-heavy "head". It is an ascension against cyclopic resistance, against gravity itself. It is related to biomorphic sculpture in the way that its rock-like individual parts seem to have been smoothed by water, and in the way that the pieces of clay, applied with a knife, distill the light that falls on them. What seems biomorphic is above all the energy that courses through the entire sculpture, uniting all the component parts to a single, collective structure. Any associations of a fist or a head are purely coincidental. Instead of aiming, like Picasso, for an anthropomorphic approach, Freundlich aims at a universal approach, seeking the kind of "cosmic socialism" reflected in his sculpture.

**Barbara Hepworth**
Two forms, 1961
Bronze; height: 117 cm
Private collection

*"A sculpture might, and sculptures do, reside in emptiness, but nothing happens until the living human encounters the image."*
BARBARA HEPWORTH

**Otto Freundlich**
Ascension, 1929
Bronze, 200 x 104 x 104 cm
Cologne, Museum Ludwig

# Post-War Positions: The Existential and the Abstract

## Aftershock or New Freedom?

The second world war made its mark on art. Picasso's *Man with Lamb* evokes the archaic image of the good shepherd, while his *Death's Head* with its harrowed face and vacant, staring eyes is a direct reference to war. Both these sculptures were created in 1942. At the same time, Lipchitz was modelling his ecstatically smouldering metamorphoses between machine, plant, animal and human in which the concept of the victim is tangible. Meanwhile, the Constructivist and Surrealist tendencies of prewar art were being further developed and expanded on the other side of the Atlantic.

Is it possible to speak of a specifically postwar art after 1945? If so, does it cover a spectrum ranging from the brutal dissolution of the human figure into flesh in the work of Germaine Richier to the faddishly misery-ridden posturing of the epigones? Does it include that frisson of angst and jeopardised identity we find in the twisted, tortured and amputated human fragments of the young British sculptors? Are not Marini's falling horsemen the fruit of a decade spent on the powder-keg of nuclear disaster? Is not the sprawling expansion of hollowed, gnawed, corroded surfaces and the bursting energy of Art Informel a sign of false security? Even Giacometti was interpreted in such a light at the time, his figures seen as representing the human figure devouring itself in the emptiness of space instead of asserting its independent existence. Was Giacometti's impassioned exploration of the fundamentally phenomenological problem of distance a reflection of the existentialist *Zeitgeist* after all?

Yet the self-same phenomena can also be interpreted in a very different way. Do we not find the expression of a new freedom in the sweeping and intensifying rhythms? Is this not a reflection of individuality returning at last after the strictly ordered structures of war and dictatorship? Does not the relaxation, scattering and labyrinthine interweaving of structures and gestures suggest a highly personal involvement with the materials into which the artists of the day poured their soul-searching dramas? The discourse of the day, with its emphasis on the essence of things, highlights above all the creative primary act in which a rapidly accessible strategy was quickly established in painting, and soon afterwards in sculpture.

Pessimistic interpretations do not apply by any means to the gestural Abstract Expressionism of the Americans in the work of David Smith, Tony Smith, Mark Di Suvero and John Chamberlain. In Germany, Hans Uhlmann and Norbert Kricke pursued a similar approach. Kricke, in particular, streamlined the contours of González to the point of racing linearity, infusing his work with the relaxed gliding of organic growth. Postwar sculpture drew its own highly original consequences from the classical modernism of Gabo, Picasso and González.

## Giacometti and the Threat to Humanity

The outstanding sculptor of the era was Albert Giacometti. For a long time, his self-doubting struggle to grasp the appearance of reality – the sole visible reality, that is – was peppered with crises, in which the years 1935, 1950/51 and 1956 each mark a radical break. It is quite possible that Giacometti himself actually saw his life in that light and even styled his œuvre according to a pathos of failure. Today, in his œuvre, the artist's constant self-questioning also reflects the continuity that held sway in the second half of his life.

It began in 1935 with a return to the life study. In the long run, neither the exalted surrealist theatre of cruelty nor the cubistically abstracted *Heads* of 1934 could withstand Giacometti's relentless pursuit of a more definitive reality. The great discovery that took him ten full years to grasp was this: we perceive each other merely as an "apparition" surrounded by space, within a certain field of vision and perspectively reduced. This mode of perception, long an accepted component of painting, was one that Giacometti was determined to transpose into the field of sculpture. In 1945, the philosopher Maurice Merleau-Ponty published his famous study of the "phenomenology of perception" in which he examines how specific, concrete reality is altered by the situation in which it is perceived. Reinhold Hohl, in his monographic study of Giacometti, emphasised the connection, writing of the sculptor's "phenomenological realism". Giacometti himself said that "life-size does not exist", and reduced his figures to matchstick dimensions, making them almost disappear, to the point that they actually crumbled between his fingers by 1943.

*"Yes, I do make pictures and sculptures, and I always have done, ever since I began drawing or painting, in order to denounce reality, in order to defend myself, to become stronger, ... in order to have a foothold so that I can move forward in every field and in every direction, in order to protect myself from hunger, cold and death, in order to be free."* ALBERTO GIACOMETTI

**Pablo Picasso**
Woman with Baby Carriage, 1950
Bronze, 203 x 145 x 61 cm
Paris, Musée Picasso

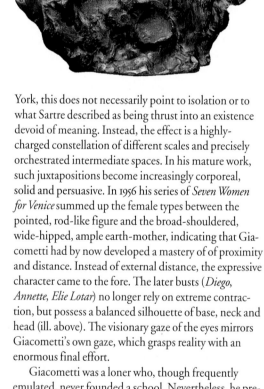

Why should a human being seem more real in the distance than in close-up? As soon as Giacometti realised that he was schematising the problem of distance, he found a distinctive artistic "style" for his archaic standing figures of life-embracing women and wiry, striding men. It was not distance, but encounter, its directness and intensity, that were the focal point. Which was why he began kneading the figures over a wire frame until they were slender as threads, paring them down linearly until they soar up before us vertically. It is the reason why he merges proximity and distance in a frontal rigidity "that summarises all the postures and glances of the world" (Albert Camus). These heads, busts and figures keep their distance. And yet, like idols, they also keep the observer at bay. The loss of corporeality becomes a stylistic figure which, paradoxically, lends visual stability to Giacometti's sculpture.

Though Giacometti illuminates, almost metaphysically, such Sartrean notions as the sublation of causality, sudden alienation and insurmountable solitude, to the point of losing sight of his obsessive quest for form, he clearly renounces the concept of "failure" by producing some of the most stunningly vital sculptures of the 20th century. Surrounding space gnaws at the ragged contours and blurred details of his works, while the modelling itself uses a classic means of rendering surfaces fluid, vibrant and potent. Slender, wiry, soaring linearity is created by the dissolution of distance, evoking an idolatric epiphany.

Where several figures are juxtaposed without touching, as in the 1948-49 *Place*, the 1950 *Forest* (ill. below) or the 1958 project for the Chase Manhattan Bank in New

**Alberto Giacometti**
Head of Diego, 1957
Bronze; height: 38.8 cm
Private collection

**Alberto Giacometti**
The Forest, 1950
Bronze, 57 x 61 x 49.5 cm
Zurich, Kunsthaus Zürich,
Alberto Giacometti Stiftung

York, this does not necessarily point to isolation or to what Sartre described as being thrust into an existence devoid of meaning. Instead, the effect is a highly-charged constellation of different scales and precisely orchestrated intermediate spaces. In his mature work, such juxtapositions become increasingly corporeal, solid and persuasive. In 1956 his series of *Seven Women for Venice* summed up the female types between the pointed, rod-like figure and the broad-shouldered, wide-hipped, ample earth-mother, indicating that Giacometti had by now developed a mastery of of proximity and distance. Instead of external distance, the expressive character came to the fore. The later busts (*Diego, Annette, Elie Lotar*) no longer rely on extreme contraction, but possess a balanced silhouette of base, neck and head (ill. above). The visionary gaze of the eyes mirrors Giacometti's own gaze, which grasps reality with an enormous final effort.

Giacometti was a loner who, though frequently emulated, never founded a school. Nevertheless, he prepared the ground for a new way of seeing in sculpture. He was the pioneer of that anti-Cartesian counterposion to Cubism that replaces rational systems with experienced perception, knowledge with specific experience.

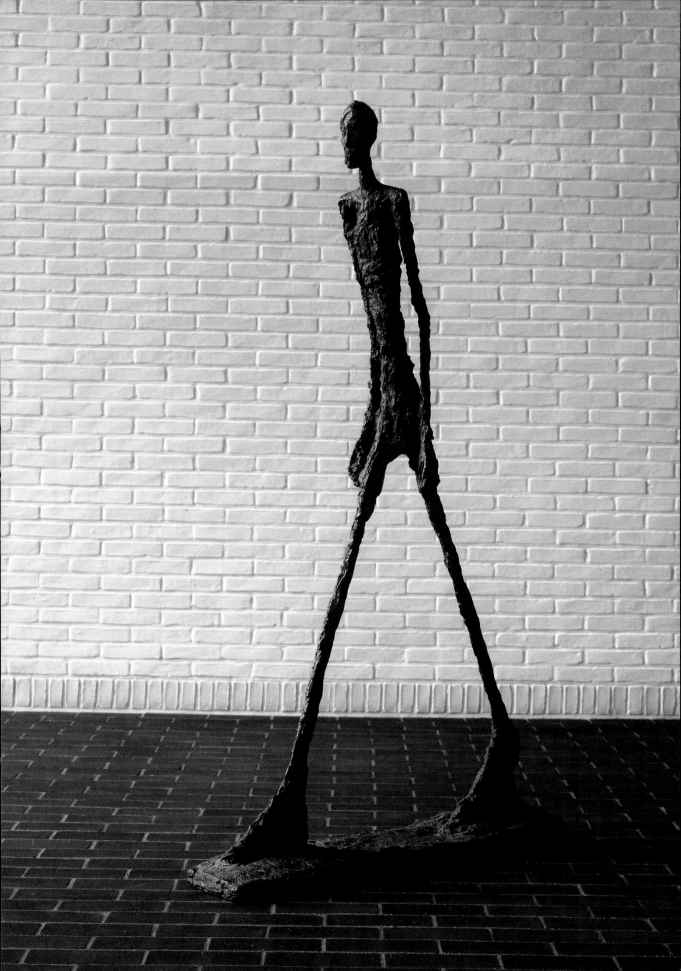

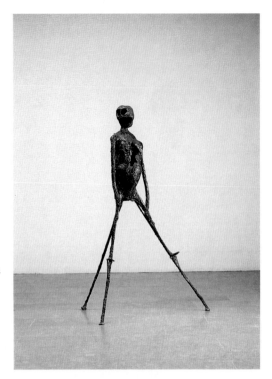

**Germaine Richier**
Le Berger des Landes, 1952
Bronze, 149 x 89 x 60 cm
Humblebæk (Denmark), Louisiana
Museum of Modern Art,
Ny Carlsbergfondet

**Bernard Schultze**
Cadaver couple, 1979
Iron frame, wire, textile, plastic,
oil, 190 x 130 x 90 cm
St. Petersburg, Russian State
Museum, Ludwig Collection

Instead of the six sides of the cube, which I know to exist, I present only four sides, which I see. Minimal Art and post-Minimalist sculpture drew upon this basic premise for their artistic credo until well into the 70s. Giacometti was the first to radically posit this stance. Small wonder that his philosophical counterpart, Merleau-Ponty, was destined to become the theoretician of the next generation.

Germaine Richier (ill. above) overshadows all the other artists vaguely referred to as postwar sculptors,

**Kenneth Armitage**
Prophet, 1961
Bronze; height: 172.5 cm
Private collection

creating weathered bronze shells and skeletons that weave humanity into a tapestry of survival teeming with harrowed, menaced and menacing creatures. Cracks, shards and rhizomes of bronze, handled with magisterial virtuosity, stress the unequivocality of the human condition. The *Migofs* by the painter Bernard Schultze (ill. above right) in paper, wire and plastic heighten morbidity and decay in a fantastic ghostly dance. The spikey, bush-like constructs by the Americans Theodore Roszak, Herbert Ferber and Seymour Lipton also draw upon the tormented Surrealist heritage in their aggressive displays of human existence as a symbolically heightened garden of thorns.

Herbert Read somewhat unfairly criticised the British sculptors after Moore, lambasting Kenneth Armitage (ill. left), Reg Butler (p. 491 below left) and Lynn Chadwick (p. 491 above) for the "excoriated flesh, frustrated sex, the geometry of fear" he saw reflected in their shrunken-headed, insect-limbed figures. Their early success owed much to the prevailing stylistic tastes of the day and a few bold methods of iron construction. Today, of all these sculptors, it is still Eduardo Paolozzi's robotic three-dimensional collages that have the greatest impact, transposing the Vorticist tradition of the machine-man into the realms of the fragmented, damaged and distressed.

Giacometti's complex phenomenology remains singular. An antipode may be found in the 40s and 50s in the work of the Austrian stone sculptor Fritz Wotruba (p. 491 below right). His œuvre is a bastion of humanity unscathed, hewn in stone, a rock of assertion in space. From the late 20s onwards his block-like figures upheld the tradition of early Derain and Brancusi, for the

next generation. In the 40s he expanded the oscillating energy of concave joints into a cylindrical rounding of torso and limbs. In the 1950s he developed an exuberant dynamism with softer transitions towards standing, walking sitting, reclining figures in which, at strategic points, the pose shifts from the rigidly static to the distinctly vital without losing its stoney balance. Around 1960, the cubic rhythms of architectonic structures then began to re-emerge, with human figures layered into stele-like structures.

## Informel: Process and Structure

Are there links between the torn and riven surfaces of Giacometti and Richier and the more abstract structures for which Michel Tapié coined the term "Informel" in 1952, referring to both painting and sculpture? Do the tangled evocations of the psyche in the paintings by Wols (pp. 249 ff) have direct analogies in sculpture? Or do sculptures, with their "higher material and temporal resistance" (in the words of Hans Uhlmann) hinder direct intellectual and emotional access to the material? Is there such a thing as Informel sculpture? Sculpture in which the formal impulse feels its way gently towards the material, as in a sketch? Sculpture that does not over-form its material between the raw state and the process, but allows it to grow and sprawl like cell

**Lynn Chadwick**
Seated Couple, 1986
Bronze; height: 23.5 cm
France, private collection

division, coral reefs or rust? Sculpture of malleable material such as clay, terracotta, plaster, bronze, wax, papier maché, wire but also in the more rugged and individualistic *cire perdu* technique, rather than sculpture with the purely reproductive approach of sand

*"The choice of means by which a creative person expresses himself may be unimportant. But I firmly maintain that I see in stone the only true medium, because it is the real material of the sculptor."*
FRITZ WOTRUBA

**Reg Butler**
Working Model for the Monument to the Unknown Political Prisoner, 1952
Bronze wire, sheet metal and plaster; height: 224 cm
London, Tate Gallery

**Fritz Wotruba**
Head, 1962
Marble; height: 47 cm
Private collection

**Jean Dubuffet**
Chair II, 1967
Painted polyester, 168 x 60 x 75 cm
Private collection

**Lucio Fontana**
Spatial Concept, Nature, 1959/60
Bronze, 74 x 80 cm
Cologne, Museum Ludwig,
Loan of Karsten Greve

casting? Sculpture that contradicts in many ways the classical concept as a firmly outlined volume and, by no coincidence, takes the painterly relievo, in particular, to its climax.

Such a sculpture does exist and it became widespread during the 50s. Its forefathers were Picasso, whose *Owl* spread its ragged wings in 1933, and Lipchitz, whose effusively undulating mature work forged a link with Baroque concepts. Its fathers, interesting enough, were painters one and all.

In his *Hostages* created in 1943/44, when France was under German occupation, Jean Fautrier had already applied oil paint, paper and clay to canvas in *haut-pate* relief (pp. 252 ff) and had cast bronze figures of irregularly fine and rough textures, described by André Malraux as "ideograms of suffering", shattered physiognomies whose fleetingly textured surface structure and anxiety-charged pose are a prelude to the art of the 50s. Jean Dubuffet's work (pp. 254 ff) is similarly harrowing, creating a new aesthetic with found objects. Although Schwitters and Arp had already revalued the worn, torn

waste of everyday life, only now did this combine with a deliberate renunciation of aestheticisation and an anticultural stance to create Art Brut.

In 1954, Dubuffet (ill. above) modelled forty *Statuettes of Endangered Life* out of newspaper, cellulose and iron slag in cement, lava, sponges, pieces of string, shards of glass, between a few centimetres and more than one metre in height. Their raw, expressively charged figuration can still be found reflected in Oldenburg's *Street* environment, Finally, Fontana's baroque, fluid ceramics, some of them as early as the 30s, and later the fruit-like expansions of his *Concetti spaziali – Natura* (ill. left) touch upon Informel sculpture, though Fontana, in particular, with his arabesque light-drawing of 1951 was to become a major source of inspiration for the Zero group of artists who railed against the Informel. He was, in other words, a borderline artist between the generations (cf p. 300).

For most young artists, the L'art informel of the 50s, especially in the field of sculpture, marked a transitional

period. Its biomorphic, mineral tendencies and ehoes of growth and decay reflected the artistic spirit of the era in which the new freedom of creativity merged with the evocations of the material. Thomas Lenk, Otto Herbert Hajek (ill. below), Erich Hauser, Ernst Hermanns, Jan Schoonhoven, as well as Paolozzi, César, Etienne-Martin and in America the syncretist Peter Grippen and the ceramic artists Peter Voulkos and John Masen all went through an Informel phase or touched upon the Informel to some degree.

François Stahly, Zoltán Kemény (ill. above right) the brothers Arnaldo (ill. above left) and Giò Pomodoro consolidated the amorphous flow to the point of rhythmic rapport before it became systematised around 1960 in patterns of grids and lines that eschew all authorial and subjective components. One of the most consistent of the Informel modellers was Emil Cimiotti, whose lyrical works addressing the fecund growth processes of nature are at the same time pictorial processes. He was perhaps the only one to adhere to the Informel throughout his entire œuvre while also adopting decorative and floral components, as in his later fountains.

**Hans Uhlmann**
Rondo, 1958/59
Brass, 150 x 90 x 80 cm
Hamburg, Hamburger Kunsthalle

## Abstract Expressionism: Construction of the Gesture

The key words were blot, drip, structure, process, and there was talk of malleable materials. Other buzzwords were gesture, action, traces of movement, and the main materials were iron and steel. The umbrella concepts beneath which this 50s inventory was gathered were Informel and Abstract Expressionism. The leading figures in painting were, above all, Wols on the one hand and Jackson Pollock (pp. 269 ff) and Franz Kline (p. 279) on the other hand. Unlike the world of painting, it was Europe that led the field in sculpture. While the Americans were still touting a second-hand Surrealism, or, like David Smith and Louise Bourgeois, exploring totemistic variations, European sculptors were transforming the Constructivist heritage into works of dynamic force as early as 1950.

In America, such re-orientation did not begin until ten years later. In 1959, Tony Smith made the shift from architecture to tension-charged modular systems. That same year, John Chamberlain created his first compressed automobile parts and Mark Di Suvero mounted his first beams. America's sculpture of the Fifties actually happened, for the most part, in the 60s. In other words, art historical reality sometimes tacked wildly through the decades.

**Pablo Picasso**
Bathers, 1956
*From left:*
Diver (264 x 83.5 x 83.5 cm),
Man with Clasped Hands
(213.5 x 73 x 36 cm),
Fountain Man
(227 x 88 x 77.5 cm),
Child (136 x 67 x 46 cm),
Woman with Outstretched Arms
(198 x 74 x 46 cm),
Youth (176 x 65 x 46 cm)
Six figures; Bronze after a plaster
original
Paris, Musée Picasso

*Page 495 above:*
**Norbert Kricke**
Large Space Curve, Cologne, 1981
Stainless steel, matt polished,
14 x 17 x 12 m; total length of line:
27 m; diameter: 13.5 cm
Cologne, Deutschlandfunk /
Deutsche Welle broadcasting
house forecourt

*Page 495 below:*
**Norbert Kricke**
Grand Reux, 1962/63
Stainless steel; height: 750 cm
Château de Reux (Normandie),
Alix de Rothschild Collection

In Europe, the Constructivist tradition still had much of its powerful appeal despite its Cold War defamation. Hans Uhlmann, a trained engineer, had already mounted *Heads* of wire and sheet iron in the 30s. Since 1946 he had reduced them to linear, arabesque signs worked from a single metal wire, in vibrantly choreographed forms that pierced the surrounding space like flashes of lightning. In his work, lines act as pointers, just as planes act as spatial boundaries (p. 494). Uhlmann worked with both these elements. Protruding planes conglomerate to form energetic silhouettes, rising, folding and breaking, embracing a dense spatial core, and at times protruding from the conglomeration or projecting beyond it. In his three-metre high sculpture *Concerto* for the Berlin Conservatory, linear cantilenas rotate and planar rhythms oscillate in polyphonic harmony, creating a melodious textural effect in steel whose gestural movement merges with a clearly stereometric approach.

Around 1950, Norbert Kricke (ill. right) took up where Uhlmann's linearity had left off. His *Space Sculpture* marks a major step in the direction that begins with the light-pooled gouging of Rodin, leading on, through the work of the Russian Constructivists, to Calder, Picasso and González. Yet Kricke, in adopting a favourite idea of the 50s, namely movement, radicalised the approach to mass and statics. His sculptures have neither volume nor outline, circumscribe no space and have no vestige of corporeality. They shoot and stream beyond the actual course of the lines, creating visual runways in an eruptive countdown of velocity or in the life rhythm of the organic world, in swirling curves of unfettered energy or gentle gliding fluidity. They evoke the quest for the future or a positively biological sense of time. In his mature work, Kricke reduced his sculpture one step further, paring the directional plurality to a single curve and enhancing the archetype, the piece of wire bent by hand and placed on the floor, curving, writhing, grasping space, vast and urban, railing against the sterile grid patterns of concrete architecture.

Uhlmann and Kricke, who were then joined by Heiliger after his beginnings in biomorphic sculpture drove the Constructivist mode towards Abstract Expressionism. Kricke added a new dynamic paradigm and imbued it with the changing spirit of the 50s, 60s and 70s. It is this that makes him the most important German sculptor in the era between Lehmbruck and Beuys.

## David Smith and Gestural Abstraction

The American sculptor David Smith could just as easily be discussed as the successor to the steel and iron sculpture of Picasso, González and Calder or as the precursor of Minimalism. Here, we intend to regard this constructor with a welding torch in the context of the 50s. At that time, his sculpture had a certain proximity to the Action painting of Kline and Willem De Kooning (pp. 274 ff) and in America (though only there) it made him a myth of modern art. He was the first truly American sculptor

**David Smith**
Blackburn–Song of an Irish
Blacksmith, 1949/50
Iron on marble base,
117 x 103.5 x 58 cm
Duisburg, Wilhelm Lehmbruck
Museum

*"To the creative artist, in the mak-
ing of art it is doubtful whether
aesthetics have any value to him.
The truly creative artist deals with
vulgarity."* DAVID SMITH

**David Smith**
Cubi XVIII 2–4, 1964
Stainless steel; height: 294 cm
New York, Marlborough Gallery

between modern industrial society and tribal mythol-
ogy. The *Ziks* (since 1961, referring to Babylonian
stepped pyramids) intersect vibrantly painted, cut-up
concave and convex pipe components. The *Cubi* (ill.
below) created between 1961 and 1965 pile up variously
high blocks, cubes and cylinders in precarious balancing
acts. Seen from the side, they seem tightly compressed.
The surfaces of stainless steel sparkle with the swirling
patterns of the steel brush.

Smith's simplification of forms and his use of
mechanical production methods influenced Minimal
Art. Nevertheless, one should not lose sight of the fact
that, Smith remained a traditionalist, insisting on figu-
rative verticality and never taking the step towards the
horizontality of "landscape". He also retained the con-
cept of compositional tension.

The architect Tony Smith (p. 497 below right) who
constructed sculptures of enormous formal variabilty on
the basis of crystalline octahedra from 1959 onwards
came closer to the modular seriality that we find in the
work of Donald Judd and Sol LeWitt. Yet here, too,
linearity and contour tend to give a gestural dynamic to
the architectural stability of the work.

Barnett Newman, the classicist of a metaphysically
profound Color Field painting (pp. 289 f) also made a
brief contribution to sculpture. In 1967, his steles culmi-
nated in the *Broken Obelisk* (p. 497 below left) whose
brilliant simplicity succinctlly summarises a monumen-
tal tradition and at the same time breaks with it. Upward
and downward movement collide at the points of the
obelisk in a concentration of energy that is suspended in
a perfect balancing act. Two years later, Newman left
verticalism behind him to create two walk-through

whose work ranged from pre-war Surrealism to the
fringes of Minimal Art.

It was not until around 1950, however, that Smith's
work took on its distinctive independence with his (long
prepared) *Drawings in Space* in the tradition established
some twenty years before by the pioneers of iron sculp-
ture. Surrealism gave his work its narrative, almost liter-
ary edge, and its rich lyricism. What is new is the sheer
frontality, as in a painting, and the unexpected views
from many sides. In *Blackburn–Song of an Irish Black-
smith* (ill. above) he rendered linear arabesques as one
with the figure and bound all the details within a frame-
work that allows the viewer's eye to penetrate the inte-
rior freely. It is an emblematic, silhouetted torso. Viewed
from the side, it seems tangled and unstable, contrasting
starkly with the serene equilibrium of the frontal view.
Here, Smith radicalises the principle of discontinuity,
which also informs his later works. These sculptures
cannot be taken in at one glance, affording instead spe-
cific individual images which seem to click into place
with each new angle.

The stilted *Tank Totems* (made of round tank lids and
referring to Freud's essay *Totem and Taboo*) are anthro-
pomorphically protruding signs that occupy a position

sculptures that foreshadowed the architectonic sculptures of the 70s.

All things said and done, the true Abstract Expressionists in the world of sculpture are Mark Di Suvero and John Chamberlain. Di Suvero (p. 498 below) added a spatial aspect to the advances already made in painting when he created his powerful beam structures, initially made of construction beams, chains, ropes and later from double T-girders. Although he shared the compositional discontinuity of Smith, the lines of energy in his sculptures have their own physically tangible tension, equilibrium and pressure, grasping and embracing the surrounding space. Towards the end of the decade, this physicality was to become a key theme of new sculpture.

Chamberlain (p. 498 above) was even more direct in articulating the concepts and spontaneity of the Abstract Expressionists in sculpture. His compressed, bent, welded and painted car parts have distinct affinities with the work of the Assembage artists as well as with the compressions of the French sculptor César. Yet in the work of Chamberlain, compression and balance of mass, nests of shadow, maelstroms of line, sweeping curves all give the impression of controlled catastrophe – composed rather than compressed. In this respect he has more affinities with Di Suvero than with César.

At this point, the English sculptor Anthony Caro immediately springs to mind. Until 1959 this former assistant of Henry Moore concentrated primarily on heavy-bodied female nudes, only to take a radical change of direction following a visit to David Smith. Together with Di Suvero, he is the true heir of the American sculptor – and yet his sculpture is so far removed from all notions of totemism and verticalism that we tend to associate him with the (almost) contemporary Minimal Art movement.

**David Smith**
Bec-Dida Day, 12 July 1963
Steel, polychromiert, 230 x 150 cm,
diameter: 47.5 cm
Bolton Landing, Estate of David Smith

**Barnett Newman**
Broken Obelisk, 1963–1967
Steel, 775 x 306 x 306 cm. Houston (TX), Institute
of Religion and Human Development

**Tony Smith**
Moses, 1968–1974
Steel, 518 x 434 cm. Seattle (WA), Seattle City
Light, Courtesy of Seattle Arts Comission

**John Chamberlain**
Colonel Splendid, 1964
Sheet steel, painted, 63 x 67 x 57 cm
Frankfurt am Main, Museum
für moderne Kunst, Sammlung
Ströher

*"Wood has its own life, wants its
own way, has its grain, and it's
grown, suffered, and by the time you
get it it has already been killed, and
your're supposed to do something;
and they have done great things
with it, just incredible sculptures in
wood."* MARK DI SUVERO

**Mark Di Suvero**
Che Faro Senza Euridici, 1959/60
Wood, rope and nails,
213 x 264 x 231 cm
Private collection

# Kinetic Expansion

## Composition and Psychology Renounced

Around 1960, two fundamental forces of Modernism came under fire: composition and psychology. Criticism was aimed at the icons of universal harmony and at the kind of art that identifies the work in an almost mystical way with the author, his or her biography, signature and gesture. Around 1960, the groundswell of resistance to Mondrian's equilibrium and Pollock's eruptiveness spread from Düsseldorf to Paris and New York, sweeping in its wake more than just painting.

Donald Judd objected that the expressive sculptor Mark Di Suvero "uses beams as if they were brushstrokes, imitating movement, as Franz Kline did." Both the Constructivist and the Expressionist view of the world had run their course. To the young generation, both seemed to be dead-end roads to pure subjectivity. The belief that art represented the order of the world or expressed the inner life of the artist was no longer an accepted credo.

The new slogans, as in Russia forty years before, called for an end to easel painting and and for concentration on the object instead. The new aims were society, life, reality, technology, beauty of the elements and the sky, fascination with street life and the media world. An immense medial breadth and enormous lust for life entered art. Not since the formative years of modern sculpture around 1910 had art moved so quickly in so many new directions.

Three forces made their mark. First of all, under the generic name of "Nouvelle Tendance", groups in South America, Britain, France, the Netherlands, Germany and Italy explored, with varying focal points, the reconciliation of art, technology and nature. In Düsseldorf, the Zero group pursued its romantic vision of the Futurist dream, while in Paris the Groupe de Recherche d'Art Visuel (GRAV) socialised it, with vibrant structures of motion, light, air, glitter and immaterial energy. Kinetic sculptures moved from the periphery to the very centre of art.

Secondly, the all but forgotten tradition of Marcel Duchamp came to light again. This time around, what Duchamp had viewed with critical consciousness, scepticism and detachment was widely accepted. The readymade had come of age. Nouveau Réalisme, Pop Art, the Assemblage artists (a term coined in 1962 on the occa-

**Jean Tinguely**
Méta-matic No. 12
(Le Grand Charles), 1959
Iron, electric motor, paper
Private collection

sion of an exhibition organised by William Seitz) charged their objects with the everyday prose of social reality, urban folklore, cityscape, mass media, wear and tear or consumption. For a while, garbage tips and rubbish heaps became what the flea-market had once been for the Surrealists.

Thirdly, at the opposite end of the spectrum, Minimal Art fundamentally redefined the relationship between viewer, object and space. It more or less stripped bare our powers of perception, leaving no shelter, and forcing viewers to find their own response to what they saw. It was the most influential purism of the entire decade. Its consequences and the shift of emphasis it entailed were to reverberate for many years.

Many of the new directions in art were at first inextricably linked. A tactical front against the art of yesteryear formed a bond between otherwise heterogeneous approaches. Apart from a few important exceptions, there was a general rejection of composition and psychology, right across the board. Serial and modular sys-

**Hans Haacke**
Condensation Cube,
(first version), 1963
Acrylic glass, water, climatological
conditions of the environment,
60.3 x 60.3 x 60.3 cm
Private collection

*"A 'sculpture' that physically reacts to
its environment nd/or affects its sur-
roundings is no longer to be regarded
as an object. The range of outsiede
factors influencing it, as well as its
own radius of action, reach beyond
the space it materially occupies. It
thus merges with the environment
in a relationship that is better
understood as a 'system' of inter-
dependent processes. ... A system is
not imagined; it is real."*
HANS HAACKE

tems were accepted as instruments to combat aesthetic
arbitrariness and the signs of individual authorship.
Impersonal and mechanical production lost its stigma.
It was the end of an understandable postwar phobia that
had tended to push technology, industrial standarisa-
tion and communications system into what Werner
Haftmann described as the "processing world".

By the end of the 60s, the very face of sculpture had
been transformed and sculpture had gone through
metamorphoses as far-reaching as those half a century
before, when the autonomy of Cubist rhythm had bro-
ken the mould of the anatomically intact human figure.
Duchamp planted the timebomb known as the ready-
made. Tatlin placed real materials in a real space. The
image of sculpture was fundamentally transformed and
yet, at its core, it still remained bound to the figure, the
sign, the object. After all, it was still a visible, tangible
art, an art that could be touched.

Now sculpture began to turn to new materials,
media, aggregates and spaces. Sculpture could be a
wedge of lard, a cloud of gas, a piece of land, an action,
an idea, a video arrangement. It took place in the gallery,
on the street, in the desert, in the sky, on the body or
simply in our minds. New terms and concepts followed
one another at breakneck speed – from object to process
to concept to attitude to situation to model – and labels
such as Kinetic, Sky Art or Body Art were coined. Most
of them came from America. Only Pierre Restany's
Nouveau Réalisme at the beginning of the decade and
Germano Celant's Arte Povera at the end of the decade
survived as European models.

What emerged was not only a boundless opening
and morphological promiscuity, not only an unparal-
leled fireworks of new possibilities, but also, if we con-
sider sculpture in the narrower sense of the term, a crisis
of identity. Around 1970, it tended towards what Lucy
Lippard has described as its dematerialisation into fleet-
ing media images, notes or ideas. This gave all the more
weight to attempts to redefine sculpture as such on the
basis of these innovative new sources. Anthony Caro,
Richard Serra, Ulrich Rückriem spring to mind.

The unadulterated patriotism of American artists
and critics made the 60s the American decade. New
York's hegemony was consolidated by the Assemblage
artists in Chicago and California. The intensity with
which each step was immediately considered, analysed
and countered in practice and in theory alike was unpar-
alleled elsewhere. Only in America was an uninter-
rupted chain of artistic developments forged in sculp-
ture as well, link by link. The ousting of the "figurative
mode of sculpture" by the "landscape mode" (according
to Robert Morris) began in New York. Instead of verti-
cality, it was now horizontality that prevailed.

In Europe, too, a central force-field was emerging in
the triangle between Paris, Düsseldorf and Milan. The
Zero and Nouveau Réalisme groups, with Yves Klein
and Tinguely as bridge-builders, formed something
akin to an unequal common front. Piero Manzoni was
the messenger between them, flitting to and fro like a
weaver's shuttle linking the threads. From the early 60s
onwards, Joseph Beuys came into the limelight and was
increasingly recognised as a major figure. In spite of its
formative role in Pop Art and despite the important con-
tributions from Eduardo Paolozzi, Anthony Caro and
Philip King, Britain was still isolated. The fact that
experiments with light fire, water and action had also
been going on in Japan since 1955 did not come to the
attention of the western world until 1963. When it
finally did, however, the parallels and priorities of the
Gutai group provided inspirational for the nascent
Fluxus movement and made a playfully ritualised contri-
bution to Happenings and Concept Art.

### Nature, Light, Movement, Technology
Whether or not the anecdote is true, or simply a good
yarn, it highlights the art historical situation. Otto Piene
told how Yves Klein suggested to him in 1958 that the
world should be divided up: Klein himself would be
responsible for the air, Norbert Kricke for the water and
Piene for the fire (which would not prevent them poach-

**Julio Le Parc**
Perpetuum Mobile, 1964
Aluminium and painted wood,
119 x 119 cm
Private collection

ing on each others' territory). This demiurgic gesture certainly suits Klein's aura as an enormously inspirational force and self-styled saviour too well to be entirely fabricated. If anything, it might even sound a little too self-effacing! Piene widened the spectrum by adding, "Our artistic interest is aimed not only at movement and light, but also at warmth, sound, optical illusion, magnetism, condensation and expansion of materials, water, the movement of sand and foam, fire, wind, smoke and many other natural and technical appearances."

This approach was by no means the sole preserve of the Zero group (and its general attitudes) or its young leader Yves Klein. As early as 1955, Kricke was designing water sculptures as mirror surfaces, wave patterns, stream, low tide, high tide and in 1957 he created his first *Waterforest* of plexiglass columns. Werner Ruhnau worked on an aerial architecture. Manzoni projected a *Pneumatic Theatre*. Hans Haacke captured condensation in his 1963 *Condensation Cube* (p. 500 above). In London, David Medella planted growing organic environments. Around 1960, the staging and alienation of physical phenomena, as Piene put it, was quite literally in the air.

At the same time, the painters of the Ecole de Paris, now in the third generation, still held sway in Paris. Since 1948, however, Nicolas Schöffer, a Hungarian in Paris, who, like his fellow countryman Victor Vasarely, was a utopian thinker in search of total urban aestheticism, had been developing his *Space-dynamic Sculptures* (p. 582). His long-term aim was the creation of a cybernetic city that reacted to times of day, temperatures and weather with light and movement.

Since the early 50s, a few younger artists had also been taking their creative experiments beyond the bounds of painting and traditional sculpture for the first time since the war. They came from Israel, Switzerland, Belgium and South America. Their centre was the recently opened Galerie Denise René. Their common factor was movement as an artistic element, in contrast to the immutability of beauty, and as a foray into the fourth dimension of time, already promised by the Constructivists in 1920 and now opening up new horizons. They saw movement as a creative principle that forges a link between art and life.

Admittedly, there had already been moving sculptures. Their history can be traced back to Duchamp's *Rotary Glass Plates* (p. 460 above left) and Naum Gabo's vibrating steel spring (both 1920), to the Bauhaus experiments with colour and light, and to Calder's mobiles. The American artist George Rickey had been constructing mobiles of glass since 1949 and was now systematically exploring movement as a creative medium. According to Rickey, even Calder, who had influenced him, was still too profoundly inspired by the abstract motifs of Magnelli, Arp and Miró. What Rickey wanted instead was pure kinetic sculpture based on highly qualified principles of engineering – oscillating, floating, circling, dangling, rising, sinking, vibrating.

**George Rickey**
Six Lines Horizontal, 1964
Stainless steel; height: 61 cm
Colorado, Collection Kimiko and
John Powers

*"Though I do not imitate nature I am aware of resemblances. If my sculptures sometimes look like plants or clouds or waves of the sea, it is because they respond to the same laws of motion and follow the same mechanial principles. Periodicity produces similar images in sand, water, a skip-rope and an oscilloscope, but none of these is a record of the other."* GEORGE RICKEY

"The catalogue of natural processes that have so far been overlooked in painting and sculpture, is endless" wrote Rickey in 1964 in his essay "The Morphology of Movement". Their combination in widely radiating, sharply pointed needles or cradling rectangular areas marks the spectrum of kinetic art. The weightlessness with which steel fingers dance around a point, graceful and languid, penetrating the light, circumscribing the radius of the trees, setting themselves apart with their rigid linearity – all this makes the breath of air, with its currents and strengths, subtly visible (ill. above). With an unconcealed technical construction, this follows the laws of nature. Rickey, along with Calder, is the master of an authentic kinetic sculpture.

## The Impetus of the Group: GRAV, ZERO, EAT, CAVS

In America Rickey remained a lone maverick for a long time. It was in Paris, with his call to form a group, that Kinetic Art moved into centre court. By 1955, the exhibition "Le Mouvement" at Denis René showed that the trend was already in full swing. The exhibition included works by Yaacov Agam, Pol Bury, Tinguely, Vasarely and others. Three years later, François Morellet (p. 348), the Argentinian artists Julio Le Parc, Francisco Sobrino and others founded the Groupe de Recherche d'Art Visuel which remained a cohesive group until 1968. Their statutes called for teamwork to explore the technical and physical problems of light movement, replacement of the Romantic concept of the artist-as-genius by a research team, and audience involvement.

In 1967, visitors to the "Lumière et mouvement" exhibition had to move through dark passageways, feel their way through mirrored labyrinths, trip over steps with padded traps and bump into all manner of unexpected interactive components. In a *Perpetuum Mobile* Le Parc (p. 500 below) threaded together a number of polished metal discs which moved in the draught of air,

**Otto Piene**
Automatic Light Ballett, 1962
Perforated metal, light, electronics
Private collection

**Heinz Mack**
The Time of the Stars, 1963
Plexiglass, Fresnel lense,
c. 325 x 35 x 9 cm
Ibiza, Spain

mirroring each other and the room in a fluctuating play of lines, angles, moving reflexes – a mobile that transformed the confusion of baroque mirrored cabinets and the shimmering light of Impressionist paintings into kinetic effects.

In Düsseldorf, too, ideas, manifestos and happenings were everywhere. In 1957, Otto Piene and Heinz Mack founded the Zero group and began corresponding with all the avant-garde movements in France, the Netherlands and Italy. In 1961, Günther Uecker joined them. Other artists such as Christian Megert, the young Hans Salentin, Hermann Goepfert, Jan Schoonhoven (of the Dutch group Nul) were loosely associated through exhibitions or cropped up in the three issues of the *ZERO* magazine. The hard core consisting of Piene, Mack and Uecker were at the vanguard of the breakthrough to the post-Informel, serial, monochrome picture. Their contribution to sculpture cannot easily be extricated from their contribution to painting. Pictures, reliefs and objects were all used as instruments to capture, rhythmicise and nuance light, with punched and perforated patterns or nail structures binding vibrations and optical energies.

Piene (ill. above) was an efficient organiser and enthusiastic theoretician. From projections of his perforated grid pictures, he developed his *Light Ballet* from 1959 onwards, initially using hand-held lamps and later by increasingly mechanical methods and electronic programming. The aim was to achieve an appearance of immateriality rather than presenting the apparatus itself. Later, Piene, as the founder of Sky Art, celebrated large-scale aerial projects. In 1972 his rainbow made of five 460 metre, helium-filled polyethylene tubes arched over the closing ceremony of the Olympic Games in Munich. Alternating with the silver water-cloud by Mack, 600 electric bulbs lit up in an arch. Was this a festive Zero zone in anticipation of a – perhaps purely decorative – preserve of art? In 1974, Piene became director of the Center of Advanced Visual Studies in Cambridge, MA, and a leading promoter of a techno-aesthetically oriented art.

Heinz Mack's sculptural œuvre (p. 502 below) alternates between a utopian dream of beauty and its pragmatic payment by instalments in the form of art-to-order. Here is a lyricist in light who wants to sing (and can) and who sometimes finds himself bogged down in the elegant rhetoric of silver reflexes and granite surfaces. A pioneer of Land Art, his Sahara project teeming with great fountains of light, artificial suns, a mirror wall, sand reliefs, a stele of light (realised in 1967), was subsequently transposed into stunning sculptures for public galleries and urban sites. Nevertheless, Mack imbued his rotating discs and dynamos with a hitherto unknown vibrancy. He also developed differentiated strategies for an urban sculpture. In the steles which were Mack's preferred form, light became a material like stone or metal.

The Zero group disbanded in 1967. Uecker resisted Piene's attempts to proclaim a New Idealism along the lines of the Nouveau Réalisme in Paris. The break-up was not only due to a conceptual disagreement. Behind it lay a latent tension that had fuelled a productive force for many years, but now caused a split. To regard Uecker, the strongest and most dedicated sculptor in the Zero group, only within the context of that group, fails to do him justice.

For Uecker (ill. above and below) Zero was not some utopian horizon, but a rite of passage. For him, art was not a reserve of idealism inebriated by light, but "the space within which he acted out his existence", according to Dieter Honisch, and within which a number of influences are evident, from Rudolf Steiner to Taoism

*"My body plays an important role in the proportions of my works. The movements of my feet. the curve of the body and of the outstreched arms ... are choreographic signs that fill a picture plane."*
GÜNTHER UECKER

**Günther Uecker**
Corner, 1968
Nails on canvas on wood,
200 x 200 x 200 cm
Collection of the artist

and Zen. In this respect, the Mecklenburg-born German artist bears more affinities with Yves Klein than with the euphoric dreamers with whom he came into contact in 1961.

When he drove in the first nails in 1957, bordering a monochrome picture, that still had nothing to do with the rhythms of light and shadow. It was only after 1959 that he also began using nails to set light in vibrant motion. He sprayed them white, overcoming their materiality in this way, and transposed them onto a floating white structure. His circle, spiral, field and wave movements, light boxes and "light plantations" were

**Günther Uecker**
Forest of one trunk, 1990
Nails, ashes, glue and wood; 7 parts,
170 x 600 cm, diameter: 80 cm
Private collection

**Panamarenko**
Unbilly II, 1976/77
Metal, plastic, styrofoam, Japanese
vellum, wood, wire and leather,
269 x 365 x 270 cm
Fürstenfeldbruck, Luftwaffe
officers' school

among the most subtle expressions of Zeroist sensibilities. In this respect, Uecker's work fitted in with that of the Zero group for a while at least.

Nails, however, are also real utensils. They derive from a practical area and represent manual work. When Uecker aestheticises them, he shows that art is made in a simple and understandable way. At the same time, these nails clearly display their physicality and aggressiveness. Uecker's path runs from light structure to physical perception and tangibility, from optics to object. Apart from pure structure, by the early 60s there were already haptic objects, brushes, nailed everyday objects such as tables, stools, a piano. The oversized nail, an extroverted, brutal object that Uecker drove through the outside wall of the Kaufhof department store in Dortmund in 1968, marks his break with the meditative panel. From then on, Uecker also presented Happenings. His sculptures became objects the viewer could walk over or through, such as his architectonically conceived table of nails.

In the 70s he expanded his sensorium, softening his materials (in the course of what might be seen as a post-Minimalist anti-form tendency), hanging torn canvases, corrugated cardboard and ropes. When he returned to the nail-relief in the 80s, he began creating expressive whirling patterns daubed in white and black. Destruction and tranquility balance each other out. This side of Uecker's work shows him to be a European sculptor who goes far beyond Zeroist idealism.

Elsewhere, related groups formed. In Milan, the Gruppo T was founded in 1959 with Giovanni Colombo, followed in Padova a little later by the Gruppo N. In Cordoba, the Gruppo Espacio turned their attention to the kinetics of light. In Amsterdam, the Nul group was formed in direct response to Zero. In London, from 1964 onwards, the artists around David Medella's *Signals* magazine propagated collaboration with industry and

the inclusion of natural forces such as steam, water, fire and magnetism in art. Even in Moscow, Lev Nusberg's Dvishene group (meaning "movement") expanded its geometric vocabulary to include works dealing with the kinetics of light.

In the USA, there was no history of Constructivist and Dadaist machine art. Even the theoretical basis derived from the Bauhaus tradition took hold relatively late. Industrial resources and rapidly progressing mass media, however, were present at a very early stage. 1964 saw the publication of Marshal MacLuhan's *Understanding Media* which heralded the end of the Gutenberg era and the age of the printed word. Isolated, abstract information would be replaced in future by a more direct and sensory pictorial experience. The neural system of global communications would produce a new, sensorily more complex individual. In his 1968 book *Beyond Modern Sculpture* Jack Burnham posited his vision of 20th century sculpture becoming assimilated into cybernetic systems. From the mid-60s onwards such ideas found currency in art practice. Accordingly, US art was dominated by a more comprehensive multi-media and multi-sensory approach.

The composer John Cage was the first to exploit fully the possibilities of audio-visual media. Right from the start, his work included happenings, theatre and ballet. The "theatrical" element became the hallmark of an art that treated objects as actors. In 1966, Robert Rauschenberg and the Swedish engineer Billy Klüver brought these various approaches together. Their EAT (Experiments in Art and Technology, Inc.) constituted the American counterpart to GRAV, with the emphasis on the artist-engineer synthesis rather than on the anonymity of the creative collective.

**Takis**
Signal, 1955–1958
Steel, iron, cement,
85.7 x 91.5 x 30.5 cm
USA, private collection

In October 1966, in the building where the legendary Armory Show had been held in 1913, a series of "Nine Evenings" was held featuring nine artists, including Cage, Rauschenberg, Robert Whitman, Öyvind Fahlström and Yvonne Rainer. They involved "reactive environments" with electronic switch systems, control nets for light patterns, amplifiers for internal body sounds, infrared television, air cushions ... "initiation rites for a new media: total theatre" according to Fahlström. One year later, the Moholy-Nagy student Gyorgy Kepes founded his Center for Advanced Visual Studies at the Massachussets Institute of Technology (MIT).

For the space of twenty years, the Center remained at the hub of a technically generated, though not technically determined art that was unafraid of popular sky decor and pneumatic starflowers. From laser artist Rokne Krebs to video pioneer Nam June Paik, almost every significant artist who helped to roll back the boundaries of what was acceptable was a fellow of the Center at some time or another. In 1977, the *Centerbeam* was presented at the documenta 6 exhibition in Kassel, Germany. It was a 61 metre long multimedia viaduct and action theatre featuring steam explosions, strobe flashes, water prisma, windwheel, neon, argon, laser, hologram, radio, video. The construct presented biological growth processes, the archaic powers of water and wind, the prototypical industrial energy of steam, various versions of artificial light, several information systems and relais switches. in short, it was a brief history of technical progress, translated to sensorily palpable effect. Was this art in the embryonic phase of its development from the mechanical to the cybernetic age?

## Kinetic Art: Crisis and Complexity

By 1977 the artist-engineer honeymoon was over. The "Art and Technology" exhibition in Los Angeles in 1971 marked the turning-point. The enthusiasm for storms of light, chromatic rainbows, flashing mirror images and synaesthetics was on the wane. Had it all just been one big funfair, the "rusting ruins of Utopia" (according to László Glozer)? Or had the prejudice that art is by definition the opposite of technology rather than its creative partner won the upper hand again? At the height of the Vietnam war, America's art-and-technology movement was accused of moral blindness.

Yet the mistrust needed no political motivation. With their halting, wobbling constructions, such machine artists as Tinguely and Harry Kramer (ill. above) had undermined the technological enthusiasm of the GRAV kinetic artists even in the 60s. They countered the smooth standardised efficiency of the machine slaves with an anarchic freedom of chance and irregularity. In the 60s art moved away from optimistic alliance with technology and the media.

The Belgian artist-engineer Panamarenko went beyond the irony with which Tinguely and Luginbühl had addressed the machine. From 1967 onwards, his

response to anonymous perfection in the supersonic age was a series of alternative, individual flying machines (p. 504 above). Though painstakingly constructed, they do not leave the ground. This is Panamarenko's personal adventure in progress – a utopia of yester-year and a poetic vision.

The historical significance of kinetics and its multimedia expansion did not, however, lie in the spectacular participatory theatre of the apparatus. Nor did it lie in the firmly established artistic principle of motion as such. Even today, it still lies in the way in which motion is applied as a differentiated expressive language: dramatic, lyrical, contemplative or comical? The Italian

**Harry Kramer**
B. E. N., 1963
Wire and wood; height: 87 cm, diameter: 142 cm
Germany, VEBA OEL A. G.

**Pol Bury**
Fifty Tons of Columns, 1972
Stainless steel; height: 200 cm each, diameter: 30 cm each
Saint-Paul-de-Vence, Fondation Maeght

**Jean Tinguely**
Carnival Fountain, 1977
Various materials, basin: 16 x 19 m
Basel, Theaterplatz

**Jean Tinguely**
Eureka 1963/64
Iron bars, steel wheels, metal pipes,
various 220 V motors, painted,
780 x 660 x 410 cm
Zollikon, Walther Bechtler
Foundation

*Page 507:*
**Jean Tinguely**
Prole Art No. 3, 1989
Assemblage, 90 x 96 x 68 cm
Zurich, Galerie Bruno
Bischofberger

artist Bruno Munari, who constructed "useless machines" set in motion by a breath of air as early as the 30s, calculated the breaking of light according to precise mathematical formulae. The Belgian artist Pol Bury (p. 505 below) uses the infinitely slow movement of spheres, discs or columns to recall the growth of nature or the orbit of the stars. The eye is geared to slow motion and meditation.

The Greek artist Takis (p. 504 below) calls upon invisible physical energy sources, especially magnetism, and translates them into visible action of almost inexplicable sudden movements and intervals. In his impressive audio spaces, magnetic effects, kinetics and a whirring, droning sound merge.

The Israeli artist Yaacov Agam (p. 346) goes through an almost limitless permutation of positions, translating the theme of variation and series into a process of virtual possibilities. Swedish artist Olof Utveldt sets objects in

motion in an ingenious way that illustrates the names by which we know them: brushes brush, flycatchers catch flies – here is motion as object art with a touch of wit.

Op Art has its own form of kinetics. It derives from the laziness of the human eye rather than from any real motion. The interference of radiating, moiré, shimmering effects confuses the retina and does allows the eye no rest. Naturally, this tends to stimulate strategies for two-dimensional rather than three-dimensional art. For this reason, the work of Victor Vasarely (pp. 345 f) is discussed in the section on painting. By contrast, the Venezuelan artist Jesús Rafael Soto, who worked in Paris from 1950, forged a link with sculpture (p. 347). In 1962, he hit upon his most effective constellation, involving thin white bars suspended on nylon threads of varying lengths in front of a striped ground. The tiniest movement by the spectator, the slightest change in viewpoint even the blinking of an eye, fragments the bars and the threads into pieces that seek to reunite. Mistily shimmering millky ways emerge. The result is a vibration as subtle as it is intensive, and Soto later sought to transpose the same effect to architectural spaces.

Even if its heyday is clearly past, Kinetic Art is by no means relegated to history, but remains a continuing expansion of sculpture.

## Tinguely: the Machine as Theatre

The Swiss artist Jean Tinguely is an outstanding figure. From his arrival in Paris in 1953 until his death in 1991, he explored the immense expressive possibilities and subtle animation of moving sculpture, revealing ever new images that were both whimsical and earnest, ironic and pathos-laden, constructive and auto-destructive, charming and monstrous. He robbed the machine of its specialist application, emancipating it into the uselessly ludic and making it the vehicle of his own emotions. He made the machine a global theatre in which, on the one hand, a vibrant lust for life and on the other hand a metaphysical fear are projected in the shaking and rattling of machine parts, scrap-yard finds and bric-a-brac. It is a spectacle that leads the practical efficiency of the machine ad absurdum while at the same time paying homage to the fascination of the mechanical universe. Yet machines with electric motors now belong to a dying age – a fact that has prompted Werner Spies to describe Tinguely's work as a "requiem to the movements and stereotypes of the homme-machine". One is reminded of Thomas Mann's description of parody "playing its game late in the day with the honoured vestiges of a longstanding tradition".

Because Tinguely was very much alone in his distinctive œuvre, he soon became a European figure of integration, like Yves Klein. Scrap-iron as readymade linked him to the Nouveaux Réalistes and the New York Assemblage artists, while his work with motion linked him to the Kineticists and his aerial "happenings" with the manifesto *Für Statik* (For Statics) over Düsseldorf to

**Jean Tinguely**
Eva Aeppli and the Burghers of
Calais, 1989
Sculpture, 7 parts; iron, found
objects, electric motors,
300 x 300 x 220
Zurich, Galerie Bruno
Bischofberger

*"Life is movement. Everything*
*transforms itelf, everything modifies*
*itself ceaselessly, and to try to stop it,*
*to try to check life in mid-flight and*
*recapture it in the form of a work of*
*art, a sculpture or a painting, seems*
*to me to be a mockery of the inten-*
*sity of life."*   JEAN TINGUELY

the Zero group. He touched upon the issues that moved
an entire generation of artists. Yet his early moving
reliefs were little more than astute comments on the sta-
tic image. In 1958 he took the decisive step from hidden
motors mobilising otherwise traditional compositions
to machines as independent sculptures. In 1958/59 he
created his series of *Méta-Matics*. They do not merely
parody the automatism of the Tachiste gesture, but, like
many of his later sculptures, also call for the utopia of a
quasi-humane machine world reconciled with human-
ity, "full of joy and with joy".

After 1958 it was the visitor who triggered the move-
ment and sound. In the early 60s, his *Balubas*, named
after an African tribe, performed their shaking dance
with feathers, fur, tin cans and cowbells. In *Paradise*,
now in Stockholm, seven complex machines attack
seven burlesque fertility dolls (*Nanas*), rendered by his
wife Niki de Saint Phalle (p. 520) with ribald jokes. In his
*Carnival Fountain* in Basel (p. 506 above) the useless
fountains engage each other in veritable spraying com-
petitions. It marks the climax of the lively, tongue-in-
cheek wit of which Tinguely was a master.

There was, however, another side to his work. In the
course of the 60s, his machines grew to monumental
proportions, solidly built, densely contoured, sculptural
and monumental. The black-outlined *Requiem for a
Falling Leaf* celebrates its movements in silhouette with
a solemn earnestness bordering on pomp. The "sculp-
ture-machine-géante-sonore-variable-extensible" bear-
ing the title *Eureka* (p. 506 below) involves almost eight

metres of wheels, bars, pistons, girders, five discs, each
with a motor, presided over by a huge iron pan. Rolling
and stamping, pushing and shoving, lifting and pulling,
they have little in common with the more relaxed spirit
of the *Méta-Matics* and fountains. Heavy limbs repeat
the same movements time and time again, conveying
cogs and wheels to and fro, pushing bars back and forth
with Sisyphean effort. The parts, according to Pontus
Hulten, are "condemned to lead a prisoner's life". Here,
the demonstration of the senselessness of anonymous
mechanisms takes on a dramatic and almost tragic
dimension.

In the last ten years of his life, Tinguely expanded
into space or, to be more precise, into a kind of stage
space. Altar-like constructions bear heaps of civilisa-
tion's garbage – a monstrous jungle of machine parts,
consumer objects, wrecks, lightbulbs (ill. above and p.
507). In 1980, he began to add symbols of death, animal
skeletons, skulls. The shock effect became increasingly
lurid, the noise increasingly unbearable. These are apoc-
alyptic scenarios in the form of monstrous assemblage
tableaux. According to Tinguely, "The artists still mak-
ing art in future will either be fantastic artists or mere
decorators." Something of the aesthetics of terror is cer-
tainly evident in the pandemonium of his late mechani-
cal Hells.

# The Direct Language of Reality

## The Ubiquitous Readymade

'I really begin to understand any society by going through its junk shops and fleamarkets. It is a form of education and historical orientation for me. I can see the results of ideas in what is thrown away by a culture," said the Californian artist Edward Kienholz in 1970, and he used his found objects to create mordantly critical social tableaux. Objects represent an entire culture. Could Duchamp have been saying something similar when he took the bottle-rack from the department store shelf or the urinal from the sanitary-fittings supplier? Could he have said that he understood French society the better for it? Had he not thrown down the gauntlet of the readymade to the Kienholz generation, only for them to discover its aesthetic beauty, as he noted, half flattered, half annoyed, in the early 60s? Was not the bottle-rack, for half a century, the question mark behind art?

The confidence Kienholz placed in the expressive power of things betrays a completely different attitude. Things no longer call art into question, nor do they present a gesture of refusal. A complex No has transformed itself into a resounding Yes. Duchamp's strategy of indifference towards art proved an immensely fertile principle. The readymade, and its derivative, the assemblage, exploded after 1960 into an unquestioningly accepted and broad-based approach. Behind that was not so much a renewal of Duchamp, as an almost insatiable hunger for reality and for immediate, commonplace, everyday reality at that. It marked the end of solemnly celebrated, excessively abstract prohibition. It marked the end of a moral attitude that disdained any attention to what Clement Greenberg termed mass culture and Theodor W. Adorno termed the *Kulturindustrie*, denouncing such trivial pursuits as tantamount to high treason against the noble realms of art.

Half a generation began delving through the rubbish tips and scrap-yards, through the junk-shops and toy stores, through the building sites and supermarkets, dismantling street signs or nailing dinner-plates to boards. In a television series that looked at different occupations, Kienholz, representing the craft of the artist, had himself filmed looking for material in a car-wreckers' yard. Arman and Dieter Roth filled wastepaper baskets

**Piero Manzoni**
The Base of the World (Hommage à Galileo), 1961
Corten steel, 82 x 100 x 100 cm
Herning, Herning Kunstmuseum

and trashcans, and the Prague artist Milan Knižák set up "sweeping environments" on the street. The way Rauschenberg, Kienholz, Tinguely, Arman or Spoerri handle the readymade has nothing to do, however, with Duchamp's negative gesture or with the projection of private wishes and drives onto the Surrealist object. The principle of the readymade had opened the floodgates through which everyday life came rushing. Here were things that retained their own life, they had own language, origins and history. Here were things that represented "life" itself – and this, of course, was modern art's most productive myth of all.

From here on in, life was linked to the commonplace, and to our urban environment with all its wear and tear and consumerism. For the readymade, this meant that the surrealist psychology of the object became a realistic sociology. The radical Dada equation of art as a way of life was turned on its head – life had become a way of art. In 1960, Manzoni placed the planet earth on an upturned base (ill. above).

In 1964, the English artist Mark Boyle began throwing nails onto maps, removing one square metre at the place they landed and preserving it. This was, in short, an aleatory fragmentation of Manzoni's globe. Manzoni, however, instead of painting them, had directly

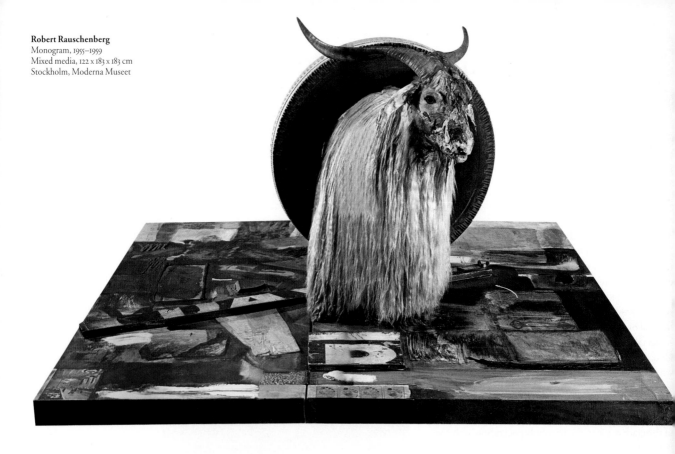

**Robert Rauschenberg**
Monogram, 1955–1959
Mixed media, 122 x 183 x 183 cm
Stockholm, Moderna Museet

signed models in 1961. That same year, Timm Ulrichs presented himself as a living work of art and went on to build up an entire catalogue and monologue of the Self as quantity and entity.

## Rauschenberg and the Gap between Life and Art

The first artist to mirror America's mass-consumption society was Robert Rauschenberg. In 1949 he arrived in New York from Texas and discovered an inexhaustible reservoir in the streets of downtown Manhattan. Mostly, he only needed to walk around the block to get his

**Jasper Johns**
Painted Bronze II
(Ale Cans), 1964
Painted bronze, 13.7 x 20 x 11.2 cm
Collection of the Artist

material. No artist since Schwitters, whose *Merz* art Rauschenberg had studied in detail, had turned his attention so devotedly to trash.

From 1953, he produced his *Combine Paintings* – fragments of an expressive gestural painting combined with street signs, traffic signs, discarded furniture, animal skins and photos from magazines. A stuffed angora goat stands on roughly painted boards with a car tyre slung around its body. The combination certainly adds life to the title *Monogram* (ill. above). Or is Rauschenberg presenting some disguised symbolism of sexuality with the goat as a faun embraced? The heterogeneous context from which the parts have been wrested, opens up a complex wealth of associations. Definitions are avoided by Rauschenberg, who fears that they take the life out of things. Rauschenberg's much-cited claim that his work plays in the gap between life and art includes a distinct formal awareness. The *Combine Paintings* (p. 315) are by no means merely a vital, arbitrary conglomeration like the impression of a street scene, but a polyphonic fabric of formal, iconographic and political cross-references.

During this period, Rauschenberg was often seen in the company of Jasper Johns, who also had a studio in Pearl Street. Johns, however, was a genuine painter who rarely worked in three dimensions. If his *Flags* and his *Targets* (pp. 309 f) and his bronze cast, painted *Ale Cans* (ill. left) nevertheless had an impact on Minimal Art, then it was primarily because they proved that pictures can be objects and objects can be pictures. This 60s

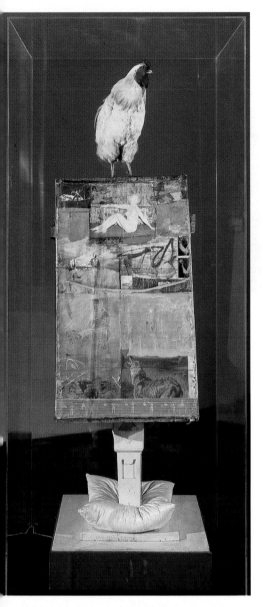

sation and emotional spontaneity linked him with the typically Californian Funk Art named after the relaxed, anarchic, funky jazz of the West Coast (as opposed to the cooler, more disciplined jazz of the East Coast). As early as 1951, Funk Artist Bruce Conner had created enormous horror-structures of raw materials which he left to rot in what Günter Metken has described as "horrifically brutal *vanitas* statements in the manner of Kienholz".

Around 1960 Kienholz arranged socially critical, satirical objects, followed shortly afterwards by scenic tableaux, in which junk and bric-a-brac were used to form a precisely reconstructed atmosphere clashing with lurid horror. An old woman awaits death as the ghost of her own memories. She is still sitting in the photographic pose, although the photographer has long since gone. A photograph of her in her youth on a glass ball (her awareness of self) and an animal skull replace the head. A chain of glass pots with the relics of child-hood, marriage, births and deaths hang around her neck. Legs and arms are made of cow bones. The cosy idyll and the artificially mounted, dehumanised figure are steeped in halted time. It is an image of frozen decay, strictly formulated in circles, ovals and rectangles. *The Wait* (ill. below) possesses an almost tender touch, which is rare indeed in the work of Kienholz.

In other scenes he reveals the shabbiness of death more tormentingly: dolls bound together as in an atomic mushroom, the sevenfold pain of birth merging with the sevenfold thorn of violation, mask-faced racists castrating a black man. *The Portable War Memorial* (p. 512 above) which can be used for all wars, is also polit-ically complex. On the left are the propaganda clichés – the barrel-body of the singing troop-entertainer Kate Smith endlessly trilling "God bless America", Uncle Sam on the enlistment letter, the famous scene of plac-ing the flag on Suribachi mountain, soldiers in real uni-forms, the gravestone with the names of 465 countries destroyed by war. On the right is a bar with tubular steel

**Robert Rauschenberg**
Odalisque, 1955–1958
Wood, fabric, wire, grass, paper, photographs, metal, cushion, stuffed rooster, four light bulbs, 205 x 58 x 58 cm
Cologne, Museum Ludwig, Ludwig Donation

*"I really begin to understand any society by going through its junk stores and flea markets. It is a form of education and historical orienta-tion for me. I can see the results of ideas in what is thrown away by a culture."* EDWARD KIENHOLZ

**Edward Kienholz**
The Wait, 1964/65
Fibreglass, furniture, glasses, photographs, stuffed cat and other materials, c. 250 x 400 x 220 cm
New York, Whitney Museum of American Art, Gift of the Howard and Jean Lipman Foundation

paradigm, turned every which way since Frank Stella (pp. 351 f) and Donald Judd, has little bearing on Rauschenberg.

## Kienholz and the American Way of Life

Edward Kienholz, on the other hand, seemed in many ways to be his Californian opposite, distorting the New Yorker's realism into shocking grimaces through Surre-alist moments. He did not insert the dynamism of the street into his pictures, but staged instead monstrous counterworlds to the illusory beauty under the Pacific skies in a grotesque *memento mori* against the suppres-sion of suffering and the Hollywood-style cosmetic camouflaging of death.

At about the same time as the first *Combine Paintings* he nailed fragments of furniture, appliances and garbage together to create wooden reliefs which he then painted with a broom. Cheap materials, do-it-yourself improvi-

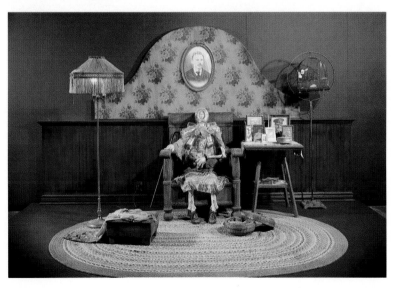

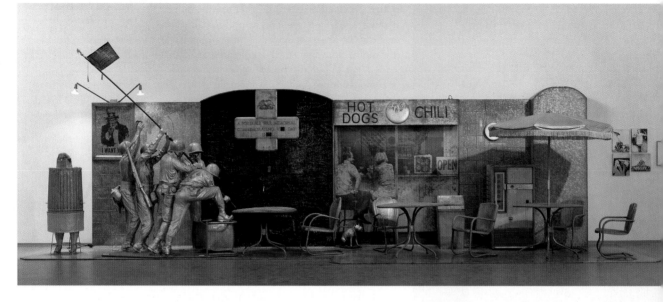

**Edward Kienholz**
The Portable War Memorial, 1968
Environment of various materials
and objects, tape recorder, Coca
Cola dispenser, 285 x 950 x 240 cm
Cologne, Museum Ludwig,
Ludwig Donation

furniture: Coca-Cola imperialism, business as usual.
The fact that the two belong together is indicated by the
soldiers, who are hoisting their flag over a fallen chair
onto a coffee-house table. A multi-purpose war memor-
ial as an anti-war memorial.

The closest we come to Kienholz' horror scenes of
the 60s is in the work of Paul Thek (ill. below) whose
assemblages attack the hypocrisy of bourgeois morality
with glaring shock effects. From 1970 onwards his social
satire fades into a world of symbolistic landscapes that
weave the tapestry of their Surrealist heritage in over-
whelmingly ritualised histrionics.

Like Kienholz, George Segal also whets our critical
view of the American scene. Like Kienholz, he presents
his tableaux as though the theatre curtain were rising.
Yet the plays he stages could hardly be more different.
Whereas the Californian Kienholz attacks specific out-

rages with grim, unreal allegories, the New Yorker Segal
heightens situations of American solitude to the point
of universality in an almost classicist mode. He fixes
breakdowns in communication against a black ground:
a two-man combo with a single dancer (p. 513 below),
an evening meal at the counter, a woman at the cinema
box-office. From 1961, the figures he used were actually
plaster casts he had made of his own friends in everyday
poses, removed by a bandage process and mounted
externally with the skin of the cast. They contrast with
real objects like white-plastered fossils. Segal creates an
aura somewhere between silence, melancholy and
depression.

Whereas the bizarre assemblages by Lucas Samaras
(p. 513 above), often strewn with nails, seem more closely
related to Surrealism and Neo-Dadaism, the documen-
tary realism of Duane Hanson's work is influenced by
Kienholz and Segal. In the mid-60s he began modelling
his socially critical, warts-and-all figures of people on
the margins of society, soldiers, the homeless, in poly-
ester, fibreglass and resin. Later, he turned his attention
to typical middle-class Americans, skilled workers,
tourists, shoppers (p. 514), depicting them with an aston-
ishing true-to-life realism that is by no means naturalis-
tic. These figures are individuals and generic representa-
tions at one and the same time, caught in an almost
autistic void.

Rauschenberg, Kienholz, Segal, the three assem-
blage artists of contemporary America are frequently
linked to Pop Art. They explore the city in all its vitality,
its wear and tear, its brutality and its breakdown of com-
munication. Yet Pop Art, by contrast, sees urban life in
the folklore of bright media images and an attractively
packaged consumer world. Nothing is dirty, everything
is ready to use. Although Jim Dine's mounted tools
(p. 318), Rosenquist's cellophane foils and Warhol's
Brillo packs may be typical of their era, the only truel
sculptor at the hard core of Pop Art is Claes Oldenburg.

**Paul Thek**
Ark, Pyramid, 1971/72
Installation; various materials,
c. 250 x 830 cm
Kassel, documenta 5 (1972)

## Oldenburg's Double Irony

Can Oldenburg be described as a Pop artist like Roy Lichtenstein, Andy Warhol and James Rosenquist? Or is he a realist who also builds on abstraction, volume, planes and colour? Or is this self-styled "everyday surrealist" an artist who leads sculpture into a new physicality, tactility, eroticism and that rare thing, irony? A sculptor who subjects form to gravity and the flexibility of the material and whose work beats a direct path to the "anti-form" of the late 60s.

In 1956, Oldenburg, the son of a Swedish diplomat, arrived in New York from Chicago. He, too, was fascinated by the street – not by the glamour of Fifth Avenue, but by the harsh and dirty life of the Lower East Side. In 1960 he put his first environment together in the Judson Gallery: traffic signs, grafitti with child-like spelling mistakes, ragged cardboard silhouettes of people and cars, found objects, echoing the power of the city as a formless, anarchic living process. In formal terms, Oldenburg followed in the footsteps of Dubuffet's Art Brut, children's art and the comic-book mythology of the ray-gun.

Whatever he drew, modelled, cut or tailored after that, he blew up into gigantic proportions, creating the same tension between intensity and irony. One year later, he presented his legendary "Store" in a former warehouse as a studio-cum-exhibition-cum-performance venue and piled shelves high with enamel-

**Lucas Samaras**
Shoe Box, 1965
Wooden construction, wool, shoe, steel nails, cotton, paint, 26.7 x 39.4 x 28 cm
Formerly Saatchi Collection, London

*"I love to watch people. I'm interested in their gestures and I'm interested in their experiences and mine. In the early years I spent a lot of time trying to look as bluntly as I could at people in their environments. Very often I saw them against garish light, illuminated signs. I saw them against visually vivid objects that were considered low class, anti-art, un-art, kitsch, disreputable ..."*
George Segal

**George Segal**
Rock and Roll Combo, 1964
Figures made of gauze dipped in liquid plaster and mounted on a wood-and-wire frame, electric guitar, drums, wooden stool, 186 x 190 x145 cm
Frankfurt am Main, Museum für Moderne Kunst

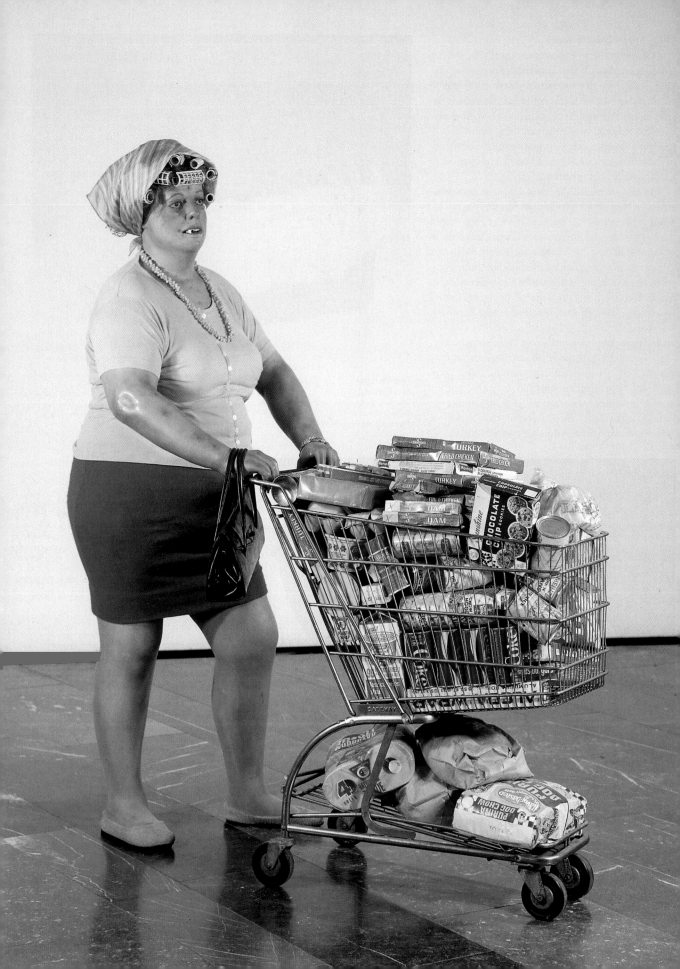

painted women's dresses roughly made of plaster and muslin strips, shoes, hot dogs and hamburgers – still lifes bursting with juicy puns from the male ice cream cone to the female sandwich. These were showcase exhibits whose wildly streaming paint undermined the existential pathos of Action Painting and translated it into a vibrant quiddity.

In his second "Store" exhibition, this time at the Green Gallery, in 1962, he showed his *Soft Sculptures* for the first time – huge, sewn items of food or clothing. From here on in, *Soft Sculpture* was to be Oldenburg's hallmark (ill. right). Its origins lie in the stuffed rags he had begun to use in performances in 1960. *Soft Sculpture* is based on a carefully considered aesthetic approach in which the transformation of an object into a soft, limp, drooping, oversized replica was preceded by hard, rigid cardboard models. In his third environment, *Bedroom Ensemble* (ill. above) in 1963, Oldenburg blended this cooler geometry of reconstructed perspectives and angular parallelograms (as in newspaper advertisements) with the deceptively sumptuous fabric imitations of the soft final version. Between cardboard models and these metallic black, porcelain white or garishly glossy final versions in vinyl, there is usually a more tempered interim version in natural-coloured canvas, which Oldenburg compares with "ghosts".

He has used this process of "softening" and magnifying telephones, typewriters, lipsticks, even toilet bowls. Although they are functional everyday objects, they feature universal forms such as the circle, the cube and the cylinder. The soft plastic materials and cushion-like, malleable curves heighten the ambiguous sensuality to the point of association with breasts or genitals. Domestic appliances are placed in a closer and almost loving relationship with people and take on anthropomorphic traits. They interact as in osmosis between one analogy and another, and in doing so almost succeed in achieving Oldenburg's utopian aim of ending the schism between humans and things.

**Claes Oldenburg**
Bedroom Ensemble I, 1963
Bed, two bedside tables,
dressing table, chair, rug,
305 x 610 x 318 cm
Installation for the Pop Art
exhibition at the Hayward Gallery,
London
Ottawa, National Gallery of
Canada

**Claes Oldenburg**
Giant Soft Swedish Light Switch
(Ghost Version), 1965
Linen, kapok, paint, wood;
height: 135 cm
Cologne, Museum Ludwig,
Ludwig Donation

*Page 514:*
**Duane Hanson**
Supermarket Lady, 1969
Painted fibreglass, polyester and
clothing, shopping cart with
product packs
Figure: c. 166 x 70 x 70 cm
Aachen, Ludwig Forum
für Internationale Kunst

His other strategy apart from "softening" involves magnifying objects into monumentality. The joke lies in the contrast between the monumental size and the banality of the object. In a world in which everything on the television screen is small and everything on the cinema screen is large, our sense of scale is confused anyway. At the same time, Oldenburg calculates geometries that work at a distance. Until 1969 he only drew them: house-high crispbread walls for Stockholm, a banana ventilator for Times Square, a scissor monument to replace the obelisk in Washington.

In 1969, the first of these was actually realised: at the height of the student protests against the war in Vietnam, he installed an eight-metre high lipstick on caterpillar tank tracks – a phallic cruise missile, war as a femininely undermined macho erection. The collapse of the (originally inflatable) bellicose-pacifist lipstick was only a question of time. In 1971, Oldenburg noticed the many building site holes and a pond with swans in the Sonsbeek exhibition park. He installed a 12-metre high trowel with its point stuck into the ground, the curve of its handle reminiscent of a swan's neck (ill. left). Since them, numerous monuments have been built. With their precise reference to their specific location, their iconographic wit and their formal stringency, they are among the rare examples of successfully innovative sculpture for public places.

## British Pop Art and Paolozzi's Machine World Collages

In the course of the 50s, the sense of unease regarding art as noble form took hold in Britain as well. Were not Henry Moore and Barbara Hepworth already on the way towards aesthetic canonisation? Did not the influential critic Herbert Read play a role similar to that played in America by Clement Greenberg? Did not the omnipresent Institute of Contemporary Arts determine what was officially fine art? Since 1951 a small debating club of artists, architects and theoreticians known as the Independent Group had begun to rebel. Their lectures and discussions on mass media, science fiction, the visual worlds of optics, information theory and mechanisation shaped the *leitbild* of popular culture and sowed the seeds of British Pop Art.

However, this generation and the subsequent one, the true Pop generation, was influenced less by an expansion of sculpture and the metamorphoses of the readymade than was the case in America and France. In the foreground were the secondary visual worlds of photography, reproduction and unlimited editions. This meant that British Pop Art was founded primarily by young painters whose fascination for the American consumer paradise found its expression in subtle, considered images. Even Peter Blake's (p. 306) nostalgic *Toyshop* of 1962 and Joe Tilson's (p. 304) mixed media works, for all their encyclopaedic wealth of objects ordered in boxes like miniature museums are in fact a variation on painting. The pin-up dolls and shoe objects

**Eduardo Paolozzi**
The Last of the Idols, 1963
Aluminium, oil paint,
244 x 71 x 64 cm
Cologne, Museum Ludwig,
Ludwig Donation

*Page 516:*
**Claes Oldenburg**
Trowel, 1971
Steel tinted with spray-paint,
1170 x 365 cm
Otterlo, Rijksmuseum Kröller-Müller, Sculpture Park

**Arman**
Accumulation of Cans, 1961
Enamel pitchers in plexiglas
showcase, 83 x 142 x 42 cm
Cologne, Museum Ludwig,
Ludwig Donation

*"I didn't discover the principle of
'accumulation'; it discovered me. It
has always been obvious that society
feeds its sense of security with a pack-
rat instinct demonstrated in its win-
dow displays, its assembly lines, its
garbage piles. As a witness of my
society, I have always been very
much involved in the pseudo-biolog-
ical cycle of production, consump-
tion, and destruction. And for a long
time, I have been anguished by the
fact that one of its most conspicuous
material results is the flooding of our
world with junk and rejected odd
objects."*                    ARMAN

presented by Allan Jones turn a Surrealist tradition into
a sexual fetish. In the end, the British Pop Art scene pro-
duced only one genuine sculptor: Eduardo Paolozzi
(p. 517).

Paolozzi, a Scot, had fallen in love with the America
of the glossy magazine and the Hollywood film as early
as 1947, in Paris of all places. His sketchbooks record nei-
ther the Eiffel tower nor the Louvre, but advertisements
for vacuum cleaners, Libby's canned peaches, starlets,
Mickey Mouse: collages that were pure Pop Art even in
1947. As he moved away from Pop motifs in the course
of the 50s, he held on to the collage principle with the
tenacity of Max Ernst. He tested ever new variations on
the cast, the copy and the objet trouvé. He adopted the
theme of man and machine from the discussions of the
Independent Group. Even before 1960 he was pressing
particles of scrap, cogs and bolts into the epidermis of
anthropomorphic figures. After 1960, he piled brightly
painted alumium casts of batteries, crankshafts and tur-
bines to create frontal mechanical idols.

Later, the static rigidity relaxed, blocks became
angled, and curved, and meandering pipelines emerged.
The man-machine became the mechanical-vegetative
mixed media image. Towards the end of the 60s, con-
cave and convex profiles followed in polished steel,
which distort and collage our mirror image. Then came
multi-part wood reliefs, floor sculptures and fountains
brimming with signs and diagrams. The kaleidoscopic,
multivocative formal world of the computer had
replaced machine art.

### Nouveau Réalisme: the Sociology of the Object
The most consistent and radical new interpretation of
the readymade occurred exactly where it had emerged
thirty-five years before–in Paris, which became a further
centre of the revolt against psychogenic drives and deco-

rative *peinture*. Here, in 1960, the thirst for direct, out-
ward reality was felt just as keenly as it was in New York.
Here, too, Schwitters was to play an important inspira-
tional role. Here, too, casts of objects or bodies conjured
up reality. In 1949, Rauschenberg had printed blueprints
of nude models, and, in 1951, he had had a Ford drive
over an ink-smeared road to create monotypes of the
tyre profile. In Paris in 1958, after experimenting with
stamp prints, Arman scattered coloured nails, radio
tubes and splinters of glass onto the canvas. In 1959, Yves
Klein used blue-painted women's bodies as "living
brushes" in creating his *Anthropometries* (p. 298).
Whether it was in 1949 that he signed the sky over Nice
or whether legend has back-dated that event, it is a
fitting gesture to mark art's quest to embrace reality.

In Paris, in 1960, the critic Pierre Restany founded
the Nouveaux Réalistes group together with such
unlikely Dioscuri as Yves Klein, Tinguely, Raymond
Hains and his Affichiste friends, Arman, Spoerri
and Martial Raysse. Soon they were joined by César and
Niki de Saint Phalle. Klein was the high priest who was
difficult to integrate, Tinguely the forceful artistic
authority, Restany the eloquently seductive lyricist and
patron. Right from the start, Klein fragmented the
group with his emphatic spirituality and his mystically
inspired insistence on the "immaterial" essence of real-
ity. The focus, however, was not on Klein's assimilation
of the void but on Tinguely's, Arman's and Spoerri's
assimilation of city, factory, machine, mass media and
consumerism.

The paradigmatic guarantors of Restany's concept of
assimilation were Arman and Spoerri. Both system-
atized what Camille Bryen called the "adventure of the
object", and both developed it in countless experiments
and inventions. For Arman, a constructive path and a
destructive one opened up. From 1959 onwards, he col-

condense welded-together tools into a single battering ram of black hammer-heads. A comprehensive inventory of new possibilities in the wake of the readymade begins to emerge which, in the long term, cannot avoid seeming somewhat mannered.

Spoerri's approach is similarly systematic, though it has a strong touch of post-Surrealist unreality. It would be far too one-sided to pin his œuvre down to the *Tableaux-pièges* (variously known as "trap" or "snare" pictures; p. 328) in which he affixed the remains of a table after a meal in an equation of our sensual, vital, untidy, dirty world, and in a quest for evidence of what Spoerri has described as "one split second in an entire cycle of life and death, decay and rebirth". Yet the hotel table that he nailed to the wall in 1960 as an *objet trouvé* was merely the point of departure in the œuvre of this dancer, publisher, poet, author, cook (p. 580), restorer, Nouveaux Réalistes, inventor of Eat Art and founder of the Musées Sentimentaux.

In 1966 he noted no fewer than seventeen "developments of the trap picture" including the "square trap picture" in which the tools for affixing the picture are also affixed with it, and (together with Robert Filliou) the *Word Traps* or idioms reified in the form of object puzzles. These include, for example, illustrating the

**Christo**
Package in Shopping Cart, 1964
Packaging; shopping cart, film, string, 100 x 45 x 37.5 cm
USA, private collection
© Christo 1964

*"But actually, what is a sculptor, a sculpture? Sculpture is something three-dimensional, that gives one the opportunity to move around it. But that is only the starting point, for the further one moves away from this sculpture, the broader is the spectrum of its possible meanings and the different ways that one can experience sculpture."* CHRISTO

lected radio tubes, jugs, combs, dolls, cogwheels and dollar notes in plexiglass containers for his *Accumulations* (p. 518).

His first *Poubelles* – trashcans containing the discarded waste of friends, children, bourgeois homes or market halls – date from the same year. Arman began sealing organic waste in polyester. There is more to this than a cursory evasion of composition; it is the condensation of consumption into the signature of our everyday life, a patinaed still-life or portrait of our civilisation. A bridge built from the readymade to sociology and psychology, a collection of cog-wheels as the commando headquarters of a mechanical, anonymous power. Under the title *Grandmother's Village*, sliced-open coffee grinders make a tongue-in-cheek comment on the "good old days". The quotation of objects is heightened by sheer quantity into the expressive, the narrative and the representative.

Alongside this positive re-evaluation of objects, Arman destroyed objects in his prototypical *colères* or bursts of rage, smashing, sawing, cutting or burning musical instruments, household goods, clocks, exploding a sports car and then fixing the fragments as relics of destruction. Again, the issue at stake is one of liberating and magnifying the power of expression lost in mass production. From 1967 onwards, other serial works formalise new Renault parts into abstract compositions or

*"I start out with an idea that is inside me, a nothing, and I venture out to the point where I find myself confronted with a thing that is alien to me. It is precisely this that makes it reality. It is detached from me, it exists in its matter, its content, its space. A sculpture has to possess its space."* CÉSAR

**César**
Compression of a Car, Ricard, 1962
Compressed automobile parts,
153 x 73 x 65 cm
Paris, Musée National d'Art Moderne, Centre Georges Pompidou

**Niki de Saint Phalle**
Black Nana, 1968/69
Painted polyester, 293 x 200 x 120 cm
Cologne, Museum Ludwig,
Ludwig Donation

German word for flattery – "bauchpinseln" (literally belly-brushing) – by applying a red, green and yellow brush to the lilac belly of a shop window dummy. Spoerri's later assemblages transpose kitsch images, meat mincers, water taps, artificial limbs, animal skulls, knives and forks in lurid juxtaposition and syncretic analogy.

In the year the group was founded, the successful trash sculptor César joined the Nouveaux Réalistes. He had recently seen the latest American car-press and had immediately recognised the chance of using the automobile as a means of direct expression for technology and urban iconography. Unlike Chamberlain, César's *Compressions* involve no formal intervention (p. 519 below). From 1962, César began regulating the pressure and cutting process to one of *Compression dirigée*, or controlled compression. Though the proximity to the concept of reality propounded by the Nouveaux Réalistes was evident, it did not last long. In 1967 César began moulding polyurethene foam, initially as a street performance. Soon, he was using this process to create sculptures that placed him close to Pop-related process art.

The Bulgarian-born artist Christo had been wrapping bottles, shoes, furniture, a pram, and a motorbike in rough plastic or fabric (p. 519 above) since 1958. Was this a critical response to the commercial world of packaging? Or was it a demonstrative alternative to the consumer aesthetic of Pop Art? Christo's further development indicates that he was not only expressing his criticism of consumption, but also aiming to aestheticise the wrapped object, building or landmark. Ropes structure a wrapped motorcycle like nervously sketched lines, the images between the lines of power tauten to a relief in dialogue with the motocycle's contours. In the 60s, Christo and Jeanne-Claude blocked the view of entire displays of goods by curtaining and concealing shop window façades or shopping malls with fabric and wrapping paper. They turn their attention in 1961 to the great outdoors (*Dockside Packages* in Cologne), installing a curtain in a Colorado valley (1970–1972), surrounding islands in Miami in the years 1980–1983 (p. 549) and, in 1995, wrapping the Berlin Reichstag (pp. 330).

Whereas Christo and Jeanne-Claude wrap the world of consumer goods and (critically?) distort it, the montages of Martial Raysee present that same world in all its seductive appeal as a glossy cosmetic finish to an artificial world that generates wishful images. Niki de Saint Phalle's monstrous yet delightful *Nanas* also address wishful images. The huge, burlesque fertility dolls play somewhere between childhood imagination and male fantasy (ill. left). Her association with Nouveau Réalisme is based not so much on her *Nanas* as on her wreaths and hearts of toys, dolls, puppets and artificial flowers veiled by a white cover. Is she returning in search of something she missed out on in the far from childlike stringency of her upbringing in an aristocratic French family?

## Intermedia, Fluxus: Object and Concept

Rauschenberg's approach, working in the gap between art and life, requires a firm footing based on specific values. These values came openly to the fore around 1960 in the work of several artists. Art was touched by life and occasionally flooded by it. The readymade, if it occurred at all, no longer merely represented reality, but became a vehicle that stimulated ideas and general creativity. Dick Higgins adapted Rauschenberg's approach, applying it to other situations and, in 1962, he coined the term Intermedia. Before moving on to Happenings he carved out a fairly unobtrusive niche for noise music, poetry readings and concrete poetry, artists' books, multiples, mail art, games without rules, and witty nonsense. This niche was dominated by the Fluxus movement from 1961.

Fluxus was not primarily concerned with objects. It tended to evoke the ephemeral. The name is as much a part of the history of Action Art and the artist's book as it is a part of the history of sculpture. Yet it also points to a productive crisis where the object is concerned. On 2 March 1961 the name graced an invitation to the New York A/G Gallery, later turning up as the title of a magazine issued by Lithuanian-born designer George Maciunas. It suggests fluidity, instability, change and chance. The imperial organisation with Maciunas as "president" and – in the manner of Breton – as Fluxus Pope, with coordinators and vice-coordinators for the zones of America and Eastern and Western Europe, was a semi-ironic, semi-utopian reference to revolutionary world changes wrought by the Fluxus concept. Anti-bourgeois, anti-commercial concepts of art, the merging of everyday reality and absurdity, musical scores and pure chance, western actionism and oriental philosophy, and anarchistically playful liberty were promoted to become articles of faith.

The spirited notion of a cultural revolution, however, initially went no further than a few fairly modest Fluxus concerts held in Wiesbaden, Copenhagen, Amsterdam and Düsseldorf, and their "unspecific creativity", as Maciunas put it, was devoted primarily to dismantling the bourgeois piano. John Cage, who had been experimenting in this vein since around 1937, paved the way with his first *Piece for prepared piano*.

Nam June Paik's *Piano Intégral* (ill. right) is the result of several concerts given beween 1958 and 1963. Eggshells, photos and glass were placed between the strings, and bicycle bells, sirens, a vacuum cleaner and a transistor radio were built in and set in motion at the touch of a key. A musical score programmed this acoustic anarchy. Though this is a process that could be continued at will, its acceptance by the established art scene marked its end, at least for a time.

Such was the more spectacular aspect of Fluxus. The typical Fluxus object, however, is a great deal less spectacular, often unaesthetic, usually small and generally boxed. The idea of the box was derived from Duchamp's *Boîte en valise*. Since 1962, Maciunas produced editions

**Nam June Paik**
Piano Intégral, 1958–1963
Assemblage; Ibach piano prepared with various items, 136 x 140 x 65 cm
Vienna, Museum moderner Kunst, formerly Hahn Collection

in specially made leather cases (p. 587), some of them containing more than thirty items by various artists: household articles, bric-a-brac, even invented games, puzzles, collages, multiples, evocative printed cards, records, stamps, miniature private messages ... all documenting "that the borders to art are further than previously assumed, or that art and certain barriers are no longer meaningful", according to George Brecht. The most faithful contributors were Brecht and Robert Watts. Objects were also supplied by Ay-O, Joe Jones, Per Kirkeby, Alison Knowles, Oldenburg, Saito and others.

The "old masters" of everyday Fluxus creativity were Robert Filliou and George Brecht (p. 522 above left). From 1965 to 1968 they worked together in a house at Villefranche-sur-mer. According to Brecht, "we made games, invented and de-invented objects, ... drank and chatted with our neighbours, produced flux poems ... and sold them by mail". Such were the activities of the *Institute for permanent creativity* projected by Filliou. His *Tool Box* of 1969 (p. 522 below) gave form to this attitude. On the lid, in neon letters, are the words *imagination*

*"The piano is a taboo. It has to be broken. By the way, it isn't even that expensive ... it's just the transport costs that are expensive."*
NAM JUNE PAIK

**George Brecht**
The Book of the Tumbler on Fire.
Twenty Footnotes to Vol. I,
No. 19, 1969
Chair, umbrella, car hazard light,
115 x 85 x 110 cm
Vienna, Museum moderner Kunst

**Tetsumi Kudo**
Your Portrait, 1964
Dimensions unknown
Netherlands, private collection

and *innocence*, the only tools we need in order to be creative. In the box there are wooden sticks with hooks and eyes.

There is virtually no end to the possible permutation of links and cross-links. All solutions are equally valid in Brecht's game, which has neither rules nor winners. The course of the universe is not affected by our decisions anyway. Filliou learned his laid-back attitude from Taoism. Brecht learned his simple, logic-defying paradoxes from Zen Buddhism. In practice, the utopia of the general accessibilty of art had failed even then. Yet the idea of Intermedia and Fluxus survived.

Artists' books and artists' magazines burgeoned. The Dutch artist Stanley Brouwn, the Czech Milan Knižák, the Dane Arthur Köpcke, the Germans Tomas Schmit and Wolf Vostell, the Romanian-born Spoerri, all found a medium here that oscillated between media, tending towards the object. Timm Ulrichs, the most imaginative Intermedia loner, is associated primarily with visual poetry and object art. The painter, typographer, poet and Intermedia artist Dieter Roth (p. 363) replaced

hierarchical qualification by quantification in his many-facetted work and manically produced arbitrary series of *Collected Works*, in keeping with the spirit of the times. He chopped up twenty volumes of Hegel and packed them into sausage skins with pork dripping and spices, thereby returning the history of human intellectual achievement to the realms of everyday life.

### Happening: Object and Action

Put extremely simply, the move away from the picture led to the object, and the move away from the object led to the Happening. Though a creative idea cannot be reduced to its historical source alone, the sensual appeal of the material, commonplace things as actors and silent partners in a game were the notions behind the early Happenings.

Allan Kaprow (p. 583) who set the ball rolling in 1959, saw the Happening as an extension of the Assemblage. Vehicles were pushed to and fro, barrels rolled, chairs moved. In 1968, eye witness Michel Ragon described the destruction of cars during the Paris student uprising of

*"I see myself as an entertainer of thoughts and works of art as an exchange of nutrients."*
ROBERT FILLIOU

**Robert Filliou**
Permanent Creation Tool Box,
1969
Toolbox, neon, wooden sticks
Paris, Ninon Robelin Collection

May not only as Happenings on a huge scale, but also as oversized versions of César's *Compressions* – the real readymade being the act itself.

Everywhere, the things featured in the Happenings were becoming the focal point. In Osaka, the painter Jiro Yoshihara founded the Gutai group in 1954, in which artists aimed to "make the naked materiality of things speak". In 1955, Kazuo Shiraga "painted" with his body in mud and made his footprints ecstatically on a canvas lying on the ground, years before Klein's *Anthropometries*. Tetsumi Kudo (p. 522 above right), who radicalised Japanese anti-art with his destructive, expressive energy, went to Paris in 1962 where, together with Jean-Jacques Lebel, he became a key figure on the Happening scene. The series of Happenings known as *Philosophy of Impotence* showed mankind (after the Day Zero of Hiroshima) as a creature caught between sexuality and collapse, metamorphosis and decay. Phallically bound cripples fragment the body.

The street also played a role. Vostell derived his *decollage* Happenings from the earlier tearing of billboard posters on the street (ill. above). In Prague, Milan Knížák piled the garbage of his "sweeping" Happenings on the street. In Poland, Tadeusz Kantor made the stage of his *Teatr Crico*, reactivated in 1955, "as concrete as the auditorium": Wheels were really dirty, old boards were really used, the gunbarrel really came from the scrapyard. The "poorer" and more "lowly" (Kantor's key terms) an object, the greater the chance of turning it into poetry. Kantor's *Emballages* were derived from the theatre. Both these Eastern European artists thus corresponded in some way with Nouveau Réalisme – Knizak corresponding with Arman's *Poubelles* and Kantor with Christo's packaging. They arrived at much the same conclusion from a totally different point of departure, confirming the close contact between readymade and action.

carpentry workshops and stockpiling huge quantities of it at her Spring Street home. From the late 50s onwards she piled crates on top of each other, filled them with table legs, fragments of balustrades, stairs, doors and boats, creating iconostases of memory, shrines, walls, pillars out of the wooden flotsam of our civilisation, a mixture of construction, composition, ornament and chance. Later the structure became more stringent, with pre-fabricated abstract forms reiterated in a geometric rapport. By colouring everything black, she created a sense of darkness and mystery – a self-styled "architect of shadows", but also of wan paleness when she used white, and of sacred brilliance when she used gold.

**Wolf Vostell**
Phenomenons, 1965
Décollage-Happening on a car dump, Berlin

**Louise Nevelson**
Royal Tide IV, 1959/60
Wood, spray-painted with gold-coloured solution, 35 parts, 323 x 445.5 x 55 cm
Cologne, Museum Ludwig, Ludwig Donation

## Strategies of Object Art

Our art historical memory tends to look for categories. This explains why generic terms such as Pop Art, groups like the Nouveaux Réalistes or movements such as Fluxus tend to be admitted more quickly to the pantheon. Loners often find it more difficult to take their place in art history. In the field of object art, in particular, there are nevertheless a number of solitary figures of considerable importance. The 60s are full of them. The present and the past are addressed by direct or aliented quotation. There is nothing that might not advance to the worthy echelons of art and succumb to an aesthetic label. Manzoni's can containing his own excrement not only cocks a snook at the romantic notion of artist-as-genius, but also comments on its development.

At around the same time as Rauschenberg, the Russian-born artist Louise Nevelson (ill. right) was combing the streets of New York, gathering wood from house conversions and demolitions, from the docks and the

# American and European Minimalists

## Minimal Art: Pure Perception

At the height of Object art in the early 60s, a new and radical movement emerged in New York. All that Rauschenberg, Kienholz and the Pop artists had piled into the world of art from the street, from rubbish tips and junk shops was exorcised. The term object repressed its derivation from *objet trouvé*. Donald Judd used it to stake his claim for a new fundamentalism of three-dimensionality. Machine-made cubes or boxes emerged. Floor tiles and mass produced neon lights were juxtaposed, modular grids and open spatial structures spread out. These things possessed a simplicity untrammeled by distracting details. They were simple enough to lead perception back to its own basic prerequisites such as viewpoint and lighting. They excluded any associative, symbolic or intellectual added value. Names like "ABC Art" and "Primary Structures" were short-lived. In 1965 the philosopher Richard Wollheim coined the term that was to take hold (though it originally covered a broader scope): Minimal Art.

The simpler the work, the more complex the commentary? Rarely has more been written about sculptures and objects that are expressly accessible without any verbal introductions and circumscriptions. Rarely have so many words been used to say what really needs no words at all. Even the artists themselves founded and fixed their positions in texts that are well worth reading. With that, it transpired that even the root of the matter is open to controversy. Judd and most American critics insisted on the validity of a direct American line of descent according to which Pollock's overall paintings prepared the ground for the non-relational, non-hierarchical, serial juxtaposition that was regarded as decidedly anti-European (pp. 268–274). Barnett Newman's huge, monochrome canvases make use of the pictorial field as an entity (pp. 289 f). With his elegantly curved aluminium sculptures, Ellsworth Kelly (p. 350) forged a link between Newman and Minimal Art from 1959 onwards. The late work of the sculptor David Smith and the crystalline, monumental forms of architect-turned-sculptor Tony Smith also forged a link between Abstract Expressionism and the younger generation.

This notion of a purely American line of descent has just one flaw—it plays down the explicit links with Bran-

*"Actual space is intrinsically more powerful and specific than paint on a flat surface. Obviously, anything in three dimensions can be any shape, regular or irregular, and can have any relation to the wall, floor, ceiling, room, rooms or exterior or none at all. Any material can be used, as is or painted."*
DONALD JUDD

**Donald Judd**
Untitled, 1984
Aluminium, spray-painted,
150 x 165 x 750 cm
Private collection

cusi, most notably his *Endless Column*, in the work of
Andre, Judd and Morris. Extreme formal reduction was
also very much a part of the Constructivism of Rod-
chenko and of Strzemiński's Unism. Sometimes the
debate about the end of easel painting actually sounded
like a replay of the Russian discourse forty years before.
As the influential art critic Patrick Ireland noted, "In the
60s we talked about Paris, but we looked to Moscow".
Gestalt psychology, which both Judd and Morris were
fond of citing, also provided some European arguments
for Minimal Art. So too did Maurice Merleau-Ponty's
*Phenomenology of Perception* which appeared in English
in 1961.

So why is it that Minimal Art nevertheless remains,
in the words of Gregor Stemmrich, the "first exclusively
American art movement". In what respect does it break
with Europe and the past? Not through its form, surely,
for Minimal Art, by rejecting content, cannot be a for-
mal art. Its true *raison d'être* lies elsewhere, in the rela-
tionship of viewer to object, in the altered aesthetic
experience. Unlike Malevich's *Black Square* (p. 164) or
Mondrian's right angle (p. 169), the simplicity of these
cubes and structures is not based on a belief that the
sum of the figural world is contained within the non-
figural, or that a universal harmony is condensed within
the basic form. They do not herald any utopia. They
restrict themselves to the interaction of object, space
and spectator and thus to the experience of self. They
draw our attention to their structural framework and
thereby reinforce our powers of perception. In 1967, the
French philosopher Roland Barthes announced the
death of the author and the birth of the reader. Which is
why Duchamp, with his dictum that a work of art is
created as much by the viewer as by the artist, is a fore-
runner of Minimal Art.

All the Minimalists have in common their rejection
of compositional equilibrium and their concentration
on elementary geometry, seriality and progression.
However fully this may apply (and it even includes
musicians such as La Monte Young, Steve Reich, Phil
Glass and Terry Riley) each of them followed their own
individual idea and made it their hallmark. That is true
of the dynamic Robert Grosvenor and of Fred Sand-
back, whose spanned threads de-materialised sculpture
to the point of virtuality. It applies to the lighter, almost
carefree Californian version of Minimal Art with the
brightly-painted fibreglass planks by John McCracken
and the tinted plexiglass cubes by Larry Bell, which frac-
ture light and space. It also applies to the inner core:
Donald Judd, Robert Morris, Carl Andre, Dan Flavin
and Sol LeWitt.

Judd's objects (ill. left and above) overcome what he
perceived as the inadequacy of painting. Only in the
third dimension does he see the last remnant of illusion
removed. The portrayal and the portrayed are meant to
coincide. To this end, Judd built "specific objects".
Boxes of stainless steel, galvanised aluminium or plexi-
glass are attached to a wall in a vertical alignment at

**Donald Judd**
Untitled, 1968
Stainless steel and anodized
aluminium; 10 parts,
23 x 101.6 x 78.7 cm
Formerly Saatchi Collection,
London

equal intervals. They present not only their front, but
also, depending on the distance of each box to the
viewer's eye level, their topside or underside as well. In
this way, the object plays through every possible permu-
tation: frontal view, view from above, view from below,
through view, fractured light, reflection. This is what
makes Judd, for all his Minimalist orthodoxy, the most
richly contrasting and formally aware of the five. He
stimulates our awareness and perception by his judi-
cious use of scale, rhythm, angle and by his alternation
of materials, surfaces, colours, open and closed forms,
positive and negative, convex and concave. His econ-
omy of means disciplines our aesthetic pelasure, but
does not negate it.

.  Judd thus more or less programmed perception into
the object. He was obsessed with the object. Morris, on
the other hand explored perception itself. His sculptures
of this period were simpler and rougher, exemplary
works of Minimalism situated between art in practice

and theoretical discourse. In 1965, at the Castelli Gallery in New York, he placed three grey plywood L-beams of the same size and shape on the ground, but in different positions, e.g. forming an upright L or up-ended to form a triangle (cf ill. below). This demonstrated that, even when we know that they are identical, we are incapable of perceiving them as identical. In other words, our visual perception is not determined by the form alone, but also by such factors as distance and viewing angle – in short, by the situation. Other works by Morris involve fine wire mesh, permitting a prompt overview and, at the same time, demonstrating the endless optical multiplicity created by the countless overlaps.

This gap between knowledge and experience, described by Merleau-Ponty as "geometry and presence", is at the centre of Minimal Art. It is also the counter-pole to Cubism, or at least to Kahnweiler's neo-Kantian interpretation of Cubism, which posits "I know that this cube has six sides, therefore I paint them". As soon as perception became charged in the following decade with aspects of experience, confusion and idiosyncracy, the wide field of "interesting", psychophysically intensive spaces that were to shape the post-Minimalist generation opened up. In this, too, Morris was a pioneer with his mirroring and his labyrinths.

Carl Andre (p. 527 below left) put himself at a distance from Judd's object-bound approach as well as from Morris' perceptual purism. He pared down volume in sculpture to the point of mere floor covering, without actually giving it up. In doing so, he imbued his work with a social and even socialist statement to the effect that mass-produced materials should be affordable, available and usable for all. Whether lining up metal plates, building bricks, concrete blocks, bars or

**Robert Morris**
Untitled (Tan Felt), 1968
Nine strips, 304.8 x 20.3 cm (each);
Installation: 172.7 x 182.8 x 66 cm
Formerly Saatchi Collection,
London

**Robert Morris**
Untitled, 1967
Playwood, painted,
244 x 244 x 61 cm
USA (CT), private collection

**Carl Andre**
Aluminium and zinc, 1970
18 aluminium squares, 18 zinc
squares, 183 x 183 cm
Formerly Saatchi Collection,
London

*Below right:*
**Carl Andre**
Secant, 1977
Pinewood, 30 x 30 x 90 cm (each)
Roslyn (NY), Nassau County
Museum of Fine Arts

*Below:*
**Carl Andre**
Timber Piece (Well), destroyed
1964, reconstructed 1970
Wood, 28 parts, 213 x 122 x 122 cm
Cologne, Museum Ludwig,
Ludwig Donation

wire (from a nearby scrapyard) on the floor – this former railyard worker sought in his materials their proximity to their production and social context.

His work developed from wooden sculptures influenced by Brancusi to complex layered beams inspired by his college friend Frank Stella in the mid-60s and from there to his first floor pieces: three squares of styrofoam planks measuring out and activating the exhibition space. One year later he placed a row of 137 bricks running from the wall into the room. The horizontal sculpture was born. Here was sculpture as "place" and as "path", as a field of operation that invited exploration.

**Dan Flavin**
Fluorescent light installation, 1974
Cologne, Kunsthalle

*"Regard the light and you are fascinated – inhibited from grasping its limits at each end."* DAN FALVIN

Since then, Andre has produced many variations in steel, lead, copper, magnesium, aluminium and zinc, in different colours, stages of oxydisation and weight, transforming them quite literally into resonators for our own corporeality and placing them in dialogue with a wide variety of settings. Here we find a new paradigm that has made its mark indelibly on the history of sculpture.

Dan Flavin (ill. above and p. 529 below) is the conjurer of light and the lyrical poet of Minimal Art. He is the classic Minimalist who left the exercises in perception propounded by Judd and Morris furthest behind. In 1963 he mounted a 244 cm long fluorescent tube directly onto his studio wall at an angle of 45 degrees and thereby abandoned the object. These standard, mass-

**Sol LeWitt**
Three-Part-Set 789 (B), 1968
Painted steel, tape strips,
80 x 208 x 50 cm
Cologne, Museum Ludwig,
Ludwig Donation

produced tubes became an elementary entelechy from which the medium of fluorescent light radiated into the distance and the realms of subtlety. Following his first installations of this kind, Flavin quickly developed a repertoire of lucid corner overlaps and dissolutions, light barriers and corridors. Since 1969 he has installed them in entire museum tracts and buildings. Few artists since the neo-Impressionists have so consistently included such phenomena as optical mix, simultaneous contrast and colour temperature and made them shine as light within a room. None has used white and coloured, cold and warm fluorescent light with such purity, stringency, precision and richness. The sparse strategies of Minimal Art are transcended here in masterpieces of precision-orchestrated light.

Sol LeWitt (p. 528 below and ill. right) takes the opposite approach. Where Flavin allows sensuality to triumph over an ascetic system, LeWitt approaches optical sensations with deliberate detachment, emphasising the intellectual concept instead. Primary forms, gener-

ally squares, are arranged serially in open or closed modules. The optical impression is confusingly irregular. It is only by reconstructing the underlying grammar that the system becomes recognisable. This is what distinguishes LeWitt from Judd and Morris with their emphasis on object and observation. The given that Judd and Morris seek to exclude returns in this way to Minimal Art – not as geometric idealism in the manner of Mondrian, but as a contrast to the confused visuality of the world as it appears. In this respect, LeWitt foreshadows certain aspects of Conceptual Art.

## Europe: System, Composition and Caro's Strategy of Discontinuity

At the same time, sculptors in Europe set about abbreviating their geometric vocabulary. They were neither Constructivists nor Concrete Artists of the second generation, nor were they disciples of Minimal Art. They had turned away from the compositional ideals of Gabo and Pevsner to explore the inner structure of volumes and the de-central tensile forces of spatiality. However, they also placed more value on an awareness of form than did the American serialists and addressed fundamental issues of sculptural language rather than basic precepts of perception. They thus established their own distinctly European position situated between economy of form and complexity, between system and composition, between analysis and intuition.

The Dutch artist Carel Visser (p. 530 above left) built his œuvre more firmly than any other on the aesthetic foundations laid by de Stijl. However, without abandoning orthogonality and balance, he brought it considerably closer to the serial approach of Minimal Art. Erwin Heerich (p. 530 above right) moved much further away from the Constructivist tradition with his fragile card-

**Sol LeWitt**
Three Part Variations on Three Different Kinds of Cubes, 1967
Steel, lackiert, 123 x 250 x 40 cm

*"Conceptual Artists are mystics rather than rationalists. They leap to conclusions that logic cannot reach."*
SOL LEWITT

**Dan Flavin**
Monument for Tatlin, 1966
Seven neon tubes of various lengths, 365.8 x 71 x 11 cm
Formerly Saatchi Collection, London

*"I can't imagine getting up in the morning full of enthusiasm to make something that I already made the day before. I just couldn't do that to myself. That's why it's good to question the things you're sure about and to relativize your own work."*

CAREL VISSER

board objects. Any comparison between his œuvre and the works of Minimal Art is flawed, for Heerich explored real morphological variety in the logically grounded formal richness of his sculptures made up of regular shapes such as the cube, block, sphere, cylinder etc. Though he shares with LeWitt the subordination of practice to thought (consider, for instance, the transience of his cardboard objects), Heerich operates by subtraction – dividing, halving, omitting – rather than by the addition or multiplication of modules. Since the 70s he has also been applying his "sculptural way of thinking" to more robust material such as steel and to architecture.

Erich Reusch explored the possibilities of horizontal sculpture (ill. below). In 1956/57, years before Andre, this student of Uhlmann was designing de-centralised, earthbound disc sculptures. He activated, intensified and expanded the surrounding space by means of template forms, panels, beams and cubes placed on the ground. Even the interim spaces oscillate in what is, to all intents and purposes, a thoroughly urban version of Land Art or at least "landscaping" art. Ernst Hermanns, on the other hand, concentrated all the tension of his work within the tiny surface space of a plinth. From 1964 onwards he erected rods, split spheres and placed them "with the sure touch of the magician" (according to Gottfried Böhm) at precisely calculated distances, abstracting the concept behind Giacometti's late spatial sculptures. In the following generation of artists, Lutz Fritsch used just one or two simple, coloured rods to create a sense of spatial tension. The steel sculptor Alf Lechner developed his elementary explorations of form (predominantly cubes) from 1964 onwards on the highly visible basis of the laws and reactions to which his chosen material, steel, is subject: bending, cutting, sawing, and later splitting the red-hot steel by means of sudden cooling. A purist and master of measurement, mass and material resistance, he influenced the following generation.

At around the same time, the English sculptor Anthony Caro (p. 531) put forward an alternative to Minimal Art. In the autumn of 1959, Caro, a former assistant of Moore, who had previously concentrated on heavy-limbed female nudes, paid a visit to David Smith. His discovery of Smith's work (and the sculptures of Kenneth Noland) was to become a fundamental catalyst for his own sculpture. In 1960, he undertook a radical change of course to ally himself with abstract steel sculpture, He welded open structures of steel plates and bars, but avoided the American step towards seriality, progression and modular regularity. On the contrary, he stressed individuality, syntax and composition, becoming the first English, and possibly even the first Euro-

**Anthony Caro**
Early One Morning, 1962
Painted steel, and aluminium,
289 x 620 x 335 cm
London, Tate Gallery

*"I have been trying, I think, all the time to eliminate references, to make truly abstract sculpture. It is like using these things like notes in music. But the note must not remind you too much of the world of things ..."*
ANTHONY CARO

pean, sculptor to find his artistic direction through American art without losing his European complexity.

He adopted Smith's strategy of discontinuity, his deliberately multi-facetted approach into which various viewpoints lock. His affinity with Minimal Art and the component that distinguishes him clearly from Smith is his earthbound contact, the inclusion of the surrounding space and the emphasis on the horizontal rather than the vertical. Rosalind Krauss has pointed out that there are two ways of relating to a sculpture such as *Early One Morning* (1962). Viewed from the side, it appears as a drawn-out horizontal sequence of beams, bars and rectangle. It casually dissolves a sense of mass, weight and centre, appearing like a piece of furniture we can walk around. Viewed from the front, it is totally different. It appears as a distinctly horizontal structure – a high

**Anthony Caro**
Early One Morning, 1962
Painted steel, and aluminium,
289 x 620 x 335 cm
London, Tate Gallery

**Anthony Caro**
Midday, 1960
Painted steel, 148 x 366 x 97 cm
London, Kasmin Ltd.

rectangle with a broad cross in front of it and three fin-ger-like protrusions jutting diagonally upwards. This view emphasises the pictorial rather than the sculptural aspect of the work and is reminiscent of an abstract painting by, say, Kandinsky. Physical structure and illusionistic composition, a sculptural aspect and a painterly aspect, physical and optical experience, all diverge. The appeal of Caro's work of the 60s lies primarily in this artful alternation between the open and the closed, the linear and the planar.

In his later work, the painterly, compositional aspect becomes stronger. His *Table Sculptures* since 1967 offer the spectator a single viewpoint against: abstract, decora-tive still lifes that overlap and thereby break the horizon-tality of the table. In Italy, Caro found a factory that could supply entirely irregular steel cuts, which he lacquered in their unfinished state. He all but abandoned the string-ency of his early sculptures of standardised elements.

Caro's art historical position is one of principle. The critic Clement Greenberg and his followers have cele-brated Caro as the founder of a sculpture based purely on relations, planes, lines, intervals and correspon-dences. Other critics have emphasised the fact that he dispensed with the base, verticality and solid core. They have pointed out his early move towards horizontal sculpture, emphasizing Caro's work of the 60s rather than the decorative work that followed.

As a teacher at St. Martin's School of Art, Caro also became the leading influence in British sculpture after Moore and made his mark on two generations of artists. Clement Greenberg's theories added a theoretical superstructure and even occasionally provided directives for actual praxis. Caro's most distinctive student, apart from William Tucker (ill. below), was Phillip King (ill. above). Born in Tunisia, King's work with its vibrant colours and its use of waved, domed and tented forms often has an exotic touch tempered by strong influences of American Minimal Art. Opposing positions, such as the work of Richard Long, also emerged from St. Mar-tin's School of Art.

# Post-Minimal: Sensual Intensity and the Expansion of Art

## The Sixties Revised

In 1968, at the Dawn Gallery in New York, Californian artist Walter De Maria (ill. right) showed his sculpture of five 2 x 2 metre steel plates covered in rows of needle-sharp spikes. At first glance, this *Bed of Spikes* is a perfect example of Minimal Art, its flawlessly geometric basic form paired with seriality and progression. On closer inspection, however, it triggers a sense of danger, with its menacingly protruding spikes which really do go under the skin, and not just figuratively. The potential for injury goes further than the formal alignment, for this sculpture is quite literally painfully sharp. In this respect, the work adds a new and immediate sensory dimension to the perceptual purism of Minimal Art, whetting perception in a very physical way.

Is this the context in which to regard the work of an artist such as Rebecca Horn (ill. right)? A winglike fan, a mask of feathers, intensify infinitely tender rituals of touch (p. 601). They are instruments meant to expand our powers of sensory perception and increase our contact with the self or with the outside world. In later works, the appliances take on a mechanical and artistic life of their own and are no longer mere props. Ladles splatter colour onto canvases jutting from the wall. A pointed pendulum hovers above a pile of pigment. In the ruins of a former prison in the northern German town of Münster, tiny steel hammers endeavour, in the words of Thomas Deecke, "to break the thick walls with their gentle yet irritatingly persistent beat" and recall at the same time the desperate communication attempts of prisoners knocking at their cell walls. The hectic irregularity of the myriad hammer-blows is countered by the languid sound of a drop of water splashing at regular intervals into a pool. Here, we find appliances imitating life and yet still remaining sculpture. They belong to a world of aesthetics that intensifies touch into energy and sublimates it at the same time.

Is sculpture responding in this way to secondary visual worlds which Pop Art would have sought to embrace, or is it a response to some deficit in direct experience? Does it render experience direct once more, and physical? Art is perceived here as a palpable flow of energy. De Maria and Horn saw in it a psychopathic force, while Beuys and the artists of Italian Arte Povera saw in it a spiritual and cultural energy.

**Walter De Maria**
Bed of Spikes, 1968/69
Stainless steel, 5 parts,
200 x 10.7 x 37.3 cm (each)
Plates, heigth: 6.5 cm
Spikes, heigth: 26.8 cm
Private collection

**Rebecca Horn**
The Moon, the Child,
the River of Anarchy, 1991
Installation, various materials
Kassel, documenta 9 (1992)

Is the trend towards an intellectualisation of art diametrically opposed to this kind of heightened sensuality? Does the conceptual approach represent a force whose impact goes far beyond the 70s and Conceptual Art as such? Language visualised and semantic questions permeate sculpture. The objects, installations and "museums" by the Belgian artist Marcel Broodthaers (ill. left and below) express a general criticism of cultural and perceptual mores based on the ambivalence of image and reality, concept and object. In the tradition of Duchamp and Magritte, they reflect a certain spirit and poetic irony, full of metaphors such as the winter garden for the 19th century or the pot of mussels suggesting *savoir vivre* (as opposed to the hamburger of Pop Art, perhaps), posing yet again the question as to the nature of art and life. Reflection is magnified by self-reflection, with art referring to art in a hermetically closed system.

The Italian artist Giulio Paolini, heir to a rich visual culture, refuses to indulge in the production of additional images, preferring instead to use his sophisticated arrangements of props to analyse the conditions of seeing and material visual elements such as frame, canvas, the myth of the artist, subjects. In one of his sculptures, entitled *Mimesis,* (p. 535 above) two casts of a Greek statue face one another. Art, this suggests, invariably has to do with art alone. American artist Joseph Kosuth (p. 535 below) also isolates art radically from non-art. Every work of art, according to Kosuth, is tautological. It describes only itself. On four glass panes of equal size leaning against the wall, we can read the words "glass", "leaning", "clear", "square". Each statement corre-

**Marcel Broodthaers**
Condemmation of Magritte, 1966
Woodpanel, painted and printed,
board, 4 jars with cotton and blue
paint, 78 x 62 x 32 cm
Brussels, Estate Broodthaers

*"Since Duchamp, the artist is the author of a definition."*
MARCEL BROODTHAERS

**Marcel Broodthaers**
Hexagon, 1966
Hexagonal shelf with 10 small
caps and 7 large jars,
57 x 66,3 x 12,3 cm
Berlin, private collection

sponds to a fact. Anything beyond that is falsification of the hermetic model of art as aesthetics. Art is the epistemological criticism of art.

Towards the end of the decade, commentaries and correctives begin to address the immediate past. This does not mean that Pop Art and Minimal Art (and with them, the inclusion of everyday reality and viewer involvement) are lost. They are simply countered from various directions. Sculpture counters the design formalism of Minimal Art by using mutable materials such as glass fibre, felt, rubber, textiles, lead and even ashes, and by fluidity, processuality and sheer physicality. It is also reduced to pure physical experience and, defends corporeality as an integral part of the self. In the form of Land Art, it expands into vast uncharted territories. The traditional concept of sculpture is completely dissolved, only to restitute itself repeatedly in individual aspects.

Many artists now begin turning away from the obsession with civilisation, consumerism and media, looking instead to nature, mythology and ecology. They choose to use "poor" materials. For a while, Arte Povera even turns up as a generic name for this entire approach. In America, Robert Pincus-Witten coins the term Post-Minimal and Morris the term Anti-form. In Europe,

*"Works of art are analytic propositions. That is, if viewed within their context – as art – they provide no information what so ever about any facts. A work of art is a tautology in that it is a presentation of the artist's intention, that is, he is saying that, that particular work of art 'is art', which means, is a 'definition' of art. Thus, that it is art is true a 'priori'…"* JOSEPH KOSUTH

**Giulio Paolini**
Mimesi, 1976
Plastercasts after the Medici
Venus, 213 x 50 x 44 cm
Mönchengladbach, Städtisches
Museum Abteiberg

**Joseph Kosuth**
Leaning, Clear, Glass, Square, 1965
Four panes of glass, 100 x 100 cm (each)
Varese, Panza di Biumo Collection

**Joseph Kosuth**
Neon Electrical Light, English
Glass Letters, 1966
Milan, Panza di Biumo Collection

**Keith Sonnier**
Wrapped Neon Piece, 1969
Neon tubes, wiring, transformer,
248 x 187 x 151 cm
Cologne, Museum Ludwig,
Ludwig Foundation

**Barry Flanagan**
Four Rahsbs 4, 1967
Resin, hessian and sand,
127 x 152.4 x 152.4 cm
New York, Solomon R.
Guggenheim Museum

*Page 537 below:*
**Eva Hesse**
Accession III, 1968
Fibreglass and plastic tubing,
80 x 80 x 80 cm
Cologne, Museum Ludwig,
Ludwig Foundation

*Right:*
**Richard Tuttle**
Wheel, c. 1964
Wood, 79 x 20.5 x 76.5 cm
Cologne, Museum Ludwig,
Ludwig Collection

artists such as Beuys, Broodthaers, Mario Merz and Jannis Kounellis seek to set their own cultural tradition against what they see as the positivist materialism and behaviourism of the Americans, and play it off against America's perceived lack of historicity.

## Minimal Processes and Physicality

Minimal Art imposed preconceived stereometrics and serial systems on sculpture. An early counter-movement was based on the materials used. Towards the end of the decade, flexibility, expansion, weight, gravitation, pressure and traction emerged as independent sculptural themes. Sculptures were no longer merely standing or reclining figures, but could lean, prop, hang, bend, be tautened, fluid or rigid. Masses of earth breaking through wooden props under the weight of tons, asphalt seeking its way, plates of lead supported by their own weight, weights balancing. The physical logic of stability, lability, freefall, processes of warming and cooling – all these were turned directly into an aethetics of material syntax. This went far beyond the old adage of choosing material appropriate to the intended form and subjected form instead to the specific properties of the material. Oldenburg's soft sculpture developed out of Pop Art.

Since 1965, British artist Barry Flanagan (ill. below) had been sewing sand and paper into flexible textile coverings, folding cloths or hanging them from a line. The concept of process art had begun to take hold. Depicting nothing and representing nothing "which it is not itself" (Max Imdahl) it was a paradigm for behavioural and learning processes that released new energies.

Artists such as Morris (whose felt works are amongst the most impressive demonstrations of this anti-form; p. 526), Bruce Nauman, Serra or Keith Sonnier (ill. left) touched only briefly on process art. For Italian Arte Povera it was only one aspect. Others, such as the German-born American artist Eva Hesse (ill. right) arrived

at psychological models through mutable and vulnerable materials – glass fibre, latex, string, wire – which seemed to freeze in a state of turmoil. According to Hesse, "I try out the most absurd, extreme opposites, I was always more interested in that than in something normal that has just the right heights and proportions." Her cuboid *Accession* reflects another form favoured by Minimal Art, but it has thousands of perforations, through which countless flexible plastic tubes run inwards like feelers, bristling and teeming, drawing the viewer's gaze into constant movement and touch. Her very last work, *Sieben Stäbe*, created while she was in hospital, heightens the effect of the upright gait of legs with milky fibreglass bandages to the point of individuality, subjectivity and even monstrosity. Hesse thus inscribed upon the anti-form her own deeply personal and sensitive physical gesture. In doing so, she led material processes towards a fragile and at times witty body language.

The Polish artist Magdalena Abakanovicz (p. 538 above) arrived at the material process entirely independently and with no contact to the western mainstream. From her beginnings in weaving and textile design, she developed monumental, biomorphic sculptures of coire, rope and jute from 1966 onwards. They are hung from the ceiling, stacked on the floor or set like bent shells of bodies. She describes them as "soft-life" sculpture. Her six-part *Embryology* of 1978-1981 is a gigantic ensemble of large, full ovoids of varying sizes, charged with the dramatic pathos that informs so much of Abakanovicz' work. In her œuvre, Process Art takes on an existential dimension paralleled only by the work of Eva Hesse.

Others have tended to concentrate more on the inherent sensibility of the material. Richard Tuttle (p. 536 below right) marks spaces with slats, scraps of fabric, thread or wire without actually defining them. A few centimetres of rope "balance a wall" (Gerhard Mack). Ephemeral materials are charged with light, fluid energies. Reiner Ruthenbeck (p. 538) translates the materiality of soft cloth and hard glass, elastic rubber and rigid steel into elementary geometric figures – such as a triangle or a cross – creating a wonderfully meditative and powerful equilibrium out of gravity and counterforce.

Ulrich Rückriem (p. 539) on the other hand employs his skills as a trained stonemason. In the 60s he sought inspiration in the work of Maurice Lipsi, Wotruba and Di Suvero. A turning point came in 1968 when he met Carl Andre. Rückriem, however, was not to become an adept of Minimal Art. He uses the American innovations as a source for a classical sculptural concept. He divides the unworked block with systematic logic and enormous economy of form. Simple interventions such as drilling, breaking, sawing and splitting do not overwork the stone, but simply reveal its underlying structure. The cuts are economical enough to avoid breaking the force of the mass when Rückriem layers the segments together again. Each step in the working process

remains legible in the end result. The aim is not some kind of didactic unequivocality, but a sensual sculptural presence. The steel sculptor Alf Lechner may be seen as a counterpart to the stone sculptor, Rückriem. Lechner's "compressions" involve rolling liquid steel up against a barrier, throwing it up in loops, pressing it together or bursting the steel by means of sudden temperature changes.

*Above:*
**Eva Hesse**
Untitled, 1970
Fibreglass on wire, latex over fabric and wire, each element 103-128 x 70-103 x 5-15 cm
New York, private collection

**Magdalena Abakanovicz**
Crowd, 1986/87
Hessian and resin; 19 figures,
170 x 530 x 40 cm (each)
Napa (CA), Hess Collection

Around 1970 sculptors discovered the sensibility of physics. At the same time, the American psychologist James J. Gibson recognised our fundamental awareness of gravity and balance as our sixth sense. A number of sculptors sublimated this sixth sense with orderly precision, dramatising it to lend it greater reality, power or nuance than sculpture had ever possessed before.

Richard Serra stages the weight of heavy metal plates as a dramatic test of strength for iron, steel and lead. Kenneth Snelson (p. 540 above left) mounts short aluminium pipes with steel cables to create a powerfield of infinitely repeating crossovers. Wolfgang Nestler presents a fragile system of iron bars, metal bands and hinges in a sequence of sculptural processes that we not only

**Reiner Ruthenbeck**
Suspension IV, 1969/70
Dark red fabric, retangular metal
tubing, 350 x 300 cm
Collection of the artist

**Reiner Ruthenbeck**
Seven Black Barriers, 1977
Aluminium, iron, lead; total
length: 30 m; mast length: 11 m;
lower diameter: 17.5 cm;
upper diameter: 8 cm
Stuttgart, Bundesgartenschau

*Page 539:*
**Ulrich Rückriem**
Dolomite, 1972
Dolomite, cut with stone-cutter,
220 x 90 x 110 cm, 310 x 110 x 110 cm
Düren, Renker Collection

**Ulrich Rückriem**
Dolomite, cut, 1976
Dolomite, 3.3 x 7.2 x 1.2 m
Münster, an der Petrikirche

perceive with the eye, but also weigh up and sublate through our physical sense of ponderation. Alf Schuler addresses the sculptural properties of filigree suspended beams. The Japanese sculptor Jiri Takamatsu, who became a co-founder of the Japanese Anti-Art group in 1962, balances the massive statics of iron blocks with tilted plates, suspended beams and lightly placed bars. Whereas Serra and Morris release the heavy gravitational force of the material, Takamatsu seems to cancel out weight and transform it into lightness. Nobuo Sekine (p. 540 below left) heightens this approach to create the drama of a twelve-ton rock on a polished pillar of steel. The mirror effect dissolves the surroundings, the rock seems to float weightlessly in the air, in a "state of nothingness" subject to no conditions. The creative play on perception becomes the metaphor for a philosophical maxim of "only nothingness is eternal" derived by Sekine from the Chinese Tao-te-ching and modified by a Japanese heritage.

The physical properties of water were also harnessed in sculpture. Apart from his physical *Primary Demonstrations*, Klaus Rinke (p. 540 above right) used the flow of water to portray the passing of time, and stretches of water or plumblines to translate gravity into a strict formal concept.

## Serra: from Materialism to Urban Sculpture

Richard Serra (pp. 541–543) dominated American sculpture for three decades. He broke with its conventions like no other sculptor, yet retained the elementary language of plasticity in its strictest form. He is that rare being – a genuine sculptor who embraced entire landscapes and cityscapes in his work. In doing so, he took weight, mass, gravity, and their expression in direction, sequence and horizon, and transformed them into sculptural qualities.

Serra's first steps are directed against the firmly defined orders of Minimal Art. In 1967 he hung strips of rubber he had found on Canal Street on the wall as *Bridles*. In 1968 he flung liquid lead into the corners of a room and then placed the solid cooled masses on the floor in the order in which they had been thrown. The form reflects the acts of throwing, flowing, cooling and solidifying. He had plates of metal left over from this which he then used to create his famous *One Ton Prop*, consisting of four plates measuring 122 x 122 cm leaned against one another in a precarious balance. They stand and fall on the basis of their own physicality alone. In his later *Towers*, including the *Terminal* (p. 541) in Bochum, Germany, the sense of confusion and danger is caused by deviations from the vertical.

Since 1972 Serra has also intervened in the landscape and soon afterwards in the urban landscape. In *Shift*, to the north of Toronto, he marked out and developed an entire slope, as far as the eye can see, with six walls of equal length. The motoric exploration on walking through this work contrasts with the overall view, and it is this dialectical approach that forms the basis of the

**Kenneth Snelson**
Fair Leda, 1968. Stainless steel tubes and cable,
387.5 x 561.5 x 331.5 cm. USA, private collection

**Klaus Rinke**
Change of Location in Intervals, 1972
Photograph on paper, 132 x 68 cm. Private collection

**Nobuo Sekine**
Phases of Nothingness, 1970
Stainless steel and rock,
625 x 216 x 435 cm
Humblebæk (Denmark), Louisiana
Museum of Modern Art,
The Japan Foundation

**Klaus Rinke**
12 casks of Rhine water, 1969
Scooped from the Rhine
at 12 points on 28 June 1969
Illustrated: Düsseldorf

*Page 541:*
**Richard Serra**
Terminal, 1976/77
Cortensteel, 4 plates,
1230 x 360 x 274 cm (each 2),
1230 x 274 x 360 cm (each 2)
Kassel, documenta 6 (1977)
Current location: Bochum,
Bahnhofvorplatz

*"My decision early on, to build site-specific works in steel took me out of the traditional studio. The sudio has been replaced by urbanism and industry. I rely upon the industrial sector to build my work, upon structural and civil engineers, upon surveyors, laborers, transporters, riggers, construction workers, etcetera ... Steel mills, shipyards and fabricating plants have become my on-the-road extended studios."*

RICHARD SERRA

**Richard Serra**
St. John's Rotary Arc, 1980
Cortensteel, 61 x 366 x 6.5 cm
New York, Holland Tunnel

new experiences and open forcefields that have now become part of his sculpture. He thus establishes a new paradigm for public art in which, according to Serra himself, the experience of the sculptural construction by the viewer is decisive.

His large-scale sculptures of straight, bent, curved and tilted plates of Corten steel possess a sculptural soverignty, but they also embrace coordinates of street plans, buildings, horizon. The react subtly and critically to the spatial situation. They alter conditions of percep-

**Richard Serra**
Shift, 1970–1972
Concrete, 6 parts, height and thickness of each section: 152 x 20 cm
Installed at King City (Ontario),
Roger Davidson Collection,
Toronto

**Richard Serra**
Untitled, 1978
Steel, wrought, 2 blocks,
150 x 70 x 70 cm and 180 x 70 x 70 cm
Stadt Marl

Richard Serra
Splash, 1969
Lead, 268 x 272 x 47,5 cm
New York, Jasper Johns Collection

Richard Serra
House of Cards (One Ton Prop),
1968/69
Lead, each plate 139.7 qcm
Formerly Saatchi Collection,
London

tion, creating a place as sculpture, and sculpture as place. These works clarify the vague contexts of urban traffic hubs, countering them, charging them with tension, condensing them into sculptural energy in an offensive strategy of assertion at the heart of an urban need.

## Land Art: Painting with Mountains

Towards the end of the 60s, a number of artists began operating outside the white-walled gallery spaces of Soho, creating works in the deserts and mountains of Nevada, Utah, Arizona and New Mexico. They used diggers and caterpillar trucks to create chasms in the earth or to construct huge ramps. The result was an enormous expansion of art, in which landscape, earth formation, horizon, weathering and erosion all became real materials. Is Land Art, as it quickly came to be known, simply a brutal intervention in the untouched expanses of the West? Or is it a protest against the alienation of nature with an escapist tendency towards ecological reparation?

Certainly, there are enormous regressive forces at work here. Circles and spirals in the earth are more than just a colossal extension of Minimal Art. The projection of a romantic atmosphere, association with cosmic orbits, cultic faith in the mythical power of place, dissemination in vast panorama images – all this touches in some way on the picturesque landscape painting of the 18th and 19th centuries. Land Art can be regarded within the Northern Romantic tradition traced by Robert Rosenblum from the work of such artists as Caspar David Friedrich and William Turner to the art of our

**Dani Karavan**
Hommage à Walter Benjamin,
1990–1994. Steel, glass and other
materials. Port Bou (Spain)

own times. In the paintings of John Constable prehistoric ritual sites evoke a frisson of the primordial and the cosmic. The American land artists, too, constantly recall megalithic stone circles, Indian calendar structures or the huge pictograms of the Peruvian coastal desert, distant vanishing points and Japanese Zen gardens.

There are also some direct precursors. As early as 1940, Isamu Noguchi created landscaped *Playgrounds* and *Playmountains*. The versatile Bauhaus emigré Herbert Bayer had explored the possibilities of the sculpted landscape in drawings as early as 1947 and had created an actual *Earth Mound* near Aspen, Colorado in 1966, approximating in effect the work of Robert Smithson. The Israeli artist Dani Karavan (ill. left) erected the architectural structure of his *Peace Monument* in the Negev Desert in 1963–1968. Dunes and chasms, watercourses and windstreams in the surrounding area were transformed into sculpture. All three artists approached Land Art *ante festum*.

Michael Heizer, Smithson, Morris and James Turrell moved vast quantities of earth. The primordial force of the scenery, the denuding of geological layers, the exposure to erosion and weather, the corporeal involvement of humans in artificial depths and heights monumentalised their work, placing it between natural history and art. It was Heizer who made the start (p. 545) by scraping his geometric patterns directly into the soil of the Mojave Desert.

One year later he stepped up the level of intervention in the natural landscape when he created his *Double Negative* on the Mormon Mesa in Nevada, excavating some 220,000 tons of earth to cut two chasms facing each other at right angles to the edge of the natural plateau. His huge *Complex I* (1972–1974) leans more towards pre-Columbian architecture. In 1986 Heizer,

**Robert Smithson**
Closed Mirror Square, 1969
Mineral salt, mirror and glass

**Robert Smithson**
Asphalt Rundown, Rome,
1969

commissioned to create a work on the site of a former coal-mine, formed four more such complexes featuring pictograms of a turtle, fish, water-beetle, snake and frog. Land Art as pre-historic landscape decor.

The path taken by Smithson (pp. 544 below and 546) leads from Abstract Expressionist paintings to the non-site theme: photos or maps document a place outside the gallery, often juxtaposed with pieces of ore, chunks of rock or minerals from the original site. From here, Smithson went on in 1970 to develop his concept of site sculpture, which defined sculpture as part of a certain place, rather than as an isolated and moveable object. The *Sleeping Cyclone under Leaden Water* on the Great Salt Lake in Utah found its response in the 1970 *Spiral Jetty* (p. 546)–a spiral of pebbles running far into the reddish water and now flooded over. The organic growth represented by the spiral counters perpetual barrenness and geological, entropic decay.

Smithson's last work, the *Amarillo Ramp* in Texas is not simply a monument in the wilderness, but a runover for the artificial Tecovas lake with its nearby subterranean cellars for helium gas. It is by no coincidence that Smithson's favourite projects are the artificial reactivation of abandoned mining sites: post-industrial spaces subject to natural forces. His version of Land Art also derived from a social strategy and was thus anything but escapist.

The light artist James Turrell takes a more formal approach. Since 1977 he has rounded the volcanic Roden Crater near Flagstaff, Arizona, to a perfect sphere. Built-in chambers and hollows allow observation of cosmic events. The *Observatory* by Robert Morris (p. 546 below) in Oostelijk-Flevoland, Netherlands, addresses the solstice with an archaic double ring recalling Stonehenge. Other artists work entirely with time. Dennis Oppenheim for example, cuts *Annual Rings* in the ice (p. 548 above) with his snowmobile or uses a combine harvester to cut patterns in ripe wheatfields, obstructing any sale of the work, comparing this to an embargo on raw pigment's development of illusionistic power on the canvas.

Walter De Maria (p. 547) sets different priorities. His laconic works of exemplary stringency are not only limited to Land Art. Whereas his works of the early 60s combined the hermetic approach of Duchamp with the serial forms of Minimal Art, De Maria's later works exemplify the most direct contemporary response to the concept of the sublime as posited by Edmund Burke in the 18th century. This explains the pronounced sense of

*Above:*
**Michael Heizer**
Double Negative, 1969
Sandstone, 240 000 tons excavated
and shifted, 457 x 15 x 9 m
Virgin River, Mormon Mesa (NV)

*Below:*
**Michael Heizer**
Displaced/Replaced Mass,
1969
Silver Springs (NV)
New York, Robert C. Scull
Collection

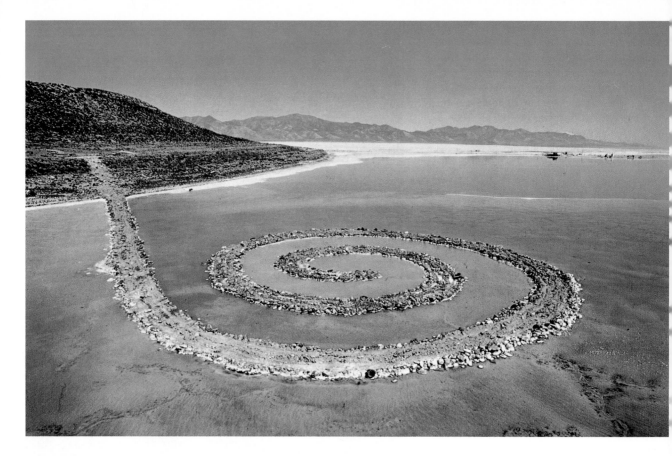

**Robert Smithson**
Spiral Jetty, 1970
Rock, Salt, Crystals, Earth and
Water; length: 475 m, width: 4.5 m
Utah, Great Salt Lake (destroyed)

**Robert Morris**
Observatory, 1977
Earth, grass, wood, steel, granite;
diameter: 91 m
Oostelijk Flevoland (Netherlands)

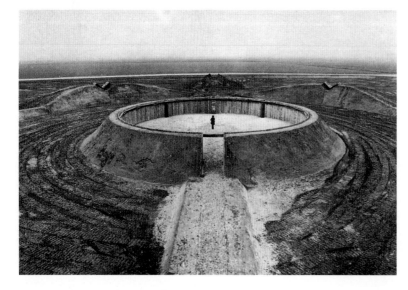

danger in his *Bed of Spikes* (p. 533). It also explains the 400 stainless steel lightning rods in his remote *Lightning Field* north of Quemedo, New Mexico, a major work of Land Art which dramatises nature, storms, sunshine in a precisely calculated geometric ritual. The desert as a metaphysical space, an extreme landscape as a place to experience the sublime.

At the same time, De Maria challenges our powers of imagination as few other artists do. His (unrealised) Munich earth sculpture (1970–1971) was planned as a 6-metre deep shaft drilled through a piled-up mound and the same distance into the earth. History and geology, war and peace as associations, with an invisible vanishing point for imagination and reflection. It is, like the *Vertical Earth Kilometer* in Kassel, an immaterial anti-monument. On the other hand, De Maria is also a master of *mis en scène*. His *Five Continents Sculpture* (1987) consisting of white lumps of rock from five continents set inside walls of glass and flooded with light radiates a cool aura of distance and vastness, as magical as a desert.

Compared to the scale on which American artists have intervened in the landscape, Richard Long (p. 548) seems like a lightfooted wanderer. What he does seems neither monumental nor heroic, but transitory and transient. As early as 1967, when he was still a student, he walked back and forth, trampling a line in the grass and documenting it in photographs (p. 591). The same sensitivity he showed in allowing traces to merge with the landscape also marks his later epic walks in the Himalayas, the Andes, Australia, Japan and Iceland. The only marks Long leaves in these solitary places are a circle of stones, a square of grass, or a spiral of seaweed, which he photographs. Soon, he also began placing his signs in museums and exhibitions in the form of geometric basic figures whose universality leave personal experience behind. With his walks Long not only continues a British tradition, from Celtic stone circles through to Wordsworth's famous walks in the Lake

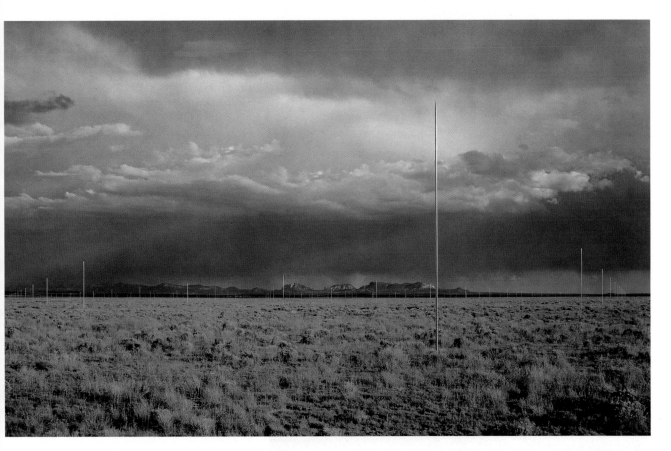

District, but he also contributes towards shaping the paradigms of a new sculpture that defines itself in terms of journey and locus.

Little could be further removed from the romantic solitude of Long than the cosmopolitan work of Christo and Jeanne-Claude. Their temporary large-scale projects demand not only political assertiveness, organisational talent and independent financing through the sale of collages and preliminary sketches (p. 336), but they also play a role in society from the very moment of their inception to their media coverage in books and film. The socio-political and economic framework is an important part of the work – it is no coincidence that the major landscape projects from the *Wrapped Coast* north of Sydney (1969) to the *Running Fence* in the Californian hills (1976), the *Surrounded Islands* of Miami in 1983 (p. 549) and the *Umbrellas* (p. 560 below) on the west coast of America and the east coast of Japan (1991) have always gone hand in hand with projects that involved "wrapping" historic urban edifices such as the Pont Neuf in Paris in 1985 and the Berlin Reichstag in 1995 (p. 550 above).

In their work, Christo and Jeanne-Claude have epitomised the extension of art and its total integration into the landscape or cityscape. The *Running Fence* meandered for some 40 km through the hills of California. Seen close up, it looked like a sail blown in convex and concave curves by maritime breezes. From a distance, it looked like a sprawling sketch underlining the

wave-like rhythm of the hills and structuring it in a sequence of perspectival foreshortenings. Obvious plasticity merged with a distant and vanishing linearity. Unparalleled as all these projects may be, they clearly fulfil a traditional aesthetic requirement in terms of the harmony between man and landscape, art and nature, as sculpture and drawing, rhythm and linear melody, even the changing mood and atmosphere of light. Two weeks later, the landscape or the urban location looks just as it did before and the materials are recycled.

**Walter De Maria**
Lightning Field, 1974–1977
Earthwork; 400 steelpoles, heigth:
470-830 cm, diameter: 5.1 cm;
area: 1.6 x 1 km
Quemado (New Mexico)

**Walter De Maria**
Munich Earth Room, 1968
Peat, c. 50 m³, 60 cm deep, spread
over 3 rooms
Munich, Galerie Heiner Friedrich
(Sept./Oct. 1968)

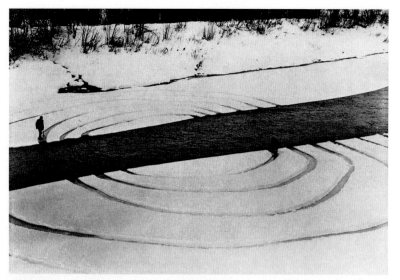

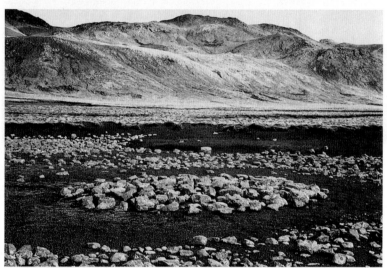

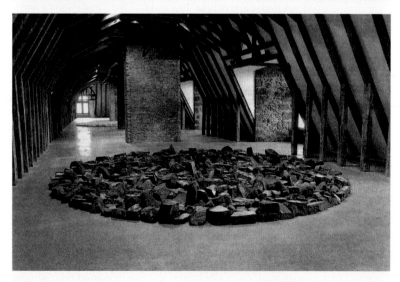

## Nauman and the Body as a Medium

Proximity meets distance when Heizer and De Maria set the scale of the human body against the vast scale of nature. One of the most fundamental experiences of the late 60s and early 70s was the discovery of the body as a medium. Or, to put it more precisely, the interaction of physical and spatial perception. Even psychologists began to question the predominant role of the retinal image. According to psychologist Norbert Bischof in 1966, "The order of perceived space is founded on the systems of motoric spatial orientation and cannot be understood without it."

The artist Bruce Nauman (pp. 561 f) applies this to the experience of the self when he maintains that undertaking physical activities fosters certain forms of awareness. Consequently, since 1966, he has been using his own body as an instrument by which to explore art and the identity of the artist. Casts of knees, arms, hands, ears, sometimes distorted or elongated, illustrate given states or reiterate Duchamp's puns. A work consisting of a hand, arm and mouth is called *From Hand to Mouth* and may either be read as a literal visual portrayal of the idiomatic saying or as an ironic comment on the life of the artist. Nauman is radically consistent in his juxtaposition of physical and spatial experience. Since 1967 he has been recording videos of detailed self-observation in his studio – walking in a square, rhythmically bouncing a ball, grimacing. These are exercices in motion within a psycho-physical space, with the body as research subject.

In 1970, he began to treat space as an independent subject, filtering perception through chambers and corridors, and later through inverted pyramids and tunnels (p. 598). These spaces are stations of isolation in which the ego (as in the more relaxed and less tortured light installations by the Californian artists Turrell, Robert Irwin and Maria Nordman) is caught up entirely in its self-awareness and insecurity.

After 1976, following numerous experiments with neon lettering, film, video, photography and hologram (p. 515), Nauman turned again to sculptures in iron, wood and fibreglass, creating large, sweeping figures of interwoven rings and arcs whose vibrant interaction is undermined by bridging, open seams, out-of-sync joints and fragile superstructures with wedge-like cross-sections open to different sides. Each site or location poses its own challenges. Nauman remains true to himself by refusing to adopt any routine based on experience, be it that of the artist or that of the viewer.

In the past decade, he has taken this approach further, to the point of shocking the viewer. Social criticism has become increasingly evident. Cast iron chairs as instruments of torture suspended from beams, life-size casts of heads dangling on wires. Cloned wild animal

*Above:* **Dennis Oppenheim**
Annual Rings, 1968. Pattern of tree's annual rings, bisected by the United States / Canada border at Fort Kent, Maine, and Claire, New Brunswick

*Middle:* **Richard Long**
A Circle in Iceland, 1974
Dimensions unknown
(destroyed)

*Below:* **Richard Long**
Alpine Circle, 1990
Sculpture; diameter: 600 cm
Rochechouart, Château de Rochechouart

*Page 549:* **Christo & Jeanne-Claude**
Surrounded Islands, 1980–1983
Fabric, 603 850 m². Biscaye Bay Greater Miami (FL). © Christo 1980–1983

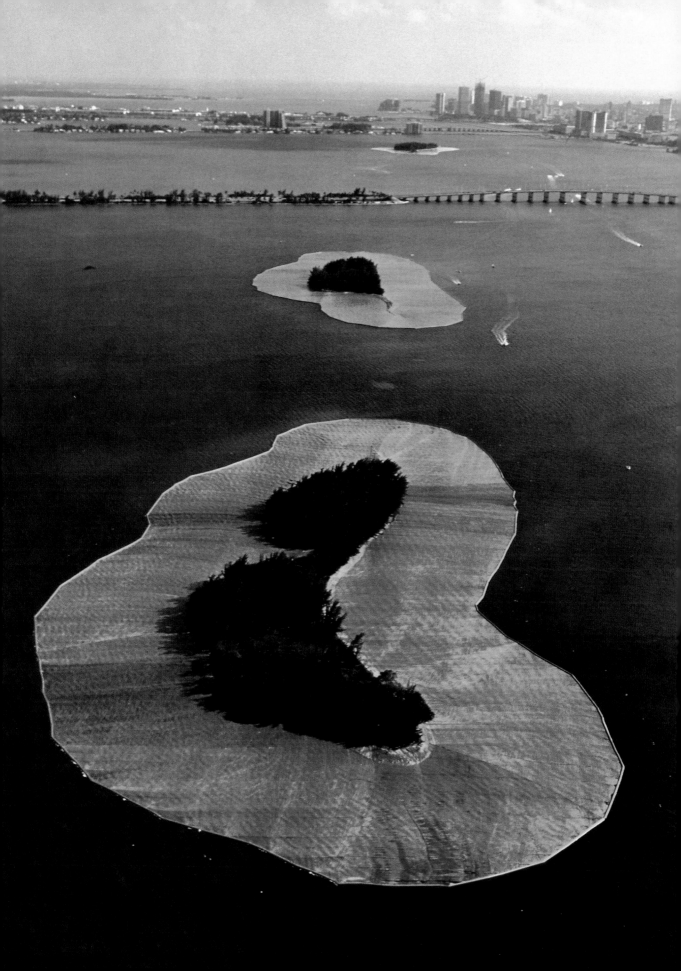

**Christo & Jeanne-Claude**
Wrapped Reichstag, Berlin,
1971–1995
Length: 135.7 m, width: 96 m, roof
heigh: 32.2 m, tower heigh: 42.5 m
Berlin, Deutscher Reichstag (1995)
© Christo 1995

*"Throughout the history of art, the
use of fabric has been a fascination
for artists. From the most ancient
times to the present, fabric – forming
folds, pleats and draperies – has
played a significant part in painting,
frescoes, reliefs and sculptures made
of wood, stone or bronze. The use of
fabric on the Reichstag follows that
classical tradition. Fabric, like cloth-
ing and skin, is fragile. It expresses
the unique quality of imperma-
nence."*
CHRISTO & JEANNE-CLAUDE

**Christo & Jeanne-Claude**
The Umbrellas
Japan – USA, 1984–1991
(Ibaraki, Japan Site)
© Christo 1984–1991

**Christo & Jeanne-Claude**
The Umbrellas
Japan – USA, 1984–1991
(California Site)
© Christo 1984–1991

*Page 551:*
**Bruce Nauman**
Animal Pyramid, 1989
Foam, iron, wood, and wire,
365.8 x 213.4 x 243.8 cm
Berlin, Marx Collection

**Bruce Nauman**
Model for Tunnel Made up of Parts
of Leftover Projects, 1979/80
Glass fibre, plaster and wood,
56 x 700 x 650 cm
Schaffhausen, Halle für Neue
Kunst

**Bruce Nauman**
From Hand to Mouth, 1967
Wax over cloth, 71.1 x 26.4 x 11.1 cm
Washington, Hirshhorn Museum
and Sculpture Garden

*Right:*
**Franz Erhard Walther**
Straight Line and Semi-Circle,
Same Length, 1975
Steel, 10 mm, 800 x 36 x 8 cm
(straight, 4 parts), 577 x 36 x 8 cm
(semicircle), 800 cm (track, 4 parts)
Stuttgart, Institut für Auslands-
beziehungen

*Page 553:*
**Franz Erhard Walther**
Work Demonstration 1,
Working aggregate, 1971
Darmstadt, Hessisches Landes-
museum, Ströher Collection

**Joseph Beuys**
Fat Chair, 1963
Wood, grease, metal 47 x 42 x 100 cm
Darmstadt, Hessisches Landes-
museum, Beuys Block,
Hessische Kulturstiftung

bodies of foam rubber are dismembered, abruptly re-
membered and rotate around themselves in a gruesome
nightmare of genetic engineering. Nauman's fury finds
its expression in the maltreated body, just as it is the
body that is the alpha and omega of his inexhaustible
artistic curiosity.

Such terms as Body Art hardly do justice to Nau-
man's probing questions. It may apply more aptly to

some of the 70s artists working on the borderline
between sculpture and performance: Stuart Brisley
(p. 602) and his social criticism, or Chris Burden
(p. 601) with his fascination with violence, Gilbert
George's self-projection as *Singing Sculpture* (p. 608) in
which the artists are synonymous with the art or Vito
Acconci (p. 607), Gina Pane or Marina Abramovic
(p. 608) whose self-inflicted injuries demonstrate bor-

derline experiences. In his *Trademark* performance in 1970, Acconci sank his teeth into his own body as deeply as possible and transposed the resulting coloured imprints onto other surfaces as a primordial, pre-linguistic articulation that translates the physical boundaries of emotion and pain directly into a visual language.

The most fundmantal, systematic approach to the use of the body in sculpture, without recourse to injury or aggression, was conceived by Franz Erhard Walther (ill. right and p. 562 below). The object becomes a *Werk-satz* or "set of working components" and the viewer becomes the user. It is the experience of actually handling the material that constitutes the work of art. Textile books, sacks, bags, covers, strips and steel planes, bars, angles or box-like fabric niches, garments affixed to the wall, determine certain attitudes, movements, counter-movement, attraction, repulsion, contact and distance. Places are occupied and silent dialogues arise. Measurements and materials interlock with physical givens.

Working in the 60s, Walther made a very early inroad into the concept of sculpture as an instruction to act, in which physical awareness, and the sense of "being at one with oneself" or "with oneself" become states in which to experience a sense of inner calm. In this respect, he provides an alternative to Nauman's idiosyncratic curiosity, though Walther does have in common with Nauman the counter-position to a media world of second-hand impressions and passive visual consumption.

## Beuys: Aura and Sculpture

In Europe, Beuys is a singular figure whose influence is wide: Fluxus, happenings, process art, environments. In the 60s and 70s, he was a maverick artist who had already prepared the ground for his life's work in the 50s and 60s. Yet as long as the Constructivist and Expressionist design for the world still seemed valid, Beuys remained an isolated figure. It was not until the mid 60s, when open processes and direct energies were starting to be explored that his extended concept of art began to make its presence felt on a broad basis without changing its course or compromising.

By then, Beuys had already created a highly distinctive œuvre ranging from infinitely subtle drawings that explore vital processes and structures to sculptures informed by an utterly untimely symbolism of material and energy. He soon added happenings, environments and, after lengthy preparation, his utopian vision of "social sculpture". From then on, Beuys the artist could barely be distinguished from Beuys the teacher, politician, theoretician and preacher. All these functions became integrated within an extended concept of art, with all forms of expression based upon the quest for the "whole person" in which nature, myth, science, intuition and reason become one again. All this is but a hair's breadth from the ideas of the Romantic movement, especially Novalis. The question of whether

age, conduction and insulation as properties of grease, felt, copper, iron etc. in which reality and metaphor are one.

Nine piles of one hundred felt mats with copper covers – the basic idea of a battery with felt as aggregate and copper as conductor. The felt stores and insulates warmth and so, for Beuys, it creates "a kind of power station, a static action" – not as a superficial and decodable meaning, but with the "evocative capacity of the material ... possessing a compelling presence" (according to Georg Jappe). A radical realignment of aesthetic categories also permits language, thought and even social and political activities to be regarded as sculptural activities. This is the root of Beuys' frequently misconstrued maxim that "everyman is an artist".

From the year 1964 onwards Beuys began to direct his energies towards concentrating his holistic concepts in large-scale happenings. They differ from the Fluxus concerts in terms of their concentrated, lengthy and ritualised working approach. The photographs of them have served to shape our image of Beuys as messianic "medium" in his signature hat and angler's waistcoat (p. 555). The happenings that led to the foundation of a Student Party in 1968 and a Free University in 1973 have provided us with most of the objects, display cases and environments in the form of fragments or relics. The display cases in which Beuys collated his objects are authentic presentations in their own right, the Beuys Block in Darmstadt, Germany, (ill. left) being the most arresting and concentrated example. Only at first glance are the rooms hermetic. On closer inspection, they reveal a welter of correspondences, precisely ordered and painstakingly formulated.

**Joseph Beuys**
Queen-Bee 2, 1952
Queen-Bee 3, 1952
Beuys Block, showcase 6
Wood, wax
Darmstadt, Hessisches
Landesmuseum

*Right:*
**Joseph Beuys**
Place (Fatfelt Sculpture), 1967
Darmstadt, Hessisches
Landesmuseum

*Page 555:*
**Joseph Beuys**
Before Leaving Camp I, 1970–1980
Environment, c. 600 x 600 cm
Private collection

Beuys actually pandered to regressive needs in pursuing such a concept is of secondary importance – after all, regression and progression have always been closely linked in the history of European thought. Claims that Beuys allegorised his materials in a traditional aesthetic sense ignore the formal precision and auratic force of his work.

Yet even those who consider his charisma and sense of calling sectarian, pseudo-religious, irrational or even fascist (all of these accusations having been explicitly voiced) find themselves confronted with an œuvre of "auratic monumentality" (in the words of Georg Jappe). It all began, after his studies under Ewald Mataré and his beginnings in the field of decorative art, with his 1962 wax sculpture *Queen Bee* (ill. above). In the soft and malleable energy-store of wax on the one hand and in the crystalline honeycomb structure on the other hand, we can already discern the basic pattern of his sculptural theory (the polarities of which, incidentally, Beuys had derived from an essay on bees by Rudolf Steiner). Beuys saw sculpture as a fluid process between organic life and stability, between chaos and crystal, between warmth and hardness. On this basis, Beuys developed the material syntax of his sculpture in the 50s: mass, weight, stor-

*Above:* **Joseph Beuys**
Snowfall, 1965. Felt mats on 3 peeled pine trunks, 120 x 375 cm. Basel, Emanuel Hoffmann-Stiftung, Depositum im Museum für Gegenwartskunst

*Below:* **Joseph Beuys**
Honey-Pump at the Workplace, 1974–1977. Electronic motor, 2 marine engines with copper rollers, steel container, pewter pipe, plastic tube, 2 tons of honey, 1000 kg of magerine. Kassel, documenta 6. Current location: Humblebæk (Denmark), Louisiana Museum of Modern Art

Nothing is pure coincidence or surrealistic chance. His works stand up to stringent formal criteria and convey complex ideas in a structured way. *Show Your Wound* (1976) addresses the experience of death, while *Capital Room 1970–1977* deals with revolution and the reactivation of all the senses. The 1977 *Honey-Pump at the Workplace* (ill. left) explores the circulation of cultural and thermal energies between art and life, and the *Tram-Stop* created in the same year addresses the artist's own childhood. In 1986, one year before his death, Beuys created his *Palazzo Regale*, musing on the regal, fur-coated artist-herald and the impoverished wanderer on the face of the earth. Time and time again, Beuys explores the fate of the earth. The rocks in his sculpture *At the End of the 20th Century* lie before us like a field of ruins or a cemetery, its petrification countered (perhaps in vain) only by a tiny implantation of grease.

The planting of *7000 oaks* in Kassel between 1982 and 1987 reversed this ratio. Next to each tree stands a stone stela. The trees, not all of them oaks, by the way, are destined to grow higher than the accompanying stone. According to Beuys, this represents "a complete transformation from the sick to the healthy." The 39-part bronzecast sculpture *Lightning Flash with Light Striking Stag* (1986) is an apocalyptic vision between icy death and hope. The sculptor who had opened up sculpture to new materials as no other had done before, returned to the classical material bronze. This is a sculptor whose magnetic appeal goes far beyond any cult-like following.

### Arte Povera: an Alphabet for Materials

Manzoni's canned *Artist's shit* (1961) trashed the romantic notion of the artist-as-genius in no uncertain terms. In the course of the 60s other Italian artists also sought some legitimation beyond the painterly gesture and they found it in the socio-political proclamation. The militant spirit of the Futurists reared its head once more, with artists seeing themselves as cultural revolutionaries in the struggle against sclerotic social structures, the economic system and the art establishment.

In 1967, Michelangelo Pistoletto rolled bales of newspaper across the street between Turin galleries, illustrating how art absorbs the topical and the everyday. The writer Umberto Eco propagated what he described as the "open work of art": ambiguous, uncertain and fragmented as life itself. The young critic Germano Celant, who sought from 1967 onwards to bundle culturally-critical, anti-institutional artistic forces ideologically under the name Arte Povera also belonged to the circle around Umberto Eco's Grupa 63.

The term is derived from Jerzy Grotowski's *teatro povero* and its reference to the use of "poor" materials such as earth (Pino Pascali), coal (Kounellis), sticks (Merz), newspaper (Fabro), eternit (Alighiero E. Boetti) is misleading. Not only because these artists also use gold, marble, silk and Murano glass, but more importantly because they dismantled the hierarchy of mater-

ials, turned their backs on consumerism and looked instead to the forces of nature, without excluding industrial modernism, and to the spiritual permeation of material without abandoning themselves to conceptualism.

Strictly speaking, no Arte Povera group as such ever actually existed. Does this mean that the term is merely the product of strategic mediation set loose by a single critic, and soon to take on a life of its own on the art scene? Though Mario Merz, Pistoletto, Kounellis, Luciano Fabro (ill. above right), Giovanni Anselmo (ill. above left), Giuseppe Penone and Gilberto Zorio (ill. below) did not ascribe themselves to a group, they all

used art as a base from which to address life (whatever that may have meant in the 60s), and clearly imbued their material with associations of Italo-European mythology and cultural history, reflecting on the present through the vehicle of the past.

Theirs was a poetic criticism of modern civilisation in which regressive and utopian traits often became inextricably interwoven. Influenced by Beuys, they contributed to the history of sculpture an interpretation of the world in metaphors, based on the symbolic power and sensual density of new, unorthodox and often clashing materials. The fact that their cultural revolution led almost immediately to art exhibitions, while the rest-

**Giovanni Anselmo**
Direzione, 1967
Granite with compass,
220 x 101 x 16 cm
New York, Sonnabend Collection

**Luciano Fabro**
Feet, 1968–1972
Installation; Murano glass and Shantung silk
Venice, Biennale 1992

*Below left:* **Gilberto Zorio**
Spears and Lamps Live, 1974
Installation; 4 spears, 12 lamps,
c. 250 x 250 cm
Duisburg, Wilhelm Lehmbruck
Museum

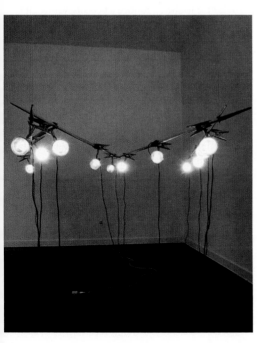

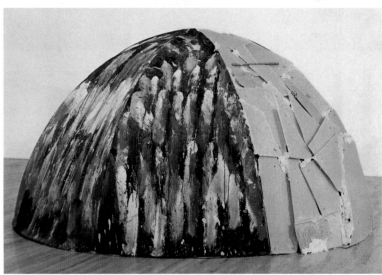

**Mario Merz**
The House of the Gardener, 1983/84
Metal tubes, wire mesh, oil and acryl on canvas, wax, metal, mussels and pine cones, 200.6 x 401 cm. Courtesy Sperone Westwater, New York

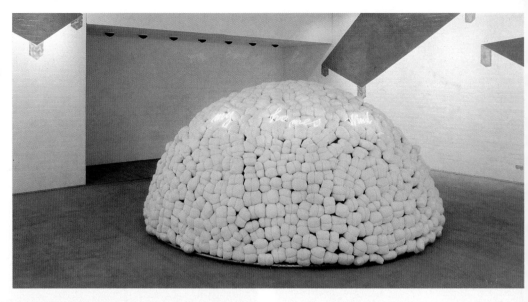

**Mario Merz**
My Homes Wind and Fibonacci
Tables, 1969–1982
Various materials,
diameter: 200 cm
Humblebæk (Denmark), Louisiana
Museum of Modern Art

**Mario Merz**
Che fare?, 1968
Metal pan, wax, neon lettering,
15 x 45 x 18 cm
Private collection

**Jannis Kounellis**
Untitled, 1978
Plastercasts, stuffed crow, table,
chair, cello
Mönchengladbach, Städtisches
Museum Abteiberg

lessly wandering artist-as-nomad became a highly marketable master of metaphor, is something the Arte Povera artists have in common with the Futurists who preceded them by half a century.

Mario Merz and Jannis Kounellis are regarded as the paradigmatic artists of a movement that knew no paradigms. Merz (ill. above and p. 557) was originally a painter (p. 361), but in the mid-60s he turned his attentions to such materials as earth, sticks, glass and neon tubes. Their symbolic power is as palpable as it is striking: origins, growth, transparency, modern energy. In 1968, the year of the May demonstrations, he found the original cell of human and nomadic dwelling in the form of the *Igloo* and went on to create meaningful variations on it in the primordial material clay, applied over thin ribs of glass or sticks, sometimes coupled with panels of lead or leather. It formed a personal centre and world model as the expression of an alternative culture. The Fibonacci numbers are closely involved. The discovery of this mediaeval mathematician was to become, for Merz, the ubiquitous growth spiral of life, the "universal equation". The sequence 1,2,4,8,16,32... extends infinitely from the snail's shell to the galaxy. In whatever Merz staged in the course of three decades, he sought to counter the "emptiness of today's technical-mindedness ... a very distant non-void". This explains the evocation of his metaphors and materials, his igloos, tables, bundles of sticks, fruits, neon lances, number sequences, newspapers, pre-historic animals and the way they appeal to our imagination, opening up new areas of freedom. A regressive utopianism as harbinger of a counter-world of poetic enlightenment.

In comparison to Merz, who lived and worked in Turin, Kounellis (ill. left and p. 559), a Greek, who lived and worked in Rome is more strongly oriented towards the heritage of antiquity, Byzantium and the Renaissance. One issue addresses the origins of culture and the historic processes of alienation in mass civilisation.

With metaphors of fire, smoke, glass, coal, scree, steel plates and plaster fragments of ancient statues, he presents a precise and subtly calculated emblematic theatre between remembrance and presence, a stage of cultural levels that denies the linear progressiveness of classical modernism, tableaux of rugged, evocative presence that were not to petrify into self-citation until the 90s. The spectrum of art gathered beneath the makeshift umbrella of Arte Povera ranges from Paolini's staged explorations of visual perception to Fabro's opulent materials and culturally analytical metaphors. It reaches from Anselmo's conceptual demonstrations to Zorio's symbols of energy and purification featuring stars and glowing spears (p. 557) and from Pino Pascali's experimentations with scale and material to Pier Paolo Calzolari's emotive visual theatre (Marlies Grüterich) with its neon signs and thermal processes.

Pistoletto and Penone use the most varied vocabulary. Pistoletto (p. 346) has been encoding the interaction between image, spectator and reflection since 1962. In the upheavals of the 60s, he brought his revolutionary stimulus to bear in the *azione povera* of street performances and combined museum-style casts with commonplace junk and rags. This anti-aesthetic stance was to turn in 1980 to powerful sculptures of polyurethane or marble in which the canon of Michelango's œuvre is fragmented and barbarised.

Penone (ill. above) is already one of the younger generation. His Mediterranean homage to a "vegetative culture", his intervention in the natural process of growth, are accompanied by skinprints of his own body. He explores the magic of the imprint, as a zone of contact with the outside world, in subtle strategies between identity and alienation.

*Above:*
**Giuseppe Penone**
Untitled, 1974
Plaster, body hair, slide projection
Collection of the Artist

*Below:*
**Jannis Kounellis**
Untitled, 1975
Fragment of plaster head,
propan gas cylinder, steel base,
fragment: 28 x 18 x 12 cm;
base: 125 x 40 x 40 cm
Private collection

# The Delta of the Contemporary

## The End of the Avant-Garde

*"The relation of one person to his surroundings is a continuing preoccupation. It can be casual or close; simple or involved; subtle or blunt. It can be painful or pleasant. Most of all it can be real or imaginary. This is the soil from which all my work grows. The problems of realization – technical, and even formal and aesthetic – are secondary; they come afterward and they can be solved."* LOUISE BOURGEOIS

At what point do we define art as contemporary? When it is produced by artists who are still alive and continually developing? When it involves the latest new movement to differ from all previous movements? Or is it simply a chronological question, no matter in what era the style may have originated? Although Louise Bourgeois works in a mode that follows on directly from Giacometti's psychological extroversion of sexuality in the 30s, she did not really come into her own as an artist until thirty years later. Born in Paris in 1911, she settled in New York in 1938. Her fragile, totemic works of the 60s possessed a delicate equilibrium. In the 60s she created "unconscious landscapes" of swelling body fragments with gaping wounds like vulva or bulbous, phallic protrusions. In her later work she presented, as though in miniature theatres, the neuroses and hysteria she derived from childhood experience of her father. *Precious Liquids*

(1992) is a dimly lit barrel which the spectator can enter, containing two wooden spheres and dozens of glass phials (ill. below) Suspended from bars, they hover over a metal-framed bed. According to Barbara Catoir, this is "an alchemy of memory sealed in vessels, barrels and cages, in minds and skulls".

What if the linear thread is lost in the pluralistic confusion of rival designs? What if related approaches no longer achieve a superficial stylistic similarity, as they did in the 60s? Then we no longer examine the external appearances, but the concepts behind them. What has frequently been hailed as the end of the avant-garde or even as the end of art history refers primarily to the end of an all-embracing epochal style. Perhaps our contemporary era begins at the point where style as the hallmark of a period disappears. This began to happen in the 70s.

This does not mean that there is no key challenge. However, it does mean that there are a number of con-

**Louise Bourgeois**
Precious Liquids (detail), 1992
Installation. wood and various materials. Height and diameter: 426.7 cm
Kassel, documenta 9 (1992)

**Alice Aycock**
The Angels Continue Turning
the Wheels of the Universe,
Part II, 1978
Wood, 700 x 700 x 500 cm (tower)
Made for the Stedelijk Museum in
Amsterdam (dismantled)

*"The works are a synthesis. They
give me pleasure. They turn back on
history and back on themselves.
Like the example of Christianity
outrunning the sign of the cross, the
generative ideas/sources outrun the
actual structures."* ALICE AYCOCK

trasting responses.In the 70s, artists reacted critically to
the onslaught of secondary images and illusions in which
the Baudrillardian *simulacrum* came to replace primary,
tangible reality. Sculpture, on the other hand, offers
direct experience. Much can be heightened to focus on
things and their traces as a means of defining the body
and its basic orientation within a given space. It is here
that we can find the common denominator of such diverse
directions as architectonic sculpture and the ever-widen-
ing annual rings that lead us from object to readymade
to traces of evidence. Herein lies the core of a dialectic
counterposition set against the previous decade.

The media world, too, began to make its presence
felt. In the course of the 80s, new sculpture revoked the
approach that appealed to direct physical experience.
Instead, the principle of depiction became predomi-
nant. Portrayal, illustration and fiction became key
strategies of presentation. Theatre, architectural mod-
els, simulated museum situations and showcases set the
tone. Suddenly, it became acceptable for sculpture to be
whimsical, literary, symbolic, narrative or even anecdo-
tal. What classical modernism had regarded as detri-
mental to sculptural autonomy now became an inde-
pendent quality in sculpture. In the post-modern 90s
this tendency grew. In recycling readymades and found
objects, their presentation became the *raison d'être* that
imbued the objects with meaning, lending them aura
and significance.

Another question arose in this connection. Follow-
ing the intensification of exercises in individual percep-
tion, did the art of the 80s backtrack in the face of his-
toric social developments? After the era of Arte Povera,
did sculpture return once more to the arena of memory

and recollection? Did sculpture gain in social impact
following the myth of autonomy and the self-referential-
ity of the medium? Did it develop critical models for
social action? And, if so, were these models a part of the
critical social and philosophical discourse, albeit with a
certain ironical detachment? Or was it only such artists
as Hans Haacke, Ilya Kabakov, Haim Steinbach, Robert
Longo and Olaf Metzel who touched upon the polit-
ical?

## Architecture, Sculpture and Forms of Action

In 1978, Robert Morris pointed out that white gallery
spaces could be taken in at a single glance, that they
were, in this sense, the equivalent of Minimal Art, anti-
spatial or un-spatial in terms of behavioural experience.
He made a point of correcting this demonstratively in
his own installations. At the Louisiana Museum near
Copenhagen he positioned large beams in the gallery
with mirrors between them to create a space so complex
and that it became a confusingly labyrinthine, frag-
mented challenge to the spectator's powers of percep-
tion and orientation.

Morris demonstrated what the younger generation
no longer wanted. No pure stereometry, no anonymous
space, no absorption in the institution of Art as repre-
sented by the white cube. Instead, he presented places
charged with psychology and specific behavioural pat-
terns or with the memory and traces of daily use. "Inter-
esting" places that take Smithson's concept of site speci-
ficity one step further, creating a transition from land-
scape to architecture. The important point here is the
new approach to space. Space is no longer derived from
the dissolution and crystalline fragmentation of volume,

**George Trakas**
Transfer Station, 1978
Wood and steel
Toronto, Art Gallery of Toronto

as in the work of the Constructivists. Nor is it the equally weighted counterpart to volume, as in Minimal Art. It is neither ideal nor abstract, but operates instead with fundamental concepts of our architectural and natural surroundings. It is, in short, what Christian Norberg-Schulz described as the "existential space" in which we live and move. From here on in, many sculptures can be defined in terms of such categories as path and direction, place and centre, field and era, inside and outside, rather than according to such traditional concepts as material, mass, volume, composition and rhythm.

Some influences from the late 60s and 70s are still evident. Nauman's *Corridors* explore perception between irritation and hesitant self-assurance. Serra

heightens the psycho-physical properties of a space to the point at which it begins to seem threatening. Long's *Walks* take the principle of following a path quite literally, just as his stone circles are archetypal sites. In the 20th century precursors range from Giacometti's *Board-Game* and *City-Square* sculptures around 1930 to Noguchi's *Playgound* and *Playmountain*. Now, such diverse artists as Alice Aycock, Claus Bury, Richard Fleischner, Dani Karavan, Per Kirkeby, Mary Miss, Walter Pichler, George Trakas and Micha Ullman devise their sculptural constructions and spaces as places of psycho-physical shelter or unease. Their corridors tunnels, labyrinths, towers, shafts, bridges and piers influence our behaviour to the point of evoking the claustrophobia of a maze from which there is no escape.

In Europe, the Austrian artist Pichler set an early example with his concepts of subterranean buildings, his mythically charged excavations and ritual architecture in the village of St Martin in Burgenland. In America, there was a renaissance of spatial forms that link idiosyncratic effects with universal symbolism, such as the labyrinth. Fully aware of the literary analogies in the works of Jorge Luis Borges, Octavio Paz and Lawrence Durrell, Alice Aycock (p. 561) constructed mazes and labyrinthian architectural meta-apparatuses as metaphors for the disorientation of modern life.

George Trakas (ill. above) dramatised exterior spaces with his bridges, piers and contrasting materials, exploring physical perception and he experience of walking. Israeli artist Karavan's *Hommage à Walter Benjamin* (p. 544) combines a steel shaft in the cliff face with a view of the sea, whirling water and horizon. For Micha Ullman, a fellow Israeli, the *Earth Chair* (ill. below left) is a concise formula referring to the body, excavation, occu-

**Micha Ullman**
Earth Chair, 1983
Limestone, 280 x 280 x 400 cm
Tel Hai, Contemporary Art
Meeting

**Gordon Matta-Clark**
Office Baroque, 1977
Sections through a condemned
building
Amsterdam, I. C. C.

*"Wood includes all the elements of origin, of growth and of time."*
MAGDALENA JETELOVÁ

**Magdalena Jetelová**
Der Setzung andere Seite, 1987
Wood, c. 385 x 700 x 300 cm
Aachen, Ludwig Forum für
Internationale Kunst

pation, observation, shelter – a symbolic place whose instability also reflects the political situation.

The sculptures invite the viewer to become the user and, with that, to become a protagonist who, in the words of Merleau-Ponty, does not permit the space to affect him passively, but who absorbs and discovers its intrinsic significance. We have to experience this space at first hand, by walking it, climbing it, touching it. F. E. Walther realised this in the early 60s, summing up the concepts of "instructions for use" and "fields of use" without taking his fundamental phenomenology of the body to architectural or psycho-physical extremes.

Other artists posited their sculptures as architectural criticism. Gordon Matta-Clark (p. 562 below right) opened up condemned buildings by cutting sections representing a breakthrough in new forms of communication for a changing and more open society. Japanese artist Tadashi Kawamata (ill. right) uses outwardly spiralling welters of wooden planking to make a critical comment not only on architecture, art and the city, but also on categorisation, the ghettoisation of culture and the prevailing political power structures. Matta-Clark, would undubitably have approved.

Magdalena Jetelová (ill. above) who came to Germany from Prague in 1986, forces her huge wooden stairs, chairs and tables into tiny spaces. In Vienna, she cut a wall open with a chain saw and used computer control to bundle the light that flowed through it in the next room. At the opposite pole to the deconstructivist form of architectural criticism, are such artists as Gerhard Merz, who clarifies architectural sculpture into

ideal proportions and pure beauty, or the Danish sculptor Kirkeby, whose brick structures are variations on ancient temples and the Gothic traditions of his homeland.

The transition to the next generation is marked in 1980 by the Büro Berlin group centred around Raimund Kummer and Hermann Pitz. Other leading artists are also willing to cooperate. The connection between place and intervention becomes increasingly important. However, the intervention is now aimed at places not related to art, such as a factory or a railway station, to be infiltrated, interpreted and creatively developed. In Paris and Düsseldorf, Bogomir Ecker placed non-

**Tadashi Kawamata**
Destroyed Church Project, 1987
Wood, 10 x 12 x 20 m
Kassel, Garnisonskirche
(documenta 8, 1987)

**Thomas Schütte**
Ice, 1987
Concrete, plaster and other
materials, max. diameter: 664 cm;
max. height: 526 cm
Kassel, documenta 8 (1987)

doors was built on the grounds of the Auerpark in Kassel, illustrating a topographical view of a house between cellar and roof. Alongside it, a 60 cm wide steel pier by Trakas ran 200 m long into the park. At right angles to it was an unwieldy bridge of wood. Ascent and descent, a forward rush, a perspectival pull, the staccato of hurried footsteps, the subtle experience of one's own body in space – all these were typical of sculpture in the 70s.

In 1987, Thomas Schütte (ill. left) placed his bucket-like *Ice* pavilion at the edge of that same park. To the side of it, Heinrich Brummack placed his whimsical tent-like baldachins. In the middle was a circular ottoman by Scott Burtun, with plants growing in it. Near the Orangery was Klaus Kumrow's imaginative, perspectivally structured *Sedan-Chair*. Inside the Orangery was Armajani's decorative paraphrasing of doors, windows, stairs, a framework of plants. Everything was playful, narrative and either destined for actual use or ironically suggesting functionality. Ice cream and coffee were on sale in Schütte's pavilion. Instead of addressing the fundamental experience of self or orientation in space, sculpture was taking on an increasingly functional aspect. In this respect, it was narrowing the gap betwen sculpture and building, furniture or appliance. Whether this already heralded the beginnings of a social utopia, suggesting a return from the ivory tower of autonomy in society, remains a moot point.

Armajani and Burton see their buildings and model sculptures in this light. Armajani even cites the utopian visions of Russian revolutionary artists such as El Lissitzky and Klucis or the "enlightened" American architecture of the late 18th century. His *Dictionary of Building* isolates, in more than 200 models, such ele-

descript objects on the street, such as a dummy letterbox and a viewing apparatus in the late 70s. Norbert Rademacher develops this into subtle interventions between intimacy and the public sphere. Instead of exhibitions, we find stationary and temporary "situations" taking us into the next decade.

## Furniture and Models
The shift in focus can be seen clearly in the difference between the documenta 6 art show of 1977 and the documenta 8 ten years later. In 1977, Aycock's wooden tower complex with its platforms, ladders and trap-

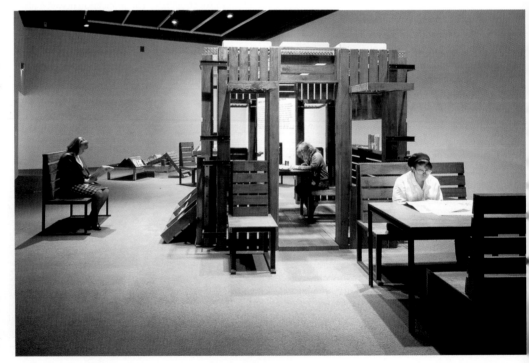

*"My intention is to build open, available, useful, common, public, gathering places. Gathering places which are neighbourly. They are not conceived in terms of wood or steel but in terms of their nature as places at hand, ready to be used."*
SIAH ARMAJANI

**Siah Armajani**
Sacco and Vanzetti Reading
Room #2, 1987/88
Steel, brick, aluminium, wood and
paint; various dimensions
Cambridge (MA), List Visual Arts
Center, M. I. T. (dismantled)

**Richard Artschwager**
Chair, 1966
Formica, 151 x 46 x 77 cm
Formerly Saatchi Collection,
London

*"I'm making objects for non-use: by use, I mean cups to drink out of, a spoon to stir with. By killing off the use part, non-use aspects are allowed living space, breathing space."*
RICHARD ARTSCHWAGER

between free object, architectural model, environment and furniture design" go for pure utility or exercise a critique of knowledge. Susana Solano (ill. below) mediates between the Catalonian traditions of iron sculpture and the younger generation. Compact planes and weight are set against grids, grilles and bars that render spaces permeable and full of correlations. The objects recall a bed, a table, steps or a doorway, but also a landscape, and thus keep our powers of association in suspense. Hers is the most important Spanish contribution to art since Chillida.

The winds of change swept through the world of German sculpture in the 60s too. Whereas the "hunger for images" led to enormously expressive wooden figures in the work of the painter-sculptors Baselitz and Lüpertz, a certain leaning towards the iconic led to rigidly simplified and narratively eloquent models by the generation that followed them. These artists either came straight from the Art Academy in Dusseldorf (Schütte, Reinhard Mucha, Katharina Fritsch, Ludger Gerdes, Wolfgang Luy, Ecker, Harald Klingelhöller, Thomas Virnich) or from Berlin (Hermann Pitz), Hamburg (Klaus Kumrow) or Munich (Stephan Huber and Albert Hien). The general designation "model" leaves room for misinterpretation, for these are not "models" intended to be constructed on a larger scale. Unlike architecture, they do not designate a field of action, but a field of imagination. They stimulate our imagination in an interim zone in which attitudes, memories, associations and projections become fluid. They offer visual food for thought.

Armajani's perhaps somewhat naive belief in a return to social values by entering the world of utilisation is broken by the sceptical, ironical fictionality of their work. These artists use traditional rhetorical means in doing so. Stephan Schmidt-Wulfen has shown how the metonymic principle of *pars pro toto* exceeds other symbolic languages (metaphor, allegory). In Stephan Huber's work, a chandelier stands for luxury and

*"The proportions of a sculpture, the material, the craftsmanship, have to correspond to the material: this is important. Nothing has priority, proportion, concept, material, craftsmanship have to be equal. The atmosphere exuded by an object interests me more than the object itself."*
SUSANA SOLANO

**Susana Solano**
Pervigiles Popinae, 1986
Iron, 303 x 342 x 105 cm
Kassel, documenta 8 (1987)

ments as wall, roof, window, stairway, cupboard, fireplace, "deconstructs" them and puts them together again according to formal rules. Since 1967 he has been designing bridges, reading-houses, reading-gardens, reading-rooms (p. 564 below) or picnic-gardens. In doing so, he has set new standards for a public art, which, for Armajani, means a useable and communicative art.

The pioneers of these furniture sculptures is Richard Artschwager (ill. above). In the 50s and 60s he even ran a professional carpentry workshop for individually designed items of furniture. Since 1962, each item of furniture is an independent sculpture. Tables, benches, mirrors and doors consist of cheap fibreboard and formica, in all manner of patterns and colours. They oscillate between reality and illusion–tangible ideas for reappraising established ways of seeing. In this way, Artschwager forges a link between Jasper Johns' critique of knowledge and the cool styling of post-modern Object art.

Not all the artists working within what Armin Zweite has described as the "broad frame of reference

wealth, a barrow for labour and endeavour, both loosely associated with a feudal or capitalist society. Ecker's red megaphones and hearing appliances represent entire systems of communication and at the same time undermine them through their visibly simple construction. Hien uses miniature ships sinking in sand and aircraft sinking in water to demonstrate the Janus-headed nature of civilisation's progress. The first to present "models" with a critical content as opposed to those intended as preliminary studies, was Schütte, around 1980. His tongue-in-cheek scenographic installations, architectural designs and monuments marry potentially practical functionality with formal stringency and autonomy. Yet the "model" approach does not apply to all the sculptors of this generation.

Reinhard Mucha piles up pieces of furniture he find to create tipping, tumbling visual symbols for trains, aircraft or fun-fairs, in memory patterns that recall his childhood in the 50s. Felt (as a decorative material) and linoleum (for low-income housing) are pointers to his petty bourgeois youth. Yet he creates a balance that has all the artistry of a stage performance. Mucha reflects on the principle of presentation, museum and gallery like no other artist. A chair bears a base which bears a chair – the relationship between the base and the work could hardly be expressed and doubly inverted more elegantly. Unlike Mucha, Thomas Virnich destroys and mutilates his found objects: a doll's house, an instrument case, a rotting boat found on the banks of the Arno (ill. below left). He dimantles them, makes casts of voids, covers them, giving them a new and seemingly provisional order. This is an open, playful approach to the *object trouvé*, which Virnich certainly sees as an expression of human liberty in the spirit of Friedrich von Schiller.

Felix Droese and Olaf Metzel are moralists whose work is a far cry from such artistic speculation. Droese is primarily a painter, though his large-scale *House of Non-Armament* shown at the Venice Bienale in 1988 is a major work reflecting a profound sense of artistic responsibility: "Art, not as a question of style, but as a question of truth, as a question of humankind's future." In the more keenly critical atmosphere of Berlin, Metzel (ill. below right) shifts the focus from the existential to the specifically political: his themes address leisure culture, consumerism, racism, state violence and counterviolence, technology and media. Metzel is not driven by the passion that informs Droese's work, but by a rage against the injustice of the system. He channels this rage into a precise, destructive and formally sure-footed strategy.

*Above:*
**Thomas Virnich**
Amerigo Vespucci at the Scala, 1987/88
Wood, lead, aluminium, clay and paint; 400 parts, c. 50 m²
Aachen, Ludwig Forum für Internationale Kunst

*Below:*
**Olaf Metzel**
13.4.1981, 1987
Cordons, shopping carts and stones; height: c. 900 cm
Berlin, Kurfürstendamm
(Sculpture Boulevard 1987)

His carefully targeted aggressive interventions in the public sphere are rare examples of a complex political art in Germany.

The fact that fundamental questions of sculptural language are being explored at the same time is evident in the work of two generations of steel sculptors: represented by Erich Hauser and Thomas Lenk, and the younger generation by Joachim Bandau, Ansgar Nierhoff, Heinz-Günther Prager, James Reineking, Edgar Gutbub, Wilfried Hagebölling. Hauser uses curved segments and pipe constructions, while Lenk uses spatial layering. Bandau's sculptures have a certain block-like reduction, exploring problems of shell and core, with expressive references to bunkers and fortifications. Nierhoff's folds and changing stereometries have affinities with certain aspects of Process art. Prager (ill. right) develops his square-and-cross sculptures from a formal system based on anthropometric modules of scale. Reineking, Gutbub and Hagebölling employ stringently syntactic planar sections. There is a plastic autonomy of form here, that has left its mark in particular in German cities.

## Traces of Memory

In the 70s a different, "quieter" avant-garde had emerged. The extroversion of the 60s was followed by an introversion, a return to the private, memories of a personal or a different past. Reconstruction and documentation replaced art in the present tense. This had been foreshadowed by Beuys, Etienne-Martin, Nouveau Réalisme and Arte Povera. Yet the subtle experience of self filtered through the world outside was new. It set itself apart from Arman's sociology of the object and remained at a modest remove from the cultural-revolution claims of Arte Povera. On the other hand, parallels for self-questioning could be found in the medium of objects in the Nouveau Roman or in the poems of François Ponge.

The critic Günther Metken specified the line of observation. It was Metken, too, who coined the term "Spurensicherung" or "trace or clue-finding art" in this context. Accurate as the term may be, there was also a question of fictional traces and their reconstruction in the form of a model – a spectrum ranging from Nikolaus Lang to Christian Boltanski to Anne and Patrick Poirier. What may be regarded as evidence differs very widely indeed: objects, photographs, videos, drawings, texts. This accumulation of evidence thus overlaps with the history of sculpture and is not absorbed by it.

Here, too, presentation is an important artistic aspect. In this respect, we find a number of parallels between the 70s and the 90s. Collections and museums influence content. The seeming objectivity of inventory, archive or showcase is structured with pseudo-scientific mimicry and self-questioning. When Lang presents the relics of the dead Götte siblings – clothing, household goods, letters, animal bones, reports, maps, photos – in a grain chest (ill. right) he is, at the same time, examining

his own childhood memories and himself within the context of place, time, past, present and imagination. When Boltanski (pp. 568 f), on the other hand, uses the school class photos of others, reconstructed toys, paper weapons and so on to recreate a fictitious childhood for himself, he still adheres to the same average childhood. He experiences it as a sociological model, or, to use the terminology of the 70s, as a sociological structure. Yet

**Heinz-Günther Prager**
Double Cross 14/89, 1989
Steel, burned; height: 130 cm, diameter: 320 cm
Bonn, Foreign Office

**Nikolaus Lang**
Chest for the Götte Siblings, 1973/74
Grain chest, inserts, found objects, texts, photographs, maps, 60 x 320 x 87 cm
Munich, Städtische Galerie im Lenbachhaus

**Christian Boltanski**
Untitled, 1988
Three columns of 84 pewter boxes,
three framed black-and-white
photographs and three electric
lamps with cables, 235 x 50 x 23 cm
Private collection

**Nancy Graves**
Camels VII, VI, and VIII, 1968/69
Wood, steel, canvas, polyurethane,
animal skin, wax, oil paint,
244 x 274 x 121, 228 x 366 x 122,
and 228 x 305 x 122 cm. Ottawa,
National Gallery of Canada

class in Lyon, the Mickey Club–are rendered anonymous by the laws of statistical averages. The containers of the administratively ordered world extinguish the individual. A depressive silence merges archive, file and store, right through to the trauma of the Holocaust. The archives are also monuments to the dead.

Boltanski returns time and time again, with almost obsessive persistence, to the house of his childhood: French, non-religious, middle class. Lang draws sweeping arcs from his native Bavarian village near Oberammergau to Japan and the Australian aborigines. Just as Boltanski takes the approach of the sociologist, Lang takes the approach of the ethnologist among the collectors of traces of evidence. He delves deep into his childhood and, in his *Chest for the Götte Siblings* he collates a major work of early "Spurensicherung". He returns from a four-year expedition to Australia with a *Culture Heap* of real and fabricated stone weapons and other primitive paraphernalia, grids of nuanced sacred ochre earth and eerie wedge formations of hunting dingos and hunted kangaroos. Here, we have traces of evidence as a deliberate exploration of mythical thinking from the standpoint of Western consciousness.

Anne and Patrick Poirier (p. 569 above) began lyricising ancient archaeological sites in model situations in 1971. Eclecticism and imagination conjure up an urban repertoire from the Roman villa of Hadrian to the revolutionary architecture of Claude-Nicolas Ledoux. Dark night, glittering water, labyrinthine corridors conjure up the "myths, dreams and wishes of a collective subconscious". Freud's famous analogy of archaeology and the psyche, ruins and amnesia, takes on firm contours in imaginary architecture.

At the same time, the American artist Charles Simonds (p. 569 below) places the miniature villages of a fictitious "little people" in the niches of crumbling walls on the Lower Eastside, without any reference to Classical Antiquity, but as timeless, organic, spiraling or axial Ur-forms of architecture behind which there is a variety of different archaic social systems and matriarchal or

the search for the past is also the search for self. Museum-style presentation and encyclopaedic rationality are merely operative.

Boltanski is the paradigmatic producer of "traces of evidence". The showcases full of childhood documents are followed by huge, illuminated puppets, projections and shadows of marionetties in fleeting twilight, jerky movement or enchanting dance between vanitas and *varieté*. Later, he recorded his childhood in files, drawers, piled-up boxes, accessible through dimly lit corridors. Photos of the early years–the D. family, the school

**Anne** and **Patrick Poirier**
Ausée, the Black City, 1975/76
Charcoal, cork, water basin,
c. 1000 x 550 cm
Cologne, Museum Ludwig

*Below:*
**Charles Simonds**
Dwelling, 1975
Brick, wood, sand
New York, Queens, rooftop of
P. S. I. Building

patriarchal stages of development. Fictitious traces of evidence thus represent a regressive utopia against the New York skyline.

By contrast, Nancy Graves (p. 568 below) takes a more scientific approach to pre- and proto-history, though her reconstructions, including ice-age camels, still claim to be abstract sculptures, however true to life they may appear. "Spurensicherung" in the narrower sense of a quest to secure "traces of evidence" ranges from Dorothee von Windheim's auratic prints to Raffael Rheinsberg's history-laden series of found objects. More broadly defined, it also includes Anna Oppermann's hypertrophic chains of association in the form of sprawling ensembles of photographs and objects. Can we also include in this category the singular work of Christiane Möbus? Can her metaphoric juxtaposition of, say, fish and glass, or crow and stone, be seen as "associative ordering" in the spirit of Novalis? Can they be regarded as metaphors of flowing, swimming, flying that suggest departure and travel within a context of yearning for distant places and familiar home territory?

Others, such as the French artists Jean Le Gac, Didier Bay and Paul-Armand Gette, have moved away from the history of sculpture. Jochen Gerz, by contrast, the most radical sceptic of all, who casts doubt on concretion and communication much as Boltanski does, has moved ever closer to the field of discourse on monuments and memory – one of the most important sculptural tasks of the 80s and 90s. Precisely because he is a "conceptual" artist, a "writer" who writes books against the writing of books, he is able to open up a new view of a traumatically burdened past in his *Harburg Monument* (p. 570 above). The call for solidarity against "fascism, war and violence" which allows the stele to be submerged ever further into the ground, does not uphold the memory of the dead, but places the living under moral obligation instead. It adds a new paradigm to the discourse by addressing the way people deal with memory, rather than addressing memory itself. At the same

**Christian Boltanski**
Showcase II, 1972
Various materials, 20 x 122 x 71 cm
Private collection

**Esther** and **Jochen Gerz**
Harburg Monument Against
Fascism, 1986
Hamburg-Harburg, 1986

The Hamburg stela documented
at various stages of submersion
until it diappears completely in the
ground (far right)

Steinbach transform Duchamp's question. *Bertrand
Lavier* (ill. below) plays the established game of Object
art in which two quotations, when juxtaposed, produce
a new poetic sentence. A heater on an office cupboard –
a magically radiant sculpture, a fetish of commonplace
product, sculptural intensity and the bizarre. The
stronger the transformation, the more brilliant the irony
Lavier's answer, then, is that art arises out of the phys-
iognomic, expressive concentration inherent in the
object itself. Its forerunners are Duchamp's *Bottle-Rack*
and Picasso's *Head of a Bull* (p. 479) made of a bicycle
saddle and handlebars.

Haim Steinbach (p. 571 above) turns the founding
father upside down, as it were. He replaces Duchamp's
dispassionate approach by a strategy in which the object
is allowed to convey its full socio-cultural powers of
expression. Here, we find once more the important
principle of metonymics: an artificial limb or a necklace
on a velvet neck represent the entire body, while a child's
potty or school desk suggest forced cleanliness, obedi-
ence, repression. By placing the objects side by side on a
hand-made shelf, Steinbach gives the mass produced
item a firm position as art. By allowing the objects to
speak, he transforms the Duchampian readymade into
a wordless theatre of the object with a mordant social
critique.

The same is true of Mike Kelley's "socialist ready-
mades", as Thomas Kellein has called them. They are
animals and dolls, presented in multi-media mode,
revealing the gender-specific games, the mythology of

time, it marks a departure from monuments and monu-
mentality, and is, in this respect, an anti-monument that
sublates itself by disappearing. The invisible stele passes
the burden of memory back to us. This, too, secures
traces of evidence – within each individual.

### Recycling and Readymade

In 1914, Marcel Duchamp placed a *Bottle-Rack* on a
pedestal. In doing so, he raised the question as to the
conditions under which art is created. He posed a criti-
cal question that seemed to bear within it the unequivo-
cal answer that art is the consensus regarding art. Yet
neither the question nor the answer have come to rest in
the course of the 20th century. Their intrinsic ambiva-
lence is one of the most productive stimuli in modern
art. Attempts are still being made to somehow circum-
vent Duchamp in order to imbue the readymade with a
new significance.

In the 60s, Assemblage and Accumulation expanded
the horizons of the objet trouvé, which thus entered a
new phase, that of the "adventure of the object". In the
words of Pierre Restany, the object became "entirely
dependent on the institutions of the museum and com-
mentary". Because it was displayed in a museum the
mass-produced object was now elevated to the status of
a piece of art. Nevertheless, Object artists such as the
Frenchman Betrand Lavier and the American Haim

**Bertrand Lavier**
"5/9", 1986
Plaster and metal, 194 x 80 x 81 cm
Paris, Galerie Durand-Dessert

**Haim Steinbach**
Untitled (Walking Canes, Fireplace Sets) # 1, 1987
Chrome and brass laminated wood shelf, aluminium, plastic and rubber walking canes; brass fireplace sets, 157.5 x 229 x 67 cm
FER Collection

everyday life in America and the mechanism of early childhood repression (p. 571 below right). They serve as an ideological model, soft and uncontradictory, just as parents hope their children will be, albeit at the price of repression.

Steinbach's American antipode is Jeff Koons (ill. below left). Opinions vary as to whether his work possesses the same critical clout and whether his bunnies, piglets and Cicciolinas (Ilona Staller), frozen as idols, in icy stainless steel, smooth porcelain or decroatve Venetian glass, represent an actual transcendence or merely a variation of that which they portray. Are they a double-coding of the simulacrum or a mere replica? Does the polished presentation of a cliché reveal the

**Jeff Koons**
Pink Panther, 1988
Porcelain, 104.1 x 52.1 x 48.3 cm
Private collection

**Mike Kelley**
Estral Star No. 1, 1989
Fabric animals, 80 x 30 x 15.2 cm
USA, Collection of Mr. and Mrs. Melvin J. Estrin

machinations of the art market? All these issues are hotly debated. As a media star who introduced the iconography of kitsch to sculpture, with or without breaks and ambivalence, Koons is very much a figure of his time, an artist who rose with the art-boom that continued into the late 80s.

**Young British Sculptors**

An independent centre of gravity has emerged in the British Isles. Here, a keenly critical artistic consciousness has seen the emergence of a group of "young sculptors" to follow on from the "new generation" of the Caro school. Assisted by public funding and brought together in group exhibitions, they have in common with the German "model builders" a distinctly figurative tendency. Nevertheless, a thoroughly English preference for empiricism has led to direct inductive derivation of fiurations from the specific materials and objects in question. The result is a vibrant form of Assemblage, often witty and humorous.

It was Tony Cragg (ill. above) who led the way. As a teacher at the Düsseldorf Art Academy, he has also imported certain elements of this approach to Germany. Since 1976, he has sorted and arranged flotsam and jetsam, used, battered, thin-walled plastic articles and waste from rubbish tips, to create synthetically puzzle-like portrayals of the Union Jack, a submarine, a policeman – all of them totem figures of the consumer age. In the 80s he expanded his repertoire by adding commonplace wooden household items. He realigns the discarded objects so that they march off, ramp-like into their new existence. Later, Cragg was to turn to such traditional techniques as turning, welding and casting for oversized works situated somewhere between laboratory pistons and organic mutations, on the knife-edge between industry and nature.

Bill Woodrow (ill. middle), Richard Wentworth and Alison Wilding also use household items or office appliances, car parts or tools, to create effective metaphors, albeit in a rather different vein. Woodrow's visually stunning capriccios are full of references and associations, and their mordant wit belies their underlying moral stance.

The large-scale projects of younger artists beyond the established mainstream are based on the direct language of reality. In 1993, Rachel Whiteread cast in concrete the rooms of a condemned housed in the East End of London (where she had previously lived). The doors, windows and panelling form mouldings on the concrete block, which stands as a multi-facetted monument to the sum of all memories. Damien Hirst (p. 573 below right) takes quotation to the point of monstrosity, monumental as his works may be: a shark or half a cow swimming in huge glass tanks filled with formaldehyde. Does this mean that galleries and exhibition spaces are becoming fairgrounds and sideshows for today's notion of undecaying eternity?

Not all the young British sculptors work with found

*Above:* **Tony Cragg**
Middle Layer, 1984
Wood components;
length: c. 600 cm
Cologne, Kölnscher
Kunstverein

*Middle:* **Bill Woodrow**
Cello Chicken, 1983
Two car bonnets,
150 x 300 x 1300 cm
London, Saatchi Collection

*Below:* **Anthony Gormley**
Fathers & Sons, Gods & Artists,
Monuments & Toys, 1985/86
Lead, fibreglass, air, plaster;
258 x 68 x 48 cm, 103 x 35.5 x 25.4 cm
Private collection

**Robert Longo**
Coporate Wars: Walls of
Influence, 1982
Cast aluminium bonding,
lacquer on wood; total size:
274 x 792,5 x 122 cm
Formerly Saatchi Collection,
London

objects and direct reality, however. Richard Deacon, for example, combines the sweeping curves of his cut, sawn, drilled and bonded sculptures with outer and inner convergences derived from the realms of linguistic theory. Anish Kapoor covers the sculptural form in pure pigment to draw the spectator's gaze into what seems like a void of infinite depth. Anthony Gormley (p. 572 below) also looks to Buddhism in emphasising the spirituality of the human body in the fluent transition from birth to life to death.

## Intimacy and the Public Sphere

In 1974, in his widely debated book *The Fall of Public Man*, Richard Sennett diagnosed the end of public life and regretted the tyranny of intimacy. Surely such a tendency must have some bearing on sculpture, as the genre with the greatest public exposure. Do younger artists such as Kiki Smith and Robert Gober confirm Sennett's thesis of the prevailing *zeitgeist* by addressing the intimacy of the human body to the radical exclusion of everything else?

**Damien Hirst**
The Physical Impossibility of
Death in the Mind of Someone
Living, 1991
Installation; glass, steel, silicone,
shark in in 5 % formaldehyde
solution, 213.4 x 640.1 x 213.4 cm
London, Saatchi Collection

Kiki Smith casts bodies, male and female, in bronze, using wax, fabric, clay or glass, with protruding veins and arteries. They show signs of stress, give birth, withdraw in a foetal position, trailing traces of blood or urine or chains behind them like some ornamental floral frieze. Here are bodies that are biologically determined yet still capable of elevation to the status of biblical heroines (p. 574 above). Gober fragments the male

*Left:*
**Jonathan Borofsky**
Hammering Man, 1981/82
Steel; heigth: 21.5 cm
Frankfurt am Main,
Trade Fair Grounds

**Kiki Smith**
Untitled, 1990
Wax, pigments; life size
Courtesy Pace Wildenstein,
New York

Haacke or Ilya Kabakov. In creating their anti-monument, Esther and Jochen Gerz have even developed a new paradigm of public art. The notion of the absolute autonomy of art, which is a modern hypothesis in any case, seems to be fading into uncertainty as the century comes to a close. At the same time, the various generations overlap. While Smith and Gober create their monument to the prevailing *zeitgeist*, other older artists continue to uphold the tradition of an emancipatory and critical modernism. This vibrant juxtaposition of contradictory approaches is very much a characteristic of the 90s. Longo (p. 573 above), like Kienholz, is a fascinated critic of the American way of life. He focuses on the ecstacies and horrors of the postmodern urban scene, its lawlessness, its corporate wars, the struggle for money and survival, the arms race, the illusion of the media. His direct and hard-hitting tableaux somewhere between photography and sculpture take the visual language of advertising, Hollywood, science fiction and computers and charge it with vehement criticsm. The work of Haacke, on the other hand, is still rooted very much in the elementarism of Zero art. From the anorganic to the organic, he moves on to social "real time systems". Originally geared to statistical polls of museum visitors, he later demonstrated the covert seizure of power in the cultural domain by corporations and the manipulation of the arts by the business world, and the connections with dictatorial and racist regimes.

Ilya Kabakov (p. 575) brought a touch of globalism to art following decades of East-West dualism. Not that his works do not convey a precise location. On the contrary, they refer specifically to their origins and the visual repertoire that entails. Kabakov, who came to the West from Moscow in 1987, has created a detailed monument to the last days of the Soviet system. His works chart the complete topography of a society, from the cramped

body, positing it as the arena where the struggle between his own homosexuality and anti-gay social conventions is acted out. Body parts, such as a leg or lower torso, protrude through the wall, with plug-holes embedded in thighs or buttocks like some festering ulcer. These are dense, deep-rooted metaphors for isolation, exclusion, expulsion. Gober acts out the conflict quite literally on his own body (ill. below).

Yet that is only one side of the coin. On the other hand, we have been witness for a number of years now to a return of sculpture (in the broader sense) to the realms of public and political discourse and critique. Be it Jonathan Borofsky's *Hammering Man* – gigantic urban guardians whose huge black form is outlined against the sky at the entrance to Frankfurt's trade fair grounds, and other sites – (p. 573 below left), be it the ideological critique posited by Robert Longo, Hans

**Robert Gober**
Untitled (Leg), 1990
Wood, wax, cotton, leather,
human hair, 32 x 15 x 52 cm
Private collection

*"One of the most important protago-
nists in a gesamtkunstwerk is light.
Literally everything depends on light.
Its functions in the installation are
incredibly varied. Above all, it is
involved in creating the setting and
a distinctive, intensive atmosphere."*
ILYA KABAKOV

**Ilya Kabakov**
NOMA or Moscow Conceptual
Circle, 1993
Mixed media, round space;
diameter: 25 m, height: 3.5 m
Hamburg, Hamburger Kunsthalle

*Communal Living Quarters* to the permanently unfin-
ished building site to the red propaganda pavilion. Real-
ism and symbolism are united. He goes beyond Kienholz
in creating "installations" without surreal refractions,
which draw their own aesthetic laws and totality from
the visual impact, setting, mood, voices and memories.
It is, indeed, partly because of this consistent expansion
of the genre that Kabakov is so successful in his work.

   As the 20th century draws to a close, everything
seems to remain open-ended. The delta becomes a
paddy-field in which we cannot even discern the various
directions. Not even the explanation that the present
invariably seems chaotic seems to hold true. Did we not
have a clearer view of things in the 60s and 70s, and even
in the 80s? The sign of the 90s is the lack of direction.
Some may choose to see in that the underlying pattern
for a post-avatgarde era. Is the avant-garde running out
of steam? Whether that triggers feelings of disorienta-
tion, resignation or freedom depends very much on
one's personal point of view. in the mid-90s, the artistic
design is no longer moving forward in sync with other
designs. The collective developments have either come
to a standstilll or have slowed to the point of invisibility.
Art – or perhaps just sculpture, or maybe only painting –
is no longer regenerating itself from the revolutionary
breaks and grand evolutionary lines of the past, but is
drawing instead on the wellspring of each individual work.

   The fetish-word "new" is losing ground – perhaps
only temporarily – to the claim of "authenticity". Where
the driving force of a widespread movement is lacking,
the work must be sufficient unto itself. And so, the "styl-
istic unease" noted by Werner Schmalenbach does not
only represent a loss, but also a fresh opportunity.

**Ilya Kabakov**
Red Pavilion, 1993
Installation; wood, loudspeakers,
music system, tapes,
500 x 920 x 460 cm
Cologne, Museum Ludwig,
Sammlung Ludwig

# Activation of the Senses

## "Everything disappears"

"You have to be quick if you want to see something. Everything disappears." If Paul Cézanne were alive today he would see his fears confirmed to an alarming degree. By the latter part of the last century it was becoming clear that the technical media developing in the wake of the industrial revolution could not fail to have a radical effect on traditional art production methods. Yet the majority of those interested in art remained unaware of these far-reaching changes. We are sitting on a mountain of artefacts that has piled up over thousands of years and are still busily trying to take stock of it, to order it and to understand it. In the meantime, ideas developed in our own era have been yellowing with age. So many experiments and innovations which have so enriched this century are just being forgotten. Others are simply stored in photographic or electronic archives or have entered the realm of myth, like the Actions of Joseph Beuys. Who was there when he explained the pictures to the dead hare (ill. right)?

Artists have been reacting to the extraordinary dynamics of this century with its wars and disputes, its major scientific and technological changes. They have turned hitherto accepted notions of aesthetic structures upside-down, tested them for their validity today and rejected them. They have adopted the new technical media of photography, film, video and computers as creative tools and as modes of communication. Today they are beating a path into electronic information systems in order to explore promising digital territory. Working with the limitations and potential of the new media, artists are searching for answers that are both creative and critical.

## "Burn the Museums!"

The 20th century was barely ten years old when a determined handful of young artists set about dismantling high art in order to devote their energies to the changes in the real world. As Futurists, they were fascinated by racing cars "more beautiful than Nike of Samothrace," by "lurid electric moons," by "greedy stations" and by "broad-chested locomotives" – and "with compelling, inflammatory force" they hurled their 1st Manifesto out into the world. Their hope was to free the world from its cancerous proliferation of museums and libraries. The

**Joseph Beuys**
how You Explain Pictures to a Dead Hare, 1965
Performance at the opening of the exhibition '... irgend ein Strang ...' in the Galerie Schmela, Düsseldorf, 26 November 1965

*"A hare understands a lot more than many human beings with their stubborn rationalism ... I told him that he just had to look straight at the pictures to understand what was really important about them. Doubtless the hare knows better than human beings that directions are important."* JOSEPH BEUYS

Futurists were the first to recognise how far the arts were lagging behind the reality of the fundamental scientific and technological changes that had affected contemporary life.

Neither traditional modes of artistic expression (media) nor their parameters seemed equal to the challenges of the present and the future. The Futurists used their Manifesto to put forward their provocative demands for an unlimited *tabula rasa* and a Futuristic "newly constructed universe." Even before the outbreak of the First World War, they were concentrating their efforts on finding themes and developing forms that were relevant to their era of heavy industry and accelerated communications.

In the initial Manifesto which came out on 20. February 1909, written by the Futurists' spiritual mentor, Filippo Tommaso Marinetti, the vitalist concept of art as propounded by Umberto Boccioni and Carlo Carrà was extended to include news technology as a model of a vital source of experience. In his manifesto, *Il Tattilismo*, (1921) Marinetti speaks out for the "devel-

**Nam June Paik**
Voltaire, 1989
Video sculpture, 300 x 200 x 55 cm
Courtesy Galerie Beaubourg, Paris

**Jacques de la Villeglé** tearing down posters in Paris, 1961

**Lucio Fontana** perforating a canvas

*"The affected material reveals its entire being, as it unfolds in time and space and in the process of changing goes through various stages of existence. We ask that the primary values of existence should be fully understood."* LUCIO FONTANA

opment and intensification of communications" and wants to see "people linked into the network of the media" with the ultimate aim of bringing human beings back to humanistic values.

In 1933 Marinetti and Pino Masnata wrote in *LA RADIA – Manifesto futurista* on the Futuristic use of the new mass-medium of television. They viewed television as the "perfect synthesis of synaesthetic dreams" with radio simply being a transitional stage in the process. "We now have at our disposal a television with more than 50,000 dots for each large picture on the large screen. In expectation of the invention of tele-touch, tele-smell and tele-taste, we Futurists are perfecting radiophony, which will multiply the creative genius of the Italian race by hundreds and will put an end to the time-honoured torment of distance and will establish liberated words as its logical and natural mode of expression."

### Demonstrative Gestures, Furious Protests and Constructive Plans

Marcel Duchamp regarded the exhibiting of a signed urinal (*Fountain*, p. 459) as a demonstrative gesture, taking radical issue with the principle of individual creativity and with art as an institution. All too aware of the absurd horrors of the First World War and subsequent socio-political developments, the Dadaists gave vent to furious protest at the way the system was being propped up by beautiful museum pieces and threadbare Philistinism. They transferred their artistic activities from the studio to publishing houses and the stage. They entered the public arena with provocative texts, ironic caricatures, aggressive slogans and pseudo-advertisements in journals they published themselves. In a constant race against the censor they sold these publications as part of a Dadaist campaign. Radical left-wing artists and writers found a platform in publications by the Malik Verlag

founded by John Heartfield in 1917 (p. 122). Hugo Ball, striving for the Gesamtkunstwerk, included theatrical, action-based and poetic elements in his exhibitions. In 1921 Kurt Schwitters (pp. 130ff, 461f) set his sights on a *Merzgesamtkunstwerk* that was to unite all art-forms in one artistic entity in order to "blur the boundaries of art."

During this same period, the Russian and East European avant-garde aims were constructive rather than anarchic. They saw what they were doing as their part in the construction of a new society, determinedly believing this society would be free from despotic power and capitalist domination. Many artists gave up painting in order to work in 'production art,' using photography, typography and film to help build their new society. People had to work for life, declared Alexander Rodchenko (p. 448), not just for palaces, churches, cemeteries and museums. "Down with art that is simply a means of escaping from a life that is not worth living." Vladimir Tatlin conceived his *Model for the Monument to the Third International* (p. 444) as a political headquarters and as a propagandistic communications centre.

In the Bauhaus, László Moholy-Nagy (p. 454), much to the alarm of his colleagues, was energetically exploring the radically new materials, media and methods of the time. "Nothing but optics, mechanics, the decommissioning of the static painting of the past," complained Lyonel Feininger in a letter to his wife. There was endless talk of cinema, optics, mechanics, projection and motion – even of machine-produced optical slides, multi-coloured, in all the most beautiful colours of the spectrum, that could be stored like gramophone records.

Pioneering work in the field of abstract film was being carried out by figures such as Viking Eggeling, Hans Richter, Walther Ruttmann and Oskar Fischinger. With the ultimate aim of replacing the static character of painting with the dynamism of film, they addressed themselves to the practical and theoretical fundamentals of art in motion.

## Forays into the Third and Fourth Dimensions

After the Second World War the prevalent negative mood meant that artists immediately "moved away from painting." The persecution and annihilation of recent years had put paid to the notion that art should relate as closely as possible to reality. On the contrary, the autonomy of art was now regarded as the guarantor for maximum personal freedom. This was seen at its most extreme in Action Painting which was often described as 'lyrical' rather than 'anarchic.'

When L'art informel was at its height, Lucio Fontana made some momentous forays into the third and the fourth dimensions and, in his *Manifesto blanco*, called for the rejection of traditional art forms. In his *Concetti spaziali – Spatial Concepts* (pp. 300, 301; 1949/50 onwards) Fontana introduced 'space' into the picture by perforating or slitting his canvases (ill. left). He determinedly opened up the picture surface to an encounter with a phenomenon that would soon be beyond the artistic capabilities of both painting and sculpture. "In our art the lines of the horizon multiply into infinity, into infinite dimensions. They derive from a striving for an aesthetic where the picture is no longer a picture, sculpture is no longer sculpture and the written page becomes independent of its typographical form": Fontana's words in his 1952 *Manifesto del movimento spaziale per la televisione*, where he was also speaking on behalf of his colleagues Alberto Burri (p. 260), Roberto Crippa (p. 260), Gianni Dova, Milena Milani and Benjamino Joppolo, expounded the notion of a form of spatial art that would be transmitted by television. After 1948, Jackson Pollock with his 'drip paintings' (pp. 268–274) developed the idea of 'walkable' pictures, which he created in a radically free manner – dripping, dribbling and even throwing liquid paint onto the canvases.

A low level of resistance and a lack of vision were to be the death of L'art informel. Rapidly and comprehensively commandeered by the new cultural establishment of the post-war years, this style of painting, with its inflationary, rigidly academic tendencies was heading for a crisis. The final blow was delivered by the so-called *affichistes* with their 'torn posters' and by the New Realists. 'Pure' painting was abandoned in favour of a new form of artistic activity centering on phenomena and objects from everyday life and using these for a whole number of different purposes: for tearing down – Raymond Hains (p. 329), Jacques de la Villeglé (p. 329), Wolf Vostell (p. 329); for movement – Jean Tinguely (pp. 499, 506–508), Otto Piene (p. 502), Heinz Mack (p. 502), Günther Uecker (p. 503); for collecting and accumulat-

**Günther Uecker**
Günther Uecker, Works 1960–1977
(Light Objects, Sculptures and Actions)
Still from a 16mm video film by Karl Wiehn, 1977
Video tape, colour, sound, 45 mins
Cologne, Westdeutscher Rundfunk

*"But tomorrow in our search for a new dimension in art, we will also have to search for new places where our art will be incomparable: places like the sky, the sea, the Antarctic, the deserts, with areas, like purpose-built islands, set aside for art."*
HEINZ MACK

**Heinz Mack**
TELE MACK, TELE-MACK,
TELEMACK, 1968/69
2 stills from a 16 mm video film
Video tape, colour, sound, 45 mins
Cologne and Saarbrücken, Westdeutscher and Saarländischer Rundfunk

in a quarry near Düsseldorf, where he exploded a white sports car belonging to the successful advertising photographer Charles Wilp, as well as a piano, a fridge and a television set. Afterwards, the remains of these dynamited status-symbols of civilisation were then fixed to panels of wood and exhibited in the Galerie Schmela in Düsseldorf.

Niki de Saint Phalle's *Shooting Pictures* (tirs/tableaux-surprises) were only finished when they had been shot with live ammunition and had, so to speak, yielded up their inner life, in the form of liquid paint. Spoerri's *Trap-Pictures* (tableaux pièges) were made from the leftovers from meals to which Spoerri would send out official invitations from time to time. The leftovers plus bowls, plates and ashtrays were then fixed on a base and hung up on the wall (p. 328).

Yves Klein's *Anthropométries* of the blue era, (p. 298) were created during a solemn ceremony in front of an invited audience and to orchestral accompaniment. The artist used 'live' paintbrushes in the form of three naked,

**Georges Mathieu** in Otto Piene's studio having just painted – in 70 mins – 'The Abduction of Henry IV by Archbishop Anno of Cologne when He was Taken from Kaiserpfalz to Kaiserswerth' for the opening of Mathieu's first solo exhibition in the Galerie Schmela, Düsseldorf, 11 January 1958

ing, dissecting, destroying and singeing – Arman (p. 518); for compressing – César (p. 519); for fixing – Daniel Spoerri; for wrapping – Christo (p. 519); for shooting (pictures) – Niki de Saint Phalle (p. 581 below); for playing, dismantling and reconstructing – Dieter Roth (p. 363).

By 1958, when Georges Mathieu (p. 258) took no more than 70 minutes to paint the picture *The Abduction of Henry IV by Archbishop Anno of Cologne when He was Taken from Kaiserpfalz to Kaiserswerth* in the Atelier Otto Piene (ill. above), *informel* was no more than a gimmick and Tinguely poked fun at it with his 'drawing and painting machines' (p. 499).

Restaurant in the Galerie J, Paris, März 1963. The Chef **Daniel Spoerri** talking to his guests

*"In the exhibition 'Restaurant in the Galerie J' I showed some hundreds of kitchen utensils and turned the gallery into a restaurant.*
*a) The tables in the restaurant functioned as 'Trap-Pictures'*
*b) As in 'Krämerladen' items of food served as exhibits without being specially presented.*
*c) Each person was allowed, under license, to create 'their own 'Trap-Picture' form the remains of their meal …"*
DANIEL SPOERRI

### Artistic Activity: a Splendid Spectacle

Whereas Pollock, in his own words, was using his canvas as an "arena," where painting functioned as part of his biography, Mathieu chose to perform feverish acts of painting on stage. Similarly Nicolas Schöffer (p. 582) organised a grand entrance for his kinetic, later cybernetic sculptures. He was the first artist to equip his works with photo-electric cells, sensors and microphones, and used electronic automatic control technology to construct systems that reacted to sounds and silence, to movement, light and darkness. In 1956 he installed his first cybernetic sculpture, *CSYP*, in the Théâtre Sarah Bernhardt on the occasion of the 'Nuit de la poésie,' and in the same year Mathieu painted his *Hommage aux poètes du monde entier* before an audience of 2000.

The farewell to 'pure' painting and the exploration of new artistic materials went hand in hand with experiments with gestural modes of expression. Under the gaze of the public, artists put on actions during which a work of art might be created. Some of the results have been preserved in museums as incunabula. Thus in 1963, Arman realised his most spectacular work, *White Orchid*,

**Daniel Spoerri**
Menu from the 'Restaurant in the Galerie J', Paris, 1963

female models (ill. right). Meanwhile Tinguely was making auto-destructive works that reversed the process of artistic creation. Between 1960 and 1962 he constructed elaborate machines, purely for the purposes of self-destruction.

## Proto-Actions and Proto-Installations and the first Multiples

Despite their critical attitude to *informel*, the gestural works of the *affichistes* and the 'New Realists' were the apotheosis of the pictorial. A sense of a new beginning rather than of rejection characterised these artists' attitude in a time when the burgeoning economic miracle was marking both the end of the era of post-war reconstruction and the start of the adventure of space exploration. In this context their gestures, which were staged purely for their own sake, had more to do with liberation than explosive destruction.

In his 1959 manifesto *For Statics* Tinguely exhorted his fellow artists to "Stop 'painting' time. Cease building cathedrals and pyramids that crumble away like sugar decorations. Breathe deeply, live in the Now, live on and in time. For a beautiful and absolute reality!" He then abridged his manifesto, had 150,000 copies printed and dropped them from airplane over Düsseldorf. For his part, Yves Klein released blue balloons at an exhibition opening (Galerie Iris Clert, Paris 1957), 'sensitised' a room by his presence (Galerie Colette Allendy, Paris 1957) and followed a blue line (Galerie Schmela, Düsseldorf 1957). In 1961 and 1962, the ZERO artists, who had adopted Tinguely as their mentor, put on exuberant ZERO parties, namely light-demonstrations with ZERO soap-bubbles, ZERO girls, ZERO hot-air balloons, aluminium flags and sheets of metal with light shows, search lights and fireworks.

However, no artistic intervention on a limited time scale could have been more solemn or splendid than when Yves Klein put a guard in republican uniform at the entrance to *Le Vide* (The Void) when it was 'exhibited' at the Galerie Iris Clert in Paris in 1958. Arman provided something alien to a reply two years later with *Le Plein* (The Abundance). In its approach, this last work, which involved completely filling the gallery up with all sorts of objects until it was no longer possible to enter the space, was clearly light years away from Walter De Maria's 1968 room filled with earth. At the time De Maria was pointedly marking his withdrawal from the art business in the expectation of not needing it again. Christo and Jeanne-Claude made a more thought-provoking point in Paris 1962 when they reacted to the Berlin Wall with a street barricade made from piled up barrels. They called it *Iron Curtain* (Rideau de fer).

Still in the 50s Spoerri was making mobiles going back to Duchamp's notion of multiple reproductions. Confronted with the tactile serial objects that Spoerri produced under the name 'édition MAT' ('Multiplication d'Art Transformable,' 1959–1965), the hitherto passive viewer was now to become active, 'responding' to

art. Naturally enough, the artists who participated in the production of 'édition MAT' were above all those artists who were experimenting with light and movement, with investigations into seeing and perception. Amongst others these included Paul Talman, Yaacov Agam, Mack, Jesús Rafael Soto and Tinguely, but also the inventors of kinetic objects: Marcel Duchamp, Man Ray and Victor Vasarely.

Opposition to salon painting seems to have been the most important common denominator shared by a veritable concert of different artistic trends in the 50s – from Schöffer's somewhat totalitarian notion of art as all-embracing and with an aesthetic effect on both society and the environment, through Tinguely's confident

**Yves Klein** painting three nude female models blue: following this they imprinted their bodies on canvas according to his directions. Paris, Galerie Internationale d'Art Contemporain, 9 March 1960

**Niki de Saint Phalle**
Shooting Picture
(Shooting with a rifle), 1963
Munich, Neue Galerie im Künstlerhaus

sense of freedom that allowed him to create works that would self-destruct and disappear into nothing, to the miraculously radical work of an Yves Klein. The latter boldly exhibited the 'void,' sold shares in *Zones of Immaterial Pictorial Sensibility* (Zone de sensibilité picturale immatérielle, 1959) and even dared leap into the emptiness of the void of space itself (*The Leap into the Void*, 1960).

*"It was an astonishing feeling, shooting at a picture and seeing how it changed into a new one. It was exciting and sexy but also tragic because we were witnessing simultaneous birth and death. It was a mysterious event, and everyone who shot found it utterly gripping."*
NIKI DE SAINT PHALLE

Destruction and emptiness or silence – setting the tone for what was to follow, but the one too noisy and the other too quiet for the eyes and ears of the older generation, which was so busily involved with the economic miracle, firmly believing that it would last forever and that it could only improve our daily lives. What did they expect from art in a time when economic and political conditions had changed so rapidly and when peace could only exist in an awareness of the worst possible scenario?

**Nicolas Schöffer**
Space-Dynamic Sculptures, c. 1960
Mixed media, 107 x 90 x 75 cm
Paris, Musée National d'Art Moderne,
Centre Georges Pompidou

# 2 Intermedia: Happenings, Actions and Fluxus

### John Cage and the Intermingling of Art Forms

In Europe in the 50s, the progressive mingling of individual art forms was an accepted part of 'conventional' art practice – but when it emerged in the USA around 1960 it took a much more radical form than anyone might have expected, and it was the composer John Cage (p. 583 above) who 'pushed open' this particular aesthetic door. In 1947 John Cage came into contact with Zen-Buddhism and he was as deeply affected by it, as was Yves Klein. Cage discovered the phenomenon of silence as the musical equivalent of pure nothingness; at the same time he became convinced of the equality of all aspects of Creation. Consequently he rejected any form of hierarchy, preferring to see all intentionally and unintentionally produced sounds and noises as equal. In addition, he was also guided by the Buddhist precept that everything should be able to develop freely. Finally, taking the principle of chance to its logical conclusion,

Cage freed himself from the obligation 'to want to seek out the best' by relying in all he did on the Chinese oracle book, the *I Ching*.

In a sound-proof room at Harvard, Cage discovered that there is no such thing as pure silence. A year later, in 1952, he premiered his legendary composition 4'33". It has three movements called 33", 2'40" and 1'20" and the performer David Tudor 'played' the piece by closing the piano lid at the beginning of the movement and opening it again at the end. The sounds that the audience had come for were not to be heard. However, as a result of this, the audience became aware that it was getting noisier and noisier in the auditorium and that they were the ones making the noise.

Cage's treatment of sound broke a whole number of taboos. Yet he was never destructive. On the contrary, Cage's work was about integration. He did not separate the auditory sense from the other senses. Instead of writ-

ing music he organised sounds and events. His scores – for example, his *Water Music* for prepared piano, radio, 3 pipes, waterball, 2 water-containers, a deck of cards and wooden stick (1952) – contain instructions beyond those referring to the sounds, as to how they could be performed interestingly. Thus his performances took on something of the character of multi-sensory theatrical events.

Cage became a key figure at the interface of various art forms. In the late 50s he was teaching at the New York School for Social Research, where he communicated to his students a sensitivity towards complex situations, taught them about the principles of chance and discussed ways of organising sounds and events. This was to a large extent the source of the many very different 'action arts' that then went down in art history as 'Happenings' and 'Fluxus.'

### Allan Kaprow's Happenings

Allan Kaprow, who was a student of John Cage's and the inventor of the Happening, developed Cage's concept of lived experience and the experience of perception, taking it to the point where reality broke into art, as it were, in a form that embraced the totality of life. His first publicly performed piece, 18 Happenings in 6 Parts (1959) comprised film and slides, dance, music and language, a sculpture on wheels, concrete music and sound constellations, the production of a painting and various banal acts. In this piece, Kaprow mingled visual material and events in the way that the Dadaists had once done, when they had constructed their collages. Yet no single person was in a position to take in the whole event. Kaprow confronted and overwhelmed his public with simultaneous events in three separate spaces.

As far as Kaprow's early Happenings were concerned, the public either had very little part in them or none at all. In his 1961 *Spring Happening*, the public were put into a narrow tunnel with peep-holes. They were

then subjected to the droning noise of a lawn-mower and the entrance was blocked with an over-sized ventilator. There was the sound of car horns and drums. When the noise had reached its peak the walls of the tunnel fell away and the public could leave the room. Later Kaprow developed a different type of Happening, where the public and the artist participated to an equal degree. For *Yard* (ill. below), the artist collected together a huge number of tires in a yard, where the public could actively move about or just be passive observers. In the late 60s Kaprow devoted himself increasingly to the question of interpersonal relationships. He developed a form of 'activity' for a small number of participants which had, if anything, an intimate and playful feel about it, and which needed no public.

### Wolf Vostell and the Therapeutic Disaster

Rather than creating tangible, material works, Happenings produced lasting effects and experiences in the minds of the participants. According to the curator Henry Geldzahler they also had group-therapeutic effects. At any rate, he maintained that whenever he had taken part in a Happening he was much easier to get on with even ten days later.

As opposed to the 'loose structures' of Kaprow's Happenings, Vostell's instructions for his Actions seemed authoritarian and hampered any initiatives by the participants. In fact, one is more likely to do his activities justice if one views them from their destructive side. Vostell always worked with shock tactics, generally in a demonstrative form, more directed towards confrontation than real participation. When he looked back, he felt that his childhood had been dominated by the sight of dying people. He experienced his own first 'Happenings' at the age of eight or nine when individuals were thrown back on their own resources and had to find shelter from horrendous air-raids as best they could.

**John Cage** (right) in the Sixties with his favourite interpreter, David Tudor, 1960s

**Allan Kaprow**
Yard, 1961
Environment with car tires etc.
Remscheid, Feelisch Collection

**Wolf Vostell**
Neun-Nein-dé-collagen, 1963
Happening in nine locations in
the town of Wuppertal (Detail),
Wuppertal, 1963

**Wolf Vostell**
Neun-Nein-dé-collagen
(Partitur), 1963
Pencil and coloured crayon on
paper, 70 x 100 cm
Wuppertal, 1963

Vostell's art lives and breathes brute force. Traffic accidents and the thought of a plane crash immediately after take-off gave him the idea of using the term 'décollage' ('unsticking' or 'take-off'). Since that time he would appear to have been working on destruction – using décollage, blurring, distorting and manipulating it. In the late 50s and early 60s Vostell started tearing down posters in Paris.

Next he took to blurring images in illustrated journals, manipulated television sets (*Television Decollage*, New York 1963), caused interference on a television screen (*Sun in Your Head*, 1963), the burial of a television (as part of the "Yam" Festival, 1963) and caused a locomotive travelling at 80 miles an hour to smash into a Mercedes standing on the railway track. Finally, he shot a television while it was turned on (Wuppertal 1963).

### Viennese Actionism

From Vostell's traumatic disasters, which were generally directed against inanimate objects, it is only a short step to the 'abreaction-games' in the 'Orgies Mysteries (O.M.) Theatre' devised by Hermann Nitsch (p. 585 below), or the 'material actions' put on by Otto Mühl, the self-decorations and self-mutilations of Günter Brus (p. 585 above), or the auto-destructive actions of Rudolf Schwarzkogler (p. 586). There could be no stauncher refusal to gloss over society's dark chasms, and artists like Vostell and the Viennese Actionists showed us that large tracts of Western society no longer have the necessary rites to deal with trauma and mental stress.

Of course Nitsch's Action Theatre derives from the Action Painting of *informel*. And a similar connection could reasonably be made between the use of dead animals, the attacks on organic materials and Fontana's attacks on the picture surface and the New Realists' appropriation of reality. In order to understand the phenomenon of the Viennese Actionists it is essential to bear in mind the extremely conservative social context in which they were working.

Nitsch saw his 'abreaction-games' as relieving inner drives during which pent-up energies would come to the surface and become part of the subject's conscious awareness. In its most disturbing manifestation, the breaking of taboos turned from gestural painting and self-decoration into the self-mutilations of Brus. It was in the mid-60s that Brus – who has been called the 'Father of Body Art' – made the transition from fictive to actual self-mutilation, while Schwarzkogler created tableaux of bandaged bodies, demonstrating his hypersensitive ideas on colour, proportions and the spatial relations between objects.

In contrast to Happening and Fluxus artists, the Viennese Actionists were alive to the possibilities of photography and film, and used them for their own purposes. Their interest, which was at its height in the 60s, can partly be traced back to the fact that Austrian avant-garde film was already well-established at the time. But probably the main reason for their interest in transpos-

ing their work into film and photography was their distinctly pictorial, painterly approach.

## The Phenomenon of Fluxus

"Fluxus-art-fun should just be simple, entertaining and undemanding, it should be about insignificant things, it shouldn't require special skills and countless rehearsals, it should have no commercial or institutional value" – the words of George Maciunas, who devoted himself to the phenomenon of Fluxus as its self-styled chief coordinator, having also given the movement its name. Fortunately Fluxus never could be reduced to some common denominator, due largely to the resilience and waywardness of its own protagonists, due also to its international dimensions and also to its indeterminate position amongst the other arts. Fluxus resisted definition: it was neither painting nor sculpture, neither theatre, literature, film nor music, even although it was born in the environs of the musical avant-garde and would have been unthinkable without John Cage. It was the first inter-medial art form since Dada that transcended and mingled individual genres.

While most Fluxus artists were part of the experimental avant-garde in literature and music, they had originally come from very different professional backgrounds. First the New Yorkers: Maciunas, an immigrant from Lithuania was a trained artist, art-historian, architect and musicologist. He served as a graphic designer in the US Army in Wiesbaden where he organised the Fluxus 'Internationale Festspiele Neuester Musik' in 1962. Benjamin Patterson was a classical double-bass player with the 7th US Army in Germany and with the Ottawa Philharmonic; George Brecht worked as a chemist and Robert Watts as an engineer. Yoko Ono arrived on the New York Fluxus scene having studied both literature and music; Alison Knowles came from painting; Dick Higgins from music and graphic design. Charlotte Moorman (Nam June Paik's partner for many years) was a cellist, Al Hansen studied social pedagogy, Joe Jones studied music. Takako Saito came to New York from Japan in 1963, uniquely able to arouse creative powers in others by his playing.

In Cologne there were Nam June Paik, a trained composer, and Wolf Vostell, a graphic artist in advertising; in Berlin there was Tomas Schmit, of no fixed occupation. In Paris were Robert Filliou, nomad, economist (by training) and poet (by vocation), and Emmett Williams, also a poet. Nice was and still is the home of the artist-shopowner, Ben Vautier. From Copenhagen came Arthur a.k.a. Addi Köpke, artist and avant-garde gallerist, and from Prague came Milan Knížák, who had trained as a painter.

Fluxus was not a movement, if one ignored the nomad-like wanderings of the artists who came into contact with it. It was a phenomenon that appeared on an international level. In some places it was more concentrated at certain times, perhaps because a certain person or institution was emerging there at the time

**Günter Brus**
Self-Decoration, 1964
Action. Vienna, Atelier Otto Mühl,
December 1964

**Hermann Nitsch**
Scene from a performance by the
Orgies Mysteries Theatre, 50th
action, 1975. Prinzendorf (Austria),
Schloß 1

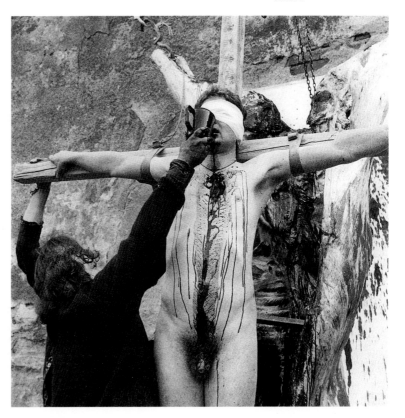

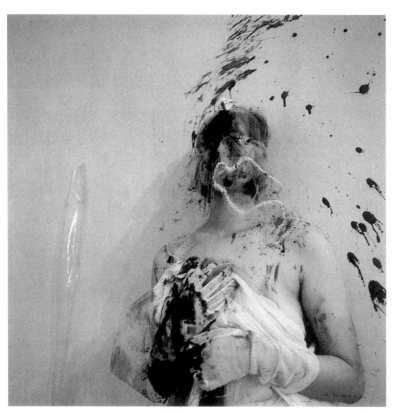

**Rudolf Schwarzkogler**
Wedding, 1965
Action, 6 February 1965 Vienna,
Heinz Cibulka's flat

(Proto-Fluxus involving Cage's students in New York from 1958–1960; Nam June Paik and Mary Bauermeister's studio and the studio for electronic music at the Westdeutscher Rundfunk in Cologne), which meant that Fluxus events would be taking place there (1962 in Wiesbaden, Copenhagen and Paris, 1963 in Düsseldorf, Amsterdam, Den Haag, London and Nice), or that Fluxus protagonists lived there.

What did Fluxus have to offer? No collages of events, time and materials as in Happenings, no group-dynamic processes, no therapeutic systems. Instead it offered concerts consisting of sequences of simple, self-contained acoustic and visual acts, and were called 'events' or sometimes even 'activities.' They could be performed with or without their originators, in front of an audience, occasionally with the audience, but very seldom completely without an audience. In addition, Fluxus sometimes offered apparently oddly constructed objects and 'instruments' such as Paik's *Ur-Musik*, a wooden packing chest strung with simple wire (strings) and with a removable box mounted on the front that could be rotated and that produced sounds (ill. below). From 1962 onwards George Maciunas produced countless little objects and editions which were extremely cheap and could be ordered by mail or bought in 'Flux-shops'. Amongst these were a number of games, so-called 'Flux Kits' (p. 587 above right) leatherette suitcases with a representative selection of Fluxus objects by various artists, special Fluxus postage stamps and rubber stamps (Mail Art), signs and anthologies, artists' books in low print-runs, pamphlets and posters, audio cassettes and films.

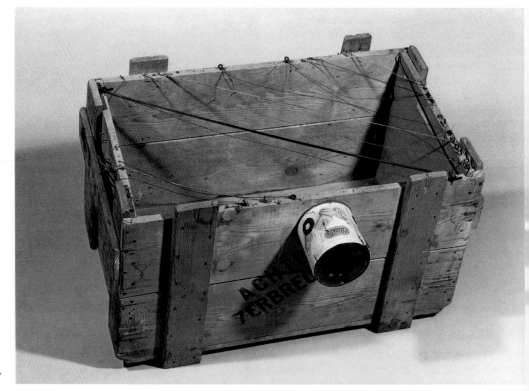

**Nam June Paik**
Ur-Musik, 1961
Object Instrument, 52 x 92 x 68 cm
Vienna, Museum moderner Kunst,
Stiftung Ludwig

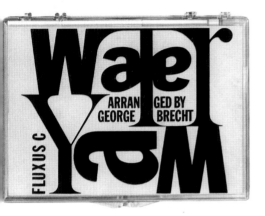

## Variations for Butterflies and Double-Bass

Some Fluxus events were playful and high-spirited like La Monte Young's *Composition 1960 # 5* with butterflies that were supposed to be released from the room where the performance was taking place. Other Fluxus events could be facetiously shocking like Paik's 'peeing competition' called 'fluxus contest' or his piece, *One for Violin* where a violin was raised slowly upwards with the utmost concentration, the light went out and suddenly the violin was smashed (1962). Philip Corner's *Piano Activity* (ill. below) lasted for several performances during which a grand piano was painstakingly dismantled, little by little.

Fluxus events were spontaneous in so far as their execution depended on participants and materials, both present and absent. Furthermore, the scores that were used left the interpreters plenty of room for manoeuvre. In his *Variations for Double-Bass*, (1962), Patterson pulled a long rope made of old rags and bits of cable out of the body of the bass, drew it as quickly as possible through the strings and then stuffed it back in again. Paik interpreted La Monte Young's *Draw a Straight Line and Follow It* by dipping his tie and his hair into a chamber pot filled with ink and then drawing a line on strips of paper lying on the floor: *Zen for Head* (p. 588 above). Fluxus events could be succinct like George Brecht's word-event *Exit*, which ended the Fluxus concert on the first day in Düsseldorf in 1962. Some events 'performed themselves.' Williams, appointed by Maciunas as the Fluxus co-ordinator in Europe, created his concrete poetry by letting mice run around with fluorescent letters on their backs.

Brecht also originated events that anyone could put on for themselves. From 1962 onwards, Maciunas put his scores on little, square cards and offered these for sale in so-called 'Water Yam' boxes (ill. above). These also included instructions for building an 'instrument' that would make 'droplet music' or a 'droplet event.' In 1970 Wolfgang Feelisch realised his eponymous event with a water tap and water pipe mounted on a piece of wood with a bowl to catch the water (p. 589). Another card, entitled *Symphony*, has a hole in the middle that one can look through. Whatever one sees through it, that is now a "symphony" of the passing moment and is unquestionably a matter of perspective.

## Infected by the Fluxus Virus

Fluxus came into being with the 'concerts' and festivals that Maciunas organised in 1962/63. Yet opinion differs as to whether its origins and its end can be dated with any real certainty. Fluxus turned out to be too unwieldy and undefined to fit conveniently into any particular art-historical compartment. "Fluxus has not been invented yet," as Emmett Williams said. Perhaps it has not yet been invented because it is impossible to take out a patent on phenomena which are more a state of mind than anything else. "A long history with many knots" was the description used in the comprehensively documented exhibition in the Institut für Auslands-beziehungen in Stuttgart in 1994, dedicated to 32 years of Fluxus in Germany.

The immense influence of Fluxus is unquestionable, but there has been as yet little research into its detail. Joseph Beuys soon became a thorn in its flesh and subsequently established a position that was distinctly different from Fluxus as propagated by Maciunas. As Uwe M. Schneede put it, Beuys was not the one for short,

focused events where materials and objects were employed for their own sake and freed of any other significance. On the contrary, he piled them high with autobiographical, historical and mythical meaning. Nor could Beuys do anything with the required anonymity of Fluxus. His Actions were imbued with his personal experience of life, suffering and happiness – coloured in every sense with his own range of expression, his biography and his body language.

Nam June Paik, the 'Father of Video Art,' was hugely influenced by Fluxus. Born in Korea, he had studied piano and composition in Freiburg, and moved into Fluxus with theatrically staged performances of compositions and absurd acts of aggression that went far beyond Cage. Paik wanted to disturb and to shock and, at the same time, he was searching for his own mode of expression. This was perhaps what induced him to cut off his highly-respected teacher's necktie during the Action *Etude for Piano (forte)*, (1960). However, the trigger for his decision to work with television was not his destructive leaning, which in itself, sets him clearly apart from Vostell. The deciding factors were his technical skills in electronics (driven initially by sheer curiosity) and his knowledge of the experiments and theories relating to the production of abstract, tele-visual images by the painter Karl Otto Götz.

Paik, unlike Vostell, was not concerned with the 'box' as an object. He was much more interested in the aesthetics of the images that he was creating and affecting by his own interventions, that is to say, he was interested in the software. These then are the circumstances which meant that Paik could take his work beyond Fluxus and usefully extend it to video art. Thus it is hardly surprising that Paik was one of the first to buy the new portable video recorders that came on to the market in 1965, or that in 1970 he and Shuya Abe (p. 590

above right) carried out pioneering work on video-synthesisers.

Fluxus has been a rich source of inspiration to young artists. Sigmar Polke's (pp. 387 ff) *Potato Machine* of 1969 and Rosemarie Trockel's chewed and silvered *Mouth Sculptures* of the early 90s positively exude the spirit of Fluxus. Concept Art, Performance Art, Video Art and, not least, the remarkable revival of Multiples are all unthinkable without Fluxus. The only regret is perhaps that the original Fluxus objects and Multiples, despite their apparent waywardness, have nevertheless largely fallen prey to museums and galleries. But does that mean that Fluxus failed?

### The Principle of "Permanent Creation"
Why is it that artists are held solely responsible when their apparently promising endeavours in fact have no real impact on everyday life? Artistic works are about communication, whatever form this may take – as an idea, transient or tangible – and are intrinsically dependent on an opposite number. This even applies to a phenomenon like Fluxus which managed to tear down the barriers between supposedly 'high art' and a much broader public. Filliou went a step further when he said: "Whatever I say is meaningless if it does not inspire you to follow up my ideas with your own."

Filliou, whose motto was 'permanent creation,' saw creation as a process that every human being could take forwards. He viewed himself as providing the necessary tools for this, namely 'imagination' and 'innocence.' In 1969 he stored these in the form of a neon sign in a *Permanent Creation Tool Shed* (ill. above). His message was that there is no need for a technically complex array of

tools for creating the world: the most important thing was that a person should use these two, intrinsically childlike qualities – imagination and innocence.

As far as disseminating his ideas was concerned, Filliou was always restrained and relatively low-key. He was the epitome of casual and wrote above his door: "Le vagabond de l'art est *toujours* en voyage. Laissez nom et ('et' was then crossed out and replace with 'sans') adresse, il vous touchera *un jour* sans doute. (*par télépathie*)." Anyone trying to get in touch with the 'vagabond of art' was kindly requested to leave behind their name without address and, no doubt, one day Filliou would touch them, if only by telepathy.

### The Message of Felt TV
In contrast to Filliou, Beuys devoted his entire life and energy as an artist to propagating his own inner convictions. It would simply not have occurred to him to put his message up on a sign above his front-door. He knew of more effective tools and channels. Beuys capitalised first and foremost on his own charismatic personality (in Actions from 1963 onwards), then after 1965 he made multiples and following this turned to the mass-media. He carried out over thirty Actions in the period 1963–1985, mostly in the 60s. These were accompanied by tireless appearances as a speaker, in interviews and discussions. He took part in documenta 5 in Kassel in 1972 with his "Büro der Organisation für direkte Demokratie durch Volksabstimmung". For 100 days he sat there with two colleagues and discussed issues with interested

**Robert Filliou**
Permanent Creation Tool Shed, 1969
Garden shed with neon installation, 250 x 300 x 300 cm
Remscheid, Feelisch Collection

*"I could never do the things that people who have been to art school do. I doubt whether they can do what I can do. But my child can."*
ROBERT FILLIOU

**George Brecht**
Drip Music (Fountain), 1963–1970
Oak with brass and bronze installation, 200 x 35 x 8 cm
Remscheid, Feelisch Collection

*"A source of dripping water and a container are arranged so that the water falls into the container."*
GEORGE BRECHT

**Nam June Paik**
Sonatine for Goldfish, 1975
Old television casing with
aquarium

Fred Barzyk, Shuya Abe and **Nam June Paik** at the synthesizer in a studio at the WGHB-TV station in Boston, 1970

**Joseph Beuys**
Felt TV II, 1968
Television set made by Nordmende,
89 x 62.5 x 64.5 cm with felt-covered
screen, 37 x 47 cm; internal aerial,
felt-covered wooden panel on the
wall, 58 x 90 x 2 cm
Kassel, Staatliche Museen Kassel,
Neue Galerie

visitors: ranging from his attitude to what being human means, through the creativity that results from individual freedom and the related notion of 'democracy from below,' to the matter of pay for housewives and any other questions that visitors might put. At 3 o'clock on one of the 100 days, Dirk Schwarze from the *Hessisch Niedersächsischen Allgemeine*, a local newspaper, noted down: "560 visitors so far. A young girl comes up to Beuys and says, 'This is art?' – Answer: 'A special kind of art. You are allowed to think too.'"

Beuys made use of the mass-media just as he used his multiples, namely as a vehicle for spreading his concept of 'social plastic.' In June 1977, when he had the chance at the opening of documenta 6 to participate in a live satellite broadcast and to make whatever use he liked of television, he decided simply to deliver a speech. Whatever form of address Beuys chose, his over-riding concern was to spread his own 'extended concept of art' which was to go beyond mere aestheticism and to embrace all areas of life.

Consequently he also viewed his own artistic activity as a 'far-reaching educative programme' for freedom. This was effectively reflected in *Felt TV*: a television Action first performed in 1966 and then again in 1970 for Gerry Schum's television exhibition, *Identifications*. "Turn the television away, look at yourselves!" With these words the art historian Wulf Herzogenrath got to the heart of the message of *Felt TV*. Sitting in front of a television screen covered in felt (ill. left) and boxing himself in the face, Beuys symbolically negated the one-sided broadcaster-viewer relationship, so that something "could develop in radically new circumstances."

# At the Interface of Art and the Media Industry

## Land Art

Richard Long did not stop walking across the field until his footsteps had beaten a clearly visible track. *A Line Made by Walking* (ill. right) was his first 'walked' sculptural work. In order to present it to the public he had to photograph it. A year later, in 1968, he undertook *A Ten Mile Walk on November 1*. There were not even any footsteps left behind after this walk. Afterwards the only aesthetic experience offered to the viewer was a map in landscape format with the route of the walk marked as a straight, diagonal line crossing the whole area. The art historian Antje von Graevenitz has described the actual work as lying between the documents. It has to be "(re)-constructed" in the viewer's imagination.

The need to explore new 'work'-spaces outside of the studio presented artists with a problem. How should such expansive works be presented to the public? What form should these artistic works take in a time when the notion of the 'art-work' as a commercially viable product had been so seriously discredited? Different artists found different solutions, some taking a conventional path, others taking a more unusual route. But the results were seldom as brittle and conceptual as Long's ten mile walk. For example Dennis Oppenheim's *snow projects* (p. 548) are practically all presented as collages, consisting of coloured or black and white photographs, cartographic materials, aerial shots and a short typewritten description of the work itself.

Michael Heizer (p. 545) presented his at times extremely transient and inaccessible works partly on mural-sized coloured photographs which a contemporary critic mockingly described as "big, brightly coloured landscapes." Robert Smithson devised a possibly more elegant solution to the problem of how one should bring works created in inaccessible places to the public: he made the question of representation part of his own strategy as an artist. He used photographs, plans and sketches as intermediaries and transferred items, such as pebbles, from the 'site' of the work to the exhibition space ('non-site'). Thus he spared his public tedious pilgrimages to the sites where he had been working – that is, until he created his *Spiral Jetty* in 1970, the first of his stunning outdoor sculptures (p. 546).

When on-site artistic activities only produced perishable results, or wholly intangible results, conventional modes of expression such as plans, sketches or work-descriptions and photographs came up against their natural limitations. A number of ambitious storyboards by Smithson (usually as drawings) have survived, although only one could ever be realised – a 30 minute 16 mm film called *Spiral Jetty* (1970). In 1967 he was thinking about using "the real land as a medium" and then to televise his work and broadcast it throughout the world.

Walter De Maria pursued a similar idea in the expectation that in the future he would be able to do without museums and art galleries altogether. In 1968 he made a dramatic exit from the 'art business' because he had bigger things in mind. But before he went into the desert to start work on his *Three Continents Project*, he planned to bury the Galerie Friedrich in Munich in earth (p. 547). Regrettably, De Maria was not able to find a sponsor for his project that was to have been photographed from a satellite and broadcast via television. It was never realised and thus shared the fate of so many similar projects which failed because of the conditions of production and distribution that prevail in the film and television industry.

*"I use the world as I find it – as a plan and as chance."*
RICHARD LONG

**Richard Long**
A Line Made by Walking, 1967

By 1970 the numbers of artists using previously 'unusable' materials had grown to such an extent that the New York Museum of Modern Art felt justified in putting on a major exhibition presenting an overview of these activities. "Information" brought together numerous works from previous years that had left behind no tangible results and which were now only to be found as drawings. What a shock for the public whose perceptions had been trained in the luscious visual world of the Pop Artists and the gigantic canvases of the Abstract Expressionists! The works in "Information" were hiding behind mounds of stored audio, photographic and film records. Even their originators seemed to be disappearing behind banks of telex machines, telephones, radio equipment and screens. As one artist commented sarcastically at the time: "There weren't any artists in the show."

### Laboratories for the Art of the Future

In 1965 in the USA, the Japanese firm of Sony brought out a piece of portable electronic equipment for semi-professional use, called 'Portapak.' With it the person-in-the-street could record and play back visual images. Until this point, only television stations had had this type of equipment. Of course these new gadgets were somewhat restricted in their use. By all accounts Paik bought one of the very first 'Portapaks' when they came onto the market. He shot his first tape during a taxi journey on 4 October 1965 when the Pope visited New York. Then he sent out flyers to announce the presentation of

**Andy Warhol**
John Giorno in 'Sleep,' 1963
16 mm film, black and white, silent,
6 hrs

*"It started with someone sleeping and then it just went on and on. I did actually spend all those hours filming it, although I did somewhat tidy up the end-result in order to achieve a better line."*

ANDY WARHOL

his tape in the Café "Au Go Go". On the flyer he prophesied a bright artistic future for the medium: "Just as collage has ousted oil painting, so the cathode ray tube will replace the canvas."

In the years that followed, three distinct groups began to use video. The first group consisted of engineers, film-makers and artists with a professional or non-professional interest in electronics. The second group consisted of artists with a background in music, the theatre, dance and the visual arts; they saw video as the logical extension of their creative work at the time. The third group consisted of collectives who, in a conscious rejection of television, were concerned to publicly document social and political reality.

In the USA in the late 60s and early 70s, numerous artists had the opportunity to apply their know-how in professional television studios. Hitherto television producers had been relatively conventional in their use of electronics. Now there was a need for new ideas. Financial assistance from specifically created foundations made it possible for WGBH in Boston, WNET in New York and KQED in San Francisco to accommodate 'guests' in the studios and to run workshops. Thus the first television program created by artists was made at WGBH and was transmitted in March 1969. Aldo Tambellini, Thomas Tadlock, Allan Kaprow, James Seawright, Otto Piene and Paik were all invited to test the creative potential of television and to explore it as a new art form.

Of the six participants in the workshop, the 'artist-technicians' Tadlock and Seawright proved to be most professional in the way they handled the possibilities of electronic image makingt that were given to them. Tambellini and Piene, on the other hand, were less interested in the possibilities provided by equipment and technology: they created a multi-media event in the ZERO-Action tradition and controlled it from the mixing desk. Kaprow and Paik also stayed true to their own backgrounds. As committed representatives of Fluxus and Happenings they included the viewers in their concept. Kaprow put on a live broadcast from four squares in Boston during which the public in the four locations could talk and wave amiably to each other. Paik emerged as an exuberant technician and Fluxus-man uncowed by the supposed humiliations of art and life. He humorously exhorted the viewers to join in: "This is participating TV. Please follow instructions!" Not only did he offer them a deformed Richard Nixon and a few Hippies, but also a naked go-go girl and decorative, electronically produced 'dancing patterns.'

### Explorers of the Moving Picture

The technically adept artists, who were already working in the 60s in the USA at the interface of art and media-technology, only enjoyed the limelight in the art world for a short time. They had been thrown up in the general explosion of forces, tiny pieces in a kaleidoscope of political, artistic and technological ideas and experi-

ments. And yet this was not a happy moment, for with the culmination of the events of 1968 and their imminent failure, the climate changed. Cracks were beginning to show in the belief in infinite economic growth – as its limitations and its detrimental effect on humankind and Nature were becoming increasingly obvious – and it seemed that the art business was no longer interested in innovation in visual technology.

In the 70s Larry Cuba was recognised worldwide as one of the few artists exclusively using digital computer techniques to explore the possibilities of abstract animation. His work followed in the tradition of abstract film going back to the 20s in the work of artists such as Oskar Fischinger, Len Lyes, Norman McLaren and the Whitney brothers. Cuba collaborated with the pioneer of computer-animation, John Whitney Sr., but also worked for Hollywood. However, he used 16 mm film which meant that his work was of not of primary interest to art-mediators. Significantly enough, this was the same fate that awaited Andy Warhol's films (p. 592) and also the less well-known, yet richly endowed, field of independent experimental and underground film.

Ed Emshwiller on the other hand received wider public recognition, as did the married couple Steina and Woody Vasulka, who – for reasons of their individual talents – oriented their work more strongly towards the artistic avant-garde. In the 60s and early 70s Emshwiller produced experimental films, cinema-dance projects, documentaries and low-budget feature films. He was employed for most of the 70s as permanent artist at WNET/13 in New York, which is also where he created a number of video tapes that are now regarded as classics in the genre (ill. above).

During the course of the 70s the Vasulkas built up their own laboratory. Having made their own equipment, they then devoted themselves to producing and working with sounds and video-images (ill. below). In 1970 Paik, in collaboration with Shuya Abe, was also constructing technical equipment (Paik/Abe Synthesisers) specifically to suit his own needs. However, Paik did not use this synthesiser to create images but to synthesise existing images. He was of the opinion that it was much harder to reverse information than to record it. And this attitude, plus his conviction that video art should be an intrinsic part of both art and everyday life, in effect prevented him from losing his way as an explorer in the lonely electronic image world. Paik's interest is in communication, not research. His sphere of operation is the world-wide culture of television and communication, including shows, rock music and advertising just as much as traditional Asian dance, Indian ritual and various other things particularly dear to his heart, such as when Cage talks about silence or when Charlotte Moorman, the cellist, uses her body as a string instrument (p. 594).

**Ed Emshwiller**
Sunstone, 1979
Video tape, colour, sound, 3 mins

*"Now we are trying to visualise the space which only exists as an electro-magnetic field."*
WOODY & STEINA VASULKA

**Woody & Steina Vasulka**
Heraldic View, 1974
Video tape, colour, sound, 5 mins

### 'Black Gate Cologne'

Although German viewers are as prone to television-fatigue as any, and there is a constant search for innovation, financial support for artists in television studios was only short-lived. Even the legendary WDR production, *Black Gate Cologne*, by Tambellini and Piene was only made by chance. After the event, television producers were surprised at the art-historical success of this "brew of black and white pictures with humming noises and sirens" which is claimed to be the first artist-made television production.

The raw material was two performances of a joint multi-media production by Tambellini and Piene called *BLACK air*. It was filmed using a number of studio cameras and then finished at the mixing desk. In addition, Piene contributed two light sculptures and a pneumatic flower, while Tambellini contributed documentary slides and footage of the assassinations of Martin Luther King and Robert Kennedy, amongst other things. After this, all that was needed was eleven monitors, four screens and an audience. Originally consisting of two 45 minute programmes it was heavily cut both before and after its first broadcast in January 1969 because it was felt that the audience could not take more than 23 minutes of *Black Gate Cologne*. The final bill for those 23 minutes of broadcast material came to 45,000 DM, and was accompanied by the undisguised regret that instead of the brilliant masterpieces mediating art to an enthused audience, it is this 'meta-artwork' that seems to have entered the annals (ill. right).

If it was not possible to use television in Germany as a laboratory for artistic experiment – as was happening in the USA – then this was also because the technology and the personnel in German television studios were primarily geared towards handling pre-packed film material. Experimental, electronic productions, on the other hand, require a particular kind of cost and labour intensive professionalism – this was true of the audio-visual works that José Montes-Baquer directed between 1969 and 1980, composed by Jan W. Morthenson, Bernard Parmegiani, Jan Bark and himself. Morthenson's *Supersonics* of 1969 even had specially programmed computer and speaker software to create the visual and sound effects he wanted. The automatic mixing desk was capable of producing 35 images per second, cox-box fades and optical feedback effects.

### The Gerry Schum Television Gallery

As a state institution with a public duty to disseminate culture and information to as wide a spectrum of the population as possible, German television barely demonstrated any interest whatsoever in testing the level of its own art coverage. Therefore it was hardly surprising when a young independent camera-man and film-maker dared to set up an alternative to the all-encompassing claims of professional television. In 1968 Gerry Schum, together with the art historian Hannah Weitemeier and the artist Bernhard Höke, came up with the idea of a television gallery.

Probably the television gallery would not have excited so much criticism and notice if it had only been about mediating art in a manner suited to the medium

*"I have got a hangover from music. It looks as though I can handle a music-video better than someone coming from the visual arts. I think I understand time and sequences, kinetics, better than a video artist with a visual background."*
NAM JUNE PAIK

**Nam June Paik**
Global Groove, 1973
Video tape, colour, sound,
28 mins

of television. But in 1968 it had to be about more. The aim was to rescue art from the "art-aura of the museum and the gallery" and to create a forum where discussion could focus on the notion of art serving society. However, when the first of a total of four programmes was transmitted in 1969, there was little left of the earlier high expectations. Schum, in his television gallery, used television as it ever had been, as a means of publication. He put on a vernissage-style 'opening' with invited guests and left no-one in any doubt that the transmitted 'exhibits' were of his own artistic making.

"Land Art" was the title of the first television exhibition to be transmitted nationwide. It presented an overview of a new, artistic phenomenon, namely Earth Art: in Europe it became known as "Land Art" following this programme. It consisted of eight, carefully constructed film reports without commentary and set in magnificent locations: the breathtaking mountain panorama of the Mohjave Desert in Walter De Maria's *Two Lines Three Circles in the Desert* – filmed from a camera as it rotated three times on its own axis, while the artist grew smaller and smaller, walking all alone between two white lines; Jan Dibbets's square marked out in the sand, parallel to the edge of the picture, which was then obliterated by the tide; *Hole in the Sea* by Barry Flanagan, and more. While these were impressive images, nevertheless they were open to criticism as smacking of 'blood and soil' mysticism and were scorned by some as a *Heimatfilm*. Even some of the more elevated critics felt that these artists had somehow succumbed to the age-old search for the blue flower (Jürgen Claus), or asked what was the difference between Richard Long and a rambler putting on a slide show in his sitting room. In an article for *Die Zeit*, Petra Kipphoff asked pointedly: "Is it possible to behave more aestheticisingly than this or to beat a hastier retreat from reality?"

What matters is the heated debate that Schum's productions aroused and how controversial they seemed, particularly when one bears in mind that today they are held in the picture stores and video-archives of a number of museums: now they are regarded as fine examples of a classic avant-garde movement, however precarious

it was at the time. They were never originally intended to end up in museums. Film-artworks were only supposed to exist for the duration of the transmission. They were never intended for the art market. As it turned out, it was Schum's persistent refusal to add any form of commentary to his films that ultimately meant an end to the television gallery.

Schum was then left with no alternative other than to retreat back into the art business. He therefore realigned his focus, turning to video, and in 1971 opened the first gallery in the world specialising in video art. However, in doing so he in effect fell between two stools. He had initially gone into television art in order to escape the commercial exploitation of art, but now that he had a new medium, namely video, at his disposal – that seemed like no other art form before it to hold out hope of the democratisation of access to art – he set about establishing it precisely where many people felt it did not belong: right inside the art market.

**Otto Piene** and **Aldo Tambellini**
Black Gate Cologne, 1968
A light-show, black and white, sound, 23 mins (abridged version)
Broadcast by the Westdeutscher Rundfunk, Cologne, 26 January 1969. Directed by Ferdi Roth

*"We live in a reality with structures defined by the inventions of the mass media – printed and electronic images are the building blocks of our cultural evolution."*
ALDO TAMBELLINI

# Video-Software, Hardware and Performance

### Pixel-Theatre on the Screen

In the art world, video most frequently appears in the form of video tapes, that is to say as an immaterial, screen-dependent artwork. Thus right from the outset – and seen from a conservative perspective – it has struggled for recognition as an artform in its own right. In his day, Schum sought a way out of this dilemma by bringing out not only unlimited video editions, but also certain video tapes in limited numbers like multiples. From a more progressive perspective, things look rather different. For example, Fred Forest, living and working in France as a media and communication artist, believes that what he sees as a broadly-based cultural evolution, beginning in 1970, means that eventually electronic image production will completely supersede the traditional variety.

The most serious and persistent problem facing video as a medium is that one cannot hold a tele-visual image in one's hands and one cannot hang it above one's sofa. It shatters our perception by the shock of its momentary transmission, but offers no bodily resistance. "Our problem," writes Forest, "is no longer that of Classical art – the beholding of an object – but rather the dynamics of the emergence of the object!"

Visual information is electronically stored on tape. One cannot take a tape between one's fingers and pour over it frame by frame like a film strip. The video camera codifies the received light rays as abstract values which are then transformed into individual pixels on the screen when the tape is played. Thus there is no sequence of images as in a film. It is much more a case of images that are in a constant process of transformation and nowadays each individual pixel can be edited electronically or digitally, eliminated, hidden, reversed, coloured and replaced.

### Mishandled Objects, Sculptures and 'Short' Circuits

Video objects, video sculptures and video installations are, if anything, closest to traditional art forms. Even Vostell's prepared, shot and buried television sets and Paik's objects with their altered image-creation capability from the early 60s acquired the character of objects in that they had been 'prepared.' In a similar vein, Beuys covered over the screen of a television set with felt. Thus he alienated the set from its actual purpose and released it for a new function (*Felt TV*, p. 590).

Similarly traditional in approach are those works which are constituted as a closed form with integrated software. The deciding factor is whether or not the plastic object and the video image come together in such a way that the two are mutually dependent. For example, Shigeko Kubota's *Nude Descending a Staircase* (ill. left) without the software would be no more than a plywood box which could equally well be a prop in a shop-window display. Kubota, born in Japan, created this piece – by now a classic – in homage to Duchamp's 1912 picture of the same name (p. 129). The irony of this work lies in the total immovability of the plywood staircase which Kubota uses for her 'running' electronic animation of a nude going down some stairs.

**Shigeko Kubota**
Nude Descending a Staircase
(Duchampiana), 1975/76
Video sculpture; 4 monitors,
1 recorder, 1 video tape, plywood
structure, c. 170 x 79 x 170 cm
Kassel, documenta 6 (1977)

*"The invasion of sculpture by video has finally dismissed persistent prejudices against video, namely that it is 'fragile,' 'superficial,' time-dependent' and 'transient.'"*
SHIGEKO KUBOTA

The Belgian artist Marie Jo Lafontaine integrates a monitor into a larger sculptural form that the public can walk into. *Victoria* (ill. right) draws visitors into its spirally opened interior, where they are enveloped in a maelstrom of time-delayed images. Two young men circle round each other, watching each other, wooing each other? It is impossible to tell. It is about life and death on a highly erotic level, where hatred and lust, beauty and horror come together. Again and again the artist draws visitors out of their distanced attitude and involves them emotionally, despite themselves and the feeling of contradiction this induces. She seems unintimidated by taboos and is not frightened of pathos.

Video objects and sculptures are characterised by their flexibility and movability. By contrast, 'installations' generally have a much more intimate relationship with the location. Klaus vom Bruch's works require constructions much like 'installations.' *The Hardening of the Average Souls* (Die Verhärtung der Durchschnittsseelen), made in 1986, consists of two video recorders and metal structures, placed between the floor and the ceiling in two opposite parts of the room. These serve as carriers for transmitting and receiving equipment. Two antennae transmit visual material on video tapes to two monitors positioned opposite each other, sending a signal across the space between them. But of course this is not all. What intransigent technology does not allow – namely physical and bodily intervention – is demonstrated by the artist in video images. These show a rotating parabola antenna superimposed on a breathing thorax. What seems to be a puzzling object in interstellar space turns out to be a close-up of a bicycle pump. Is this perhaps the key that vom Bruch will use to unlock the 'hardening of the average souls'?

Other works involve an entire room and are clearly following in the tradition of environments. An example

**Marie Jo Lafontaine**
Victoria, 1987/88
Video sculpture made from 19 wooden sections in the form of a spiral; 19 monitors, 6 video tapes; width: c. 900 cm
Installation; Prato, Centro per l'Arte Contemporanea Luigi Preti

**Marcel Odenbach**
Tobacco College or I am itching to ..., 1994/95
Installation with video projection Bonn, Kunst- und Ausstellungshalle der Bundesrepublik Deutschland

*"I don't evaluate what is more important and what is less important: instead I work with juxtapositions."*
MARCEL ODENBACH

**Fabrizio Plessi**
Roma, 1987
Video installation; marble slab,
43 monitors, conveyor belt,
380 x 1000 x 700 cm
Kassel, documenta 8 (1987)

*"An awareness of one's own person
comes from a certain level of activity
and not just from thinking about
oneself. You have to practise it."*
BRUCE NAUMAN

**Bruce Nauman**
Live Taped Video Corridor,
1968–1970
Installation; 2 monitors, camera,
video tape, walls,
c. 533 x 1220 x 90 cm
Milan, Count Panza di Biumo
Collection

of these would be Paik's *TV Garden* (1974–1978) made
from about thirty different television sets plus plants
and trees, which can be viewed from a raised ramp. In
1977, Fabrizio Plessi (ill. above) designed an 'environ-
ment project' for an empty swimming pool, where a
swimmer swims lengths on 24 monitors set up next to
each other. The images were shot using 24 synchronised,
fixed underwater-cameras. A huge effort but results are
simply breathtaking. This particular project was realised
by the artists of the Studio Azzurro who were working
on the boundary between art and entertainment, and
who repeatedly demonstrated their skill in making the
best use of effects, as Edith Decker has pointed out. Per-
haps one might just add a sentence here from Walter
Benjamin's 1936 essay "The Work of Art in the Age of
Mechanical Reproduction": "The history of every art
form shows critical epochs in which a certain art form
aspires to effects which could be fully obtained only
with a changed technical standard, that is to say, in a
new art form."

Things become more complicated for the viewer,
when the environment consists of not only images but
also sound. Marcel Odenbach's *Tobacco College or I am
itching to …* (Tabakkollegium oder es brennt mir unter
den Nägeln; p. 597) takes place in a darkened room.
The viewer is faced with video images and sound pro-
jected simultaneously and in succession from different
directions. On the two longer walls, facing each other,
there is a counterpoint of images: on the one side there
are images of hatred and violence from a society spin-
ning out of control and on the other side is the artist
looking stoically into the camera and smoking a ciga-
rette. This is accompanied by live sound until suddenly
Beethoven piano music wells out of one of the four

**Wolf Vostell**
Grashoppers, 1969/70
Collage; 20 TVs, camera, photo on
canvas overpainted and smeared
with acid, bones, hair, shoes, tennis
racquets, 280 x 800 x 200 cm
Vienna, Museum Moderner Kunst,
on loan from the Austrian Ludwig
Stiftung

speakers positioned in the corners of the room, distracts the viewer's attention and completely changes the atmosphere.

Odenbach proves himself to be a virtuoso choreographer in this audio-visual event which only lasts a few minutes. With a fine sense of timing he controls perception and the mood in a way that could almost be described as totalitarian. But Odenbach is not only a master of smoothly operating equipment: he also

throws a few monkey wrenches into the works, generating ambiguity and confusion. Taking on the role of the viewer, he presents himself as a voyeur and perhaps even as an observer somewhat out of his depths. He neither takes sides nor pins the work he is presenting to any particular ideology. Doubtless this is the source of the challenge inherent in his work.

Yet other installations involve closed circuit television, where live video pictures are played on a monitor.

*Below left:*
**Peter Campus**
Interface, 1972
Closed circuit installation; 1 black
and white camera, 1 black and
white video projector, 1 spotlight,
1 sheet of glass, 180 x 250 cm
Cologne, Kölnischer Kunstverein

*Below right:*
**Nan Hoover**
Movement from Either Direction,
1995
Video installation
Bonn, Kunst- und Ausstellungs-
halle der Bundesrepublik Deutsch-
land

**Nam June Paik**
TV-Buddha, 1974
Monitor, camera, statue
Amsterdam, Stedelijk Museum

Frequently the viewer is caught up in the 'short' circuit between camera and monitor. Vostell integrates the viewer on twenty monitors into an eight metre wide scenario showing a collage of a lesbian couple and the violent end of the 'Prague Spring' (p. 599 above). Bruce Nauman creates a deep sense of unease in the visitor to his *Live Taped Video Corridor* (p. 598 below): having squeezed into a narrow passage, the visitor then walks down this, approaching an image of him or herself on one of two monitors (placed on top of each other) only to find, contrary to expectations, that the image is grow-

ing ever smaller. Instead of confronting visitors with themselves, as it were, Paik shows an antique statue of a meditating Buddha facing an image of itself on a television screen (ill. left).

Peter Campus, who first worked in experimental psychology, created spaces where a person could encounter his or her own image (pp. 599 and 608). His closed circuit installations, made between 1972 and 1978, are characterised by an immense stillness which results from a combination of darkened room, black and white images, and a strictly limited means of expression. Dan Graham's specialised in reflected time-delay spaces where the viewer is confronted with his or her own immediate past.

In works produced during the 80s, the pendulum swings towards interventions which have concrete aesthetic or optical consequences. The American artist Nan Hoover works in her closed circuit installations with coloured, video projections of light phenomena. The visitor can then enter into these and intervene in them (p. 599 below right). Klaus vom Bruch's 1988 *Radar Space (*Radarraum) in fact has nothing to do with video any more. It consists of a rotating radar dish with an ultra-sound sensor and a monitor mounted on it. Using a time-delay, it translates the presence of bodies and their movements into graphic curves. Members of the public produce the images.

## Transformations in Live Art

The appropriation of the hitherto artistic phenomenon of the Happening by the revolutionaries of the Paris Spring marked both the highpoint and the end, for the time being, of modes of artistic expression that tried to

**Klaus Rinke**
Mutations I. Primary Demonstration, 1970
Photo sequence (112 parts in total), each 59.5 x 42 cm

*"I have chosen the body and bodily gesture as a dematerialised, particularly clear medium and explained it with a text."*
KLAUS RINKE

enter into 'real' life by means of explosion and provocation. It was also not possible to go on endlessly repeating acts intended to expand and heighten consciousness, if these were not so much performed as simply reliant on shock tactics, spontaneity and an element of therapy. Performable live art only developed into an independent art form when the energies formerly invested in proclamations and Actions were redirected towards art-immanent questions.

One way out was taken by certain artists working in the tradition of the Viennese Actionists who, although much more analytical than their predecessors, were now turning their attention to their own bodies. The Austrian artist Valie Export devoted herself in her feminist Actions to historical manifestations of female body language (ill. right). Gina Pane and Chris Burden set out on a voyage of self-discovery via their own bodies (ill. below left). Nauman and Klaus Rinke used their bodies as a sculptural medium (p. 600 below) and Arnulf Rainer also used his body as a telling means of expression.

In its essence a performance is intended to be a-medial, conveying information directly and without any other intermediary. It 'happens' in a particular place at a particular time, but also in the hearts and minds of those present. It is a unique poetic act with a potentially enduring effect if it then takes on a life of its own in the viewer's head. For this reason it is also quite impossible to document performances adequately. No photograph and no film could convey the ceremonial, highly aesthetic, atmospheric moments of a James Lee Byars performance with all its sights and sounds (p. 602 below

left); however sensitive, no documentation could convey the almost unbearable tension that was created between Beuys and his public.

Performance would not have acquired the significance that it has already commanded for some time, if it had *only* remained an a-medial medium. When performance reached the point that it began to embrace photography, film and video it also began to develop a wide spectrum of modes of expression. Rebecca Horn

**Valie Export**
Tap and Touch Cinema, Expanded Movie, 1968. Action, Vienna

**Chris Burden**
Stills from 'Documentation of Collected Works,' 1971-1975
Video tape, black and white and colour, 36 mins
Cologne, 235 Media

**Rebecca Horn**
The Gentle Prisoner, 1978
Metal, peacock feathers and other materials, 100 x 83 x 32 cm (closed)
Private collection

**Jochen Gerz**
Calling Out until the Point of
Exhaustion, 1972
Performance recorded on video,
black and white, sound, 25 mins

Gerz stands 60 metres away from a
video camera plus microphone and
shouts as long and as loudly as pos-
sible until his voice becomes hoarse
and then inaudible.

staged her puzzling acts with body objects purely for
film and the video camera (p. 601 below right). Jürgen
Klauke (p. 603 below) and Rainer, in intimate perform-
ances, poured existential psychograms into frozen, pho-
tographic images.

The use of video made it possible to undertake per-
formances without the constraints of time and place or
even without an audience. Certain artists like Nauman
and Rinke working on body/space processes, conceived

performances for the camera alone. In the case of
Jochen Gerz the camera was the only viewer at his
Action *Calling Out until the Point of Exhaustion* (Rufen
bis zur Erschöpfung; ill. left). Sixty metres away from a
video camera plus microphone, he shouted as loudly as
he could until his voice began to go and finally went
completely. Vito Acconci also used the camera to wit-
ness his activities: however, unlike Gerz, there was an
audience, although either kept at a distance from the
performance or excluded altogether. In *Isolation is trans-
parent* (1973), Ulrike Rosenbach performed behind a
transparent sheet, where she spun herself like a spider
into a net of thick, white rope. The public were able to
watch on a monitor which showed the proceedings from
a bird's eye view above the artist.

In the 70s, performance entered its 'monitor phase.'
This was when Gerhard Johann Lischka coined the
phrase "Taumel des Sehens" meaning something along
the lines of 'giddy vision.' And indeed, when an event is
simultaneously filmed or shown on a monitor the
demands on the viewer are at least doubled. In principle,
as in Cubism, the viewer is now confronted with several
perspectives at once. The difficulty here for the viewer,
however, is that the perspectives are not all shown in the
same medium: the multiple views in a Cubist picture or
sculpture are at least all contained within the same whole.
By contrast, the public in a video performance is con-
fronted with an event that is both live and on film, invit-
ing comparison between the two modes of expression.

How differently real and camera-mediated events
can be weighted is demonstrated by Rosenbach in *Don't*

**James Lee Byars**
The Play of Death, 1976
Performance
Cologne, Dom Hotel

**Stuart Brisley**
Untitled, 1993
Performance. Hellerau

*think I'm an Amazon* (Glauben Sie nicht, daß ich eine Amazone bin; ill. right). In this live video action in 1975 she shot fifteen arrows at a reproduction of Stefan Lochner's famous *Madonna im Rosenhag* (1451, Wallraf Richartz Museum, Cologne). The crux of the performance lies in the superimposition and synthesis on the screen of images from two different cameras, which means that the arrow not only pierces the face of the Madonna, but also her own.

By the late 70s there was a clear move towards camera-led image production: there were economic reasons for this, but it was also connected with the fact that individual self-discovery became less important as a theme. Some artists turned back to painting which had recently been resurrected, as it were. Others turned their attention to the realm of installation which was now creating a higher level of interest in the art business. Some performance activists sought out new surroundings and a new, unprejudiced public. For years Tom Marioni attended a regulars' table in his local pub. Tehching Hsieh spent a year in a cage and another year outside in the open air. Res Ingold founded his own airline. And if performance art still has an effect today, then that may have something to do with the fact that we live in a time that is sadly in danger of choking on its own clutter.

# The Seventies: a Reservoir of Ideas

### Actors in Time and Space

Many artists in the late 60s and early 70s made videos because what they wanted to do could be best expressed on video. This was also true of John Baldessari, whose *Folding Hat* (ill. below) is about the genesis of a plastic work. The video shows a half-hour, uncut close-up of the artist holding a hat which he proceeds to knead, form, manipulate and generally play with. The work is intrinsically bound up in video, although this may not at first sight be obvious. It is neither a documentation that could have been filmed nor do Baldessari's actions actually result in a plastic work: the point of the work is in fact the interaction between the artist and the video camera. The instant replay of the recorded images allowed him to re-adjust the appearance both of the object and of himself on the screen moment by moment. Baldessari's *Folding Hat* is therefore at one and the same time a plastic creation and a two-dimensional picture-surface composition.

In photography, film and video, 'interactivity' could well be the most fitting description of the relationship between artist and medium. In this dialogue with a certain mode of visual expression, the action of the artist takes on a new aesthetic identity. And the work can be carried out unhampered by economic constraints (which dominate the work done in television studios) in the intimate atmosphere of the studio and with a minimum of equipment.

The video pioneer Bruce Nauman ended his training at a time when many young artists were painting their last ever pictures, and he, too, rapidly turned his back on painting. In 1965/66 he began to address the question of "how objects relate to the space around them." He created abstract objects using flexible materials such as fibre glass and rubber. After 1968 he also used his own body as a sculpture and staged poses and sequences of movements for film and video.

In *Manipulating a Fluorescent Tube* (p. 605 above) which he made in 1969, he created a variety of poses involving a fluorescent tube and himself, and concerning the relationship between the two. Nauman's use of a neon tube is of course reminiscent of Dan Flavin's gleaming neon light zones creating walls of light and later entire rooms of light (p. 528 f). However, while

*"It should not be called: 'Now I am going to make a video piece' but: 'What I want to do is best expressed on video.'"* JOHN BALDESSARI

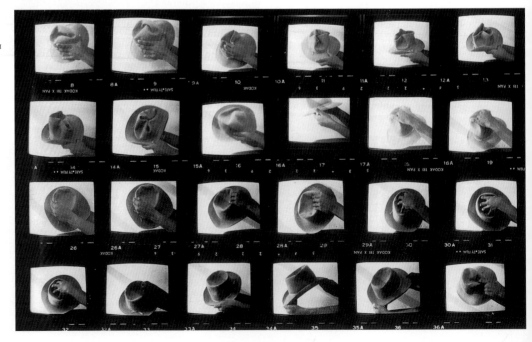

**John Baldessari**
Folding Hat: Version 1, 1970
Video tape, black and white,
sound, 30 mins

Flavin – in accordance with the precepts of Minimal Art – was working with neutral, geometric and above all pre-existent basic forms, Nauman introduces his own body into the situation and, in doing so, re-introduces all those qualities into the artwork that the Minimalists had banned: namely the organic (with all its ambiguity and uncertainty), the mystic and the erotic. Nauman's exploration of the parameters of plastic forms is typical of a particular kind of basic research that was being carried out in the arts at the time by musicians, dancers, film-makers, theatre people and artists alike, sometimes even in collaboration. Interest centred on the principles and procedures of any artistic activity, be it music, movement or plastic, in a search for the intrinsic aesthetic of these principles. Richard Serra, inspired by the experimental motion studies carried out by the dancer Yvonne Rainer, made a series of 16 mm films in which hands perform particular, almost pictorial, actions (p. 606). The length of the films is dictated by the length of time required to perform the individual actions. Franz Erhard Walther used textiles in his Actions which were intended to induce an awareness in the 'user' of his own body and of his relationship to others (ill. below).

**Bruce Nauman**
Manipulating a Fluorescent Tube, 1969
Video tape, black and white,
sound, 60 mins
Zurich, Kunsthaus Zürich

**Franz Erhard Walther**
Just Before Dark No. I/32 (Kurz vor der Dämmerung Nr. I/32), 1967
Action with cotton material,
c. 600 x 45 cm, 9 loops, 9 bolts
From "Walking as Sculpture"
(Gehen als Skulptur)
Frankfurt/Main, Museum für Moderne Kunst

## Messages in the First Person

There is a commonly held view that in the 70s, after the failure of 1968, people withdrew back into their own private spheres in order to explore their own inner worlds. But this is blinkered at best. Self-discovery was indeed an essential element in the mood of the late 60s and the full emancipation of the individual leading to mental, physical and creative freedom was the aim of all the 're-volutions.' However, in actual fact, artists took up at the point the 68ers had vainly tried to reach, vainly in that their vision was clouded with ideological ballast. In Beuys's words: *La rivoluzione siamo Noi* (We are the re-volutions; ill. left). He located the creative source of freedom within the individual. The situation would only be changed through human creativity.

**Joseph Beuys**
La rivoluzione siamo Noi, 1972
Photoprint on polyester sheet,
191 x 100 cm
Heidelberg, Edition Staeck

*"I think I wanted to create some kind of filmic analogy - I use lead to construct these parts - and my own hand as my equipment."*
RICHARD SERRA

**Richard Serra**
Hand Catching Lead, 1968
16 mm film, black and white,
silent, 210 mins
Bochum, m Bochum, Galerie

Pieces of lead fall at short intervals and are visible as a grey blurred movement. The hand just has time to close and to open again. If Serra manages to catch the falling lead he immediately lets go again in order to have his hand ready for the next piece. The constant tension eventually tires the hand out. It becomes cramped and its reaction times slow down until it seizes up altogether. The effect is oppressive.

representation on the other. In *Vertical Roll* (ill. below) which she made in 1972, she increases the distance between the two (which she has established by means of video) by enveloping herself in material, hiding her face with a mask, or formalising her image to the point of unrecognisability by cropping it, showing it in extreme close-up, or hopping rhythmically.

Easily the most unusual form of self-representation is seen in the team of Gilbert & George, who have billed themselves as living sculpture since 1969. They set out neither to ask questions or to explore things nor to pursue any form of critical enquiry. The beginning of their work together was to be a 'tabula rasa.' In their words,

Looking back today, the 70s seem like a huge reservoir of ideas. It was a time of experiment focusing on the ego. Vito Acconci, with his background in literature, emerged in 1969 with performances and body works, where he exposed himself to highly volatile inter-personal situations. Later, he also used video and sound in order to communicate his experiences to the viewer, typically involving the viewer in his own personal feelings, by addressing him or her directly. In *Recording Studio from Air Time* (ill. above), he spent two weeks in a room in the Leo Castelli Gallery in New York. The room itself was closed to the public. There he then sat in front of a mirror and relentlessly tried to come to terms with an old, failed relationship. A video camera transmitted his at times dramatic attempts to understand what had happened and the blame he heaped on himself.

Nobody confronted their public more directly with fear, oppression, courage and aggression than Acconci. In performances by Marina Abramovic and Ulay there are echoes of the young Acconci's provocative manner and willingness to lay himself on the line. Characteristic of the work done by Abramovic and Ulay, who worked together after the mid-70s, is the fact of having to endure an oppressive or dangerous situation. In *Light/Dark* (p. 608 below left), lit by bright lamps, they knelt and hit each other in the face until one of them stopped. In the 80s Abramovic/Ulay dealt with intercultural experiences. In 1988 they set out from opposite ends of the 4,000 kilometre long Great Wall of China, only to part forever at the moment, weeks later, when they met up in the middle.

Peter Campus and Joan Jonas looked at the 'question-ability' of their own personas. *Three Transitions* (p. 608 above) was produced in 1973 by Campus at the WGBH television station in Boston and was to become a classic amongst early coloured videos. In this six-minute work, one sees Campus (by means of superimposition and two camera images) apparently slitting himself open and stepping through himself, creating a second face for himself and getting rid of it again by burning it.

Jonas's video works operate a fine balance of intimate self-reflection on the one hand and distanced self-

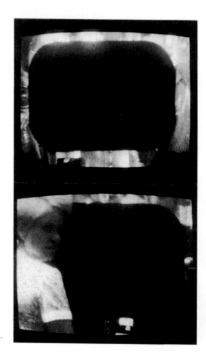

**Peter Campus**
Three Transitions, 1973
Video tape, colour, sound, 6 mins
Bonn, Städtisches Kunstmuseum

they neither wanted nor were able to add anything more to art: they refused to be creative. They decided to declare themselves, their life and their partnership as the art work. Nowadays it is no longer possible quite to imagine how extraordinary this apparently utterly indifferent artistic partnership appeared against a background of heated debate in so many areas. These two young men simply enjoyed their own existence in a state of Epicurean pleasure. They performed as 'singing sculptures' and justified their role as 'living sculptures' in the most diverse of media – initially in letters, then in photography and video or in drawing and painting (ill. below right).

It is naturally no coincidence that it was specifically men who felt that everything had already been said in art. Contemporary female artists would not have dreamt of making a similar statement. They had other things to do at this late stage in a culture which, for the last however many thousands of years, had had its contents and standards almost entirely dictated by men. Now women were taking up an issue that had hitherto been an exclusively male preserve: the portrayal of their own sex. In order to achieve this they turned to the new, as yet impartial, medium of video. Between 1973 and 1977 Friederike Pezold created a staged video cycle called *The New Incarnate Sign Language of a Sex According to the Laws*

**Marina Abramovic** and **Ulay**
Light / Dark, 1977
Performance; duration: 20 mins
Cologne, International Art Fair

*"We kneel opposite each other. Our faces are lit by two strong lights. We hit each other alternately in the face until one of us stops."*
MARINA ABRAMOVIC / ULAY

**Gilbert & George**
Underneath the Arches - Singing Sculpture, 1970
Performance
Düsseldorf, Kunsthalle

*"People thought it was very clever. But it was quite simple. We called it sculpture because we were studying sculpture."*
GILBERT & GEORGE

## Videos, Politics and the Media

In the 70s there was no shortage of attempts to rescue art from its ivory tower by means of video. Thus video in its simplest form – namely as a sound-synchronised recording of an event that takes place in time – was taken up above all by those who wanted their work to have an effect on the reality of everyday life. The New Zealander, Darcy Lange, set out in the 70s to depict the sheep-farmers of New Zealand and steel-workers in England exactly as he found them, in order to instigate discussion on the issues raised. Others set up as production groups with the aim of developing 'alternative' media work with ordinary citizens, minorities and those on the margins of society. However, the fact that other artists – such as Rosenbach, vom Bruch and Odenbach – who

**Ulrike Rosenbach**
Dance for a Woman, 1975
Video tape, black and white, sound, 12 mins
Bonn, Städtisches Kunstmuseum

**Friederike Pezold**
The New Incarnate Sign Language of a Sex According to the Laws of Anatomy, Geometry and Kinetics, 1973–1976
Video tape, 6 parts, black and white, silent, 10 mins (per section)
Bonn, Städtisches Kunstmuseum

of Anatomy, Geometry and Kinetics (Die neue leibhaftige Zeichensprache eines Geschlechts nach den Gesetzen der Anatomie, Geometrie und Kinetik; ill. right). This consisted of ten-minute motion sequences of body parts covered in black make-up. These were translated by a fixed camera into strongly abstracted symbols. In a sequence of unedited close-ups breasts, arms, eyes, thighs and pudenda took on a highly stylised life of their own, which in turn opened up a whole range of associations.

With the goals of the student movement in mind, in the early 70s Rosenbach set out in search of a strong, female ego. Her early videos are stylistically still broadly in line with the purism that held sway at the time. As far as content is concerned they are analytical and initially also autobiographical. In these works Rosenbach uncovers fixed roles and patterns of behaviour that women are subjected to in a male-dominated society.

Without doubt one of her most beguiling videos is her ten-minute *Dance for a Woman* (Tanz für eine Frau; ill. above). Wearing heavy, white, circular skirts she dances to the well-known waltz melody 'Ich tanze mit Dir in den Himmel hinein,' turning round and round until she becomes completely dizzy and sinks to the ground.

Vom Bruch and Odenbach also confront historical role-models and definitions. Vom Bruch uses video to examine historical documentary material and intimate self-portraits, which he then harshly juxtaposes. In his 1982 *Allied Band* (Alliiertenband; p. 610 above) he creates a collage of Gioacchino Rossini's *The Dance* and melodies from the film *Notte a Venezia*, archive footage of the advancing allied troops in the Second World War, aerial shots of the Rhineland devastated by bombing, and himself in a double role: as a voyeur who saves himself in a game of forgetting, and as a participant mimicking a bomber pilot. Narcissism, male eroticism, the pathos of the hero and the horror of annihilation are closely linked here. This video which won a number of awards owes its explosive impact not least to its finely balanced ambiguity.

**Klaus vom Bruch**
The Allied Band, 1982
Video tape, colour, sound, 10 mins
Bonn, Städtisches Kunstmuseum

were mainly producing 'art videos' – nevertheless also turned to a wider public with similar initiatives of their own, gives a significant insight into the deep sense of contradiction that must have accompanied their artistic work at the time.

Art that loses itself in everyday reality – as opposed to having formerly been totally isolated from it – forfeits any real distance to reality and with this, the capacity to take a critical stance vis-à-vis that reality. It was for precisely this reason that the American media artist Les Levine had to close his "Levine's Restaurant" – opened in New York in 1969 – after only one year. His "Museum of Mott Art Inc." which he founded as a service-oriented meeting place for interested amateurs and profes-

sionals turned out to be a more suitable venue for looking at the function of the artist: the artist's tasks and modes of expression as well as his or her role in society.

With Levine, Lange and the German group "Telewissen" as notable exceptions [translator's note: "Telewissen" is a German word-play which sounds like 'television' and means 'tele-knowledge'], few artists made any real effort to meet their untrained lay-public – a strenuous task and one for which they would receive few laurels from the art world. Artists were much more likely to adopt the position of critical analyst. There are numerous analyses of television, our 'Big Brother,' its forms of mediation and its aesthetic. Daniel Buren interrupted Schum's television exhibition, *Identifications* (1970), creating interference with a specially developed jamming signal. Serra served up harmless music plus a continuous text detailing critical facts and evaluations on the subject of television consumption and its effects (*TV delivers People*, 1973). Reiner Ruthenbeck retreated behind his *Object for Partially Hiding a Video Scene* (Objekt zur teilweisen Verdeckung einer Video-Szene; p. 607 below). Douglas David on the other hand sought actual contact with his viewers: in his *Austrian Tapes* (1974; ill. left) made for broadcast by Austrian Television, he incites viewers to go to the screen and make contact with the palms of their hands, their finger-tips, their cheeks and their lips.

**Douglas Davis**
The Austrian Tapes, 1974
Video tape, colour, sound, 15 mins

# The Eighties: "We're switching over!"

## Accelerated Images

In the 80s the visual arts became socially acceptable. In 1982, at the opening of an exhibition of the Neue Wilden at the Folkwang Museum in Essen, hundreds of buyers, television shows and magazines fought to acquire the new figurative paintings by artists from Berlin and Cologne. Four months earlier, a mere 25 visitors had attended an opening for a joint-exhibition by Baldessari and Odenbach in the same venue. Odenbach recalls exhibitions with a social and political message "for a society that did perhaps exist but which was just not interested." In addition, he also recalled "empty galleries, pieces that were unsellable: exhibitions for colleagues." In the booming art business video found itself increasingly marginalised, and ultimately relegated altogether from the art league: "Down with video art!" ran the art-critic Alfred Nemeczek's cover for the March issue of the journal *Art* in 1983.

All those who were not painting in a 'young' enough style now had to embark on various survival strategies. However, the barque manned by the Neue Wilden then foundered more quickly than had been expected and the art market greedily set about launching new trends. Odenbach described the situation at the end of the decade: "first there was sculpture, then everything had to have a text and now it's photography." But who would refuse to go along with this when starvation was the only alternative? Odenbach began working with large format drawings again. In 1986 vom Bruch produced his last studio tape, before turning exclusively to sculpture and installations. Nan Hoover announced that she would not be making any more videos because she had started drawing again.

However, these moves back towards the traditional genres of art history were certainly not purely strategic on the part of these artists. A whole new 'clip industry'

**Jenny Holzer**
Protect Me from What I Want.
From the 'Survival Series,' 1987
Installation, San Francisco
Courtesy Barbara Gladstone
Gallery, New York

**Les Levine**
Sell Yourself, 1987
Screen prints on billboards,
c. 292 x 658 cm (each)
Kassel, documenta 8 (1987)

**Barbara Kruger**
Untitled, 1994/95
Spatial installation with photographic screen prints on paper;
various sizes
Cologne, Museum Ludwig,
Ludwig Collection

was beginning to change the customary modes of perception of broad swathes of the population, but in a manner that some more critical observers felt to be threatening. Technical progress provided the means. The introduction of VHS standards, improved colour systems for videos and new possibilities for electronic post-production created a less expensive product, which could nevertheless achieve a high technical standard. At the same time improved systems of training and education smoothed the path for younger artists wanting to work with electronic art. Was this the chance to make use at last of those mass-media that had previously always been rejected on the grounds of technical inadequacy?

Perhaps the 80s, blithely going to seed, were just the foil needed by socially committed artists such as Levine, Jenny Holzer and Barbara Kruger for their uncompromising and disturbing work. In 1979 Levine primarily

aroused attention with his billboard campaigns (p. 611 right). Holzer displayed her initially laconic, later provocative, texts on posters and commercial advertising hoardings, LED signs, electronic message boards and in magazines (p. 611 left). Kruger combined existing black and white pictures with disconcerting texts, which she then put on walls, hoardings, T-shirts, shopping bags and postcards (ill. above).

## Cross-Fertilisation: High and Low Art

In the 70s video art was caught somewhere between the clip-world (with its clip-criticism) and other unrelated areas. It was elaborate and optically sophisticated. Its makers, a new generation of video artists, had grown up with television, were at home with different media and open-minded towards technology. "We're switching over: 'Let's go for the real public!'" This was the title given by the well-known video-joker, Herbert Went-

**Bob Wilson**
Stations, 1982
Video tape, colour, sound, 57 mins

**Laurie Anderson**
United States I–IV, 1979–1983
Performance

scher, to an article he wrote for the journal *Kunstforum* in early 1985. In it he brought to Europe the glad tidings of a new style of American video art.

The borders between different professions began to blur with astonishing speed. Freelance authors, directors and visual technicians all began to produce art videos, while artistic activity began to extend into the world of commercial film and television. The 80s celebrated the resurrection of a number of the ambitious pioneers who had already occupied the interface between research, commerce and art in the late 60s. Now personalities – such as the American couple working as video and TV artists, John Sanborn and Mary Perillo, or the performance artist Laurie Anderson (ill. p. 612 below left) – emerged into the light of the art world's attention, with careers that were centred as much in the media industry as in the art business.

Anderson, a trained violinist, art-historian and sculptor, became known in the 70s for her incisive, minimalist sound performances. Towards the end of the decade she then turned to multi-media music performances using synchronised instrumental, vocal, visual and text elements, which later became positively operatic performances. In the early 80s she moved into film and the electronic media. Anderson in fact managed to switch from audio-art actions into the popular media industry, while Brian Eno trod precisely the opposite path. In 1979 he stopped writing songs, brought his career as a pop musician in *Roxy Music* to a halt and

started to work on spatial, very meditative sound and video installations, which are at times reminiscent of the psychedelic light shows of the late 60s.

Clearly the cross-fertilisation of high and low art had something to do with the fact that video art, long thought to be dead and gone, was once again the subject of animated discussion. Max Almy made a name in the early 80s as the author of biting clips in which she

**Pipilotti Rist**
Pipilottis' Fault, 1988
Video tape, colour, sound, 12 mins
Collection of the artist

*Upper row:*
**Paul Garrin**
Free Society, 1988
Video tape, colour, sound,
c. 300 mins
Cologne, 235 Media

*Lower row:*
**Max Almy**
Perfect Leader, 1983
Video tape, colour, sound, 251 mins
Cologne, 235 Media

**Gary Hill**
Circular Breathing, 1994
Single channel video / sound
installation
5 video projectors, video disc and
video disc player, computer-con-
trolled video-switcher, amplifier,
loudspeaker; various sizes
Basel, Öffentliche Kunstsamm-
lung Basel, Museum für Gegen-
wartskunst

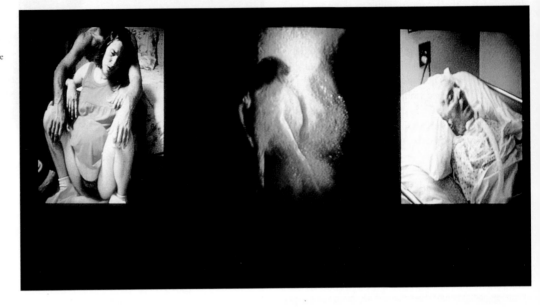

**Bill Viola**
Nantes Triptychon, 1992
Installation on three screens with
projection from behind
Nantes, Musées des Beaux-Arts de
Nantes

**Tony Oursler**
Broken, 1994
Video recorder, VCR, video tape,
wood, fabric; various sizes
Munich, Goetz Collection

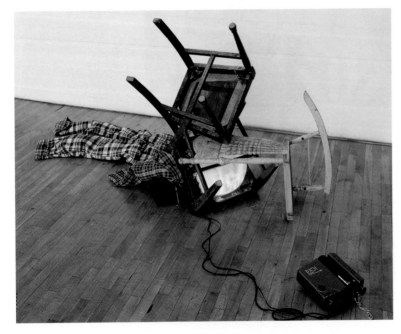

directed acerbic asides towards the latest video and
computer based modes of expression (ill. p. 613 upper
row). Dara Birnbaum isolated stereotypical elements
from popular television series like *Kojak/Wang* (ill. p. 615
left). She then integrated these as 'readymades' into her
video collages, using repetition, time lapse and time
delay techniques to uncover their concealed codes. In
the compelling video clip, *Free Society* (ill. p. 613 lower
row), Paul Garrin 'sold' his criticisms to a society that
thought it could only secure its 'freedom' by employing
a "special unit of the God Squad" (Pat Robertson,
American television preacher).

### The Video-Maker as Seer

The question is whether artists who put their 'artistry' at
the service of the media industry can, in the long run,
still produce independent works of a high artistic stan-
dard – that is to say, whether they can maintain any real
distance from the media industry. In 1987 the media
expert, Dieter Daniels, declared that "it is not the job of
video art to produce demo-clips for industrial prod-
ucts." Barely two years later it seemed to him that video
had been led into "an albeit comfortable" cul-de-sac by
the electronics industry that was marketing it. The posi-
tion of the artist was now more insecure than ever. Now
it was entirely the artists' own decision as to where they

should concentrate their energies and where they might find a forum for their work. What precisely are those artists doing who are not using the visual potential of the media industry to create a form of commercial added-value, but who use the screen as an opportunity for creative, experimental interchange with another language? In the hands of those such as Bill Viola, Gary Hill and Nauman, video techniques are simply a transition into a different, inner reality. Hill uses video as a visual medium to explore the complex inter-relationships between language, image and our processes of comprehension and perception (ill. p. 614 above). The American Bill Viola, past master of video art, reveals phenomena that are otherwise hidden below the surface, by speeding up images, or stretching them until they come to a complete halt; expanding and dissolving them, superimposing and reversing them. His works are extraordinarily pictorial in the way that they are conceived.

Viola's images not only have the tendency to burrow right into the viewer's consciousness, they also touch an existential chord. As early as 1979 his desert portrait, *Chott-el-Djerid (A Portrait in Light and Heat)*, took the viewer right to the threshold between physically verifiable facts and figments of one's imagination. Viola's main interest is in the unfathomable macrocosm of consciousness, ideas and phantasmagoria. For him the door

into this world is to be found in archetypal conditions of existence, in the secrets of the new-born child (*Silent Life*, 1979), in the cry of fear (*Anthem*), in the mystery of sleep (*The Sleepers*, 1992), in the silence of death and in the expectation of life (*Nantes Triptychon*, p. 614).

In his more recent video works since 1985 – having made none for twelve years previously – Nauman has been addressing traumatic, scarcely bearable aspects of human existence. "No, No, No, No" a clown cries in the face of some invisible threat. Other participants in the installation *Clown Torture* (ill. above right) try to complete absurd, impossible tasks. One is even observed in the toilet "while shitting."

No other contemporary artist has come so movingly close to the pitiable and the wretched as this supreme master of all media. "The True Artist Helps the World by Revealing Mystic Truths" (Window or Wall Sign, Rijksmuseum Kröller-Müller, Otterlo): a neon sign by Bruce Nauman in 1967. The sentence was a test that was to be examined for its validity. Today Nauman would like to extend the word 'mystic' to include notions of the hidden and the real. He has said that most of his works are the product "of aggression and anger." Sometimes this was specifically in response to world politics but, whatever the case, it was always about "the inability of human beings to get on with each other."

**Dara Birnbaum**
Pop-Pop Video: Kojak / Wang, 1980
Video tape, colour, sound, 4 mins

**Bruce Nauman**
Clown Torture (Dark & Stormy Night with Laughter), 1987
Installation; 2 colour monitors, 4 loudspeakers, 2 video projectors, 4 video tapes, colour und sound; various sizes
Installation; Lannan Foundation, Los Angeles

# The Nineties: Interaction in Virtual Space

**Stelarc**
The Third Hand, 1995
Performance
Tokyo, Yokohama, Nagoya

### Encounters on the User-Interface

Little by little the avant-garde movement in this century "moved away from painting" in order to meet the challenges of reality. Improving the world is no longer an option for artists working with technical media today. At best one might see oneself as helping to form the world. Media artists today benefit from the fact that interactive media available both on CD-ROM and on-line are competing increasingly effectively with the classical mass media. Meanwhile we are beginning to understand how radically digital technology is changing the reality of our everyday lives. Artists who concentrate their efforts on the interface between humans and technology show us what it means to live under these conditions.

In 1988 Jeffrey Shaw (Director of the Institute for Visual Media at the Centre for Art and Media Technology in Karlsruhe) and Dirk Groeneveld created an interactive, computer-graphics installation where the 'viewer' had to get on to a bicycle in order to simulate a journey through a virtual, three-dimensional space. This space was called *The Legible City* (ill. below). Its streets are formed from letters, that is, from words and sentences.

No-one could fail to be moved by a work like this: in contrast to our response to a painting or a video where we can only ever be a viewer or an observer. Indeed the 'legible city' requires bodily activity even to get into the space itself. And what then emerges in that space depends entirely on the input and decisions of individual users. They can travel quickly or slowly, to the left or to the right, they can turn off or take a short cut. The walls are permeable. There is no dramatic action, no beginning and no end. Shaw and Groeneveld turn the readers into *flâneurs*, who create their own 'story' from the textual building blocks, making the best use they can of the possibilities open to them – change of speed, change of direction, short-cuts.

There is one thing, however, that the readers of the *Legible City* most certainly cannot do: they cannot look behind the 'facades' or into the 'cellars.' There are no doors that can be opened to reveal more information with the click of a 'mouse' like the 'hot spots' on a CD-ROM or on the Internet. Hypertext is the name given to

**Jeffrey Shaw** and
**Dirk Groeneveld**
The Legible City, 1988
Interactive computer installation
Karlsruhe, Museum für Neue
Kunst, ZKM

a non-linear collage of information that users can create for themselves combining networked text or other materials (images, film, sound and video sequences). A specialist in this field, using hypertext data on several levels with text and video, is the American media artist Bill Seaman. The user navigating his or her way through his systems will find an infinite variety of combinations of text, language and images (ill. below). The user thus creates audio-visual poetry, or can have the computer create them.

The technology of virtual reality (VR) does not merely offer access to an artificial, computer generated landscape. It also offers the user the chance to personally – in the form of an artificial body – enter into that landscape and to interact bodily with other users in the system. One of the central challenges to the artists in the realm of tele-virtuality is to test and develop substitute body languages. With *Between the Words* (ill. above) the Hungarian artist Agnes Hegedüs has created equipment whereby two people can enter into a realm of virtual communication. The participants see each other as an outline through a semi-transparent opening in a wall, but they cannot talk to each other. They hold joysticks in their hands which they then use to steer computer generated substitute hands in the space between them. Each movement creates an algorithmic metamorphosis of the line of the hands which is then translated into a specific gesture.

The Australian performance artist, Stelarc, takes the basic genetic deficiency of the human body as the basis

**Peter Weibel**
Virtual Reality: Language World
(Virtuelle Welt: Sprach-Welt), 1992
Interactive computer installation
Video projector, projection screen,
carpets, sensors, dial box, silicone
graphics 4D / 320 vgx, computer,
silicone graphics video framer
Cologne, Klemens Gasser and
Tanja Grunert GmbH

*"I wouldn't like to limit myself to
individual media in my work. I
don't like that kind of professiona-
lism where you say, that one's a
painter but the other one's a writer.
My slogan is: Everything is poetry."*
PETER WEIBEL

of his work. He is seeking to answer the question
whether a "two footed, breathing body with binocular
vision and a brain of 1400 cubic centimetres is a viable
biological structure." In order to bolster the functioning
and performance of this 'out-moded' body he develops
robots, medical and virtual systems. In his performances
he interacts with miniaturised technologies that link up
with his own body, in the form of a third hand, a virtual
arm or an implant (p. 616 above). For one of his most
recent projects he has developed a touch-screen inter-
face whereby objects can be remotely controlled and
choreographed through muscular stimulation.

### The Gesamtkunstwerk in the Public Arena
What became of William S. Burrough's dream of the
viruses that were to make many programmes out of
"one?" Bertolt Brecht had already made the visionary
suggestion that radio should be transformed from a
broadcasting service into a communicating service. As
early as 1932 he wrote in his theory of radio that then
"radio would be the most magnificent imaginable sys-
tem of communication in public life." It could be a vast
"system of channels if it were only able not just to trans-
mit but also to receive, that is, allowing the listener not
only to listen but also to speak and not to isolate the
listener but to establish contact." However, the history

of electronic media shows all too clearly that this poten-
tial means of democratisation has until now only achiev-
ed the opposite, namely state-controlled centralisation.

Despite unfulfilled visions and attempts that have
fallen by the wayside, artists have continued to search
for ways to open up official systems of communication
for the emancipation of the users. In 1977 the Australian
sound artist, Bill Fontana, called for all radio listeners in
the whole of Australia to record the sounds of their
everyday environment and to transmit them (by tele-
phone) live to the studio where they were then mixed by
artists. In 1984 Ingo Günther (ill. right), in his study of
satellite images, discovered a hitherto unknown lake,
which then gave Iraq the decisive strategic advantage
over Iran in the war between them. Thus he showed that
even an isolated individual can gain access to apparently
closed computer systems and have a major impact on
events.

Since 1986 the teams 'Minus Delta t,' 'Van Gogh TV'
and 'PONTON, Fernseh- und Radiosender' have been
working on the development of multi-media communi-
cations systems. At the 1992 documenta Van Gogh TV
invited visitors to their *Piazza Virtuale* to take part in the
(inter)active production of a television programme
which in itself was part of a largely open-ended sched-
ule. For the virtual location the team created a com-
puter-controlled tele-visual field where video images,
computer animations, text and sound could be com-
bined. Visitors could actively participate in this project
in a number of ways. They could dial in by telephone,
make live contact with the screen via a modem or fax,
use the key-pad to access an 'interactive orchestra,' or try
out digital painting in a 'virtual studio (p. 617).'

### "You don't throw a grand piano away just because you've got a synthesiser."
The question as to the effect electronic information and
communications systems are having on traditional art
production elicits a variety of responses from experts in
the field. Some see the electronic media as having
already stepped into the shoes of traditional art. How-
ever, many view the situation today with a certain degree
of scepticism. According to the media artist and theo-
retician Peter Weibel (ill. left), our culture is dominated
by an aesthetic which is both static and object-based,
while motion and time, despite their increasing impor-
tance, are either marginalised or banned altogether.
Heinrich Klotz, the founder and director of the Karls-
ruhe 'Zentrum für Kunst und Medientechnologie' is
convinced that traditional art forms will never in fact
become anachronistic. In his view, we now "simply have
a wider spectrum of medial forms at our disposal" and
conventional art remains a part of this spectrum. The
history of art over the last 180 years has shown that the
spectrum of media has been extended without resulting
in any single medium becoming obsolete. "You don't
throw a grand piano away just because you've got a syn-
thesiser."

The American media specialist, Gene Youngblood, is prepared to risk some bold predictions. Taking an overall loss of meaning in art as his premise, he contends that this may only be reversed if we avail ourselves of the tools to match our current situation. Youngblood pleads for a genuine alliance of art and technology, which would both enliven art and humanise technology. He suggests that a new creative discipline should be developed: it would no longer be art in the familiar sense, but a kind of design. He envisions a "true renaissance, where art, science and social interaction grow inextricably together as one."

Will this form of design ever outstrip art as Youngblood would like to imagine? After all, many artists working today on the interface between humanity and technology are above all seeking to find new paths to images and virtual worlds. Of course the achievement of the arts may be defined in their capacity to criticise, to reflect and to search for aesthetic standards and how these may be operated. But perhaps some are beginning to weary of taking responsibility for the cultural deficiencies of our present-day media society. So far, attempts to open up new media for art have always foundered on the conservative structures of the art world. It is perfectly understandable that artists actively involved at the crossroads between art and the media are turning increasingly to software firms and television companies. On the other hand, the undisputed success of a figure such as Bruce Nauman demonstrates just how much our society needs a form of art that can step back and pose the basic questions of our existence which must be answered, helping us to understand better the meaning of our lives.

Thus we can only hope that the broad range of the arts, touching each and every one of our senses, may not fall victim to digitalisation. It might even be that one day it will seem a luxury to switch on a 'machine' after an exhausting day at the computer screen. And then it will be good to remind oneself of the message Beuys was transmitting with his *Felt TV* and to turn again to the tools that Filliou has stored in his tool-shed: "innocence" and "imagination."

**Ingo Günther**
K4 (C31), 1987
Video installation; video projector, video tape, sound, marble
Kassel, documenta 8 (1987)

# Photography between Art and Consumerism

Shortly before the turn of the century it seemed as though it was all over. On the one hand photography was becoming an industry in its own right and rapid technical advances had made taking photographs ever simpler but at the same time there was a strikingly obvious qualitative decline in photography. Yet the two factors were not directly connected – even although the siren sounds of commerce, reinforced by technical progress, had indeed largely undermined photography's artistic substance.

In June 1888 George Eastman brought out the first box camera and called it 'Kodak No. 1.' It contained his new, recently patented film-roll and the firm of Eastman, later to become the mighty Kodak empire, advertised it with the catchy slogan: "You press the button – we do the rest." All people had to do was send the camera with the film still in it to the factory: now they no longer needed to bother about the complicated business of developing and fixing.

And so it was that Eastman, inventive as well as a skilled organiser, ushered in the age of mass media. Photography now entered a period of major change. Thanks to the appeal of Eastman's idea, photography little by little persuaded almost everyone to see the world through its eyes at the same time as giving many of those same people the means to create their own images of the visible world. So the 'industrialisation' of photography also meant the 'democratisation' of the visual arts.

But it would be quite wrong to blame Eastman, the astute entrepreneur, for the pitiful aesthetic standards of the photography of the day. Its decline was due to a whole complex of reasons: for example technical innovation, that eased the lot of the professional photographer and brought the price of the end-product down, was combined with unimaginable demand, and this tempted some to neglect the finer details of the photographic process. In fact, the climate of economic competition was too much even for some respected, successful, important photographers such as Nadar in Paris and Mathew Brady in Washington, artist and entrepreneur in one. Although these photographers now rarely took a direct hand in the process in the studio, nevertheless they were still at pains to maintain professional standards in photography with the result that their pictures were beyond the means of most customers. "In the end,

though, businessmen invaded professional photography from every side, and when later on the retouched negative, which was the bad painter's revenge on photography, became ubiquitous, a sharp decline in taste set in. This was the time that photograph albums came into vogue."[1]

This situation was exacerbated by the deep-rooted economic crisis that followed the Franco-Prussian War in Europe (1870/71), in the wake of which there was a sharp downturn in interest in photography. And few small photographic businesses, still reliant on manual skills, were equal to this. Many had to give up. This in itself exemplifies one of the many paradoxes that have defined and determined the course of photography, in that it was pure coincidence that manual skills in the newest of the visual arts were to wither away at exactly the point when its commercial side was taking off.

Whereas on a social level it was only the economic basis of photography that changed, on an aesthetic level there was a real decline in standards. "This was the period of those studios, with their draperies and palm trees, their tapestries and easels, which occupied so ambiguous a place between execution and representation, between torture chamber and throne room, and to which an early portrait of Franz Kafka bears pathetic witness. There the boy stands, perhaps six years old, dressed up in a humiliatingly tight child's suit overloaded with trimming, in a sort of conservatory landscape. The background is thick with palm fronds. And as if to make these upholstered tropics even stuffier and more oppressive, the subject holds in his left hand an inordinately large broad-brimmed hat, such as Spaniards wear."[2]

Walter Benjamin's drastic assessment also applies equally to the portraits of the social elite – for example, the Crown Prince William, later to be Kaiser and King of Prussia (1888–1918), dressed as a member of a fraternity at Bonn University, sits forlornly like a lost holidaymaker against a truly kitsch Rhine backdrop: the photographer, Theo Schafgans, had simply copied the image of his illustrious client into a hideously romantic painting. More grotesque variations on the theme emanated from the famous studios of Hippolyte Lazergues and Adolphe-Jean François Maria Dallemagne in France. In addition to the usual visual props of grand

*"My photographs are always born of an inner need. I do not make 'pictures'... I have a vision of life and try to find equivalents for it in the form of photographs. It is because of the lack of inner vision amongst those who photograph that there are really very few photographers... There is art or no art. There is nothing in between."*
ALFRED STIEGLITZ

**Alfred Stieglitz**
The Steerage, 1907
Heliogravure, 19.7 x 15.8 cm
Cologne, Museum Ludwig

**Alfred Stieglitz**
In the New York Central Yards
("Camera Work" 36), 1911
Photogravure, 19.4 x 15.9 cm
Cologne, Museum Ludwig,
Gruber Donation

Stieglitz had exceptional skills of organisation and an incredible feel for the artistic mood of that restless time at the beginning of the 20th century. He was a gifted photographic artist and although by no means a theoretician he turned to art to underpin the aesthetic claims of photography – despite the fact that it was the leading artists of the time such as Jean Auguste Dominique Ingres and Eugène Delacroix or that incomparable critic and most sensitive of poets, Charles Baudelaire, who, along with other luminaries of the 'beaux arts,' had denied any claims that photography might have had to artistic viability. They were, in fact, perfectly happy to quietly profit from the benefits of photography at the same time as refusing to see any artistic value in "pictures from a machine," which they saw as automatic imprints of the visible and neither imbued with the artist's inspiration nor formed by the artist's hand.

Stieglitz retaliated in a piece for *Scribner's Monthly* (1889) with the bold proposition that "photographic equipment: the lens, the camera, the plate and so on

curtains, "pedestals and balustrades and little oval tables" (Benjamin), they also often provided their upper-class sitters with a kind of baroque surround which lent them a ridiculous air as though they were the last travellers from the disappearing age of the post-coach.

Let there be no misunderstanding: these pictures are not clouded by the slightest shimmer of irony, least of all self-irony. It was only in the USA that photography avoided the worst excesses, perhaps because social conflict and the contradictions of a fluid society in a young country prevented people exploring their land visually – and photography would have had an important hand in this – before they had come to terms with it on a physical level.

It was in the USA and in Great Britain, the most industrially advanced country in 'old' Europe, that the strongest forces amassed to prevent the demise of photography. It may surprise some to learn that the most powerful of these were the enthusiasts, the amateurs, artists, photographers and collectors who were immune to the lure of commerce. Alfred Stieglitz (ill. above and pp. 620 and 624) was one of the most influential spirits in this respect. After high school in New York he studied engineering at the Technische Hochschule in Berlin. In Germany he also encountered photography. There is still much work to be done on the inspiration that he found there as well as the inspiration that he later provided for others. At any rate, after his return to New York, Stieglitz became a member of the Society of Amateur Photographers and by 1892 he was already publishing the journal, *American Amateur Photographer.* Then he started taking his delicate shots of winter in New York followed by his first night-shots. In 1902, together with Alvin Langdon Coburn (ill. right) and Edward Steichen, he founded the 'Photo Secession' as well as the hugely influential journal, *Camera Work.*

**Alvin Langdon Coburn**
The Ipswich Bridge, c. 1904
Photogravure, 19.4 x 15 cm
Cologne, Museum Ludwig,
Gruber Donation

*Page 623:*
**Edward Steichen**
John Pierpont Morgan, 1903
Silver bromide print, 25 x 19.6 cm
Cologne, Museum Ludwig

constitute a flexible instrument and not a mere mechanical tyrant."[3] He was quite ready to admit that negative attitudes to photography were not without foundation and indeed wholly justifiable in most cases, but nevertheless the "skilled photographer" was able to extract a whole "variety of interpretations" from the photographic plate or negative without interfering manually in the process.

The negative itself, that "incomparably faithful" (Alexander von Humboldt) material basis of the automatic reproduction of the visible, was taboo. Stieglitz was insistent on a strict code of ethics for photographers: there was to be no unauthorised image manipu-

**Alfred Stieglitz**
End of the Line
("Camera Work" 36), 1911
Photogravure, 12.2 x 15.9 cm
Cologne, Museum Ludwig,
Gruber Donation

*"Photography being in the main a process in monochrome, it is on subtle gradations in tone and value that its artistic beauty so frequently depends."* ALFRED STIEGLITZ

lation! But at the same time, in mapping out the territory for artistic manoeuvre for the serious photographer, he opened up the route into the laboratory. What throngs of assistants had previously attended to for the pioneers in the medium, namely the 'secondary' matter of producing the prints themselves, was now viewed by Stieglitz and his friends as a yardstick of artistic quality. For Stieglitz, everything centred on the precision with which individual shots were handled, which led him quite simply to put the photographer's laboratory on a par with the artist's studio.

Stieglitz & Co found their European kindred spirits in Great Britain as well as in the Austro-Hungarian Empire and Germany. In the United Kingdom the secessionist photographers became known as the "Linked Ring". Despite national differences the various groups shared the same motivation and the arguments they put forward for the aesthetic aspirations of photography are, bar a few nuances, wholly interchangeable.

Symptomatic of these arguments is, however, their striking ambivalence. On the one hand, they looked to art as the arbiter of the aesthetic value of photography. There was, after all, the story of one artist's reaction to his first sight of a photographic reproduction. This was in the earliest days of the discovery of photography (1839) and the artist, one now long forgotten Paul Delaroche, a leading proponent of the still sacrosanct traditions of academic art, is said to have cried out when he saw the photograph that "now painting was dead." On the other hand, Stieglitz and other like-minded spirits simply re-drew the battle lines in the conflict over whether photography was an art form by freeing it from the constraints of artistic considerations whose authority was in any case crumbling under the onslaught of the

avant-garde in the form of Edouard Manet, Edgar Degas, Paul Cézanne and the Impressionists.

A strangely duplicitous situation – for the outraged question facing the art-conscious bourgeoisie as to whether 'this was art' was by no means directed at photographers alone. It was also familiar to the artists of the avant-garde, namely Cézanne, Manet, Monet – in short the Impressionists. A reminder: 'Impressionist' had been an insult on the part of an art critic. It was the great photographer Nadar who had opened the doors of his atelier on the boulevard des Capucines to the artists under attack so that they could show their works free from the dictates of a blinkered panel of selectors. The real cause of the aesthetic hullabaloo was the widespread shift in artistic focus. And, as so often, this in itself was the result of a shift in society as a whole, spurred on not least by ground-breaking advances in science along with all the practical consequences that this implied.

In a word, if art up until this point had been primarily concerned with depicting the world, both tangible and otherwise, now, since the middle of the 19th century, art was becoming increasingly concerned with the problem of the individual perception of this same world. As the art-historian Wolfgang Kemp puts it: "Now artists were not so much concerned with the sight of something, as with sight itself."[4] Although Stieglitz cannily restricted his comments to matters of manual technique, he was already, presumably subconsciously, coupling the by-now free carriages of photography behind the engine of advanced art as it hurtled into the future.

Of course he turned a blind eye to the possibilities of photography as a mass medium. These no doubt did not particularly interest him. In any case it was only to the sounds of battle across Europe that the technical conditions were created that would truly bring photography to the masses: for example the epoch-making invention of halftone printing was still far from technically perfect and although as early as 1880 the New York newspaper, the *Daily Graphic,* had printed a photograph mechanically, transferring the image directly from the original to the newsprint, the process was immensely complicated and involved dividing the image up into infinitesimal parts. 'Experiments' of this kind were thoroughly unsatisfying to photographers. Nevertheless, Tim N. Gidal (p. 636), one of the most successful photo-journalists between the 20s and 40s, who later wrote on the history of photography, rightly included Stieglitz amongst the forerunners of his own profession, namely 'modern photo-reportage.'

This is perfectly plausible in view of his early motifs. Stieglitz's pictures deal with wholly unspectacular events and occurrences. In fact, they are only remarkable in the sense that the photographer has decided to capture them on film. Stieglitz probably took the legendary picture *End of the Line* (ill. above) at the last stop of a New York horse-drawn tram line. It shows the coach-

man attending to his steaming tram-horses on an icy winter's night. At the right-hand edge of the shot someone is shovelling snow, on the left a bowler-hatted man is stamping out of the picture and in the background there is the façade of a building with a grand entrance. Nothing that would really catch one's attention beyond, perhaps, its subtle composition. A picture like this would certainly have added immeasurably to any photo-reportage.

The choice here of an everyday subject links this masterpiece with the best of photo-reportage as the age of mass media was dawning in the early 30s. And yet the difference between the two is equally evident: not so much the fact that Stieglitz conceived this as an individual photograph, as the particular quality of the prints themselves, precious and exquisite. Collectors' items in the truest sense. One prerequisite of this was the use of pigment paper which allowed the photographer to intervene, treating each picture individually and subtly differently during the printing process. The picture was dependent for its very existence on direct manual intervention and was therefore subject to the whims of the photographer's will rather than to some iron natural law, as the critic Robert de la Sizeranne wrote: "The negative is the province of the equipment, the print is the province of the human being, and the style is the person."[5]

The aesthetic standards that were set by this form of art-centred photography defined the medium in the early decades of this century. But of course even this was a temporary state of affairs and was soon discredited, above all by the many who leapt on the bandwagon. Beyond this it was the First World War and its consequences that finally lifted the lid on that idyllic art-realm of bromine and gum bichromate prints with atmospheric landscapes and sunny portraits, exposing them as just as false as the grandiose platitudes about love of the Fatherland for which millions of young people were killed.

Yet not all serious photographers accepted the aesthetic maxims of art-photography. There were those who not only wanted to see its documentary nature preserved – but in fact viewed this as the real domain of the aesthetics of photography and took a dim view of those who were constantly looking over their shoulders towards art. The British photographer, Frederic H. Evans pleaded for pure, thoroughly "photographic" photography, which he called 'straight photography.' In his view the creative moment in photography was concentrated in what went on behind the camera and not in devising nifty tricks in the lab. If he was not happy with a shot he refused to rescue it in the laboratory – he would take it again even if that meant a long journey.

Evans' preferred motifs were Gothic cathedrals, both from outside and from inside. He also loved fine prints and perfected the use of expensive platinotypes. His friend and comrade-in-arms George Bernard Shaw, a passionate amateur photographer, supported him in

this, emphasised the "realistic representational power" of photography and, letting his love of paradox run riot, romped towards the conclusion that painting was the mechanical art form, and not photography, for all that it was a technical medium.

But for too long the images of Pictorialism were viewed through the spectacles of the later photographic avant-garde. In the meantime we have developed a more sober approach and, in addition, outstanding examples of art-photography have since become much sought-after collectors' items. Gradually, too, they are also being recognised for their aesthetic contribution to direct photography. Numerous elements in the matter of motif and pictorial composition as well as in the choice of apparently unremarkable details – significant features of art-photography – have passed more or less fluidly into the repertoire of avant-garde photography today.

Edward Steichen (ill. below and p. 623), one of the key figures in the history of photography, once virtually lost control when it seemed to him that the whole discussion – art photography as opposed to pure photogra-

**Edward Steichen**
The Flatiron Evening
("Camera Work" 14), 1906
Three-colour halftone
reproduction, 20.6 x 16 cm
Cologne, Museum Ludwig,
Gruber Donation

**Heinrich Kühn**
Alfred Stieglitz, 1907
Gum bichromate print,
29.6 x 23.2 cm
Cologne, Museum Ludwig

phy – was narrowing down the potential of the medium to an unacceptable extent, even before it had been properly explored. Steichen had been trained as a painter and, as a photographer, was extremely successful in all disciplines and areas of photography, an indescribably skilled operator in its cause, albeit perhaps not without a degree of self-interest. In his words: "We have experienced the astonishingly rapid unfolding of ideas in the area of photo-mechanics. Colour art-photography is at a problematic stage, in the cinematograph we have the completely unexploited possibility of creating a completely new art form all of its own. We still have to learn to master countless other technical possibilities – so how can we talk about technical limits, limitations on and the limitedness of a form of artistic expression? A whole world lies before us, we feel its heartbeat, it pulsates with life, beauty and strength – we can't have people simply telling us: this is as far as art goes."[6]

So it is not surprising that the critic Eugenia Perry Janis, looking back, should describe photographers such as Stieglitz, Steichen, Coburn, Karl Struss and others from that circle as the "young moderns." Indeed she even risks a direct comparison between the supposed opposing sides in the photographic dispute of the day, between the one side supporting photographic photography and the other who favoured artistic photography. In her view, at least in terms of the USA, both sides had portrayed the growing city metropolises with equal success, "documenting the physiognomies of America's new citizens, and while one side celebrated modern technology the other concentrated on the might of technical symbolism."[7]

Misconceptions of art-photography derive perhaps above all from its European exponents: these included Hans Watzek, who was actually more interested in the technical side of photography, and Heinrich Kühn (ill. left). Although they were both Austrians, they were in touch either in person or through letters with their American and British colleagues, their compatriot Hugo Henneberg, the German brothers Theodor and Oscar Hofmeister, Robert Demachy and Constant Puyo from France, and James Craig Annan whose father, Thomas, had used a naive reportage style for his photographs of the appalling conditions in the slums of Glasgow. They loved to indulge their taste for cosy landscapes and enchanting townscapes, preferably of Venice and created ardent portraits of prominent artists with a decided preference for their own friends. Delightful pictures – the ultimate in photographic skill. Against the backdrop of a society that was being driven by the fires of the industrial revolution towards World War and catastrophe these images do, however, seem like pure escapism.

In contrast to this, it was not through chance alone that the Flatiron Building in New York – reaching out into the junction of Fifth Avenue and Broadway, a bold structure and a stirring monument to the dawning technical age – should become the striking symbol of American art-photography and Pictorialism. Although American photographers, too, flooded their seductive images with iridescent light, nevertheless their more 'technical' approach set them apart from their kindred spirits in Europe. They breathed the air of the modern cities. And even the clear, identifiable structures of a picture like Kühn's *At the Coast* pointed towards the photographic avant-garde. Constantly looking towards art had put photography under somewhat negative pressure to legitimise itself but, as it turned out, photography simply emerged all the stronger from the crisis.

# Art from a Machine: 'New Seeing'

No helpful hints here for the viewer's orientation. The author has even denied the picture a title. In the lower centre there is a circle surrounded by other circles; above this there is a diagonal section of scaffolding breaking off at a right angle at the right-hand edge. A few flowing lines, partly very dark grey, partly light grey, are as uninformative as the even lines around the circles. The picture has no real centre, somehow things have slipped out of the schema of traditional composition theory, although there is a certain, albeit uneasy, balance within the picture itself. And yet this picture is by no means an abstract composition.

In many respects this photograph, *Untitled,* taken in 1928 by László Moholy-Nagy is, in fact, more realistic than any of the images of art-photography. Nothing has been manipulated here: this is a product of direct photography par excellence. Yet there is one difference: normal perception is not equal to a picture of this sort. This is not some detail of reality that one can immediately assimilate visually. There is no focal point drawing together the lines of perspective, nor does there seem to be any particular object at their centre. And when viewers discovered what they were looking at, a sudden dizziness must surely have hit them – for Moholy-Nagy had taken his camera up the Berlin radio tower and photographed the view looking virtually vertically downwards.

The shock created by pictures of this sort is hard to reconstruct now; although a certain sense of irritation remains. The moment the supposedly abstract distorting image has revealed its true nature as an identifiable slice of reality, the viewer's gaze hits the ground with a thud, like the body of a suicide victim. Subliminal fears are aroused. In his masterpieces, Alfred Hitchcock, having perfected his skills as a film-maker in 20s Berlin played the same devilish game with people's fears and even today, shots from up above still signal acute danger in the better horror films.

In this sense the photographie image that Moholy-Nagy created also lent vivid expression to a feeling shared by many at the time. Nothing was any longer the way it used to be. The certainties and ideas that had shaped and steadied the world had been shattered in the battles of the First World War. In Russia the Bolsheviks had waged a bloody civil war and set up a new regime that held out hope to all those who had up until then been at the foot of the social pyramid in Europe, including the majority of intellectuals and artists. In Germany revolution had only been avoided by a hair's breadth. Uprisings on both sides of the political spectrum had shaken the country and reparations to the victorious powers were a huge burden to the economy, yet for a few short years before the Great Depression was to hit the world, the Weimar Republic basked in a wholly false sense of security. The forces of democracy were, however, too weak and too fragmented to prevent the disaster that was looming on the horizon and not even intellectuals and artists had much to say in the Republic's favour. For most it was no more than a form of camouflage.

While the First World War had wrought radical change in the world, many people could see only too clearly traits of the bad, old world in this new, changed world. No brave, new world here – with the exception of

**László Moholy-Nagy**
Bauhaus Balconies, 1925
Gelatin silver print, 8.2 x 6.1 cm
Cologne, Museum Ludwig,
Gruber Donation

the Soviet Union, where war and art had been enlisted in the attempt to create a new kind of human being and a new kind of society. In the face of the might of Soviet 'revolutionary art' even the brand-new, refreshingly trivial culture of the USA blenched. However, it had ultimately been the power of American industrialism that had decided the outcome of the war. The furious attacks by the Dadaists in Germany were still making themselves felt and enlightened artists saw bourgeois art as synonymous with the false cultural face of a social system that was morally, economically and culturally bankrupt. In rejecting this, it seemed simplest to include Futurism and Cubism whilst one was about it.

The cry for a completely new form of art did the rounds and found a particular resonance above all in the defeated nations of Europe, in Germany and in the Soviet Union. And the collapse of the imperial Austro-Hungarian monarchy released a positive explosion of creative energy in middle and southern Europe. However, as the rise of nationalist and anti-Semitic sentiment suppressed this again, the more forward-looking artists of largely Jewish origin went on the move: many were drawn to the German metropolis of Berlin, with its electric atmosphere and myriad contradictions. For a short while Berlin, even Germany itself, became the citadel of contemporary art. But what should be the demands on a new art form?

"Viewed in terms of traditional means of visual expression the photographic process is incomparable. And the results are also incomparable, when it uses its own potential" – Moholy-Nagy (ill. right and p. 627), in a programmatic text in the first volume of the yearbook *Das deutsche Lichtbild*.[8] As an avant-garde artist, unlike the art-photographers, he stressed the autonomy of the medium very much in the spirit of direct photography. Naturally he was only interested in purely photographic matters as a side-issue, purely as a means to an end as it were. His attitude was one of principle.

He was interested in the perception of reality unclouded by any kind of cultural convention and this he felt could be had from the pictures that came from the camera: "The secret of their effect is that the photographic equipment reproduces a purely optical picture and thus shows optically true images, distortions, foreshortenings and so on whereas our eyes take up what is seen and, with the assistance of our intellectual experience, make associative connections and round it out formally and spatially into some imaginary image. Thus in photography we have the most reliable aid to achieving the first stages of objective seeing. The individual viewer will be forced to see the optical truth, which can be understood from within itself, before even beginning to come to some possible subjective attitude…"[9]

This enthusiasm for the 'machine' after the experience of the First World War, the first technological war, which itself had been decided on superior machine power, may seem surprising. Had it not been the supremacy of American technological resources that

had tipped the balance on the battlefield? Yet, on the other hand, at the time those with any kind of an open mind could see no alternative to technology. It seemed that the only hope of improving the human condition was going to be by exploiting technology to the full. Only a few dreamers nurtured their anxieties about technology, harked back to Nature myths and adopted an "anti-civilisation" stance.

Nevertheless, the first technological conflict of major proportions in world history engendered an awareness in Germany that "the technology that had produced bombs and tanks could equally well be used to produce goods for a new society. Machines were now being used to make simple yet elegant kitchen utensils, lighting equipment or vehicles. Industrial architecture emphasised the technical structures of its building design and artists and other creative minds became increasingly interested in the precision engineering needed for cog-wheels, conduits and aircraft made from sheet aluminium and in the structural composition of other materials. From this extended awareness of the aesthetic possibilities of geometric forms, be it in machinery or be it in architecture, a new avant-garde movement in photography evolved in Germany which was often referred to as 'New Seeing.'"[10]

'New Seeing', (Neues Sehen). The very term makes it clear that what is meant here is not the mode of perception – a mixture of physiological pre-conditions and sensual, mental and spiritual mechanisms – nor is the illusionism of academic art nor the disruptive view of the avant-garde meant. 'New Seeing' is instead the immediate image produced by the camera lens. No subjective impulse falsifies this picture of the world. The technical apparatus guarantees objectivity. In the optics of 'New Seeing' visible reality manifests itself as a construct. As Moholy-Nagy stated: "You could say that we see the world with completely different eyes."[11] In the light of his views all other types of representation become, at best, inadequate illustrations of reality or, at worst, wholly inept. The 'constructivist' photographs of 'New Seeing' reflect the notion that science and technology should now also provide the guidelines needed by art.

Progressive artists like Moholy-Nagy and before him the Dadaists, George Grosz and John Heartfield (p. 122), along with Hannah Höch and Raoul Hausmann (p. 122), saw the 'apparatus-made,' so to speak automatically produced images of photography (which was in itself the product of research in chemistry and physics) as the only suitable artistic means to construct the longed-for 'new' world and to create its 'new' people.[12] In 1923 Walter Gropius invited Moholy-Nagy to the Bauhaus in Weimar to take up a position as 'Master of Forms in the Metal Shop.' From October of that year the Hungarian, responsible for the teaching of basic principles to second semester students, offered the course 'Material and Space', along with Gropius himself. Through his teachings, photographic experiments

**László Moholy-Nagy**
Photogram, 1924
Gelatin silver print, 39.8 x 29.8 cm
Cologne, Museum Ludwig

**Andreas Feininger**
New York, Midtown Manhattan,
42nd Street, 1947
Gelatin silver print, 25.3 x 34.2 cm
Cologne, Museum Ludwig,
Gruber Donation

**Boris Kudoyarov**
October Revolution Celebration,
c. 1935–1940
Gelatin silver print, 26 x 37 cm
Cologne, Museum Ludwig,
Ludwig Collection

and bold publications, including the legendary Bauhaus book *Painting, Photography, Film* (1925), Moholy-Nagy exercised a decisive influence on the self-image of advanced art.

Although photography was not studied as such at the Bauhaus and Moholy-Nagy never taught it as a subject, his ground-breaking ideas were enthusiastically received by numerous students at the institute. Playfully yet persistently, many acquired the essential skills of photography and some, such as the brothers Andreas (ill. above) and Lux T. Feininger made productive contact with the new genre of photo-journalism that was blossoming in Germany at the time; others found their own individual visual language in various realms of photography, independent of Moholy-Nagy, with the list including Werner Graeff, Florence Henri, Lucia Moholy (p. 631 below), Moshe Raviv-Vorobeichic (Moi Ver), Xanti Schavinsky, Ellen Auerbach, Irene Bayer

(married for a time to Herbert Bayer) and the great Umbo (Otto Umbehr).

Without mentioning him by name, Walter Benjamin, in his *Small History of Photography*, quotes a forward-looking statement by Moholy-Nagy: "'The illiteracy of the future,' someone has said, 'will be ignorance not of reading or writing, but of photography.'" But he had misunderstood the artist Moholy-Nagy's aesthetic aims, for the latter was not particularly concerned with photography as a medium and not at all with 'photography' as a means of expression: instead he saw photography as a viable way of presenting the complex inter-connections of space and time in keeping with the latest advances in science. There can be no doubt as to the fascination that his aesthetic thinking had for advanced artists both in Germany and in the Soviet Union – in the latter as a country where determined attempts were being made to realise, through positive action, the hope of a world where freedom and justice would prevail.

Yet, in the early days of the Soviet Union photography did not enjoy a high status. Although the artists of the avant-garde did occasionally try out various photographic games such as montage and photograms, nevertheless these were generally applied rather than actually experimental. Alexander Rodchenko (p. 633) illustrated Vladimir Mayakovsky's *Pro Eto* (1923) and created a poster for the 'History of the Russian Communist Party' as part of a series that the Constructivist El Lissitzky (p. 631 above) also participated in. It is possible that they had been inspired by the German Dadaist 'Fotomonteurs.' Lissitzky and Kasimir Malevich made frequent trips to Germany – and were good communicators.

Half in undisguised anger, half out of a boisterous delight in contradiction, the Dadaists had broken all the prevailing cultural codes, dismissed works that had long been held dear, exploded familiar symbols and invoked a *tabula rasa* scenario. Like Grosz and Heartfield they cut up coherent pictorial elements and combined them with trenchant, sometimes totally incomprehensible texts. Or, like Höch, Hausmann and Heartfield again, they would construct confusing visual impromptus from a montage of a wide variety of photographic images. These photomontages could be read like a text, not that one could be certain of being much the wiser afterwards. "The revolutionary power of Dada was that it tested the authenticity of art."[13] It did not in fact have any particular political striking power.

In the Soviet Union, where the communists were fighting for survival in a horrendous civil war, and also in Germany, where conflict was germinating, film was luring the masses into the cinema and its brand new aesthetics did not fertilise photography alone. Sergei Eisenstein, Vladimir Pudovkin and the 'documentarist' Dsiga Vertov did much to refine the principles of montage and their inventions also affected both art and photography. In the realms of popular culture montage was already a commonplace tool.

Heartfield and Grosz had first met it in American advertising while Moholy-Nagy had encountered it in the military propaganda of the imperial army; and popular postcards from seaside and mountain resorts had long used montage to create more or less entertaining effects. But it was film that was to set alight the creative hot-heads in Germany and the Soviet Union: less so in fact the American films by David Wark Griffith, who was the first to utilise the hugely effective potential of montage, than the 'Russian films' with their association-laden montage sequences structured around collision and contradiction.

In comparison to film, photography in the 1920s in the Soviet Union was seen as old hat. Most photographers continued to pay homage to art-photography. In addition the fact that there was a paucity of suitable paper and a shortage of supplies of the right chemicals made it difficult for photography to become a propaganda tool, directed at the masses. After the dust had settled somewhat and film had so dramatically shown empirical reality as a subject for aesthetic treatment, then in the Soviet Union, too, there was a rapid rise in interest in a new visual language for photography.

In 1923 a group of artists founded LEF (The Left Front of Art): "a society of Futurist and Constructivist artists – the first to focus on and reflect the theoretical problems of photography as a medium that both creates and alters awareness."[14] A leading newspaper published their aesthetic views under the same name. Writers, film-makers, typographers, painters and theoreticians all belonged to LEF. After various interruptions – from time to time disagreements, conflicts and normal wear and tear put a halt to the group's activities altogether – it then reformed in 1928 as 'Nowy LEF.' Boris Ignatovich (p. 632 above), his wife Jelisaveta and his sister Olga, Eliasar Langman, Dimitri Debakov, Boris Kudoyarov (p. 630) and Georgi Petrussov (p. 632 below right) all became involved. Moholy-Nagy's Bauhaus book, *Painting, Photography, Film,* lifted their spirits and his declaration that in the "extended field of vision ... now even today's lens was no longer bound by the narrow confines of the human eye" and that "no manual tool (paintbrush, pencil etc) could "capture details of the world seen in this manner"[15] was absolutely in keeping with Vertov's definition of the "cinema-eye" and its "point of departure," whereby the "filmic eye" was "better able than any human eye" to examine the "chaos of visual phenomena."[16] With the help of montage Vertov constructed a new world in his films. "I am a cinema eye. I am an edifier,"[17] he declared.

On 14 November 1928 Rodchenko held a slide lecture with the title "On New Photography or Photo-LEF" in the State Academy of Art in Moscow. During the course of this lecture he explained that the new movement in photography in the Soviet Union brought together two opposing positions: one took the view that photography was a form of documentation (the position of LEF and Nowy LEF) while the other subscribed to

the notion that photography was a constituent part of contemporary art. Although Rodchenko did speak out against art itself, saying that it was possible "through photography and other documents ... to expose the falseness that was inherent in all art products"[18] his attack was directed mainly at traditional art and art-photography.

He and other like-minded spirits drove the process of photographic innovation forwards on two fronts at once: on the one hand concentrating on honing the individual picture to perfection and on the other hand, in apparent contradiction of the 'supremacy' of the individual image, looking at series and picture sequences. In

**El Lissitzky**
Composition with Spoon, c. 1924
Gelatin silver print, 23.4 x 29 cm
Cologne, Museum Ludwig,
Ludwig Collection

**Lucia Moholy**
Wassily and Nina Kandinsky in their Dining Room, 1926
Gelatin silver print, 19.4 x 25.1 cm
Cologne, Museum Ludwig,
Gruber Donation

**Boris Ignatovich**
Factory Window, 1929
Gelatin silver print, 24 x 17.8 cm
Cologne, Museum Ludwig,
Ludwig Collection

In an essay with the revealing subtitle "Against the synthetic portrait – for the monumental snapshot" (1928) Rodchenko focused on the 'secular' figure of the Soviet revolutionary Vladimir Ilich Lenin in order to expound the problems surrounding any artistic attempt to convey the full personality of one individual. "There is no complete picture of Lenin," he wrote, "nor of any-one else ... yet, there is this: a representation based on photography, books and notes. The fact is that since the advent of photography there can be no more general, immutable notions of what a picture is. And further-more, a person is not a single entity, a person is many-sided, dialectical."[19] In this Rodchenko was not only drawing a parallel with film and its inspired use of mon-tage but also with photo-journalism, which at the time had its strongest foothold in Germany and the Soviet Union – rather, significantly enough, than in the USA.

Nevertheless, within a relatively short time this tire-less photo-artist – who always involved his intellect in any practical steps he took – found himself buffeted by storms of protest. These started with photographers who had pinned their colours to reportage. They denounced Rodchenko as a 'Formalist,' a reproach that was potentially life-threatening during that period of consolidation of the Soviet regime under the power pol-itics of the feared figure of Stalin. He provoked criticism for his sometimes daring visual constructions rather than for his futuristic, serial working method which points to the extent to which the supposedly leading lights in the USSR were still entangled in out-dated modes of seeing, even before the party instituted the petit-bourgeois flavoured doctrine of Socialist Realism in art.

The journal *Proletarske Foto,* the mouthpiece of the Russian Society of Proletarian Photo-Reporters (ROPF), started the most disgraceful attacks on Rod-

his work he realised the artistic principles of 'New Seeing' with his preference for extremely close close-ups for portraits, his extensive use of steep angles from above and monumentalising angles from below as well as often arranging the pictorial motifs diagonally. The fragmentary quality of the individual picture invites viewers to complete it mentally, mobilises their powers of imagination and accords them the status of co-authors (p. 633).

**Arkadi Shaikhet**
Strengthening the Body, 1927
Gelatin silver print, 31.5 x 41 cm
Cologne, Museum Ludwig,
Ludwig Collection

**Georgi Petrussov**
Soldiers with Helmets, 1935
Gelatin silver print, 30 x 25 cm
Cologne, Museum Ludwig,
Ludwig Collection

chenko and his followers. They accused him of pursuing Western "decadence as purveyed by modern bourgeois photographers,"[20] with Moholy-Nagy and his imitators at their head, to the detriment of his commitment to the proletariat. The fact that his staunchest critics, such as the leading photographer, Arkadi Shaikhet (p. 632 below left), were themselves infected by the 'bacillus' of 'New Seeing' was obviously completely beside the point in this confrontation fed by artistic jealousy.

However, Rodchenko continued to work as a photographer – although under considerably harder conditions than before – and still managed to have startling reportages accepted by illustrated journals such as *Dai-josch* and *Isogis,* reporting for example on the building of the hydro-electric power station in Magnitogorsk on the Dnieper or focusing on the Turkestan-Siberian Railway, while an important piece on the building of the White Sea Canal was published by *SSSR Na Stroike* (The USSR under Construction). The precisely constructed montages of individual pictures in the pages of these journals as well as the fact that these pictures were intended all along for mass-reproduction raises these 'documentations' far above the usual standard found in illustrated journals at the time. "The different angles from which an object is photographed set up ever new tensions whose formal qualities modify the semantic content."[20]

In the matter of form, some of Rodchenko's pictures, for example his *Woodcutters* (1932), seem strangely inept as soon as they are extracted from their context – in this case a photographic essay on a saw-mill. The sense of unease only abates when they are restored to the context of a whole spread of pictures on the same theme. With supreme artistic intelligence Rodchenko was able to integrate modern rotary printing processes and techniques of mass-distribution into his own aesthetic calculations. Amongst other advanced artists in the 20s John Heartfield was the only one to pursue a similarly radical course.

**Alexander Rodchenko**
Dynamo Club, 1930
Gelatin silver print, 26.5 x 40 cm
Cologne, Museum Ludwig,
Ludwig Collection

**Alexander Rodchenko**
Portrait of his Mother, 1924
Gelatin silver print, 39 x 29 cm
Cologne, Museum Ludwig,
Ludwig Collection

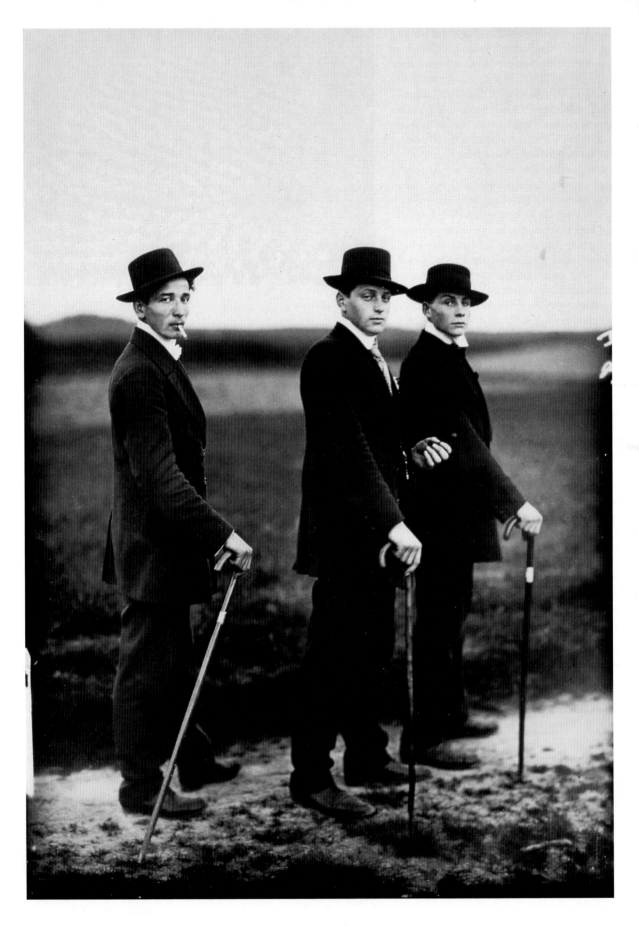

# The Material World in Focus – 'Neue Sachlichkeit'

Photo-journalists in Germany came into the profession from all walks of life; most were new to the business. The impending world economic crisis had catapulted many out of their old jobs. On the other hand, the illustrated journals in the mid to late 20s were sorely in need of creative rejuvenation. Circulation numbers were stagnating and although the mechanisms for industrial plate printing from photographs were all in place, printed images only functioned as appendages to texts of varying quality. The publishers made money with serialisations of well-written novels such as Erich Maria Remarque's *All Quiet on the Western Front*. It seemed that even in the USA people had forgotten the committed reportages by photographers such as Jacob Riis, Lewis Hine (p. 636 above) or Francis Benjamin Johnston, although these admittedly could not yet be printed by the journals.

Under the Weimar Republic a particularly fortunate configuration of circumstances, not least an astonishing concentration of bright, daring spirits led to a positive blossoming of photo-journalism. Far-sighted publishers like Kurt Safranski, imaginative editors, gifted designers, including Richard Lindner for the *Münchner Illustrierte Presse*, who later achieved recognition as a painter and forerunner of Pop Art, as well as a number of inquisitive photographers all underpinned the huge contribution that photography made as a mass medium. The *Berliner Illustrirte Zeitschrift* had the highest circulation figures, at times swamping the market with over a million and a half copies; far behind it lay the *Münchner Illustrierte Presse* although in hot competition with its Berlin counterpart. Against a background of rising unemployment, spectacular business failures, increasingly brutal street fights and growing social misery and hunger, the insatiable thirst for 'authentic' images was fed amongst others by the *Arbeiter Illustrierte Zeitung* (AIZ, supported by the Communist Party and with Heartfield on its books), the *Kölnische Illustrierte Zeitung* and magazines such as *Uhu, Das Magazin* (which still exists), *Scherl's Magazin, Dame,* and the illustrated weekend supplements issued by the dailies.

A legendary figure amongst the photographers of the day was Dr Erich Salomon (p. 637) . With a doctorate in law and his shots of prominent contemporaries in 'unguarded moments' he was a star. Whether his subject

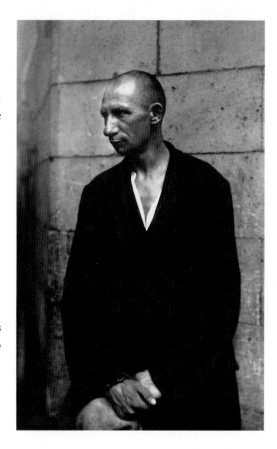

*"Forgive me if, as a healthy person, I am so bold as to see things as they are and not as they should be, but I cannot do otherwise."*
AUGUST SANDER

**August Sander**
Unemployed, 1928
Gelatin silver print, 22.5 x 14.2 cm
Cologne, Museum Ludwig

was the lighted windows of the presidential palace during a reception in honour of King Fuad, exhausted French and German ministers at one o'clock in the morning during an all-night sitting at the second Den Haag Conference, or the French Foreign Minister Aristide Briand at precisely the moment when he notices the photographer with his camera at the ready – thanks to their intelligent visual significance, Salomon's pictures always received a high degree of attention. He perfected the notion of 'snapshot photography.' His experience, his education, his pleasant demeanour along with his striking inventiveness and intrepid cleverness all marked him out as a specialist in the unusual.

Scarcely less successful was Martin Munkacsi (p. 650), born in a Hungarian enclave in Romania. He apparently managed to achieve the impossible: he com-

**August Sander**
Young Farmers in their Sunday Best, Westerwald, 1913
Gelatin silver print, 30.4 x 20.5 cm
Cologne, Museum Ludwig

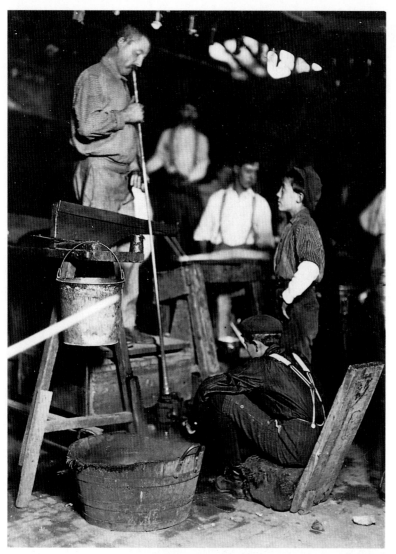

photographer; Hans Baumann, known as Felix H. Man who became one of the most interesting photographers in his field, also an art historian by training; Umbo (p. 640), a Bauhaus product and a real poet with the camera; the committed social critic Wolfgang Weber who had studied ethnography and musicology in Leipzig; and a physician with a doctorate, Dr Paul Wolff, who was the first to set the small Leicas on the road to success and was also soon producing Nazi propaganda.

Of course 'quick' cameras, the Leica and the Ermanox, one as handy as the other, in conjunction with the greater light sensitivity of the film that was now available had laid the technical basis for the blossoming of photo-journalism – but its massive success was due both to the individual achievements of the photographers themselves and to editorial ambitions to use images in the telling of remarkable stories. In the process, the structure of the reports became ever more filmic, ranging from the meaningful combining of individual pictures to an inspired montage of the wider context. "Nowadays, in the major journals we see behind the scenes, eavesdrop on politicians, gaze on distant lands: everything has become photographable. The photographers discover new angles on things and are expected to deliver new ways of looking at social and political life."[21]

Tim N. Gidal, one of the most prominent in the ranks of photo-journalists, once described the themes of everyday life as the main motif for the photo-reportages of the illustrated journals. "The real yardstick became the humanity of the photo-journalist, the honesty of the report on what was to be seen, whether beautiful or not,

**Lewis Hine**
Glass Factory, 1908
Gelatin silver print, 16.7 x 11.8 cm
Cologne, Museum Ludwig,
Jeane von Oppenheim Donation

bined the aesthetic principles of the artistic avant-garde with the demands of professional photography. Munkacsi was the aesthetic catalyst of artistic invention and electrifying visual effect. His particular way of seeing the world, his pronounced feel for original, accessible compositions, his extraordinary sensitivity towards the feverish dynamic of his own age, whose aura he both breathed and portrayed – all these marked his pictures out as unique records of the modern era.

Alongside Salomon and Munkacsi there was a whole troupe of excellent photographers, including Walter Bosshard from Switzerland, who had studied art history; Alfred Eisenstaedt (p. 643), originally a haberdashery salesman who took photographs in his spare time before becoming a legendary member of staff on the American magazine *Life* (from 1937 onwards); George Gidal (who died prematurely), brother of Tim N. Gidal (ill. right) who had studied history, art history and economics; Kurt Hübschmann (Kurt Hutton); André Kertész (pp. 638 f), a compatriot of Munkacsi's and one of the greatest photographers of all; Harald Lechenperg, the travel

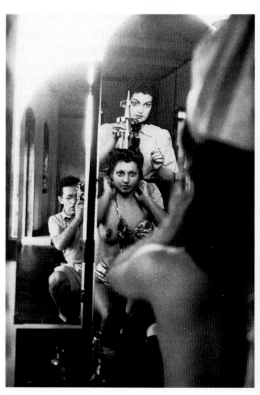

**Tim N. Gidal**
Cheerful Self-Portrait, 1940
Gelatin silver print, 17.5 x 12 cm
Cologne, Museum Ludwig

whether positive or negative. The reader then experienced this immediate kind of reportage, observing hitherto unobserved spheres in the lives of his or her fellow human beings, a privilege brought to him or her by the modern photo-journalist, who nevertheless respected the actual boundaries of an individual's private life."[22]

This, then, is where the aims of the professional photographer meet the aesthetic intentions of the artistically ambitious photographer. Unlike the leading proponents of 'New Seeing' the photographers of Neue Sachlichkeit (New Objectivity) were keen to exploit the actual characteristics of photography and its very real possibilities, taking up where direct photography had left off in the 19th century. Among their number were Albert Renger-Patzsch, August Sander (pp. 634 f), Werner Mantz (p. 638) and Karl Blossfeldt (even if the latter qualified more on account of his photographic approach rather than his aesthetic intentions.)

As a result, they identified their sharpest aesthetic opposition as coming from the still tremendously successful art-photographers such as the sensitive portraitist Hugo Erfurth (ill. below). However, their work was not centred on perception and "seeing vision" (Max Imdahl) as was that of Moholy-Nagy and his followers. They were interested instead in the soberest, most factual representation of the photographic subject. Renger-Patzsch (p. 640) summed up the artistic aims of Neue Sachlichkeit: "The secret of a good photograph, which can have artistic value just like any work of art, lies in its realism. In photography we have a reliable means to communicate the impressions we might have at the sight of Nature, a plant, an animal, works by builders or sculptors, the creations of engineers and technicians."[23]

Furthermore, he appealed to his fellow photographers: "Let us therefore leave art to the artists and use the means of photography to create photographs that stand on their photographic quality alone – without having to borrow from art."[24]

His photographic works, prime examples of Neue Sachlichkeit, reveal a dry, engineer-like view, the precise representation of things, giving a clear over-view of their formal order, yet resisting any temptation into Formalism, in the same sense that the fine differentiation of their grey tones is achieved by even, wholly undramatic lighting. His impressive book, *Die Welt ist schön* (The World is Beautiful) – he himself would have preferred a more laconic title, namely *Die Dinge* (Things) – provoked scorn from Walter Benjamin, yet it became a kind of Bible to the photographers of Neue Sachlichkeit,

**Erich Salomon**
Round-Table Talks, 1930
Gelatin silver print, 27.8 x 36 cm
Cologne, Museum Ludwig

**Erich Salomon**
King Fuad of Egypt with Hindenburg, 1930
Gelatin silver print, 17.7 x 23.7 cm
Cologne, Museum Ludwig,
Gruber Donation

**Hugo Erfurth**
Käthe Kollwitz, 1929
Gelatin silver print, 24 x 18.5 cm
Bonn, Rheinisches Landesmuseum Bonn

more influential even than Sander's *Antlitz der Zeit* (Face of the Times), a social panorama of the Weimar Republic embodied in its own social mask, and more influential too than Karl Blossfeldt's *Urformen der Kunst* (Art Forms in Nature; ill. below) with its monumental yet unpretentious depictions of flowers and plants against a neutral background.

Gustav F. Hartlaub, who invented the term 'Neue Sachlichkeit', described what this meant for painting as "the discovery of the thing after the crisis of the ego during Expressionism."[25] This description also exactly fits the photographic work of Renger-Patzsch, Sander and those of a similar leaning. Norbert M. Schmitz summed up the situation in film: "The films of 'Neue Sachlichkeit' ... practise an objective view of things, a distanced, distinctly scientific attitude which nevertheless presupposes an underlying acceptance of our industrial present."[26] Renger-Patzsch had just embarked on an ambitious project aiming at a photographic documentation of the Ruhr area, when the National Socialist government stripped him of his post at the Folkwang School in Essen. In response he abruptly called a halt to the project and withdrew into 'inner emigration' just as Sander, too, was also unable to pursue his ground-breaking chronicle of humanity under the Nazi dictatorship.

Advanced German photography celebrated its triumph in the Stuttgart exhibition "Film und Foto" in 1929. Yet by that time it was already past its artistic best. The future now belonged to American and French photography. The Americans included Berenice Abbott, Paul Outerbridge, Man Ray (although living in Paris), Charles Sheeler (also well-regarded as a painter), Steichen, Ralph Steiner and Edward Weston. Although this was a relatively small contingent, and without Stieglitz, nevertheless they manoeuvred more pragmatically and skilfully than the Europeans between the actual pitfalls of advanced photography, between the Scylla of formalist game-playing and the Charybdis of advertising. It was not only younger photographers like Margaret Bourke-White who had quietly, without any great ado, cut loose from the Pictorialism of the past: its leading proponents, Stieglitz and Steichen, had done exactly the same.

**Albert Renger-Patzsch**
At Oberhausen, 1932
Gelatin silver print, 21.7 x 16.4 cm
Bonn, Rheinisches Landes-
museum Bonn

**Umbo**
Sinister Street, 1928
Gelatin silver print, 29.8 x 22.8 cm
Cologne, Museum Ludwig

**Albert Renger-Patzsch**
Advertising Picture for the Jena
Works, c. 1935
Gelatin silver print, 38 x 28.2 cm
Cologne, Museum Ludwig

Although Stieglitz continued to handle photo-
graphic prints with the utmost care, in his masterpiece
– a series of portraits of his partner Georgia O'Keeffe –
he in fact fulfilled, in an exemplary manner, all the aes-
thetic demands of specifically photographic photogra-
phy, absolutely in line with Rodchenko's thinking,
which he had explained using the example of a portrait
of Lenin. Using a whole number of different space and
time angles the American created his breath-taking por-
trait of the legendary artist, a project that has proved to
be unique in its fragmented perfection, so suited to the
medium.

Yet there was not such an abrupt rejection of art-
photography in the USA as in Europe. Although the
excellent Paul Strand (p. 641 below) pilloried the notion
of mistaking the camera for a paintbrush, calling the
whole discussion 'foolish,' he never became self-right-
eous, but could not help being pleased that in the wake
of this discussion, now nobody knew any more "what
art is."[27] And the result of this was that "fortunately
some photographers show in their work that the camera
is a machine, indeed a truly wonderful machine. They
prove that, used properly and sensibly, the camera can
become the instrument of a new way of seeing, an
instrument with undreamt of potential – admittedly
related to painting and the other arts but in no way
usurping their territory."[28] Strand's own sensitive works
manage to maintain a balance between realistic-docu-
mentary closeness and formal-aesthetic finesse and for
him the camera was indeed, as the Italian philosopher
Benedetto Croce had famously called it, an instrument
of "intuitive recognition."

Given the two poles of sensitivity and analysis, Ger-
man photography favoured an analytical attitude while
Strand and Weston (p. 641 above) relied more on their

sensitivity. "Dare to be irrational, steer clear of formulas, stay open to every fresh influence, stay flexible … As soon as they are formed, theories lead straight to academism"[29] read a diary entry by Weston. Under the spiritual umbrella of American transcendentalism which saw things as "vital symbols" (Wolfgang Kemp), Weston sought to sink into the essence of things: not to mediate them empirically but, by means of empathetic assimilation, to experience them and to bring that experience to others too. He wanted to show the 'thing' in itself, not merely an object. As a result, the kaleidoscope of contrasting haptic qualities is virtually tangible in Weston's work: the lively fruitfulness of Nature and plants, the porcelain or metallic coldness of man-made artefacts, the finely-grained structure of the hot sands of the dunes, the tender skin of the naked human form.

Like Strand and Weston, Walker Evans (p. 642), the outstanding American photographer of the 30s, fought against what he despised as photography's "pretensions to art." Non-conformist and impressively cynical, although not without humour, Evans was a passionate photographer who scorned the work produced by his compatriots Stieglitz and Steichen whilst admiring Sander and – with certain reservations – Renger-Patzsch. He found his aesthetic legitimation in literature rather than in painting. His guiding lights were writers like Gustave Flaubert, Ernest Hemingway and James Joyce and his constant catch phrase was "I am a man of letters." Tangible reality was his terrain, the street was his route and the town was his world. "In the street I can train my sight and give it the nourishment it needs."[30]

He experimented tirelessly, with all kinds of cameras, with colour and even with instant photography. He

did not even disdain chance as an aesthetic tool, as for example in his candid shots in the subway; an undertone of Surrealism pervades his work. Evans became the definitive portraitist of the USA in the difficult years stretching from 1927 to 1974. His pictures say more than contemporary painting and sculpture. He was also one of the legendary troop of photographers who were commissioned by the Roosevelt Administration to realise an epoch-making project to create a photographic documentation of rural America (Farm Security Administration – FSA), covering the areas that had suffered worst in the world economic crisis. Other photographers involved in the project included Dorothea Lange (p. 642 below), Arthur Rothstein, the painter Ben Shahn, Russell Lee, Jack Delano, Carl Mydans, John Vacon, John Collier and Marion Post Wolcott – the elite of American photography; with the exception of Bourke-White, who with her husband, the writer Erskine Caldwell, was in any case working along the same lines.

American photography, which was already flourishing, then received another vigorous creative boost with the arrival of immigrants from Germany after Hitler came to power and the Nazis had begun their systematic policy of taking control of the country. And a few years

**Edward Weston**
Nude, 1934
Gelatin silver print, 24.5 x 19.3 cm
Cologne, Museum Ludwig

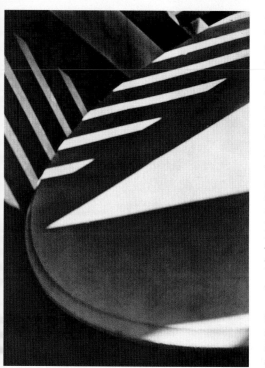

**Paul Strand**
Abstraction, Shadows of a
Veranda, Connecticut, 1916
Handgravure, provided by the
Aperture Foundation, 33.1 x 24.3 cm
Cologne, Museum Ludwig,
Gruber Donation

later, more were to come from Austria, Czechoslovakia, the Netherlands and France. The shadow of terror drove Munkacsi and Eisenstaedt to the USA, Gidal to Palestine and England, which also became the destination for Hübschmann and Man. Robert Capa, who had mainly only carried out lab work in Berlin and who was to become an unsurpassed chronicler of the war, first went to France and then, with the arrival of the German army of occupation, moved on to the USA along with Kertész,

George Hoyningen-Huene, the latter's pupil Horst P. Horst (p. 651) and the incomparable Erwin Blumenfeld (ill. below right). The young Helmut Newton fled via Asia to Australia. His teacher Yva was killed in Auschwitz, as was Salomon who had only found temporary refuge in Holland.

In England the newly founded *Weekly Illustrated* and the rather more successful *Picture Post* under the direction of Stefan Lorant, erstwhile chief editor of the

*Münchner Illustrierte Presse,* carried on the tradition of photo-journalism with Man, Hübschmann and Gidal and in 1963, *Life,* with the duo Bourke-White / Eisenstaedt, rang in the last and most brilliant phase of photo-reportage. Since then the USA has been the home of the mass media with New York as the centre of photography and Hollywood as the centre of the film industry.

Yet, in the first instance, France and its capital, Paris, were the first destinations for photographers leaving or fleeing from Germany, fearing for their lives because of their Jewish backgrounds. Some were swept temporarily towards Prague, such as Heartfield, where there was already a lively experimental photographic circle including František Drtikol (p. 645), Jaroslav Rössler, Jaromir Funke and Adolf Schneeberger. But most had already been attracted by the magnetic pull of the French capital. Now in Paris, Kertész (pp. 638 f) nevertheless continued to work for German publishers. Raviv-Vorobeichic, a convinced Zionist, drew inspiration from the art-soaked atmosphere of the city on the Seine, as did Germaine Krull from Poland (ill. below) and the American writers of the 'lost generation.' Surrealism was riding high, leading to heated debate in the ateliers and cafés and spicing the 'small talk' at luxurious parties. Paris was now the undisputed world centre of art and literature and second only to Hollywood in the film industry, now that Berlin had disappeared from sight in a brown haze.

Surrealist writers and painters harboured a distinct weakness for photographic images: what better parallel

to their own notion of écriture automatique than the 'automatic' process of photography? They could search photographic images unhindered for revelations from the subconscious. Eugène Atget (pp. 645 f), the tireless itinerant photographer, owes his reputation as an exceptional artist to the Surrealists. He had photographed a world on the verge of disappearing: old Paris, the customs of its long-term inhabitants, the palace at Versailles in decay. And this he did using out-dated techniques, yet utterly obsessively and stunningly systematically. The writer Camille Recht described his photographs in terms of shots taken at the 'scene of the crime,' and they do indeed convey a sense that here we are seeing the 'scenes of the crimes' of history.

**Alfred Eisenstaedt**
V-Day, 1945
Gelatin silver print, 24 x 15 cm
Cologne, Museum Ludwig

**Germaine Krull**
Pont Transbordeur, Marseille, 1926
Gelatin silver print, 19.8 x 14.4 cm
Cologne, Museum Ludwig

The Surrealist painter Man Ray (pp. 646 f), on the other hand, who much admired Atget's work, was a photographic magician by comparison. He earned his living with outstanding images and portraits from the world of fashion and high society, and no other artist extended the scope of the medium as he did. He embodied a completely new type of artist. He constantly moved between painting, photography and film as between 'free' and 'applied' art. A subversive magician with a tendency towards pragmatism. This may be why he was somewhat reluctant to agree with the painter Salvador Dalí's assertion that photography was a "pure creation of the spirit."[31]

While the night of terror gradually closed in on Germany and Adolf Hitler wrote the introduction to the 1934 edition of the periodical *Das Deutsche Lichtbild*, Paris was reaching new cultural heights. In the late 20s 'New Photography' had made a breakthrough in Paris too. Burgeoning consumerism leading to an increase in advertising plus a growing need for illustration was a fertile breeding ground for open-minded photographers who relished the risks involved. Kertész, his compatriot Ergy Landau, the Romanian Eli Lotar – all immigrants – and the Frenchman Jacques André Boiffard along with Man Ray and Krull forced French photography into self-renewal. The ball was kept in the air by Maurice Tabard, Emanuel Sougez, Roger Parry, the Hungarian-born Brassaï and Roger Schall along with the Bauhaus products Florence Henri (p. 646 below) and Raviv-Vorobeichic (Moi Ver) while artists such as Dora Maar, sometime companion of Pablo Picasso, Henri Cartier-Bresson and Raoul Ubac along with the photographers Nora Dumas and Emerique Feher played their part in creating a lively photographic scene.

They made their livings from illustrated journals such as *Vu*, under the committed leadership of Lucien Vogel, as well as from other magazines and the daily press. And while Kertész and Brassaï produced 'Poetic Realist' volumes of photographs putting a beguiling gloss on the myth of the French capital, Raviv-Vorobeichic portrayed the explosive vitality of the city and in

his book – simply called Paris, with a foreword by none other than Fernand Léger – in keeping with 'New Seeing,' made the most of the possibilities of montage, double exposure and sandwich printing.

Thus the photographers who had fled, been driven out, or who had left Germany of their own accord, found themselves in an artists' paradise. Yet they were hardly welcomed with open arms and their work as photographers was not made any easier by their not having work permits. Ilse Bing, Hans Namuth, Georg Reisner, Josef Breitenbach, Gisèle Freund, Willy Maiwald, Robert Capa, Gerta Taro and more besides – they all had endless difficulties to overcome. Following a temporary relaxation of regulations, these were tightened again by later reactionary governments. For Namuth and Reisner and for Capa and Taro the Spanish Civil War marked the turning point in their professional careers.

Capa's disturbing images, epitomised by his *Death of a Spanish Loyalist* made him world famous. This cruel war cost his friend and sometime lover, Gerta Taro, her life. Although the real cause of her death was a terrible accident, Louis Aragon and the French Communist Party gave her an extravagant funeral and used this to portray her as a martyr to a 'just cause' – for a time her name was forgotten in the icy winds of the 'Cold War' until tenacious research by a German historian reawakened her memory in the early 90s.

**Man Ray**
Lips on Lips, 1930
Gelatin silver print, 22.9 x 17.5 cm
Cologne, Museum Ludwig

**Florence Henri**
Composition II, 1928
Gelatin silver print, 17.2 x 23.9 cm
Cologne, Museum Ludwig

*Page 647:*
**Man Ray**
Kiki, Violon d'Ingres, 1924
Gelatin silver print, 38.6 x 30 cm
Cologne, Museum Ludwig

# A Meaningful Relationship: Fashion and Photography

Adolf de Meyer (ill. right), certainly no blue-blooded aristocrat but created a baron by his royal patron, was the product of that stratum of society that nurtured the rise of fashion. Social protection had allowed Meyer-Watson, as he was born, to enter the ranks of the fashion-conscious Prince of Wales's entourage even if, by the turn of the century, the latter's role as a leader of fashion in London already seemed to smack of an age that was slowly but surely fading away. In Donna Olga Alberta Caraciolo, supposedly an illegitimate daughter of King Edward VIII, de Meyer found a faithful wife and ideal partner. She planned his career and smoothed his path at court. According to his biographer Philippe Julian, the Jewish homosexual Meyer and his aristocratic wife Olga possessed all the right qualities for an ultra-modern version of a marriage à la mode.[32] Upstarts, parvenus, cocottes, actors and actresses, artists, in short: society's outsiders with their own looser social structures were always susceptible to fashion – exactly as they still are today.

Pictorialism lent character to the flamboyant baron's photographs while their light came from Whistler's painting. Stieglitz admired his photographs and exhibited them in his legendary gallery '291,' the 'entrée' for European avant-garde art into the USA, and published them in his journal *Camera Work*. Meyer's real breakthrough came at the beginning of the century when the American publisher Condé Nast engaged him for the magazine *Vogue* which he had recently acquired for his expanding empire. At the time *Vogue* had very low circulation figures but within a few years Nast, an imaginative and effective publisher and patron of modern fashion photography, had built it up into a force to be reckoned with in the world of fashion, into a publishing *arbiter elegantarium*. Meyer's images with their gloss of extravagant glamour were the backbone of his campaign.

*Vogue* developed standards for society life and Baron Adolf, an entrepreneur of good taste – as the fashion historian Nancy Hall-Duncan was to call him – controlled the magazine's visual appearance until Steichen eventually took over. Meyer left when Nast had turned down his suggestion that the new British and French editions should be produced in Paris, at which point Nast's competitor, the newspaper tycoon Randolph

**Adolf de Meyer**
The Silver Cup, c. 1908
Gelatin silver print, 39.2 x 15.2 cm
Amsterdam, Heiting Collection

*Page 649:*
**Irving Penn**
Lisa with Roses, 1950
Gelatin silver print, 41.5 x 34.5 cm
Cologne, Museum Ludwig,
Gruber Donation

Hearst, who had achieved immortality in Orson Welles' *Citizen Kane,* snapped the celebrated fashion photographer up for his own illustrated magazine, *Harper's Bazaar.*

*Vogue* and the elite *Vanity Fair* were, along with *Harper's Bazaar,* the unchallenged leaders of opinion in matters of haute couture and high society, fulfilling the role of the royal courts in the early days of fashion magazines, even before the First World War broke out. These three magazines provided a suitable framework for socialites wearing the latest of fashions to see and be seen. Thus in Meyer's photos ladies of good breeding modelled the fashions, wearing what they had ordered

**Martin Munkacsi**
Torso, 1944
Gelatin silver print, 33.8 x 27.4 cm
Cologne, Museum Ludwig

**Martin Munkacsi**
Skier, 1930
Gelatin silver print, 29.7 x 21.6 cm
Private collection

in this. They drove the process speedily forwards, at the same time as producing the necessary publicity to make this happen. Film actors suddenly found themselves in the harsh light of public interest while stage actors were relegated to the margins of press attention.

And as 'show business' took off, leading serious artists, writers, musicians, painter and sculptors became promoters of fashion as had many of their fore-bears – including Baudelaire, Gioacchino Rossini, Jean-François Millet, Jules Champfleury, Giacomo Meyer-beer and Alexandre Dumas. Now Gertrude Stein, Aldous Huxley, Picasso, André Breton, even the shy James Joyce, the sensitive Virginia Woolf, the vitriolic Karl Kraus and the narcissistic poseur Jean Cocteau – more or less the entire serious avant-garde – were only too glad to oblige photographers because this was how to raise one's social profile. The artists in turn lent the relevant magazines and up-and-coming journals an air of legitimacy and respectability, propagated a life-style both exotic and enviable and held their own as perma-nent features in the roulette of the social elite in the years between the two World Wars.

Photography is the perfect means of visual expres-sion for fashion. And the triumphant progress of this particular technical medium, hugely accelerated by the mass press with its circulation figures in the millions, greatly increased the sphere of influence of fashion. And beyond this there are other points of contact between fashion and photography: fashion is like the materialisa-tion, as it were, of a fleeting moment in the continuum of time; a moment which is shown by photography to be irretrievably past. Fashion and photography comple-ment one another. While fashion is utterly of the pre-sent, photography documents the passing of what it portrays. "There is a superimposition here: of reality and of the past" (Roland Barthes).[33] And there is another sig-nificant additional factor: fashion needs the wearer to pose, and in photography even a fraction of a second can be captured as a pose. Thus both photography and fash-ion are synonymous with artificiality and pure superfi-ciality.

Nevertheless, it does seem at first sight as though the comparatively more recent genre of fashion photogra-phy, which does after all pre-date Meyer, still reflects a particularly antiquated notion of photography. Before Steichen nimbly came and cleared the stylistic clutter out of fashion photography, it was still wallowing in the out-dated precepts of art photography. The latest fash-ions were being shown in photographs which them-selves seemed strangely old-fashioned. Not a trace of 'New Seeing' or 'Neue Sachlichkeit.' Is there perhaps a contradiction to be seen in this?

Clearly fashion photography had its own laws – as did its subject matter. It is an attempt to completely aes-theticise visible and tangible reality and postulates an absolutely artificial universe. Even Steichen did not pilot fashion photography into the waters of cold sobri-

and acquired. So, for a time there was no difference between mannequins, dummies and the owner of a new fashionable 'creation' – which means that the resulting fashion photography does have its own documentary authenticity.

However, the more fashions by new designers – led by the unforgettable Gabrielle 'Coco' Chanel – reflected women's aspirations towards a career outside the home, the more the world of fashion presented itself in a distinctly different manner. The war had swept aside numerous social barriers and young women no longer viewed themselves as the 'representatives' of their well-heeled, upper class husbands' 'conspicuous con-sumption.' Soon professional mannequins and specialist 'models' replaced the countesses, industrialists' wives, courtesans and actresses, rapidly establishing themselves as the new role-models of the time.

At the same time the popular theatre, born of operetta and vaudeville, was mutating into the mighty machinery of show business. Photography and film, the new medium of moving pictures, had a double role

ety. He chose instead a form of diluted Neo-Classicism with faintly absurd, occasionally even Surrealist overtones. Of course, fashion photography is not immune to impulses from external reality. Sometimes it even pre-empts these, but much more importantly, it creates a domain for collective dreams. And when it pointedly shuts out the complications of reality, this is at least indirectly a symptom of an underlying fear of the power of reality. Fashion photography is a web of expectation, ideas, wishes, dreams and anxieties.

One of the most radical innovators in the field of fashion photography was Martin Munkacsi. He was an outstanding photo-journalist, famous for his fine photographs, particularly for his sports and dance photographs (p. 650 above). Although he had virtually no experience of fashion photography, Carmel Snow of *Harper's Bazaar* and her art director, Alexei Brodovich, gave him a contract as soon as he arrived in the USA, having been driven out of Germany by the Nazis. Carmel Snow had come from *Vogue* to its competitor and within two years she had become the most influential fashion editor in the world. She had fired Meyer and completely revamped the magazine. Now she expected Munkacsi to blow a fresh breeze into the sails of fashion photography. He was not familiar with the old habits and well-worn clichés of fashion photography, which proved to be an advantage, because fashion trends in the 30s – replacing stiff elegance with a more relaxed style that drew heavily on sports clothing – perfectly suited his own ideas about photography.

At first sight the models in his shots could easily be taken for young women snapped by chance in the street, on the beach or at the sports ground. They seem to have passed before the camera apparently relaxed and wholly unintentionally, liberated from the corset of social strictures, and lending his pictures the spontaneity of 'snapshot photography.'

Of course, fashion as Munkacsi captured it was by no means 'natural,' having much more to do with attitude; in fashion everything is 'parure' – decoration (René König). And while Meyer was clothing his models in the glittering sheen of ostentatious luxury and Steichen was bathing his in the cool light of reserved elegance, Munkasci was mobilising the dynamism of sport and of the hectic 'theatre' of street life. But even his Realism is stage-managed, if only for the reason that his subject was fashion. Fashion is the antithesis to Nature, even the nudist on the beach – as the sociologist René König mockingly pointed out – is as much a slave to fashion as ladies in the dim and distant past on holiday at the seaside with their elaborate clothes and hats as big as carriage wheels.[34]

Nevertheless, it seems that opposing positions in photography come together in Munkacsi's work, which combines a strictly authentic style of documentary photography with stage-managed fiction. And in the end, it in fact turns out that the two are interchangeable. For even the most undirected version of photographic praxis imposes a visual frame on the subject and, although this framework can take an immense variety of forms, it is still an ineradicable constituent of any photographic image. And fashion too rests on a paradox: its particular elixir of life is perpetual self-destruction. Each new fashion kills yesterday's fashion and it is only in photography that the fleeting appearance of fashion can find an apparent licence for permanence.

Munkacsi's aesthetic strategies wrought lasting changes in the stylistics of fashion photography and

**Horst P. Horst**
Mainbocher Corset, Paris, 1939
Gelatin silver print, 24.2 x 19.2 cm
Cologne, Museum Ludwig,
Gruber Donation

**George Hoyningen-Huene**
Bathing Suits by Izod, 1930
Gelatin silver print, 28.8 x 22.6 cm
Cologne, Museum Ludwig,
R. Wick Donation

**F. C. Gundlach**
Jump Suit, Mirella, Oslo, 1963
Gelatin silver print, 40.8 x 30.5 cm
Bonn, Rheinisches Landes-
museum Bonn

*Page 653:*
**Robert Lebeck**
Jayne Mansfield, Berlin, 1961
Gelatin silver print, 61.4 x 50.7 cm
Köln, Museum Ludwig

inspired his contemporaries including Toni Frissell,
Herman Landshoff, sometimes even leading figures
such as Steichen and George Hoyningen-Huene as well
as photographers from the next generation such as
Richard Avedon, but this does not mean that they com-
pletely dominated fashion photography in the 30s and
40s. On the contrary, artificiality was also able to cele-
brate its own, bizarre triumph in the seductive pho-
tographs of Cecil Beaton (p. 654) with their double
images, confusing reflections and formal poses. And
at times Hoyningen-Huene and Horst P. Horst took
Steichen's diluted Classicism to the point of involuntary
parody.

Hoyningen-Huene (p. 651 below), in carefully con-
structed, evenly lit compositions with Classical Greek
props lent his photographs the aura of some apparently
timeless ideal of beauty, which he at the same time
wholly consciously undermined with various Surrealist
visual touches; meanwhile Horst P. Horst complicated
the Classical moment by purposely ironically emphasis-
ing the *trompe l'œil* (deceiving the eye) of the Classical
scenery, and thus destroying it in the process (p. 651).

Blumenfeld and Man Ray strove to synthesise the
two poles; and in fact, with their unusual pictures, they
succeeded in portraying – between the lines, as it were –
the deep discrepancies of the era between the two World
Wars, the tensions in Europe, dominated in large areas
by National Socialism and Fascism, as well as the dor-
mant anxieties just below the surface. High above Paris
at the top of the Eiffel Tower, in one of Blumenfeld's
most famous images, a model performs acrobatic feats
above a deep abyss; the young woman spreads out her
skirt like a bird spreading its wings, and yet her position
is at least as precarious as that of the artiste in the circus
tent. A distant echo of Moholy-Nagy's view from the

Berlin Radio Tower – but this time with a figure for the
viewer to identify with.

The inferno that was the Second World War, with its
unimaginable intensity and cruelty, brought with it the
final demise of the old world and, against this backdrop,
Louise Dahl-Wolfe's over-loaded fashion tableaux and
Cecil Beaton's apparently contradictory photographs,
that were shot amongst the ruins in London after the
heavy bombing inflicted by the Germans, would seem
to be a last desperate attempt to cling to the familiar
ideas and habits of a 'golden' past. No documentary
photographs betray the chasm between reality and what
one wishes were true so movingly.

After the end of the Second World War, in the years
marked by widespread deprivation, dreams flourished
in fashion photography again. Fashion photographers
portrayed an 'anti-world' in their images, contrasting
with the reality of the ruined towns and cities of Europe
as with the reality of the arduous struggle for daily sur-
vival. Although the shots are generally taken out of
doors, the models behave exactly as though they are on a
stage. In elegant dresses, suits and coats they re-awaken
the ideal of the lady, far away from the grinding routine
of professional life and far away from the ruins of
destroyed cities. And of course in these constructs of
fashion photography there is also a resonant sense of
longing for a transfigured past. However, at the same
time, there was a drive to get all those women – who had
fought so 'manfully' while their men were away – back
into their traditional place in the home. The men who
had survived the war returned and were now demanding
their old place in society back again. Yet, the impending
gender-conflicts were only indirectly evident in Euro-
pean and American fashion photography – most
notably, in fact, in the way that they were painfully
avoided, with Avedon and Irving Penn providing the
only real exceptions to the rule.

Following in Munkacsi's footsteps, whose intention-
ally lively style he much admired, Richard Avedon
worked his way towards fashion. He had learnt his trade
in the Marines taking photographs for identity cards.
He then took up where Munkacsi left off. The Hungar-
ian had freed fashion photography from the fetters of
convention and literally got his models moving – and
now Avedon allowed them to have souls, feelings,
moods and weaknesses. His early pictures on the streets
of Paris overflow with a zest for life after getting through
the years of deprivation. The models positively spin
through the pictures, seldom finding a moment's peace
to smoke a cigarette or drink a glass of wine. The feverish
intensity of their attitude to life translates directly into
dynamic action.

In contrast to this, aesthetic discipline and a con-
scious economy of formal means characterise Penn's
work (p. 649). Penn was a fashion photographer for
*Vogue* – Avedon worked first for *Harper's Bazaar* before
also going to *Vogue* – his rise to fame was as fast as Ave-
don's, and as a portraitist for the same magazine he also

breathed new life into portraiture. His portraits, that seem to 'dissect' the subject, and his fashion shots which imperceptibly acquire the status of portraits of the models, portray the individual qualities and characteristics of the subject, as do also the majority of his pictures of American Indians, Arabs and people from other ethnic backgrounds. Many of his pictures are reminiscent of still lifes and later on he was to devote himself almost exclusively to this genre. But even his fashion photographs were often already imbued with a sense of momento mori.

In the 60s and 70s the aesthetics and the look of fashion photography underwent a radical change. This was due, on the one hand, to the shift from haute couture to *prêt-à-porter* and, on the other, to increasing prosperity which ensured a wide interest in cheaper fashion items – but most significant of all was the cult of youth that was now spreading like wildfire. And the cult of youth lost none of its impetus as the end of the century approached. On the second of two portraits of the renowned model Simone d'Aillecourt, taken twenty years apart by the German photographer F. C. Gundlach (p. 652), the model looks like her own daughter. Constant conflict between the generations became the prevalent social structure. In fashion photography the deep-seated external and internal changes in society were reflected more clearly in the aspect of the models than in the fashions they were presenting. Avedon and, even more so, David Bailey sensitively reflected impressions of the mood in Western society fixated on a youthful image of humanity. Little by little they blurred the boundaries between photo-journalism and fashion photography.

In this sense Helmut Newton's images (p. 657) also break the bonds of convention when it comes to his pictures of fashions by those such as Yves Saint-Laurent, Claude Montana and Karl Lagerfeld. In his hot-cold (Andreas Kilb) images, there are always undertones of the social and psychological discord which also pervade fashion. Although his work is characterised by an unsettlingly cool sense of distance, nevertheless it is as though there is something simmering just below the surface. Hidden aggressions break through, predominantly – but not only – sexual. Concealed desires come to the surface. Hidden anxieties. His work: a psychogram of *fin de siècle* society.

In Newton's photographic works one can see how deeply fashion is anchored in what drives humanity and how little it has to do with the need to protect oneself from the prevailing climate. And it is not surprising that, with time, Newton has switched his interest as a photographer from professional fashion photography to making portraits of the idols of our modern media society, that layer of society that has slipped into the erstwhile function of the 'upper crust.' In addition, Newton cultivates the language of the expressive German photographers and film makers of the 20s and 30s, as it was preserved in Hollywood's 'Black Series' which was entirely

**Will McBride**
Overpopulation, c. 1969
Gelatin silver print, 26.7 x 40.5 cm
Cologne, Museum Ludwig,
Uwe Scheid Donation

**Robert Doisneau**
Gate of Hell, Boulevard de Clichy, Paris, 1952
Gelatin silver print, 30.4 x 24 cm
Cologne, Museum Ludwig

created by directors, camera men and musicians who had emigrated from Germany.

It may well be that fashion photography – along with journalistic photography – is the most suitable and convincing means of expression of this particular technical medium. And yet it is closer than any other photographic genre to questions of aesthetics, although art, submitting to the dictates of the avant-garde, rejects it as its supposedly opposite pole. In the 50s and 60s fashion photographers also examined photography's claims to authenticity by adopting various elements of photojournalism.

Amongst those who spring to mind in this connection are Avedon, William Klein, Will McBride (p. 655 above) and F. C. Gundlach (p. 652) as well as the obsessive 'scene of the crime' photographer Guy Bourdin,

*Page 654:*
**Cecil Beaton**
Fashion, c. 1935
Gelatin silver print, 24 x 18 cm
Cologne, Museum Ludwig

realism of the image becomes a stage-managed representation. Therefore, in a certain sense, fashion photography, by never hiding its own stage-management, becomes the most authentic form of photographic representation.

Nick Knight and Olaf Martens (p. 675 below) – one a middle-class Englishman, the other an East-German – underline with their bold, brazen pictures the vitality of fashion photography in the late 20th century. It is neither infected by the boredom of contemporary art photography nor by the tribulations of new technologies such as digitisation and cyber space. Knight creates an utterly artificial world, a shrill reflection of that attitude to life that has surrendered unconditionally to the 'here and now.' Martens melds this attitude with the biting contrasts and grotesque distortions of reality. For this reason he generally chooses locations in Eastern Europe after the collapse of the Soviet government and the disappearance of 'truly existing Socialism' as settings for his photographic visions where fiction and real life collide with such force.

In the arc spanning Knight to Martens there are yet more outstanding talents such as Bruce Weber, Peter Lindbergh, Deborah Turbeville, Bettina Rheims (ill. above) and Herb Ritts; and while none of them is a specialist fashion photographer, they and many other talented and imaginative photographers have reached into people's hearts and minds with their unmistakable works.

**Bettina Rheims**
Claudya with Gloves, Paris, 1987
Gelatin silver print, 57.3 x 42.8 cm
Cologne, Museum Ludwig,
Uwe Scheid Donation

whose radical treatment brought a new, sharper aestheticism to images of crime in New York of the kind that 'Weegee the Famous' had created two decades earlier. Sexuality and death were the essential backdrop to his images and, particularly in a widely acclaimed series for a Charles Jourdan advertising campaign, he often homed in on the trappings of fashion as fetishes pandering to the most dubious of desires.

As in fashion so, too, in photography everything is ultimately stage-managed; naturalness is no more than a fiction, or, at best, simply the least artificial moment. This means that in fact fashion photography is of greater documentary interest than a great deal of photography which is flagged as such. For the transience of existence is concentrated in fashion into laws with an immensely wide application but with a very short shelf-life, which is the reason that stage-management plays such an important part in this context.

And, vice versa, each picture grasps the fleeting moment like a model his or her clothes, as in war pictures by Capa, Cartier-Bresson's genre scenes and Robert Frank's visions of everyday political life. The

*Page 657:*
**Helmut Newton**
Violetta des Bains, 1979
Gelatin silver print, 40.3 x 30.3 cm
Cologne, Museum Ludwig,
Gruber Donation "

# War – The Father of all Photographs

*"If your pictures aren't good enough, you aren't close enough."*
ROBERT CAPA

When Hermann Claasen (ill. below) climbed up to the top of the spire of Cologne Cathedral to turn his camera on the destroyed Hohenzollern Bridge across the river Rhine, he was confronted with an image of utter destruction. Not only had the bridge burst asunder, its mighty arches now lying in the water below – what Claasen saw was a scene of devastation of unimaginable dimensions.

The old town of Cologne was a heap of rubble, the writing on the wall had come true in the shape of ruined houses, churches and towers. This view out over the town and across the country to the horizon in the distance was like the symbolic end to what had begun on 26 April 1336 when the Italian poet Petrarch (1304–1374) had climbed Mont Ventoux in Provence: he wanted to feel the sense of liberation in a view of the whole landscape where he was living in self-imposed exile, and, with this gaze, set the ball of modern times rolling as it were. Petrarch raised himself up above perspective, that same perspective with which painting was soon to conquer symbolic space and humanity was to conquer real spaces, the world as it was known and as yet unknown.

In photography the perspectives of spatial representation were confirmed on a technical level; but at the same time, by virtue of its capacity for infinite reproduction, photography also negated the apparently mandatory nature of this principle of spatial representation. Space in photography turned out to be a fiction, no more than a construct, in fact virtual space.

A few days before Claasen, the chronicler of the devastation of the Rheinland, two well-known photographers had also scaled the heights of the spire of Cologne Cathedral. Lee Miller (p. 659 below), a reporter with British *Vogue* and Margaret Bourke-White, the head photographer from *Life,* had come to Cologne in spring 1945 with the advance guard of the Ninth Army and had photographed conditions in Germany after its defeat, with the sober gaze of professional journalists and without sympathy for the losers. Writing not long afterwards about their experiences, Bourke-White gave a vivid account of her feelings as she looked out over the ruins on all sides: "The spire of Cologne Cathedral was a wonderful spot to take pictures from. After the steep climb I was a little out of breath when I looked through the gap in the stonework. But perhaps I would have felt that way anyway because far below me flowed the Rhine, splashing up against the edge of Pan-Germany. The river was still dangerous, the banks were swarming with German soldiers, hidden, lurking, ready to kill – the watch on the Rhine."[5]

It is not the motifs that distinguish these pictures from the airy peaks of the spires of Cologne Cathedral from other war pictures, but the perspective that was used in their creation. It is a perspective known familiarly as a 'bird's eye view.' And in contrast to the 'frog's eye view' where the low viewpoint makes even human beings seem larger than life, a bird's eye view affords the viewer a liberating overview and the edges of mountains and man-made constructions which usually halt the line of sight suddenly recede into the far distance where they dissolve in the haze so that the whole view opens up in a quite unaccustomed manner. Notions of escaping from gravity and dreams of flying have long been a persistent part of human mythology.

In photography Nadar was the first to put this into practice. He caused a sensation in Paris by having a huge

**Hermann Claasen**
Neumarkt Cologne
First daylight bombing raid of Cologne, October 1944, 1944
Gelatin silver print, 30.2 x 40.3 cm
Bonn, Rheinisches Landesmuseum Bonn

tography. On the one hand the images that were produced under his command documented the actual and symbolic superiority of the American forces and it is likely that the pilots of the British Royal Air Force used these same pictures to guide them on their 1000th raid on Cologne on 31 May 1942. On the other hand, Steichen ran his information delivery service like a small factory: "... it was the first time that pictures were produced on a production line. The photos lost their episodic quality, instead of individual pictures there was a flow of pictures, matching the tendency towards statistics of all kinds in this military/industrial war..."[36]

Steichen "was working towards a new concept of the image, which had a direct link with reconnaissance photography and the organised production processes involved. 'I decided to learn how to make photographs for newsprint because I was determined to reach a large public, rather than just the few I had reached as a painter.' In Steichen's hands war photography became the photography of the 'American dream.'"[37] After the war, around 1.3 million prints of war photographs found their way into Steichen's private collection. Then, having roundly renounced art photography, in his capacity as a fashion photographer he became one of the most successful magazine photographers of his day. In Robert Altman's ironic film on the fashion trade, *prêt-à-porter*, the actress Kim Basinger, playing a fashion editor, remarks, "Fashion is war."

The coda to the persistent interconnections between war and photography was orchestrated by Margaret Bourke-White with her ambitious project for *Life* magazine: a comprehensive series of pictures on the effects of the allied bombing of the towns and cities of the German Empire. "The pictures that she made for this purpose are amongst the most impressive

balloon constructed for himself, which almost plunged him into commercial ruin and which gave him the nickname "Le Géant" (the Giant). A friend, the graphic artist and painter Honoré Daumier, teased him that he had elevated photography into an art form and portrayed Nadar with his camera in the basket of an ascending captive balloon. But in fact Nadar did open up a whole new dimension of photography and his deed resulted in nothing less than a dramatic change in the accepted view of perspective in the representation of visible objects. In his aerial images 'without perspective' the photographer was actually focusing on the dimension of time. Ever since then art critics refer to illusionistic perspective in painting as opposed to 'realistic/naturalistic' pictures.

If photography was already serving such utilitarian purposes as propaganda, Nadar then hammered it into an effective war weapon. It is probably fair to say that his aerial images saved the French capital from Prussian occupation in 1871. Examination of his aerial photographs revealed to the defenders of the French capital what the soldiers on the ground could not see: not only the exact positions of the troops laying siege to the capital but also their likely points of attack and tactical angles as well as the overall logistics that would have supported the Prussian army as they stormed the city. Nadar's images put the French in the position to react instantly and spared them unpleasant surprises. Nevertheless, short-sighted military leaders in the army at the time were quite unable to recognise or to capitalise on the value of Nadar's initiative.

It was to fall to another photographer to demonstrate the practical value of photography in the conduct of war. As a colonel in the United States expeditionary forces in France, Steichen was in charge of air-reconnaissance. Thanks to his particular organisational talents he made a major contribution in this field, and in the process also significantly affected accepted modes of perception. His war experiences radically changed his attitude to pho-

**David Douglas Duncan**
Corea, 1950
From "This was War", 1951
Gelatin silver print, 35.5 x 50.8 cm
Collection of the artist

documents of the time. They show with oppressive monotony how the allied aerial attacks had turned the towns of Germany into endless city deserts."[38] As a technical medium, photography registered from above with the neutral (objective) view of technical equipment the visible results of the final loss of human perspective.

The fact that photography repeatedly becomes entangled in modern warfare is due not least to the fact that photography is a 'machine art' and war in fact embodies the ultimate triumph of the machine over humanity. If the experience of war hastened Steichen's departure from art photography, then the contact with the mechanical/technological aesthetics of 'New Seeing' were crucial for Bourke-White. As the daughter of an engineer-inventor, she had no qualms about technological progress and an industrialised society, much like the artists of the avant-garde in Germany and the Soviet

Union. The smoothness and the coldness of the product was for her a synonym for authenticity and objectivity, as proof that here a purely photographic aesthetic was being applied.

The same aesthetic precepts also fired the leading Soviet war photographers: Georgi Selma, Arkadi Shaikhet, Georgi Petrussov, Max Alpert and others. Yevgeni Chaldei (p. 659 below), on the other hand, had formerly photographed workers and had been active since 1936 as a photojournalist. Soviet photographers portrayed the vast 'War for the Fatherland' as an affecting epic in black and white with many moving moments that came together as undeniably ambiguous ciphers: symbols of heroism and horror, of superhuman struggles and inhuman suffering. In the harshest of circumstances, occasionally having to resort to the most primitive of photographic techniques, they generally fought on the front with their weapons in one hand and a camera in the other. The Soviet photographers' coarse-grained, 'dirty' yet nonetheless theatrical war images bear all the hallmarks of authentic experience. Fear, horror, dirt and delirium transcend the pathos of the images themselves. Even before the outbreak of the Second World War, on 3 December 1938 the *Picture Post* had already hailed Capa as the greatest war photographer in the world; the pictures that he had taken during the Spanish Civil War and the Sino-Japanese War had established his reputation. This attentive and passionate promoter of the emergent media world was also one of its most fascinating protagonists. Incurably restless, a passionate drinker and loved by women, he hated war and yet it was war that determined his life and ultimately his death in Indo-China.

Not for him the cynicism of the credo that if a photograph was not quite satisfying then the photographer had not been close enough: instead, he followed his own instructions to the official photography unit of the US Army during a training course: "When you are under fire, don't go where the shooting is: go where there are good pictures to be had."

Capa worked for several North American and British magazines before he reported for *Life* on the invasion of Normandy in June 1944. The results were a handful of pictures that avoided any trace of heroic posturing. Yet somehow they got to the bottom of the truth of one aspect of that invasion: the sea itself was a much greater threat to the allied soldiers landing on Omaha Beach than the defending German soldiers. In Capa's images the brave attacking forces are in acute danger of drowning even before they have joined battle. Although Capa did admittedly jump with the paratroops before the last battle for the Rhine at Wesel, he was not foolhardy. His pictures showed the victims of war, dead and wounded soldiers, helpless children in bombed-out cities, anxious boredom before battle, the misery of waiting, filth, madness. Because they showed the war from the point of view of the victims, from the point of view of the ordinary G.I.s and not from the commanding officers' vantage point, their success in the press was guaranteed.

Thanks to their renown as photographers, Capa and Bourke-White could seek out their own 'seats' in the theatre of war, as long as military considerations allowed. The extraordinarily wide distribution of their images helped them to overcome a certain degree of military resistance. In any case, most of the commanding officers recognised the propaganda value of the millions of reproductions of pictures by leading war photographers and Capa was positively 'adopted' by certain regiments.

He also reported on the struggle for independence in Palestine in 1948. Wherever he went, he only stayed for a relatively short time. Benno Rothenberg, himself once an Israeli war photographer and later a highly respected professor of architecture at a research institute in London, recalled Capa using vast quantities of film and, as a rule, producing by far the most impressive pictures of any event. It was, of course, not coincidence that war became the dominant subject in photography in Israel, which had to fight for its independence in the immense upheavals that followed the Second World War. Many immigrant photographers from Germany, committed to the cause, created a kind of visual myth of Israel in moving, powerful images comparable with pictures of Brady and his troops from the American Wars of secession, but also not unrelated to Soviet war photography particularly – sad to say – in their aesthetic standards.

Hans Chaïm Pinn made a sober, yet precise record of the daring landings of Jewish immigrants on the shores of Haifa, and also recorded the catastrophes, the street fights and the heavy fighting around the mosque between Tel Aviv and the old Arabian port of Jaffa. Rothenberg, who served in the army, as did the Soviet photographers, was generally able to use his military connections to beat the international press to the spot and produced the most up-to-the-minute pictures of the struggles for independence. A key photograph from that war was taken by Boris Carmi almost despite himself: he photographed a group of young Isreali soldiers without noticing that one of them had a concentration camp number tattooed on his arm.

Micha Bar-Am and David Rubinger produced their gripping images of the subsequent war with total commitment but also with a degree of distance in view of potential consequences. Bar-Am put together a photo-reportage on imprisoned Arab fighters and Rubinger created a symptomatic image of peace born of a mixture of exhaustion and reason during the meeting between President Sadat of Egypt with Minister President Begin of Israel, who for one moment in history looked just like old friends.

"War and photography now seem inseparable:"[39] the words of Susan Sontag, a moral critic of photography as a technical medium. And in photography she found evidence for what she saw as the sad state of a society that

lived at more and more of a voyeuristic distance to first-hand reality. And, in accordance with this, photographers whose personal concern was apparently with finding out and understanding were doing no more than satisfying the human thirst for sensation and driving this to extremes by ever more sensational images – until ultimately all feeling was lost. And yet, after seeing pictures from Bergen-Belsen and Dachau by George Rodger and Miller, this same passionate critic did admit quite as a matter of course to dividing her life into two periods: "before I saw those photographs ... and after."[40] Nothing had ever cut her "as sharply, deeply, instantaneously"[41] as these image of unimaginable terror, nothing, neither photograph nor reality.

Bourke-White recorded some of the feelings of the allied photographers when they were confronted with the horror of the German death camps. She herself, travelling with the advance guard of the 3rd US Army, had gone to Weimar and the concentration camp at Buchenwald. "This April day in Weimar had something unreal about it. I could only feel one thing, and I clung to this. I kept saying to myself that I would only believe the indescribably abominable picture in the yard in front of me when I saw my own photos. It was almost a relief to operate my camera. It created a fragile barrier between me and the blank horror that was before me... I wanted it to disappear, for as long as it was there, I could not stop thinking that it really was human beings that had done this... and it made me ashamed to be a member of the human race."[42]

She photographed the charred remains of people who had got caught in the barbed wire trying to escape from the concentration camp at Erla near Leipzig-Mockau and she photographed a man mourning a dead friend who was so thin that he was no more than a skeleton. The formal precision of these pictures does not alleviate their awfulness, nor does it explain it. It remains incomprehensible. The instruments of reason fail in the face of such horror.

Miller sought refuge in bitter irony and acrid sarcasm, by remarking that her own 'Fine Baedecker Tour' of Germany with the American Army had included places such as Buchenwald and Dachau, which had received no mention in her 1930 edition of Baedecker. And then she added, that presumably editions after the war would not be recommending them to tourists either because apparently no-one in Germany knew anything about the camps.[43] In Buchenwald she photographed the 'unsuspecting' inhabitants (who had known nothing because they had wanted to know nothing) on their enforced visit to the concentration camp on the orders of General Patton, commander of the 3rd Army. Human beings had reduced other humans beings to soulless automata and after their ability to work had been utterly exhausted, reduced them yet further to their material value – the value of their hair and teeth – turning this into hard cash even before their tormented bodies were burnt.

The Second World War was also the first media war of global proportions. Words and images played a decisive role, with an immense task falling to photography and film with their 'mechanical' images. Their particular characteristic, the fact that "in the photograph, something 'has posed' in front of the tiny hole,"[44] endowed photographic and film images with an air of credibility and laid the foundations for people's trust in their authenticity. At the same time, however, this also meant that all kinds of potential had now been opened for deception, directed as much at the enemy as at one's own people. In fact the 'immutable' quality of a photograph is not only influenced by its surrounding context – the caption, its appearance in a newspaper with a particular leaning, the angle it has been taken from, editorial choice and layout: photography also 'documents' the sets which are created for no other purpose than to deceive the enemy and – from time to time – the home public as well.

In the 90s the French photographer Sophie Ristelhuber took shots of the deserted Gulf War battlefields from an angle that made them look like sandpits where children and generals fight their battles. She then created a provocative montage combining these images with close-ups of scarred skin-wounds. On the television screens of our media society the 'Gulf War' just seemed like a computer game. The bloody carnage in the Balkans, on the other hand, was a reminder to people that war means brutality, atrocities and endless suffering. There is no place any more for warlike heroes – and for 'conventional' war photography?

*Page 663:*
**David Seymour**
Greece, Evacuation of Children,
c. 1940
Gelatin silver print, 23.7 x 19.3 cm
Cologne, Museum Ludwig,
Gruber Donation

# The Challenge from Television

Europe was largely destroyed. People were starving, and not only in defeated Germany. The Soviet Union extended its sphere of influence right to the river Elbe and forced eastern and south-eastern Europe to submit to the dictatorship of the Communist regime. The Western world set itself against this and East and West prepared for the Cold War. The vast Chinese empire was shaken by bloody civil war; in British, French and Dutch colonies independence fighters took to arms. The unconditional surrender of Germany and Italy with their allies, as well as of Japan on the other side of the globe, had radically altered the world and these changes would continue to determine the course of world history until the end of the century.

What the champions of international Communism had not managed to achieve was effected by two World Wars: namely world revolution; both political and social, economic and cultural – on a technological level and affecting individual and collective perceptions alike. But, for all that, change did not seem to go so deep as after the First World War. For various reasons. Perhaps there was a feeling that this had all happened once before. For a short time there was a sense of a new start, the benevolent influence of a supposed 'zero hour,' but then the shadow of the Cold War descended on the world and for nearly fifty years divided it into two rival halves. Restoration and rebellion marked its history, alternating with ever increasing speed.

At first photography, like film, prospered as never before. *Life* magazine reached its highest circulation figures and in the devastated continent of Europe there was a growing need for pictures from all four corners of the earth. War had speeded up transport routes immeasurably and had considerably telescoped the dimensions of time. Events in far away countries were no longer purely of exotic interest. In the age of atom bombs, hydrogen bombs and intercontinental rockets these could be the fuse to set off the proverbial powder keg. And the German word 'Angst' had become part of the English language. At the same time the experience of collective suffering in the war had greatly heightened the desire for individual freedom; and this desire was particularly pronounced amongst artists and photographers.

Many photographers were annoyed by the high-handedness with which the mighty illustrated maga-

zines had used their pictures during the war. They felt they had been robbed of their rights. Capa realised a dream of his and founded the agency Magnum, together with Cartier-Bresson, the courageous war photographer David 'Chim' Seymour (p. 663) and two other kindred spirits – bringing together the most successful photographer-journalists in the world.

One of these was William Eugene Smith who many regarded as the best photographer who had ever worked for *Life*. Smith was the embodiment of a strongly individual, independent photographer, who consistently and unswervingly followed his own aesthetic aims, committed to the ethos of photographic truth and at the same time the visionary creator of an artistic universe in its own right. He had been severely wounded in the Pacific. His recovery took two years and he had to undergo over thirty operations on his mouth and nose. Smith has been hailed as a 'moralist' with a camera; he preferred to describe himself as a 'compassionate cynic.' His approach as an artist was defined by his understanding of the things he photographed, by his compassion for people living and working in harsh conditions, and by his deep sensitivity to human emotions and social strictures. And these were also reflected in his methods as a photographer.

Smith succumbed utterly to the object he was photographing, and his pictures were coloured with an intimate knowledge of the world in front of the camera lens. Before he put the finishing touches to his photo-essays, Smith would have spent a considerable amount of time with his subjects, sometimes even years – regardless of who these subject were: it could be a country doctor going about his daily business, he could be trying to track down a black midwife, it could be the fishermen of Haiti – "an underdeveloped, starving, wonderful land" (Smith) – he might be portraying a Spanish village during the dying years of Franco's reign, or it might be the people of Minamata – a Japanese town whose residents had been the victims of a terrible, hushed-up pollution scandal.

His human compassion was always in evidence, however open he was to the formal qualities of photography, contrasts of light and shade, the clarity of the overall composition, the occasional use of iconographic forerunners from art history, the effective choice of

*Page 665:*
**Bill Brandt**
Nude, from the cycle "Perspectives of Nudes", 1961
Gelatin silver print, 34.9 x 28.9 cm
Cologne, Museum Ludwig

**Ernst Haas**
Homecoming, 1947–1950
Gelatin silver prints, each
c. 18 x 12 cm
Cologne, Museum Ludwig,
Gruber Donation

**Otto Steinert**
Pedestrian's Foot, 1950
Gelatin silver print, 28.7 x 40 cm
Cologne, Museum Ludwig

detail. And Smith demanded the same level of commitment from those who viewed his pictures: "I try to lend my voice to those who have none," was how he explained his tremendous output.

Alongside Smith many photographers now laid a greater emphasis than before on the subjective nature of their work: these included his compatriots Walker Evans, Bourke-White and Strand (who moved to Europe) and in the next generation Avedon, Penn, the younger Diane Arbus and Turbeville. The same could also be said of Ansel Adams and, in France, of Cartier-Bresson, Robert Doisneau (p. 655) and Marc Riboud, in Great Britain Bill Brandt (p. 665), Philip Jones Griffiths and Donald McCullin, in Switzerland Werner Bischof and in Austria Ernst Haas (ill. above); and in Japan, too, little by little an independent photographic idiom was coming into being.

In Germany after its annihilating defeat, the physician, photographer and college lecturer Otto Steinert

(ill. below) referred to this current – with a fine sense of the prevalent mood – as 'subjective photography', although most of the photographers whom he counted as having a subjective view were really only adapting the aesthetic achievements of 'New Seeing' or of Neue Sachlichkeit and only a few, like Peter Keetman (p. 667 above), really developed a truly unmistakable pictorial style. While photographers in the United States, France and Great Britain were portraying visible reality in a variety of different, admittedly subjective ways, the 'subjective' photographers in Germany did their utmost to avoid this and were instead still trying to tap the flow of photographic experiment even although the source had long since run dry. They took up from before where the avant-garde had left off when it was stamped out by National Socialism and, like most Germans in the Bundesrepublik (founded in 1949), behaved as though the terror that the National Socialists had inflicted on the land had simply been a stroke of fate and certainly not of their doing.

The leading photo-journalist to have stayed in Germany, Wolfgang Weber, came back from his extensive travels and, as the chief photographer on the *Neue Illustrierte,* put together a series of critical reports from the four zones that Germany was now divided into. These reports were the only reflection of Italian Neo-Verismus in West German photography. Public opinion was ruled by a mixture of denial and self-pity, particularly in the West after it had been divided up, and these sentiments were faithfully reflected by the mass media even although the latter had actually been intended, on the initiative of the victorious allied powers, as a tool to re-educate the Germans into democracy. There was no shortage of films and illustrated journals. And, as in the USA, Great Britain and France, photo-journalism in Germany in the 50s found a huge response.

The 50s and 60s saw the end of the line for the German matadors of early photo-reportage and for the former propagandists from the Nazi era who had continued to work as though nothing had ever been: both groups were now replaced by photographers such as Robert Lebeck (pp. 653 and 669), Thomas Höpker, Will McBride, Heinz Mack, Werner Bockelberg and, in the field of fashion and society photography, Regi Relang, Hubs Flöter and Gundlach. And at the same time, the Folkwang School in Essen, where Steinert was a successful teacher, sent out important aesthetic impulses into professional photography in post-war Germany, much of which was, however, internationally underestimated.

And yet: their work was only rarely equal to that of Den Smith, Eliot Elisofon, David Douglas Duncan (p. 660), Dimitri Kessel, Arnold Newman, Philippe Halsman, Gjon Mili, Gordon Parks (p. 669) – already working for the FSA – Mydans, Ralph Crane, Bert Hardy and Larry Burrows, not to mention Bourke-White, Capa, Seymour, Cartier-Bresson and, originally from Germany – Eisenstaedt, Gisèle Freund and Eric

and both photography and the way people see things underwent radical change.

Electronic images were not only faster than photography: they also implied on-the-spot immediacy and did away with the inherent distance of photography, which always contains an element of 'you've just missed it,' and were able to transport viewers instantly anywhere in the world. The eye-witness taking photographs became superfluous. Photographers could only survive in some niche in the television world if they were ingenious enough to find pictures that the electronic media had missed. But now, ever since it has been possible to use advanced computing equipment to generate the 'immediate' images that television transmits across the world about the world, the question of credibility has become a matter of opinion.

With the advent of the 'virtual reality' of digitised images that seem as real as any authentic representation of reality it becomes hard to tell the two apart. The end of photography? Probably not. But its particular aesthetic flavour is disappearing. Photography no longer embodies the certainty that something must have happened in front of the camera and which is now shown as a photographic image, something irretrievable and yet which nevertheless "was there" (Barthes). And the simple loss of this claim to 'reality' is enough to invalidate the debate as to whether photography is an art form or not. But one thing is for certain: photographic techniques have been adopted by art, as a medium for the imagination and for aesthetic manipulation. The camera had become a additional technological extra to the artist's traditional tools – brushes, drawing tools, hammer and chisel...

But even before the artificial world of digitised images had become a kind of reality, there had been changes in what was generally expected of photography and this had already affected the medium's own self-image. Even before the War the Museum of Modern Art in New York had set up a photography section which

Schaal – who were, without exception, all employed on *Life* magazine.

In the Soviet-occupied section of Germany which, under the watchful eye of its 'big brother' in Moscow, held its own for over forty years as the German Democratic Republic, the German tradition of socially committed photography continued unbroken although with a quite distinctive viewpoint as in the *AIZ (Arbeiter Illustrierte Zeitschrift* – Workers' Illustrated Journal), and with the occasional intermezzo of Socialist pathos. Once the German Democratic Republic had established itself, photographers such as Richard Peter Snr, Erich Höhne, Arno Fischer (ill. right) and Evelyn Richter took a decidedly realistic approach in their work, clearly at pains not to be taken in by the way things appear to be but to discover the mechanisms that lie behind the exterior.

An undreamt of variety of reproduced images was flooding into the consciousness of those living in the western hemisphere, who now were no longer content to experience the world at one remove through photography, but – like early American settlers – were setting out to record their own presence in those places that photography had now opened up to them.

As yet no-one was paying much attention to the wooden box in the corner of the room with its wavery, grey, unfocused images, and it was hard to imagine that these electronic television pictures – which were to be perfected with stunning speed by the 80s – would mean the end for most branches of professional photography. Nevertheless it was ultimately television that dug the grave for photo-journalism and destroyed the foundations of its existence. Very few illustrated journals survived the spread of this particular electronic medium

reaffirmed photography's claims to be an art form – claims which leading German museum directors such as Alfred Lichtwark and Carl Georg Heise had already lent credence to fifty years before. When the energetic Steichen took over the photography section of the Museum of Modern Art in 1947 the changes fermenting within photography were impelled effectively forwards. Steichen's legendary exhibition, "The Family of Man" (1955), was not only the most comprehensive photographic exhibition so far anywhere in the world, it also established photography as part of the museum and gallery world. At the same time, the anthropological basis of the show created an effective contrast to the success of abstraction in contemporary art, with the result that suddenly photography was seen as a convincing alternative. Indeed the very 'realism' of photography justified the movement towards abstraction in contemporary art.

Many photographers now turned to the walls of galleries and museums as a fitting place to publicise their work. Smith, Strand, Stieglitz, Steichen, Brassaï and Kertész now either only occasionally worked for illustrated journals or not at all. Most were unsatisfied with the quality of the images as printed in these journals and now discovered monographs in book form as a way of publishing their works which both suited the works and gave their makers editorial control.

The controversial project, *The Americans,* put on by the Swiss Robert Frank was also intended from the outset to be quite separate from the illustrated mass press. When it first came into the bookshops in 1958 with a French title, it was immensely shocking to Americans and some felt as though they were looking into a distorting mirror. The book's impact was huge. But it did not only provoke protest and rejection. It was also seen as a blow for liberation. In his unusual visual language Frank touched a nerve. Frank's pictures did not just capture the "crazy feeling" that you get "when the sun is burning on the streets and you can hear the sounds of music from a juke-box or from a funeral" as Jack Kerouac put it in the introduction to the American edition – he also did this in a style that directly communicated these feelings to the viewer.

The most notable aspect of Frank's work was not the shabby side of a country that had been the only symbol of hope to many people for so long, the important thing was the form that he adopted. Frank consciously ignored the conventional rules and laws of pictorial composition: falling lines structure his compositions; pictorial planes intersect; crude lighting sets the tone.

He consciously stage-managed his compositions – but not like Heartfield, the inspired creator of photocollages, or like Rodchenko with his disparate props – instead Frank would wait and simply not release the shutter until the reality before the lens had crystallised into its own montage: the picture with the American flag hiding the face of someone watching the Hoboken Parade, the view from a window looking down at a man

running along the street in the opposite direction to an arrow above him on the façade of a house. Smith called Frank the "Franz Kafka of photography." And he also said: "He maintains his own integrity at the expense of the object's." Frank's vision of the world is evident in his own particular language rather than in his choice of motifs.

The more photography lost ground to the mass media, the more it gained ground in the realms of art. Museums and galleries put on ever more exhibitions and built up their collections, while numerous American universities set up museums of photography, concerned to back up theoretical teaching with the best of visual material. Photographers such as Anselm Adams (p. 668) and Evans were successful teachers and, similarly in

Germany, Steinert complemented the education of his students with exhibitions in the Folkwang Museum as well as donating a collection on the history of photography.

Step by step the medium of the fleeting moment became the subject of conservation and observation in galleries and museums. It is true that this process was not without complications and difficulties: nevertheless, by the 90s, photography, alongside the other 'new media' of virtual reality had reached a point where these now seemed to be the only really interesting modes of expression for contemporary art, particularly since traditional disciplines such as painting, drawing and sculpture were so obviously in decline.

In the second half of the 20th century photography took on a diverse, even confusing appearance. While it continued to extend its documentary role, photogra-

phers also were making increasing use not only of the book-market but also of galleries and museums, withdrawing of their own accord, as it were, from their established means of distribution. On the other hand, advanced art was slowly but surely assimilating the techniques of photography and, in the process, infecting photography with the germ of its own aesthetic. Photographers such as Garry Winogrand, Lee Friedlander and Duane Michals (ill. below) produced work exclusively for galleries and museums while vice versa the art business discovered and took on photographers such as Sander, Renger-Patzsch, Evans, Brassaï and Cartier-Bresson and outstanding portrait photographers such as Liselotte Strelow (ill. above right), Gisèle Freund (ill. above left), Milton H. Greene, Lisette Model and Lord Snowdon. And as it happened artistic photography was promoted by ephemeral phenomena like Happenings, Fluxus, Land Art, notably Conceptual Art, Performance Art and Action Art, although these movements' primary interest in photography was in order to record their own aesthetic aspirations.

Under these circumstances the work of the German photographic team of Hilla and Bernd Becher (p. 671) took on symptomatic significance. The range of responses it provoked reflects the changes that were occurring. Hilla Becher had trained as a photographer and her husband, Bernd, as a painter. Although they followed in the tradition of the industrial photography of Renger-Patzsch and Mantz with no less rigour than one such as Sander, at first they were simply greeted with laughter and scorn. 'Boring' was the kindest response to their vivid 'Anonymous Sculptures' as they called their photo objects. In images that were strikingly factual and avoided any form of dramatisation, with utterly neutral lighting and with the stereo-typical frame of the plate-back camera, they portrayed the architectonic face of

**Bernd** and **Hilla Becher**
Typology of Half-Timbered
Houses, 1959–1974
Gelatin silver prints, each
40 x 31 cm, arranged on 4 panels of
148.3 x 108 cm (2 panels shown)
Cologne, Museum Ludwig,
Ludwig Donation

industrialism photographed from exactly calculated distances and from fixed angles: winding gear and watertowers, blast furnaces and factory halls, industrially produced half-timbered houses and whole pubs.

In fact it was the art business that first provided them with a platform for their art. Their works began to emerge in exhibitions and catalogues of concept art. The Bechers ran the entire gamut of critical opinion without in the slightest altering their work as artists or their attitude to it; with documenta 5 in Kassel (1972) as the start of the process and documenta 6 (1977) as its conclusion. While the former ascribed a subordinate artistic role to photography, the latter elevated photography to an artistic medium in its own right.

This most important and influential of exhibitions of contemporary art anywhere was the first occasion that photography was not only shown as a vehicle for primarily artistic expression, but also the first time that the full range of its visual potential was accepted into the world of art. In addition to this, documenta 6 departed from the normal practice and, instead of concentrating exclusively on contemporary art, presented the whole of the history of photography by means of carefully selected examples. Furthermore it did away, once and for all, with the categoric difference between professional photography, responding to a commission from outside, and artistic photography which is purely an expression of the photographer's subjective drive. At the international art critics' conference (AICA) in 1977, Oto Bihalji-Merin declared this controversial media-documenta to be just as important as the Armory Show in 1913 which, at the time, had helped the avant-garde to make the breakthrough in the United States.

Thus the list of artists represented in Kassel in 1977 reads like a *Who's Who* of the history of photography:

alongside Stieglitz and Strand, Sheeler and Krull, Mantz and Renger-Patzsch, Sander and Erfurth, Freund and Halsman, Rodchenko and Steichen, Abbott and Evans, Capa and Duncan, Bourke-White and Cartier-Bresson, Salomon and Weegee (p. 672 below), Atget and Brassaï, Lange and Arbus, Blossfeldt and Friedlander there were also works by Robert Mapplethorpe (his European premiere), Gabriele and Helmut Nothhelfer (p. 672 above), Eve Sonneman, Bernhard Johannes Blume, Christian Boltanski, Ger van Elk, Gilbert & George, John Hilliard, Jürgen Klauke, Les Krims (p. 675), Jean Le Gac, Peter Roehr, Lucas Samaras and, last but not least, Katharina Sieverding.

Since then the corridor of photography in the world of art has continually broadened. This broadening has taken various forms: the traditional 'classical' genres of

**Gottfried Helnwein**
The Last Supper, 1987
Colour print, 40 x 59 cm (?)
Cologne, Museum Ludwig

photography – portrait, landscape and still life as well as the different genres of bourgeois art – have acquired a new artistic accent; specific photographic disciplines like social documentation, photo-reportages and systematic analysis in the form of rows, series and sequences have been developed further on aesthetic lines; artists have visibly turned their critical attention to photography as a mass phenomenon.

Klauke's (p. 673 below) often comprehensive photo sequences draw the viewer's attention to the monstrous sides of daily life and use conscious stage-management to open up a universe of hidden longings, fantasies, suppressed wishes and repressed fears. Klauke unites the aesthetic impulses of theatre, film, advertising photography, Surrealism and concept art. Along with Sieverding, Blume and Floris Neusüss (p. 674) Klauke was one of the first – in Germany and beyond – brave enough to use photography's striking ability to visibly portray those connections and resonances that are not in fact visible at all.

Anna and Bernhard Blume (p. 673 above), with their 'Transcendental Constructivism' (Blume) entered into the dangerous world of metaphysics and for years have been portraying things that do not exist, cannot exist, or at least which cannot be seen – although many sense the consequences of these things, some feel these consequences and others actively fear them. In their photo sequences, laden with the meaning, the world – to quote Bertolt Brecht – is distorted to the point of recognition. With their sardonic visual wit and sarcastic, cynical gestures, they provoke laughter that shocks. In their works things rebel against people, the system that claims to be running the world breaks apart – like the meanwhile outdated notion that the images of art could satisfy our Faustian search for knowledge.

But photography as practised by artists has not merely crossed beyond the bounds of the visible: it has also broken taboos that have hitherto obscured our vision. Robert Mapplethorpe tore the veil of lustful deceit and desiccated prudery that shrouded the premisses and abysses of sexuality, revealing with almost Classical restraint what had previously always been kept strictly behind closed doors; Andres Serrano attacked the Christian symbol of the Cross and pilloried the discrepancy between theory and practice in a society that claimed to follow the ideals of Christianity, and in increasingly aggressive images Cindy Sherman unrolled the shimmering sight of the woman in the modern world of consumerism and advertising; from filmic icon – a vessel for unfulfilled desires – through the cheap double spread in a girlie magazine to the repellent grimace of a male-chauvinist reflection. Nan Goldin (p. 677 above right) mercilessly dissected her own life with her camera.

In the hands of these artists photography often became a weapon in the conflict between the generations and the sexes, between the powerful and the oppressed. Is that why photography has found such

favour amongst female artists? Although it has to be said that, in comparison to painting, women photographers have played a proportionately much greater role in this technological medium. While it would be unthinkable to conceive of a history of art without naming male artists, in the field of photography this could be done with very little loss to the quality of the result.

Many outstanding names spring to mind: Julia Margaret Cameron and Lady Hawardan in the 19th century, Johnston, Gertrude Kaesebier, Doris Ulman, Jelisaveta Ignatovicha, Abbott, Lucia Moholy, Imogen Cunningham, Lange and Bourke-White, Barbara Morgan, Frissell, Lilo Raymond, Helen Levitt, Arbus and Turbeville, Tina Modotti and Annie Leibowitz, Gina Lee Felber, Annette Frick, Barbara Klemm, Herlinde Koelbl, Angela Neuke, Freund, Henri, Karen Knorr, the formidable Mary Ellen Mark and many others – not even in the field of literature have so many excellent female artists carved out such a clear identity for themselves.

Did Stieglitz not once praise photography for its flexibility? It has to be said, that on the verge of a new millennium which humanity may or may not survive, photography as an independent medium would seem to represent a historic chapter in the history of the visual arts. Certainly more than a footnote and possibly as significant as the invention of printing with movable type. But in the sense that photography, as a means of artistic expression, cannot be defined as pursuing any particular direction or programme, it is still waiting to be properly discovered.

Old photographic techniques are currently inspiring artists again while others are experimenting with new techniques: amongst the latter are William Wegman (p. 676), Toto Frima, Bernard Faucon, Gottfried Helnwein (p. 671 below), Axel Hütte, Thomas Ruff, Anke Erlenhoff (with a smart combination of photography and painting) and Candida Höfer. Whatever the case, photography has in the meantime become a perfectly natural art medium.

**Bernhard** and **Anna Blume**
Meal, 1986
Gelatin silver print, 5 parts,
each 126.8 x 91.1 cm
Cologne, Museum Ludwig,
Hypo-Bank Donation

**Jürgen Klauke**
Self-Portrait (from: Pro Securitas),
1987
Gelatin silver print, 60.8 x 51.6 cm
Cologne, Museum Ludwig,
Gruber Donation

# The Conquest of Art and the Loss of Character

At the Venice Biennale in 1993 the photographers Hilla and Bernd Becher were awarded the prize for sculpture. But a number of questions are raised by what at first sight may look like a witty or even inspired choice – particularly if this choice was based on a regressive tendency on the part of the jury to regard photography as a representational medium, seeing the photographic images as no more than a vehicle to depict the subject matter and display technical skills instead of taking into account the artists' actual stage-management of the photographs in their own right. The use of aesthetic strategies and methods such as sequences, series and montage diverts the viewer's attention from the real photographed subject matter towards the artistic construction of these works.

By means of their particular form of construction, the Bechers had specifically abandoned crude representation in favour of a revelatory, open, even contradictory form of empiricism where the very appearance of the photography is affected by fault lines and ruptures. This approach by the Bechers marks a shift in the paradigms of photography which, with their assistance and that of other advanced artists, is now entering into a critical phase. And it is at this point that it suddenly becomes clear that the history of photography is now a whole chapter in its own right.

Although artists involved in photography came together from very different directions, nevertheless they always had one thought in common. They viewed photography as something which they could, by their own artistic intervention, transform into an autonomous aesthetic material. For them photography was no longer a means to appropriate and appropriately depict chunks of visible reality: instead they recognised photography as itself being part of that reality and, as such, open to question. Comparable moves were being made in painting, similarly critical, yet also with the ultimate aim of both laying bare the essence of the medium in question and taking advantage of its aesthetic potential.

Sigmar Polke experimented at length with the multifarious possibilities of photo-chemistry and destroyed the apparent oneness of photographic motif and chemical ingredients. The material substratum that under normal circumstances leads from the photographic shot to the image itself was suddenly accorded its own aesthetic value and now entered into competition with the representation of the visible subject. Besides this Polke also revealed the beguiling range of colours of the chem-

**Floris Neusüss**
Nudogram, 1966
Gelatin silver print on canvas,
231 x 104 cm
Cologne, Museum Ludwig,
Gruber Donation

icals used in the process of photography and discovered a new colourfulness with many fascinating connections and 'poisonous' aesthetic effects. Numerous artists followed Polke down this path – particularly in Germany – including Johannes Brus, Achim Duchow (who worked with Polke from time to time) and Floris Neusüss. This led to striking "infringements" (Theodor W. Adorno) between photography and painting. Brus simultaneously did away with the smooth surface of the photographic image and the stasis of the world of photography by unhinging both the laws of probability and the laws of gravity. He presented photographic images that made nonsense of human experience. Polke (pp. 387 ff), inspired by Andy Warhol (pp. 323 ff), used technical procedures such as screen printing to transfer photographic Benday dots to large canvases and thus constructed a 'montage' of various elements – photography, painting, the physical world around us – creating pictures that operate in a kind of inter-media sphere and which are no longer subject to the perameters of conventional aesthetics.

These experiments led to a flood of imitative photopainting which, however, only succeeded in discrediting this entire route, until younger artists like Anke Erlenhoff began to systematise the process, which was possible partly thanks to the availability of digital techniques. This in itself again set up antagonistic yet informative correspondences between autonomous painting and photographic representation; although admittedly at the expense of the essence of photography which was gradually being stripped of its apparent claims to authenticity.

The Canadian artist Jeff Wall (p. 676) approached the problem from another side and undermined photography's claims to authenticity by doubling images. Using massive light boxes he created scenes of almost uncanny normality. But this very depiction of normality is disturbing and seems to open up some kind of an abyss although it would be impossible to say what is generating this latent feeling of anxiety. This confusing

**Jeff Wall**
Jell-O, 1985
Aluminium box, plexiglas, neon
tubes, cibachrome, 143 x 148 cm
Munich, Goetz Collection

**William Wegman**
Directional Shepard, 1987
Polacolour II print, 61 x 50.8 cm
Amsterdam, Heiting Collection

response is a result of the careful, sometimes even man-
nered, staging of the tableaux, where every nuance is
deliberate – so that all life seems somehow petrified –
and where carefully planned lighting lends the scene a
touch of horror, realer than real. Photographic reality
slips into the wholly calculated artificiality of the art of
photography.

The result is an aesthetic heightening even of photo-
realist painting which nevertheless does not cast doubt
on the 'noema' (Roland Barthes) of photography as a
medium which claims that photographic slides show
that that is 'how it was.' And yet what a camera captures
is not in itself empirical but is the result of an inten-
tional artistic act for the purposes of representation.
Thus what began as authentic becomes fake, created
solely for the purposes of illusion, to create the sense of
'as though.'

Wall's images are influenced both by painting and
the commercial film industry. His varied works – some
peopled with human protagonists, others strangely
bereft of human beings – seem like condensed film

sequences. His works, whether describing a narrative or
not, are in some way reminiscent of still lifes, and the
oppressive stillness spreading over everything is
reflected in the deathly rigidity of what is being shown.
If the camera would only 'travel' slowly as it would in a
similar situation in a film, then there might be some
release, but Wall refuses his viewers this as long as they
are caught up in the spell of his visual images.

Film was also an early source of inspiration to the
American Cindy Sherman (p. 677 above left) who shot
like a comet into the international scene in the 80s and
at times even glittered like a megastar. Her early, small-
format black and white photographs bring to mind
nostalgic memories of scenes in certain films although
one cannot immediately identify these: generally these
consist of a figure without any particular distinguishing
features alone in some rural, urban or domestic situa-
tion. The figure in them seems vaguely at home and yet
oddly alien as though it does not really belong there. In
fact, this figure in a variety of outfits turns out to be the
artist herself. Allowing her imagination to run free in a

**Andreas Gursky**
Paris-Montparnasse, 1993
Colour print, mixed media,
180 x 350 cm
Cologne, Museum Ludwig,
Ludwig Collection

**Nan Goldin**
Cricket Putting a Wig on
Siobhan, Paris 1991
Cibachrome print, 61 x 50.8 cm
Hamburg, F. C. Gundlach Collection

*Left:*
**Cindy Sherman**
Untitled, 1982
Colour print
Private collection

**Thomas Struth**
Galleria dell'Accademia,
Venice, 1992
Colour print, 184.5 x 228.3 cm
Private collection

whole series of roles, she nevertheless concealed her own identity behind the striking masks she adopted, revealing nothing of her own personality, other perhaps than to hint that she was doing all of this as an alien in an alien world. Her ego manifests itself as a multiple subject, ready to split on demand, the embodiment of multiplicity.

Her later photographic works, in increasingly lurid colours and also using larger formats extended the range of vision from commercial film to the whole panorama of culture. At the same time Sherman's works also became more critical reflecting, in predominantly aggressive scenarios and arrangements, the image of women in a male-dominated society where women were not in control of their own lives. For these she used anything from double spreads of female models in the relevant magazines – typically with the staple through the woman's navel – to parts of fetish dolls with monstrously inflated private parts. And she did not even shrink at using female figures from art history, different representations of the Madonna, finding even there a primarily male view plus the – at least underlying – intention to deny the female half of human society the chance to develop freely or to determine its own role.

Later, with a group of 'disgust pictures' Sherman moved out from the sphere of social issues and extended her artistic range to include anthropological questions of growing and dying, mostly focusing on the process of rotting and abandoning social issues. Ultimately she replaced visual horror with dreadful outsized masks clearly drawing on modern horror films with their dreadful organic growths.

Living and dying are also the main themes in Nan Goldin's (p. 677) photographic output, although her pictures neither have a sociological nor an anthropological backdrop: her perspective is directed much more towards her own biography. Unlike a written diary that she might consciously withhold from public scrutiny, Goldin sees her photographic records as a "public report." And although these deal with the most intimate moments of life and portray death as a long drawn out, tortuous process, although life and death are shown in some ways to be excessive, the images are not there to satisfy some voyeuristic cravings. And are any notions of voyeuristic titillation simply dispelled by Goldin's

uncompromising honesty towards herself and others? Are they equally dispelled by the direct, apparently unforced objectivisation of private matters?

The boundaries between the public and the private are blurred – boundaries which bourgeois society had put in place and which Goldin's generation, once part of the 'hot' scene in New York in the 70s and 80s, had removed. Many of them have since died – artists, designers, stylists, mostly the victims of AIDS and drug misuse. Goldin's radically narrow view plus her subjective approach produces objectively quantifiable results. Thus she has created a disturbing portrait of a generation that had lost its way, thrown back on the most basic needs of existence, longing for a sense of security and yet at the same time obsessed with a disproportionate desire to break down the bounds of social convention. Goldin is not a trained photographer but her stunning work shows just how breath-taking photography can be – today as ever – even without trying to grind some particular artistic axe.

The 'Becher School,' apparently without artistic pretension, has produced photographers such as Candida Höfer, Thomas Struth and Thomas Ruff as well as Axel Hütte and Andreas Gursky (p. 676 below) who in their various ways have achieved international renown as artists. It is only on closer examination that their photographic works reveal their aesthetic refinement. They cut through conventional patterns of perception and with the subtlest of means draw out the dazzling complexity of the medium.

Many of their shots, often out-sized, focus on the act of seeing and on modes of perception. They capture

the viewer's interest with the full rhetorical power of the photographic image, before gradually revealing their inner construction. And suddenly, faced with townscapes and landscapes by Hütte or with towns and museums photographed by Thomas Struth (p. 677 below), viewers find that they have become part of the visual equation and that they are no longer simply a beholder viewing a world outside of themselves with the proverbial 'disinterested pleasure.' In short, they have become protagonists in an aesthetic game that is apparently unfolding before their very eyes.

In addition to this, Ruff (p. 678 above left) explores as yet uncharted territory in photography, which it has acquired through technical developments – although these do at the same time radically change the character of photography. He became famous for his larger than life portraits of young people of no particular distinction, people whose names were not specially known. These images make an ironic point with regard to the personality cult found elsewhere in the medium: here normality itself is being lionised. Now, thanks to the Bechers and their students, as well as Neusüss, Klauke, Bernhard and Anna Blume, Astrid Klein and Katharina Sieverding (p. 678 above right), photography in Germany once again had the status that it had previously enjoyed during the era of 'New Seeing' in the 20s. In their ability to explore the aesthetics of photography, their willingness to take risks and their sensual intelligence, these artists put similar endeavours in Europe and the USA largely in the shade.

During the 80s and the 90s art photography in the USA indulged in more or less fruitless exercises which involved adopting intellectual property from elsewhere, as in 'Appropriation Art' which topped the artistic fashion charts for a short time. The artists concerned included Sherrie Levine – who followed this route with baffling stubbornness – Richard Prince (p. 678 below) – criticising the media – and Louise Lawler. At the same time the British performance artists Gilbert & George were also vastly overrated. They put together montages of vast dimensions showing images of socially unacceptable issues which they then sent circling around their own gleaming personalities (ill. above) like planets round the sun. The Frenchman Christian Boltanski, on the other hand, has maintained a high standard although his photographic installations do at times take on a rather too ghostly aspect – death watches! Photogra-

*Above:*
**Gilbert & George**
Hands up, 1984
Colour print, 241.3 x 401.3 cm
Private collection

**Wolfgang Tillmans**
Suzanne & Lutz,
Bournemouth, 1993
Colour print, 60 x 40 cm

phers with artistic ambitions, for example, Lewis Baltz and Robert Adams took forward the aesthetic precepts of those such as Walker Evans and W. Eugene Smith in their extensive documentations of social and ecological calamities.

Against the backdrop of the millennium which has lured cultural pessimists of every shade out of the woodwork, it is nevertheless clear that 'photographic photography' (Renger-Patzsch) can still achieve stunning results as in the work of Michael Ruetz and Angela Neuke in Germany, the Frenchman Gilles Peress with his 'revelatory' camera and Sebastião Ribeiro Salgado in Paris with his gripping, aggressive reportage essays on the lives of country labourers in Latin America, the famine in the Sahel region of Africa and the demise of craft skills through the introduction of industrial production processes in the world's most sensitive regions. And yet: for lack of suitable routes to publicise their work, they are forced to channel their work through the art market in order to present it to the public. This liaison has not been without certain consequences. On the one hand, photography has profited from adapting the aesthetic strategies and methods of contemporary art, but this has meant, on the other hand, that it has lost its specifically photographic character – at least according to the theories of media aesthetics as proposed by Siegfried Kracauer and Roland Barthes.

But for every loss there is a gain. After a visit to a private collection of photography with works by Sherman, Matthew Barey, Wolfgang Tillmans (p. 679 below) Mike Kelley and the obsessive Nobuyoshi Araki from Japan – a collection which included works by most of today's advanced photography-artists – the art critic Rudolf Schmitz expressed his amazement: "Far from being filled with a sense of imitative repetition going down a well-trodden visual path, one is overcome with astonishment at the fertility of the photographic notion of the constructiblity of images and of the world." A hopeful view of the future, even if he does add the proviso that this collection does not show "photographers as impassioned artists, but artists as impassioned photographers."

1 Walter Benjamin, 'A Small History of Photography', in *One Way Street*, transl. by Edmund Jephcott and Kingsley Shorter, London 1979, p. 246
2 Ibid., p. 247
3 Alfred Stieglitz, transl. from 'Bildmässige Fotografie', in: Wolfgang Kemp (ed.), *Theorie der Fotografie I* 1839-1912, Munich 1980, p. 221
4 Wolfgang Kemp, 'Fotografie als Kunst', in: Wolfgang Kemp (as note 3), p. 20
5 Robert de la Sizeranne, 'Ist die Fotografie eine Kunst?', in: Wolfgang Kemp (as note 3), p. 215
6 Eduard J. Steichen, 'Grenzen', in: Wolfgang Kemp (as note 3), p. 215
7 Eugenia Parry Janis, in: *At the Still Point. Photographs from the Manfred Heiting Collection*, Amsterdam 1995, p. 265
8 László Moholy-Nagy, 'Beispiellose Fotografie', in: Wolfgang Kemp, *Theorie der Fotografie II* 1912–1945, Munich 1979, p. 72
9 László Moholy-Nagy, *Malerei-Fotografie-Film*, ed. by H.M. Wingler. Facsimile reprint of the original 1927 edn, Mainz 1967, p. 26
10 Van deren Coke, *Avantgardefotografie in Deutschland* 1919–1939, Munich 1982, pp. 8f.
11 László Moholy-Nagy (as note 9), p. 27
12 Cf. Herbert Molderings, 'Lichtjahre eines Lebens', in: exh. cat. *László Moholy-Nagy, Fotogramme 1922–1943*, Essen 1996, pp. 8f.
13 Walter Benjamin in a lecture given in Paris on the opposing artists. Cited from Eckard Siepmann, *Montage: John Heartfield*, Berlin 1977, p. 166. Cf. also Klaus Honnef, 'Symbolische Form als anschauliches Erkenntnisprinzip', in: Peter Pachnicke and Klaus Honnef (eds), *John Heartfield*, Cologne 1991, pp. 38ff.
14 Rosalind Sartori, in: exh. cat. *Film und Foto der zwanziger Jahre*, Stuttgart 1979, p. 184
15 László Moholy-Nagy, (as note 9), p. 5
16 Cited from Alexander Lavrentiev, 'Die Photo-Träume der Avantgarde', in: exh. cat. *Russische Photographie*, Berlin and Bonn 1993, p. 61
17 Alexander Lavrentiev, ibid.
18 Alexander Rodchenko, 'Gegen das synthetische Porträt, für den Schnappschuß', in: Wolfgang Kemp (as note 8), p. 81
19 Alexander Rodchenko, ibid.
20 Hubertus Gaßner, 'Analytische Sequenzen', in: exh. cat. *Rodtschenko. Fotografien 1920–1938*, Cologne 1978, p. 32

21 Ute Eskildsen, in: exh. cat. Fotografie in deutschen Zeitschriften, Stuttgart 1982, p. 12
22 Tim N. Gidal, *Chronisten des Lebens,* Berlin 1993, p. 40
23 Albert Renger-Patzsch, 'Ziele', in: Wolfgang Kemp (as note 8), p. 74
24 Albert Renger-Patzsch, ibid.
25 Cited from Norbert M. Schmitz, 'Zwischen Neuem Sehen und Neuer Sachlichkeit', in: *Gleissende Schatten,* Berlin 1994, p. 86
26 Norbert M. Schmitz, ibid.
27 Paul Strand, 'Fotografie und der Neue Gott', in: Wolfgang Kemp (as note 8), p. 61
28 Paul Strand, ibid., pp. 61f.
29 Edward Weston, 'Präsentation statt Interpretation', in: Wolfgang Kemp (as note 8), p. 69
30 All quotations from Walker Evans in: John T. Hill, Gilles Mora, Walker Evans, *Der unstillbare Blick,* Munich 1993
31 Salvador Dalí, 'Die Fotografie, reine Schöpfung des Geistes!', cited from Wolfgang Kemp, (as note 8), p. 98
32 Cited from Nancy Hall-Duncan, *The History of Fashion Photography,* New York 1979, p. 32
33 Roland Barthes, *Camera Lucida,* transl. by Richard Howard, London 1982, p. 76
34 René König, *Menschheit auf dem Laufsteg. Die Mode im Zivilisationsprozeß,* Munich and Vienna 1985, p. 32
35 Margaret Bourke-White, transl. from *Deutschland, April 1945,* Munich 1979, p. 33
36 Paul Virilio, transl. from *Krieg und Kino – Logistik der Wahrnehmung,* Munich 1986, pp. 36ff.
37 Paul Virilio, ibid.
38 Klaus Schröder, transl. from introduction to German edn of Margaret Bourke-White (as note 35).
39 Susan Sontag, *On Photography,* London 1979, p. 167
40 Ibid., p. 20
41 Ibid.
42 As note 35, p. 90
43 *Lee Miller's War,* Boston, Toronto and London 1992, p. 161
44 As note 33, p. 78

# Lexicon of artists

*by Ingo F. Walther*

The LEXICON OF ARTISTS is a 150-page appendix providing biographical data and bibliographies on all 780 artists whose works are illustrated in this publication, including photographs of the artists wherever possible. The biographies are brief outlines of key facts such as place of birth, education or training, important events, meetings with other artists, time spent abroad, awards and prizes, major solo and group exhibitions etc. and generally forego or keep to a minimum any aesthetic judgements or art historical classification.

The detailed bibliographies are intended as suggested further reading on specific themes or individual artists. The length of a bibliography or biography has no bearing whatsoever on the evaluation of an artist or his/her work. In the case of major publications translated into several languages, the original edition is frequently given alongside those of the translations. The bibliographies are divided into three groups:

WRITINGS
CATALOGUES RAISONNES
MONOGRAPHS, CATALOGUES

We have only listed stand-alone publications in the form of books, monographs and important catalogues pertaining to solo exhibitions. We have not included essays, contributions from works covering more than one artist, joint/group exhibition catalogues, or catalogues which are either minor or of little significance. In the field of photography, publications which mainly or exclusively cover the work of just one photographer have generally not been included.

We have endeavoured to list CATALOGUES RAISONNES as completely as possible. These are often difficult to trace. The result is the most comprehensive listing of this kind in any available publication.

The individual titles are alphabetically ordered rather than chronologically. Exhibition catalogues (**cat.**) are ordered according to the name of the respective editor (**ed.**) or main author. In some cases, this may be an editor, organiser, author of preface or other individual involved in the organisation of the respective exhibition.

We have made every effort to list exhibition catalogues bibliographically by author, as the conventional listing of catalogues merely by the name of the artist and the venue is both strenuous to read and barely informative. The place specified in the case of catalogues may also be the exhibition venue and need not necessarily correspond with the place of publication, which was not always possible to determine. Martin De Mattia, Marc Weis, Ludger Derenthal, Antje Günther and Birgit Mersmann (all based in Munich) assisted in compiling the biographies and bibliographies (more than 1.5 million characters).

**ABAKANOVICZ Magdalena**
born **1930** Falenty (Warsaw)
Polish sculptress. **1950–1954** Studied at the Academy of Art in Warsaw. **1960–1969** Invented her own weaving technique. Made *Abakany*, large-scale sculptures out of soft materials. **1965** Grand Prix at the São Paulo Biennale. **1965–1990** Professorship at the Academy in Posen. **1970–1979** Series entitled *Alterations*, figurative und non-figurative groups of sculptures made of sacking and synthetic resin. Wrote metaphorical essays on the human brain, mythology and religion. In subsequent years worked in various materials such as wood, ceramics, stone and bronze. Produced numerous works for public places and museums. **1988** Ten bronze animal heads for the Olympic Park in Seoul. **1991/92** a 36-figure group *The Crowd* for the Walker Art Center, Minneapolis.
WRITINGS: M. A. and P. Restany: Katarsis. Florence 1987
MONOGRAPHS, CATALOGUES: M. A. Städtische Kunsthalle Mannheim. Mannheim 1969 (cat.).– M. A. Musée d'Art Moderne de la Ville de Paris. Paris 1982 / Museum of Contemporary Art, Chicago. New York 1982 (cat.).– M. A. Mücsarnok. Budapest 1988 (cat.).– Brenson, M. et al. (ed.): M. A. Sculpture. Institute for Contemporary Art P. S. 1. New York 1993 (cat.).– Gallwitz, K. (ed.): M. A. Skulpturen 1967-1989. Städtische Galerie im Städelschen Kunstinstitut. Frankfurt-on-Main 1989 (cat.).– Kato, K. L.: M. A. Tangible Eternity. Tokyo 1991.– Murray, P. (ed.): M. A. Bronze Sculpture. Llandudno 1996 (cat.).– Neray, K. et al.: M. A. Budapest 1988.– Rose, B.: M. A. New York 1994.– Rosenfeld, D. (ed.): M. A. Recent Sculpture. Museum of Art, Rhode Island School of Design, Providence et al. Providence 1993 (cat.).– Turske, I. (ed.): M. A. 2 vols. Galerie Turske & Turske. Zurich 1988 (cat.)

**ABRAMOVIC Marina**
born **1946** Belgrade
Serbian performance and video artist. **1965–1970** Studied at the Academy of Fine Arts in Belgrade. From **1973** put on performances with dangerous objects and medicines to explore the limits of physical and psychic endurance. **1975–1988** Worked with Ulay. Besides the juxtaposition of dualistic

principles, the two artists focused on questions raised by archaic cultures they had encountered on their extensive travels. **1982–1992** Participation in documenta 7 – 9 in Kassel. **1988** End of collaboration with Ulay, after a 90-day exploration of the Great Wall of China, *The Great Wall Walk*. From **1989** tried to bring about the transition from individual to collective consciousness through meditative installations and object arrangements, using materials such as wood, crystals and stones. **1992–1995** Professorship at the Academy of Fine Arts in Hamburg.
WRITINGS: M. A.: The Architecture of M. A. Champaign and Urbana 1992.– M. A. and Ulay: Relation Work and Detour. Amsterdam 1980.– M. A. and Ulay: Performance – eine andere Dimension. Berlin 1983.– M. A.: Sur la voie. Ulay: Ode à l'urne. 2 vols. Centre Georges Pompidou. Paris 1990 (cat.)
MONOGRAPHS, CATALOGUES: Birnie Danzker, J.-A. and C. Iles (ed.): M. A. Museum Villa Stuck, Munich et al. Munich 1996 (cat.).– Drahten, D. v. (ed.): M. A. Galerie des Beaux-Arts. Paris 1992 (cat.).– Iles, C. (ed.): M. A. Objects, Performance, Video, Sound. Museum of Modern Art, Oxford et al. Oxford 1995 (cat.).– Iles, C. (ed.): Ulay & A. Perfomances 1976-1988. Stedelijk Van Abbe Museum. Eindhoven 1997 (cat.).– McEvilley, T. et al. (ed.): Ulay / M. A. Modus Vivendi. Works 1980-1985. Stedelijk Van Abbe Museum, Eindhoven et al. Eindhoven 1985 (cat.).– Meschede, F. (ed.): M. A. Neue Nationalgalerie, Berlin. Stuttgart 1993 (cat.).– Mignot, D. (ed.): M. A./Ulay. The Lovers. Stedelijk Museum. Amsterdam 1989 (cat.).– Pijnappel, J. (ed.): M. A. Cleaning the House. London 1995.– Wulffen, T.: M. A. Biography. Stuttgart 1993

**ACCONCI Vito**
born **1940** New York
American sculptor and action artist. **1962–1964** Studied at the University of Iowa. **1964–1969** Freelance writer. **1968–1971** Lectureship at the School of Visual Arts, New York. From **1969**, through his performances and environments, became one of the main exponents of Concept and Body Art. **1971** *Centers*, a video-installation in which he films himself pointing at a television screen. **1969** Joint editor of the art magazine o to 9. **1972–1982** Took part in documenta 5 – 7 in Kassel. **1976** Lectured at California Institute of Art, Valencia, and took part in the Venice Biennale.
WRITINGS: V. A.: Four Book. New York 1968
MONOGRAPHS, CATALOGUES: Barzel, A. (ed.): V. A. Museo d'Arte Contemporanea Luigi Pecci. Prato 1992 (cat.).– Diacono, M.: V. A. Dal test-azione al corpo come testo. New York 1975.– Eigenheer, M. and M. Kunz (ed.): V. A. Cultural Space Pieces 1974-1978. Kunstmuseum. Lucerne 1978 (cat.).– Herzogenrath, W. (ed.): V. A. Arbeiten in Deutschland 1971-1981. Kölnischer Kunstverein et al. Cologne 1981 (cat.).–

Kirshner, J. R. (ed.): V. A. A Retrospective 1969-1980. Museum of Contemporary Art. Chicago 1980 (cat.).– Linker, K.: V. A. New York 1994.– Noever, P. et al. (ed.): V. A. The City Inside Us. Österreichisches Museum für angewandte Kunst. Vienna 1993 (cat.).– Onorato, R. (ed.): V. A. Domestic Trappings. La Jolla Museum of Contemporary Art et al. La Jolla 1987 (cat.).– Shearer, L. (ed.): V. A. Public Places. The Museum of Modern Art. New York 1988 (cat.)

**ADAMS Ansel**
**1902** San Francisco–**1984** Monterrey (Mexico)
American photographer. **1916** First visit to Yosemite valley, to which he returned many times to photograph. **1914–1927** Studied Music. Developed a strong interest in landscape photography. **1916/17** Studied Photography with Frank Dittman in San Francisco. **1927** First book published with his *Parmelian Prints of the High Sierras*, elevating landscape photography to mythical realms. **1932** Founded the f/64 group together with Weston, Willard Van Dyke, Imogen Cunningham and others, to promote *straight photography*: exploring all technical possibilities to the full in order to prove that photography has an artistic character of its own. **1935** Publication of *Making of Photography*. **1936** Solo-exhibition at Stieglitz' gallery. **1940** Together with Beaumont Newhall, set up a department of photography in the Museum of Modern Art in New York; fighting for recognition of photography as art. **1946** Guggenheim stipendium. **1958** Brehm Award from the Rochester Institute of Technology. Numerous prizes and honours in later years. **1981** Hasselblad Award.
WRITINGS: R. A.: Why People Photograph. Selected Essays and Reviews. New York 1994
MONOGRAPHS, CATALOGUES: A. A. Classic Images. Kunstverein für die Rheinlande und Westfalen. Düsseldorf 1993 (cat.).– Alinder, A. (ed.): A. A. Classic Images. National Gallery of Art, Washington. Boston 1985 (cat.).– Callahan, H. M. (ed.): A. A. in Color. Boston 1993 / A. A. Farbfotografie. Munich 1993.– De Cock, L. (ed.): A. A. New York 1972.– Newhall, N.: A. A. The Eloquent Light. San Francisco 1963, New York 1980.– Wortz, M. (ed.): A. A. Fiat Lux. University of California. Irvine (CA) 1990 (cat.)

**ADLER Jankel**
**1895** Tuszyn–**1949** Aldbourne (near London)
Polish painter. **1906** Began training as an engraver. **1912–1918** Studied with Wiethüchter at the School of Arts and Crafts in Barmen. From **1922** joined Max Ernst and Campendonk in Düsseldorf; Member of the Rhenish Secession. **1931–1933** Lectureship at the Düsseldorf Academy. Made contact with Klee. Works rescued from the Nazis and sent to Poland. **1935** First major

exhibition, followed by others in Italy, Czechoslovakia and Russia. Influenced by his Jewish background, his paintings develop a quasi-religious, quasi-mystical lyricism. **1937** Came to know Picasso in Cagnes-sur-Mer. His painting style became more monumental and his colours more intensive. **1940** Volunteered for the Polish army. **1941** Discharged from military service; settled in Kirkcudbright (Scotland). Lived in Aldbourne, near London, until his death in **1943**.
MONOGRAPHS, CATALOGUES: J. A. Städtisches Museum. Wuppertal 1955 (cat.).– J. A. Galerie Ketterer. Munich 1971 (cat.).– J. A. Galerie Hasenclever. Munich 1977 (cat.).– J. A. Muzeum Sztuki. Lodz 1985 (cat.).– J. A. 100 Werke zum 100. Geburtstag. Düsseldorf 1995 (cat.).– Feldhaus, I. (ed.): J. A. Clemens-Sels-Museum. Neuss 1967 (cat.).– Fierens, P.: J. A. London 1948.– Guralnik, N. (ed.): J. A. Tel Aviv Museum. Tel Aviv 1985 (cat.).– Hayter, S. W.: J. A. London 1948.– Klapheck, A.: J. A. Recklinghausen 1966.– Krempel, U. and K. Thomas: J. A. 1895-1949. Städtische Kunsthalle Düsseldorf et al. Cologne 1985 (cat.).– Themerson, S.: J. A. London 1948

**AFRO**
(Afro Basaldella)
**1912** Udine – **1976** Zurich
Italian painter. Studied art in Florence and Venice. **1933/34** and **1940–1944** military service. **1930–1933** lived in Milan. Had contact with Birolli and Ennio Morlotti. **1932** First solo-exhibition in the Galleria del Milione, Milan. Joint projects with the sculptor Arturo Martini. Lived **1936–1940** in Rome. **1952** Joined the abstract-gestural painters' association Gruppo degli otto Pittori italiani. Took part in the Venice Biennale. Became acquainted with Abstract Expressionism on a trip to the USA; especially impressed by Gorky's works. **1955** Awarded International Prize for Painting at the São Paulo Biennale and participation in documenta 1 in Kassel. **1956** Received special honours at the Venice Biennale. **1958** Guest-professor at Mills College, Oakland (CA). **1964** Participation in documenta 3 in Kassel.
CATALOGUES RAISONNES: Bettini, L. (ed.): A. Tutta l'opera grafica. Galleria d'Arte Moderna, Udine. Milan 1986 (cat.).– Brandi, C. et al. (ed.): A. Roma 1977

MONOGRAPHS, CATALOGUES: A. Kestner-Gesellschaft. Hanover 1953 (cat.).– A. Galleria del Milione. Milan 1974 (cat.).– A. L'itinerario astratto, opere 1948-1945. Milan 1989 (cat.).– Amico, F. d' (ed.): A. Il disegno. Galleria Civica, Modena. Florence 1992 (cat.).– Drudi, G.: Immagini di A. Roma 1986.– Feo, G. di (ed.): A. Galleria Nazionale d'Arte Moderna e Contemporanea. Roma 1978 (cat.).– Manturana, B. (ed.): A. fino al 1952. Palazzo Rosari-Spada. Spoleto 1987 (cat.).– Sweeney, J. J. (ed.): A. Roma 1961.– Venturi, L.: A. Florence 1954

**AGAM Yaacov**
(Jacob Gibstein)
born **1928** Rishon-le-Zion
Israeli painter and object artist. **1947/48** Studied at the Academy of Art in Bezalel, Jerusalem. **1949** Zurich School of Arts and Crafts. **1951** Moved to Paris; worked at the Atelier d'Art Abstrait. Built his first kinetic objects that change their appearance depending on the position of the viewer or when handled directly. **1953** Solo-exhibition in the Craven gallery, Paris. **1955** Experimental abstract films. From **1961** extended the sensual effect of his objects by incorporating sound effects and tactile stimuli. Produced large murals and playgrounds with variable colour components for architectural schemes. **1964** Participation in documenta 3 in Kassel. **1972** Retrospective in the Musée d'Art Moderne, Paris.
WRITINGS: Y. A. Textes de l'artiste / Texte des Künstlers. Neuchâtel 1962
MONOGRAPHS, CATALOGUES: Y. A. Stedelijk Museum, Amsterdam. Amsterdam 1973 / Y. A. Bilder und Skulpturen. Städtische Kunsthalle Düsseldorf. Düsseldorf 1973 (cat.).– Grambu, H. (ed.): Y. A. Pictures – Sculptures. Tel Aviv Museum. Tel Aviv 1973 (cat.).– Leymarie, J. et al. (ed.): Centre National d'Art Contemporain. Paris 1972 (cat.).– Metken, G.: Y. A. London and New York 1977.– Popper, F.: A. New York 1976, 1990.– Reichardt, J. (ed.): Y. A. Marlborough-Gerson Gallery. London 1966 (cat.)

**ALBERS Josef**
**1888** Bottrop – **1976** New Haven (CT)
German-American painter and art teacher. Studied **1913–1915** at the Berlin Academy, **1916–1920** at Essen School of Arts and Crafts with Thorn-Prikker and the Munich Academy with Franz von Stuck, and **1919/20** at the Bauhaus in Weimar. **1922** Qualified and then taught preliminary courses himself at the Bauhaus. Directed workshop for stained glass and later furniture design. **1925** Appointed Bauhausmeister. Married the artist Anneliese Fleischmann. **1933–1949** Emigrated to the USA and taught at Black Mountain College, North Carolina. His pupils included Motherwell, De Kooning und Rauschenberg. **1950–1960** Head of Department of Design at Yale University School of Art in New Haven. Visiting lecturer at numerous universities and institutes in America and at the Academy of Art and Design in Ulm, Germany. **1955** Participation in documenta 1 in Kassel. **1963** Wrote *Interaction of Colour*, research into the perception of colour. Albers became interested in geometric abstraction as early as **1920** and is best known for his series of paintings, begun in **1950**, entitled *Homage to the Square*. Can be regarded as a forerunner of Op Art and Minimal Art.
WRITINGS: J. A.: Structural Constellations. New York 1961.– J. A.: Hommage to the Square. New Haven (CT) 1962.– J. A.: Interaction of Color. New Haven (CT) 1940, 1975, London 1963 / J. A.: Interaction of Color. Grundlegung einer Didaktik des Sehens. Cologne 1970.– J. A.: Search versus Research. Hartford 1969.– J. A.: Formulation. Articulation. New York 1972
CATALOGUE RAISONNE: Miller, J. (ed.): J. A. Prints 1915-1970. Brooklyn 1973
MONOGRAPHS, CATALOGUES: Alviani, G. (ed.): J. A. Milan 1988.– Benezra, N: D. The Murals and Sculpture of J. A. New York 1985.– Bucher, F.: J. A. Trotz der Geraden. Eine Analyse seiner graphischen Konstruktionen. Bern 1961 / J. A. Despite Straight Lines. An Analysis of His Graphic Constructions. New Haven (CT) 1961, Cambridge (MA) 1977.– Fox-Weber, N. et al. (ed.): J. A. A Retrospective. Solomon R. Guggenheim Museum. New York 1988 (cat.).– Gomringer, E.: J. A. Starnberg 1968, 1971 / J. A. His Work as a Contribution to Visual Articulation in the 20th Century. New York 1968 / J. A. Son œuvre et sa contribution à la figuration visuelle au cours du XXe siècle. Paris 1972.– Licht, F. and N. F. Weber (ed.): J. A. Glass, Color and Light. Solomon R. Guggenheim Museum. New York 1994 (cat.).– Lück, M. and A. Schmidt: A. Bibliographie. Bottrop 1983.– Poetter, J. (ed.): J. A. 1888-1976. Staatliche Kunsthalle Baden-Baden. Baden-Baden 1988 (cat.).– Schell, M. (ed.): A. und J. A. Eine Retrospektive. Museum Villa Stuck, Munich et al. Munich 1989 (cat.).– Spies, W.: A. Stuttgart 1970, New York 1970.– Stockebrand, M. (ed.): J. A. Photographien 1928-1955. Kölnischer Kunstverein et al. Munich 1992 (cat.).– Thomas, K. (ed.): J. A. Eine Retrospektive. Staatliche Kunsthalle Baden-Baden et al. Cologne 1988 (cat.).– Weber, N. F.: The Drawings of J. A. New Haven (CT) and London 1984 / Die Zeichnungen von J. A. Bottrop 1988.– Wißmann, J.: J. A. Recklinghausen 1971

**ALBRIGHT Ivan Le Lorraine**
**1897** Chicago – **1983** Woodstock (VT)
American painter. **1916/17** Studied architecture at the University of Illinois, Urbana. **1918/19** served as a medical draughtsman in World War I. **1920–1923** Studied at the Art Institute of Chicago and at the National Academy of Design, New York. **1926** Awarded special honours by the Art Institute of Chicago. **1930** First solo-exhibition in the Walden Bookshop in Chicago. His meticulous representations of processes of bodily growth and decay, often so exaggerated they become surreal, are closely related to Magical Realism. From **1938** Professorship at the Art Institute of Chicago. **1942** Special award for a painting in the exhibition "Artists for Victory" at the Metropolitan Museum of Art, New York. **1943** various commissions to paint film set details for Hollywood films such as *Dorian Gray*, *Bel Ami* and *The Temptation of Saint Anthony*. **1964** Retrospective at the Art Institute of Chicago.
CATALOGUE RAISONNE: Coryden, M. (ed.): Graven Image. The Prints of I. A. 1931-1977. Lake Forest 1978
MONOGRAPHS, CATALOGUES: Croyden, M.: I. A. New York 1978.– Donnell, C. et al. (ed.): I. A. The Art Institute of Chicago. New York 1997 (cat.).– Sweet, F. and J. Dubuffet (ed.): I. A. The Art Institute of Chicago. Chicago 1964 (cat.)

**ALECHINSKY Pierre**
born **1927** Brussels
Belgian painter. **1944–1948** Studied at the Ecole Nationale Supérieure d'Architecture et des Arts Décoratifs in Brussels. **1947** Travelled through Morocco and Yugoslavia; joined the group of painters known as the Jeune Peinture Belge. **1949–1951** With Appel, Jorn and Constant, formed the group Cobra. **1951** Moved to Paris; worked in Hayter's studio Atelier 17. **1955** Visited Japan. Strongly infuenced by calligraphic characters and Eastern painting techniques. **1957** Wall paintings for the Cinémathèque in Paris. **1964** and **1977** participation in documenta 3 and 6 in Kassel. Up to **1970** on the committee for the Salon de Mai. Alechinsky's form of Abstract Expressionism, his paintings peopled with grotesque and fantastic figures, are clearly influenced by Surrealism and techniques developed in American Action Painting.
WRITINGS: P. A.: La Vie comme elle tourne. Montrouge 1979.– P. A.: L'Autre main. Saint-Clément-de-Rivière 1988.– P. A.: Lettre suit. Paris 1992.– P. A.: Baluchon et ricochets. Paris 1994.– P. A.: Travaux à deux ou trois. Paris 1994.– Ionesco, E. and Y. Rivière (ed.): P. A. Peintures et écrits. Trois approches. Paris 1977 / P. A. Paintings and Writings. New York 1977
CATALOGUES RAISONNES: Butor, M. and M. Sicard (ed.): P. A. Travaux d'impres-

sion. Paris 1992.– Loo, O. v. d. (ed.): P. A. 20 Jahre Impressionen. Œuvre-Katalog Druckgraphik. Munich 1967.– Rivière, Y.: P. A. Les Estampes de 1946 à 1972. Paris 1973
MONOGRAPHS, CATALOGUES: Bonnefoy, Y.: A. Les Traversées. Saint-Clément 1992.– Bosquet, A.: P. A. Paris 1971.– Butor, M. and M. Sicard: A. dans le texte. Paris 1985.– Butor, M. and M. Sicard: A. Travaux d'impression. Paris 1992.– Güse, E.-E. (ed.): P. A. Zwischen den Zeilen. Saarland Museum, Saarbrücken. Stuttgart 1993 (cat.).– Haenlein, C. (ed.): P. A. Bilder, Aquarelle, Zeichnungen. Eine Retrospektive. Kestner-Gesellschaft. Hanover 1980 (cat.).– Heusch, L. d.: A. Copenhagen 1950.– Putman, J.: A. Milan 1967, Paris 1967.– Sello, K. and O. Paz (ed.): P. A. Margin and Center. Solomon R. Guggenheim Museum, New York et al. New York 1987 (cat.) / P. A. Margin and Center. Kunstverein Hanover et al. Hanover 1988 / P. A. Centres et marges. Musées Royaux des Beaux-Arts de Belgique et al. Brussels 1988 (cat.).– Sicard, M. (ed.): P. A. Extraits pour traits. Paris 1989.– Sicard, M. (ed.): P. A. Séquence 1980-1992. Paris 1994.– Sicard, M.: A. sur Rhône. Arles 1990.– Tardieu, J. et al. (ed.): A. Entre les lignes. Paris 1996.– Vree, F. d.: A. Schelderode 1976

**ALMY Max**
born **1948** Omaha (NE)
American video artist. **1970** Studied art and art history at the University of Nebraska, Lincoln and the University of Minnesota, Minneapolis. From **1974** worked as a video and media artist. Moved to Los Angeles. **1978** Graduated as a Master of Fine Arts in Film und Video from Californian College of Arts and Crafts in Oakland. **1984–1994** Taught at the UCLA School of Theatre, Film and Television. **1995** Awarded the International Prize for Video Art by ZKM in Karlsruhe.

**ALTENBOURG Gerhard**
(Gerhard Ströch)
**1926** Roedichen-Schnepfenthal (Thuringia) –**1989** Altenburg
German painter and graphic artist. **1944** Active military service. **1945–1948** Worked as a journalist and writer. **1946–1948** Drawing lessons with Erich Dietz. **1948–1950** Studied at the Academy of Fine Arts in Weimar under Hans Hoffmann-Lederer. **1950** First engravings. **1957** Early sculptures. **1952** First one-man exhibition in the Springer gallery, Berlin. **1959** Took part in documenta 2 and **1977** in documenta 6 in Kassel. **1966** Burda Award for Graphic Art. **1968** Won the Will-Grohmann Award. From **1970** member of the Academy of Arts in West Berlin. Retrospectives in various German cities. Altenbourg's works are closely related to Fantastic Realism.
WRITINGS: G. A.: Ich-Gestein. Frankfurt-on-Main 1971.– Brusberg, D. (ed.): G. A. Das einschauende Anschauen. Köpfe und

Szenen 1949-1986. Berlin 1986 (cat.).–
Brusberg, D. (ed.): Das dritte Auge. Ein
Dialog der Freunde G. A. und Erhart
Kästner. Frankfurt-on-Main 1992
CATALOGUES RAISONNES: Altenbourg,
G. and A. Janda (ed.): G. A. Werk-Ver-
zeichnis 1947-1969. Hanover 1969.– Thor-
mann, O. and A. Janda (ed.): Sah ichs wie
Feuer glänzen um und um. Werkverzeichnis
der Metallarbeiten und zugehörigen Zeich-
nungen von G. A. Berlin and Leipzig 1994
MONOGRAPHS, CATALOGUES: G. A.
Hamburger Kunstverein. Hamburg 1970
(cat.).– G. A. Staatliche Kunstsammlung
Dresden. Dresden 1979 (cat.).– Brusberg,
D. (ed.): G. A. "Schnepfenthaler Suite"
und "Aus dem Hügelgau". Galerie Brusberg.
Berlin 1989 (cat.).– Janda, A. (ed.): G. A.
Arbeiten aus den Jahren 1947-1989. Institut
für Auslandsbeziehungen. Stuttgart 1992
(cat.).– Roters, E. et al. (ed.): G. A. Das
einsschauende Ausschauen. Köpfe und
Szenen 1949-1986. Galerie Brusberg, Berlin.
Hanover 1986 (cat.).– Salzmann, S. et al.
(ed.): G. A. Arbeiten 1947-1987. Kunsthalle
Bremen et al. Bremen 1988 (cat.).– Ströch,
A. and G. Brusberg (ed.): G. A. Der
Gärtner. Eine Monografie in Bildern.
Frankfurt-on-Main 1996

**ANDERSON Laurie**
born **1947** Chicago
American musician and performance artist.
**1954-1966** Studied violin. **1958-1965**
Attended the Saturday School of the Art
Institute of Chicago. **1966** Moved to New
York. **1966-1969** Studied history of art.
**1969** Became acquainted with Philip Glass.
**1970** First objects and sound sculptures
with taped sound effects. **1972/73** Studied
sculpture at Columbia University, New
York. Worked as a teacher and art critic.
**1972** First *Automotive* performance. Used a
variety of mediums of expression in her per-
formances, such as music, dramatic and
sculptural elements, gestures or off-stage
voices or sounds. **1977** Participation in
documenta 6 in Kassel. **1979** Release of the
record *Big Ego*. **1981** Publication of the pop
song *O Superman*. **1983** Guggenheim Fel-
lowship. **1986** Took the show *Home of the
Brave* on an international music and perfor-
mance tour. A film-musical of the same
name appeared in the cinemas. **1995** Toured
with *Stories from the Nerve Bible*.
WRITINGS: L. A.: The Package. New York
1971.– L. A.: The Rose and the Stone. New
York 1974.– L. A.: Typisch Frau. Regensburg
1981.– L. A.: United States. New York 1984
MONOGRAPHS, CATALOGUES: L. A.
Solomon Gallery. New York 1977 (cat.).–
Kardon, J. (ed.): L. A. Works from 1969 to
1983. Institute of Contemporary Arts, Uni-
versity of Pennsylvania. Philadelphia 1983
(cat.)

**ANDRE Carl**
born **1935** Quincy (MA)
American sculptor. **1951-1953** Studied at
the Phillips Academy, Andover. **1954** Trav-

elled through England and France. **1958/59**
Came to know Stella whose comic strips
(*Black Series*), together with Brancusi's
works, inspired him to create his first large
wood sculptures. **1960-1964** Worked on
the Pennsylvania railroad as a brakeman and
conductor. **1964** Took part in "8 Young
Americans", an exhibition of the works of
sculptors using a formalised, minimalist lan-
guage. Developed grounded sculptures
(*Element Series*) based on identical wooden
units arranged in horizontal configurations
on the ground. **1965** First solo-exhibition in
the Tibor de Nagy gallery, New York. From
**1967** applied his module technique to metal
sculptures: arrangements of iron, alu-
minium or copper plates laid out flat on the
floor to be walked over. **1968** Participated in
documenta 4 in Kassel and in the exhibi-
tion of Minimal Art at the Geementemu-
seum in The Hague, where he was pre-
sented as a leading exponent of this move-
ment. Gave sculpture a new direction by
redefining its spatial location. **1982** Partici-
pation in documenta 7 in Kassel.
WRITINGS: Buchloh, B. H. D. (ed.): C. A.
and H. Frampton. 12 Dialogues 1962-1963.
Halifax and New York 1980
MONOGRAPHS, CATALOGUES: C. A.
Solomon R. Guggenheim Museum. New
York 1971 (cat.).– C. A. The Museum of
Modern Art. New York 1973 (cat.).– C. A.
Die Milchstrasse, der Frieden von Münster
und andere Skulpturen. Westfälischer
Kunstverein Münster et al. Münster 1985
(cat.).– C. A. Haags Gemeentemuseum,
The Hague et al. The Hague 1987 (cat.).–
Battock, G.: C. A. New York 1968.–
Bourdon, D. (ed.): C. A. Sculpture 1959-
1977. Laguna Gloria Art Museum. Austin
1978 (cat.).– Brouwer, M. and D. Zacharo-
poulos (ed.): C. A. Sculptor 1997. Musée
Cantini. Marseille 1997 (cat.).– Develing, E.
(ed.): C. A. Haags Gemeentemuseum. The
Hague 1969 (cat.).– Develing, E.: C. A. The
Hague 1974.– Jonge, P. d. (ed.): C. A. Haags
Gemeentemuseum et al. The Hague 1987
(cat.).– Lauter, R. (ed.): C. A. Extraneous
Roots. Museum für Moderne Kunst. Frank-
furt-on-Main 1991 (cat.).– Meyer-Hermann,
E. (ed.): C. A. Sculptor. Krefelder Kunst-
museen und Kunstmuseum Wolfsburg.
Stuttgart 1996 (cat.).– Serota, N. (ed.): C.
A. Sculpture 1959-1978. Whitechapel Art
Gallery. London 1978 (cat.).– Waldman, D.
(ed.): C. A. Solomon R. Guggenheim
Museum. New York 1970 (cat.).– West-
water, A. (ed.): C. A. Sculpture 1958-1974.
Kunsthalle Bern. Bern 1975 (cat.)

**ANSELMO Giovanni**
born **1934** Borgofranco d'Ivrea
Italian object and concept artist. Self-
taught. **1967** Exhibited two works as part of
an exhibition in the Sperone gallery in
Turin. **1965-1968** Constructed a series of
untitled, three-dimensional objects repre-
senting basic physical concepts such as
*energy* and *power*. After **1969** focused on
more abstract concepts such as *infinity* and
*invisibility*. **1972** and **1982** participation in

documenta 5 and 7 in Kassel. From **1974**
installations involving projected images,
drawings or granite rocks, as in *particolare*,
a work requiring 20 slide projectors.
Anselmo could be said to stand somewhere
between Italian Arte Povera and Concept
Art. **1992** Received special honours at the
Venice Biennale.
WRITINGS: G. A.: Leggere. Torino 1972.–
G. A.: 116 Particolari visible e misurabli di
INFINITO. Torino 1975
MONOGRAPHS, CATALOGUES:
Ammann, J.-C. (ed.): G. A. Kunstmuseum.
Lucerne 1973 (cat.).– Ammann, J.-C. and
R. Fuchs (ed.): G. A. Kunsthalle Basel.
Basel 1979/G. A. Stedelijk Van Abbe
Museum. Eindhoven 1979 (cat.).– G. A.
Musée de Peinture et de Sculpture. Greno-
ble 1980 (cat.).– Merz. B. and W. Guada-
gnini (ed.): G. A. Palazzo de Giardini Pub-
blici. Modena 1989 (cat.).– G. A. Musée
d'Art Moderne et d'Art Contemporain. Nice
1996 (cat.).– Pagé, S. and D. Soutif (ed.):
G. A. Musée d'Art Moderne de la Ville de
Paris. Paris 1985 (cat.)

**ANTES Horst**
born **1936** Heppenheim
German painter. **1957-1959** Studied at the
Karlsruhe Academy under HAP Grieshaber.
**1960** Received a grant from the arts society
of the national association of German
industries. First solo-exhibition in Der
Spiegel gallery in Cologne. One of the first
exponents of a new figurative style of paint-
ing in Germany, taking over from the L'art
informel of the 50s. A central feature in his
paintings is the *cephalopod*, an archaic
figure with an oversized head in boxed-in
spaces. **1962/63** Study visit to the Villa
Romana in Florence, and scholarship from
the Villa Massimo in Rome. **1964-1977**
Participation in documenta 3, 4 and 6 in
Kassel. **1966** UNESCO Award at the 33rd
Venice Biennale. **1967-1973** Professorship
at the Karlsruhe Academy. Since **1984**
teaching again in Karlsruhe.
WRITINGS: H. A.: Poggibonsi 1979-1980.
Frankfurt-on-Main 1980
CATALOGUES RAISONNES: Fehlemann,
S. et al. (ed.): H. A. Auflagen von flachen
dreidimensionalen Gegenständen. Ein
Werkverzeichnis. Museum Moderner
Kunst, Passau et al. Passau 1997 (cat.).–
Franzke, A. (ed.): H. A. Metallplastik.

Vollständiges Werkverzeichnis. Munich
1976.– Gercken, G. (ed.): Werkverzeichnis
der Radierungen H. A. 1962-1966. Munich
1968.– Lutze, B. (ed.): H. A. Werkverzeich-
nis der Lithographien, Offsets, Siebdrucke,
Holzschnitte und verwandter Techniken.
Stuttgart 1976
MONOGRAPHS, CATALOGUES: H. A.
Kunstmuseum Hannover. Hanover 1983
(cat.).– H. A. Votives. Solomon R. Gug-
genheim Museum. New York 1984 (cat.).–
H. A. Bilder von 1959-1993. Von der
Heydt-Museum. Wuppertal 1994 (cat.).–
Bischoff, U. (ed.): A. Bilder von 1959-1993.
Bayerische Staatsgemäldesammlungen im
Haus der Kunst, Munich et al. Munich
1993 (cat.).– Gallwitz, K. (ed.): A. Bilder
1965-1971. Staatliche Kunsthalle Baden-
Baden. Baden-Baden 1971 (cat.).– Gallwitz,
K. (ed.): H. A. 25 Votive. Städtische Galerie
im Städelschen Kunstinstitut. Frankfurt-
on-Main 1983 (cat.).– Lehmann, U. and N.
Nobis (ed.): H. A. Druckgraphik, Farbige
Blätter, Zeichnungen, Collagen und Skulp-
turen. Verzeichnis der Bestände Sammlung
Wolf und Ursula Hermann. Sprengel
Museum. Hanover 1989 (cat.).– Lutze, B.:
H. A. Lithographien. Stuttgart 1976.–
Schwarz, M. (ed.): H. A. Der Kopf. Badi-
scher Kunstverein, Karlsruhe et al. Karls-
ruhe 1978 (cat.)

**ANUSZKIEWICZ Richard**
born **1930** Erie (PA)
American painter and graphic artist. **1948-
1953** Studied at Cleveland Institute of Art,
Ohio. **1953-1955** studied at Yale University
of Art in New Haven under Albers and
**1955/56** at the University of Ohio. **1957**
Moved to New York. **1963-1965** Taught at
the Cooper Union School of Art in New
York. **1968** Participation in documenta 4 in
Kassel. Since **1983** teaching at the School of
Visual Arts in New York. Influenced by
Alber's theories, Anuszkiewicz is one of the
leading exponents of Op Art in America.
His work is typically concerned with radiat-
ing expanses of lines, and visual perceptual
phenomena.
CATALOGUE RAISONNE: Brooke, D. and
G. Baro (ed.): R. A. Prints and Multiples.
Brooklyn Museum. New York 1979 (cat.).
MONOGRAPHS, CATALOGUES: R. A.
Retrospektive. Josef Albers Museum.
Bottrop 1997 (cat.).– Lunde, K.: A. New
York 1976

**APPEL Karel**
born **1921** Amsterdam
Dutch painter. **1940-1943** Studied painting
at the Rijksakademie in Amsterdam. **1948**
Co-founder of the Experimental Group
that later became Cobra. Other members of
the group included Alechinsky, Jorn, Con-
stant and Corneille. They put on joint-exhi-
bitions and published a magazine. **1948**
Unveiling of a large wooden relief, commis-
sioned for the city hall in Amsterdam,
caused a scandal. **1950** Moved to Paris. **1951**
Cobra disbanded. Produced oil paintings,

ceramics, church windows, reliefs and sculptures in wood and polyester. **1956** Murals for the Stedelijk Museum in Amsterdam and **1958** for UNESCO in Paris, as well as the 100 metre long *Energy Wall* in Rotterdam. **1959** and **1964** participation in documenta 2 and 3 in Kassel. **1964/65** large multicoloured reliefs and figures in wood and polyester. **1971** First monumental sculptures out of aluminium in the USA. **1989** large retrospectives in five Japanese museums.
WRITINGS: K. A. over K. A. Amsterdam 1971
CATALOGUES RAISONNES: Kuspit, D. (ed.): K. A. Sculpture. Catalogue Raisonné. New York 1994.– Ragon, M. (ed.): C. A. Catalogue raisonné des peintures de 1937-1957. Paris 1988
MONOGRAPHS, CATALOGUES: Alvard, J. et al. (ed.): K. A. 40 ans de peinture, sculpture et dessins. Paris 1987.– K. A. Stedelijk Museum. Amsterdam 1965 (cat.).– Bellew, P.: K. A. Paris and Milan 1968.– Berger, P.: K. A. Venlo 1977.– Berger, P. et al. (ed.): Ecrits sur K. A. Paris 1982.– Claus, H.: K. A. Painter. Amsterdam 1962.– Frankenstein, A.: K. A. The Art of Style and Styles of Art. New York 1980.– Frankenstein, A.: K. A. Amsterdam 1989.– Fuchs, R. et al. (ed.): K. A. Dipinti, sculture e collages. Castello di Rivoli, Museo d'Arte Contemporanea. Milan 1987 (cat.).– Fuchs, R. (ed.): K. A. Ik wou dat ik een vogel was. Berichten uit het atelier/Ich wollte ich wäre ein Vogel. Berichte aus dem Atelier. Haags Gemeentemuseum et al. The Hague 1991 (cat.).– Hagenberg, R. (ed.): K. A. Dupe of Being. Paris 1989.– Lambert, J.-C.: K. A. Works on Paper/Œuvres sur papier. New York 1980, Paris 1988.– Ragon, M.: K. A. Peintures 1937-1957. Paris 1988.– Ragon, M.: K. A. De Cobra à un art autre. Paris 1988.– Restany, P.: Street Art: le second souffle de K. A. Paris 1982.– Restany, P. and A. Ginsberg: K. A. Street Art, Ceramics, Sculpture, Wood Reliefs, Tapestries, Murals. Villa El Salvador. New York 1985 (cat.).– Schmidt, K. (ed.): K. A. Arbeiten auf Papier. Staatliche Kunsthalle Baden-Baden. Baden-Baden 1982 (cat.).– Vrijman, J.: De werkelijkheid van K. A. Amsterdam 1962

**ARAKAWA Shusaku**
born **1936** Nagoya
Japanese painter and graphic artist. **1954**–

**1958** Studied medicine and mathematics at the University of Tokyo. **1958–1961** Took part in neo-dadaist exhibitions and happenings. **1960** Founded his own Dada movement in Japan. **1961** First solo-exhibition in the Mudo gallery in Tokyo. **1961** Moved to the USA. Joint projects with his wife, the American writer Madeline Gris. Began large-scale drawings, paintings and diagrams. **1968** and **1977** participation in documenta 4 and 6 in Kassel. **1970** Took part in the Venice Biennale. **1972** DAAD scholarship to Berlin. **1978** Retrospectives in the Stedelijk Museum, Amsterdam, and **1979** at the Minneapolis Institute of Art.
WRITINGS: A.: For Example (A Critique of Never). Milan 1974.– A. and M. H. Gins: Mechanismus der Bedeutung. Munich 1971/The Mechanism of Meaning. Work in Progress. New York 1979, 1988.– A. and M. H. Gins: Pour ne pas mourir. To not to die. Paris 1987
MONOGRAPHS, CATALOGUES: A. Editions Maeght. Montrouge 1977 (cat.).– A. Editions Maeght. Montrouge 1982 (cat.).– A. Bilder und Zeichnungen 1962-1981. Kestner-Gesellschaft. Hanover 1981 (cat.).– Gins, M. H. (ed.): S. A. Seibu Museum of Art. Tokyo 1979 (cat.).– Govan, M. and J.-F. Lyotard (ed.): S. A. & Madeleine Gins. Reversible Destiny. Guggenheim Foundation, SoHo. New York 1997 (cat.).– Iwasaki, Y. (ed.): Constructing the Perceiver. A. Experimental Works. National Museum of Modern Art, Tokyo et al. Tokyo 1991 (cat.).– Partenheimer, J. (ed.): S. A. Städtische Kunsthalle Düsseldorf. Düsseldorf 1977 (cat.).– Zweite, A. (ed.): A. Bilder und Zeichnungen 1962-1981. Städtische Galerie im Lenbachhaus. Munich 1981 (cat.)

**ARBUS Diane**
(Diane Nemerov)
**1923** New York–**1971** New York
American photographer. **1941** Married the fashion photographer Allan Arbus. Worked in advertising. **1955–1957** Studied under Lisette Model. From **1960** became a freelance photographer. Took fashion photos for *Harper's Bazaar*, *Esquire* and *New York Times Magazine*. Photographs of marginalised groups: drug addicts, the destitute and disabled people, as well as numerous pictures of "typical American citizens" in absurd or grotesque poses and sterile surroundings. **1965/66** Taught at Parsons School of Design in New York. **1968/69** Taught at the Cooper Union in New York. **1971** Solo-exhibition at the Museum of Modern Art, New York. Commited suicide. In the same year, a book was published of her photographs taken in the last eight years of her life.
MONOGRAPHS, CATALOGUES: D. A. and M. Israel (ed.): D. A. An Aperture Monograph. Millerton (NY) 1972.– D. A. Stedelijk van Abbe Museum. Eindhoven 1977 (cat.).– D. A.: D. A. Magazine Work. Helen Foresman Spencer Museum of Art et al. Millerton (NY) 1984 (cat.).– Bosworth, P.: D. A. A Biography. New York

1984/D. A. Eine Biographie. Munich 1984.– Roegiers, P.: D. A. ou le rêve du naufrage. Paris 1985

**ARCANGELO Allan d'**
born **1930** Buffalo (NY)
American painter. **1948–1953** Studied art history at Buffalo University, New York. **1953/54** Studied at City College and at the New School for Social Research, New York, and **1957–1959** at Mexico City College. From **1959** taught at the School of Visual Arts in New York. His early pictures of film stars and everyday subjects foreshadowed American Pop Art. Used abstract style of Hard-Edge painting in his pictures of highways, roadblocks and fences, representing landscape as seen from a car driver's seat. **1965** Artist-in-residence at Aspen Institute, Colorado. **1973** Professorship at Brooklyn College in New York. In **1982**, after a long pause, started painting again, focusing primarily on clearly delineated, geometric paintings of aspects of modern civilization.
MONOGRAPHS, CATALOGUES: A. d'A. Paintings of the Early Sixties. Neuburger Museum, State University of New York. New York 1978 (cat.).– Ashton, D. (ed.): The American Landscape. Paintings by A. d'A. Burchfield Center, Western New York Forum for American Art. Buffalo 1979 (cat.).– Towle, T. (ed.): A. d'A. Institute of Contemporary Art, University of Pennsylvania, Philadelphia et al. Philadelphia 1971 (cat.)

**ARCHIPENKO Alexander**
**1887** Kiev–**1964** New York
Russian sculptor. **1902–1905** Studied painting and sculpture at Kiev School of Arts. **1906** Moved to Moscow, and in **1908** on to Paris. Made contact with Léger, and Apollinaire and the Cubists. **1910–1919** Exhibited regularly at the Salon des Indépendants and Salon d'Automne. Applied the cubist style of painting to sculpture, thereby creating Sculpto-painting: objects made of various materials such as wood, glass, metal and steel wire. **1912** Founded his own art school and the Section d'Or in Paris, exhibiting works by Picasso, Braque and Gris among others. **1913** Took part in the Armory Show in New York. **1921–1923** Taught at his own art school in Berlin. **1923** Emigrated to

America. **1924** Produced a series of movable paintings, including *Peinture Changeante* and *Archipentura*, seen as forerunners of Kinetic art. Opened further art colleges in New York and other cities in America. Lectured frequently at universities on the definition of sculpture.
WRITINGS: A. A. et al.: Fifty Creative Years 1908-1958. New York 1960
CATALOGUES RAISONNES: Karshan, D. (ed.): A. The Sculpture and Graphic Art. Including a Print Catalogue Raisonné. Tübingen 1974, Boulder (CO) 1975.– Karshan, D. (ed.): A. Sculpture, Drawings and Prints 1908-1963. Centre College, Danville (KY) 1985 (cat.)
MONOGRAPHS, CATALOGUES: A. Fifty Creative Years 1908-1958. New York 1960.– Jánszky Michaelsen, K. and N. Guralnik (ed.): A. A Centennial Tribute. National Gallery of Art, Washington et al. Washington 1986 (cat.).– Karshan, D. H.: A. Content and Continuity 1908-1963. Chicago 1968.– Karshan, D. H. (ed.): A. Visionnaire international. Musée Rodin. Paris 1969 (cat.).– Karshan, D. (ed.): A. Themes and Variations 1908-1963. Museum of Arts and Sciences. Daytona Beach (FL) 1989 (cat.).– Michaelsen, K. J.: A. A Study of the Early Works 1908-1920. New York and London 1977.– Michaelsen, K. J. and N. Guralnik (ed.): A. A Centennial Tribute. National Gallery of Art, Washington et al. New York 1986 (cat.).– Pontiggia, E. (ed.): A. A. L'arte e l'universo. Montebelluna 1988.– Schmoll gen. Eisenwerth, H. and G.-W. Költzsch (ed.): A. A. 2 vols. Vol. 1: A. A.'s Erbe. Werke von 1908-1936 aus dem testamentarischen Vermächtnis. Vol. 2: Aufsätze, Archipenko-Symposion in Saarbrücken. Moderne Galerie des Saarland-Museums. Saarbrücken 1986 (cat.)

**ARMAGNAC Ben d'**
**1940** Amsterdam–**1978** Amsterdam
Belgian painter and multimedia artist. **1959–1963** Studied painting at the Antwerp Academy. **1965** Worked together with Gerrit Dekker. Moved out of the city to Süd-Beverland. Concentrated on meditative environments and performances. **1976** Moved to Maastricht. **1977** Took part in documenta 6 in Kassel. **1981** Retrospective in the Stedelijk Museum, Amsterdam.
MONOGRAPHS, CATALOGUES: Brand, J. et al. (ed.): B. d'A. Stedelijk Museum, Amsterdam et al. Amsterdam 1981 (cat.).– Gachnang, J. and A. Hubschmidt (ed.): Armanac/Dekker 1968-1973. Stichting De Appel. Amsterdam 1974 (cat.)

**ARMAJANI Siah**
born **1939** Teheran
American environment artist, architect and philosopher of Iranian origin. **1960** Moved to the USA. **1960–1963** Studied at Macalester College, St. Paul. Began concept art projects involving computers. Since **1967** has worked as an architect, focusing on the design of reading gardens, common-rooms

and parks. **1974–1976** Published a *Dictionary of Buildings*, a complex of 2000 architects' models. Since **1986** developing so-called *Elements*, objects raising questions about architectural situations and their significance. **1987** Exhibitions at the Stedelijk Museum, Amsterdam, and the Kunsthalle Basel.
MONOGRAPHS, CATALOGUES: Ammann, J.-C. (ed.): S. A. Kunsthalle Basel et al. Basel 1987 (cat.).– S. A. List Visual Arts Center, Massachusetts Institute of Technology. Cambridge (MA) 1988 (cat.).– Brown, J. (ed.): S. A. Hudson River Museum. Yonkers (NY) 1981 (cat.).– Bußmann, K. et al. (ed.): S. A. Westfälisches Landesmuseum, Münster et al. Münster 1987 (cat.).– Kardon, J. and K. Linker (ed.): S. A. Bridges, Houses, Communal Spaces. Dictionary for Buildings. Institute for Contemporary Art, University of Philadelphia. Philadelphia 1985 (cat.).– Princethal, N. and J.-P. Vienne (ed.): S. A. Anarchistics Controbutions 1962-1994. Nice 1994 (cat.).– Reck, H.-U.: S. A. Nicht Stil: Konstruktion. S. A.'s Abneigung der Moderne. Frankfurt-on-Main 1991 (cat.)

**ARMAN**
(Armand Fernandez)
born **1928** Nice
French-born object artist who became an American citizen. **1946–1949** Studied at the Ecole Nationale des Art Décoratifs in Nice, and **1949–1951** at the Parisian Ecole du Louvre. Became acquainted with Yves Klein, with whom he organised joint happenings and events from **1953** onwards. **1955** Influenced by the works of Schwitters, produced neo-dadaist *Cachets*, pictures covered with ink stamps. **1958** Adopted the name Arman as a result of a printer's error on the cover of a catalogue. **1959/60** Produced *Poubelles* – domestic rubbish poured into plexiglas containers – and Accumulations – assemblages of similar junk material in showcases. **1961** First *Coupes* (sliced objects) and *Colères* (smashed up objects). **1963** Began work on *Combustiones* (incinerations) during his stay in New York. **1964** and **1977** participation in documenta 3 and 6 in Kassel. **1967/68** Taught at the University of California, Los Angeles. **1972** Became an American citizen. **1975–1982** Worked on *Long Term Parking*, a tower of 60 crushed automobiles. Together with Klein, Tinguely, Raysse and César, considered one of the main exponents of Nouveau Réalisme.
CATALOGUES RAISONNES: Durand-Ruel, D. (ed.): A. Catalogue raisonné. 4 vols. Paris 1991ff.– Kuspit, D. (ed.): A. Monochrome Accumulations 1986-1989. Catalogue Raisonné. Stockholm 1990.– Otmezguine, J. and M. Moreau (ed.): A. Estampes. Catalogue raisonné. Paris 1991.– Otmezguine, J. and M. Moreau (ed.): A. Multiples. Catalogue raisonné. Paris 1992
MONOGRAPHS, CATALOGUES: A. Ol'oggetto come alfabeto: retrospettiva 1955-1984. Museo Civico de Belle Arti, Villa

Ciani. Lugano 1984 (cat.).– A. Objets armés 1971-1974. Musée d'Art Moderne de la Ville de Paris. Paris 1985 (cat.).– Brëhammar, M. et al. (ed.): A. Lunds Konsthall. Malmö 1989 (cat.).– Cabanne, P.: A. Paris 1993.– Hahn, O.: A. Paris 1972.– Hahn, A. and O.: A. Mémoires accumulés, entretiens. Paris 1992.– Holeczek, B. (ed.): A. Parade der Objekte. Retrospektive 1955-1982. Kunstmuseum Hannover mit Sammlung Sprengel, Hanover et al. Hanover 1982 (cat.).– Jouffroy, A.: A. Milan 1963.– Lamarche-Vadel, B.: A. Paris 1987, New York 1990.– Marck, J. v. der: A. New York 1984.– Martin, H.: A. New York 1968, Paris 1973.– Martin, H.: A. Or Four or Twenty Blackbirds Baked in a Pie. Or Why Settle for Less When You Can Settle for More. New York 1973.– Restany, P. et al.: A. 1955-1991. A Retrospective. Houston Museum of Fine Arts. Houston 1992 (cat.).– Scheps, M. (ed.): A. Parade of the Objects. Retrospective 1955-1983. Tel Aviv Museum. Tel Aviv 1983 (cat.)

**ARMITAGE Kenneth**
**1916** Leeds – **2002**
English sculptor. **1934–1937** Studied at Leeds College of Art and **1937–1939** at the Slade School. His early work was influenced by Egyptian and Cycladic sculpture, and the works of Moore. **1946–1956** Director of the department of sculpture at Bath Academy of Art in Corsham. Destroyed almost all the wooden sculptures from his early phase and began to make models in plaster, later in clay, as casts for his bronze figures and groups. **1952** First one-man exhibition at Gimpel Fils in London and participation in the Venice Biennale. **1955** and **1959** participation in documenta 1 and 2 in Kassel. **1958** Won first prize in an international competition for a war memorial in Krefeld. **1964** Visited Caracas. Used materials such as wax, resin and aluminium in stark, abstract figures. **1970** Guest-professor at Boston University.
CATALOGUE RAISONNE: Woollcombe, T. (ed.): K. A. Life and Work. London 1997
MONOGRAPHS, CATALOGUES: K. A. Marlborough Fine Art Limited. London 1962 (cat.).– K. A. The Arts Council of Great Britain. London 1972 (cat.).– Bowness, A. (ed.): K. A. Whitechapel Art Gallery. London 1959 (cat.).– Lynton, N.: K. A. London 1962.– Penrose, R.: K. A. Amriswil 1960.– Schmalenbach, W. (ed.): K. A./Lynn Chadwick. Kestner-Gesellschaft. Hanover 1960 (cat.).– Spencer, C.: K. A. London 1973.– Woollcombe, T.: The Sculpture of K. A. New York 1996

**ARP Hans** (Jean)
**1886** Strasbourg – **1966** Basel
German-French sculptor, painter and poet. **1904–1908** Studied at the Academy of Fine Arts in Weimar and at the Académie Julian in Paris. **1910** Founded the Moderner Bund with Lüthy and Helbi in Lucerne. Came in contact with the Blauer Reiter group. **1914** Beginning of a long friendship with Max

Ernst. **1915** Met Sophie Taeuber; they collaborated closely on artistic projects and married in **1922**. **1916** Together with Hugo Ball, Tristan Tzara and Richard Huelsenbeck, started the Cabaret Voltaire in Zurich. **1917** First abstract wood reliefs; simultaneous poems and automatic writing. Worked on Dada publications. **1920** Joined the Dadaists in Cologne, centred around Johannes Theodor Baargeld and Max Ernst; after the summer, active in the Parisian Dada movement. **1923** Collaborated with Schwitters on various publications. From **1924** took part in Surrealist exhibitions and activities and contributed to their publications. **1930** First round sculptures in plaster. From **1931** member of Abstraction-Création. **1954** Received special honours at the Venice Biennale. **1958** Large bronze relief for the UNESCO building in Paris. In the poetic, pictorial worlds he created, Arp succeeded in uniting two seemingly incompatible styles: Surrealism and Abstraction.
WRITINGS: A. on A. Poems, Essays, Memories. New York 1971.– Arp-Hagenbach, M. and P. Schifferli (ed.): H. A.: Gesammelte Gedichte. 3 vols. Zurich and Wiesbaden 1963, 1984.– H. A.: Unsern täglichen Traum … Erinnerungen und Dichtungen aus den Jahren 1914-1954. Zurich 1955.– H. A.: On My Way. Poetry and Essays 1912-1947. New York 1948, 1967.– H. A. and E. Lissitzky: Die Kunst-Ismen. Zurich et al. 1924.– Jean, M. (ed.): J. A. Jours effeuillés. Poèmes, essais, souvenirs 1920-1965. Paris 1966, 1986
CATALOGUES RAISONNES: Arntz, W. F. (ed.): H. A. Das graphische Werk. Haag 1980.– H. A. Skulpturen. Œuvre-Katalog. Frankfurt-on-Main 1957-1969.– H. A. Minneapolis Institute of Arts. Minneapolis 1986 (cat.).– J. A. Musée National d'Art Moderne de la Ville de Paris 1986 (cat.).– Giedion-Welcker, C. (ed.): H. A. Stuttgart 1957/H. A. 2 vols. London and New York 1957-1968.– Rau, B.: H. A. Die Reliefs. Œuvre-Katalog. Stuttgart 1981/H. A. The Reliefs. Catalogue of Complete Works. New York 1981.– Trier, E.: H. A. Skulpturen 1957-1966. Stuttgart 1968/H. A. Sculpture 1957-1966. New York 1968
MONOGRAPHS, CATALOGUES: Andreotti, M.: The Early Sculpture of H. A. London and Ann Arbor (MI) 1989.– A. The Arts Council of Great Britain. Tate Gallery. London 1962.– H. A. Centre Georges Pompidou. Paris 1987/H. A. San Francisco Museum of Modern Art. San Francisco 1988 (cat.).– H. A. Museum Würth, Künzelsau. Sigmaringen 1994 (cat.).– Bleikasten, A.: A. Bibliographie. 2 vols. London 1981, 1983.– Bolliger, H. et al. (ed.): H. A. zum 100. Geburtstag (1886-1966). Bilder- und Lesebuch. Bahnhof Rolandseck et al. Rolandseck 1986 (cat.).– Buffet-Picabia, G.: J. A. Paris 1952.– Cathelin, J.: J. A. Paris 1959.– Derouet, C. et al. (ed.): Sophie Taeuber – H. A. Künstlerpaare – Künstlerfreunde. Kunstmuseum Bern et al. Bern 1988 (cat.).– Döhl, R.: Das literarische Werk H. A.'s 1903-1930. Zur poetischen Vorstellungswelt des Dadaismus. Stuttgart 1967.– Fauchereau, S.: A. Paris 1989.– Gohr, S.

(ed.): H. A. Die Metamorphose der Figur. Museum Ludwig, Cologne. Bonn 1991 (cat.).– Hancock, J.: Form and Content in the Early Work of H. A. Harvard 1980.– Hancock, J. et al. (ed.): A. 1886-1966. Württembergischer Kunstverein, Stuttgart et al. Stuttgart 1986 (cat.).– Hopfengart, C. (ed.): H. A. Kunsthalle Nürnberg. Stuttgart 1994 (cat.).– Jianou, I.: H. A. Paris 1973.– Larsen, S. C. (ed.): J. A. Centenary Exhibition: Sculpture, Reliefs and Graphic Work. Fort Lauderdale Museum of Art 1987 (cat.).– Last, R. W.: H. A. The Poet of Dadaism. Chester Springs (PA) 1969.– Marchiori, G.: A. Cinquante ans d'activité. Paris 1954.– Marchiori, G.: H. A. Milan 1963.– Poley, S.: H. A. Die Formensprache im plastischen Werk. Stuttgart 1978.– Poley, S. (ed.): H. A. Stuttgart et al. Stuttgart 1986 (cat.).– Read, H.: The Art of J. A. London and New York 1968.– Schramm, U.: Der Raumbegriff bei H. A. Münster 1995.– Seuphor, M.: H. A. Cologne und Berlin 1961, Paris 1961, New York 1961.– Soby, J. T. (ed.): A. The Museum of Modern Art. New York 1958 (cat.).– Wasmuth, J. (ed.): H. A. und Sophie Taeuber-Arp. Ein Künstlerpaar der Moderne. Stuttgart 1996 (cat.).– Weber, S. (ed.): A. Museum Würth. Sigmaringen 1994 (cat.).– Zutter, J.: H. A. "nach dem Gesetz des Zufalls geordnet". Kunstmuseum Basel. Basel 1982 (cat.)

**ARROYO Eduardo**
born **1937** Madrid
Spanish painter. Self-taught. Educated at the Lycée Français in Madrid. **1958** After working for a short time as a journalist, moved to Paris. **1961** First solo-exhibition at the Claude Lévin gallery. As an exhibition of his paintings in Madrid had been closed owing to their provocative political message and realism, he decided not to return to Spain under the Franco regime. From **1970** used Spanish painters such as Velázquez and Miró as well as Magritte's works, which he parodied, as source material for his allusive paintings. **1975–1978** Took movie gangsters from the 30s as models for his series *Among the Painters*. Since **1980** has used sandpaper and other materials in large-scale collages.
WRITINGS: E. A.: España il poi prima. Milan 1973.– E. A.: Trente-cinq ans après. Paris 1974.– E. A.: Panama Al Brown 1902-1951. Paris 1983.– E. A.: Sardines à l'huile. Paris 1989/Sardinen in Öl. Frankfurt-on-Main 1991.– E. A.: Saturne ou le Banquet perpétuel. Paris 1994
CATALOGUE RAISONNE: Rocco, F. di (ed.): E. A. Obra gráfica. IVAM Centro Julio González, Valencia 1989 (cat.)
MONOGRAPHS, CATALOGUES: E. A. 30 Jahre danach – 30 ans après, Frankfurter Kunstverein und Musée d'Art Moderne de la Ville de Paris. Frankfurt u. Paris 1971 (cat.).– E. A. Knock-out 1969-1996. Musée Olympique. Lausanne 1997 (cat.).– E. A. Museo Nacional Centro de Arte Reina Sofía. Madrid 1998 (cat.).– Aillaud, G. et al. (ed.): A. Centre Georges Pompidou. Paris

1982 (cat.).– Astier, P.: A. Paris 1982.– Bozo, D. et al. (ed.): A. Leonard Hutton Gallerie. New York 1983 (cat.).– Dahan-Constant, B. and S. Hiekisch-Picard (ed.): E. A. Theater, Boxen, Figuration, Entwürfe, Bilder und Skulpturen. Museum für Kunst und Kulturgeschichte der Stadt Dortmund. Munich 1987 (cat.).– Serraller, F. C.: Diccionario de ideas recibidas del pintor E. A. Madrid 1991.– Soriano, J. (ed.): E. A. Sala Parpalló Provincial de Valencia. Valencia 1986 (cat.).– Spies, W. et al. (ed.): E. A. Theater – Boxen – Figuration. Museum für Kunst und Kulturgeschichte der Stadt Dortmund. Dortmund 1987 (cat.).– Zweite, A. (ed.): E. A. Blinde Maler und Exil. Bilder aus den Jahren 1970-1979. Städtische Galerie im Lenbachhaus. Munich 1980 (cat.)

## ARTSCHWAGER Richard
born **1924** Washington
American object artist and painter. **1941– 1948** Studied science at Cornell University, Ithaca. Attended the Amédée Ozenfant School in New York. **1953** Manufactured furniture. From **1961** produced his first *Pseudo paintings*, influenced by Johns, Rauschenberg and Di Suvero. Used mainly plastic coatings and fibreboard products for his furniture-like pieces. **1965** First solo-exhibition at Leo Castelli, New York. Prepared painted designs from photographs of interior decorations. From **1968** regular participation in documenta in Kassel (except for documenta 6). A recurring theme in Artschwager's œuvre is the perception of space in sculpture and painting.
CATALOGUE RAISONNE: Brooke, A. (ed.): R. A. Complete Multiples. New York 1991
MONOGRAPHS, CATALOGUES: Ammann, J.-C. (ed.): R. A. Kunsthalle Basel. Basel 1985 (cat.).– Armstrong, R. et al. (ed.): R. A. Themes. Albright-Knox Art Gallery, Buffalo et al. Buffalo 1979 (cat.).– Armstrong, R. (ed.): R. A. Whitney Museum of American Art, New York et al. New York 1988 (cat.).– R. A. Kunsthalle Basel. Basel 1988 (cat.).– Danto, A. C. et al. (ed.): R. A. Fondation Cartier pour l'Art Contemporain. Paris 1994 (cat.).– Blistène, B. (ed.): R. A. Centre Georges Pompidou. Paris 1989 (cat.).– Hentschel, M. (ed.): R. A. Archipelago. Portikus. Frankfurt-on-Main 1993 (cat.).– Kord, C. (ed.): R. A. Beschreibungen, Definitionen, Auslassungen. Hamburger Kunstverein. Hamburg 1978 (cat.)

## ATGET Eugène
**1856** Libourne – **1927** Paris
French photographer. **1875–1877** Sailor. **1879–1881** Studied at the Academy of Drama in Paris. **1881–1896** Toured with a theatre company throughout France. **1896** Began to draw, paint and photograph. In the years **1898–1914** he photographed in the Saint-Séverin district of Paris. **1899** Opened his own studio in Paris und began a long series of photographs of shopkeepers, shop-windows, houses and streets. **1920**

Sold a large portion of his Paris pictures to the Musée des Beaux-Arts. **1924** Continued the Paris series. **1926** Met Berenice Abbott, who later catalogued and published Atget's entire photographic legacy.
CATALOGUE RAISONNE: Szarkowski, J. and M. Morris Hambourg (ed.): The Work of A. 4 vols. New York 1981-1985
MONOGRAPHS, CATALOGUES: Abbott, B.: E. A. Prague 1963.– Abbott, B.: The World of A. New York 1964, 1979.– E. A. Centre National de la Photographie. Paris 1984 (cat.).– Barbin, P. (ed.): Colloque A. Paris 1986.– Borcoman, J.: E. A. 1857-1927. National Gallery of Canada. Ottawa 1984 (cat.).– Buisine, A.: E. A. ou la mélancholie en photographie. Nîmes 1994.– Christ, Y.: Le Paris d'A. Paris 1971.– Honnef, K. (ed.): E. A. Das alte Paris. Rheinisches Landesmuseum, Bonn. Cologne 1978 (cat.).– Leroy, J.: A. Magicien du vieux Paris et son époque. Paris 1976.– MacOrlan, P. (ed.): A. photographe Paris. Paris 1930.– Neal, D. L.: The Sequential Photographs of E. A. Photographer of Paris. Ann Arbor (MI) 1979.– Nesbit, M. (ed.): A.'s Seven Albums. New Haven (CT) 1992.– Nesbit, M. and F. Reynaud: E. A. Intérieurs parisiens. Un album du Musée Carnavalet. Paris 1992.– Recht, C. et al.: E. A. Lichtbilder. Munich 1975.– Reynaud, F.: E. A. Paris 1984

## ATLAN Jean
**1913** Constantine – **1960** Paris
Algerian painter. **1930** Moved to Paris. **1930 –1934** Studied philosophy at the Sorbonne. **1941** First poems and drawings. **1942–1944** Imprisoned for his involvement in the Resistance. **1944** First exhibition at the gallery L'Arc-en-Ciel. Began abstract painting. **1945** First abstract paintings. Participation at the Salon des Surindépendants. His entire exhibited works purchased by Gertrude Stein. His symbolic style, with elements of pre-Columbian and African primitive art, made Atlan an important representative of the Ecole de Paris.
WRITINGS: A.: Le Sang profond. Paris 1944.– A.: Le Sommeil dans l'art. Paris 1959
CATALOGUES RAISONNES: Atlan, D. et al. (ed.): J.-M. A. Catalogue raisonné de l'œuvre complet. Paris 1996.– Woimant, F. (ed.): A. Catalogue raisonné de l'œuvre gravé. Paris 1980

MONOGRAPHS, CATALOGUES: Cousseau, H. C. et al. (ed.): A. Premières periodes 1940-1954. Paris 1989.– Dorival, B.: A. Essai et biographie artistique. Paris 1962.– Fricker, J. (ed.): Rétrospective A. Musée National d'Art Moderne. Paris 1963 (cat.).– Le Breton, G.: A. Paris 1947.– Ragon, M.: L'Architecte et le magicien. Paris 1951.– Ragon, M. and A. Verdet: J. A. Geneva 1960.– Ragon, M.: A. mon ami 1948-1960. Paris 1989.– Verdet, A.: A. Paris 1956.– Woimant, F. (ed.): A. Œuvres des collections publiques françaises. Centre Georges Pompidou. Paris 1980 (cat.)

## AUERBACH Frank
born **1931** Berlin
English painter. **1939** Brought to England to escape the Nazi regime in Germany. **1947** Adopted British nationality. **1948–1952** Studied at St. Martin's School of Art, London and **1952–1955** at the Royal College of Art. **1956** First solo-exhibition at the Beaux-Arts Gallery, London. **1956–1968** Taught at various art schools. **1978** Large retrospective put on by the Arts Council in London. **1986** Received special honours at the Venice Biennale. Recurrent themes in his paintings are rows of houses and parks. He often uses an extreme impasto of dark, earthy colours.
WRITINGS: R. A.: An Autobiography. Munich 1993
CATALOGUE RAISONNE: F. A. The Complete Etchings 1954-1990. Marlborough Graphics. London 1990 (cat.)
MONOGRAPHS, CATALOGUES: Gooding, M. (ed.): F. A. Rijksmuseum Vincent van Gogh. Amsterdam 1989 (cat.).– Hughes, R.: F. A. London 1990, 1992.– Kossoff, L. et al. (ed.): F. A. Retrospective Exhibition. Hayward Gallery, London et al. 1978 (cat.).– Krempel, U. and K.-E. Vester (ed.): F. A. Kunstverein in Hamburg et al. Hamburg 1987 (cat.).– Lampert, C. (ed.): F. A. Paintings and Drawings 1977-1985. British Pavilion XLII. Venice Biennale. London 1986 (cat.).– Mathis, F. J.: F. A.'s Œuvre. Untersuchungen zur Farbgestaltung im kontextuellen Umfeld. Frankfurt-on-Main et al. 1993.– Shanahan, M. (ed.): Evidence 1944-1994. R. A. Whitney Museum of American Art, New York. Munich 1994 (cat.).– Spender, S. (ed.): F. A. Marlborough Gallery. New York 1982 (cat.)

## AYCOCK Alice
born **1946** Harrisburg (PA)
American sculptress. **1964–1968** Studied at Douglas College in New Brunswick, New Jersey, and **1968–1971** at Hunter College in New York under Morris. **1972/73** Taught at Hunter College and **1977–1982** at the School of Visual Arts, New York. **1977** and **1987** participation in documenta 6 and 8 in Kassel. **1980** National Endowment for the Arts Fellowship. **1983** Retrospective of *Projects and Ideas 1972–1983* at the Cologne Kunstverein. **1987** Exhibition at Lenbachhaus, Munich, and participation in docu-

menta 7 in Kassel. Aycock builds huge architectonic pieces of apparatus and machine-like constructions. Her fantastic, nonsensical installations are a parody on modern technology.
WRITINGS: A. A. Labyrinth, Symbol and Meaning in Contemporary Art. Norton (MA) 1975
MONOGRAPHS, CATALOGUES: A. A. Kölnischer Kunstverein. Cologne 1984 (cat.).– Denton, M. (ed.): A. A. After Years of Ruminating on the Events that Led up to this Misfortune. Projects and Proposals 1971-1978. Allentown Art Museum. Allentown (PA) 1978 (cat.).– Friedel, H. (ed.): A. A. Munich Installation the Six of Pentacles. To Know All Manners of Things, Past and Future. Städtische Galerie im Lenbachhaus. Munich 1987 (cat.).– Fry, E. (ed.): A. Y. Projects 1979-1981. Tampa (FL) 1981 (cat.).– Osterwald, T. (ed.): A. A. Retrospektive der Projekte und Ideen 1972-1983. Württembergischer Kunstverein. Stuttgart 1983 (cat.)

## BACON Francis
**1909** Dublin – **1992** Madrid
English painter. **1925** Moved to London. **1926** Spent a year in Berlin. **1927/28** Worked as a decorator in Paris. First drawings and watercolours, inspired by Picasso's paintings. **1928** Returned to London. **1929** Began to paint in oils. **1944** Destroyed almost all his early work and developed a new painting style, independent of contemporary trends in art. **1946** Close friendship with Sutherland. **1946–1950** Spent summer in Monaco. **1952** Trip to North Africa. **1954** British representative (along with Nicholson and Freud) at the Venice Biennale. **1955** First retrospective at the London Institute for Contemporary Arts. **1957** First one-man exhibition in Paris at the Rive Droite Gallery. **1959–1992** Participation in documenta 2, 3, 6 and 9 in Kassel. **1962** Painted his first large triptychon *Three Studies for Figures at the Base of a Crucifixion* and **1964** the triptychon *Three Figures in a Room*. **1967** Refuse the Carnegie Institute Award for Painting at the World Fair in Pittsburgh, and won the Rubens Award in Siegen. **1971** First large American retrospective at the Grand Palais in Paris and **1990** first major retrospective in the Hirshhorn Museum in Washington. Bacon's 'existential' paintings are characterised by an

unusual blend of realism and surrealism, of the figurative and the abstract, subjective experience and universal, supra-personal forms of expression.
WRITINGS: F. B. Entretiens avec M. Archimbaud. Paris 1992 / Conversation with M. Archimbaud. London 1993.– Sylvester, D. (ed.): Interviews with F. B. London and New York 1975, 1980 / Gespräche mit F. B. Munich 1982, 1997 / L'Art de l'impossible. Entretiens avec David Sylvester. Geneva 1976, Paris 1995
CATALOGUE RAISONNE: Alley, R. and J. Rothenstein (ed.): F. B. Catalogue Raisonné. London and New York 1964
MONOGRAPHS, CATALOGUES: Alley, R. (ed.): F. B. Hamburger Kunstverein et al. Hamburg 1965 (cat.).– Ades, D. et al. (ed.): F. B. Tate Gallery, London et al. London and New York 1985 / F. B. Staatsgalerie Stuttgart 1985 (cat.).– Alloway, L. (ed.): F. B. Solomon R. Guggenheim Museum, New York et al. New York 1963 (cat.).– Alphen, E. v.: F. B. and the Loss of Self. London 1992, Cambridge (MA) 1993.– Carlucci, L. (ed.): F. B. Galleria Civica d'Arte Moderna, Torino et al. Torino 1962 (cat.).– Chiappini, R. (ed.): F. B. Museo d'Arte Moderna della Città di Lugano. Milan 1993 (cat.).– Davies, H. M.: F. B. The Early and Middle Years 1928-1958. New York and London 1978.– Davies, H. and S. Yard: F. B. New York 1986, Munich and Lucerne 1986.– Deleuze, G.: F. B. Logique de la sensation. 2 vols. Paris 1981 / F. B. Logik der Sensation. 2 vols. Munich 1995.– Farson, D.: The Gilded Gutter Life of F. B. London 1993 / F. B. Aspects d'une vie. Paris 1994.– Gowing, L. and S. Hunter (ed.): F. B. Hirshhorn Museum and Sculpture Garden, Washington et al. London 1989 (cat.).– Jardine, L.: F. B. Discovery and the Art of Discourse. Cambridge (MA) 1974.– Kundera, M. and F. Borel: B. Portraits and Self-Portraits. London and New York 1997.– Leiris, M. (ed.): F. B. Grand Palais, Paris et al. Paris 1971 (cat.).– Leiris, M.: F. B. Face et profil. Paris 1983 / Full Face and Profile. Oxford and New York 1983 / F. B. Munich 1983.– Leiris, M.: F. B. London and New York 1988.– Monsel, P.: B. 1909-1992. Paris 1994.– Oliva, A. B. (ed.): F. B. Figurabile. Museo Correr, Venice. Milan 1993 (cat.).– Peppiatt, M.: F. B. Anatomy of an Enigma. New York 1996.– Peyré, Y.: L'Espace de l'immédiat, F. B. Paris 1991.– Rothenstein, J. and R. Alley: F. B. London 1964, Paris 1967.– Russell, J.: F. B. London 1971, Paris 1971, Berlin 1971.– Schmied, W.: F. B. Vier Studien zu einem Porträt. Frankfurt-on-Main 1985, Munich 1996.– Sinclair, A.: F. B. His Life and Violent Times. London 1993.– Sylvester, D. et al. (ed.): F. B. 1909-1992. Retrospektive. Centre Georges Pomidou. Paris 1996 / F. B. 1909-1992. Retrospektive. Haus der Kunst, Munich. Stuttgart 1996 (cat.).– Trucchi, L.: F. B. Milan 1975, New York 1975, London 1976.– Whitney, C.: F. B. and Modernity. New Haven (CT) 1995.– Zimmermann, J.: F. B. Kreuzigung. Versuch, eine gewalttätige Wirklichkeit neu zu sehen. Frankfurt-on-Main 1986

**BAERTLING Olle**
**1911** Halmstad – **1981** Stockholm
Swedish painter. **1948** Pupil of Lhote and later Léger. **1949** First solo-exhibition in Stockholm. **1950** Friendship with Herbin. **1950–1956** Member of Réalistes Nouvelles. **1952** Co-founder of the group Espace. **1963** São Paulo Biennale. **1964** *Compositions for Television* for Swedish television; national awards. **1981** Major retrospectives in the Konsthall, Malmö, and in the Moderna Museet, Stockholm. Strongly impressed by the works of Mondrian, Baertling set out to extend the theory of Neo-Plasticism,

without limiting himself to straight lines and rectangles.
CATALOGUE RAISONNE: Joosten J. M. and R. P. Welsh (ed.): P. M. Catalogue raisonné. Antwerp 1997
MONOGRAPHS, CATALOGUES: Brunius, T.: B. Discoverer of Open Form. Uppsala and New York 1965 / B. Précurseur de la forme ouverte. Paris 1968.– Brunius, T.: B. Mannen, verket. Uddevalla 1990.– Claeson, I. and E. Högestätt (ed.): O. B. 1911-1981. Den öppna formens skapare. Malmö Konsthall. Stockholm 1981 (cat.).– Reutersvärd, O.: B. Formelements dramaturg. Stockholm 1976.– Reutersvärd, O. et al. (ed.): O. B. Bilder und Skulpturen. Moderne Galerie Quadrat, Bottrop. Das bildhauerische Werk. Skulpturenmuseum Glaskasten, Marl et al. Bottrop 1983 (cat.).– Rickey, G. et al. (ed.): O. B. Creator of Open Form. Stockholm 1969

**BAJ Enrico**
born **1924** Milan
Italian painter. Studied at the Brera in Milan. **1951** Together with Sergio Dangelo founded the movement Movimento Nucleare, who saw themselves as the successors of Cobra, and developed a style of painting close to L'art informel. **1952** Publication of the *Manifesto della Pittura Nucleare*. **1953** With Jorn, sparked off Le Mouvement International pour une Bauhaus Imaginiste, by proposing ideas for a fantasy-orientated Bauhaus. **1959–1966** Contact with various Surrealist painters. Strongly influenced by Picasso. **1981** Set up his own exhibition centre in Milan. Created a grotesque, naive figures in collages incorporating string, wood and wallpaper.
WRITINGS: E. B.: Baj par Baj. Paris 1980.– E. B.: Automitobiografia. Milan 1983.– E. B.: Cose, fatti, persone. Milan 1988.– Eco, U. (ed.): E. B. Apocalisse. Milan 1979.– Fréchuret, M. (ed.): B., Jorn. Lettres 1953-1961. Saint-Etienne 1989
CATALOGUES RAISONNES: Crispolti, E. and H. Lust (ed.): Catalogo generale Bolaffi dell' opera di E. B. Torino 1973.– Petit, J. (ed.): B. Catalogue de l'œuvre graphique et des multiples. 2 vols. Geneva 1973.– Petit, J. (ed.): B. Catalogo generale delle stampe originali. Milan 1986.– Sanesi, R. (ed.): B. Catalogo generale delle stampe. Milan 1986
MONOGRAPHS, CATALOGUES: Bau-

drillant, J.: E. B. Paris 1980.– Baudrillard, J. et al. (ed.): B. I grandi quadri. Palazzo della Ragione, Mantua. Milan 1982 (cat.).– Baudrillard, J. et al.: E. B. Il giardino delle delizie / The Garden of Delights. Milan 1991.– Bellasi, P. et al. (ed.): E. B. 2 vols. Pinacoteca Communale, Casa Rusca, Locarno. Milan 1993 (cat.).– Jaguer, E.: B. Milan 1956.– John-Willeke, B. (ed.): E. B. "Das Begräbnis des Anarchisten Pinelli" und andere Werke aus vier Jahrzehnten. Mathildenhöhe. Darmstadt 1995 (cat.).– Jouffroy, A.: B. Paris 1972.– Lemaire, G.-G. (ed.): B. Du général au particulier. Centro attività artistiche Perrière, Bard. Milan 1985 (cat.).– Marck, J. v. d.: B. Milan 1969.– Mussini, M. (ed.): I libri di B. Teatro Municipale Romolo Valli, Reggio Emilia. Milan 1990 (cat.).– Sanesi, R.: A proposito B. Lonato 1987

**BALDESSARI John**
born **1931** National City (CA)
American photographer and multimedia artist. **1949–1953** Studied painting at San Diego State College. **1953/54** Director of the Fine Arts Gallery in San Diego. **1955–1968** Taught at various art schools and universities in San Diego, Berkeley, Los Angeles. **1960** First one-man exhibition at the Art Center in La Jolla, California. **1962–1970** Taught at the University of California, San Diego, and at Hunter College, New York. **1972** and **1982** Participation in documenta 5 and 7 in Kassel. From **1980** focused on photography, arranging pictures in multipartite compositions. **1990** Exhibition at the Musée d'Art Contemporain in Lyon and **1992** in Montréal. His alteration of his own photographs, posters and advertising bills, usually by painting over them with simple coloured dots, was meant as a comment on the role of art and artists in society. Regarded as an early exponent of Concept Art in America.
WRITINGS: J. B.: Ingres and Other Parables. London 1972.– J. B.: Four Events and Reactions. Florence 1975.– J. B.: Closs Cropped Tales. Buffalo 1981
MONOGRAPHS, CATALOGUES: J. B. Works 1966-1981. Stedelijk Van Abbe Museum, Eindhoven et al. Eindhoven 1981 (cat.).– J. B. Centre National d'Art Contemporain de Grenoble. Grenoble 1988 (cat.).– Bruggen, C. v. (ed.): J. B. Museum of Contemporary Art, Los Angeles et al. New York 1990 (cat.).– Davies, H. M. and A. Hales (ed.): J. B. National City. Museum of Contemporary Art. San Diego 1997 (cat.).– Drohojowska, H. (ed.): J. B. Santa Barbara Museum of Art. Santa Barbara 1986 (cat.).– Echevarria, G. et al. (ed.): Ni por ésas – J. B. Musée d'Art Contemporain, Bordeaux et al. Bordeaux 1989 (cat.).– Gilbert-Rolfe, J. (ed.): J. B. RMS W VU. Wallpaper, Lampsand Plants. Zurich 1998 (cat.).– Haenlein, C. (ed.): J. B. Photoarbeiten. Kestner-Gesellschaft. Hanover 1988 (cat.).– Melo, A. et al. (ed.): J. B. This Not That. Manchester et al. 1995 (cat.).– Tucker, M. and R. Pincus-Witten (ed.): J. B. New Museum. New York 1981 (cat.)

**BALLA Giacomo**
**1871** Turin – **1958** Rom
Italian painter and interior architect. Attended preparatory courses at the Accademia Albertina di Belle Arti in Turin, otherwise a self-taught painter. **1895** Moved to Rome. Worked as an illustrator, caricaturist and portraitist. **1900** Stayed seven months in Paris for the World Fair, where he encountered Pointillism. Returned to Rome. Met Boccioni, Severini und Sironi, and showed them new painting techniques he had learnt in Paris. **1910** Together with Boccioni, Carrà, Russolo and Severini signed Marinetti's *Manifesto of Futurist Painting* and shortly afterwards the *Technical Manifesto of Futurist Painting*. **1912** Several trips to Düsseldorf to decorate and furnish Haus Löwenstein. **1914/15** Together with Fortunato Depero, drew up the *Manifesto of Futurist Reconstruction of the Universe*. **1916** *Manifesto of Futurist Cinematography* (with Marinetti). **1912–1930** Applied himself intensively to decorative art. Designed furniture and futuristic objects. **1929** One of the initiators of futuristic *Aeropittura*. After **1933** turned away from Futurism and took up figurative painting again. **1935** Elected to the Accademia di San Luca in Rom. Applied Pointillist painting techniques in renderings of dynamism and speed – a favourite subject of the Futurists.
WRITINGS: Balla, E.: Con B. 3 vols. Milan 1984-1986
CATALOGUES RAISONNES: Battaglia, G. and A. M. Gambuzzi (ed.): B. Modena 1982.– Lista, G. (ed.): G. B. 1871-1958. Catalogo ragionato dell'opere. Modena 1982
MONOGRAPHS, CATALOGUES: G. B. Galleria Civica d'Arte Moderna. Torino 1963 (cat.).– G. B. Galleria Nationale d'Arte Moderna. Roma 1971 (cat.).– G. B. Musée d'Art Moderne de la Ville de Paris. Paris 1972 (cat.).– Barricelli, A.: B. Roma 1966.– Crispolti, E. (ed.): Casa B. e il futurismo a Roma. Accademia di Francia a Roma. Roma 1989 (cat.).– Crispolti, E. and M. Scdiero: B. Depero. Ricostruzione futurista dell'universo. Modena and Milan 1989.– Dorazio, V. D.: G. B. An Album of His Life and Work. New York 1970.– Fagiolo dell'Arco, M.: B. pre-futurista. Roma 1968.– Fagiolo dell'Arco, M. (ed.): Futur-Balla. Un profeta dell'avanguardia. A Prophet of the Avant-Garde. Basel et al. 1982.– Fagiolo dell'Arco, M. (ed.): B. The Futurist. Scottish National Gallery of Modern Art, Edinburgh et al. Milan 1987, New York 1988 (cat.).– Lista, G.: B. Futurista. Modena 1982, Lausanne 1984.– Magnato, L. and E. Balla (ed.): G. B. Studi, ricerche, oggetti. Museo di Castelvecchio. Verona 1992 (cat.).– Marchis, G. d.: G. B. L'aura futurista. Torino 1977.– Robinson, S. B.: G. B. Divisionism and Futurism 1871-1912. Ann Arbor (MI) 1981

**BALTHUS**
(Balthazar Klossowski de Rola)
**1908** Paris – **2001** Rossinière (Switzerland)
Polish-born French painter. Spent his youth

in Paris, Berlin and Switzerland. **1920** Met Rainer Maria Rilke, who discovered and promoted his talent. **1921** Rilke published a portfolio entitled *Mitsou* with forty of the boy's engravings and his own preface. **1924** Studied in Paris. **1925** Study trip to Italy with André Gide. After military service in **1933**, made friends with Surrealists, Giacometti and Antonin Artaud. First artistic successes. **1935** Designed sets and costumes for Artaud's "Theatre of Cruelty". **1939–1945** Lived in Switzerland. **1961–1976** Director of the French Academy at the Villa Medici in Rome. **1977** Settled in Switzerland. **1956** Exhibitions at the New York Museum of Modern Art and **1968** at the Tate Gallery, London. **1980** Participated in the Venice Biennale. **1983** Exhibition at the Pompidou Centre in Paris. Since **1981** honorary member of the Royal Academy in London. Through Surrealism, came to adopt a figurative style of painting, which melds poetic and erotic accents with cryptic subjects.
CATALOGUE RAISONNE: Roy, C. and J. Leymarie (ed.): B. Catalogue raisonné. Paris 1991
MONOGRAPHS, CATALOGUES: Caradente, G. (ed.): B. Disegni e acquarelli. Palazzo Racani-Arroni, Spoleto. Milan 1982 /B. Drawings and Watercolors. Boston 1982.– Clair, J.: Metamorphosen des Eros. Essays über B. Munich 1984.– Clair, J. et al. (ed.): B. Peintures, aquarelles, dessins. Roma 1990 (cat.).– Davenport, G.: A B. Notebook. New York 1989.– Klossowski de Rola, S.: B. New York 1996, Paris 1996.– Leymarie, J.: B. Geneva and New York 1978, 1982, Leipzig 1993.– Leymarie, J. and J. Helfenstein (ed.): B. Zeichnungen. Kunstmuseum Bern. Bern 1993 (cat.).– Leymarie, J. et al. (ed.): Omaggio a B. Accademia Valentino, Roma. Geneva 1997 (cat.).– Mentha, H. (ed.): B. Zeichnungen. Kunstmuseum Bern. Bern 1994 (cat.).– Regnier, G. (ed.): B. Centre Georges Pompidou. Paris 1983 (cat.).– Rewald, S. (ed.): B. Metropolitan Museum of Art, New York et al. New York 1984 (cat.).– Roy, C.: B. New York and Boston 1996, Paris 1996, Munich 1996.– Zutter, J. (ed.): B. Musée Cantonal des Beaux-Arts de Lausanne. Geneva 1993 (cat.)

**BAR-AM Micha**
born **1930** Berlin
Israeli photographer. **1945–1948** Active member of the Haganah underground movement. **1948/49** Fought in the infantry in the Israeli war of independence. **1949–1957** Metalworker and youth leader on a kibbutz in West Galilee. **1957–1966** Worked as a photojournalist for the magazine *Bamahane* in Israel, and freelanced for various Israeli newspapers for a year. Since **1968** photographic correspondent in the Middle East for the *New York Times* and member of *Magnum Photos* in Paris and New York. Bar-Am is credited with having increased worldwide public awareness of Israel's political conflicts and cultural inconsistencies through his photography.

**BARANOV-ROSSINE Vladimir**
**1888** Cherson (Ukraine) – **1942** (during deportation)
Russian sculptor and painter. **1903–1907** Studied painting at the Academy of Art in St. Petersburg. Contact with Larionov and the Burliuk brothers. **1910–1914** Went to Paris. Met Delaunay and the Cubists. First sculptural works. From **1913** participated regularly in the Salon des Indépendants. **1915** Inspired by Futurism to produce *Piano Optophonique*, an attempt to fuse colours, musical notes and sculptural elements so they could be experienced simultaneously. **1917** Returned to Russia. Professorship at the Academy of Art in Moscow. **1925** Settled in Paris and founded an institute of painting and audiovisual sychronisation. Transition from painting to object art, of which he became a leading exponent.
CATALOGUE RAISONNE: Breuillaud-Limondin, P. and M. J. Mausset (ed.): B.-R. Diss. Paris 1980
MONOGRAPHS, CATALOGUES: V. B.-R. Galerie Jean Chauvelin. Paris 1970 (cat.).– V. B.-R. Musée National d'Art Moderne. Paris 1973 (cat.).– Marcadé, J.-C. (ed.): V. B.-R. Galerie Brusberg. Berlin 1983 (cat.)

**BARCELO Miquel**
born **1957** Felanitx (Mallorca)
Spanish painter and material artist. **1972** Studied at the Escuela de Artes y Oficios in Palma. Encountered Art brut in Paris. **1975** Studied at the Escuela de Bellas Artes in Barcelona. Designed wooden boxes and laid various objects inside them. **1976** First one-man exhibition at the Museo de Mallorca. Joined a group of concept artists known as Taller Lunàtic. **1980** Produced abstract drip-paintings, later painted over in white. Painted books and telephone directories with thick coats of paint, made iron books, and did some figurative animal drawings. Moved to Barcelona. **1982** Took part in documenta 7 in Kassel. Met Beuys and Lucio Amelio. **1983** First sculptures. **1988–1991** Trips to Africa. Explored the river Niger in his self-constructed 'painter's boat'. **1994** Stayed in Mali. Presentation of naturally produced reliefs, such as strips of paper devoured by termites.
MONOGRAPHS, CATALOGUES: M. B. Pinturas 1984. Galerie Juana de Aizpuru. Madrid 1984 (cat.).– M. B. Galeria Soledad

Lorenzo. Madrid 1989 (cat.).– M. B. Musée de Nîmes. Nîmes 1991 (cat.).– Froment, J.-L. (ed.): M. B. Peintures 1983-1985. Musée d'Art Contemporain de Bordeaux. Bordeaux 1985 (cat.).– Lampert, C. (ed.): M. B. Whitechappel Art Gallery. London 1994 (cat.)

**BARLACH Ernst**
**1970** Wedel – **1938** Rostock
German sculptor, graphic artist and poet. **1888–1891** Studied at the School of Arts and Crafts in Hamburg. **1891–1895** Attended the Academy in Dresden as a pupil of Robert Diez. **1895–1897** Lived in Paris, working at the Académie Julian. **1904/05** Professorship at the School of Ceramics in Höhr. **1907/08** First major wooden sculpture. **1909** Trip to Russia. Inspired by the wholesome earthiness of the farming communities and by Russian folk art, developed a form of sculpture with powerful folkloristic elements. Also produced several sets of engravings to illustrate plays he had written. After **1910** settled in Güstrow, Mecklenburg. **1917** First exhibition put on by Paul Cassirer in Berlin. **1919** Member of the Academy of Arts in Berlin. **1933** Awarded the order of merit *Pour le mérite*. Discredited by the Nazis. Systematic removal of his works from museums, churches and public places. Alongside Zadkine, the most important wood sculptor of the classical Modernist period.
WRITINGS: E. B. Ein selbsterzähltes Leben. Berlin 1928/A Selfold Life. Toronto 1990.– E. B.: Briefe. 2 vols. Ed. by F. Droß. Munich 1968-1969.– E. B.: Dramen. 8 vols. Ed. by H. H. Fischer. Munich and Zurich 1987-1988.– Droß, F. (ed.): E. B. Das dichterische Werk. 3 vols. Munich 1956-1959
CATALOGUE RAISONNE: Schult, F. (ed.): E. B. Werkverzeichnis. 3 vols. Hamburg 1958-1971
MONOGRAPHS, CATALOGUES: E. B. 1870-1938. Koninklijk Museum voor Schone Kunsten, Antwerp. Leipzig 1995 (cat.).– Carls, C. D.: E. B. Das plastische, graphische und dichterische Werk. Berlin 1968.– Carls, C. D.: E. B. New York 1968.– Chick, E.: E. B. New York 1967.– Crepon, T.: Leben und Leiden des E. B. Rostock 1988.– Doppelstein, J. (ed.): E. B. Bildhauer, Zeichner, Graphiker, Schriftsteller 1870-1938. Antwerp 1994 (cat.).– Doppelstein, J.: B. und Goethe. Leipzig 1997.– Flemming, W.: E. B. Wesen und Werk. Bern 1959.– Franck, H.: E. B. Leben und Werk. Stuttgart 1961.– Groves, N. J.: E. B. Life in Work. Toronto 1982.– Hooper, K.: E. B.'s Literary and Visual Art. The Issue of Multiple Talent.– Hupp, K.: Der Kieler Geistkämpfer von E. B. Kiel 1989.– Jansen, E. (ed.): E. B. Werk und Wirkung. Frankfurt-on-Main 1972.– Jansen, E.: E. B. Werke und Werkentwürfe aus drei Jahrzehnten. 3 vols. Altes Museum. Berlin 1981 (cat.).– Jansen, E. (ed.): E. B. Werke, Meinungen. Wiener Künstlerhaus. Vienna 1984 (cat.).– Jentsch, R. (ed.): E. B. Museum Villa Stuck. Munich 1981 (cat.).– Kleberger,

I.: E. B. Der Wanderer im Wind. Munich 1986.– Knobling, H.: Studien zum zeichnerischen Werk Ernst Barlachs 1892-1912. Worms 1989.– Krahmer, C.: E. B. in Selbstzeugnissen und Bilddokumenten. Reinbek 1984.– Krahmer, C. (ed.): E. B. Un sculpteur-écrivain. Musée d'Orsay. Paris 1988 (cat.).– Kurth, W.: E. B. Berlin 1989.– Lautz-Oppermann, G.: E. B. der Illustrator. Wolfshagen-Scharbeutz 1952.– Piper, E.: E. B. und die nationalsozialistische Kunstpolitik. Munich 1983.– Schilling, J. (ed.): E. B. Plastik, Zeichnung, Druckgraphik 1906-1937. Schloß Cappenberg. Unna 1988 (cat.).– Schulz, I. (ed.): E. B. Denkzeichen. Kulturhistorisches Museum, Rostock et al. Rostock 1988 (cat.).– Schurek, P.: B. Eine Bildbiographie. Munich 1961.– Stubbe, W.: E. B. Plastik. Munich 1959, 1985.– Werner, A.: E. B. New York 1966

**BASELITZ Georg**
(Georg Kern)
born **1938** Deutschbaselitz (Saxony)
German painter and sculptor. From **1956** studied at the School of Fine and Applied Arts in East Berlin under Walter Womacka. Met Peter Graf und Ralf Winkler (A. R. Penck). **1957–1962** Further classes in painting under Hann Trier at the School of Arts in West Berlin. **1961** Adopted the pseudonym Baselitz. Inspired by Breton's Surrealist manifestos, wrote his own manifestos to accompany his action pictures: *The Night of Pandemonium* (**1962**) and *Why the Picture 'Great Friends' is a Good Picture* (**1966**). First strictly representational pictures directed against Tachisme and abstract art. **1966** Moved to Osthofen near Worms. First woodcuts. **1969** Began painting upside-down portraits and landscapes. **1965** Scholarship to the Villa Romana in Florence. **1978** Took a studio in Imparia. **1978** Professorship at the Academy of Arts in Karlsruhe. **1979** First roughly hewn wood sculptures. **1980** Together with Kiefer, represented Germany at the Venice Biennale. Taught from **1983–1988** and again from **1992** at the Berlin Academy. **1995** Major retrospective at the Guggenheim Museum, New York.
WRITINGS: G. B. im Gespräch mit H. P. Schwerfel. Cologne 1989.– G. B.: Ballsaison in Schweden. Briefe zwischen Strindberg und Hill. Derneburg 1992.– G. B. Manifeste 1961-1985. Paris 1989.– Werner, M. (ed.): G. B. Malelade. Cologne 1990
CATALOGUES RAISONNES: Gallwitz, K. (ed.): G. B. Der Weg der Erfindungen. Werkverzeichnis der frühen Zeichnungen, Bilder und der Skulpturen 1979-1988. Städtische Galerie im Städel. Frankfurt-on-Main 1988 (cat.).– Gohr, S. et al. (ed.): Pastelle 1985-1990. Bern 1990.– Haenlein, C. (ed.): G. B. Skulpturen und Zeichnungen 1979-1987. Werkverzeichnis der Skulpturen und der Zeichnungen zu den Skulpturen. Kestner-Gesellschaft. Hanover 1987 (cat.).– Jahn, F. and J. Gachnang (ed.): B. Peintre-Graveur. Werkverzeichnis der Druckgraphik 1963-1982. 2 vols. Bern and

Berlin 1983-1987.– Salzmann, S. (ed.): G. B. Das Motiv. Bilder und Zeichnungen 1987-1988. Werkverzeichnis der Aquarelle. Kunsthalle Bremen. Bremen 1988 (cat.).– Weisner, U. (ed.): B. Holzschnitte 1966-1989. Stuttgart 1991
MONOGRAPHS, CATALOGUES: G. B. Grabados, Gravures, Prints. Musée d'Art et d'Histoire, Geneva et al. Geneva 1991 (cat.).– Laffon, J. et al. (ed.): G. B. Musée d'Art Moderne de la Ville de Paris. Paris 1996 (cat.).– Franzke, A.: G. B. Munich 1988.– Gallwitz, K. (ed.): G. B. Der Weg der Erfindung. Städtische Galerie im Städel. Frankfurt-on-Main 1988 (cat.).– Gercken, G. et al. (ed.): G. B. Skulpturen. Hamburger Kunsthalle. Stuttgart 1994 (cat.).– Gohr, S. (ed.): G. B. Retrospektive 1964-1991. Kunsthalle der Hypo-Kulturstiftung, Munich et al. Munich 1992 (cat.).– Gohr, S.: Über B. Aufsätze und Gespräche 1976-1996. Cologne 1996.– Grigoteit, A. et al. (ed.): G. B. aus der Sammlung der Deutschen Bank. Moscow et al. Frankfurt-on-Main 1997 (cat.).– Güse, E.-E. (ed.): B. Werke 1981-1993. Saarland Museum, Saarbrücken. Stuttgart 1994 (cat.).– Haenlein, C. (ed.): G. B. Skulpturen und Zeichnungen 1979-1987. Kestner-Gesellschaft. Hanover 1987 (cat.).– Hofmann, W. (ed.): G. B. Bilder 1965-1987. Hamburger Kunsthalle. Hamburg 1988 (cat.).– Honisch, D. et al. (ed.): G. B. Staatliche Museen zu Berlin. Stuttgart 1996 (cat.).– Jablonka, R.: Ruins. Strategies of Destruction in the Fracture of G. B. 1966-1969. London 1982.– Koepplin, D. and R. Fuchs (ed.): G. B. Zeichnungen 1958-1983. Kunstmuseum Basel et al. Basel 1984 (cat.).– Meyer zu Eissen, A. et al. (ed.): G. B. Das Motiv. Kunsthalle Bremen. Bremen 1988 (cat.).– Muthesius, A. (ed.): G. B. Cologne 1990.– Quinn, E.: G. B. Eine fotografische Studie. Bern 1993.– Serrota, N. and M. Francis (ed.): G. B. Paintings 1960-1983. Whitechappel Art Gallery, London et al. London 1983 (cat.).– Szeemann, H. et al. (ed.): G. B. Kunsthaus Zurich et al. Zurich 1990 (cat.).– Waldman, D. (ed.): G. B. Solomon R. Guggenheim Museum, New York et al. New York 1995 (cat.).– Wedewer, R. and F. Jahn (ed.): G. B. Radierungen 1963-1974, Holzschnitte 1966-1967. Schloß Morsbroich, Städtisches Museum. Leverkusen 1974 (cat.).– Weisner, U. (ed.): G. B. Vier Wände. Kunsthalle Bielefeld. Bielefeld 1985 (cat.)

**BASQUIAT Jean-Michel**
1960 Brooklyn (NY) – 1988 New York
Graffiti artist. His father was a Haitian book keeper and his mother Puerto Rican. Had a difficult childhood. Aged 17, joined his friend Al Diaz painting graffiti in subway stations and on house-fronts under the assumed name of Samo. Jobbed and played guitar and synthesizer in a band. Became a media star after taking part in the documenta 7 in Kassel 1982 and the Whitney Biennale in New York 1983. Worked with Warhol, even painting each other's portraits. Basquiat turned graffiti

into a respected art form without denying his Brooklyn ghetto origins. Constructed assemblages from bits of rubbish. Painted on surfaces ranging from torn pieces of paper to a fridge door. Died from an overdose of drugs.
WRITINGS: J.-M. B.: Amateur Bout. New York 1989.– Warsh, L. (ed.): J.-M. B. The Notebook. New York 1993
MONOGRAPHS, CATALOGUES: Adès, M. C. (ed.): J.-M. B. Peinture, dessins, écriture. Paris 1993 (cat.).– Baghoomian, V.: J.-M. B. New York 1989.– J.-M. B. Drawings. Robert Miller Gallery. New York 1990 (cat.).– J.-M. B. Fondation Dina Vierny. Musée Maillol. Paris 1997 (cat.).– J.-M. B. King for a Decade. New York 1997.– Chemin, J. (ed.): J.-M. B. Drawings. New York 1990.– Enrici, M.: J.-M. B. Paris 1989.– Haenlein, C. (ed.): J.-M. B. Kestner-Gesellschaft. Hanover 1986 (cat.).– Haenlein, C. (ed.): J.-M. B. Das zeichnerische Werk. Kestner-Gesellschaft. Hanover 1989 (cat.).– Hebdige, D.: J.-M. B. New York 1992.– Marshall, R. (ed.): J.-M. B. Whitney Museum of American Art, New York et al. New York 1992 (cat.).– Marshall, R. (ed.): J.-M. B. Museo de Bellas Artes. Malaga 1996 (cat.).– Michetti-Prod'hom, C. and A. B. Edelman (ed.): J.-M. B. Musée d'Art Contemporain. Lausanne 1993 (cat.).– Millet, B. et al. (ed.): J.-M. B. Une rétrospective. Musée Cantini. Marseille 1992 (cat.).– Navarra, E. et al. (ed.): J.-M. B. 2 vols. Galerie Enrico Navarra. Paris 1996 (cat.).– Vierny, D. et al. (ed.): J.-M. B. Works on Paper. Galerie Enrico Navarra. Paris 1997

**BAUCHANT André**
1873 Chateaurenault (near Tours) – 1958 Montoire (Loir-et-Cher)
French painter. Apprenticed to a gardener. 1917 Worked as a surveyor. Did not turn to painting until the age of 46. Painted numerous landscapes with historical features and scenes from nature, such as gardens and birds, in a naive, poetic style. 1920 Discovered and promoted by Ozenfant and Le Corbusier. 1921 Exhibited 16 works in the Salon d'Automne. From 1927 exhibitions in the Jeanne Bucher gallery in Paris. 1928 Designed the stage set for Sergei Diaghilev's production of Igor Stravinsky's ballet *Apollon Musagète*. 1937 Exhibited together with Henri Rousseau, Camille Bombois and Louis Vivin in "Popular Masters of Reality" in Paris, Munich and New York. Alongside his painting, continued to work as a professional gardener and builder.
MONOGRAPHS, CATALOGUES: A. B. 1873-1958 Rétrospective. Musée des Beaux-Arts. Tours 1960 (cat.).– A. B. G. A. Musée d'Art Moderne et d'Art Contemporain. Nice 1987 (cat.).– A. B. Peintures, Dessins 1915-1958. Musée des Beaux-Arts. Tours 1991 (cat.).– Gauthier, M.: A. B. Paris 1942.– Killer, P.: A. B. Zurich 1991.– Zander, L. (ed.): A. B. Retrospektive. Galerie Charlotte. Munich 1993 (cat.)

**BAUMEISTER Willi**
1889 Stuttgart – 1955 Stuttgart
German painter. 1905-1907 Apprenticeship in his uncle's decorating business. From 1908 attended the Stuttgart Academy and from 1909 studied composition with Schlemmer under Hoelzl. 1914 Travelled to Holland and France with Schlemmer. 1914-1918 Military service. 1919 Returned to Stuttgart. Co-founder of Üecht, a group of Stuttgart artists. Early figurative works influenced by the Cubists were superseded by his wall pictures. 1924 Met Ozenfant, Le Corbusier and Léger in Paris. 1927 Became a member of the Circle of New Promotional Designers. 1928 Taught commercial art, typography and textile printing at the Städel Art School in Frankfurt am Main. 1930 Joined Cercle et Carré and, in 1932 Abstraction-Création. 1933 Denounced, professionally banned as a "degenerate" artist and dismissed from his post. Works painted secretly in Stuttgart became increasingly removed from the representational. 1939-1944 Worked as a painting instructor for the paint manufacturer Kurt Herbert in Wuppertal. 1941 Exhibition of his works forbidden. 1943-1947 Wrote the theoretical work *The Unknown in Art*. 1946-1955 Appointed Professor of Painting at the Stuttgart Academy. 1948 First German artist to exhibit at the Salon des Réalistes Nouvelles. 1951 Won major award at the São Paulo Biennale. After 1951 participated three times at the Venice Biennale.
WRITINGS: W. B.: Das Unbekannte in der Kunst. Stuttgart 1947, Cologne 1968.– W. B.: Magie der Form. Baden-Baden 1954
CATALOGUES RAISONNÉS: Gauss, U. et al. (ed.): W. B. Gemälde, Serigraphien, Zeichnungen, Gouachen, Collagen. 3 vols. Staatsgalerie Stuttgart. Stuttgart 1989.– Grohmann, W.: W. B. Leben und Werk. Cologne 1963 / W. B. Life and Work New York 1966, London 1985.– Ponert, D. J. (ed.): W. B. Werkverzeichnis der Zeichnungen, Gouachen und Collagen. Cologne 1988.– Spielmann, H.: W. B. Das graphische Werk. 2 vols. Hamburg 1972
MONOGRAPHS, CATALOGUES: Adriani, G. (ed.): B. Dokumente, Texte, Gemälde. Kunsthalle Tübingen. Cologne 1971 (cat.).– Boehm, G. et al.: W. B. Der Maler. Stuttgart 1995.– Bott, G.: Figuration und Bildformat. Zur Auflösung des Bildbegriffs in der Malerei W. B.'s. Frankfurt-on-Main et al. 1990.– Chametzky, P.: Autonomy and Authority in German Twentieth-Century Art. The Art and Career of W. B. New York 1991.– Hirner-Schüssek, R.: Von der Anschauung zur Formerfindung. Studien zu W. B.'s Theorie moderner Kunst. Worms 1990.– Kermer, W. (ed.): W. B. Typographie und Reklamegestaltung. Staatliche Akademie der Bildenden Künste. Stuttgart 1989 (cat.).– Kermer, W.: Der schöpferische Winkel. W. B.'s pädagogische Tätigkeit. Stuttgart 1992.– Roh, F.: W. B. Magie der Form. Baden-Baden 1954.– Schneider, A. (ed.): W. B. Gemälde. Nationalgalerie Berlin. Stuttgart 1989 (cat.).– Semff, M. (ed.): W. B. Zeichnungen. Kupferstichkabinett Dresden et al. Dresden 1996 (cat.)

**BAZAINE Jean**
1904 Paris – 2001 Paris
French painter. 1922-1925 Studied sculpture and literature at the Ecole des Beaux-Arts in Paris. 1924 Studied painting at the Lanskoy Academy. Exhibited regularly at the Tuileries from 1930 and at the Salon d'Automne from 1931 onwards. 1941 Organised the exhibition "Young Painters of the French Tradition" at the Braun gallery in Paris. Designed windows for churches at Assy 1944-1946 and Audincourt 1948-1951, and later in his years. 1953/54 Trip to Spain. 1955-1964 Participation in documenta 1-3 in Kassel. 1959 One-man exhibitions in Bern, Eindhoven and Amsterdam, and 1965 at the Musée d'Art Moderne de la Ville de Paris. His non-figurative painting made him one of the most important representatives of the Ecole de Paris. His abstract representations of nature are made up of rhythmically composed colour patterns with intense lighting effects.
WRITINGS: J. B.: Notes sur la peinture d'aujourd'hui. Paris 1947 / Notizen zur Malerei der Gegenwart. Frankfurt-on-Main 1959.– J. B.: Exercice de la peinture. Paris 1973.– J. B.: Le Temps de la peinture. Paris 1990
MONOGRAPHS, CATALOGUES: J. B. and J.-C. Schneider: Habiter la lumière. Regards sur la peinture de J. B. Montolieu 1994.– Begny, J. d. and J.-Luc Daval (ed.): B. Grand Palais. Paris. Geneva 1990 (cat.).– Cabanne, P. et al.: J. B. Geneva and Paris 1990.– Chessex, J. et al. (ed.): B. Fribourg. Geneva 1996 (cat.).– Greff, J.-P. and J.-C. Schneider (ed.): B. Galerie Adrien Maeght. Paris 1987 (cat.).– Greff, J.-P.: J. B. Dessins 1931-1988. Musée Matisse. Le Cateau-Cambrésis 1988 (cat.).– Prat, J.-L. et al. (ed.): B. Rétrospective. Fondation Maeght. Saint-Paul 1987 (cat.).– Tardieu, J. et al.: B. Paris 1975

**BAZIOTES William**
1912 Pittsburgh (PA) – 1963 New York
American painter. 1933-1936 Studied at the National Academy of Design, New York. Painted in a naturalistic style. 1938-1941 Involved, as a teacher, in the Works Progress Administration Federal Art Project. Began abstract painting. 1942 Took part in an exhibition of leading Surrealists in New York. 1944 First solo-exhibition in Peggy

Guggenheim's gallery entitled "Art of this Century". **1948** Together with Rothko, Motherwell and Newman founded the school of painting *Subjects of the Artist*, which laid the cornerstone for Abstract Expressionism in America. **1949–1952** Taught at the Museum Art School in Brooklyn and at the People's Art Center of the Museum of Modern Art, New York. From **1952** professorship at Hunter College, New York. **1955/56** Took part in the exhibition "The New American Painting" organized by the Museum of Modern Art that was taken to Europe in **1958/59**. **1959** Participation in documenta 2 in Kassel. In his paintings, displaying Surrealist influences, Baziotes attempts to portray the diversity and ambiguity of the unconscious in an extremely sparse pictorial language.
MONOGRAPHS, CATALOGUES: Alloway, I. (ed.): W. B. A Memorial Exhibition. Solomon R. Guggenheim Museum. New York 1965 (cat.).– W. B. Late Works 1946-1962. Marlborough Gallery. New York 1971 (cat.).– Cavaliere, B. and M. Hadler (ed.): B. A Retrospective Exhibition. Newport Harbor Art Museum. Newport Beach 1978 (cat.)

**BEATON Cecil**
**1904** London – **1980** Broadchalke
English photographer. **1922** Developed his skills as a photographer and painter. **1922–1925** Studied history and architecture at St. John's College, Cambridge. **1925** Numerous self-portraits. **1926–1930** Fashion photographs and portraits of the Royal Family, Winston Churchill and Marlene Dietrich, among others; **1928–1950** for *Vogue* and later for *Harper's Bazaar*. From **1938** Court Photographer to the British Royal Family. **1939–1944** Worked for the British Ministry of Information. From **1951** worked in Hollywood and London as a film designer. Designed stage sets and costumes for the theatre. **1957** and **1965** Awarded Oscars. **1957** Wrote a version of *My Fair Lady*. **1974** Suffered a stroke. From **1978** took up portrait and fashion photography again.
MONOGRAPHS, CATALOGUES: Danziger, J.: B. New York 1980.– Mellor, D. (ed.): C. B. London 1986, Torino et al. Florence 1986.– Mellor, D. and P. Garner (ed.): C. B. Boston 1975.– Mellor, D. and P. Garner (ed.): C. B. Photographien 1920-1970. Munich 1994.– Sagne, J.: C. B. Paris 1984.– Spencer, C.: C. B. Stage and Film Designs. London 1977.– Vickers, H.: C. B. A Biography. Boston 1985

**BECHER Bernd and Hilla**
born **1931** Siegen (Bernd Becher)
born **1934** Potsdam (Hilla Becher)
German photographers. Bernd Becher studied painting at the Stuttgart Academy. Since **1956** has worked as a photographer. **1957** First photographs of industrial buildings. Hilla Becher trained as a photographer and first worked in advertising. **1958–1961** Studied together at the Düsseldorf

Academy. Set up a department of photography. From **1959** worked together on a systematic photographic register of industrial buildings of the 19th and 20th centuries, applying strict structural criteria. **1959–1963** Photographic inventories of industrial plants around Siegen. **1961** Married. **1963** Photographs of mines and cement and lime works. Photographic projects throughout Europe (Belgium, France, Wales and England). **1966** British Council grant. **1968** Took a series of photographs in the USA. **1972/73** Both taught at the Hamburg Academy. **1972–1982** Participation in documenta 5 and 7 in Kassel. **1976** Professorship for Bernd Becher at the Düsseldorf Academy. **1992** Sculpture prize at the Venice Biennale.
WRITINGS: B. and H. B.: Anonyme Skulpturen. Eine Typologie technischer Bauten. Düsseldorf 1969
MONOGRAPHS, CATALOGUES: Adriani, G. (ed.): B. und H. B. Typologien industrieller Bauten 1963-1975. XXIV. Bienal internacional de São Paulo 1977. Stuttgart 1977 (cat.).– Banham, R. (ed.): B. und H. B. Wassertürme. Munich 1988.– B. and H. B. Chevalements. Centre Georges Pompidou. Paris 1985 (cat.).– Bußmann, K. (ed.): B. & H. B. Tipologie. XLIV Esposizione Internazionale d'Arte, La Biennale di Venezia 1990. Munich 1990 (cat.).– Fabrikhallen: B. und H. B. Typologien. Westfälisches Landesmuseum, Münster. Munich 1994 (cat.).– Felix, Z. (ed.): B. und H. B. Fördertürme. Museum Folkwang, Essen et al. Munich 1985 (cat.).– Finkeldey, B. and M. Müller (ed.): Aus der Distanz. Photographien von B. und H. B. Kunstsammlung Nordrhein-Westfalen. Düsseldorf 1991 (cat.).– Fuchs, R. and B. Kerber (ed.): B. and H. B. Stedelijk Van Abbe Museum. Eindhoven 1981 (cat.).– Honnef, K. (ed.): B. und H. B. Fotografien 1957-1975. Rheinisches Landesmuseum, Bonn et al. Cologne 1975 (cat.).– Lange, S. (ed.): B. und H. B. Häuser und Hallen. Frankfurt-on-Main 1992.– Morris, L. (ed.): B. and H. B. Institute of Contemporary Arts, London et al. London 1974 (cat.).– Steinhauser, M. and K.-U. Hemken (ed.): B. und H. B. Industriephotographie im Spiegel der Tradtion. Bochum 1994 (cat.)

**BECKMANN Max**
**1884** Leipzig – **1950** New York
German painter, graphic artist and sculptor. **1894** Death of his father. Family moved to Braunschweig. **1899–1903** Studied at the Weimar Academy. **1903** Long stay in Paris. **1904** Settled in Berlin. **1906** Took part in exhibition of the Berlin Secession. Awarded a six-month scholarship to the Villa Romana in Florence. Married Minna Tube. **1907** Returned to Berlin. **1907–1913** Joined the Berlin Secession, becoming a leading member in **1910**. **1911** Resigned from the Secession. **1914** Military service. **1915** Discharged after a nervous breakdown. Moved to Frankfurt am Main. **1925** Taught at the Städel Art School. Took part in the exhibi-

tion "Neue Sachlichkeit" (New Objectivity) at the Kunsthalle, Mannheim. **1929** Professor of Painting at the Städel School. **1929–1932** Lived for months at a time in Paris in a rented apartment. **1933** Dismissal. Moved back to Berlin. **1937** Ten paintings included in the exhibition of "Degenerate Art", and 590 works confiscated from German museums. Emigrated to Holland, living in Amsterdam. **1947** Moved to the United States. Taught at Washington University Art School in St. Louis. **1949** Professorship at Brooklyn Museum Art School in New York. **1950** Conte-Volpi Award at the Venice Biennale. Honorary doctorate from Washington University, St. Louis. Beckmann is important as a figurative painter working within the framework of classical Modernism.
WRITINGS: Göpel, E. (ed.): M. B. Tagebücher 1940-1950. Munich and Zurich 1984.– Kinkel, H. (ed.): M. B. Leben in Berlin. Tagebuch 1908-1909. Munich and Zurich 1984.– Schmidt, D. (ed.): M. B. Frühe Tagebücher 1903/04 und 1912/13. Munich and Zurich 1985.– Schneede, U. M. et al. (ed.): Max Beckmann. Briefe. 3 vols. Munich and Zurich 1993-1996
CATALOGUES RAISONNES: Göpel, E. and B. (ed.): M. B. Katalog der Gemälde. 2 vols. Bern 1976.– Hofmaier, J.: M. B. Catalogue Raisonné of His Prints. 2 vols. Bern 1990.– Weisner, U. and K. Gallwitz: M. B. Aquarelle und Zeichnungen. Bielefeld 1977.– Wiese, S. v.: M. B.'s zeichnerisches Werk 1903-1925. Düsseldorf 1978
MONOGRAPHS, CATALOGUES: Beckmann, M. Q.: Mein Leben mit M. B. Munich 1983.– Beckmann, P. and J. Schaffer (ed.): Die Bibliothek M. B.'s. Unterstreichungen, Kommentare, Notizen und Skizzen in seinen Büchern. Worms 1992.– Belting, H.: M. B. die Tradition als Problem in der Kunst der Moderne. Munich 1984.– Billeter, F. et al.: M. B. Bibliographie 1971-1993. Munich 1994.– Buchheim, L.-G.: M. B. Feldafing 1959.– Busch, G.: M. B. Eine Einführung. Munich 1989.– Erpel, F.: M. B. Leben im Werk. Munich 1985.– Fischer, F. W.: Der Maler M. B. Cologne 1990.– Gallwitz, K. (ed.): M. B. Frankfurt 1915-1933. Städtische Galerie im Städel. Frankfurt-on-Main 1983 (cat.).– Gallwitz, K. (ed.): M. B. Gemälde 1905-1950. Museum der Bildenden Künste, Leipzig et al. Stuttgart 1990 (cat.).– Gärtner, P. J.: M. B. Der Traum von der Imagination des Raumes. Weimar 1996.– Gerkens, G. (ed.): M. B. Seine Themen, seine Zeit. Kunsthalle Bremen. Bremen 1984 (cat.).– Göpel, B. and E. (ed.): M. B. Berichte eines Augenzeugen. Frankfurt-on-Main 1984.– Hüneke, A. (ed.): M.-B.-Colloquium 1984. Berlin 1985.– Joachim, H. and P. T. Rathbone (ed.): M. B. Museum of Fine Arts, Boston et al. New York 1980.– Lackner, S.: M. B. Cologne 1979, 1991.– Nobis, N. (ed.): M. B. Kunstmuseum Hannover. Hanover 1983 (cat.).– Peter, H.: M. B. Landschaften der Zwanziger Jahre. Frankfurt-on-Main et al. 1993.– Pillep, R.: M. B. Leben und Werk. Neue Forschungen. Halle 1993.– Reinartz,

S.: M. B. Reinbek 1995.– Rother, S.: M. B. als Landschaftsmaler. Munich 1990.– Schneede, U. M. (ed.): Stadtmuseum: Der Zeichner und Grafiker M. B. Hamburger Kunstverein. Berlin 1980 (cat.).– Schneede, U. M. (ed.): M. B. Selbstbildnisse. Hamburger Kunsthalle et al. Stuttgart 1993 (cat.).– Schulz-Hoffmann, C. and J. C. Weis (ed.): M. B. Retrospektive. Haus der Kunst, Munich et al. Munich 1984 (cat.).– Schulz-Hoffmann, C. and J. C. Weis (ed.): M. B. Retrospective. Saint Louis Art Museum. Saint Louis 1984 (cat.).– Schulz-Hoffmann, C.: M. B. Der Maler. Munich 1991.– Schütz, H. G.: Sphinx B. Exemplarische Annäherung an M. B. Munich 1997.– Selz, P.: M. B. The Self-Portraits. New York 1992.– Spieler, R.: M. B. 1884-1950. The Path to Myth. Cologne 1995

**BELLING Rudolf**
**1886** Berlin – **1972** Krailling (near Munich)
German sculptor. **1905–1907** Apprenticeship as modeller in industrial arts. **1908** Opened a workshop for small sculptures with Emil Kasalov. Commissions from the Max-Reinhardt Theatre. **1911** Attended Peter Breuer's class at the Berlin Academy. Strong Cubist influence. **1918** Founded the Novembergruppe with Mies van der Rohe and Pechstein. Held joint-exhibitions. Worked on the sculpture *Dreiklang*. **1920** First one-man exhibition at the Gurlitt gallery in Berlin. In later years, numerous commissions for public buildings and spaces. **1924** Solo-exhibition at the Nationalgalerie, Berlin. Sold *Dreiklang*. **1937** Denounced by the Nazis. Emigrated to Turkey and taught at the Art Academy and University of Technology in Istanbul. **1966** Returned to Germany.
CATALOGUES RAISONNES: Hoffmann, D. (ed.): R. B. Plastiken, Zeichnungen, Lithographien. Mit einem Werkverzeichnis des plastischen Werkes. Munich 1967 (cat.).– Nerdinger, W. (ed.): R. B. und die Kunstströmungen in Berlin 1918-1923. Mit einem Katalog der plastischen Werke. Berlin 1981
MONOGRAPHS, CATALOGUES: Killy, H. E. (ed.): R. B. Akademie der Künste. Berlin 1962 (cat.).– Schmoll gen. Eisenwerth, J. A.: R. B. St. Gallen 1971

**BELLMER Hans**
**1902** Kattowitz – **1975** Paris
German painter, graphic artist and sculptor. **1924** Worked as graphic artist. Made contact with Surrealists in Paris. **1931–1933** Travelled to Tunisia, Italy and France. **1933** Worked on *Puppe* (Doll) reminiscent of surrealist painting. **1935** Drawings of his dolls in the magazine *Minotaure* made him famous in France. **1935/36** Took part in the Surrealist exhibition at the Museum of Modern Art in New York. **1938** Moved to Paris. Close contact with Surrealists. **1939** Imprisoned, along with Ernst and Wols, in the French camp *Les Milles*. Returned to Paris after the war. **1943** Worked on

*Cephalopods.* **1953/54** Stayed in Berlin. **1966** Took part in documenta 3 in Kassel. In his anarchistic and traumatic representations of eroticism and sexuality, Bellmer built on the basic tenets of Surrealism.
WRITINGS: H. B.: Die Puppe. Karlsruhe 1934, Berlin 1962/La Poupée. Paris 1949.– H. B.: Les Jeux de la poupée. Paris 1949.– H. B.: L'Anatomie de l'image. Paris 1957.– H. B.: Petite anatomie de l'inconscient physique ou l'anatomie de l'image. Paris 1957
CATALOGUE RAISONNE: Pieyre d. Mandiargues, A. (ed.): H. B. L'œuvre gravé. Paris 1969, 1976/H. B. Das grafische Werk. Frankfurt-on-Main et al. 1973
MONOGRAPHS, CATALOGUES: H. B. photographe. Centre Georges Pompidou. Paris 1983 (cat.).– Crété, M. (ed.): H. B. Centre National d'Art Contemporain. Paris 1971 (cat.).– Eluard, P. et al. (ed.): H. B. Centre National d'Art Contemporain. Paris 1971 (cat.).– Grall, A.: Les Dessins de H. B. Paris 1966.– Grall, A. (ed.): H. B. London and New York 1973.– Haenlein, C. (ed.): H. B. Photographien. Kestner-Gesellschaft. Hanover 1984 (cat.).– Jelenski, C.: Les Dessins de H. B. Paris 1966/Die Zeichnungen von H. B. Berlin 1969.– Lattes, J.-C. (ed.): H. B. Musée Goya. Castres. Albi 1992 (cat.).– Lust, H.: H. B. New York 1990.– Pieyre d. Mandiargues, A.: Le Trésor cruel de H. B. Paris 1979.– Orgeix, C. (ed.): H. B. Paris 1950.– Prokopoff, S. S. and M. v. d. Guchte (ed.): H. B. Photographs. Kranert Art Museum, University of Illinois at Urbana-Champaign 1991 (cat.).– Revol, J.: B.: Peintures, gouaches, collages. Paris 1983.– Sayag, A.: H. B. Photographien. Munich 1984.– Schmied, W. (ed.): H. B. Kestner-Gesellschaft. Hanover 1967 (cat.).– Seuphor, M.: J. A. Cologne and Berlin 1961.– Webb, P. and R. Short: H. B. London 1985

**BENTON Thomas Hart**
**1889** Neosho (MO) – **1975** Kansas City (MO)
American painter. **1907/08** Studied at the Art Insitute in Chicago. **1908–1911** Lived in Paris. Attended the Académie Julian and Académie Colarossi. Studied Old Masters and contemporary styles of painting exemplified by Cézanne, Picasso and Matisse. **1912** Returned to New York. Continued to

paint in an abstract style. **1917** First one-man exhibition at the Daniel Gallery in New York. **1918** Began representational paintings of subjects taken from American history and everyday life. **1923** Worked on the mural *American Historical Epic.* **1926–1935** Taught at the Art Students League in New York; pupils included Pollock. **1935** Moved to Kansas City and taught at the art academy there. **1949** Travelled to France and Italy. Honorary member of the Accademia Fiorentina delle Arti del Disegno. One of the best-known exponents of American Regionalism.
WRITINGS: T. B.'s America. An Artist in America. New York 1937
CATALOGUE RAISONNE: Fath, C. (ed.): The Lithographs of T. H. B. Austin and London 1990
MONOGRAPHS, CATALOGUES: Adams, H. (ed.): T. H. B. An American Original. The Nelson-Atkins-Museum of Art, Kansas City et al. New York 1989 (cat.).– Adams, H. (ed.): T. H. B. Drawing from Life. Henry Art Gallery, University of Washington, Seattle et al. Seattle 1990 (cat.).– T. H. B. Whitney Museum of American Art. New York 1989 (cat.).– Baigell, M.: T. H. B. New York 1973.– Chiappini, R. (ed.): T. H. B. Museo d'Arte Moderna della Città di Lugano. Milan 1992 (cat.).– Coe, R. T. et al. (ed.): T. H. B. An Artist's Selection 1908-1974. William Rockhill Nelson Gallery of Art, Mary Atkins Museum of Fine Arts, Kansas City et al. Kansas City 1974 (cat.).– Doss, E.: B., Pollock and the Politics of Modernism. From Regionalism to Abstract Expressionism. Chicago 1991.– Douglas Hurt, R. and M. K. Dains: T. H. B. Artist, Writer and Intellectual. Columbia 1989.– Marling, K. A.: T. B. and His Drawings. Columbia 1985 (cat.).– Weintraub, L. (ed.): T. H. B. Chronicler of America's Folk Heritage. Edith C. Blum Art Institute, Bard College, Annandale-on-Hudson (NY) et al. Annandale 1984 (cat.)

**BERGHE Frits van den**
**1883** Ghent – **1939** Ghent
Belgian painter. **1897–1904** Attended the Académie Royale des Beaux-Arts in Ghent. First painted portraits, landscapes and interiors in the Impressionist style. **1907–1911** Professorship at the Ghent Academy of Art. Murals for the Community Centre in Ghent. **1914** Six-month visit to the USA. Returned to Amsterdam at the outbreak of World War I. Confrontation with Fauvism, Expressionism and Cubism. **1922** Set up house, near Laethem-Saint Martin, with his artist friend Smet. After his dark Dutch period, he chose brighter colours and painted larger pictures. **1927** Returned to Ghent. Joined the group L'Epoque and took up Surrealism. Painted fantastic visionary landscapes with eerie figures, in the spirit of Bosch and Ensor. **1938** Member of the Académie Picard in Brussels.
CATALOGUE RAISONNE: Langui, E. (ed.): F. v. d. B. 1883-1939. Catalogue raisonné de son œuvre peint. Brussels 1966

**BERLEVI Henryk**
**1894** Warsaw – **1967** Paris
Polish painter. **1904–1909** Studied at the Warsaw Academy, **1909–1912** at the Académie des Beaux-Arts in Antwerp and later in Paris. **1913** Returned to Warsaw. **1921** Met Lissitzky, Richter and van Doesburg. His work became clearly influenced by Constructivism. Took part in exhibitions of the Novembergruppe. Interest in mechanical processes leads to publication of a manifesto entitled *Mechano-Faktura* in **1924.** Started a business promoting mechanical advertising. One-man exhibition in Herwarth Walden's gallery Der Sturm, in Berlin. **1926** Took up figurative art again. **1927** Moved to Paris. Met Malevich. **1957** Renewed experiments with *Mechano-Faktura.*
MONOGRAPHS, CATALOGUES: Destré, J. (ed.): H. B. portraits et masques. Antwerp 1937.– Colley, H.: H. B. peintre polonais. Antwerp 1937.– Grohmann, W. and M. Besset (ed.): Retrospektive Ausstellung H. B. Gemälde, Zeichnungen, Grafik, Mechano-Fakturen, Plastik von 1908 bis heute. Maison de France. Berlin 1964 (cat.).– Olszewski, A. K.: H. B. Warsaw 1968

**BERNARD Emile**
**1868** Lille – **1941** Paris
French painter. From **1878** lived in Paris. Began artistic training at the Ecole des Arts Décoratifs and, after **1884,** entered the studio of Cormon where he met Louis Anquetin, Toulouse-Lautrec and van Gogh. **1885** Travelled through Normandy and Brittany. **1886** Van Gogh introduced him to Gauguin, whom he greatly admired. **1888–1891** Worked with Anquetin and Gauguin, leading exponents of Cloisonnism. **1891** Broke with Gauguin after an argument over a definition of the new style. Exhibition in the Salon des Indépendants. **1892** Organized the first major Van Gogh retrospective. **1893** Left Paris and travelled to Italy

and the Orient. Settled in Cairo. **1896** Visited Spain. **1900** and **1903** Trips to Venice. Solo-exhibitions: **1901** in Paris, **1905** at Cassirer, in Berlin and **1908** at the Munich Art Society. **1904** Returned to Paris. Important correspondence with Cézanne on theories of art. **1905** Brought out the famous magazine *La Rénovation Esthétique.* An important representative of Symbolism.
CATALOGUE RAISONNE: Luthi, J.-J. (ed.): E. B. Catalogue raisonné de l'œuvre peint. Paris 1982
MONOGRAPHS, CATALOGUES: Cailler, P.: E. B. Geneva 1959.– Cheyron, J. and Z. El Hakim: E. B. 1868-1941. Geneva 1966.– Luthi, J.-J.: E. B. Chef de l'école de Pont-Aven. Paris 1976.– Luthi, J.-J.: E. B. en Orient et chez Paul Cézanne 1893-1904. Paris 1979.– Mornard, P.: E. B. et ses amis. Geneva 1957.– Stevens, M. A. et al. (ed.): E. B. 1868-1941. Ein Wegbereiter der Moderne. Städtische Kunsthalle Mannheim et al. Mannheim 1990 (cat.)

**BEUYS Joseph**
**1921** Kleve – **1986** Düsseldorf
German performance and environment artist, draughtsman and sculptor. **1941–1945** Military service as fighter pilot. When his plane crashed, Tartars saved his life by wrapping him in felt and fat, materials that came to figure prominently in his later work. **1947–1951** Studied sculpture at the Düsseldorf Academy, where from **1949** he was the principal pupil of Ewald Mataré, and from **1961–1972** Professor of Monumental Sculpture. **1964–1982** Participation in documenta 3–7 in Kassel. By combining several artistic media and merging them with his own life story, he attempted to achieve a unity of art and life. Clear influence of anthroposophy, mythology and religion in his works. **1962** Met Paik and Maciunas, artists of the Fluxus movement. **1963** Staged his own Fluxus happenings; including his first *Aktion* with fat in the Rudolf Zwirner gallery in Cologne. Through a vast output of drawings, sculptures, objects, environments and performances, developed a symbolism based on mythological themes, mystical rites and archetypes. **1967** Became politically active, founding various associations and parties with the aim of promoting creativity in all areas of life. **1973** Dismissed from the Düsseldorf Academy. Founded the Free International School of Creativity and Interdisciplinary Research. As an artist, teacher and thinker, had a profound influence on subsequent generations of artists.
WRITINGS: J. B.: Kunst = Kapital. Achberger Vorträge. Ed. by R. E. Rappmann. Wangen 1992.– J. B. et E. Devolder: Conversation avec J. B. Gerpinnes 1991.– Beuys, E. and W. (ed.): J. B. Das Geheimnis der Knospe zarter Hülle. Schriften des Bildhauers aus seinem Nachlaß 1942-1986. Munich 1994.– Harlan, V. (ed.): Was ist Kunst. Werkstattgespräch mit J. B. Suttgart 1986.– Kuoni, C. (ed.): J. B. Energy Plan for the Western Man. J. B. in America. Writ-

ings by and Interviews with the Artist. New York 1990.– Wijers, L. (ed.): J. B. Schreiben als Plastik 1978-1987. Berlin 1992 CATALOGUES RAISONNES: Grigoleit, A. (ed.): J. B. Wasserfarbe auf Papier (1936-1984/85). 2 vols. Frankfurt-on-Main 1992.– Grinten, J. J. and H. (ed.): J. B. Wasserfarben/Watercolors 1936-1963. Frankfurt-on-Main et al. 1975.– Grinten, J. J. and H. (ed.): J. B. Ölfarben/Oilcolors 1936-1965. Frankfurt-on-Main et al. 1975.– Schellmann, J. et al. (ed.): J. B. Die Multiples 1965-1989. Werkverzeichnis der Auflagenobjekte und Druckgraphik 1965-1986. Munich 1992, 1997/The Multiples: Catalogue Raisonné of Multiples and Prints. New York 1997.– Schneede, U. M. (ed.): J. B. Die Aktionen. Kommentiertes Werkverzeichnis mit fotografischen Dokumentationen. Stuttgart 1994.– Theewen, G. (ed.): J. B. Die Vitrinen. Ein Verzeichnis. Cologne 1993.– Temkin, A. and B. Rose (ed.): Thinking is Form. The Drawings of J. B. London 1992.– Weiss, P. and F. Britsch (ed.): J. B. Plakate. Werbung für die Kunst. Munich 1991 MONOGRAPHS, CATALOGUES: Adriani, G. et al.: J. B. Leben und Werk. Cologne 1973, 1994/J. B. Life and Works. Woodbury (NY) 1979.– Angerbauer-Rau, M. J. B.-Kompaß. Ein Lexikon zu den Gesprächen mit J. B. Cologne 1998.– Barré, A. et al. (ed.): J. B. Centre Georges Pompidou. Paris 1994 (cat.).– Bastian, H. (ed.): J. B. Skulpturen und Objekte und Zeichnungen. 2 vols. Martin-Gropius-Bau, Berlin et al. Munich 1988 (cat.).– Bastian, H. (ed.): J. B. Block B. Munich 1990.– Boijiscul, W.: Zum Kunstbegriff des J. B. Essen 1985.– Borer, A. et al. (ed.): J. B. Kunsthaus Zurich et al. Zurich 1993 (cat.).– Borer, A.: The Essential J. B. Cambridge 1997.– Cooke, L. and K. Kelly (ed.): J. B. Arena – wo wäre ich hingekommen, wenn ich intelligent gewesen wäre. New York and Stuttgart 1994 / J. B. Arena – Where Would I Have Got if I Had Been Intelligent. New York 1994.– De Domizio, L. et al.: Incontro con Beuys. Pescara 1984.– De Domizio, L.: The Felt Hat. J. B. a Life Told. New York 1997.– Fabo, S.: Joyce and B. Ein intermedialer Dialog. Heidelberg 1997.– Haenlein, C. (ed.): J. B. Eine Innere Mongolei. Dschingis Khan. Schamanen. Aktricen. Ölfarben, Wasserfarben und Bleistiftzeichnungen aus der Sammlung van der Grinten. Kestner-Gesellschaft. Hanover 1990 (cat.).– Harlan, V. et al.: Soziale Plastik. Materialien zu J. B. Achberg 1976.– Harlan, V.: Was ist Kunst? Werkstattgespräche mit J. B. Stuttgart 1986.– Harlan, V. et al. (ed.): J.-B.-Tagung Basel 1.-4. Mai 1991. Basel 1991.– Hergott, F. (ed.): J. B. Kunsthaus Zurich et al. Paris 1995 (cat.).– Jappe, G.: B. packen. Dokument 1968-1996. Regensburg 1997.– Kramer, J. B. Das Kapital Raum 1970-1977. Heidelberg 1991.– Loers, V. and P. Witzmann (ed.): J. B. Documenta-Arbeit. Museum Fridericianum. Kassel 1993 (cat.).– Müller, M.: Wie man dem toten Hasen die Bilder erklärt. Schamanismus und Erkenntnis im Werk von J. B. Alfter 1993.– Oltmann, A.: "Der Weltstoff letztendlich ist … neu zu bilden". J. B. für und wider die Moderne. Stuttgart 1994.– Raussmüller-Sauer, C. (ed.): J. B. Schaffhausen 1988.– Röder, S. and G. Storck (ed.): Transit. J. B. 3 vols. Kaiser Wilhelm Museum. Krefeld 1991 (cat.).– Rosenthal, M.: J. B. Blitzschlag mit Lichtschein auf Hirsch. Frankfurt-on-Main 1991.– Schade, W. (ed.): J. B. Early Watercolors. New York 1991.– Schade, W. (ed.): J. B. Early Drawings. New York 1993.– Schirmer, L. (ed.): J. B. Eine Werkübersicht. Munich 1996.– Schneede, U. M.: J. B. Die Aktionen. Stuttgart 1993.– Szeemann, H. (ed.): J. B. Kunsthaus Zürich. Zurich 1993.– Szeemann, H.: Beuys-

nobiscum. Eine kleine Enzyklopädie. Dresden 1997.– Temkin, A. and B. Rose (ed.): Thinking is Form. The Drawings of J. B. The Museum of Modern Art, New York et al. New York and London 1993 (cat.).– Tisdall, C. (ed.): J. B. Solomon R. Guggenheim Museum. New York and London 1979 (cat.).– Tisdall, C.: J. B. Coyote. Paris 1982.– Verspohl, F.-J.: J. B. Das Kapital Raum 1979-1977. Frankfurt-on-Main 1984.– Vierneisel, K. (ed.): Hauptstrom Jupiter. B. und die Antike. Glyptothek. Munich 1993.– Vischer, T.: J. B. und die Romantik. Cologne 1983.– Vischer, T.: J. B. Die Einheit des Werkes. Zeichnungen, Aktionen, plastische Arbeiten, soziale Skulptur. Cologne 1991.– Zimmermann, R.: Kunst und Ökologie im Christentum "700 Eichen" von J. B. Wiesbaden 1994.– Zweite, A. (ed.): B. zu Ehren. Städtische Galerie im Lenbachhaus. Munich 1986 (cat.).– Zweite, A. (ed.): J. B. Natur, Materie, Form. Kunstsammlung Nordrhein-Westfalen, Düsseldorf. Munich 1991 (cat.)

**BILL Max**
**1908** Winterthur – **1994** Berlin
Swiss architect, painter, sculptor and designer. **1924-1927** Attended Zurich School of Art and Crafts. **1927-1929** Studied at the Bauhaus in Dessau under Albers, Kandinsky und Klee, then returned to Zurich. **1932-1936** Joined Abstraction-Création. Met Arp and Mondrian. From **1944** worked as a designer. **1949** Kandinsky Award. **1951** Inspirational force behind the Ulm School of Design. Tried to direct it in the tradition of the Dessau Bauhaus. Resigned after five years. **1956/57** Retrospectives in Ulm and Munich. **1959** and **1964** participation in documenta 2 and 4 in Kassel. **1967** Professorship at the Hamburg Academy. An important pioneer of abstract art, Bill coined the term "Concrete Art" for non-figurative modes of representation. WRITINGS: M. B.: Robert Maillard. Zurich 1949.– M. B.: Moderne Schweizer Architektur. Basel 1950.– M. B.: Wassily Kandinsky. Paris 1951.– M. B.: Form. Eine Bilanz über die Formentwicklung um die Mitte des XX. Jahrhunderts. Basel 1952.– M. B.: Mies van der Rohe. Milan 1955.– M. B.: Le Corbusier und P. Jeanneret. Zurich 1965.– M. B.: System mit fünf vierfarbigen Zentren. Anleitung zum Betrachten eines Bildes. St. Gallen 1972 CATALOGUE RAISONNE: Felix, Z. and M. Bill (ed.): M. B. Das druckgraphische Werk bis 1968. Kunsthalle Nürnberg. Nuremberg 1968 (cat.) MONOGRAPHS, CATALOGUES: Alloway, L. (ed.): M. B. Albright-Knox Art Gallery. Buffalo 1974 (cat.).– Anker, V.: M. B. ou la recherche d'un art logique. Essai d'une analyse structurale de l'œuvre d'art. Lausanne 1979.– M. B. Hamburger Kunsthalle, Hamburg et al. Zurich 1976 (cat.).– Caramel, L. and A. Thomas (ed.): M. B. Pinacoteca communale, Casa Rusca, Locarno. Lugano 1991 (cat.).– Frei, H.: Konkrete Architektur? Über M. B. als

Architekt. Baden 1991.– Gomringer, E. et al. (ed.): M. B. Teufen 1958.– Holeczek, B. (ed.): M. B. Wilhelm-Hack-Museum. Ludwigshafen 1990 (cat.).– Hüttinger, E.: M. B. Zurich 1977.– Hüttinger, E. et al. (ed.): M. B. Retrospektive. Skulpturen, Gemälde, Graphik. Schirn Kunsthalle, Frankfurt-on-Main et al. Frankfurt-on-Main and Zurich 1987 (cat.).– Maldonado, T.: M. B. Buenos Aires 1955.– Quintavalle, A. C. et al.: M. B. Parma 1977.– Rotzler, W.: M. B. Stuttgart 1977.– Schmidt, G.: M. B. Neuchâtel 1959.– Spies, W. (ed.): Kontinuität. Granith-Monolith von M. B. Frankfurt-on-Main 1987.– Staber, M.: M. B. London 1964, St. Gallen 1971

**BIRNBAUM Dara**
born **1946** New York
American video and multimedia artist. Up to **1968** studied architecture at the Carnegie Mellon University, Pittsburgh, and then studied art for five years at the San Francisco Art Institute and the New School of Social Research, New York. **1982** and **1987** took part in documenta 7 and 8 in Kassel. **1983-1986** Taught at the School of Visual Arts in New York. **1988** Commission to set up a video-installation in a public place in Atlanta. **1989** Took part in the exhibition "Video-Skulptur" in Köln. **1991** Visual Arts Fellowship and National Endowment for the Arts. **1992** German video-art award from the ZKM in Karlsruhe. Participated in documenta 9. With her video-tapes and installations, Birnbaum highlights the confrontation between new communication technologies and individual consciousness in modern society. MONOGRAPHS, CATALOGUES: D. B.: Every TV Needs Revolution. Imschoot 1992.– Celant, G. (ed.): D. B. IVAM Centro del Carme. Valencia 1991 (cat.).– D. B. Musée d'Art Contemporain. Bordeaux 1993 (cat.)

**BIROLLI Renato**
**1906** Verona – **1959** Milan
Italian painter and art critic. Studied at the Accademia Cignarolli in Verona. **1927** Moved to Milan. Met Futurist Carrà. His early portraits show the influence of van Gogh and Ensor. **1936** Encountered Impressionism in Paris. Greatly impressed by Matisse. **1937** Returned to Milan and founded Corrente, an association of young artists. Detained for anti-fascist activities. After his release, went underground. **1947-1952** Travelled to France and Germany to study Gothic churches and Cubism. Contact with the French avant-garde led to development of a concrete-abstract style. **1955** and **1958** participation in documenta 1 and 2 in Kassel. **1957** Moved to Antwerp. Affinities with L'art informel without any personal connections. WRITINGS: R. B.: Metamorfosi. Milan 1937.– R. B.: D'Arena. Galleria Schettini. Milan 1956.– Emanuelli, E. (ed.): R. B. Taccuini 1936-1959. Torino 1960

CATALOGUE RAISONNE: Mussini, M. et al. (ed.): R. B. Parma 1976 MONOGRAPHS, CATALOGUES: Birolli, Z. et al.: R. B. Milan 1978.– Emanuelli, E. (ed.): R. B. Taccuini 1936-1959. Torino 1960.– Marx, E. (ed.): R. B. Mannheim 1959 (cat.).– Tullier, A.: R. B. Milan 1951.– Valsecchi, M.: R. B. Milan 1966.– Vivarelli, P. (ed.): R. B. Palazzo Reale, Milan et al. 1989 (cat.)

**BISSIER Julius**
**1893** Freiburg i. Br. – **1965** Ascona
German painter. **1913/14** Studied history of art in Freiburg and attended the Karlsruhe Academy. **1914-1918** Military service. **1918** Took further courses in painting in Munich. **1919** Made friends with the sinologist Ernst Grosser. **1929-1933** Chair at Freiburg University where, in **1934**, a fire destroyed all his works. Met Schlemmer und Baumeister. In the 30s, his paintings became increasingly abstract. **1935-1938** Several trips to Italy. **1939** Moved to Hagnau on Lake Constance. From **1945** developed an individual calligraphic sign language, reminiscent of Far Eastern ink painting, which had a great influence on the first generation of German Informel artists. **1955/56** Began series of *miniatures*. **1959** and **1964** took part in documenta 2 and 3 in Kassel. **1960** Special honours at the 30th Venice Biennale. WRITINGS: Bärmann, M. (ed.): J. B. – Oskar Schlemmer: Briefwechsel. St. Gallen 1988 MONOGRAPHS, CATALOGUES: Büchner, J. et al. (ed.): J. B. Kunstsammlung Nordrhein-Westfalen. Düsseldorf 1970 (cat.).– Essers, V.: J. B. Kunstsammlung Nordrhein-Westfalen. Düsseldorf. Stuttgart-Ruit 1989 (cat.).– Gianadda, L. et al.: J. B. Opere 1930-1965. Museo d'Arte Mendrisio et al. Mendrisio 1988 (cat.).– J. B. 1893-1965. A Retrospective Exhibition. San Francisco Museum of Art. San Francisco 1968 (cat.).– Kettelsen, A. D.: J. B. Der Mensch und der Künstler. Stuttgart 1986.– Kuenzi, A. (ed.): J. B. Fondation Pierre Gianadda. Martigny 1989 (cat.).– Leonhard, K.: J. B. Stuttgart 1963.– Ludwig, J. and D. Weißenberger (ed.): J. B. Vom Anfang der Bilder. Städtische Museen, Museum für Neue Kunst. Freiburg 1994 (cat.).– Schiff, G. (ed.): J. B. Tuschen. Stuttgart 1989.– Schilling, J. (ed.): J. B. 1893-1965. Kunstverein Braunschweig. Brunswick 1980 (cat.).– Schmalenbach, W.: J. B. Stuttgart 1963, New York 1963, Cologne 1963.– Schmalenbach, W. (ed.): J. B. Tuschen und Aquarelle. Frankfurt-on-Main et al. Frankfurt-on-Main 1978

**BISSIERE Roger**
**1888** Villeréal (Lot-et-Garonne) – **1964** Marminiac (Lot)
French painter. **1905-1910** Studied painting at the Académie des Beaux-Arts in Bordeaux. **1910-1914** Journalist in Paris. **1920** Made friends with Lhote and Braque. Solo-exhibition at the Paul Rosenberg gallery and

participation at the Salon d'Automne in Paris. **1925–1938** Professorship at the Académie Ranson in Paris. Forced to give up painting owing to an eye ailment. **1948** Saved from blindness by a successful operation. Resumed painting with a renewed intensity and a highly colourful, poetic style that made him internationally famous. **1952** Grand Prix National des Arts. **1964** Participated at the Venice Biennale.
WRITINGS: Baptiste-Marrey (ed.): B. T'en fais pas Marie … Ecrits sur la peinture 1954-1964. Cognac 1994
CATALOGUE RAISONNE: Bissière, L. (ed.): R. B. Catalogue raisonné (in preparation)
MONOGRAPHS, CATALOGUES: Abadie, D.: B. Neuchâtel 1986.– Fouchet, M.-P.: R. B. Paris 1955.– Weelen, G. et al. (ed.): B. 1886-1964. Musée d'Art Moderne de la Ville de Paris et al. Paris 1986 (cat.)

**BLAIS Jean-Charles**
born **1956** Nantes
French painter. **1974–1979** Studied at the Ecole des Beaux-Arts in Rennes. **1979–1981** shared a studio with the sculptor Peter Briggs in Rennes. **1981** Presented blown-up reproductions of the smaller works of Malevich and Kandinsky in the exhibitions "Sans titre ou les figures du vide" (No Title or Figures from Emptiness) in Rennes and "Finir en beauté" (To End in Beauty). Affinity to Figuration Libre. Began painting on torn posters. Painted sheets of newspaper. Took capital letters as a starting point for his compositions, and often for the title too. Designed clothing for the fashion designer Jean Charles de Castelbajac. **1984** Moved into a new studio where he could paint larger canvases. The faces of the figures are lost in the vast expanse of the picture and the bodies amalgamate with the painting. In the late 80s, turned to colour drawings and graphic reproductions.
MONOGRAPHS, CATALOGUES: J.-C. B. Kestner-Gesellschaft. Hanover 1986 (cat.).– J.-C. B. Musée d'Art et d'Histoire de Fribourg. Fribourg 1984 (cat.).– J.-C. B. Galerie Buchmann. Basel 1984.– J.-C. B. Centre Georges Pompidou. Paris 1987 (cat.).– J.-C. B. Dessins. Basel 1987 (cat.).– J.-C. B. Suites lithographies, monotypes et variations. Paris 1995.– Haenlein, C. (ed.): J.-C. B. Kestner-Gesellschaft. Hanover

1986 (cat.).– Marin, L.: J.-C. B. Du figurable en peinture. Paris 1988

**BLAKE Peter**
born **1932** Dartford (Kent)
English painter. **1946–1951** Trained as a technical draughtsman at Gravesend School of Art. **1953–1956** Studied at the Royal College of Art in London. **1956/57** Studied folk art. Extended travels through Europe. **1964** Started teaching at St. Martin's School of Art in London. From **1959** painted collages with captivating irony and vibrant colours. **1967** Cover design for the Beatles LP *Sergeant Pepper*. **1969–1979** Member of the Brotherhood of Ruralists, based near Bath. **1980** Returned to London. **1981** Member of the Royal Academy, London. **1983** Major retrospective at the Tate Gallery, London. After his early period of Realism, Blake joined Hamilton in becoming a key figure of English Pop Art. Frequently took trivial pictorial clichées and worked them over in 30s style.
WRITINGS: P. B.: No Place Like Utopia. Modern Architecture and the Company We Kept. New York 1993
MONOGRAPHS, CATALOGUES: P. B. Souvenirs and Samples. Waddington Galleries and Tooth Gallery. London 1977 (cat.).– Coleman, R. (ed.): P. B. City Art Gallery. Bristol 1969 (cat.).– Compton, M. et al. (ed.): R. B. Tate Gallery. London 1983 (cat.)/P. B. Retrospective. Kestner-Gesellschaft. Hanover 1983 (cat.).– Schneede, U. M. (ed.): P. B. Hamburger Kunstverein. Hamburg 1973 (cat.).– Vaizey, M.: P. B. London 1986

**BLECKNER Ross**
born **1949** New York
American painter. **1971–1973** Studied at New York University and California Institute of the Arts, Valencia; graduated as Master of Fine Arts. **1975** First one-man exhibition put on by Mary Boone in New York. Famous for his striped pictures, related to Op Art. The strict geometry of the stripes is broken up by flecks of colour and ornamental elements giving the pictures an atmospheric, shimmering character. Further exhibitions in London, Cologne and Tokyo. **1988** Took part in the BiNationale in Boston and Düsseldorf. Bleckner

uses fire, wax, varnish and other materials to produce hallucinatory colour effects. Expansion and contraction are the fundamental creative forces underlying his art.
MONOGRAPHS, CATALOGUES: Bürgi, B. (ed.): R. B. Kunsthalle Zürich et al. Zurich 1990 (cat.).– Crone, R. (ed.): R. B. Mary Boone Gallery. New York 1987 (cat.).– Dennison, L. et al. (ed.): R. B. Solomon R. Guggenheim Museum. New York 1995 (cat.).– Schjeldahl, P. (ed.): R. B. Waddington Galleries. London 1987 (cat.).– Sobel, D. (ed.): R. B. Milwaukee Art Museum. Milwaukee 1989 (cat.)

**BLOSSFELDT Karl**
**1865** Schielo (Harz) – **1932** Berlin
German photographer. **1881–1884** Apprenticeship as sculptor and modeller at the art foundry in Mägdesprung. **1886–1890** Studied at the School of Art and Crafts and the Academy in Berlin. **1891** Grant for tours of Italy, Greece and North Africa; first photographic projects. **1896** Assistant to Prof. Ernst Ewald at the Royal School of Art in Berlin. **1898** Professor of botanical modelling in the education department of the Museum of Arts and Crafts, Berlin. **1900** Took a series of photographs of plants with a home-made view camera. **1928** Publication of book *Urformen der Kunst* (Art Forms in Nature), followed by *Wundergarten der Natur* (Nature's Garden of Wonders) in **1932**.
MONOGRAPHS, CATALOGUES: Honnef, K. (ed.): K. B. Fotografien 1900-1932. Rheinisches Landesmuseum Bonn. Cologne 1976 (cat.).– Hüneke, A. and G. Ihrke (ed.): K. B. Fotografien zwischen Natur und Kunst. Leipzig 1990.– Mattenklott, G.: K. B. 1895-1932. Das fotografische Werk. Munich 1981.– Sachsse, R.: K. B. Photographien 1895-1932. Cologne 1993.– Schreier, C. (ed.): K. B. Fotografie. Kunstmuseum Bonn et al. Bonn 1994 (cat.).– Wilde, A. (ed.): K. B. Photographien. Munich 1991.– Wilde A. and J. Wilde (ed.): K. B. Fotografie. Kunstmuseum Bonn et al. Stuttgart 1994 (cat.)

**BLUME Anna** and **Bernhard Johannes**
born **1937** Bork (Anna)
born **1937** Dortmund (Bernhard Johannes)
German photographers. Bernhard trained as a cinema and decorative painter and graphic artist, while Anna had a technical training. **1960–1965** Studied together at the Düsseldorf Academy. From **1964** Anna worked as an art teacher in a number of high schools. **1966** They married. **1967–1971** Bernhard completed his philosophy degree and taught for 15 years in Cologne. Since **1980** intensive team-work on large-scale photographic projects centering on the theme of absurd and alienating encounters with the world of objects.
WRITINGS: A. and B. B.: Ideoplastie. Cologne 1970.– A. and B. B.: Paraphrase zur Psychopathologie künstlerischer Produktion. Cologne 1973.– A. and B. B.:

Malerei als Medienreflexion. Bergisch-Gladbach 1976.– A. and B. B.: heilig, heilig, heilig. Munich 1986.– A. and B. B.: Vasen Exstasen. Frankfurt-on-Main 1991
CATALOGUE RAISONNE: Honnef, K. et al. (ed.): A. and B. B. 3 vols. Cologne 1992-1995
MONOGRAPHS, CATALOGUES: Ammann, J. C. et al. (ed.): A. and B. B. Kunsthalle Basel. Basel 1987 (cat.).– Ammann, J. C. (ed.): Das Ich und die Dinge: Kommentare zu einem philosophischen Text von A. and B. B. in Form inszenierter Fotografien. Frankfurt-on-Main 1991.– A. and B. B.: Trautes Heim. Fotos aus dem wirklichen Leben. Kunsthalle Basel. Basel 1989 (cat.).– A. and B. B. Photo-Work. Milwaukee Art Museum, Milwaukee et al. Stuttgart 1996 (cat.).– Brock, B. and N. Smolik (ed.): A. B. Die reine Empfindung. Stuttgart 1994.– Hamburger, K.: Zu den Ideografien B. J. B. Cologne 1977.– Schulte, G.: Zur Ästhetik der Fotografie, insbesondere der transzendentalen Fotografie B. J. B.'s. Bonn 1976.– Wieland, A. (ed.): A. & B. B.: Grossfotoserien 1985-1990. Rheinisches Landesmuseum, Bonn. Cologne 1992 (cat.)

**BLUMENFELD Erwin**
**1897** Berlin – **1969** Rome
German photographer. **1913–1916** Apprenticeship as a fashion designer. Contact with Else Lasker-Schüler, Grosz and the Dadaists. **1916–1918** Military service. **1919** Moved to the Netherlands. **1919–1923** Opened a Dada centre in Amsterdam with Paul Citroën. Began to paint, write and photograph. **1922–1935** Sold photographs in his own leather shop. **1936** Moved to Paris, working as a professional photographer. First publications of portraits and advertising photographs. From **1938** worked for *Vogue* and *Harper's Bazaar*. **1940/41** Held as prisoner of war in the USA, where he then emigrated. **1941–1943** Worked for numerous American magazines. **1943** Set up his own studio in New York. Used various distancing effects such as solarisation, double exposure and positive/negative combinations in his fashion photography. **1955** Began writing his autobiography. **1962** Lived in Berlin for a year. **1976** Autobiography published.
MONOGRAPHS, CATALOGUES: Ewing, W. A. and M. Schinz (ed.): B. Photographs, a Passion for Beauty. New York and Kilchberg 1996.– Gundlach, F. C. and P. Weiermair (ed.): E. B. Museum Folkwang, Essen et al. Essen 1987 (cat.)

**BOCCIONI Umberto**
**1882** Reggio di Calabria – **1916** Verona
Italian painter and sculptor. **1898–1902** Studied painting in Rome. Met Severini and Balla. **1902** Travelled to Paris. Strongly influenced by Neo-Impressionism, especially by the works of Seurat. **1907** Settled in Milan. **1910** Met Marinetti and, along with Carrà, Russolo, Balla and Severini,

signed the *Manifesto of Futurist Painters.*
**1911** Returned to Paris and made contact
with the Cubist circle centred around Apol-
linaire, Picasso, Braque and Dufy. Fused
elements of Cubism with Futurist concepts
of dynamism and speed. **1912** Took part in
the first international Futurist exhibition at
the Bernheim-Jeune gallery in Paris and
drew up the *Manifesto of Futurist Sculp-
ture.* **1913** Exhibition of his Futurist sculp-
tures at the Galerie de la Boètie. **1914** Criti-
cal analysis of the basic tenets of Futurism
in an article entitled *Pittura, scultura futur-
ista, dinamismo plastico* (Painting, Futurist
Sculpture, Plastic Dynamism). One of the
leaders of the Futurist movement.
WRITINGS: Birolli, Z. (ed.): U. B. Gli
scritti editi e inediti. Milan 1971.– Birolli, Z.
(ed.): U. B. Altri inedite e apparati critici.
Milan 1972
CATALOGUES RAISONNES: Bellini, P.
(ed.): Catalogo completo dell'opera grafica
di U. B. Milan 1972.– Bruno, G. and A.
Palazzeschi (ed.): L'opera completa di B.
Milan 1969.– Calvesi, M. and E. Coen
(ed.): L'opera completa di B. Milan 1983.–
Marinetti, F. T. (ed.): U. B. Opera com-
pleta. Florence 1927.– Palzzeschi, A. and G.
Bruno (ed.): L'opera completa di B. Milan
1969.– Taylor, J. (ed.): The Graphic Work of
U. B. The Museum of Modern Art. New
York 1961 (cat.).– Verzotti, G. B. Cat-
alogo completo dei dipinti. Florence 1989
MONOGRAPHS, CATALOGUES: Argan,
G. C. and M. Calvesi: U. B. Roma 1953.–
B. prefuturista. Museo Nazionale, Reggio
Calabria. Milan 1983 (cat.).– Ballo, G.: B.
La vita e l'opera. Milan 1964, 1982.– Ballo,
G. et al. (ed.): B. e Milano. Palazzo Reale,
Milan et al. Milan 1982 (cat.)/B. und Mai-
land. Kunstmuseum Hannover. Hanover
1983 (cat.).– Birolli, Z.: U. B. Racconto
critico. Torino 1983.– Calvesi, M.: U. B.
Incisioni e disegni. Florence 1973.– Cam-
poresi, F.: L'architettura e il dinamismo.
Studio sulla poetica di U. B. Bologna 1982.–
Coen, E. et al. (ed.): B. a Venezia. Chiesa
di S. Stae, Venice. Milan 1985 (cat.).– Coen,
E. (ed.): U. B. Metropolitan Museum of
Art. New York 1988 (cat.).– Golding, J.: B.
Unique Forms of Continuity in Space.
London 1985.– Grada, R. d.: B. Il mito del
moderno. Florence 1962.– Lista, G.: U. B.
Dynamisme plastique. Lausanne 1975.–
Marchiori, G.: U. B. scultore. Milan 1969.–
Rossi, L. M. (ed.): B., 1912, Materia. Galle-
ria dello Scudo, Verona. Milan 1991 (cat.)/
B. 1912, Materia. Fondazione Antonio Maz-
zotta. Milan 1995 (cat.).– Schneede, U. M.:
U. B. Stuttgart 1993.– Schulz-Hoffmann,
C.: U. B. Volumi orizzontali. Munich
1981.– Tallarico, L. (ed.): B. cento anni.
Roma 1982

**BOECKL Herbert**
**1894** Klagenfurt – **1966** Vienna
Austrian painter. Self taught. Studied archi-
tecture at the Technical College in Vienna.
**1913** Joined the Austrian Artists' Associa-
tion. Became friends with Adolf Loos. **1921
–1924** Travelled to Berlin, Palermo and

Paris; leanings towards French art. **1928**
First important religious work, the fresco
*Rescue of the Apostle Peter from the Sea of
Galilee* in the pilgrims church at Maria Saal.
**1931** Studied anatomy at the Franz-Joseph
Hospital inVienna in preparation for an
extensive series of drawings and sketches
in oils for his treatise *Anatomy.* **1935–1939**
Professor of Painting at the Vienna
Academy. **1941** Joined the NSDAP but
continued to criticize the cultural policies
of the Nazis. **1945–1950** Withdrawal of
charges of collaboration with the Nazis.
Superintendent of art colleges around
Vienna. **1962–1965** Director of the Vienna
Academy.
CATALOGUE RAISONNE: Frodl, G.: H.
B. Mit einem Werkverzeichnis der Ölge-
mälde von Leonore Boeckl. Salzburg 1976
MONOGRAPHS, CATALOGUES: H. B.
Malerei, Zeichnungen und Aquarelle.
Städtische Galerie im Lenbachhaus.
Munich 1954 (cat.).– H. B. Museum des
20. Jahrhunderts. Vienna 1964 (cat.).– H. B.
Aquarelle und Zeichnungen. Graphische
Sammlung Albertina. Vienna 1969 (cat.).–
H. B. Gemälde und Collagen. Akademie
der bildenden Künste. Vienna 1976 (cat.).–
H. B. Werke nach 1945. Salzburger Lan-
dessammlungen Rupertinum et al. Graz
1988 (cat.).– H. B. Körper und Räume. 1915-
1931. Graphische Sammlung Albertina,
Vienna et al. 1989 (cat.).– H. B. Kunstforum
der Bank Austria. Vienna 1994 (cat.).–
Diehl, G.: H. B. Salzburg 1978.– Frodl, G.:
H. B. Salzburg 1976.– Skreiner, W.: H. B.
Gemälde. Graz 1979.– Stary, O. and W.
Kallen: Die Seckauer Apokalypse von H. B.
Graz 1989

**BOLTANSKI Christian**
born **1944** Paris
French object artist. Self-taught. **1958–1967**
Series of large-scale works representing his-
torical events combined with personal expe-
riences. After **1968** produced works (mostly
photographic) reconstructing his childhood
or tracing the life history of other people.
From **1970** collaborated with Jean Le Gac.
**1971** Started to use videos. Publication of
photographs in book form. Since **1972**
regular participation at the documenta in
Kassel. Boltanski is a leading representative
of the so-called "trace- and clue-finding
artists" (Spurensicherer).

WRITINGS: C. B.: Livres. Paris 1991,
Cologne 1991.– C. B.: Zeit. Munich 1996
CATALOGUE RAISONNE: Flay, J. (ed.): C.
B. Books, Printed Matter, Ephemera 1966-
1991. Cologne 1991
MONOGRAPHS, CATALOGUES: C. B.
Württembergischer Kunstverein, Stuttgart.
Münster 1974 (cat.).– C. B. Modellbilder.
Rheinisches Landesmuseum. Bonn 1977
(cat.).– C. B. Reconstitution. Badischer
Kunstverein. Karlsruhe 1978 (cat.).– C. B.
Musée de Calais. Calais 1980 (cat.).– C. B.
Lessons of Darkness. Museum of Contem-
porary Art. Chicago 1988 (cat.).– C. B.
Réserves: La Fête de Pourim. Museum für
Gegenwartskunst. Basel 1989 (cat.).– C. B.
Reconstitution. Whitechapel ArtGallery,
London 1990 (cat.)/Reconstitution. Musée
de Grenoble 1990 (cat.).– C. B. Städtisches
Museum Abteiberg. Mönchengladbach 1993
(cat.).– C. B. Menschlich. Cologne 1994.–
Bozo, D. et al. (ed.): C. B. Centre Georges
Pompidou. Paris 1984 (cat.).– C. B. Staatliche
Kunsthalle Baden-Baden et al. Baden-
Baden 1984 (cat.).– Eccher, D. (ed.): C. B.
Bologna 1997 (cat.).– Franzke, A. and M.
Schwarz (ed.): C. B. Reconstitution. Badi-
scher Kunstverein. Karlsruhe 1978 (cat.).–
Gumpert, L.: C. B. Paris and New York
1994.– Holsten, S. (ed.): C. B. Staatliche
Kunsthalle Baden-Baden. Baden-Baden
1984 (cat.).– Jacob, M. J. and L. Gumpert
(ed.): C. B. Lessons of Darkness. Museum
of Contemporary Art, Chicago et al.
Chicago 1989 (cat.).– Metken, G.: C. B.
Memento mori und Schattenspiel. Frank-
furt-on-Main 1991.– Moure, G. (ed.): C. B.
Advent and Other Times. Santiago de
Compostela 1996 (cat.).– Schneede, U. M.
et al. (ed.): C. B. Inventar. Hamburger
Kunsthalle. Hamburg 1991 (cat.).– Schra-
nen, G. (ed.): C. B. Neues Museum Weser-
burg. Bremen 1996 (cat.).– Semin, D.: C. B.
Paris 1988.– Semin, D. et al.: C. B. London
1997.– Theewen, G. (ed.): Confusion –
Selection: Gespräche und Texte über Biblio-
theken, Archive, Depots von und mit C. B.
Cologne 1996.– Viéville, D. (ed.): C. B.
Compositions. Musée d'Art Moderne de la
Ville de Paris. Paris 1981

**BOMBOIS Camille**
**1882** Venerey-les-Laumes – **1970** Paris
French painter. Self-taught. Earned his
living as a farm labourer, circus wrestler and
weightlifter. **1914–1918** Military service.
**1922** His artistic talent was discovered
through a roadside exhibition in Mont-
martre, Paris. Promoted by Wilhelm Uhde
and Florent Fels. Increasing public recogni-
tion encouraged him to take up painting
full-time. **1964** Took part in the exhibition
"Le Monde des Naïfs" in Paris. His simple,
powerful scenes of the circus, and town and
country life put him alongside Rousseau
and Bauchant, as a key representative of
French naïve art.
MONOGRAPHS, CATALOGUES:
Bodmer, H. B.: C. B. Paris 1951.– Vallier, D.
et al. (ed.): C. B. Galerie Vierny. Paris 1981
(cat.)

**BONNARD Pierre**
**1876** Fontenay-aux-Roses – **1947** Le Cannet
French painter. **1886–1889** Studied law in
Paris. **1888/89** Trained as a painter at the
Académie des Beaux-Arts and the Académie
Julian. Made friends with Denis, Vuillard
und Sérusier, who introduced him to
Gauguin's concept of art. **1889** Sold a stylis-
tically novel poster design *France-Cham-
pagne.* After short military service, set up
studio in **1890** with Denis and Vuillard and
founded the artists' group Nabis, promoting
Symbolist and anti-naturalistic ideals.
Strongly attracted to Japanese art. **1891–
1905** Exhibitions in the Salon des Indépen-
dants. Publication of his first poster.
Became acquainted with Toulouse-Lautrec.
**1893** First lithographs printed in *La Revue
Blanche.* From **1895** onwards, Vollard pub-
lished Bonnard's lithographs and book illus-
trations, partly influenced by Redon. **1896**
First solo-exhibition put on by Durand-
Ruel. **1903** Exhibition at the new Salon
d'Automne. **1906** Taught at the Académie
Ranson. **1905** Travelled to Spain with Vuil-
lard. Numerous trips to neighbouring coun-
tries and to North Africa over the next few
years. **1909** Long visits to the South of
France, where he settled permanently after
**1925.** In a late-impressionist style and deli-
cate colours, he painted porcelain-like
domestic scenes, portraits, female nudes,
landscapes and aspects of city life.
WRITINGS: Clair, J. and A. Terrasse (ed.):
B. – Matisse. Correspondance. 1925-1946.
Paris 1991
CATALOGUES RAISONNES: Bouvet, F.
(ed.): P. B. L'œuvre gravé. Catalogue
complet. Paris 1981. The Complete Graphic
Work. London and New York 1981.– Bou-
venne, A. (ed.): Catalogue de l'œuvre gravé
et lithographié de R. P. B. Paris 1873.–
Curtis, A. (ed.): Catalogue de l'œuvre litho-
graphié et gravé de R. P. B. London and
Paris 1939.– Dauberville, J. and H. (ed.): B.
Catalogue raisonné de l'œuvre peint. 4 vols.
Paris 1965-1974, 1993.– Dauberville, J. and
H. (ed.): B. Catalogue raisonné de l'œuvre
peint révisé et augmenté. Vol. 1. Paris 1992.–
Heilbrunn, F. and P. Néagu (ed.): P. B.
photographe. Musée d'Orsay. Paris 1987,
Munich 1988 (cat.).– Roger-Marx, C. (ed.):
B. Lithographie. Monte Carlo 1952, 1981.–
Terrasse, A. (ed.): B. Illustrateur. Catalogue
raisonné. Paris 1988/B. Illustrator. New
York 1989
MONOGRAPHS, CATALOGUES: Beer, F.
J.: P. B. Marseille 1947.– P. B. Kunstmu-
seum Basel. Basel 1955 (cat.).– P. B. The
Late Paintings. The Phillips Collection,
Washington et al. New York 1984 (cat.).– P.
B. Das Glück zu malen. Kunstsammlung
Nordrhein-Westfalen. Düsseldorf 1993
(cat.).– Clair, J. (ed.): P. B. Palazzo Reale.
Milan 1988 (cat.).– Cogeval, G.: B. Paris
1993.– Cogniat, R.: P. B. Paris 1989.– Ives, C.
et al. (ed.): P. B. The Graphic Art. New
York 1989 (cat.).– Gobin, M.: R. P. B. Paris
1950.– Hagen, M. v. (ed.): B. Kunsthalle der
Hypo-Kulturstiftung. Munich 1994 (cat.).–
Ives, C. et al. (ed.): P. B. The Graphic Art.
Metropolitan Museum of Art, New York et

al. New York 1989 (cat.).– Jedlicka, G.: P. B. Ein Besuch. Zurich 1949.– Mann, S.: B. Drawings. London 1991.– Matta, M. and T. Stoos (ed.): B. Kunsthaus Zurich et al. Zurich 1985 (cat.).– Natanson, T.: Le B. que je propose. Geneva 1951.– Raynal, M.: Histoire de la peinture moderne. De Baudelaire à Bonnard. Geneva 1949.– Rewald, J. (ed.): P. B. New York 1948 (cat.).– Russell, J. et al. (ed.): B. Centre Georges Pompidou, Paris et al. Paris 1984 (cat.).– Shirley, A.: B. London 1940.– Terrasse, A.: P. B. Paris 1967/P. B. Leben und Werk. Cologne 1989.– Terrasse, A. (ed.): P. B. Haus der Kunst, Munich 1967 (cat.)/Musée National du Louvre, Paris 1967 (cat.).– Terrasse, A.: P. B. Paris 1988, Cologne 1989.– Terrasse, M.: B. Du dessin au tableau. Paris 1996.– Thomson, B. and S. Mann (ed.): B. at Le Bosquet. Hayward Gallery, London et al. London 1994 (cat.).– Vaillant, A.: B. ou le bonheur de voir. Neuchâtel 1965.– Vaillant, A.: B. Munich 1966.– Watkins, N.: B. London 1994, 1996

**BOROFSKY Jonathan**
born **1942** Boston
American concept and multimedia artist. **1960–1964** Studied at the Carnegie Mellon University in Pittsburgh. **1964** Travelled to Paris. **1964–1966** Studied at Yale School of Art and Architecture in New Haven. **1969–1977** Taught at the School of Visual Arts in New York. After **1972** numbered his drawings, painting and sculptures consistently. Some recurring motifs: the hammering man, silhouettes riddled with hole and the flying figure. **1975** First one-man exhibition at the Paula Cooper Gallery, New York. Spatial arrangement of single objects into combination art works. Numerous commissions for schlptures in public places. **1977–1980** Taught at the California Institute of Art in Los Angeles. **1982–1992** Took part in documenta 7 – 9 in Kassel. **1984** Start of a major touring retrospective at the Philadelphia Museum of Art.
MONOGRAPHS, CATALOGUES: Ammann, J.-C. et al. (ed.): J. B. Träume 1972-1981. Kunsthalle Basel et al. Basel 1981 (cat.).– J. B. The Museum of Modern Art. New York 1978 (cat.).– J. B. Philadelphia Museum of Art. Philadelphia 1984 (cat.).– J. B. Tokyo Metropolitan Art Museum. Tokyo 1987.– J. B. Counting 3287718-3311003. Portikus, Frankfurt-on-Main. Cologne 1991 (cat.).– Cuno, J. (ed.): Subject(s). Prints and Multiples by J. B. 1982-1991. Hood Museum of Art, Dartmouth College et al. Hanover 1992 (cat.).– Geelhaar, C. (ed.): J. B. Zeichnungen. 1960-1983. Kunstmuseum Basel et al. Basel 1983 (cat.).– Kittelmann, U.: J. B. Dem Publikum gewidmet. Stuttgart 1993.– Rosenthal, M. and R. Marshall (ed.): Philadelphia Museum of Art, Philadelphia et al. New York 1984 (cat.).– Simon, J. (ed.): J. B. Dreams 1973-1981. Institute of Contemporary Arts, London et al. London 1981 (cat.).– Springfeldt, B. (ed.): J. B. Moderna Museet. Stockholm 1984 (cat.)

**BOTERO Fernando**
born **1932** Medellín
Columbian painter, sculptor and draughtsman. **1944–1946** Trained as a torero. **1951** Moved to Bogotá, where his first exhibition was held at the Galerías de Arte-Foto Estudio Leo Matiz. **1952** Studied painting at the Real Academia de Bellas Artes de San Fernando in Madrid and, from **1953**, at the Academia die San Marco in Florence. Studied Renaissance painting and the Old Masters, Dürer, Rubens and Velázquez. **1958** Taught at the Art Academy in Bogotá. **1959** Took part in the São Paulo Biennale. **1960** Moved to New York. Became acquainted with Franz Kline, Willem De Kooning, Mark Rothko. **1966** First European solo-exhibition in the Kunsthalle Baden-Baden. **1973** Moved to Paris. From **1976** did still lifes and animal sculptures in bronze, marble and cast synthetic resin. **1977** Participation in documenta 6 in Kassel. **1979** Retrospective in the Hirshhorn Museum, Washington. **1992** Exhibition of 32 monumental bronzes at the Champs-Elysées in Paris. Combined painting styles of the Old Masters with modern pictorial language in portraits and naive-narrative paintings displaying a grotesque sense of humour and luxuriant sensuality.
MONOGRAPHS, CATALOGUES: Arciniegas, G.: F. B. New York 1977.– Atkinson, T.: B. Munich 1970.– Auzias d. Turenne, S. (ed.): B. en Avignon: le gai savoir de F. B. Palais des Papes. Avignon 1993 (cat.).– Bode, U.: F. B. Fondation Pierre Gianadda. Martigny 1990 (cat.).– F. B. Antologica 1949-1991. Palazzo delle Esposizioni. Roma 1991 (cat.).– F. B. New Works on Canvas. New York 1997.– Brusberg, D. (ed.): F. B. Das plastische Werk. Galerie Brusberg, Hanover et al. Hanover 1978 (cat.).– Caballero Bonald, J. M.: B., la corrida. Un réalisme énigmatique. Paris 1990.– Daix, P. et al. (ed.): B. aux Champs-Elysées. Exposition. 3 vols. Galerie Didier Imbert, Mairie de Paris. Paris 1992 (cat.).– Durozoi, G.: F. B. Paris 1992.– Escallom: B. New York 1997.– Jouvet, J.: F. B. Gemälde, Aquarelle, Pastelle. Zurich 1983.– Lascault, G.: B. Eloges des sphères, de la chair, de la peinture. Paris 1992.– McCabe, C. J. (ed.): F. B. Hirshhorn Museum and Sculpture Garden. Washington 1979 (cat.).– Paquet, M.: B. peintures. Paris 1983.– Paquet, M.: B. Philosophie de la création. Tielt 1985.– Ratcliff, C.: B. New York 1980.– Restany, P.: B. New York 1984.– Rivero, M.: B. Bogotá 1973.– Soavi, G.: F. B. Milan 1988.– Spies, W. (ed.): F. B. Bilder, Zeichnungen, Skulpturen. Kunsthalle der Hypo-Kulturstiftung, Munich et al. Munich 1986 (cat.).– Spies, W. (ed.): B. Retrospektive. Zeichnungen, Bilder, Skulpturen. Kunsthaus Wien. Vienna 1992 (cat.).– Spies, W.: B. New York 1997.– Sullivan, E. J.: B. Sculpture. New York 1986.– Sullivan, E. J.: F. B. Dessins et aquarelles. Paris 1992/F. B. Drawings and Watercolors. New York 1993

**BOURGEOIS Louise**
born **1911** Paris
French-American sculptress, graphic artist and painter. **1936–1938** Studied painting at the Ecole des Beaux-Arts and in the studios of Bissière and Léger. **1938** Moved to the USA. **1945** First solo-exhibition at the Bertha Schaefer Gallery, New York. Subsequently taught at the Pratt Institute, the School of Visual Art and New York University. **1949** Gave up painting and turned to sculpture. Tried various methods in combination with different materials. Published numerous essays in American art journals. **1977** Received an honorary doctorate from Yale University and other public honours. **1992** Designed the American pavilion at the Venice Biennale and took part in documenta 9 in Kassel. Her symbolic and psychologizing sculptural language revolves around topics such as sexuality, feminism and repression.
WRITINGS: Bernadac, M.-L. and H.-U. Obrist (ed.): L. B. Destruction of the Father. Writings and Interviews 1923-1997. London 1998.– Kuspit, D.: B. Interview. New York 1988
CATALOGUE RAISONNE: Wye, D. and C. Smith (ed.): The Prints of L. B. The Museum of Modern Art. New York 1995 (cat.)
MONOGRAPHS, CATALOGUES: Bernadac, M.-L. and D. Wye (ed.): L. B. Paris 1995, New York 1996.– Bernadac, M.-L. et al. (ed.): L. B. Recent Works. Bordeaux et al. Bordeaux 1998 (cat.).– L. B. Retrospective 1947-1994. Galerie Maeght-Lelong. Paris 1985 (cat.).– L. B. Fundació Antoni Tàpies. Barcelona 1990 (cat.).– L. B. Rijksmuseum Kröller-Müller. Otterlo 1991 (cat.).– Felix, Z. et al. (ed.): L. B. Der Ort des Gedächtnisses. Deichtorhallen. Hamburg 1995 (cat.).– Gardner, P.: L. B. New York 1994.– Gorovoy, J. and J. Cheim (ed.): L. B. Drawings. Robert Miller Gallery. New York 1988 (cat.).– Gorovoy, J. et al. (ed.): L. B. Blue Days and Pink Days. Palazzo Reale. Milan 1997 (cat.).– Haenlein, C. (ed.): L. B. Skulpturen und Installationen. Kestner-Gesellschaft. Hanover 1994 (cat.).– Kotik, C. et al. (ed.): L. B. The Locus of Memory. Works 1982-1993. The Brooklyn Museum, New York et al. New York 1994 (cat.).– Lippard, L. R.: L. B. From the Inside Out. New York 1978.– Meyer-Thoss, C.: L. B. Konstruktionen für den freien Fall. Designing for Free Fall. Zurich 1992.– Parent, B. (ed.): L. B. Sculptures, environnements, dessins 1938-1995. Musée d'Art Moderne de la Ville de Paris. Paris 1995 (cat.).– Strick, J. (ed.): L. B. The Personages. Saint Louis Art Museum. Saint Louis 1994 (cat.).– Weiermair, P. et al. (ed.): L. B. Frankfurter Kunstverein. Zurich 1989 (cat.)/L. B. Städtische Galerie im Lenbachhaus, Munich. Schaffhausen 1989 (cat.).– Weiermair, R. et al. (ed.): L. B. New York 1995.– Wye, D. (ed.): L. B. The Museum of Modern Art, New York et al. New York 1982 (cat.).– Xenakis, M.: L. B. Lieux de mémoire. Paris 1996

**BOURKE-WHITE Margaret**
**1904** New York – **1971** Stamford (CT)
American photographer. Studied at the Clarence H. White School of Photography. **1929–1933** Worked for the magazine *Fortune* and took numerous industrial photographs in Germany. From **1930–1932** made three trips to the Soviet Union, photographing machines and people. **1939** Worked with the writer Erskin Caldwell – later her husband – on a documentary of the life of tenant farmers in the southern states of America entitled *You Have Seen Their Faces*. From **1936** photographed for *Life* magazine. **1941** War correspondent in the Soviet Union and elsewhere. Took photographs of the concentration camp Buchenwald and the devastation left at the end of the war in Germany. **1956** Forced to stop working for health reasons.
MONOGRAPHS, CATALOGUES: Ayer, E. H.: M. B.-W. Photographing the World. Parsippany 1992.– M. B.-W. Amerika-Haus Berlin 1984 (cat.).– Brown, T. M.: M. B.-W. Photojournalist. Ithaca (NY) 1972.– Callahan, S. (ed.): The Photographs of M. B.-W. New York 1972, London 1973.– Goldberg, V.: M. B.-W. A Biography. New York 1986.– Silverman, J.: The Life of M. B.-W. New York 1983

**BRANCUSI Constantin**
**1876** Pestisani (Gorj) – **1957** Paris
French-Romanian sculptor. **1894–1902** Attended the School of Arts and Crafts in Craiova and the Art Academy in Bucharest. **1904** Moved to Paris. **1907** Met Rodin, already working on his first version of the sculpture *The Kiss*. Simplified his shapes to elementary abstract forms. Made friends with Modigliani, Rousseau and Léger and had contact with the Cubists. **1913** Took part in the Armory Show in New York. **1914** First solo exhibtion in Alfred Stieglitz' gallery. **1914–1918** Produced his most important wood sculptures. **1918** Beginning with his series *Endless Column*, attempted to break down the barriers between sculpture and architecture. **1937/38** Travelled to India and designed a temple. Carried out a huge sculptural project in the small Romanian town of Tîrgu-Jiu, including *Endless Column, Gate of Kisses and Table of Silence*. **1938/39** Visited Egypt, Holland, Romania and the USA. **1952** Took French

citizenship. His pure, symbolic forms strongly influenced future generations of sculptors.

CATALOGUES RAISONNES: Geist, S.: B. The Sculpture and Drawings. New York 1975.– Jianou, I.: B. Paris 1963, 1982, New York 1963
MONOGRAPHS, CATALOGUES: Aillagon J.-J. et al.: Album B. Paris 1997.– Bach, F. T.: C. B. Metamorphosen plastischer Form. Cologne 1987.– Bach, F. T.: B. Photoreflexion. Paris 1991.– Bach, F. T. et al. (ed.): C. B. Centre Georges Pompidou, Paris et al. Paris 1995 (cat.).– Balas, E.: The Sculpture of B. in the Light of His Rumanian Heritage. Ann Arbor (MI) 1982.– Balas, E.: B. and the Romanian Folk Tradition. New York 1987.– Brezianu, B.: B. in Romania. Bucharest 1976.– Bush, F. T. (ed.): C. B. 1876-1957. Philadelphia Museum of Art. Philadelphia 1995 (cat.).– Chave, A. C.: C. B. Shifting the Bases of Art. New Haven (CT) and London 1993.– Geist, S.: B. A Study of His Sculpture. New York 1968.– Geist, S. (ed.): C. B. Solomon R. Guggenheim Museum. New York 1969 (cat.).– Giedion-Welcker, C.: C. B. 1876-1957. Neuchâtel 1958, New York 1959.– Hetzler, F. M.: B. The Courage to Love. New York 1992.– Hulten, P. et al. (ed.): B. Paris 1986, New York 1987, Stuttgart 1987.– Jianou, I.: B. Paris 1963, New York 1963.– Klein, I.: C. B. Natur, Struktur, Skulptur, Architektur. 2 vols. Cologne 1995.– L'Atelier de B. Centre Georges Pompidou. Paris 1997 (cat.).– Lewis, D.: C. B. London 1957, 1975, Teufen 1958.– Miclea, I.: B. at Tirgu Jiu. Bucharest 1973.– Miller, S.: C. B. A Survey of His Work. Oxford 1995.– Partenheimer, J. (ed.): C. B. Der Künstler als Fotograf seiner Skulptur. Eine Auswahl 1902-1943. Kunsthaus Zürich. Zurich 1976 (cat.).– Salzmann, S. (ed.): C. B. Plastiken, Zeichnungen. Wilhelm Lehmbruck Museum. Duisburg 1976 (cat.).– Shanes, E.: C. B. New York 1989.– Spear, A. T.: B.'s Birds. New York 1969.– Tabart, M. and I. Monod-Fontaine (ed.): B. photographe. Centre Georges Pompidou. Paris 1977 (cat.).– Tabart, M. and I. Monod-Fontaine (ed.): B. Photographer. Centre Georges Pompidou, Paris. New York 1980 (cat.).– Varia, R.: B. New York 1986.– Viatte, G. et al. (ed.): C. B. Centre Georges Pompidou, Paris et al. Paris 1995 (cat.).– Zervos, C.: C. B. Sculptures, peintures, fresques, dessins. Paris 1957

**BRANDT Bill**
**1904** London – **1983** London
English photographer. **1929/30** Assistant to Man Ray in Paris. Interested in Surrealism. Made friends with Brassaï. **1931** Returned to England. Photo-documentary of the misery of the English people during the recession. Worked for *Verve*, *Picture Post* and *Lilliput*. **1940-1945** Began series of portraits of artists and writers. Commissioned by the British Home Office to document life in bunkers and air-raid shelters during German bombardments. From **1945** focused on nude photography, often comic, combined with

landscapes and surrealist city scenes. **1959** Stayed in Provence. **1961** Publication of *Perspective of Nudes*. **1977** Honorary doctorate from the Royal College of Art in London. **1980** Honorary member of the Royal Photographic Society of Great Britain.
WRITINGS: Warburton, N. (ed.): B. B. Selected Texts and Bibliography. Oxford and New York 1993
MONOGRAPHS, CATALOGUES: Haworth-Booth, M. (ed.): Literary Britain – Photographed by B. B. Victoria and Albert Museum. London 1984 (cat.).– Jeffrey, I. (ed.): B. B. Photographs 1929-1983. London 1994.– Mellor, D. (ed.): B. B. Behind the Camera. Philadelphia Museum of Art. Oxford and New York 1985 (cat.).– Roegiers, P.: B. B. Paris 1990.– Scharf, A. (ed.): B. B. Photographs. Hayward Gallery, London et al. London 1970 (cat.).– Turner, P. (ed.): B. B. Early Photographs 1930-1942. Hayward Gallery. London 1975 (cat.)

**BRAQUE Georges**
**1882** Argenteuil-sur-Seine – **1963** Paris French painter. Apprenticed to a decorator in Le Havre. **1902-1904** Attended the Académie Humbert and the Ecole des Beaux-Arts in Paris. **1905** Links with the Fauves. **1907** The Cézanne memorial exhibition, a meeting with Picasso, and seeing *Les Demoiselles d'Avignon* in his studio had a powerful influence on Braque's painting. **1908** His intersecting shapes and curving planes forming structural blocks, described by the critic Louis Vauxcelles as cubes. **1909-1912** Period of Analytical Cubism in which objects were broken down into a multitude of facets and presented as flat, almost unrecognisable structures. **1912** Birth of Synthetic Cubism: a bringing together of the fragmented, multi-facetted view of the subject in a compositional unit. Worked closely with Picasso until the outbreak of World War I. **1917** Resumed painting and produced monumental figure paintings, mantlepiece and table pictures and numerous landscapes. Worked with Gris. **1920** First sculptures. **1948** Received special honours at the Venice Biennale. **1952/53** Painted ceilings in the Louvre. **1956** Retrospective in the Tate Gallery, London. Beside Picasso, the most important representative of Cubist painting.
WRITINGS: G. B.: Le Jour et la nuit. Paris 1952, 1988/Der Tag und die Nacht. Zurich 1953
CATALOGUES RAISONNES: Engelberts, E. and W. Hofmann (ed.): G. B. L'œuvre graphique de G. B. Lausanne 1960. Das graphische Werk. Stuttgart 1961.– Mangin, N. S. (ed.): Catalogue de l'œuvre de G. B. 7 vols. Paris 1959-1973.– Mourlot, F. (ed.): B. lithographé. Monte Carlo 1963.– Vallier, D. (ed.): B. Catalogue raisonné de l'œuvre gravé. Paris 1982/B. Das graphische Gesamtwerk. Stuttgart 1982/B. The Complete Graphics. New York 1988.– Worms de Romilly, N. and J. Laude (ed.): B. Cubisme 1907-1917. Paris 1987.– Wünsche, H. (ed.): G. B. Das lithographische Werk. Bonn 1971

MONOGRAPHS, CATALOGUES: B. The Late Works. Royal Academy of Arts, London. New Haven (CT) 1997 (cat.).– Brunet, C.: B. et l'espace. Langage et peinture. Paris 1971.– Chipp, H. B. (ed.): G. B. The Late Paintings 1940-1963. Phillips Collection, Washington et al. Washington 1982 (cat.).– Clement, R. T.: G. B. A Bio-Bibliography. Westport (CT) 1994.– Cogniat, R. G. B. New York 1980.– Heinrichs, H.-J. (ed.): Raumgestaltungen: der Beginn der modernen Kunst im Kubismus und Werk von G. B. Frankfurt-on-Main 1978.– Hope, H. R. (ed.): G. B. The Museum of Modern Art. New York 1949 (cat.).– Leymarie, J.: G. B. Solomon R. Guggenheim Museum, New York 1988 (cat.)/G. B. Kunsthalle der Hypo-Kulturstiftung, Munich 1988 (cat.).– Leymarie, J.: B. Les Ateliers. Aix-en-Provence 1995.– Martin-Méry, G. (ed.): G. B. en Europe. Galerie des Beaux-Arts, Bordeaux et al. Bordeaux 1982 (cat.).– Monod-Fontaine, I. and E. A. Carmean (ed.): G. B. Les Papiers collés. Centre Georges Pompidou, Paris et al. Paris 1982 (cat.)/G. B. The Papiers Collés. National Gallery of Art, Washington et al. Washington 1982 (cat.).– Mullins, E.: B. London 1968.– Paulhan, J.: B. Le Patron. Paris 1987.– Ponge, F. et al.: G. B. New York 1971, Stuttgart 1972.– Pouillon, N. et al. (ed.): B. 1882-1963. Centre Georges Pompidou. Paris 1982 (cat.).– Prat, J.-L. et al. (ed.): G. B. Fondation Pierre Gianadda. Martigny 1992 (cat.).– Prat, J.-L. et al. (ed.): G. B. Retrospective. Fondation Maeght. Saint-Paul 1994 (cat.).– Rubin, W. (ed.): Picasso and B. Pioneering Cubism. The Museum of Modern Art, New York. Boston 1989 (cat.).– Rubin, W. (ed.): Picasso and B. Die Geburt des Kubismus. The Museum of Modern Art. Munich 1990 (cat.).– Zurcher, B.: B. Vie et œuvre. Paris 1988/B. Leben und Werk. Munich 1988/B. Life and Work. New York 1988

**BRAUNER Victor**
**1903** Piatra Neamtz – **1966** Paris Romanian painter. **1921** Studied briefly at the Academy of Fine Arts in Bucharest. **1924** Founded a Dada magazine *75 HP*. Exhibition of Dadaist paintings in the Mozart gallery in Bucharest. Publication of the manifesto Pictopoesie. **1930** Moved to Paris. Met Brancusi, Giacometti and Tanguy. **1933** Joined the Surrealists. **1935** and **1937** in Bucharest. **1938** Returned to Paris again. Lost one eye in a fight, having painted a one-eyed self-portrait seven years earlier. **1940** Fled to the Pyrenees and later to the Alps. Experimented with wax painting. Developed his own mythology through his paintings and poetry. **1945** Returned to Paris. **1948** Broke away from the Surrealists. From **1953** spent three years on the Côte d'Azur for his health. Worked with the ceramic artists at Vallauris. **1959** Participation in documenta 2 in Kassel. In the 50s, inspired by Heidegger's existentialist philosophy, produced many paintings on the theme of premonitions of death.

MONOGRAPHS, CATALOGUES: B. The Late Works. Royal Academy of Arts, London. New Haven (CT) 1997 (cat.).–

MONOGRAPHS, CATALOGUES: Alexandria, S.: V. B. l'illuminateur. Paris 1954.– Bozo, D. and J. Leymarie (ed.): V. B. Musée National d'Art Moderne. Paris 1972 (cat.).– Carrein, C. (ed.): V. B. Musée d'Art Moderne, Saint-Etienne et al. Saint-Etienne 1992 (cat.).– Ceysson, B. (ed.): V. B. 1903-1966. Graphik aus der Sammlung des Musée d'Art Moderne de Saint-Etienne. Villa Merkel, Galerie der Stadt Esslingen. Lyon 1991 (cat.).– Fagiolo dell'Arco, M. (ed.): V. B. L'enigma del veggente. Galleria del Sogno. Lugano 1993 (cat.).– George, P. and D. Bozo (ed.): V. B. Les Dessins de V. B. au Musée National d'Art Moderne, Centre Georges Pompidou. Paris 1975 (cat.).– Jouffroy, A.: V. B. Paris 1959.– Kuni, V.: V. B. Der Künstler als Seher, Magier und Alchimist. Untersuchungen zum malerischen und plastischen Werk 1940-1947. Frankfurt-on-Main et al. 1995.– Ottinger, D. (ed.): Les V. B. de la collection de l'Abbaye Sainte-Croix des Sables d'Olonne. Paris 1991 (cat.).– Semin, D.: V. B. Musée d'Art Moderne. Paris 1990 (cat.)

**BRECHT George**
born **1924** Halfway (OR)
American action artist and theoretician.
**1943-1945** Military service. **1946-1950** Studied natural sciences in Philadelphia. **1950-1965** Worked as a chemist and engineer. **1958/59** Studied at the New School for Social Research in New York; some courses with Cage. **1959** First solo-exhibition "Towards Events" at the Reuben Gallery in New York. Involved in key international Fluxus events and happenings. **1962** Took part in "Festum Fluxorum" in Copenhagen. From **1962** worked together with Paik, La Monte Young and Cage. **1966** Founded the Non-Ecole de Villefranche together with Filliou. **1972** Moved to Germany. Took part in documenta 5 in Kassel and later in documenta 6 and 8. **1978** Joint publication of the book *Die Scheinwelt des Paradoxons* (The Illusory World of the Paradox) with Patrick Hughes. **1983** Won the Will-Grohmann Award presented by the Berlin Academy. Brecht took part in international Fluxus events and concerts, and wrote many theoretical analyses of the relationship between aspects of new music and specific environments.
WRITINGS: G. B.: Change Imagery. New York 1966.– G. B. and R. Filliou: Games at the Cedilla, or the Cedilla Takes Off. New York 1967.– G. B. and P. Hughes: Vicious Circles and Infinity. New York 1975.– Daniels, D. and H. Braun (ed.): G. B. Notebooks 3 vols. Cologne 1991
MONOGRAPHS, CATALOGUES: Frank, P. et al. (ed.): G. B. Works 1957-1973. Onnasch Galerie. New York 1973 (cat.).– Martin, H.: An Introduction to G. B.'s "Book of the Tumbler on Fire". Milan 1978.– Schmidt-Miescher, M. et al. (ed.): Jenseits von Ereignissen. Texte zu einer Retrospektive von G. B. Kunsthalle Bern. Bern 1978 (cat.)

**BRISLEY Stuart**
born **1933** Haslemere
English performance artist. Studied painting at the Munich Academy. **1960–1964** Lived in America. **1966** First performances. Since **1971** member of the Performance Art Cooperative of the British Artists Union. Presently working with other artists on performances extending over several days and representing a temporal dimension linked with a sense of human alienation. **1973–1974** Scholarship from the DAAD (German academic exchange programme) to Berlin. Since **1974** taught at the Slade School, London. **1977** Participation in documenta 6 in Kassel. Brisley belongs to the Artist Placement Group, who incorporate the passage of time into their works.
MONOGRAPHS, CATALOGUES: S. B. Tate Gallery. London 1982 (cat.).– S. B. Georgiana Collection. Third Eye Centre. Glasgow 1986 (cat.).– Nairne, S. (ed.): S. B. Institute of Contemporary Arts. London 1981 (cat.)

**BROODTHAERS Marcel**
**1924** Brussels – **1976** Cologne
Belgian artist. Began his career as a lyrical abstractionist. **1940** Had contact with Magritte. From **1945** connected to Groupe Surréaliste-révolutionnaire (The Surrealist Revolutionaries). **1957** Publication of first volume of poetry *Mon livre d'Ogre* and his first film *La clef de l'Horloge*. From **1964** wrote critiques of exhibitions of contemporary American art. First objects and pictorial works. **1968** Founded the fictitious Musée d'Art Moderne, Department des Aigles with sections on the 17th and 19th centuries, Cinéma and Des Figures, by means of which he referred in disparaging quotes and ironic descriptions of art institutions and theories of art. **1969** Became acquainted with Byars. **1970** Moved to Düsseldorf and in **1972** to London. **1973–1975** Scholarship from the DAAD (German academic exchange programme) to Berlin. **1972–1975** Series of exhibitions in which he took recourse to 19th century techniques to illustrate his new concept of art. **1977** and **1982** participation in documenta 6 and 7 in Kassel.
WRITINGS: M. B. Correspondances, Korrespondenzen. Ed. by Galerie Hauser & Wirth, Zurich, and Gallery David Zwirner,

New York. Stuttgart 1995.– Buchloh, B. H. D. (ed.): M. B. Writings, Interviews, Photographs. Cambridge 1988.– Dickhoff, W. (ed.): M. B. Interviews und Dialoge 1946-1976. Cologne 1994
CATALOGUES RAISONNES: Borja-Villel, M. et al. (ed.): M. B. Cinema. Barcelona 1997 (cat.).– Brachot, I. (ed.): M. B. Œuvres 1963-1975. Brussels 1990 (cat.).– M. B. Katalog der Bücher 1957-1975. Galerie Werner. Cologne 1982 (cat.).– M. B. The Complete Prints. Gallery Werner. New York 1991 (cat.).– Lubbers, F. (ed.): M. B. Projections. Stedelijk Museum. Eindhoven 1994 (cat.).– Nobis, N. and W. Meyer (ed.): M. B. Katalog der Editionen, Graphik und Bücher. Hanover et al. 1996.– Nuyens, M.-C. (ed.): M. B. Het volledig grafisch werk en de boeken / Komplettes graphisches Werk und Bücher. Knokke-Duinbergen 1989
MONOGRAPHS, CATALOGUES: Borgemeister, R. and P. Viaccoz (ed.): M. B. L'œuvre graphique. Centre Genevois de gravure contemporaine. Geneva 1991 (cat.).– M. B. L'Angelus de Daumier. 2 vols. Centre Georges Pompidou. Paris 1975 (cat.).– M. B. Œuvres 1963-1975. Galerie Isy Brachot. Brussels 1990 (cat.).– Compton, M. and B. Reise (ed.): M. B. Tate Gallery. London 1980 (cat.).– Compton, M. et al. (ed.): M. B. Museum of Contemporary Art, Los Angeles et al. Los Angeles 1990.– Cuenat, P. (ed.): M. B. Autour de la Lorelei / En lisant la Lorelei. 2 vols. Musée d'Art Moderne et Contemporain, Geneva 1997 (cat.).– David, C. (ed.): M. B. Galerie Nationale du Jeu de Paume, Paris et al. Paris 1991 (cat.).– De Vree, F.: M. B. Œuvres 1963-1970. Brussels 1990.– Gevaert, Y. (ed.): M. B. Catalogue. Palais des Beaux-Arts. Brussels 1974 (cat.).– Gilissen, M. (ed.): M. B. in Zuid-Limburg. Fotos 1961-1970. Bonnefantenmuseum. Maastricht 1987 (cat.).– Gilissen, M. (ed.): M. B. La salle blanche, l'emsemble des plaques et l'entrée de l'exposition. Bienal Internacional de São Paulo. São Paulo 1994 (cat.).– Gilissen, M. and B. H. D. Buchloh (ed.): M. B. Musée d'Art Moderne. Marian Goodman Gallery. New York 1995 (cat.).– Goldwater, M. and M. Compton (ed.): M. B. Walker Art Center, Minneapolis et al. New York 1989 (cat.).– Marí, B. (ed.): M. B. L'Architecte est absent. Le Maçon. Fondation pour l'architecture, Brussels. Ghent 1991 (cat.).– Weiss, E. et al. (ed.): M. B. Museum Ludwig. Cologne 1980 (cat.).– Zwirner, D. (ed.): M. B. Korrespondenzen. Galerie Hauser & Wirth, Zurich et al. Zurich and New York 1995 (cat.).– Zwirner, D.: M. B. Die Bilder die Worte die Dinge. Cologne 1997

**BRUCH Klaus vom**
born **1952** Cologne
German video artist. **1975/76** Studied at the California Institute of the Arts in Valencia. **1976–1979** Studied philosophy at Cologne University. Put together videotapes like collages of film sequences on sociological and political themes. **1984** Took part in the

Venice Biennale. **1986** Stopped producing videotapes and focused on video-installations. **1987** Took part in documenta 8 in Kassel. Since **1991** Professorship at the Karlsruhe School of Design. **1996** Stage sets for the opera house in Frankfurt am Main.
MONOGRAPHS, CATALOGUES: Andersson, P. (ed.): K. v. B. Surface to Surface. Installation 1989. Moderna Museet. Stockholm et al. Stockholm 1989 (cat.).– K. v. B. Radarraum. Städtisches Museum Abteiberg. Cologne 1988 (cat.).– K. v. B. Arbeiten 1987-1989. Städtische Kunsthalle Düsseldorf. Düsseldorf 1989 (cat.).– Haenlein, C. (ed.): K. v. B. Video-Iinstallationen. Kestner-Gesellschaft. Hanover 1990 (cat.).– Mecky, A. et al. (ed.): K. v. B. Jam-Jam-Projekt. Kölnischer Kunstverein. Cologne 1993 (cat.)

**BRÜNING Peter**
**1929** Düsseldorf – **1970** Ratingen
German painter. **1950** Studied at the Stuttgart Academy under Baumeister. **1952–1954** Travelled to Spain, Italy and France. Through Cubism developed his own abstract and autonomous pictorial language. **1955** Cornelius scholarship from the City of Düsseldorf. First experiments in Tachisme. Affinity to L'art informel. **1961** Selected for the Villa Romana Award. **1964** Received special honours at the III. International Biennale for young artists in Tokyo. **1969** Professor of Painting at the Academy in Düsseldorf. Constructed objects outside in the open-air. Brüning is one of the main exponents of Lyrical Abstraction in Germany.
CATALOGUES RAISONNES: Otten, M.-L.: P. B. Studien zur Entwicklung und Werk. Werkverzeichnis der Bilder und Objekte. Cologne 1988.– Otten, M.-L.: P. B. das zeichnerische Werk. Mit dem Werkverzeichnis der Zeichnungen. Cologne 1977
MONOGRAPHS, CATALOGUES: P. B. Städtische Kunsthalle Mannheim et al. Mannheim 1962 (cat.).– Dienst, R. G.: P. B. Recklinghausen 1973.– Dienst, R.-G. et al. (ed.): P. B. Superländer und Signale. Kunstverein für die Rheinlande und Westfalen. Düsseldorf 1970 (cat.).– Dienst, R.-G. et al. (ed.): P. B. Retrospektive. Moderne Galerie des Saarland Museums, Saarbrücken et al. Cologne 1988 (cat.).– Motte, M. d. la and M.-L. Otten: P. B. Berlin 1989.– Nobis, N. et al. (ed.): P. B. Arbeiten auf Papier 1952-1970. Sprengel Museum, Hanover et al. Cologne 1997 (cat.)

**BRUS Günter**
born **1938** Ardning (Steiermark)
Austrian action artist and writer. **1950–1956** Studied at the School of Arts and Crafts in Graz and at the Vienna Academy of Applied Arts. **1963** First solo-exhibition "Malerei-Selbstbemalung-Selbstverstümmelung" (Painting-Self-decoration-Self-mutilation) **1964** Together with Otto Muehl, Nitsch and Schwarzkogler founded Wiener Aktionismus. **1968** Sentenced to six months

imprisonment for degrading the Austrian national symbol and offending public morals and modesty through his Action painting *Art + Revolution* at the University of Vienna. **1969–1976** Editor of the magazine *Die Schastrommel*. **1970** Last Action painting *Zerreißprobe* in Munich. **1971** Publication of his novel *Irrwisch*. **1972–1982** Took part in documenta 5 – 7 in Kassel. **1974** Together with Arnulf Meifert founded the *I. Deutsches Trivialeum*. **1980** Participation in the Venice Biennale. Touring exhibition "Bild-Dichtungen" (Picture Poems).
WRITINGS: Amannshauser, H. and D. Ronte (ed.): G. B. Der Überblick. Salzburg and Vienna 1986.– G. B.: Irrwisch. Frankfurt-on-Main 1971.– G. B.: Der Geheimnisträger. Roman. Salzburg and Vienna 1984.– G. B.: Morgen des Gehirns, Mittag des Mundes, Abend der Sprache. Schriften 1984-1988. Salzburg 1993
MONOGRAPHS, CATALOGUES: Fuchs, R. (ed.): G. B. Augensternstunden. Stedelijk Van Abbe Museum, Eindhoven 1984 (cat.).– Grenier, C. (ed.): G. B. Limite du visible. Centre Georges Pompidou. Paris 1993 (cat.).– Meifert, A.: G. B. Zeichnungen und Schriften. Kunsthalle Bern. Bern 1976.– Meifert, A. (ed.): G. B. Blitzartige Einfälle in vorgegebenen Ideen. Neue Galerie im Landesmuseum Graz. Graz 1996 (cat.).– Serota, Nicholas et al. (ed.): G. B. Bild-Dichtungen. Whitechapel Art Gallery, London 1980 (cat.)

**BRUSKIN Grigori**
born **1945** Moscow
Russian painter. **1963–1968** Studied in the Faculty of Applied and Decorative Art at the Textile Institute in Moscow. **1966** First exhibition of his works with other young artists in Moscow. From **1969** member of the Artists' Association of the USSR. After **1980** in contact with Moscow intellectuals and artists propounding alternative lifestyles, including Dimitri Prigov. **1983** Forced closure of a one-man exhibition in Wilna. Ordered to explain his paintings to the Moscow Artists' Association. From **1983** worked on the series *Alefbet and Lexika*. **1984** Another exhibition cancelled by the Cultural Department of the Moscow City Soviets. **1988** One of Bruskin's works fetched a record price for contemporary Russian art at a Sotheby's auction in Moscow.

## BUCHHEISTER Carl

**1890** Hanover – **1964** Hanover
German painter. Studied art in Hanover and Berlin. **1921** Friendship with Kurt Schwitters. From **1923** his painting became more abstract. **1925** Contact with van Doesburg and De Stijl. **1926** First solo-exhibition at the gallery Der Sturm, in Berlin. **1928** President of the artists' group Die Abstrakten Hannover (The Hanoverian Abstractionists), also joined by Schwitters and Vordemberge-Gildewart. **1932–1936** Member of Abstraction-Création. **1933** Denounced by the Nazis and forbidden to paint. **1945** Resumed painting and founded the artists' association for north-west Germany. Since **1954** professor at the Meisterschule in Hanover.
WRITINGS: Rump, G. C. (ed.): B. Schriften und Briefe in Auswahl. Hildesheim 1980
CATALOGUES RAISONNES: Buchheister, E. and W. Kemp (ed.): C. B. Werkverzeichnis der abstrakten Arbeiten. 2 vols. Cologne 1998.– Buchheister, E. and W. Kemp (ed.): C. B. 1890-1964. Werkverzeichnis der gegenständlichen Arbeiten, Gemälde, Gouachen, Aquarelle, Zeichnungen, typografische Arbeiten, Druckgraphik. Nuremberg 1986
MONOGRAPHS, CATALOGUES: Büchner, J. and P. Lottner (ed.): C. B. Sprengel Museum. Hanover 1990 (cat.).– Fath, M. (ed.): C. B. Städtische Kunstsammlungen, Ludwigshafen et al. Ludwigshafen 1975 (cat.).– Holeczek, B. et al. (ed.): C. B. Gemälde und Zeichnungen. Verzeichnis der Bestände. Ausstellung zum 90. Geburtstag. Kunstmuseum mit Sammlung Sprengel. Hanover 1980 (cat.).– Lange, R.: C. B. Göttingen 1964.– Lange, R. (ed.): C. B. Kunstverein Hannover. Hanover 1964 (cat.).– Schönewald, U. (ed.): C. B. Altes Rathaus. Göttingen 1994 (cat.)

## BUCHHOLZ Erich

**1891** Bromberg – **1972** Berlin
German painter. **1911–1915** Taught at an elementary shcool. From **1915** lived in Berlin. **1917** Engaged as artistic director at the theatre in Bamberg. Member of the Novembergruppe. **1919** First abstract and geometric works. **1921** Exhibition at Herwarth Walden's gallery Der Sturm, in Berlin. Contact with Lissitzky, the Dadaists led by

Richard Huelsenbeck in Berlin and Hausmann, Mies van der Rohe and Moholy-Nagy. **1925** Left Berlin to live in the country. From **1926** involved in the "Große Berliner Kunstausstellung". **1933** Banned from exhibiting by the Nazis. Resumed painting after World War II. Retrospectives at the Rose Fried Gallery in New York **1956**, Munich and Ludwigshafen **1979**, and Tübingen **1996**.
WRITINGS: E. B.: Rotes Heft 1. Berlin 1927.– E. B.: Die große Zäsur. Berlin 1953.– E. B.: Grundelemente. (n. p.) 1970
MONOGRAPHS, CATALOGUES: E. B. Galerie Teufel. Cologne 1978 (cat.).– Buchholz, M. and E. Roters (ed.): E. B. Berlin 1993.– Heckmanns, F. W. (ed.): E. B. Städtisches Kunstmuseum Düsseldorf et al. Cologne 1978 (cat.).– Wiesenmayer, I.: E. B. (1891-1972). Tübingen 1996

## BUFFET Bernard

born **1928** Paris
French painter and graphic artist. **1944** Studied at the Ecole des Beaux-Arts in Paris. **1946** Exhibited at the Salon des Indépendants. **1948** Critics Award. Member of the anti-abstract artists' group L'homme témoin. From **1950** worked on the series *Christ's Passion* (1952), *The Circus* (1956) and *Bullfight* (1967) as well as on book illustrations. Buffet's ascetic and realistic paintings portray fear, suffering, poverty and the experience of war.
WRITINGS: B. B.: Les Oiseaux. Paris 1960
CATALOGUES RAISONNES: Pichon, J. Le (ed.): B. B. 1943-1981. 2 vols. Paris 1986.– Mourlot, F. (ed.): B. B. Lithographies 1952-1966. Paris 1967.– Reinz, G. F. (ed.): B. B. Gravures 1948-1967. Nice 1968, Cologne 1968, New York 1968.– Rheims, M. (ed.): B. B. Graveur. Catalogue raisonné de l'œuvre gravé de 1948-1980. Paris 1984.– Simenon, G. (ed.): B. B. Lithographs 1952-1966. New York 1968.– Sorlier, C. (ed.): B. B. Litographe. 2 vols. Monte Carlo 1975-1979, San Francisco 1987
MONOGRAPHS, CATALOGUES: Avila, A. A.: B. B. Paris 1989.– Bergé, P.: B. B. Geneva 1958.– B. B. Geneva 1964.– Cabanne, P.: B. B. Paris 1966.– Descargue, P.: B. B. Paris 1952.– Druon, M.: B. B. Paris 1964.– Giono, J.: B. B. Paris 1956.– Le Pichon, Y.: B. B. 1943-1981. Paris 1986.– Letze, O. and T. Buchsteiner (ed.): B. B. Retrospektive. Documenta-Halle, Kassel. Stuttgart 1994 (cat.).– Mourlot, F.: B. B. œuvre gravé. Paris 1967

## BULATOV Erik

born **1933** Sverdlovsk
Russian painter. **1947–1952** Participate in a drawing group in the Pioneers' House. Studied at the Technical College of Art in Moscow. **1952–1958** Studied painting at the Surikov Art Institute. **1957** Exhibited *At the Source* in the Soviet pavilion at the World Youth Festival in Moscow. From **1959** illustrated children's books. **1965** Tried to put on his first exhibition at the Kurtshatov

Institute for Nuclear Physics. Forced to remove his paintings one hour after the opening. **1967** Admitted to the Moscow Association of Book Illustrators. **1968–1986** Joint-exhibition with Kabakov in the young people's café Der blaue Vogel. Further exhibitions in Moscow and at the museum in the city of Tartu, Estonia. **1986** One of his most important works, the painting *The Poet Vsevolod Nekrassov*, shown at the Art Fair in Chicago.
MONOGRAPHS, CATALOGUES: E. B. Kunsthalle Zürich et al. Zurich 1988 (cat.).– E. B. Centre Georges Pompidou. Paris 1989 (cat.).– Jolles, C. et al. (ed.): E. B. Moscow. Institute of Contemporary Arts, London et al. London 1989 (cat.)

## BURDEN Chris

born **1946** Boston
American performance artist. **1969–1971** Studied sculpture at the University of California, Irvine, graduating with a Master's degree in Fine Arts. The extreme dimensions of his sculptures, reaching heights of 60 m, rendered his objects inaccessible and awakened a desire for a return to human dimensions. He then took up Body Art. From **1971** events, performances and videos exploring the limits of physical and psychic tolerance to enable the viewer to experience extreme physical situations. **1974** Built vehicles and gave lectures about them. **1977** Participation in documenta 6 in Kassel.
WRITINGS: Perrin, F. (ed.): C. B. Un livre de survie. Paris 1995
MONOGRAPHS, CATALOGUES: C. B. Musée d'Art Contemporain. Marseille 1996 (cat.).– C. B. Born in the USA. Österreichisches Museum für angewandte Kunst. Vienna 1996 (cat.).– Hsayre, M.: C. B. The Object of Performance. Chicago 1989.– Kuspit, D. et al. (ed.): C. B. A Twenty-Year Siurvey. Newport Harbor Art Museum et al. Newport Beach 1988 (cat.).– Mourne, G. et al. (ed.): C. B. Barcelona 1996 (cat.)

## BUREN Daniel

born **1938** Boulogne-sur-Seine
French artist. **1965** Together with Olivier Mosset, Michel Parmentier and Niele Toroni founded the group BMPT whose aim was to reduce painting to a few basic elements. **1969** Worked around Paris. **1971**

Installation in the Guggenheim Museum, New York. **1972–1982** Participation in documenta 5 – 7 in Kassel. **1976** DAAD scholarship to Berlin. Buren's backgrounds were always alternating white and coloured stripes painted onto various grounds or prefabricated as in awning canvas. Through their definite spacing, striped paintings create a tight interweaving of space and form.
WRITINGS: D. B.: Limites critiques. Paris 1970.– D. B.: Rebondissements. Brussels 1977.– D. B.: Entrevue. Conversations avec A. Baldassari. Paris 1987.– D. B.: Les Ecrits 1965-1990. 3 vols. Musée d'Art Contemporain de Bordeaux. Bordeaux 1991 (cat.).– Celant, G. (ed.): D. B. Scritti 1967-1979. Milan 1979.– Fietzek, G. and G. Inboden: D. B. Achtung! Texte 1969-1994. Dresden 1995.– Poinsot, J.-M. (ed.): D. B. Les écrits 1965-1990. 3 vols. Bordeaux 1991
MONOGRAPHS, CATALOGUES: Baldassari, A.: D. B. Entrevue. Paris 1987.– Buchloh, B. H. D. (ed.): D. B. Les Couleurs: sculptures. Les Formes: peintures. Centre Georges Pompidou, Paris et al. Paris 1981.– D. B. Ponctuations. Statue/ Sculpture. Lyn 1980.– D. B. Photos Souvenirs 1965-1985. Le Nouveau Musée. Villeurbanne 1987 (cat.).– Couderc, S. et al. (ed.): D. B. Arguments topiques, CAPC Musée d'Art Contemporain de Bordeaux. Bordeaux 1991 (cat.).– Francklin, C.: D. B. Paris 1987.– Granath, O. (ed.): D. B. Coincidences. Arbeiten in situ. Moderna Museet. Stockholm 1984 (cat.).– Inboden, G. and J. Meinhardt (ed.): D. B. Staatsgalerie Stuttgart. Stuttgart 1990 (cat.).– Krystof, D. et al. (ed.): D. B. Erscheinen. Scheinen. Verschwinden. Kunstsammlung Nordrhein-Westfalen. Düsseldorf 1996 (cat.).– Lyotard, J.-F.: Über D. B. Stuttgart 1987.– Mahr, B. and H. Merten (ed.): D. B. Voile/Toile, Toile/Voile. Akademie der Künste. Berlin 1975 (cat.).– Maubant, J.-L. (ed.): D. B. Erinnerungsphotos 1965-1988. Basel 1989.– Martin, J.-H. and R. Fuchs (ed.): D. B. So ist es und anders. Kunsthalle Bern. Bern 1983 (cat.).– Nuridsany, M. (ed.): D. B. au Palais-Royal. "Les deux plateaux". Le Nouveau Musée. Villeurbanne 1993 (cat.).– Parmentier, M. (ed.): D. B. Propos délibérés. Le Nouveau Musée. Villeurbanne 1991 (cat.)

## BURRI Alberto

**1915** Città di Castello (Perugia) – **1995** Nice
Italian painter. **1934–1939** Studied medicine in Perugia. Served four years as a military doctor in North Africa. **1945** On returning from prisoner of war camp in America, gave up his medical career and started to paint full-time. **1949** First abstract paintings, the *Catrame*, in tar and oil on canvas. **1950** Together with Capogrossi, Ettore Colla and others, founded Gruppo Origine in Rome. **1952** First sack pictures and experiments with materials such as wood, metal and plastic. **1953–1960** Worked as an art teacher in the USA. **1959–1982** Participation in documenta 2, 3 and 7

in Kassel. **1960** Returned to Rome. **1973** First *Cretto*, a clay picture the aesthetic attraction of which lies in the cracks formed when the kaolin surface cracks open on firing. **1976** Created a monumental *Grande Cretto Nero* for the sculpture garden at the University of California in Los Angeles. **1981** Plans to transform the ruins of the town of Gibellina in Sicily, destroyed by an earthquake, into a huge Cretto. Work began in **1985** but the project was abandoned in **1989**. Burri was a pioneer of monochrome reduction and the transformation of pictures into 3-dimensional objects. In his works he developed an individual polymaterialistic style, combining elements of Neo-Dadaism, material Informel, Constructivism and Arte Povera.
CATALOGUE RAISONNE: Zamboni, G. P. et al. (ed.): A. B. Contributi al catalogo sistematico. Città di Castello 1990
MONOGRAPHS, CATALOGUES: Christov-Bakargiev, C. et al. (ed.): A. B. Palazzo delle Esposizioni, Romaa et al. Milan 1997 (cat.).– Christov-Bakargiev, C. and M. G. Tolomeo (ed.): A. B. Opere 1944-1995. Palazzo delle Esposizioni, Roma et al. Milan 1996 (cat.).– Brandi, C.: A. B. Roma 1955, 1963.– Brandi, C.: Collezione Burri. Città di Castello 1982.– Calvesi, M.: A. B. Milan 1971.– Caroli, F.: A. B. La forma e l'informe. Milan 1979.– Collezione B. Citta di Castello. Perugia 1986 (cat.).– Engelke, I. S.: A. B. Betrachtungen, Analysen, Materialien zum Werkabschnitt 1944-1990. Hamburg 1991.– Mantura, B. and G. De Feo (ed.): A. B. Galleria Nazionale d'Arte Moderna. Roma 1976 (cat.).– Nordland, G. (ed.): A. B. A Retrospective View 1948-1977. The Frederick S. Whight Art Gallery, University of California. Los Angeles 1977 (cat.).– Pirovano, C. (ed.): B. Pinacoteca di Brera. Milan 1984 (cat.).– Pirovano, C. (ed.): A. B. Palazzo Pepoli Campogrande, Bologna. Florence 1991 (cat.).– Rubio, V.: A. B. Torino 1975.– Steingräber, E. (ed.): A. B. Il viaggio. Staatsgalerie moderner Kunst. Munich 1980 (cat.)

**BURY Pol**
born **1922** Haine-Saint-Pierre
Belgian painter and sculptor. **1938** Studied at the Académie des Beaux-Arts in Mons. **1943** Member of the surrealist group Jeune Peinture Belge (Young Belgian Painters).

**1949** Co-founder of the artists' association Cobra. **1952** Joined the group Abstrakte Kunst (Abstract Art). Developed an interest in displacement of space and time, which led in **1953** to his first kinetic objects *Plans mobiles*. **1955** Participated in the exhibition "Mouvement" at the Denise René gallery in Paris. **1964** Travelled to New York. Took part in the Venice Biennale and documenta 3 in Kassel. From **1970** taught at the University of California, Berkeley. **1979** Work on monumental sculptures. Designed large public fountains in Paris and Brussels, and for the Guggenheim Museum in New York. **1983** Professor of Sculpture at the Ecole Nationale Supérieure des Beaux-Arts in Paris.
WRITINGS: P. B.: La Boule et le trou. Brussels 1961.– P. B.: L'Art à bicyclette et la révolution à cheval. Paris 1972.– P. B.: Les Gaietés de l'esthétique. Paris 1984.– P. B.: Le Monochrome bariolé. Paris 1991
MONOGRAPHS, CATALOGUES: Abadie, D. (ed.): P. B. CNAC. Paris 1970 (cat.).– Ashton, D.: P. B. Paris 1970.– Balthazar, A.: P. B. Milan 1967.– Balthazar, A. and W. Schmied (ed.): P. B. Kestner-Gesellschaft. Hanover 1971 (cat.)/ P. B. Städtische Kunsthalle Düsseldorf. Düsseldorf 1972 (cat.).– P. B. Solomon R. Guggenheim Museum. New York 1971 (cat.).– P. B. Musée d'Art Moderne de la Ville de Paris, Paris 1982 (cat.).– Pahlke, R. E. (ed.): P. B. Museum am Ostwall, Dortmund et al. Dortmund 1994 (cat.).– P. B. Miroirs et fontaines. Galerie A. Maeght. Paris 1995 (cat.).– P. B. and P. Alechinsky: Le Dérisoire absolu. La Louvière 1980.– Dorchy, H.: P. B. et le temps dilaté. Brussels 1976.– Ionesco, E. and A. Balthazar: P. B. Brussels 1976.– Langui, E. (ed.): P. B. 25 tonnes de colonnes. Fondation Maeght, Saint-Paul. Paris 1974 (cat.).– Selz, P. (ed.): P. B. University Art Museum, Berkeley et al. Berkeley 1970 (cat.)

**BUTLER Reg**
**1913** Buntingford (Hertfordshire) –
**1981** Berkhamstead (Hertfordshire)
English sculptor. **1937** Studied architecture and became a member of the Royal Institute of British Architects. **1941** Conscientious objecter. Worked as a smith in Sussex. **1944** First sculptures inspired by Giacometti. **1950**–**1953** Taught at the Slade School in London and at the University of Leeds. **1953** Won an international competition for a *Monument to the Unknown Political Prisoner*. **1955** Participation in documenta 1 in Kassel. Together with Chadwick and Armitage, the first of the post-war generation of abstract metal sculptors in England.
WRITINGS: R. B.: Creative Development. Five Lectures to Art Students. London 1962
MONOGRAPHS, CATALOGUES: Bowness, A. et al. (ed.): R. B. Tate Gallery. London 1983 (cat.).– R. B. Pierre Matisse Gallery. New York 1973 (cat.).– Calvocoressi, R. (ed.): R. B. Tate Gallery. London 1983 (cat.)

**BYARS James Lee**
**1932** Detroit – **1997** Cairo
American performance and concept artist. Studied at the Merill Palmer School and at Wayne State University. **1958** One-year visit to Japan. Later lived mainly in Kyoto, being intensely interested in Japanese culture and philosophy. **1960** William Copley Award. **1965** Staged the performance *A Mile Long Paper Walk*. Numerous works over the following years were characterised by a concentrated stillness, in the spirit of Japanese tradition. **1969** Travelled to Europe. Met Broodthaers and Beuys. Participated regularly in subsequent documenta and the Venice Biennale. **1974** DAAD scholarship to Berlin. After **1975** reduction of sculptures to basic forms such as circles or spheres, and increasing use of granite, marble, glass and *objets trouvés* (found objects). **1977**–**1987** Participation in documenta 6 – 8 in Kassel.
WRITINGS: J. L. B. im Gespräch mit J. Sartorius. Cologne 1996
CATALOGUE RAISONNE: Deecke, T. and G. Schraenen (ed.): J. L. B. Perfect is My Death Word. Bücher, Editionenen, Ephemera. Bremen 1995
MONOGRAPHS, CATALOGUES: J. L. B. Golddust is My Wxlibris. Musée d'Art Moderne de la Ville de Paris. Paris 1983 (cat.).– Deecke, T. (ed.): J. L. B. im Westfälischen Kunstverein. Münster 1982 (cat.).– Elliott, J. (ed.): The Perfect Thought. Works by J. L. B. University Art Museum, University of California. Berkely 1990 (cat.).– Gachnang, J. (ed.): J. L. B. Kunsthalle Bern. Bern 1978 (cat.).– Harten, J. (ed.): J. L. B. The Philosophical Palace/ Palast der Philosophie. Städtische Kunsthalle Düsseldorf. Düsseldorf 1986 (cat.).– Heil, H. et al. (ed.): J. L. B. The Perfect Moment. IVAM Centro Julio González, Valencia 1995 (cat.).– Todoli, V. (ed.): J. L. B. The Palace of the Perfect. Villa Serralves. Porto 1997 (cat.).– Winkler, R.: J. L. B. Cologne 1985

**CAGE John**
**1912** Los Angeles – **1992** Los Angeles
American composer. **1930** Studied architecture and took music lessons in France. **1931** –**1937** Studied composition at the New School of Social Research in New York and at the University of California in Los Angeles, under Arnold Schönberg. Intensely interested in Far-Eastern philosophy. **1938**

Taught at Mills College, California, where he became acquainted with László Moholy-Nagy. **1941** Lectured in experimental music at Chicago Institute of Design. **1942** Moved to New York, where he met Mondrian, Breton and Duchamp. From **1946** Musical Director of the Merce Cunningham Dance Company. **1948** Taught at Black Mountain College, North Carolina. From **1950** aleatoric compositions and experiments with unusual purpose-built instruments, computers and audiotapes. Incorporation of theatrical elements into his musical compositions. **1952** Performance of the composition 4'33, inspired by Rauschenberg's *White Paintings*. Together with Merce Cunningham and Rauschenberg, organised early forms of happenings. **1956**–**1958** Taught at the New School of Social Research, New York. By incorporating aleatoric elements and everyday sounds into his works, Cage contributed significantly to a broadening of the definitions of classical music and art.
WRITINGS: J. C.: Silence. Lectures and Writings. Middletown (CT) 1963, London 1968, Frankfurt-on-Main 1995.– J. C.: A Year from Monday. New Lectures and Writings. Middletown (CT) 1967.– J. C.: Notations. New York 1969.– J. C.: Writing Through Finnegans Wake. New York 1978.– J. C. I-IV. The Charles Eliot Norton Lectures 1988/89. Cambridge (MA) 1990.– Kostelantz, R. (ed.): J. C. Writer. New York 1993.– Nattiez, J.-J. (ed.): J. C. & Pierre Boulez. Der Briefwechsel. Hamburg 1997
MONOGRAPHS, CATALOGUES: Amiot, A.-M. et al. (ed.): J. C. Toulouse 1988.– Bischoff, U. (ed.): J. C. als Grenzbeschreibung J. C. und die Moderne. Neue Pinakothek. Munich 1992 (cat.).– J. C. An Anthology. New York 1991.– Campana, D. A.: Form and Structure in the Music of J. C. Ann Arbor (MI) 1985.– Charles, D.: J. C. oder Die Musik ist los. Berlin 1979.– Charles, D.: J. C. Pour les oiseaux. Entretiens avec D. Charles. Paris 1976/ Für die Vögel. J. C. im Gespräch mit D. Charles. Berlin 1984.– Erdmann, M.: Untersuchungen zum Gesamtwerk von J. C. Bonn 1993.– Fürst-Heidtmann, M.: Das präparierte Klavier des J. C. Regensburg 1979.– Gena, P. (ed.): A. J. C. Reader. New York 1982.– Kostelanetz, R. (ed.): J. C. New York 1970, London 1971.– Kostelanetz, R. (ed.): J. C. im Gespräch. Cologne 1989.– Kostelanitz, R. (ed.): J. C. An Anthology. New York 1991.– Kostelanitz, R. (ed.): Writings about C. Ann Arbor (MI) 1994.– Lazar, J. et al. (ed.): J. C. Rolywholyover. New York 1993.– Metzger, H.-K. and R. Riehn (ed.): J. C. I. Munich 1978.– Pritchett, J. W.: The Development of Chance Techiques in the Music of J. C. New York 1988.– Pritchett, J. W.: The Music of J. C. Cambridge 1993.– Revill, D.: The Roaring Silence. J. C. a Life. New York 1992/ Tosende Stille. Eine J. C. Biographie. Munich 1995

**CALDER Alexander**
**1898** Philadelphia – **1976** New York
American sculptor. **1916**–**1919** Studied

engineering in New Jersey. **1923-1925** Attended the Art Students League in New York. **1926** Lived in Paris where his acquaintance with Miró inspired him to create animal and plant figures out of steel wire that were exhibited in the New York Salon des Indépendants in **1928**. **1929** Met Mondrian, van Doesburg and Léger. Experiments with mobile wire constructions. **1931** Joined the group Abstraction-Création. From **1932** made mechanical and later airborne sculptures, termed *Mobiles* by Duchamp. **1936** Works shown at the exhibition "Cubism and Abstract Art" at the Museum of Modern Art, New York make him famous throughout the USA. **1935/36** Various stage designs for the choreographer Martha Graham. **1941** Constructed large mobile sculptures, termed *Stabiles* by Arp. **1943** Retrospective in New York. **1952** Received special honours at the Venice Biennale. **1955-1964** Participation in documenta 1-3 in Kassel. **1968** Produced the largest stabile *Red Sun* (24 m high) and the largest mobile *Red, Black and Blue* (14 m wide). In Calder's sculptures elements of Abstract Surrealism are combined with a severe Constructivism. In the 60s and 70s, his monumental steel constructions gave a new impetus to sculpture in public places.
WRITINGS: A. C.: An Autobiography with Pictures. New York 1966/Autobiographie. Paris 1972
CATALOGUE RAISONNE: Caradente, G. (ed.): C. Palazzo a Vela, Torino. Milan 1983 (cat.)
MONOGRAPHS, CATALOGUES: Abadie, D. and P. Hulten (ed.): A. C. Die großen Skulpturen. Der andere C. Kunst- und Ausstellungshalle der Bundesrepublik Deutschland, Bonn. Stuttgart 1993 (cat.).– Arnason, H. H.: C. Princeton (NJ) 1966.– Arnason, H. H. and U. Mulas: C. New York 1971, Paris 1971, Munich 1971.– Besset, M. (ed.): C. Haus der Kunst, Munich et al. Munich 1975 (cat.).– Bourdon, D.: A. C. Mobilist/Ringmaster/Innovator. New York 1980.– Bruzeau, M. and J. Masson: C. New York 1979.– A. C. Stedelijk Museum, Amsterdam et al. Amsterdam 1959 (cat.).– A. C. Fondation Maeght. Saint-Paul 1969 (cat.).– A. C. Whitney Museum of American Art. New York 1976 (cat.).– A. C. 1898-1976. Musée National d'Art Moderne. Paris 1996 (cat.).– A. C. The Major Sculptures. New York (n. d.).– Elsen, A. E. (ed.): A. C. A Retrospective Exhibition. Works from 1925 to 1974. Museum of Contemporary Art. Chicago 1974 (cat.).– Gibson, M.: C. Paris 1988.– Lipman, J. (ed.): C.'s Circus. Whitney Museum of American Art. New York 1972 (cat.).– Lipman, J. and R. Wolfe (ed.): C.'s Universe. Whitney Museum of American Art, New York et al. New 1976, Philadelphia 1989 (cat.).– Lipman, J. and M. Aspinwall: A. C. and His Magical Mobiles. New York 1981.– Marcadé, J.-C.: C. Paris 1996.– Marchesseau, D. (ed.): C. intime. Musée des Arts Décoratifs. Paris 1989 (cat.)/The Intimate World of A. C. Musée des Arts Décoratifs, Paris. New York 1989 (cat.).– Marter, J. M.: A. C. Cambridge and New York 1991, Cambridge 1997.– Prévert, J.: C. Montrouge 1966.– Sweeney, J. J.: A. C. New York 1951, 1964.– Sweeney, J. J.: A. C. The Artist, the Work. Boston 1971/A. C. L'Artiste et l'œuvre. Montrouge 1971

## CALDERARA Antonio
**1903** Abbiategrasso (near Milan) – **1978** Vacciago
Italian painter. Self-taught. First studied engineering then took up painting in **1924**. For a long time preferred to paint landscapes and portraits. **1959** Influenced by Mondrian and Albers, changed his style to a

geometric Constructivism with subdued translucent colouring. He applied many layers of colours, with about 40 coats of glazes, which he then abraded. **1960** First solo-exhibition in Ulm. **1968** Participated in documenta 6 in Kassel.
WRITINGS: Jochims, R. (ed.): A. C. in Briefen und Gesprächen. Kiel 1982
MONOGRAPHS, CATALOGUES: Agnetti, V.: 12 opere di A. C. Milan 1970.– Eco, U.: Novi serigrafie di A. C. con una piccola antologia di scritti pitagorici. Milan 1964.– Giolli, R.: A. C. Domodossola 1944.– Haldemann, M. (ed.): C. Kunsthaus Zug. Zug 1993 (cat.).– Heckmanns, F. W.: A. C. Aquarelle. Cologne 1974.– Heckmanns, F. W. (ed.): A. C. 1903-1978. Kunstverein für die Rheinlande und Westfalen und Kunstmuseum Düsseldorf. Cologne 1981 (cat.).– Holeczek, B. (ed.): A. C. 39 Ölbilder von 1957-1975. 27 Aquarelle von 1959-1976. Kunstverein Freiburg. Freiburg 1976 (cat.).– Jensen, J. C. (ed.): Der Maler A. C. Freunde, Einflüsse, Anregungen. Kunsthalle zu Kiel der Christian-Albrechts-Universität. Kiel 1982 (cat.).– Jochims, R.: Der Maler A. C. Starnberg 1972.– La Penna, G. (ed.): A. C. Pittura dal 1936 al 1974. Termoli 1974.– Lipman, J.: C.'s Universe. New York 1977.– Lipman, J.: C. Creatures. Great and Small. New York 1985.– Mendes, M.: A. C. Pitture dal 1925 al 1965. Milan 1965.– Saba Sardi, F. (ed.): F. C. Milan 1965

## CAMPENDONK Heinrich
**1889** Krefeld – **1957** Amsterdam
German painter. **1905 – 1909** Studied art at the Krefeld School of Arts and Crafts with Thorn-Prikker. **1911** Became acquainted with Marc, Macke and Kandinsky. Participated in an exhibition of the Blauer Reiter group at the Thannhauser Gallery. **1913** Participation in the First german Autumn Salon in Berlin and the exhibition of the Rhenish Expressionists in Bonn. In **1916**, after military service, moved to Seeshaupt on lake Starnberg in Bavaria. Inspired by traditional Bavarian folk art, he worked on glass-paintings. **1920** Travelled to Italy. **1922** Returned to Krefeld and taught at the School of Arts and Crafts there. **1926** Professor of Monumental Painting at the Düsseldorf Academy. **1933** Emigration to Belgium. **1935** Nomination to the Rijksakademie in Amsterdam. **1937** Eighty seven

of his works in German museums confiscated and classified as "degenerate art". **1955** Participation in documenta 1 in Kassel. **1989** Retrospective at the Kaiser Wilhelm Museum in Krefeld.
CATALOGUES RAISONNES: Engels, M. T. (ed.): H. C. Holzschnitte. Werkverzeichnis. Stuttgart 1959.– Engels, M. T. (ed.): H. C. als Glasmaler. Mit einem Werkverzeichnis. Krefeld 1966.– Engels, M. T. and G. Söhn (ed.): H. C. Das Graphische Werk. Düsseldorf 1996.– Firmenich, A. (ed.): H. C. 1889-1957. Leben und expressionistisches Werk. Mit Werkkatalog des malerischen Œuvres. Recklinghausen 1989.– Wember, P.: H. C. (mit Werkverzeichnis der Gemälde). Krefeld 1960
MONOGRAPHS, CATALOGUES: H. C. Städtische Galerie. Munich 1960 (cat.).– H. C. Städtische Kunsthalle Düsseldorf. Düsseldorf 1972 (cat.).– H. C. Städtisches Museum. Bonn 1973 (cat.).– Engels, M. T.: H. C. Recklinghausen 1958.– Fiedler-Bender, G. and H. Campendonk (ed.): H. C. 1889-1957. Pfalzgalerie. Kaiserslautern 1982 (cat.).– Röder, S. (ed.): H. C. Ein Maler des Blauen Reiter. Kaiser Wilhelm Museum, Krefeld et al. Krefeld 1989 (cat.).– Wember, P.: H. C. Krefeld 1889-1957 Amsterdam. Krefeld 1960

## CAMPIGLI Massimo
**1895** Florence – **1971** Saint-Tropez
Italian painter. Self-taught. **1914** Military service. Taken prisoner in Russia in **1916**. From **1919**, newspaper correspondent in Paris. His interest in modern French art led him to painting. Through the study of Egyptian art at the Louvre, he developed an archaic style of painting. While travelling to Rome in **1928** he became familiar with Etruscan art. **1929** Solo-exhibition at the Jeanne Bucher Gallery in Paris. Further presentations of his work in Milan, New York, Amsterdam, London and elsewhere. **1933** Signing of the *Manifesto of Wall Painting*. Collaboration with Sironi, Funi and De Chirico on murals for the Triennale in Milan. **1959** Participation in documenta 2 in Kassel.
WRITINGS: M. C.: Prefazione dello stesso. Milan 1931
MONOGRAPHS, CATALOGUES: Apollonio, U. (ed.): M. C. Galleria Civica d'Arte Moderna. Ferrara 1979 (cat.).– Carrieri, R.: M. C. Milan 1941.– Cassou, J.: C. Paris u. Zurich 1957.– Chastell, A.: Les Idoles de C. Paris 1961.– Mantura, B. and P. Rosazza Ferraris (ed.): M. C. Palazzo della Ragione, Padua. Milan 1994 (cat.).– Mele, G. L. (ed.): Mostra di M. C. Palazzo Reale. Milan 1967 (cat.).– Ruggeri, G.: Lo specchio di Giuditta. La favola senza fine di M. C. Bologna 1981.– Russoli, F.: C. pittore. Milan 1965.– Serafini, F. (ed.): Omaggio a C. Roma 1968, 1972

## CAMPUS Peter
born **1937** New York
American video artist. **1955-1962** Studied

psychology at Ohio State Universitiy, Columbus and at the City College Film Institute in New York. **1960-1962** Also worked as producer's assistant in film and television. **1970-1972** Video adviser at the Metropolitan Museum of Art in New York. First video tapes. **1972** Video installation with black and white projectors dealing with man's experience of himself through technical media. First solo-exhibition at the Bykert Gallery in New York. **1973** Research grant at the television stations WGBH in Boston and WNET in New York. **1975** Guggenheim grant. **1976-1980** Lecturer at the Massachusetts Institute of Technology, Cambridge. **1977** Participation in documenta 6 in Kassel. **1979** Focused again on photography, employing digital techniques. **1980** Solo-exhibition at the Pompidou Centre in Paris. **1982/83** Lectureship at Rhode Island School of Design.
MONOGRAPHS, CATALOGUES: P. C. Everson Museum of Art. Syracuse (NY) 1974 (cat.).– Herzogenrath, W. et al. (ed.): P. C. Video-Installationen, Foto-Installationen, Fotos, Videobänder. Kölnischer Kunstverein. Cologne 1979 (cat.).– Kersting, H. (ed.): P. C. Dia-Projektionen. Städtisches Museum Abteiberg. Mönchengladbach 1990 (cat.).– Niemczyk, T. (ed.): P. C. Selected Works 1973-1987. Freedman Gallery Albright College. Reading (PA) 1987

## CAPA Robert
(André Friedmann)
**1913** Budapest – **1954** Thai-Binh (Indochina)
Hungarian photographer. **1930** Started to photograph. **1931-1933** Studied politics at the University of Berlin. **1931** Published his first photographs in the *Berliner Illustrirte Zeitung*. **1933** Moved to Paris. Changed his name to Capa. **1933-1939** Photographed for the magazines Life, Time and the *Illustrated London News*. In **1936** his photographs of the Spanish Civil War for *Vu* and *Regard* made him internationally renowned. **1939** Emigrated to America. **1941-1945** War correspondent, covering Europe and North Africa for *Life* magazine. **1947** Founded the photo agency *Magnum* with Cartier-Bresson, Seymour and Roger and acted as president from **1948-1954**.
MONOGRAPHS, CATALOGUES: Capa, C. (ed.): R. C. 1913-1954. New York 1974.– Capa, C. and R. Whelan (ed.): R. C. Pho-

tograps. New York 1985.– Capa, C. (ed.): Children of War, Children of Peace. Photographs by R. C. Boston 1991.– R. C. 1913-1954. London 1974.– R. C. Photographs. New York 1985.– Fárová, A. (ed.): R. C. New York 1968.– Karinthy, F.: Vége a világnak: R. C. képeinul. Budapest 1988.– Lacouture, J. (ed.): C. Centre National de la Photographie. Paris 1993 (cat.).– Martinez, R.: R. C. Milan 1979.– Whelan, R.: R. C. A Biography. New York 1985.– Whelan, R.: Die Wahrheit ist das beste Bild. R. C. Photograph. Cologne 1989.– Whelan, R. et al. (ed.): R. C. Photographies. Paris 1996

**CAPOGROSSI Giuseppe**
**1900** Rome – **1972** Rome
Italian painter. **1919–1923** Studied law in Rome. **1926** Started painting. **1927–1933** Lived in Paris. Influenced by the Cubists. **1928** Participation at the Venice Biennale. **1946 – 1965** Lecturer at a school of art (Liceo Artistica) in Rome. **1951** Founded the Gruppo Origine together with Ettore Colla and Burri. Developed his own abstract, ornamental picture-writing consisting of curved comb-like signs with which he produced strong rhythmical compositions. **1952** Member of Gruppo Spaziale in Milan. **1955** and **1959** Participation in documenta 1 and 2 in Kassel. **1965–1970** Lectureship at the Academy of Arts in Naples. **1974** Retrospective at the Galleria Nazionale d'Arte Moderna, Rome.
CATALOGUE RAISONNE: Hase-Schmundt, U. v. (ed.): C. Das graphische Werk. St. Gallen 1982
MONOGRAPHS, CATALOGUES: Apa, M. (ed.): C. Opere dal 1947 al 1972. Urbino 1987 (cat.).– Argan, G. C.: C. Roma 1967.– C. Staatliche Kunsthalle Baden-Baden et al. Baden-Baden 1967 (cat.).– Mantura, B. et al. (ed.): G. C. Galleria Nazionale d'Arte Moderna. Roma 1974 (cat.).– Mantura, B. (ed.): C. Fino al 1948. Palazzo Rosari Spada, Spoleto. Roma 1986 (cat.).– Porzio, F. (ed.): C. Gouaches, collages, disegni. Milan 1981.– Seuphor, M.: C. Venice 1954.– Tapié, M.: C. Venice 1962

**CARO Anthony**
born **1924** London
English sculptor. **1942–1944** Studied engineering in Cambridge and **1946–1952** art at

the Royal Academy Schools. **1951–1953** Assisted Moore who, together with Picasso, Bacon and De Kooning had a strong influence on his early bronzes. From **1953** lectureship at St. Martin's School of Art. **1959/60** Travelling grant from the Ford Foundation to New York where he met Noland and David Smith. Gave up figurative sculpture and started to make densely painted, abstract steel constructions. **1964** and **1968** participation in documenta 3 and 4 in Kassel. **1969** Retrospective at the Hayward Gallery, London. From **1984** bronze sculptures related to his earlier works from the 50s. As a reformer of his own teaching methods, Caro had a great influence on subsequent generations of artists in England.
CATALOGUE RAISONNE: Blume, D. et al. (ed.): The Sculpture of A. C. Catalogue Raisonné. 9 vols. Cologne 1981-1991
MONOGRAPHS, CATALOGUES: Blume, D. (ed.): A. C. Table and Related Sculptures 1976-1978. Städtische Galerie im Lenbachhaus, Munich et al. Munich 1979 (cat.).– Caradente, G.: C. at the Trajan Markets, Romae. New York 1994.– A. C. Städtische Galerie im Städelschen Kunstinstitut. Frankfurt-on-Main 1981 (cat.).– A. C. Sculpture 1969-1984. Serpentine Gallery, London et al. London 1984.– A. C. Œuvres 1961-1989. Musée de Calais. Calais 1990 (cat.).– Fauchereau, S.: A. C. The Marker Series. Paris 1996.– Fenton, T.: A. C. London 1986.– Fried, M. (ed.): A. C. The Arts Council of Great Britain. Hayward Gallery. London 1969 (cat.).– Fried, M. (ed.): A. C. Tisch-Skulpturen. 1966-1977. Städtische Kunsthalle Mannheim. Mannheim 1979 (cat.).– Hilton, T. (ed.): A. C. Sculptor 1969-1984. The Arts Council of Great Britain. London 1984.– Moorhouse, P. (ed.): A. C. Sculpture Towards Architecture. Tate Gallery. London 1991 (cat.).– Rubin, W. (ed.): A. C. The Museum of Modern Art. New York 1975 (cat.).– Spurling, J. et al. (ed.): The Trojan War. Sculptures by Sir A. C. English Heritage and Yorkshire Sculpture Park. London 1994 (cat.).– Sylvester, D.: A. C. Sculptures. Munich 1991.– Waldman, D.: A. C. New York and Oxford 1982.– Whelan, R. et al.: A. C. Harmandsworth 1974, New York 1975.– Wilkin, K.: C. Munich 1991

**CARRA Carlo**
**1881** Quargneto – **1966** Milan
Italian painter. After attending classes at the Milan Brera School, worked as a freelance painter. Joined the Futurists in **1909** and signed their manifesto. **1911** Acquaintanceship with Modigliani, Picasso and Apollinaire in Paris. In **1915** he split with the Futurists. **1917** During military service in Ferrara became acquainted with De Chirico who was developing his ideas on *Pittura Metafisica* (Metaphysical Painting). As a result, Carrà's paintings became calmer, with a structured objectivity and subdued coloration. **1919 – 1922** Intensive collaboration with the journal *Valori Plastici*. **1924**

Wrote a monograph on Giotto and numerous critical and therotical essays on art. In **1926** and **1929** participated in the exhibitions of the group Novecento calling for a return to traditional values. Development of a stylized and archaic realism of melancholy solemnity. Carrà lived and worked in Milan until he died.
WRITINGS: C. C.: Pittura metafisica. Florence 1918, Milan 1945.– C. C.: Giotto. Roma 1924, London 1925.– Carrà, M. and V. Fagone (ed.): C. C. e Ardengo Soffici. Lettere 1913-1929. Milan 1983.– Carrà, M. (ed.): C. C. Tutti gli scritti. Milan 1978.– Caruso, L. (ed.): C. C. Guerra pittura, Futurismo politico, dinamismo plastico. 12 disegni guerreschi, parole in libertà. Florence 1978
CATALOGUES RAISONNES: Bigongiari, P.: L'opera completa di C. Dal futurismo alla metafisica e al realismo mitico 1910-1930. Milan 1970.– Carrà, M.: C. C. Tutta l'opera pittorica 1900-1963. 3 vols. Milan 1967-1969.– Carrà, M. and M. Valsecchi (ed.): C. C. Opera grafica 1922-1964. Vicenza 1976.– Carrà, M. (ed.): C. C. Disegni, acquaforti, litografi. Florence 1980
MONOGRAPHS, CATALOGUES: Ballo, G.: L'opera grafica di C. Milan 1967.– Carile, L. (ed.): C. C. Disegni 1908-1923. Palazzo Rosso. Genoa 1983 (cat.).– Carrà, M. (ed.): C. C. Mostra antologica. Palazzo Reale. Milan 1987 (cat.).– C. C. The Primitive Period 1915-1919. Kouros Gallery. New York 1987 (cat.).– C. Mostra Antoligica. Palazzo Braschi, Roma. Roma 1987 (cat.).– Dell'Acqua, G. A. et al. (ed.): C. Palazzo Reale. Milan 1987 (cat.).– Fagiolo dell'Arco, M. (ed.): C. C. Il primitivismo 1915-1919. Chiesa di S. Bartolomeo, Venice. Milan 1988 (cat.).– Haenlein, C. (ed.): C. C. Zeichnungen. Kestner-Gesellschaft. Hanover 1981 (cat.).– Longhi, R.: C. C. Milan 1945.– Pacchioni, G.: C. C. Milan 1959.– Poetter, J. (ed.): C. C. Staatliche Kunsthalle Baden-Baden. Milan 1987 (cat.).– Riccio, L. and F. Riccio (ed.): C. C. Disegni 1918-1965. Torino 1987.– Russoli, F. and M. Carrà: C. Disegni. Bologna 1977.– Sprovieri, P. (ed.): C. C. Zeichnungen 1908-1920. Berlin 1987 (cat.)

**CARTIER-BRESSON Henri**
**1908** Chanteloup – **2004** Céreste
French photographer and film-maker. **1928 –1930** Studied painting in the studio of Lhote in Paris. **1930** Took up photography. **1936–1939** Assistant to director Jean Renoir. In **1937** he shot the documentary film *Return to Life*. During World War II he was taken prisoner but escaped. Joined the Resistance and became a war correspondent after the liberation of France. **1945** Shot the documentary film *Le Retour* and photographed for *Harper's Bazaar*. **1946** Visited New York. **1947** Founded the photographic agency *Magnum* together with Capa and Seymour. Exhibition of his photographs at the Museum of Modern Art in New York. **1955** Publication of several photographs taken in the Soviet Union the pre-

vious year in the book *People in Moscow*.
MONOGRAPHS, CATALOGUES: Bonnefoy, Y. (ed.): H. C.-B. Photographer. London 1981, New York 1979, 1992/H. C.-B. Die Photographien. Munich 1992.– Clair, J.: Line by Line. The Drawings of H. C.-B. New York 1989.– Contensou, B. et al. (ed.): H. C.-B. Dessins 1973-1981. Musée d'Art Moderne de la Ville de Paris. Paris 1981 (cat.).– Elliott, D. et al. (ed.): H. C.-B. Drawings and Paintings. Museum of Modern Art. Oxford 1984 (cat.).– Fárová, A.: H. C.-B. Prague 1958.– Galassi, P. (ed.): H. C.-B. The Early Work. The Museum of Modern Art, New York et al. Boston 1987 (cat.).– Gombrich, E. H. (ed.): H. C.-B. Fruit Market Gallery. Edinburgh 1978 (cat.).– Kirstein, L. and B. Newhall: The Photographs of H. C.-B. New York 1947, 1963.– Montier, J.-P.: H. C.-B. L'art sans l'art. Paris 1995/H. C.-B. Seine Kunst, sein Leben. Munich 1997.– Palazzoli, D.: H. C.-B. Milan 1978.– Roy, C.: H. C.-B. Paris 1976

**CASORATI Felice**
**1886** Novara – **1963** Turin
Italian painter. **1907** Qualified as a lawyer. Until **1915** attended art academies of Padua, Naples and Verona. In **1913** exhibition at the Ca' Pesaro in Venice. Absorbed strong Symbolist and Pre-Raphaelite tendencies into his painting. **1914–1918** After military service, settled in Turin. **1920** Influenced by the ideas of *Pittura Metafisica*, as expounded in the journal *Valori Plastici*, his style moved towards a poetic realism. A large room was dedicated to him at the **1924** Venice Biennale. **1928/29** Lectureship at the Accademia Albertina in Turin. **1938** Awards at the Venice Biennale and the International Exhibition of Art in Paris. **1941** Professor at the Accademia Albertina, and from **1954** its president.
CATALOGUE RAISONNE: F. C. Opera grafica. Milan 1966
MONOGRAPHS, CATALOGUES: Carluccio, L.: F. C. Le Sculpture. Milan c. 1980.– Carluccio, L. (ed.): F. C. Galleria Civica d'Arte Moderna. Ferrara 1981 (cat.).– Carluccio, L. and M. Rosci (ed.): F. C. Incisioni, sculture e disegni. Academia Albertina di Belle Arti. Padua 1985 (cat.).– Galvani, A.: F. C. Milan 1947.– Lamberti, M. M. (ed.): F. C. 1883-1963. Accademia Albertina di Belle Arti di Torino. Milan 1985 (cat.).– Lamberti, M. M. (ed.): C. Palazzo Reale. Milan 1989 (cat.).– Lamberti, M. M. and P. Fossati (ed.): F. C. 1883-1963. Academia Albertina di belle arti, Torino. Milan 1985 (cat.).– Marinelli, S. (ed.): F. C. a Verona. Milan 1986.– Valsecchi, M.: F. C. Roma 1977

**CAULFIELD Patrick**
born **1936** London
English painter. **1956–1960** Studied at the Chelsea School of Art, and **1960–1963** at the Royal College of Art. **1961** Participation in the exhibition Young Contemporaries in

London. **1963–1971** Lectureship at the Chelsea School of Art. Early still life and landscape paintings mainly influenced by Gris, Léger and Magritte. Caulfield painted till the mid-60s with brilliant domestic gloss paints on hard fibreboard. **1965** Participation at the Biennale des Jeunes in Paris. Applied silk-screen printing to his paintings. **1979** Developed a *trompe-l'œil* realism. **1981** Major retrospective at the Tate Gallery, London. Caulfield was inspired by Pop Art, particularly by Lichtenstein. Many of his works are representations of commonplace objects as shining colour fields framed by uniform black lines.
MONOGRAPHS, CATALOGUES: Finch, C.: P. C. Harmondsworth 1971.– Livingstone, M. (ed.): P. C. Paintings 1963-1981. Tate Gallery, London et al. London 1981 (cat.).– Livingstone, M. (ed.): P. C. Paintings 1963-1992. Serpentine Gallery. London 1992 (cat.).– Robertson, B. (ed.): P. C. Prints 1964-1981. Waddington Galleries. London 1981 (cat.)

**CESAR**
(César Baldaccini)
born **1921** Marseille
French sculptor and object artist. **1935**–**1942** Studied at the Ecole des Beaux-Arts in Marseille and in **1943–1948** at the Ecole Nationale Supérieure des Beaux-Arts in Paris. From **1950** made metal sculptures from collected pieces of industrial waste and scrap metal. **1954** First solo-exhibition "Animaux en ferraille" at the Lucien Durand Gallery in Paris. **1959–1968** Participation in documenta 2–4 in Kassel. From **1960** started to produce *Compressions Dirigées*, car bodies or other metal objects compressed into rectangular cuboids with a hydraulic press. He took part in Nouveau Réalisme events. **1961** During a visit to America he became acquainted with Duchamp and various Pop Art artists. Created sculptures which represent enlarged parts of the body such as thumbs or parts of the chest. **1967** First *Expansions*: happening-like events involving the pouring of liquid plastics. **1970** Professorship at the Ecole Nationale des Beaux-Arts in Paris. **1972** Mask series with the cast of his own face. **1985/86** Flat compressions of Peugeot cars. **1997** Major retrospective at the Galerie du Jeu de Paume in Paris.

CATALOGUE RAISONNE: Durand-Ruel, D. (ed.): C. Catalogue raisonné. Vol. 1: 1947-1964. Paris 1994
MONOGRAPHS, CATALOGUES: Cabanne, P. (ed.): C. par C. Paris 1971.– C. Musée d'Art Moderne de la Ville de Paris. Paris 1976 (cat.).– C. Œuvres de 1947 à 1993. Musée de Marseille 1993 (cat.).– Cooper, D.: C. Amriswil 1960.– Franzke, A. et al. (ed.): C. Galerie Nationale du Jeu de Paume. Paris 1997 (cat.).– Hahn, O.: Les sept vie de C. Lausanne 1988.– Hahn, O. (ed.): C. Compressions 1959-1989. Galerie Beaubourg. Paris 1990 (cat.).– Legrand, V. et al. (ed.): C. Œuvres de 1947 à 1993. Centre de la vieille Charité. Marseille 1993 (cat.).– Mason, R. M. (ed.): C. Rétrospective des sculptures. Musée d'Art et d'Histoire. Geneva 1976 (cat.).– Mathey, F. and P. Restany (ed.): C. Centre National d'Art Contemporain. Paris 1970 (cat.).– Restany, P.: C. Paris and Monte Carlo 1975, New York 1976.– Restany, P. and D. Durand-Ruel: C. Paris 1988

**CEZANNE Paul**
**1839** Aix-en-Provence – **1906** Aix-en-Provence
French painter. Came to Paris in **1861** to study law and attend classes at the Académie Suisse. Rejected by the Ecole des Beaux-Arts in Paris for lack of talent, he returned to Aix-en Provence to join his father's bank. **1862–1864** Second stay in Paris. Made friends with Renoir, Monet, Sisley and Bazille. Met Manet in **1865**. **1872**–**1874** Joined Pissarro and Guillaumin in Anvers. **1874** Participation in the first Impressionist exhibition. **1879** Returned to Aix-en-Provence. **1882** Broke away from the Impressionists and developed a new style of painting: clear tectonic compositions in which he tried to reveal the underlying structure of nature rather than capturing the fleeting effects of light. **1895** Important solo-exhibition at Vollard with 150 paintings. **1900–1905** Geometrical compositions culminate in his painting *The Bathers*. **1907** Retrospective at the Salon d'Automne. Working parallel to the first generation of Impressionists and periodically also belonging to that circle, Cézanne nevertheless followed his own artistic creed. His art had a great influence on subsequent generations of painters and laid the foundations for modern painting.
WRITINGS: Doran, M. (ed.): Conversations avec C. Paris 1978, Zurich 1982.– Kendall, R.: C. by Himself. Drawings, Paintings, Writings. London 1988.– Rewald, J. (ed.): P. C. Correspondance. Paris 1937, 1978/P. C. Correspondance. New York 1984/P. C. Briefe. Zurich 1962, 1988
CATALOGUES RAISONNES: Chappuis, A. (ed.): Die Zeichnungen von P. C. 2 vols. Olten and Lausanne 1962/The Drawings of P. C. A Catalogue Raisonné. 2 vols. London and Greenwich (CT) 1973.– Dunlop, J. (ed.): The Complete Paintings of C. London 1972.– Gatto, A. (ed.): L'opera completa di C. Milan 1970.– Orienti, S.

(ed.): The Complete Paintings of C. London 1972, New York 1972.– Picon, G. and S. Orienti: Tout l'œuvre peint de C. Paris 1975.– Rewald, J. (ed.): P. C. The Watercolours. A Catalogue Raisonné. Boston and London 1984/Les Aquarelles de C. Catalogue raisonné. Paris 1984.– Rewald, J. and W. Feilchenfeldt (ed.): The Paintings of P. C. A Catalogue Raisonné. 2 vols. New York 1997.– Venturi, L. (ed.): C. Son art, son œuvre. 2 vols. Paris 1936, San Francisco 1989
MONOGRAPHS, CATALOGUES: Adriani, G. (ed.): P. C. Zeichnungen. Cologne 1978.– Adriani, G.: P. C. "Der Liebeskampf": Aspekte zum Frühwerk C. Munich 1980.– Adriani, G. (ed.): P. C. Die Aquarelle 1866-1906. Kunsthalle Tübingen. Cologne 1981 (cat.).– Adriani, G.: C. Gemälde. Meisterwerke aus vier Jahrzehnten. Kunsthalle Tübingen. Cologne 1993 (cat.)/C. Paintings. Kunsthalle Tübingen. New York 1993 (cat.).– Barnes, A. C. and V. d. Mazia: The Art of C. Merion (PA) 1986.– Boehm, G.: P. C. Montagne Sainte-Victoire. Eine Kunst-Monographie. Frankfurt-on-Main 1988.– Cachin, F. and J. J. Rishel (ed.): C. Grand Palais, Paris et al. Paris 1995 (cat.).– C. les années de jeunesse 1859-1872. Musée d'Orsay. Paris 1988 (cat.).– Coutagne, D. et al. (ed.): Sainte-Victoire. C. Musée Granet, Aix-en-Provence. Paris 1990 (cat.).– Düchting, H.: P. C. 1839-1906. Nature into Art. Cologne 1989.– Geist, S.: Interpreting C. Cambridge (MA) 1988.– Gowing, L. et al. (ed.): C. The Early Years 1859-1872. Royal Academy of Arts, London et al. London and New York 1988 (cat.).– Kendall, R.: C. by Himself. Drawings, Paintings, Writings. New York 1988/P. C. Leben und Werk in Bildern und Briefen. Munich 1989.– Krumrine, M. L. (ed.): P. C. Die Badenden. Kunstmuseum Basel. Basel 1989/The Bathers. Kunstmuseum Basel. New York 1990 (cat.).– Lévêque, J.-J. (ed.): La Vie et l'œuvre de P. C. Paris 1988.– Lévêque, J. J.: P. C. Le Précurseur de la modernité. Courbevoie 1995.– Lewis, M. T.: C.'s Early Imagery. Berkeley 1989.– Loran, E.: C.'s Composition. Analysis of His Forms with Diagrams and Photographs of His Motifs. Berkeley 1943.– Perruchot, H.: C. Paris 1956, London 1961.– Plazy, C.: C. ou la peinture absolue. Paris 1988.– Reff. T. and I. H. Shoemaker. P. C. Two Scetchbooks. Philadelphia Museum of Art. Philadelphia 1989 (cat.).– Rewald, J.: C. A Biography. New York 1939, 1996.– Rewald, J. et al. (ed.): C. The Early Years 1859-1872. Royal Academy of Art, London et al. London 1988 (cat.).– Rewald, J.: C. and America. Dealers, Collectors, Artists and Critics. Princeton 1989.– Rubin, W. (ed.): C. The Late Work. The Museum of Modern Art. New York 1977 (cat.).– Vallès-Bled, M.: C. Biographie 1839-1906. Paris 1995.– Venturi, L.: C. New York 1978

**CHADWICK Lynn**
**1914** London – **2003** Stroud
English sculptor. Trained as an architect. **1941–1944** Military service. **1945** First

sculptural works. **1950** Influenced by Calder and González, created movable abstract metal sculptures. First solo-exhibition at Gimpel Fils in London. **1953** Participation in the international competition for the unknown political imprisoner. Incorporated more and more semi-figurative motifs, such as centaur-like creatures, into his formal idiom. **1956** International award for sculpture at the Venice Biennale. **1959** and **1964** participation in documenta 2 and 3 in Kassel. Beside Butler and Armitage, Chadwick is one of Britain's leading metal sculptors.
CATALOGUE RAISONNE: Farr, D. and E. Chadwick (ed.): L. C. Sculptor. With a Complete Illustrated Catalogue 1947-1988. Oxford 1990
MONOGRAPHS, CATALOGUES: Bowness, A.: L. C. London 1962.– Causey, A. (ed.): L. C. Sculpture 1951-1991. Yorkshire Sculpture Park. Wakefield 1991 (cat.).– L. C. Musée National d'Art Moderne. Paris 1957 (cat.).– Hodin, J. P.: C. Amsterdam, London and New York 1961.– Koster, N. and P. Levine: L. C. The Sculptor and His World. Leyden 1988.– Levine, P.: L. C. London 1988.– Read, H.: L. C. Amriswil 1958

**CHAGALL Marc**
**1887** Liosno (near Vitebsk) – **1985** Saint-Paul-de-Vence
Russian painter and graphic artist. **1907** Studied painting in St. Petersburg. **1910**–**1913** Lived in Paris. Met Modigliani, Delaunay, Gleizes and other artists. Encountered the contemporary art movements Cubism and Fauvism. **1914** First solo-exhibition at Herwarth Walden's gallery Der Sturm in Berlin. **1915** Returned to Russia. During World War I, developed an intensely personal style in which he combined Jewish-folkloristic ideas with forms of Western avant-garde. **1917** Founder and director of the School of Art in Vitebsk. Appointed, among others, Lissitzky, Pougny and Malevich as teachers. After interim periods in Moscow and Berlin, went to Paris in **1923** where he started doing book illustrations. From **1925** the circus became a recurrent theme in his works. His figures, painted in bright colours, are often suspended in pictorial space. **1941** Emigration to the United States, where he met Léger, Masson, Mondrian and Breton. **1946** Major retrospective exhibition at the Museum of Modern Art in New York. In **1947** he moved back to France, settling in Vence in **1950**. Public commissions for church windows, ceiling-paintings, tapestries and murals. Important representative of classical Modernism, combining elements of Fauvism and Surrealism with his own formal language and brilliant coloration.
WRITINGS: M. C.: Ma Vie. Paris 1931, 1957 /M. C. Mein Leben. Stuttgart 1959/M. C.: My Life. New York 1960, London 1967.– Sorlier, E. (ed.): C. by C. New York 1979
CATALOGUES RAISONNES: Forestier, S. and L. Sigalas (ed.): M. C. L'œuvre gravé.

Musée National Message Biblique, Nice. Paris 1987.– Forestier, S. and M. Meyer (ed.): Les Céramiques de C. Catalogue raisonné du travail de C. céramiste. Paris 1990. C. Keramik. Munich 1990.– Kornfeld, E. W. (ed.): Verzeichnis der Kupferstiche, Radierungen und Holzschnitte von M. C. Vol. 1: Werke 1922-1966. Bern 1970.– Leymarie, J. (ed.): M. C. Monotypes 1966-1975. 2 vols. Geneva 1966-1977.– Maier-Preusker, W. (ed.): M. C. Kritischer Werkkatalog der originallithographischen Künstlerplakate und Varianten. Bonn 1996.– Meyer, F.: M. C. Leben und Werk. Cologne 1961 / M. C. Life and Work. New York 1963 / M. C. Paris 1964, 1995.– Mourlot, F. and C. Sorlier (ed.): C. Lithographe. 6 vols. Monte Carlo 1960-1986 / The Lithographs of C. 6 vols. New York et al. 1960-1986.– Sorlier, C. (ed.): Les Céramiques et sculptures de M. C. Monte Carlo 1972 / The Ceramics and Sculptures of C. Monte Carlo 1972 / Die Keramiken und Skulpturen von C. Monaco 1972.– Sorlier, C. (ed.): Les Affiches de M. C. Paris 1975 / C.'s Poster. A Catalogue Raisonné. New York 1975 / Die Plakate von M. C. Geneva 1976.– Sorlier, C. (ed.): M. C. The Illustrated Books. Paris 1990 / C. Le Livre des livres. Catalogue raisonné des livres, albums, revues … illustrés par C. Paris 1990
MONOGRAPHS, CATALOGUES: Alexander, S.: M. C. A Biography. New York 1978.– Anatova, I.: C. Discovered. From Russian and Private Collections. Moscow 1988.– M. C. Œuvres sur papier. Centre Georges Pompidou. Paris 1984 (cat.).– M. C. Musée National Message Biblique. Nice 1990 (cat.).– M. C. Die russischen Jahre 1906-1922. Schirn Kunsthalle, Frankfurt-on-Main. Bern 1991 (cat.).– Chatelain, J. (ed.): Le Message biblique. M. C. Paris 1972.– Compton, S. (ed.): M. C. Royal Academy of Arts, London et al. London 1985 (cat.).– Compton, S.: M. C. Mein Leben, mein Traum. Berlin and Paris 1922-1940. Wilhelm-Hack-Museum, Ludwigshafen. Munich 1990 (cat.).– Crespelle, J.-P.: M. C. Liebe, Traum und Leben. Hamburg 1970.– Forestier, S. et al. (ed.): M. C. 1908-1985. Palazzo dei Diamanti, Ferrara. Roma 1992 (cat.).– Forestier, S.: M. C. Seine Farbfenster aus aller Welt. Stuttgart, Zurich 1995 / C. Les Vitraux. Paris 1996.– Güse, E.-E. (ed.): M. C. Druckgraphik. Saarland Museum, Saarbrücken. Stuttgart 1994 (cat.).– Haftmann, W.: M. C. Stuttgart 1975, New York 1984.– Kamenski, A.: C. Période russe et soviétique 1907-1922. Paris 1988. The Russian Years 1907-1922. New York 1988. Die russischen Jahre 1907-1922. Stuttgart 1989.– Keller, H.: M. C. Leben und Werk. Cologne 1978.– Krens, T. and J. Blessing (ed.): M. C. and the Jewish Theatre. Solomon R. Guggenheim Museum. New York 1992 (cat.).– Leymarie, J. (ed.): M. C. Grand Palais. Paris 1969 (cat.).– McMullen, R.: The World of M. C. Garden City 1968.– Mathey, F. (ed.): M. C. Musée des Arts Décoratifs. Paris 1959 (cat.).– Meyer, F.: M. C. His Graphic Work. New York 1957.– Rakitin, W. et al. (ed.): C. Bilder, Träume, Theater. 1908-1920. Jüdisches Museum der Stadt Wien. Vienna 1994 (cat.).– Schmalenbach, W. (ed.): M. C. Frankfurt-on-Main 1979.– Schneider, P.: M. C. Fast ein Jahrhundert. Stuttgart 1995.– Sidney, A.: M. C. eine Biographie. Munich 1984.– Sorlier, C.: M C.: Traum, Vision und Wirklichkeit. Munich 1991, 1995.– Vitali, C. (ed.): M. C. Die russischen Jahre 1906-1922. Schirn Kunsthalle. Frankfurt-on-Main 1991 (cat.).– Vogt, P. (ed.): M. C. Kunsthalle der Hypo-Kulturstiftung. Munich 1991 (cat.).– Walther, I. F. and R. Metzger: M. C. 1887-1985. Painting as Poetry. Cologne 1987

**CHAISSAC Gaston**
**1910** Avallon (Bourgundy) – **1964** La Roche-sur-Yon
French painter and graffiti artist. Encouraged to paint by the German sculptor and painter Freundlich. **1938** Produced gouaches, watercolours and animal drawings. **1940** Participation at the Salon des Indépendants. **1942–1945** First graffiti works and painted stones. **1944** Started to paint with oils. Correspondence with Jean Paulhan and Dubuffet who remained close friends for life. **1947/48** Acquaintance with André Breton. Continued stone painting and graffiti on buildings. Made sculptures from pieces of rubbish and roots. Utilization of *empreintes*, object outlines for oil and gouache paintings. **1953–1955** Series of collages and *objets*, painted and pasted objects. **1959–1963** Worked on a series of totem poles, monumental oil paintings on wrapping paper, and collages of patterned wallpaper.
WRITINGS: G. C.: Hippobosque au Bocage. Paris 1951
CATALOGUE RAISONNE: Cousseau, H.-C. (ed.): L'Œuvre graphique de G. C. 1910-1964. Paris 1981
MONOGRAPHS, CATALOGUES: Affentranger-Kirchrath, A. (ed.): G. C. Galerie Nathan. Zurich 1994 (cat.).– Affentranger-Kirchrath, A. et al. (ed.): G. C. 1919-1964. Neue Galerie, Linz et al. Linz 1996 (cat.).– Brütsch, F.: G. C. Berlin 1994.– G. C. Musée National d'Art Moderne. Paris 1973 (cat.).– G. C. Kunsthalle Tübingen et al. Tübingen 1996 (cat.).– Cousseau, H.-C.: G. C. Paris 1986.– Fauchereau, S. (ed.): G. C. Paris et al. Paris 1989 (cat.).– Gachnang, J. and F. Brütsch (ed.): G. C. Neuchâtel 1988.– Jakovsky, A.: G. C. L'Homme-orchestre. Paris 1952.– Michaud, D. A.: G. C. Puzzle pour un homme seul. Paris 1974, 1992.– Nathan-Nehler, B.: C. Stuttgart 1987

**CHALDEI Yevgeni**
born **1917** Moscow
Russian photographer. First trained as a steel worker. **1930** Apprenticeship at the photographic agency TASS in Moscow. From **1941–1945** war photographs, including front-line pictures, taken with a portable Leica, of the first day of Hitler's invasion of the Soviet Union. Documented the retreat of German troops through Romania, Bul-

garia, Hungary and Austria, right back to Berlin. **1945/46** Photojournalist at the Potsdam Conference and at the Nuremberg Trials. **1946–1949** Commissioned by TASS to photograph crisis points along the Chinese border and in Yugoslavia. **1950** Dismissal from Pravda-editorial staff due to his Jewish origins. **1956** Reemployment. Worked until the 70s as a photojournalist for TASS and *Pravda*.
MONOGRAPHS, CATALOGUES: Volland, E. (ed.): Von Moskau nach Berlin: Bilder des russischen Fotografe J. C. Berlin 1994, 1995

**CHAMBERLAIN John**
born **1927** Rochester (IN)
American sculptor. **1951/52** Studied at the Art Institute in Chicago and in **1955/56** at Black Mountain College, North Carolina. **1957** Impressed by Abstract Expressionism and the tendencies of Nouveau Réalisme, he made his first works out of old metal and compressed car elements of particular shapes, combined with other pieces of industrial waste, like flexible tubes and iron bars. From **1966** on produced *Instant Sculptures* made from urethane-plastic foam and experimented with various materials such as acrylic glass, aluminium foil, electroplated metal and car finish on plastic material. **1974** Reliefs 1960-1982. The John C. car-parts series of sculptures. **1977** Started to use a panoramic camera with a wide-angle lens of 26 mm and a fixed focus. **1982** Participation in documenta 7 in Kassel. **1986** Retrospective at the Museum of Contemporary Art in Los Angeles.
WRITINGS: Thomson, E. M. (ed.): The C. Letters. London 1965
CATALOGUE RAISONNE: Sylvester, J. (ed.): J. C. A Catalogue Raisonné of the Sculpture 1954-1985. New York and Los Angeles 1986
MONOGRAPHS, CATALOGUES: Auping, M. (ed.): J. C. Reliefs 1960-1982. The John and Mable Ringling Museum of Art. Sarasota (FL) 1983 (cat.).– J. C. Cleveland Museum of Art. Cleveland 1967 (cat.).– J. C. Stedelijk Van Abbe Museum. Eindhoven 1980 (cat.).– Fuchs, R. et al. (ed.): J. C. Current Works and Fond Memories. Amsterdam 1996 (cat.).– Gachnang, J. and R. Fuchs (ed.): J. C. Kunsthalle Bern et al. Bern 1979 (cat.).– Gachnang, J. (ed.): J. C. Oils. Galerie Fred Jahn. Munich 1986 (cat.).– Poetter, J. and D. Judd (ed.): J. C. Staatliche Kunsthalle Baden-Baden et al. Stuttgart 1991 (cat.).– Waldman, D. (ed.): J. C. Solomon R. Guggenheim Museum. New York 1971 (cat.)

**CHARCHOUNE Sergei**
**1888** Buguruslan (Ukraine) – **1975** Paris
Russian painter. Attended classes at various academies in Moscow. Moved to Paris in **1912**. **1913** Exhibited with the Cubists Le Fauconnier and Metzinger at the Salon des Indépendants. **1914–1917** Lived in Spain. Participation in some Dada events in Barcelona and Zurich. Settled in Berlin in

**1922** and exhibited his abstract paintings in Herwarth Walden's gallery Der Sturm. Collaboration with Schwitters, Lissitzky, Tzara and Arp. International exhibitions in Barcelona, Stockholm, Brussels and New York. **1923** Returned to Paris. **1947–1956** Repeated exhibitions at the Creuze gallery.
CATALOGUES RAISONNES: Creuze, R. (ed.): C. 2 vols. Paris 1975-1976.– Delettre, P. (ed.): Catalogue raisonné de l'œuvre peint de S. C. 1888-1975 (in preparation)
MONOGRAPHS, CATALOGUES: Brisset, P.: C. le solitaire. Paris 1970.– S. C. Musée National d'Art Moderne. Paris 1967 (cat.).– Creuze, R.: Charchouiana. Paris 1989.– Delettre, P. (ed.): C. Galerie Fanny Guillon-Laffaille. Paris 1988 (cat.).– Delettre, P. (ed.): C. 1888-1975. Centre Culturel de la Somme, Amiens et al. Amiens 1989 (cat.).– Waldberg, P. (ed.): C. Centre National d'Art Contemporain, Musée National d'Art Moderne. Paris 1971 (cat.)

**CHARLTON Alan**
born **1948** Sheffield (Yorkshire)
English painter and sculptor. **1965/66** Studied at Sheffield School of Art, **1966–1969** at Camberwell School of Art and **1969–1972** at the Royal Academy in London. As a student, painted his first monochrome paintings in grey. **1972** First solo-exhibition at the Konrad Fischer Gallery in Düsseldorf. **1982** Participation in documenta 7 in Kassel. **1991** Solo-exhibition at Haus Esters and Haus Lange in Krefeld. In ever-changing variations Charlton arranges his monochrome-grey canvases in strict geometrical order to form integrated compositions.
MONOGRAPHS, CATALOGUES: A. C. Stedelijk Van Abbe Museum. Eindhoven 1982 (cat.).– A. C. Institute of Contemporary Arts. London 1991 (cat.).– A. C. Museum Haus Esters. Krefeld 1992 (cat.).– Fuchs, R. (ed.): A. C. Castello di Rivoli, Museo d'Arte Contemporanea. Milan 1989 (cat.).– Raussmüller, U. and C. Sauer (ed.): A. C. Hallen für Neue Kunst. Schaffhausen 1991 (cat.).– Tosatto, G. (ed.): A. C. Musée d'Art Contemporain. Nîmes 1997 (cat.)

**CHIA Sandro**
born **1946** Florence
Italian painter. **1965–1969** Studied at the Accademia di Belli Arti in Florence. First

solo-exhibition at the La Salita Gallery in Rome. **1979** Solo-exhibition at the Paul Maenz Gallery in Cologne. **1980/81** Lived in Germany. From **1981** temporary jobs in Ronciglione and New York. **1982** Participation in documenta 7 in Kassel. **1984** Solo-exhibition at the Metropolitan Museum of Art in New York. **1993** Retrospective at the Nationalgalerie in Berlin. Numerous solo and group shows in America, Japan and Europe. Together with Clemente, Cucchi and Paladino, Chia belongs to the young generation of Italian artists named by Achille Bonito Oliva the Transavantguardia. In his predominantly mythological paintings he developed a free gestural style which repeatedly refers back to elements of painterly tradition.
WRITINGS: S. C.: Intorno a Se. Roma 1978
MONOGRAPHS, CATALOGUES: Celaya, G.: Die Räume bei C. Barcelona 1974.– S. C. Desert Museum. Palm Springs 1992 (cat.).– S. C. Novanta spine al vento. Museum Moderner Kunst. Vienna 1989 (cat.).– Esteban, C.: C. Paris 1972.– Frisa, M. L. (ed.): S. C. Dipinti, e titoli recenti. Palazzo Medici Riccardi, Museo Mediceo, Florence. Milan 1991 (cat.).– Geldzahler, H. (ed.): S. C. Prints 1973-1984. Metropolitan Museum of Art. New York 1984 (cat.).– Haenlein, C. et al. (ed.): S. C. Bilder 1976-1983. Kestner-Gesellschaft. Hanover 1983 (cat.).– Honisch, D. et al. (ed.): S. C. Nationalgalerie. Berlin 1992 (cat.).– Weisner, U. (ed.): S. C. Passione per l'arte. Kunsthalle Bielefeld. Bielefeld 1986 (cat.).– Wilde, E. d. and A. v. Grevenstein (ed.): S. C. Stedelijk Museum. Amsterdam 1983 (cat.)

**CHILLIDA Eduardo**
**1924** San Sebastián – **2002** San Sebastián
Spanish sculptor. **1943-1946** Studied architecture at Madrid University. **1947** Artistic training at a private school in Madrid. **1948** Moved to Paris. Made his first figurative sculptures from plaster and clay. **1951** Returned to Spain. First abstract iron sculptures. **1958** Received special honours at the Venice Biennale. Started to use other materials like steel, wood, marble or alabaster for his sculptures. Over the following years, awarded numerous prizes and honours. **1964-1977** Participation in documenta 3, 4 and 6 in Kassel. **1966** Wilhelm Lehmbruck award in Duisburg. **1971** Guest-professorship at the Carpenter Centre, Cambridge. **1974** First retrospective in Chateau de Ratilly, Burgundy. Chillida's abstract-monumental sculptures combine expressive intensity with stylistic elements of Constructivism.
CATALOGUES RAISONNES: Aresti, G. (ed.): C. Obra gráfica completa. Madrid 1977.– Esteban, C. (ed.): C. (mit Werkverzeichnis der Skulpturen). Paris 1971.– E. C. A Retrospective. Carnegie Institute, Pittsburgh et al. Pittsburgh 1979 (cat.).– Clay, J. (ed.): C. L'œuvre graphique. Paris 1978.– Koelen, M. v. de (ed.): E. C. Catalogue Raisonné of the Prints 1973-1996. 2 vols.

Mainz 1996-1997.– Michelin, G. (ed.): E. C. Das graphische Werk 1959-1972. Ulm 1973.– Michelin, G. (ed.): C. 2 vols. Paris 1979.– Paz, O.: C. Paris 1979
MONOGRAPHS, CATALOGUES: Barañano, K. M. d. (ed.): La obra artistica de E. C. Bilbao 1988.– Barañano, K. M. d. (ed.): Symposium C. San Sebastián 1990.– Barañano, K. M. d. et al. (ed.): E. C. Palacio de Miramar. San Sebastián 1992 (cat.).– Bußmann, K. et al. (ed.): E. C. Zeichnungen als Skulptur. Städtisches Kunstmuseum Bonn et al. Münster 1989 (cat.).– Celaya, G.: Les Espaces de C. Paris 1974.– C.'s Räume. Geneva 1974.– Dempsey, A. et al. (ed.): E. C. Neuer Berliner Kunstverein. Stuttgart 1991 (cat.).– C. en San Sebastián. Palacio de Miramar, San Sebastián. Madrid 1992 (cat.).– E. C. Hayward Gallery. London 1990 (cat.).– Esteban, C.: C. Paris 1971.– Gervasoni, M.-G. (ed.): E. C. Galleria Internazionale d'Arte Moderna Ca' Pesaro. Venice 1990 (cat.).– Haenlein, C. (ed.): E. C. Kestner-Gesellschaft. Hanover 1981.– Jabès, E. et al. (ed.): C. Musée d'Art Moderne. Brussels 1985 (cat.).– Lichtenstern, C. (ed.): C. und die Musik. Baumeister von Zeit und Klang. Bad Homburg 1997 (cat.).– Messer, T. M. et al. (ed.): E. C. Eine Retrospektive. Schirn Kunsthalle. Frankfurt-on-Main 1993 (cat.).– Paz, O. et al. (ed.): C. Martin-Gropius-Bau. Berlin 1991 (cat.).– Ragon, M.: C. Paris 1968.– Schmalenbach, W. (ed.): E. C. Zeichnungen. 3 vols. Frankfurt-on-Main 1977.– Schmidt, K. and M.-A. v. Lüttichau (ed.): E. C. Zeichnung als Skulptur 1948-1989. Städtisches Kunstmuseum Bonn et al. Bonn 1989 (cat.).– Selz, P. and J. J. Sweeney: C. New York 1986.– Volboudt, P.: C. Paris 1967, Stuttgart 1967

**CHRISTO & JEANNE-CLAUDE**
born **1935** Gabrovo (Christo)
born **1935** Casablanca (Jeanne-Claude)
Christo: born Christo Javacheff, June 13, Gabrovo, of a Bulgarian industrialist family. Jeanne-Claude: born Jeanne-Claude de Guillebon, June 13, Casablanca, of a French military family, educated in France and Switzerland. **1953-1956** Christo: Studied at Fine Arts Academy, Sofia. **1956** Arrival in Prague. **1957** One semester's study at the Vienna Fine Arts Academy. **1958** Christo: Arrival in Paris. Packages and "Wrapped Objects". **1960** Birth of their son, Cyril, May 11. **1961** Project for the "Wrapping of a Public Building". "Stacked Oil Barrels" and "Dockside Packages" in Cologne Harbor (their first collaboration). **1962** "Iron Curtain-Wall of Oil Barrels" blocking the Rue Visconti, Paris. **1963** "Showcases". **1964** "Stor Fronts". Establishment of permanent residence in New York City. **1966** "Air Package" and "Wrapped Tree", Stedelijk van Abbe Museum, Eindhoven. "42,390 cubic feet Package" at the Walker Art Center, Minneapolis School of Art. **1968** "Wrapped Fountain" and "Wrapped Medieval Tower", Spoleto. Wrapping of a public building "Wrapped Kunsthalle Berne, Switzerland".

"5,600 Cubicmeter Package" documenta 4, Kassel, an Air Package 280 feet high. **1969** "Wrapped Museum of Contemporary Art" Chicago. "Wrapped Floor and Stairway" Museum of Contemporary Art, Chicago. "Wrapped Coast, Little Bay, One Million Square Feet, Sydney, Australia." **1970** Wrapped Monuments, Milano: Monument to Vittorio Emanuele, Piazza Duomo; Monument to Leonardo da Vinci, Piazza Scala. **1971** "Wrapped Floors and Covered Windows and Wrapped Walk Way", Museum Haus Lange, Krefeld, Germany. **1972** "Valley Curtain, Grand Hogback, Rifle, Colorado, 1970 – 1972". **1974** "The Wall, Wrapped Roman Wall", Via V. Veneto and Villa Borghese, Rome. "Ocean Front, Newport, Rhode Island. **1976** "Running Fence, Sonoma and Marin Counties, California, 1972 – 1976". 18 feet high, 24-1/2 miles long. **1978** "Wrapped Walk Ways, Loose Park, Kansas City, Missouri, 1977 – 1978. **1979** "The Mastaba of Abu Dhabi, Project for the United Arab Emirates," (in progress). **1979** "The Gates, Project for Central Park New York City," (in progress). **1983** "Surrounded Islands, Biscayne Bay, Greater Miami, Florida, 1980 – 1983." **1985** "The Pont Neuf Wrapped, Paris, 1975 – 1985." **1991** "The Umbrellas, Japan-U.S.A., 1984 – 1991." 3100 umbrellas. **1992** "Over The River, Project for the Arkansas River, Colorado", (in progress). **1995** "Wrapped Floors and Stairways and Covered Windows" Museum Würth, Künzelsau, Germany. "Wrapped Reichstag, Berlin, 1971 – 1995" 100,000 sq. meters (1,076,000 sq. ft.) of fabric, 15,600 m. (51,181 feet) of rope and 200 tons of steel. **1997** "Wrapped Trees, Project for Foundation Beyeler and Berower Park, Riehen-Basel, Switzerland", (in progress).
CATALOGUES RAISONNES: Hovdenakk, P. (ed.): C. Complete Editions 1964-1982. New York and Munich 1982.– Schellmann, J. and J. Benecke (ed.): C. Prints and Objects. Munich and New York 1988, 1996.– Varenne, D. (ed.): C. Catalogue raisonné (in preparation)
MONOGRAPHS, CATALOGUES: Alloway, L.: C. New York and London 1969, C. Stuttgart 1969.– Baal-Teshuva, J. (ed.): C. The Reichstag and Urbane Projects. Kunst-Haus, Vienna et al. Munich 1993 (cat.).– Baal-Teshuva, J. and W. Volz: C. & J.-C. Berlin 1995, New York 1995.– Bourdon, D.: C. New York 1970.– Bourdon, D. (ed.): C. Running Fence. New York 1978.– Bourdon, D. (ed.): C. Surrounded Islands. New York 1986.– Bourdon, D. (ed.): The Pont-Neuf Wrapped. New York 1990.– Bourdon, D. et al.: C. Milan 1965.– Bourdon, D.: C. The Pont Neuf, Wrapped. Cologne 1990.– C. John Kaldor Projekt 1990. Art Gallery of New South Wales. Sydney 1990 (cat.).– C. & J.-C. et al.: C. Le Pont-Neuf empaqueté. Paris 1990.– C. & J.-C.: Wrapped Reichstag. Berlin 1971-1995. Photographs: W. Volz, Picture notes: D. Bourdon. Cologne 1996.– Cullen, M. S. (ed.): C. Der Reichstag. Frankfurt-on-Main 1984.– Kellein, T.: Montage der Abstraktion. C.'s Kölner Anfänge zu Großprojekten. Cologne 1986.– Laporte, D. G.: C. New York 1985, Paris 1985.– Sommer, A. (ed.): C. The Pont Neuf, Wrapped, Paris 1974-1985. Städtisches Kunstmuseum Bonn. Bonn 1993 (cat.).– Spies, W.: C. The Running Fence. New York and Paris 1977, Stuttgart 1977.– Spies, W.: C. Surrounded Islands. Cologne 1984.– Vaizey, M.: C. New York 1990, Recklinghausen 1990.– Volz, W. (ed.): C. Surrounded Islands. Cologne 1985.– Weiss, E. et al. (ed.): C. Projekte in der Stadt. 1961-1981. Museum Ludwig. Cologne 1981 (cat.).– Yard, S. (ed.): C. Oceanfront. The Art Museum, Princeton (NJ) et al. Princeton 1975 (cat.)

**ČIURLIONIS Mikolajus Konstantinas**
**1875** Varéna (Lithuania) – **1911** Pustelnik (near Warsaw)
Lithuanian musician and painter. **1884-1889** Studied at the Warsaw Institute of Music and **1901/02** at the Imperial Conservatory in Leipzig. **1904-1906** Attended the Warsaw School of Art. **1903-1905** First Symbolist works such as *The Flood* and the *Creation of the World*. **1906** Gave up traditional composition to develop a dynamic formal language of lines and circles creating an abstract pictorial space. **1907-1909** Exhibition curator and choir director in Vilnius. Author of therotical essays on art. **1908/09** Worked in St. Petersburg, painting the symbolic, abstract series *Sonata of the Stars* and *Sonata of the Pyramids* and landscapes of his homeland. **1909** Nervous breakdown. **1910** Admitted to a sanatorium near Warsaw. **1911/12** First posthumous solo-exhibitions in St. Petersburg and Moscow. Regarded as one of the founding fathers of abstract painting.
CATALOGUE RAISONNE: Landsbergis, V. (ed.): M. K. C. Vilnius 1992
MONOGRAPHS, CATALOGUES: Brockhaus, C. et al. (ed.): C. und die litauische Malerei 1900-1940. Wilhelm Lehmbruck Museum. Duisburg 1989 (cat.).– Landsbergis, V.: Tvorchestro Churlyonisa. Leningrad 1975.– Landsbergis, V. et al. (ed.): M. K. C. Vilnius 1997.– Rannit, A.: M. K. C. 1875-1911, Pionnier de l'art abstrait. Paris 1949.– Rannit, A.: M. K. C. Lithnian Visionary Painter. Chicago 1984.– Senn, A. et al.: M. K. C. Music of the Speres. Newtonville 1986.– Vaitkunas, C.: M. K. C. Dresden 1975.– Venclova, A.: M. K. C. Vilnius 1961.– Verkelyte-Federaviciene, B. et al. (ed.): M. K. C. Paintings, Sketches, Thoughts. Vilnius 1997.– Worobiow, N.: M. K. C. Der litauische Maler und Musiker. Leipzig 1938

**CLAASEN Hermann**
**1899** Cologne – **1987** Cologne
German photographer. Before World War I experimented with photography using a camera constructed out of a cigar box and spectacle lense. **1914** Suspected of spying and arrested for photographing with his home-made camera. Gave up working in his parents' textile business in order to become a professional photographer. **1927/28** Pho-

tographed skaters on the frozen Rhine. **1930** Worked as a portrait and advertising photographer. Took colour photographs of paintings in Cologne museums and churches. **1942** Lost nearly all his early works in the bombardment of May 31. Despite strict prohibition, photographed war damage in the city of Cologne from **1943–1945**. In **1947** met Konrad Adenauer. Took portrait-photos of the chancellor. Further portraits of VIPs from political and cultural circles. **1950** Participation in the first photokina. In the 60s, focused on industrial and portrait photography.

**CLEMENTE Francesco**
born **1952** Naples
Italian painter. **1968** Acquaintance with Twombly in Rome, whose work made a great impression on him. **1970** Began studying architecture in Rome. **1971** Exhibited first collages at the Valle Giulia Gallery in Rome. Travels to India and Afghanistan, which he later revisited many times for longer periods. Elements of these foreign cultures appear in his paintings. **1980** Visited New York. First solo-exhibition at the Sperone Westwater Gallery. **1982** Installation of a studio in New York. Participation in documenta 7 in Kassel. Clemente's pictures combine abstract forms with figurative elements. Together with Chia and Cucchi, is one of the main representatives of the Italian Transavanguardia.
WRITINGS: F. C.: Chi pinge figura, si non puo esser lei non la puo porre. Adyar 1980.– Crone, R. and G. Marsh (ed.): An Interview with F. C. New York 1987 / Interview mit F. C. Cologne 1990
MONOGRAPHS, CATALOGUES: Ammann, J.-C.: F. C. Bestiarium. Frankfurt-on-Main 1991.– Auping, M. (ed.): F. C. The John and Marble Ringling Museum of Art, Sarasota (FL) et al. New York 1985 (cat.).– Cortez, D. et al. (ed.): F. C. Fundación Caja de Pensiones. Madrid 1987 (cat.).– Crone, R. (ed.): F. C. Pastelle 1973-1983. Nationalgalerie, Berlin et al. Munich 1984 (cat.).– Francis, M. (ed.): F. C. Whitechapel Art Gallery, London et al. London 1983 (cat.).– Geldzahler, H. et al. (ed.): F. C. Affreschi. Pinturas al fresco. Fundación Caja de Pensiones. Madrid 1987 (cat.).– Haenlein, C. (ed.): F. C. Bilder und Skulpturen. Kestner-Gesellschaft. Hanover 1984 (cat.).– Koepplin, D. (ed.): F. C. Museum für Gegenwartskunst, Basel et al. Zurich 1987 (cat.).– McClure, M.: F. C. Testa coda. New York 1985.– Maenz, P. (ed.): F. C. "Il Viaggiatore Napoletano". Cologne 1982.– Percy, A. and R. Foye (ed.): F. C. Three Worlds. Philadelphia Museum of Art et al. New York 1990 (cat.)

**CLOSE Chuck**
born **1940** Monroe (WA)
American painter. **1958–1962** Studied at the University of Washington, **1962–1964** at Yale University in New Haven and **1964/65** at the Academy of Fine Arts in Vienna. **1967**

Lectureships at the School of Visual Arts in New York and at New York University. From **1970** did colour as well as black and white paintings, superimposing layers of primary colours to imitate commercial printing techniques. **1972** and **1977** participation in documenta 5 and 6 in Kassel. From **1979** painted over and manipulated enlarged polaroid photographs, and later used pâpier-maché collages to produce screen images. **1980** Retrospective in Minneapolis. Close is one of the most important representatives of American Superrealism and Photorealism. As demonstration material for his full size portraits, he uses self-made passport photos.
CATALOGUE RAISONNE: C. C. Editions: A Catalogue Raisonné. The Butler Institute of American Art. Youngstown (OH) 1989.– Lyons, L. and R. Storr: C. C. Paintings and Drawings. New York 1987
MONOGRAPHS, CATALOGUES: Brehm, M. et al. (ed.): C. C. Werke 1967-1992. Stuttgart 1994.– C. C. Works on Paper. Contemporary Arts Museum. Houston 1985.– Danto, A. C. (ed.): C. C. Recent Paintings. The Pace Gallery. New York 1993 (cat.).– Kern, H. (ed.): C. C. Kunstraum. Munich 1979 (cat.).– Lyons, L. and M. Friedman (ed.): C. Portraits. Walker Art Center. Minneapolis 1980 (cat.).– Poetter, J. and H. Friedel (ed.): C. C. Retrospektive. Staatliche Kunsthalle Baden-Baden et al. Stuttgart 1994 (cat.).– Storr, R. (ed.): C. C. The Museum of Modern Art, New York et al. New York 1998 (cat.).– Westerbeck, C. (ed.): C. C. The Art Institute of Chicago. Chicago 1989 (cat.)

**COBURN Alvin Langdon**
**1882** Boston – **1966** Colwyn Bay
American-English photographer. **1898** First photos. **1899–1900** Together with F. Holland Day, organized the exhibition "American Pictorial Photography". As an exponent of Pictorialism, he was convinced that photography could be as expressive a medium as painting. **1900** Travelled to Europe. **1902** Founding member of the Photo-secession. Specialized in portrait photography. Photographed numerous famous artists, authors and actors including Rodin, Henry James and Mark Twain. **1910** Published 20 photos in Stieglitz' *Camera Work*. **1912–1928** Worked as a photo-

grapher in London. **1916** Together with Gertrude Kaesebier and Clarence H. White, set up the group Pictorial Photographers of America **1917** Inspired by Cubism, produced his first abstract photos. **1917/18** Joined the Vorticists. **1931** Gave up photography.
WRITINGS: Gernsheim H. and A. (ed.): A. L. C. An Autobiography. London and New York 1966, 1978
MONOGRAPHS, CATALOGUES: Blatchford, P. (ed.): A. L. C. 1882-1966. Camden Arts Centre. London 1966 (cat.).– Weaver, M.: A. L. C.: Symbolist Photographer 1882-1966. New York 1986

**COLVILLE Alex**
born **1920** Toronto
Canadian painter. **1938–1942** Studied painting at Mount Allison University in Sackville, New Jersey. **1942–1946** Military service. From **1946** lived and worked as a freelance painter in Nova Scotia. **1967** Commissioned by the Canadian government to design various gold coins. **1946–1963** Lectureship at Mount Allison University and **1967/68** at the University of California in Santa Cruz. **1971** DAAD scholarship to Berlin. Numerous prizes and honorary awards from various universities and institutions in the United States and Canada. In his detailed and intensely atmospheric portrayals of man and nature, Colville displays a close affinity to the school of Magic Realism.
WRITINGS: Meston, G. and C. Maclean (ed.): A. C. Diary of a War Artist. Halifax 1981
CATALOGUE RAISONNE: Dow, H. J. (ed.): The Art of A. C. Toronto 1972
MONOGRAPHS, CATALOGUES: Burnett, D. and M. Schiff (ed.): Art Gallery of Ontario. Toronto 1983 (cat.).– Burnett, D. and M. Schiff (ed.): A. C. Gemälde und Zeichnungen. Munich 1983.– A. C. Gemälde und Zeichnungen (1970-1977). Städtische Kunsthalle Düsseldorf. Düsseldorf 1977 (cat.).– C. Staatliche Kunsthalle Berlin et al. Berlin 1983 (cat.).– Cheetham, M. A.: A. C. Toronto 1994.– Dow, H.: The Art of A. C. Toronto 1994.– Fry, P. (ed.): A. C. Embarquement. Musée des Beaux-Arts. Montreal 1994 (cat.).– Schmied, W. and R. Melville (ed.): A. C. Kestner-Gesellschaft. Hanover 1969 (cat.)

**CONSTANT**
(Constant A. Nieuwenhuys)
born **1920** Amsterdam
Dutch painter, sculptor and architect.
**1938/40** Attended the School of Applied Arts and **1940–1942** the Rijksakademie in Amsterdam. **1945** Abstract iron sculptures and expressive paintings. Together with Jorn, Corneille and Appel, founded the group Cobra. From **1952** focused on architecture, especially problems of regional and town planning. **1956** Participation at the Venice Biennale. **1959** and **1964** participation in documenta 2 and 3 in Kassel. **1958** His futuristic architectural ideas developed

into a visionary model of a "New Babylon" combining politics, architecture and aesthetics. **1965** Retrospective in the Gemeentemuseum in The Hague. **1991** Resistance Prize for artists.
WRITINGS: C.: New Babylon. The Hague 1974.– C.: A propos Cézanne. Amsterdam 1980
MONOGRAPHS, CATALOGUES: C. Schilderijen 1969-1977. Stedelijk Museum. Amsterdam 1978 (cat.).– Haaren, H. v.: C. Amsterdam 1967.– Honnef, K. (ed.): C. 1945-1983. Rheinisches Landesmuseum, Bonn. Cologne 1986 (cat.).– Jitta, M. J. et al. (ed.): C. Schilderijen 1940-1980. Haags Gemeentemuseum. The Hague 1980 (cat.).– Lambert, J.-C.: C. Les trois espaces. Paris 1992.– Lambert, J.-C.: C. Les Aquarelles. Paris 1994.– Locher, J. L. (ed.): C. Schilderijen 1940-1980. Gemeentemuseum. The Hague 1980 (cat.).– Vree, F. De: C. Schelderode 1972

**CORINTH Lovis**
**1858** Tapiau – **1925** Zandvoort
German painter and graphic artist. **1876–1880** Attended the Königsberg Academy. **1880–1884** Studied with Franz von Defregger at the Munich Academy. **1884** Travelled to Antwerp where he became familiar with the works of Rubens. From **1884–1886** studied at the Académie Julian in Paris under Adolphe William Bouguereau and Joseph Nicolas Robert-Fleury. Strongly impressed by works of Gustave Courbet. **1887–1891** Lived in Berlin. **1891** Moved to Munich for 8 years; first successes with landscapes, religious paintings and portraits. **1901** Returned to Berlin. Joined the Berlin Secession and, together with Walter Leistikow, founded a painting school for women. Inspired by Slevogt and Liebermann, developed an impressionist style. **1911** Chairman of the Berlin Secession. A stroke forced him to interrupt his creative work but then induced a change of style: violent brush strokes, strong colour and a sombre mood mark his later work, bringing it closer to Expressionism. From **1918** onwards lived in his country house at Urfeld on the Walchensee.
WRITINGS: Englert, K. (ed.): L. C. Gesammelte Schriften. Berlin 1920, 1995.– Hartleb, R. (ed.): L. C. Selbstbiographie. Leipzig 1993

CATALOGUES RAISONNES: Berend-Corinth, C. and B. Hernad (ed.): L. C. Die Gemälde. Werkverzeichnis. Munich 1992.– Müller, H. (ed.): Die späte Graphik von L. C. Hamburg 1960 / The Late Graphic Work. San Francisco 1994.– Schwarz, K. (ed.): Das graphische Werk von L. C. 2 vols. Berlin 1917-1922. The Graphic Work. San Francisco 1985

MONOGRAPHS, CATALOGUES: Bussmann, G.: L. C. Carmencita. Malerei auf der Kante. Frankfurt-on-Main 1985.– Corinth, T.: L. C. Eine Dokumentation. Tübingen 1979.– Deecke, T.: Die Zeichnungen von L. C. Studien zur Stilentwicklung. Diss. Berlin 1973.– Felix, Z. (ed.): L. C. 1858-1925. Museum Folkwang, Essen et al. Cologne 1985 (cat.).– Hahn, P.: Das literarische Figurenbild bei L. C. Tübingen 1970.– Heise, C.-G.: L. C. Bildnisse der Frau des Künstlers. Stuttgart 1958.– Keller, H.: L. C. Walchensee. Munich and Zurich 1976.– Müller, H.: Die späte Graphik von L. C. Hamburg 1960, San Francisco 1994.– Netzer, R.: L. C. Graphik. Munich 1958.– Osten, G. v. d.: L. C. Munich 1955.– Schröder, K. A. (ed.): L. C. 1858-1925. Landesmuseum Hanover et al. Munich 1992 (cat.).– Schuster, P.-K. et al. (ed.): L. C. Haus der Kunst, Munich et al. Munich 1996 (cat.).– Timm, W. et al. (ed.): L. C. Die Bilder vom Walchensee. Vision und Realität. Ostdeutsche Galerie, Regensburg et al. Regensburg 1986 (cat.).– Uhr, H.: L. C. Berkeley 1990

**CORNEILLE**
(Cornelis Guillaume van Beverloo)
born **1922** Liège
Belgian painter with Dutch parents. **1940-1943** Attended drawing classes at the Art Academy in Amsterdam. **1946** First solo-exhibition in Groningen. **1948** Together with Appel, Constant and Alechinsky, founded the group Cobra. **1948** and **1949** visits to Tunisia. Solo-exhibition in Paris followed by others in Amsterdam, Budapest, Copenhagen and Antwerp. **1950** Moved to Paris. Participated regularly in the Salon de Mai. Took part in the São Paulo Biennale in **1953** and was represented at the Venice Biennale in **1954**. Worked on ceramics with Jorn. **1956** Guggenheim Award for the Netherlands. **1957/58** Toured Africa visiting the Sudan, Nigeria, Ethiopia and Kenya, and gathering many strong impressions later incorporated into his work. **1958** Visited South America, Mexico and New York. **1959** and **1964** participation in documenta 2 and 3 in Kassel. Corneille's fine style of drawing and economic, delicate use of colour have close affinities to French Informel.
CATALOGUES RAISONNES: Birtwistle, G. et al. (ed.): C. L'Œuvre gravé 1948-1975. 1993.– Donkersloot-v. d. Berghe, P. (ed.): C. Het complete grafische werk 1948-1975. Amsterdam 1992.– Maurizzi, E. (ed.): L'Opera grafica di C. 1948-1974. Pollenza 1975
MONOGRAPHS, CATALOGUES:
Bierman, M. den (ed.): C. An Early Bird.

Amsterdam 1997 (cat.).– Claus, H. Over het werk vamn C. Amsterdam 1951.– Cluny, C.-M.: C. Paris 1992.– C. Stedelijk Museum. Amsterdam 1966 (cat.).– Dupen, L. and E. Slagter (ed.): C.'s weergaloze werkelijkheid. Amsterdam 1997.– Gribling, F. T.: C. Amsterdam 1997.– Kerkhoven, T. A. T.: Het Afrikaanse gericht van C. The Hague 1992.– Lambert, J. C.: C. Paris 1960.– Lambert, J.-C.: C. L'Œil de l'été. Paris 1989.– Lambert, J.-C. (ed.): C. Het oog van de zomer. Jaski Art Gallery, Amsterdam. Venlo 1992 (cat.).– Laude, A.: C. Le Roi-image. Paris 1973.– Paquet, M.: C. La Sensualité du sensible. Paris 1988.– Paquet, M.: C. Peintures et gouaches. Paris 1989.– Slagter, E.: C. Schelderode 1976

**CORNELL Joseph**
**1903** Nyack (NY) – **1972** New York
American sculptor. Originally a self-taught painter. **1932** Inspired by works of Max Ernst and other Surrealists, produced his first assemblages, collages and boxes. Participation in the exhibition "Surrealist Group Show" at the Julien Levy Gallery in New York. **1939-1945** Close contact with the Surrealists living in New York. First film projects. **1967** Retrospectives at the Pasadena Art Museum and at the Solomon R. Guggenheim Museum, New York. **1968** and **1972** Participation in documenta 4 and 5 in Kassel. Cornell's poetic, farcical assemblies of commonplace objects, usually displayed in glass boxes, anticipate various neo-dadaist techniques and Pop Art trends.
WRITINGS: Caws, M. A. (ed.): J. C.'s Theater of the Mind. Selected Diaries, Lettersand Files. New York 1993
MONOGRAPHS, CATALOGUES: Ashton, D.: A J. C. Album. New York 1974, 1989.– J. C. Musée d'Art Moderne de la Ville de Paris. Paris 1981 (cat.).– Hartigan, L. R. (ed.): J. C. An Exploration of Sources. National Museum of American Art. Washington 1983.– Huici, F. (ed.): J. C. Fundación Juan March. Madrid 1984 (cat.).– Jaguer, E.: J. C. Jeux, jouets et mirages. Paris 1989.– McShine, K. (ed.): J. C. The Museum of Modern Art, New York et al. New York 1980, Munich 1990 (cat.).– Porter, F. (ed.): J. C. Pasadena Art Museum. Pasadena 1966 (cat.).– Simic, C.: Dimestore Alchemy. The Art of J. C. Hopewell (NJ) 1992.– Solomon, D.: Utopia Parkway: The Life and Work of J. C. New York 1997.– Starr, S. L.: J. C. Art and Metaphysics. New York 1982.– Starr, S. L. and M. Kobayashi (ed.): J. C. Museum of Modern Art, Kamakura. New York 1994 (cat.).– Tashjian, D.: J. C. Gifts of Desire. Miami Beach 1992.– Waldman, D.: J. C. New York 1977

**CORPORA Antonio**
**1909** Tunis – **2004** Rome
Italian painter. Studied art in Tunis. Moved to Florence in **1929** where he copied Old Masters in the Uffizi. **1930** Continued to study in Paris, encouraged and supported by

the art dealer Léopold Zborowski, a friend of Modigliani. Up to **1937** lived alternately in Paris and Tunis. Influenced by French painting, developed a neo-cubist style and rejected the traditional ideas of the Novecento group. **1947** Joined Fronte Nuovo delle Arti whose members, such as Vedova, Birolli and Giulio Turcato, represented a variety of abstract styles. After some changes in membership and under the name Gruppo degli otto Pittori italiani this group made its first public appearance at the **1952** Venice Biennale exhibiting gestural abstract paintings. **1955** and **1959** Participation in documenta 1 and 2 in Kassel. Corpora has been represented in numerous exhibitions throughout Italy, Tunisia and France.
CATALOGUE RAISONNE: Steingräber, E. and H. Friedel (ed.): A. C. Druckgraphik. Werkkatalog. Bayerische Staatsgemäldesammlungen in der BMW-Galerie. Munich 1976 (cat.)
MONOGRAPHS, CATALOGUES: Ballo, G.: C. Roma 1956.– Frazzetto, G. (ed.): A. C. Opere 1945-1988. Monastero dei Benedettini. Catania 1990 (cat.).– Monferini, A. (ed.): C. Galleria Nazionale d'Arte Moderna, Roma. Segrate 1988 (cat.).– Restany, P. et al. (ed.): C. Gallerie dell'Accademia, Venice. Roma 1988 (cat.).– Schulz-Hoffmann, C. (ed.): C. Bayerische Staatsgemäldesammlungen, Munich. Baierbrunn 1981 (cat.).– Steingräber, E. et al. (ed.): A. C. Die Grenze des Unendlichen. Galerie Günther Franke. Munich 1973 (cat.).– Viviani, C.: A. C. Roma 1971

**COTTINGHAM Robert**
born **1935** Brooklyn (NY)
American painter. **1959-1964** Studied at the Pratt Institute in Brooklyn. **1962** Supplementary studies in design. **1955-1958** Military service. **1959-1964** Art Director for advertising in New York and in **1964-1968** in Los Angeles. **1968** First solo-exhibition at the Molly Barnes Gallery in Los Angeles. As a freelance painter he specialized in hyperrealistic representations of neon-advertising and store fronts for which he used sections of enlarged photographs. **1969/70** Lectureship at the Art Centre of Design, Los Angeles. **1972** Participation in documenta 5 in Kassel. Received the National Endowment for the Arts Grant in **1974** and, in **1988**, the Artist of the Year Award from the Fairfield

Chamber of Commerce, Connecticut.
MONOGRAPHS, CATALOGUES: R. C. Wichita Art Museum. Wichita (KS) 1983 (cat.).– R. C. The Museum of Art, Science and Industry. Bridgeport (CT) 1986 (cat.)

**CRAGG Tony**
born **1949** Liverpool
English sculptor. **1966-1968** Worked as a laboratory technician in the chemical industry. **1970-1973** Studied painting at Wimbledon School of Art. **1973** Studied sculpture at the Royal College of Art in London. **1976** Lectureship at the Art Academy in Metz. **1977** Moved to Germany. **1979** First solo-exhibition at the Lisson Gallery, London. Ambiguous, farcical sculptures made of materials such as synthetic plastics, consumer waste, metal and gum. **1982** and **1987** participation in documenta 7 and 8 in Kassel. **1988** Received the Turner Prize in London. Represented Great Britain at the Venice Biennale. **1989** Professorship for sculpture at the Düsseldorf Academy. With his murals of plastic debris and object arrangements made from stone, glass, silicates and other materials, Cragg highlights the material wealth of this world, as manifest in nature, science, technology and industry, and draws attention to the prefabricated nature of everyday objects and modern life.
WRITINGS: T. C. Schriften 1981-1972. Brussels 1992 (cat.)
MONOGRAPHS, CATALOGUES: Barnes, L. et al. (ed.): T. C. Sculpture 1975-1990. Newport Harbor Art Museum et al. London 1990 (cat.).– Castro Flórez, F. C. et al. (ed.): T. C. Museo Nacional Centro de Arte Reina Sofía. Madrid 1995 (cat.).– Celant, G. and D. Eccher (ed.): T. C. Galleria Civica d'Arte Contemporanea, Trento. Milan 1994 (cat.).– Celant, G.: T. C. London 1996.– Cooke, L. (ed.): T. C. Hayward Gallery. London 1987 (cat.).– T. C. Openluchtmuseum voor Beeldhouwerkunst. Middelheim 1997 (cat.).– Grenier, C. et al. (ed.): T. C. Paris 1995 (cat.).– Haenlein, C. (ed.): T. C. Skulpturen. Kestner-Gesellschaft. Hanover 1985 (cat.).– Martin, J.-H. (ed.): T. C. Kunsthalle Bern. Bern 1983 (cat.).– Mittringer, M. (ed.): T. C. Silikate. Holbein-Haus. Augsburg 1994 (cat.).– Müller, M. (ed.): T. C. Kunstsammlung Nordrhein-Westfalen. Düsseldorf 1989 (cat.).– Pohlen, A. (ed.): T. C. Palais des Beaux-Arts. Brussels 1985.– Schimmel, P. (ed.): T. C. Sculpture 1975-1990. Newport Harbor Art Museum. London 1991 (cat.).– Schwarz, M. (ed.): T. C. Skulpturen. Badischer Kunstverein. Karlsruhe 1982 (cat.).– Wildermuth, A.: T. C. Zwei Landschaften. Basel 1983.– Wildermuth, A.: T. C. Eine Werkauswahl. Stuttgart 1990.– Wildermuth, A. (ed.): T. C. Dessins, Zeichnungen. Stuttgart 1994 (cat.)

**CRIPPA Roberto**
**1921** Monza – **1972** Milan
Italian painter. Studied at the Milan Brera

for the house of Pierre Cocteau in the Touraine, through which he developed a naturalistic formal language. **1973** First retrospective at the Dépot 15 gallery in Paris.
MONOGRAPHS, CATALOGUES: J. C. Musée d'Art Moderne. Troyes 1986 (cat.).– Karshan, D.: C. Paris 1973.– Reichard, R.: J. C. 1888-1971. Einführung in das plastische Werk. 2 vols. Frankfurt-on-Main 1983.– Reichard, R. (ed.): J. C. Kubistische und nachkubistische Skulpturen 1913-1950. Galerie Reichard. Frankfurt-on-Main 1988 (cat.)

School with Achille Funi and Carrà till **1940**. Influenced by Matta, he developed an abstract-expressionistic style. With his free, expansive calligraphy, he ranks with Fontana and Emilio Scanavino as one of the most important protagonists of the Movimento Spaziale in Italy. He participated regularly in the Venice Biennale. From **1951** his works were also exhibited in the United States. **1955** Participation in documenta 1 in Kassel. In **1972** he died in an airplane crash near Milan.
MONOGRAPHS, CATALOGUES: Ballo, G. (ed.): R. C. Palazzo Reale. Milan 1971 (cat.).– Giani, G. (ed.): R. C. Venice 1954.– R. C. Galleria Cortina. Milan 1971 (cat.).– Tapié, M.: C. Milan 1969

**CROTTI Jean**
**1878** Bulle (near Fribourg) – **1958** Paris
Swiss painter. **1896** Studied applied art in Munich and then worked for four years as a stage designer in Marseille. From **1901** studied in Paris. Travelled to Italy in **1905** and **1912**. Was influenced by Cubism and after **1923** incorporated Orphist ideas into his paintings. **1915/16** Lived in New York where he made friends with Duchamp. First paintings on glass and mechanical constructions. **1919** Married the artist Suzanne Duchamp, sister of Marcel Duchamp, in Paris, and exhibited with her in **1921** and **1923**. Bought a house in Mougins in **1925**, where he was a neighbour of Picabia. **1937** Gave an abstract, coloured light performance at the Paris World Fair. **1947** Exhibited his *Gémeaux* (Gemini) at the cultural centre of the French Embassy in New York, demonstrating a new technique of painting on glass.
MONOGRAPHS, CATALOGUES: Camfield, W. A. and J.-H. Martin (eds.): Tabu Dada. J. C. & Suzanne Duchamp 1915-1922. Kunsthalle Bern et al. Bern 1983 (cat.).– Cartier, J. A.: J. C. (n. p.) 1956.– J. C. 1878-1958. Gimpel Fils Gallery, London et al. London 1974 (cat.).– J. C. Centre Georges Pompidou. Paris 1983 (cat.).– George, W.: J. C. Paris 1930.– George, W.: J. C. et la primauté du spirituel. Geneva 1959

**CRUZ-DIEZ Carlos**
born **1923** Caracas
Venezuelan painter and kinetic artist. **1940**-

**1945** Studied at the Escuela de Artes Plásticas in Caracas. **1944–1955** Graphic designer for the Creole Petroleum Corporation. **1946**–**1951** Art director for the advertising company McCann-Erickson. **1957** Set up his own graphic and industrial design company. **1958–1960** Second chancellor of the Escuela de Artes Plásticas in Caracas. **1959** Started his series *Psychochromatics* and *Chromatic-Interferences*. **1960** Took part in the exhibition "Mouvement" at the Stedelijk Museum in Amsterdam and at the Moderna Museet in Stockholm. **1962** Participation at the Venice Biennale and in **1963** in the exhibition "Nouvelle Tendance" in Zagreb. **1965** First solo-exhibition in London and Paris. **1967** Received special honours at the São Paulo Biennale. Published the book *Refléxion sobre el color* in **1989**. Cruz-Diez experiments in his pictures and objects with optical phenomena set up by overlapping colour fields and stripes. His works, in which objects can be manipulated by the spectator, are closely linked to kinetic art.
WRITINGS: C.-D.: Reflexión sobre el color. Caracas 1989
MONOGRAPHS, CATALOGUES: Bordier, R.: C.-D. ou la couleur comme événement. Paris 1972.– Boulton, A.: C.-D. Caracas 1975.– Clay, J.: C.-D. et les trois étapes de la couleur moderne. Paris 1969.– C. C.-D. Musée des Beaux-Arts. Caracas 1960 (cat.).– C. C.-D. Didattica e polemica del colore. Centro iniziative culturali. Prodenone 1981 (cat.).– Guevara, R. (ed.): C. C.-D. Museo de Arte Contemporánea. Caracas 1974 (cat.)

**CSAKY Joseph**
**1888** Szeged (Hungary) – **1971** Paris
Hungarian-French sculptor. **1908** Moved to Paris after attending a few classes at the Academy of Applied Arts in Budapest. Acquaintance with Léger and Archipenko, later with the Cubists centred around Picasso and Braque. **1911** Exhibition at the Salon d'Automne in Paris. **1912** Some works exhibited at the Salon de la Section d'Or and in **1913/14** at the Salon des Indépendants. **1921–1923** Participation in the permanent exhibition "Maître du Cubisme". **1922** Acquired French citizenship. **1924** Member of the Hungarian artists' group KUT. **1927–1930** Created fish sculptures

**CUCCHI Enzo**
born **1950** Morro d'Alba
Italian painter, sculptor and draughtsman. Apprenticed to a restorer. **1966–1968** Worked as a surveyor before becoming a freelance artist. **1977** First solo-exhibition in Milan. **1979** Together with Chia, Clemente, Paladino and others, formed the group Transavanguardia. **1982** and **1987** participation in documenta 7 and 8 in Kassel. **1984** Designed a sculpture for the Bruglinger-Park in Basel, followed by a series of works for public places. **1986** Retrospective at the Pompidou Centre, Paris and solo-exhibition at the Guggenheim Museum, New York. Numerous stage-and costume designs for the theatre, among others for operas by Gioacchino Rossini and dramas by Heinrich von Kleist. Absorbed elements of painterly tradition in his pictures and sculptures, combining them in his own individual pictorial and sign language.
WRITINGS: E. C.: Disegno finito. Roma 1978
MONOGRAPHS, CATALOGUES: Ammann, J.-C. et al. (ed.): E. C. Giulio Cesare Rom. Stedelijk Museum, Amsterdam et al. Amsterdam 1983 (cat.).– Barzel, A. (ed.): E. C. Centro per l'Arte Contemporanea Luigi Pecci. Prato 1989 (cat.).– Blistène, B. et al. (ed.): E. C. Centre Georges Pompidou. Paris 1986 (cat.).– E. C. Sparire. 2 vols. New York 1987.– Delgado, G. (ed.): E. C. Musée d'Art Contemporain de Bordeaux. Bordeaux 1986 (cat.).– Eccher, D.: E. C. Roma. Paris 1992.– Felix, Z. (ed.): E. C. Museum Folkwang. Essen 1982 (cat.).– Friedel, H. (ed.): E. C. Testa. 2 vols. Städtische Galerie im Lenbachhaus, Munich et al. Munich 1987 (cat.).– Gianelli, I. (ed.): C. Castello di Rivoli, Museo d'Arte Contemporanea. Milan 1993 (cat.).– Hohl, H. et al. (ed.): E. C. Roma. Hamburger Kunsthalle. Stuttgart 1992 (cat.).– Perucchi, U. (ed.): E. C. Zeichnungen 1975-1989 / La disegna 1975-1988 / Drawings 1975-1989. Kunsthaus Zurich et al. unich 1988, New York 1990 (cat.).– Schneider, U. (ed.): E. C. Näher zum Licht. Aachen 1997 (cat.).– Schulz-Hoffmann, C. and U. Weisner (ed.): E. C. Guida al disegno. Kunsthalle Bielefeld et al. Munich 1987 (cat.).– Schwander, M. and D. Davvetas: E. C. L'ombra vede. 1987.– Waldman, D. (ed.): E. C. Solomon R. Guggenheim Museum. New York 1986 (cat.)

**DADO**
(Miodrag Djuric)
born **1933** Cetinje (Montenegro)
Montenegran painter. **1947–1952** Studied at the Academy of Arts in Hercegnovi, Montenegro and in **1947–1952** at the Belgrade Academy. **1956–1958** Worked as a lithographer in Paris. Discovered by Dubuffet, he worked as a freelance painter in Paris and Courcelle from **1958** and had his first solo-exhibition at the Daniel Cordier gallery in the same year. **1964** and **1977** participation in documenta 3 and 6 in Kassel. **1982** Retrospective at the Pompidou Centre in Paris. Dado's paintings, which are a blend of veristic Realism and magic Surrealism, are animated by illusory figures.
MONOGRAPHS, CATALOGUES: Barousse, P.: D. Un signe des temps. Musée Ingres, Montabon. Paris 1984 (cat.).– Bosquet, A.: D. Un univers sans repos. Paris 1991.– D. Centre National d'Art Contemporain. Paris 1970 (cat.).– Derouet, C. (ed.): D. Dessins, tekeningen. Galerie Isy Brachot. Brussels 1982 (cat.).– Louis-Combet, C.: Dadomorphes et dadopathes. Montolieu 1992.– Picon, G.: D. Galerie J. Bucher. Paris 1971 (cat.)

**DAI Guangyu**
born **1955** Cchengdu (Province of Sichuan)
Chinese painter. **1986** Founded the Red-Yellow-Blue Group. **1994** Invited by the US information office to spend two months in the USA as a guest researcher.

**DALI Salvador**
**1904** Figueras (near Gerone) – **1989** Figueras
Spanish artist. Even as a student Dalí was a trouble-maker: after three years of studying at the Madrid Academy, he was expelled in **1924**. **1925** Became interested in the psychoanalytical theories of Sigmund Freud. **1929** Moved to Paris, the centre of Surrealism. Developed "critical paranoia", a positive form of automatism, whereby he aimed to portray not visible objects but their associated images and subconscious meanings. Stay in Cadaqués together with Magritte, Luis Buñuel, Paul Eluard and his wife Gala. Gala, the Muse of the Surrealists, was to become Dalí's lover. Collaboration on Buñuel's film *Un Chien andalou* and in

1931 on the film *L'Age d'or*. 1937 Despite being officially excluded by Breton, he participated in the activities of the Surrealist Circle. Travelling through Italy in 1937–1939, he studied Palladian architecture and Renaissance and Baroque painting. 1940 Went to America where he proclaimed his return to classical art. 1949 Returned to Port Lligat in Spain and converted to Catholicism. 1951 Published his *Mystical Manifesto*. 1971 Opening of a Dalí Museum which was later transferred to St. Petersburg, Florida in 1982. In 1979, the largest-ever Dalí retrospective at the Pompidou Centre in Paris, and the Tate Gallery in London.
WRITINGS: S. D.: Diary of a Genius. Garden City 1965.– S. D.: La conquête de l'irrationnel. Paris 1935, 1971.– S. D. and F. G. Lorca: Correspondance 1925-1936. Paris 1987.– Mathes, A. and T. D. Stegmann (ed.): S. D. Unabhängigkeitserklärung der Phantasie und Erklärung der Rechte des Menschen auf seine Verrücktheit. Gesammelte Schriften. Munich 1974
CATALOGUES RAISONNES: Descharnes, R. and G. Néret (ed.): S. D. The Paintings. 2 vols. Cologne 1994.– Löpsinger L. and R. Michler (ed.): S. D. Das druckgraphische Werk 1924-1980. 2 vols. Munich 1994. S. D. Catalogue Raisonné of Etchings and Mixed-Media Prints 1924-1980. 2 vols. Munich 1995
MONOGRAPHS, CATALOGUES: Abadie, D. (ed.): S. D. Rétrospective 1920-1980. Centre Georges Pompidou. Paris 1979 (cat.) /S. D. Retrospektive 1920-1980. Centre Georges Pompidou, Paris. Munich 1980 (cat.).– Abadie, D. (ed.): La Vie publique de S. D. Paris 1979.– Ajame, P.: La double vie de S. D. Paris 1984.– Bosquet, A.: Entretiens avec S. D. Paris 1983.– Cowles: Der Fall S. D. Munich 1981.– S. D. Museum Boymans-van Beuningen. Rotterdam 1974 (cat.).– S. D. 400 Obras de S. D. del 1914 al 1983. Palau Reial de Pedralbes, Barcelona et al. Madrid 1983 (cat.).– Descharnes, R.: S. D. Stuttgart and Munich 1985.– Descharnes, R. and G. Néret: S. D. Cologne 1990.– Descharnes, R.: D. The Work, the Man. New York 1999, 1997.– Etcherington-Smith, M.: D. une vie. Paris 1994.– Finkelstein, H.: S. D.'s Art and Writing 1927-1942. The Metamorphoses of Narcissus. New York 1996.– Gallwitz, K. (ed.): D. Staatliche Kunsthalle Baden-Baden. Baden-Baden 1971 (cat.).– Gibson, I. et al. (ed.): S. D. The Early Years. Hayward Gallery, London et al. London 1994.– Gibson, I.: The Shameful Life of S. D. London 1997.– Gomez de la Serna, R.: D. Paris 1989.– Gorsen, P.: S. D. Der kritische Paranoiker. Frankfurt-on-Main 1983.– Lubar, R. S. (ed.): The S. D. Museum Collection. Boston 1991.– Maur, K. v. (ed.): S. D. 1904-1989. Staatsgalerie Stuttgart et al. Stuttgart 1989 (cat.).– Musildak-Schlott, G.: S. D. und die Bildtradition. Tübingen 1982.– Parinaud, A. (ed.): The Unspeakable Confessions of S. D. New York 1981.– Passoni, F. et al.: D. nella terza dimensione. Milan 1986.– Radford, R.: S. D. London 1997.– Raeburn, M. (ed.): S. D. The Early Years. Hayward Gallery, London et al. London and New York 1994 (cat.).– Rey, H.-F.: D. dans son labyrinthe. Paris 1974.– Rogerson, M.: The D. Scandal. An Investigation. London 1987.– Rojas, C.: El mundo mítico y mágico de S. D. Barcelona 1985.– Romero, L.: D. Barcelona 1975.– Santos Torroella, R.: La miel es más dulce que la sangre: las épocas lorquiana y freudiana de S. D. Barcelona 1984.– Schiebler, R.: Das geheime Leben des S. D. Munich 1984.– Schiebler, R. (ed.): D., Lorca, Buñuel. Aufbruch in Madrid. Stuttgart 1993.– Secrest, M.: S. D. The Surrealist Jester. London and New York 1986/S. D. Bern and Munich

1987/S. D. L'extravagant surréaliste. Paris 1988.– Toroella, R. S.: S. D. Richford 1997

**DARBOVEN Hanne**
born 1941 Munich
German artist. Studied at the Hamburg School of Fine Arts. 1966–1968 Lived in New York, where she established contact with minimal artists such as Sol LeWitt and Carl Andre. Serial drawings with numbers on graph paper with millimetre squares. 1967 First solo-exhibition at the Konrad Fischer gallery in Düsseldorf. From 1968 created registers of calendar dates, set out in columns and strictly organised squares. 1969 Return to Hamburg. 1972–1982 Participation in documenta 5–7 in Kassel. After 1973 worked on the subject of re-writing literature (among others Homer's *Odyssey* and Heinrich Heine's *Atta Troll*). Her pages entitled *Writing Time* of 1975–1980 are concerned with historical and political events. 1978 Integrated photographic material in her writing-drawings. 1982 Participation at the Venice Biennale. 1986 Won the Edwin Scharff Award in Hamburg. 1989 Retrospective at the Musée d'Art Moderne de la Ville de Paris.
WRITINGS: H. D.: Das Sehen ist nämlich auch eine Kunst. Brussels and Hamburg 1974.– H. D.: El Lissitzky. Hamburg and Brussels 1974.– H. D.: New York Diary. New York 1976.– H. D. Briefe. Stuttgart 1995
CATALOGUE RAISONNE: H. D. Kinder dieser Welt. Stuttgart 1997 (cat.)
MONOGRAPHS, CATALOGUES: Bischoff, U. (ed.): H. D. Evolution "86". Staatsgalerie moderner Kunst. Munich 1991 (cat.).– Burgbacher-Krupka, I.: Konstruiert, Literarisch, Musikalisch/Constructed, Literary, Musical. H. D. The Sculpting of Time. Stuttgart 1994.– Cladders, J. and H. Honnef (ed.): H. D. Ein Monat, ein Jahr, ein Jahrhundert. Kunstmuseum Basel. Basel 1974 (cat.).– Cladders, J. (ed.): H. D. Pavillon der Bundesrepublik Deutschland. Venice 1982 (cat.).– H. D. Westfälischer Kunstverein. Münster 1971 (cat.).– H. D. Een maand, een jaar, een eeuw. Werken von 1968 en met 1974. Stedelijk Museum. Amsterdam 1975 (cat.).– H. D. Musée d'Art Moderne de la Ville de Paris. Paris 1986 (cat.).– H. D. Quartett "88". University of Chicago. Cologne 1990 (cat.).– H. D. Evolution Leibniz 1986. Sprengel Museum, Hanover. Stuttgart 1996 (cat.).– Honnef, K. et al. (ed.): H. D. Bismarckzeit. Rheinisches Landesmuseum. Bonn 1979 (cat.).– Jochimsen, M.: H. D. Wende "80". Bonner Kunstverein. Bonn 1982 (cat.).– Meyer, F. (ed.): H. D. Stedelijk Museum. Amsterdam 1975 (cat.).– Tacke, C. (ed.): H. D. Für Rainer Werner Fassbinder. Kunstraum. Munich 1988 (cat.).– Vries, G. d. (ed.): ART RANDOM. H. D. Kyoto Shoin. Kyoto 1990 (cat.).– Vries, G. d. (ed.): H. D. Die geflügelte Erde, Requiem. Deichtorhallen, Hamburg. Stuttgart 1991 (cat.).– Weiss, E. (ed.): H. D. XII. Bienal. São Paulo 1973 (cat.)

**DAVIE Alan**
born 1920 Grangemouth
Scottish painter. 1937–1940 Studied at Edinburgh College of Art and at the Royal Scottish Academy. 1941–1946 Military service. 1945 First abstract colour compositions, influenced by Klee and the formal language of Picasso. 1946 First exhibition in Edinburgh. 1947/48 Public performances as jazz musician. 1948 Extended travels to France, Spain and Italy. Intensive study of Pollock's paintings. Settled in London in 1949. From 1953 trained goldsmiths at the Central School of Arts and Crafts in London. 1956 Visited New York. Won Prix Guggenheim at the Musée d'Art Moderne, Paris. From 1959 taught at the Central School in London. 1959–1977 Participation in documenta 2, 3 and 6 in Kassel. 1963 Received special honours at the São Paulo Biennale. Graphic award in Krakow. 1973–1975 Travelled around the central American archipelago.
CATALOGUE RAISONNE: Bowness, A. (ed.): A. D. London 1967
MONOGRAPHS, CATALOGUES: A. D. Kunsthalle Bern et al. Bern 1963 (cat.).– A. D. Kunstverein für die Rheinlande und Westfalen. Düsseldorf 1968 (cat.).– A. D. Royal Scottish Academy, Edinburgh 1972 (cat.).– Hall, D. and M. Tucher (ed.): A. D. London 1992.– Horowitz, M.: A. D. London 1963.– Robertson, B. (ed.): A. D. Whitechappel Art Gallery. London 1958 (cat.).– Tucker, M. (ed.): A. D. Quest for the Miraculous. New York 1992

**DAVIS Douglas**
born 1933 Washington
American performance and video artist. 1948–1950 Studied at Abbott Art School, Washington, 1952–1958 at the American University, Washington, and at Rutgers State University in New Brunswick (NJ). From 1960 worked as an art critic and editor for *Art in America, Newsweek* and other magazines. 1967 First events and performances. From 1970 video series and actions. 1972 First solo-exhibition at Everson Museum of Art, Syracuse (NY). From 1976 taught at many art colleges and universities. 1977 DAAD scholarship to Berlin and participation in documenta 6 in Kassel. 1981 Grant from the National Endowment for the Arts, Washington. 1988

Retrospective at the Solomon R. Guggenheim Museum, New York and 1995 at the Muzeum Sztuki, Lódz. Davis has written several books on art and art theory.
WRITINGS: D. D.: Art and the Future. New York 1973.– D. D.: Vom Experiment zur Idee. Die Kunst des 20. Jahrhunderts im Zeichen von Wissenschaft und Technologie. Cologne 1975.– D. D.: Artculture: Essays on the Post-Modern. New York 1977.– D. D.: Photography as Fine Art. Tokyo 1993, New York 1984.– D. D.: The Museum Transformed. New York 1990.– D. D.: The Five Myths of TV Power. New York 1993
MONOGRAPHS, CATALOGUES: Czartoryska, U. (ed.): D. D. Redness. Muzeum Sztuki. Lodz 1995 (cat.).– D. D. Arbeiten 1970-1977. Neuer Berliner Kunstverein und Berliner Künstlerprogramm des DAAD. Berlin 1978 (cat.).– Kuspit, D.: D. D. Solomon R. Guggenheim Museum. New York 1988 (cat.).– Stanislawski, R. (ed.): D. D. Video Objekty Grafika. Muzeum Sztuki. Lódz 1982 (cat.)

**DAVIS Stuart**
1894 Philadelphia – 1964 New York
American painter. 1909–1912 Private instruction from Robert Henri in New York. 1913 Participation in the Armory Show. 1913–1916 Illustrator and cartoonist for *The Masses* and *Harper's Weekly*. 1917 First solo-exhibition at the Sheridan Square Gallery in New York. About 1919 took up non-figurative painting. 1927/28 First abstract paintings, including the series Egg-beater. 1928 Travelled to Paris. 1933–1940 Held numerous public offices as a politician and trade unionist. Publisher of the journal *Art Front*. 1949–1950 Lectureship at the New York School for Social Research, New York and in 1951 at Yale University. 1956 Member of the National Institute of Arts and Letters. 1957 Retrospective in Minneapolis and 1966 in Paris. Outlined his attitude towards modern art in numerous essays and in his autobiography.
CATALOGUES RAISONNES: Agee, W. C. (ed.): S. D. A Catalogue Raisonné. New Haven (CT) 1989.– J. Myers and D. Kelder (ed.): S. D. Graphic Works and Related Paintings. With a Catalogue Raisonné of His Prints. Amon Carter Museum, Fort Worth. Austin 1986 (cat.)
MONOGRAPHS, CATALOGUES: Arnason, H. H. (ed.): S. D. Memorial Exhibition 1894-1964. Smithsonian Institution, Washington et al. Washington 1965 (cat.).– Blesh, R.: S. D. New York 1960.– S. D. The Drawings of S. D. American Federation of Fine Arts, New York et al. New York 1992 (cat.).– S. D. Peggy Guggenheim Collection. Venice 1997 (cat.).– Goosen, E. C.: S. D. New York 1959.– Hills, P.: S. D. New York 1996.– Kelder, D.: S. D. New York 1971.– Lane, J. R. (ed.): S. D. Art and Theory. The Brooklyn Museum. New York 1978 (cat.).– Rylands, P. (ed.): S. D. Venice et al. 1997 (cat.).– Sims, L. S. (ed.): S. D. American Painter. Metropolitan Museum of

Art, New York et al. New York 1991 (cat.).– Sims, P. (ed.): S. D. Whitney Museum of American Art. New York 1980 (cat.).– Wilkin, K.: S. D. New York 1987

## DAVRINGHAUSEN Heinrich Maria
**1894** Aachen – **1970** Cagnes-sur-Mer German painter. **1913/14** Studied at the Düsseldorf Academy and took private lessons from Wilhelm Eckstein. **1914** Exhibition at Alfred Flechtheim's gallery in Düsseldorf. Visited Carlo Mense in Ascona. **1915–1918** Lived in Berlin. In **1918** moved to Munich. Participation in the exhibition "New Religious Art" at the Kunsthalle Mannheim. **1919** Solo-exhibition in Hans Goltz' gallery Neue Kunst in Munich. Participation in the first exhibition of the Junges Rheinland (Young Rhineland), later known as the Rhenish Expressionists, at the Düsseldorf Kunsthalle. **1922** Returned to Berlin. **1924/25** Travelled to Spain. Participated in the exhibition "Neue Sachlichkeit" (New Objectivity) at the Kunsthalle Mannheim. In **1927** he moved to Cologne and made friends with Räderscheidt. **1928** Participation in the exhibition "Raum und Wand" (Space and Wall) in Cologne. **1933** Fled to France. **1939/40** Internment in Cagnes-sur-Mer and escape from the Germans. **1945** Returned to Cagnes-sur-Mer. CATALOGUES RAISONNES: Eimert, D. (ed.): H. M. D. Leben und Werk. Cologne 1995.– Heusinger v. Waldegg, J. (ed.): H. M. D. 1894-1970. Monographie mit Werkkatalog 1912-1932. Cologne and Bonn 1977.– Tekampe, H. (ed.): H. M. D. 1894-1970. Monographie und Werkverzeichnis. Leopold-Hoesch-Museum Düren. Cologne 1995 (cat.)
MONOGRAPHS, CATALOGUES: Eimert, D. (ed.): H. M. D. Emigration 1933-1945. Leopold-Hoesch-Museum. Düren 1988 (cat.).– Eimert, D. (ed.): H. M. D. Spätwerk. Leopold-Hoesch-Museum. Düren 1991 (cat.).– Heusinger v. Waldegg, J. (ed.): H. M. D. Der General. Aspekte eines Bildes. Rheinisches Landesmuseum. Bonn 1975 (cat.)

## DE CHIRICO Giorgio
**1888** Volos (Greece) – **1978** Rome Italian painter. **1906–1908** Studied painting under Max Klinger at the Munich Academy. Moved to Florence in **1910**. From **1911–1915**

lived in Paris, where he had contact with the Cubists centred around Apollinaire, and painted the series *Italian Squares*, combining his impressions of piazzas in Turin and Florence with classic architecture. **1915** Military service in Italy. **1917** Together with Carrà, Alberto Savinio and Morandi, developed *Pittura Metafisica* and became the most important representative of that style. **1918/19** Lived in Rome and had contact with artists and writers contributing to the journal *Valori Plastici*. Tended towards classical composition in his paintings. **1924–1931** Joined the Surrealists led by Breton in Paris and participated in the exhibition "La Peinture Surréaliste" in **1925**. **1926** Exhibited with the group Novecento in Milan. **1929** Designed stage sets for Diaghilev. **1936** Visited America. After World War II he lived alternately in Milan, Florence and Rome. **1949** and **1955** major retrospectives in London and New York. In De Chirico's *Pittura Metafisica*, objects, figures and scenes are brought together in strange combinations. This method of free association and combination creates an alienating and enigmatic stillness in his pictures. WRITINGS: Carrà, M. (ed.): G. De C. Metafisica. Milan 1968.– Carrà, M. et al. (ed.): G. De C. Metaphysical Art. New York and London 1971.– G. De C.: Piccolo trattato di technica pittorica. Milan 1928, 1962.– G. De C.: Hebdomeros. Paris 1929, 1983.– G. De C.: Memorie della mia vita. Roma 1945.– G. De C.: Wir Metaphysiker. Gesammelte Schriften. Berlin 1973.– G. De C. par De C. Paris 1978.– G. De C.: Penso alla pittura, solo scopo della vita mia. 51 lettere ad Ardengo Soffici 1914-1942. Ed. by L. Cavallo. Milan 1987.– G. De C.: L'Art métaphysique. Ed. by G. Lista. Paris 1994.– Fagiolo dell'Arco, M. (ed.): G. De C.: Il meccanismo del pensiero. Critica, polemica, autobiografia 1911-1943. Torino 1985 CATALOGUES RAISONNES: Brandani, E. (ed.): G. De C. Catalogo dell'opera grafica 1969-1977. Bologna 1990.– Brandani, E. (ed.): G. De C.: Catalogue Raisonné of the Graphic Work 1969-1977. San Francisco 1990.– Bruni, C. and I. Far (ed.): Catalogo generale dell'opera di G. De C. 8 vols. Milan 1971-1983.– Ciranna, A. (ed.): G. De C. Catalogo delle opere grafiche. Incisioni e litografie 1921-1969. Roma and Milan 1969.– Fagiolo dell'Arco, M. and P. Baldacci: G. De C. Parigi 1924-1929. Dalla nascita del Surrealismo al crollo di Wall Street. Milan 1982.– Fagiolo dell'Arco, M. (ed.): L'opera completa di De C. 1908-1924. Milan 1984.– Fagiolo dell'Arco, M. (ed.): I Bagni Misteriosi. De C. negli anni trenta. Milan 1991.– Sakraischik, C. B. (ed.): Catalogo Generale G. De C. 3 vols. Milan 1971-1987.– Vastani, A. (ed.): G. De C. Catalogo dell'opera grafica 1921-1969. Bologna 1997 MONOGRAPHS, CATALOGUES: Baldacci, P. G. De C. La metafisica 1888-1919. Milan 1997.– Benzi, F. and M. G. T. Speranza (ed.): G. De C. Pictor optimus. Palazzo delle Esposizioni. Roma 1992 (cat.).– Calvesi, M. and M. Ursino: G. De C. The New Metaphysics. London 1996.– Carlino, M.: Una penna per il pennello. G. De C. scrittore. Roma 1989.– Dalla Chiesa, G. al al. (ed.): G. De C. Gallerie Civiche d'Arte Moderna, Ferrara. Roma 1985 (cat.).– Dalla Chiesa, G.: De C. scultore. Milan 1988.– Duca, L: G. De C. Milan 1945.– Fagiolo dell'Arco, M.: G. De C. Le Rêve de Tobie. Un interno ferrarese. 1917 e le origini del Surrealismo. Roma 1980.– Fagiolo dell'Arco, M. (ed.): G. De C. The Museum of Modern Art, New York et al. London 1982 (cat.).– Fagiolo dell'Arco, M.: G. De C. Il tempo di "Valori plastici" 1918-1922. Roma 1980.– Fagiolo dell'Arco, M.: G. De C. Il tempo di Apollinaire. Paris 1911-1915. Roma 1981.– Fagiolo dell'Arco, M. (ed.): De C. Gli

anni venti. Palazzo Reale. Milan 1987, 1995 (cat.).– Fagiolo dell'Arco, M.: La vita di G. De C. Torino 1988.– Fagiolo dell'Arco, M. (ed.): De C. Anni trenta. Milan 1991 (cat.).– Far, I.: G. De C. Roma 1953, 1979. New York 1970. Herrsching 1979.– Far, I. and D. Porzio (ed.): Conoscere De C. La vita e l'opera dell'inventore della pittura metafisica. Milan 1979.– Gribaudo, E.: 194 disegni di G. De C. Torino 1967.– Hüttinger, E.: Zeichnungen von G. De C. Zurich 1969.– Jouffroy, A. et al.: De C.: La vita e l'opera. Milan 1979 / De C.: Leben und Werk. Munich 1980.– Rubin, W. et al. (ed.): G. De C. The Museum of Modern Art. New York 1982 (cat.) / G. De C. der Metaphysiker. Haus der Kunst. Munich 1982 (cat.) / G. De C. Centre Georges Pompidou, Paris. Paris 1983 (cat.).– Schmied, W. et al.: G. De C.: Leben und Werk. Munich 1980.– Schmied, W.: De C. und sein Schatten. Munich 1989.– Schmied, W.: G. De C. Die beunruhigenden Musen. Frankfurt-on-Main 1993.– Soby, J. T.: G. De C. New York 1954, 1966.– Soby, J. T. (ed.): The Early De C. The Museum of Modern Art. New York 1941, 1969 (cat.).– Vivarelli, P. et al. (ed.): G. De C. 1888-1978. Galleria Nazionale d'Arte Moderna. Roma 1981 (cat.)

## DEGAS Edgar
(Hilaire Germain Edgar de Gas)
**1834** Paris – **1917** Paris
French painter and sculptor. After briefly studying law, attended the Ecole des Beaux-Arts in Paris from **1855/56**, and entered the studio of Louis Lamothe. **1856–1859** Lived in Italy, then returned to Paris where he joined the Impressionists and made friends with Manet. **1870** Developed an eye disease which had almost blinded him by **1900**. In **1872/73**, he travelled to New Orleans. **1874–1881** and **1886** participated in seven Impressionist exhibitions despite being a critic and opponent of Impressionism. From **1880** many paintings of ballet dancers from unusual viewpoints and in various unconstrained attitudes. After **1909**, owing to his failing eyesight, he created only wax models of dancers, horses and female nudes which were cast in bronze after his death. His work was suffused with a very personal kind of psychological observation that sought to capture fleeting scenes and fragments, as did the new technique of instantaneous photography. He was less interested in nature than in modern city life and people. WRITINGS: Guérin, M. (ed.): E. D. Lettres. Paris 1931, 1945 / E. D. Letters. Oxford 1945.– Halévy, D. (ed.): E. D. Lettres. Paris 1997.– Halévy, D. (ed.): D. parle … Paris 1996.– Reff, T.: The Notebooks of E. D. 2 vols. London 1976, New York 1986 CATALOGUES RAISONNES: Adhémar, J. and F. Cachin (ed.): D. Gravures et monotypes. Paris 1973 / D. Radierungen und Monotypien. Munich 1973 / D. The Complete Etchings, Lithographs and Monotypes. New York 1973.– Brame, P. et al. (ed.): D. et son Œuvre. A Supplement.

New York 1984.– Janis, E. P. (ed.): D. Monotypes. Catalogue Raisonné. Cambridge (MA) 1968.– Lassaigne, J. (ed.): Tout l'œuvre peint de D. Paris 1974.– Lemoisne, P. A. (ed.): D. et son œuvre. 4 vols. Paris 1946-1949, London and New York 1984.– Matt, L. v. and J. Rewald: D. Das plastische Werk. Zurich 1957.– Millard, C. W.: The Sculpture of D. Princeton (NJ) 1976.– Minervino, F. (ed.): Tout l'œuvre peint de D. Paris 1988.– Minervino, F. (ed.): Das Gesamtwerk von D. Lucerne (n. d.).– Parry Janis, E. (ed.): D. Monotypes. Cambridge 1968.– Pingeot, A. and F. Horvat (ed.): D. Sculptures. Paris.– Reed, S. W. and B. S. Shapiro (ed.): E. D. The Painter as Printmaker. The Complete Prints of E. D. Museum of Fine Arts. Boston 1984 (cat.).– Rewald, J. (ed.): D.'s Complete Sculpture. A Catalogue Raisonné. New York 1944, San Francisco 1990
MONOGRAPHS, CATALOGUES: Adriani, G. (ed.): E. D. Pastelle, Ölskizzen, Zeichnungen. Kunsthalle Tübingen et al. Cologne 1984 (cat.).– Armstrong, C. M.: Odd Man Out. Readings on the Work and Reputation of E. D. Chicago 1991.– Boggs, J. S.: Portraits by D. Berkeley 1962.– Boggs, J. S. et al. (ed.): D. Grand Palais, Paris 1988 / D. Metropolitan Museum, New York 1988 (cat.).– Cabanne, P.: E. D. Paris 1957, Munich 1960.– Champigneulle: D. Dessins. Paris 1952.– Dunlop, I.: D. London and New York 1979.– Fosca, F.: D. Etude biographique et critique. Geneva 1954.– Gordon, R. and A. Forge: D. Cologne 1985, Paris 1988.– Growe, B.: Zur Bildkonzeption E. D.'s. Frankfurt-on-Main 1981.– Guillaud, M. et al.: D.: Form and Space. Paris 1984.– Kendall, R. (ed.): E. D. Leben und Werk in Bildern und Briefen. Munich 1988.– Kendall, R. (ed.): D. Beyond Impressionism. New Haven (CT) 1996.– Keyser, E. d.: D. Réalité et métaphore. Louvain 1981.– Lefèbvre, A.: D. Paris 1981.– Lipton, E.: Looking into D. Los Angeles 1986.– Loyrette, H.: D. Paris 1990.– McMullen, R.: D. His Life, Time and Work. Boston 1984, London 1985.– Pool, P.: D. New York 1963.– Reff, T.: D. The Artist's Mind. New York 1976.– Rewald, J.: D. Sculpture. New York 1956.– Rich, D. C.: D. Cologne 1959, New York 1985.– Roberts, K.: D. Oxford and New York 1976.– Rouart, D.: D. à la recherche de sa technique. Paris 1945.– Rouart, D.: D. monotypes. Paris 1948.– Sérullaz, M.: L'univers de D. Paris 1979.– Sutton, D.: E. D. Life and Work. New York 1986 / Leben und Werk. Munich 1986.– Terrasse, A.: D. et la photographie. Paris 1983.– Terrasse, A.: E. D. Paris 1987.– Thomson, R.: The Private D. London 1987.– Thomson, R.: D. The Nudes. London 1988.– Vitali, L.: E. D. Milan 1966.– Werner, A.: D. Pastels. New York 1968

## DE KOONING Willem
**1904** Rotterdam – **1997** New York American-Dutch painter. **1916-1920** worked for an art dealer in Rotterdam while

attending evening classes at the Academy. **1926** Emigrated illegally to the US. **1927–1935** Worked as a graphic artist. **1930** Shared a studio with Gorky. **1934** Member of the newly founded Artists' Union. **1937** Commission for a 27 m long mural for the Pharmacy Pavilion at the New York World Fair. **1938–1944** First pictures of women. From **1940** commissions for stage designs. **1942** Met Pollock. **1948** Taught at Black Mountain College in North Carolina and **1950** at the School of Fine Arts in Yale. **1950** Continued *Women* series and worked on abstract compositions with great colour intensity. **1957** First graphic prints. **1958** Rauchenberg did an etching from one of De Kooning's drawings. **1959–1977** Participation in documenta 2, 3 and 6 in Kassel. **1963** New studio in Springs on Long Island. **1970** Life-size sculpted figures. **1975** Founded the Rainbow Foundation, supporting the work of young artists. **1989** In spite of his serious illness, he went on working until his death. Beside Pollock, De Kooning is one of the most important Abstract Expressionist painters.
WRITINGS: W. De K.: Ecrits et propos. Paris 1993
CATALOGUE RAISONNE: Graham, L. (ed.): L'Œuvre gravé de W. De K. 1957-1971. Paris 1991
MONOGRAPHS, CATALOGUES: Abadie, D.: De K. ou le corps dispersé. Paris 1994.– Cummings, P. et al. (ed.): W. De K. Drawings, Paintings, Sculptures. Whitney Museum of American Art, New York et al. New York 1984/Zeichnungen, Gemälde, Skulpturen. Akademie der Künste, Berlin et al. Munich 1984 (cat.).– W. De K. Stedelijk Museum, Amsterdam et al. Amsterdam 1969 (cat.).– W. De K. Museum of Art, Carnegie Institute. Pittsburgh, Pennsylvania 1979 (cat.).– W. De K. The North Atlantic Light 1960-1983. Stedelijk Museum. Amsterdam 1983 (cat.).– W. De K. Centre Georges Pompidou. Paris 1984 (cat.).– Denby, E. W.: W. De K. Paris 1994.– Drudi, G.: W. De K. Milan 1972.– Gaugh, H. F.: W. De K. New York 1983, Munich and Lucerne 1984.– Sans, S. (ed.): W. De K. Skulpturen. Josef-Haubrich-Kunsthalle. Cologne 1983 (cat.).– Hess, T. B. (ed.): W. De K. Stedelijk Museum, Amsterdam et al. Amsterdam 1968 (cat.).– Hess, T. B. (ed.): W. De K. Drawings. London and Greenwich (CT) 1972.– Kertess, K. (ed.): W. De K. Guild Hall Museum. East Hampton 1994 (cat.).– Prather, M. et al. (ed.): W. De K. Paintings. National Gallery of Art, Washington et al. Washington and London 1994 (cat.).– Rosenberg, H.: W. De K. New York 1974, 1978.– Sollers, P.: De K., vite. Paris 1988.– Storr, R. and G. Garells (ed.): W. De K. The Late Paintings. San Francisco Museum of Modern Art et al. San Francisco 1995 (cat.)/W. De K. Das Spätwerk. Kunstmuseum Bonn et al. Bonn 1996 (cat.).– Waldman, D.: W. De K. New York 1988.– Wilde, E. d. et al. (ed.): W. De K. Het Noordatlant. licht. 1960-1983. Stedelijk Museum, Amsterdam et al. Amsterdam 1983 (cat.).– Yard, S.: W. De K. The First Twenty-Six Years in New York. New York 1980.– Yard, S.: W. De K. New York 1997.– Zilczer, J.: W. De K. From the Hirshhorn Museum Collection. Hirshhorn Museum, Washington et al. New York 1993 (cat.)

### DELAUNAY Robert
**1885** Paris – **1941** Montpellier
French painter. **1902** Apprenticed to a decorator. **1904** Visited Brittany. Influenced by the Pont-Aven group. Studied Neo-Impressionist colour theories and philosophical works in depth. **1910** Participated in the Salon des Indépendants and revealed Cubist tendencies in his Eiffel Tower series. **1911**

Participation in the first exhibition of the Blauer Reiter group. **1912/13** With his *Formes Circulaires* developed an individual, coloristic and formal language related to Cubism and described by Apollinaire as "Orphism" emphasizing the relation of colour to sound and musical resonance. **1913** Travelled to Berlin and exhibited in Herwarth Walden's gallery Der Sturm. **1914–1920** Lived in Spain. **1921** Returned to Paris where his painting became more abstract. **1937** Designed decorations for the Palais des Chemins de Fer at the Paris World Fair. **1939** Co-founder of the Salon des Réalités Nouvelles.
WRITINGS: Cohen, A. A.: The New Art of Colour. The Writings of R. and S. D. New York 1978.– Düchting, H. (ed.): R. D. Zur Malerei der reinen Farbe. Schriften von 1912-1940. Munich 1983.– Francastel, P. (ed.): R. D. Du cubisme à l'art abstrait. Documents inedits. Paris 1957
CATALOGUE RAISONNE: Loyer, J. and C. Péruseau (ed.): Catalogue de l'œuvre lithographique. Paris 1974
MONOGRAPHS, CATALOGUES: Buckberrough, S. A.: R. D. The Early Years. Ann Arbor (MI) 1981.– Buckberrough, S. A.: R. D. The Discovery of Simultaneity. Ann Arbor (MI) 1982.– Cassou, J.: R. D. Première époque 1903-1910. Paris 1961.– Chadwick, W.: Significant Others: S. and R. D. London 1993.– Dorival, B.: R. D. 1885-1941. Paris 1975.– Düchting, H.: R. D.'s "Fenêtres". Paradigma einer modernen Wahrnehmungsform. Diss. Munich 1982.– Hoog, M. et al. (ed.): R. D. Orangerie des Tuileries. Paris 1976/Staatliche Kunsthalle Baden-Baden. Baden-Baden 1976 (cat.).– Hoog, M.: R. D. Munich 1983.– Jenderko, I. (ed.): R. D. Staatliche Kunsthalle Baden-Baden. Baden-Baden 1976 (cat.).– Kuthy, S. and K. Satonobu (ed.): Künstlerpaare, Künstlerfreunde. Sonia und Robert D. Kunstmuseum Bern. Stuttgart 1991 (cat.).– Molinari, D. le (ed.): R. et Sonia D. Musée d'Art Moderne de la Ville de Paris. Paris 1985 (cat.).– Molinari, D. le: R. et Sonia D. Paris 1987.– Schuster, P.-K. (ed.): D. und Deutschland. Staatsgalerie moderner Kunst, Munich. Cologne 1985 (cat.).– Tourette, F. G. d.: R. D. Paris 1950.– Vriesen, G. and M. Imdahl: R. D. Licht und Farbe des Orphismus. Cologne 1967, 1992/R. D. Light and Color. New York 1967

### DELAUNAY-TERK Sonia
**1885** Gradisk (Ukraine) – **1979** Paris
Russian-French painter. **1903** Studied in Karlsruhe, Germany. In **1905** she moved to Paris and studied at the Académie de la Palette; contact with Ozenfant and André Dunoyer de Segonzac. Married Robert Delaunay in **1910**. **1912** First simultaneous compositions of circular forms, combining the ideas of the Fauves and Cubists in intensely expressive abstract paintings. From **1913** onwards, she used her own rhythmical colour-orchestrations for book illustrations, book covers, textile designs and decorations.

**1914–1920** Lived in Spain and Portugal. **1918** Costume designs for Diaghilev's ballet *Cleopatra*. **1920** Returned to Paris and came in contact with the Surrealists gathered around Aragon and Breton. Applied her style of painting to fashion and textile designs. **1924** Opened her own fashion studio. From **1935–1937**, together with Robert Delaunay, worked on a large mural for the Paris World Fair. **1939** Co-founder of the Salon des Réalités Nouvelles.
WRITINGS: Cohen, A. A. (ed.): The New Art of Colour. The Writings of R. and S. D. New York 1978.– S. D.-T.: Compositions, couleurs, idées. Paris 1930.– S. D.-T.: Nous irons jusqu'au soleil. Paris 1978
MONOGRAPHS, CATALOGUES: Baron, S. and J. Damase: S. D. The Life of an Artist. New York 1995/S. D. Ihre Kunst, ihr Leben. Munich 1995.– Buckberrough, S. A. et al. (ed.): S. D. A Retrospective. Albright-Knox Art Gallery, Buffalo et al. Buffalo 1980 (cat.).– Callu, F. et al.: S. et R. D. Paris 1977.– Chadwick, W.: Significant Others: S. and R. D. London 1993.– Cohen, A. A.: S. D. New York 1975, 1988.– Damase, J.: S. D. Notes biographiques. Paris 1971.– Damase, J.: S. D. Rythms and Colors. London and Greenwich (CT) 1972.– Damase, J. (ed.): S. D. Mode et tissus imprimés. Paris 1991/S. D. Fashion and Fabrics. New York 1991/S. D. Mode und Design. Zurich 1991.– Desanti, D.: S. D., magique magicienne. Paris 1988.– Dorival, B.: S. D. Sa Vie, son œuvre 1885-1979. Paris 1980/S. D. Leben und Werk 1885-1979. Munich 1985.– Dupuits, P. (ed.): S. D. Metz est venu. Stedelijk Museum. Amsterdam 1992 (cat.).– Hoog, M. et al.: S. D. Rythmes et couleurs. Paris 1971.– Kuthy, S. and K. Satonobu (ed.): Künstlerpaare, Künstlerfreunde. S. und Robert D. Kunstmuseum Bern. Stuttgart 1991 (cat.).– Madsen, A.: S. D. Artist of the Lost Generation. New York 1989.– Molinari, D. le (ed.): S. D. Musée d'Art Moderne de la Ville de Paris. Paris 1985 (cat.).– Morano, E.: S. D. Art into Fashion. New York 1986.– Viatte, G.: S. D. Dessins: Noirs et blancs. Paris 1978

### DELVAUX Paul
**1897** Antheit – **1994** Furnes
Belgian painter. **1917–1924** Studied architecture and painting at the Académie des Beaux-Arts in Brussels. Influenced by

Belgian Expressionism and Ensor. **1932** Strongly impressed by the waxwork figures of the Musée Spitzner which became a recurrent theme in his pictures. Seeing the works of Magritte, De Chirico and Max Ernst at the Surrealist exhibition "Minotaure" in Paris in **1934** inspired paintings remarkable for their veristic detail and subdued coloration. **1938** Participation in the international exhibition of the Surrealists organized by Breton. After discovering the Italian Renaissance on travels through Italy, he tended to paint classical landscapes as backgrounds for his somewhat theatrical compositions. **1944/45** First retrospective at the Palais des Beaux-Arts in Brussels. **1950–1962** Professor of Monumental Painting at the Ecole Nationale d'Art et d'Architecture. Stage decorations and murals. **1965/66** President of the Académie des Beaux-Arts of Belgium. Numerous retrospectives in Paris, Rotterdam, Tokyo and elsewhere. Beside Magritte, the most important representative of Belgian Surrealsim.
CATALOGUES RAISONNES: Butor, M. et al. (ed.): D. Catalogue de l'œuvre peint. Brussels 1975, Lausanne and Paris 1976.– Jacob, M. (ed.): P. D. L'œuvre graphique. Monte Carlo 1976
MONOGRAPHS, CATALOGUES: Bock, P.-A. d.: P. D. Der Mensch, der Maler. Hamburg 1965/P. D. L'homme, le peintre, psychologie d'un art. Brussels 1967.– Butor, M. et al.: D. Bruxelles 1975.– P. D. Museum Boymans-van Beuningen. Rotterdam 1973 (cat.).– P. D. Rétrospective. Musée d'Art Moderne. Brussels 1997 (cat.).– Clair, J.: Promenades et entretiens avec P. D. Paris 1991.– Devillers, V.: P. D. Le Théâtre des figures. Brussels 1993.– Dypéreau, J. et al. (ed.): P. D. Gallerie Civiche d'Arte Moderna. Ferrara 1986 (cat.).– Emerson, B.: P. D. Antwerp 1985, San Francisco 1996.– Engel, L. and C. van Deun (ed.): Le Pays Mosan de P. D. Musée Communal, Huy et al. Liège 1997 (cat.).– Meure, J. and M. v. Jole (ed.): P. D. Fondation Pierre Gianadda. Martigny 1987 (cat.).– Grall, A. (ed.): Die Zeichnungen von P. D. Berlin 1968.– Hammacher-v. d. Brande, R. (ed.): P. D. Kunsthalle der Hypo-Kulturstiftung. Munich 1989 (cat.).– Langui, E.: P. D. Venice 1949.– Meuris, J.: 7 dialogues avec P. D. Accompagnés de 7 lettres imaginaires. Paris 1971.– Nadeau, M.: Les Dessins de P. D. Paris 1967.– Paquet, M.: P. D. et l'essence de la peinture. 2 vols. Paris 1982.– Rombaut, M.: P. D. Paris 1990, London 1991.– Scheurmann, K.: P. D. Gießen 1976.– Scott, D.: P. D. Surrealizing the Nude. London 1992.– Sojcher, J.: P. D. ou la passion puérile. Paris 1991.– Spaak, C.: P. D. Brussels 1948.– Vignon, D. and C. (ed.): P. D. Galleria Civica d'Arte Moderna. Ferrara 1986 (cat.)

### DE MARIA Walter
born **1935** Albany (CA)
American artist. **1953–1959** Studied at the University of California in Berkeley. **1959** Staged first happenings and decided, in **1960**, to move to New York. Exhibited

plywood boxes, for example his *Box for Meaningless Work* and *Invisible Drawings*, words pencilled extremely lightly onto paper. **1963** First solo-exhibition in Nine Great Jones Street, New York. **1965** Played drums in Velvet Underground. **1968** Presented his *Earth Room* (1,600 cubic feet of earth spread over the gallery floor) at the Heiner Friedrich gallery in Munich, and carried out his Land Art action *Mile Long Drawing* (two lines, 360 cm apart running parallel for a mile) in the Mogave desert in California. **1968** Participation in documenta 4 in Kassel. **1969** Participation in documenta 4 in Kassel. **1970** Participated in the exhibition "Land Art, Conceptual Art, Arte Povera" in Turin. **1977** His earth sculpture (a one-kilometre long brass pole pointing down towards the centre of the earth), planned in **1972** for the Olympiade in Munich, presented with slight modifications at documenta 6 in Kassel and entitled *The Vertical Earth Kilometer*. **1984** Took part in the exhibition of 20th century sculpture in the Merian Park in Basel. De Maria's Land Art, developed against a background of art trends and movements such as happenings, Concept Art and Minimal Art, has symbolic, mythological roots.
WRITINGS: Mac Low, J. et al. (ed.): W. De M. An Anthology. New York 1963
MONOGRAPHS, CATALOGUES: Kellein, T. (ed.): W. De M. 5 Kontinente Skulptur. Staatsgalerie Stuttgart. Stuttgart 1987 (cat.).– W. De M. Skulpturen. Kunsthalle Basel. Basel 1972 (cat.).– W. De M. Der große Erdraum. Hessisches Landesmuseum. Darmstadt 1974 (cat.).– W. De M. Museum Boymans-van Beuningen. Rotterdam 1984.– Meyer, F.: W. De M. Frankfurt-on-Main 1991.– Nittve, L. (ed.): W. De M. 2 Very Large Presentations. Moderna Museet. Stockholm 1989 (cat.).– Schoon, T. (ed.): W. De M. Museum Boymans-van Beuningen. Rotterdam 1984 (cat.).– Szeemann, H. (ed.): W. De M. The 2000 Sculpture. Kunsthaus Zürich. Zurich 1992 (cat.)

**DEMUTH Charles**
**1883** Lancaster (PA) – **1935** Lancaster
American painter. **1903–1905** Studied at the School of Industrial Art in Philadelphia, and in **1905/06** at the Pennsylvania Academy of Fine Arts. **1907** Travelled to Paris but returned to America to continue his studies. From **1912–1914**, lived in Paris again, attending classes at various academies. Close relations with Picasso, Delaunay and Picabia; became friends with Duchamp. **1915** First solo-exhibition at the Daniel Gallery in New York. Contact with Alfred Stieglitz and the collector-couple Arensberg. Painted watercolours for book illustrations, displaying elements of Cubism and Realism. **1916/17** Travelled to the Bermudas. Over the following years, worked intensively on representations of architecture. **1925** First joint projects with the Stieglitz gallery. **1929** Participation in the exhibition "Paintings by 19 Living Americans" at the Museum of Modern Art, New York.

MONOGRAPHS, CATALOGUES:
Eiseman, A. L.: C. D. New York 1982.–
Fahlman, B.: Pennsylvania Modern. C. D. of Lancaster. Philadelphia Museum of Art et al. Philadelphia 1983 (cat.).– Farnham, E.: C. D. His Life, Psychology and Works. Diss. Columbus (OH) 1959.– Farnham, E.: C. D. Behind a Laughing Mask. Norman (OK) 1971.– Frank, R. J. (ed.): C. D. Poster Portraits 1923-1929. Yale University Art Gallery. New Haven (CT) 1994 (cat.).– Haskell, B. (ed.): C. D. Whitney Museum of American Art, New York et al. New York 1987 (cat.).– Ritchie, A. C. (ed.): C. D. The Museum of Modern Art. New York 1950 (cat.)

**DENIS Maurice**
**1870** Granville – **1943** St.-Germain-en-Laye
French painter. **1888** Studied at the Paris School of Art and at the Académie Julian. Met Bernard, Bonnard and Sérusier, who introduced him to the ideas of Gauguin and painters of the Pont-Naven school. **1890** Co-founder of the symbolist group, the Nabis. He shared a studio with Bonnard and Vuillard. **1892/93** Stage designs for the Théatre de l'Œuvre. In **1895** and **1898** he travelled to Italy to study Early Renaissance painting, particularly Piero della Francesca and Fra Angelico. **1901** Group portrait of the Nabis and *Hommage à Cézanne*. Worked as a book illustrator and lithographer. **1903** Travelled to Germany. **1906** Went with Bernard and Roussel to visit Cézanne in Aix-en-Provence. Besides Impressionist portrait studies and garden scenes, produced mainly Art-Nouveau-style and Symbolist paintings on religious themes. In **1914** and **1917** Decorations in St. Paul, and glass paintings for Notre-Dame in Geneva. **1909** Joined Rouault in founding workshops for religious art.
WRITINGS: Collet, G.-P.: Correspondance Jacques-Emile Blanche-M. D. 1901-1939. Geneva 1989.– M. D.: Théories 1890-1910. Paris 1920.– M. D.: Paul Sérusier, sa vie, son œuvre. Paris 1942.– M. D.: Journal 1884-1943. 3 vols. Paris 1957-1959.– M. D.: Du symbolisme au classicisme. Théories. Paris 1964.– M. D.: Le Ciel et l'arcadie. Ed. by J.-P. Bouillon. Paris 1993
CATALOGUE RAISONNE: Cailler, P. (ed.): Catalogue raisonné de l'œuvre gravé et lithographié de M. D. Geneva 1968
MONOGRAPHS, CATALOGUES:
Barazzetti-Demoulin, S.: M. D. Paris 1945.– Barruel, T. et al. (ed.): Un nouveau regard sur M. D. Paris 1996.– Bouillon, J.-P.: M. D. 1870-1943. Geneva 1993.– Bouillon, J.-P. (ed.): M. D. 1870-1943. Musée des Beaux-Arts, Lyon et al. Lyon 1994 (cat.).– Delanoy, a. (ed.): Symbolistes et Nabis. M. D. et son temps. Saint-Germain-en-Laye 1996 (cat.).– M. D. Musée de l'Orangerie. Paris 1970 (cat.).– M. D. 1870-1943. Musée des Beaux-Arts, Lyon et al. Lyon 1994, Merseyside 1995 (cat.).– Gerkens, G. et al. (ed.): M. D. Aquarelle, Handzeichnungen, Druckgraphik. Kunsthalle Bremen. Bremen 1971 (cat.).– Janin-Juvigny, S. (ed.): M. D.

100 ans après à Alençon. Musée des Beaux-Arts et de la Dentelle. Alençon 1985 (cat.).– Lacambre, G. and D. Delouche (ed.): M. D. et la Bretagne. Musée de Morlaix. Morlaix 1985 (cat.).– Salmon, M.-J. (ed.): L'âge d'or de M. D. Musée Départemental de l'Oise. Beauvais 1982 (cat.).– Terrasse, A.: D. Intimités. Lausanne 1970

**DEPERO Fortunato**
**1892** Fondo (Trentino) – **1960** Rovereto
Italian painter and sculptor. Self-taught. From **1913** belonged to the inner circle of the Futurists. Wrote several manifestos of which *La ricostruzione futurista dell'universo* was published. **1916** Costume and stage designs for a Diaghilev ballet. **1919** Opened the Casa d'arte in Rovereto, a workshop in which numerous *objets d'art*, vases, textiles and wallpapers were made. Influenced by the post-Cubist works of Léger, entered a second Futurist phase, in which his paintings had a stronger narrative content and his figures more plasticity. **1924** Staging of the ballet *Anihccam*. **1927** Signed the manifesto of the *Aeropittura*. **1928–1930** Stay in America.
WRITINGS: F. D.: Spezzatura-Impressioni. Segni e ritmi. Rovereto 1913.– F. D.: So I Think so I paint. Trento 1947
MONOGRAPHS, CATALOGUES: Belli, G. et al. (ed.): F. D. La Casa del Mago: le arti applicate nell'opera di F. D. 1920-1942. Archivio del '900, Rovereto. Milan 1992 (cat.).– Belli, G. (ed.): F. D. Dal Futurismo alla Casa d'Arte. Roma 1994 (cat.).– D. Futurista. Milan 1927, Florence 1978.– F. D. Museum am Ostwall. Dortmund 1994 (cat.).– Fagiolo del'Arco, M. et al.: D. Milan 1988.– Passamani, B. (ed.): D. e la scena da colori alla scena mobile 1916-1930. Torino 1970.– Passamani, B. (ed.): F. D. Museo Depero. Rovereto 1981 (cat.).– Passamani, B. (ed.): La sala del Consiglio Provinciale di Trento di F. D. Trento 1990.– Scudiero, M. et al. (ed.): D. Futurista + New York. Futurism and the Art of Advertising. Museo Depero. Rovereto 1986 (cat.).– Scudiero, M. F. D. Opere. Trento 1987.– Scudieo, M. (ed.): D. per Campari. Milan 1989.– Universo, M. (ed.): F. D. Fiero di Padova. Padua 1990 (cat.)

**DERAIN André**
**1880** Chatou (near Paris) – **1954** near Garches
French painter. **1898–1900** Studied at the Académie Carrière in Paris. **1901** Met Matisse and Vlaminck who were to become important companions. **1901–1904** Painting studies interrupted but taken up again briefly at the Académie Julian. During summer **1905** he painted together with Matisse in Collioure on the Mediterranean and exhibited his Fauvist paintings at the Paris Salon d'Automne in the same year. **1908** Spent several months with Picasso in Avignon and was strongly influenced by Cubism. **1912** Beginning of the *période gothique*. **1913** Participation in the First

Autumn Salon in Berlin. **1920–1930** Visits to the South of France. Produced *Pierrot* and *Harlequin* paintings. **1935** Retrospective at the Kunsthalle Bern. Numerous commissions for costumes and sets at the Paris Opera. **1944** Worked on illustrations and stage set designs. **1994** Important retrospective at the Musée d'Art Moderne de la Ville de Paris.
WRITINGS: A. D. Lettres à Vlaminck. Paris 1955, 1994
CATALOGUES RAISONNES: Cailler, P. (ed.): Catalogue raisonné de l'œuvre sculpté de A. D. L'œuvre édité. Lausanne 1965.– Kellermann, M. (ed.): A. D. Catalogue de l'œuvre peint. 1895-1934. 2 vols. Paris 1992-1996
MONOGRAPHS, CATALOGUES:
Adhémar, J.: D. peintre-graveur. Paris 1955.– Bachelard, P.: D. Un fauve pas ordinaire. Paris 1994.– Cabanne, P.: A. D. Paris 1990.– D. The Late Work. Scottish National Gallery of Modern Art. Edingburgh 1991 (cat.).– Flam, J. et al. (ed.): A. D. Paris 1994 (cat.).– George, W. A. D. Das plastische Werk. 37 Bronzen. Düsseldorf 1961.– Goray, P. (ed.): A. D. Bildhauer. Galleria Pierre Goray, Lugano et al. Milan 1994 (cat.).– Hilaire, G.: D. Geneva 1959.– Hoog, M. (ed.): Un certain D. Musée de l'Orangerie. Paris 1991 (cat.).– Kalitina, N. N.: A. D. Leningrad 1976.– Lee, J. (ed.): D. Museum of Modern Art, Oxford et al. London 1990 (cat.).– Leymarie, J. (ed.): A. D. Grand Palais. Paris 1977 (cat.).– Marquet, F.: D. et la photographie. Neuchâtel 1997.– Pagé, S. (ed.): A. D. Musée d'Art Moderne de la Ville de Paris. Paris 1994 (cat.).– Parke-Taylor, M. (ed.): A. D. in North American Collections. Norman Mackenzie Art Gallery, University of Regina et al. Regina 1982 (cat.).– Sutton, D.: A. D. London 1959. Cologne 1960

**DEWASNE Jean**
born **1921** Lille
French painter. Studied music and architecture at the Ecole des Beaux-Arts in Paris. **1943** First abstract paintings. Influenced by Mondrian, he painted in a geometric Constructivist style. **1946** Kandinsky Award, Paris. Close contact with artists of the Denise René Gallery, like Hartung, Schneider and Poliakoff. Together with Arp, Pevsner and Sonia Delaunay-Terk he was a

committee-member of the Salon des Réalités Nouvelles. **1950–1952** Founder and co-director, with Edgar Pillet, of the Académie d'Art Abstrait. Experiments with varnish paint and use of prefabricated objects for his *Antisculptures*. **1968** Solo-exhibition at the Venice Biennale.
WRITINGS: J. D.: Robert Jacobsen, sculpteur danois. Copenhagen 1951
MONOGRAPHS, CATALOGUES: Cordier, D. (ed.): D. Lefebre Gallery. New York 1972 (cat.).– Descargues, P.: J. D. Paris 1952.– J. D. Kunsthalle Bern. Bern 1966 (cat.).– J. D. Musée de Grenoble. Grenoble 1970 (cat.).– J. D. Tenue de rigueur. Paris 1995

**DEXEL Walter**
**1890** Munich – **1973** Brunswick (Germany) German painter and designer. **1910–1914** Studied history of art in Munich. Took private drawing lessons with Hermann Gröber. **1912/13** Travelled to Italy. **1914** Studied in Paris. First solo-exhibition at the Dietzel Gallery in Munich. **1916** Doctorate under Botho Gräf in Jena. **1916–1928** Director of the Jena Arts Association. **1917** First abstract paintings, influenced by Constructivism. **1918** Exhibition at Herwarth Walden's gallery Der Sturm in Berlin. **1919** Friendship with Schwitters. Close contact to the Bauhausmeister (Bauhaus Masters) in Weimar whose works he exhibited in Jena. **1921/22** Developed a concrete-abstract style of painting. From **1923** member of the Novembergruppe, and from **1928** joined Schwitters in the Ring Neuer Werbegestalter (Association of New Advertisers). **1928–1935** Lectureship at the Magdeburg School of Applied Arts and Crafts. **1933** Denounced by the Nazis, stopped painting. **1942–1955** Set up the Collection of Historic Forms in Brunswick and published numerous books on design. **1961** Took up painting again.
WRITINGS: W. D.: Unbekanntes Handwerksgut. Berlin 1935.– W. D.: Holzgerät und Holzform. Ravensburg 1943.– W. D.: Glas, Werkstoff und Form. Ravensburg 1950.– W. D.: Keramik, Stoff und Form. Berlin and Brunswick 1958.– W. D.: Das Hausgerät Mitteleuropas. Brunswick and Berlin 1962.– W. D.: Der Bauhausstil. Ein Mythos. Texte 1921-1965. Mit 4 Aufsätzen von G. Dexel. Ed. by W. Vitt. Starnberg 1976.– W. D.: Köpfe. 1930-1933. Starnberg 1979
CATALOGUES RAISONNES: Vitt, W. (ed.): W. D. Werkverzeichnis der Druckgraphik 1915-1971. Cologne 1971.– Vitt, W. et al. (ed.): W. D. 1890-1973. Werkverzeichnis. Heidelberg 1995.– Wöbkemeier, R. (ed.): W. D. Werkverzeichnis. Heidelberg 1995
MONOGRAPHS, CATALOGUES: Friedl, F.: W. D. Neue Reklame. Düsseldorf 1987.– Güse, E.-G. and W. Vitt (ed.): W. D. Bilder, Aquarelle, Collagen. Westfälisches Landesmuseum. Münster 1979 (cat.).– Hofmann, W.: Der Maler W. D. Starnberg 1972.– Vitt, W. (ed.): Hommage à W. D. 1890-1973. Starnberg 1980.– Vitt, W. and R. Stolz (ed.): Schöne Tage im Hause Dexel.

Das Gästebuch. W. D. zum 100. Geburtstag. Galerie Stolz. Cologne 1990 (cat.).– Wöbkemeier, R. et al. (ed.): W. D. Bild, Zeichen, Raum. Kunsthalle Bremen. Bremen 1990 (cat.)

**DIEBENKORN Richard**
**1921** Portland (OR) – **1993** Berkeley (CA) American painter. **1940–1943** Studied in Stanford and Berkeley. **1946/47** Continued his studies in San Francisco and **1950–1952** at the University of New Mexico. His first paintings, influenced by Motherwell and Hoffmann, display elements of Abstract Expressionism. **1954** Participation in the exhibition "Younger American Painters" at the Guggenheim Museum, New York. Influenced by Hopper, his paintings became more figurative. From **1967** on he returned to abstraction. **1966–1973** Professorship at the University of California, Los Angeles. **1968** Took part in the Venice Biennale. **1972** Solo-exhibition at the San Francisco Museum of Art. One of the main representatives of Abstract Expressionism in California.
CATALOGUES RAISONNES: Guillemin, C.: R. D. Catalogue raisonné. Eaux-fortes de 1949 à 1980. Houston 1981.– Newlin, R. (ed.): R. D. Works on Paper. Houston 1987.– Stevens, M. (ed.): R. D. Etchings and Drypoints 1949-1980. The Minneapolis Institute of Arts et al. Houston 1981 (cat.)
MONOGRAPHS, CATALOGUES: Buck, R. T. et al. (ed.): R. D. Paintings and Drawings 1943-1976. Albright-Knox Art Gallery, Buffalo et al. Buffalo 1976 (cat.).– Cathcart, L. L. (ed.): R. D. 38th Venice Biennal 1978, United States Pavilion. New York 1978 (cat.).– R. D. Pasadena Art Museum, Pasadena et al. Pasadena 1960 (cat.).– R. D. Washington Gallery of Modern Art et al. Washington 1965 (cat.).– R. D. Paintings from the Ocean Park Series. San Francisco Art Museum. San Francisco 1973 (cat.).– Elderfield, J. (ed.): The Drawings of R. D. The Museum of Modern Art, New York et al. Houston 1989 (cat.).– Elderfield, J. et al. (ed.): R D. Whitechappel Art Gallery, London et al. London 1991 (cat.)/R. D. Frankfurter Kunstverein et al. Frankfurt-on-Main 1992 (cat.).– Flam, J.: R. D. Ocean Park. New York 1992.– Livingstone, J. (ed.): The Art of R. D. Whitney Museum of American Art, New York et al. New York 1997 (cat.).– Newlin, R. (ed.): R. D. Works on Paper. Houston 1987.– Nordland, G.: R. D. New York 1987

**DILLER Burgoyne**
**1906** Battle Creek (MI) – **1965** New York American painter. **1928–1933** Studied art at the Art Students League in New York and took private lessons from Hoffmann. Influenced by Mondrian, he developed his own abstract, geometric style, based on three primary colours and black. **1933** First solo exhbition at the Contemporary Art Gallery in New York. **1935–1941** Directed the department of mural painting within the Federal Arts Project. Worked with Pollock,

Rothko and Reinhardt. **1936** Together with Fritz Glarner and Albers, founded the artists' association American Abstract Artists. **1945–1964** Professorship at Brooklyn Art College. **1966** Retrospective at the New Jersey State Museum, Trenton. **1968** Participation in documenta 4 in Kassel. **1972** Retrospective at Walker Art Gallery, Minneapolis. Regarded as one of the founding fathers of Neo-Plasticism in America.
MONOGRAPHS, CATALOGUES: B. D. Trenton State Museum. Trenton (NJ) 1966 (cat.).– Haskell, B. (ed.): B. D. Whitney Museum of American Art. New York 1990 (cat.).– Larsen, P. and P. Dchjeldahl (ed.): B. D. Paintings, Sculptures, Drawings. Walker Art Center. Minneapolis 1971 (cat.).– Rand, H. (ed.): B. D. Meredith Long Contemporary Art. New York 1980 (cat.).– Schlégl, I. (ed.): B. D. 1906 New York City – 1965 New York City. Galerie und Edition Schlégl. Zurich 1991 (cat.)

**DINE Jim**
born **1935** Cincinnati (OH)
American painter and sculptor. **1953–1957** Studied at the University of Cincinnati, at Boston Museum School and finally at Ohio University, Athens. From **1958** he lived in New York, where, with his installations, environments and happenings, he set up a counter-movement to the predominant Abstract Expressionism. **1960–1965** various guest-professorships, among others at Yale University, New Haven and at Oberlin College, Ohio. **1964** Participated in the Venice Biennale. From **1967** he taught at the College for Architecture, Cornell University, Ithaca and lived temporarily in London in order to experience the English Pop Art scene directly. **1968** and **1977** participation in documenta 4 and 7 in Kassel. Since **1980** member of the American Academy of Arts and Letters. Created large murals for public places in Boston and San Francisco. Dine's paintings are usually combined with collages, assemblages and three-dimensional objects and have a home-made, personal character, distinguishing them from the mechanical style of picture production emphasized in Pop Art.
WRITINGS: J. D.: Welcome Home Lovebirds. London 1969.– J. D.: Letters to Nancy. New York 1970.– J. D.: Gedichte und Zeichnungen. Frankfurt-on-Main 1971

CATALOGUES RAISONNES: Bonin, W. v. and M. S. Cullen (ed.): J. D. Complete Graphics 1960-1970. Galerie Mikro. Berlin, Hanover and London 1970.– J. D. Prints 1970-1977. Williams College Museum, Williamstown. New York 1977.– D'Oench, E. G. and J. E. Feinberg (ed.): J. D. Prints. 1977-1985. Davison Art Center, Wesleyan University, Middletown et al. New York 1986 (cat.)
MONOGRAPHS, CATALOGUES: Ackley, C. (ed.): Etchings by J. D. New York 1983.– Beal, G. W. J. (ed.): J. D. Five Themes. Walker Art Center, Minneapolis et al. Minneapolis and New York 1984 (cat.).– Codognato, A. (ed.): J. D. Galleria d'Arte Moderna Ca' Pesaro, Venice. Milan 1988 (cat.).– Dagbert, A.: J. D. Une exposition pour Paris. Paris 1986.– J. D. in der Glyptothek. Munich 1990 (cat.).– J. D. et al. (ed.): J. D. Drawing from the Glyptothek. New York 1993.– J. D. Venus. Revoltella Museum. Triest 1996 (cat.).– Glenn, C. W.: J. D. Drawings. New York 1985.– Gordon, J. (ed.): J. D. Figure Drawings. Whitney Museum of American Art. New York 1985.– Livingstone, M.: J. D. Flowers and Plants. New York 1994.– Livingstone, M.: J. D. The Alchemy of Images. New York 1997.– Rogers-Lafferty, S. (ed.): Drawings J. D. 1973-1987. The Contemporary Arts Center, Cincinnati et al. Cincinnati 1988 (cat.).– Shapiro, D.: J. D. Painting What One Is. New York 1981/J. D. Malen, was man ist. Stuttgart 1984.– Shapiro, D. et al.: J. D. Milan 1988

**DISLER Martin**
**1949** Seewen (Solothurn) – **1996** Geneva Swiss painter and graphic artist. Self-taught. **1969** Worked as an auxiliary nurse in the psychiatric clinic in Rosegg, Solothurn. **1970** Stage director and theatre critic in Olten. Solothurn Award for graphics. **1971** First solo-exhibitions at the Kunstzone (Art Zone) Munich and Delphin Gallery, Olten. **1973** Studied in Bologna and Paris. **1976/77** Kiefer-Hablitzel Grant. Continued studies in America. **1978** Moved to Zurich. **1980** Solo-exhibition at the Kunsthalle, Basel. After **1981** travelled to America. Worked in various places, including Zurich, New York, Lugano and Harlingen. **1982** Participation in documenta 7 in Kassel. **1983** Solo-exhibitions at the Stedelijk Museum Amsterdam and at the Museum für Gegenwartskunst in Basel. **1985** Bremen Art Award, exhibition at the Folkwang Museum, Essen. **1987** Award from Zurich Art Society. **1997** Exhibition of last series of watercolours at the Kunstmuseum Basel and Museum Ludwig, Cologne.
WRITINGS: M. D.: Reise nach Pisa. Zurich 1975.– M. D.: Das Lebenjacket. Olten 1977.– M. D.: Bilder vom Maler. Dudweiler 1980.– M. D.: Der Zungenkuss. Biel 1980.– M. D.: Schwarzweisse Novelle. Zurich 1983
CATALOGUE RAISONNE: Davvetas, D. (ed.): M. D. Werke 1982-1986. Bern 1996.– Willi-Cosandier, J. and R. M. Mason (ed.): M. D. L'œuvre gravé 1978-1988. Musée d'Art et d'Histoire. Geneva 1989 (cat.)

MONOGRAPHS, CATALOGUES:
Ammann, J. C. et al. (ed.): M. D. Invasion durch eine falsche Spur. Kunsthalle Basel. Basel 1980 (cat.).– Cornips, M. H. et al. (ed.): M. D. Zeichnungen 1968-1983. Museum für Gegenwartskunst, Basel et al. Basel 1983 (cat.).– M. D. et al. (ed.): M. D. Dossier: Arbeiten der 70er Jahre und Bilderzyklus "Februar '91". Kunstmuseum. Solothurn 1991 (cat.).– Felix, Z. (ed.): M. D. Folkwang Museum, Essen et al. Essen 1985 (cat.).– Firmenich, A. and A. Sommer (ed.): M. D. Skulpturen 1985-1994. Kunsthalle Emden. Cologne 1995 (cat.).– Jenny, C. (ed.): M. D. Zeichnungen. Zurich 1989.– Kellein, T. (ed.): M. D. Häutung und Tanz. London, Basel and Munich 1991 (cat.).– Koepplin, D. (ed.): M. D. Die letzten Aquarelle. Kunstmuseum Basel et al. Stuttgart 1997 (cat.).– Osterwold, T. and D. Hall (ed.): M. D. Die Umgebung der Liebe. Württembergischer Kunstverein. Stuttgart 1981 (cat.)

**DI SUVERO Mark**
born **1933** Shanghai
American sculptor. **1941** Left China, emigrating to the USA. Studied **1953/54** at City College, San Francisco and **1954/55** at the University of California in Santa Barbara and in Berkeley, before settling in New York. **1960** First solo-exhibition at the Green Gallery, New York. **1968** Took part in documenta 4 in Kassel. **1969** Taught at the University of California, Berkeley. **1971** Moved to Holland. **1972** Solo-exhibition at the Stedelijk Van Abbe Museum, Eindhoven. **1973** Professorship at the Academy of Arts in Venice. **1975** Exhibited at the Whitney Museum, New York and participated at the Venice Biennale. **1988** Retrospective at the Württembergischer Kunstverein, Stuttgart. **1991** Retrospective at the Musée d'Art Moderne in Nice. Di Suvero's public sculptures articulate space but have no recognisable formal logic of their own; in essence, they are almost deconstructivist. After working in wood, the artist began to use steel, especially industrially manufactured double-T-beams, for his sculptures.
MONOGRAPHS, CATALOGUES: M. Di S. Open Secret: Sculpture 1990-1992. Gagosian Gallery. New York 1993 (cat.).– M. Di S. Storm King Center. New York 1985 (cat.).– M. Di S. Museo de Bellas Artes. Valencia 1994 (cat.).– Evrard, M. and B. Roge: M. Di S. Chalons-sur-Saône 1975.– Monte, J. K. (ed.): M. Di S. Whitney Museum of American Art. New York 1975 (cat.).– Osterwald, T. (ed.): M. Di S. Württembergischer Kunstverein. Stuttgart 1988 (cat.).– Perlein, G. (ed.): M. Di S. Retrospective 1959-1991. Musée d'Art Moderne et d'Art Contemporain. Nice 1991 (cat.)

**DIX Otto**
**1891** Untermhaus (near Gera) –
**1969** Singen
German painter and graphic artist. **1905–1909** Apprenticeship as a decorative painter in Gera. **1910–1914** Studied at Dresden School of Arts and Crafts School. **1914–1918** Military service. **1919–1922** Studied at the Dresden Academy. Founding member of Gruppe 1919 attached to the New Dresden Secession. **1922–1924** Contact with the Junges Rheinland, young artists gathered around the gallerist Johanna Ey in Düsseldorf and later known as the Rhenish Expressionists. **1925** Participation in the exhibition "Neue Sachlichkeit" (New Objectivity) at the Kunsthalle Mannheim. **1927–1933** Professorship at the Dresden Art Academy. **1933** Forbidden to exhibit his works and dismissed from the Prussian Art Academy for political reasons. **1937** More than 200 paintings confiscated as "degenerate art". **1939** Arrested for suspected participation in the Munich assassination attempt on Hitler. Burning of paintings classified as "degenerate". **1943** Started *Primamalerei*, a painting technique. **1945** Called up and taken prisoner in France. **1950** Professorship at Düsseldorf Academy. **1959** Cornelius Award from the City of Düsseldorf and Großes Bundesverdienstkreuz (National Service Cross). **1962** Guest-residency at the Villa Massimo, Rome. **1964** Honorary member of the Accademia delle Arte del disegno in Florence. Awarded the Carl-von-Ossietzky medal. **1966** Lichtwark Award from the City of Hamburg and Martin-Andersen-Nexö Prize from the City of Dresden. **1967** Ernst-Thoma Award from the federal state of Baden-Württemberg. **1968** Honorary member of Karlsruhe Art Academy.
WRITINGS: O. D.: Kinderalbum. Ed. by D. Gleisberg. Leipzig 1991
CATALOGUES RAISONNES: Karsch, F. (ed.): O. D. Das graphische Werk 1913-1960. Berlin 1961, Hanover 1970.– Löffler, F. (ed.): O. D. Werkverzeichnis der Gemälde 1891-1969. Recklinghausen 1981.– Pfäffle, S. (ed.): O. D. Werkverzeichnis der Aquarelle und Gouachen. Stuttgart 1991.– Rüdiger, U. (ed.): O. D. Werkverzeichnis der Zeichnungen und Pastelle. 4 vols. Weimar 1998
MONOGRAPHS, CATALOGUES: Beck, R. (ed.): O. D. 1891-1969. Museum Villa Stuck. Munich 1985 (cat.).– Beck, R.: O. D. 1891-1969. Zeit, Leben und Werk. Constance 1993.– Conzelmann, O.: Der andere D. Sein Bild vom Menschen und vom Krieg. Stuttgart 1983.– Fischer, L.: O. D. Ein Malerleben in Deutschland. Berlin 1981.– Hagenlocher, A. (ed.): O. D. Bestandskatalog. Zeichnungen, Pastelle, Aquarelle, Kartons und Druckgraphik der Jahre 1912-1969 aus der Stiftung Walther Groz. Albstadt 1985.– Hartmann, C.: Untersuchungen zum Kinderbild bei O. D. Münster 1989.– Hollmann, A. and U. Zeller (ed.): O. D. Zum 100. Geburtstag. Galerie der Stadt Stuttgart et al. Stuttgart 1991 (cat.).– Hollmann, A. and U. Zeller (ed.): D. Tate Gallery, London et al. London 1992 (cat.).– Karcher, E.: Eros und Tod im Werk von O. D. Studien zur Geschichte des Körpers in den zwanziger Jahren. Münster 1984.– Karcher, E.: O. D. Life and Work.

Cologne 1989.– Kim, J.-H.: Frauenbilder von O. D. Münster 1994.– Kinkel, H.: Die Toten und die Nackten. Beiträge zu D. Berlin 1991.– Lehmann, H.-U. (ed.): O. D. Die Zeichnungen im Dresdner Kupferstichkabinett. Kupferstichkabinett Dresden et al. Dresden 1991 (cat.).– Löffler, F.: O. D. Leben und Werk. Dresden 1960, Wiesbaden 1982/O. D. Life and Work. New York 1982.– Rüdiger, U.: Grüße aus dem Krieg. Die Feldpostkarten der O.-D.-Sammlung in der Kunstgalerie Gera. Gera 1991.– Sabarsky, S. (ed.): O. D. Staatliche Kunsthalle Berlin et al. Berlin 1987 (cat.).– Schmidt, D.: O. D. im Selbstbildnis. Berlin 1978.– Schmidt, J.-K. (ed.): O. D. Bestandskatalog: Gemälde, Aquarelle, Pastelle, Zeichnungen, Holzschnitte, Radierungen, Lithographien. Galerie der Stadt Stuttgart. Stuttgart 1989 (cat.).– Schneede, U. (ed.): O. D. Zeichnungen, Aquarelle, Graphiken, Kartons. Kunstverein in Hamburg. Hamburg 1977 (cat.).– Schneede, U. (ed.): O. D. Bestandskatalog. Galerie der Stadt Stuttgart. Stuttgart 1989.– Schubert, D.: O. D. In Selbstzeugnissen und Bilddokumenten. Reinbek 1991.– Schwarz, B.: O. D. Großstadt. Frankfurt-on-Main and Leipzig 1993.– Strobl, A.: O. D. Eine Malerkarriere der zwanziger Jahre. Berlin 1991.– Tittel, L.: O. D. Die Friedrichshafener Sammlung. Bestandskatalog. Friedrichshafen 1992

**DOESBURG Theo van**
**1891** Utrecht – **1931** Davos
Dutch painter, architect and theoretician. **1908** Exhibited Impressionist paintings for the first time in The Hague. From **1912** published criticisms and articles on art. After **1916** developed an austere geometrical style and collaborated on architectural projects with the architects Jacobus Oud and Jan Wils. **1917** Together with Mondrian, founded the association of artists De Stijl and periodical of the same name. Developed the style of painting known as Neo-Plasticism. **1922** Collaborated briefly with the Dada movement, introducing it to Holland, and published the magazine *Mecano*. **1923** Moved to Paris. **1924** Published the Bauhaus book *Principles of the New Art*. First contra-compositions laid the foundations for Elementarism and introduce the dynamic diagonal. **1926–1928** Wall paintings for a restaurant in Strasbourg. **1929** Founded the magazine *L'Art Concret* and built his house and studio in Meudon.
WRITINGS: T. v. D.: De nieuwe beweging in de schilderkunst. Delft 1917, Amsterdam 1983.– T. v. D.: Drie voordrachten over de nieuwe beeldende kunst. Amsterdam 1919.– T. v. D.: Grundbegriffe der neuen gestaltenden Kunst. Munich 1925/Principles of Neo-plastic Art. Greenwich (CT) 1968.– T. v. D.: Naar een beeldende architectuur. Nijmwegen 1983.– T. v. D.: Das andere Gesicht. Gedichte, Prosa, Manifeste, Romaan 1913-1928. Ed. by H. Bulkowski. Munich 1983.– T. v. D.: De Stijl en de Europese architectuur. De architectuurop-

stellen in het Boubedrijf 1924-1931. Nijmwegen 1983.– Polano, S. (ed.): T. v. D. Scritti di arte e di architettura. Roma 1979
MONOGRAPHS, CATALOGUES: Baljieu, J.: T. v. D. London and New York 1974.– Boekraad, C. (ed.): T. v. D. De Stijl en de europese architectur. Nijmwegen 1986.– Doig, A.: T. v. D. Painting into Architecture, Theory into Practice. Cambridge (MA) 1986.– Georgel, P. and E. d. Lillers (ed.): T. v. D. Projets pour l'Aubette. Centre Georges Pompidou. Paris 1977 (cat.).– Hedrick, H. L.: T. v. D. Propagandist and Practitioner of the Avant-Garde 1909-1923. Ann Arbor (MI) 1980.– Jaffé, H. L. C.: T. v. D. Amsterdam 1983.– Leering, J. et al.: T. v. D. 1883-1931. Eindhoven 1968.– Lemoine, S. (ed.): T. v. D. Peinture, architecture, théorie. Paris 1990.– Straaten, E. v. (ed.): T. v. D. Een documentataire op basis van materiaal uit de schenking Van Moorsel. The Hague 1983.– Straaten, E. v. (ed.): T. v. D. Schilder en architect. Museum Boymans-van-Beuningen, Rotterdam. The Hague 1988 (cat.).– Weyergraf, C.: Piet Mondrian und T. v. D. Deutung von Werk und Theorie. Munich 1979

**DOISNEAU Robert**
**1912** Gentilly – **1994** Paris
French photographer. **1925–1931** Apprenticeship as a lithographer and photographer. **1931** Assistant to the stage director André Vigneau. **1932** First photojournalism for *Excelsior*. **1934–1939** Photographer for Renault. After **1940** became a freelance photographer. From **1945** worked for the photographic agency *Agence Alliance Photo* and from **1946** for the agency *Rapho*. Collaboration on a book project with the author Blaise Cendrars. **1947** Kodak Award. From **1949** contracted to work for *Vogue* as a fashion photographer. **1960** Travelled to the United States. **1968** Reported on the 50th anniversary of the Soviet Union. **1973** Together with F. Porcile, made the short film *Le Paris de R. Doisneau*. **1983** Broadcasting of the film *5 photographes* on TV France 3. One of the leading French photographers of the 40s and 50s. Apart from his innumerable fashion photographs he became famous for his reportages, his advertising work and for his satirical portraits.
WRITINGS: R. D.: A l'imparfait de l'objectif. Souvenirs et portraits. Paris 1989.– R. D.: J'attends toujours le printemps. Lettres à M. Baquet. Arles 1991
MONOGRAPHS, CATALOGUES:
Chevrier, J.-F. R. D. Paris 1982.– R. D. Musée des Arts Décoratifs. Nantes 1975 (cat.).– R. D. Centre national de la photographie. Paris 1983 (cat.).– R. D.: Un certain R. D. Paris 1986.– R. D.: R. D. London 1991.– R. D. and P. Ory: R. D. Paris 1994.– R. D. Musée Carnavalet. Paris 1996 (cat.).– Hamilton, P. (ed.): R. D. A Photographer's Life. New York 1995/R. D. La Vie d'un photographe. Paris 1995.– Roumette, S.: R. D. Paris 1983, London 1991.– Vautrin, J.: R. D. Paris 1996

**DOMELA César**
(César Domela-Nieuwenhuis)
**1900** Amsterdam – **1992** Paris
Dutch painter. Self-taught. **1922/23** Brief stays in Ascona and Berne. First Constructivist works. Participation in an exhibition of the Novembergruppe in Berlin. **1924** Moved to Paris. Met Mondrian and van Doesburg and joined De Stijl. **1927–1933** Lived in Berlin. Member of Die Abstrakten Hannover (The Hanoverian Abstract Artists). Contact with the Bauhaus. Made relief-like assemblages out of various materials. **1933** Went back to Paris. Joined Abstraction-Création. **1937** Founded the journal *Plastique* with Taeuber-Arp and Arp. **1947–1956** Participated in the Salon des Réalités Nouvelles. **1955–1960** Wall paintings in various Dutch cities. **1987** Exhibition at the Musée d'Art Moderne de la Ville de Paris.
WRITINGS: C. D.: L'Art en écrit. Paris 1982
CATALOGUE RAISONNE: Clairet, A. (ed.): D. Catalogue raisonné de l'œuvre de C. D.-Nieuwenhuis. Peintures, reliefs, sculptures. Paris 1978
MONOGRAPHS, CATALOGUES: Brion, M.: D. Paris 1961.– Briot, M.-O. (ed.): D. 65 ans d'abstraction. Musée d'Art Moderne de la Ville de Paris et al. Paris 1987 (cat.).– Cless, F. (ed.): D. Schilderijen, reliefs, grafisch œuvre. Van Reekum Museum, Apeldoorn et al. Apeldoorn 1990 (cat.).– Derouet, C. (ed.): D. Gouaches de la période parisienne. Utrecht 1984.– C. D. Schilderijen, reliefs, beelden, grafiek, typografie, fotos. Gemeentemuseum. The Hague 1980 (cat.).– C. D. Stedelijk Museum. Amsterdam 1987 (cat.).– Hering, K.-H. (ed.): C. D.: Werke 1922-1972. Retrospektive. Kunstverein für die Rheinlande und Westfalen. Düsseldorf 1972 (cat.).– Jaffé, H. L. C.: D. Paris 1980.– Martini, G. B. and A. Ronchetti (eds.): C. D. Fotografie, fotomontaggi, disegni. Galleria Martini & Ronchetti. Genoa 1981 (cat.).– Pobé, M.: D. Hilversum 1965.– Zervos, C.: D. Amsterdam 1966

**DOMINGUEZ Oscar**
**1906** La Laguna (Canary Islands) – **1957** Paris
Spanish-French painter. Self-taught. **1927** Moved to Paris where he had contact with the Surrealists. **1929** First Surrealist works. **1930** Founded an artists' centre on Tenerife

where he organised an exhibition of Surrealist paintings in **1933**. **1934** Returned to Paris where he invented *Décalcomanie*, a blotting technique used to generate images and later adopted by Max Ernst. **1937** First abstract works. **1938** Participation in the "International Surrealist Exhibition" in Paris. **1948** Became a French citizen. **1957** Suicide.
MONOGRAPHS, CATALOGUES: Castro, F. (ed.): O. D. y el surrealismo. Madrid 1978 (cat.).– O. D. Schloß Morsbroich, Städtisches Museum. Leverkusen 1967 (cat.).– Vazquez de Parga, A. et al.: O. D. Antologica 1926-1957. Las Palmas 1996.– Walberg, P.: Black Irises for O. D. London 1961.– Westerdahl, E.: O. D. Barcelona 1968.– Xuriguera, G.: O. D. Paris 1973, Berlin 1973

**DONGEN Kees van**
(Cornelis Theodorus Maria van Dongen)
**1877** Delfshaven (near Rotterdam) – **1986** Monte Carlo
Dutch painter. Studied at an arts and crafts school and trained as a technical draughtsman. **1897** Broke off his apprenticeship and left home. Settled in Montmartre, Paris, doing odd jobs to earn a living. **1906** Joined the Fauves and shortly after became a guest-member of the Dresden Brücke group. **1907** He lived at Bateau-Lavoir in Rue Ravignan, where he met Picasso. **1908** Contract with the Bernheim-Jeune Gallery. Van Dongen's paintings display intense, voluptuous colour effects and emotive contrasts. After World War I he became a successful portraitist, mainly of prominent figures in high society, although his style became increasingly trivial and decorative.
CATALOGUE RAISONNE: Wildenstein Institute (ed.): K. van D. Catalogue raisonné (in preparation)
MONOGRAPHS, CATALOGUES: Adrichen, J. v. et al. (ed.): K. v. D. Museum Boymans-van Beuningen, Rotterdam. Amsterdam 1989 (cat.).– Chaumeil, L.: V. D. L'homme et l'artiste. La vie et l'œuvre. Geneva 1967.– Diehl, G.: K. v. D. Paris 1968.– Hopmans, A. (ed.): K. v. D. Early and Fauvist Drawings 1895-1912. Museum Boymans-van Beuningen, Rotterdam et al. Rotterdam 1997 (cat.).– K. v. D. Retrouvé. L'œuvre sur papier 1895-1917. Musée des Beaux-Arts. Lyon 1997 (cat.).– Hild, E. (ed.): K. v. D. 1877-1968. Musée de l'Annonciade. Saint-Tropez 1985 (cat.).– Kyriazi, J. M.: V. D. et le fauvisme. Lausanne and Paris 1971.– Kyriazi, J. M.: V. D. après le fauvisme. Lausanne 1976.– Pagé, S. et al. (ed.): V. D. le peintre 1877-1968. Musée d'Art Moderne de la Ville de Paris. Paris 1989 (cat.).– Wentinck, C.: V. D. Amsterdam 1962

**DORAZIO Piero**
born **1927** Rome
Italian painter. Studied architecture in Rome. **1942** Started to paint. **1947** Co-founder of the artists' group Forma I which opposed expressionist and traditional tendencies in painting and tended towards

abstraction. **1947/48** Studied painting in Paris. Contact with avant-garde artist circles. Over the following years worked full-time as an exhibition curator and art publisher. **1949** Travelled to Austria and Germany where he met Baumeister, Geiger and Winter. **1953** Moved to America. **1961-1970** Lectureship at the Graduated School of Fine Arts in Pennsylvania. **1963** Together with Angelo Savelli, founded the Institute of Contemporary Art at Pennsylvania University. **1964** Participation in documenta 3 in Kassel.
WRITINGS: P. D.: La fantasia dell'arte nella vita Moderna. Roma 1955
CATALOGUE RAISONNE: Volpi Orlandini, M. et al. (ed.): D. Venice 1977, Stuttgart 1978
MONOGRAPHS, CATALOGUES: Boehm, G. et al.: P. D. Arbeiten auf Papier. Saulgau 1992.– Durbé, D. and M. Faggio dell'Arco (ed.): D. Galleria Nazionale d'Arte Moderna, Roma. Milan 1983 (cat.).– Fry, E. E. et al. (ed.): D. Bayerische Staatsgemäldesammlungen, Munich et al. Munich 1981 (cat.).– Schultz, D. G. (ed.): P. D. A Retrospective. Albright-Knox Art Gallery, Buffalo et al. Buffalo 1979 (cat.).– Ungaretti, G.: P. D. St. Gallen 1976.– Vernizzi, N. (ed.): P. D. Musée de Grenoble et al. Milan 1990 (cat.).– Zevi, A. (ed.): P. D. Pinacoteca communale di Ravenna. Ravenna 1985 (cat.)

**DOVE Arthur**
**1880** Canandaigua (NY) – **1946** Centerport (NY)
American painter. **1898-1903** Studied painting and law at Cornell University in Ithaca, New York. **1906** Worked as a freelance advertising draughtsman in New York. **1907/08** Lived in Paris. While in the South of France, moved away from Impressionism and closer to Fauvism. **1909** After his return to America, he ran a farm in Connecticut and continued to do illustrations. Became friends with the art dealer Stieglitz. **1912** First solo-exhibition with ten abstract pastel-crayon works at Stieglitz' Gallery 291 in New York. **1924-1930** Lived on a houseboat on Long Island. Made assemblages from *objets trouvés* and, influenced by Kandinsky's musical approach to art, developed a more abstract style. **1930-1934** Produced abstractions that were somewhat surreal but based on natural forms. **1935**

Gave up organic-abstractionism to experiment with geometrical compositions.
CATALOGUE RAISONNE: Morgan, A. L. (ed.): A. D. Life and Work, with a Catalogue Raisonné. London, Newark and Toronto 1984
MONOGRAPHS, CATALOGUES: Balken, D. B. et al. (ed.): A. D. A Retrospective. Cambridge (MA) 1997 (cat.).– Cohn, S.: A. D. Nature as Symbol. Ann Arbor (MI) 1985.– Haskell, B. (ed.): A. D. San Francisco Museum of Art et al. San Francisco and Boston 1974 (cat.).– Newman, S. M. (ed.): A. D. and Duncan Phillips. Artist and Patron. The Phillips Collection, Washington et al. Washington 1981 (cat.).– Wight, F. S. A. D. Berkeley and Los Angeles 1958

**DRTIKOL František**
**1883** Pribram (CSSR) – **1961** Prague
Czech photographer. **1895-1901** Apprenticeship in the photographic studio of Antonin Matta. **1901-1903** Attended classes at the Lehr- und Versuchsanstalt für Fotografie (College of Experimental Photography) in Munich. **1903/04** Worked in various studios. **1910** Set up his own business in Prague, receiving numerous commissions for portraits. Representations of female nudes in highly abstract compositions. **1915-1918** Military service. Numerous publications of his work in magazines. **1925-1935** Designed Art Deco requisites and started painting. Exhibitions all over the world. **1929** Publication of a collection of photographs in the book *Les Nus de Drtikol*. From **1935** gave up photography in order to concentrate on the study of theosophy. One of the main representatives of Art Deco photography. In their formalised flatness, his frequently retouched photographs resemble Art Nouveau paintings.
MONOGRAPHS, CATALOGUES: Birgus, V. and A. Brandy: F. D. Prague 1988.– Birgus, V. (ed.): Fotograf F. D. Prague 1994.– Fárová, A. (ed.): F. D. SICOF. Milan 1973 (cat.).– Fárová, A. (ed.): F. D. Photographie des Art Déco. Munich 1986, 1993.– Klaricová, K.: F. D. Prague 1989

**DUBUFFET Jean**
**1901** Le Havre – **1985** Paris
French painter. **1918** After a two-year course in painting at the academy in Le Havre, went to Paris to study at the Académie Julian. Met Suzanne Valadon, Max Jacob, Léger and Dufy. **1924** Worked as a technical draughtsman in Buenos Aires. **1925-1932** Gave up his artistic ambitions to work in his father's wine business. **1933** Took up painting again. **1944** First solo-exhibition at the René Drouin Gallery in Paris. **1945** Started to collect Art Brut, paintings by children and mental patients. **1947** Founded the Société de L'Art Brut and painted the humorous and ironical series of portraits entitled *More beautiful than you think*.

**1955** Moved to Vence. From **1956** he constructed large sculptures from small, jigsaw-like pieces. These structures, resembling mountain ranges, could be expanded into architectural forms. **1959–1968** Participation in documenta 2–4 in Kassel. **1960** Musical experiments with Asger Jorn. **1967** First architectural environments. **1973** Retrospective at Guggenheim Museum in New York, where his surrealist play *Coucou Bazar* was performed. **1976** Presented his Art Brut collection to the city of Lausanne.
WRITINGS: Damisch, H. (ed.): J. D. Prospectus et tous écrits suivants. 2 vols. Paris 1967.– J. D.: L'homme du commun à l'ouvrage. Paris 1973.– J. D.: La Botte à nique. Geneva and Paris 1973.– J. D.: Bâtons rompus. Paris 1986.– J. D.: Asphyxiante culture. Paris 1986.– J. D.: Lettres à Jacques Berne. 1946-1985. Paris 1991.– Franzke, A. (ed.): J. D. Schriften. 4 vols. Bern and Berlin 1991-1994.– Glimcher, M. (ed.): J. D. Towards an Alternative Reality. New York 1987
CATALOGUES RAISONNES: Arnaud, N. (ed.): J. D. Gravures et lithographies. 2 vols. Paris 1961-1966.– Bonnefoi, G. (ed.): J. D. L'œuvre lithographique 1944-1984. Paris 1992.– Franzke, A. (ed.): J. D. Petites statues de la vie précaire. Bern and Berlin 1988.– Graham, L. (ed.): L'œuvre gravé et les livres illustrés de J. D. Catalogue raisonné. 2 vols. Paris 1992.– Loreau, M. and A. d. Trentinian (ed.): Catalogue intégral des travaux de J. D. 38 vols. Paris 1964-1991
MONOGRAPHS, CATALOGUES: Armengaud, J.-P.: La Musique chauve de J. D. Paris 1991.– Barilli, R.: D. materiologo. Bologna 1962.– Berne, J.: L'Herne. J. D. Paris 1973.– Cordier, D.: Les Dessins de J. D. Paris 1960 / The Drawings of J. D. New York 1960.– Chalumeau, J.: J. D. Paris 1996.– Damisch, H. (ed.): J. D. Del paisaje fisico al paisje mental. Fundación La Caixa, Madrid 1992.– Danchin, L.: J. D. Peintre-philosophe. Lyon 1988.– Demetrion, J. T. (ed.): J. D. 1943-1963. Paintings, Sculptures, Assemblages. Hirshhorn Museum and Sculpture Garden. Washington 1993 (cat.).– J. D. 1942-1960. Musée des Arts Décoratifs. Paris 1960 (cat.).– J. D. Lithographies. Série des phénomènes. Paris 1960.– J. D. Livres et estampes. Bibliothèque nationale de France. Paris 1982 (cat.).– J. D. Hauts lieux, paysages 1944-1984. Palais des Papes. Avignon 1994 (cat.).– J. D. Les dernières années. Galerie Nationale du Jeu de Paume. Paris 1991 (cat.).– Franzke, A.: J. D. Basel 1975.– Franzke, A.: J. D. Zeichnungen. Munich 1980.– Franzke, A.: D. New York 1981, Cologne 1990.– Glimcher, M.: J. D. Towards an Alternative Reality. New York 1987.– Haas, M.: J. D. Materialien für eine "andere Kunst" nach 1945. Berlin 1998.– Lhote J.-M.: J. D. Dessins-peintures 1942-1983. Paris 1984.– Limbourg, G.: Tableau bon levain à vous de cuire la pâte. L'art brut de J. D. Paris 1953.– Loreau, M.: D. et le voyage au centre de la perception. Paris 1966.– Loreau, M.: J. D. Delits, deportes, lieux de haut jeu. Geneva 1971.–

Loreau, M.: J. D. Stratégie de la création. Paris 1973.– Marchesseau, D. (ed.): D. Fondation Gianadda. Martigny 1993 (cat.).– Merkert, J. et al. (ed.): D. Retrospektive. Akademie der Künste, Berlin et al. Berlin 1980 (cat.).– Messer, T. M. (ed.): J. D. 1901-1985. Schirn Kunsthalle, Frankfurt-on-Main et al. Stuttgart 1990 (cat.).– Monferini, A. and L. Trucchi (ed.): J. D. 1901-1985. Galleria Nazionale d'Arte Moderna, Roma. Milan 1989 (cat.).– Pacquement, A. and F. Bonnefoy (ed.): J. D. Les dernières années. Galerie Nationale du Jeu de Paume. Paris 1991 (cat.).– Pacquet, M.: D. Paris 1993.– Picon, G.: Le Travail de J. D. Geneva 1973.– Prat, J.-L. (ed.): J. D. Rétrospective. Peintures, sculptures, dessins. Fondation Maeght. Saint-Paul 1985 (cat.).– Ragon, M.: J. D. Paysage du mental. Paris and Geneva 1989.– Rowell, M.: J. D. A Retrospective. New York 1993.– Selz, P.: The Work of J. D. The Museum of Modern Art. New York 1962 (cat.).– Thévoz, M.: D. Mires, structures dissipatives. Paris 1984.– Thévoz, M.: D. Geneva 1986.– Trucchi, L.: J. D. Milan 1965.– Vialatte, A.: J. D. et le grand magma. Paris 1988

**DUCHAMP Marcel**
**1887** Blainville Crevon – **1968** Neuilly-sur-Seine
French artist. Studied at the Académie Julian in Paris and was first influenced by Cézanne, then by the Fauves, the Cubists and Futurists. **1913** With his *Bicycle Wheel* on a stool he coined the term "readymade" for mass-produced articles. He held the view that the choosing of subject matter is an integral part of the creative process. **1915** Went to New York and, together with Man Ray, Picabia, Crotti and Marius de Zayas, founded the pre-Dada group around Arensberg and Stieglitz, the Society of Independent Artists and in **1920**, with Katherine Dreyer and Man Ray, the Sociéte anonyme, Museum of Modern Art 20. **1921** Published *New York Dada* with Man Ray. **1925** Construction of the optical machines *Rotating Hemispheres*. **1936** Participation in the exhibitions "International Surrealist Exhibition" in London and "Fantastic Art, Dada, Surrealism" at the Museum of Modern Art, New York. **1938** Project for the portable museum *Boîtes-en-Valise* which contained most of the artist's works reproduced on a smaller scale. **1951** Member of the Collège de Pataphysique. **1957** Exhibition "Les Frères Duchamp" at Solomon R. Guggenheim Museum, New York. **1967** Published *Boîte blanche* (Notes on the *Large Glass*) at Cordier & Ekstroem in New York. **1968** Participation in the exhibition "Dada, Surrealism and their Heritage" at the Museum of Modern Art, New York. Since Duchamp's anti-art radically challenged traditional concepts of art and anticipated numerous later developments, he is regarded as one of the most important avant-garde artists and a central figure in 20th century art.
WRITINGS: M. D.: D. du signe. Ecrits. Ed. by M. Sanouillet. Paris 1975.– M. D.: Inter-

views and Statements. Ed. by S. Stauffer. Stuttgart 1991.– Hill, A. (ed.): D. Passim. A M. D. Anthology. Roadtown 1994.– Sanouillet, M. and E. Peterson (ed.): M. D. Marchand de sel. Paris 1958 / Salt Seller. The Writings of M. D. New York and Oxford 1973.– Stauffer, S. (ed.): M. D. Die Schriften. 2 vols. Zurich 1981-1993
CATALOGUES RAISONNES: Clair, J. and P. Hulten (ed.): M. D. 4 vols. Centre Georges Pompidou. Paris 1977 (cat.).– M. D. Graphics. Kyoto 1991.– Schwarz, A. (ed.): The Complete Works of M. D. London 1969, New York 1970, Florence 1974, New York 1997
MONOGRAPHS, CATALOGUES: Adcock, C. E.: M. D.'s Notes from the Large Glass. An N-Dimensional Analysis. Ann Arbor (MI) 1983.– Bailly, J.-C.: M. D. Paris 1984.– Berswordt-Wallrabe, K. v. (ed.): M. D. Respirateur. Staatliches Museum, Schwerin. Stuttgart 1995 (cat.).– Bonk, E.: M. D. La Boite en valise. Die Schachtel im Koffer. De ou par M. D. ou Rose Sélavy. Inventar einer Edition. Munich 1989 / M. D. Box in a valise. New York 1989.– Cabanne, P.: Gespräche mit M. D. Cologne 1972.– Cabanne, P.: Les Trois Duchamp. Neuchâtel 1975 / The Brothers D. New York 1975 / Duchamp & Cie. Paris 1997.– Camfield, W. A. (ed.): M. D. Fountain. The Menil Foundation. Houston 1987 (cat.).– Clair, J.: M. D. ou le Grand Fictif. Essai de mythanalyse du Grand Verre. Paris 1975.– Daniels, D.: D. und die anderen. Der Modellfall einer künstlerischen Wirkungsgeschichte in der Moderne. Cologne 1992.– Dörstel, W.: Augenpunkt, Lichtquelle und Scheidewand. Die symbolische Form im Werk M. D.'s. Unter besonderer Berücksichtigung der Witzzeichnungen von 1907-1910 und der Radierungen von 1967 / 68. Cologne 1989.– Duve, T. d.: Pikturaler Nominalismus. M. D. – Die Malerei der Moderne. Munich 1987.– Duve, T. d.: Résonances du Readymade. D. entre avant-garde et tradition. Nîmes 1989.– Duve, T. d. (ed.): The Definitively Unfinished M. D. Halifax and Cambridge (MA) 1992.– Erfurth, E. (ed.): M. D. Flaschentrockner. Doxographie. Oldenburg 1997.– Fischer, A. M. and D. Daniels (ed.): Übrigens sterben immer die anderen. M. D. und die Avantgarde seit 1950. Museum Ludwig. Cologne 1988 (cat.).– Gibson, M.: Duchamp Dada. Paris 1991.– Hamilton, R. (ed.): The Almost Complete Work of M. D. Tate Gallery. London 1966 (cat.).– Harnoncourt, A. d' and K. McShine (ed.): M. D. The Museum of Modern Art, New York et al. New York 1973, Munich 1989 (cat.).– Hopps, W. (ed.): M. D. A Retrospective Exhibition. Pasadena Art Museum 1963 (cat.).– Hulten, P. et al. (ed.): M. D. Opera. Palazzo Grassi. Venice 1993 (cat.) / M. D. Work and Life. Palazzo Grassi, Venice. Cambridge (MA) 1993 (cat.).– Jones, A.: Postmodernism and the En-gendering of M. D. Cambridge 1994.– Kuenzli, R. E. and F. M. Naumann (ed.): M. D. Artist of the Century. Cambridge (MA) 1989.– Lebel, R.: Sur M. D. Paris 1959, 1985, New York 1959.– Lebel, R.: D. Von der Erscheinung zur Konzeption. Cologne 1972.– Lebel, R.: M. D. Paris 1985.– Masheck, J. (ed.): M. D. in Perspective. Englewood Cliffs (NJ) 1975.– Molderings, H.: M. D. Parawissenschaft, das Ephemere und der Skeptizismus. Frankfurt-on-Main 1983, Düsseldorf 1997.– Moure, G. (ed.): D. Museum Ludwig. Cologne 1984 (cat.).– Partouche, M.: M. D. J'ai une vie absolument merveilleuse … Biographie 1887-1968. Une Vie d'artiste. Marseille 1991.– Paz, O.: M. D. Appearance Stripped Bare. New York 1978 / Nackte Erscheinung: Das Werk von M. D. Berlin 1987.– Schwarz, A.: M. D. The Large Glass and Related Works. 2 vols. Milan 1967.– Seigel, J.: The Private World of M. D.

Berkeley 1997.– Suquet, J.: Le grand verre rêvé. Paris 1991.– Tomkins, C.: D. A Biography. New York 1996.– Zaumschirn, T. et al. (ed.): 100 Jahre M. D. 3 vols. Klagenfurt 1986

**DUCHAMP-VILLON Raymond**
**1876** Damville (Eure) – **1918** Cannes
French sculptor. Brother of Marcel Duchamp and Jacques Villon. **1898** Dropped his medical studies to take up sculpture. First influenced by Rodin. From **1902** he participated regularly in the Salon de la Société Nationale des Beaux-Arts and later in the Salon d'Automne in Paris. **1912** Had contact with the Cubists and applied their principles to his sculptures. Cofounder of the Section d'Or. Regular meetings with artists, writers and critics including Albert Gleizes, Jean Metzinger, Guillaume Apollinaire, Alexander Archipenko and his brothers. **1913** Participated in the Armory Show in New York. Together with Gleizes, organized the First German Autumn Salon in Berlin. **1914** Produced his most celebrated work *The Horse*.
MONOGRAPHS, CATALOGUES: Cabanne, P.: Les Trois Duchamp. Neuchâtel 1975 / The Brothers D. New York 1975 / Duchamp & Cie. Paris 1997.– Cassou, J. and R. V. Gindertael (ed.): R. D.-V. Le Cheval majeur. Galerie Louis Carré & Cie. Paris 1966 (cat.).– Hamilton, G. H. and W. C. Agee: R. D.-V. 1876-1918. New York 1967.– Pach, W.: R. D.-V. Sculpteur 1876-1918. Paris 1924.– Popovitch, O. and M.-N. Pradel (ed.): R. D.-V. 1876-1918. Musée des Beaux-Arts. Rouen 1976 (cat.).– Pradel, M. N.: R. D.-V. La Vie et l'œuvre. Diss. Paris 1960.– Sweeney, J. (ed.): J. V.-D. Solomon R. Guggenheim Museum. New York 1957

**DUFY Raoul**
**1877** Le Havre – **1953** Forcalquier
French painter. Began work aged 14 in a coffee import business and attended evening classes at an art school. **1900** Awarded a scholarship at the Ecole des Beaux-Arts in Paris. From **1904** had contact with the group the Fauves and was greatly influenced by Matisse. When staying with Braque in L'Estaque, he adopted elements of Cubism and his palette became almost monochrome. **1912** Impressions from his

travels led to a brightening of the coloration of his landscapes. **1920** Moved to Vence. Paintings of racecourses, sandy bays and concerts. **1937** Designed a mural for the Palais d'Electricité at the World Fair in Paris with several panels, covering a surface ten metres high and sixty metres wide. **1950/51** Went to the United States. Numerous designs for textiles, stage decorations and carpets. CATALOGUES RAISONNES: Guillon-Laffaille, F. (ed.): R. D. Catalogue raisonné des aquarelles, gouaches et pastels. 2 vols. Paris 1981-1982.– Guillon-Laffaille, F. (ed.): Catalogue raisonné des dessins. Vol. 1. Paris 1991.– Laffaille, M. and F. Guillon-Laffaille (ed.): R. D. Catalogue raisonné de l'œuvre peint. 5 vols. Geneva and Paris 1972-1985 MONOGRAPHS, CATALOGUES: Cogniat, R.: D. décorateur. Geneva 1957.– Cogniat, R.: R. D. Paris and New York 1962.– Courthion, P.: R. D. Geneva 1951.– Dorival, B.: La Belle histoire de la fée électricité de R. D. Paris 1953.– R. D. Créateur d'étoffes. 1910-1930. Musée d'Art Moderne de la Ville de Paris. Paris 1977 (cat.).– Forneris, J. (ed.): R. D. 1877-1953. KunstHaus. Vienna 1996 (cat.).– Girard, X. and D. Perez-Tibi: D. Le Peintre décorateur. Paris 1993.– Guillon-Laffaille, F. (ed.): R. D. Kunsthaus Bühler. Stuttgart 1989 (cat.).– Hunter, S.: R. D. New York 1954.– Laffaille, M. (ed.): R. D. 1877-1953. Haus der Kunst. Munich 1973 (cat.).– Lassaigne, J.: R. D. Geneva 1954, 1970.– Pérez-Tibi, D.: D. Paris 1989, New York 1989.– Robertson, B. and S. Wilson (ed.): R. D. Paintings, Drawings, Illustrated Books. Hayward Gallery. London 1983 (cat.).– Sussan, R. B.: R. D. Paintings and Watercolours. London 1958.– Valaison, M.-C. et al. (ed.): R. D. et le Midi. Palais des Rois de Majorque. Perpignan 1990 (cat.).– Werner, A.: R. D. New York 1953, 1970, 1985

**DUNCAN David Douglas**
born **1916** Kansas City (MI)
American photographer. **1935** Studied archaeology at the University of Arizona, Tuscon, and **1935-1938** marine biology at the University of Miami. Through deep-sea diving developed an interest in underwater photography. **1938** Expeditions to Chile and Peru in his capacity as a photographer and art historian working for the American Museum of Natural History, New York. Short-term employment as a boxer and deep-sea diver. During World War II, photographed the capitulation of the Japanese on a battleship in the Bay of Tokyo. **1946-1956** Worked as a photojournalist for *Life* magazine, covering Korea, Indochina and Palestine. From **1957** took many photographs of Picasso, and became close friends with his. **1966** Awarded the Gold Medal by U. S. Camera. **1972** Retrospective at the Whitney Museum of American Art, New York. **1977** Participated in documenta 6 in Kassel. **1981** Exhibition of "250 Photographs of Picasso" at the Sidney Janis Gallery, New York. MONOGRAPHS, CATALOGUES: D. D. D. William Rockhill Nelson Gallery. Kansas City 1971 (cat.).– D. D. D. Whitney

Museum. New York 1981 (cat.).– D. D. D. 250 Photographs of Picasso. Sidney Janis Gallery. New York 1981 (cat.)

**EDDY Don**
born **1944** Long Beach (CA)
American painter. **1965-1970** Studied at the University of Hawaii, Honolulu and at the University of California, Santa Barbara. **1968** First solo-exhibition at Kranin Gallery Honolulu. Since **1972** professorship at the New York University. **1972** and **1977** participation in documenta 5 and 6 in Kassel. Painted in a hyper-realistic style mainly from photographs of chromium-plated car parts such as bumpers, engine bonnets or hub caps reflecting surroundings. From the early 70s, window-paintings in which the theme of consumerism is related to urban environments.
MONOGRAPHS, CATALOGUES: D. E. University of Hawaii. Manoa 1982 (cat.).– D. E. Nancy Hoffman Gallery. New York 1986 (cat.).– Faison, S. L. and J. Hallmark (ed.): D. E. Williams College Museum. Williamstown (MA) 1975 (cat.)

**EISENSTAEDT Alfred**
**1898** Dierschau – **1995** Oaks Bluffs Martha's Vineyard (MA)
German-American photographer. **1913-1916** Studied at the University of Berlin. **1916-1918** Military service. **1926** First photographs. **1928** Worked as a freelance photojournalist for the *Berliner Tagblatt* and the *Weltspiegel*. **1929** First reportage of Thomas Mann receiving the Nobel prize in Stockholm. **1929-1935** Worked for the agency Pacific & Atlantic. **1933-1935** Portraits of leading Nazis. **1935** Emigration to the USA. **1935/36** Worked for *Vogue* and *Harper's Bazaar*. **1936** Chief photographer at *Life*. Over the following years he illustrated more than 90 front pages. **1966** Publication of first book *Witness to Our Time*. **1979** Returned to Germany and took numerous photographs which were published in the picture book *Eisenstaedt: Deutschland*. It is thanks to Eisenstaedt that photojournalism became an independent discipline. WRITINGS: Adam, P. (ed.): E. on E. A Self-portrait. New York 1985/E. über E. Munich 1985.– A. E.: E.'s Guide to photography. New York 1978

MONOGRAPHS, CATALOGUES: A. E. Deutschland. Rheinisches Landesmuseum. Bonn 1980 (cat.).– O'Neil, D. C. (ed.): E. Remembrances. Boston 1990

**EMSHWILLER Ed**
born **1925** Lansing (MI)
American video artist and film-maker. After finishing his degree in design at the University of Michigan, Ann Arbor he moved to Paris in **1949** to study graphic arts at the Ecole des Beaux-Arts. **1951** Continued his graphic studies in New York. Besides working as a science-fiction illustrator he started to work with film in **1956** and in **1971** with video. **1971** First solo-exhibition at the Whitney Museum of American Art, New York. **1973** Artist in residence at WNET-TV station in New York. **1977** and **1987** participation in documenta 6 and 8 in Kassel. Through his video tapes Emshwiller experiments with the possibilities of electronic image manipulation, for example the graphical breakdown of the image into outlines.

**ENSOR James**
**1860** Ostend – **1949** Ostend
Belgian painter and graphic artist. Ensor received his first drawing lessons as a child in Ostend. **1877-1880** Studied at the Academies of Ostend and Brussels. His darkly dramatic interiors, landscapes and portraits were a renunciation of traditional conventions of art as taught by the academies. **1883** Founder member of the group Les XX in Brussels where, from **1885**, he regularly exhibited works rejected by the Brussels Salon. **1886** Visited England and experienced the ephemeral, airy quality of Turner's paintings. Developed a more impressionist painting technique. **1888** Painted *Entry of Christ into Brussels*, later to become his most famous work. After **1900** his creativity waned. **1901** Co-founder of the Libre Académie de Belgique (Independent Academy of Belgium). **1926** Participation in the Venice Biennale. **1929** Raised to the peerage. **1929** Exhibition at the Palais des Beaux-Arts in Brussels. **1939** Important retrospective in Paris. Ensor's subject-matter tended towards the fantastic, macabre and other-wordly. In his carnavalesque, expressive and colourful paintings and grotesque, bizarre etchings he portrayed the world of human fears and nightmares in the form of frightening creatures and mask-like faces.
WRITINGS: Hellens, F. (ed.): J. E. Mes écrits. Liège 1974
CATALOGUES RAISONNES: Croquez, A. (ed.): L'œuvre gravé de J. E. Geneva 1947.– Elesh, J. N. (ed.): J. E. The Complete Graphic Work. 2 vols. New York 1982.– Geyer, M.-J. et al. (ed.): J. E. Das druckgraphische Werk. Strasbourg 1995 (cat.).– Taevernier, A. (ed.): J. E. Catalogue illustré de ses gravures. Ghent and Brussels 1973.– Tricot, X. (ed.): J. E. Catalogue raisonné des peintures. 2 vols. Antwerp 1992/J. E. Cata-

logue Raisonné of the Oil Paintings. 2 vols. London 1992, Cologne 1992, New York 1993 MONOGRAPHS, CATALOGUES: Avermaete, R.: J. E. Antwerp 1947.– Brown, C. (ed.): J. E. Theatre of Masks. London 1997 (cat.).– Croquez, A.: L'œuvre gravé de J. E. Geneva 1947.– Croquez, R.: E. en son temps. Oostende 1970.– Daguerre de Hureaux, A. and D. Morel (ed.): J. E. Musée du Petit Palais. Paris 1990 (cat.).– Damase, J.: L'œuvre gravé de J. E. Geneva 1967.– Delevoy, R. L.: E. Antwerp 1981.– Ik, J. E. Museum voor Schone Kunsten. Ghent 1987 (cat.).– Florizoone, P.: J. E. over dierenbescherming en vivisektie. Nieuwpoort 1994.– Florizoone, P.: J. E. Les Bains à Oostende. Antwerp 1996.– Gindertael, Roger van: E. Boston 1975.– Hassaerts, P.: J. E. Bruxelles 1957, Stuttgart 1959, New York 1959.– Heusinger v. Waldegg, J.: J. E. Legende vom Ich. Cologne 1991.– Hoozee, R. et al.: J. E. Dessins et estampes. Antwerp 1987.– Hostyn, N. and X. Tricot (ed.): E. in Oostendse verzamelingen. Museum voor Schone Kunsten. Oostende 1985 (cat.).– Hostyn, N.: J. E. Vie et œuvre. Bruges 1996.– Janssens, J.: E. Paris 1978, 1984.– Kiefer, T.: J. E. Recklinghausen 1976.– Lebeer, L.: J. E. aquafortiste. Antwerp 1952.– Legrand, F.-C.: E. cet inconnu. Brussels 1971.– Legrand, F.-C.: E., la mort et le charme. Un autre E. Antwerp 1993.– Lesko, D.: J. E. The Creative Years. Princeton (NJ) 1985.– McGough, S.: J. E.'s "The Entry of Christ into Brussels in 1889". New York 1985.– Magnaguagno, G. and M. Matta (ed.): J. E. Kunsthaus Zurich et al. Zurich 1983 (cat.).– Ollinger-Zinque, G.: E. par lui-même. Brussels 1976/E. by Himself. Brussels 1976.– Ridder, A. d.: J. E. Herdacht. Brussels 1950.– Szeemann, H. et al. (ed.): J. E. Kunsthaus Zurich et al. Zurich 1983 (cat.).– Tannenbaum, L. (ed.): J. E. The Museum of Modern Art. New York 1951 (cat.).– Tavernier, S. (ed.): J. E. Gallerie Civiche d'Arte Moderna, Ferrara. Roma 1986 (cat.).– Tricot, X.: Ensoriana. Oostende 1985.– Verhaeren, E.: J. E. Brussels 1980

**EPSTEIN Jacob**
**1880** New York – **1959** London
American-English sculptor of Russian descent. **1988-1900** Studied at the Art Students League and worked in a bronze foundry. **1902/03** Attended classes at the Ecole des Beaux-Arts and the Académie Julian in Paris. **1905** Moved to England. First commissions for portrait busts. **1907** First public commissions for building sculptures. **1911** Made a sculpture for the grave of Oscar Wilde. **1912/13** Contact with Picasso, Brancusi, and Modigliani in Paris. **1913** First solo-exhibition at Twenty One Gallery, Adelphi. Up to **1916** follower of Vorticism. Made numerous bronze busts of public figures and several sculptures on Christian themes.
WRITINGS: J. E.: Let There Be a Sculpture. An Autobiography. London 1940, 1963.– Haskell, A. L. (ed.): J. E. The Sculptor Speaks. London 1931

CATALOGUE RAISONNE: Silber, E. (ed.): The Sculpture of E. With a Complete Catalogue. Lewisburg 1987
MONOGRAPHS, CATALOGUES: Black, R.: The Art of J. E. Cleveland and New York 1942.– Buckle, R. u. k. Epstein (ed.): E. Drawings. London 1962.– Buckle, R.: E. Sculptor. London and New York 1963.– Cork, R. (ed.): J. E. The Rock Drill Period. Anthony d'Offay Gallery. London 1973.– J. E. Sculpture. Corcoran Gallery of Art. Washington 1973 (cat.).– J. E. Centenary. Tate Gallery. London 1980 (cat.).– Friedman, T.: "The Hydepark Atrocity". E.'s Rima. Creation and Controversy. Leeds 1988.– Gardiner, S.: E. Artist Against the Establishment. London 1992.– Silber, E.: The Sculpture of J. E. Oxford 1986.– Silber, E. et al. (ed.): J. E. Sculpture and Drawings. City Art Galleries, Leeds et al. Leeds 1987 (cat.)

**ERFURTH Hugo**
**1874** Halle – **1948** Gaienhofen (Lake Constance)
German photographer. **1892 – 1896** Apprenticed to the Dresden court photographer Höffert. Afterwards studied painting and photography at Dresden Art Academy. From **1896** on, set up his own studio in Dresden which became a meeting point for artists in **1906**. Co-founder of the Gesellschaft Deutscher Lichtbildner (Society of German Photographers). Moved to Cologne in **1933** and then to Lake Constance. Regarded as one of the most important portrait photographers of the 20s. His portrayals are remarkable for their psychological perception and avoidance of any characterization through choice of background or surroundings.
MONOGRAPHS, CATALOGUES: Dewitz, B. v.: H. E. Menschenbild und Prominentenporträt 1902-1936. Cologne 1989.– Dewitz, B. v. and K. Schuller-Procopovici (ed.): H. E. 1874-1948. Photograph zwischen Tradition und Moderne. Agfa Foto-Historama im Museum für angewandte Kunst, Cologne et al. Cologne 1992 (cat.).– H. E. Bildnisse. Museum Folkwang. Essen 1961 (cat.).– Grohmann, W. (ed.): H. E. Wesenberg Galerie. Constance 1947 (cat.).– Gruber, F. (ed.): Über H. E. Städtische Galerie Siegen. Siegen 1964 (cat.).– Lohse, B. (ed.): H. E. 1874-1948. Der Fotograf der Goldenen Zwanziger Jahre. Seebruck 1977.– Steinert, O. (ed.): Bildnisse H. E. Museum Folkwang. Essen 1961 (cat.)

**ERNST Max**
**1891** Brühl (near Cologne) – **1976** Paris
German painter, graphic artist and sculptor. Studied classical philology at Bonn University and painted on the side. After military service, returned to Cologne and founded a Dada group with Arp in **1918**. **1919** First overpaintings, cliché-prints and collages which were exhibited, at the invitation of Breton, in Paris in **1921**. **1922** Moved to Paris and was a co-founder of the Surrealist

group led by Breton. **1925** Introduced and developed several new art techniques, such as *frottage, grattage* and *décalcomanie*, which were to introduce the stimulus of the coincidental into the creative process. His works from the late 20s had poetic, surreal titles such as *Windsbraut, Vogelmonument, Muschelblumen* (Bride of the Winds, Bird Monument, Shell Flowers). **1929 – 1934** Made collage novels. **1930** Collaborated with Luis Buñuel and Dalí on the film *L'Age d'Or*. **1938** Broke away from the Surrealists. **1939** Was interned in France. **1941** Emigrated to the USA. **1946** Settled in Sedona, Arizona, where he concentrated mainly on sculptural works. Despite the widespread recognition he received in America, he returned to Paris in **1953** and, in **1963**, settled in the South of France. **1961** First important retrospective at the Museum of Modern Art, New York.
WRITINGS: Bertelé, R. (ed.): M. E. Ecritures. Paris 1970.– Gallissaires, P. (ed.): M. E. Schnabelmax und Nachtigall. Texte und Bilder. Hamburg 1994.– Motherwell, R. et al. (ed.): M. E. Beyond Painting and Other Writings by the Artist and His Friends. New York 1948
CATALOGUES RAISONNES: Spies W. et al. (ed.): M. E. Œuvrekatalog. 6 vols. Cologne and Houston 1975-1997.– Spies, W. (ed.): M. E. Das plastische Werk. Düsseldorf and Hanover 1998
MONOGRAPHS, CATALOGUES: Alexandrian: M. E. Paris 1986.– Bousquet, A.: M. E. Œuvre sculpté 1913-1961. Paris 1961.– Camfield, W. A. (ed.): M. E. Dada and the Dawn of Surrealism. The Museum of Modern Art, New York et al. Munich 1993 (cat.).– Derenthal, L. and J. Pech: M. E. Paris 1992.– Ernst, J.: A Not-So-Still Life. A Memoir. New York 1984 / Nicht gerade ein Stilleben. Erinnerungen an meinen Vater M. E. Cologne 1985.– Herzogenrath, W. (ed.): M. E. in Köln. Die rheinische Kunstszene bis 1922. Kölnischer Kunstverein. Cologne 1980 (cat.).– Hofmann, W. et al. (ed.): M. E. Inside the Sight. Rice University Institute of Arts. Houston 1973 (cat.).– Lake, J.: Skulpturen von M. E.: aesthetische Theorie und Praxis. Frankfurt-on-Main 1986.– Legge, E. M.: M. E. The Psychanalytic Sources. Ann Arbor (MI) 1989.– Leffin, G.: Bildtitel und Bildlegenden bei M. E. Frankfurt-on-Main 1988.– McLeod, F. and J. Findlasy (ed.): M. E. The Sculpture. Newport Harbor Art Museum. Newport Beach and Edinburgh 1992 (cat.).– Pech, J. (ed.): M. E. Fotografische Porträts und Dokumente. Max-Ernst-Kabinett, Brühl. Cologne 1991 (cat.).– Pech, J. (ed.): M. E. Skulpturer. Malmö Konsthall. Malmö 1995 (cat.).– Quinn, E. (ed.): M. E. Boston 1976, Zurich and Freiburg 1977.– Rainwater, R. (ed.): M. E. Beyond Surrealism. New York 1986.– Russell, J.: M. E. Leben und Werk. Cologne 1966 / M. E. His Life and Work. New York 1967.– Schneede, U. M.: M. E. Stuttgart 1972 / The Essential M. E. London 1972.– Spies, W. (ed.): M. E. Retrospektive 1979. Haus der Kunst, Munich et al. Munich 1979 (cat.).– Spies, W.: M. E.

Frottagen. Stuttgart 1986.– Spies, W.: M. E. Loplop. Die Selbstdarstellung des Künstlers. Munich 1986.– Spies, W.: M. E. 1950-1970. Die Rückkehr der schönen Gärtnerin Cologne 1971, 1988 / The Return of La Belle Jardinière. R. u. K. New York 1971.– Spies, W.: M. E. Collagen. Inventar und Widerspruch. Cologne 1974, 1988 / M. E. Les Collages. Inventaire et contradictions. Paris 1984 / M. E. Collages. The Invention of the Surrealist Universe. New York 1991.– Spies, W. et al. (ed.): M. E. A Retrospective. Tate Gallery, London et al. Munich 1991 (cat.) / M. E. Retrospektive. Staatsgalerie Stuttgart et al. Munich 1991 (cat.).– Spies, W. (ed.): M. E. Skulpturen. Centre Georges Pompidou, Paris et al. Paris 1998 / M. E. Skulpturen. Kunstsammlung Nordrhein-Westfalen, Düsseldorf et al. Cologne 1998 (cat.).– Trier, E.: Schriften zu M. E. Cologne 1993.– Waldberg, P.: M. E. Paris 1958.– Waldman, D. (ed.): M. E. A Retrospective. Solomon R. Guggenheim Museum. New York 1975 (cat.)

**ERRO**
(Gudmundur Gudmundsson)
born **1932** Olafsvik (Iceland)
Icelandic painter. **1949 – 1951** Studied at the Art Academy in Reykjavik. **1952 – 1954** Studied mural painting at Oslo Academy. **1953/54** Visited France, Italy, Spain and Germany. **1955 – 1958** Studied at the Art Academy in Florence. Apprenticeship in mosaic techniques in Ravenna. **1957** Visited Israel. **1958** Moved to Paris. **1962** Published the first *Mécanifeste* in Venice. **1963** Visited the United States where he directed happenings. **1971** For nine months he travelled round the world, stopping in Thailand among other places. Erro's paintings combine styles and quotes from various eras and genres into amusing satires on modern society.
WRITINGS: E.: Easy is interesting. Paris 1993
CATALOGUES RAISONNES: Lebel, J.-J. (ed.): E. 1937-1986. Catalogo generale. Bergamo 1986 / Catalogue raisonné. E. 1974-1986. Paris 1986
MONOGRAPHS, CATALOGUES: Ammann, J.-C. (ed.): E. Tableaux chinois. Kunstmuseum Luzern. Lucerne 1975 (cat.).– Ammann, J.-C. (ed.). E. Art History, Politics, Science Fiction. Copenhagen et al. Copenhagen 1993 (cat.).– Augé, M. (ed.): E. peintre mythique. Paris 1995.– Brownstone: E. Paris 1972.– E. Museum Moderner Kunst. Vienna 1996 (cat.).– Kvaran, G. and H. J. Neyer: E. Politische Bilder 1966-1996. Stuttgart 1996.– Moreau, X: E. New York 1983, Paris 1983.– Sergeant, J.: E. ou le langage infini. Paris 1979.– Tilman, P.: E. Paris 1976

**ESTES Richard**
born **1936** Kewanee (IL)
American painter. **1952 – 1956** Studied at the Art Institute of Chicago and moved to New York in **1959**. Originally earned his

living by doing illustrations and lay-outs. From **1966** devoted himself to painting. **1968** First solo-exhibition at Alan Stone Gallery in New York. **1972** Participation in documenta 5 in Kassel. **1979** Retrospective in Washington and in **1983** at the Museum of Fine Arts in Boston. He is one of the American Hyper- or Photorealists who represent real situations but exagerrate them through minute attention to detail. As in Pop Art, his subject-matter is taken from everyday life, but he uses photos and postcards as starting material. To intensify the brilliancy and glamour in his paintings, he occasionally uses fluorescent colours.
CATALOGUE RAISONNE: Meisel, L. K. (ed.): R. E. The Complete Paintings 1966-1985. New York 1986
MONOGRAPHS, CATALOGUES: Arthur, J.: R. E. Paintings and Prints. San Francisco 1993.– Canaday, J. and J. Arthur (ed.): R. E. The Urban Landscape. Museum of Fine Arts, Boston et al. Boston 1978 (cat.)

**ESTEVE Maurice**
**1904** Culan (Cher) – **2001** Culan (Cher)
French painter. Studied at various Parisian Art Schools, including the Académie Colarossi, but was mainly self-taught. **1923** Went to Spain. Managed the design department of a textile factory in Barcelona. From **1924** worked as a freelance artist. **1930** First solo-exhibition at Yvangot Gallery in Paris. From **1931** exhibition at the Salon des Surindépendants and from **1941** at the Salon d'Automne. Participated in the group exhibition "Jeunes peintres de la tradition française". **1937** Joint projects with Delaunay at the Paris World Fair. **1939/40** Military service. **1953** Participation in the São Paulo Biennale and in the **1954** Venice Biennale. **1959** Participation in documenta 2 in Kassel. Estève, who combines Cubist forms with Fauvist coloration, is regarded as one of the main representatives of Lyrical Abstraction in the Ecole de Paris.
CATALOGUE RAISONNE: Prudhomme-Estève, M. and H. Moestrup (ed.): M. E. L'œuvre gravé. Catalogue raisonné. Skorping 1989
MONOGRAPHS, CATALOGUES: Elgar, F.: E. Dessins. Paris 1960.– Ferrier, J. L. (ed.): M. E. Städtisches Kunstmuseum Düsseldorf. Düsseldorf 1961 (cat.).– Francastel, P.: E. Paris 1956.– Francastel, P. (ed.):

E. Collagen. Neue Galerie. Zurich 1969 (cat.).– LeBot, M. (ed.): E. Œuvres de 1950 à 1980. Musée Cantini, Marseille et al. Marseille 1981 (cat.).– Leymarie, J. (ed.): E. Oelbilder. Galerie Nathan. Zurich 1982 (cat.).– Leymarie, J. (ed.): E. Grand Palais, Paris et al. Paris 1986 (cat.).– Müller, J. E.: E. Paris 1974.– Prudhomme-Estève, M. (ed.): Collection du Musée de la Ville. Bourges 1990 (cat.).– Vallier, D. et al. (ed.): Hommage à M. E. Paris 1975

**ETIENNE-MARTIN Henri**
(Martin Etienne)
**1913** Loriol (Drôme) – **1995** Paris
French sculptor. **1929 – 1933** Studied sculpture at the École des Beaux-Arts in Lyon. **1933 – 1939** Studied at the Académie Ranson in Paris, attending classes given by Malfray. **1935** Acquaintance with Duchamp, later with Brancusi, Michaux and Dubuffet. **1939 – 1942** Military service and imprisonment. **1949** Prix de la Jeune Sculpture. Exhibited regularly at the Salon de Mai and at the Salon des Réalités Nouvelles. **1958 – 1960** Lectureship at the School for Applied Arts and from **1958** at the Art Academy in Paris. **1960** First solo-exhibition at the Breteau Gallery in Paris. **1964** and **1972** participation in documenta 3 and 5 in Kassel. **1966** Major Award at the Venice Biennale. **1972** Solo-exhibition at the Musée Rodin and at the Grand Palais in Paris. His enigmatic wood, wire and textile constructions have a symbolist quality and fascinate through their subtle expression of things hidden, unseen and untouchable.
CATALOGUE RAISONNE: Szeemann, H. et al. (ed.): E.-M. Paris 1991
MONOGRAPHS, CATALOGUES: Allemand, E.-D. (ed.): E.-M. Sculptures/passementeries. Musée des Beaux-Arts. Calais 1984 (cat.).– Ammann, J.-C. et al. (ed.): E. M. Paris 1991.– Bozo, D. et al. (ed.): E.-M. Les Demeures. Centre Georges Pompidou. Paris 1972 (cat.).– Dypréau, J. (ed.): E.-M. Musée d'Art et d'Industrie de Saint-Etienne. Saint Etienne 1966 (cat.).– Lassaigne, J. (ed.): E.-M. Musée Rodin. Paris 1971 (cat.).– E.-M. Les Demeures. Centre Georges Pompidou. Paris 1984 (cat.).– E.-M. 1913-1995. Fondation de Coubertin. Saint-Rémy-les-Chevreuse 1996 (cat.).– Le Buhan, D.: Les Demeures-mémoires d'E.-M. Paris 1982.– Ragon, M.: E.-M. Büssel 1970.– Szeemann, H. et al. (ed.): E.-M. Les Demeures. Centre Georges Pompidou. Paris 1984 (cat.)

**EVANS Walker**
**1903** St. Louis (MO) – **1975** New Haven (CT)
American photographer. Studied literature and languages in Andover, at Loomis and Williams. **1926 – 1927** Studied at the Sorbonne in Paris. Returned to New York and started his career as a photographer. Beside reportage, he treated various themes such as African art. **1933** First solo-exhibition with architectural photos at the Museum of

Modern Art, New York. **1935 – 1937** Photoreportage on rural poverty commissioned by the Resettlement Administration and the FSA. Further reportages on social topics. **1945–1965** Editor and photographer for the magazine *Fortune*. From **1965** professorship at Yale University, New Haven. **1997** Posthumous participation in documenta 10 in Kassel.
WRITINGS: W. E.: Let Us Now Praise Famous Men. New York 1966
MONOGRAPHS, CATALOGUES: Baier, L. K. (ed.): W. E. at Fortune 1945-1965. Wellesley College. Wellesley (MA) 1978 (cat.).– W. E. American Photographs. Modern Museum of Art. New York 1939, 1988.– Farmer, D. and W. Scott (ed.): W. E. Austin 1974.– Greenough, S. (ed.): W. E. Subways and Treets. National Gallery of Art. Washington 1991 (cat.).– Hill, J. T. and G. Mora (ed.): W. E. The Hungry Eye. The Museum of Modern Art. New York 1993, London 1994/ W. E. La Soif du regard. Paris 1993/ W. E. Der unstillbare Blick. Die endgültige Monographie. The Museum of Modern Art, New York. Munich 1993 (cat.).– Keller, J. (ed.): W. E. The Getty Museum Collection. Los Angeles 1995 (cat.).– Papageorge, T. (ed.): W. E. and Robert Frank. New Haven (CT) 1981 (cat.).– Rathbone, B.: W. E. A Biography. Boston and London 1995.– Szarkowski, J.: W. E. New York 1971, London 1972.– Thompson, Jerry L. (ed.): W. E. at Work. New York 1982.– Trachtenberg, A.: The Presence of W. E. Boston 1978

**EXPORT Valie**
(Waltraud Höllinger)
born **1940** Linz
Austrian multimedia artist. Studied design at the School for Applied Arts in Linz and at HTL in Vienna. **1955 – 1958** First self-portraits in the photo-series *Metamorphosen der Identität* (Metamorphoses of Identity). **1968** Cofounder of Austrian Filmmakers' Cooperative. **1975** Participation in the 9th Paris Biennale. **1978** Recorded the record *Wahre Freundschaft* (Real Friendship) with Monsti Wiener. **1980** Together with Maria Lassnig, represented Austria at the Venice Biennale. From **1985** foreign member of the American Cinematheque in Los Angeles. **1987** Retrospective of her features and experimental films at the National Film Theatre in London and at San Francisco

Cinematheque. **1990** Prize of the city of Vienna. **1991** Austrian cultural award for film. Export's extended cinema-events, designed to intensify sensual aspects of psychophysical experience, are related to Viennese Aktionism.
MONOGRAPHS, CATALOGUES: Braun, C. v. et al. (ed.): V. E. Oberösterreichische Landesgalerie. Linz 1992 (cat.).– Braun, C. (ed.): Split: Reality V. E. Vienna 1997 (cat.).– Breitwieser, S. (ed.): White Cube/ Black Box. Vienna 1996.– V. E. Projektstudie Alpha. Linz 1997.– V. E. Fragments of the Imagination. Bloomingtom (IN) 1994.– Prammer, A.: V. E. Eine multimediale Künstlerin. Vienna 1988

**EXTER Alexandra**
**1882** Belostok – **1949** Fontenay-aux-Roses
Russian painter and stage designer. **1901 – 1903** Studied at Kiev Art Academy. **1906 – 1908** Attended classes at the Academie Grande Chaumière in Paris. **1908** First works exhibited in public. Book designs and illustrations. **1909 – 1914** Lived in Paris, in close contact with the Cubists centred around Picasso and the Futurists led by Marinetti. **1912** Travelled to Italy. **1915** Returned to Russia. Influenced by Tatlin and Malevich, turned to non-objective painting. **1916** Designed a mural for a studio theatre in Moscow. Started to work intensively as a costume and stage set designer. **1919** Artistic advisor to the Ukraine ministry of information. **1920** Moved to Moscow. **1925** Joined the Constructivist group 5x5 = 25 led by Rodchenko. **1922/23** Designed uniforms for the army. **1924** Helped to organize the Russian pavilion at the Venice Biennale. Moved to Paris. **1925 – 1930** Taught at the private academy of Léger. **1927** First solo-exhibition at Der Sturm gallery in Berlin.
MONOGRAPHS, CATALOGUES: Ciofi degli Atti, F. (ed.): A. E. e il teatro da Camera. Archivio del' 900, Rovereto. Milan 1991 (cat.).– A. E. Artist of the Theatre. New York Public Library. New York 1974 (cat.).– Nakow, A. B.: A. E. Galerie Jean Chauvelin. Paris 1972 (cat.).– Thompson, J. L.: A. E. at Work. New York 1982.– Tugendkhold, J.: A. E. Berlin 1922

**FABRO Luciano**
born **1936** Turin
Italian painter and object artist. Self-taught. **1954–1958** Experiments with kinetic objects. **1965** First solo-exhibition in the Galleria Vismara in Milan. **1968–1975** Series of representations of Italy, using materials such as metals, glass and textiles in outline entitled *Itàlia*. **1972** Participated in documenta 5 in Kassel. From **1980** created installations with an enigmatic, poetic atmosphere. **1981** Major one-man exhibition in Essen and Rotterdam. **1982** and **1992** Participation in documenta 7 and 9 in Kassel. **1996** Retrospective at the Centre Georges Pompidou, Paris. With his minimal object arrangements, made with simple

materials, Fabro is one of the most important exponents of Italian Arte Povera.
WRITINGS: L. F.: Apologhi 1969-1978. Attaccapanni. Torino 1978.– L. F.: Lavori 1963-1986. Torino 1987/Travaux, Entretiens. Paris 1987.– L. F.: Regole d'arte. Milan 1980.– L. F.: Aufhänger. Cologne 1983.– L. F.: Arte torna arte. Milan 1987/Kunst wird wieder Kunst. Arte torna arte. Bern and Berlin 1990
MONOGRAPHS, CATALOGUES: Caldwell, J. (ed.): L. F. San Francisco Museum of Modern Art. San Francisco 1992 (cat.).– L. F. Lavori 1963-1986. Torino 1987.– Felix, Z. and W. A. L. Beeren (ed.): L. F. Sehnsucht. Museum Folkwang, Essen et al. Essen 1981 (cat.).– Francis, M. (ed.): L. F. Works 1963-1986. Fruitmarket Gallery, Edinburgh et al. Edinburgh 1986 (cat.).– Gachnang, J. et al. (ed.): L. F. Castello di Rivoli, Museo d'Arte Contemporanea. Torino 1989 (cat.).– L. F. (ed.): L. F. Centre Georges Pompidou. Paris 1996 (cat.).– Mauban, J. L. (ed.): L. F. Musée d'Art Moderne de la Ville de Paris et al. Paris 1987 (cat.).– Morris, F. (ed.): L. F. Tate Gallery. London 1997 (cat.).– Mundici, C. (ed.): L. F. Castello di Rivoli, Museo d'Arte Contemporanea. Milan 1989 (cat.).– Risso, B. L. F. Torino 1980.– Rowell, M. (ed.): L. F. Fundació Joan Miró. Barcelona 1990 (cat.).– Sanna, J. d. (ed.): F. Logetta Lombardesca. Ravenna 1983 (cat.).– Schwander, M. (ed.): L. F. Die Zeit. Werke 1963-1991. Kunstmuseum Luzern. Basel 1991

**FAHLSTRÖM Öyvind**
**1928** São Paulo – **1976** Stockholm
Swedish painter, collage and object artist. **1949–1952** Studied history of art and archaeology at Stockholm University. **1950–1955** Began to draw and paint while working as a journalist, dramatist and lyricist. **1953** Influenced by Bill's Concrete Art, he brought out the *Manifesto of Concrete Poetry*. **1955** Exhibition with the artists' group Phase. From **1961** lived alternately in New York and Stockholm, and worked on *Variable Paintings*, pictures with component parts that can be rearranged by means of magnetic attachments. **1967** Designed the Swedish pavilion at the Venice Biennale.
MONOGRAPHS, CATALOGUES: Avery-Fahlström, S. et al. (ed.): Ö. F. Die Installationen, the Installations. Gesellschaft für

Aktuelle Kunst, Bremen et al. Stuttgart 1995 (cat.).– Ö. F. IVAM Centro Julio González. Valencia 1992 (cat.).– Hulten, P. (ed.): Ö. F. La Biennale di Venezia. Venice 1966 (cat.).– Hulten, P.: Ö. F. Milan 1976.– Hulten, P. and B. Springfeldt (ed.): Ö. F. Centre Georges Pompidou. Paris 1980 (cat.).– Springfeldt, B. et al. (ed.): Ö. F. Moderna Museet. Stockholm 1979 (cat.).– Springfeldt, B.: Ö. F. Solomon R. Guggenheim Museum. New York 1982 (cat.).– Springfeldt, D. and F. Feuk (ed.): Ö. F. IVAM Centro Julio González, Valencia 1992 (cat.)

**FAUTRIER Jean**
1898 Paris – 1964 Châtenay-Malabry
French painter. Lived from 1908 in London, where he studied at the Royal Academy and the Slade School of Art. 1917 Returned to France. At first enjoyed little success as a painter, but received important backing from André Malraux and Jean Paulhan. From 1934–1939 worked in the French Alps as an hotelier and ski instructor, neglecting his painting to a certain extent. 1945 First major artistic success with the series *Hostages*. 1950 Invented a process for printing reproductions, the *Originaux multiples*, with the aim of rendering the one-off original obsolete. 1955/56 Turned away from L'art informel, portraying *Objects* and *Nudes* in his former naturalistic style. Further development of *Multiples* for a wider distribution of works of art. 1959 Participated in documenta 2 in Kassel. 1960 Grand Prix at the Venice Biennale. 1963 Retrospectives in Scandinavia. 1976 Solo-exhibitions in the Stedelijk Museum, Amsterdam, and the Kunsthaus Zurich. 1979 Major retrospective in the Musée d'Art Moderne de la Ville de Paris. Fautrier is considered one of the main exponents of L'art informel, although he himself objected to this label.
WRITINGS: J. F.: Sur la virtuosité. Lettre à Jean Paulhan. Caen 1987
CATALOGUES RAISONNES: Bucarelli, P. (ed.): J. F pittura e materia. Milan 1960.– Engelberts, E. (ed.): J. F. Œuvre gravé. Œuvre sculpté. Essai d'un catalogue raisonné. Geneva 1969.– Galansino, G. (ed.): J. F. A Chronology of His Early Paintings (1921-1942). Chicago 1973.– Lefort, M.-J. (ed.): J. F. Catalogue raisonné (in preparation).– Mason, R. M. (ed.): J. F. Les Estampes. Geneva 1986/ J. F.'s Prints. San Francisco 1986/ J. F. Die Druckgraphik: neuer Versuch eines Werkverzeichnisses. Stuttgart 1987
MONOGRAPHS, CATALOGUES: Argan, G. C.: F. Matière et mémoire. Milan 1960.– Bucarelli, P.: F. Pittura e materia. Milan 1960.– Cabanne, P.: J. F. Paris 1988.– Dickhoff, W. (ed.): J. F. Bilder 1926-1956. Galerie Sprüth, Cologne. Düsseldorf 1989 (cat.).– J. F. Gemälde, Skulpturen, Radierungen. Insel Hombroich. Neuss 1987 (cat.).– J. F. Musée National Fernand Léger, Biot et al. Paris 1996 (cat.).– Gohr, S. et al. (ed.): J. F. Gemälde, Skulpturen und Handzeichnun-

gen. Josef-Haubrich-Kunsthalle. Cologne 1980 (cat.).– Lafargue, J. and R. M. Mason (ed.): F. 1898-1964. Musée d'Art Moderne de la Ville de Paris. Paris 1989 (cat.).– Paulhan, J. and A. Berne Joffroy (ed.): J. F. Rétrospective. Musée d'Art Moderne de la Ville de Paris. Paris 1964 (cat.).– Paulhan, J.: F. l'enragé. Paris 1989.– Peyré, Y.: F. ou les outrages de l'impossible. Paris 1990.– Ragon, M.: F. Paris 1957, New York 1958.– Stalter, M.-A.: Recherches sur la vie et l'œuvre de J. F. de leurs commencements a 1940. Diss. Paris 1982.– Tuchel, H. G. (ed.): J. F. Kunstverein in Hamburg. Hamburg 1973 (cat.)

**FEININGER Andreas**
born 1906 Paris
American photographer and photojournalist. Studied 1925–1927 at the Weimar Bauhaus where his father Lyonel, was teaching. 1929–1931 worked as an architect in Dessau and Hamburg and 1932–1933 with Le Corbusier in France. From 1939 lived in Sweden, working as an architectural photographer. 1939–1962 Photojournalist for *Life* magazine in New York, and thereafter freelance photographer. 1997/98 Several large retrospectives. 1998 Cultural Prize of the German Photographic Society. Feininger wrote many books on photography.
WRITINGS: A. F.: F. on Photography. Chicago and New York 1949.– A. F.: Advanced Photography. New York 1952.– A. F.: Successful Color Photography. Englewood Cliffs (NJ) 1957.– A. F.: Das Buch der Farbfotografie. Düsseldorf 1959.– A. F.: Der Schlüssel zur Fotografie von heute. Düsseldorf 1960.– A. F.: Die Hohe Schule der Fotografie. Düsseldorf 1961, Munich 1977/A Manuel of Advanced Photography. London 1962.– A. F.: The Complete Photographer. London 1966.– A. F.: Quellen der Kunst. Düsseldorf 1975/Roots of Art. New York and London 1975
MONOGRAPHS, CATALOGUES: Hattersley, R.: A. F. New York 1973

**FEININGER Lyonel**
1871 New York – 1956 New York
American painter and graphic artist. 1887 Moved with his family to Germany. 1887–1891 Attended the Hamburg School of Arts and Crafts and the Berlin Academy of Arts.

1890 First caricatures. 1892/93 Studied at the Académie Cola Rossi in Paris. 1893 Returned to Berlin where he worked as a caricaturist for German and American magazines until 1906. 1906/07 Went to Paris and met the German artists gathered around Matisse, and also made contact with the Cubists and Delaunay, leading to a prismatic structuring of his paintings. 1909 Joined the Berlin Secession. 1913 Invited by members of the Blauer Reiter to take part in the First German Autumn Salon. 1918 Member of the Novembergruppe. 1919–1933 Taught graphic art and painting at the Bauhaus in Weimar and Dessau. 1924 Together with Jawlensky, Kandinsky and Klee, founded the group Die Blauen Vier. 1933 Moved to Berlin. 1936 Emigrated to the United States and taught at Mills College in Oakland, California. 1937 Moved to New York. 1945 Taught at Black Mountain College, North Carolina.
WRITINGS: Schreyer, L. (ed.): L. F. Dokumente und Visionen. Munich 1957
CATALOGUES RAISONNES: Hess, H. and J. Feininger (ed.): L. F. Mit Werkverzeichnis der Gemälde. Stuttgart 1959, 1989/ L. F. New York 1961.– Prasse, L. E. (ed.): L. F. Das graphische Werk. Radierungen, Lithographien, Holzschnitte. Berlin 1972/ L. F. A Definite Catalogue of His Graphic Work. Etchings, Lithographs, Woodcuts. Cleveland Museum of Art. Cleveland 1972 (cat.)
MONOGRAPHS, CATALOGUES: Büche, W. et al. (ed.): L. F. Die Halle-Bilder. Staatliche Galerie Moritzburg, Halle. Munich 1991 (cat.).– Deuchler, F.: F. in Paris. L. F.: Die Pariser Zeichnungen von 1892-1911. Germanisches Nationalmuseum. Nuremberg 1992 (cat.).– Deuchler, F.: L. F. Sein Weg zum Bauhaus-Meister. Leipzig 1996.– Dorfles, G.: L. F. Milan 1958.– L. F. Kunsthaus Zürich/Haus der Kunst, Munich. Munich and Zurich 1973 (cat.).– L. F. Zeichnungen und Aquarelle. Hamburger Kunsthalle et al. Hamburg 1998 (cat.).– Feininger, T. L.: Die Stadt am Ende der Welt. L. F. Munich 1965/ L. F. City at the Edge of the World. New York 1965.– Firmenich, A. and U. Luckhardt (ed.): L. F. Natur-Notizen. Skizzen und Zeichnungen aus dem Busch-Reisinger-Museum, Harvard University. Kunsthalle Emden et al. Cologne 1993 (cat.).– Hentzen, A.: L. F. Aquarelle. Munich 1958.– Hess, H. (ed.): L. F. Haus der Kunst. Munich 1973 (cat.).– Jensen, J. C. (ed.): L. F. Gemälde, Aquarelle und Zeichnungen, Druckgraphik. Kunsthalle zu Kiel. Kiel 1982 (cat.).– Kahn-Rossi, M. and M. Franciolli (ed.): L. F. Museo Cantonale d'Arte, Lugano 1991 (cat.).– Luckhardt, U.: L. F. Die Karikaturen und das zeichnerische Frühwerk. Munich 1987.– Luckhardt, U.: L. F. Munich 1989, New York 1995.– Luckhardt, U. (ed.): L. F. Karikaturen. Hamburg 1998 (cat.).– Luckhardt, U. (ed.): L. F. Die Zeichnungen und Aquarelle. Hamburger Kunsthalle et al. Hamburg 1998 (cat.).– März, R.: L. F. Berlin 1981.– Ness, J. L. (ed.): L. F. London and New York 1975.– Romanus, P. (ed.): L. F. Die Halle-Bilder. Munich 1991.– Sabarsky, S.: L. F. Zeichnungen und Aquarelle. (n. p.) 1991.– Schmied, W.: L. F. Frankfurt-on-Main 1961.– Schreyer, E.: L. F. Caricature and Fantasy. Detroit 1964.– Timm, W. (ed.): L. F. Erlebnis und Vision. Die Reisen an die Ostsee 1892-1935. Museum Ostdeutsche Galerie. Regensburg 1992 (cat.)

**FELIXMÜLLER Conrad**
1897 Dresden – 1977 Berlin
German painter and graphic artist. 1911 School of Arts and Crafts in Dresden. 1912–1915 Attended the Art Academy in Dresden.

1915 Contributed to the journals *Der Sturm* and *Aktion*. Contact with the Berlin avant-garde. 1918 Joined the German Communist Party. 1919 Founded the New Secession in Dresden and Gruppe 1911 and joined the Novembergruppe. 1920 Major national painting award. 1934 Moved to Berlin. 1937/38 Confiscation and destruction of 151 works by the Nazis. Forty works hung in the exhibition of "degenerate art" in Munich. 1944–1964 Lived in Tautenhain near Leipzig. 1945 Prisoner of war in Russia. 1949–1962 Professorship at the University of Halle. 1964–1977 Lived in East Berlin, then moved to West Berlin. 1973 First retrospective in the *Verein Bildender Künstler* in Berlin. 1974 Received special honours at the IV International Biennale for Graphic Art in Florence.
WRITINGS: Söhn, G. (ed.): C. F. Von ihm, über ihn. Texte von und über C. F. Düsseldorf 1977.– Herzog, G. H. (ed.): C. F. Legenden 1912-1976. Tübingen 1977
CATALOGUES RAISONNES: Heckmanns, F. W. (ed.): Das druckgraphische Werk von C. F. Düsseldorf 1986.– Söhn, G.: C. F. Das graphische Werk 1912-1977. 2 vols. Düsseldorf 1975-1980, 1987.– Spielmann, H. (ed.): C. F. Monographie und Werkverzeichnis der Gemälde. Cologne 1996
MONOGRAPHS, CATALOGUES: C. F. 1897-1977. Museum am Ostwall. Dortmund 1978 (cat.).– C. F. Retrospektive. Städtisches Kunstmuseum Düsseldorf. Düsseldorf 1977 (cat.).– Gleisberg, D. et al. (ed.): C. F. Gemäldegalerie Neue Meister, Dresden. Berlin 1975 (cat.).– Gleisberg, D.: C. F. Leben und Werk. Dresden 1982.– Heckmanns, F. W.: F. Buch der Holzschnitte. Düsseldorf 1985.– Heckmanns, F. W. (ed.): C. F. Das druckgraphische Werk 1912-1916 im Kunstmuseum Düsseldorf. Düsseldorf 1986.– Herzog, G. H.: C. F. Legenden 1912-1976. Tübingen 1977.– Krempel, U. (Hg.): C. F. Die Dresdner Jahre 1914-1934. Gemäldegalerie Neue Meister, Dresden et al. Köln 1997 (cat.).– Pese, C. (ed.): C. F. Werke und Dokumente. Germanisches Nationalmuseum. Nuremberg 1981 (cat.).– Rathke, C. (ed.): C. F. Gemälde, Aquarelle, Zeichnungen, Druckgraphik, Skulpturen. Schleswig-Holsteinisches Landesmuseum, Schloß Gottorf. Schleswig 1990 (cat.).– Söhn, G.: C. F. Von ihm – über ihn. Düsseldorf 1977

**FETTING Rainer**
born 1949 Wilhelmshaven
German painter. 1972–1978 Studied painting at the Berlin School of Arts. 1975–1981 Made various films including *Birthday* and *Brooklyn 11238*. 1977 Together with Helmut Middendorf, Salomé and Bernd Zimmer, founded Galerie am Moritzplatz. 1977/78 DAAD overseas grant for New York. 1980 First group exhibition entitled "Vehement Painting" with members of the Galerie am Moritzplatz at Haus am Waldensee, Berlin. 1980–1983 Serial repetitions of specific themes in series of works. 1984 Worked with found materials, attached to the canvas

and then painted over. Fetting is one of the main representatives of the Junge Wilde.
MONOGRAPHS, CATALOGUES: Felix, Z. (ed.): R. F. Folkwang Museum, Essen et al. Essen 1986 (cat.).– R. F. Studio d'Arte Cannaviello, Milan et al. Berlin 1983 (cat.).– R. F. Berlin, New York. Gemälde und Skulpturen. Staatliche Museen, Nationalgalerie, Berlin et al. Berlin 1990 (cat.).– Georg, B. and U. E. Huse (ed.): R. F. Gemälde und Zeichnungen. Harenberg City-Center. Dortmund 1994 (cat.)

**FILATOV Nikolai**
born **1952** Lemberg
Russian painter. **1969**–**1971** Studied architecture at Lemberg Polytechnic. **1971**–**1977** Continued architectural studies at the Institute of Applied and Decorative Arts in Lemberg where from **1978**–**1982** he taught composition, colour theory and painting. **1982** Moved to Moscow. **1984** Joined the Youth Section of the Moscow Department of the Soviet Artists' Association. Since **1983** has taken part in exhibitions in the USSR and abroad.

**FILLIOU Robert**
**1926** Sauve – **1987** Les Eyzies (Dordogne)
French action and object artist. **1943** Fought with the Communist partisans. **1948**–**1951** Studied economics in Los Angeles. **1951**–**1954** Extensive travels in the Far East. Greatly interested in Zen-Buddhism. **1960** Returned to France where from **1961** he produced neo-dadaist action poetry and plays. From **1962** took part in numerous Fluxus events. **1965**–**1968** Together with

George Brecht, managed the business enterprise "La Cédille qui Sourit", marketing jewellery, games and Fluxus items, and **1966** founded the Non-Ecole de Villefranche, also with Brecht. From **1968** lived alternately in France and Germany. **1972** Participated in documenta 5 in Kassel. **1980** Guest-Professor at the Academy of Arts in Hamburg. **1982** Kurt Schwitters Award from the City of Hanover. **1984**–**1987** Retired to a monastery in the Dordogne. Filliou's performances and happenings revolve around the theme *Permanent Creation*, defining *Work as Play* or *Work as Thought*.
WRITINGS: R. F.: Ample Food for Stupid Thought. New York 1965.– R. F. and G. Brecht: Games at the Cedilla, or the Cedilla Takes Off. New York 1967.– R. F. et al.: Lehren und Lernen als Aufführungskünste. Cologne 1970
MONOGRAPHS, CATALOGUES: Erlhoff, M. et al. (ed.): R. F. Das immerwährende Ereignis zeigt. Sprengel Museum Hanover et al. Hanover 1984 (cat.)/La Fête permanente présente: R. F. Musée d'Art Moderne de la Ville de Paris, Paris et al. Paris 1984 (cat.).– Kellein, T. et al. (ed.): R. F. Kunsthalle Basel et al. Basel et al. 1990 (cat.).– Mirotchnikoff, F. (ed.): R. F. Centre Georges Pompidou. Paris 1991 (cat.).– Parsy, P.-H. et al. (ed.): R. F. Paris 1991 (cat.).– Schmidt, H.-W. (ed.): R. F. zum Gedächtnis. 1926-1987. Städtische Kunsthalle Düsseldorf. Düsseldorf 1988 (cat.)

**FISCHER Arno**
born **1927** Berlin
German photographer. **1947**–**1953** Studied sculpture at the Käthe Kollwitz School of Art in East Berlin and at the School of Art in Weissensee, near Berlin, where he worked as an assistant and teacher from **1956**–**1971**. Thereafter worked as a freelance photographer and journalist. **1985**–**1992** Guest-professorship at the Leipzig School of Graphic Art and Book Design, and full professorship from **1985**–**1993**. From **1990** taught at the Technical College in Dortmund. **1997** Nominated "Fotopersönlichkeit des Jahres" (Photo-personality of the Year). Fischer specializes in fashion photography, portraits and live photography. One of his photoseries documents life in Berlin when still divided into East and West.
MONOGRAPHS, CATALOGUES: Immisch, T. O. and K. E. Göltz (ed.): A. F. Photographien. Staatliche Galerie Moritzburg. Halle 1997 (cat.)

**FISCHL Eric**
born **1948** New York
American painter. **1968/69** Studied at Arizona State University in Phoenix and **1970**–**1973** at California Institute of the Arts in Valencia. Became acquainted with Salle and Bleckner. **1974** Continued studies at Nova Scotia College of Art and Design in Halifax, Canada. **1975** First solo-exhibition

at the Dalhousie Gallery, Halifax. **1976/77** After an early abstract phase, turned to figurative painting. Created the Fisher Family, whose members became principal figures in many of his paintings. **1978** Sojourn in New York. **1979/80** *Sleepwalker*, his painting of a boy masturbating in a swimming pool, made him famous throughout America and Europe. **1987** Took part in documenta 8 in Kassel. **1991** Exhibition at the Louisiana Museum for Modern Art, Humblebæk. Fischl's portrayals of everyday life and leisure activities highlight the ambiguity underlying American politics and society and the American way of life
WRITINGS: Kuspit, D.: An Interview with E. F. New York 1987
MONOGRAPHS, CATALOGUES: Billeter, E. (ed.): E. F. Bilder und Zeichnungen. Akademie der Bildenden Künste, Vienna et al. Bern 1990 (cat.).– E. F.: E. F. Aarhus Kunstmuseum et al. Aarhus 1991 (cat.).– Doctorow, E. L. et al. (ed.): E. F. Scenes and Sequences. Hood Museum of Art, Dartmouth College. Dartmouth 1990 (cat.).– E. F. Kunsthalle Basel et al. Basel 1985 (cat.).– Glenn, C. W. and L. Barbnes (ed.): E. F. Scenes before the Eye. Long Beach Museum of Art et al. Long Beach 1986 (cat.).– Schjeldahl, P.: E. F. New York 1988.– Whitney, D. (ed.): E. F. New York 1988

**FLANAGAN Barry**
born **1941** Prestatyn (Wales)
English sculptor. **1964**–**1966** Studied sculpture under Phillip King at St. Martin's School of Art in London. **1966** First solo-exhibition, at the Rowan Gallery London, of small sculptures, purposefully contrasted with the monumental works of Moore and Caro. Experiments with new materials such as textiles, brushwood, rope and sand. **1969** Lived in New York. **1972** Grant from the Gulbenkian Foundation. Collaborated with Carolyn Carlson on a ballet. In **1973** worked mainly in stone. **1979** In creating the sculpture *Leaping Hare*, he found an attractive motif that he developed in further variations and other materials such as bronze and plaster. **1982** Represented Great Britain at the Venice Biennale and participated in documenta 7 in Kassel. **1983** Retrospective at the Centre Georges Pompidou, Paris.

MONOGRAPHS, CATALOGUES: Compton, M. et al. (ed.): B. F. Sculpture. British Pavillion, Biennale Venice et al. London 1982 (cat.).– B. F. Sculptures. Centre Georges Pompidou. Paris 1983 (cat.).– B. F. Prints 1970-1983. Tate Gallery. London 1986 (cat.).– B. F. Musée de Nantes. Nantes 1993 (cat.).– Fuchs, R. and C. Lampert (ed.): B. F. Stedelijk Van Abbe Museum, Eindhoven 1977 (cat.).– Joubert, C. and E. Pernoud (ed.): B. F. Estampes. Paris 1996 (cat.).– Juncosa, E. (ed.): B. F. Fundación La Caixa, Madrid et al. Madrid 1993 (cat.)

**FLAVIN Dan**
**1933** New York – **1996** Riverhead (NY)
American object artist. Self-taught. **1953** Trained as a meteorologist with the US Air Force. Served as a weather monitor during the Korean war. **1956**–**1959** Studied at the New School of Social Research and at Columbia University in New York. **1961** Exhibited watercolours and abstract constructions at the Judson Gallery in New York, and used light as an artistic medium. **1963** First light installations, incorporating standard, commercial fluorescent strip lighting. **1966** Took part in the exhibition of Minimal Art, entitled "Primary Structures" at the Jewish Museum, New York. **1967** Taught at the University of North Carolina. **1968** and **1977** Participation in documenta 4 and 6 in Kassel. **1973** Guest-professorship at the University of Bridgeport, Connecticut. **1992** Neon installations at the Guggenheim Museum, New York. **1996** Decorated the front of the Berlin Museum of Modern Art with green and blue fluorescent tubes. Flavin dedicated many of his light objects to well-known art historians, gallery-owners and artists such as Robert Rosenblum, Heiner Friedrich, Tatlin, Barnett Newman and Roy Lichtenstein.
MONOGRAPHS, CATALOGUES: Belloli, J. and E. S. Rauh (ed.): D. F. Drawings, Diagramms and Prints 1972-1975. The Fort Worth Art Museum et al. Fort Worth 1977 (cat.).– D. F. Fluorescent Light. National Gallery of Canada. Ottawa 1969 (cat.).– D. F. Fünf Installationen in fluoreszierendem Licht. Kunsthalle Basel. Basel 1975 (cat.).– D. F. Solomon R. Guggenheim Museum. New York 1982 (cat.).– Koshalek, R. and K. Brougher (ed.): D. F. Monuments for Tatlin 1964-1982. Museum of Contemporary Art. Los Angeles 1989 (cat.).– D. F. Städtisches Museum Abteiberg. Mönchengladbach 1990 (cat.).– Friedel, H. (ed.): D. F. Kunstbau Lenbachhaus München. Munich 1994 (cat.).– Gallwitz, K. et al. (ed.): D. F. Installationen in fluoreszierendem Licht 1989-1993. Städtische Galerie im Städel, Frankfurt-on-Main. Stuttgart 1993 (cat.).– Meyer, F. et al. (ed.): D. F. Drawings, Diagrams and Prints 1972-1975. The Fort Worth Art Museum et al. Fort Worth 1976 (cat.).– Poetter, J. and M. Deschamps (ed.): Neue Anwendungen fluoreszierenden Lichts mit Diagrammen, Zeichnungen und Drucken von D. F. Staatliche Kunsthalle Baden-

Baden. Stuttgart 1989 (cat.).– Schneckenburger, M. et al. (ed.): D. F. Drei Installationen in fluoreszierendem Licht. Kunsthalle Köln. Cologne 1973 (cat.)

**FLEISCHMANN Adolf Richard**
**1892** Esslingen – **1968** Stuttgart
German painter. **1908–1913** Studied at the Royal School of Arts and Crafts and at the Stuttgart Academy. **1922** Exhibited in the New Secession in Munich. **1925** First abstract works in cubist style. **1930–1938** Long visits to Spain, Italy and Switzerland. **1938** Moved to Paris, and was active in the underground movement during the war. **1946** Member of the group Réalités Nouvelles. **1950** Began the series *equérres*, taking up and developing Mondrian's theories of Neo-plasticism. **1952** Moved to the USA. **1962** Taught at Columbia University, New York. Member of the group American Abstract Artists. **1965** Returned to Germany. With his geometrically structured, rhythmically vibrating colour compositions, Fleischmann anticipated Op Art.
CATALOGUE RAISONNE: Fischer, A. M. (ed.): A. F. Tübingen 1976
MONOGRAPHS, CATALOGUES: Damsch-Wiehager, R. (ed.): A. F. Retrospektive zum 100. Geburtstag. Galerie der Stadt Esslingen, Villa Merkel. Esslingen 1992 (cat.).– Fischer, A. M.: A. Fleischmann 1892-1968. Tübingen 1976.– Gomringer, E. (ed.): A. F. Bilder, Relief, Collagen, Goauches. Moderne Galerie. Bottrop 1979 (cat.).– Költzsch, G.-W. et al. (ed.): A. F. Retrospektive. Moderne Galerie des Saarland Museums. Saarbrücken 1987 (cat.).– Schneckenburger, M. et al. (ed.): A. F. Villa Merkel. Esslingen 1975 (cat.).– Schulze-Vellinghausen, A.: A. F. Stuttgart 1966.– Wedewer, R.: A. F. Stuttgart 1977

**FONTANA Lucio**
**1899** Rosario (Argentina) – **1968** Comabbio (Varese)
Italian painter and sculptor. **1914/15** Studied at the Istituto Tecnico Carlo Cattaneo and **1920–1922** at the Accademia di Brera in Milan. **1922** Returned to Buenos Aires, working as an assistant sculptor for four years in his father's studio. **1926–1930** Continued his training as a sculptor at the Brera in Milan. **1934** Founded an association of

Italian abstract artists and in **1935** joined the Parisian group Abstraction-Création. Despite his leanings to abstract art, he continued to produce some figurative works up to **1947**. **1936** Manifesto on Italian abstract art. **1940–1947** Settled in Buenos Aires again where, in **1946**, he helped to issue the *White Manifesto*, followed by four *Spatialist Manifestos* and *The Technical Manifesto of Spatialism*. **1949** Slit and perforated monochrome canvases, creating his first *Ambienti Spaziali* and *Buchi*, entitled *Concetti Spaziali*. **1951** Light installations with neon tubes in the main entrance hall of the Palazzo dell'Arte at the Milan Triennale. **1952–1957** Experiments with stone (*Pietri*), pastels (*Barocchi*), gypsum (*Gessi*) and ink (*Inchiostri*). **1958** First *Concetti Spaziali*, with slit canvases creating special effect. **1959** and **1968** participation in documenta 2 and 4 in Kassel. **1966** Major retrospective at the Walker Art Center in Minneapolis.
WRITINGS: L. F.: Primo manifesto dello spazialismo. Milan 1947.– L. F.: Secondo manifesto dello spazialismo. Milan 1948.– L. F.: Manifesto tecnico dello spazialismo. Milan 1951
CATALOGUES RAISONNES: Crispolti, E. and J. v. d. Marck (ed.): L. F. 2 vols. Brussels 1974, Milan 1976.– Crispolti, E. (ed.): F. Catalogo generale. 2 vols. Milan 1986, 1996
MONOGRAPHS, CATALOGUES: Ballo, G.: F. Idea per un ritrastto. Torino 1970/B. Cologne 1971/B. New York 1971.– Ballo, G. (ed.): L. F. Mostra antologica. Sala Comunale d'Arte Contemporanea. Rimini 1982 (cat.).– Bartolomeis, F. de: Segno Antidisegno di L. F. Torino 1967.– Billeter, E. et al. (ed.): L. F. 1899-1968. A Retrospective. Solomon R. Guggenheim Museum. New York 1977 (cat.).– Blistène, B. (ed.): L. F. Centre Georges Pompidou, Paris et al. Paris 1987 (cat.).– Cirlot, J. E.: F. Barcelona 1966.– Cispolito, E.: Ommaggio a F. Roma 1971.– Crispolti, E. et al. (ed.): F. e lo Spazialismo. Villa Malpensata. Lugano 1987 (cat.).– L. F. 1899-1968. Fundació Caixa de Pensiones. Barcelona 1988 (cat.).– Fuchs, R. (ed.): L. F. La cultura dell'occhio. Castello di Rivoli, Museo d'Arte Contemporanea. Milan 1986.– Giani, G. P.: L. F. Venice 1958.– Gualdoni, F. (ed.): L. F. Il disegno. Galleria Civica, Modena. Bologna 1990 (cat.).– Joppolo, G.: Une Vie d'artiste: L. F. Marseille 1992.– Loers, V. (ed.): L. F. Il disegno – Zeichnungen und Skulpturen. Mönchengladbach 1997 (cat.).– Manganelli, G.: L'ironia teologica di F. Milan 1978.– Messer, T. M. (ed.): L. F. Retrospektive. Schirn Kunsthalle, Frankfurt-on-Main. Stuttgart 1996 (cat.).– Pica, A.: F. e lo spazialismo. Venice 1953.– Sanesi, R.: L. F. Milan 1980.– Sanna, J. d.: L. F. Materia, spazio, concetto. Milan 1993/L. F. Materie, Raum, Konzept. Klagenfurt 1995.– Schulz-Hoffmann, C. and C. Syre (ed.): L. F. Staatsgalerie moderner Kunst, Munich et al. Munich 1983 (cat.).– Tapié, M.: Devenir de F. Torino 1961

**FÖRG Günther**
born **1952** Füssen
German painter, sculptor and photographer. **1973–1979** Studied painting under K. F. Dahmen at the Munich Academy. **1980** Solo-exhibition at the Rüdiger Schöttle gallery in Munich. **1984** Participation in the exhibition "von hier aus" in Düsseldorf. **1992** Took part in documenta 9 in Kassel. **1993** Professorship at the ZKM in Karlsruhe. **1995** Solo-exhibition at the Stedelijk Museum, Amsterdam. Förg combines materials and media in painting, sculpture and photography. The themes of his large-scale architectural photographs are Bauhaus aesthetic and Fascism, while his mono-

chrome wall paintings and lead paintings and sculptures are reflexions on art.
WRITINGS: G. F. im Gespräch mit S. Gohr. Cologne 1997
CATALOGUES RAISONNES: Buck, M. and C. Nagel (ed.): G. F. Verzeichnis der Arbeiten seit 1973. Munich 1987.– Capitain, G. and J. Hofmaier (ed.): G. F. Gesamte Editionen 1988-1991. Stuttgart 1991.– G. F. Gesammelte Editionen 1974-1988. Museum Boymans-van Beuningen, Rotterdam. Stuttgart 1989 (cat.)
MONOGRAPHS, CATALOGUES: Aupetitallot, Y. and F. Migayrou (ed.): G. F. Maison de la Culture et de la Communauté de Saint-Etienne. Saint-Etienne 1987 (cat.).– Boerma, S. and K. Heymer (ed.): G. F. Kunstverein Hannover. Düsseldorf 1996 (cat.).– Bool, F. and R. Fuchs (ed.): G. F. 1988. Haags Gemeentemuseum. The Hague 1988 (cat.).– Buhlmann, B. and M. Wechsler (ed.): G. F. Museum Haus Lange, Krefeld et al. Krefeld 1987 (cat.).– G. F. Bilder, Skulpturen, Fotografien. Orangerie Herrenhausen und Kunstverein Hannover. Düsseldorf 1995 (cat.).– G. F. Große Zeichnungen. Galerie Gisela Capitain. Cologne 1990 (cat.).– Fuchs, R. (ed.): G. F. Stedelijk Museum. Amsterdam 1995 (cat.).– Groot, P. (ed.): G. F. Westfälischer Kunstverein. Münster 1986 (cat.).– Henger, S. (ed.): G. F. Painting, Sculpture, Installation. Newport Harbour Art Museum et al. Newport Beach 1989 (cat.).– Horn, L. et al. (ed.): G. F. Kunstraum. Munich 1984 (cat.).– Loers, V. and I. Rein (ed.): G. F. Museum Fridericianum, Kassel et al. Stuttgart 1990 (cat.).– Loock, U. (ed.): G. F. Kunsthalle Bern. Bern 1986 (cat.).– Parent, B. et al. (ed.): G. F. Musée d'Art Moderne de la Ville de Paris. Stuttgart 1991 (cat.).– Preiss, A. (ed.): G. F. Fotografien 1982-1992. Werkbund, Frankfurt-on-Main et al. Stuttgart 1993 (cat.).– Sommer, A. and C. Schreier (ed.): G. F. Druckgraphische Serien. Städtisches Kunstmuseum Bonn. Bonn 1994 (cat.).– Speck, R. and G. Theewen (ed.): G. F. Munchs Bettdecke. Cologne 1996.– Ungers, S.: G. F. Brussels 1986.– Wechsler, M. and B. E. Buhlmann (ed.): G. F. Museum Haus Lange Krefeld et al. Krefeld 1987 (cat.)

**FRANCIS Sam**
(Samuel Lewis Francis)
**1923** San Mateo (CA) – **1994** Santa Monica (CA)
American painter. **1941–1943** Studied botany and medicine at Berkeley. Military service in the US Army Air Corps. **1944** Spinal injury in a plane crash. Taught himself to paint while bedridden. **1948–1950** Studied painting and history of art, among other teachers, under Rothko and Still. Travelled around the world, stopping in Mexico, India, Japan and Thailand. Early paintings influenced by Abstract Expressionism. Up to **1949** he painted irregular, cell-like patches of colour with thinned oil or acrylic paints, while after **1950** his characteristic patches and blot patterns flowed into one another, forming monochromes.

**1956** Wall paintings for the Kunsthalle, Basel. **1958** Took part in the exhibition "New American Painting" that was shown in eight European cities. **1959** and **1964** participation in documenta 2 and 3 in Kassel. **1963** Moved to Santa Monica, California. **1969** Honorary doctorate from the University of Berkeley. **1973** Visited Japan. **1974** Returned to California. **1977–1983** Exhibitions in Copenhagen, Paris, Boston and St. Paul. Besides being one of the chief exponents of Action Painting in America, Sam Francis worked in other materials such as clay and ceramics and also used techniques such as lithographs and monotypes.
WRITINGS: S. F.: Aphorisms. Santa Monica 1984
CATALOGUES RAISONNES: Hulten, P. and G. Tullis (ed.): The Monotypes of S. F. Die Monotypien von S. F. Stuttgart 1994.– Lembark, C. W. (ed.): The Prints of S. F. A Catalogue Raisonné. 1960-1990. 2 vols. New York 1992
MONOGRAPHS, CATALOGUES: Buck, R. T. et al. (ed.): S. F. Paintings 1947-1972. Albright-Knox Art Gallery, Buffalo et al. Buffalo 1972 (cat.).– Butterfield, J. (ed.): S. F. Los Angeles County Museum of Art. Los Angeles 1980 (cat.).– S. F. Pasadena Box. Bern 1968.– S. F. Werke 1945-1900. Kunsthalle Bern. Bern 1991 (cat.).– S. F. The Edge Paintings. James Corcoran Gallery. Los Angeles 1992 (cat.).– S. F. Les Années parisiennes 1950-1961. Galerie du Jeu de Paume. Paris 1995 (cat.).– Hulten, P. (ed.): S. F. Kunst- und Ausstellungshalle der Bundesrepublik Deutschland, Bonn. Stuttgart 1993 (cat.).– Lytard, J. F.: S. F. Lessons on Darkness Like the Paintings of a Blind Mand. Venice (CA) 1993.– Michaud, Y.: S. F. Paris 1992.– Paquement, A. (ed.): S. F. Peintures récentes 1976-1978. Centre Georges Pompidou. Paris 1978 (cat.).– Schneider, P. et al. (ed.): S. F. 1968/69. CAPC. Paris 1969 (cat.).– Schneider, P. et al. (ed.): S. F. Les années parisiennes 1950-1961. Paris 1995 (cat.).– Selz, P.: S. F. New York 1975, 1982.– Sweeny, J. J. (ed.): S. F. Houston Museum of Fine Arts et al. Houston 1967 (cat.).– Tono, Y.: S. F. Tokyo 1964.– Waldberg, M.: S. F. Métaphysique du vide. Paris 1987

**FRANK Robert**
born **1924** Zurich
Swiss photographer. **1941/42** Trained as a photographer and graphic designer in Zurich. **1946** Visited Milan and Paris. **1947** Fashion photographs for *Harper's Bazaar*. **1949** Documented his travels in Peru in spiral-bound photo-books. **1950** Returned to New York where he did freelance work for *Fortune, Life, Look, McCall's* and the *New York Times*. **1955** First European to receive a Guggenheim grant. Worked with Walker Evans on photo-essays. **1957** Photographed Eisenhower and Nixon's inauguration ceremony in Washington. **1958** Publication of the volume of photographs *The Americans in France*. **1959–1971** Branched into film as cameraman and producer. **1972**

**–1977** Began to use a Polaroid pack film camera for his photographic art work and experimented with prints from Polaroid negatives on photographic paper. **1985** Won the Erich Salomon Award from the German Photographic Society in Berlin.
MONOGRAPHS, CATALOGUES: Brookman, P. (ed.): R. F. Photographer/Filmmaker. Works from 1945-1979. Long Beach Museum of Art. Long Beach 1979 (cat.).– Di Piero, W. S. et al. (ed.): R. F. Moving out. Washington et al. Washington 1995 (cat.).– R. F. Centre National de la Photographie. Paris 1996 (cat.).– Greenough, S.: R. F. Moving Out. National Gallery of Art, Washington et al. Washington 1994 (cat.).– Katz, P. (ed.): R. F. Sidney Janis Gallery. New York 1979 (cat.).– Papageorge, T.: Walker Evans and R. F. An Essay on Influence. New Haven (CT) 1981.– Tucker, A. W. (ed.): R. F. New York to Nova Scotia. Museum of Fine Arts. Houston 1986 (cat.)

**FRANKENTHALER Helen**
born **1928** New York
American painter. **1945–1950** Studied at Bennington College in Vermont, at the Art Students League and with H. Hofmann in New York. From **1951** developed her own technique related to Pollock's drip paintings. **1958** Married Robert Motherwell. Taught at various universities including Yale and Princeton. **1959** Participation in documenta 2 in Kassel and special honours at the Paris Biennale. **1965** Took part in the Venice Biennale. With her technique of saturating raw, untreated canvas with thinned paint, Frankenthaler created free, lyrical improvisations which had a decisive influence on the works of Kenneth Noland and Morris Louis.
CATALOGUES RAISONNES: Harrison, P. (ed.): F. Catalogue Raisonné. Prints 1961-1994. New York 1996.– Krens, T. et al. (ed.): H. F. Prints 1961-1979. Sterling and Francine Clark Art Institute Williamstown (MA) et al. New York 1980 (cat.)
MONOGRAPHS, CATALOGUES: Belz, C. (ed.): F. The 1950s. Rose Art Museum, Brandeis University. Waltham (MA) 1981 (cat.).– Carmean, E. A. (ed.): H. F. A Paintings Retrospective. The Museum of Modern Art, New York et al. New York 1989 (cat.).– Elderfield, J.: F. New York 1989.– Fine, R. E. (ed.): H. F. Prints. National

Gallery of Art, Washington et al. New York 1993 (cat.).– H. F. Paintings 1969-1974. Corcoran Gallery of Art. Washington 1975 (cat.).– H. F. Solomon R. Guggenheim Museum, New York et al. New York 1998 (cat.).– Goosen, E. C. (ed.): H. F. Solomon R. Guggenheim Museum. New York 1969 (cat.).– O'Hara, F. (ed.): H. F. Paintings. The Jewish Museum. New York 1960 (cat.).– Rose, B.: F. New York 1971.– Wilkin, K. (ed.): H. F. Works on Paper 1949-1984. Solomon R. Guggenheim Museum, New York et al. New York 1984, 1995 (cat.)

**FREUD Lucian**
born **1922** Berlin
German-born English painter. Grandson of Sigmund Freud. **1933** Emigrated to England. **1938–1939** Attended the Central School of Arts and Crafts in London. **1939–1942** Studied at the East Anglian School of Painting and Drawing in Dedham. **1942/43** Part-time studies at Goldsmith's College in London. **1944** First exhibition in the Lefèvre Gallery in London. **1946/47** Trips to Paris and Greece. **1949–1954** Guest-lecturer at the Slade School of Fine Arts in London. **1951** Arts Council Prize at the Festival of Britain. **1954** Exhibited with Ben Nicholson and Francis Bacon in the British Pavilion at the Venice Biennale. **1958–1968** Series of exhibitions at the Marlborough Gallery, London. **1987–1993** Touring exhibitions organised worldwide by the British Council. With psychological acuity and analytical skill, Freud dissected subjects familiar to him, above all acquaintances and friends. Towards the end of the 50s, Freud's precise, veristic painting style became more expressive and he applied the paint more thickly as an impasto. By adding Kremnitz white Freud gave his paint the appearance of flesh.
CATALOGUES RAISONES: L. F. The Complete Etchings 1946-1991. Thomas Gibson Fine Art Ltd. London 1991 (cat.).– Hartley, C. (ed.): The Etchings of L. F. A Catalogue Raisonné 1946-1995. London and New York 1995
MONOGRAPHS, CATALOGUES: Bernard, B. and D. Birdsall: L. F. New York 1996.– Calvocoressi, R.: L. F. Early Works. Edinburgh 1997 (cat.).– L. F. Gemälde. Neue Nationalgalerie. Berlin 1988 (cat.).– L. F. Dipinti e opere su carta 1940-1991. Palazzo Ruspoli. Roma 1991 (cat.).– L. F. Art Gallery of New South Wales, Sydney et al. Sydney 1992 (cat.).– Gowing, L.: L. F. London 1982.– Hughes, R. (ed.): L. F. Paintings. Hirshhorn Museum and Sculpture Garden, Smithsonian Institution, Washington et al. London 1987 (cat.).– Hughes, R.: L. F. Paintings. New York 1993, 1997.– Lampert, C. (ed.): L. F. Recent Works. Whitechapel Art Gallery, London et al. New York 1993 (cat.).– Mantura, B. et al. (ed.): L. F. Paintings and Works on Paper 1940-1991. Castello Sforzesco, Milan et al. Milan and London 1991.– Penny, N. and R. F. Johnson (ed.): L. F. Works on Paper. Ashmolean Museum of Art, Oxford

et al. London and New York 1988 (cat.).– Russel, J. (ed.): L. F. Hayward Gallery. London 1974

**FREUND Gisèle**
born **1912** Berlin
German photographer. **1931–1933** Studied history of art and social sciences in Freiburg and Frankfurt am Main. **1932** Met Walter Benjamin. **1933** Emigrated to France and studied at the Sorbonne in Paris until **1936**. Wrote a doctoral thesis on Photography in France in the 19th century. Thereafter published portraits of writers and artists, including James Joyce, Virginia Woolf, Jean-Paul Sartre, Simone de Beauvoir and Henri Matisse in *Life* magazine, *The Weekly Illustrated* and *Paris-Match*. **1940** Fled, via the South of France, to Argentinia and then Chile where, from **1943/44**, she worked with the theatre company of L. Jouvet. **1947–1954** Joined the photographic agency *Magnum*. **1950–1952** Lived in Mexiko. From **1963** numerous exhibitions. **1977** Participated in documenta 6 in Kassel. **1978** Won a cultural award from the German Photographic Society and, in **1980**, the Grand Prix National des Arts in France. Pioneered the use of three-layer colour reversal film in art photography.
WRITINGS: G. F.: La Photographie en France au dix-neuvième siècle. Paris 1936.– G. F.: Photographie und bürgerliche Gesellschaft. Munich 1968, 1976/Photographie et Société. Paris 1974/Photography and Society. London and Boston 1980
MONOGRAPHS, CATALOGUES: G. F. and R. Jamis: G. F. Portrait. Paris 1991.– Honnef, K. (ed.): G. F. Fotografien 1932-1974. Rheinisches Landesmuseum. Bonn 1977 (cat.).– Puttni, H.: G. F. Paris 1991

**FREUNDLICH Otto**
**1878** Stolp (Pomerania) – **1943** Lublin-Maidanek (Poland)
German painter and sculptor. Training business. **1903–1906** Studied history of art in Berlin, Munich and Florence. **1907** Studied sculpture with Arthur Levin-Funcke. **1909** Moved to Paris. First paintings and sculptures, inspired by Picasso and the Cubists. **1910** First exhibition at the Galerie Saguet, Paris. **1913** Exhibits at the First German Autumn Salon and the gallery

Der Sturm in Berlin. **1914–1924** Lived mostly in Cologne where he made friends with Siewert and joined the Novembergruppe. From **1930** member of the group Cercle et Carré and from **1931** of Abstraction-Création. Worked for a Cologne workers' newspaper, the *Arbeiter-Zeitung*. **1934** First architectonic plastic works and architectonic relief. Founded the Académie de Peinture, Dessin, Sculpture, Gravure. **1937** The sculpture *L'homme nouveau* appeared on the cover of the catalogue of the exhibition of "degenerate art" in Munich. The same year, his works were confiscated from all German museums. **1939** Interned. **1940** Escaped to the Pyrenees. **1943** Deported to the concentration camp Maidanek and murdered. **1954** Retrospective in the gallery Rive Droite in Paris.
WRITINGS: Bohnen, U. (ed.): O. F. Schriften. Ein Wegbereiter der gegenstandslosen Kunst. Cologne 1982
CATALOGUE RAISONNE: Heusinger v. Waldegg, J. (ed.): O. F. Monographie mit Dokumentation und Werkverzeichnis. Rheinisches Landesmuseum, Bonn. Cologne 1978 (cat.)
MONOGRAPHS, CATALOGUES: Aust, G.: O. F. 1878-1943. Cologne 1960.– Bonfand, A. et al. (ed.): O. F. Musée Départemental de Rochechouart. Paris 1988. Paris 1988 (cat.).– Duvivier and E. Maillet (ed.): O. F et ses amis. Musée de Pontoise. Pontoise 1993 (cat.).– Fischer, Y. (ed.): O. F. Israel Museum. Jerusalem 1978 (cat.).– Heusinger v. Waldegg, J.: O. F. Ascension. Anweisung zur Utopie. Frankfurt-on-Main 1987.– Leistner, G. and T. Rodiek (ed.): O. F. Ein Wegbereiter der abstrakten Kunst. Museum Ostdeutsche Galerie, Regensburg et al. Regensburg und Osnabrück 1994 (cat.)

**FRIESZ Othon**
**1879** Le Havre – **1949** Paris
French painter. Took lessons under Charles-Marie Lhuillier at the School of Drawing in Le Havre. **1899–1904** Studied at the Ecole Nationale Supérieure des Beaux-Arts in Paris. Met Dufy, Rouault, Marquet and Matisse, and was strongly influenced by their Fauvist style of painting. **1903/04** Exhibitions at the Salon d'Automne and the Salon des Indépendants. **1905** Participation in the exhibition "Fauves" at the Salon d'Automne. **1906** Stayed with Braque in La Ciotat. **1911** Travelled to Portugal. Explored the pictorial limits of Cubism. **1912** Opened an art school in Paris and taught there until **1914**. During this teaching period, his Fauvist approach lost some of its intensity and his paintings gradually became more harmonious and calm. From **1914** professorship at the Académie Moderne, from **1929** at the Académie Scandinave and from **1944** at the Académie de la Grande Chaumière. **1925** Won the Carnegie Foundation Award. **1937** Commissioned to decorate the Palais de Chaillot, together with Raoul Dufy.
MONOGRAPHS, CATALOGUES: Brielle, R.: O. F. Paris 1930.– Fleuret, F. et al.: F.

Œuvres 1901-1927. Paris 1928.– O. F. Exposition rétrospective 1879-1949. Musée des Beaux-Arts André Malraux. Le Havre 1979 (cat.).– Gauthier, M. and P. Cailler: O. F. Geneva and Paris 1957.– Giry, M.: La Jeunesse d'O. F. Diss. Lyon 1951.– Salmon: O. F. Paris 1920

**FRIZE Bernard**
born **1954** Saint Mandé
French painter who achieved fame in **1977** with his series *All over*, in which multicolored trails of paint, produced with a specially fine brush, form arabesques all over the canvas. **1979** First solo-exhibition at the Galerie Lucien Durand in Paris. **1986** Further exhibitions at the Maison de la Culture in St. Etienne and in the Villa Medici in Rome. Frize can be seen as a representative of aleatoric art. He used new subversive methods and unusual materials in his attempts to let painting produce itself through the medium of chance.
MONOGRAPHS, CATALOGUES: Meschede, F. (ed.): Malerei ohne Sprache. B. F. Kunstverein Arnsberg. Arnsberg 1995 (cat.).– Pagé, S.: B. F. Musée d'Art Moderne de la Ville. Paris 1988 (cat.).– Tosatto, G.: A l'image de la peinture. B. F. Musée Départemental d'Art Contemporain. Rochechouart 1991 (cat.).

**FRUHTRUNK Günter**
**1923** Munich – **1982** Munich
German painter. **1940/41** Studied architecture. **1945**-**1950** Studied painting under William Straube, among other teachers, at a private school. **1954** Grant from the state of Baden-Württemberg and the French government. Moved to Paris and worked in the studios of Léger and Arp. **1961** Won the Jean Arp Award in Cologne. **1963** Retrospective at the Museum am Ostwall, Dortmund. **1966** Awarded a silver medal at the Prix d'Europe in Ostend. From **1967** Professor of Painting at the Art Academy in Munich. Impressed by the Concrete painting of Auguste Herbin, Fruhtrunk developed a dynamic formal language, of intensely coloured, diagonal stripes, like vectors, arranged in alternating colours to set up powerful rhythms. He thereby consciously distanced himself from Constructivism

CATALOGUE RAISONNE: Gomringer, E. et al. (ed.): F. Starnberg 1978
MONOGRAPHS, CATALOGUES: Besset, M. (ed.): F. Musée d'Art Moderne de la Ville de Paris. Paris 1970 (cat.).– G. F. Kunstverein Braunschweig. Brunswick 1983 (cat.).– Imdahl, M. et al. (ed.): F. Bilder 1952-1972. Städtische Galerie im Lenbachhaus. Munich 1973 (cat.).– Ludwig, J. and U. Spranger-Hauschild (ed.): G. F. Frühe Bilder 1950-1954. Museum für Neue Kunst, Freiburg. Waldkirch 1993 (cat.).– Schuster, P.-K. (ed.): G. F. Neue Nationalgalerie, Berlin et al. Munich 1993 (cat.)

**GABO Naum**
(Neemia Borissovich Pevsner)
**1890** Brjansk (Russia) – **1977** Waterbury (CT)
Russian sculptor, painter and architect. **1909**-**1914** Studied medicine and natural sciences in Munich and attended H. Wölfflin lectures in art history on the side. **1912** Contact with Kandinsky and the Blauer Reiter. Trip to Italy. **1913/14** Stayed with his brother Antoine Pevsner in Paris. **1914**-**1917** Lived in Copenhagen and Oslo, where he produced his first sculptural constructions under the name of Gabo. **1917** Moved to Moscow and made contact with the group of artists around Tatlin, Malevich and Rodchenko. **1920** Together with his brother, published the *Realistic Manifesto*, in which they oppose the ideas of Cubism and Futurism and the bringing together of politics and art in the new Socialist Realism. First kinetic sculptures. **1922** Moved to Berlin. **1925** Became a director of the Novembergruppe. **1927** Together with his brother Antoine, designed sets and costumes for Diaghilev's ballet *La Chatte*. Guest-lecturer at the Bauhaus in Dessau. **1932** Joined Abstraction-Création, and from **1935** lived alternately in Paris and Berlin. **1935**-**1946** Lived in London and South England. **1946** Emigrated to the USA, settling in Middlebury, (CT). **1948** Exhibition in the Museum of Modern Art, New York. **1953/54** Professorship at Harvard University. Gabo contributed significantly to the development of Kinetic Art, as represented by artists such as George Rickey, Alexander Calder and Jean Tinguely.
WRITINGS: N. G.: Of Divers Arts. New York 1962
CATALOGUES RAISONNES: Nash, S. A. and J. Merkert (ed.): N. G. Sixty Years of Constructivism. Including a Catalogue Raisonné of the Constructions and Sculptures. Dallas Museum of Art et al. Munich 1985 (cat.)/N. G. Sechzig Jahre Konstruktivismus (mit dem Œuvre-Katalog der Konstruktionen und Skulpturen). Akademie der Künste, Berlin et al. Munich 1986 (cat.).– Williams, G. (ed.): N. G. Monoprints. Cambridge (MA) 1987, New York 1992
MONOGRAPHS, CATALOGUES: Beaud, M.-C. (ed.): N G. G. A. Musée de Peinture et de Sculpture, Grenoble et al. Paris 1971 (cat.).– El-Danasouri, A.: Kunststoff und Müll. Das Material bei N. G. und Kurt

Schwitters. Munich 1992.– Forge, C.: Appreciation of N. G New York 1990.– N. G. Musée National d'Art Moderne. Paris 1971 (cat.).– Merkert, J. (ed.): N. G. Ein russischer Konstruktivist in Berlin 1922-1932. Skulpturen, Zeichnungen und Architekturentwürfe. Berlinsche Galerie. Berlin 1989 (cat.).– Moser, B. (ed.): N. G. und der Wettbewerb zum Palast des Sowjets, Moscow 1931-1933. Berlinische Galerie. Berlin 1992 (cat.).– Newman, T. (ed.): N. G. The Constructive Process. Tate Gallery. London 1976 (cat.).– Pevsner, A.: A Biographical Sketch of My Brothers N. G. and Antoine Pevsner. Amsterdam 1964.– Read, H. and L. Martin (ed.): G. Constructions, Sculpture, Paintings, Drawings, Engravings. Cambridge (MA) 1957.– Read, H. and L. Martin: N. G. Neuchâtel 1957.– Williams, L.: N. G. Monoprints. New York 1990

**GARGALLO Pablo**
**1881** Maella (Zaragoza) – **1934** Reus (Tarragona)
Spanish sculptor. **1900** Attended the art school *La Lonja* in Barcelona. Grant to study in Paris. **1907**-**1911** First metal works in copper foil and wire. Contact with Picasso, Gris and Modigliani. **1912** First works in iron (*Napolitain*). **1915** Gave up sculpting in stone owing to a lung disorder and instead made small plastic works and jewellery. **1920**-**1923** Professorship at the Belli Officis in Barcelona. Returned to Paris and started to produce large-scale sculptures agian. **1934** Solo-exhibition at the Brummer Gallery in New York.
CATALOGUE RAISONNE: Courthion, P. (ed.): L'Œuvre complète de. P. G. Paris 1973
MONOGRAPHS, CATALOGUES: Anguera, J.: G. Paris 1979.– Borra, M. L. et al. (ed.): G. Exposició del centenari. Barcelona 1981.– Catalogo del Museo P. G. Saragossa 1988.– Cirici, A.: G. i. B. Barcelona 1975.– Courthion, P.: P. G. Paris 1937.– Dagen, P. and R. Ordóñez Fernández (ed.): G. La nueva edad de los metales. Fundación Mapfre Vida. Madrid 1991 (cat.).– Fernández, R. O.: G. Madrid 1991.– Fernández, R. O. (ed.): Museo P. G. Madrid 1994.– P. G. 1881-1934. Musée d'Art Moderne de la Ville de Paris. Paris 1980 (cat.).– P. G. 1881-1934. Musées de Pontoise. Pontoise 1992 (cat.).– Ordóñez Fernández, R. (ed.): Catálogo del Museo P. G. Saragossa 1988

**GAROUSTE Gérard**
born **1946** Paris
French painter. **1965**-**1972** Studied at the Ecole Nationale des Beaux-Arts in Paris. **1979**-**1982** Designed scenery for the miniature Italian theatre at the theatre Le Palace in Paris and experimented with various stage set techniques. **1980** Performance of his play *La règle du Jeu* at the Museum of Contemporary Art in Ghent. **1984** Moved to Marcilly-sur-Eure. **1987** Painted his first *Indienne*, a free-hanging canvas, 7.60 m wide and 4.10 m long. Up to **1988** produced

further *Indiennes*, based on the theme of Dante's *Divine Comedy*. **1990** Helped in the setting up of a graphic studio at the French cultural centre in Tetouan, Morocco. Created mega-sculptures out of iron.
MONOGRAPHS, CATALOGUES: Blistène, B. et al. (ed.): G. G. Centre Georges Pompidou, Paris et al. Paris 1988 (cat.).– Dagbert, A.: G. G. Paris 1996.– Froment, J.-L. et al. (ed.): G. G. Peintures de 1985-1987. C. A. P. C. Musée d'Art Contemporain de Bordeaux. Bordeaux 1987 (cat.).– Giudiera, R. and B. Blistène (ed.): G. G. Centre Georges Pompdou, Paris et al. Paris 1988.– Giudiera, R. and B. Blistène (ed.): G. G. Städtische Kunsthalle Düsseldorf et al. Düsseldorf 1989 (cat.).– Lebeer-Hossmann (ed.): G. G. Palais des Beaux-Arts. Chaleroi and Brussels 1988 (cat.).– Risset, J. et al. (ed.): G. G. Peintures de 1985-1987. Musée d'Art Contemporain de Bordeaux. Bordeaux 1987 (cat.)

**GARRIN Paul**
born **1957** Philadelphia
American video and multimedia artist. **1978**-**1982** Studied at Cooper Union School of Arts in New York. From **1983** produced installation video tapes for Paik. From **1985** put together his own video tapes using original footage of street fighting and race riots as a critical documentary of race relations in America. Worked from **1981** for Paik, as one of his chief assistants. **1988** Prize at the Videonnale in Bonn. **1989** Retrospective at the Museum Folkwang, Essen. New York Foundation for the Arts Fellowship. **1991** Participation in Multimediale 2 in Karlsruhe. **1992** Featured at the Mediale in Hamburg with his computer-controlled, interactive video-installation *White Devil*. Won the Karlsruhe ZKM award for video art.

**GAUDIER-BRZESKA Henri**
**1891** Saint-Jean-de-Braye (near Orléans) – **1915** Neuville-Saint-Vaast (Pas-de-Calais)
French sculptor, painter and draughtsman. **1909** After a visit to England, began to study art while working as a textile designer in Paris. **1910** First sculptures. Met Sophie Brzeska from Poland. **1911** Returned to London. **1912** First published drawing in the

magazine Rhythm. Began to sign his works with the double-barrelled surname Gaudier-Brzeska. **1913** Friendship with Ezra Pound. Aligned himself with the Vorticist artists and writers, including Wyndham Lewis, Edward Wadsworth and Jacob Epstein, whose short-lived movement was strongly influenced by Futurism and Cubism. Devoted himself more intensively to sculpture. **1913/14** Participated in the Allied Artists' Association Exhibition. **1915** Exhibited various works in the Vorticist Exhibition. Signed up to fight on the French front and was killed at Neuville-Saint-Vaast. His sculptures had a strong influence on subsequent generations of English sculptors, including Henry Moore.
CATALOGUE RAISONNE: Silber, E. and D. Finn (ed.): H. G.-B. Life and Art. London 1996
MONOGRAPHS, CATALOGUES: Brodzky, H.: H. G.-B. 1891-1915. London 1933.– Cassat, B.: La Caritas. Une œuvre de G.-B. De Rodin à l'abstraction. Orléans 1992.– Cole, R.: Burning to Speak. The Life and Art of H. G.-B. Oxford 1978.– Ede, H. S.: Savage Messiah. A Life of G.-B. London and New York 1931.– H. G.-B. 1891-1915. Skulpturen, Zeichnungen, Briefe. Kunsthalle Bielefeld. Bielefeld 1969 (cat.).– H. G.-B. Scottish National Gallery of Modern Art. Edingburgh 1972 (cat.).– H. G.-B. Musée des Beaux-Arts, Orléans et al. Orléans 1993 (cat.).– Koslow, F.: The Graphic Work of H. G.-B. Diss. Boston 1981.– Lewison, J. (ed.): H. G.-B. Sculptor 1891-1915. Cambridge et al. Cambridge 1983 (cat.).– Levy, M.: H. G.-B. Drawings and Sculpture. New York 1965.– Pound, E.: H. G.-B. London 1960, Paris 1992.– Secrétain, R.: Un sculpteur "maudit". G.-B. 1891-1915. Paris 1980

**GAUGUIN Paul**
**1848** Paris – **1903** Atuona Hiva-Oa (Marquesas Islands)
French painter. **1849–1855** Grew up in Lima (Peru), thereafter living in Orléans and Paris. **1865–1871** Joined the merchant marine and went to sea. **1871–1883** Worked as a stockbroker in Paris. **1873** Married Dane Mette Gad and had five children. **1874** Studied at the Académie Colarossi. **1876** First work accepted by the Salon. Up to **1886** took part in the IV–VIII Impres-

sionist exhibitions. **1881** Worked with Pissarro und Cézanne. **1882** Moved to Rouen and later Copenhagen. Financial difficulties. **1885** Returned to Paris. **1886** Met Bernard while staying in Pont-Aven. Became acquainted with the van Gogh brothers in Paris. **1887** Travelled with the painter Laval to Panama and Martinique. **1888** Returned to Pont-Aven. Developed Synthetism in his paintings of Breton life and customs. Exhibition organised by Theo van Gogh. A disastrous quarrel with Vincent van Gogh in Arles severed relations between the two artists. **1889** Exhibited with the group Les XX in Brussels and in the Café Volpini at the Paris World Fair. **1891** Emigrated to Tahiti, where he painted symbolic pictures from life, in a flat decorative style with large areas of strong, glowing colours, that today are seen as incunabula of Exotic and Primitive Art. Contracted syphilis. **1893–1895** Lived alternately in Paris, Copenhagen and Brittany. **1895–1901** Returned to Tahiti. First sculptural works. **1897** Published his autobiographical work *Noa, Noa*. **1898** Attempted suicide. **1901** Settled on Dominica, one of the Marquesas Islands where, in **1902**, he had a political battle with the colonial authorities and was prosecuted. **1903** Died, weakened by illness and poverty, at the age of 54.
WRITINGS: P. G.: The Intimate Journals of P. G. Repr. London 1985.– Merlhès, V. (ed.): Correspondance de P. G. Documents, témoignages. Paris 1984.– Monfreid, G. D. d. (ed.): Lettres de P. G. Paris 1930.– Thomson, B.: G. par lui-même. Evreux 1993
CATALOGUES RAISONNES: Agustino, F. and G. Lari (ed.): G. Catalogo completo dell' opera grafica. Milan 1972.– Field, R. (ed.): P. G. Monotypes. Philadelphia Museum of Art. Philadelphia 1973 (cat.).– Gray, C. (ed.): Sculpture and Ceramics of P. G. Baltimore 1963, New York 1980.– Guérin, M. (ed.): Catalogue raisonné de l'œuvre gravé de G. Paris 1927, San Francisco 1980.– Joachim, H. et al. (ed.): P. G. A Catalogue Raisonné of His Prints. Bern 1988.– Morgan, E. et al. (ed.): P. G. Catalogue Raisonné of His Prints. Bern 1988.– Sugana, G. M. (ed.): Tout l'œuvre peint de G. Paris 1981.– Wildenstein, G. (ed.): G. Catalogue critique des peintures. Paris 1964
MONOGRAPHS, CATALOGUES: Beaute, G.: P. G. vu par les photographes. Lausanne 1988.– Brettell, R. (ed.): The Art of P. G. National Gallery of Art. Washington 1988 (cat.).– Burnett, R.: P. G. Munich 1948.– Clement, R. T.: P. G. A Bio-Bibliography. New York 1991.– Daix, P.: P. G. Paris 1989.– Gibson, M.: P. G. Recklinghausen 1991, New York 1993.– Goldwater, R.: P. G. Cologne 1957, 1989.– Hoog, M.: G. Vie et œuvre. Paris 1987/P. G. Life and Work. New York 1987/P. G. Leben und Werk. Munich 1987.– Jaworska, W.: P. G. et l'école de Pont-Aven. Neuchâtel 1971.– Lewandowski, H.: P. G. Die Flucht vor der Zivilisation. Frankfurt-on-Main 1991.– Prather, M. (ed.): P. G. 1848-1903. Cologne 1994.– Rohde, P.-A.: P. G. auf Tahiti. Rheinfelden 1988.– Sweetman, D.: P. G. A Complete Life. London 1995

**GEIGER Rupprecht**
born **1908** Munich
German painter. **1926–1935** Studied architecture at the School of Arts and Crafts and the College of Civil Engineering in Munich. Worked as an architect up to World War II when he began painting. **1948** First abstract painting exhibited in the Salon des Réalités Nouvelles in Paris. **1949** Together with Baumeister, Meier-Denninghoff and Winter, founded the group Zen 49. **1951** Received the Domnick Prize. Between **1959** and **1977** participation in documenta 2–4

and 6 in Kassel. **1962** Stopped working as an architect and devoted himself to radical abstraction and the visualisation of colours. **1965–1976** Professorship at the Düsseldorf Academy. From the mid-70s tended to use synthetic red tones that he condensed, by a spraying technique, into rectangular or oval colour fields. **1982/83** Member of the Academy of Fine Arts in Munich. **1987** Large sculpture *Gerundetes Blau* (Rounded Blue) for the cultural centre Gasteig in Munich. With his abstract colour compositions, Geiger is one of the main exponents of Color Field Painting in Germany.
WRITINGS: R. G.: Farbe ist Element. Düsseldorf 1972
CATALOGUES RAISONNES: Geiger, M. (ed.): R. G. Werkverzeichnis Druckgraphik 1948-1972. Düsseldorf 1972.– Honnef, K. and H. Read: R. G. Werkverzeichnis 1948-1972. Düsseldorf 1972
MONOGRAPHS, CATALOGUES: R. G. Gemälde und Zeichnungen. Städtische Galerie im Lenbachhaus. Munich 1978 (cat.).– Giloy-Hirtz, P. (ed.): R. G. Russian State Museum, St. Petersburg et al. Stuttgart 1994 (cat.).– Güse, E.-E. (ed.): G. Zeichnung als Licht. Saarland Museum, Saarbrücken. Munich 1990 (cat.).– Heißenbüttel, H.: G. Stuttgart 1972.– Riese, H.-P. et al. (ed.): R. G. Retrospektive. Akademie der Künste, Berlin et al. Berlin 1985 (cat.).– Schuster, P.-K. (ed.): R. G. Staatsgalerie moderner Kunst im Haus der Kunst. Munich 1988 (cat.).– Volkmann, B. and R.-F. Raddatz (ed.): R. G. Retrospektive. Akademie der Künste, Berlin et al. Berlin 1985 (cat.)

**GERTSCH Franz**
born **1930** Möringen
Swiss painter. Studied **1947–1950** at the Max von Mühlenen School of Painting in Bern. First woodcuts. **1950–1952** Learnt painting techniques from Hans Schwarzenbach in Bern. From **1969** produced monumental canvases with enormously enlarged motifs, using transparencies as models. Subsequent intensification, through painting over the images projected onto the canvas, produced a hyper-realistic effect that appeared to dematerialise the objects portrayed. **1972** Participated in documenta 5 in Kassel. **1974/75** DAAD scholarship to Berlin. Family and group scenes became a

favourite theme throughout the 70s. **1986** Last oil painting, entitled *Johanna II*. Thereafter produced large-scale, hyper-realistic woodcuts. Gertsch is one of the main exponents of Photo Realism in Europe.
CATALOGUE RAISONNE: Castleman, R. et al. (ed.): F. G. Large-scale Woodcuts/ Xilografias monumentales. Geneva 1990 (cat.).– Ronte, D. (ed.): F. G. (with catalogue raisonné). Bern 1986
MONOGRAPHS, CATALOGUES: Billeter, E. et al. (ed.): F. G. Kunsthaus Zurich et al. Zurich 1980 (cat.).– F. G. Holzschnitte. Kunstmuseum Bern et al. Baden-Baden 1994 (cat.).– Mason, R. M. et al. (ed.): F. G. Holzschnitte. Städtische Galerie im Lenbachhaus. Munich 1991 (cat.).– Ruhrberg, K. et al. (ed.): F. G. Deutscher Akademischer Austauschdienst, Berlin et al. Berlin 1975 (cat.).– Stuffmann, M. and P. Tanner (ed.): F. G. Landschaften. Graphische Sammlung der ETH Zurich et al. Stuttgart 1993 (cat.)

**GERZ Jochen**
born **1940** Berlin
German writer, installation and action artist. **1958–1962** Studied German and English literature and Chinese at Cologne University, and archaeology in Basel. **1960** First literary texts – in the style of Concrete Poetry. **1967** Moved to Paris. Founded the authors' self-publishing company "Agentzia". **1968** Published first book entitled *Footing*. First happenings and environments. From **1969** put together pictures from photographs and texts on the theme of the limitations of language and communication. **1970** First video works. **1972** Founded the Gesellschaft zum Studium des praktischen Lebens, (Society for the Study of Practical Life). **1975–1979** Series entitled *Griechische Stücke* (Greek Pieces). **1976** Presented the performance *Die Schwierigkeit des Zentauren beim vom Pferd steigen* (The Centaur having difficulty getting his horse) at the Venice Biennale, for which the artist spent four days inside a wooden horse. As part of the happening *Transsib-Prospekt* at documenta 6 in **1977** he travelled from Moscow to Vladvostok behind blacked-out windows. **1978–1984** Series *Kulchur-Pieces*. **1981** Trips to Canada. **1984** Joint art projects with Esther Shalev-Gerz. Since **1987** coloration of used photographs and texts. Participated in documenta 8 in Kassel.
WRITINGS: Franz, E. (ed.): J. G. Texte. Bielefeld 1985.– J. G.: Von der Kunst. Dudweiler 1985.– J. G. Gegenwart der Kunst. Interviews 1970-1995. Regensburg 1995
MONOGRAPHS, CATALOGUES: Friese, P. (ed.): J. G. Life After Humanism. Photo, Text 1988-1992. Neues Museum Weserburg, Bremen et al. Stuttgart 1992 (cat.).– J. G. 2146 Steine. Mahnmal gegen Rassismus, Saarbrücken. Stuttgart 1993.– J. G. Les Images. Musée d'Art Contemporain. Strasbourg 1994.– J. G. Ancienne douane. Strasbourg 1994 (cat.).– J. G. The French Wall. Germanisches Nationalmuseum. Nuremberg 1996 (cat.).– Jussen, B. (ed.): J. G.

Von der künstlerischen Produktion der Geschichte I. Göttingen 1997.– Könneke, A. (ed.): J. G. Das Hamburger Mahnmal gegen Faschismus. Stuttgart 1994.– Rattemeyer, V. (ed.): J. G. Get Out of My lies. Wiesbaden 1997.– Schwarz, M. (ed.): J. G. Foto, Texte, The French Wall & Stücke. Badischer Kunstverein. Karlsruhe 1975 (cat.).– Shalev-Gerz, E. (ed.): J. G. Griechische Stücke, Kulchur pieces. Wilhelm-Hack-Museum. Ludwigshafen am Rhein 1984 (cat.).– Shalev-Gerz, E. (ed.): J. G. Kunstsammlung Nordrhein-Westfalen, Düsseldorf. Cologne 1988 (cat.).– Wolf, E.: J. G. Die Arbeit am Mythos. Diss. Brunswick 1992

**GIACOMETTI Alberto**
**1901** Borgonovo (near Stampa) – **1966** Chur
Swiss sculptor and painter. Studied sculpture at the Ecole des Arts et Metiers in Geneva. **1920/21** Travelled to Italy, staying in Rome. From **1922** pupil of the sculptor Emile Bourdelle at the Académie de la Grande Chaumiére in Paris. **1927** Intense confrontation with Cubism. **1928** Exhibition of *Scheibenplastiken* (discs) at the Galerie Jeanne Bucher, Paris. Became friends with Masson, Leiris and Tériade. **1930** Met Aragon, Dalí and Breton. First Cage sculptures shown by Pierre Loeb in the exhibition "Miró – Arp – Giacometti". **1932** Joined the Surrealists. Encountered literary existentialism. First solo-exhibition at the Galerie Pierre Colle in Paris. **1935** Abandoned Surrealism and began to work again from natural models. **1940** Became acquainted with Picasso, Jean-Paul Sartre and Simone de Beauvoir. **1942–1945** Lived in Geneva. **1948** Returned to Paris and started portrait painting. Applied the principles of his later sculptures to paintings to develop his highly original conception of the human head. **1951** Friendship with Samuel Beckett. **1954/55** Painted portraits of Matisse. **1955** Retrospective at the Arts Council Gallery, London and the Solomon R. Guggenheim Museum, New York. **1962** Won a major award for sculpture at the Venice Biennale. **1965** Retrospective at the Tate Gallery, London and the Museum of Modern Art, New York. Setting-up of the Giacometti Foundation in Zurich.
WRITINGS: Dupin, J. and Leiris, M. (ed.): A. G. Ecrits. Paris 1990.– Scheidegger, E. (ed.): A. G. Schriften, Fotos, Zeichnungen. Zurich 1958
CATALOGUE RAISONNE: Lust, H. C. (ed.): G. The Complete Graphics. New York 1970, San Francisco 1991
MONOGRAPHS, CATALOGUES: Aragon, L. et al. (ed.): Wege zu J. G. Munich 1987.– Barañano, K. M. d. (ed.): A. G. 2 vols. Museo Nacional Centro de Arte Reina Sofía, Madrid. Barcelona 1990 (cat.).– Beye, P. (ed.): A. G. Nationalgalerie, Staatliche Museen Preussischer Kulturbesitz, Berlin. Munich 1987 (cat.).– Bonnefoy, Y.: A. G. Biographie d'une œuvre. Paris 1991/A. G. A Biography of His Work. New York 1991/A. G. Eine Biographie seines Werkes. Bern

1992.– Bovi, A.: A. G. Florence 1974/A. G. Lucerne 1974.– Brenson, M.: The Early Works of A. G. 1925-1935. Diss. Baltimore 1974.– Bucarelli, P.: A. G. Roma 1962.– Crescenzo, C. di: A. G. Early Works in Paris. 1922-1930. New York 1994.– Crescenzo, C. di (ed.): A. G. Sculture-dipinti-disegni. Palazzo Reale. Milan 1995 (cat.).– Derouet, C. et al. (ed.): A. G. Le Retour à la figuration. Musée Rath, Geneva et al. Geneva 1986 (cat.).– Didi-Hubermann, G.: Le Cube et le visage. Autour d'une sculpture d'A. G. Paris 1993.– Dufrêne, T.: G. Les Dimensions de la réalité. Geneva 1994.– Dupin, J.: A. G. Paris 1963, 1978.– Fletcher, V. J. (ed.): A. G. 1901-1966. Hirshhorn Museum and Sculpture Garden. Washington 1988 (cat.).– Fletcher, V.: A. G. The Paintings. Diss. Columbia University. New York 1994.– Genet, J.: A. G. Zurich 1962.– A. G. The Museum of Modern Art, New York et al. New York 1965 (cat.).– A. G. Royal Academy, London et al. London 1996 (cat.).– A. G. Kunsthalle Wien. Vienna 1996 (cat.).– Hohl, R.: A. G. Stuttgart 1971, 1987, New York 1972.– Juliet, C.: G. Paris 1985.– Klemm, C.: Die Sammlung der A.-G.-Stiftung, Kunsthaus Zürich. Zurich 1990.– Koella, R. (ed.): A. G. Munich 1997.– Kuenzi, A. (ed.): A. G. Fondation Pierre Gianadda. Martigny 1986 (cat.).– Lamarche-Vadel, B.: A. G. Paris 1984, New York 1989, 1995.– Lord, J.: A. G. Drawings. Greewich 1971.– Lord, J.: G. A Biography. New York 1983, London 1986/A. G. Der Mensch und sein Lebenswerk. Bern 1987, Munich 1991.– Matter, H. and M.: A. G. Bern 1987, New York 1987.– Pagé, S. (ed.): A. G. Sculptures, peintures, dessins. Musée d'Art Moderne de la Ville de Paris. Paris 1991 (cat.).– Rotzler, W.: Die Geschichte der A.-G.-Stiftung Bern 1985.– Scheidegger, E.: Spuren einer Freundschaft. A. G. Zurich 1990/A. G. Traces d'une amitié. Paris 1992.– Schneider, A. (ed.): A. G. Nationalgalerie, Berlin et al. Berlin 1987 (cat.).– Schneider, A. (ed.): A. G. Skulpturen, Gemälde, Zeichnungen. Nationalgalerie, Berlin et al. Munich 1994 (cat.)/A. G. Sculptures, Paintings, Drawings. Nationalgalerie, Berlin et al. New York 1994 (cat.).– Soavi, G.: G. Paris 1991.– Soldini, J.: Il colossale, la madre, il "sacro". L'opera di A. G. Bergamo 1991.– Stooss, T. et al. (ed.): A. G. 1901-1966. Kunsthalle Vienna et al. Stuttgart 1996 (cat.).– Sylvester, D. (ed.): A. G. Paintings, Drawings. Tate Gallery. London 1965 (cat.).– Sylvester, D.: Looking at G. London 1994, New York 1996

**GIDAL Tim N.**
(Nachum Ignaz Gidalevich)
**1909** Munich – **1996** Jerusalem
German-born Israeli photographer. One of the first photojournalists. Studied history. **1929** While still a student, published his first reportages in the *Münchner Illustrierte Presse*. **1936** Received his doctorate in Basel and emigrated to Palestine. Worked as a photojournalist for *Picture Post* in London. **1947** Lectured in visual communications in

New York. **1975** Returned to Israel. Member of the German Photographic Society and the Royal Society of Photographers in England. **1983** Won the Erich Salomon Award together with Lotte Jacobi.
WRITINGS: T. N. G.: Deutschland. Beginn des Modernen Photojournalismus. Frankfurt-on-Main 1972.– T. N. G.: Modern Photojournalism. Origin and Evolution 1910-1933. New York 1973
MONOGRAPHS, CATALOGUES: T. G. In the 30's. Israel Museum, Jerusalem et al. Jerusalem 1975 (cat.).– T. G. In the 40's. Israel Museum, Jerusalem et al. Jerusalem 1975 (cat.)

**GILBERT & GEORGE**
born **1943** St. Martin (South Tyrol): Gilbert Proersch
born **1942** Devon (England): George Passmore
English performance, photo and object artists. After attending various other art schools, Gilbert & George met at St. Martin's School of Art in London. **1968** First joint-exhibition of *Object-Sculptures* at Frank's Sandwich Bar. Radically extended the definition of sculpture in that they posed themselves as *Living Sculptures* and stylised everyday activities such as smoking, drinking and taking walks into exact, ritualised actions. **1969** Presented themselves as *Singing Sculptures* in *Underneath the Arches*. **1971** First photographic works on the themes of alcohol, grief and degeneration. **1972–1982** Participation in documenta 5 – 7 in Kassel. From **1974** photopieces, heavily screened by grouping of the photographs in black frames. **1977** Gilbert & George gave up living sculpture performances but continued with a media-oriented dramatisation of their lifestyle. Since **1980** large-format photographic self-portraits, mounted and framed. Supplemented with pictographs, everday scenes, graffiti and drawings, these photographs are ironic and diverse commentaries on sexuality, politics and aggression. **1981** Autobiographical film *Gilbert & George*. **1986** Retrospective in Bordeaux.
WRITINGS: Obrist, H.-U. and R. Violette (ed.): The Words of G. & G. London 1997
CATALOGUE RAISONNE: Ratcliff, C. (ed.): G. and G. The Complete Pictures 1971-1985. CAPC Musée d'Art Contemporain, Bordeaux et al. Munich, New York and London 1986 (cat.)
MONOGRAPHS, CATALOGUES: Farson, D.: With G. & G. in Moscow. London 1991.– G. & G. Musée d'Art Contemporain de Bordeaux. Bordeaux 1986 (cat.).– G. & G. Museo d'Arte Moderna della Città di Lugano. Milan 1994 (cat.).– Grosenick, U. (ed.): G. & G. Shitty Naked Human World 1994 und andere Bilder. Kunstmuseum Wolfsburg. Stuttgart 1994 (cat.).– Jahn, W.: The Art of G. & G. Or an Aesthetic of Existence. London 1987/Die Kunst von G. & G. oder eine Ästhetik der Existenz. Munich 1989.– Ratcliff, C. et al. (ed.): G. & G. 1968-1980. Stedelijk Van Abbe Museum.

**GIRKE Raimund**
born **1930** Heinzendorf (now Jasienica near Kattowitz)
German painter. **1951/52** Studied at the School of Arts and Crafts in Hanover and **1952–1956** at the Düsseldorf Academy. **1959** Won an award for painting from the City of Wolfsburg. From **1961** most paintings monochrome and predominantly white. **1962** Youth Art Prize, Stuttgart. In numerous series of works after **1970** experimented with the structure of his brush stroke and the effect of overlapping layers of colour. **1964–1966** Produced the series *Fluctuations*, followed in **1967/68** by *Progressions*. **1973** Series of large-scale gestural paintings of white structures on a dark background. **1966–1971** Taught at the School of Arts and Crafts in Hanover. **1971–1996** Professorship at the Berlin Academy. **1977** Took part in documenta 6 in Kassel. **1995** Retrospective at the Sprengel Museum, Hanover.
WRITINGS: R. G.: Texte 1960-1995. Kunsthaus Zug. Zug 1995
MONOGRAPHS, CATALOGUES: Bischof, U. (ed.): R. G. zu Gast in der Gemäldegalerie Neue Meister. Dresden 1996 (cat.).– Boehm, G. (ed.): R. G. Malerei 1956-1986. Neuer Berliner Kunstverein et al. Berlin 1986 (cat.).– Elger, D. (ed.): R. G. Arbeiten auf Papier. Museum am Ostwall, Dortmund et al. Dortmund 1988 (cat.).– Elger, D. (ed.): R. G. Malerei. Sprengel Museum, Hanover et al. Stuttgart 1995 (cat.).– Heckmanns, F. W. (ed.): R. G. Arbeiten auf Papier. Daadgalerie, Berlin et al. Berlin 1981 (cat.).– Honnef, K. et al. (ed.): R. G. Westfälischer Kunstverein. Münster 1974 (cat.).– Schilling, J. (ed.): R. G. Arbeiten auf Leinwand und Papier. Kunstverein Hannover. Hanover 1979 (cat.).– Schmied, W. (ed.): R. G. Arbeiten 1953-1989. Kunstverein Ludwigshafen. Ludwigshafen am Rhein 1989 (cat.)

**GLARNER Fritz**
**1899** Zurich – **1972** Locarno
Swiss-American painter. **1914–1920** Studied at the Accademia di Belle Arti in Naples. **1923–1935** Lived in Paris. Attended the Académie Colarossi and became acquainted with Sonja and Robert Delaunay. **1929** First geometric, abstract paintings inspired by his meeting with Mondrian. **1931–1936** Joined Abstraction-Création. **1936** Moved to the USA and took American citizenship. **1938–1944** Member of the group American Abstract Artists. **1945** Began *Relational Paintings*, in which he experimented with alternating and contrast effects between figure and background, thereby extending

Mondrian's theory of Neo-Plasticism. **1955** Took part in documenta 1 in Kassel. **1958–1960** Wall painting for the Time-Life building in New York. **1964** Exhibited at the Venice Biennale.
WRITINGS: F. G.: What Abstract Art Means to Me. The Museum of Modern Art. New York 1951
MONOGRAPHS, CATALOGUES: Arici, L.: Der Tondo im Werk von F. G. Zurich 1987.– Bill, M. and C. Huber (ed.): F. G. Kunsthalle Bern. Bern 1972 (cat.).– Edgar, N. (ed.): F. G. 1944-1970. San Francisco Museum of Modern Art. San Francisco 1970 (cat.).– Frigerio, S.: F. G. Peintures 1949-1962. Paris 1966.– Hrikova, D. (ed.): F. G. im Kunsthaus Zürich. Zurich 1982 (cat.).– Kahn-Rossi, M. (ed.): F. G. Museo Cantonale d'Arte, Lugano et al. Lugano 1993 (cat.).– Mason, R. M. and D. Abadie (ed.): F. G. Dessins, peintures 1940-1969. Cabinet des estampes, Musée d'Art et d'Histoire. Geneva 1979 (cat.).– Staber, M.: F. G. Zurich 1976.– Staber, M. et al. (ed.): F. G. Museo Cantonale d'Arte. Lugano 1993 (cat.).– Wißmann, J. et al. (ed.): F. G. Quadrat, Moderne Galerie Bottrop 1978 (cat.)

**GLEIZES Albert**
**1881** Paris – **1953** St.-Remy-de-Provence
French painter and writer. Trained as a technical draughtsman. **1903** Co-founder of the Salon d'Automne. **1910** Exhibited with leading Cubists, including Delaunay, Le Fauconnier, Metzinger and Picasso at the Salon des Indépendants. **1912** Joined the Section d'Or and, together with Metzinger, published the first theoretical treatise on Cubism: *Du Cubisme*. **1913** Exhibited at the Armory Show in New York. **1914/15** Military service. **1914** Extended trips to America, Spain and Cuba. **1919** Returned to Paris. **1923** Publication of the work *La Peinture et ses lois*, a study of religious art in the Middle Ages. **1927** Founded the craftsmen's association *Moly-Sabata* in Sablons. **1937** Wall paintings for the World Fair in Paris. **1941** Converted to Catholicism, which strongly influenced his attitude to art and also his painting. **1951** Grand Prix at the French Biennale in Menton. **1947** Retrospective in Lyon. **1952** Frescoes on religious themes for the chapel of Les Fontaines in Chantilly. As one of the Cubists around Metzinger,

Gleizes set out the theoretical principles of the style introduced by Braque and Picasso as well as developing them in his own paintings.
WRITINGS: A. G.: La Peinture et ses lois. Paris 1923, Aix-en-Provence 1961.– A. G.: Vers une conscience plastique: La Forme et l'histoire. Paris 1932.– A. G.: Homocentrisme. Sablons 1937.– A. G.: Souvenirs: Le Cubisme 1908-1914. Extraits. Lyon 1957.– A. G.: Puissances du cubisme. Chambéry 1969.– A. G.: Art et religion. Art et science. Art et production. Chambéry 1970.– A. G. and J. Metzinger: Du cubisme. Paris 1912, Sisteron 1980/Kubismus. Munich 1928, Mainz and Berlin 1980
CATALOGUE RAISONNE: Fondation Gleizes (ed.): A. G. Catalogue raisonné (in preparation)
MONOGRAPHS, CATALOGUES: Alibert, P.: A. G. Naissance et avenir du cubisme. Saint-Etienne 1982.– Alibert, P.: G. Biographie. Paris 1990.– Chevalier, J.: A. G. et le cubisme. Basel 1962.– Dorival, B. and P. Alibert (ed.): A. G. 1881-1953. Legs de Madame Juliette Roche Gleizes. Fondation nationale des arts graphiques et plastiques, Paris. Saint-Etienne 1982 (cat.).– Georgel, P. (ed.): Dessins d'A. G. Musée National d'Art Moderne. Paris 1976 (cat.).– A. G. L'œuvre graphique. Musée de l'Imprimerie et de la Banque. Lyon 1990 (cat.).– Henry, A.: A. G. 1881-1953. Musée des Beaux-Arts et d'Archéologie de Besançon. Besançon 1993 (cat.).– Indlefofer Robbins, D. (ed.): A. G. Solomon R. Guggenheim Museum. New York 1964 (cat.).– Robbins, D.: The Formation and Maturity of A. G. Ann Arbor (MI) 1981.– Tapié, A. and P. Alibert (ed.): L'Art sacré d'À. G. Musée des Beaux-Arts de Caen. Caen 1985 (cat.)

**GNOLI Domenico**
**1933** Rome – **1970** Rome
Italian painter. Self-taught. **1953/54** Lived temporarily in London and Paris. **1955** Visited the USA. Worked as a stage-set and costumer designer for various theatres in Italy. **1960** First major solo-exhibition at the Bianchini Gallery in New York, with paintings of domestic items. Illustrated literary publications and magazines such as *Fortune, Holiday* and *Horizon*. **1965** Influenced by American Pop Art and Surrealist Painting, painted enormously enlarged parts of the body and items of clothing. His pictures appeared regularly in the journal of the Society of Illustrators. **1966** Nominated American Illustrator of the Year and awarded a gold medal. In later years, he abandoned his fresco-type painting technique, in which he used a mixture of oil and sand, to work on bronze sculptures. **1968** Took part in documenta 4 in Kassel. **1970** Exhibition at the Krugier Gallery in Genoa. **1987** Retrospective in the Galleria Nazionale d'Arte Moderna in Rome. Gnoli's œuvre combines the commonplace directness of Pop Art with a form of magical, symbolic realism.

**GOBER Robert**
born **1954** Wallingford (CT)
American object artist. **1972–1976** Studied at Middleburg College in Vermont. **1973/74** Attended the Tyler School of Art in Philadelphia. Moved to New York, where he worked as a carpenter and joined the Johanna Boyce dance company. Influenced by minimal artists such as Donald Judd and Carl Andre, he took up sculpture. **1979** Took part in the exhibition "Amore Store" at 112 Greene Street, New York. **1984** First solo-exhibition at the Paula Cooper Gallery. **1986** Worked with the painter Kevin Larmon. Began joint projects with artists such as Christopher Wool, Sherrie Levine and Meg Webster. **1989** Designed the book *Heat*, written by Joyce Carol Oates, and printed the designs from the book onto wallpaper. **1990** Exhibition at the Boymans-van-Beuningen Museum in Rotterdam. **1992** Took part in documenta 9. Gober manually manipulated simple everyday items such as washbasins or playpens, to create installations full of poetic, erotic and ironic allusions.
MONOGRAPHS, CATALOGUES: David, C. and J. Simon (ed.): R. G. Galerie Nationale du Jeu de Paume, Paris et al. Paris 1991 (cat.).– R. G. The Art Institute of Chicago. Chicago 1988 (cat.).– R. G. Museum Boymans-van Beuningen, Rotterdam et al. Rotterdam and Bern 1990 (cat.).– R. G. Galerie Nationale du Jeu de Paume. Paris 1991 (cat.).– R. G. Museo Nacional Centro de Arte Reina Sofia. Madrid 1992 (cat.).– Hickey, D. (ed.): R. G. Dia Center for the Arts. New York 1994 (cat.).– Nesbit, J. et al. (ed.): R. G. Serpentine Gallery, London et al. London 1993 (cat.).– Rouse, Y. (ed.): R. G. Museo Nacional Centro de Arte Reina Sofia. Madrid 1991 (cat.).– Schimmel, P. (ed.):

CATALOGUES RAISONNES: Calvino, I. et al. (ed.): G. Milan 1983.– Sgarbi, V. (ed.): L'opera grafica di D. G. Milan 1985
MONOGRAPHS, CATALOGUES: Carluccio, L.: D. G. Lausanne 1974, New York 1975.– Corral, M. and R. Barilli (ed.): D. G. Ultimas obras 1963-1969. Fundación Caja de Pensiones. Madrid 1990 (cat.).– Cortenova, G. et al. (ed.): D. G. Antologia. Galleria d'Arte Moderna e Contemporanea, Palazzo Forti. Verona 1982 (cat.).– D. G. Palazzo Forti, Verona. Milan 1982 (cat.).– Mantura, B. and M. Quesda (ed.): D. G. Padiglione d'Arte Contemporanea. Milan 1985 (cat.).– Mantura, B. (ed.): D. G. 1933-1970. Galleria Nazionale d'Arte Moderna, Roma. Milan 1987 (cat.).– Meyer zu Eissen, A. (ed.): D. G. 1933-1970. Gemälde, Skulpturen, Zeichnungen, Druckgraphik. Kunsthalle Bremen. Bremen 1981 (cat.).– Prat, J.-L. (ed.): D. G. Fondation Maeght. Saint-Paul 1987 (cat.).– Quesada, M. (ed.): D. G. Palazzo Racani-Arroni, Spoleto. Milan 1985 (cat.).– Quesada, M. (ed.): D. G. Disegno e pittura. Padiglione d'Arte Contemporanea. Milan 1985 (cat.).– Sgarbi, V.: G. Milan 1983

**GOGH Vincent van**
**1853** Groot-Zundert (North Brabant) – **1890** Auvers-sur-Oise (near Paris)
Dutch painter and draughtsman. First employed by a firm of art dealers with branches in The Hague, London and Paris. Worked as an unpaid assistant at an English school, and later as a Methodist preacher in the poor mining community of Borinage in Belgium. When dismissed from this post, he devoted himself to painting. His first paintings were of dismal scenes of poverty, painted in sombre colours. He often returned to his parents' house in Nuenen where, between **1883** and **1885**, he painted his best-known Dutch works. Up to **1886** he lived in Antwerp and tried to study at the Academy there. His discovery of Japanese coloured woodblock prints had a profound and lasting influence on his work. Spent two years in Paris from **1886–1888**, where he met the Impressionists and Gauguin, as well as the Symbolists and Pointillists. **1888** His longing for southern sunlight brought him to Arles, where Gauguin visited him. Between **1889** and **1890** he continued to paint in the asylum at St.-Rémy, after which he turned for help to the patron and friend of many painters, Dr. Paul Gachet, who lived in Auvers-sur-Oise. The doctor could not cure him, and in a severe fit of depression, van Gogh shot himself. In thirty months of frenzied creative activity, between **1888** and his death, van Gogh produced 463 paintings; paintings that became famous all over the world and were fundamental to the development of 20th century art, especially Fauvism and Expressionism.
WRITINGS: V. v. G.: The Complete Letters. 3 vols. London and Greenwich (CT) 1958, 1979/Correspondance complète de V. v. g. 3 vols. Paris 1960/V. v. G. Sämtliche Briefe. 6 vols. Berlin 1965-1968
CATALOGUES RAISONNES: Faille, J. B. d. la (ed.): L'œuvre de V. v. G. Catalogue raisonné. 4 vols. Paris and Brussels 1928.– Faille, J. B. d. la (ed.): The Works of V. v. G. His Paintings and Drawings. Amsterdam and London 1970.– Heutgen, S. van et al. (ed.): V. v. G. Complete Paintings and Drawings. Vol. 1 and 2. London 1996-1997.– Hulsker, J. (ed.): V. G. en zijn weg. Het complete werk. Amsterdam 1977/The Complete V. G. Paintings, Drawings, Sketches. New York 1977.– Hulsker, J. (ed.): The New Complete V. G. Paintings, Drawings, Sketches. Amsterdam and Philadelphia 1996.– Lecaldano, P. (ed.): Tout l'œuvre peint de v. G. 2 vols. Paris 1971.– Testori, G. and L. Arrigoni (ed.): V. v. G. Catalogo completo dei dipinti. Florence 1990.– Walther, I. F. and R. Metzger: V. v. G. Sämtliche Gemälde. 2 vols. Cologne 1989/V. v. G. L'œuvre complète. 2 vols. Cologne 1990/V. v. G. The Complete Paintings. 2 vols. Cologne 1990

R. G. Museum of Contemporary Art. Los Angeles 1997 (cat.).– Vischer, T. (ed.): R. G. Museum für Gegenwartskunst, Basel. Cologne 1995 (cat.)

**GOINGS Ralph**
born **1928** Corning (CA)
American painter. **1950–1953** Studied at the
California School of Arts, Oakland and
**1965/66** at Sacramento State College, Cali-
fornia. **1955–1970** Taught at various schools
and universities in California, including the
State University of Sacramento and the
University of California in Davis. **1972**, in
documenta 5 in Kassel and, in **1974** Took
part in the Tokyo Biennale. Goings is one
of the main exponents of Hyperrealism in
the USA. Status symbols of bourgeois
society, such as houses, swimming pools,
neat front-gardens and the car are recurring
themes in his satirical paintings modelled
on photographs.
MONOGRAPHS, CATALOGUES: Chase,
L.: R. G. New York 1988.– R. G. Tampa
Museum of Art. Tampa (FL) 1987 (cat.)

**GOLDIN Nan**
born **1953** Washington
American photographer. Photographed full-
time from the age of 16. **1973** First solo-
exhibition in Cambridge (MA). **1978**
Moved to New York. Her slide show *The
Ballad of Sexual Dependency* brought her
instant fame in the 80s. This series of about
700 slides, with musical accompaniment,
was shown in galleries, cinemas, museums
and film festivals throughout Europe and
America. The artist received numerous
awards and a DAAD scholarship to Berlin
**1991/92**. From the start, Goldin's photo-
graphy has focused on the theme of human
sexuality. For years she has photographed
both men and women on the borderline of
sexual norms.

**GOLLER Bruno**
**1901** Gummersbach – **1998** Düsseldorf
German painter. Took private lessons from
the landscape painter Julius Jungheim. **1920**
Moved to Düsseldorf. Joined the young
artists' association Das Junge Rheinland
(Young Rhineland) and The Rhenish Seces-
sion. Contact with artists gathered around
the gallery owner Mutter Ey. **1939–1945**
Military service. **1943** All his early works
destroyed in a fire in his Düsseldorf studio.
In his new creative period, his early narrative
formal language is replaced by a symbolic,
magic realism in which commonplace

objects such as hats, umbrellas and ties are
presented in an exaggerated and puzzling
manner. **1949–1964** Professor at the Düs-
seldorf Academy, where his pupils included
K. Klapheck. **1950** Cornelius Award from
the City of Düsseldorf. **1958** Retrospective
at the Kestner Society in Hanover. **1959**
Took part in documenta 2 in Kassel. **1965**
Major art award from the state of Nor-
drhein Westphalen. **1967** Member of the
Berlin Academy of Arts. **1980** Lichtwark
Award, Hamburg. **1981** Retrospective in the
arts centre at the railway station Rolandseck
near Bonn.
MONOGRAPHS, CATALOGUES: B. G.
Städtische Kunsthalle Düsseldorf. Düssel-
dorf 1969 (cat.).– Kahmen, V.: B. G. zum
95. Geburtstag. Rolandseck et al. Bonn
1981.– Klapheck, A.: B. G. Recklinghausen
1958.– Krupp, W. et al. (ed.): B. G. Bilder,
Zeichnungen. Bahnhof Rolandseck et al.
Bonn 1991 (cat.).– Merkert, J. and W.
Schmalenbach (ed.): B. G. Werke aus sechs
Jahrzehnten. Kunstsammlung Nordrhein-
Westfalen. Düsseldorf 1986 (cat.).– Ruhr-
berg, K. (ed.): B. G. Städtische Kunsthalle
Düsseldorf. Düsseldorf 1969 (cat.)

**GOLUB Leon**
born **1922** Chicago
American painter. **1940–1942** Studied
history of art at the University of Chicago.
**1946–1950** Studied painting at the Art
Institute of Chicago. **1943–1946** Military
service. **1950** First solo-exhibition at the
Contemporary Gallery, Chicago. **1951**
Married Nancy Spero. **1956/57** Spent a year
in Italy. **1959–1964** Lived in Paris. **1964** and
**1987** participation in documenta 3 and 8 in
Kassel. **1968** Awarded a Guggenheim grant.
Since **1970** Professor at Rutgers University,
New Brunswick. Golub is an opponent of
Abstract Expressionism, preferring to follow
the representational approach of the
Chicago School of painting. A recurrent
motif in his œuvre is the figure of an iso-
lated, introverted person.
WRITINGS: Obrist, H.-U. (ed.): L. G. Do
Painting Bite? Selected Texts. Stuttgart 1997
MONOGRAPHS, CATALOGUES: Alloway,
L. (ed.): Museum of Contemporary Art,
Chicago 1974 (cat.).– Bird, J. and M.
Newman (ed.): L. G. Mercenaries and
Interrogations. Institute of Contemporary
Arts. London 1982 (cat.).– Fehlemann, S.

(ed.): L. G. Violence Report. Von der
Heydt-Museum, Wuppertal et al. Wupper-
tal 1993 (cat.).– L. G. Kunstverein Mün-
chen. Munich 1993 (cat.).– Gumpert, L.
and N. Rifkin (ed.): L. G. New Museum of
Contemporary Art, New York et al. New
York 1984 (cat.).– Kuspit, D. B.: The Exis-
tential/Activist Painter. The Example of L.
G. New Brunswick (NJ) 1985.– Kuspit, D.
(ed.): L. G. Kunstmuseum Luzern et al.
Lucerne 1987 (cat.).– Marzorati, G.: A
Painter of Darkness. L. G. and Our Times.
New York 1990.– Murphy, P. T. (ed.): L. G.
Paintings 1987-1992. Institute of Contem-
porary Art, University of Pennsylvania.
Philadelphia 1992 (cat.).– Nordgren, S.
(ed.): L. G. Malmö Konsthall et al. Malmö
1992 (cat.).– Robbins, C. (ed.): L. G.
National Gallery of Victoria. Melbourne
1970 (cat.).– Schjeldahl, P. (ed.): G. Barbara
Gladstone Gallery. New York 1986 (cat.)

**GONCHAROVA Natalia**
**1881** Ladyshkino (near Tula) – **1962** Paris
Russian painter and stage designer. **1898**
Studied sculpture at the Moscow Art
Academy. Extensive travels through Europe.
**1904** Took up painting. Met Mikhail Lari-
onov, with whom she exhibited at the Salon
d'Automne in Paris in **1906**. Together they
developed the abstract style Rayonism, an
attempted synthesis of the observed action
of light rays with the Futurist idea of 'lines
of force' and the Cubist fragmentation of
the subject into bundles of slanting lines.
**1913** Along with ten other artists signed a
joint Rayonist and Futurist manifesto.
Launching of Rayonism through the Target
exhibition. **1914** Participation in an exhibi-
tion at the Galerie Guillaume in Paris.
Painted less and began to design sets and
costumes for the theatre and ballet. **1915**
Moved to Paris. Met Diaghilev and
designed sets for his ballets *Le Coq d'Or*,
*Les Noces* and *The Firebird*. From **1917**
illustrated numerous books and worked all
over the world as a stage and costume
designer for theatre and opera. **1948** Retro-
spective in Paris. **1956** Took up painting
again.
MONOGRAPHS, CATALOGUES: Boissel,
J. and G. Viatte (ed.): N. G. & Michael Lari-
onov. Centre Georges Pompidou. Paris 1995
(cat.).– Boissel, J. (ed.): Larionov et G.
Centre Georges Pompidou. Paris 1995
(cat.).– Chamot, M.: G. Paris 1972.–
Chamot, M.: G. Stage Designs and Paint-
ings. London 1979.– Cvetaeva, M. I.: N. G.
Sa Vie, son œuvre. Paris 1990.– M. G.
Musée des Beaux-Arts. Lyon 1969 (cat.).–
Gray, C.: Larionov and G. London 1961.–
Loguine, T.: G. et Larionov. Cinquante ans
à Saint Germain-des-Prés. Paris 1971

**GONZALEZ Julio**
**1876** Barcelona – **1942** Arcueil (near Paris)
Spanish sculptor. Taught metal working by
his father, a goldsmith and sculptor, and
studied painting at the Art Academy in
Barcelona. **1900** Moved to Paris. Friendship

with Picasso, Braque and Brancusi. From
**1908** numerous iron sculptures, inspired
by Cubism. **1927** First forged and cut-out
sculptures *Masques découpés et natures
mortes*. **1929–1932** Intensive collaboration
with Picasso. **1931** Contact with the Sur-
realists and joint-exhibitions at the Salon
des Sur-Indépendants. **1932** Joined the
artists' group Cercle et Carré in Paris. **1937**
First large sculpture *La Montserrat* dis-
played in the Spanish pavilion at the World
Fair in Paris. **1939/40** Started with the series
*Cactus Man*. González' basic, constructive
formal language had a profound influence
on later generations of American and
English sculptors.
WRITINGS: J. G.: Les Matériaux de son
expression. 2 vols. Paris 1970
CATALOGUES RAISONNES: Cerni, V. A.
(ed.): Julio, Joan, Roberta G. Itinerario de
una dinastia. Barcelona 1973.– Gibert, J.
(ed.): J. G. Catalogue raisonné des dessins
de. J. G. 9 vols. Paris 1975.– Merkert, J. et al.
(ed.): J. G. Catalogue raisonné. Milan
1987.– Withers, J. (ed.): J. G. Sculpture in
Iron. New York 1978
MONOGRAPHS, CATALOGUES: Cerni,
V. A.: J. G. Roma 1962.– Cerni, V. A.: J. G.
Madrid 1971.– Curtis, P. (ed.): J. G. Sculp-
tures and Drawings. Art Gallery and
Museum, Glasgow. London 1990 (cat.).–
Degand, L.: G. Cologne 1956, London
1958.– Descargues, P.: J. G. Paris 1971.–
Gibert, J.: J. G. Dessins. 9 vols. Paris 1975.–
J. G. Tate Gallery. London 1970 (cat.).– J.
G. Sculptures and Drawings. Whitechappel
Art Gallery, London et al. London 1990.–
Llorens, T. (ed.): J. G. Las colecciones del
IVAM. Museo Nacional Centro de Arte
Reina Sofia. Madrid 1986 (cat.).– Ritchie, A.
(ed.): J. G. The Museum of Modern Art.
New York 1956 (cat.).– Rowell, M. (ed.): J.
G. 1876-1942. A Retrospective. Solomon R.
Guggenheim Museum, New York et al.
New York 1983 (cat.)/ J. G. 1876-1942.
Akademie der Künste, Berlin et al. Berlin
1983 (cat.).– Stooss, T. and T. Bhattacharya-
Stettler (ed.): J. G. Zeichnen im Raum.
Bern 1997 (cat.).– Vidal, C. et al. (ed.): J. G.
Dibujos. Salas Pablo Ruiz Picasso. Madrid
1982 (cat.).– Withers, J. (ed.): J. G. Les
matériaux de son expression. 2 vols. Galerie
de France. Paris 1970 (cat.).– Withers, J.: J.
G. Sculpture in Iron. New York 1978

**GORKY Arshile**
(Vosdanig Manoog Adoian)
**1950** Hayotz-Dzore (Turkish Armenia) –
**1948** Sherman (CT)
Armenian-born American painter. **1920**
Emigrated to the USA. First auto-didactic
attempts at painting clearly influenced by
Cézanne's works. **1920–1922** Studied at
Rhode Island School of Design. **1923/24**
Taught at the New School of Design in
Boston. Exhibitions of Surrealist Art in New
York in the 30s introduced him to the works
of Picasso, Miró, and Masson, and inspired
experiments with biomorphic forms. From
**1941** worked with luminous grounds and
calligraphic lines. **1947** Abandoned Surreal-

Wilkin, K. (ed.): A. G. Pictographs. Edmonton Art Gallery et al. Edmonton 1977 (cat.).

ism and spoke out against Abstract Expressionism, although he had a fundamental influence on painters in this movement. After paralysing his right hand in a car accident, he commited suicide. With his Color Fields and *hybrid forms*, Gorky played a key role in the development of Abstract Expressionism in America.

CATALOGUE RAISONNE: Goldwater, R. and J. M. Jordan (ed.): The Paintings of A. G. A Critical Catalogue. New York and London 1982
MONOGRAPHS, CATALOGUES: Auping, M. (ed.): A. G. The Breakthrough Years. Modern Art Museum of Fort Worth et al. New York 1995 (cat.).– Billeter, E. (ed.): A. G. Arbeiten auf Papier. Musée Cantonal des Beaux-Arts de Lausanne et al. Bern et al. 1990 (cat.).– Golding, J. et al. (ed.): A. G. 1904-1948. Fundación Caja de Pensiones, Madrid et al. Madrid 1989 (cat.).– Goodrich, L.: A. G. New York 1957.– A. G. Drawings. New York 1970.– A. G. 1904-1948. Fundación Caja de Pensiones, Madrid et al. Madrid and London 1990 (cat.).– Lader, M. P.: A. G. New York 1985.– Levy, J.: A. G. New York 1966.– Melville, R. (ed.): A. G. Paintings and Drawings. Tate Gallery. London 1965 (cat.).– Mooradian, K.: A. G. Chicago 1978, 1980.– Mooradian, K.: The Many Worlds of A. G. Chicago 1980.– Rand, H.: A. G. The Implications of Symbols. Montclair (NJ) and London 1980, Berkeley 1991.– Reiff, R. F.: A Stylistic Analysis of A. G.'s Art from 1943-1948. New York 1977.– Rosenberg, H.: A. G. The Man, the Time, the Idea. New York 1962.– Schwabacher, E. (ed.): A. G. Memorial Exhibition. Whitney Museum of American Art, New York et al. New York 1951 (cat.).– Schwabacher, E. K.: A. G. New York 1957.– Seitz, C. (ed.): A. G. Paintings, Drawings, Studies. The Museum of Modern Art, New York et al. New York 1962 (cat.).– Spende, M. and B. Rose (ed.): A. G. and the Genesis of Abstraction. Drawings from the Early 1930's. Princeton (NJ) et al. Princeton 1994 (cat.).– Waldman, D. and D. Tabak (ed.): A. G. 1904-1948. A Retrospective. Solomon R. Guggenheim Museum. New York 1981 (cat.)

## GORMLEY Anthony

born **1950** London
English sculptor. **1968-1970** Studied at Trinity College, Cambridge, **1973/74** at the Central School of Art and Design in London, and **1975-1977** at Goldsmith's College. **1981** First solo-exhibition at the Serpentine Gallery and Whitechapel Gallery, London. **1987** Participated in documenta 8 in Kassel. **1991** Designed an installation, entitled *Field*, consisting of 35,000 small terracotta figures, which was shown that year at the Galerie Salvatore Ala in New York. **1996** Guest-professor at the Munich Academy. Gormley's works are references to urban architecture. His stylised human figures are mostly made of lead, covered with fibreglass and terracotta, with

dimensions based on his own body measurements.

MONOGRAPHS, CATALOGUES: Briggs, L. et al. (ed.): A. G. Malmö Konsthall et al. Malmö 1993 (cat.).– Champ: A. G. Musée des Beaux Arts, Montreal. Stuttgart 1993 (cat.).– A. G. Malmö Konsthall et al. Malmö 1993 (cat.).– A. G. Body and Light and Other Drawings. 1990-1996. London 1996 (cat.).– A. G. Still Moving. Works 197-1996. Kamakura et al. Kamakura 1996 (cat.).– Hutchinson, J. and L. B. Njatin (ed.): A. G. London 1995.– Loers, V. et al. (ed.): A. G. Städtische Galerie, Regensburg et al. Regensburg 1985 (cat.).– Lomax, J. (ed.): A. G. Sculpture. Whitechapel Art Gallery. London 1981 (cat.)

## GOTTLIEB Adolph

**1903** New York – **1974** New York
American painter. **1920-1924** Studied under Robert Henri and John Sloan at the Art Students League in New York. **1921** Studied in Paris. **1935** Founder-member of the Expressionist group The Ten. **1939** Wall paintings for the post office in Yerington, Nevada. From **1941** produced *Pictographs*, symbolic drawings in a magic realist style. **1944/45** Director of the Federation of Modern Painters and Sculptors in New York. After **1951** numerous paintings for synagogues in Millburn, Springfield and New York. From **1957** reduced his pictorial language to a few minimal elements such as orbs and blotches hovering in suspended tension. **1959** Participated in documenta 2 in Kassel. **1963** Major prize at the São Paulo Biennale. **1974** Member of the New York Art Commission. Gottlieb's condensed pictorial language aligns him with Abstract Expressionists such as Marc Rothko and Franz Kline.

MONOGRAPHS, CATALOGUES: Alloway, L. and M. D. MacNaughton (ed.): A. G. 1903-1974. A Retrospective. Corcoran Gallery of Art, Washington et al. New York 1981 (cat.).– Burns O'Connor, L. (ed.): The Pictographs of A. G. The Phillips Collection, Washington DC. New York 1994 (cat.).– Doty, R. and D. Waldman (ed.): A. G. Solomon R. Guggenheim Museum. New York et al. 1968 (cat.).– Friedman, M.: A. G. Minneapolis 1963.– Hirsch, S. et al. (ed.): The Pictographs of A. G. Phillips Collection, Washington. New York 1994 (cat.).–

## GÖTZ Karl Otto

born **1914** Aachen
German painter. **1932-1934** Attended the School of Arts and Crafts in Aachen. **1935/36** Travelled throughout Switzerland and Italy. **1936** Made abstract films and experimented with photographic painting and photograms. **1945** Joined Baumeister, Hartung and Nay in the group Rosen-Kreis. **1948-1953** Editor of the journal *Meta*. **1949** Contact with the Cobra artists. Contributed to their magazine. **1952** Together with O. Greis, H. Kreutz and Schultze, founded the group Quadriga in Frankfurt. First Informel paintings inspired by Wols and Tachisme. **1958** Participated in the Venice Biennale and **1959** in documenta 2 in Kassel. **1959-1979** Taught painting at the Düsseldorf Academy. Götz' calligraphic improvisations make him one of the main exponents of Lyrical Abstraction in Germany.

WRITINGS: K. O. G.: Bildende Kunst und Kommunikation. Düsseldorf 1965.– K. O. G.: Erinnerungen und Werk 1914-1959. 2 vols. Neuss 1983.– K. O. G.: Erinnerungen 1959-1975. Aachen 1996
CATALOGUES RAISONNES: Geiger, U. und Manfred Hügelow (ed.): K. O. G. Werkverzeichnis der Original-Lithographien 1946-1994. Offenbach 1995
MONOGRAPHS, CATALOGUES: Bojescul, W. (ed.): K. O. G. Bilder und Arbeiten auf Papier 1935-1988. Kunstverein Braunschweig. Brunswick 1988 (cat.).– Grohmann, W.: K. O. G. Malerei 1940-1943. Witten 1948.– Grohmann, W. et al. (ed.): K. O. G. Roma 1962.– Harten, J. and M. Heinz (ed.): K. O. G. Monotypien, Gemälde, Gouachen 1935-1983. Städtische Kunsthalle Düsseldorf et al. Düsseldorf 1984 (cat.).– K. O. G. Gemäldegalerie Neuer Meister. Dresden 1994 (cat.).– Motte, M. d. la (ed.): K. O. G. Eine Dokumentation. Galerie Hennemann. Bonn 1978

## GRAESER Camille

**1892** Carouge (Canton Geneva) – **1980** Zurich
Swiss painter and interior designer. **1913-1915** Studied interior- and product design

at the School of Arts and Crafts in Stuttgart. Member of the Werkbund in Germany. Contact with Herwarth Walden's Sturm gallery in Berlin. **1918/19** Private painting lessons with Adolf Hoelzel. **1929** Worked for Mies van der Rohe at Weissenhof in Stuttgart. **1933** Destroyed a large portion of his œuvre and Bill and Richard Paul Lohse in the Zürcher Konkrete began developing a new, abstract-constructivist style. **1938** Became a member of the group *Allianz*. **1964** Retrospective at the Kunsthaus Zurich. **1975** Art award from the City of Zurich. **1977** Took part in documenta 6 in Kassel. In Graeser's paintings basic, geometric forms are built into *Dynamic Constructions, Rotations* and *Loxodromic Compositions*.

CATALOGUES RAISONNES: Paradowski, S. (ed.): C. G. Druckgraphik und Multiples. Zurich 1990.– Schwarz, D. (ed.): C. G. Zeichnungen. Zurich 1986
MONOGRAPHS, CATALOGUES: Billeter, E. et al. (ed.): C. G. Kunsthaus Zurich et al. Zurich 1979 (cat.).– Heckmanns, F. W. et al. (ed.): C. G. Retrospektive. Westfälisches Landesmuseum, Münster et al. Münster 1976 (cat.).– Koella, R. (ed.): C. G. 1892-1980. Kunstmuseum Winterthur et al. Zurich, Munich and Stuttgart 1992 (cat.).– Ludwig, J. and D. Zinke (ed.): C. G. Museum für Neue Kunst, Freiburg et al. Freiburg and Zurich 1988 (cat.).– Müller, F. and E. Gomringer: C. G. Eine Monographie. Teufen 1968.– Rotzler, W.: C. G. Lebenswerk und Lebensweg eines konstruktiven Malers. Zurich 1979

## GRANDMA MOSES

(Anna Mary Robertson)
**1860** Eagle Bridge (NY) – **1961** Hoosick Falls (NY)
American naive painter. Married to a farmer, she first began to paint in **1930** at the advanced age of 70. **1938** First exhibition in a drugstore. **1939** Became widely known for her paintings of the seasons, shown at the exhibition "Unknown American Painters". **1952** Publication of her autobiography *My Life's History*. **1962** Solo-exhibition at the Galerie St. Etienne, New York. Grandma Moses is one of the main representatives of naive painting in America. Her portrayals of the landscapes of her homeland and childhood memories are not painted on canvas, but on plywood covered with three coats of white paint, so as to capture and enhance the magic of light.

WRITINGS: Kallir, O. (ed.): G. M. My Life's History. New York 1948, 1952
CATALOGUES RAISONNES: Kallir, O. (ed.): G. M. New York 1973/G. M. Ihre Kunst und ihre Persönlichkeit. Cologne 1979
MONOGRAPHS, CATALOGUES: Brown, C.: A. M. R. M. 1860-1961. National Gallery of Art. Washington 1979 (cat.).– G. M. The Artist Behind the Myth. New York State Museum. Albany 1983 (cat.).– Johansson, E.: R. M. Copenhagen 1962.– Kallir, J.: G. M. The Artist Behind the

Myth. New York 1982.– Ketchum, W.: G. M. An American Original. New York 1996.– Nirenstein, O.: Grandma Moses. New York 1973

**GRAUBNER Gotthard**
born **1930** Erlbach
German painter. **1947/48** Studied at the Berlin School of Fine Arts, **1948–1952** at the Dresden Art Academy and **1954–1959** at the Düsseldorf Academy. **1965** Taught at the Berlin School of Fine Arts. During his professorship at this school (**1969–1972**) he soaked cushions with synthetic covers in thinned paints, in an attempt to embody colour and make out of it a spatial entity. **1968** and **1977** participated in documenta 4 and 6 in Kassel. Created environments entitled *Nebelräume* (Fog Rooms). **1971** Extended his cushion series, creating *Farbraumkörpern* (Spatial colour bodies), enormous painted pillows. Extended trips to Central and South America. **1973** Study trip to Asia. **1976** Professor of Painting at the Düsseldorf Academy. **1988** Interior decoration of the official residence of the Bundespräsident in Schloss Bellevue, Berlin. MONOGRAPHS, CATALOGUES: Bleyl, M.: G. G. Farbraumkörper der XL. Biennale Venice 1982. Frankfurt-on-Main 1991.– Güse, E. (ed.): G. G. Malerei. Saarland Museum, Saarbrücken et al. Saarbrücken and Cologne 1995 (cat.).– Harten, J. et al. (ed.): G. G. Farbräume, Farbraumkörper, Arbeiten auf Papier. Städtische Kunsthalle Düsseldorf. Düsseldorf 1977 (cat.).– Helms, D. et al. (ed.): G. G. Werke 1959-1969. Kunstverein für die Rheinlande und Westfalen. Düsseldorf 1969 (cat.).– Helms, D.: G. G. Recklinghausen 1974.– Hofmann, W. (ed.): G. G. Hamburger Kunsthalle. Hamburg 1975 (cat.).– Imdahl, M. et al. (ed.): G. G. Staatliche Kunsthalle Baden-Baden et al. Baden-Baden 1980 (cat.).– Merkert, J. and M. Imdahl (ed.): G. G. Malerei aus den Jahren 1984-1986. Kunstsammlung Nordrhein-Westfalen. Düsseldorf 1987 (cat.).– Peters, H. A. (ed.): G. G. Kunstmuseum. Düsseldorf 1982 (cat.).– Salzmann, S. et al. (ed.): G. G. Malerei auf Papier. Kunsthalle Bremen et al. Bremen 1990 (cat.).– Schmidt, K. (ed.): G. G. Farbräume, Farbraumkörper. Arbeiten auf Papier. Städtische Kunsthalle Düsseldorf. Düsseldorf 1977 (cat.).– Schmidt, K. and B. Growe (ed.): G. G. Zeichnung, Aquarell. Städtisches Kunstmuseum Bonn. Bonn 1986 (cat.).– Schmied, W. and V. Kahmen (ed.): G. G. Kestner-Gesellschaft. Hanover 1969 (cat.)

**GRAVES Nancy**
**1940** Pittsfield (MA) – **1995** New York
American painter and object artist. **1957–1961** Studied literature at Vassar College in New York. **1961–1964** Studied art at Yale University, New Haven (CT). **1964/65** Trips to Paris and Italy. Developed the theme of the camel in drawings, sculptures and films. **1968** First solo-exhibition in the Graham Gallery, New York. **1969** First woman to

have a solo-exhibition in the Whitney Museum of American Art in New York. **1970** Made her first five documentary films. **1972** Focused once again on painting, producing expressive abstract paintings inspired by photographs of the surface of the moon. **1972** and **1977** participation in documenta 5 and 6 in Kassel. From **1976** experimented with old bronze casting techniques. Incorporated various materials, collected on her extensive travels, into her sculptures and objects. **1985** Received the Yale Arts Award. **1986** Created an outdoor sculpture for the United Missouri Bank, Kansas City. **1987** Retrospective at the Hirshhorn Museum, Washington. CATALOGUE RAISONNE: Carmean, E. A. et al. (ed.): The Sculpture of N. G. A Catalogue Raisonné. Fort Worth Art Museum et al. New York 1987 (cat.).– Pardon, T. (ed.): N. G. Excavations in Print. New York 1996 MONOGRAPHS, CATALOGUES: Bricker Balken, D. (ed.): N. G. Painting, Sculpture, Drawing 1980-1985. Vasar College, Poughkeepsie et al. Poughkeepsie (NY) 1986 (cat.).– Cassidy, M. (ed.): N. G. Institute of Contemporary Art. Philadelphia 1972 (cat.).– Cathcart, L. L. (ed.): N. G. A Survey 1969-1980. Albright-Knox Art Gallery, Buffalo et al. Buffalo 1980 (cat.).– Tuchman, P. (ed.): N. G. Sculpture, Drawings, Films 1969-1971. Neue Galerie der Stadt Aachen. Aachen 1971 (cat.)

**GREEN Alan**
born **1932** London
English painter and graphic artist. **1949–1953** Studied at the Beckenham School of Art in Kent, and **1955–1958** at the Royal College of Art in London. **1953–1955** Military service. **1961–1966** Taught at Leeds College of Fine Arts. **1963** First solo-exhibition at the A1A Gallery in London. **1972/73** Produced *Block Paintings* and *Column Paintings*, in which several layers of paint document the process of picture production. From **1974** combined single panels into larger polyptychs. Started to work on graphic reproductions. **1977** Participated in documenta 6 in Kassel. **1979** Received special honours at the International Graphic Biennale in Tokyo. Green is famous for his structured grid-like paintings which are a schematic representation of the interaction of a limited number of colours.

**GRIS Juan**
(José Victoriano Gonzáles)
**1887** Madrid – **1927** Boulogne-sur-Seine
Spanish painter. **1902–1904** Studied at the School of Arts and Crafts in Madrid while working as an illustrator on satirical periodicals. **1906** Went to Paris, where he rented a room in the same studio-apartment house as Picasso. Encouraged by the art dealer Daniel-Henry Kahnweiler to join the Cubists Picasso and Braque and develop their artistic ideas. **1912** Exhibition at the Salon des Indépendants. First *papiers collés*. **1914** Visited Collioure and became friends with Matisse. **1916–1919** Tectonic period. Subordination of form and colour to compositional structure. **1919** First major solo-exhibition organised by the art dealer Rosenberg. Participated in the last joint Cubist exhibition at the Salon des Indépendants. **1922/23** Designed stage sets and costumes for Diaghilev's ballets. **1924** Gave a lecture at the Sorbonne entitled *Sur les possibilités de la peinture* (The Possibilities of Painting). In his last years, Gris worked mostly as an illustrator. His goal was to combine the separate phases of Cubism and all the directions the movement had taken into one approach: Synthetic Cubism.
WRITINGS: Cooper, D. (ed.): The Letters of J. G. London 1956.– J. G.: Des possibilités de la peinture. Caen 1989/Über die Möglichkeit der Malerei. Hamburg 1997 CATALOGUE RAISONNE: Cooper, D. and M. Potter (ed.): J. G. Catalogue raisonné de l'œuvre peint. 2 vols. Paris 1977 MONOGRAPHS, CATALOGUES: Bréon, E.: J. G. à Boulogne. Paris 1992.– Cooper, D. (ed.): J. G. Staatliche Kunsthalle Baden-Baden. Stuttgart 1974 (cat.).– Derouet, C. (ed.): J. G. Correspondance. Dessins 1915-1921. IVAM Centro Julio González, Valencia/Centre Georges Pompidou. Valencia 1990, Paris 1991 (cat.).– Gaya-Nuño, J. A.: J. G. Geneva and Paris 1974, Boston 1975, New York 1986.– Green, C. et al. (ed.): J. G. Whitechapel Art Gallery, London et al. London and Stuttgart 1992 (cat.).– Kahnweiler, D. H.: J. G. Sa Vie, son œuvre, ses écrits. Paris 1946, 1990/J. G. His Life and Work. London and New York 1947, 1969/J. G. Leben und Werk. Berlin 1929, Stuttgart 1968.– Leymarie, J. (ed.): J. G. Orangerie des Tuileries. Paris 1974 (cat.).– Overy, P.: K. The Language of the Eye. New York 1969.– Richardson, J. (ed.): J. G. Museum am Ostwall. Dortmund 1965 (cat.).– Rosenthal, M. (ed.): J. G. National Gallery of Art, Washington et al. Berkeley and New York 1983 (cat.).– Schmidt, G.: J. G. und die Geschichte des Kubismus. Baden-Baden 1957.– Soby, J. T. (ed.): J. G. The Museum of Modern Art. New York 1958 (cat.).– Tinterow, G. (ed.): J. G. Salas Pablo Ruiz Picasso. Madrid 1985 (cat.).– Waldemar, G.: J. G. Paris 1931

MONOGRAPHS, CATALOGUES: Franz, E. (ed.): A. G. Paintings 1969-1979. Kunsthalle Bielefeld. Bielefeld 1979 (cat.)

**GROMAIRE Marcel**
**1892** Noyelles-sur-Sambre – **1971** Paris
French painter and graphic artist. Attended various private schools in Montparnasse, including the Académie de la Palette and the Académie Colarossi. Acquainted with pupils of Matisse. **1911** Exhibited at the Salon des Indépendants. **1914** Military service. **1916** Wounded. After the First World War he developed a monumental, expressive style, influenced by the works of Léger. **1918** Woodcuts as illustrations for the book *Homme de Troupe*. **1922** First etchings. **1925** Illustrations for *Ruptures*. **1937** Member of the Société des Peintres-Graveurs français. Designed the Sèvres pavilion at the World Fair in Paris. **1939** Worked with Jean Lurçat as a designer at the Gobelin manufacturers in Aubusson. His tapestries had powerful structural elements with less emphasis on colour. **1952** Carnegie award. **1977** Retrospectives in Chicago and **1980** at the Musée d'Art Moderne de la Ville de Paris.
WRITINGS: M. G.: L'Art moderne. Paris 1919.– M. G.: Notes sur l'art d'aujourd'hui. Paris 1919
CATALOGUES RAISONNES: Gromaire, F. (ed.): L'œuvre gravé de M. G. 2 vols. Lausanne and Paris 1976.– Gromaire, F. and F. Chibret-Plaussus (ed.): M. G. La Vie et l'œuvre. Catalogue raisonné des peintures. Paris 1993
MONOGRAPHS, CATALOGUES: Besson, G.: M. G. Paris 1950.– Briot, M.-O. (ed.): M. G. 1892-1971. Musée d'Art Moderne de la Ville de Paris. Paris 1980 (cat.).– Briot, M.-O. (ed.): M. G. Peinture 1921-1939. Paris 1980.– Cassou, J.: M. G. Paris 1925.– Cassou, J. (ed.): M. G. Musée d'Art Moderne de la Ville de Paris. Paris 1963 (cat.).– George, W.: M. G. Paris 1928.– M. G. L'œuvre gravé 1892-1971. Musée du Dessin. Gravelines 1980 (cat.).– Johnson, R. S. (ed.): M. G. 1892-1971. R. S. Johnson Fine Art. Chicago 1987 (cat.).– Zahar, M.: G. Geneva 1961

**GROSSBERG Carl**
**1894** Wuppertal-Elberfeld – **1940** Laon
German painter. **1913/14** Studied architecture in Aachen and Darmstadt. **1914–1918** Military service. **1919–1921** Studied at the Weimar Academy of Arts and the Bauhaus, where his teachers included Feininger. **1921**

Moved to Sommerhausen near Würzburg. **1925** Visited the Netherlands. Drawings and watercolours of industrial landscapes. **1926** First solo-exhibition at the Neumann-Nierendorf gallery and Kunsthaus Schaller in Stuttgart. **1929** Took part in the exhibition "Neue Sachlichkeit" (New Objectivity) at the Stedelijk Museum in Amsterdam. **1931** Won the Rome Award from the Prussian Academy of Arts, a scholarship to Villa Massimo in Rome. **1934** Retrospective at the Kestner Society in Hanover. Commission for a propagandist mural *Deutsches Volk, deutsche Arbeit* (German people, German work). **1935** Retrospective at the Folkwang Museum, Essen. **1939/40** Military service in Poland and France, where he died after a car crash.
CATALOGUE RAISONNE: Fehlemann, S. (ed.): C. G. Retrospektive zum 100. Geburtstag. Von der Heydt-Museum, Wuppertal et al. Cologne 1994 (cat.)
MONOGRAPHS, CATALOGUES: Hamburger, D.: C. G. Industrie und Imagination in der Malerei der Neuen Sachlichkeit. Kassel 1990.– Schmidt, H.-M. (ed.): C. G. Gemälde, Aquarelle, Zeichnungen und Druckgraphik. Hessisches Landesmuseum, Darmstadt et al. Darmstadt 1976 (cat.)

**GROSZ George**
**1893** Berlin – **1959** Berlin
German painter and graphic artist. **1909**–**1912** Studied at the Dresden Art Academy and **1912**–**1916** at the School of Arts and Crafts in Berlin, under Emil Orlik. **1914**–**1916** and **1917/18** military service. Court-marshalled for anti-war protests. **1918** Co-founder of the Berlin Dada group. Joined the German Communist Party. **1919/20** Co-editor of the publications *Der blutige Ernst*, *Die Pleite* and *Der DADA*. **1920** First solo-exhibition at the Hans Goltz gallery in Munich. Prosecuted for attacking the military in his portfolio *Gott mit uns* (God with us). Helped to set up the first international DADA-Messe (Dada trade fair) in Berlin. **1922** Went to Russia. **1923** Charged with obscenity for his collection of drawings *Ecce Homo*. One-man exhibition at Alfred Flechtheim's gallery. **1924** Director of the Rote Gruppe (Red Group), Berlin: contributed to the magazines *Der Knüppel* and *Der Querschnitt*. **1925** Took part in the exhibition "Neue Sachlichkeit" (New Objectivity) in the Kunsthalle Mannheim. Publication of *Spießer-Spiegel*. **1926** Co-publication, with Herzfelde, of the pamphlet *Die Kunst ist in Gefahr* (Art is in Danger). **1929** Took part in the exhibition "Neue Sachlichkeit" at the Stedelijk Museum in Amsterdam. **1931** Guest-lecturer at the Art Students League in New York. **1933** Emigrated to the USA. Opened his own art institute, the Sterne-Grosz School. **1937** Included in the exhibition of "degenerate art" in Munich. Confiscation of 385 works. **1940** Awarded the Carol H. Beck Medal. **1954** Major retrospective at the Whitney Museum of American Art, New York. Elected member of the American Academy of Arts and Letters. **1958** Member of the Academy of Arts in Berlin. **1959** Awarded a Gold Medal by the United States National Institute of Arts and Letters.
WRITINGS: G. G.: Die Kunst ist in Gefahr. Berlin 1925.– G. G.: A Little Yes and a Big No. New York 1946/Ein kleines Ja und ein großes Nein. Sein Leben von ihm selbst erzählt. Reinbek 1974.– G. G.: Briefe 1913-1939. Ed. by H. Knust. Reinbek 1979.– G. G.: An Autobiography. New York 1983.– G. G.: Ach knallige Welt, du Lunapark. Gesammelte Gedichte. Munich 1986.– Knust, H. (ed.): G. G. Briefe 1913-1959. Reinbek 1979
CATALOGUE RAISONNE: Dückers, A. (ed.): G. G. Das druckgraphische Werk. Frankfurt-on-Main et al. 1979, San Francisco 1996
MONOGRAPHS, CATALOGUES: Anders, G.: G. G. Zurich 1961.– Baur, J. I. H.: G. G. New York 1954.– Bittner, H. (ed.): G. G. New York 1960.– Fischer, L.: G. G. in Selbstzeugnissen und Bilddokumenten. Reinbek 1976.– Flavell, K. M.: G. G. A Biography. New Haven (CT) 1988.– Hess, H.: G. G. London 1974, New Haven (CT) 1985, Dresden 1982.– Kane, M.: Weimar Germany and the Limits of Political Art: A Study of Work of G. G. and Ernst Troller. Tayport 1987.– Kranzfelder, I.: G. G. 1893-1959. Cologne 1994.– Lang, L. (ed.): G. G. Berlin 1979.– Lewis, B. I.: G. G. Art and Politics in the Weimar Republic. Princeton (NJ) 1991.– McCloskey, B.: G. G. and the Communist Party. Princeton (NJ) 1997.– Neugebauer v. d. Schulenburg, R.: G. G. Macht und Ohnmacht satirischer Kunst. Berlin 1993.– Sabarsky, S. (ed.): G. G. Gli anni di Berlino. Palazzo Reale. Milan 1985 (cat.)/G. G. Die Berliner Jahre. Museum Villa Stuck. Munich 1986 (cat.)/G. G. The Berlin Years. New York 1985.– Schneede, U. M. et al. (ed.): G. G. Leben und Werk. Hamburger Kunstverein. Stuttgart 1975 (cat.)/G. G. His Life and Work., London 1979.– Schneede, U. M.: G. G. Der Künstler in seiner Gesellschaft. Cologne 1977, 1984.– Schuster, P. K. (ed.): G. G. Berlin – New York. Nationalgalerie Berlin et al. Berlin 1995 (cat.).– Whitford, F. (ed.): The Berlin of G. G. Drawings, Watercolors and Prints 1912-1930. Royal Academy. London 1997 (cat.).

**GRUBER Francis**
**1912** Nancy – **1948** Paris
French painter. **1929**–**1932** Studied at the Académie Scandinave under H. Dufresne, Friesz and Waroquier. Visited the studios of Braque and Bissière. Studied old German painting. **1936** Designed a wall painting for the Lycée de Lakanel in Sceaux. **1937** Took part in the group exhibitions "Salon des jeunes artistes" and "L'Art cruel" at the Billiet-Worms gallery. **1942** His painting *Hommage à Jacques Callot*, exhibited at the Friedland gallery, earned him widespread recognition. **1947** Prix National de la peinture. **1949** Retrospective at the 60th Salon des Indépendants. **1959** Retrospective at the Tate Gallery, London. Gruber's compositions, which can be taken as examples of Fantastic Realism, had a decisive influence on the works of Bernard Buffet and Alberto Giacometti.
MONOGRAPHS, CATALOGUES: Bernad-Gruber, C. and A. Vanazzi: F. G. Neuchâtel 1989.– Dorival, B. (ed.): F. G. Musée National d'Art Moderne. Paris 1976 (cat.).– F. G. Musée d'Art Moderne de la Ville de Paris. Paris 1976 (cat.).– Huyghe, R. (ed.): F. G. 1912-1948. Tate Gallery. London 1959 (cat.).– Schmidt, M. and J. Gachnang (ed.): F. G. 1912-1948. Kunsthalle Bern et al. Bern 1976 (cat.).– Testori, G. et al. (ed.): F. G. 1912-1948. Compagnia del disegno. Milan 1991 (cat.)

**GRÜTZKE Johannes**
born **1937** Berlin
German painter. **1957**–**1964** Studied at Berlin School of Fine Arts. Prize pupil of Peter Janssen. **1973** Together with Manfred Bluth, Mathias Koeppel and Karlheinz Ziegler founded the Schule der neuen Prächtigkeit (School of New Magnificence). **1978/79** Published three plays, *Pantalon Ouvert*, *Im Watt* and *Die Schaukel*, and devoted his time to stage design. From **1985** artistic advisor to Peter Zadek in Hamburg. **1987/88** Monumental wall paintings portraying German parliamentarians in St. Paul's church in Frankfurt. Grützke uses critical realism and a traditional painting style modelled on the Old Masters to expose empty demonstrations of pathos and to parody certain forms of behaviour.
CATALOGUE RAISONNE: Holeczek, B. (ed.): J. G. Werkverzeichnis der Druckgraphik 1964-1975. Freiburg 1975
MONOGRAPHS, CATALOGUES: Bacher, J. (ed.): J. G. Theater der Menschheit. Aachen et al. Aachen 1997 (cat.).– Grisebach, L. et al. (ed.): "Unser Fortschritt ist unaufhörlich". J. G. Skizzen zu Bildern. Nationalgalerie. Berlin 1984 (cat.).– Hoffmann, K. and K. Beck (ed.): J. G. Kunstpreisträger der Stadt Wolfsburg. Städtische Galerie und Kunstverein Wolfsburg. Wolfsburg 1992 (cat.).– Holeczek, B. and E. Schenk zu Schweinsberg (ed.): J. G. Gemälde 1964-1977. Kunstverein Braunschweig. Brunswick 1977 (cat.).– Jensen, J. C. (ed.): J. G. Neue Bilder 1988-1990. Gemälde und Pastelle. Kunsthalle zu Kiel. Kiel 1990 (cat.)

**GUNDLACH F. C.**
born **1926** Heinebach (Hesse)
German photographer. **1947**–**1949** Studied at the Institute of Photography in Kassel. **1954** Set up his own photographic studio in Stuttgart. **1956** Moved his business to Hamburg and began working as a fashion photographer for women's magazines such as *Film und Frau*, *Elegante Welt* and *Annabelle*. Up to **1968** put together photo-reportages on *haute couture* in Paris. Also specialised in taking portraits of filmstars.

**1975** Founded the PPS-Galerie in Hamburg, with the aim of promoting photography and the recognition of photographs as art works and collector's items.
MONOGRAPHS, CATALOGUES: F. C. G. and U. Richter (ed.): Berlin en Vogue. Geschichte der Modephotographie in Berlin. Berlin 1993.– Honnef, K. (ed.): F. C. G. Modewelten. Photographien 1950 bis heute. Rheinisches Landesmuseum, Bonn et al. Berlin 1986 (cat.)

**GÜNTHER Ingo**
born **1957** Bad Eilsen (near Hanover)
German video and multimedia artist. **1978**–**1983** Studied at the Düsseldorf Art Academy under Uecker and Paik. **1979** First video sculptures and installations. **1982** Worked with the American Peter Fend on the project *Ocean Earth Corp.*, questioning the extent of man's capacity to process the huge amounts of data obtainable through computerised satellite photography. **1984** Participation at the Venice Biennale, and **1987** in documenta 8 in Kassel. **1990** Set up an independent TV broadcasting station *Kanal X* in Leipzig. Professorship at the Media Arts Academy in Cologne. Günther, one of the third-generation video artists, explores the technical possibilities of information manipulation in his sculptural video works.
MONOGRAPHS, CATALOGUES: Dehara, H. (ed.): I. G. After Hiroshima. Hiroshima City Museum of Contemporary Art. Hiroshima 1995.– Diwo, M. D.: Gesellschaftskritische Aspekte bei Joseph Beuys, Lothar Baumgarten und I. G. Bonn 1993.– I. G. World Processor. Produzentengalerie Hamburg. Hamburg 1989 (cat.)

**GURSKY Andreas**
born **1955** Leipzig
German photographer. **1978**–**1981** Attended the Folkwangschule in Essen. **1981**–**1987** Studied at Art Academy in Düsseldorf under Prof. Bernd Becher, among other teachers. From **1981**–**1984** produced serial works, while after **1984** he tended to take single pictures, each with a different motif. **1987** First solo-exhibition at Düsseldorf airport. **1989** Won the "Erster Deutscher Photopreis" (First German Photographic Award) and took part in the first

international Photo-Triennale in Esslingen. **1990** Participated in the Venice Biennale. **1991** Won the "Bremer Kunstpreis" (Bremen Art Award) and the Renta Prize awarded by the Kunsthalle Nuremberg. **1994** Solo-exhibition at the Deichtorhallen in Hamburg. Gursky's photographs are inspired by various motifs and genres from the history of art and photography. For him, pictorial language is more important than experiments with phototechnical processes.
MONOGRAPHS, CATALOGUES: Bradley, F. (ed.): A. G. Bilder. Tate Gallery Liverpool. Stuttgart 1995.– Bürgi, B. (ed.): A. G. Kunsthalle Zürich. Cologne 1992 (cat.).– Felix, Z. (ed.): A. G. Fotografien 1984-1993. Deichtorhallen, Hamburg et al. Munich 1994.– A. G. Kunsthalle Zürich. Zurich 1992 (cat.).– Irrek, H. (ed.): A. G. Montparnasse. Portikus, Frankfurt-on-Main. Stuttgart 1995 (cat.).– Heynen, J. (ed.): A. G. Krefelder Kunstmuseum. Krefeld 1989 (cat.).– Tuyl, G. v. (ed.): A. G. Photographien 1994-1997. Kunstmuseum Wolfsburg. Wolfsburg 1998 (cat.)

**GUSTON Philip**
**1913** Montreal – **1980** Montreal
Canadian-born American painter. Short training at the Arts High School and the Otis Art Institute in Los Angeles. Friendships with Pollock, De Kooning, Arshile Gorky and James Brooks. **1934/35** Extended trip to Mexico. Mexican wall paintings and his study of the works of Picasso and de Chirico pushed him towards realism and social criticism in his art. Moved to New York. **1940** Involved in the WPA Federal Art Project. **1941-1947** Taught at the University of Iowa, Ames and later at Washington University in St. Louis. **1945** First solo-exhibition at the Midtown Galleries in New York. **1947** Guggenheim grant. **1949** Tours of Spain, Italy and France. Abandoned figurative paintings for lyrical, abstract improvisations. **1959** Participation in documenta 2 in Kassel. **1960** Participation at the Venice Biennale. **1962** Retrospective at the Guggenheim Museum, New York. **1968** Took up figurative painting again, but with parodistic elements. Though Guston's paintings from the 50s are representative of Abstract Impressionism, his works from the 80s anticipate New Image Painting.
MONOGRAPHS, CATALOGUES: Arnason, H. et al. (ed.): P. G. Solomon R. Guggenheim Museum. New York 1962 (cat.).– Ashton, D.: A Critical Study of P. G. New York 1976, Berkeley 1990.– Corbett, W.: P. G.'s Late Work. A Memoir. Cambridge (MA) 1994.– Dabrowski, M. (ed.): The Drawings of P. G. The Museum of Modern Art, New York et al. New York 1988, London 1992 (cat.).– Dabrowski, M. (ed.): P. G. Opere su carta 1933-1980. Roma 1989 (cat.).– Feld, R. and H. Hopkins (ed.): P. G. San Francisco Museum of Modern Art et al. New York 1980 (cat.).– Feldman, M. (ed.): P. G. 1980. The Last Works. Phillips Collection. Washington 1981 (cat.).– P. G. Das Spätwerk. Kunsthalle Basel. Basel

1983 (cat.).– P. G. La raiz del dibujo. Sala de Exposiciones Rekalde. Bilbau 1993 (cat.).– Hunter, S. (ed.): P. G. Recent Paintings and Drawings. Jewish Museum. New York 1966 (cat.).– Lynton, N. (ed.): P. G. Paintings 1969-1980. Whitechapel Art Gallery, London et al. London 1982 (cat.).– Mayer, M.: Night Studio. A Memoir of P. G. by His Daughter. New York 1988.– Storr, R.: P. G. New York 1986

**GUTFREUND Oto**
**1889** Dvur Králové (Königinhof) – **1927** Prague
Czech sculptor. **1903-1906** Trained at Bechin School of Ceramics. **1906-1909** Studied at Prague School of Arts and Crafts and **1909/10** at the private school Grande Chaumière in Paris. Encountered Cubism for the first time. **1910** Returned to Prague. **1911-1914** Joined a group of avant-garde artists attempting to fuse Cubism with Expressionism. **1914** Went with his friend Emil Filla to Paris, and signed up to serve in the Foreign Legion. **1916** Interned in the prison camp Saint Michel de Frigolet for subversive activities. **1920** Returned to Prague where, in **1921**, he became a member of the association of sculptors S.V.U. Mánes. From **1926** Professor of Sculpture at the School of Arts and Crafts in Prague. In addition to his small representational works of the 20s, in the style of Neue Sachlichkeit and contemporary realism, Gutfreund created numerous public monuments.
WRITINGS: O. G.: Zázemí tvorby. Ed. by Jirí Setlík. Prague 1989
CATALOGUE RAISONNE: Císarovský, J. (ed.): O. G. Prague 1962.– Setlik, J. (ed.): O. G. Prague 1995 (cat.)
MONOGRAPHS, CATALOGUES: Gaßner, H. (ed.): O. G. Haus der Kunst. Munich 1997 (cat.).– O. G. Internationales Kulturzentrum Egon Schiele. Krumau 1996 (cat.).– Kotalík, J. (ed.): O. G. Museum des 20. Jahrhunderts. Vienna 1969 (cat.).– Pecírka, J.: O. G. Prague 1948.– Setlík, J. (ed.): O. G. Prague 1989.– Weidemann, F. (ed.): O. G. 1889-1927. Plastiken und Zeichnungen. Staatliche Museen zu Berlin, Otto-Nagel-Haus. Berlin 1987 (cat.)

**GUTTUSO Renato**
**1912** Bagheria (near Palermo) – **1987** Rome
Italian painter. Trained as a picture restorer. **1930** Began studying law in Rome. **1935/36** Military service in Milan. Became friends with Birolli, Manzù and Fontana. **1937** Moved to Rome. **1938** First still lifes and portraits. **1940** Became a member of the Communist party and the anti-Fascist artists' group Corrente. **1943** Joined the Resistance. **1947** Founded the group Fronte Nuovo delle Arti in Rome. **1948-1960** Regular participation at the Venice Biennale. **1952** and **1972** won the Soviet Lenin Award. **1963** Elected to the USSR Academy. **1968** Professorship at the Hamburg Academy of Arts. **1973** Deeply shaken by the death of Picasso, he produced the series

*Omaggio a Picasso*. His political career reached its peak in **1975** with his nomination as Senator of the Italian Republic. **1977** Participation in documenta 6 in Kassel. **1982** Major solo-exhibition at the Palazzo Grassi in Venice. Guttuso is one of the leading exponents of Socialist Realism in Italy.
WRITINGS: R. G.: Contadini di Sicilia. Roma 1951.– R. G.: Mestiere di pittore. Scritti sull'arte e la società. Bari 1972.– R. G.: Negli scritti. Milan 1976
CATALOGUE RAISONNE: Crispolti, E. (ed.): Catalogo ragionato generale dei dipinti di R. G. 4 vols. Milan 1983-1991
MONOGRAPHS, CATALOGUES: Brandi, C. and V. Rubiu (ed.): G. Opere dal 1931 al 1981. Palazzo Grassi, Venice. Milan 1982 (cat.).– Brandi, C.: G. Antologia critica. Milan 1983.– Calvesi, M. et al. (ed.): R. G. Gemälde und Zeichnungen. Kunsthalle Tübingen et al. Stuttgart 1991 (cat.).– Calvesi, M. and D. Favatella Lo Cascio (ed.): R. G. Museo G. Palermo 1991 (cat.).– Constantini, E.: Ritratto di R. G. Milan 1985.– Cortenova, G. and E. Mascelloni (ed.): G. 50 anni di pittura. Palazzo Forti, Verona. Milan 1987 (cat.).– Crispolti, E. (ed.): G. nel disegno. Anni venti/ottanta. Roma 1983.– Crispolti, E.: Leggere G. Milan 1987.– Grasso, F.: R. G. Pittore di Bagheria. Catania 1982.– R. G. Whitechapel Art Gallery. London 1996 (cat.).– Haftmann, W.: G. Autobiographische Bilder. Frankfurt-on-Main et al. 1973.– Hiepe, R.: R. G. Dresden 1961.– Longhi, R. et al.: Hommage à G. Paris 1981.– Monferini, A. (ed.): La Donazione G. Galleria Nazionale d'Arte Moderna. Roma 1987 (cat.).– Moravia, A. and F. Grasso: R. G. La vita e l'opera. Palermo 1962.– Rubiu, V. (ed.): G. Opere dal 1931 al 1981. Centro di cultura di Palazzo Grassi, Venice. Florence 1982 (cat.).– Rubiu, V. et al. (ed.): G. Grandi opere. Palazzo Reale, Milan 1984 (cat.).– Vittorini, E.: Storia di R. G. e nota congiunta sulla pittura contemporanea. Milan 1960

**HAACKE Hans**
born **1936** Cologne
German concept and object artist. **1956-1960** Studied at the Academy of Arts and Crafts in Kassel. **1960/61** DAAD scholarship for Paris, where he worked in Hayter's

graphic studio Atelier 17. Contact with the Zero group in Düsseldorf. Interested in the representation of scientific phenomena. **1961** Fulbright scholarship to Philadelphia. **1962** Moved to New York. His fascination with natural physical laws led, in **1963**, to the construction of so-called *Condensation Cubes* which he used to demonstrate processes whose full timecourse can be observed. **1963-1965** Lived in Germany. **1966/67** Taught at various American universities. From **1967** taught at the Cooper Union in New York. **1972-1997** Participation in documenta 5, 8 and 10 in Kassel. **1973** Guest-professor at the Hamburg Academy of Arts. **1973/74** Guggenheim Fellowship Award. **1993** Represented Germany at the Venice Biennale. With his physical, meteorological, biological and sociological works, extended the traditional definition of sculpture and the plastic arts to include the representation of systems.
WRITINGS: Bourdieu, P. and H. H. Libreéchange. Paris 1994/Freier Austausch. Frankfurt-on-Main 1995
MONOGRAPHS, CATALOGUES: Aue, W.: P. C. A. Projekte, Konzepte, Aktionen. Cologne 1971.– Brown, T. and W. Grasskamp (ed.): H. H. Works 1978-1983. Tate Gallery. London 1984 (cat.).– Bußmann, K. (ed.): H. H. Bodenlos. Biennale Venice 1993, Deutscher Pavillon. Stuttgart 1993.– Fry, E. F.: H. H. Werkmonographie. Mit Texten des Künstlers. Cologne 1972.– Grasskamp, W. et al. (ed.): H. H. Obra Social. Barcelona 1995 (cat.).– H. H. Volume I. Museum of Modern Art. Oxford 1978 (cat.).– H. H. Volume II. Tate Gallery. London 1983 (cat.).– H. H. et al.: H. H. Bodenlos/Bottomless. Stuttgart 1993.– Martin, J.-H. (ed.): H. H. Artfairismes. Centre Georges Pompidou. Paris 1989 (cat.).– Straka, B. et al. (ed.): H. H. Nach allen Regeln der Kunst. Neue Gesellschaft für bildende Kunst. Berlin 1984 (cat.).– Wallis, B. (ed.): H. H. Unfinished Business. New Museum of Contemporary Art. New York 1987 (cat.)

**HAAS Ernst**
**1921** Vienna – **1986** Vienna
Austrian photographer. **1939** Studied medicine and philosophy. **1943** Worked part-time in a photographic studio in Vienna. Photojournalist for the journals *Der Film* and *Heute*. **1945** Photographed soldiers returning home, at the railway station, and street scenes in Vienna after the war. **1948** Member of the photographic agency Magnum in Paris. **1951** Emigrated to the USA and began to use colour as a means of shaping his photographs. From **1953** photoseries and reportages for *Life*, *Look* and *Vogue*. **1959** Elected president of *Magnum*. **1960** Covered the Olympic Games for *Life* magazine. **1964** First film projects with John Houston. **1972** Commissioned to photograph Marlboro cowboys. **1972-1987** Participation in documenta 5, 7 and 8 in Kassel. **1980** Publication of the audiovisual work *To Dream with Open*

*Eyes.* **1986** First showing of the audiovisual work *Abstracts.*
WRITINGS: E. H.: The Joy of Photography. Rochester (NY) 1979.– E. H.: The Joy of Photography II. Rochester (NY) 1981

### HAINS Raymond
born **1926** Saint-Brieuc (Côtes-du-Nord) French artist. **1945** Studied sculpture at the Ecole des Beaux-Arts in Rennes. Worked in the photographic department of *France Illustration.* **1948** Exhibited first abstract works (*Photographies hypnogogiques*) in Paris. **1950** Invented the idea of the *Ultra-lettre* and worked with *lettres éclatées* (fragmented letters). **1957** Exhibition of *Affiches déchirées* (torn posters) in Paris, followed by exhibitions at the first Paris Biennale, the Stedelijk Museum in Amsterdam and the Museum of Modern Art in New York. **1960** Founder member of the group Nouveaux Réalistes. **1963** Distanced himself from Nouveau Réalisme. **1964** Took part in the Venice Biennale. **1968** Exhibited three giant books of matches at documenta 4 in Kassel. **1968–1971** Lived and worked in Venice. **1971** Returned to Paris. **1990** Retrospective at the Centre Georges Pompidou in Paris. **1997** Participation in documenta 10 in Kassel.
MONOGRAPHS, CATALOGUES: Abadie, D. et al. (ed.): R. H. et la photographie. Centre Georges Pompidou. Paris 1976 (cat.).– Bompuis, C. (ed.): R. H. Centre Georges Pompidou. Paris 1990 (cat.).– David, C. et al. (ed.): Guide des collections ou mises en plis: R. H. Centre Georges Pompidou. Paris 1990 (cat.).– Fleck, R. et al. (ed.): R. H. Akzente 1949-1995. Vienna 1995 (cat.).– R. H. Fondation Cartier. Jouyen-Josas 1986 (cat.).– R. H. Poitou-Charentes. PS 1. New York 1989 (cat.).– R. H. Musée de Poitiers. Poitiers 1989 (cat.)

### HAJEK Otto Herbert
born **1927** Kaltenbach (Bohemia) German sculptor. **1947–1954** Studied sculpture at the Stuttgart Art Academy. From **1955** worked with *Raumknoten* (spatial knots), *Raumschichtungen* (spatial layers) and sculptures that can be walked on. **1959** Participation in documenta 2 in Kassel. **1960** Guest-lecturer at the University of California. **1963** Covered objects with colour trails to create links with their surroundings. **1972–1979** Director of the Deutsche Künstlerbund (German Artists' Association). From **1973** produced single sculptural works entitled *Raumzeichen* (spatial signs). **1977** Designed an artificial landscape which could be walked on, in Adelaide, southern Australia. **1979** Visited Japan and India. **1980–1992** Professor of Sculpture at the Karlsruhe Academy. With the colour combinations and spatial tensions he creates in his town-planning concepts and geometric designs for interiors and public spaces, Hajek is concerned with the integration of sculpture and architecture.
WRITINGS: O. H. H.: Darlegung zur Naturbetrachtung. Über die Voraussetzung, daß Kunst entstehen kann. Stuttgart 1982
MONOGRAPHS, CATALOGUES: Gomringer, E. (ed.): Kunst stiftet Gemeinschaft. O. H. H. Das Werk und seine Wirkung. Stuttgart and Berlin 1993.– O. H. H. Ikonographien, Zeichen, Plätze, Stadtbilder. Staatsgalerie Stuttgart. Stuttgart 1978 (cat.).– Pese, C. (ed.): O. H. H. Die Durchdringung des Lebens mit Kunst. Germanisches Nationalmuseum, Nuremberg. Stuttgart and Zurich 1987 (cat.).– Stulle, J. (ed.): O. H. H. Sculture, pitture e opere urbanistiche. Museo Nazionale di Castel Sant'angelo. Roma 1981 (cat.).– Stulle, J. (ed.): O. H. H. Plastiken, Bilder, Stadtikonographien. Stuttgart 1981 (cat.).– Weisner, U. (ed.): O. H. H. Farbwege 1952-1974. Kunsthalle Bielefeld. Stuttgart 1974 (cat.)

### HALLEY Peter
born **1953** New York
American painter. Studied until **1975** at Yale University, New Haven, Connecticut, and up to **1978** at the University of New Orleans. **1977** Trip to Europe. **1978** First solo-exhibition at the Contemporary Art Center, New Orleans. **1980** Returned to New York. Abandoned traditional artists' materials in favour of industrial substitutes. Developed a Minimalist style. **1981/82** Joined a New York artists' group through which he met Rosalind Krauss, Renée Santos, Peter Fend and Jeff Koons. **1983** Artistic director of the exhibition "Science Fiction" in the John Weber Gallery. **1983–1988** Production of the series *Kodalithes basés*, an attempted synthesis of painting and writing. Besides painting, Halley has published numerous essays on art and aesthetics. His most important work, *The Crisis of Geometry*, is the fruit of intensive research into the works of Michel Foucault and Jean Baudrillard.
WRITINGS: P. H.: Collected Essays 1981-1987. Zurich 1988
MONOGRAPHS, CATALOGUES: P. H. Institute of Contemporary Art. London 1989 (cat.).– P. H. Museum Haus Esters. Krefeld 1989 (cat.).– P. H. Musée d'Art Contemporain, Pully. Lausanne 1992 (cat.).– P. H. Paintings 1989-1992. Art Center. Des Moines 1992 (cat.).– Hixson, K. (ed.): P. H. Madrid et al. Madrid 1991 (cat.).– Michetti-Prod'hon, C. (ed.): P. H. Œuvres de 1982 à

1991. Musée d'Art Contemporain, Bordeaux et al. Bordeaux 1993 (cat.)

### HALSMAN Philippe
**1906** Riga – **1979** New York
Latvian-born American photographer. **1924–1928** Studied electrical engineering in Dresden. Freelance photographer for the publishers Ullstein in Berlin. **1931** Studied at the Sorbonne in Paris. Opened a portrait studio. Became acquainted with Man Ray and Maurice Tabard through his work as a fashion photographer. **1940** Emigrated to the USA. **1941** Won the Art Directors Club Award. Photographed for magazines and newspapers including *Look* and the *Saturday Evening Post.* 103 of his photographs appeared on front covers of *Life* magazine. **1944** Nominated first President of the American Society of Magazine Photographers in New York. **1958** Photographed Robert Oppenheimer. **1967** Award from the American Academy of Achievement. **1969–1979** Taught at the Photographers School in Westport, Connecticut. **1971** Lectured at the New York School for Social Research. **1979** First solo-exhibition at the International Center of Photography in New York. Halsman took portrait photographs of numerous public figures including Albert Einstein, Winston Churchill, John F. Kennedy and Marilyn Monroe.

### HAMILTON Richard
born **1922** London
English painter. **1938** Studied painting at the Royal Academy Schools in London. **1941–1945** Worked as a technical draughtsman. **1948–1951** Continued his studies at the Royal Academy Schools and the Slade School of Art. **1950** First solo-exhibition of etchings organised by Gimpel Fils. **1952** Taught silverwork, typography and industrial design at the Central School of Arts and Crafts. Together with Paolozzi, founded the Independent Group. **1953** Lecturer at the University of Durham. **1956** Created the first Pop collage as a catalogue and poster design for the exhibition "This is Tomorrow" in the Whitechapel Gallery. **1957–1961** Taught interior design at the Royal College of Art. **1965** Reconstruction of Marcel Duchamp's work *The Large Glass.* **1966** Organised a major Marcel Duchamp

retrospective at the Tate Gallery. **1968** and **1977** participation in documenta 4 and 6 in Kassel. **1970** Awarded the Talens International Prize. **1979** Retrospective at the Tate Gallery in London and the Kunsthalle Bern. After **1980** focused on computer art. Hamilton is a leading exponent of English Pop Art. His paintings are a biting critique of consumerism and mass culture. **1997** Took part in documenta 10 in Kassel.
WRITINGS: R. H.: Collected Words 1953-1982. London 1982
CATALOGUES RAISONNES: R. H. Prints 1939-1983. A Complete Catalogue of Graphic Works. Stuttgart 1984.– R. H. Prints. Graphic Works Continued 1984-1991. Waddington Graphics Gallery, London. Stuttgart 1992 (cat.)
MONOGRAPHS, CATALOGUES: Field, R. S. (ed.): R. H. Image and Process. 2 vols. Tate Gallery, London et al. Stuttgart 1983 (cat.).– R. H. Tate Gallery, London et al. London 1992 (cat.).– Leach-Ruhl, D.: Studien zu R. H. Das Frühwerk. Diss. Bochum 1986.– Leach, D.: R. H. The Beginnings of His Art. Frankfurt-on-Main et al. 1993.– Morphet, R. (ed.): R. H. Tate Gallery, London et al. London 1970 (cat.).– Nilson, B. (ed.): R. H. Teknologi, idé, konstverk. Moderna Museet. Stockholm 1989 (cat.).– Pauseback, M. and E. Kroppenstedt (ed.): R. H. Studien – Studien 1937-1977. Kunsthalle Bielefeld et al. Bielefeld 1978 (cat.).– Schwarz, D. et al. (ed.): R. H. Exteriors, Interiors, Objects, People. Kunstmuseum Winterthur et al. Hanover 1990 (cat.)

### HANSON Duane
**1925** Alexandria (MN) – **1995** Davie (Florida)
American sculptor. **1943–1951** Studied at art institutes in Washington, Minnesota and Bloomfield Hills. From **1951** taught at various schools. **1953** Tour of Europe. Taught in Munich and Bremen at American army schools. **1959** Kontact with George Grygo, who was experimenting with synthetic materials. **1961** Returned to America. **1965** Settled in Miami, Florida. **1967** Began to construct realistic life-size models of people out of polyester resin and fibreglass. **1972** Participation in documenta 5 in Kassel. **1974** DAAD scholarship to Berlin. **1979** Professorship at the University of Miami. **1985** Awarded first Florida prize for sculpture. **1992** Selected for the Florida Artists Hall of Fame. His precise, veristic representations of normal American people, e.g. housewives, cleaning ladies, workers or drug addicts, make Hanson one of the leading exponents of Hyper Realist sculpture.
CATALOGUE RAISONNE: Bush, M. H. and T. Buchsteiner (ed.): D. H. Skulpturen. Kunsthalle Tübingen et al. Stuttgart 1990
MONOGRAPHS, CATALOGUES: Bush, M. H. (ed.): D. H. Edwin A. Ulrich

Museum of Art, Wichita State University, Wichita et al. – Bush, M. H.: Sculptures by D. H. McKnight Art Center. Wichita (KS) 1985 (cat.).– Hobbs, R. (ed.): D. H. The New Objectivity. Florida State University Art Gallery. Talahassee. Seattle 1991 (cat.).– Livingstone, M. (ed.): D. H. Montreal Museum of Fine Arts et al. Montreal 1994 (cat.).– Osterwold, T. (ed.): D. H. Württembergischer Kunstverein. Stuttgart 1974 (cat.).– Ruhrberg, K.: D. H. Skulpturen. Stuttgart 1992.– Varnedoe, K.: D. H. New York 1985

**HANTAI Simon**
born **1922** Bia (Hungary)
Hungarian-born French painter. **1941–1947** Attended the Budapest Art Academy. **1949** Moved to Paris. **1952** Contact with the Surrealists. Experiments with techniques such as frottage, automatism and collage leading to gestural lyrical abstraction. **1953** First solo-exhibition at the Galerie L'Etoile Scellée in Paris, for which Breton wrote a preface to the catalogue. **1954** Split away from the Surrealists and became interested in Pollock's drip painting technique. Inspired by contact with Georges Mathieu and J. Degottex to develop a new painting style. Adopted a radically different approach to subject matter, painting materials and painting surfaces, and ventured towards free canvas works, via folding techniques. **1957** Together with Mathieu, organised the exhibition "Cérémonies de la seconde condamnation de Siger de Brabant" at the Galerie Kléber in Paris. **1959** Artistic decoration of liturgical texts; participation in documenta 2 in Kassel. **1966** Took French citizenship. **1968** Won the Foundation Maeght Award. **1973/74** Series of white paintings. **1974** Began the *Tabula* series. **1976** Retrospective at the Musée National d'Art Moderne, Paris. **1982** Took part at the Venice Biennale.
MONOGRAPHS, CATALOGUES: Baldeassari, A.: S. H. Paris 1992.– Bozo, D. and Y. Michaud (ed.): S. H. La Biennale di Venezia. Venice 1982 (cat.).– Froment, J.-L. et al. (ed.): Musée d'Art Contemporain de Bordeaux. Bordeaux. 1981 (cat.).– Hulten, P. et al. (ed.): S. H. Musée National d'Art Moderne. Paris 1976 (cat.).– Mathey, F. (ed.): S. H. Peintures 1958-1968. Fondation Maeght. Saint-Paul 1968 (cat.)

**HARING Keith**
**1958** Kutztown (PA) – **1990** New York
American painter. Began to draw comic figures at an early age. After attending the Ivy School of Art in Pittsburgh, studied from **1978** at the School of Visual Arts in New York, under Sonnier and Kosuth. **1979** First chalk drawings on New York subway billboards covered with black paper. **1981** Acquainted with Warhol, Basquiat, Clemente, Hopper, Borroughs, Madonna and Grace Jones. **1982** Distributed 20,000 posters, printed and designed by himself, at an anti-nuclear demonstration in Central Park. First solo-exhibition at the Tony Shafrazi Gallery and participation in documenta 7 in Kassel. **1983** First body painting. Murals in Milwaukee, New York and Tokyo. **1984** Painted the body of Grace Jones in New York. **1985** Stage designs for Brooklyn Academy of Music in New York and the Ballet National de Marseille. **1986** Opened a *Pop Shop*, selling multiples and commonplace objects painted by the artist. **1987/88** Further stage set and costume designs. **1989** Involved 300 school children in a wall painting project in Chicago. Set up the Keith Haring Foundation supporting social projects. Haring's simple, symbolic statements, painted onto T-shirts, buttons and plaster casts of sculptures, helped to blur the distinctions between high art and trivial Pop culture.
WRITINGS: K. H.: Journals. New York 1996/Tagebücher. Frankfurt-on-Main 1997
CATALOGUE RAISONNE: Littmann, K. (ed.): K. H. Editions on Paper 1982-1990. Das druckgraphische Werk. Stuttgart 1993
MONOGRAPHS, CATALOGUES: Blinderman, B. (ed.): K. H. Future Primeval. Queens Museum, New York et al. New York 1990 (cat.).– Celant, G. et al. (ed.): K. H. Munich 1992.– Celant, G. and I. Gianelli (ed.): K. H. Castello di Rivoli, Museo d'Arte Contemporanea, Torino et al. Milan 1994 (cat.).– Gruen, J.: K. H. The Authorized Biography. Englewood Cliffs (NJ) and London 1991/K. H. Die autorisierte Biographie. Munich 1991.– Gysin, B. and S. Couderc (ed.): K. H. Musée d'Art Contemporain de Bordeaux. Bordeaux. 1985 (cat.).– K. H. Peintures, sculptures and dessins. Musée d'Art Contemporain de Bordeaux. Bordeaux 1985 (cat.).– K. H. A Retrospective. Whitney Museum of American Art, New York. Boston 1997 (cat.).– Littmann, K. (ed.): K. H. Editions on Paper 1982-1900. Galerie der Stadt. Stuttgart 1993 (cat.).– Sussman, E. (ed.): K. H. Whitney Museum of American Art. New York 1997 (cat.)

**HARTLEY Marsden**
**1877** Lewiston (ME) – **1943** Ellsworth (ME) American painter. **1899–1904** Studied at the Chase School and the National Academy of Art, New York. **1909** Exhibited post-impressionist landscapes at Alfred Stieglitz' Galerie 291. **1912/13** Lived in Germany. Collaborated and held joint-exhibitions with artists of the Blauer Reiter movement, and took part in the First German Autumn Salon. **1913** Exhibited in the Armory Show in New York. **1921–1936** Lived alternately in France, Italy, Germany and Mexico. Abandoned abstract painting and devoted his time to landscapes and portraits. **1935** Unable to cover storage costs, destroyed more than a hundred of his own works, and went to live with a poor farming family in the Canadian province of Nova Scotia. **1937** Returned to the USA. Series of pantheistic coastal and mountain landscapes shown in a joint-exhibition with Stuart Davis at the Cincinnati Art Museum. Hartley, whose art is clearly influenced by Cézanne, Picasso and Matisse and whose intuitive abstractions successfully combine elements of Expressionism, Fauvism and Cubism, is considered one of the first American painters of the modernist.
WRITINGS: M. H.: Adventures in the Arts. New York 1921, 1972.– M. H.: Androscoggin. Portland 1940.– Wells, H. W. (ed.): M. H. Selected Poems. New York 1945.– Scott, G. R. (ed.): On Art by M. H. New York 1982.– Scott, G. R. (ed.): The Collected Poems of M. H. Santa Rosa 1987
MONOGRAPHS, CATALOGUES: Burlingame, R.: M. H. A Study of His Life and Creative Achievement. Diss. Prividence 1953.– Ferguson, G. (ed.): M. H. and Nova Scotia. Art Gallery Mont Saint Vincent University, Halifax et al. Halifax 1987 (cat.).– M. H. Somehow a Past. The Autobiography of M. H. Cambridge (MA) 1996.– Haskell, B. (ed.): M. H. Whitney Museum of American Art, New York et al. New York 1980 (cat.).– Hokin, J.: Pinnacles and Pyramids. The Art of M. H. Albuquerque 1993.– King, L.: M. H. 1908-1942. The Ione and Hudson D. Walker Collection. Visual Arts Gallery, Florida International University, Miami et al. Minneapolis 1984 (cat.).– Ludington, T.: M. H. The Biography of an American Artist. New York 1992.– McCausland, E.: M. H. Minneapolis 1952.– McCausland, E. (ed.): M. H. Stedelijk Museum. Amsterdam 1961 (cat.).– Scott, G. R.: M. H. New York 1988.– Scribner, A.: M. H. in Maine. Orono (ME) 1972

**HARTUNG Hans**
**1904** Leipzig – **1989** Antibes
German-French painter. **1924/25** Studied philosophy and history of art at Leipzig University and then attended the Art Academies in Leipzig and Dresden. **1932** After living for a time on the island of Menorca, he settled in Paris. **1935** Contact with Domela, Kandinsky, Magnelli, Mondrian, Miró and Calder. Participated in exhibitions at the Salon des Surindépendants and Galerie Pierre in Paris. Joined the Foreign Legion. **1944** Severely wounded at the front. **1945** Returned to Paris and obtained French citizenship. From **1949** exhibitions in Paris, Brussels, Munich and Basel. **1955–1964** Participation in documenta 1 – 3 in Kassel. **1956** Received the Guggenheim Award and was nominated a special member of the Berlin Academy. **1960** Major international award for painting at the Venice Biennale. **1964** National decoration for service to the German community. **1976** Publication in Paris of his autobiography *Autoportrait*. **1977** Member of the Institut de France and Académie des Beaux-Arts, Paris. **1981** Oskar Kokoschka Award from the Republic of Austria. Beside Fautrier, Wols and Riopelle, Hartung was one of the most important representatives of the Ecole de Paris. His works broke away from Abstract Expressionism and anticipated L'art informel.
WRITINGS: Lefebre, M. (ed.): H. H. Autoportrait. Paris 1976. Berlin 1981
CATALOGUE RAISONNE: Schmücking, R. (ed.): Werkverzeichnis der Graphik 1921-1965. Brunswick 1965, Basel 1990
MONOGRAPHS, CATALOGUES: Abadie, D. and M. Georget (ed.): H. et la musique. Centre d'arts plastiques. Royan 1993 (cat.).– Apollonio, U.: H. H. New York 1972.– Contensou, B. et al. (ed.): H. Œuvres de 1922 à 1939. Musée d'Art Moderne de la Ville de Paris. Paris 1980 (cat.).– Corray, L. et al. H. H. Milan 1992 (cat.).– Daix, P.: H. H. Paris 1991.– Descargues, P.: H. Paris 1977, New York 1977.– Gindertaël, R. V.: H. H. Paris 1960, Berlin 1962.– Giraudy, D. (ed.): H. H. Premières peintures 1922-1949. Musée Picasso, Château Grimaldi. Antibes 1987 (cat.).– Grohmann, W.: H. H. Aquarelle. St. Gallen 1966.– Haftmann, W. (ed.): H. H. Retrospektive 1921-1973. Staatliche Museen Preussischer Kulturbesitz, Nationalgalerie. Berlin 1975 (cat.).– H. H. Musée National d'Art Moderne. Paris 1969 (cat.).– H. H. Galleria Civica d'Arte Moderna, Palazzo dei diamanti. Ferrara 1988 (cat.).– H. Peintre moderne. Centre d'Art Contemporain, Paris et al. Milan 1996 (cat.).– Merkert, J. et al. (ed.): H. H. Malerei, Zeichnung, Photographie. Städtische Kunsthalle Düsseldorf et al. Berlin 1981 (cat.).– Rousseau, M. et al.: H. H. Stuttgart 1949.– Vergara, J.: H. Madrid 1961

**HARTUNG Karl**
**1908** Hamburg – **1967** Berlin
German sculptor. **1923** Apprenticeship as a wood sculptor. **1925–1929** Studied at the Hamburg School of Applied Arts. **1929–1932** Lived in Paris. Most strongly influenced by Maillol. **1932** Visited Florence. Studied Etruscan art. **1935** First abstract sculptural works. **1936** Moved to Berlin. **1939** Met Brancusi, Arp and Laurens again in Paris. **1946** First solo-exhibition at the Gerd Rosen gallery, Berlin. **1950** First monumental sculpture. **1951** Professor of Sculpture in Berlin. **1953** Retrospective at the Kestner Society in Hanover. **1955–1964** Participation in documenta 1 – 3 in Kassel. **1961** Major prize for sculpture from the State of Nordrhein-Westphalen.
CATALOGUE RAISONNE: Krause, M. (ed.): K. H. 1908-1967. Metamorphosen von Mensch und Natur. Monographie und Werkverzeichnis. Germanisches Nationalmuseum, Nuremberg. Nuremberg et al. Munich 1998 (cat.)
MONOGRAPHS, CATALOGUES: K. H. Haus Waldsee. Berlin 1952 (cat.).– K. H. Kestner-Gesellschaft. Hanover 1953 (cat.)

**HAUSMANN Raoul**
**1886** Vienna – **1971** Limoges
German-Austrian painter, photographer and writer. **1901** Moved to Berlin. **1905** First contact with Johannes Baader. From **1912** wroted critiques and literary articles for the journals *Der Sturm*, *Die Aktion* and *Die Freie Straße*. Became acquainted with Hans Richter and Emmy Hennings. **1918** Close collaboration with the Zurich Dada move-

ment. Together with Baader, Grosz, Tzara and Huelsenbeck set up the Berlin Dada movement and signed the Berlin Dada Manifesto. Invented photomontage and exhibited his assemblage *Holzkopf.* **1919** Together with Baader, issued the journal *Der Dada.* Participated in the first Dada exhibition in Berlin at the Graphisches Kabinett Neumann. Publication of further manifestos. **1920** Organised the Erste Internationale Dada Messe. **1921** Contact, leading to joint happenings, with Kurt Schwitters in Hanover. **1922** Took part in the constructivist Dada congress in Weimar. **1927** Construction of the Optophone. **1931** Took part in an exhibition of photomontages organised by Domela, in Berlin. **1933** Fled from the Nazi regime to Ibiza. **1936** Fled from the Spanish Fascists to France where he lived illegally from **1939–1944** in Peyrat-le-Château. **1944** Moved back to Limoges where, from **1959** to **1964**, he produced impulsive gestural paintings. **1971** Finished writing *Am Anfang war Dada,* a retrospective account of Dadaism in Berlin. WRITINGS: R. H.: Hyle. Ein Traumsein in Spanien. Frankfurt-on-Main 1969.– R. H.: Am Anfang war Dada. Ed. by K. Riha and G. Kämpf. Gießen 1972, 1992.– R. H.: Texte bis 1933. Ed. by M. Erlhoff. 2 vols. Munich 1982.– R. H.: La Sensorialité excentrique. Die exzentrische Empfindung. Ed. by Adelheid Koch. Linz 1994.– Züchner, E. (ed.): Fort mit allen Stühlen. R. H. in Berlin 1900-1933. Unveröffentlichte Texte. Stuttgart 1995.– Züchner, E. (ed.): R. H. Scharfrichter der bürgerlichen Seele. Stuttgart 1998
MONOGRAPHS, CATALOGUES: Benson, T. O.: R. H. and Berlin Dada. Ann Arbor (MI) 1987.– Bory, J.-F.: Prolegomènes à une monographie de R. H. Paris 1972.– Erlhoff, M.: R. H. Dadasoph. Versuch einer Politisierung der Ästhetik. Hanover 1982.– Giroud, M.: R. H. Je ne suis pas une photographe. Paris 1975.– Haus, A. (ed.): R. H. Kamerafotografien 1927-1957. Munich 1979.– R. H. autour de l'esprit de notre temps. Assemblages, collages, photomontages. Musée National d'Art Moderne. Paris 1974 (cat.).– R. H. Retrospektive. Kestner-Gesellschaft. Hanover 1981 (cat.).– R. H. 1886-1971. Musée Départemental de Rochechouart. Rochechouart 1986 (cat.).– R. H. Musée d'Art Moderne. Saint-Etienne 1994 (cat.)/ R. H. IVAM Centro Julio Gonzáles. Valencia 1994 (cat.).– Hulten, K. G. (ed.): R. H. Moderna Museet. Stockholm 1967.– Koch, A.: Ich bin immerhin der größte Experimentator Österreichs. R. H., Dada und Neodada. Innsbruck 1994.– Züchner, E. et al. (ed.): Der deutsche Spießer ärgert sich. R. H. 1886-1971. Berlinische Galerie, Berlin et al. Stuttgart 1994 (cat.)

## HAUSNER Rudolf
**1914** Vienna – **1994** Mödling (near Vienna) Austrian painter. **1931–1936** Studied painting at the Vienna Academy. **1936** Toured as a jazz musician. **1941–1943** Military service. **1946** Together with Edgar Jené, Ernst

Fuchs, Wolfgang Hutter and others, founded a Surrealist art group. **1956** Completed his painting *Arche des Odysseus.* Created the mythical figure of Adam Jedermann. **1957** Produced the first *Adam* paintings. **1959** First joint-exhibition at Oberen Belvedere in Vienna and participation in documenta 2 in Kassel. **1966** Guest-professor at the Hamburg School of Fine Arts. From **1968** professorship at the Vienna Academy. **1970** Austrian national award. **1984** Retrospectives at the Neue Galerie in Linz and Künstlerhaus in Vienna. Hausner's paintings, which are closely related to Fantastic Realism, are portrayals of visionary, alienating Surrealist dreams. Together with Ernst Fuchs, he is one of the main representatives of the Vienna School.
WRITINGS: R. H.: Vom Bewußtsein des Unbewußten. Munich 1982
CATALOGUES RAISONNES: Holländer, H.: R. H. Werkmonographie. Offenbach 1985.– Huber, V. (ed.): R. H. Werkverzeichnis der Druckgraphik 1966-1975. Offenbach 1977.– Schmied, W. (ed.): R. H. Salzburg 1970
MONOGRAPHS, CATALOGUES: Flemming, H. T.: R. H. Stuttgart 1976.– R. H. 1914-1995. Museum Würth. Künzelsau 1996 (cat.).– Schurian, W. (ed.): R. H. Munich 1987

## HEARTFIELD John
(Helmut Herzfelde)
**1891** Berlin – **1968** Berlin German painter, photographer, typographer and writer. **1907–1910** Studied at the School of Applied Arts in Munich and **1912 –1914** at the School of Arts and Crafts in Berlin. **1914/15** Military service. **1916** Publication and typographical design of the magazine *Neue Jugend.* **1917** Together with his brother Wieland, set up the Malik Verlag. Became friends with Grosz, Jung and Huelsenbeck. Made films at the UFA. **1918** Joined the German Communist Party. **1919** Together with Grosz, Huelsenbeck, Hausmann and others, took part in various Dada activities in Berlin. Published magazines such as *Jedermann sein eigener Fußball* and *Der Kunstlump.* **1920** First photomontages for book covers. **1921** Prosecuted for denigration of German Nationalism with his sculpture *Preussischer Erzengel* (Prussian Archangel). **1921–1923** Stage designs for

Max Reinhardt. **1929** Photographs and photomontages for Kurt Tucholsky's book *Deutschland über alles.* Up to **1933** contributed to various Communist and antinationalist publications. After ransacking of his house by the SA, he fled to Prague to escape the Nazi regime. **1938** Moved to London. From **1950** lived in East Berlin and Leipzig, and began working with Bert Brecht.
WRITINGS: März, R. (ed.): J. H. Der Schnitt entlang der Zeit. Selbstzeugnisse, Erinnerungen, Interpretationen. Dresden 1981
MONOGRAPHS, CATALOGUES: Evans, D. (ed.): J. H. AIZ 1930-1938. Catalogue Raisonné of the Photomantages Published in AIZ and VI. New York 1992.– Frederiksson, I.: Konsten spränger ramarna. J. H. och det politiska fotomontaget. Stockholm 1979.– J. H. Krieg im Frieden. Fotomontagen zur Zeit 1930-1938. Munich 1972.– J. H. The Museum of Modern Art. New York 1993 (cat.).– Herzfelde, W.: J. H. Leben und Werk, dargestellt von seinem Bruder. Berlin 1962.– Honnef, K. and H.-J. v. Osterhausen (ed.): J. H. Dokumentation. Reaktionen auf eine ungewöhnliche Ausstellung. Cologne 1994.– Kahn, D.: J. H. Art and Mass Media. New York 1985.– März, R.: H. montiert. 1930-1938. Leipzig 1993.– Pachnicke, P. and K. Honnef (ed.): J. H. Akademie der Künste zu Berlin et al. Cologne 1991 (cat.)/ J. H. New York 1993.– Siepmann, E.: Montage. J. H. Vom Club Dada zur Arbeiter-Illustrierten-Zeitung. Dokumente, Analysen, Berichte. Berlin 1977.– Thomas, et al. K. (ed.): J. H. Berlin, Bonn et al. Cologne 1991 (cat.).– Töteberg, M.: J. H. in Selbstzeugnissen und Bilddokumenten. Reinbek 1978

## HECKEL Erich
**1883** Döbeln (Saxony) – **1970** Hemmenhofen (near Radolfzell)
German painter and graphic artist. **1901** Friendship with Schmidt-Rottluff. **1904** Studied architecture at the Technical College in Dresden. On 7 July **1905** together with Bleyl, Kirchner and Schmidt-Rottluff, founded the artists' group Brücke. Rented a former butcher's premises as the Brücke studio. **1907** Visited Dangaster Moor for the first time. From May to October **1908** stayed with Schmidt-Rottluff in Dangast. **1909** Tour of Italy (Verona, Padua, Venice, Rome). Spent the summer with Kirchner at the Moritzburger lakes. **1910** Changed his early Brücke style replacing, the flowing lines and rounded contours and somewhat decorative rhythmic elements being replaced with a reduced pictorial language in woodcut-style. **1911** Moved to Berlin. **1912** Made friends with Marc and Feininger. **1913** Break-up of the Brücke. First solo-exhibition at the Galerie Gurlitt, Berlin. **1914** Participated in the exhibition of the Werkbund in Cologne. Signed up as a medical orderly. **1915** Met Beckmann and Ensor. November **1918** settled in Berlin. **1919–1944** Spent summers in Osterholz.

**1929** Tour of Provence, the Pyrenees, northern Spain and Aquitaine. **1937** Confiscation of 729 of his works from German museums. **1944** Destruction of his Berlin studio in a bombing raid. Moved to Hemmenhofen on Lake Constance. **1949–1955** Professorship at the Karlsruhe School of Fine Arts.
CATALOGUES RAISONNES: Dube, A. and W. (ed.): E. H. Das graphische Werk. 3 vols. New York and Berlin 1964-1974.– Vogt, P. (ed.): E. H. (mit Werkverzeichnis der Gemälde, Wandmalereien und Plastik). Recklinghausen 1965
MONOGRAPHS, CATALOGUES: Bojescul, W. (ed.): E. H. Kunstverein Braunschweig. Brunswick 1985 (cat.).– Borries, J. E. v.: E. H. Gemälde, Aquarelle und Zeichnungen im Besitz der staatlichen Kunsthalle. Karlsruhe 1968.– Felix, Z. (ed.): E. H. 1883-1970. Gemälde, Aquarelle, Zeichnungen und Graphik. Museum Folkwang, Essen et al. Munich 1983 (cat.).– Gabler, K. (ed.): E. H. 2 vols. Städtische Galerie im Prinz-Max-Palais, Karlsruhe et al. Stuttgart and Zurich 1983 (cat.).– Geissler, H.: E. H. Aquarelle vom Bodensee. Munich and Zurich 1981.– Henze, A.: E. H. Leben und Werk. Stuttgart and Zurich 1983.– Hofmann, A.: E. H. Die Jahre am Bodensee 1944-1970. Friedrichshafen 1994.– Lucke, A. and A. Hüneke: E. H. Lebensstufen. Die Wandbilder im Angermuseum zu Erfurt. Dresden 1992.– Moeller, M. M. (ed.): E. H. Aquarelle, Zeichnungen, Druckgraphik aus dem Brücke-Museum Berlin. Munich 1991.– Rathenau, E.: E. H. Handzeichnungen. New York 1973.– Rathke, C. (ed.): E. H. im Schleswig-Holsteinischen Landesmuseum. Gemälde, Aquarelle, Zeichnungen. Schloß Gottorf in Schleswig 1980 (cat.).– Stabenow, C. (ed.): E. H. Ein Farbmusterbuch für Walter Gramatté. Munich 1989.– Tormaehlen, L.: E. H. Karlsruhe 1953.– Vogt, P.: E. H. Recklinghausen 1965

## HEERICH Erwin
born **1922** Kassel
German sculptor. **1945–1954** Studied sculpture under Ewald Mataré at the Düsseldorf Academy. **1950** First cardboard works and isometric drawings. **1961–1969** Taught in courses for workers in Düsseldorf. **1964** First solo-exhibition at Haus van der Grinten in Kranenberg. **1968** and **1977** participation in documenta 4 and 6 in Kassel. From **1969** Professor at the Düsseldorf Academy. **1974** Member of the Berlin Academy. From **1978** public commissions for large sculptures. Although Heerich's formal language developed out of Neo-Plasticism and the Bauhaus, his cardboard works, drawings, prints and graphic works are free stereometric constructions.
CATALOGUES RAISONNES: E. H. Kartonskulpturen. 5 vols. Düsseldorf 1979-1987.– Grinten, F. J. v. d. (ed.): E. H. Œuvrekatalog, Folge I (Kartenobjekte). Düsseldorf 1970.– Storck, G. (ed.): E. H. Œuvrekatalog, Folge II (Arbeiten aus Karton). Düsseldorf 1979

MONOGRAPHS, CATALOGUES: Brockhaus, C. (ed.): E. H. Plastische Prozesse. Wilhelm Lehmbruck Museum. Duisburg 1992 (cat.).– Claddders, J.: E. H. Arbeiten im Raum. Essen 1981.– Grinten, H. v. d. (ed.): E. H. und Hildegard Heerich. Cologne 1995.– E. H. Kunstverein Freiburg. Freiburg 1976 (cat.).– E. H. Städtische Kunsthalle Düsseldorf. Düsseldorf 1979 (cat.).– E. H. Städtisches Museum Schloß Morsbroich. Leverkusen 1980 (cat.).– E. H. Wilhelm Lehmbruck Museum. Duisburg 1992 (cat.).– E. H. Skulptur und der architektonische Raum. Cologne 1998.– Kastner, J. P.: E. H. Cologne 1991.– Kastner, P. and W. Zschokke: E. H. Museum Insel Hombroich. Stuttgart 1996

**HEGEDÜS Agnes**
born **1964** Budapest
Hungarian video artist. **1985–1988** Studied photography and video art at the Academy of Applied Arts in Budapest, **1988** at the Minerva Academy in Groningen and **1988–1990** at the Academy of Arts, Enschede. **1990** Postgraduate work under Weibel at the Städelschule and Institute of New Media in Frankfurt am Main. **1992** Guest-artist at the ZKM in Karlsruhe. **1993** Placed in the category of Interactive Art at Ars Electronica, Linz. **1995** Solo-exhibition at the Federal Art and Exhibition Centre in Bonn. Subsequently to her early video works in the early 90s, Hegedüs created interactive installations designed to encourage dialogue and games.

**HEILIGER Bernhard**
**1915** Stettin – **1995** Berlin
German sculptor. **1934–1941** Studied at the Stettin School of Arts and Crafts and at the Berlin School of Fine Arts. **1938** Went to Paris. **1945** First busts and small sculptures inspired by Maillol and Despiau. **1950–1984** Professor at the Berlin School of Fine Arts. From **1951** his works became increasingly abstract. Produced a 28 m long mural relief for the Schiller Theater, Berlin. **1954** Member of the Deutscher Kunstrat (German Arts Council). **1955–1964** Participation in documenta 1–3 in Kassel. **1956** Took up organic abstraction. **1961** Tour of the USA. **1966** Stage designs for Ernst Schröder's production of *Faust II* in the

Schiller Theater, Berlin. **1978** Elected to the Accademia Fiorentina delle Arte del Disegno. **1980** Produced a series of monumental metal sculptures with notched and smooth surfaces setting up an interplay of the static and the dynamic. **1985/86** Retired from his professorship in Berlin. Heiliger's abstract sculptures are representations of time, speed and events. Beside his works in bronze, steel and aluminium, Heiliger experimented with synthetic materials such as plexiglas and polyester.
WRITINGS: B. H.: Skizzen – Figuren – Entwürfe. Berlin 1957
CATALOGUE RAISONNE: Salzmann, S. and L. Romain (ed.): B. H. Frankfurt-on-Main and Berlin 1989
MONOGRAPHS, CATALOGUES: Brockhaus, C. and B. Lepper (ed.): B. H. Retrospektive. Wilhelm Lehmbruck Museum, Duisburg et al. Duisburg 1985 (cat.).– Flemming, H. T.: B. H. Berlin 1962.– Flemming, H. T. and W. Schmied (ed.): B. H. Kunstverein und Akademie der Künste, Berlin et al. Berlin 1975 (cat.).– Hammacher, A. M.: B. H. St. Gallen 1978.– Romain. L. (ed.): B. H. Retrospektive 1945 bis 1995. Kunst- und Ausstellungshalle der Bundesrepublik Deutschland, Bonn. Bonn 1995 (cat.).– Papies, H. J. (ed.): B. H. Staatliche Museen zu Berlin. Berlin 1991 (cat.).– Salzmann, S. (ed.): B. H. Skulpturen, Reliefobjekte, Collagen. Galerie Pels-Leusden. Berlin 1987 (cat.).– Volkmann, B. (ed.): B. H. Skulpturen und Zeichnungen 1960-1975. Akademie der Künste. Berlin 1975 (cat.)

**HEISIG Bernhard**
born **1925** Breslau
German painter and graphic artist. **1941/42** Attended the School of Arts and Crafts in Breslau but was forced by the war to interrupt his studies and enlist for military service. **1946/47** Worked as a graphic artist in Breslau. **1948** Resumed his training at the Leipzig School of Applied Arts, followed by a course at the School of Graphics and Book Design until **1951**. **1961** Appointed director of the Leipzig School of Arts. **1964** Dismissed from his post for his championing of artists' rights and provocative article *Kritik an seiner Zeit*. **1965/66** Publication of a series of lithographs, *Der faschistische Alptraum* (The Fascist Nightmare), in which he attempts to come to terms with his own history. **1968–1976** Worked as a freelance painter and graphic artists. **1975** Completed the monumental wall painting *Ikarus* for the Palast der Republik in East Berlin. **1976** Resumed directorship of the Leipzig School of Arts until his retirement in **1987**. **1977** Participation in documenta 6 in Kassel. **1989** Returned two national awards, received in **1972** and **1978**, in protest against abuse of power and corruption in the former GDR. Heisig is one of the most important painters of the former GDR. His expressive and aggressive painting style, showing the influence of Lovis Corinth and Oskar Kokoschka, consciously opposes Socialist Realism.

MONOGRAPHS, CATALOGUES: Hartleb, R.: B. H. Dresden 1975.– B. H. Gemäldegalerie Neue Meister. Leipzig 1973 (cat.).– B. H. Retrospektive. Gaphik und Illustration. Sprengel Museum, Hanover et al. Hanover 1990 (cat.).– B. H. Mönchehaus-Museum. Goslar 1996 (cat.).– Helmert-Corvey, T. (ed.): B. H. Zeiten zu leben. Daniel-Pöppelmann-Haus. Herford 1994 (cat.).– Merkert, J. and P. Pachnicke (ed.): B. H. Retrospektive. Berlinische Galerie, Berlin et al. Munich 1989 (cat.).– Kober, K. M. (ed.): B. H. Kulturhistorisches Museum. Magdeburg 1978 (cat.).– Kober, K. M.: B. H. Dresden 1981.– Pachnicke, P. (ed.): B. H. Malerei, Graphik, Zeichnungen. Museum der bildenden Künste. Leipzig 1985 (cat.)

**HEIZER Michael**
born **1944** Berkeley (CA)
American painter and land artist. **1963/64** Studied at San Francisco Art Institute. **1965/66** Abstract Expressionist style. **1966** Moved to New York. **1966–1968** Encounters and experiments with Minimal Art. From **1967** first Land Art projects: alteration of natural grassy areas, hills and river courses to give a vivid representation of temporal processes such as weathering and sedimentation. These projects were documented through film and photography. **1969** Two massive cuts made into rocks in the California desert, entitled *Double Negative*. **1969/70** *Displaced/Replaced Mass*, in which granite blocks were sunk into rectangular pits dug into the Nevada desert. Digging of a deep pit at a building site in Neuperlach near Munich (*Munich Depression*). **1971** First drawings on zinc plates. From **1973** grey monochrome paintings with minimal step-like geometric forms. **1977** Participation in documenta 6 in Kassel.
MONOGRAPHS, CATALOGUES: Brown, J. (ed.): M. H. Sculpture in Reverse. Museum of Contemporary Art. Los Angeles 1984 (cat.).– Celant, G. (ed.): M. H. Milan 1996 (cat.).– Felix, Z. and E. Joosten (ed.): M. H. Museum Folkwang, Essen et al. Essen 1979 (cat.).– M. H. Sculpture in Reverse. Museum of Contemporary Art. Los Angeles 1984 (cat.).– M. H. Waddington Galleries. London 1990 (cat.).– M. H. Effigy Tumuli. The Reemergence of Ancient Mount Building. New York 1990.– M. H. Double Negative. New York 1992.– McGill, D. C. (ed.): M. H. Effigy Tumuli. The Reemergence of Ancient Mound Building. New York 1990

**HELD Al**
born **1928** New York
American painter. **1948/49** Studied at the Art Students League in New York. **1949** Moved to Paris. Contact with Rivers, Kelly, Francis and Noland. **1950–1952** Studied under Ossip Zadkine at the Académie de la Grande Chaumière. **1952** First solo-exhibition at Galerie 8 in Paris. **1953** Returned to New York. **1960** Abandoned Abstract

Expressionism and experimented with simple, spatially related geometric forms, superimposed on each other. From **1962** taught at Yale University. Took part in the exhibition "Geometric Abstraction in America" at the Whitney Museum of American Art, New York. **1966** Guggenheim grant. **1968** and **1977** Participation in documenta 4 and 6 in Kassel. Eliminated colour and produced a series of black-and-white paintings, later broadening his palette again. In the politically active early phase of his career there were parallels between Held's works and Social Realism; later, however, he disengaged himself from the prevailing Abstract Expressionism and took up Hard-Edge painting.
MONOGRAPHS, CATALOGUES: Armstrong, T.: A. H. New York 1991.– Green, H. (G.): A. H. San Francisco Museum of Art. San Francisco 1968 (cat.).– A. H. Stedelijk Museum. Amsterdam 1966 (cat.).– A. H. Museum of Art. San Francisco 1968 (cat.).– A. H. Recent Paintings. Institute of Contemporary Art, Philadelphia et al. Philadelphia 1969 (cat.).– A. H. Paintings and Drawings 1973-1978. Institute of Contemporary Art. Boston 1978 (cat.).– Rotzler, W. and A. Forge (ed.): A. H. Quadrat, Moderne Galerie. Bottrop 1980 (cat.).– Sandler, I.: A. H. New York 1984, London 1987.– Tucker, M. (ed.): A. H. Whitney Museum of American Art. New York 1974 (cat.)

**HELION Jean**
**1904** Couterne (Orne) – **1987** Paris
French painter. Studied architecture and engineering. **1922** Began painting. **1928** Exhibited at the Salon des Indépendants. **1929** First abstract paintings, inspired by Mondrian's Neo-Plasticism. Co-founder of the group and journal *Art Concret*. **1931/32** Travelled through Europe, Russia and the USA. **1932–1934** Joined Abstraction-Création. Went to America. **1933** Solo-exhibition at the John Becker Gallery, New York. **1936** Moved to the USA. **1937** Painted large abstract figures. **1939** Last abstract compositions. Return to figurative painting. **1941–1945** Solo-exhibitions at the Paul Rosenberg Gallery, New York. **1946** Returned to France. **1964** Sets and costumes for TV adaptation of *King Lear*. **1971** Retrospective "Cent tableaux, 1928 – 1979" at the Grand

Palais, Paris. In the 80s, further retrospectives at the Musée d'Art Moderne in Strasbourg, at Lenbachhaus in Munich, at the Guggenheim Museum in Venice and finally **1995** at the Musée d' Unterlinden in Colmar.
WRITINGS: J. H.: They Shall Not Have Me. New York 1943.– J. H.: Journal d'un peintre. 2 vols. Ed. by A. Moeglin-Delacroix. Paris 1992.– J. H.: Mémoire de la chambre jaune. Paris 1994.– J. H.: A perte de vue. Paris 1997.– J. H.: Lettres d'Amérique. Correspondance avec Raymond Queneau 1934-1967. Paris 1997
CATALOGUE RAISONNE: Cousseau, H.-C. and I. d'Hauteville: H. Paris 1992
MONOGRAPHS, CATALOGUES: Abadie, D.: Hélion ou la force des choses. Brussels 1975.– Alloway, L. (ed.): J. H. Paintings and Drawings from 1939-1960. Robert Miller Gallery. New York 1981 (cat.).– Cousseau, H.-C. et al. (ed.): J. H. IVAM Centro Julio González, Valencia et al. Valencia 1990 (cat.).– Micha, R.: H. Paris 1979.– Ottinger, D.: J. H. Paris 1992.– Zweite, A. et al. (ed.): J. H. Abstraktion und Mythen des Alltags. Bilder, Zeichnungen, Gouachen 1925-1983. Städtische Galerie im Lenbachhaus, Munich et al. Munich 1984 (cat.)

**HELNWEIN Gottfried**
born **1948** Vienna
Austrian painter and graphic artist. **1965–1969** Studied at the College of Education and Research in Vienna. **1966** First autoaggressive actions and bandagings. While studying at the Academy of Arts in Vienna (**1969–1973**), produced hyper-realistic paintings of injured and maltreated children. From **1971** used offset printing as an artistic medium in itself. **1973** First etchings. **1977** Lived in the USA. From **1981** works incorporating trivial-culture figures such as Donald Duck and celebrities such as Niki Lauda and The Rolling Stones. Numerous poster designs, cover pictures for magazines and record sleeves. **1983/84** Copies of his self-portrait with bandaged head and clamps on front covers throughout the international press. **1985** Moved to Germany and produced abstract gestural paintings as well as some monochrome canvases. Worked increasingly from enlarged photographs. **1986** Solo-exhibition at the Mittelrhein-Museum in Koblenz and **1992** at the Pfalzgalerie, Kaiserslautern and **1996** at the Fine Arts Museum, Otaru (Japan). **1997** Major retrospective at the Russian State Museum, St. Petersburg.
MONOGRAPHS, CATALOGUES: Borovsky, A. et al. (ed.): G. H. St. Petersburg 1997 (cat.).– Feierabend, V. (ed.): H. Cologne 1992.– Gorsen, P. (ed.): G. H. Autoportraits 1970-1987. Heidelberg 1988.– G. H. Neunter November Nacht. Museum Ludwig. Cologne 1988 (cat.).– G. H. Arbeiten auf Papier 1969-1989. Museum Folkwang, Essen et al. Essen 1989 (cat.).– G. H. Faces. Stadtmusem München. Schaffhausen 1992 (cat.).– G. H. Retrospektive. Petersburg Museum. St. Petersburg 1996.–

Koschatzky, W. et al. (ed.): G. H. Arbeiten von 1970-1985. Graphische Sammlung Albertina. Vienna 1985 (cat.).– Roschitz, K. (ed.): H. Vienna 1981

**HENRI Florence**
**1893** New York – **1982** Bellival
Swiss photographer and painter. **1911–1914** Studied music at the Conservatoire in Paris. **1914** Studied painting at the Berlin Academy and **1915–1919** at the private academy of H. Hofmann in Munich. **1924** Attended Léger and Ozenfant's Académie Moderne. **1927** Studied painting and photography at the Bauhaus in Dessau under László Moholy-Nagy and Albers. From **1929** devoted herself exclusively to photography. Portraits of artists and advertising and fashion photographs published in leading periodicals and magazines such as *Art et Décoration*, *Vogue* and *The New York Herald*. Also took numerous self-portraits. **1930–1935** worked on the photoseries Vitrines. **1931** Took part in photographic exhibitions in Paris, Basel and Essen. **1933** Travelled to Spain and Greece. **1935/36** Extended stay in Italy. Took up painting again. **1937** Participation in the exhibition "Foto 37" in Amsterdam. Photographic work interrupted by the outbreak of war. **1962** Settled in Bellival near Paris, producing collages.
MONOGRAPHS, CATALOGUES: Du Pont, D. (ed.): F. H. Artist-Photographer of the Avant-Garde. San Francisco Museum of Modern Art. San Francisco 1990 (cat.).– Fagiolo, M.: F. H. Torino 1975.– F. H. Westfälischer Kunstverein. Münster 1976 (cat.).– F. H. 70 Photographies 1928-1938. Musée d'Art d'Histoire. Geneva 1981.– Marcenaro, G. et al. (ed.): F. H. Aspetti di un percorso. Banco di Chiavarie. Genoa 1979 (cat.).– Miro, E. d. (ed.): F. H. Galleria Martini & Ronchetti. Genoa 1974 (cat.).– Molderings, H.: F. H. Aspekte der Photographie der 20er Jahre. Münster 1976.– Pagé, S. and H. Molderings: F. H. Paris 1978

**HEPWORTH Barbara**
**1903** Wakefield (Yorkshire) – **1975** Saint Ives (Cornwall)
English sculptress. **1920** Attended Leeds School of Art. Friendship with Henry

Moore. **1921–1924** Studied at the Royal College of Art, London. **1924–1926** Extended visits to Florence, Carrara and Rome. **1926** Returned to London, later taking a studio in Hampstead, close to Moore and Nicholson. **1932/33** Travelled through France. Contact with Brancusi, Braque, Picasso and Arp. Joined Abstraction-Création and published *Unit One*, a compilation of the writings of that group of abstract artists. First pierced sculptures. **1934** Moved to St. Ives, Cornwall. Together with Nicholson and then Gabo, set up the nucleus of an artists' colony, later joined for a while by Gropius, Moholy-Nagy and Breuer. From **1938** used threaded string as a sculptural element. **1949** Bought the Trewyn Studio in St. Ives and settled there. **1951** and **1955** Stage sets and costume designs. **1952** First group sculptures (*People waiting*). **1955** and **1959** participation in documenta 1 and 2 in Kassel. **1956** Inspired by a trip to Greece, she made a series of sculptures out of African wood with Greek titles. **1962/63** Exhibition at the Whitechapel Gallery, London. Public commissions including a memorial to Dag Hammerskjöld (*Single Form*) in New York. **1968** Retrospective at the Tate Gallery, London. Hepworth was one of the leading English abstract sculptors. She died in **1975** in a fire at her studio in St. Ives.
CATALOGUES RAISONNES: Bowness, A. (ed.): The Sculpture of B. H. 1960-1969. London and New York 1971 (cat.).– Hodin, J. P.: B. H. Life and Work. London and New York 1961/B. H. Neuchâtel 1961
MONOGRAPHS, CATALOGUES: Adams, A. (ed.): B. H. A Pictorial Autobiography. Bath 1970, New York 1970.– Alley, R. et al. (ed.): B. H. Tate Gallery. London 1968 (cat.).– Baxandall, D. (ed.): B. H. Retrospective Exhibition. Whitechappel Art Gallery. London 1954 (cat.).– Bowness, A. (ed.): B. H. Late Carvings, Early Life. Elizabethan Exhibition Gallery. Wakefield 1985 (cat.).– Curtis, P. and A. G. Wilkinson: B. H. A Retrospective. Tate Gallery, Liverpool et al. London 1994, Seattle 1995.– Festing, S.: B. H. A Life of Forms. London 1995.– Gardiner, M.: B. H. Edinburgh 1982.– Gibson, W.: B. H. London 1946.– Hammacher, A. M.: B. H. Cologne 1958, London 1959, 1987, New York 1968.– B. H. Tate Gallery. London 1968 (cat.).– Read, H. (ed.): B. H. Carvings and Drawings. London 1952.– Sheperd, M.: B. H. London 1963.– Wilkinson, A. G. (ed.): B. H. The Art Gallery of Ontario Collection, Toronto et al. Toronto 1991 (cat.)

**HERBIN Auguste**
**1882** Quiévy (near Cambrai) – **1960** Paris
French painter. **1900/01** Attended the Ecole des Beaux-Arts in Lille. Moved to Paris, where he joined the Impressionists and then the Fauves. **1913** First Cubist-inspired paintings. **1917–1921** Geometric abstract phase. Designs for *Objets monumentaux*. Wood sculptures and reliefs. **1920** Joined the Communist party. **1922** Brief return to a fig-

urative style. **1926–1939** Two geometric abstract periods. **1926** Co-founder of the Salon des Surindépendants. **1931** Together with Vantongerloo, founded the group Abstraction-Création. **1946** Invented the *alphabet plastique* as a compositional framework. **1947** Co-founder and vice-president of the Salon des Réalités Nouvelles. Protested against Socialist Realism by leaving the Communist party. **1949** Published his own theoretical treatise *L'art non-figuratif non-objectif*. **1953** Partially paralysed, he learned to paint with his left hand. **1955** President of the Salon des Réalités Nouvelles.
WRITINGS: A. H.: L'Art non figuratif, non objectif. Paris 1946
CATALOGUE RAISONNE: Claisse, G. (ed.): H. Catalogue raisonné de l'œuvre peint. Lausanne et Paris 1993
MONOGRAPHS, CATALOGUES: A. H. 1882-1960. Stedelijk Museum. Amsterdam 1963 (cat.).– A. H. Musée d'Art Moderne de la Ville de Paris. Paris 1984 (cat.)/A. H. Städtische Galerie im Lenbachhaus. Munich 1984 (cat.).– A. H. Musée de Céret/Musée Matisse. Cateau-Cambrésis 1994 (cat.).– A. H. Retrospektive. Wilhelm-Hack-Museum. Ludwigshafen 1997 (cat.).– Jakovski, A.: A. H. Paris 1933.– Massat, A.: A. H. Paris 1953.– Schmied, W. (ed.): A. H. Kestner-Gesellschaft. Hanover 1967 (cat.)

**HEROLD Jacques**
**1910** Piatra – **1987** Paris
Romanian-born French painter. **1925–1927** Attended art school in Bucharest. **1927–1929** Studied at the Art Academy in Bucharest. **1930** Moved to Paris. Met Tanguy and joined the Surrealists, but dissociated himself from the movement in **1938**. When France capitulated, he first went to Marseille but later returned to Provence. **1947** Organised the Surrealist exhibition in Paris, in which his own sculpture *Large Banner* was displayed. **1951** Abandoned Surrealism and developed a lyrical abstract style. **1952–1954** Lived in Frankfurt am Main and Brussels. **1958** Awarded the Foundation Copley Prize. Exhibitions at the Salon de Mai and the Salon des Surindépendants.
MONOGRAPHS, CATALOGUES: Butor, M.: J. H. Paris 1964

**HESSE Eva**
**1936** Hamburg – **1970** New York
German-born American sculptress. **1954** Studied drawing at the Art Students League, **1954–1957** at the Cooper Union, New York, and **1957–1959** at Yale University, New Haven. From **1961** gestural drawings in Abstract Expressionist tradition. **1964/65** Took up sculpture while living in Germany. **1965** Solo-exhibition at the Kunsthalle Düsseldorf. **1968** Solo-exhibition at the Fischbach Gallery in New York and participation in the exhibition "Antiform". Taught at the School of Visual Arts. **1969** Exhibited with Nauman, Serra

and Sonnier at the Whitney Museum of American Art in "Anti-Illusion: Procedures/Materials", an exhibition presenting new material concepts in sculpture. **1972** and **1977** participation in documenta 5 and 6 in Kassel. Hesse, who died at the age of 34 from a brain tumour, used a variety of materials including rubber, fibreglass, synthetic textiles and artificial resin in her amorphous arrangements and mural reliefs. Her obsessive, allusive surrealism had a profound influence on American sculpture in the 70s. CATALOGUE RAISONNE: Barrette, B. (ed.): E. H. Sculpture. Catalogue Raisonné. New York 1989, 1992 MONOGRAPHS, CATALOGUES: Cooper, H. A. et al. (ed.): E. H. A Retrospective. Yale University Art Gallery, New Haven et al. New Haven (CT) 1992 (cat.).– David, C. and C. Diserens (ed.): E. H. Galerie Nationale du Jeu de Paume, Paris et al. Paris 1993 (cat.).– Haenlein, C.-A. et al. (ed.): E. H. 1936-1970. Skulpturen und Zeichnungen. Kestner-Gesellschaft. Hanover 1979 (cat.).– Johnson, E. H. (ed.): E. H. A Retrospective of the Drawings. Allen Memorial Art Museum. Oberlin 1982 (cat.).– Lippard, L. R.: E. H. New York 1976, 1992.– Pincus-Witten, R. (ed.): E. H. A Memorial Exhibition. Solomon R. Guggenheim Museum. New York 1972 (cat.).– Reinhardt, B. (ed.): E. H. Drawings in Space. Bilder und Reliefs. Ulmer Museum. Ulm and Stuttgart 1994 (cat.).– Serota, N. et al. (ed.): E. H. Sculpture. Whitechappel Art Gallery, London et al. London 1979 (cat.)

**HILL Gary**
born **1951** Santa Monica (CA)
American multimedia artist. **1969** Attended the Art Students League in Woodstock. Created sculptural works out of wire netting. **1971** First solo-exhibition at the Polaris Gallery in Woodstock. Began to experiment with audiovisual media and took videos of performances and environments. **1973** First video-installation *The Fall.* **1974-1976** Employed by Woodstock Community Video. **1977** Set up the Open Studio Video Project in Barrytown. First use of digital technology in the work Bathing. **1979-1980** Lectured at the State University of New York in Buffalo. **1983** Installation *Primarily Speaking*, in which two "speaking" walls of screens hold a dialogue, exhibited at the Whitney Museum of American Art. **1985-1991** Taught at Cornish College of the Arts in Seattle. **1987** and **1992** took part in documenta 8 and 9 in Kassel. **1995** Received special honours at the Venice Biennale. Grants from the National Endowments for the Arts, the Guggenheim and the Rockefeller Foundation. Hill's video works, shown at the Anthology Film Archives, the Museum of Modern Art in New York and the Pompidou Centre in Paris, focus on the the role of the counterplay of projected image and speech in perception and communication.
MONOGRAPHS, CATALOGUES: Assche, C. v. et al. (ed.): G. H. IVAM Centre del

Carme, Valencia et al. Valencia 1993 (cat.).– Boehm, G. and T. Vischer (ed.): G. H. Museum für Gegenwartskunst, Basel. Stuttgart 1995.– Devrient, C.: L'œuvre vidéo de G. H. Rennes 1990.– G. H. And Sat Down Beside Her. Galerie des Archives. Paris 1990 (cat.).– G. H. Video Installations. Stedelijk Van Abbe Museum. Eindhoven 1992 (cat.)/ G. H. Centre Georges Pompidou. Paris 1992 (cat.).– G. H. Hirshhorn Museum. Washington 1994 (cat.).– Liesbrock, H. (ed.): G. H. Midnight Crossing. Westfälischer Kunstverein. Münster 1997 (cat.).– Mignot, D. et al. (ed.): G. H. Stedelijk Museum, Amsterdam et al. Amsterdam 1993 (cat.).– Quasha, G. and C. Stein: G. H. Heard Liminal Objects/Tall Ships/ Viewer. G. H.'s Projective Installations. 3 vols. Barrytown 1996-1997.– Sarrazin, S.: G. H. Centre International de Création Vidéo. Montbéliard Belfort 1992

**HINE Lewis**
**1874** Oshkosh (WI) – **1940** New York
American photographer. **1892-1900** Studied painting and drawing in Oshkosh. **1900-1902** Studied sociology and education theory at the University of Chicago. **1901-1908** Taught natural history and geography at the Ethical Culture School in New York. **1905** Photographed immigrants on Ellis Island. **1906-1918** Photographic director of the National Child Labor Committee in New York. **1908** First publication in *Charities and Common*, documenting the life of American miners. **1909** Photoseries on child labour in the USA. **1910-1914** Worked as a photographer for the Red Cross in America and later in Europe. **1922-1929** Photographed for Survey, the *Milbank Foundation* and the *National Consumers' League*. **1930/31** Documented the building of the Empire State Building in New York. **1936/37** Director of the "National Research Project". From **1938** until he died, worked as a freelance photographer. Hine's social documentation set new directions for FSA photography.
WRITINGS: Kaplan, D. (ed.): Photo Story. Selected Letters and Photographs of L. W. H. Washington and London 1992
MONOGRAPHS, CATALOGUES: Gutman, J. M.: L. W. H. and the American Social Conscience. New York 1967.– Gutman, J. M.: L. W. H. 1874-1940. Two Perspectives. New York 1974.– L. H. Musée Carnavalet. Paris 1990 (cat.).– L. H. Centre National de la Photographie. Paris 1992 (cat.).– Kaplan, D.: L. H. in Europe. New York 1988.– Rosenblum, W. and A. Trachtenberg: America and L. H. New York 1977.– Steinorth, K. (ed.): L. H. Passionate Journey. Photographs 1905-1937. Zurich 1997.– Trachtenberg, A. and N. Rosenblum (ed.): America and L. H. New York 1976, 1997

**HIRSHFIELD Morris**
**1872** Poland – **1946** Brooklyn (NY)
Polish-born American painter. As a boy, carved figures for the temple in his home-

town. **1890** Emigrated to the USA and worked for twelve years as a tailor for a manufacturer of ladies' wear before setting up his own business, producing slippers. **1936** After a protracted illness, gave up his business and began to paint. **1937** First painting, *Beach Girl*. The main subjects of subsequent paintings were female nudes and animals. **1939** His exotic, oriental paintings were discovered by the American art dealer and critic Sidney Janis, who then promoted him as a modern primitive artist. In **1946**, the year in which the artist died, an extensive retrospective was held in the Museum of Modern Art in New York.
MONOGRAPHS, CATALOGUES: M. H. 1872-1946. American Primitive Painter. Sidney Janis Gallery. New York 1965 (cat.).– Saroyan, W.: M. H. Parma 1975

**HIRST Damien**
born **1965** Bristol
English sculptor and installation artist. **1986-1989** Studied at Goldsmith's College in London. Began to explore the theme of death in his works. **1991** Completion of the work *The Physical Impossibility of Death in the Mind of Someone Living*, showing a 4.5 metre long tiger-shark in an aquarium filled with formalin. **1993** Exhibited the carcass of a cow, also preserved in formalin, at the Venice Biennale. This style of work, which he continued, provoked much controversy. **1995** Awarded the Prix Eliette von Karajan and the Turner Prize for his Biennale project. **1997** Opening of *Pharmacy*, a bar designed by the artist in London.
MONOGRAPHS; CATALOGUES: Blazwik, I.: D. H. Internal Affairs. Institute of Contemporary Arts. London 1991 (cat.).– D. H. Galerie Jablonka. Cologne 1994 (cat.).– D. H. A Bad Environment for White Monochrome Paintings. Mattress Factory. Pittsburgh 1994 (cat.).– D. H. A Good Environment for White Monochrome Painting. Daadgalerie et al. Berlin 1994 (cat.).– D. H. Institute of Contemporary Arts. London 1991 (cat.).– D. H. Making Beautiful Drawings. Bruno Brunnet Fine Arts. Berlin 1994 (cat.).– D. H. Prix Eliette v. Karajan '95. Max Gandolph Bibliothek. Salzburg 1995 (cat.).– D. H. No Sense of Absolute Corruption. Gargosian Gallery. New York 1996 (cat.).– Shone, R. (ed.): D. H. Third International Istanbul Biennial. British Council. Istanbul 1992 (cat.).– Violette, R.: D. H. I Want to Spend the Rest of My Life Everywhere. London 1997

**HÖCH Hannah**
**1889** Gotha – **1978** Berlin
German painter, photographer and collage artist. **1912** Attended the Berlin School of Arts and Crafts. From **1915** studied at the college attached to the Berlin Museum of Arts and Crafts. Friendship with Raoul Hausmann. **1918** Participated in various events organised by the Berlin Dada movement. Made dadaesque dolls and worked

with Hausmann on a series of photomontages. **1919** Took part in the Dada exhibition at the Graphische Kabinett Neumann. Joined the Novembergruppe and exhibited with them regularly. Contact with Schwitters, van Doesburg, Arp and Moholy-Nagy. **1920** Participated in the First International Dada Trade Fair. **1921/22** Dada tour with Schwitters to Prague. Worked on the *Merzbau project*. **1924** Went to Paris, where she met Mondrian. **1926-1929** Lived in Holland. **1929** Several photomontages displayed in the exhibition "Film and Foto" in Stuttgart. **1933-1945** Denounced by the Nazis and forbidden to exhibit. After World War II experimented with printing techniques.
MONOGRAPHS, CATALOGUES: Adriani, G. (ed.): H. H. Fotomontagen, Gemälde, Aquarelle. Kunsthalle Tübingen et al. Cologne 1980 (cat.).– Boswell, P. et al. (ed.): The Photomontages of H. H. Walker Art Center. Minneapolis 1996 (cat.).– Dech, J.: Schnitt mit dem Küchenmesser DADA durch die letzte Bierbauchkulturepoche Deutschlands. Untersuchungen zur Fotomontage bei H. H. Münster 1981.– Dech, J. and E. Maurer (ed.): Da-da-zwischen-Reden zu H. H. Berlin 1990.– H. H. Kunst, Wissenschaft. Internationales Symposium. Berlin 1989.– H. H. Musée d'Art Moderne de la Ville de Paris et al. Paris 1985 (cat.).– Lavin, M.: H. H. Photomontage and the Representation of the New Woman in Weimar Germany 1918-1933. New York 1991.– Lavin, M.: Cut with the Kitchen Knife. The Weimar Photomontages of H. H. New Haven (CT) and London 1993.– Maurer, E.: H. H. Jenseits fester Grenzen. Das malerische Werk bis 1945. Berlin 1995.– Moortgat, E. and C. Thater-Schulz (ed.): H. H. 1889-1978. Ihr Werk, ihr Leben, ihre Freunde. Berlinische Galerie. Berlin 1989 (cat.).– Ohff, H.: H. H. Berlin 1968.– Pawlow, K. (ed.): H. H. Gotha 1889-1978 Berlin. Museen der Stadt Gotha. Gotha 1993 (cat.).– Remmert, H.: H. H. Werke und Worte. Berlin 1982.– Thater-Schulz, C. (ed.): H. H. Eine Lebenscollage. 2 vols. Berlin 1989

**HOCKNEY David**
born **1937** Bradford (Yorkshire)
English painter, graphic artist and photographer. **1953-1957** Studied at Bradford College of Art, and **1959-1962** at the Royal College of Art in London. Won his first art award before leaving the Royal College. **1961/62** Travelled to New York and Berlin and set off for Egypt to collect ideas for illustrations. Encouraged by Henry Geldzahler, custodian of the Metropolitan Museum of Art in New York, to move to Los Angeles. **1963-1967** Taught at the University of Iowa, the University of Colorado, in Los Angeles and in Berkeley. **1966** First stage designs. **1968** and **1977** participation in documenta 4 and 6 in Kassel. **1969** Guest-professor at the Hamburg School of Arts. **1975-1992** Designed numerous sets for ballets and the operas by Mozart,

Stravinsky, Wagner and Strauss. From **1982** made Polaroid collages, combining the Cubist principle of simultaneity with chronophotographic sequences. In the late 80s, produced four-colour prints, abstract computer graphics and fax-drawings. Hockney's penchant for harsh, cold acrylic paints led to the categorization of his works as Pop Art, a label he disliked. In paintings, based on his own photographs, he developed a stylised realism.
WRITINGS: H. on Photography. Conversations with Paul Joyce. London 1988.– Stangos, N. (ed.): D. H. by D. H. My Early Years. London 1976 New York 1988.– Stangos, N. (ed.): D. H. That's the Way I See It. London and New York 1993 / D. H. Die Welt in meinen Augen. Autobiographie. Cologne 1994
CATALOGUE RAISONNE: The Scottish Arts Council, The Midland Group and Petersburg Press (ed.): D. H. Prints 1954-1977. London 1979, Paris 1987
MONOGRAPHS, CATALOGUES: Friedman, M. (ed.): D. H. Paints the Stage. Walker Art Center, Minneapolis et al. New York 1983 (cat.).– Livingstone, M.: D. H. London and New York 1981, 1987, Paris 1991.– Luckhardt, U. and P. Melia (ed.): D. H. A Drawing Retrospective. Royal Academy. London 1995 (cat.) / D. H. Zeichnungen 1954-1995. Hamburg 1995.– Luckhardt, U. and P. Melia (ed.): D. H. Zeichnungen. Stuttgart 1995.– Mißelbeck, R. (ed.): D. H. Photoworks. Museum Ludwig. Cologne 1998 (cat.).– Melia, P. and U. Luckhardt: D. H. Gemälde. Munich 1994 / D. H. Paintings. New York 1994.– Sayag, A. (ed.): D. H. photographe. Centre Georges Pompidou. Paris 1982 (cat.).– Stangos, N. (ed.): D. H. by D. H. London 1976.– Stangos, N. (ed.): Bilder von D. H. Zurich 1980.– Stangos, N. (ed.): D. H. London 1981.– Tuchman, M. and S. Barron (ed.): D. H. A Retrospective. Los Angeles County Museum of Art et al. Los Angeles and London 1988, Cologne 1988 (cat.).– Webb, P.: A Portrait of D. H. London 1988 / D. H. Paris 1991.– Weschler, L. (ed.): D. H. Camera Works. London and New York 1984

**HÖDICKE Karl Horst**
born **1938** Nuremberg
German painter and object artist. **1959–1964** Studied under Fred Thieler at the Berlin School of Fine Arts. **1961** Joined the artists' group *Vision*. **1964** Founder member of the artists' cooperative gallery Großgörschen 35, where he held his first solo-exhibition. City street-scenes with neon signs. **1965–1968** Painted onto glass surfaces. **1966/67** Experimental film work in New York. **1968** Scholarship to the Villa Massimo in Rome. Developed the ideas of Duchamp and Magritte in his works combining sculpture and paintings. **1969** Created the work *Kalter Fluß*, in which fluid tar poured slowly out of a bin, attached to the wall, onto the floor. From **1974** professor at the Berlin School of Fine Arts. The main themes of Hödicke's

gestural paintings are Berlin cityscapes and human figures. **1977** Retrospective at the Badischer Kunstverein, Karlsruhe and **1986** at the Kunstsammlung Nordrhein-Westfalen, Düsseldorf.
WRITINGS: K. H. H.: Anatomie – Autonomie – Anomalie. Berlin 1976.– K. H. H.: Kalenderblätter. Aufzeichnungen. Berlin 1980
MONOGRAPHS, CATALOGUES: Billeter, E. et al. (ed.): K. H. H. Gemälde, Skulpturen, Objekte, Filme. Kunstsammlung Nordrhein-Westfalen, Düsseldorf et al. Düsseldorf 1986 (cat.).– Block, R. and M. Schwarz (ed.): K. H. H. Badischer Kunstverein. Karlsruhe 1977 (cat.).– K. H. H. Berliner Ring. Bilder und Skulpturen 1975-1992. Neuer Berliner Kunstverein et al. Stuttgart 1992 (cat.).– Schneede, U. (ed.): K. H. H. Hamburger Kunstverein. Hamburg 1984 (cat.).– Wiesler, H.: K. H. Hödicke. Bonn 1989

**HODLER Ferdinand**
**1853** Bern – **1918** Geneva
Swiss painter. **1871–1876** Studied at the Geneva School of Arts under B. Menn, who promoted him and brought him into contact with Ingres, Delacroix, Corot, Courbet and Manet. Studied the works of Corot and the French Impressionists. **1878/79** Spent nine months studying paintings in Madrid. Developed his own monumental style characterised by flat areas of colour, firm contours and symmetric/rhythmic, repetitive patterns of lines. Produced portraits, history paintings and works with a symbolist flavour. **1891** Went to Paris and joined the Rosicrucians. **1892** Exhibited at the first Salon de la Rose + Croix in Paris. His tendency towards the monumental brought him many commissions for wall-paintings. **1897** Won first prize for his mural design for the armoury at the Landesmuseum in Zurich. **1901–1905** Took part in the Vienna Secession and also exhibited at the Munich and Berlin Secessions. In **1905** and **1911** made trips to Italy. **1907** Wall-paintings for Jena University. **1913** Made an officer of the French Legion of Honour. **1917** Major retrospective in Zurich. Hodler attempted to achieve a synthesis of Impressionism, Realism and Symbolism in his painting. He is one of the few Swiss painters with a worldwide reputation.
CATALOGUE RAISONNE: Loosli, C. A. (ed.): F. H. Leben, Werke und Nachlass. 4 vols. Bern 1921-1923
MONOGRAPHS, CATALOGUES: Bätschmann, O. et al. (ed.): F. H. (ed.): Sammlung Max Schmidheiny. Kunstmuseum des Kantons Thurgau. Frauenfeld 1989 (cat.).– Bender, E. and W. Y. Müller: Die Kunst F. H.'s. Reife und Spätwerk 1895-1918. Zurich 1941.– Brüschweiler, J. (ed.): Ein Maler vor Liebe und Tod. F. H. und Valentine Godé-Darel. Ein Werkzyklus 1908-1915. Kunsthaus Zurich et al. Zurich 1976 (cat.).– Brüschweiler, J. and G. Magnaguagno (ed.): F. H. Neue Nationalgalerie, Berlin et al. Berlin 1983 (cat.).– Brüsch-

weiler, J. (ed.): F. H. Fondation Pierre Gianadda. Martigny 1989 (cat.).– Der frühe H. Das Werk 1870-1890. Kunstmuseum Bern. Bern 1981 (cat.).– Eisenmann, S. F. and O. Bätschman (ed.): F. H. Landscapes. Los Angeles, New York and Chicago 1987 (cat.).– Grabner, S. et al. (ed.): F. H. und Wien. Vienna 1992 (cat.).– Guerzoni, S.: F. H. als Mensch, Maler und Lehrer. Zurich 1952 / F. H. Sa Vie, son œuvre, son enseignement, souvenirs personnels. Geneva 1957.– Hirsh, S. L.: F. H. Munich 1981, London and New York 1982.– F. H. Die Mission des Künstlers. Bern 1982.– F. H. Kunstmuseum Solothurn et al. Solothurn 1996 (cat.).– Hugelshofer, W.: F. H. Eine Monographie. Zurich 1952.– Magnaguagno, G. et al. (ed.): F. H. Kunsthaus Zürich et al. Zurich 1983 (cat.).– Perucchi, U. (ed.): F. H. Zeichnungen der Reifezeit 1900-1918. Kunsthaus Zürich. Zurich 1992 (cat.).– Selz, P. (ed.): F. H. University Art Museum, Berkeley et al. Berkeley 1972 (cat.).– Steinberg, S. D.: F. H. Ein Platoniker der Kunst. Zurich 1947.– Überwasser, W.: H. Köpfe und Gestalten. Zurich 1947

**HOEHME Gerhard**
**1920** Greppin (near Dessau) – **1989** Neuss
German painter. **1948–1951** Studied under H. Post in Burg Giebichstein, near Halle. **1951** Moved to Düsseldorf. From **1952** studied at the Düsseldorf Art Academy. Painted in a style close to Tachisme. **1954–1957** Leading member of the Düsseldorf artists' association Gruppe 53. From **1955** took up Lyrical Abstraction. From **1957** painted on shaped canvases and mixed his paints with other materials to experiment with spatial structures. **1959** Participation in documenta 2 in Kassel. **1963** Extension of the painting into 3-dimensional space: the linear framework of the picture was broken up or actually replaced by concrete elements such as pieces of string. **1960** Villa Massimo Award in Rome. **1960–1984** Professorship at the Düsseldorf Academy. In the 70s, Hoehme produced his *Damast-bilder*, which constituted a further step towards the *offenes Bild* (open picture) and the idea that paintings are not on canvas but in the mind of the viewer.
WRITINGS: G. H.: Wegzeichen im Unbekannten. Heidelberg 1962
MONOGRAPHS, CATALOGUES: Argan, G. C. and M. d. la Motte (ed.): G. H. Roma 1969.– Argan, G. C. and H. P. Thurn: G. H. Werk und Zeit 1948-1983. Stuttgart 1983.– Bartsch, I.: G. H. Wir haben den Kosmos in uns. Museum am Ostwall, Dortmund. Cologne 1992 (cat.).– Bojescul, W. (ed.): G. H. Das offene Bild. Kunstverein Braunschweig. Braunschweig 1984 (cat.).– Güse, E.-G. (ed.): G. H. L'Etna. Mythos und Wirklichkeit. Saarland Museum. Saarbrücken 1990 (cat.).– G. H. Kunstverein Bielefeld et al. Bielefeld 1996 (cat.).– Jensen, J. C.: In memoriam G. H. Kunsthalle Kiel. Kiel 1989 (cat.).– Partenheimer, J.: G. H. Städtische Kunsthalle Düsseldorf et al. Düsseldorf 1979 (cat.)

**HOELZEL Adolf**
**1853** Olmütz – **1934** Stuttgart
German painter, art teacher and colour theoretician. **1876–1879** Studied at the Vienna Art Academy. **1880/81** Attended the Munich Academy. **1882** Encountered Impressionism on a visit to Paris. **1888** Founded a school of painting in Dachau near Munich. **1904** Published his first theoretical essays in *Die Kunst für Alle*. From **1906** professor at the Stuttgart Academy, where his pupils included Baumeister, Itten and Schlemmer. First abstract compositions. **1914** Stained-glass windows and decorative paintings for the factories of Wagner and Bahlsen in Hanover. **1923** Began a series of works in pastels. Hoelzel succeeded in extending the six-colour circle to a twelve-part chromatic circle. His theory of colour, based on the researches of J. W. v. Goethe and M. E. Chevreul, was developed by Itten and incorporated into Bauhaus theory and teaching.
WRITINGS: A. H.: Gedanken und Lehren. Stuttgart 1933
CATALOGUE RAISONNE: Venzmer, W. (ed.): A. H. Leben und Werk. Monographie mit Verzeichnis der Ölbilder, Glasfenster und ausgewählter Pastelle. Stuttgart 1982
MONOGRAPHS, CATALOGUES: Beck, R. (ed.): A. H. Aufbruch zur Moderne. Museum Villa Stuck. Munich 1980 (cat.).– Haenlein, C. (ed.): A. H. Bilder, Pastelle, Zeichnungen, Collagen. Kestner-Gesellschaft. Hanover 1982 (cat.).– Hildebrandt, H.: A. H. Zeichnungen, Farbe, Abstraktion. Darmstadt 1969.– Venzmer, W. et al. (ed.): A. H. Galerie der Stadt Sindelfingen et al. Sindelfingen 1987 (cat.)

**HOERLE Heinrich**
**1875** Cologne – **1936** Cologne
German painter. Walking tours through Belgium and Holland. Joined various artists' groups. **1912** Sporadic attendance at the Cologne School of Arts and Crafts. **1913** Friendship with Max Ernst and contact with the Lunists. **1917** Military service. **1919** Worked with Baargeld and Ernst on the Dada magazine *Der Ventilator* and helped to found the group stupid. **1923** Produced a series of prints with a subversive political slant. **1924** Founded the Gruppe progressiver Künstler (Group of Progressive Artists) with Seiwert in Cologne. Returned to a sur-

realist style of painting. **1928** Produced some of his most famous works, including *Grüßende Jungfrau, Fabriklandschaft* and *Melancholie*. **1929** Issued the magazine *a bis z*. **1930** Joint-exhibitions with the Group of Progressive Artists in Cologne, Nuremberg, Berlin, Amsterdam, Paris and Chicago. Period of purist, constructivist compositions. **1932** Retrospective at the Cologne Kunstverein. **1933** Travelled to Mallorca. Paintings on religious themes. CATALOGUE RAISONNE: Backes, D. (ed.): H. H. Leben und Werk. 1895-1936. Kölnischer Kunstverein. Cologne 1981 (cat.) MONOGRAPHS, CATALOGUES: Schmidt-Rost, H.: H. H. Recklinghausen 1965

**HOFER Karl**
1878 Karlsruhe – 1955 Berlin
German painter and graphic artist. **1898** Studied at the Karlsruhe Academy. **1900-1902** Pupil of Hans Thoma. **1902** Went to the Stuttgart Academy. **1903-1908** Lived in Rome. **1908** Went to Paris where he was deeply impressed by the works of Cézanne. **1914-1917** Military service. Taken prisoner in France. **1917** Lived in Zurich. From **1919** taught at the Berlin Academy. **1923** Member of the Prussian Academy of Arts. **1933** Dismissed. **1934** First prize from the Carnegie Institute of Arts. **1937** Confiscation of many of his works. **1940** Moved to Konstanz. **1943** Destruction of his Berlin studio and numerous works in a bombing raid. **1948** Honorary doctorate from the Humboldt University in Berlin and honorary membership of the Karlsruhe Academy. **1950** Elected first president of the German Artists' Association. Hofer's combination of Expressionist subjectivity with a strict classical objectivity aligns him with Neue Sachlichkeit.
WRITINGS: Feist, U. and G. (ed.): K. H. und T. Reinhart. Maler und Mäzen. Ein Briefwechsel. Berlin 1989.– K. H.: Aus Leben und Kunst. Berlin 1952.– K. H.: Erinnerungen eines Malers. Berlin 1953.– K. H.: Über das Gesetzliche in der bildenden Kunst. Berlin 1956.– Hünecke, A. (ed.): K. H. Malerei hat eine Zukunft. Briefe, Aufsätze, Reden. Leipzig 1991.– Kupper, D. (ed.): K. H. Schriften. Berlin 1996 CATALOGUE RAISONNE: Rathenau, E. (ed.): K. H. Das graphische Werk. Berlin and New York 1969, 1991 MONOGRAPHS, CATALOGUES: Feist, U.: K. H. Berlin 1977.– Feist, U.: K. H. Bilder im Schlossmuseum Ettlingen. Berlin 1983.– Furler, E. (ed.): K. H. Leben und Werk in Daten und Bildern. Frankfurt-on-Main 1978.– Hartleb, R.: K. H. Leipzig 1987.– Hartleb, R. and K.-H. Mehnert (ed.): K. H. Tischgesellschaft. Museum der Bildenden Künste, Leipzig. Berlin and Leipzig 1992 (cat.).– Jannasch, A. C. H. Potsdam 1946.– Martin, K.: K. H. Karlsruhe 1957.– Raum, H. and S. Hartmann (ed.): K. H. Malerei, Grafik, Zeichnung. Staatliche Galerie Moritzburg. Halle 1978 (cat.).– Rigby, I. K.: K. H. New York 1976.–

Ruckhaberle, D. et al. (ed.): K. H. Staatliche Kunsthalle Berlin et al. Berlin 1978 (cat.).– Schilling, J. (ed.): K. H. Schloß Cappenberg. Unna 1991 (cat.)

**HOFMANN Hans**
1880 Weißenberg (Bavaria) – 1966 New York
German-born American painter. Grew up in Munich. **1904-1906** Studied at the Académie de la Grande Chaumière in Paris. Worked with Matisse in the Atelier Colarossi. Came to know Delaunay, Braque, Pascin, Gris and Picasso. **1910** First solo-exhibition at Paul Cassirer's gallery in Berlin. **1915** Returned to Munich and opened his own school of modern art with a strong emphasis on Cubism. **1930-1932** Taught at the University of California, Berkeley and at the Art Students League in New York. **1933** Settled in New York. His teaching at his own school in New York from **1934** to **1958** influenced a whole generation of American abstract artists. **1949** Met Braque, Brancusi and Picasso in Paris. **1959** Participated in documenta 2 in Kassel. **1960** Took part in the Venice Biennale. In the early 40s, Hofmann developed a form of Abstract Expressionism out of the traditions of Cubism and Fauvism, in which dynamic tension is set up through a counterplay of unbroken colour and free gestural elements. WRITINGS: H. H.: Search for the Real and Other Essays. Andover (MA) 1948.– H. H.: Selected Writings on Art. New Hampshire 1962.– Seitz, W. C.: H. H. with Selected Writings by the Artist. New York 1963 MONOGRAPHS, CATALOGUES: Banard, W. D. (ed.): H. H. A Retrospective Exhibition. Hirshhorn Museum and Sculpture Garden Washington et al. Washington and Houston 1976 (cat.).– Friedel, H. (ed.): H. H. Wunder des Rhythmus und dr Schönheit des Raumes. Städtische Galerie im Lenbachhaus, Munich et al. Munich 1997 (cat.).– Goodman, C.: H. New York 1986.– Goodman, C. et al. (ed.): H. H. Whitney Museum, New York et al. New York and Munich 1990 (cat.).– Greenberg, C.: H. Paris 1961.– H. H. Das Spätwerk. Städtische Galerie im Lenbachhaus, Munich et al. Stuttgart 1997 (cat.).– Hoyland, J. (ed.): H. H. Late Paintings, Tate Gallery. London 1988 (cat.).– Hunter, S.: H. H. New York 1963, Paris 1963.– Seitz, W. C. (ed.): H. H. The Museum of Modern Art. New York 1963 (cat.).– Wight, F. S.: H. H. Berkeley and Los Angeles 1957

**HOLZER Jenny**
born 1950 Gallipolis (OH)
American multimedia artist. **1968-1970** Studied art at Duke University in North Carolina and at Ohio University in Athens. **1970/71** Transferred to the University of Chicago. **1973** Graduated in painting and graphic art from Ohio University. **1974-1977** Attended Rhode Island School of Design in New York, where she taught some undergraduate classes. From **1976**

incorporated words in her paintings. **1977** Collection of writings *Truism*, in which texts are circulated through media such as posters, audio-tapes, photos and printed T-shirts. **1979/80** Worked as a typesetter. **1980-1982** Together with Peter Nadin, drew up the texts for her *Living Series*. **1981** Participation in the exhibition "Westkunst" in Cologne. **1982** First presentation of *Truism* via neon signs in Time Square, New York. Experiments with electronic scripts. Took part in documenta 7 and **1987** in documenta 8 in Kassel. **1985/86** Chiselled her texts into granite benches. **1986** Texts from the *Survival Series* broadcast on American television. **1990** Retrospective at the Guggenheim Museum, New York. First woman to represent America at the Venice Biennale. WRITINGS: J. H.: Abuse of Power Comes as no Surprise. Truisms and Essays. Halifax and New York 1983.– J. H. im Gespräch mit N. Smolik. Cologne 1993.– Smolik, N. (ed.): J. H. Schriften. Stuttgart 1996.– Smolik, N.: J. H. Gesammelte Schriften. Stuttgart 1996 MONOGRAPHS, CATALOGUES: Auping, M.: J. H. New York 1992.– J. H. Kunsthalle Basel et al. Basel 1984 (cat.).– J. H. Signs. Institute of Contemporary Arts. London 1988 (cat.).– J. H. The Venice Installation. Albright-Knox Art Gallery. Buffalo 1991 (cat.).– J. H. Signs. Art Center. Des Moines 1993 (cat.).– J. H. Lustmord. New York 1997.– J. H. Rosebud. New York (n. d.).– Waldman, D. (ed.): J. H. Solomon R. Guggenheim Museum. New York 1989, 1992 (cat.).– Waldman, D.: J. H. Stuttgart 1997

**HOOVER Nan**
born 1931 New York
American installation and performance artist. **1949-1954** Studied painting at the Corcoran Gallery School in Washington. From **1957** exhibitions of paintings and drawings in New York, Washington and Amsterdam. **1969** Moved to Amsterdam. **1972-1974** Worked alternately in France and Amsterdam. **1974** First videos and performances. **1975** Video exhibition with the painter Richard Hefti at the Jurka Gallery, Amsterdam. **1977** and **1987** took part in documenta 6 and 8 in Kassel. **1978/79** First film project entitled *Lapses*. Participated in

Videowochen at the Museum Folkwang in Essen. **1980/81** DAAD scholarship to Berlin. Since **1989** professorship at the Düsseldorf Academy. MONOGRAPHS, CATALOGUES: Dabniels, D. et al. (ed.): N. H. Movements in Light. Amsterdam 1991 (cat.).– Gosselin, C. (ed.): N. H. Photo, Video, Performance 1980-1982. Musée d'Art Contemporain. Montreal 1982 (cat.).– N. H. Kunstverein Heilbronn et al. Heilbronn 1996 (cat.).– Mignot, D. et al. (ed.): N. H. Stedelijk Museum. Amsterdam 1979 (cat.).– Perée, R. (ed.): N. H. Kunstmuseum Bern. Bern 1988 (cat.).– Stoos, T. (ed.): N. H. Photowork, Video, Performance. Daadgalerie. Berlin 1981 (cat.)

**HOPPER Edward**
1882 Nyack (NY) – 1967 New York
American painter. **1900-1906** Studied commercial art and painting at the New York School of Art. **1906 – 1910** Extended trips to Europe, mainly to Paris, where he painted impressionist-style street scenes. **1908** Settled in New York. Worked as an illustrator and poster painter. Exhibited **1913** at the Armory Show and **1917** at the "First Annual Exhibition" of the American Society of Independent Artists. **1924** Exhibition of watercolours at the Frank K. M. Rehn Gallery. **1933** Retrospective at the Museum of Modern Art, New York. **1945** Made a member of the National Institute of Arts and Letters. **1950** Received an honorary doctorate from the Art Institute of Chicago. **1952** Participated at the Venice Biennale. **1964** and **1980** major retrospectives at the Whitney Museum of American Art. **1968** His entire œuvre donated to the Foundation of the Whitney Museum of American Art in New York. Hopper' distinctive style was uninfluenced by any of the avant-garde movements in Europe and America. The central themes of his work were modern civilization, particularly urbanization, loneliness in the city, the expansion of industry and the eccentricities of American architecture. CATALOGUES RAISONNES: Levin, G. (ed.): E. H. The Complete Prints. New York 1979 / E. H. Die Druckgraphik. Munich 1986.– Levin, G. (ed.): E. H. A Catalogue Raisonné. 3 vols. New York and Munich 1995 MONOGRAPHS, CATALOGUES: Beck, H.: Der melancholische Blick. Die Großstadt im Werk des amerikanischen Malers E. H. Frankfurt-on-Main et al. 1988.– Beck, H.: E. H. Hamburg 1992.– Goodrich, L.: E. H. London 1949, New York 1964.– Güse, E.-G. and Borge-Keweloh, N. (ed.): D. H. Das Frühwerk. Westfälisches Landesmuseum. Münster 1981 (cat.).– Hobbs, R.: E. H. New York 1987.– Költzsch, G. W. and H. Liesbrock (ed.): E. H. und die Fotografie. Die Wahrheit des Sichtbaren. Museum Folkwang, Essen. Cologne 1992 (cat.).– Kranzfelder, I.: E. H. 1882-1967. Vision of Reality. Cologne 1995.– Levin, G. (ed.): E. H. as Illustrator. Whitney Museum

of American Art. New York 1979.– Levin, G. (ed.): E. H. The Art and the Artist. Whitney Museum of American Art, New York et al. New York 1980 (cat.).– Levin, G.: E. H. New York 1984.– Levin, G. (ed.): E. H. Gemälde und Zeichnungen. Folkwang Museum, Essen. Munich 1992 (cat.).– Liesbrock, H.: E. H. Die Wahrheit des Lichts. Duisburg 1985.– Liesbrock, H.: E. H. Das Sichtbare und das Unsichtbare. Stuttgart 1992.– Lyons, D. and A. D. Weinberg: E. H. and The American Imagination. New York 1995.– Renner, R. G.: E. H. 1882-1967. Transformation of the Real. Cologne 1992.– Schultze, S. (ed.): E. H. 1882-1967. Schirn Kunsthalle. Frankfurt-on-Main 1992 (cat.)

### HORN Rebecca
born **1944** Michelstadt
German object artist and film-maker. **1964 –1969** Studied at the Hamburg School of Fine Arts. **1968** First body sculptures in which peacock feathers and other items are worn like clothes. **1971/72** DAAD scholarship to London. **1972** Moved to New York. **1972-1992** Participation in documenta 5 – 9 in Kassel. **1972/73** *Performances I + II* highlighting the interaction of people and objects. **1974** Guest-lecturer at the University of San Diego. **1978** and **1981** Made the films *Der Eintänzer* and *La Ferdinanda – Sonate für eine Medici-Villa*, later using objects and props from these films for arrangements and installations such as the work *Körper-Raum-Reflexe*. **1986** Won the Arnold Bode Award in Kassel. **1989** Production of the cinema film *Buster's Bedroom*. **1992** Prize for media art from the ZKM in Karlsruhe and Kaiserring, Goslar. **1994/95** Retrospective at the Guggenheim Museum in New York and the Gropius Bau in Berlin. Horn's videos and perfomances are choreographic rituals revolving around extensions of the body and the mythical identification of man with nature.
WRITINGS: R. H.: Dialogo della Vedova Paradisaca. Genoa 1975.– R. H.: Buster's Bedroom. A Filmbook. Zurich, New York and Frankfurt-on-Main 1991.– R. H.: The Glance of Infinity. New York (n. d.)
MONOGRAPHS, CATALOGUES: Baum, T.: Rebeccabook I. New Yok 1975.– Baum, T. et al. (ed.): R. H. Objekte, Video, Filme. Kölnischer Kunstverein et al. Cologne 1977 (cat.).– Celant, G. and K. Schmidt (ed.): R. H. Staatliche Kunsthalle Baden-Baden et al. Baden-Baden 1981 (cat.).– Celant, G. et al. (ed.): R. H.: Diving through Buster's Bedroom. Museum of Contemporary Art. Los Angeles 1990 (cat.).– Celant, G. et al. (ed.): R. H.: Filme 1978-1990. Kestner-Gesellschaft. Hanover 1990 (cat.).– Celant, G. et al. (ed.): R. H. Solomon R. Guggenheim Museum, New York et al. New York 1993 (cat.).– Celant, G. et al. (ed.): G. H. Kunsthalle Vienna et al. Vienna 1994 (cat.).– Curiger, B. et al. (ed.): R. H. Museum of Contemporary Art, Chicago et al. Chicago 1984 (cat.).– Haenlein, C.-A. et al. (ed.): R. H. Der Eintänzer. Kestner-Gesellschaft, Hanover et al. Hanover 1978 (cat.).– Haen-

lein, C. (ed.): R. H. The Glance of Infinity. Kestner-Gesellschaft. Hanover 1997 (cat.).– R. H.: La Lune rebelle. Stuttgart 1993.– Mosebach, M. et al. (ed.): R. H. Nuit et jour sur le dos du serpent à deux têtes. Musée d'Art Moderne de la Ville de Paris. Paris 1986 (cat.).– Stoss, T. et al. (ed.): R. H. Kunsthaus Zurich et al. Zurich 1983 (cat.)

### HORST Horst P.
**1906** Weißenfels (Saale)  – **1999** Palm Beach
German-born American photographer. **1926-1928** Studied art and architecture under Walter Gropius at the Hamburg School of Arts and Crafts. From **1931** photographed for numerous journals. Besides fashion photographs did mainly portraits of famous artists, writers and politicians, including Dalí and Cocteau. **1931-1935** Photographed for *Vogue* in Paris with Hoyningen-Huene. **1935-1943** Photographed fashion shows in New York and Paris. **1943-1945** Military service. Portraits of high-ranking officers. **1950** First advertising photographs for Cadillac. **1950-1968** Directed his own photographic studio in New York. **1974-1980** Regular exhibitions at the Ileana Sonnabend Gallery in New York. **1977** Participation in documenta 6 in Kassel. Horst often uses classical props in his photographs, and works with dramatic lighting effects.
MONOGRAPHS, CATALOGUES: Kazmair, M. (ed.): H. Sixty Years of Photography. New York 1996.– Lawford, V.: H. His Work and His World. Harmondsworth 1985

### HOYNINGEN-HUENE George
**1900** St. Petersburg – **1968** Los Angeles
Russian-born American photographer. **1912** Lived in Italy. **1917** Fled to England to escape the Russian revolution. **1921-1924** Lived in Paris, earning his living as a translator. **1925** Drew fashion designs for *Harper's Bazaar*. Began working as a professional photographer. **1926** Head photographer for *Vogue* in France. **1927** Worked with Paul Outerbridge. Produced fashion films for *Vogue*. **1929** Sent by *Vogue* to Paris. Built up a portfolio of portraits of film celebrities in Hollywood. **1931** Took portraits for Condé Nast in Berlin. **1935-1945**

Worked for *Harper's Bazaar*. **1937** Trip to Greece. **1938** First book publication. From **1946** taught at the Art Center School in Los Angeles and worked as a portraitist for several leading film companies. **1955-1968** Made documentary films in Hollywood.
MONOGRAPHS, CATALOGUES: Ewing, W. (ed.): Eye for Elegance. G. H.-H. National Center of Photography. New York 1980.– Ewing, W.: The Photographic Art of H.-H. New York 1986.– H. P. H. CCD-Galerie. Düsseldorf 1982 (cat.).– Pucciani, O.: H.-H. and the Fashion Image. Los Angeles County Museum of Art. Los Angeles 1970 (cat.)

### HUBBUCH Karl
**1891** Karlsruhe – **1979** Karlsruhe
German painter and graphic artist. **1908- 1914** Studied at the Karlsruhe Academy and under Emil Orlik at the institute attached to the Museum of Arts and Crafts in Berlin. **1914-1918** Military service. **1920-1922** Continued studies under Walter Conz at the Karlsruhe Academy, where from **1924/25** he himself taught drawing. Participated in the exhibition "Neue Sachlichkeit" at the Kunsthalle Mannheim. **1928** Appointed Professor at Karlsruhe. Member of the Vereinigung revolutionärer Künstler (ASSO), an association of revolutionary artists. **1929** Took part in the exhibition "Neue Sachlichkeit" at the Stedelijk Museum, Amsterdam. **1930** Co-founder of the journal *Monatsschrift für Zeitkunst, Zeitbetrachtung, Satire und Karikatur*. **1932/33** Publication of a collection of drawings entitled *Deutsche Belange* (German Interests). Dismissed from his post and forbidden to paint or exhibit. **1939-1945** Painted flowers at the Majolika factory in Karlsruhe and at Schmid-Schlenkers, a firm in Schwenningen making cuckoo clocks. **1945-1947** Active in anti-fascist organisations. **1947** Taught architecture at Karlsruhe Technical College. **1948-1957** Professor of Painting at the Karlsruhe Academy.
CATALOGUE RAISONNE: Riester, R. (ed.): K. H. Das graphische Werk. Freiburg 1969
MONOGRAPHS, CATALOGUES: Goettl, H. et al. (ed.): K. H. 1891-1979. Badischer Kunstverein, Karlsruhe. Munich 1981 (cat.).– Hartmann, W. (ed.): K. H. Der Zeichner. Wilhelm-Busch-Museum, Hanover et al. Stuttgart 1991 (cat.).– Kinkel, H. (ed.): Der frühe H. Zeichnungen und Druckgraphik 1911-1925. Kunsthalle Bremen et al. Bremen 1973.– Rödiger, D. (ed.): K. H. Retrospektive. Städtische Galerie im Prinz Max Palais, Karlsruhe. Stuttgart 1993 (cat.).– Schmidt, D.: K. H. Munich 1976

### HUNDERTWASSER Friedensreich
(Friedrich Stowasser)
**1928** Vienna  – **2000** on sea
Austrian painter and graphic artist. Attended the Montessori School Vienna, and studied for one year at the Vienna Art Academy. **1949** Travelled throughtout

Europe and North Africa. On his return, he took the name Hundertwasser and produced his first art works, categorising them as "half Klee – half Rousseau". **1953** First solo-exhibition in Vienna, and further exhibitions in Cologne, Paris and Milan. **1956** Publication of his article *La visibilité de la création transautomatique*. **1958** Issued the *Verschimmelungsmanifest gegen den Rationalismus in der Architektur* (Mould Manifesto Against Rationalism in Architecture). **1959** Together with Bazon Brock staged the happening *Endlose Linie* in Hamburg. **1961** Worked with Japanese wood-engravers, and printed his graphic works in Japan. **1964** Participation in documenta 3 in Kassel. In the 70s, decorated buildings with murals inlaid with ceramic pieces. **1982** Promoted and designed ecological architecture. **1983- 1985** Building of Hundertwasser houses in Vienna and further architectural commissions. Hundertwasser's brilliantly coloured paintings are influenced by Viennese Jugendstil and the works of Klee. His spectacular public appearances and speeches, his commitment to nature and his highly individual lifestyle have made him well-known to a wide public.
WRITINGS: F. H.: Der Transautomatismus. Eine allgemeine Mobilmachung des Auges. Roma and Paris 1956.– F. H.: Verschimmelungsmanifest gegen den Rationlismus in der Architektur. Seckau 1958.– F. H.: Das H.-Haus. Vienna 1985.– Schurian, W. (ed.): F. H. Schöne Wege. Gedanken über Kunst und Leben. Munich 1983
CATALOGUES RAISONNES: Koschatzky, W. (ed.): F. H. Das vollständige druck-graphische Werk 1951-1986. Zurich and Schwäbisch Hall 1986.– Koschatzky, W. (ed.): Catalogue raisonné de l'œuvre gravé 1951-1986. Paris 1986.– Schmied, W. (ed.): H. Vollständiger Œuvre-Katalog. Hanover 1964
MONOGRAPHS, CATALOGUES: Chipp, H. B. and B. Richardson (ed.): H. University Art Museum, Berkeley. New York 1968 (cat.).– Hofmann, W.: H. Salzburg 1965, New York 1976.– Schmied, W. (ed.): F. H. Stedelijk Museum. Amsterdam 1964 (cat.).– Hulten, K. G. and K. Bergquist (ed.): F. H. Moderna Museet. Stockholm 1965 (cat.).– F. H. Regentag. Museum Ludwig. Cologne 1980 (cat.).– H. Tapisserien. Museum für Angewandte Kunst. Vienna 1978 (cat.).– Mathey, J. F.: H. Munich 1985.– Rand, H.: F. H. Der Maler. Munich 1986.– Rand, H.: F. H. Cologne 1993.– Restany, P.: H. Paris 1957.– Schmied, W.: H. Frankfurt-on-Main 1968.– Schmied, W.: H. Salzburg 1974

### HUSZAR Vilmos
**1884** Budapest – **1960** Hierden
Hungarian painter. Trained as a wall decorator at the Budapest School of Arts and Crafts. From **1904** studied at the Munich Academy of Arts. **1909** Moved to Holland. **1915-1916** First Cubist works and designs for stained-glass windows. **1917** Co-founder of De Stijl. First abstract compositions. Interior and colour designs, partly in collab-

oration with Jan Wils, Piet Zwart and van der Kloot Meyburg. **1921** Took part in the Constructivist convention in Düsseldorf, where he met El Lissitzky. **1922** Designed a room in the house of T. Brugman in The Hague, for which van Doesburg and Schwitters had also designed interiors. Stage designs. From **1925** graphic sketches for advertising, industry and exhibitions posters. **1930** Continued painting, but also designed furniture. Huszár was one of the theoreticians whose ideas contributed to Neo-Plasticism. He also tried to apply the principles of De Stijl to theatre design. MONOGRAPHS, CATALOGUES: Ey, S. and E. Hock: De mechanisch dansende Figur van V. H. Utrecht 1984.– Ex, S. and E. Hock: V. H. Schilder en ontwerper 1884-1960. Utrecht 1985

### IGNATOVICH Boris

**1899** Loutzk (Ukraine) – **1976** Moscow
Ukranian photographer. **1918–1921** Worked for various newspapers in Kharkov. **1919** Editor of the journal *Krasnaia Bachkria*. **1923** Studied photographic techniques with Rodchenko. **1926** Head of the Photoreporters' Association in Moscow. **1926–1930** Photographed for various newspapers and journals, including *Ogonyok*, and published the magazine *Bednota*. **1932 –1939** Worked on a number of documentary films. **1941–1943** War correspondent. **1945** Worked as a photographer with the *Soyuzfoto* Agency. Experimented with colour photography. **1969** Publication of *The National Collection of Weapons in the Kremlin*. Ignatovich's photographs document many historical events and personalities.
MONOGRAPHS, CATALOGUES: Volkov-Lannit, L.: B. I. Moscow 1973

### IMMENDORFF Jörg

born **1945** Bleckede
German painter. **1963/64** Studied theatrical set design at the Düsseldorf Academy. Joined Beuys' class. **1965/66** Happenings with social and political content at the Academy. **1968/69** Appeared under the name of *Lidl* in political rallies in Düsseldorf and other cities. Later began to produce pictures and posters heavily influenced by social realism. **1972** and **1982** took part in documenta 5 and 7 in Kassel. **1976**

Organised happenings in East Berlin with A. R. Penck. **1978** Started work on *Café Deutschland*, a series of paintings, rich in allusive symbolism, on the theme of divided Germany. **1979** Took part in "Initiative für eine bunte Liste". **1981** Guest-professor at the Academy in Stockholm. **1982/83** Taught at the College of Plastic Arts, Hamburg. **1997** Received the world's most lucrative award, the Marco Prize from the Museo de arte contemporáneo in Monterrey (Mexico). Immendorff stands for politically active art.
WRITINGS: J. I.: Lidlstadt. Düsseldorf 1968.– J. I.: Den Eisbären mal reinhalten. Düsseldorf 1968.– J. I.: Hier und jetzt: Das tun, was zu tun ist. Cologne and New York 1973 Cologne 1990.– J. I. and A. R. Penck: Deutschland mal Deutschland. Munich 1979.– J. I. im Gespräch mit P. Kort. Cologne 1993
MONOGRAPHS, CATALOGUES: Boetzkes, M. and D. Nguy (ed.): I. Zeichnungen 1959-1989. 4 vols. Roemer-Museum, Hildesheim 1989.– Bojescul, W. (ed.): J. I. Kunstverein Braunschweig. Brunswick 1985 (cat.).– Fuchs, R. et al. (ed.): I. Langer Marsch auf Adeler. Museum Boymans-van Beuningen, Rotterdam et al. Rotterdam 1992 (cat.).– Gachnang, J. et al. (ed.): I. Kunsthaus Zurich et al. Düsseldorf 1983 (cat.).– Gohr, S. (ed.): J. I. The Rake's Progress. Stuttgart 1994.– Harten, J. and U. Krempel (ed.): J. I. Café Deutschland. Adlerhälfte. Städtische Kunsthalle Düsseldorf. Düsseldorf 1982 (cat.).– Harten, J. et al. (ed.): J. I. Kunstmuseum Wolfsburg. Stuttgart 1997.– I.'s Handbuch der Akademie für Adler. Portikus. Frankfurt-on-Main 1990 (cat.).– Koepplin, D. (ed.): J. I, Café Deutschland. Kunstmuseum Basel. Basel 1985 (cat.).– Kort, P.: J. I. Zeichnungen 1964-1993. Bern and Berlin 1994.– Schmidt, M. and J. Gachnang (ed.): J. I. Malermut rundum. Kunsthalle Bern. Bern 1980 (cat.).– Tolnay, A. (ed.): I. Malerei 1883-1990. Galerie der Stadt Esslingen, Villa Merkel. Esslingen et al. Esslingen 1991 (cat.)

### INDIANA Robert

(Robert Clark)
born **1928** Newcastle (IN)
American painter. Studied at the John Herron School of Art in Indianapolis, at the Art Institute of Chicago and, while staying in Scotland **1953/54** at the Edinburgh College of Art. **1960–1962** Produced a group of Hermes figures with enormous phalli, made out of wood and metal. Made *objets trouvés*. From **1966** the word "Love" became one of his favourite motifs. **1968** Participation in documenta 4 in Kassel. **1973** Designed a postage stamp for the United States Post Office using the word and later transformed it into huge aluminium and steel sculptures. Friendship with Ellsworth Kelly in New York had an important influence on his formal language. Indiana's pictures and serigraphs are often categorized as Pop Art. He developed an individual style of Hard-Edge painting out of words, letters, and symbols.

CATALOGUE RAISONNE: Sheehan, S. (ed.): R. I. Prints. A Catalogue Raisonné 1951-1991. New York 1991
MONOGRAPHS, CATALOGUES: R. I. University Art Museum. Austin 1977 (cat.).– Katz, W. (ed.): R. I. Druckgraphik und Plakate 1961-1971/ The Prints and Posters. Stuttgart and New York 1971.– Katz, W. (ed.): R. I. Early Sculpture 1960-1962. Salma-Caro Gallery. London 1991.– McCoubrey, J. W. (ed.): R. I. Institute of Contemporary Art, Philadelphia et al. Philadelphia 1969 (cat.).– Mecklenburg, V. M. (ed.): Wood Works. Constructions by R. I. National Museum of American Art, Smithsonian Institution, Washington et al. Washington 1984 (cat.).– Weinhardt, C. J.: R. I. New York 1990

### ITTEN Johannes

**1888** Südern-Linden (near Thun) – **1967** Zurich
Swiss painter and art teacher. **1909–1913** Studied mathematics and attended the Ecole des Beaux-Arts in Geneva. **1913–1916** Studied under Hoelzel at the Stuttgart Academy. **1915** First abstract pictures, based on Delaunays *Formes Circulaires*. **1916** First solo-exhibition in the gallery Der Sturm in Berlin. Opening of the Itten Art School in Vienna. **1919–1923** Set up the preliminary course, teaching the general principles of form and colour, at the Weimar Bauhaus. **1926** Founded another art school in Berlin. **1931–1938** Director of Krefeld School of Textile Design. **1938** Emigration to Switzerland. Appointed director of the School and Museum of Arts and Crafts in Zurich. Director of the Museum until **1953** and of the Zurich College of Textile Design **1943–1960**. From **1949** helped to set up the Rietberg Museum, which he directed from **1952–1955**. **1961** Publication of the book *Kunst der Farbe*. Itten became known as an art teacher and colour theorist. His paintings, which run the gamut from Expressionism through Orphism to Constructivism, are a practical realisation of his theoretical research into colour.
WRITINGS: Badura-Triaska, E. (ed.): J. I. Tagebücher 1913-1919. 2 vols. Vienna 1990.– Itten, A. (ed.): J. I. Mein Vorkurs am Bauhaus. Gestaltungs- und Formenlehre. Ravensburg 1975/Design and Form. London 1964.– Itten, A. (ed.): J. I. Tagebuch. Beiträge zu einem Kontrapunkt der bildenden Kunst. Ravensburg 1980.– J. I.: Kunst der Farbe. Subjektives Erleben und objektives Erkennen als Wege zur Kunst. Ravensburg 1961/The Art of Colour. London and New York 1961, 1970.– J. I.: Elemente der bildenden Kunst. Ravensburg 1980.– Itten, A. and W. Rotzler (ed.): Werke und Schriften. Zurich 1972.– Wick, R. (ed.): J. I. Bildanalysen. Ravensburg 1988
CATALOGUES RAISONNES: Helfenstein, J. and H. Mentha (ed.): J. I. Das Frühwerk 1907-1919. Kunstmuseum Bern. Bern 1992 (cat.).– Itten, A. and W. Rotzler (ed.): J. I. Werke und Schriften. Zurich 1972 and 1978

MONOGRAPHS, CATALOGUES: Baumhoff, A. et al. (ed.): Das frühe Bauhaus und J. I. Kunstsammlungen zu Weimar et al. Stuttgart 1994 (cat.).– Bogner, D. (ed.): J. I. Museum Moderner Kunst, Vienna et al. Vienna 1980 (cat.).– Bothe, R. et al. (ed.): Das frühe Bauhaus und J. I. Kunstsammlungen zu Weimar et al. Stuttgart 1994 (cat.).– Güse, E.-E. and N. Borger-Keweloh (ed.): J. I. Gemälde, Gouachen, Aquarelle, Tuschen, Zeichnungen. Westfälisches Landesmuseum. Münster 1980 (cat.).– Poot, J. (ed.): J. I. Het Velum. Stedelijk Museum. Amsterdam 1991 (cat.).– Tavel, H.-C. v. and J. Helfenstein (ed.): J. I. Künstler und Lehrer. Kunstmuseum Bern et al. Bern 1984 (cat.).– Thönissen, K. (ed.): J. I. und die Höhere Fachschule für textile Flächenkunst in Krefeld. Deutsches Textilmuseum. Krefeld 1992 (cat.)

### JACOBSEN Robert

**1912** Copenhagen – **1993** Egtved
Self-taught Danish sculptor. **1930** first wood sculptures. From **1936** began to use metal. **1940** First exhibition in the Copenhagen Autumn Salon. Friendship with Jorn and Mortensen. **1941** Stone sculptures influenced by Arp. **1947** Scholarship to Paris. Contact with the artists associated with the Salon des Réalités Nouvelles. **1949** Experimental film *Reality A*, with background music in the concrete style, in which his own iron sculptures play a key role. In the 50s, regular participation in exhibitions at the Salon de Mai, Salon de la Jeune Sculpture and the Salon des Réalités Nouvelles. After **1955** curving iron installation – sculptures bearing clear toolmarks. **1959** Participation in documenta 2 in Kassel. **1962–1981** Professor at the Munich Academy of Arts. **1966** Sculpture Prize at the Venice Biennale. **1967** Set design for the ballet *Don Juan*. Since **1970** strongly rhythmical constructions with a weightless appearance. **1984** Major retrospective at the Musée Rodin in Paris and the Musée des Beaux-Arts in Rennes.
MONOGRAPHS, CATALOGUES: Der Bildhauer R. J. und seine Welt. Kunsthalle Kiel et al. Kiel 1984 (cat.).– Descargues, P.: R. J. Passeport. Paris 1993.– Dewasne, J.: R. J. Sculpteur danois. Copenhagen 1951.– R. J. Parcours. Musées de Toulon et al. Paris 1984 (cat.).– Jespersen, P. J. R. J. Oslo 1978.– Kronjäger, J. (ed.): Raum und Zeichen. Werke des Bildhauers R. J. Städtische Kunsthalle Mannheim et al. Mannheim 1987 (cat.).– Romain, L. and C. S. Weber (ed.): R. J. 2 vols. Museum Würth, Künzelsau. Sigmaringen 1992 (cat.)

### JACQUET Alain

born **1939** Neuilly-sur-Seine (near Paris)
French painter. **1959/60** Studied architecture at the Ecole Nationale des Beaux-Arts in Paris. Was an actor before he became an artist. **1961** Appearance of the work *Jeu de Jacquet*, which presents the last name of the artist in the form of a backgammon board.

**1962/63** Camouflage series, which also included a large-scale "camouflage" painting of a hot-dog picture by Lichtenstein; this was later cut up and sold in pieces. **1964** Started the picture series *Déjeuner sur l'Herbe*: a photographic reenactment of Manet's famous painting, using his friends as models. Preferred techniques: silkscreen and painting on plexiglas. In the late 60s he produced sculptures using apparently real but actually false materials. Since **1980** use of new media techniques, from satellite photographs to laser printing.
MONOGRAPHS, CATALOGUES: Hahn, O. (ed.): A. J. City-Galerie. Zurich 1965.– Pagé, S. and P. Restany (ed.): A. J. Donut Flight 6078. Musée d'Art Moderne de la Ville de Paris. Paris 1978 (cat.).– Restany, P.: A. J. Le Déjeuner sur l'herbe 1964-1989, 25e anniversaire. Paris 1989.– Smith, D.: A. J. Paris 1990

**JANCO Marcel**
(Marcel Iancu)
**1895** Bucharest – **1984** Tel Aviv
Romanian painter and architect. **1910-1914** Studied painting under Josef Istler. **1912** Publication with Tristan Tzara and Ion Vinea of the journal *Simbolul*. **1915** Studied architecture in Zurich. **1916** Together with Hugo Ball, Richard Huelsenbeck, Tristan Tzara, Hans Arp and others, started up the *Cabaret Voltaire* and produced masks and decorations for its dadaist productions. Began abstract painting. **1917-1919** Work on abstract plaster reliefs. **1919** Founding of the Artists Radicaux group together with Arp, Richter, Eggeling, Giacometti and others. **1921** Moved to Paris. **1922** Returned to Romania, where he published the magazine *Contimporanul*. From **1926** architectural commissions. **1941** Emigration to Israel. **1953** Founding of the El Hod artists' colony. **1959** Retrospective at the Tel Aviv Museum. Participation in numerous retrospectives of the Dada Movement. **1982** Opening of the Marcel Janco Museum in the El Hod artists' colony. Janco, who combined the expressive power of folk art with Dadaism, can be considered the forerunner of modern art in Romania.
MONOGRAPHS, CATALOGUES: Enache, V. M.: M. J. in Romania. Diss. Bucharest 1976.– M. J. Tel Aviv Museum. Tel Aviv 1972 (cat.).– M. J. Tel Aviv Museum. Tel

Aviv 1982 (cat.).– Mendelson, M. L.: M. J. Tel Aviv 1962.– Seiwert, H.: M. J. Dadaist, Zeitgenosse, wohltemperierter morgenländischer Konstruktivist. Frankfurt-on-Main 1993.– Seuphor, M.: M. J. St. Gallen 1963

**JAVLENSKY Alexei von**
**1864** Torschok (Russia) – **1941** Wiesbaden
Russian painter. **1882-1896** Military service as an officer, while continuing (from **1889**) his art studies at the Academy in St. Petersburg. **1896** Moved, together with Marianne von Verefkin, to Munich, where he attended Azbè's private art school and became friends with Kandinsky. **1903** Participation in the exhibition of the Berlin Secession. **1907** Acquainted with Matisse in Paris. **1909** Co-founder of the Neue Künstlervereinigung (New Artists' Association) in Munich. Resignation from the NKVM and participation in the exhibition of the Blauer Reiter. **1912** Takes part in the Sonderbund Exhibition in Cologne and the first show of the Blauer Reiter in Berlin, in Walden's gallery Der Sturm. Acquaintance with Nolde. Lived from **1914-1921** in exile in Switzerland. Separated in **1921** from Verefkin and moved to Wiesbaden. **1929** Founded the group Die Blauen Vier with Kandinsky, Klee and Feininger. First signs of paralysis. **1933** Forbidden to exhibit. **1937** 72 of his works classified as "degenerate art" and confiscated. **1938** Became totally paralysed. An increasing emphasis on religion in his late works reached a climax in his *Meditations*, in which the human face becomes an icon to be regarded with spiritual fervour.
CATALOGUES RAISONNES: Jawlensky, M. et al. (ed.): A. J. Catalogue Raisonné of the Oil Paintings, Watercolours and Drawings. 4 vols. London and Munich 1991-1998.– Rosenbach, D. (ed.): A. v. J. Leben und druckgraphisches Werk. Hanover 1985
MONOGRAPHS, CATALOGUES: Chiappini, R. (ed.): A. J. Pinacoteca Communale, Casa Rusca, Locarno. Milan 1989 (cat.).– Demetrion, J. T. (ed.): A. J. A Centennial Exhibition. Pasadena Art Museum. Pasadena 1964 (cat.).– Eichhorn, H. (ed.): A. v. J. Gemälde, Aquarelle, Zeichnungen. Städtische Galerie. Bietigheim-Bissingen 1994 (cat.).– Fäthke, B. (ed.): A. J. Zeichnungen, Graphik, Dokumente. Landesmuseum Wiesbaden. Wiesbaden 1983 (cat.).– Mochon, A. (ed.): A. J. From Appearance to Essence. Long Beach Museum of Art. Long Beach 1991 (cat.).– Moutashar, M. and A. Charron (ed.): A. v. J. Espace Van Gogh. Arles 1993 (cat.).– Rathke, E.: A. J. Hanau 1968.– Rattemeyer, V. (ed.): A. v. J. zum 50. Todesjahr. Gemälde und graphische Arbeiten. Landesmuseum Wiesbaden. Wiesbaden 1991 (cat.).– Rattemeyer, V. et al. (ed.): A. v. J. Museum Boymans-van Beuningen, Rotterdam 1994 (cat.).– Schampers, K.: A. v. J. Washington 1995.– Schultze, J.: A. v. J. Cologne 1970.– Weiler, C.: A. v. J. Der Maler und Mensch. Wiesbaden 1955.– Weiler, C. A. J. Cologne

1959.– Weiler, C.: A. J. Köpfe, Gesichter, Meditationen. Hanau 1970.– Zweite, A. (ed.): A. J. 1894-1941. Städtische Galerie im Lenbachhaus, Munich et al. Munich 1983 (cat.)

**JENNEY Neil**
born **1945** Torrington (CT)
American painter. **1964-1966** Studied at the Massachusetts College of Art in Boston. Moved to New York. After an early minimalist phase in the early 60s, Jenney developed a more strongly substantive painting style, eclectically mixing styles and eras, which culminated in his so-called *Bad Paintings* of **1969-1971**. **1972** Participation in documenta 5 in Kassel. As a form of Concept Art, created simple narrative pictures often involving a play on words and set in severe frames. After these attempts to connect art and language, Jenney put more emphasis on the picture frame: picture fragments and cropped close-ups are set in massive black frames, like an architrave. **1980** Participation at the Venice Biennale. At the beginning of the 80s, the artist chose a narrow horizontal format, like a viewing slit, for his socially critical pictures, which document the destruction of the natural habitat.
MONOGRAPHS, CATALOGUES: N. J. The Museum of Modern Art. New York 1991 (cat.).– Rosenthal, M. (ed.): N. J. University Art Museum. Berkleley 1981 (cat.).– Yonkers, N. Y. (ed.): N. J. Hudson River Museum 1985 (cat.)

**JENSEN Alfred**
**1903** Guatemala – **1981** Livingston (NJ)
Danish-American painter and concept artist. **1924-1925** Studied at the San Diego Fine Arts School, **1926-1928** at the Hofmann School in Munich, and from **1930** at the Académie Scandinave in Paris. **1938** Developed J. W. v. Goethe's *Theory of Colour* in diagrams through which he investigated light and colour values. **1951** Moved to New York. **1952** First solo-exhibition in the John Heller Gallery, New York. **1957** First murals. **1958** Taught at the Maryland Institute in Baltimore. **1961** Exhibition at the Guggenheim Museum in New York. **1964** and **1972** participation in documenta 3 and 5 in Kassel. **1974-1976** Works based on numerical systems and phenomena based on cyclical patterns, incorporating the theories of Michael Faraday. **1977** Participant at the São Paulo Biennale. **1978** Retrospective at the Albright-Knox Art Gallery, Buffalo. After an early phase of gestural abstraction, Jensen developed a geometric, abstract painting style combining colour analysis with numerical mysticism.
MONOGRAPHS, CATALOGUES: Cathcart, L. and M. Tucker (ed.): A. J. Paintings and Diagrams from the Years 1957-1977. Albright-Knox Art Gallery. Buffalo 1978 (cat.).– Schjeldahl, P. and M. Reidelbach (ed.): A. J. Solomon R. Guggenheim Museum. New York 1985 (cat.).– Schmied,

W. et al. (ed.): A. J. Kestner-Gesellschaft, Hanover et al. Hanover 1973 (cat.)

**JETELOVA Magdalena**
born **1946** Semil
Czech sculptress. **1965-1971** Attended the Academy of Art in Prague. **1967/68** Studied under Marini at the Accademia di Brera in Milan. **1984** Scholarship awarded by the city of Munich to the Villa Waldberta. **1986** Prizewinner in the *dimension V* competition. Grant from the city of Munich. First laser projection projects for removing existing space boundaries and creating new spacial orientation points. Exploration of the opposites Rationality and Irrationality, Stability and Instability in room-oriented sculptures, like *Steps, Chairs, Doors, and Houses*. **1987** Participant in documenta 8 in Kassel. **1988** Visiting professor at the Art Academy in Munich. Solo-exhibition in the Hamburg Kunsthalle. **1989** Professor at the summer academy in Salzburg. From **1990** professor at the National Art Academy in Düsseldorf. Multi-layered and associative installations in Plymouth, Halifax, Vienna, and Prague between **1990** and **1993** which incorporate architecture and landscape. Jetelová's complex artistic philosophy combines elements of Constructivism with features of Arte Povera and Land Art.
MONOGRAPHS, CATALOGUES: Guthbrod, H. (ed.): M. J. Multi Purposes – Zwischen den Stühlen. Karlsruhe 1997 (cat.).– M. J. Sculpture. Riverside Studios. London 1986 (cat.).– M. J. Staatliche Kunsthalle Baden-Baden. Baden-Baden 1987 (cat.).– M. J. Skulpturen. Städtische Galerie. Göppingen 1990 (cat.).– M. J. The Henry Moore Sculpture Trust Studio. Manchester 1991 (cat.).– M. J. Belveder, Royal Garden of the Prague Castle, Prague. Munich 1993 (cat.).– M. J. Kunstverein Hannover. Hanover 1994 (cat.).– Wolbert, K. (ed.): M. J. Orte und Räume. Mathildenhöhe, Darmstadt. Stuttgart 1996

**JOCHIMS Raimer**
born **1935** Kiel
German painter and art theoretician. During his philosophy and art history studies, he began as of **1955** to study painting as well. Developed his own conceptual identity after **1961** through work on his

chromatic pictures and fading pictures, which portray fluctuations between colour and surface. **1967** Taught at the Art Colleges in Karlsruhe and Munich. After **1971** professor for painting and art theory at the Art College in Frankfurt. **1973/74** Production of single and series works using plywood and torn paper, focusing on forms of colour. After **1979** production of painting books. **1986–1988** Exploration of the interplay of colour and form.
WRITINGS: R. J.: Visuelle Identität. Frankfurt-on-Main 1975
MONOGRAPHS, CATALOGUES: Bauermeister, V. et al. (ed.): R. J. Klagenfurt 1987 (cat.).– Boehm, G. et al. (ed.): R. J. Bilder/Paintings 1961-1993. Kunstmuseum Bonn. Stuttgart 1994 (cat.).– R. J. Arbeiten 1961-1975. Kunstmuseum Bonn et al. Bonn 1975 (cat.).– R. J. Bilder, Papierarbeiten R. J. Zueignung. Dichtung und Malerei, Zyklen von Papierarbeiten 1982-1988. Goethe-Museum. Frankfurt-on-Main 1990 (cat.)

**JOHNS Jasper**
born **1930** Augusta (GA)
American painter. **1947/48** Studied at the University of South Carolina. **1949** Attended art school in New York, followed by two years in the army including a posting to Japan. **1952** Returned to New York, where he earned his living selling books. **1954** Worked with Rauschenberg as a window decorator for department stores. **1956/57** Began to integrate objects into his paintings. Contact with Leo Castelli. First solo-exhibition in **1958** in the Leo Castelli Gallery in New York, generally heralded as the beginning of Pop Art. **1959** Carnegie Prize at the Pittsburgh Biennale. Participated in a happening with Kaprow. **1960** First lithographs; later, further graphic works for ULAE (Universal Limited Art Edition). **1961** Set designs and costumes for the Merce Cunningham Dance Company. Collaboration with the composer John Cage. **1963** Set up a foundation for contemporary performance art. Between **1964** and **1977** participation in documenta 3 – 6 in Kassel. **1967** Prize at the São Paulo Biennale. **1975** Illustrations for Beckett's *Fizzles/Foirades*. **1988** Important prize for painting at the Venice Biennale. Together with Rauschenberg, Johns is considered one of the artists who brought key innovations to modern art after Abstract Expressionism. His paintings draw on a relatively narrow repertoire of images, for example the American flag, letters, numbers or targets. He also produced assemblages of real objects as well as commonplace objects which he encased in molten metal (sculpmetals).
WRITINGS: Hollevoet, C. and K. Varnedoe (ed.): J. J. Writings, Sketchbooks, Notes, Interviews. New York 1996.– Stemmrich, G. (ed.): J. J. Interviews, Statements, Skizzenbuchnotizen. Dresden 1997
CATALOGUES RAISONNES: Field, R. S. et al. (ed.): The Prints of J. J. 1960-1993. A Catalogue Raisonné. 3 vols. West Islip

(NY) 1994.– Huber, C. (ed.): J. J. Graphik. Bern 1970
MONOGRAPHS, CATALOGUES: Bernstein, R.: J. J. Paintings and Sculptures 1954-1974. Ann Arbor (MI) 1985.– Boudaille, G.: J. J. Paris 1991, Recklinghausen 1991.– Cage, J. et al. (ed.): Echo and Allusion in the Art of J. J. Grunwald Center at the University of California. Los Angeles 1987.– Castelli, L.: J. J. Paris 1997.– Castleman, R. (ed.): J. J. A Print Retrospective. The Museum of Modern Art. New York 1986 (cat.)/J. J. Die Druckgraphik. Munich 1986 (cat.).– Chalumeau, J.-L. (ed.): J. J. Paris 1995.– Crichton, M. (ed.): J. J. Whitney Museum of American Art. New York et al. New York 1977 (cat.)/J. J. Museum Ludwig in der Joseph-Haubrich-Kunsthalle. Cologne 1978 (cat.).– Crichton, M.: J. J. London and New York 1977, 1994.– Francis, R.: J. J. New York 1984, Munich 1985.– Field, R.: J. J. Prints 1960-1981. San Francisco 1981.– Geelhaar, C. (ed.): J. J. Working Proofs. Kunstmuseum Basel. Basel 1979 (cat.).– Hulten, P. et al. (ed.): J. J. Centre Georges Pompidou. Paris 1978 (cat.).– J. J. Museum Ludwig. Cologne 1984 (cat.).– Johnston, J.: J. J. Privileged Information. London 1996.– Kozloff, M.: J. J. New York 1967.– Orton, F.: Figuring J. J. London 1994, Cambridge (MA) 1996.– Rosenthal, M. (ed.): J. J. Work Since 1974. Philadelphia Museum of Art. New York 1988 (cat.).– Rosenthal, N. and R. E. Fine (ed.): The Drawings of J. J. National Gallery of Art, Washington et al. London 1990 (cat.).– Shapiro, D.: J. J. Drawings 1954-1984. New York 1984.– Steinberg, L.: J. J. New York 1963.– Varnedoe, K. et al. (ed.): J. J. A Retrospective. The Museum of Modern Art, New York et al. New York 1996 (cat.)/J. J. Eine Retrospektive. Museum Ludwig, Cologne et al. Munich 1997 (cat.)

**JONAS Joan**
born **1936** New York
American performance and video artist. Until **1972** studied at various institutes, including the Boston Museum School, Columbia University and the Video School of Visual Arts in New York. First performances during her student days. Production of the film *Wind* in collaboration with Peter Camput. **1971** First video works together with Serra. **1964–1987** Participation in documenta 5 – 8 in Kassel. **1974** Taught at Princeton University, New Jersey, and at Yale University, New Haven. **1975** Teacher at the Otis Art Institute, Los Angeles. **1982** DAAD scholarship to Berlin. **1982/83** Branched out into video, film, dance, and environment-like stage sets in the performance *He Saw Her Burning*. **1987** Performance *Volcano Saga*, produced after a trip to Iceland. Jonas, who attempts to explode our stereotype perception through her video works, deals in her later performances with female roles and the female body.
MONOGRAPHS, CATALOGUES: Block, R. (ed.): J. J. He Saw Her Burning. Video-

installation, Videobänder, Zeichnungen. Daadgalerie. Berlin 1984 (cat.).– Crimp, D.: J. J. Scripts and Descriptions 1968-1982. University Art Museum, Berkeley et al. Berkeley 1983 (cat.).– Mignot, D. (ed.): J. J. Works 1968-1994. Stedelijk Museum. Amsterdam 1994 (cat.)

**JONES Allen**
born **1937** Southampton
English painter. Studied **1955–1959** at the Hornsey College of Art in London and then for a year with Kitaj and Hockney at the Royal College of Art. **1961–1964** Taught lithography at Croydon College of Art and drawing at the Chelsea School of Art. **1964** and **1968** participation in documenta 3 and 4 in Kassel. **1968–1983** Visiting professorships at the Hamburg Academy of the Arts, at the University of South Florida in Tampa, at the University of Los Angeles and at the Berlin Art Academy. **1984/85** Commission to do a sculpture for the Frederick R. Weisman Foundation in Los Angeles. **1986–1990** Further public commissions for steel sculptures. **1991** Design for a telephone card for the Pop Art exhibition at the Royal Academy in London. **1992/93** Large steel sculpture for the Chelsea and Westminster Hospital theatre and health project. Jones is one of the best-known exponents of English Pop Art. He used sex magazines and underground pornographic literature as models for his lascivious female figures in the form of furniture.
CATALOGUE RAISONNE: Lloyd, R. (ed.): A. J. Prints. London 1995
MONOGRAPHS, CATALOGUES: Jencks, C. et al. (ed.): A. J. London 1993.– A. J. Waddington Art Galleries. London 1993 (cat.).– A. J. Kunsthalle. Darmstadt 1996 (cat.).– Livingstone, M.: Sheer Magic by A. J. London and New York 1979.– Livingstone, M.: A. J. Retrospective of Paintings 1957-1978. Walker Art Gallery, Liverpool et al. London 1979 (cat.).– Peters, H.-A. et al. (ed.): A. J. A Retrospective of Paintings 1957-1978. An Exhibition. Walker Art Gallery, Liverpool et al. Liverpool and Baden-Baden 1979 (cat.).– Stünke, H.: A. J. Das graphische Werk. Cologne 1969

**JORN Asger**
(Asger Oluf Jorgensen)
**1914** Vejrum (Jutland) – **1973** Århus
Danish painter. Moved in **1929** to Silkeborg, where he began to paint. Designed large decorations, in collaboration with Léger, for Le Corbusier's Pavillon des Temps Nouveaux at the **1937** Paris World Fair. **1938** First solo-exhibiton in Copenhagen of paintings full of imagery and fantastic figures inspired by Ernst and Klee. **1941** Co-founder of the magazine *Helhesten*. **1947** Participated at the Conference of the Surréalistes Révolutionnaires in Brussels. **1948** Founded the Cobra group, along with Appel, Constant, Corneille, Dotremont and Noiret. **1949** First large Cobra exhibition at the Stedelijk Museum, Amsterdam. **1959**

and **1964** participation in documenta 2 and 3 in Kassel. Up until **1961** he wrote manifestos for the Situationistische Internationale, a group of anarchistic artists who were against capitalist functionalism. **1963** Founding of the Institute for Comparative Vandalism, whose sole purpose was to collect graffiti and assess their artistic worth. **1964** Rejection of the Guggenheim Prize. Worked with décollage and torn paper. **1970–1972** Resumed painting and began bronze and marble sculptures. **1973** Major retrospective at the Kestner Society in Hanover. Jorn's expressive gestural pictures, full of demonic, mythical creatures, constitute a northern variety of Abstract Expressionism.
WRITINGS: Hofman Hansen, P.: Bibliografi over A. J.'s skrifter. Silkeborg 1988.– A. J.: Guldhorn og lykkehjul. Copenhagen 1957.– A. J.: Pour la forme. Paris 1958/Plädoyer für die Form. Entwurf einer Methodologie der Kunst. Munich 1990, 1997.– A. J.: Gedanken eines Künstlers. Munich 1966, 1997.– A. J.: La Langue verte et la cuite. Etude gastrophonique sur la marmythologie musiculinaire. Paris 1968.– A. J.: Folke kunstens Didrek. Copenhagen 1978.– A. J.: Fin de Copenhague. Paris 1995
CATALOGUES RAISONNES: Atkins, G. (ed.): A. J. Catalogue Raisonné. 4 vols. London and New York 1968-1986.– Loo, O. v. de (ed.): A. J. Werkverzeichnis Druckgrafik. Munich 1976.– Rasmussen, M. (ed.): A. J.'s tegninger. Silkeborg 1983
MONOGRAPHS, CATALOGUES: Andersen, T.: A. J. 1914-1973. A Catalogue of Works in the Silkeborg Kunstmuseum. Silkeborg 1974.– Andersen, T. (ed.): A. J. Solomon R. Guggenheim Museum. New York 1982 (cat.).– Andersen, T.: A. J. En biografi. Copenhagen 1994.– Andersen, T. et al. (ed.): A. J. 1914-1973. A. J. Stedelijk Museum. Amsterdam 1994 (cat.).– Atkins, G. and E. Schmidt (ed.): A Bibliography of A. J.'s Writings to 1963. Copenhagen 1964.– Atkins, G. and T. Andersen: J. in Scandinavia 1930-1953. London 1968.– Atkins, G.: A. J. The Crucial Years 1954-1964. London 1976.– Atkins, G.: A. J. The Final Years 1965-1973. London 1980.– Birtwistle, G.: Living Art. A. J.'s Comprehensive Theory of Art Between Helhesten and Cobra. Utrecht 1986.– Caprile, L. et al. (ed.): A. J. 2 vols. Milan 1996.– De Micheli, M.: J. scultore. Torino 1974.– Jansen, P. H.: Bibliografi over A. J.'s skrifter. Silkeborg 1988.– A. J. Stedelijk Museum. Amsterdam 1964 (cat.).– A. J. Musée des Beaux-Arts. Nîmes. 1987 (cat.).– A. J. Pinacoteca Casa Rusca, Locarno. Milan 1996 (cat.).– Lehmann, H.-U. (ed.): A. J. 1914-1973. Das graphische Werk. Die Schenkung Otto van de Loo. Kupferstich-Kabinett der Staatlichen Kunstsammlungen Dresden im Albertinum et al. Dresden 1994 (cat.).– Loo, O. v. d. (ed.): A. J. in München. Dokumentation seines malerischen Werks. Munich 1997.– Messer, T. M. (ed.): A. J. Retrospektive. Schirn Kunsthalle. Frankfurt-on-Main 1994 (cat.).– Schade, V.: A. J. Copenhagen 1968.– Schmied, W.: J. St. Gallen 1973.–

Schmied, W. (ed.): A. J. Kestner-Gesellschaft, Hanover et al. Berlin 1973 (cat.).– Zweite, A. (ed.): A. J. 1914-1973. Gemälde, Zeichnungen, Aquarelle, Gouachen, Skulpturen. Städtische Galerie im Lenbachhaus. Munich 1987 (cat.)

## JUDD Donald
**1928** Excelsior Springs (MO) – **1994** New York

American sculptor. **1948–1953** Studied art at the Art Students League, New York. **1957–1962** Studied philosophy and art history under Rudolf Wittkower and Meyer Schapiro at Columbia University, New York. **1959–1965** Worked as art critic for various magazines. **1961** Gave up painting to make relief pictures and free-standing wood and metal objects. **1962–1964** Teacher at the Brooklyn Institute of Arts and Sciences, New York. **1967** Teaching fellowship at Yale University. Between **1968** and **1987** participation in documenta 4, 6 and 7 in Kassel. From **1970** his sculptures were more and more influenced by their architectural environment and began to take on the form and function of furniture. From **1973** worked on the construction and design of a large building complex in Marfa, Texas in conjuction with other artists, including Oldenburg and Kabakov. **1976** Appointed Baldwin Professor at Oberlin College, Ohio. **1986** Permanent installation, consisting of variations on an aluminium box module, to mark the opening of the Chinati Foundation in Marfa. **1987** Awarded the Skowhegan and the Brandeis University medals for sculpture. **1988** Retrospective at the Whitney Museum, New York. His minimal, factory-made and serially arranged sculptural works have established Judd as a leading exponent of Minimal Art. WRITINGS: D. J.: Complete Writings 1959-1975. New York and Halifax 1976.– D. J.: Complete Writings 1975-1986. Eindhoven 1987.– D. J.: Ecrits 1963-1990. Paris 1991 CATALOGUES RAISONNES: Cowel, W. and J.-A. Birnie Danzker (ed.): D. J. Furniture. Museum Boymans-van Beuningen, Rotterdam et al. New York 1993 (cat.).– Schellmann, J. and M. J. Jitta (ed.): D. J. Prints and Works in Editions. A Catalogue Raisonné. Cologne and Munich 1993, 1997.– Smith, B. and D. d. Balso (ed.): D. J. Catalogue Raisonné of Paintings, Objects and Wood-Blocks 1960-1974. National Gallery of Canada. Ottawa 1975 (cat.) MONOGRAPHS, CATALOGUES: Bois, Y.-A.: D. J. Paris 1991.– Foster, H. (ed.): D. J. Sculpture, Prints, Furniture. Lisbon 1997 (cat.).– Fuchs, R. and R. Crone (ed.): D. J. Stedelijk Van Abbe Museum, Eindhoven et al. Eindhoven 1987 (cat.).– Fuchs, R. et al. (ed.): D. J. Spaces. Stankowski Foundation. Stuttgart 1994.– Haskell, B. (ed.): D. J. Whitney Museum of American Art, New York et al. New York 1988 (cat.).– D. J. Pasadena Art Museum. Pasadena 1971 (cat.).– D. J. Skulpturen. Kunsthalle Bern. Bern 1976 (cat.).– D. J. Retrospective. Museum Boymans-van Beuningen, Rotter-

dam et al. Rotterdam 1993 (cat.).– D. J. Räume – Spaces. Kunst + Design. Landesmuseum Wiesbaden. Stuttgart 1994 (cat.).– Koepplin, D. (ed.): D. J. Zeichnungen/Drawings 1956-1976. Kunstmuseum Basel et al. Basel 1976.– Petzinger, R. and H. Dannenberger (ed.): Kunst und Design. D. J. Landesmuseum Wiesbaden et al. Stuttgart 1993 (cat.).– Poetter, J. (ed.): D. J. Staatliche Kunsthalle Baden-Baden. Stuttgart 1989 (cat.).– Smith, B. (ed.): D. J. The National Gallery of Canada. Ottawa 1975 (cat.).– Stockebrand, M. (ed.): D. J. Architektur. Westfälischer Kunstverein. Münster 1989, Stuttgart 1992 (cat.)

## KABAKOV Ilya
born **1933** Dnjepropetrovsk (Ukraine)

Russian environment and installation artist. **1951–1957** Studied graphics at the Surikov Art Institute in Moscow. From **1956** worked as a book illustrator, illustrating over 100 books. **1955** Began to work as an independent artist. **1965** Joined the Artists Union of the USSR. **1970–1978** Put together albums of his drawings. Kabakov invented Expo Art with his environment-type spaces in which he placed souvenirs from his youth together with commonplace objects from everyday life in Russia in ironic and suggestive arrangements. **1978–1982** Large murals entitled *Schek Art*, in Socialist Realist style. **1982/83** Fictitious exhibition at the Pushkin Museum, Moscow ("Fly With Wings"). **1988** Took part in the Venice Biennale and, **1992**, in documenta 9 in Kassel. Moved to New York. **1993** Represented Russia at the Venice Biennale. Guest-professor in Frankfurt am Main.
WRITINGS: I. K. and B. Groys: Die Kunst des Fliehens. Dialoge über Angst, das heilige Weiß und den sowjetischen Müll. Munich and Vienna 1991.– I. K. and B. Groys: Die Kunst der Installation. Munich 1996.– I. K.: Les Souvenirs de la cuisine communautaire. Galerie Dina Vierny. Paris 1992 (cat.).– I. K.: SHEK 8, Bauman Bezirk, Stadt Moskau. Ed. by G. Hirt and Sascha Wonders. Leipzig 1994.– I. K.: Über die "totale" Installation. On the "Total" Installation. Stuttgart 1995
MONOGRAPHS, CATALOGUES: Groys, B. (ed.): I. K. Das Leben der Fliegen. Kölnischer Kunstverein. Stuttgart 1992 (cat.).– Groys, B. et al. (ed.): I. K. The Garbage Man. Oslo 1996 (cat.).– Jaukkuri, M. et al. (ed.): I. K. 5 albumia Installaatio Leikkaussali. Nykytaiteen Museo. Helsinki 1994 (cat.).– I. K. Vor dem Abendessen. Grazer Kunstverein. Graz 1988 (cat.).– I. K. Que sont ces petits hommes? Galerie de France, Paris et al. Paris 1989 (cat.).– I. K. Fliege mit Flügeln. Installation. Kunstverein Hannover. Hanover 1991 (cat.).– I. K. Night Lines. Centraal Museum. Utrecht 1991 (cat.).– I. K. We are Leaving Here Forever. Installation. Carnegie Museum. Pittsburgh 1991 (cat.).– I. K. Het grote archief. Stedelijk Museum. Amsterdam 1993 (cat.).– I. K. Incident in the Museum or Water Music. Museum of Contemporary Art,

Chicago et al. Chicago 1993 (cat.)/Zwischenfall im Museum oder Wassermusik. Hessisches Landesmuseum, Darmstadt et al. Darmstadt 1994 (cat.).– I. K. Lesesaal. The Reading Room. Deichtorhallen. Hamburg 1996 (cat.).– I. K. On the Roof. Palais des Beaux-Arts, Brussels et al. Düsseldorf 1997 (cat.).– Lingwood, J. (ed.): I. K. Ten Charakters. Institute of Contemporary Arts, London et al. London 1989 (cat.).– Martin, J.-H. and C. Jolles (ed.): I. K. Kunsthalle Bern et al. Bern 1985 (cat.).– Martin, J.-H. et al. (ed.): I. K. Installations 1983-1995. Centre Georges Pompidou. Paris 1995 (cat.).– Vischer, T. (ed.): I. K. Ein Meer von Stimmen. Museum für Gegenwartskunst, Basel. Stuttgart 1995 (cat.).– Wallach, A.: I. K. The Man Who Never Threw Anything Away. New York 1996

## KAHLO Frida
(Magdalena Carmen Frieda Kahlo Calderón)
**1907** Coyoacán (Mexico City) –
**1954** Coyoacán

Mexican painter. **1925** Suffered serious back injuries at the age of 17 as a result of a car accident, necessitating repeated operations throughout her life. **1928** Joined the Mexican Communist Party and met her future husband, the painter Rivera. **1932** Moved to the USA for two years, where Rivera executed several murals. **1938** First solo-exhibition in New York. Acquaintanceship with Breton, who was travelling in Mexico and wanted to meet Leon Trotsky, who was living in Kahlo's house. **1939** During a trip to Paris, she met several of the important surrealist painters and poets. From **1943** taught drawing at the La Esmeralda school of painting and sculpture; along with her favorite students she started the Los Fridos group. **1946** Awarded the National Prize for Painting. In the late 40s, her health deteriorated rapidly; she had to wear a steel corset and could only get around in a wheelchair. **1953** First solo-exhibition in Mexico City at the Lola Alvarez Bravo gallery. A year later she died after a leg amputation. In her highly personal pictures, close to folk art, Kahlo, the incarnation of the surrealist woman, expresses the convulsive beauty of the injured body and suffering soul.
WRITINGS: Fuentes, C. (ed.): The Diary of F. K. An Intimate Self-Portrait. New York 1995.– F. K.: Le Journal de F. K. Paris 1995/Gemaltes Tagebuch. Munich 1995 CATALOGUES RAISONNES: Herrera, H. (ed.): F. K. The Paintings. London 1991/F. K. Die Gemälde 1926-1954. Munich 1992.– Prignitz-Poda, H. et al. (ed.): F. K. Das Gesamtwerk. Frankfurt-on-Main 1988 MONOGRAPHS, CATALOGUES: Billeter, E. (ed.): Das Blaue Haus. Die Welt der F. K. Schirn Kunsthalle, Frankfurt-on-Main et al. Bern 1993 (cat.).– Billeter, E. (ed.): The World of F. K. The Blue House. Museum of Fine Arts, Houston. Washington 1994 (cat.).– Conde, T. Del: Vida de F. K. Mexico City 1976.– Drucker, M.: F. K. Torment and Triumph in Her Life and Art. New York 1991.– García, R.: F. K. A Bibli-

ography. Berkely 1983.– Herrera, H.: Frida. A Biography of F. K. New York 1983.– Jamis, R.: F. K. Un portrait d' une femme. 1985.– Ketchum, W. C.: F. K. New York 1997.– Lowe, S. M.: F. K. New York 1991.– Salber, L.: F. K. Reinbek 1997.– Tibol, R.: F. K. Crónica, testimonios y aproximaciones. Mexico City 1977.– Tibol, R. F. K. Frankfurt-on-Main 1980/F. K. Una vida abierta. Mexico City 1983/F. K. An Open Life. Albuquerque (NM) 1993.– Ullán, J.-M. (ed.): F. K. Salas Pablo Ruiz Picasso. Madrid 1985 (cat.).– Zamora, M.: F. K. The Brush of Anguish. San Francisco 1990/F. K. Paris 1992

## KANDINSKY Wassily
**1866** Moscow – **1944** Neuilly-sur-Seine (near Paris)

Russian painter and art theoretician. **1886–1892** Studied law in Moscow. **1893** Taught at Moscow University. **1896** Moved to Munich. **1897** Attended the private school run by Anton Azbè. Transferred in **1900** to the Munich Academy to study under Franz von Stuck. **1901** Co-founder of the artists' group Phalanx. **1902** Meeting with Münter. **1903–1908** Trips with Münter to Italy, France, Switzerland, Tunisia and Russia. **1908** Returned to Munich, acquaintance with Werefkin and Javlensky; first study trip to Murnau. **1909** Chairman of the Neue Künstlervereinigung (New Artists' Association) in Munich. Moved with Münter to Murnau. Influenced by the Fauves and discovered Bavarian glass painting. **1910** Friendship with Marc. **1911** Resigned from the Neue Künstlervereinigung and set up, with Marc, the editorial committee of Blauer Reiter. **1912** Published the book *Concerning the Spiritual in Art* and the Blauer Reiter almanac. **1913** First abstract watercolour painting, later predated to **1910**. Participated in the First German Autumn Salon in Berlin. **1914** Returned to Russia on the outbreak of war. **1916** Final separation from Münter. **1918** Professor at the State Art Workshops in Moscow. **1921** Co-founder of the Academy of Artistic Sciences in Moscow. **1822–1933** Teacher at the Bauhaus in Weimar and Dessau. **1924** Co-founder of the group Die Blauen Vier, with Feininger, Klee and Javlensky. **1926** Publication of his book *Point and Line to Plane*. **1928** Took German citizenship. **1933** Moved to Paris. **1939** Became a French citizen. In his last years, he came closer to Arp and Miró and began to favour organic forms and a brighter palette.
WRITINGS: W. K.: Über das Geistige in der Kunst. Munich 1911/W. K.: Du spirituel dans l'art et dans la peinture en particulier. Paris 1988/W. K. Concerning the Spiritual in Art. New York 1972.– W. K. and F. Marc (ed.): Der Blaue Reiter. Munich 1912/The Blaue Reiter Almanac. New York 1974.– W. K.: Klänge. Munich 1912.– W. K.: Punkt und Linie zur Fläche. Munich 1926/Point and Line to Plane. New York 1947/Point et ligne sur plan. Contribution à l'analyse des éléments de la peinture.

Paris 1991.– W. K.: Essays über Kunst und Künstler. Ed. by M. Bill. Stuttgart 1955.– W. K.: Regards sur le passé et autres textes 1912-1921. Paris 1974.– W. K.: Correspondances avec Zervos et Kojève. Ed. by C. Derouet. Paris 1992.– W. K. and A. Schöneberg: Der Briefwechsel. Ed. by J. Hahl-Koch. Stuttgart 1993.– Lankheit, K. (ed.): W. K. und F. Marc. Briefwechsel. Munich 1983.– Lindsay, K. C. and P. Vergo (ed.): K. Complete Writings on Art. 2 vols. Boston 1982.– Roethel, K. and J. Hahl-Koch (ed.): K. Die gesammelten Schriften. Bern 1980.– Sers, P. (ed.): W. K.: Ecrits complets. 3 vols. Paris 1970 CATALOGUES RAISONNES: Barnett, V. E. (ed.): K. Watercolors. Catalogue Raisonné. 2 vols. London and New York 1992-1993 / K. Werkverzeichnis der Aquarelle 1900-1944. 2 vols. Munich 1992-1993 / K. Catalogue raisonné des aquarelles. 2 vols. Paris 1992-1993.– Roethel, H. K. (ed.): K. Das graphische Werk. Cologne 1970.– Roethel, H. K. and J. K. Benjamin (ed.): K. Werkverzeichnis der Ölgemälde. 2 vols. Munich 1982-1984 / K. Catalogue raisonné de l'œuvre de K. 2 vols. Paris 1982-1984 / K. Catalogue Raisonné of the Oil Paintings. 2 vols. London 1984-1987
MONOGRAPHS, CATALOGUES: Barnett, V. and A. Zweite (ed.): K. Aquarelle und Zeichnungen. Kunstsammlung Nordrhein-Westfalen. Munich 1992 (cat.).– Barnett, V. E. and H. Friedel (ed.): K. im Lenbachhaus. Städtische Galerie im Lenbachhaus. Munich 1995 (cat.) / W. K. A Colorful Fife: The Collection of the Lenbachhaus, Munich. New York 1996 (cat.).– Bill, M.: W. K. Paris 1951.– Becks-Malorny, U.: W. K. The journey to abstraction. Cologne 1994.– Boissel, J. and C. Derouet (ed.): K. Centre Georges Pompidou. Paris 1985 (cat.).– Brisch, K.: W. K. Untersuchungen zur Entstehung der gegenstandslosen Malerei an seinem Werk von 1900-1921. Diss. Bonn 1955.– Bowlt, J. E. and R.-C. Washton Long (ed.): The Life of V. K. in Russian Art. Newtonville 1980.– Cortenova, G. (ed.): W. K. Palazzo Forti, Verona. Milan 1993 (cat.).– Dabrowski, M.: K. Compositions. New Yok 1995.– Derouet, C. and V. E. Barnett (ed.): K. in Paris 1934-1944. Solomon R. Guggenheim Museum. New York 1985 (cat.).– Eichner, J.: K. und Gabriele Münter. Vom Ursprung moderner Kunst. Munich 1957.– Grohmann, W.: K. Leben und Werk. Cologne 1958, 1981 / K. Life and Work. London and New York 1958 / K. Paris 1958.– Hahl-Koch, J.: K. Stuttgart 1992, New York 1993.– Halm, P. (ed.): W. K. Russian and Bauhaus Years 1915-1933. Solomon R. Guggenheim Museum. New York 1983 (cat.) / K. Russische Zeit und Baushausjahre 1915-1933. Bauhaus-Archiv. Berlin 1984 (cat.).– Hoberg, A. (ed.): W. K. und Gabriele Münter in Murnau und Kochel 1902-1914. Briefe und Erinnerungen. Munich 1994.– Kandinsky, N.: K. und ich. Munich 1976.– W. K. Die erste sowjetische Retrospektive. Schirn Kunsthalle. Frankfurt-on-Main 1989 (cat.).– Kleine, G.: Gabriele Münter und W. K. Biographie eines Paares. Frankfurt-on-Main 1990.– Lindsay, K. C.: An Examination of the Fundamental Theories of W. K. Diss. Madison (WI) 1951.– Long, R.-C.: K. The Development of an Abstract Style. Oxford 1980.– Moeller, M. M. (ed.): Der frühe K. 1900-1910. Brücke-Museum, Berlin et al. Munich 1994 (cat.).– Overy, P.: K. The Language of the Eye. New York 1969.– Poling, C. V.: K.'s Teaching at the Bauhaus. New York 1986.– Roethel, H. and K. Benjamin: K. New York 1979, Munich 1979.– Sers, P.: K. Philosophie de l'abstraction, l'image métaphysique. Geneva 1995.– Thürlemann, F.: K. über K. Der Künstler als Interpret eigener Werke. Bern 1986.– Washton-Long, R.-C.: K. The Development of an Abstract

Style. Oxford 1980.– Weis, P.: K. in Munich. The Formative Jugendstil Years. Princeton (NJ) 1979, 1985.– Weis, P.: K. in Munich 1896-1914. Solomon R. Guggenheim Museum. New York 1982 (cat.).– Weis, P.: K. and Old Russia. The Artist as Ethnographer and Shaman. New Haven (CT) 1995.– Zweite, A. (ed.): K. und München. Begegnungen und Wandlungen 1896-1914. Städtische Galerie im Lenbachhaus. Munich 1982 (cat.)

## KANOLDT Alexander
**1881** Karlsruhe – **1939** Berlin
German painter and graphic artist. **1899-1900** Studied at the Karlsruhe School of Arts and Crafts. **1901-1904** Continued his studies at the Karlsruhe Academy. **1908** Transferred to Munich. Travels to England, France, Italy, and Switzerland. **1909** Co-founder of the Neue Künstlervereinigung (New Artists' Association) in Munich, together with Javlensky, Kandinsky and Münter. **1913** Co-founder of the New Secession in Munich. **1914-1918** War service as an officer. **1924** While staying in Italy, he painted bleak suburban landscapes with multiple perspectives. **1925** Participated in the "Neue Sachlichkeit" exhibition in the Mannheim Art Museum. Appointed professor at the Breslau Academy. **1927** Participated in the "Neue Sachlichkeit" exhibition in the Neumann-Nierendorf gallery in Berlin. **1931** Resignation from his position in Breslau; opened a private painting school in Garmisch. **1932** Member of the Munich artists' group Die Sieben and participation in their exhibition. **1933** Appointed professor at the Art Academy in Berlin. **1937** Confiscation of several works classified as "degenerate art". Kanoldt painted mostly still lifes and Italian landscapes, whose sober, frozen aspects align them clearly with Neue Sachlichkeit.
CATALOGUES RAISONNES: Ammann, E. (ed.): Das druckgraphische Werk von A. K. Karlsruhe 1963.– Fischer-Hollweg, B. (ed.): A. K. und die Kunstrichtungen seiner Zeit. Diss. Bochum 1971
MONOGRAPHS, CATALOGUES: Dürr, H. (ed.): A. K. Städtische Wesenberg-Gemäldegalerie. Constance 1973 (cat.).– A. K. Stadthalle. Freiburg 1966 (cat.).– A. K. Graphik. Der Bestand des Graphischen Kabinetts an Handzeichnungen und Lithographien. Museum Folkwang. Essen 1977 (cat.).– A. K. 1881-1939. Gemälde, Zeichnungen, Lithographien. Museum für Neue Kunst. Freiburg 1987 (cat.)

## KANOVITZ Howard
born **1929** Fall River (MA)
American painter. **1945-1951** Studied at the Rhode Island School of Design in Providence. **1951** Moved to New York, where he worked as a shop window dresser and for Franz Kline. **1956-1958** Lived in Florence. **1962** First solo-exhibition in the Stable Gallery in New York. In developing his hyperrealist style, he began in **1963** to paint

from photographs and snapshots, limiting himself to narrow spatial fields seen from unusual angles. **1966** Important solo-exhibition at the Jewish Museum, New York. From **1967** painted with a spray-gun. **1972** and **1977** participation in documenta 5 and 6 in Kassel. **1979** DAAD scholarship to Berlin. **1979** Retrospective in the Berlin Art Academy. Kanovitz's hyperrealist pictures portray realistic scenes in new spatial constellations which deliberately subvert conventional perception.
MONOGRAPHS, CATALOGUES: Hunter, S. (ed.): H. K. Jewish Museum. New York 1966 (cat.).– Kotte, W.: H. K. Museum van Hedendaagse Kunst, Ghent. Utrecht 1974 (cat.).– Kultermann, U. (ed.): H. K. Wilhelm Lehmbruck Museum. Duisburg 1974 (cat.).– Merkert, J. (ed.): H. K. Akademie der Künste, Berlin et al. Berlin 1979 (cat.).– Volkmann, B. (ed.): H. K. Arbeiten 1951-1978. Akademie der Künste, Berlin et al. Berlin 1979 (cat.)

## KANTOR Tadeusz
**1915** Wielopole Skrzynskie (near Rzeszóv) – **1990** Cracow
Polish painter, set designer, and theatre director. **1936-1939** Studied at the Academy in Cracow. **1942-1944** Director of an underground theatre during German occupation. **1944-1955** Set design for various theatres in Cracow and Warsaw. **1945** Took up painting. **1947** Lived in Paris. **1948** Organized the first exhibition of contemporary Polish art after the war in Cracow. Withdrew from the art world **1949-1954** in protest against the imposed Socialist Realism. **1955** Returned to Paris and founded the Cricot 2 Theatres. Extension of paintings into three-dimensional objects. **1959** Informel paintings exhibited at documenta 2 in Kassel. **1965** Staged *Cricotage*, the first theatrical happening. **1967** Prize for painting at the São Paulo Biennale. Staged many pieces with his own Informel theatre group and other ensembles. **1987** Presented the performance *The Death and Love Machine* at documenta 8. **1992** Major retrospective in the Cracow National Museum. After an early Surrealist phase, Kantor extended his painting style, which was influenced by L'art informel, to develop an Informel-assemblage concept on the theme of the artist under threat.

WRITINGS: T. K.: Emballages. Chexbres 1963.– T. K.: Multipart. Warsaw 1970.– T. K.: Le Théâtre de la mort. Lausanne 1977.– T. K.: Metamorphoses. Paris 1982.– T. K. Ein Reisender. Seine Texte und Manifeste. Institut für moderne Kunst. Nuremberg 1988 (cat.) / Ma création, mon voyage. Commentaires intimes. Paris 1991
MONOGRAPHS, CATALOGUES: Borowski, W. and R. Stanislawski (ed.): T. K. Emballages. Muzeum Sztuki. Lodz 1975 (cat.) / T. K. Emballages 1960-1976. Whitechappel Art Gallery. London 1976 (cat.) / T. K. Emballages 1960-1976. Galerie R, Johanna Ricard. Nuremberg 1976 (cat.).– Borowski, W.: T. K. Warsaw 1982 (cat.).– T. K. Métamorphoses. Galerie de France. Paris 1982 (cat.).– T. K. Muzeum Narodowe. Kraków 1991 (cat.).– T. K. Germanisches Nationalmuseum. Nuremberg 1996 (cat.).– Klossowicz, J.: T. K. Warsaw 1991.– Nowaczyk, W.: Dziela Tadeusza Kantora w kolekcji Muzeum Narodowego w Pozna-niu. Muzeum Narodowe, Poznaniu 1993 (cat.)

## KAPROW Allan
born **1927** Atlantic City (NJ)
American artist. **1945-1949** Studied architecture. **1947/48** Painting classes under Hans Hofmann in New York. **1950-1952** Studied art history at Columbia University, New York. **1953** First solo-exhibition at the Hansa Gallery, New York. Encountered Abstract Expressionism, mainly through the works of Pollock. **1957-1959** Studied at the New School for Social Research under Cage, whose work inspired him to transform his environments into happenings. **1959** Staged *18 Happenings in Six Parts* in the Reuben Gallery in New York. **1961** Presented the environment *Yard*, which was a collection of old car tyres, in the M. Jackson Gallery in New York. **1961-1969** Lectureship at the State University in New York. From **1965** staging of actions and happenings. **1969-1972** Professorship in Princeton, New Jersey. From **1974** director of the Visual Arts Department at the University of San Diego. **1975** DAAD scholarship to Berlin. **1977** and **1987** participation in documenta 6 and 8 in Kassel. As an artist and director, Kaprow is one of the central figures on the action and happening scene.
WRITINGS: A. K.: Assemblage, Environments and Happenings. New York 1966.– A. K.: Untitled Essay and Other Works. New York 1967.– A. K.: Warm-ups. Cambridge (MA) 1975
MONOGRAPHS, CATALOGUES: Berman, B. (ed.): A. K. Pasadena Art Museum. Pasadena 1967 (cat.).– Diederichs, J.: A. K. Diss. Bochum 1971.– Diederichs, J. (ed.): A. K. Kunsthalle Bremen. Bremen 1976 (cat.).– A. K. Chicago 1981.– Schnackenburg, B. (ed.): A. K. Activity-Dokumente 1968-1976. Kunsthalle Bremen. Bremen 1976 (cat.).– Thiemann, E. et al. (ed.): A. K. Collagen, Environments, Videos 1956-1986. Museum am Ostwall. Dortmund 1986 (cat.).–

Williams, T. D. und Sanford Sivitz: Standards by A. K. Gallery of Art, University of Northern Iowa. Iowa 1979 (cat.)

## KARAVAN Dani
born **1930** Tel Aviv

Israeli sculptor and environment artist. Studied art in Tel Aviv and at the Art Academy in Jerusalem. Until **1955** lived on a kibbutz, then continued his studies at the Accademia delle Belle Arti in Florence and at the Académie de la Grande Chaumière in Paris. **1960–1973** Worked as a stage designer for ballet and theatre. **1962** Worked on a wall relief for the Weizmann Institute in Rehovot, Israel. Over the following years received a large number of commissions for public sculptures and monuments. Produced numerous local environments using diverse media and materials such as lasers, glass, sand and water. **1976** Styled the Israeli Pavilion at the Venice Biennale. **1977** and **1987** participation in the documenta 6 and 8 in Kassel. **1978** Awarded the Israeli Prize for Culture and Art. **1984** Guest-professorship at the Ecole Nationale Supérieure des Beaux-Arts in Paris. **1996** Awarded the "Kaiserring" in Goslar. **1997** Received the Order of Merit in Germany and in **1998** the "Praemium Imperiale" in Japan.
MONOGRAPHS, CATALOGUES: Bott, G. and P. Laub (ed.): Straße der Menschenrechte. D. K. Germanisches Nationalmuseum. Nuremberg 1995 (cat.).– Brockhaus, C.: D. K. Ma'alot. Museumsplatz Cologne 1979-1986. Museen der Stadt. Cologne 1986 (cat.).– Finkeldey, B. (ed.): D. K. Dialog Düsseldorf – Duisburg. Kunstsammlung Nordrhein-Westfalen, Düsseldorf et al. Düsseldorf 1989 (cat.).– D. K. Due ambienti per la pace. Forte di Belvedere, Florenz et al. Milan 1978 (cat.).– D. K. Makom. Staatliche Kunsthalle Baden-Baden. Baden-Baden 1982 (cat.).– D. K. L'Axe majeur de Cergy-Pontoise. Paris 1987.– D. K. Dialogue with the Environment. Resonance with the Earth. Asahi Shimbun 1997 (cat.).– Restany, P. (ed.): D. K. Projekte im urbanen Raum. Museum Ludwig, Cologne. Munich 1992 (cat.).– Restany, P. (ed.): D. K. Tel Aviv Museum of Art. Tel Aviv 1990 (cat.).– Scheurmann, I. and K. (ed.): D. K. Hommage à Walter Benjamin. Mainz 1995

## KASSAK Lajos
**1887** Érsekújvár – **1967** Budapest

Hungarian painter and writer. **1909** Travels through Austria, Germany, and France. **1915** First poems published. Founded the magazine and movement *The Act*. **1919** During the Hungarian soviet republic era, he worked as an editor for socialist newspapers. **1920** Emigrated to Austria, settling in Vienna. Connections with Archipenko, Schwitters, Richter, Moholy-Nagy. **1922** Published the volume *Book of New Artists* together with Moholy-Nagy. **1924** First solo-exhibition at the Würthle Gallery in

Vienna. Exhibition in the gallery Der Sturm in Berlin. **1926** Returned to Budapest. Founding of *Document* magazine. Wrote various theoretical articles on Constructivism. **1945–1948** Held a cultural political post in Hungary. From **1957** dedicated himself again to painting and poetry writing. **1965** Received the Kosuth Prize. **1966** Participant in the Dada exhibition at the Zurich Art Museum. Kassák's constructivist pictures have much in common with Russian and Dutch abstraction.
WRITINGS: L. K. and L. Moholy-Nagy: Buch neuer Künstler. Vienna 1922, Baden 1991.– L. K.: Eljünk a mi idönkeben. Irások a képzömüvészetröl. Budapest 1978.– L. K.: Als Vagabund unterwegs. Erinnerungen. Berlin 1979.– L. K.: Laßt uns leben in unserer Zeit. Gedichte, Bilder und Schriften zur Kunst. Budapest 1989
MONOGRAPHS, CATALOGUES: Aradi, N.: L. K. Konstruktive Kunst. Nürnberg 1969.– Bori, I. and E. Körner (ed.): K. Irodalma és festészete. Budapest 1967.– Czaplár, F. and T. Frank (ed.): L. K. 1887-1967. Akademie der Künste der DDR. Berlin 1987 (cat.).– Körner, E. and T. Gergely (ed.): L. K. 1887-1967. Magyar Nemzeti Galéria. Budapest 1987 (cat.).– Kruse, J. A. (ed.): L. K. 1887-1967. Heinrich-Heine-Institut. Düsseldorf 1989 (cat.).– Laszlo, C.: K. Basel 1968.– L. K. 1887-1967. Neue Galerie am Landesmuseum Joanneum. Graz 1971 (cat.).– L. K. 1887-1967. Museum Bochum. Bochum 1973 (cat.).– L. K. Retrospective Exhibition. Matignon Gallery. New York 1984 (cat.).– L. K. 1887-1967. Magyar Nemzeti Galéria. Budapest 1987 (cat.).– L. K. 1887-1967. Budapest 1988 (cat.).– L. K. az európai avantgárd mozgalmakban. 1916-1928. Kassák Múzeum és Archívum. Budapest 1994 (cat.).– Rónay, G.: L. K. Budapest 1971.– Schmidt, L. E. (ed.): L. K. Ein Protagonist der ungarischen Avantgarde. Berlin 1991.– Straus, T. (ed.): K. Ein ungarischer Beitrag zum Konstruktivismus. Galerie Gmurzynska. Cologne 1975 (cat.).– Vadas, J.: K. a konstruktör. Budapest 1979

## KAWAMATA Tadashi
born **1953** Hokkaido

Japanese sculptor and installation artist. **1972** Went to Tokyo. Studied painting at Tokyo College of Art, graduating as a Bachelor of Fine Arts. From **1975** constructed unwieldy installations out of wood, that were displayed in public places from **1976** onwards. He favours deserted places such as ruins for his architectonic installations. **1981** Obtained his Master's degree in Fine Arts. **1984** Taught at Tokyo College of Art, and began to travel a great deal. **1987** Exhibited *Destroyed Church* at documenta 8 and *People's Garden* at documenta 9 in Kassel in **1992**.
MONOGRAPHS, CATALOGUES: Bekaert, G. et al. (ed.): T. K. Begijnhof Kortrijk. Gendaikikakushitsu Publishing and Kanaal Art Foundation. Tokyo and Kortrijk 1991 (cat.).– Bois, Y.-A. et al. (ed.): T. K. Project on Roosevelt Island. Gendaikikakushitsu Publishers and On the Table. Tokyo and New York 1993 (cat.).– Brayer, M.-A. et al. (ed.): T. K. Centre de Création Contemporain & Atelier Calder. Tours and Saché 1994 (cat.).– Finkenpearl, T. (ed.): T. K. Project. On the Table. Tokyo 1986 (cat.).– Gould, C. F. (ed.): T. K. Project in Roosevelt Island 1990. Kodama Gallery. Osaka 1989 (cat.).– Jurejevec, V. et al. (ed.): T. K. Tram Passage. StadtRaum Remise. Vienna 1995 (cat.).– T. K. PH Studio. Tokyo 1979 und 1980 (cat.).– T. K. Projects 1980-1990. Annely Juda Fine Art. London 1990 (cat.).– T. K. Field Work. On the Table. Tokyo 1991 (cat.).– T. K. Gallery Kobayashi. Tokyo 1992 (cat.).– T. K. Prefabrication. Gallery Kobayashi. Tokyo 1993 (cat.).– T. K. in Zürich. Helmhaus. Zurich 1993 (cat.).– Obigane, A. (ed.): T. K. Maquettes. Kodama Gallery. Osaka 1992 (cat.).– Okouchi, K. (ed.): T. K. Archives 1984-1994. Izami City Museum of Art. Itami 1994 (cat.).– Orchard, K. (ed.): T. K. Field Work. Stuttgart 1997.– Ullrich, F. (ed.): T. K. Städtische Kunsthalle Recklinghausen. Cologne 1996 (cat.)

## KAWARA On
born **1933** Aichi-ken

Japanese concept artist. Left Japan in **1955** to study architecture in Mexico. **1961** Moved to New York. From **1966** first of the *Date Paintings* in which he painted the date the work was created. **1968** Start of the series *I went*: street maps showing where the artist had been on a single day, and *I met*: lists of the people he met on one day. **1969** Creation of the ten-volume work *One Million Years*, a hand-drawn list of a million years. From **1970** he sent telegrams to certain people with the text, "I am still alive". **1972** Participated in the exhibition "Conceptual Art" at the Kunstmuseum, Basel, **1977** and **1982** in documenta 6 and 7 in Kassel, and **1989** in the exhibition "Bilderstreit" in Cologne. Kawara's systematic works, defining time and place in artistic terms, place him among the foremost proponents of Concept Art. Kawara's autobiography reads: 23,975 days on the day this book is published.
WRITINGS: O. K. 1952-1956. Tokyo 1991.– O. K.: I Went, I Met, I Read, Journal 1969. 4 vols. Cologne 1992
MONOGRAPHS, CATALOGUES: Block R. (ed.): O. K. 1976-1986. Daadgalerie. Berlin 1987 (cat.).– Denizot, R. and K. König (ed.): O. K. 1973. Produktion eines Jahres. Kunsthalle Bern. Bern 1974 (cat.).– Denizot, R.: Les Images quotidiennes du pouvoir. O. K. au jour le jour. Paris 1979.– Denizot, R.: O. K. Frankfurt-on-Main 1991.– Douroux, X. and F. Gautherot (ed.): O. K. Whole and Parts 1964-1995. Le Nouveau Musée. Villeurbanne 1996 (cat.).– Granath, O. and P. Nilson (ed.): O. K. Continuity/Discontinuity 1963-1979. Moderna Museet, Stockholm et al. Stockholm 1980 (cat.).– Hulten, P. (ed.): O. K. 97 Date-paintings consécutives et journaux. de 1966-1975. Centre

Georges Pompidou. Paris 1977 (cat.).– O. K. 1967. Otis Art Institute Gallery. Los Angeles 1977 (cat.).– O. K. Museum für Moderne Kunst. Frankfurt-on-Main 1994 (cat.).– Kittelmann, U. (ed.): O. K. Erscheinen – Verschwinden. Kölnischer Kunstverein. Cologne 1995 (cat.).– Schampers, K. (ed.): O. K. Date Paintings in 89 Cities. Museum Boymans-van Beuningen, Rotterdam et al. Rotterdam 1991 (cat.).– Wäspe, R. (ed.): O. K. 1964 – Paris – New York. St. Gallen 1997 (cat.)

## KEETMAN Peter
born **1916** Wuppertal

German photographer. Studied at the Bavarian Photographic College in Munich from **1925**. After this training, he was employed in Gertrud Hesse's photographic studio in Duisburg and worked as an industrial photographer for the C. H. Schmeck company in Aachen. **1948** Continued his studies in Stuttgart under Adolf Lazi. **1949** Together with Otto Steinert, founded the Photo-Form Group. **1950** Participated in the first Photokina exhibition in Cologne. Since **1980** he has worked as a freelance commercial and industrial photographer in Thiersee, Austria. Keetman is considered one of the best representatives of subjective photography. He became well-known through his experimental photographs of water droplets as well as his abstract documentary photographs of the Volkswagen factory.

## KELLEY Mike
born **1954** Detroit

American artist. Studied at the University of Michigan, Ann Arbor. **1976–1978** Studied under Baldessari at the California Institute of the Arts in Valencia. **1978** First public performance (*Poetry in Motion*) at the Los Angeles Contemporary Exhibitions. **1985** Grant from the National Endowment for the Arts. **1986** Began to make sculptures and installations out of found objects like teddy bears or rag dolls. **1988** In the installation *Pay for your pleasure*, he placed 42 poster-portraits of poets, philosophers, and other famous personalities facing paintings by a murderer. **1992** Participation in documenta 9 in Kassel with an installation combining instructive narrative texts with

schematic drawings of bodily functions. Exhibited *Riddle of the Sphinx*, an Afghan carpet which filled the entire gallery space. **1995** Retrospective at the Haus der Kunst in Munich. **1997** Participation in documenta 10 in Kassel. Kelley, whose works delight in juxtaposing "low" and "high" art to the point of caricature, is one of the most important American performance artists.
WRITINGS: M. K. im Gespräch mit T. Kellein. Stuttgart 1993
MONOGRAPHS, CATALOGUES: Bartman, W. S. and M. Barosh (ed.): M. K. Art Resources Transfer. New York 1992.– Haenlein, C. (ed.): M. K. Missing Time. Works on Paper 1974-1976, Reconsidered. Kestner-Gesellschaft. Hanover 1995 (cat.).– Kellein, T. (ed.): M. K. Kunsthalle Basel et al. Stuttgart 1992 (cat.).– M. K. Three Projects. Renaissance Society at the University of Chicago. Chicago 1988 (cat.).– M. K. Jablonka Galerie. Cologne 1989 (cat.).– Lebrero Stals, J. (ed.): M. K. 1985-1996. Barcelona et al. Barcelona 1996 (cat.)– Sussman, E. et al. (ed.): M. K. Catholic Tastes. Whitney Museum of American Art, New York et al. New York 1993 (cat.)

**KELLY Ellsworth**
born **1923** Newburgh (near New York) American painter and sculptor. **1941/42** Art studies at the Pratt Institute, New York. **1944** Took part in the invasion of Normandy as a soldier. First visit to Paris. **1946**–**1948** Drawing and painting studies at the School of the Museum of Fine Arts, Boston. **1948** Studied at the Ecole des Beaux-Arts in Paris. **1950/51** Lectureship at the American School in Paris. Inspired by visits to the studios of Brancusi, Vantongerloo, Picabia, Arp and Taeuber-Arp, he produced his first abstract pictures, in which geometric areas in varying colour strengths are set against each other. **1954** Returned to the USA. **1957** Commission for a mural in Philadelphia. Between **1964** and **1992** participation in documenta 3, 4, 6 and 9 in Kassel. **1966** Participation in the Venice Biennale. **1969** Commissioned to design a mural for the UNESCO building in Paris. **1974** Prize for painting from the Art Institute of Chicago. Member of the National Insitute of Arts and Letters. **1980** First wood and metal sculptures with Peter Carlson. After the installation of a sculpture in Lincoln Park in Chicago, further commissions for public sculptures. **1989/90** Organized his own exhibition at the request of the Art Institute of Chicago and the Museum of Modern Art, New York. **1998** Major retrospectives in New York, Los Angeles and Munich. Kelly, who began by working in minimal and hard-edge styles, developed through his mathematically precise sculptures a new picture form, in which the classical 2-dimensional panel painting is replaced by a 3-dimensional pictorial object.
CATALOGUES RAISONNES: Axsom, R. H. (ed.): The Prints of E. K. A Catalogue Raisonné 1949-1985. New York 1987.– Bois, Y.-A. et al. (ed.): E. K. Die Jahre in Frank-

reich 1948-1954. Westfälisches Landesmuseum, Münster et al. Munich 1992 (cat.)/ E. K. Les années françaises 1948-1954. Paris 1992 (cat.).– Sims, P. and E. Rauh Pulitzer (ed.): E. K. Sculpture. Whitney Museum of American Art, New York et al. New York 1982 (cat.).– Waldman, D. (ed.): E. K. Drawings, Collages, Prints. Greenwich (CT) 1971
MONOGRAPHS, CATALOGUES: Baker, E. C. (ed.): E. K. Recent Paintings and Sculptures. Metropolitan Museum of Art. New York 1979 (cat.).– Boehm, G.: E. K. Yellow Curve. Stuttgart 1992.– Coplans, J.: E. K. New York 1973.– Goosen, E. C. (ed.): E. K. The Museum of Modern Art. New York 1973 (cat.).– Hentschel, M. (ed.): E. K. Yellow Curve. Portikus, Frankfurt-on-Main. Stuttgart 1992 (cat.).– Offay, A. d' and M. Marks (ed.): Spencertown. Recent Paintings by E. K. New York 1994.– Rose, B. (ed.): E. K. Paintings and Sculptures 1963-1979. Stedelijk Museum. Amsterdam 1979 (cat.).– Rose, B. et al. (ed.): E. K. Gemälde und Skulpturen 1966-1979. Staatliche Kunsthalle Baden-Baden. Baden-Baden 1980 (cat.).– Upright, D. et al. (ed.): E. K. Works on Paper. The Fort Worth Museum et al. New York 1987 (cat.).– Waldman, D. (ed.): E. K. Solomon R. Guggenheim Museum, New York et al. New York and London 1996 (cat.)/ E. K. Haus der Kunst. Munich 1997 (cat.).– Yakush, M. (ed.): E. K. The Years in France 1948-1954. National Gallery of Art, Washington et al. Munich 1992 (cat.)

**KEMENY Zoltán**
**1907** Banica (Transylvania) – **1965** Zurich Hungarian-born Swiss sculptor and painter. Worked **1923**–**1930** as a cabinet maker in Budapest. **1927**–**1930** Studied architecture at the Ecole des Arts Décoratifs and painting at the Ecole des Beaux-Arts in Budapest. **1931** Moved to Paris, where he worked as an architect and fashion designer. **1942** Moved to Zurich. **1947** Began to incorporate materials like sand, stone, scrap iron and dried plants into his pictures. From **1951** he glued various materials onto illuminated reinforced glass to transform the picture into a lighted space. **1954** First metal reliefs. **1957** Became a Swiss citizen. Received numerous commissions from public institutions, including the University of St. Gallen and the Frankfurt Municipal Theatre. **1959** Took part in documenta 2 in Kassel. **1963** First architectural sculptures and three-dimensional brass constructions. **1964** Participation in documenta 3 in Kassel. Awarded first prize for sculpture at the Venice Biennale. **1967** Retrospective in the Musée National d'Art Moderne in Paris. Kemény became well-known at the beginning of the 50s for his metal reliefs, constructed from ready-made and handmade metal parts, assembled and welded together in a special process producing colour changes.
MONOGRAPHS, CATALOGUES: Bownes, A. (ed.): Z. K. 1907-1965. Tate Gallery. London 1967 (cat.).– Durrer, J. (ed.): Z. K.

Kunstmuseum Bern. Bern 1982 (cat.).– Giedion-Welcker, C.: Z. K. St. Gallen 1968.– Heusser, H.-J.: Z. K. Das Frühwerk. 1943-1953. Katalog der Peintures, Sculpture und Reliefs-Collages. Basel 1993.– Z. K. Kestner-Gesellschaft. Hanover 1963 (cat.).– Z. K. Musée National d'Art Moderne. Paris 1966 (cat.).– Z. K. Wallraf-Richartz-Museum. Cologne 1967 (cat.).– Z. K. Fondation Maeght, Saint-Paul 1974 (cat.).– Lauter, R.: Z. K. Galleria Peccolo. Livorno 1986 (cat.).– Picon, G. and F. Rathke: Z. K. Reliefs en métal. Paris 1973.– Ragon, M.: Z. K. Neuchâtel 1960.– Ragon, M. (ed.): K. Fondation Maeght. Saint-Paul 1974 (cat.).– Schwarz, D. (ed.): Z. K. Die Werke im Kunstmuseum Winterthur. Kunstmuseum. Winterthur 1993 (cat.).– Tavel, H. C. v. and H.-J. Heusser (ed.): Z. K. Kunstmuseum Bern. Bern 1982 (cat.)

**KERTESZ André**
**1894** Budapest – **1985** New York Hungarian-American photographer. **1910**–**1912** Attended the School of Economics in Budapest. **1915** First documentary war photographs. **1922** Honorary diploma from the Hungarian Photographic Association. **1925**–**1935** Worked as a photographer in Paris for the *Berliner Illustrirte* magazine and the *London Times*. Acquaintanceship with Mondrian, Prampolini, Brancusi; contacts with P. Outerbridge, Man Ray and the Surrealist circle around André Breton. **1927** First solo-exhibition in Paris. **1936** Emigration to New York. **1937**–**1949** Photographed for various fashion magazines, such as *Harper's Bazaar*, *Vogue* and *Look*. Worked from **1949**–**1962** exclusively for Condé-Nast. **1963** Gold Medal at the Venice Biennale. **1974** Grant from the Guggenheim Museum in New York. **1977** Participation in documenta 6 in Kassel. **1982** Honorary doctorate from the Royal Photographic Society, London. **1983** Elected Knight of the Legion of Honour in France.
WRITINGS: A. K.: Kertesz on Kertesz. London 1985, New York 1996
MONOGRAPHS, CATALOGUES: Borhan, P. et al. (ed.): A. K. La Biographie d'une œuvre. Paris 1994/A. K. His Life and Work. Boston and New York 1994.– Ducrot, N. (ed.): A. K. Sixty Years of Photography 1912-1972. New York 1972.– Fárová, A.: A. K. Prague and New York 1966.– Gaillard, A.: A. K. Paris 1980.– Harder, S. and H. Kubota: A. K. Diary of Light 1912-1975. New York 1987.– Harris, J. and M. Holtman (ed.): In Focus A. K. Photographs from the J. Paul Getty Museum. Malibu 1994 (cat.).– Hinson, H. and A. Gaillard: A. K. 70 années de photographie. Neuilly 1987.– Johnson, B.: A. K. Master of Photography. The Chrysler Museum. Norfolk 1982 (cat.).– A. K. Bibliothèque Nationale. Paris 1963 (cat.).– A. K. Fotografier 1913-1971. Moderna Museet. Stockholm 1971 (cat.).– A. K. Centre Georges Pompidou. Paris 1977 (cat.).– A. K. An Exhibition of Photographs from the Centre Georges Pompidou, Paris. London 1979 (cat.).–

A. K. Ma France. Palais de Tokyo. Paris 1990 (cat.).– Kincses, K. (ed.): A. K. 1894-1985-1994. Musée Hongrois de la Photographie. Budapest 1994 (cat.).– Kismaric, C.: A. K. Millerton 1977.– Omaggio ad A. K. 1894-1985. Budapest, Paris, New York, Romaa. Roma 1986.– Phillips, S. S. et al. (ed.): A. K. Of Paris and New York. Metropolitan Museum of Modern Art. New York 1985 (cat.).– Phillips, S. S. et al. (ed.): A. K. in Paris. Photographien 1925-1936. Munich 1995.– Szarkowski, J.: A. K. Photographer. New York 1964.– Wedewer, R. (ed.): A. K. Fotografien. 1914-1972. Städtisches Museum Leverkusen, Schloß Morsbroich. Leverkusen 1977 (cat.)

**KIEFER Anselm**
born **1945** Donaueschingen German painter. **1965** Studied law and romance languages at the University of Freiburg. **1966**–**1968** Attended painting courses under Peter Dreher in Freiburg and studied **1969** at Karlsruhe Academy under Antes. In the same year, he achieved notoriety with his photoseries *Besetzungen* (Occupations), in which he himself gives a Nazi salute at symbolic locations in France, Italy, and Switzerland. **1970**–**1972** Studied under Beuys at the Düsseldorf Academy and developed an individual painting style, in which paint is applied thickly in layers and often mixed with materials like earth, sand, straw, and hair. The impasto is often so thick that it is necessary to chop it away with an axe, or burn it off. The painting process reflects the theme of the picture, as in *Malerei der verbrannten Erde*, a confrontation with Germany's national (-socialist) history. **1976** Series of paintings entitled *Hermannsschlacht im Teutoburger Wald* (Hermann's victory over the Romans in the Teutoburger Forest). **1977** and **1987** participation in documenta 6 and 8 in Kassel. **1981**–**1983** Painted over photographs and books. Tackled the theme of the Jewish genocide in the picture series *Margarete* and *Sulamith*, which refer to Paul Celan's poem *Todesfuge*. **1987** Major retrospective at the Art Institute of Chicago and **1991** at the Nationalgalerie in Berlin. In the 90s numerous book objects, sculptures (for example, jet fighters constructed out of lead plates), and installations. Kiefer is the principal proponent of the so-called "Neue Deutsche Malerei" (New German Painting).
WRITINGS: A. K.: Die Donauquelle. Cologne 1978.– A. K.: Hoffmann von Fallersleben auf Helgoland. Groningen 1980.– A. K.: Nothung, ein Schwert verhieß mir der Vater. Baden-Baden 1983.– A. K.: A Book by A. K. New York 1988/Ein Buch von A. K. Erotik im Fernen Osten oder: Transition from Cool to Warm. Stuttgart 1988.– A. K.: Zweistromland. Cologne 1989.– A. K. Über 5 Räume und Völker. Nachwort von K. Gallwitz. Frankfurt-on-Main 1990
CATALOGUES RAISONNES: Adriani, G. (ed.): A. K. Bücher 1969-1990. Kunsthalle Tübingen et al. Stuttgart 1990 (cat.)/The

Books of A. K. 1969-1990. Kunsthalle Tübingen et al. New York 1991 (cat.)
MONOGRAPHS, CATALOGUES: Beeren, W. (ed.): A. K. Bilder 1980-1986. Stedelijk Museum. Amsterdam 1986 (cat.).– Cacciari, M. and G. Celant (ed.): A. K. Venice 1997 (cat.).– Esser, W.: A. K. Glaube, Hoffnung, Liebe 1973. Stuttgart 1992.– Felix, Z. and N. Serota (ed.): A. K. Museum Folkwang, Essen et al. Essen 1981 (cat.)/A. K. Whitechapel Art Gallery. London 1981 (cat.).– Fuchs, R. (ed.): A. K. Stedelijk Van Abbe Museum. Eindhoven 1979 (cat.).– Fuchs, R. (ed.): A. K. Verbrennen, verholzen, versenken. Biennale Venice, Deutscher Pavillon. Venice 1980 (cat.).– Gachnang, J. and M. Schmidt-Miescher (ed.): A. K. Kunsthalle Bern. Bern 1978 (cat.).– Gilmour, J. C.: Fire on the Earth: A. K. and the Postmodern World. Philadelphia 1990.– Harten J. and M. Heinz (ed.): A. K. Städtische Kunsthalle Düsseldorf et al. Düsseldorf 1984 (cat.).– Lopez-Pedraza, R.: A. K. The Psychology of "After the Catastrophe". New York 1996.– Meier, C.: A. K. Die Rückkehr des Mythos in der Kunst. Essen 1992.– Osterwold, T. (ed.): A. K. Württembergischer Kunstverein. Stuttgart 1980 (cat.).– Rosenthal, M. (ed.): A. K. The Art Institute of Chicago, Chicago et al. Munich 1987 (cat.).– Schmidt-Miescher, M. (ed.): A. K. Bilder und Bücher. Kunsthalle Bern. Bern 1978 (cat.).– Schneider, A. et al. (ed.): A. K. Neue Nationalgalerie. Berlin 1991 (cat.).

### KIENHOLZ Edward

**1927** Fairfield (WA) – **1994** Hope (ID)
American sculptor. Self-taught. Studied at various colleges in the American west, and worked as a car dealer, male nurse, restaurateur. **1953** Moved to Los Angeles, where he produced his first wood reliefs. **1956** Opening of the first avant-garde gallery in Los Angeles. **1957** Founding of the Ferus Gallery. Relief assemblages made of discarded objects, the waste products of consumerism. **1961** His environment *Roxy's* depicts in an obsessive, surrealist scenario a brothel from the 40s. **1966** First retrospective in the County Museum of Art in Los Angeles. **1968** Participation in documenta 4 in Kassel. **1972** Delivered a critical commentary on race discrimination in his environment *Five Car Stud* at documenta 5 in Kassel. **1973** DAAD scholarship to Berlin. Confrontation with German history in works such as *Volksempfänger*. **1977** Opening of a gallery in Hope, Idaho, with his wife Nancy. **1984** Important exhibition in the San Francisco Museum of Modern Art with works by Edward and Nancy Kienholz. **1996** Retrospective at the Whitney Museum of American Art, New York, and **1997** in the Berlinische Galerie. Kienholz, who started as a painter and went on to assemblages and environments via wooden reliefs, revealed with his deformed bodies and dehumanized the moral decline and alienation of the individual in our mass culture.

MONOGRAPHS, CATALOGUES: Baur, K. F. (ed.): Medien, Macht Manipulation. E. K., N. R. K. Stuttgart 1987 (cat.).– Conner, G. H. and J. Bernhardt: E. K. New York 1986.– Harten, J. et al. (ed.): E. and Nancy K. 1980's. Städtische Kunsthalle Düsseldorf et al. Düsseldorf and Vienna 1989 (cat.).– Hopps, W. et al. (ed.): E. K. Whitney Museum of American Art. New York 1996 (cat.)/E. K. Berlinische Galerie, Berlin. Munich 1997 (cat.).– E. and N. R. K.: Human Scale. San Francisco Museum of Modern Art et al. Houston 1984 (cat.).– Merkert, J. (ed.): E. K. Volksempfänger. Nationalgalerie. Berlin 1977 (cat.).– Pincus, R. L.: On a Scale that Competes with the World. The Art of E. and Nancy Reddin K. Berkeley 1990.– Reddin, N. et al. (ed.): E. K. Roxys and Other Works. GK-Gesellschaft für aktuelle Kunst, Bremen 1982 (cat.).– Schmidt, H.-W.: E. K. The Portable War Memorial. Moralischer Appell und politische Kritik. Frankfurt-on-Main 1988.– Tuchman, M. (ed.): E. K. Los Angeles County Museum of Art. Los Angeles 1966 (cat.).– Weschler, L. (ed.): E. K. 2 vols. Los Angeles 1977

### KING Phillip

born **1934** Carthage (Tunisia)
English sculptor. **1954–1957** Studied languages at Cambridge University. Studied art from **1957/58** at the St. Martin's School of Art in London, where he also taught between **1959–1978**. **1959/60** Assistant to Henry Moore. **1964** and **1968** participation in documenta 3 and 4 in Kassel. **1967–1969** Member of the board of the Tate Gallery. **1977** Elected member of the Royal Academy. **1979–1981** Guest-professorship at the Berlin Academy. **1980–1990** Professor of sculpture at the Royal College of Art and at the Royal Academy Schools in London. **1987** Participant at the International Sculpture Symposium in Yawata, Japan. **1990** Emeritus Professor at the Royal College of Art. King's cheerfully coloured, expansive sculptures out of moulded plastic and fibreglass combine abstract composition with real objects, and had an important influence on English sculpture in the 60s.
MONOGRAPHS, CATALOGUES: Hilton, T.: The Sculptures of P. K. London 1992.– P. K. Sculptures 1970-1975. Palais Galliera. Paris 1975 (cat.).– P. K. Skulpturen. Städtische Kunsthalle Mannheim 1992 (cat.).– Lampert, C. and R. Cass (ed.): P. K. Hayward Gallery. London 1981 (cat.).– Oxenaar, R. et al. (ed.): P. K. Hayward Gallery, London et al. London 1981 (cat.).– Thompson, D. (ed.): P. K. Kröller-Müller National Museum. Otterlo 1974 (cat.)

### KIPPENBERGER Martin

**1953** Dortmund – **1997** Vienna
German painter. **1972** Studied at the Hamburg School of Fine Arts. Moved in **1978** to Berlin, where he founded Kippenberger's Office and organized exhibitions

with Walter Dahn, Werner Büttner, Oehlen, etc. **1984** Group exhibition "Arbeit ist Wahrheit" (Work is Truth) with Büttner and Oehlen in the Museum Folkwang, Essen. **1986** Extended study trip to Brazil. **1988** Move to Los Angeles. **1990** Guest-professor at the Städel Art School, Frankfurt am Main. **1991** Solo-exhibition at the San Francisco Museum of Modern Art. **1992** Took part in documenta 9 in Kassel. **1993** Founding of the Museum of Modern Art on the island of Syros as well as solo-exhibitions in the Pompidou Centre, Paris. **1994** Exhibition "The Happy End of Franz Kafka's Amerika" in the Boymans-van Beuningen Museum, Rotterdam. **1995** Unveiling of *Exit of the Underground Station Dawson City West*, a public sculpture in Dawson City, Canada. **1997** Participation in documenta 10 in Kassel. Kippenberger, whose anti-art polemic is related to Dada and Fluxus, works with mixed media. Drawing material from photos and text quotations from the mass media, commonplace objects, paintings, and photographs, he builds a kaleidoscopic, often contradictory pictorial world, centred around his own biography.
WRITINGS: Capitain, G. (ed.): Gespräche mit M. K. Stuttgart 1994
CATALOGUE RAISONNE: M. K.: Kippenbergerweg 25-2-53. (Œuvrekatalog der Plakate). Cologne 1989
MONOGRAPHS, CATALOGUES: Baumann, D. et al. (ed.): K. leicht gemacht/ K. sans peine. Geneva 1997 (cat.).– Gretenkort, D. and J.-K. Schmidt (ed.): M. K. Miete, Strom, Gas. Hessisches Landesmuseum. Darmstadt 1986 (cat.).– M. K. Villa Arson. Nice 1989 (cat.).– M. K.: Tiefes Kehlchen. Topographie I: Festraum. Vienna 1991 (cat.).– M. K. Musée des Beaux-Arts. Le Havre 1993 (cat.).– M. K. Villa Merkel, Esslingen. Stuttgart 1997 (cat.).– M. K. Musée d'Art Moderne et Contemporain. Geneva 1997 (cat.).– Loers, V. (ed.): M. K. Der Eiermann und seine Ausleger. Cologne 1997.– Muthesius, A. (ed.): M. K. Ten Years After. Cologne 1991.– Ohrt, R. (ed.): M. K. Cologne 1997.– Schappert, R.: M. K. Die Organisation des Scheiterns. Cologne 1998.– Schmidt, J.-K. et al. (ed.): M. K. Miete Strom Gas. Hessisches Landesmuseum. Darmstadt 1986 (cat.)

### KIRCHNER Ernst Ludwig

**1880** Aschaffenburg – **1938** Frauenkirch (near Davos), Switzerland
German painter and graphic artist. **1901–1903** Studied architecture in Dresden; acquaintanceship with Fritz Bleyl. **1903/04** Studied at the von Debschitz Art School, and continued architecture studies in Dresden. **1905** Founding of the artists' group Brücke together with Bleyl, Heckel, and Schmitt-Rottluff. **1906** Drew up the group's programme. Spent the summer of **1907** with Pechstein in Goppeln near Dresden. **1908** First stay on the island of Fehmarn. **1909–1911** Trips to Moritzburger lakes. **1910/11** Member of the New Seces-

sion. In October **1911** moved to Berlin, where he and Pechstein founded the MUIM Institute (Moderner Unterricht in Malerei). Painted numerous city scenes. His *Chronik der Brücke* led in **1913** to the disbanding of the group. **1914** Participation in the Werkbund exhibition in Cologne. Nervous breakdown after volunteering for military service. **1923** Large solo-exhibition in Basel. **1925/26** Travelled around Germany, visiting Frankfurt am Main, Chemnitz, Dresden and Berlin. **1929** Trips to Essen, Berlin and Frankfurt am Main. **1933** Extensive exhibition in Bern. **1937** His works classified as "degenerate art" and 639 confiscated from public collections. **1938** Suicide. Kirchner is probably the most important painter and graphic artist among the German Expressionists.
WRITINGS: Grisebach, L. (ed.): E. L. K.'s Davoser Tagebuch. Stuttgart 1996.– Henze, W. (ed.): E. L. K. und G. Schieffler. Briefwechsel 1910-1935/38. Stuttgart and Zurich 1990
CATALOGUES RAISONNES: Dube, A. and W.-D. (ed.): E. L. K. Das graphische Werk. 2 vols. Munich 1967, 1980, 1991.– Gordon, D. E. (ed.): E. L. K. Mit einem kritischen Katalog seiner Gemälde. Munich and Cambridge (MA) 1968.– Presler, G. (ed.): E. L. K. Die Skizzenbücher. Weingarten 1996.– Schiefler, G. (ed.): Das graphische Werk von E. L. K. 2 vols. Berlin 1926-1931
MONOGRAPHS, CATALOGUES: Ehrmann, A.-M. and V. Wahl (ed.): E. L. K. Von Jena nach Davos. Stadtmuseum Göhre in Jena. Leipzig 1993 (cat.).– Froning, H.: E. L. K. und die Wandmalerei. Entwürfe zur Wandmalerei im Museum Folkwang. Recklinghausen 1991.– Gabler, K.: E. L. K. Dokumente, Zeichnungen, Pastelle, Aquarelle. 2 vols. Aschaffenburg 1980.– Grisebach, L. and A. Meyer zu Eissen (ed.): E. L. K. 1880-1938. Nationalgalerie, Berlin et al. Munich 1979 (cat.).– Grisebach, L. and W. Henze (ed.): E. L. K. Zeichnungen, Aquarelle, Pastelle. Kunsthalle. Nuremberg 1991 (cat.).– Grisebach, L.: E. L. K. 1880-1938. Cologne 1996.– Grisebach, L.: K. New York 1996.– Grohmann, W.: E. L. K. Stuttgart 1958, London and New York 1961.– Henze, A.: E. L. K. Leben und Werk. Stuttgart 1980.– Henze, W. (ed.): E. L. K. Kirchner Museum Davos. 2 vols. Stuttgart 1992-1994.– Ketterer, R. N. (ed.): E. L. K. Zeichnungen und Pastelle. Stuttgart 1979/E. L. K. Drawings and Pastells. New York 1995.– E. L. K. Aquarelle, Pastelle, Zeichnungen. Museum am Ostwall. Dortmund 1986 (cat.).– Kornfeld, E. W.: E. L. K. Nachzeichnung seines Lebens. Bern 1979.– Lohberg, G. (ed.): E. L. K. Kunst und Technik der Radierung. Kirchner Museum, Davos 1994.– Moeller, M. M. (ed.): E. L. K. Meisterwerke der Druckgraphik. Stuttgart 1990.– Moeller, M. M. (ed.): E. L. K. Zeichnungen und Aquarelle. Brücke-Museum, Berlin et al. Munich 1993 (cat.).– Moeller, M. M.: E. L. K. Die Straßenszenen 1913-1915. Munich 1993

**KIRKEBY Per**

born **1938** Copenhagen
Danish painter and sculptor. **1957–1964** Studied biology at the University of Copenhagen. **1958** and **1960** made expeditions to Greenland. In later years numerous expeditions to various parts of the globe. **1962–1964** Attended the Experimental Art School in Copenhagen. **1964** First solo-exhibition at the Hoved Library, Copenhagen. **1966/67** Lived in New York, where he put together his first brick sculptures. Performances in collaboration with Beuys, Paik, Immendorff, and others. **1968** Published poetry and essays on art. **1978** Lecturer at the Karlsruhe Academy. **1980** Participant at the Venice Biennale. **1982** Awarded a DAAD scholarship to Berlin. Member of the Danish Academy of Literature. Participation in documenta 7 in Kassel. **1986** Journey to Australia. **1990** Awarded the art prize of the Nord/Landesbank. **1992** Participation in documenta 9 in Kassel.
WRITINGS: P. K.: Selected Essays from Bravura. Eindhoven 1982.– P. K.: Fortgesetzter Text – Hinweise. Bern and Berlin 1985.– P. K.: Rodin, la porte de l'enfer. Bern and Berlin 1985.– P. K.: Kristallgesicht. Ausgew. Essays aus Naturhistorie und Udviklingen. Bern and Berlin 1990.– P. K.: Nachbilder. Bern, Berlin 1991.– P. K.: Natural History and Evolution. The Hague 1991.– P. K.: Handbuch. Texte zu Architektur und Kunst. Berlin and Bern 1993.– P. K. im Gespräch mit S. Gohr. Cologne 1994.– P. K.: Manuel. Musée d'Art Moderne de la Ville de Paris. Paris 1998 (cat.).– P. K.– Lars Morell. Gespräche. Cologne 1998
CATALOGUES RAISONNES: Andersen, T. (ed.): P. K. Werkverzeichnis der Radierungen 1977-1983. Bern and Berlin 1986, 1992.– Gachnang, J. et al. (ed.): P. K. Bachsteinskulptur und Architektur. Werkverzeichnis. Cologne 1997.– Honov, J. (ed.): P. K. Œuvre Katalog 1958-1977. Copenhagen 1979
MONOGRAPHS, CATALOGUES: Anderson, T. et al. (ed.): P. K. Städtisches Museum Abteiberg. Mönchengladbach 1986 (cat.)/P. K. Museum Ludwig, Cologne et al. Cologne 1987 (cat.).– Crouwel, W. et al. (ed.): P. K. Museum Boymans-van Beuningen. Rotterdam 1987.– Felix, Z. and T. Andersen (ed.): P. K. Museum Folkwang. Essen 1977.– Fuchs, R. et al. (ed.): P. K. Stedelijk Van Abbe Museum. Eindhoven 1982 (cat.).– Gallwitz, K. (ed.): P. K. Gemälde, Arbeiten auf Papier, Skulpturen 1977-1990. Städtische Galerie im Städelschen Kunstinstitut. Frankfurt-on-Main 1990 (cat.).– Geyer, M.-J. (ed.): P. K. Musée d'Art Moderne de Strasbourg. Strasbourg 1984 (cat.).– Godfrey, T. et al. (ed.): P. K. Whitechapel Art Gallery. London 1986 (cat.).– Gohr, S. et al. (ed.): P. K. Retrospektive. Museum Ludwig. Cologne 1987 (cat.).– Haenlein, C. A. (ed.): P. K. Bilder. Kestner-Gesellschaft. Hanover 1992 (cat.).– Horn, L. and C. Tacke (ed.): P. K. 1964-1984. Kunstraum Munich et al. Munich 1984 (cat.).– Jorgensen, T. and A. Schnack: P. K. Stein, Papier, Schere. Münster 1991.–

P. K. Kunstverein Braunschweig. Brunswick 1985 (cat.).– P. K. Recent Painting and Sculpture. Whitechapel Art Gallery. London 1985 (cat.).– P. K. Ville de Lyon. Lyon 1987 (cat.).– P. K. Pinturas, esculturas, grabados y escritos. IVAM Centre del Carme. Valencia 1989 (cat.).– P. K. Excursions et expéditions. Grenoble 1992 (cat.).– P. K. Großformatige Zeichnungen 1977-1994. Portikus, Frankfurt-on-Main et al. Münster 1994 (cat.).– P. K. Museum of Modern Art. Ishoj 1996 (cat.).– P. K. and L. Morell: Svanesoen. Copenhagen 1997.– Koella, R. (ed.): P. K. Werke 1983-1988. Kunstmuseum Winterthur 1989 (cat.).– Lamarche-Vadel, B. (ed.): P. K. Centre de Création Contemporain de Tours. Tours 1987 (cat.).– Morell, L.: P. K. Baukunst. Copenhagen 1996.– Nilsson, B. and E. Lidman (ed.): P. K. Malerei, skulptur, teckningar, böcker, film. 1964-1990 / P. K. Paintings, Sculptures, Drawings, Books, Films 1964-1990. Moderna Museet. Stockholm 1990 (cat.).– Schjeldahl, P. (ed.): P. K. Mary Boone Gallery. New York 1986 (cat.).– Schmidt-Miescher, M. and J. Gachnang (ed.): P. K. Kunsthalle Bern. Bern 1979 (cat.).– Ullrich, F. (ed.): P. K. Städtische Kunsthalle Recklinghausen. Recklinghausen 1994 (cat.)

**KISLING Moïse**

**1891** Cracow – **1953** Sanary-sur-Mer (Var) Polish painter. **1906** Studied at the Art Academy in Cracow under J. Pankiewicz. Influenced by Impressionism. **1910** Moved to Paris. Contact with the artists around Picasso. **1914/15** Fought with the French Foreign Legion. **1915** Founded the artists' group Morbidezza in Paris with Modigliani and Soutine. **1919** First solo-exhibition at the Galerie Drouet with melancholy pictures in a realist style. **1940** Fled from the Nazi regime to America via Portugal. **1947** Returned to France and settled in Sanary-sur-Mer. The focus of Kisling's work was the human figure, particularly the female body, preferably in dramatic, melancholic settings.
CATALOGUE RAISONNE: Kessel, J. et al. (ed.): K. 1891-1953. 3 vols. New York and Lanshut 1971-1985
MONOGRAPHS, CATALOGUES: Kessel, J.: K. 1891-1953. Torino 1971.– M. K. Petit Palais Genève. Geneva 1972 (cat.).– M. K. Rétrospective. Grand Palais. Paris 1984 (cat.).– M. K. Retrospective K. Grande Galerie Odákyu. Tokyo 1984 (cat.).– M. K. Centenaire K. Galerie Daniel Malingue. Paris 1991 (cat.).– Rey-Pieferd, A. and P. Ebéli (ed.): Montparnasse. Atelier du Monde, ses artistes venus d'ailleurs. Hommage à K. 1891-1953. Palais de la Bource. Marseille 1992 (cat.)

**KITAJ Ronald B.**

born **1932** Cleveland (OH)
American painter. **1950** Studied at the Cooper Union for the Advancement of Science and Art in New York. **1951/52**

Studied at the Vienna Academy under Albert Paris von Gütersloh and Fritz Wotruba. **1953–1957** Worked as a merchant seaman. **1958** Continued studies at the Ruskin School of Drawing in Oxford and from **1959–1961** at the Royal College of Art in London. **1961–1967** Teacher at various colleges and art schools in London. **1970** Guest-professor at the University of California in Berkeley. **1964** and **1968** participation in documenta 3 and 4 in Kassel. **1971** Returned to London, where he taught at various universities; in **1976** organized an exhibition of figurative painting under the title "The Human Clay". **1980** The Tate Gallery bought his painting *The Rise of Fascism*. **1995** Received the Painting Prize at the Venice Biennale. In London, Kitaj's figurative painting had a great influence on his fellow-students Jones and Hockney; all three later becoming well known as British Pop artists. Kitaj himself, however, disclaimed belonging to the Pop Art movement, using the argument that his themes came not from popular culture but from philosophy, literature and politics.
WRITINGS: R. B. K. Erstes Manifest des Diasporismus. Zurich 1988 / First Diasporist Manifesto. London 1989.– R. B. K. Szétszórva a világban. Egy zsidó fetö vallomása az életröl, a müvészetröl … A diaszporizmus elsö kiáltványa. Budapest 1994
CATALOGUES RAISONNES: Ashbery, J. et al. (ed.): K. Paintings, Drawings, Pastels. London 1986.– Kinsman, J. (ed.): The Prints of R. B. K. Brookfield 1994
MONOGRAPHS, CATALOGUES: Ashbery, J.: R. B. K. Städtische Kunsthalle Düsseldorf. Düsseldorf 1982 (cat.).– Deppner, M. R.: R. B. K. Mahler Becomes Politics, Beisbol. Hamburger Kunsthalle. Hamburg 1990 (cat.).– Deppner, M. R.: Zeichen und Bildwanderung. Zum Ausdruck des "Nicht-Seßhaften" im Werk R. B. K. Münster and Hamburg 1992.– R. B. K. Kestner-Gesellschaft. Hanover 1970 (cat.).– R. B. K. Museum Boymans-van Beuningen. Rotterdam 1970 (cat.).– R. B. K. Marlborough Fine Art, London, Marlborough Gallery, New York. London 1985 (cat.).– R. B. K. Astrup Fearnley Museet, Oslo et al. Oslo 1998 (cat.).– Livingstone, M.: R. B. K. Oxford and New York 1985, Oxford 1992.– Morphet, R. et al. (ed.): R. B. K. Tate Gallery, London et al. London and New York 1994 (cat.).– Ríos, J. R.: R. B. K. Pictures and Conversations. London 1994.– Shannon, J. et al. (ed.): R. B. K. Hirshhorn Museum, Washington et al. Washington 1982 (cat.).– Spender, S. (ed.): R. B. K. Pastels and Drawings. Marlborough Fine Art. London 1980 (cat.)

**KLAPHECK Konrad**

born **1935** Düsseldorf
German painter. Studied **1954–1958** under Goller at the Düsseldorf Academy. Already in his student days, he discovered the central theme of all his works: figurative portrayals of machinery in what he called prosaic super-objectivity. First picture of a

typewriter. **1956/57** Study trip to Paris; became acquainted with the work of Duchamp. **1959** First solo-exhibition at the Schmela Gallery in Düsseldorf. **1960** Met Oelze. **1961–1966** Contact with the Surrealist circle around Breton. Between **1964** and **1977** participation in documenta 3, 4 and 6 in Kassel. **1968** Participation in the "Dada, Surrealism and Their Heritage" exhibition in the Museum of Modern Art, New York. **1974/75** Important retrospective in the Boymans van Beuningen Museum, Rotterdam. **1976–1980** Worked intensively on etching techniques. **1979** Professor at the Düsseldorf Academy. **1985/86** Retrospective in Hamburg, Tübingen and Munich. Klapheck's painting, which soberly portrays home appliances such as typewriters, sewing machines, telephones and irons in stark objectivity, is a reaction to lyrical Tachisme.
CATALOGUES RAISONNES: Pierre, J. (ed.): K. K. Œuvre-Verzeichnis der Gemälde. Cologne 1970.– Zwirner, R. (ed.): K. K. Werkverzeichnis der Druckgraphik. 1960-1977. Cologne 1977.– Zwirner, R. (ed.): K. K. Werkverzeichnis der Druckgraphik. 1977-1980. Düsseldorf and Cologne 1980
MONOGRAPHS, CATALOGUES: Breton, A. and W. Schmied (ed.): K. K. Kestner-Gesellschaft. Hanover 1966 (cat.).– Chapon, F.: K. Montrouge 1980.– Hofmann, W. (ed.): K. K. Retrospektive 1955-1985. Hamburger Kunsthalle et al. Munich 1985 (cat.).– K. K. Museum Boymans-van Beuningen. Rotterdam 1974 (cat.).– K. K. Entwürfe und Bilder 1971-1982. Kunstverein für die Rheinlande und Westfalen. Düsseldorf 1983 (cat.).– K. K. Peintures et dessins. Galerie Lelong. Paris 1990 (cat.)

**KLAUKE Jürgen**

born **1943** Kliding (near Cochem)
German artist. **1964–1970** Studied graphic art at the Cologne School of Art and Design and taught there from **1970** until **1975**. Began in **1970** to make daily entries in a kind of diary, with drawings and photographs describing his momentary surroundings. **1972** In performances such as *Transformer* or *Made in Germany (Hinsetzen-Aufstehen)* of **1979**, used symbolic, ritualistic repetition to exaggerate and portray gender roles and everyday conflicts. **1977**

Took part in documenta 6 in Kassel. Between **1980** and **1986** guest-professorships at the Hamburg and Munich Art Academies and Kassel Comprehensive Art College. **1980** Large-format picture series with posed photographs, such as the multipartite photoseries *Formalisierung der Langeweile* (The Shape of Boredom). **1987** Professor of photography at the University of Essen. Participation in documenta 8 in Kassel. From **1993** professor at Cologne Media Academy. **1997** Retrospective in Tokyo. Klauke developed a mannered and theatrical style of performance art, which ritualized ordinary everyday situations.

WRITINGS: J. K. im Gespräch mit H.-M. Herzog und G. J. Lischka. Cologne 1997 MONOGRAPHS, CATALOGUES: Herzog, H. M. (ed.): J. K. Prosecuritas. Kunsthalle Bielefeld. Stuttgart 1994 (cat.).– Honnef, K. (ed.): J. K. Formalisierung der Langeweile. Kunstmuseum Luzern et al. Cologne 1981 (cat.).– Honnef, K. et al. (eds.): J. K. Phantomempfindungen – Phantom Sensation. The Museum of Modern Art, Saitama et al. Saitama 1997 (cat.).– Poetter, J. (ed.): J. K. Sonntagsneurosen. Staatliche Kunsthalle Baden-Baden. Baden-Baden 1992 (cat.).– Vowinckel, A. and E. Weiss (ed.): J. K. Eine Ewigkeit im Lächeln. Zeichnungen, Fotoarbeiten, Performances 1970-1986. Badischer Kunstverein, Karlsruhe et al. Cologne 1986 (cat.)

## KLEE Paul

**1879** Münchenbuchsee (near Bern) – **1940** Muralto (near Locarno)
German painter, graphic artist, and art theoritician. **1898** Art instruction at a private painting school in Munich under Heinrich Knirr. **1900** Attended Franz von Stuck's painting class at the Munich Academy. **1901** Trip to Italy. **1905** Lived in Paris. In the years from **1902-1906**, when he was living in Bern, he produced etchings inspired by Francisco de Goya, James Ensor and Aubrey Beardsley. **1911** Returned to Munich, where he became acquainted with Macke, Marc, Javlensky, Münter, Verefkin and Kandinsky. **1912** Participation in the second exhibition of the Blauer Reiter group. Trip to Paris, where he met Delaunay and saw pictures by Braque and Picasso **1914** Co-founder of the Munich New Secession. Travelled to Tunis with Louis Moilliet and Macke. **1916** Military service. **1919** Began painting in oils, taking abstract forms as objects. **1920** Appointed to the Bauhaus in Weimar. Published the essay *Creative Confessions*, begun in **1918**. **1931-1933** Professor at the Düsseldorf Academy. Period of divisionist painting. **1933** Returned to Bern owing to National Socialist pressure. **1937** Confiscation of 102 of his works by the Nazis, of which 17 were exhibited in the exhibition of "degenerate art" in Munich. Klee's hieroglyphic picture language, which works with an abstract vocabulary of forms but never completely loses its ambiguous connection to the real world, is often ambiguous and slightly ironic.

WRITINGS: Geelhaar, C. (ed.): P. K. Schriften, Rezensionen und Aufsätze. Cologne 1976.– Klee, F. (ed.): P. K. Briefe an die Familie. 1893-1940. 2 vols. Cologne 1979.– P. K.: Tagebücher. 1898-1918. Textkritische Neuedition. Stuttgart 1988/The Diaries of P. K. 1898-1918. Berkeley and Los Angeles 1964.– Regel, G. (ed.): P. K. Kunst-Lehre. Aufsätze, Vorträge, Rezensionen und Beiträge zur bildnerischen Formlehre. Leipzig 1991.– Spiller, J. (ed.): The P. K. Notebook. 2 vols. London and Woodstock (NY) 1992 CATALOGUES RAISONNES: Frey, S. and J. Helfenstein (ed.): P. K. Verzeichnis der Werke des Jahres 1940. Stuttgart 1991.– Glaesemer, J. (ed.): P. K. Handzeichnungen. 3 vols. Bern 1973-1984.– Kornfeld, E. W. (ed.): Verzeichnis des graphischen Werkes von P. K. Bern 1963.– Paul-Klee-Stiftung (ed.): Catalogue Raisonné P. K. Vol. 1: 1883-1912. Bern 1998 MONOGRAPHS, CATALOGUES: Bischoff, U.: P. K. Munich 1992.– Bonfand, A.: P. K. L'œil en trop. 2 vols. Paris 1988.– Boulez, P.: Le Pays fertile. P. K. Paris 1989.– Buderer, H.-J.: P. K. Konstruktion, Intuition. Städtische Kunsthalle Mannheim. Stuttgart 1990 (cat.).– Chapeaurouge, D. d.: P. K. und der christliche Himmel. Stuttgart 1990.– Comte, P.: K. Paris 1991, Woodstock (NY) 1991.– Cortenova, G. (ed.): P. K. Palazzo Forti, Verona. Milan 1992 (cat.).– Crone, R. and J. L. Koerner: P. K. Legends of the Sign. New York 1991.– Dennison, L. (ed.): P. K. at the Guggenheim Museum. Guggenheim Museum. New York 1993 (cat.).– Franciscono, M.: P. K. His Work and Thought. Chicago 1991.– Franz, E. (ed.): P. K. Späte Zeichnungen von 1939. Museum Folkwang. Essen 1989 (cat.).– Frontisi, C.: K. Anatomie d'Aphrodite. Le polyptyque démembré. Paris 1990.– Geelhaar, C.: P. K. und das Bauhaus. Cologne 1972/P. K. and the Bauhaus. Neuchâtel 1972.– Geelhaar, P.: P. K. Leben und Werk. Cologne 1974/P. K. Life and Work. New York 1982.– Glaesemer, J. (ed.): P. K. Die farbigen Werke im Kunstmuseum Bern. Bern 1976/P. K. The Colored Works in the Kunstmuseum Bern. Bern 1979.– Glaesemer, J. (ed.): P. K. Beiträge zur bildnerischen Formlehre. Basel 1979.– Glaesemer, J. et al. (ed.): P. K. Leben und Werk. Kunstmuseum Bern et al. Stuttgart 1988, 1996 (cat.)/P. K. Life and Work. The Museum of Modern Art, New York et al. New York 1988 (cat.).– Gohr, S. et al. (ed.): P. K. Das Werk der Jahre 1919-1933. Josef-Haubrich-Kunsthalle. Cologne 1979 (cat.).– Grohmann, W.: P. K. Stuttgart 1954, Paris 1954, New York 1954.– Güse, E.-G. (ed.): P. K. Wachstum regt sich. K. Zwiesprache mit der Natur. Saarland Museum, Saarbrücken et al. Munich 1990 (cat.).– Güse, E.-G. (ed.): P. K. Dialogue with Nature. New York 1995.– Haftmann, W.: P. K. Wege bildnerischen Denkens. Frankfurt-on-Main 1961.– Haxthausen, C. W.: P. K. The Formative Years. New York 1981.– Helfenstein, J. (ed.): P. K. Das Schaffen im Todesjahr. Kunstmuseum Bern. Stuttgart 1990 (cat.).– Hofmann, W. (ed.): P. K. 50 Werke aus 50 Jahren. 1890-1940. Hamburger Kunsthalle. Hamburg 1990 (cat.).– Hoppe-Sailer, R.: P. K. Ad Parnassum. Frankfurt a. M. 1993.– Huggler, M.: P. K. Die Malerei als Blick in den Kosmos. Frauenfeld et al. 1969.– Jordan, J. M.: P. K. and Cubism. Princeton (N J) 1984.– Kagan, A.: P. K. Art and Music. Ithaca (NY) et al. 1983.– Kagan, A. (ed.): P. K. At the Guggenheim Museum. Solomon R. Guggenheim Museum. New York 1993 (cat.).– Kersten, W.: P. K. Übermut. Allegorie der künstlerischen Existenz. Frankfurt a. M. 1990.– Kersten, W. and O. Okuda (ed.): P. K. Im Zeichen der Teilung. Die Geschichte zerschnittener Kunst Paul Klees 1883-1940. Kunstsammlung Nordrhein-Westfalen, Düsseldorf et al. Stuttgart 1995.– Klee, F. (ed.): P. K. Leben und Werk in Dokumenten. Zurich 1960/P. K. His Life and Work in Documents. New York 1962.– Klee, P. K. Œuvres de 1933 à 1940. Musées des Beaux-Arts. Nîmes 1984 (cat.).– Kornfeld, E. W.: Verzeichnis des graphichen Werkes von P. K. Bern 1963.– Kruszynski, A. (ed.): P. K. Im Zeichen der Teilung: die Geschichte zerschnittener Kunst P. K. 1883-1940. Kunstsammlung Nordrhein-Westfalen, Düsseldorf et al. Düsseldorf and Stuttgart 1995 (cat.).– Kuenzi, A. (ed.): K. Fondation Pierre Gianadda. Martigny 1985 (cat.).– Lanchner, C. (ed.): P. K. The Museum of Modern Art, New York et al. New York 1987 (cat.).– Moe, O. H. et al. (ed.): K. et la musique. Centre Georges Pompidou. Paris 1985 (cat.).– Nauber-Riser, C.: K. Paris 1997.– Osterwold, T. (ed.): P. K. Spätwerk. Württembergischer Kunstverein. Stuttgart 1990 (cat.).– Plant, M.: P. K. Figures and Faces. London 1978.– Rathke-Köhl, S. (ed.): P. K. nelle collezioni private. Museo d'Arte Moderna Ca' Pesaro. Venice 1986 (cat.).– Rewald, S. (ed.): P. K. The Berggruen Klee Collection in the Metropolitan Museum of Art. New York 1988.– Schulz-Hoffmann, C. et al. (ed.): P. K. Wachstum der Nachtpflanzen, Vogelgarten. Staatsgalerie moderner Kunst. Munich 1992 (cat.).– Verdi, R.: K. and Nature. New York 1985.– Vitali, C. (ed.): P. K. und die Musik. Schirn Kunsthalle. Frankfurt-on-Main 1986 (cat.).– Vogel, M.: Zwischen Wort und Bild. Das schriftliche Werk Paul Klees und die Rolle der Sprache in seinem Denken und in seiner Kunst. Munich 1992.– Werckmeister, O. K.: Versuche über P. K. Frankfurt-on-Main 1981/The Making of P. K.'s Career 1914-1920. Chicago 1989.– Zweite, A. (ed.): P. K. Das Frühwerk 1883-1922. Städtische Galerie im Lenbachhaus. Munich 1979 (cat.)

## KLEIN William

born **1928** New York
American photographer and film-maker. **1943-1947** Studied social sciences at the City College, New York and at the Sorbonne in Paris. **1948** Assistant in Léger's studio. **1952** First photographic work. **1954** Returned to New York. **1956** Published his book of photographs *New York*, in which he portrays life in the city in apparently random and often unfocused pictures. He was artistic advisor to Louis Malle during the filming of *Zazie in the Metro*. **1955-1965** Staff member at *Vogue*. In addition to fashion pictures, he did numerous portraits of celebrities. **1957** Received the Prix Nadar. **1958** Shot his first film, *Broadway by Light*, followed by 20 further films and documentaries. **1964** Published two photograph books on Tokyo and Moscow. **1965** Gave up photography and dedicated himself to film. **1966** Release of the film *Qui êtes-vous, Polly Maggoo?* In the 50s, Klein worked mostly as a photographer, experimenting with photographic manipulation to produce abstract effects. From the beginning of the 60s, he became increasingly interested in film production.

MONOGRAPHS, CATALOGUES: Caujolle, C. (ed.): W. K. Centre de la Photographie. Paris 1992 (cat.).– Heilpern, J. W. K. Photographs. New York 1981.– W. K. Schilderijen, foto's, films. Stedelijk Museum. Amsterdam 1967 (cat.).– Tweedie, K. (ed.): W. K. Photographer, Filmmaker. New York 1982

## KLEIN Yves

**1928** Nice – **1962** Paris
French artist. **1944-1946** Studied at the

Ecole Nationale de la Marine marchande. **1946/47** Friendship with Claude Pascal and Arman. Developed first theories on monochromism and composed his *Symphonie monoton*, a work consisting of one single note, which was performed in **1949** for the first time with Klein conducting. **1952/53** Lived in Japan, where he won a black belt in judo. **1955** Returned to Paris and ran a judo school. From **1956** monochrome pictures in International Klein Blue (IKB), a luminous ultramarine blue whose mixture Klein himself developed. **1957** Showed his *Période bleue* in the Galleria Apollinaire in Milan. **1958** First *Anthropométries*: Body prints of female models, who were dipped in Yves Klein Blue. Presentations of empty rooms. **1960** Exhibition of his first *Monochrome gold* paintings at the Salon Antagonismes and of his *Anthropométries de l'Epoque* in the Galerie Internationale d'Art Contemporain in Paris. Founder member of the Nouveaux Réalistes. First *Cosmogonies*, images created by the action of natural elements (e.g. rain, wind, plant imprints). **1961** First planetary relief and first fire pictures. **1962** Composition of the *Symphonie Monoton No. 2*. Created complete body casts of his friends Arman, Martial Raysse and Claude Pascal. **1964** and **1968** participation in documenta 3 and 4 in Kassel. **1983** Major retrospective at the Pompidou Centre in Paris, and **1994** at the Ludwig Museum, Cologne. With his use of unusual materials and unconventional techniques, and the involvement of the elements fire, water and air in the creative process, Klein did much to extend the boundaries of what is considered "art".

WRITINGS: Caumont, J. and J. Gough-Cooper (ed.): Y. K. 1928-1962. Selected Writings. Tate Gallery. London 1974 (cat.).– Y. K.: Les Fondements du judo. Paris 1954.– Y. K.: Le Dépassement de la problématique de l'art. La Louvière 1959 CATALOGUES RAISONNES: Wember, P.: Y. K. Cologne 1969.– Klein-Moquay, R. et al. (ed.): Y. K. Catalogue raisonné (in preparation) MONOGRAPHS, CATALOGUES: Heynen, J. (ed.): Y. K. Monochrome und Feuer, Krefeld 1961. Ein Dokument der Avantgarde. Krefeld 1994.– Krahmer, C.: Der Fall Y. K. Zur Krise der Kunst. Munich 1974.– Martano, G.: Y. K. Il mistero ostentato. Torino 1970.– Millet, C.: Y. K. Paris 1983.– Mock, J.-Y. et al. (ed.): Y. K. Centre Georges Pompidou. Paris 1983 (cat.).– Prats Okuyama, C. and K. Okuyama: K. L'Arbre, grande éponge bleue. Paris 1994.– Restany, P.: Y. K. Paris 1982, New York 1982, Munich 1983.– Restany, P. et al. (ed.): Y. K. 1928-1962. Retrospective. Rice University Museum, Houston et al. Houston 1982 (cat.).– Restany, P.: Y. K. Le feu au cœur du vide. Paris 1990/Y. K. Fire at the Heart of the Void. New York 1992.– Restany, P. et al. (ed.): Y. K. Oslo et al. Oslo 1997 (cat.).– Rosenthal, N.: The Blue World of Y. K. Cambridge 1976.– Schneider, A. and H. Weitermeier (ed.): Y. K. Nationalgalerie Berlin et al. Berlin 1976 (cat.).– Stich, S.

(ed.): Y. K. Museum Ludwig, Cologne et al. Stuttgart 1994 (cat.).– Stöhr, J.: Y. K. und die ästhetische Erfahrung. Bochum 1992.– Weitemeier, H.: Y. K. 1928-1962. International Klein Blue. Cologne 1995.– Wember, P.: Y. K. Cologne 1969, 1972

## KLIMT Gustav

**1862** Baumgarten – **1918** Vienna

Austrian painter. **1876–1882** Attended the Vienna School of Arts and Crafts. **1886–1888** Along with his brother Ernst and Franz Matsche, painted a ceiling at the Burgtheater in Vienna. **1890–1892** Spandrel and intercolumnation paintings for the staircase of the Art History Museum in Vienna. **1897** Founder member of the Vienna Secession and its president until he resigned from the movement in **1905**. **1898** Participation in the first exhibition of the Secession. Worked for *Ver Sacrum* magazine. **1890** Participation in the Paris World Fair. Mural decorations for the Banqueting Hall of the University of Vienna on the themes of Philosophy, Jurisprudence and Medicine. **1902** Creation of the *Beethoven Frieze* in the room of the left of the Vienna Secession. **1905** Designs for a mosaic in the Stoclet Palace in Brussels. **1906–1909** Travelled to Belgium England, Florence, Paris, and Madrid. **1910** Enthusiastic reception of his work at the Venice Biennale. **1917** Made an honorary member of the Vienna Academy after he had been refused a professorship. Klimt, with his preference for decorative motifs and symbolic images, had a formative influence on Viennese Jugendstil, especially on the work of the artists and craftsmen at the Wiener Werkstätte (Vienna Workshops).
CATALOGUES RAISONNES: Coradeschi, S. (ed.): Tout l'œuvre peint de K. Paris 1983.– Dobai, G. and F. Novotny (ed.): G. K. Catalogue Raisonné. Salzburg 1967, 1975 / G. K. With a Catalogue Raisonné of His Paintings. London 1968, Boston 1975.– Strobl, A. (ed.): G. K. Die Zeichnungen. 4 vols. Salzburg 1980-1989
MONOGRAPHS, CATALOGUES: Bisanz-Prakken, M.: G. K. Der Beethovenfries. Geschichte, Funktion und Bedeutung. Munich 1980.– Brandstätter, C.: G. K. und die Frauen. Vienna 1994.– Breicha, O.: G. K. Die goldene Pforte. Werk, Wesen, Wirkung. Bilder und Schriften zu Leben und Werk. Salzburg 1978.– Breicha, O.: G. K. Die Bilder und Zeichnungen der Sammlung Leopold. Salzburg 1990.– Comini, A.: G. K. London and New York 1975.– Dobai, J. and S. Coradeschi: L'opera completa di Klimt. Milan 1979.– Dobai, J.: G. K. Die Landschaften. Salzburg 1981 / G. K. Landscapes. London 1988.– Ducros, F.: K. Paris 1992.– Fliedl, G.: G. K. 1862-1918. The World in Female Form. Cologne 1990.– Fliedl, G.: K. The Definite Monograph on the Viennese Artist. New York 1997.– Frodl, G.: K. et l'école de Vienne. Paris 1990.– Frodl, G.: K. Cologne 1992, London 1992.– Hofmann, W.: G. K. und die Wiener Jahrhundertwende. Salzburg 1970 / G. K. New York 1971.– Hofstätter, H. H. (ed.):

G. K. Erotische Zeichnungen. Cologne 1979.– G. K. 1862 – Wien – 1918. Zeichnungen aus Privatbesitz. Düsseldorf 1987 (cat.).– Melloni, C.: G. K. Il sigillo della contraddizione. Venice 1989.– Nebehay, C. M.: G. K. Eine Dokumentation. Vienna 1969.– Nebehay, C. M.: G. K. Sein Leben nach zeitgenössischen Berichten und Quellen. Munich 1976, 1992.– Nebehay, C. M.: G. K. Das Skizzenbuch aus dem Besitz von Sonja Knips. Vienna 1987.– Nebehay, C. M.: G. K. Von der Zeichnung zum Bild. Vienna 1992 / G. K. From Drawing to Painting. New York 1994 / G. K. Paris 1993.– Néret, G.: G. K. Cologne 1993.– Partsch, S.: G. K. Maler der Frauen. Munich 1994.– Sabarsky, S. (ed.): G. K. Musées Royaux des Beaux-Arts de Belgique. Brussels 1987 (cat.).– Sabarsky, S. (ed.): G. K. Palazzo Strozzi. Florence 1992 (cat.).– Sármány, I.: G. K. Budapest 1989.– Stooss, T. and C. Doswald (ed.): G. K. Kunsthaus Zürich. Stuttgart 1992 (cat.).– Welz, F. (ed.): G. K. Salzburg 1975.– Whitford, F.: K. London 1990

## KLINE Franz

**1910** Wilkes-Barre (PA) – **1962** New York

American painter. **1931–1935** Studied in Boston and from **1936** at the Heatherley School of Fine Art in London. **1938** Moved to New York. **1943** Became friends with de Kooning, who kindled his interest in abstraction. At first he painted portraits, seated figures in rocking chairs, railway bridges, and Pennsylvania landscapes. By the end of the 40s, he had developed his own personal style of gestural painting requiring ever larger canvases. Finally limited himself to black and white. From **1950** produced powerful tectonic constructions, whose origin he attributed to Mondrian. **1954** Participation in the Symposium "Abstract Art Around the World Today" at the Museum of Modern Art, New York. **1958/59** Colour experiments with the goal of being able to use colours structurally, like the non-colours black and white. **1959** and **1964** participation in documenta 2 and 3 in Kassel. Kline, who died of a heart attack in **1962**, developed an individual form of action painting language reminiscent of Far Eastern calligraphy.
MONOGRAPHS, CATALOGUES: Dawson, F.: An Emotional Memoir of F. K. New York 1967.– Foster, S. C. et al. (ed.): F. K. Art and Structure. Fundació Antoni Tàpies, Barcelona et al. Barcelona 1994 (cat.).– Gaugh, H. F. (ed.): F. K. The Color Abstractions. The Phillips Collection. Washington 1979 (cat.).– Gaugh, H. F. (ed.): F. K. The Vital Gesture. Cincinnati Art Museum et al. New York 1985, 1994 (cat.).– Gordon, J. (ed.): F. K. 1910-1962. Whitney Museum of American Art, New York et al. New York 1968 (cat.).– F. K. Stedelijk Museum. Amsterdam 1963 (cat.).– F. K. Museum des 20. Jahrhunderts. Vienna 1964 (cat.).– F. K. Kunsthalle Basel. Basel 1964 (cat.).– F. K. The Color Abstractions. Phillips Collection. Washington 1979

(cat.).– F. K. Whitechappel Art Gallery. London 1994 (cat.).– Whitney, D. and D. Anfam (ed.): F. K. Black & White 1950-1961. The Menil Collection, Houston et al. Houston 1994 (cat.).– Zevi, A.: F. K. Milan 1987

## KLIUN Ivan

**1873** Kiev – **1942** Moscow

Russian painter and sculptor. Art studies in Warsaw and Kiev. From **1900** private lessons in Moscow under Rerberg and Mashkov. **1907** Acquaintance with Malevich. **1910** One of the founders of the Moscow Salon. **1913** First relief sculptures. **1915** In depth study of Suprematism, the painting style invented by Malevich. Participation in the first Futurist exhibition "Tramway V" in St. Petersburg. Exhibited **1916** at the "Last Futurist Exhibition: 0,10" in St. Petersburg. From **1917** held various cultural posts; for example, director of the central exhibition office Narkompros. **1918–1921** Taught at the Vhumtemas art institute in Moscow. **1922** Participation in the "First Russian Art Exhibition" at the van Diemen gallery in Berlin. **1923** Worked on the production of various futurist book publications. **1925** Joined the Company of the Four Arts. Kliun experimented in his still lifes with geometric forms and investigated their colour relationships. With the advent of the politically motivated shift from abstract art to Socialist Realism in the 20s, Kliun gave up his geometric colour and form experiments and resumed figurative painting.
MONOGRAPHS, CATALOGUES: I. K. Matignon Gallery. New York 1983 (cat.).– Kliunkova-Soloveichnik, S.: I. K. New York 1993

## KNOEBEL Imi

born **1940** Dessau

German painter and object artist. **1964–1971** Studied at the Düsseldorf Art Academy under Beuys. Close contact to Imi Giese and Palermo. Worked with light projections. Worked together with Imi Giese in Copenhagen. First room installations out of fibre board. **1969–1975** Experiments with a single line in over 250,000 drawings. **1972** Production of the videotape *X* for the video gallery run by Gerry Schum. **1972–1987** Participation in

documenta 5 – 8 in Kassel. **1975/76** Multipartite picture constellations, entitled *White Pictures*. **1976–1981** Period of the *Mennige Pictures* with designs and construction sketches cut out of white paper. **1980** Large environment with coloured cut-out plywood rectangles, which are layered, stacked, and hung (*Genter Raum*). **1982** Environment *Radio Beirut*. **1984** Room construction using fibre board, outlining the measurements of the studio kitchen (*Heerstraße*). Influenced by Malevich's Suprematism and Russian Constructivism, Knoebel's geometric abstract works address the fundamental problems of painting and form.
MONOGRAPHS, CATALOGUES: Bloem, M. and H. Gaßner (ed.): I. K. Retrospektive 1966-1996. Haus der Kunst, Munich et al. Stuttgart 1996 (cat.).– I. K. Kunstmuseum. Winterthur 1983 (cat.).– I. K. Städtisches Museum Abteiberg. Mönchengladbach 1984 (cat.).– I. K. Rijksmuseum Kröller-Müller. Otterlo 1985 (cat.).– I. K. Staatliche Kunsthalle Baden-Baden. Baden-Baden 1986 (cat.).– I. K. Werken uit de verzameling Ingrid en Hugo Jung. Museum van Hedendaagse Kunst. Antwerp 1988 (cat.).– I. K. Tentoonstellingsinstallaties 1968-1988 / Austellungsinstallationen 1968-1988. Bonnefantenmuseum. Maastricht 1989 (cat.).– I. K. Hessischens Landesmuseum. Darmstadt 1992 (cat.).– I. K. Kunstverein St. Gallen. St. Gallen 1996 (cat.).– I. K. Rot Gelb Weiß Blau. Ludwig Forum für Internationale Kunst. Aachen 1996 (cat.).– Loers, V. (ed.): Shapes and Positions. Kunsthalle Ritter et al. Klagenfurt 1992 (cat.).– Stüttgen, J.: Der Keilrahmen des I. K. 1968/89. Cologne 1991

## KOBRO Katarzyna

**1898** Moscow – **1951** Lódz

Polish sculptress. **1917–1920** Studied painting in Moscow. **1920** Married Strzemiński and moved to Smolensk. Member of the Unowis artist's group. **1920–1922** Maintained contacts with the OBMOChU group. **1922** Moved to Poland. From **1924** member of the Blok artists' group. Taught in industrial schools in Szczekociny and Koluszki. **1925–1933** *Spatial Compositions* in sheet metal. **1929** Co-founder of the a. R. group. **1931** Taught at the Industrial School for Women in Lódz. **1933** Joined Abstraction-Création. **1936–1947** Due to the difficult wartime circumstances, she gave up her artistic activities. **1948** Last cubist-style nude sculptures. Kobro's floating metal compositions are similar to Tatlin's constructions.
WRITINGS: K. K. and W. Strzeminski: L'Espace uniste. Ecrits du constructivisme polonais. Lausanne 1977
MONOGRAPHS, CATALOGUES: Grzechca-Mohr, U.: K. und die konstruktivistische Bewegung. Diss. Münster 1986.– Jedlinski, J. (ed.): K. K. 1898-1951. Städtisches Museum Abteiberg, Mönchengladbach. Cologne 1991 (cat.).– K. K. Muzeum Sztuki, Lodz / Städtisches Museum

Abteiberg, Mönchengladbach. Mönchengladbach 1991 (cat.).– Zagrodzki, J.: K. K. i Kompozycja przestrzeni. Warsaw 1984 (cat.)

## KOKOSCHKA Oskar

**1886** Pöchlarn (on the Danube) – **1980** Villeneuve (on Lake Geneva)
Austrian painter, graphic artist and poet. **1905–1909** Studied at the Vienna School of Arts and Crafts. **1907–1909** Worked in the Wiener Werkstätte (Vienna Workshops). **1909/10** Period of portraits: dissecting the human psyche on canvas. **1910** Moved to Berlin and worked on *Der Sturm* magazine. **1911** Returned to Vienna, where he worked as an assistant at the School of Arts and Crafts, and began his fatal love affair with Alma Mahler. **1914** Separated from Alma Mahler. The male-female conflict, which he had already treated in his drama *Mörder, Hoffnung der Frauen* (Murderer: Women's Hope), became an allegory of unbridled love in his painting *Die Windsbraut* (Kunstmuseum, Basel). **1915** Taken to a military hospital soon after signing up for military service. **1917** Moved to Dresden, where he was appointed professor at the Art Academy in **1919**. In addition to portraiture painted pictures of towns. **1924** Resigned his professorship and travelled extensively through Europe, North Africa, and the Near East. **1933** Returned to Vienna. **1934** Moved to Prague. **1937** Confiscation of 417 works classified as "degenerate art." **1938** Emigrated to England and settled in London. **1947** Became a British citizen. **1953** Moved to Villeneuve on Lake Geneva. Found the School of Seeing at the summer school in Salzburg. **1975** Became an Austrian citizen again. Kokoschka, an artist who was responsible for introducing psychology into Expressionism, worked in many art forms. His œuvre includes not only paintings, but graphic works and stage designs, as well as poems, which he illustrated himself.
WRITINGS: Breicha, O. (ed.): O. K. Vom Erlebnis im Leben. Schriften und Bilder. Salzburg 1977.– O. K.: Mein Leben. Munich 1971/My Life. London 1974.– Marnau, A. (ed.): O. K. Berichte aus einer eingebildeten Welt. Vienna, Graz and Cologne 1996.– Marnau, A. and O. Kokoschka (ed.): O. K. Letters 1905-1976. London and New York 1992.– Spielmann, H. (ed.): O. K. Das schriftliche Werk. 4 vols. Hamburg 1973-1976.– Spielmann, H. and Oda Kokoschka (ed.): O. K. Briefe. 4 vols. Düsseldorf 1984-1988.– Wingler, H. M. (ed.): O. K. Schriften. Munich 1956
CATALOGUES RAISONNES: Rathenau, E.: O. K. Handzeichnungen. 5 vols. Berlin 1935-1977.– Spielmann, H.: O. K. 1886-1980. Welt-Theater, Bühnenbilder und Illustrationen 1907-1975. Museum für Kunst und Gewerbe, Hamburg et al. Hamburg 1986.– Wingler, H. M. (ed.): O. K. Das Werk des Malers (mit Werkverzeichnis der Gemälde, Plastik und anderer Arbeiten). Salzburg 1956/O. K. The Work of the Painter. Catalogue Raisonné. London 1958.– Wingler, H. M. and F. Welz (ed.):

O. K. Das druckgraphische Werk. 2 vols. Salzburg 1975-1981.– Winkler, J. and K. Erling (ed.): O. K. Œuvrekatalog der Gemälde. Band I: Die Gemälde (1906-1929). Salzburg 1995
MONOGRAPHS, CATALOGUES: Borchert, B. K. Berlin 1959.– Bultmann, B.: O. K. Salzburg 1959, London 1961.– Borchert, B. K. London 1960.– Calvocoressi, R. et al. (ed.): O. K. 1886-1980. Tate Gallery. London 1986 (cat.)/O. K. 1886-1980. Kunsthaus Zürich. Zurich 1986 (cat.)/O. K. 1886-1980. Solomon R. Guggenheim Museum. New York 1986 (cat.).– Calvocoressi, R.: K. Recklinghausen 1992, New York 1992.– Gallwitz, K. (ed.): O. K. Das Porträt. Badischer Kunstverein. Karlsruhe 1966 (cat.).– Gatt, G.: O. K. London 1971, Lucerne 1972.– Hodin, J. P.: O. K. The Artist and His Time. London and Greenwich (CT) 1966/O. K. Sein Leben, seine Zeit. Frankfurt-on-Main 1968.– Hodin, J. P.: O. K. Eine Psychographie. Vienna 1971.– Hoffmann, E.: K. Life and Work. London and Boston 1943, 1947.– Hofmann, W. (ed.): O. K. Tate Gallery, London et al. London 1986 (cat.).– Hülsewig-Johnen, J. (ed.): O. K. Emigrantenleben, Prag und London 1934-1953. Kunsthalle Bielefeld. Bielefeld 1995.– O. K. Die frühen Jahre. Aquarelle und Zeichnungen 1906-1924. Kestner-Gesellschaft. Hanover 1983 (cat.).– O. K. 1886-1980. The Late Work 1953-1980. Marlborough Fine Art, London et al. London 1990 (cat.).– O. K. und Dresden. Gemäldegalerie Neue Meister, Dresden et al. Dresden 1996 (cat.).– Koller, G. and O. Oberhuber (ed.): O. K. Städteporträts. Österreichisches Museum für angewandte Kunst. Vienna 1986 (cat.).– Leshko, J.: O. K. Paintings 1907-1915. Ann Arbor (MI) 1981.– Lischka, G. J. O. K. Maler und Dichter. Bern und Frankfurt-on-Main 1972.– Mauron, V.: Werke der O. K.-Stiftung. Mainz 1994.– Mauron, V. (ed.): O. K. Viaggi e figure. Civica Galleria d'Arte Villa dei Cedri. Bellinzona 1996 (cat.).– Patka, E. (ed.): O. K. Symposium. Salzburg et al. 1986.– Plaut, J.: O. K. New York 1945.– Schmalenbach, F.: O. K. Königstein i. T. 1967.– Schröder, A. and J. Winkler (ed.): O. K. Kunstforum Länderbank Wien. Munich 1991 (cat.).– Schvey, H.: O. K. The Painter as Playwriter. Detroit 1982.– Schweiger, W. J.: Der junge K. Leben und Werk 1904-1914. Vienna and Munich 1983.– Schweiger, W. J.: O. K. Der Sturm. Die Berliner Jahre. 1910-1916. Eine Dokumentation. Munich 1986.– Spielmann, H.: O. K. Lebensspuren. Schleswig-Holsteinisches Landesmuseum. Schleswig 1992 (cat.).– Strobl, A. and A. Weidinger (ed.): O. K. Das Frühwerk 1897-1917. Albertina. Vienna 1994 (cat.).– Strobl, A. and A. Weidinger (ed.): O. K. Works on Paper. The Early Years 1897-1917. Solomon R. Guggenheim Museum. New York 1995 (cat.).– Werner, N.: K. Leben und Werk in Daten und Bildern. Frankfurt-on-Main 1991.– Whitford, F. O. K. A Life. London 1986

## KOONS Jeff

born **1955** York (PA)
American object and concept artist. **1972-1975** Studied at the Maryland Institute of Art, Baltimore. **1975/76** Attended the Art Institute of Chicago. For many years he worked as a stockbroker on Wall Street in New York. In **1979**, he presented his first toys in plexiglas boxes. **1980** First solo-exhibition at the New Museum of Contemporary Art in New York with his series *The New*, which showed household appliances in illuminated display windows. **1985** Exhibition at the International With Monument Gallery in New York with the series *Equilibrium*, which consisted of aquariums with

floating basketballs and bronze castings of swimming and diving accessories. **1986** In the series *Statuary*, he dealt with artistic symbols and commonplace and kitsch objects manufactured either in precious metals (e.g. *Rabbit*, a inflatable plastic rabbit cast in stainless steel) or made by woodcarvers, such as the **1987** sculpture *String of Puppies*. The life-size sculpture *Made in Heaven*, produced for the **1990** Venice Biennale, depicted the artist and his wife, the Italian pornographic actress Cicciolina, making love. Koons' ironic presentations of consumer goods and his erotic-pornographic tableaux are his way of exposing the psychological manipulation and financial profiteering in the art market.
MONOGRAPHS, CATALOGUES: Beeren, W. and G. Inboden (ed.): J. K. Stedelijk Museum, Amsterdam et al. Amsterdam and Stuttgart 1992 (cat.).– Caldwell, J. et al. (ed.): J. K. Museum of Modern Art. San Farncisco 1992 (cat.).– Danoff, M. (ed.): J. K. The Art Institute of Chicago. Chicago 1988 (cat.).– J. K. Museum of Contemporary Art. Chicago 1988 (cat.).– Muthesius, A. (ed.): J. K. Cologne 1992.– Rosenblum, R. (ed.): The J. K. Handbook. New York 1992/Das J. K. Handbuch. Munich 1992.– Rosenblum, R. et al. (ed.): J. K. Celebration. Solomon R. Guggenheim Museum. New York 1996 (cat.).– Simpson, F. W. (ed.): J. K. San Francisco Museum of Modern Art 1992 (cat.)

## KOSSOFF Leon

born **1926** London
English painter. **1945–1948** Military service in France, Belgium, Holland and Germany. Studied from **1949–1953** at St. Martin's School of Art and under David Bomberg at Borough Polytechnic in London. **1953–1956** Continuation of his art studies at the Royal College of Art. **1959–1964** Taught at the Regent Street Polytechnic and at Chelsea School of Art. **1966–1969** Teacher at St. Martin's School of Art. **1972** Solo-exhibition at the Whitechapel Art Gallery, London. **1981** Exhibition of his early drawings at Riverside Studios in London and his paintings from the 70s in the Museum of Modern Art in Oxford.
MONOGRAPHS, CATALOGUES: Elliott, D. (ed.): L. K. Paintings from a Decade 1970-1980. Museum of Modern Art. Oxford

1981 (cat.).– Gowing, L. (ed.): L. K. Anthony d'Offay Gallery. London 1988 (cat.).– L. K. Kunstverein für die Rheinlande und Westfalen. Düsseldorf 1995 (cat.).– Mercer, D. (ed.): L. K. Recent Paintings and Drawings. Whitechappel Art Gallery. London 1972 (cat.).– Moorhouse, P. (ed.): L. K. London 1996 (cat.)

## KOSUTH Joseph

born **1945** Toledo (OH)
American concept artist and photographer. **1955–1962** Studied at the Toledo School of Design, **1963/64** at the Cleveland Art Institute and **1965–1967** at the School of Visual Arts in New York. **1965** Appearance of his first conceptual work, *One and three chairs* – a three-fold presentation of a chair as the actual object, a photograph, and an enlarged photograph of its dictionary entry. **1967** First one-man exhibition at the Museum of Normal Art, New York. From **1968** lecturer at the School of Visual Arts, New York. **1969–1970** As editor of the magazine *Art-Language*, wrote numerous theoretical texts on the subject of Concept Art. **1971/72** Studied philosophy. **1972–1982** Participation in documenta 5–7 in Kassel. **1975** Founded *The Fox* magazine. **1992** Installation *Documenta-Flânerie* at documenta 9 in Kassel. Kosuth is a principal proponent of analytical Concept Art.
WRITINGS: Inboden, G. (ed.): J. K. Bedeutung von Bedeutung. Texte und Dokumentation der Investigationen über Kunst seit 1965 in Auswahl/The Making of Meaning. Selected Writings and Documentation of Investigations on Art Since 1965. Staatsgalerie Stuttgart. Stuttgart 1981 (cat.).– Guercio, G. (ed.): J. K. Art After Philosophy. Collected Writings 1966-1990. Cambridge (MA) and London 1991.– J. K.: J. K. Interviews 1969-1989. Stuttgart 1989.– Meyer, E. and S. Schmidt-Wulffen (ed.): J. K. A Grammatical Remark/Eine Grammatische Bemerkung. Stuttgart 1993
MONOGRAPHS, CATALOGUES: Ammann, J.-C. and M. Eigenheer (ed.): J. K. Investigationen über Kunst und Problemkreise seit 1965. Kunstmuseum Luzern. Lucerne 1973 (cat.).– Damsch-Wiehager, R. (ed.): J. K. Kein Ding, kein Ich, keine Form, kein Grundsatz "sind sicher". Villa Merkel, Esslingen. Stuttgart 1993/J. K. No Thing, No Form, No Principle (Was Certain). Stuttgart 1993 (cat.).– Freedberg, D. (ed.): J. K. The Play of the Unmentionable. An Installation by J. K. at the Brooklyn Museum. London 1992 (cat.).– Kaiser, W. M. H.: J. L. Artworks and Theories. Amsterdam 1977.– J. K. Bedeutung von Bedeutung. Staatsgalerie Stuttgart. Stuttgart 1981 (cat.).– J. K. Exchange of Meaning, Translation in the Work of J. K. Museum van Hedendaagse Kunst. Antwerp 1989 (cat.)

## KOUNELLIS Jannis

born **1936** Piräus
Greek-Italian painter and object artist. **1956** Moved to Rome, where he attended the Art

Academy for a short time. **1958/59** Painted a series of text and alphabet pictures. **1960** First solo-exhibition with painting actions and songs at the Galleria la Tartaruga in Rome. From **1967** used materials and elements such as coal, soot, fire, wood, or flowers for his highly symbolic installations and performances. **1969** Exhibition of twelve live horses in the Galleria l'Attico in Rome. Began a series of room installations, for which he closed up doors and windows with pieces of furniture, plaster figures, bits of wood and other objects. **1972–1982** Participation in documenta 5–7 in Kassel. **1978** Short theatrical works with Carlo Quartucci. Numerous exhibitions, **1990** at the Stedelijk Museum, Amsterdam and **1995** at the Hamburg Kunsthalle. Kounellis, one of the most important practitioners of Arte Povera in Italy, often includes remnants of ancient culture in his installations.
WRITINGS: Fuchs, R. (ed.): J. K. Ein Magnet im Freien. Schriften und Gespräche 1966-1991. Bern and Berlin 1992.– J. K. Odyssée lagunaire. Ecrits et entretiens 1966-1989. Paris 1990.– J. K.: Fragmente der Erinnerung. Berlin 1991
CATALOGUES RAISONNES: Galleria Sprovieri, Roma (ed.): J. K. Catalogue raisonné (in preparation).– Schellmann, J. (ed.): J. K. Verzeichnis der druckgraphischen Arbeiten von 1972-1990 / J. K. Editions 1972-1990. Munich 1992
MONOGRAPHS, CATALOGUES: Celant, G. (ed.): J. K. Musei Comunali. Rimini 1983 (cat.).– Celant, G. (ed.): J. K. Padiglione d'Arte Contemporanea. Milan 1992 (cat.).– Codognato, M. (ed.): J. K. Odissea lagunare. Associazione Culturale d'Arte Contemporanea e Moderna. Palermo 1993 (cat.).– Corà, B. (ed.): J. K. Esposizione di paesaggi invernali. Palazzo Fabroni, Pistoia. Milan 1993 (cat.).– Corà, B. (ed.): J. K. Mistral. Bergamo 1996.– Danoff, I. M. et al. (ed.): J. K. Museum of Contemporary Art, Chicago et al. Chicago 1986 (cat.).– Felix, Z. and B. Corà (ed.): J. K. Museum Folkwang. Essen 1979 (cat.).– Friedel, H. (ed.): J. K. Städtische Galerie im Lenbachhaus. Munich 1985 (cat.).– Froment, J.-L. and R. Fuchs (ed.): J. K. Musée d'Art Contemporain de Bordeaux. Bordeaux 1985 (cat.).– Fuchs, R. (ed.): J. K. Stedelijk Van Abbe Museum, Eindhoven et al. Eindhoven 1981 (cat.).– Fuchs, R. (ed.): J. K. Castello di Rivoli, Museo d'Arte Contemporanea, Torino. Milan 1989 (cat.).– Haenlein, C.-A. (ed.): J. K. Frammenti di memoria. Kestner-Gesellschaft, Hanover et al. Hanover 1991 (cat.).– Jacob, M. J. (ed.): J. K. Museum of Contemporary Art. Chicago 1986 (cat.).– Mignot, D. (ed.): J. K. Via del Mare. Stedelijk Museum. Amsterdam 1990 (cat.).– Moure, G. (ed.): K. New York 1990.– Pagé, S. (ed.): J. K. Musée d'Art Moderne de la Ville de Paris. Paris 1980 (cat.).– Ullrich, F. and H. H. Schwalm (ed.): J. K. Lineare Notturno. Städtische Kunsthalle Recklinghausen. Recklinghausen 1993 (cat.).– Westheider, O. and H. R. Leppien (ed.): J. K. Die eiserne Runde. Hamburger Kunsthalle. Hamburg 1995 (cat.).

## KRAMER Harry
born **1925** Lingen
German sculptor and film-maker. Trained as a dancer and choreographer. From **1952** design of moveable figures out of wood and wire for his Mechanical Theatre. **1956** Moved to Paris. **1957** Collaborated with Wolfgang Ramsbott on the short films *Die Stadt* (The Town) and *Defense – 5824*. **1958** First *Automobile Sculptures*. From **1961** exhibited wire sculptures set in motion by small electric motors. **1964** Participation in documenta 3 in Kassel. **1965/66** Lived in the USA, where he produced *Schiebeplastiken* (Sliding Sculptures), *Bauelemente* (Constructional Elements) and *Puzzles* out of industrially prefabricated materials. **1971** Lectureship at the Kassel Comprehensive Art College. Kramer's kinetic wire constructions show the influence of Tinguely's machine art.
CATALOGUE RAISONNE: Willhardt, M. (ed.): H. K. Ein Frisör aus Lingen. Stuttgart et al. Stuttgart 1990 (cat.).
MONOGRAPHS, CATALOGUES: H. K. Automobile Skulpturen. Atelierhaus Halfmannshof. Gelsenkirchen 1964 (cat.).– H. K. Plastik, Objekte, Filme. Städtische Kunsthalle Mannheim. Mannheim 1969 (cat.).– H. K. Objekte, Plastiken. Karl-Ernst-Osthaus-Museum. Hagen 1970 (cat.).– H. K. Retrospektive. Württembergischer Kunstverein. Stuttgart 1990 (cat.)

## KRICKE Norbert
**1922** Düsseldorf – **1984** Düsseldorf
German sculptor. **1946/47** Studied at the Berlin School of Fine Arts. **1947** Moved to Düsseldorf. **1949** First steel sculptures. **1953** First solo-exhibition at the Ophir Gallery in Munich. **1955/56** Commission for the Opera House in Münster. From **1955** sculptural designs for fountains. **1959** Designed water sculptures for the University of Bagdad with Walter Gropius. **1959** and **1964** participation in documenta 2 and 3 in Kassel. **1961** Exhibition at the Museum of Modern Art in New York. **1964** Professorship at the Düsseldorf Academy where, from **1972–1981**, he was director. The main elements in Kricke's abstract sculptures are usually metal rods welded together in various configurations, forming flat surfaces, moving in circles or at angles, and thrusting out into the surrounding space.

MONOGRAPHS, CATALOGUES: Adolphs, V. (ed.): Adolphs, A. u.a. (Hg.): N. K. Zeichnungen. Kunstmuseum Bonn et al. Cologne 1995 (cat.).– Kersting-Bleyl, H. and J. Morschel (ed.): N. K. Raumplastiken und Zeichnungen. Städtische Galerie im Städelschen Kunstinstitut. Frankfurt-on-Main 1980 (cat.).– Harten, J. and S. Salzmann (ed.): N. K. Wilhelm Lehmbruck Museum, Duisburg et al. Düsseldorf 1975 (cat.).– Morschel, J. (ed.): N. K. Staatsgalerie Stuttgart et al. Stuttgart 1976 (cat.).– Morschel, J. (ed.): N. K. Raumplastiken und Zeichnungen. Städelsches Kunstinstitut und Städtische Galerie. Frankfurt-on-Main 1980 (cat.).– N. K. The Museum of Modern Art. New York 1961 (cat.).– Thwaites, J. A.: N. K. Stuttgart 1964, New York 1964.– Trier, E.: N. K. Recklinghausen 1963

## KRIMS Les
(Leslie Robert Krims)
born **1942** New York
American photographer. **1960–1964** Attended sculpture classes at the Cooper Union School in New York. **1964–1967** Continued his studies at the Pratt Institute in Brooklyn. **1966** First solo-exhibition at the Pratt Institute. **1967–1969** Photographer at the Rochester Institute of Technology. From **1969** professor at the State University of New York, Buffalo. **1971/72** Under the influence of the medium of film and produced a number of photoseries including *Little People of America* and *The Deer Slayers*: dramatic and provocative portrayals of everyday scenes and characters in America. **1975** Development of a process which he called Fictcrytokrimsography, for manipulating Polaroid photographs. **1977** Participation in documenta 6 in Kassel. **1980** Experiments with large format colour prints

## KRUGER Barbara
born **1945** Newark (NJ)
American photographer and concept artist. Attended the Parsons School of Design in Syracuse, New York. Her teachers included the photographer Diane Arbus and the graphic designer and art director of *Harper's Bazaar*, Marvin Israel. Moved to New York in the mid-70s and became chief designer for *Mademoiselle* magazine. Also produced book covers for political texts and, from the

early 70s, began writing her own texts. **1976** Taught photography and graphic design for one year at the University of California. Until **1980** lived and worked in Berkeley. P*ictures and Promises*, a video work that was shown in **1981** in New York in the alternative gallery The Kitchen documented the shifting boundaries between art and advertising. Kruger's photographic images, based on the iconography of cinema and TV, visually and verbally expose and breakdown the stereotypes of the mass media. **1982** and **1987** participation in documenta 7 and 8 in Kassel.
WRITINGS: B. K.: Picture / Readings. New York 1978.– B. K.: Beauty and Critic. New York 1983.– B. K.: Remote Control. Cambridge (MA) 1994
MONOGRAPHS, CATALOGUES: Fuchs, R. (ed.): B. K. Castello di Rivoli, Museo d'Arte Contemporanea. Milan 1989 (cat.).– King, S.: B. K. "My Pretty Pony". New York 1988.– Linker, K. and C. Miers (ed.): Love for Sale. The Words and Pictures of B. K. New York 1990, 1996.– Thomas, G. (ed.): B. K. National Art Gallery. Wellington 1988 (cat.)

## KRULL Germaine
**1897** Wilda (Poland) – **1985** Wetzlar
Polish photographer. **1916–1918** Attended the Munich School of Photography. **1919** Opened a portrait studio in Munich. **1921–1924** Worked as a free-lance photographer in Holland. **1924–1931** In Paris, fashion, advertising, and portrait photographs for magazines and companies such as Peugeot, Citroën and Columbia Records. She was fascinated by monumental engineering works such as the Eiffel Tower. **1925** Group exhibition with Abbott, Kertész, Lotar and Man Ray in Paris. **1931–1939** Numerous trips through Europe. **1940** Took over the photographic agency France Libre in Africa. **1943–1946** One of the first woman photographers to cover the war in Germany, Italy, and Indochina. **1965** Moved to India; friendship with the Dalai Lama. **1967** Major retrospective in Paris, opened by André Malraux. **1977** Retrospective at the Rheinisches Landesmuseum, Bonn and participation in documenta 6 in Kassel.
MONOGRAPHS, CATALOGUES: Bouqueret, C. (ed.): G. K. Photographie 1924-1936. Musée Réattu, Rencontres Internationales de la Photographie. Arles 1988 (cat.).– Fels, F. (ed.): 100 x Paris (G. K.). Berlin 1929.– Honnef, K. et al. (ed.): G. K. Fotografien 1922-1966. Rheinisches Landesmuseum, Bonn. Cologne and Bonn 1977 (cat.).– Langlois, H. (ed.): G. K. 1927-1967. Musée du Cinéma. Paris 1967 (cat.)

## KUBOTA Shigeko
born **1937** Niigata (Japan)
Japanese video and multimedia artist. Studied at teacher training college in Tokyo. **1963** Acquaintance with Paik. **1964** First solo-exhibition in the Naigua Gallery in Tokyo. **1965–1968** Moved to New York,

where she attended the New School for Social Research and Art School of the Brooklyn Museum in New York and participated in happenings and Fluxus festivals. Since **1968** fascination with the figure of Duchamp, who appears in numerous works. **1972** First video sculpture *Marcel Duchamp's Grave*. **1974** Participation on the Projekt '74 in the Kunsthalle Cologne. **1977** and **1987** participation in documenta 6 and 8 in Kassel. Lectured at the School of Visual Arts in New York. Marriage to Paik. **1978** Teacher at the Düsseldorf Academy. **1979** DAAD scholarship to Berlin. **1985** Creation of the video installation *Niagara Falls*, exploring the theme of the American landscape.
MONOGRAPHS, CATALOGUES: Felix, Z. (ed.): S. K. Video Sculptures. Museum Folkwang, Essen et al. Essen 1981 (cat.).– Jacob, M. J. (ed.): S. K. Video Sculpture. American Museum of the Moving Image. Seattle 1991 (cat.).– S. K. Kodama Gallery. Tokyo 1989 (cat.)

**KUDO Tetsumi**
**1935** Osaka – **1990** Tokyo
Japanese happening and object artist. **1954–1958** Studied at the University of Tokyo. **1955–1958** Taught at a private art school in Tokyo. From **1958** worked as a free-lance artist, exhibited objects and staged performances. **1962** Won the Young Asian Artists Exhibition prize in Tokyo. Moved to Paris, where he was involved in sadomasochistic happenings such as *Philosophy of Impotence* and in **1963** *Harakiri of Humanism* which dealt with the theme of the male body and male sexuality. **1965** First solo-exhibition in the Galerie J in Paris entitled "Rien n'est laissé au hasard". **1977** Award at the São Paulo Biennale.
WRITINGS: T. K.: Pollution, cultivation, nouvelle écologie. Amsterdam 1970.– T. K.: Sartori. Tokyo 1981
MONOGRAPHS, CATALOGUES: Hering, K.-H. (ed.): T. K. Cultivation by Radioactivity. Kunstverein für die Rheinlande und Westfalen. Düsseldorf 1970 (cat.).– T. K. Stedeljik Museum. Amsterdam 1972 (cat.)

**KUDOYAROV Boris**
**1898** Taschkent – **1974** Moscow
Russian photographer. **1917–1920** Served in the Red Army, then worked for several years

as an amateur photographer. From **1926** photojournalist for *Russfoto* (later *Unionfoto*). From **1931** overseas photographic correspondent for the magazine Sojusfoto. **1930–1932** Member of the avant-garde artists' group Oktober. Influenced by Rodchenko and Ignatovich. Became famous for his photographs of the siege of Leningrad, taken while working as a war correspondent in World War II. After the war, worked as a photojournalist for *TASS*. Kudoyarow's compositions adhere to the traditional tenets of Constructivism.
MONOGRAPHS, CATALOGUES: Dyko, L.: B. K. Moscow 1975

**KÜHN Heinrich**
**1866** Dresden – **1944** Birgitz
German photographer. **1885–1887** Studied medicine in Leipzig, Berlin and Innsbruck. **1888** Began taking photographs. **1896** Member of the Vienna Kamera Klub. Founded the Kleeblatt group along with Hugo Henneberg and Hans Watzek; collaborated on experiments in photographic technique, including development of the autochrome process invented by Lumière. **1907** Acquaintance with Stieglitz and Steichen. **1909** Organised an international photo exhibition in Dresden. **1912–1916** Directed a school for artistic photography in Innsbruck. **1920** Move to Birgitz. **1923–1935** Photographed portraits, still lifes, architecture and landscapes for numerous magazines. Developed photographic processes for companies in Austria and Germany. **1937** Honorary doctorate from the University of Innsbruck. In numerous essays and books, Kühn discussed the aesthetics of photography from a technical point of view.
WRITINGS: H. K.: Technik der Lichtbildnerei. Halle 1921.– H. K.: Zur photographischen Technik. Halle 1926
MONOGRAPHS, CATALOGUES: Appel, M. O. and U. Eskildsen (ed.): H. K. 1866-1944. 110 Bilder aus der Fotografischen Sammlung, Museum Folkwang, Essen. Essen 1978 (cat.).– Kaufhold, E.: H. K. und die Kunstfotografie um 1900. Berlin 1988.– Kicken, R. (ed.): Eine Ausstellung von hundert Photographien von H. K. Stefan Lennert, Munich. Cologne 1981 (cat.).– Knapp, U.: H. K. Photographien. Salzburg and Vienna 1988.– Speer, H. (ed.): H. K. 1866-1944. Galerie im Taxispalais. Innsbruck 1976 (cat.).– Weiermair, P. (ed.): H. K. 1866-1944. Innsbruck 1978.– Weiermair, P. (ed.): H. K. 1866-1944. Photographien. Frankfurter Kunstverein. Frankfurt-on-Main 1981 (cat.)

**KUPKA František**
**1871** Opocno (Bohemia) – **1957** Puteaux (near Paris)
Czech painter. After studying at the Prague Art Academy from **1888–1891** he transferred to the Vienna Academy for two years. **1895** Moved to Paris. From **1904** lived in Puteaux and joined the group of artists

around Jacques Villon, including Léger, Gris, Duchamp, Metzinger and Archipenko. Began to involve himself intensely with theosophy, eastern philosophy, and spiritualism. His neo-impressionist pictures were exhibited regularly at the Salon d'Automne. Around **1910** turned to abstraction; he is considered one of its founders, along with Kandinsky and Delaunay. In his pictures, he tried to portray movement and light as independent colour effects. **1912** His first fully abstract paintings (*Amorpha: Fugue à deux couleurs* and *Chromatique chaude*) exhibited at the Salon d'Automne and categorized as orphist on account of their close relationship to music. **1914** Volunteered for military service. **1918–1920** Guest-professor in Prague. **1931–1934** Member of the Abstraction-Création group. **1955** Participation in documenta 1 in Kassel. **1957** Retrospective at the Guggenheim Museum in New York. In the 40s and 50s Kupka was finally recognized as one of the pioneers of abstract art and his works were displayed in international exhibitions and purchased by important museums.
WRITINGS: F. K.: La Création dans les arts plastiques. Paris 1989
CATALOGUE RAISONNE: Vachtová, L.: F. K. Pioneer of Abstract Art. London and New York 1968
MONOGRAPHS, CATALOGUES: Andel, J. et al. (ed.): F. K. Painting the Universe. Kunstmuseum Wolfsburg. Stuttgart 1997 (cat.).– Arnoud-Grémilly, L.: F. K. Paris 1922.– Cassou, J. and D. Fédit: K. Paris 1964, Stuttgart 1964, London 1965.– Fauchereau, S.: F. K. Paris 1988, New York 1989.– Fedit, D. (ed.): L'Œuvre de K. Musée du Louvre. Paris 1966 (cat.).– Kotalik, J. (ed.): F. K. Palazzo Massari. Ferrara 1987 (cat.).– F. K. Kestner-Gesellschaft. Hanover 1966 (cat.).– F. K. Museum des 20. Jahrhunderts. Vienna 1967 (cat.).– F. K. Stedelijk Museum. Amsterdam 1968 (cat.).– Lamac, M.: F. K. Prague 1984.– Leroy, B. and A. Linthal (ed.): F. K. 1871-1957. Ou l'invention d'une abstraction. Musée d'Art Moderne. Paris 1989 (cat.).– Mladek, M. and M. Rowell (ed.): F. K. 1871-1957. Solomon R. Guggenheim Museum, New York et al. New York 1975, Zurich 1976.– Nasi, V. and C. Polcina: F. K. Carte e dipinti. Roma 1980 (cat.).– Pagé, S. et al. (ed.): F. K. 1871-1957 ou l'invention d'une abstraction. Musée d'Art Moderne de la Ville de Paris. Paris 1989 (cat.).– Rubinger, K. and H. Jordan (ed.): F. K. Galerie Gmurzynska. Cologne 1981 (cat.).– Vachtová, L. et al. (ed.): F. K. Die andere Qualität. Cologne 1995 (cat.)

**KUSHNER Robert**
born **1949** Pasadena (CA)
American artist. **1967–1971** Studied at the University of California in San Diego. **1971/72** Lived in Boston. First collages and performances with costumes he made himself. **1972** Moved to New York, where he designed costumes and sets for numerous theatre and ballet productions, and

staged performances dressed in his own costumes. From **1974** very interested in Siddha Meditation. **1976** First solo-exhibition in New York at the Holly Solomon Gallery. **1979** First lithographs. From **1981** occupied with painters of the early modern era such as Léger, Bonnard, Picasso and Gris. **1987** First retrospective at the Institute of Contemporary Art in Philadelphia. In addition to costumes, which are based on oriental models, Kushner also employed decorative elements from other cultures – Chinese, Japanese, and European – in his productions and performances.
WRITINGS: R. K.: The Persian Poems. New York 1980
MONOGRAPHS, CATALOGUES: Armstrong, R. (ed.): R. K. Dreams and Visions. Holly Solomon Gallery. New York 1981 (cat.).– Kardon, J. (ed.): R. K. Institute of Contemporary Art, University of Pennsylvania. Philadelphia 1987 (cat.).– Marshall, R. (ed.): R. K. Paintings on Paper. Whitney Museum of American Art. New York 1984 (cat.)

**LAFONTAINE Marie Jo**
born **1950** Antwerp
Belgian video artist. **1975–1979** Studied at the Ecole Nationale Supérieure d'Architecture et des Arts Visuels in Brussels. **1977** Awarded Prix de la Jeune Peinture Belge in Brussels. Produced monochrome textile murals and paintings. **1979** Prix de la Critique, Antwerp. First video work *La batteuse de palplanches*. **1982** Video-Prize Meatball, Amsterdam. **1985** Grant from the Institute of Arts and Humanities. **1987** Showed the video-installation *Les larmes d'acier* at documenta 8 in Kassel. Later created environments with multimonitor installations: *Victoria* 1987/88, *Passio* **1989/90**, *Jeder Engel ist schrecklich* (Every angel is terrible) **1993**. **1990** Guest-professor at the Salzburg Summer Academy. Since **1992** professor at the Karlsruhe School of Design.
MONOGRAPHS, CATALOGUES: M. J. L. Immaculata. Ric Urmel Gallery, Ghent. Stuttgart 1992.– M. J. L. Himmel and Hölle. Dewer Art Gallery. Otegem 1993 (cat.).– MacLeon, F. et al. (ed.): M. J. L. The Fruitmarket Gallery, Edinburgh et al. Edinburgh 1989 (cat.).– Meyer, W. (ed.): M. J. L. Städtische Galerie. Göppingen

1990 (cat.).– Neumaier, O. et al. (ed.): M. J. L. Stuttgart 1998.– Foncé, J. (ed.): M. J. L. Videoskulpturen. Sculptures-Video. Video Sculptures. Zedelgem 1987.– Bussmann, G. and L. Malle (ed.): M. J. L. Passio. Städtisches Museum Abteiberg. Mönchengladbach 1990 (cat.).– Pühringer, A. et al. (ed.): M.-J. L. La Vie – une hésitation. Salzburg 1991

**LA FRESNAYE Roger de**
**1885** Le Mans – **1925** Grasse
French painter. **1903** Began studies at the Académie Julian, then transferred to the Ecole des Beaux-Arts and Académie Ranson in Paris where, in **1908** he attended the classes of Paul Sérusier and Maurice Denis. **1909/10** Exhibitions at the Salon de Indépendants and Salon d'Automne. **1913** Joined the Cubist movement. Contributed to the journal *Montjoie*. **1917** Worked on newspapers for soldiers at the front. Went to a sanatoruim in Grasse for his tuberculosis. Did several portraits there of his painter friend J.-L. Gampert as well as drawings and gouaches of the other patients. Works from around **1920** are closely related to Synthetic Cubism. Exhibition at the Salon des Tuileries. La Fresnaye painted in the tradition of the Nabis. Since he never gave up portraying people, he is classified as a humanist Cubist.
CATALOGUES RAISONNES: Cogniat, R. and W. George (ed.): Œuvre complète de R. d. L. F. Paris 1950.– Seligman, G. (ed.): R. d. L. F. Avec le catalogue raisonné de l'œuvre. Neuchâtel 1969, London and Greenwich (CT) 1969
MONOGRAPHS, CATALOGUES: Chabert, P. (ed.): R. de L. F. Musée de l'Annonciade, Saint-Tropez et al. Saint-Tropez 1983 (cat.).– Gaffé, R.: R. d. L. F. Brussels 1956.– R. de L. F. Musée National d'Art Moderne. Paris 1950 (cat.).– R. de L. F. aurait 100 ans. Abbaye de L'Epau. Le Mans 1985 (cat.).– Nebelthan, E.: R. d. L. F. Paris 1935.– Seligman, G.: R. d. L. F. Greewich (CT) 1945, 1969

**LAKNER László**
born **1936** Budapest
Hungarian painter. **1954**–**1960** Studied painting at the Budapest Academy of Arts. From **1968** made frequent visits to Germany.

Began to incorporate documentary materials such as press cuttings, photographs and letters into his paintings. From **1970** produced the book-object *Georg-Lukácz-Buch*, worked over and tied up with string. **1974** DAAD scholarship to Berlin. **1977** Participation in documenta 6 in Kassel. **1979/80** Lectured in history of art at the School of Art in Essen and the Freie Universität in Berlin. Experimented in so-called *Duchamp paintings* with writing scratched into thick layers of paint. **1981/82** Scholarship to New York. **1982** Professorship at the University of Essen. In the 70s, Lakner was occupied as a painter and object artist with written and printed texts, while in the 80s he resumed free-style gesural painting.
MONOGRAPHS, CATALOGUES: Becker, W. (ed.): L. L. Gesammelte Dokumente. 1960-1974. Neue Galerie – Sammlung Ludwig. Aachen 1974 (cat.).– Deecke, T. (ed.): L. L. Bilder, Bücher, Filme, Zettel. Neuer Berliner Kunstverein und Berliner Künstlerprogramm des DAAD. Berlin 1975 (cat.).– Index L. L. 1968-1993. 4 vols. Goethe Institut. Budapest 1994.– L. L. Malerei 1974-1979. Westfälischer Kunstverein. Münster 1979 (cat.).– Motte, M. d. la (ed.): L. L. Galerie Nothelfer. Berlin 1985 (cat.).– Motte, M. d. la and J. Sartorius (ed.): L. L. Papierarbeiten, Objekte und 3 Skulpturen. Daadgalerie. Berlin 1991 (cat.)

**LAM Wifredo**
(Wifredo Oscar de la Conception Lam y Castilla)
**1902** Sagua la Grande (Kuba) – **1982** Paris
Cuban painter. **1920**–**1923** Studied at the Academy San Alejandro in Havanna. **1924** Continued studies in Madrid and Barcelona. **1928** Saw African sculptures from New Guinea and the Congo for the first time, which were to influenc his work as much as his meeting with Picasso in **1937** in Paris. **1940** Fled, along with other Surrealist artists to Marseille. **1941** Set sail with Breton, Masson and Lévi-Strauss for Martinique, finally disembarking in Cuba. **1945** Returned to Paris, met Gorky and Duchamp and from then on moved restlessly to and fro' between the continents. **1964** Set up house in Albisola Mare in Italy. **1959** and **1964** Participation in documenta 2 and 3 in Kassel. Lam's paintings are an excellent example of Surrealist attempts to incorporate African and Caribbean mythology into western art. Cuban gods and legends, the Voodoo cult and the dangerous, wild jungle are the main themes of his work.
CATALOGUES RAISONNES: Fouchet, M.-P.: W. L. Paris 1989.– Laurin-Lam, L. (ed.): W. L. Catalogue Raisonné of the Painted Work. Vol. 1: 1932-1960. Lausanne 1996.– Tonneau-Ryckelynck, D.: W. L. Œuvre gravé et lithographié. Catalogue raisonné. Gravelines 1994
MONOGRAPHS, CATALOGUES: Ayllón, J. and L. L. Lam (ed.): Homenaje a W. L. 1902-1982. Museo Nacional de Arte Contemporáneo, Madrid et al. Madrid 1982 (cat.).– Benitez, H. H.: W. L. Interlude

Marseille. Copenhagen 1993.– Blanc, G. (ed.): W. L. and His Contemporaries 1938-1952. Studio Museum of Harlem. New York 1992 (cat.).– Curzi, L.: W. L. Bologna 1978.– Daniel, S. G.: The Early Works of W. L. 1941-1945. Diss. College Park, University of Maryland 1983.– David, C.: W. L. Paris 1991.– David, C. et al. (ed.): W. L. Obra sobre papel. Fundació Caixa de Pensiones. Barcelona 1993 (cat.).– Fouchet, M.-P.: W. L. Paris 1976, 1984.– Gaudiberti, P. et al. (ed.): W. L. Kunstsammlung Nordrhein-Westfalen, Düsseldorf et al. Düsseldorf 1988 (cat.).– Jouffroy, A.: L. Paris 1972.– W. L. Les Années cubaines. Maison de l'Amérique latine. Paris 1989 (cat.).– W. L. ou L'éloge du métissage". Académie de France à Rome. Roma 1992 (cat.).– W. L. Fundació Joan Miró. Barcelona 1992 (cat.).– W. L. Museo Nacional Centro de Arte Reina Sofía, Madrid et al. Madrid 1992 (cat.).– Leiris, M.: W. L. Paris 1970, New York 1970.– Merewether, C. (ed.): W. L. A Retrospective of Works on Paper. Americas Society Art Gallery. New York 1992 (cat.).– Nuñez Jiménez, A.: W. L. Havanna 1982.– Ortiz, F.: W. L. y su obra vista a través de significados criticos. Havanna 1950.– Soupault, P.: W. L. Dessins. Paris 1975.– Taillander, I.: W. L. Paris 1970.– Vidal, A. (ed.): W. L. 1902-1982. Musée d'Art Moderne. Paris 1983 (cat.).– Xuriguéra, G.: W. L. Paris 1974

**LANG Nikolaus**
born **1941** Oberammergau
German sculptor and object artist. **1956**–**1960** Trained as a wood-carver in Oberammergau. **1960**–**1966** Attended the Munich Academy. **1966/67** DAAD scholarship to London. **1967**–**1969** Taught sculpture at Camberwell School of Arts and Crafts in London. Worked with various synthetic objects. **1971/72** DAAD scholarship to Tokyo. Documented his own travels and excursions in photoseries, drawings, catalogue-type indexes and boxes of *objets trouvés*. **1973/74** Put together his work *Chest for the Götte Siblings*, a reconstruction of the life of a loner, incorporating collected objects and other biographical relics. **1976** Villa-Romana scholarship to Florence. **1977** and **1987** took part in documenta 6 and 8 in Kassel. **1979** First of numerous working trips to Australia and other countries including Sweden and Italy. **1984** Together with the architect Jürgen Wenzel won a competition for the design of a monument to victims of National Socialism, which however, was never realised. **1987** Overseas grant to work at the South Australian College of Art, Adelaide. Since **1989** member of the Bavarian Academy of Fine Arts in Munich. **1996** Another sojourn in Australia.
MONOGRAPHS, CATALOGUES: Haenlein, K. A. (ed.): N. L. Kestner-Gesellschaft. Hanover 1975 (cat.).– N. L. Japanische Landschaften. Städtische Galerie im Lenbachhaus. Munich 1973 (cat.).– N. L. Württembergischer Kunstverein. Stuttgart 1976 (cat.).– N. L. Farben, Zeichen, Steine. Westfälischer Kunstverein. Münster

1978 (cat.).– N. L. Australisches Tagebuch. Aargauer Kunstmuseum. Aarau 1979 (cat.).– Liebelt, U. (ed.): N. L. Druckstock I, 1980. Installation. Sprengel Museum. Hanover 1995 (cat.).– Schulz, I.: N. L. "Für die Geschwister Götte". 1973/74. Museum anonymer Persönlichkeiten. Hamburg 1985.– Tacke, C. et al. (ed.): N. L. Nunga und Goonya. Städtische Galerie im Lenbachhaus. Munich 1991 (cat.)

**LANGE Dorothea**
**1895** Hoboken (NJ) – **1965** San Francisco
American photographer. **1914**–**1917** Teacher training. **1917/18** Studied at the Clarence H. White School of Photography at Columbia University in San Francisco. **1919** Opened her own portrait studio in San Francisco. **1935** Expanded her area of interest and did more documentary work. **1935**–**1942** Photographed for the Farm Security Administration. **1941** Grant from the Guggenheim Foundation. **1941** Solo-exhibition at the Guggenheim Museum of Modern Art. **1942** Documented the internment of the Japanese in concentration camps on the West Coast. **1943**–**1945** Photographic correspondent for the Office of War Information in Washington. **1954** Reportages on Asia, the Middle East and South America for *Life* and other magazines. Extensive travels abroad throughout the 70s. **1958**–**1962** Taught at the San Francisco Art Institute. **1966** Major retrospective at the Museum of Modern Art in New York.
MONOGRAPHS, CATALOGUES: Becker Ohrn, K.: D. L. and the Documentary Tradition. Baton Rouge and London 1980.– Davis, K. F.: The Photographs of D. L. New York 1996.– Elliott, G. P. (ed.): D. L. The Museum of Modern Art, New York et al. New York 1966 (cat.).– Meltzer, M.: D. L. A Photographer's Life. New York 1978.– Newhall, B. (ed.): D. L. Looks at the American Woman. Fort Worth et al. 1967.– Ohrn, K. B.: D. L. and the Documentary Tradition. Baton Rouge 1980.– Partridge, E.: D. L. A Visual Life. Washington 1994.– Thau Heyman, T. et al. (ed.): D. L. American Photographs. San Francisco Museum of Modern Art. San Francisco 1994 (cat.).– Wollenberg, C. (ed.): Photographing the Second Gold Rush. D. L. and the Bay Area at War 1941-1945. Berkeley 1995

**LANSKOY André**
**1902** Moscow – **1976** Paris
Russian-born French painter. **1919** Fled to Kiev to join the White Army. **1921** Moved to Paris, where he studied painting at the Académie de la Grande Chaumière. **1925** First solo-exhibition in Paris of portraits, landscapes and still lifes, works clearly influenced by Matisse and van Gogh. **1939** First abstract gouaches. **1944** Abstract compositions with dynamic colour components. In his works from the 40s he focused on the handling of paint: crushing, squeezing or letting it flow freely. **1950** Took part in the exhibition "Advancing French Art", at the

galleries of Louis Carré in Paris and New York. **1959** and **1964** Participation in documenta 2 and 3 in Kassel. **1966** Tapestry designs on cardboard. **1974** Exhibition of mosaics in Caujours. Designed a monumental mosaic for the Faculté des Sciences in Rennes. With his brightly coloured abstract paintings, Lanskoy is representative of the Ecole de Paris.
CATALOGUES RAISONNES: Bernard, C. and M. Guinle (ed.): L. Catalogue raisonné des mosaïques. Lyon 1990
MONOGRAPHS, CATALOGUES: Allemand, M. (ed.): Exposition L. Galerie de la Société industrielle de la Bourse. Mulhouse 1970 (cat.).– Dron, P. and A. Pittiglio: A. L. Moscou, 1902 – Paris, 1976. Paris 1990.– Gindertael, R.-V.: L. Paris 1957.– Grenier, J.: A. L. Paris 1960.– A. L. Le Journal d'un fou, de Gogol. Collages, tapisseries et autres livres. Musée d'Art et d'Industrie de Saint-Etienne. Saint-Etienne 1968 (cat.).– A. L. Dernières œuvres. Galerie Cyrus. Paris 1977 (cat.).– A. L. Peintures de 1944 à 1961. Galerie Louis Carré & Cie. Paris 1990 (cat.)

**LAPICQUE Charles**
**1898** Theizé (Rhône) – **1988** Orsay
French painter. Self-taught. **1919–1922** Studied natural sciences in Paris. **1922–1924** Worked as an engineer. **1929** First solo-exhibition at the Galerie Jeanne Bucher in Paris. Caused a sensation with his painting *Palestrina*, which has marked Cubist features. **1931–1943** Technical assistant at the Sorbonne. **1938** Completed a doctoral thesis on the perception of colour. **1937** Interior designs for the Palais de la Découverte. Contact with Manessier, Bazaine, Villon. **1940** Developed his Blue Grid style of painting combining figurative and abstract elements set against a blue grid, culminating in his masterpiece *Joan of Arc crossing the Loire*. **1954–1956** Scenes of Venice, inspired by the Venetian paintings of Tintoretto and Tiepolo. **1967** Retrospective at the Musée National d'Art Moderne, Paris.
WRITINGS: C. L.: Essais sur l'espace, l'art et la destinée. Paris 1958
CATALOGUES RAISONNES: Auger, E. and B. Balanci (ed.): C. L. Catalogue raisonné de l'œuvre peint et de la sculpture. Paris 1972.– Balanci, B. and G. Blanche (ed.): Catalogue raisonné de l'œuvre complet des lithographies, eaux-fortes et gravures. Paris 1981
MONOGRAPHS, CATALOGUES: Cousseau, C. (ed.): L. Oelbilder 1939-1978. Galerie Nathan. Zurich 1983 (cat.).– Dorival, B. (ed.): L. Musée National d'Art Moderne. Paris 1967 (cat.).– Dorival, B. (ed.): L. Galerie Nathan. Zurich 1978 (cat.).– C. L. Gemälde, Aquarelle, Zeichnungen. Folkwang Museum, Essen et al. Essen 1964 (cat.).– C. L. Musée Toulouse-Lautrec. Albi 1970 (cat.).– C. L. Peintures de 1940 à 1973. Galerie Louis Carré & Cie. Paris 1989 (cat.).– Lescure, J.: L. Paris 1956.– Nathan, P. and A. Affentranger (ed.): L. Nachtbilder. Galerie Nathan. Zurich 1986

**LARDERA Berto**
**1911** La Spezia – **1989** Paris
Italian sculptor. Self-taught. **1942** First 3-dimensional object, an assembly of metal plates. First solo-exhibition at the Milione gallery in Milan. **1946/47** Font relief in the Church of St. Piero ai Prati in Florence. **1948** Moved to Paris. Solo-exhibition at the Galerie Denise René. **1949/50** Large sculpture for Haus Lange in Krefeld, a house designed by Mies van der Rohe, leading to further commissions. His sculptures from the 50s are prime examples of Abstract Expressionism. **1954** Designed the sculpture *Colloquio terzo* for a town square in Marl. **1955–1964** Took part in documenta 1 – 3 in Kassel. **1958** His work *Alla I* erected near the Alvar Aalto and O. Niemeyer building in the Hansa district of Berlin. **1960** Exclusive presentation of his sculptures at the Venice Biennale. **1969** Invented a new technique for reproducing pictures with polygraphs on plexiglas and stainless steel.
WRITINGS: B. L.: Témoignage pour la sculpture abstraite. Paris 1956
CATALOGUE RAISONNE: Jianou, I.: L. Paris 1968
MONOGRAPHS, CATALOGUES: Brion, M.: L. Paris 1968.– Güse, E.-G. and S. Salzmann (ed.): B. L. Plastiken. Collagen. Graphiken. Wilhelm-Lehmbruck-Museum, Duisburg et al. Duisburg 1976 (cat.).– Haftmann, W.: L., la rose des vents. New York 1969.– Jianou, I.: L. Paris 1968.– B. L. Skulpturen. Museum Haus Lange. Krefeld 1956 (cat.).– B. L. Plastik, Gouachen, Collagen. Hamburger Kunstverein. Hamburg 1961 (cat.).– B. L. Kunstverein Hannover. Hanover 1971 (cat.).– Seuphor, M. B. L. Neuchâtel 1960

**LARIONOV Mikhail**
**1881** Tiraspo – **1964** Fontenay-aux-Roses
Russian painter. **1898–1908** Studied at the Moscow Art Academy. **1906** Helped Diaghilev to organise an exhibition of Russian paintings in the Salon d'Automne in Paris. From **1907** member of the Society of Free Aesthetics. Organised numerous exhibitions of avant-garde art in Russia. While still painting in an Impressionist style, he showed strong tendencies towards abstraction. **1912** Together with Goncharova, launched Rayonism, the Russian counterpart of Futurism. **1913** Rayonist manifesto. **1914** Military service. Invalided out and settled in Paris. Worked almost exclusively for Diaghilev's Ballets Russes. **1915** Stage designs for L. Massine's *Soleil de nuit* and **1922** for Stravinsky's *Le Renard*. Larionov developed the theory of Rayon-

ism. Based on French Cubist theory and the ideas of the Futurists in Italy, it was an attempt to create a new form of pictorial space from the dynamic force of light alone.
WRITINGS: Hoog, M. and S. de Vigneral (ed.): M. L. Une avant-garde explosive. Lausanne 1978.– M. L.: Diaghilev et les Ballets Russes. Dessins et textes de M. L. Paris 1970.– M. L.: Manifestes. Paris 1995
MONOGRAPHS, CATALOGUES: Boissel, J. and G. Viatte (ed.): Nathalie Gontcharova & M. L. Centre Georges Pompdou. Paris 1995 (cat.).– Bowlt, J. E. and A. Parton (ed.): M. L. Pasteller, gouacher, teckningar. Galerie Aronowitsch. Stockholm 1987 (cat.).– George, W.: L. Paris 1966, Lucerne and Frankfurt-on-Main 1968.– Kovtun, E.: M. L. London 1997.– M. L. Rétrospective. Maison de la Culture de Nevers et la Nièvre. Nevers 1972 (cat.).– M. L. et son temps. Musée Toulouse-Lautrec. Albi 1973 (cat.).– Nakov, A. B. (ed.). M. L. Der Weg in die Abstraktion. Werke auf Papier 1908-1915. Schirn Kunsthalle, Frankfurt-on-Main et al. Stuttgart 1987 (cat.).– Parton, A.: M. F. L. 1881-1964. A Study of Chronology and Sources of His Art. Diss. Newcastle upon Tyne 1985.– Parton, A.: M. L. and the Russian Avant-Garde. London and Princeton (NJ) 1993.– Rusza, G.: L. Budapest 1977

**LASKER Jonathan**
born **1948** Jersey City (New Jersey)
American painter. **1975–1977** Attended the School of Visual Arts in New York. From **1977** studied at the California Institute of the Arts in Valencia. **1981** First solo-exhibition at the Landmark Gallery, New York. In **1987** and **1989** received the National Endowment for the Arts Fellowship. **1989** Grant from the New York Foundation for the Arts Fellowship. Lasker is one of the great American abstract painters. He combines Color Field Painting with a minimalist gestural style. **1992** Participation in documenta 9 in Kassel.
WRITINGS: J. L.: Complete Essays 1984-1998. New York 1998
MONOGRAPHS, CATALOGUES: Crone, R. and D. Moos: J. L. Telling the Tales of a Painting. Stuttgart 1993.– Feldman, M. (ed.): J. L. Paintings 1985-1991. Institute of Contemporry Art. Philadelphia 1992 (cat.).– Gooking, K. et al. (ed.): J. L. Sperone Westwater Gallery. New York 1991 (cat.).–

Herzog, H.-M. and K. Bitterli (ed.): J. L. Gemälde 1977-1997. Kunsthalle Bielefeld et al. Stuttgart 1997 (cat.).– Ostrow, S. (ed.): J. L. Paintings 1978-1982. Bravin Post Lee Gallery. New York 1994 (cat.).– Schjeldahl, P. (ed.): J. L. Soledad Lorenzo Galería. Madrid 1995 (cat.)

**LASSNIG Maria**
born **1925** Kappel am Krappfeld (Carinthia) Austrian painter. **1941–1943** Studied painting at Klagenfurt Academy of Art. **1948** Met Arnulf Rainer. First compositions with surreal figures. **1951** Moved to Vienna. Grant to work in Paris, where she met Paul Celan and André Breton. **1961** Returned to Vienna. Painted large-scale *Körpergefühls-Figurationen* (Body awareness figurations). **1968** Emigrated to America, settling in New York. Experimented with large silk-screen prints. **1970** Attended an animation course at the School of Visual Arts in New York. **1973** Realist portraits, self-portraits and still lifes. **1978** DAAD scholarship to Berlin. **1980** Represented Austria at the Venice Biennale. Professor of Painting at the Vienna School of Applied Arts where, in **1981**, she set up an animation studio. **1982** Took part in documenta 7 in Kassel. **1988** Awarded the Großen Österreichischen Staatspreis. **1989/90** Retrospective at the Kunstmuseum in Lucerne and the Vienna Secession.
CATALOGUE RAISONNE: Gross, B. (ed.): M. L. Werkverzeichnis der Druckgraphik 1949-1987. Munich 1988.– Weskott, H. and J. Helfenstein (ed.): M. L. Zeichnungen und Aquarelle 1946-1995. Kunstmuseum Bern et al. Bern 1995 (cat.)
MONOGRAPHS, CATALOGUES: Breicha, O. (ed.): M. L. Aquarelle. Kärtner Landesgalerie, Klagenfurt et al. Klagenfurt 1988 (cat.).– Das Innere nach Aussen. M. L. Bilder. Stedelijk Museum, Amsterdam et al. Amsterdam 1994 (cat.).– Drechsler, M. et al. (ed.): M. L. Museum des 20. Jahrhunderts, Vienna et al. Klagenfurt 1985 (cat.).– Kunz, M. (ed.): M. L. Mit dem Kopf durch die Wand. Neue Bilder. Kunstmuseum Luzern et al. Klagenfurt 1989 (cat.).– M. L. La mostra Austriaca nell' quadro della Biennale de Venezia. Venice 1980 (cat.).– M. L. Von Innen nach Außen. Frankfurter Kunstverein. Frankfurt-on-Main 1994 (cat.).– M. L. Ulmer Museum et al. Munich 1996 (cat.).– Murken, C.: M. L. Ihr Leben und ihr malerisches Werk. Ihre kunstgeschichtliche Stellung in der Malerei des 20. Jahrhunderts. Aachen 1990.– Peters, H. A. and W. Skreiner (ed.): M. L. Zeichnungen, Aquarelle, Gouachen 1949-1982. Mannheimer Kunstverein et al. Düsseldorf 1982 (cat.).– Tolnay. A. et al. (ed.): M. L. Neue Bilder und Zeichnungen. Berlinische Galerie, Berlin et al. Berlin 1997

**LAURENCIN Marie**
**1883** Paris – **1956** Paris
French painter. Studied at the Ecole des Beaux-Arts in Paris. **1905** First works shown

at the Salon des Indépendants. **1907** Met Guillaume Apollinaire, who promoted her and introduced her to Picasso. Joined Bateau-Lavoir a group of artists and writers. Published her first poems under the pseudonym Louise Lalanne. **1908** Her painting *Apollinaire et ses amis* bought by Gertrude Stein. **1912** Exhibition at the Section d'Or. **1913** Exhibited at the Armory Show in New York. **1924** Stage design for Diaghilev's Ballet *Les Biches* with music by Poulenc. **1928** Worked for the Comédie Française. Numerous book illustrations including ones for André Gide's *La Tentative amoureuse* and Lewis Carroll's *Alice in Wonderland.* Despite her close contact with the Cubists, there are no traces of Cubism in Laurencin's paintings. She developed her own ornamental, figurative style, and favoured simple schematic compositions.
WRITINGS: M. L.: Le Carnet des nuits. Geneva 1956
CATALOGUES RAISONNES:
Marchesseau, D. (ed.): M. L. Catalogue raisonné de l'œuvre gravé. Tokyo 1981.– Marchesseau, D.: M. L. 1885-1956. Catalogue raisonné de l'œuvre peint. Tokyo 1986
MONOGRAPHS, CATALOGUES: Day, G.: M. L. Paris 1947.– Gere, C.: M. L. London and New York 1977.– Groult, F.: M. L. Paris 1987 / M. L. Ein Leben für die Kunst. Munich 1992.– Hyland, D. K. S. and H. McPherson (ed.): M. L. Artist and Muse. Birmingham Museum of Art et al. Birmingham et al. 1989 (cat.).– Marchesseau, D.: M. L. Paris 1981.– Marchesseau, D. (ed.): M. L. Cent œuvres des collections du Musée Martigny. Martigny 1993 (cat.).– M. L. 1885-1956. Städtische Kunsthalle Düsseldorf. Düsseldorf 1957 (cat.).– Pierre, J.: M. L. Paris 1988

**LAURENS Henri**
**1885** Paris – **1954** Paris
French sculptor. Trained at a school of arts and crafts and in a workshop for ornamental stonemasonry. **1911** Introduced by Braque to leading Cubist artists and subsequently inspired to apply Cubist principles of form to sculptural works. **1913** Exhibited at the Salon des Indépendants. **1915**–**1919** Pasted paper works. **1916** First solo-exhibition at the Galerie de l'Effort moderne in Paris. **1917** *Papiers collés* and book illustrations.

**1919** First real sculptures out of stereometric, angular and interlinked. From **1925** stage designs for Diaghilev's Ballets Russes. Sculptures of human figures with short, stubby limbs, curled up into a compact form. **1936/37** Numerous works displayed at the Paris World Fair, some in Le Corbusier's pavilion. **1948** Represented France at the Venice Biennale. **1953** Received special honours at the São Paulo Biennale. Along with Jacques Lipchitz, Laurens was one of the leading Cubist sculptors.
CATALOGUES RAISONNES: Brusberg, D. et al. (ed.): H. L. Werkverzeichnis der Druckgraphik. Berlin and Hanover 1985.– Goldscheider, G.: L. Cologne 1956, New York 1959.– Hofmann, W. and D.-H. Kahnweiler (ed.): H. L. Das plastische Werk. Stuttgart 1970 / The Sculpture of H. L. New York 1970.– Nobis, N. et al. (ed.): H. L. Skulpturen, Collagen, Zeichnungen, Aquarelle, Druckgraphik. Œuvreverzeichnis der Druckgraphik. Sprengel Museum. Hanover 1985.– Völker, B. (ed.): H. L. Werkverzeichnis der Druckgraphik. Berlin 1985 / H. L. The Graphic Work. San Francisco 1985
MONOGRAPHS, CATALOGUES: Beloubek-Hammer, A. (ed.): H. L. 1885-1954. Bronzen, Steine und Arbeiten auf Papier. Staatliche Museen, Nationalgalerie. Berlin 1991 (cat.).– Falcidia, G.: H. L. Milan 1966.– Goldscheider, C.: H. L. New York 1959, Munich 1964.– Hohl, R. (ed.): L. cubista. Galleria Pieter Coray, Lugano. Milan 1986 (cat.).– Kuthy, S. (ed.): H. L. 1885-1954. Kunstmuseum Bern. Fribourg 1985 (cat.) / H. L. 1885-1954. Paris 1985.– H. L. Exposition de la donation aux Musées Nationaux. Grand Palais. Paris 1967 (cat.).– H. L. 1885-1954. Musée de Metz. Metz 1971 (cat.).– H. L. Plastiken, Grafiken, Zeichnungen. Kunsthalle Bielefeld. Bielefeld 1972 (cat.).– H. L. 1885-1954. 60 œuvres 1915-1954. Galerie Louise Leiris. Paris 1985 (cat.).– H. L. Rétrospective. Musée d'Art Moderne de la Communauté Urbaine de Lille, Villeneuve d'Ascq. Paris 1992 (cat.).– Laurens, M.: H. L. Sculpteur 1885-1954. Paris 1955.– Leymarie, J. (ed.): H. L. Accademia di Francia a Roma. Roma 1980 (cat.).– Monod-Fontaine, I. et al. (ed.): H. L. Le cubisme. Constructions et papiers collés 1915-1919. Centre Georges Pompidou. Paris 1985 (cat.).– Nardin, A. and J. Pijaudier (ed.): H. L. Rétrospective. Musée d'Art Moderne de la Commune Urbaine de Lille, Villeneuve d'Ascq. Paris 1992 (cat.).– Waldberg, P.: H. L. ou la femme placée en abîme. Paris 1980

**LAVIER Bertrand**
born **1949** Châtillon-sur-Seine
French painter and object artist. **1968**–**1972** Studied horticulture at the Ecole Nationale Supérieure d'Horticulture in Versailles. **1972** Gave up his studies to become an artist. Experimented with reproduction techniques and theories of perception using photography, painting and language. Since the 80s he has worked on modifications of

ready-made articles, covering commonplace objects with thick layers of paint in colours related to the object's original colouring. In **1982** and **1987** took part in documenta 7 and 8 in Kassel. **1984** First important solo-exhibition at the Kunsthalle Bern. **1984** Works drawing attention to the sculptural aspects of objects by placing two objects (e.g. a refrigerator and an armchair) one on top of the other. In his object art, Lavier not only weakens the distinctions between sculpture, painting, photography and language but also blurs the dividing line between the real object and its artistic image.
MONOGRAPHS, CATALOGUES: Celant, G. (ed.): B. L. Atheneum, Le Consortium, Musée des Beaux-Arts, Dijon et al. Dijon 1986 (cat.).– Douroux, X. and F. Gautherot (ed.): B. L. Le Nouveau Musée, Villeurbanne et al. Villeurbanne 1983 / B. L. Kunsthalle Bern et al. Bern 1983 (cat.).– Duve, T. d. (ed.): B. L. Centre Georges Pompidou. Paris 1987 (cat.).– Gianelli, I. and G. Verzotti (ed.): B. L. Castello di Rivoli, Museo d'Arte Contemporanea. Milan 1996 (cat.).– Hegyi, L. and P. Restany (ed.): B. L. Museum Moderner Kunst Stiftung Ludwig. Vienna 1992 (cat.).– Millet, C. et al. (ed.): B. L. Centre Georges Pompidou. Paris 1991 (cat.)

**LEBECK Robert**
born **1929** Berlin
German photographer. Self-taught. **1944/45** Stationed with the German Army in Berlin and Stettin. **1948/49** Studied ethnology at Zurich University and **1949**–**1951** at Columbia University in New York. **1952**–**1955** Photojournalist for the *Heidelberger Tageblatt*, **1960**–**1965** for the magazine Kristall in Hamburg and **1969**–**1977** and since **1979** for *Stern Magazine* in Hamburg and New York. **1977/78** Editor of the journal *GEO* in Hamburg. **1980** Exhibited in the Photokina in Cologne. Lebeck, who has travelled and photographed in almost every country of the world, is considered one of the leading German photographers of the 20th century.
MONOGRAPHS, CATALOGUES: Nannen, H.: Augenzeuge R. L. 30 Jahre Zeitgeschichte. Munich 1984.– Steinorth, K. and M. M. Grewenig: R. L. Fotoreportagen. Stuttgart 1993.– Troeller, G. S. (ed.): R. L. Der Abenteurer. Gütersloh 1968

**LECK Bart van der**
**1876** Utrecht – **1958** Blaricum (near Hilversum)
Dutch painter. **1891**–**1899** Worked in stained-glass workshops. **1900**–**1904** Attended a school of arts and crafts as well as evening classes at the Rijksakademie in Amsterdam. Designed furniture with Piet Klaarhamer and did book illustrations. From **1914** designs for stained-glass windows for the company Kröller-Müller. His early paintings are scenes of everyday life, especially factory work. From **1916**

close contact with Mondrian; the two artists influenced each other's work considerably, Leck's paintings becoming increasingly abstract. As a founder member of De Stijl, he contributed to the first edition of the journal published under that name. **1918** Broke away from De Stijl owing to disagreements over the function of architecture, and reverted to representational painting. Interior and textile designs and, from **1935**, ceramics. Despite their naturalistic motifs, Leck's later works, such as T*he Drinker* from **1955**, still betray a strong affinity to Neo-Plasticism, the formal language of De Stijl.
MONOGRAPHS, CATALOGUES: Feltkamp, W. C.: B. v. d. L. Leven en werken. Leyden 1950.– Hefting, P. and A. v. d. Woud (ed.): B. v. d. L. 1876-1958. Rijksmuseum Kröller-Müller, Otterlo et al. Hilversum 1976 (cat.).– Kooten, T. v. (ed.): B. v. d. L. 1876-1958. Rijksmuseum Kröller-Müller. Otterlo 1994 (cat.).– B. v. d. L. Stedelijk Museum. Amsterdam 1956 (cat.).– B. v. d. L. Städtische Kunsthalle Recklinghausen. Recklinghausen 1959 (cat.).– Müller-Haas, M. (ed.): B. v. d. L. Maler der Moderne. Kunstmuseum. Wolfsburg 1994 (cat.).– Oxenaar, W. D.: B. v. d. L. tot 1920: een primitief van de nieuwe tijd. Utrecht 1976.– Oxenaar, W. D. (ed.): B. v. d. L. 1876-1958. A la recherche de l'image des temps modernes. Institut néerlandais. Paris 1980 (cat.)

**LE CORBUSIER**
(Charles-Edouard Jeanneret)
**1887** La-Chaux-de-Fonds (Switzerland) – **1965** Cap Martin
Swiss-French architect, sculptor and painter. **1900** Trained as an engraver. **1901**–**1905** Studied architecture at La-Chaux-de-Fonds School of Arts. **1917** Moved to Paris. Began to paint, concentrating mainly on still lifes. **1918** Became acquainted with Ozenfant with whom he drew up the manifesto *Après le Cubisme, le purisme*, rejecting Cubist painting and propounding an objective approach to art based on clear architectonic principles. **1920**–**1925** Published the journal *L'Esprit Nouveau* and began to sign his articles with the pseudonym Le Corbusier. **1924** Set up a professional architects' office with his brother Pierre in Paris, undertaking projects all over the world.

From **1929** designed metal furniture. In his painting, he gradually moved away from his own Purist theories, developing a freer, expressive style, with the human figure as his central theme. **1939** Joined the group Cercle et Carré. **1953** Retrospective of his paintings at the Musée d'Art Moderne in Paris. **1959** Participation in documenta 2 in Kassel.

WRITINGS: Giedion-Welcker, C. (ed.): L. C. Schriften 1926-1971. Stationen zu einem Zeitbild. Cologne 1973.– L. C. and A. Ozenfant: Après le cubisme. Paris 1918.– L. C.: L'Atelier de la recherche patiente. Paris 1960.– L. C.: Mein Werk. Stuttgart 1960 CATALOGUES RAISONNES: Boesinger, W. (ed.): L. C. et P. Jeanneret. Œuvre complète 1910-1965. 7 vols. Zurich 1930-1971.– Weber, H. (ed.): L. C. L'œuvre lithographique. Zurich 1967 MONOGRAPHS, CATALOGUES: Baker, G.: L. C. An Analysis of Form. London 1984, New York 1991.– Besset, M.: L. C. Geneva et al. 1987.– Biadene, S.: L. C. Pittore e scultore. Museo Correr. Venice 1986 (cat.).– Billeter, E. (ed.): L. C. secret. Musée Cantonal des Beaux-Arts. Lausanne 1987 (cat.).– Bolle-Reddat, R.: Un évangile selon L. C. Paris 1987.– Brady, D.: L. C. An Annot. Bibliography. New York 1985.– Brooks, A. (ed.): L. C. The Garland Essays. New York 1987.– Cresti, C.: L. C. Lucerne 1973.– Curtis, W. J.: L. C. Ideas and Forms. New York 1986 / L. C. Ideen und Formen. Stuttgart 1987.– Ducret, A. et al. (ed.): L. C. Le peintre derrière l'architecte. Grenoble 1988.– Fondation L. C. (ed.): L. C. Sketchbooks. 4 vols. Cambridge 1981-1982.– Graves, M. E.: L. C. Selected Drawings. New York 1981.– Gresleri, G. (ed.): L. C. Il viaggio in Toscana. Palazzo Pitti. Florence 1987 (cat.).– Hervé, L. (ed.): L. C. Der Künstler und der Schriftsteller. Neuchâtel 1970.– Hohl, R.: L. C. Thesen und Werke. Stuttgart 1972.– Huse, N.: L. C. In Selbstzeugnissen und Bilddokumenten. Reinbek 1976.– Klopmann, A.: L. C. L'homme. Geneva 1995.– L. C. Architektur, Malerei, Plastik, Wandteppiche. Kunsthaus Zürich. Zurich 1957 (cat.).– Lucan, J. et al. (ed.): L. C. Une encyclopédie. Centre Georges Pompidou. Paris 1987 (cat.).– Monnier, G.: L. C. Lyon 1986.– Petit, J.: L. C. lui-même. Geneva 1970.– Sekler, M. P.: The Early Drawings of Charles-Edouard Jeanneret. Diss. Cambridge (MA), Harvard University. New York 1977.– Tentori, F.: Vita e opere di L. C. Roma 1983.– Weber, H. (ed.): L. C. Maler, Zeichner, Plastiker, Poet. Zurich 1988

**LEGER Fernand**
**1881** Argentan (Orne) – **1955** Gif-sur-Yvette
French painter. Began his career as an architectural draughtsman and continued this work in Paris until **1903**. From **1908** mixed with artists from the artists' colony Zone, including Delaunay, Archipenko, Laurens, Lipchitz. From **1910** works exhibited by the dealer D.-H. Kahnweiler, who also represented Picasso and Braque. Léger was

drawn towards Cubism. **1914-1916** His experiences during World War I led him to the central theme of his œuvre, the technological face of the 20th century, and he did a series of paintings of a silent mechanized world populated solely by workers. **1917** The tubular appearance of his gigantic figures led one critic to suggest mockingly that the man's art be referred to not as Cubism but as Tubism. **1920** His friendship with the architect Le Corbusier inspired him to branch out into monumental murals, mosaics and stained-glass windows. This led to his so-called monumental period, in which he portrayed monstrous stereotyped figures with heavily outlined limbs. From **1927** his figures became increasingly realistic. **1932** Taught at the Académie de la Grande Chaumière in Paris. **1952** Decorations for the assembly hall of the UNESCO in New York. Despite his close connection to Cubism, Léger was not so much concerned with an analytical breakdown of the pictorial field but rather with an unfolding of art through a celebration of pure colours and rhythms, as shown in his work *Form Contrasts*.
WRITINGS: F. L.: Propos et présence. Paris 1959.– F. L.: Mes voyages. Paris 1960.– F. L.: Fonctions de la peinture. Paris 1965 / Functions of Painting. New York 1965.– F. L.: Lettres à Simone. Correspondance établie et annotée par C. Derouet. Paris 1987.– F. L.: Une correspondance de guerre à Louis Poughon 1914-1918. Texte présenté, établi et annoté par C. Derouet. Paris 1990.– F. L. Une correspondance d'affaires. F. L. – L. Rosenberg. Paris 1996 CATALOGUES RAISONNES: Bauquier, G. and N. Maillard (ed.): F. L. Catalogue raisonné de l'œuvre peint 1903-1931. 4 vols. Paris 1990-1995.– Cassou, J. and J. Leymarie (ed.): F. L. Dessins et gouaches. Paris 1972 / F. L. Drawings and Gouaches. London 1973, Greenwich (CT) 1973 / F. L. Das graphische Werk. Tübingen 1973.– Saphire, L. (ed.): F. L. The Complete Graphic Work. New York 1978, Yorktown 1992 MONOGRAPHS, CATALOGUES: Aragon, L.: F. L. Contrastes. Paris 1959.– Bauquier, G.: F. L. Vivre dans le vrai. Paris 1987.– Briot, M.-O. et al. (ed.): F. L. et l'esprit moderne. Une alternative d'avant-garde à l'art non-objectif (1918-1931). Musée d'Art Moderne de la Ville de Paris et al. Paris 1982 (cat.).– Buck, R. T. et al. (ed.): F. L. Albright-Knox Art Gallery, Buffalo. New York 1982 (cat.).– Conzen-Meairs, I. et al. (ed.): F. L. The Later Years. Whitechapel Art Gallery, London et al. London 1987 (cat.).– Cooper, D.: F. L. et le nouvel espace. London, Paris and Geneva 1949.– Derouet, C. (ed.): F. L. La Poésie de l'objet 1928-1934. Centre Georges Pompidou. Paris 1981 (cat.).– Derouet, C. (ed.): Léger och Norden. Museet för Finländsk Konst Ateneum et al. Stockholm 1992 (cat.).– Derouet, C. et al. (ed.): F. L. Centre Georges Pompidou, Paris et al. Paris 1997 (cat.).– Descargues, P.: F. L. Paris 1955.– Francia, P. d.: F. L. New Haven (CT) and London 1983.– Green, C.: L. and the Avant-Garde. New Haven (CT) and London 1976.– Kosinski, D. (ed.): F. L. 1911-1924. Der Rhythmus des modernen Lebens (Le rythme de la vie moderne). Kunstmuseum Wolfsburg et al. Munich 1994 (cat.) / F. L. 1911-1924. The Rhythm of Modern Life. Kunstmuseum Wolfsburg et al. New York 1994 (cat.).– Lanchner, C. (ed.): F. L. The Museum of Modern Art. New York 1998 (cat.).– Lasalle, H. (ed.): F. L. Palazzo Reale. Milan 1989 (cat.) / F. L. Musée d'Art Moderne de la Communauté Urbaine de Lille, Villeneuve d'Ascq. Milan 1990 (cat.).– Laugier, C. and M. Richet: L. Œuvres de F. L. 1881-1955. Centre Georges Pompidou. Paris 1981 (cat.).– F. L. Musées des Beaux-

Arts de Montreal et al. New York 1982 (cat.).– F. L. Musée des Arts Décoratifs. Paris 1956 (cat.).– Le Noci, G.: F. L. Sa Vie, son œuvre, son rêve. Milan 1971.– Leymarie, J. and M. Richet (ed.): F. L. Grand Palais. Paris 1971 (cat.).– Néret, G.: F. L. Paris 1992, London 1993.– Prat, J.-L. (ed.): F. L. Rétrospective. Fondation Maeght. Saint-Paul 1988 (cat.).– Ruckhaberle, D. (ed.): F. L. Staatliche Kunsthalle Berlin. Berlin 1980 (cat.).– Schmalenbach, W.: F. L. New York 1976, Cologne 1977.– Schmalenbach, W. and M. Moeller (ed.): F. L. Kunsthalle der Hypo-Kulturstiftung. Munich 1988 (cat.).– Schneede, U. (ed.): F. L. Gouachen, Aquarelle, Zeichnungen. Kunsthalle Tübingen et al. Stuttgart 1983 (cat.).– Serota, N. (ed.): F. L. Zeichnungen, Bilder, Zyklen. 1930-1955. Staatsgalerie Stuttgart. Munich 1988 (cat.)

**LEHMBRUCK Wilhelm**
**1880** Meiderich (near Duisburg) – **1919** Berlin
German sculptor. **1895-1899** Studied at the Düsseldorf School of Arts and Crafts and **1901-1907** at the Düsseldorf Academy. **1905** Scholarship for a study trip to Italy. **1910** Moved to Paris. Acquainted with Archipenko, Brancusi, Modigliani and Derain. **1911** Modelled his first *Kniende* (Kneeling figures). Took up copperplate engraving and lithography. **1912** Participated at the Sonderbund exhibition. Second trip to Italy. **1914** Moved to Berlin, and exhibited with the German Werkbund that same year. **1916** First major solo-exhibition at the Kunsthalle Mannheim. **1917/18** Spent a year in Zurich. **1919** Elected to the Prussian Academy of Fine Arts. Suicide. Lehmbruck, whose attenuated, dynamic figures stem from the symbolist-existentialist tradition founded by Adolf von Hildebrand and Rodin, is seen as a key figure in the history of sculpture.
CATALOGUES RAISONNES: Lahusen, M. C. (ed.): W. L. Gemälde und großformatige Zeichnungen. Munich 1997.– Petermann, E. (ed.): Die Druckgraphik von W. L. Stuttgart 1964 MONOGRAPHS, CATALOGUES: Betthausen, P. and C. Brockhaus (ed.): W. L. 1881-1919. Plastik. Malerei. Graphik. Aus den Sammlungen des W.-L.-Museums der Stadt Duisburg. Museen der Stadt Gotha et al. Duisburg 1987 (cat.).– Bock, H. et al. (ed.): W. L. Nationalgalerie. Berlin 1973 (cat.).– Franz, E. (ed.): W. L. Zeichnungen aus dem W.-L.-Museum Duisburg. Kunsthaus Zurich et al. Zurich 1990 (cat.).– Güse, E. G.: L. und Italien. Duisburg 1979.– Händler, G.: W. L. Die Zeichnungen der Reifezeit. Stuttgart 1985.– Heller, R. (ed.): The Art of W. L. National Gallery of Art, Washington et al. Washington 1972 (cat.).– Hofmann, W.: W. L. Cologne 1957, New York 1959, Munich 1964.– Hoff, A.: W. L. Leben und Werk. Berlin 1933, 1961 / W. L. Life and Work. Washington 1969.– Holländer, G.: L. in Duisburg. Eine rezeptionsgeschichtliche Studie. Bonn 1995.–

Markin, J. P. and J. V. Bugoevc: Vil'gel'm Lembruk. Moscow 1989.– Pfeiffer, A. (ed.): W. L. Städtische Museen, Heilbronn et al. Heilbronn 1981 (cat.).– Riden, G. (ed.): W. L. Sieben Beiträge zum Gedenken seines 50. Todestages. Duisburg 1969.– Salzmann, S. (ed.): W. L. 1881-1919. National Gallery, Edinburgh et al. Edinburgh 1979 (cat.).– Salzmann, S. and K.-E. Vester (ed.): Hommage à L. / L. in seiner Zeit. Wilhelm-Lehmbruck-Museum. Duisburg 1981 (cat.).– Schubert, D.: Die Kunst L.'s. Worms 1981, Dresden 1990.– Syamken, G.: W. L. Hamburg 1991

**LEIBOWITZ Annie**
born **1949** Warterbury (CT)
American photographer. **1970** Studied photography and painting in San Francisco, and worked for the magazine Rolling Stone. **1971** Bachelor of Fine Arts at the Art Institute of San Francisco. **1973** Head of photography at *Rolling Stone*. **1975** Accompanied the group The Rolling Stones on a concert tour. From **1983** photographed for Condé Nast at *Vanity Fair*. Won the Granny Award for photography for the Album Cover of the Year. **1984** Nominated Photographer of the Year by the American Society of Magazine Photographers. **1987** Portrait and advertising campaign for American Express, for which she won the Campaign of the Decade prize. Prize for Innovation and Photography from the Society of Magazine Photographers. **1989** Did portraits of the American Ballet Theater. Received the Infinity Award for Applied Photography from the International Center of Photography, New York.

**LE MOAL Jean**
born **1909** Authon-du-Perche (Eure-et-Loire)
French painter. **1926-1929** Studied at the Ecole des Beaux-Arts in Lyon and **1934-1938** at the Académie Ranson in Paris under Bissière. **1939** Travelled to the USA. Took up abstract painting. **1941** Together with Bazaine, Manessier, Lapicque and Singier, founded the group "Mouvement des jeunes peintres de la tradition française" and took part in their joint-exhibitions at the Galerie Braun in Paris. From **1943** exhibitions in the Salon de Mai, and from **1944** joint exhibitions with Manessier and Singier at the

Galerie de France. **1950** Awarded the Prix de la critique. **1959** Participation in documenta 2 in Kassel. Le Moal's rhythmically organised colour structures are representative of the Ecole de Paris.
MONOGRAPHS, CATALOGUES: J. L. M. Galerie Beyeler. Basel 1956 (cat.).– J. L. M. Overbeck-Gesellschaft. Lübeck 1961 (cat.).– J. L. M. Museum. Metz 1963 (cat.).– J. L. M. Galerie Appel und Fertsch. Frankfurt-on-Main 1967 (cat.).– J. L. M. Galerie de France. Paris 1974 (cat.)

**LEMPICKA Tamara de**
**1898** Warsaw – **1980** Cuernavaca
Polish painter. **1917** Fled with her husband to Paris, where she took private lessons with Denis and Lhote. Developed an independent style, combining elements of Neo-Classicism and Post-Cubism in which she painted erotic motifs. **1925** Completed her best-known work, the self-portrait *Tamara in Bugatti*, where she presents herself as a vamp. Became known to a wider public through her participation in the first Art Deco exhibition in Paris and was subsequently the most sought-after portraitist in Parisian high society. **1928** Portrait of Baron Raoul Kuffner's mistress *Nana de Herrera*. **1933** Married Kuffner. **1939** Moved to Beverley Hills in the USA, where she painted portraits of numerous Hollywood stars. **1973** Retrospective in Paris. **1974** Moved to Mexico.
WRITINGS: Ishioka, E. (ed.): Five Days with T. de L. Tokyo 1980
CATALOGUE RAISONNE: Blondel A. (ed.): T. de L. Catalogue raisonné 1921-1979. Lausanne 1998
MONOGRAPHS, CATALOGUES: Bazin, G.: T. de L. Paris 1980.– Calvesi, M. and A. Borghese (ed.): T. de L. Tra eleganza e trasgressione. Accademia di Francia, Villa Medici. Roma 1994 (cat.).– T. de L. de 1925 à 1935. Galerie de Luxembourg. Paris 1972 (cat.).– Lempicka-Foxhall, K. d. and C. Phillips: Passion by Design. The Art and Times of T. de L. Oxford and New York 1987 / T. d. L. Malerin aus Leidenschaft, Femme Fatale der 20er Jahre. Munich 1987.– Marmori, G. (ed.): T. de L. The Major Works of T. de L. 1925-1935. Parma 1977.– Mori, G.: T. de L. Parigi 1920-1938. Florence 1994 / T. de L. Paris 1920-1938. Paris 1995.– Néret, G.: T. de L. 1898-1980. Cologne 1991.– Parco View: T. de L. Tokyo 1980.– Thormann, E.: T. de L. Kunstkritik und Künstlerinnen. Berlin 1993

**LE PARC Julio**
born **1928** Mendoza
Argentinian kinetic artist. Began studying at the age of 15 at the Escuela de Bellas Artes in Buenos Aires. **1958/59** Grant from the French government and assistantship with Victor Vasarely. Together with artist friends, undertook an analysis of the works of famous avant-garde artists, which led to his abandoning a freestyle formal language and beginning to work with sequences and

series. **1960** Founded the Groupe de Recherche d'Art Visuel, whose aim was to encourage active viewer participation. This Le Parc achieved by creating special environments such as labyrinths, playrooms, street events or mobile objects, affecting the viewer's body awareness. From **1965** participated in numerous exhibition of Groupe de Recherche d'Art Visuel and Tendances Nouvelles in Europe, North and South America and Japan. **1968** Participation in documenta 4 in Kassel.
MONOGRAPHS, CATALOGUES: Elia, A. (ed.): J. L. P. Experiencias 30 años 1958-1988. Buenos Aires 1988 (cat.).– Mari, E.: J. L. P. Milan 1960.– J. L. P. Galerie Buchholz. Munich 1968 (cat.).– J. L. P. Experiment plats för upplevelse av ögats, kroppens och tingens rörelser. Konst Museum, Göteborg et al. Stockholm 1969 (cat.).– J. L. P. Kinetische Objekte. Museum. Ulm 1970 (cat.).– T. de L. J. L. P. Recherches 1959-1971. Städtische Kunsthalle Düsseldorf et al. Düsseldorf 1972 (cat.).– J. L. P. Pinturas recientes. Museo de Arte Moderno. Bogotá 1976.– Popper, F. and J. Clay (ed.): L. P. Museo de Bellas Artes. Caracas 1967 (cat.)

**LEROY Eugène**
born **1910** Tourcoing
French painter. **1931-1932** Attended the Ecole des Beaux-Arts in Lille and Paris. **1936-1956** Went to Brussels and Amsterdam to study the works of Rembrandt and Malevich, to Italy where he developed a passion for Bellini and Giorgione, and to Munich where he visited exhibitions of Klee and Kandinsky. From **1958** lived and worked in Wasquehal, a remote spot that became his *point de fixation*. Between **1965** and **1972,** in search of a mode of painting, he produced numerous graphic works, especially gouaches and later acrylic and oil paintings in which figures and landscapes appear to emerge from a brown-coloured substance like clay or earth. **1972-1974** Trips to New York and Washington, where Rothko's paintings had a profound effect on him. Also went to Leningrad and Moscow. **1977** Exhibition at the Ecole des Beaux-Arts in Lille. **1980** Retrospective at the Museum van Hedendaagse Kunst in Ghent. **1992** Took part in documenta 9 in Kassel.
MONOGRAPHS, CATALOGUES: Hergott, F. (ed.): E. L. Le retour d'Ulysse / Ulysses

Returns. Stedelijk Van Abbe Museum, Eindhoven et al. Eindhoven 1988 (cat.).– E. L. Museum van Hedendaagse Kunst. Ghent 1982 (cat.).– E. L. Musée d'Art Moderne de la Communauté Urbaine de Lille. Villeneuve d'Ascq 1987 (cat.).– E. L. Dessins. Musée de Poitiers. Poitiers 1990 (cat.).– E. L. Kunsthalle Basel. Basel 1997 (cat.).– Marcadé, B.: E. L. Paris 1994.– Pleynet, M. (ed.): E. L. Rétrospective. Musée d'Art Moderne et d'Art Contemporain. Nice 1993 (cat.)

**LEVINE Les**
born **1935** Dublin
Irish-born American multimedia artist. Studied at the Central School of Arts and Crafts in London and first worked as a designer and photographer. **1958** Moved to Canada, where he produced his first sculptures. From **1965** incorporated videos into his works. **1967-1969** Projects involving video, film, telephones and other media leading to the series *Disposable Art* and *Software Art.* **1970** Set up the Museum of Mott Art offering careers advice to artists. From **1972** taught at New York University. **1974** Received the National Endowment for the Arts and was made Professor of Video Art at William Patterson College Wayne in New York. **1975** Broadcasting of Les Levine Festival by the cable TV station Cable Arts. **1977** and **1987** took part in documenta 6 and 8 in Kassel. **1990** Solo-exhibition at the Centraal Museum in Utrecht.
MONOGRAPHS, CATALOGUES: Gisler, V. and L. Kurmann (ed.): L. L. Media Projects and Public Advertisements. Mai 36 Galerie. Lucerne 1988 (cat.).– Nahas, D. (ed.): Public Mind. L. L.'s Media Sculpture and Mass Ad Campaigns 1969-1990. Everson Museum of Art. Syracuse (NY) 1990 (cat.).– Schmidt, J.-K. (ed.): L. L. Medienskulptur. Galerie der Stadt Stuttgart. Stuttgart 1997 (cat.).– Video-As Art-By L. L. Plattsburg (NY) 1979

**LEWITT Sol**
born **1928** Hartford (CT)
American object and concept artist. **1945-1949** Studied at Syracuse University, New York. **1953** Attended the Cartoonist and Illustrator School in New York. **1955/56** Worked as a graphic artist for the architect

I. M. Pei. **1960-1965** Instructor at the Museum of Modern Art in New York. Became acquainted with Mangold, Ryman and Flavin. **1963/64** First sculptures, influenced by Bauhaus and De Stijl. **1964-1971** Taught at the Cooper Union and the Education Department of New York University. **1965** First solo-exhibition at the Daniels Gallery in New York. **1966** First open structures with cuboid modules. From **1968** numerous wall drawings: strictly schematic compositions with rhythmic lines painted directly onto walls. **1968-1982** Participation in documenta 4-7 in Kassel. From **1970** concentrated on printing techniques. LeWitt designed serial systems, based on geometric and mathematical laws, that could be transformed into sculptural structures through a third modifier. This approach to art makes him one of the leading exponents of Concept Art in America.
WRITINGS: S. L.: Autobiography. New York and Boston 1980.– Zevi, A. (ed.): S. L. Critical Texts. New York 1995
CATALOGUES RAISONNES: Fuchs, R. and W. Kaiser (ed.): S. L. Drawings 1958-1992. Haags Gemeentemuseum, The Hague et al. The Hague 1992 (cat.).– Lewison, S. (ed.): S. L. Prints 1970-1986. Tate Gallery. London 1986 (cat.).– S. L. Books 1966-1990. Portikus. Frankfurt-on-Main 1990 (cat.).– Singer, S. (ed.): S. L. Wall Drawings 1968-1984. Stedelijk Museum, Amsterdam et al. Amsterdam 1984 (cat.).– Singer, S. (ed.): S. L. Wall Drawings 1984-1992. Kunsthalle Bern. Bern 1992 (cat.)
MONOGRAPHS, CATALOGUES: Batchelor, D. and R. Krauss (ed.): S. L. Structures 1962-1993. Museum of Modern Art, Oxford et al. Oxford and Munich 1993 (cat.).– Haenlein, C. (ed.): S. L. Walldrawings. Kestner-Gesellschaft. Hanover 1988 (cat.).– Legg, A. et al. (ed.): S. L. The Museum of Modern Art. New York 1978 (cat.).– Lewison, J. (ed.): S. L. Prints 1970-1996. Tate Gallery. London 1986 (cat.).– S. L. Gemeentemuseum. The Hague 1970 (cat.).– S. L. Structures. Museum of Modern Art, Oxford et al. Oxford 1993 (cat.) / S. L. Structures. Museum Villa Stuck, Munich et al. Munich 1993 (cat.).– Paoletti, J. T. (ed.): No Title (The Collection of S. L.) Wesleyan University Art Gallery et al. Middletown 1981 (cat.).– Reynolds, J. (ed.): S. L. Twenty-Five Years of Wall Drawings 1968-1993. Addison Gallery of American Art. Andover 1993 (cat.).– Rose, B. et al. (ed.): S. L. The Museum of Modern Art, New York et al. New York 1978 (cat.)

**LHOTE André**
**1885** Bordeaux – **1962** Paris
French painter and art critic. Self-taught. Studied sculpture at the Ecole des Beaux-Arts in Bordeaux. **1908** Moved to Paris. **1910** First solo-exhibition at the Galerie Drouet in Paris. Co-founder of the journal *Nouvelle Revue française*, for which he worked until **1940** as an art critic. **1911**

Joined the Section d'Or. **1914–1917** Military service. **1918** Opened his own school of painting in Paris. **1922–1925** Numerous lecture tours at home and abroad. Influenced by Cubism and the paintings of Cézanne, Lhote developed a sharp-edged, geometric style of figurative painting. As a teacher and critic of modern art (*Traité du paysage, Traité de la figure, Ecrits sur l'art*), Lhote had a massive influence on subsequent generations of artists.
WRITINGS: A. L.: Sonia Delaunay. Ses peintures, ses objets, ses tissus simultanés, ses modes. Paris 1925.– A. L.: Traité du paysage. Paris 1939.– A. L.: Ecrits sur la peinture. Paris and Brussels 1946.– A. L.: Traité de la figure. Paris 1950, 1955/Figure Painting. London 1953.– A. L.: Peinture libérée. Paris 1956
MONOGRAPHS, CATALOGUES: Cassou, J.: A. L. Les Invariants plastiques. Paris 1967.– Cassou, J. et al. (ed.): A. L. 1885-1962. Cubism. Leonard Hutton Galleries. New York 1976 (cat.).– Dorival, B. (ed.): A. L. Rétrospective 1907-1962. Peintures, aquarelles, dessins. Artcurial, Centre d'Art plastique contemporain. Paris 1981 (cat.).– Garcia, F.: La Peinture, le cœur et l'esprit. Catalogue des œuvres d'A. L. Musée des Beaux-Arts. Bordeaux 1967 (cat.).– Jakovsky, A.: A. L. Paris 1947.– A. L. Musée National d'Art Moderne. Paris 1958 (cat.).– A. L. Musée de Lyon. Lyon 1966 (cat.).– A. L. L'Art au service de la paix. Lhote et les individualistes du cubisme. Petit Palais. Geneva 1982 (cat.).– A. L. "Un certain regard." Dessins anciens, aquarelles, peintures. Galerie Aittouares. Paris 1985 (cat.).– Martin-Méry, G. (ed.): A. L. Hommage à A. L. Musée des Beaux-Arts. Bordeaux 1967 (cat.)

**LICHTENSTEIN Roy**
**1923** New York – **1997** New York
American painter and graphic artist. **1940–1943** Studied at Ohio State University in Columbus. **1946–1950** Continued his studies at the Art Students League in New York. **1951–1957** Worked as a technical draughtsman and began to paint in an Abstract Expressionist style. **1960** Assistant professor at New State University in Oswego, New York and **1960–1963** at Douglas College at Rutgers University in Brunswick, New Jersey. **1961** Began working from printed pictures, using the Beday system whereby a picture is divided up on a dot matrix. He used this method to copy not only comic strips and cartoons but also famous paintings by Picasso, Mondrian and other artists, and transfer them, enlarged, onto canvas. **1964–1969** Picture series of architectonic monuments (pyramids, temples and cathedrals) **1966** First solo-exhibition at the Cleveland Museum of Art. First *Modern Paintings*. **1969** Series of paintings of Rouen Cathedral. First retrospective in New York at the Solomon R. Guggenheim Museum. **1970** Moved to Southampton, Long Island. Designed monumental wall paintings for the medical

faculty of Düsseldorf University. **1973–1979** Period of *Ecole-de-Paris paintings*, plus trompe-l'œil and Futurist-, Surrealist- and Expressionist-style works. **1977** Participation in documenta 6 in Kassel. Along with Warhol, Lichtenstein was a leading exponent of American Pop Art. Though primarily a painter, he did designs for works in ceramic, steel and glass that were then manufactured commercially.
WRITINGS: Sylvester, D.: R. L. Interviewed by D. Sylvester. London 1997
CATALOGUES RAISONNES: Bianchini, P. (ed.): R. L. Drawings and Prints. New York 1970.– Corlett, M. L. (ed.): The Prints of R. L. A Catalogue Raisonné 1948-1993. New York 1994.– Sundell, N. et al. (ed.): L. La grafica. Milan 1990 (cat.).– Waldman, D. (ed.): R. L. Drawings and Prints. New York 1969, Secaucus (NJ) 1988
MONOGRAPHS, CATALOGUES: Adelman, B. and C. Tomkins (ed.): The Art of R. L. Mural with Blue Brushstroke. New York 1987, London 1994.– Alloway, L.: R. L. New York 1983, Munich and Lucerne 1984.– Busche, E.: R. L. Das Frühwerk 1942-1960. Berlin 1988.– Coplans, J. (ed.): R. L. New York and Washington 1972.– Cowart, J. (ed.): R. L. 1970-1980. The Saint Louis Art Museum et al. New York 1981, Munich 1982 (cat.).– Hendrickson, J.: R. L. Cologne 1989.– Kerber, B.: R. L. Ertrinkendes Mädchen. Stuttgart 1970.– R. L. Tate Gallery. London 1968 (cat.).– R. L. Kestner-Gesellschaft. Hanover 1968 (cat.).– R. L. Tate Gallery. Liverpool 1993 (cat.).– R. L. Musée d'Art Contemporain. Lausanne 1993 (cat.).– Riley, C. A. (ed.): R. L. Musée d'Art Contemporain. Pully/Lausanne 1992 (cat.).– Rose, B. (ed.): The Drawings of R. L. The Museum of Modern Art, New York et al. New York 1987 (cat.)/R. L. Die Zeichnungen 1961-1986. Schirn Kunsthalle, Frankfurt-on-Main et al. Frankfurt-on-Main 1988 (cat.).– Sundell, N. (ed.): R. L. La grafica. Palazzo delle Albere, Trento. Milan 1990 (cat.).– Tomkins, C.: R. L. Mural with Blue Brushstroke. New York 1987.– Tomkins, C. and B. Adelman: L'Art de R. L. Paris 1994.– Tuten, F.: R. L. Bronze Sculpture 1976-1989. New York 1989.– Waldman, D. (ed.): R. L. Solomon R. Guggenheim Museum. New York 1969 (cat.).– Waldman, D.: R. L. New York and London 1971, Tübingen 1971.– Waldman, D. (ed.): R. L. Solomon R. Guggenheim Museum, New York 1993 (cat.)/R. L. Haus der Kunst, Munich. Stuttgart 1994 (cat.)

**LIEBERMANN Max**
**1847** Berlin – **1935** Berlin
German painter. **1868–1872** Studied at the Weimar Academy. **1871** First trip to Holland which he then visited every year up to **1913**. Met the Hungarian painter Mihály von Munkácsi in Düsseldorf, who inspired his most successful painting *Women plucking Geese* (Berlin, Nationalgalerie). **1873–1878** Lived in Paris, where he aligned himself with G. Courbet, J.-F. Millet and T. Ribot. Spent the summer months in Barbizon.

**1878** After a trip to Venice, moved to Munich, where he lived for six years. **1884** Returned to Berlin. **1899** Co-founder of the Berlin Secession. **1904** Member of the board of the German Artists' Association. **1920** Elected President of the Berlin Academy. Liebermann, whose style developed out of traditional Realism, is one of the main representatives of German Impressionism. Besides oil paintings, he produced drawings, watercolours and etchings, and also wrote many articles on the theory of art.
WRITINGS: Busch, G. (ed.): M. L. Die Phantasie in der Malerei. Schriften und Reden. Frankfurt-on-Main 1978.– Eipper, P.: Ateliergespräche mit L. und Corinth. Munich 1971.– Küster, B.: M. L. Ein Maler-Leben. Hamburg 1988.– Landsbergen, F. (ed.): M. L. Siebenzig Briefe. Berlin 1937.– Lichtwark, A.: Briefe an M. L. Hamburg 1947.– L. M.: Die Phantasie in der Malerei. Berlin 1916.– L. M.: Gesammelte Schriften. Berlin 1922.– M. L.: Künstlerbriefe über Kunst. Dresden 1957
CATALOGUES RAISONNES: Achenbach, S. (ed.): Die Druckgraphik M. L.'s. Heidelberg 1974.– Eberle, M. (ed.): M. L. Werkverzeichnis der Gemälde und Ölstudien. 2 vols. Munich 1995-1996.– Schiefler, G. (ed.): M. L. Sein graphisches Werk 1876-1923. 3 vols. Berlin 1907-1923/M. L. The Graphic Work 1876-1923. San Francisco 1991
MONOGRAPHS, CATALOGUES: Achenbach, S. (ed.): M. L. in seiner Zeit. Nationalgalerie, Berlin et al. Berlin 1980 (cat.).– Boskamp, K.: Studien zum Frühwerk von M. L. Hildesheim et al. 1994.– Branner, L.: M. L. Berlin 1966.– Bunge, M.: M. L. als Künstler der Farbe. Diss. Berlin 1990.– Busch, G.: M. L. Maler, Zeichner, Graphiker. Frankfurt-on-Main 1986.– Busch, G. and A. Keul (ed.): M. L. Der deutsche Impressionist. Kunsthalle Bremen. 1995 (cat.).– Eberle, M. (ed.): Max Liebermann in seiner Zeit. Nationalgalerie, Berlin et al. Berlin and Munich 1979 (cat.).– Friedländer, M. J.: M. L.'s graphische Kunst. Dresden 1920.– Hansen, D. (ed.): M. L. – der deutsche Impressionist. Kunsthalle Bremen. Munich 1995 (cat.).– Küster, B.: M. L. Ein Künstler-Leben. Hamburg 1988.– Meißner, G.: M. L. Leipzig 1974, 1986.– Lenz, C.: M. L. "Münchner Biergarten". Munich 1986.– M. L. Niedersächsische Landesgalerie. Hanover 1954 (cat.).– M. L. Deutsche Akademie der Künste. Berlin 1965 (cat.).– Stuttmann, F.: M. L. Hanover 1961

**LINDNER Richard**
**1901** Hamburg – **1978** New York
German-born American painter and graphic artist. **1922–1924** Studied at the Nuremberg School of Arts and Crafts, then in Munich at the School of Arts and Crafts and the Academy of Fine Arts and finally, **1927/28**, at the Berlin Academy of Arts. **1929–1933** Artistic director to the publishers Knorr & Hirth in Munich. **1933** Fled from the Nazi regime to Paris, where he worked as a commercial artist. **1941** Emi-

grated to the USA and did illustrations for books and prestige magazines such as *Vogue* and *Harper's Bazaar*. **1948** Took American citizenship. **1950** Began painting. **1952–1965** Taught at the Pratt Institute in Brooklyn. **1968** and **1977** participation in documenta 4 and 6 in Kassel. Lindner's painting style, which is influenced by German Expressionism and Neue Sachlichkeit, combines illustrative elements with the glaring colours of urbanized American Pop Art.
CATALOGUE RAISONNE: Kramer, H.: R. L. Berlin 1975, London 1975, Paris 1978
MONOGRAPHS, CATALOGUES: Ashton, D.: R. L. New York 1969.– Dienst, R.-G.: L. Stuttgart 1969, New York 1970.– Karpf, G. and C. Schulze (ed.): R. L. Arbeiten auf Papier. Galerie Thomas. Munich 1990 (cat.).– R. L. Städtisches Museum. Leverkusen 1968 (cat.).– R. L. Kunsthalle Nürnberg. Nuremberg 1974 (cat.).– R. L. Kunsthalle Nürnberg. Nuremberg 1987 (cat.).– R. L. Museum Boymans-van Beuningen. Rotterdam 1974 (cat.).– R. L. Kunsthaus Zürich. Zurich 1974 (cat.).– R. L. Fondation Maeght. Saint Paul 1979 (cat.).– R. L. Kunsthalle Nürnberg. Nuremberg 1986 (cat.).– Martin, J.-H. (ed.): R. L. Musée National d'Art Moderne, Paris et al. Paris 1974 (cat.).– Spies, W.: L. Paris 1980.– Tillim, S.: L. London 1961.– Zilczer, J.: R. L. Paintings and Watercolors 1948-1977. New York 1996/R. L. Haus der Kunst. Munich 1997 (cat.)

**LIPCHITZ Jacques**
(Chaïm Jacob Lipchitz)
**1891** Druskieniki (Lithuania) – **1973** Capri
Lithuanian-born French-American sculptor. **1909** Moved to Paris. Attended the Ecole des Beaux-Arts and the Académie Julian in Paris. **1913** Contact with Archipenko, Picasso and the Cubists. **1912** Participated in the Salon d'Automne. **1915** First Cubist sculptures. **1914** Trip to Spain with Rivera. **1920** First solo-exhibition at the Galerie de l'Effort Moderne in Paris. **1922** Joined the group Esprit Nouveau. **1925** In his *Transparents* he abandoned Cubist principles and became preoccupied with open forms and the interpenetration of solids and voids. **1937** Sculpture for the Paris World Fair. **1941** Emigration to the USA. Exhibition at the Buchholz Gallery in New York. **1947** Moved to Hastings-on-Hudson. **1948** Took American citizenship. **1959** and **1964** participation in documenta 2 and 3 in Kassel. **1962** Numerous commissions for large-scale public monuments in America and Israel. **1978** His colossal bronze sculpture *Our Tree of Life* – completed by his second wife, the Berlin sculptress Yulla Halberstadt – erected on Mount Scopus, the highest point in Jerusalem. Excellent sculptor of Cubism.
WRITINGS: J. L.: Amedeo Modigliani. New York 1952, Paris 1954.– J. L. and H. H. Arnason: My Life in Sculpture. London and New York 1972
CATALOGUE RAISONNE: Wilkinson, A. G. (ed.): The Sculpture of J. L. Vol. 1: The Paris Years 1910-1940. London 1996

MONOGRAPHS, CATALOGUES:
Arnason, H. H.: J. L. Sketches in Bronze. New York 1969.– Barbier, N.: L. Œuvres de J. L. 1891-1973. Centre Georges Pompidou. Paris 1978 (cat.).– Bermingham, P.: J. L. Sketches and Models in the Collection of the University of Arizona Museum of Art, Tucson (AZ). Tucson 1982.– Bork, B. van: J. L. The Artist at Work. New York 1966.– Dorival, B. (ed.): Sculptures by J. L. Tate Gallery. London 1959 (cat.).– Goldwater, R.: L. New York 1959.– Haftmann, W. (ed.): J. L. Skulpturen und Zeichnungen 1911-1969. Nationalgalerie. Berlin 1970 (cat.).– Hammacher, A. M.: J. L. His Sculpture. New York 1960, 1975.– Hammacher, A. M.: J. L. Cologne 1961.– Hammacher, A. M. (ed.): A Tribute to J. L. in America 1941-1973. Marlborough Gallery. New York 1973 (cat.).– Hope, H. R. (ed.): The Sculpture of J. L. The Museum of Modern Art, New York et al. New York 1954 (cat.).– Jenkins, D. F. and D. Pullen (ed.): The L. Gift. Models for Sculpture. Tate Gallery. London 1986 (cat.).– J. L. A Retrospective Selected by the Artist. The Art Galleries, University of California, Los Angeles et al. Los Angeles 1963 (cat.).– Patai, I.: Encounters. The Life of J. L. New York 1961.– Raynal, M.: J. L. Paris 1947.– Scott, D.: J. L. and Cubism. New York 1978.– Wilkinson, A. G. (ed.): J. L. A Life in Sculpture. Art Gallery of Ontario, Toronto et al. Toronto 1989 (cat.).– Yvars, J. F. et al. (ed.): J. L. escultor 1891-1973. Madrid and Valencia 1997 (cat.)

**LISSITZKY El**
(Elieser Marcovic Lissizki)
**1890** Polschinok (near Smolensk) –
**1941** Moscow
Russian artist. **1909–1913** Studied architecture in Darmstadt. **1914** Returned to Moscow. **1914–1918** Studied at Riga Polytechnic. **1919–1921** Professor at the art school founded by Chagall in Vitebsk. Inspired by Malevich's Suprematism and his contact with the artists group Unovis (Promoters of the New Art), began work on his *Proun* series (pro unovis), aimed at a radical restructuring of living spaces. **1921** Head of the architectural faculty Wchutemas in Moscow. **1923** Set up a *Proun*-room in Berlin and arranged and designed exhibitions of non-representational art in Dresden and Hanover. Met Schwitters in Hanover and encountered the De Stijl movement. **1925** Returned to the Soviet Union. From **1930** head architect for the Central Park of Culture and Recreation in Moscow. Numerous architectonic works and designs for propaganda campaigns. In the 20s, Lissitzky did more than any other artist to promote the exchange of ideas and art works across the East-West divide. With his *Proun* projects, he moved from painting into the field of architecture, thereby making the transition from the world of art to real social environments.
WRITINGS: E. L. and H. Arp: Die Kunstismen. Zurich 1924, Baden-Baden 1990.– Lissitzky-Küppers, S. and J. Lissitzky (ed.):

E. L. Proun und Wolkenhügel. Schriften, Briefe, Dokumente. Dresden 1977 / E. L. Life, Letters, Texts. London and Greenwich (CT) 1968, 1980, London and New York 1992.– Tschichold, J. (ed.): E. L. Werke und Aufsätze. Berlin 1971
MONOGRAPHS, CATALOGUES: Birnholz, A.: E. L. Diss. Yale University, New Haven. Ann Arbor (MI) 1978.– Debbaut, J. et al. (ed.): E. L. 1890-1941. Architect, schilder, fotograaf, typograaf. Stedelijk Van Abbe Museum, Eindhoven et al. Eindhoven 1990 (cat.)/E. L. Architecte, peintre, photographe, typographe 1890-1941. Musée d'Art Moderne. Paris 1991 (cat.).– Erenburg, I. (ed.): Vesc, Objet, Gegenstand. E. L. Baden 1994.– Hemken, K.-U.: E. L. Revolution und Avantgarde. Cologne 1990.– E. L.: More about Two Squares. Forest Row 1990.– Lissitzky-Küppers, S. (ed.): E. L. Maler, Architekt, Typograph, Fotograf. Erinnerungen, Briefe, Schriften. Dresden 1967, Leipzig 1976/E. L. Life, Letters, Texts. London 1968.– Lubbers, F.: E. L. New York 1991.– Malsy, V. (ed.): E. L. Konstrukteur, Denker, Pfeifenraucher, Kommunist. Mainz 1990.– Nisbit, P. (ed.): E. L. 1890-1941. Cambridge (MA) 1990 (cat.).– Nobis, N. et al. (ed.): E. L. 1890-1941. Retrospektive. Sprengel Museum, Hanover et al. Hanover 1988 (cat.).– Richter, H.: E. L. Sieg über die Sonne. Zur Kunst des Konstruktivismus. Cologne 1958.– Rubinger, K. (ed.): E. L. Galerie Gmurzynska. Cologne 1976 (cat.).– Scharfe, S. (ed.): E. L. Maler, Architekt, Typograf, Fotograf. Staatliche Galerie Moritzburg. Halle 1982 (cat.).– Simons, K.: E. L. Proun 23 N. Eine Werkmonographie. Frankfurt-on-Main 1993

**LIU Wei**
born **1965** Peking
Chinese painter. **1989** Completed his studies at the Central Academy of Fine Arts in Peking.

**LOHSE Richard Paul**
**1902** Zurich – **1988** Zurich
Swiss painter and graphic artist. **1918–1922** Trained as a commercial draughtsman and attended the Zurich School of Arts and Crafts. From **1922** worked for various advertising companies. **1937** Co-founder of the Swiss artists' association Allianz. From **1942**

experiments with modular and serial chequer-board arrangements of colour fields. **1947–1955** Editor of the magazine *Bauen and Wohnen*. **1949** Awarded the Swiss national prize for painting. Numerous public commissions including the Swiss pavilion at the Milan Triennale in **1957**, and designs for a school in Rapperswil in **1967**. **1958–1965** Editor of the Zurich journal *Neue Grafik*. **1965** Took part in the São Paulo Biennale. **1973** Art award from the City of Zurich. Together with Bill and Graeser, Lohse is considered one of the leading exponents of Concrete Art in Switzerland.
WRITINGS: Albrecht, H. J. et al. (ed.): R. P. L. Modulare und Serielle Ordnungen 1943-1984/Modular and Seriel Orders 1943-1984. Zurich 1984.– R. P. L.: Über Vordemberge-Gildewart. Teufen 1959.– R. P. L.: Die gemeinsamen Grundlagen der Architektur und des Bildes. Zurich 1969

MONOGRAPHS, CATALOGUES: Bojescul, W. (ed.): R. P. L. Modulare und Serielle Ordnungen. Kunstverein Braunschweig. Brunswick 1985 (cat.).– Gomringer, E. et al. (ed.): R. P. L. Modulare und Serielle Ordnungen. Cologne 1973.– Holeczek, B. (ed.): R. P. L. 1902-1988. Wilhelm-Hack-Museum, Ludwigshafen am Rhein et al. Heidelberg 1992 (cat.).– Kallhardt, R. and Z. Felix (ed.): R. P. L. Kunsthalle Bern. Bern 1970 (cat.).– Kunz, M. (ed.): Fragen an L. Kunstmuseum. Lucerne 1985 (cat.).– Lemoine, S. (ed.): R. P. L. Rétrospective. Musée de Grenoble et al. Grenoble and Kassel 1988 (cat.).– R. P. L. Wiener Secession. Vienna 1986 (cat.).– Matheson, J. et al. (ed.): R. P. L. Modulare und Serielle Ordnungen. Städtische Kunsthalle Düsseldorf. Düsseldorf 1975 (cat.).– Neuberg, H. et al.: R. P. L. Teufen 1962.– Riese, H.-P. and F. W. Heckmanns: R. P. L. Zeichnungen 1935-1985. Baden 1986/R. P. L. Drawings 1935-1985. New York 1986

**LONG Richard**
born **1945** Bristol
English artist. **1962–1965** Studied at the West of England College of Art in Bristol and **1966–1968** at St. Martin's School of Art in London. **1967** Endeavouring to extend the definition of sculpture, he made minimal alterations to the landscape such as *A Line Made by Walking*, which he documented in photographs, drawings and diagrams. **1968** First solo-exhibition at the Konrad Fischer gallery in Düsseldorf. **1970** designed sculptural geometric structures for interiors: labyrinth-like arrangements of natural materials such as wood, stone or clay. **1972** and **1982** took part in documenta 5 and 7 in Kassel. **1976** Represented Great Britain at the Venice Biennale. **1986** Exhibition at the Guggenheim Museum, New York. **1988** Won the Aachen Art Award and in **1989** the Turner Prize. Long, whose art actions have taken him to remote places all over the world, is one of the most important representatives of Land Art.

MONOGRAPHS, CATALOGUES: Barleycorn, J. (ed.): R. L. Stedelijk Museum. Amsterdam 1973 (cat.).– Cladders, J. (ed.): R. L. Skulpturen. Städtisches Museum. Mönchengladbach 1970 (cat.).– Davis, H. M. (ed.): Surg Roar: R. L. La Jolla Museum of Contemporary Art. La Jolla 1989 (cat.).– Fuchs, R. (ed.): R. L. Solomon R. Guggenheim Museum. New York and London 1986 (cat.).– Gallwitz, K. (ed.): Labyrinth: Bristol 1990, R. L. Städtische Galerie im Städelschen Kunstinstitut. Frankfurt-on-Main 1991 (cat.).– R. L. Works 1966-1977. Stedelijk Van Abbe Museum. Eindhoven 1979 (cat.).– R. L. Selected Works. National Gallery of Canada. Ottawa 1983 (cat.).– R. L. Postcards 1968-1982. Musée d'Art Contemporain de Bordeaux. Bordeaux 1984 (cat.).– R. L. Old World, New World. London 1988.– R. L. Walking in Circles. Hayward Gallery, London. London 1991, New York 1994 (cat.) /In Kreisen gehen. Hayward Gallery, London. Stuttgart 1991, 1994 (cat.).– R. L. River to River. Musée d'Art Moderne de la Ville de Paris. Paris 1993 (cat.).– R. L. Skulpturen, Fotos, Texte, Bücher. Neues Museum Weserburg. Bremen 1993 (cat.).– R. L. Mountains and Waters. New York 1993.– R. L. Palazzo delle Esposizioni, Roma. Milan 1994 (cat.).– R. L. Neues Museum Weserburg. Bremen 1994 (cat.).– R. L. From Time to Time. Stuttgart 1997.– R. L. A Walk Across England. London 1997

**LONGO Robert**
born **1953** Brooklyn (NY)
American artist. **1971** First art lessons from the sculptor Leonda Finke. Scholarship to study history of art and restoration at the Accademia di Belle Arti in Florence. **1973** Returned to New York and attended art school in Buffalo. **1974** Met Cindy Sherman. Experiments with perfomances, installations and videos. **1977** Assistant to Vito Acconci. **1979** Solo-exhibition *Boys Slow Dance* in New York. Large black-and-white drawings from photographs of friends and pictures from magazines. Played guitar in various bands. **1982** Exhibited *Corporate Wars: Walls of Influence* at documenta 7 in Kassel. **1984** Joint projects with the composer Stuart Argabright. **1986** First music video, Golden Palominos' *Boy (Go)*. **1987** Première of the film *Arena Brains* at the New York Film Festival; took part in documenta 8. **1989** Participated in a media symposium in Tokyo. Longo was part of the New Wave Scene of the late 70s. His multimedia art is a protest against sensory overload and the stultifying impact of the flood of visual stimuli pouring through new media channels.
MONOGRAPHS, CATALOGUES: Danof, S. M. (ed.): R. L. Drawings and Reliefs. Akron Art Museum. Akron (OH) 1984 (cat.).– Fox, H. N. (ed.): R. L. Los Angeles County Museum of Art, Los Angeles et al. New York 1989 (cat.).– Gibson, W.: R. L. Kyoto 1991.– Hobbs, R. (ed.): R. L. Disillusons. University of Iowa Museum of Art.

Iowa City 1985 (cat.).– Kellein, T. (ed.): R. L. Magellan. Kunsthalle Tübingen et al. Tübingen 1997 (cat.).– Prince, R. (ed.): R. L. Men in the Cities 1979-1982. New York 1986.– Ratcliff, C.: R. L. New York 1985, Munich 1985.– Tsuzuki, K.: R. L. Kyoto 1992

**LOUIS Morris**
(Morris Louis Bernstein)
1912 Baltimore (PA) – 1962 Washington
American painter. 1927–1932 Studied at Maryland Institute of Fine and Applied Arts. From 1936 to 1943 he lived in New York, then moved to Baltimore, finally settling in Washington in 1952 Led a workshop at the Center of the Arts in Washington and became friends with Noland. Originally strongly influenced by Abstract Expressionism, he abandoned this style in 1957 after destroying more than 300 of his paintings. Developed his own form of Color Field Painting and became one of the most important exponents of post-painterly abstraction in America. His most famous work consists of four large series: *Veils* (1954 – 1959), *Florals* (1959/60), *Unfurleds* (1960) and *Stripes* (1961/62). 1964 and 1968 participation in documenta 3 and 4 in Kassel. In his Color Field Painting Louis applies liquid acrylic paints to unprimed canvas, now and then guiding the flow of the paint with a stick. The fluid paint soaks into the canvas, leaving soft borders as in a stain.
CATALOGUES RAISONNES: Upright, D. (ed.): The Drawings of M. L. National Collection of Fine Arts, Smithsonian Institution, Washington et al. Washington 1979 (cat.).– Upright, D. (ed.): M. L. The Complete Paintings. New York 1985
MONOGRAPHS, CATALOGUES: Ashton, D. (ed.): M. L. Padiglione d'Arte Contemporanea. Milan 1990 (cat.).– Elderfield, J. (ed.): M. L. Hayward Gallery. London 1974, New York 1991 (cat.).– Elderfield, J. (ed.): M. L. The Museum of Modern Art, New York et al. New York 1986 (cat.).– Fried, M.: M. L. New York 1970.– M. L. 1912-1960. Memorial Exhibition. Paintings from 1954-1960. Solomon R. Guggenheim Museum. New York 1963 (cat.).– M. L. 1912-1962. Museum of Fine Arts. Boston 1967 (cat.).– M. L. Städtische Kunsthalle Düsseldorf. Düsseldorf 1974 (cat.).– Lemoine, S. et al. (ed.): M. L. Westfälisches Landesmuseum, Münster et al. Münster 1996 (cat.).– Moffet, K.: M. L. in the Museum of Fine Art. Boston 1979.– Swanson, D. and D. Upright Headly (ed.): M. L. The Veil Cycle. Walker Art Center, Minneapolis et al. Minneapolis 1977 (cat.)

**LUGINBÜHL Bernhard**
born 1929 Bern
Swiss sculptor. 1945–1948 Trained as a sculptor at the Bern School of Arts and Crafts. 1949 First sculptures in iron. 1961 First copperplate engravings. 1964 Awarded the Colin Prize at the Venice Biennale; took part in documenta 3 in Kassel. 1967 Began

making films. 1976 In a joint action with Tinguely, burned a large sculpture on meadowland outside Bern. 1977/78 Staged three *Zorn-Aktionen* (Wrath happenings) protesting against the destruction of the environment. 1980/81 DAAD scholarship to Berlin. 1989 Retrospective at the Kunstmuseum Bern. Luginbühl's incongruous conglomerations of manufactured machine parts are reminiscent of Kinetic Art and Nouveau Réalisme.
CATALOGUE RAISONNE: Aebersold, M. and P. Tanner (ed.): B. L. Die Druckgraphik 1945-1996. Zurich 1996 (cat.)
MONOGRAPHS, CATALOGUES: Bezzola, L.: Sapperlot – Der Eisenplastiker B. L. Bern 1967.– Billeter, E. et al. (ed.): L. Zorn. Eine Dokumentation aller Verbrennungen. Bern 1984.– Gallwitz, K. (ed.): B. L. Die kleine explosive Küche. Frankfurt-on-Main 1981.– Haenlein, C.-A. (ed.): B. L. Kestner-Gesellschaft. Hanover 1975 (cat.).– Haftmann, W. and F. Baumann (ed.): B. L. Nationalgalerie. Berlin 1972 (cat.).– Kamber, A. (ed.): B. L. Zeichnungen 1946-1984. Kunstmuseum Solothurn al. Solothurn 1984 (cat.).– B. L. Grafikkatalog 1974. Ulmer Museum. Geneva 1974 (cat.).– B. L. Holderbank. Holderbank-Management und -Beratung 1994 (cat.).– Sculpteurs à l'usine: B. L. Zurich et al. 1990.– Tavel, C. v. et al. (ed.): B. L. Figuren 1947-1989. Reithalle und Kunstmuseum Bern. Bern 1989 (cat.)

**LÜPERTZ Markus**
born 1941 Reichenberg (Bohemia)
German painter. 1956–1961 Studied at the Krefeld School of Arts and Crafts and the Düsseldorf Academy. 1962 Moved to Berlin where he founded the artists' cooperative gallery Großgörschen 35. Contrary to the contemporary trends towards Abstraction, Lüpertz' first paintings were figurative compositions. 1966 He labelled his eloquent expressive style *dithyrambische Malerei* (dithyrambic painting), after a cult song to the Greek god of fruitfulness Dionysos. 1969–1977 *Motiv-Bilder*, still-life compositions of objects such as steel helmets, shovels and flags, grossly enlarged and loaded with historic symbolism. 1970 Awarded a year's scholarship to the Villa Romana in Florence. 1976 Appointed professor at the Karlsruhe Academy. From 1977

reverted to his abstract approach of the 50s again in *Stil-Bildern*. 1977 and 1982 Participation in documenta 6 and 7 in Kassel. 1980–1985 Stage designs and wall paintings. 1986 Professorship at the Düsseldorf Academy of Arts where, in 1988, he became director. In the late 80s and 90s, Lüpertz resumed representational painting, and also produced colourfully painted, figurative monumental bronzes.
WRITINGS: M. L.: Dithyrambisches Manifest. Berlin 1966.– M. L.: Tagebuch. New York 1984. Berlin 1984.– M. L.: Bleiben Sie sitzen Heinrich Heine. Vienna 1984.– M. L.: M. L. im Gespräch mit H. P. Schwerfel. Cologne 1989
CATALOGUE RAISONNE: Hofmaier, J. (ed.): M. L. Druckgraphik. Werkverzeichnis 1960-1990. Munich and Stuttgart 1991
MONOGRAPHS, CATALOGUES: Bätschmann, O. et al. (ed.): M. L. Gemälde nach Poussin. Museum Ostdeutsche Galerie. Regensburg 1993 (cat.).– Bojescul, W. (ed.): M. L. Arbeiten auf Papier, Bilder und Skulpturen. Kunstverein Braunschweig. Brunswick 1987 (cat.).– Caradente, G. di (ed.): M. L. Milan 1994.– Fuchs, R. (ed.): M. L. Stedelijk Van Abbe Museum. Eindhoven 1977 (cat.).– Gachnang, J. and T. Kneubühler (ed.): M. L. Dithyrambische und Stil-Malerei. Kunsthalle Bern. Bern 1977 (cat.).– Gachnang, J. et al. (ed.): M. L. Retrospectiva 1963-1990. Pintura, escultura, dibujo. Museo Nacional Centro de Arte Reina Sofia. Madrid 1991 (cat.).– Gallwitz, K. (ed.): M. L. Eine Festschrift. Staatliche Kunsthalle Baden-Baden. Baden-Baden 1973 (cat.).– Gohr, S. (ed.): M. L. Gemälde und Handzeichnungen 1964-1979. Josef-Haubrich-Kunsthalle. Cologne 1979 (cat.).– Gohr, S. (ed.): M. L. Deutsche Motive. Stuttgart 1993.– Gohr, S. (ed.): M. L. Kunsthalle der Hypo-Kulturstiftung, Munich et al. Munich 1997 (cat.).– Haaser, S. (ed.): M. L. Museum Moderner Kunst Stiftung Ludwig. Vienna 1994 (cat.).– Haenlein, C. (ed.): M. L. Bilder 1970-1983. Kestner-Gesellschaft. Hanover 1983 (cat.).– Hofmann, W. and S. Holsten (ed.): M. L. Hamburger Kunsthalle. Hamburg 1977 (cat.).– Irsigler, K. A. (ed.): M. L. Museum Moderner Kunst Stiftung Ludwig. Vienna 1994 (cat.).– Jensen, H. C. (ed.): M. L. Bilder 1985-1988. Kunsthalle zu Kiel und Schleswig-Holsteinischer Kunstverein. Kiel 1988 (cat.).– Kempas, T. (ed.): M. L. Folgen: Zeichnung und Malerei auf Papier. Haus am Waldsee. Berlin 1989 (cat.).– Kronjäger, J. (ed.): M. L. Skulpturen in Bronze. Städtische Kunsthalle Mannheim et al. Heidelberg 1995 (cat.).– M. L. Musée de Strasbourg. Strasbourg 1983 (cat.).– M. L. Stedelijk Museum. Amsterdam 1997 (cat.).– Rödiger-Diruf, E. (ed.): M. L. Rezeptionen, Paraphrasen. Städtische Galerie im Prinz Max Palais. Karlsruhe 1991 (cat.).– Rudloff, M. et al. (ed.): M. L. Skulpturen in Bronze. Städtische Kunsthalle Mannheim et al. Mannheim 1995 (cat.).– Schmidt, J. K. (ed.): Homo homini lupus. M. L. Krieg. Kunst- und Kunstgewerbeverein Reuchlinhaus, Pforzheim et al. Pforzheim 1994 (cat.).– Schrenk, K. (ed.): M. L. Malerei, Plastik, Zeichnung. Städtisches Kunstmuseum Bonn. Cologne 1993 (cat.).– Serota, N. and S. Gohr (ed.): M. L. Style-Paintings 1977-1979. Whitechappel Art Gallery. London 1981 (cat.).– Sommer, A. (ed.): M. L. Malerei, Plastik, Zeichnung. "Ausstellung als Konflikt und Traum des Sammlers". Städtisches Kunstmuseum Bonn. Bonn 1993 (cat.).– Zweite, A. (ed.): M. L. Belebte Formen und kalte Malerei. Gemälde und Skulpturen. Städtische Galerie im Lenbachhaus. Munich 1986 (cat.).– Zweite, A. (ed.): M. L. Gemälde, Skulpturen. Kunstsammlung Nordrhein-Westfalen. Stuttgart 1996 (cat.)

**MCBRIDE Will**
born 1931 St. Louis (MO)
American photographer. Studied illustration under N. Rockwell at the Academy of Design in New York, and art and art history at the Art Institute of Chicago and at Syracuse University in New York. 1953–1955 Worked as a military photographer for the US Army in Würzburg. 1955–1957 Studied German literature and philology at Berlin University. While still a student, sold photographs to newspapers in Berlin. From 1959 worked as a freelance photographer for *Life* magazine, *Look*, *Stern*, *Paris-Match* and, above all, for *Twen*; first in Berlin, and from 1961–1972 in Munich. Thereafter moved to Casoli in Italy, where he worked as a sculptor. Between 1968 and 1972 he won the Gold Medal of the Art Directors Club of Germany three times. 1982 Publication of his most famous volume of photographs *Siddhartha*.
MONOGRAPHS, CATALOGUES: Finck v. Finckenstein, H.-W. v.: W. M. Adenauer: Ein Porträt. Starnberg 1965.– W. M.: I, W. M. Cologne 1997.– Weiermair, P. (ed.): W. M. 40 Jahre Fotografie. Frankfurter Kunstverein. Frankfurt-on-Main 1992 (cat.)

**MCCOLLUM Allan**
born 1944 Los Angeles
American painter and sculptor. 1971 First solo-exhibition at the Jack Glenn Gallery, Corona Del Mar (CA). 1988 Exhibited at Portikus in Frankfurt am Main. 1988 Participated at the Venice Biennale, and 1989 in the exhibition "Bilderstreit", organised by Museum Ludwig at the Cologne Trade Centre. 1993 Showed his *240 Plaster Surrogates* at the Shiraishi Contemporary Art Inc. in Tokyo. 1996 Solo-exhibition in the Sprengel Museum in Hanover.
MONOGRAPHS, CATALOGUES: Nittve, L. et al. (ed.): A. M. Malmö Konsthall. Malmö 1990 (cat.).– A. M. Perfect Vehicles. The John and Mable Ringling Museum of Art. Sarasota (FL) 1988 (cat.).– A. M. Musée d'Art Contemporain. Nîmes 1988 (cat.).– A. M. 240 Plaster Surrogates. Shiraishi Contemporary Art. Inc. Tokyo 1993 (cat.).– A. M. Natural Copies. Sprengel Museum. Hanover 1996 (cat.).– Rorimer, A. et al. (ed.): A. M. Stedelijk Van Abbe Museum, Eindhoven et al. Eindhoven 1989 (cat.)

## MACDONALD-WRIGHT Stanton
**1890** Charlottesville (VA) – **1973** Pacific Palisades (CA)
American painter. Went to art school in Los Angeles. **1907** Moved to Paris, where he studied at the Académie des Beaux-Arts, the Académie Julian and at the Sorbonne. **1912** Founded the Synchromist movement with Morgan Russel. **1913** Exhibition at the Salon des Indépendants in Paris. Took part in a presentation of Synchromism in Munich and in the Armory Show in New York. **1916** Returned to the USA. Solo-exhibition at Stieglitz' Gallery 291 in New York. **1919** Experimented with colour films. Paintings became representational again. **1922–1930** Director of the Los Angeles Art Students League. **1937** Went to Japan and afterwards lectured in oriental and modern art at the University of California and in Los Angeles. In the early 40s developed his own Petrachrome-technique for wall painting. **1954** Resumed abstract painting. **1956** Major retrospective at the County Museum in Los Angeles. Macdonald-Wright is one of the main representatives of Synchromism, an art movement stressing the importance of colour and closely related to Delaunay's Orphism.
MONOGRAPHS, CATALOGUES: M.-W. A Retrospective of the Work of S. M.-W. Los Angeles 1956 (cat.).– Scott, D. (ed.): The Art of M.-W. National Collection of Fine Arts. Washington 1967 (cat.)

## MACIUNAS George
**1931** Kaunas (Lithuania) – **1978** New York
Lithuanian-born American artist. **1949–1952** Studied art and architecture at the Cooper Union School of Art in New York and **1952–1954** architecture and musicology at the Carnegie Institute of Technology in Pittsburgh. **1955–1960** Research into European and Siberian Art during the period of the migration of peoples at the Institute of Fine Arts in New York. **1960** Took classes in electronic music under Richard Maxfield at the New School for Social Research in New York. Met the composer La Monte Young and other artists studying with Cage, including George Brecht and Allan Kaprow, who would later form the Fluxus movement. **1961** Gave a series of lectures and demonstrations, entitled *Musica Antiqua*

*et Nova* in the AG Gallery in New York, which he owned. **1961–1963** Stationed in Germany, working as a graphic artist for the airforce. **1962** Organised the Festum Fluxorum in Wiesbaden, coordinating Fluxus concerts worldwide, from Berlin to New York. **1963** Publication of the Fluxus manifesto. Maciunas was the founder and chief organiser of the Fluxus movement. He wrote scores for music performances in which he often participated himself, wrote theoretical articles about Fluxus and designed Fluxus objects.
MONOGRAPHS, CATALOGUES: Hendricks, J.: Fluxus Codes. New York 1988

## MACK Heinz
born **1931** Lollar
German artist. **1950–1953** Studied at the Düsseldorf Art Academy. **1956** Graduated from Cologne University. First monochrome *Dynamic Structures*. **1957** First solo-exhibition at the Galerie Schmela in Düsseldorf. **1958–1961** Founded the Zero group with otto Piene and Günther Uecker, and issued their magazine. **1959** Participated in documenta 2 in Kassel. **1962/63** Trips to Algeria and Morocco, where he carried out his first light experiments in the desert. Up to **1964** worked as an art teacher. **1967** Moved to Mönchengladbach. **1968** Carried out the Sahara project, conceived in 1958: the building of an artificial light garden supported on 11 m high posts in the desert. From **1968** structure reliefs such as light wings and light compartments out of aluminium. **1972** Developed the idea of a water cloud for the Olympic Games in Munich. **1979** Won the international competition Licht 79. **1983** Participated in the Sky Art Conference in Munich. **1987** Order of merit from the state of Nordrhein Westphalen. The kinetic light artist Mack is best known for his architectonic light arrangements in cities and his light environments in desert landscapes.
WRITINGS: H. M. and T. Höpker: Expedition in künstliche Gärten. Hamburg 1976
CATALOGUES RAISONNES: Honisch, D.: M. Skulpturen 1953-1986. Düsseldorf and Vienna 1986/M. Sculptures 1953-1986. London 1986, New York 1989.– Fulda-Kuhn, A. and U. Mack (ed.): H. M. Drei von Hundert. Werkverzeichnis der Druckgraphik und Multiples. Stuttgart 1991
MONOGRAPHS, CATALOGUES: Bense, M.: M. Kunst in der Wüste. Starnberg 1969.– Heckmanns, H.: M. Handzeichnungen. Cologne 1974.– Leismann, B. (ed.): MACK Lichtkunst. Cologne 1994.– Mack, U. (ed.): Wegweise zu den Werken von H. M. Düsseldorf, Vienna 1992.– M. Skulpturen. Im Raum der Natur. Cologne 1991.– Ruhrberg, K. (ed.): M. Sehverwandtschaften. Stuttgart 1989.– Ruhrberg, K. (ed.): H. M. Licht und Licht in der Kirche. Köln 1997.– Staber, M.: H. M. Cologne 1968.– Staber, M. (ed.): H. M. Akademie der Künste. Berlin et al. Berlin 1972 (cat.).– Stemmler, D. (ed.): Zero-M. Der Lichtwald 1960-1969. Städtisches Museum Abteiberg.

## MACKE August
**1887** Meschede (Sauerland) – **1914** Perthes-les-Hurlus (Champagne)
German painter. **1904–1906** Studied at the Art Academy and the School of Arts and Crafts in Düsseldorf. **1905** First trip to Italy. **1906** Visits to Belgium, Holland and England. **1907/08** Attended the Corinth School of Painting in Berlin. **1908** Extended visit to Paris with Elisabeth Erdmann. Settled near the Tegernsee and **1909/10** had contact with the Neue Künstlervereinigung München (New Artists' Association) in Munich. Close friendship with Marc. **1911** Contributed to the Blauer Reiter Almanac and took part in their exhibition. Moved to Bonn. **1912** Helped to set up the Sonderbund exhibition in Cologne. Went to Paris with Marc to contact Apollinaire and Delaunay. **1913** Organised the exhibition of the Rhenish Expressionists in Bonn. **1914** On a trip to Tunisia, with Moilliet and Klee, painted a series of watercolours in the powerful colours and clear tectonic style for which he is famous. He was killed in action on the German-French front in World War I. Macke's prismatically structured paintings, flooded with light, are representative of German Orphism.
WRITINGS: Macke, W. (ed.): A. M./F. Marc: Briefwechsel. Cologne 1964.– Frese, W. and E.-G. Güse (ed.): A. M. Briefe an Elisabeth und die Freunde. Munich 1987
CATALOGUES RAISONNES: Güse, E.-G. (ed.): A. M. Gemälde, Aquarelle, Zeichnungen. Munich 1986.– Heiderich, U. (ed.): A. M. Die Skizzenbücher. 2 vols. Stuttgart 1987.– Heiderich, U. (ed.): A. M. Zeichnungen. Werkverzeichnis. Stuttgart 1993.– Heiderich, U. (ed.): A. M. Aquarelle. Werkverzeichnis. Stuttgart 1997.– Vriesen, G.: A. M. Stuttgart 1953, 1957
MONOGRAPHS, CATALOGUES: Bartmann, D.: A. M. Kunsthandwerk. Glasbilder, Stickereien, Keramiken, Holarbeiten und Entwürfe. Berlin 1979.– Bitter, R. v.: A. M. Munich 1993.– Busch, G.: A. M. Das Russische Ballett. Stuttgart 1966.– Busch, G.: A. M. Handzeichnungen. Mainz, Berlin 1966.– Bußmann, K. and B. Kühn (ed.): A. M. 1887-1914. Aquarelle und Zeichnungen. Westfälisches Landesmuseum, Münster et al. Münster 1976 (cat.).– Erdmann-Macke, E.: Erinnerung an A. M. Stuttgart 1962.– Firmenich, A. (ed.): A. M. "Gesang der Schönheit der Dinge". Aquarelle und Zeichnungen. Kunsthalle Emden et al. Cologne 1992 (cat.).– Friesen, A. v.: A. M. Ein Maler-Leben. Hamburg 1989 (cat.).– Güse, E.-G. (ed.): A. M. Retrospektive zum 100. Geburtstag. Westfälisches Landesmuseum, Münster et al. Münster 1986 (cat.).– Gustav, J.: A. M. Ramerding 1978.– A. M. Gedenkausstellung zum 70. Geburtstag. Westfälisches Landesmuseum. Münster 1957 (cat.).– A. M. Kunsthalle Bremen.

Bremen 1964 (cat.).– A. M. 1887-1914. Zeichnungen, Aquarelle, Graphik. Städtische Kunstsammlung. Bonn 1964 (cat.).– A. M. Gemälde, Aquarelle, Zeichnungen. Hamburger Kunstverein. Hamburg 1968 (cat.).– Macke, W.: A. M. Aquarelle. Munich 1958.– Meseure, A.: A. M. Cologne 1991.– Moeller, M. M.: A. M. Kön 1988.– Moeller, M. M. (ed.): A. M. Die Tunisreise. Munich 1989/A. M. Le Voyage en Tunisie. Paris 1990.– Röthel, H. K. (ed.): A. M. Städtische Galerie im Lenbachhaus. Munich 1962 (cat.).– Weyandt, B.: Farbe und Naturauffassung im Werk von A. M. Hildesheim and Zurich 1994

## MCLEAN Bruce
born **1944** Glasgow
English performance artist, painter and sculptor. **1961–1966** Studied at the Glasgow School of Art and at St. Martin's School of Art, London. Began working on minimal sculptures and staging events. **1965** Pratt Sculpture Bequest. **1969** First solo-exhibition at the Konrad Fischer gallery, Düsseldorf. From then on, used the human body as well as traditional art mediums and postcards in his works, the relation to sculpture remaining a key element. From **1971** photo, video and film projects. **1971–1974** Collaboration with the group Nice Style. **1975** Further performances, performance-sculptures and theater projects. Received an Arts Council award. **1977–1987** Participation in documenta 6 – 8 in Kassel. **1981** DAAD scholarship to Berlin.
WRITINGS: B. M. Dream Works. London 1985.– B. M. Ladder. London 1987.– B. M. Apropos the Jug. London 1988.– B. M. A Scone off a Plate. Glasgow 1990
CATALOGUE RAISONNE: Hunt, J. (ed.): B. M. Prints 1978-1991. London 1992
MONOGRAPHS, CATALOGUES: Ammann, J.-C. et al. (ed.): B. M. Kunsthalle Basel et al. Basel 1981 (cat.).– Beaumont, M. R. (ed.): B. M. The Scottish Gallery. Edinburgh 1986 (cat.).– Dimitrijevic, N. (ed.): B. M. Whitechapel Art Gallery, London et al. London 1981 (cat.).– Genger, G. et al. (ed.): B. M. Minimal Moves. Galerie Gmyrek. Düsseldorf 1991 (cat.).– Gooding, M.: B. M. Oxford 1990.– B. M. Where Do You Stand? Museum voor Hedendaagse Kunst. 's-Hertogenbosch 1988 (cat.)

## MAGNELLI Alberto
**1888** Florence – **1971** Meudon
Italian painter. Self-taught. After a technical training he devoted himself to painting. **1914** Contact with the Futurists and Cubist in Paris. Close relations to Guillaume Apollinaire, Max Jacob, Picasso, Giorgio De Chirico, J. Gris, F. Léger and Archipenko. **1915** First fully abstract paintings. **1917** Use intense, garish colours in the series *Lyrical Explosions*. **1918** Reverted to representational painting. **1919** Trips to Germany and Austria. **1931** Moved to Paris. **1934** Met Kandinsky and Arp. **1940–1944** Lived with

Arp, Taeuber-Arp and Sonja Delaunay in the artists' colony in Grasse. **1947** Exhibition at the Galerie René Drouin in Paris. From **1950** geometric colour compositions in an Analytical Cubist style. **1955** and **1959** participation in documenta 1 and 2 in Kassel. **1963** Major retrospectives in Zurich, Florence and Essen. In his works from the 60s, including paintings and collages, Magnelli moved away from Cubism to a clearly delineated geometry, closely related to Hard-Edge painting.

CATALOGUES RAISONNES: Maisonnier, A. (ed.): A. M. Catalogue raisonné de l'œuvre peint. Paris 1975.– Maisonnier, A. (ed.): Catalogue raisonné de l'œuvre gravé. Paris 1980.– Maisonnier, A. (ed.): Les Ardoises peintes. Paris 1981.– Maisonnier, A. (ed.): Collages. Paris 1990
MONOGRAPHS, CATALOGUES: Abadie, D. and G. C. Argan (ed.): M. Ardoises et collages. Centre Georges Pompidou, Paris et al. Paris 1986 (cat.).– Abadie, D. et al. (ed.): M. Centre Georges Pompidou. Paris 1989 (cat.).– Calvesi, M. and S. Salvi (ed.): Omaggio a M. Palazzo Vecchio, Florence. Milan 1988 (cat.).– De Micheli, M. (ed.): A. M. Realismo immaginario. Disegni editi e inediti 1920-1929. Forte dei Marmi. Milan 1987 (cat.).– Lassaigne, J. and A. Lochard (ed.): A. M. 1909-1918. Palais des Beaux-Arts, Brussels et al. Brussels 1973 (cat.).– Lochard, A.: M. Opere 1907-1939. Roma 1972.– A. M. Kunsthaus Zürich. Zurich 1963 (cat.).– A. M. Folkwang Museum. Essen 1964 (cat.).– A. M. Dessins florentins 1914-1918. Musée des Beaux-arts. Rennes 1981 (cat.).– A. M. Angermuseum. Erfurt 1993 (cat.).– Maisonnier, A.: Les. M. de Vallauris. Etapes d'une abstraction formelle. Paris 1994.– Maisonnier, A. (ed.): A. M. Dessins. Musée d'Art Moderne de Saint-Etienne. Saint-Etienne 1988 (cat.).– Mendes, M.: A. M. Roma 1964.– Ponente, N.: A. M. Roma 1973.– Russoli, F. et al. (ed.): A. M. Palazzo Strozzi. Florence 1963 (cat.)

**MAGRITTE René**
**1898** Lessines (Hennegau) – **1967** Schaerbek (near Brussels)
Belgian painter. **1916–1919** Attended the Académie des Beaux-Arts in Brussels. **1922** Worked as a designer and draughtsman in a wallpaper factory, and from **1923** designed posters and fashion advertise-ments. Together with the Constructivist Victor Servranckx, wrote the text to *L'art pur: défense de l'esthéthique*. First geometric abstract paintings. **1924** Encountered De Chirico's Pittura Metafisica. **1925** Co-editor of the magazine *Œsophage*, propounding dadaist-surrealist principles. **1927** First solo-exhibition at the Galerie Le Centaure in Brussels. Moved to Perreux-sur-Marne near Paris. Made contact with Surrealist artists centred around Paul Eluard and André Breton in Paris. **1930** Returned to Brussels. **1936** First solo-exhibition in the USA at the Julien Levy Gallery in New York. Participated in the International Surrealist Exhibition in London and helped to organise the exhibition "Fantastic Art, Dada, Surrealism" at the Museum of Modern Art in New York. **1943** La période Renoir. **1948** La période vache. **1953** Produced a series of wall paintings (*Enchanted Land*) for the Casino in Knokke le Zoute. **1960–1967** Retrospectives in America, Germany, Holland and Sweden. **1996** and **1998** major retrospectives in Düsseldorf and Brussels. Magritte participated in all the important Surrealist exhibitions, and holds a special position in the Surrealist movement. His representation of commonplace objects avoids any illusion of reality and attempts to reveal the riddles hidden within.
WRITINGS: Blavier, A. (ed.): Les Ecrits complets de R. M. Paris 1978 / R. M. Sämtliche Schriften. Darmstadt 1985.– Hunter, S. (ed.): M. / Torczyner. Letters Between Friends. New York 1994.– Perceval, F. (ed.): R. M. Lettres à André Bosmans. 1958-1967. Paris 1990
CATALOGUES RAISONNES: Goemans, C. (ed.): Œuvre 1922-1957. Couverture de R. M. Brussels 1979.– Kaplan, G. E. and T. Baum (ed.): The Graphic Work of. R. M. New York 1982.– Sylvester, D. and S. Whitfield (ed.): R. M. Catalogue raisonné. 6 vols. Antwerp and London 1992-1996
MONOGRAPHS, CATALOGUES: Blistène, B. et al. (ed.): R. M. La Période "vache". Musée Cantini, Marseille. Paris 1992 (cat.).– Cortenova, G. (ed.): Da M. a M. Palazzo Forti, Verona. Milan 1991 (cat.).– Dachy, M. et al. (ed.): R. M. et le surréalisme en Belgique. Musées Royaux des Beaux-Arts de Belgique. Brussels 1982 (cat.).– Faerna, J. M.: M. New York 1996.– Foucault, M.: Ceci n'est pas une pipe. Montpellier 1973, Munich 1974 / This Is Not a Pipe. Illustrations and Letters by R. M. Berkeley 1982.– Gablik, S.: M. London and Greenwich (CT) 1970, Zurich and Munich 1971.– Gimferrer, P.: M. Recklinghausen 1987, New York 1987, 1990.– Haddad, H.: M. Paris 1996.– Hammacher, A. M.: R. M. Paris 1968, 1974, New York 1974, 1995, Cologne 1975.– Jongen, R.-M.: R. M. ou la pensée imagée de l'invisible. Brussels 1994.– Kaulingsfreks, R.: Meneer ledereen: over het denken van R. M. Nijmwegen 1984.– Konersmann, R.: R. M. Die verbotene Reproduktion. Über die Sichtbarkeit des Denkens. Frankfurt-on-Main 1991.– R. M. The Museum of Modern Art, New York et al. New York 1965 (cat.).– R. M. Het mysterie van de werkelijkheid. Museum Boymans-van Beuningen. Rotterdam 1967 (cat.).– R. M. Fondation de l'Hermitage. Lausanne 1987 (cat.).– R. M. Provincial Museum voor Moderne Kunst. Oostende 1990 (cat.).– R. M. Die Kunst der Konversation. Kunstsammlung Nordrhein-Westfalen, Düsseldorf. Munich 1996 (cat.).– R. M. Musée d'Art Ancien. Stuttgart 1998 (cat.).– Marcadé, B.: R. M. Attempting the Impossible. Brussels 1992.– Mariën, M.: Apologies de M. 1938-1993. Brussels 1994 (cat.).– Meuris, J.: R. M. Paris 1988, Cologne 1990, Woodstock (NY) 1990.– Meuris, J.: R. M. Cologne 1991.– Meuris, J.: M. et les mystères de la pensée. Brussels

1992.– Müller, A.: R. M. Die Beschaffenheit des Menschen. Frankfurt a. M. 1989.– Ollinger, Zinque, G. et al. (ed.): R. M. Musée d'Art Ancien. Brussels 1998 (cat.).– Paquet, M.: M. ou l'éclipse de l'être. Paris 1982.– Paquet, M.: R. M. Thought rendered visible. Cologne 1994.– Passeron, R.: R. M. Paris 1970, 1972, New York 1972, 1980, Cologne 1986.– Roberts-Jones, P.: M. Poète visible. Brussels 1972.– Schiebler, R.: Die Kunsttheorie R. M.'s. Munich and Vienna 1981.– Schmied, W. (ed.): R. M. Kunsthalle der Hypo-Kulturstiftung. Munich 1987 (cat.).– Schneede, U. M.: R. M. Leben und Werk. Cologne 1975.– Schreier, C.: R. M. Sprachbilder 1927-1930. Hildesheim, Zurich 1985.– Scutenaire, L.: Avec M. Brussels 1977, 1987.– Scutenaire, L.: La Fidélité des images. R. M., le cinématographe et la photographie. Brussels 1978.– Scutenaire, L. et al. (ed.): R. M. Palais des Beaux-Arts, Brussels et al. Brussels 1979 (cat.).– Sylvester, D.: M. The Silence of the World. New York 1992, 1994 / M. Basel 1992 / M. Paris 1992.– Takashi, K. et al. (ed.): R. M. 1898-1967. Le Musée National d'Art Moderne. Tokyo 1988 (cat.).– Torczyner, H.: R. M. Signes et images. Paris 1977 / R. M. Ideas and Images. New York 1977 / R. M. Zeichen und Bilder. Cologne 1977.– Torczyner, H.: L'Ami M. Correspondance et souvenirs. Antwerp 1992.– Waldberg, P.: R. M. Brussels 1965, New York 1965.– Whitfield, S. (ed.): M. Hayward Gallery, London et al. London 1992 (cat.)

**MAILLOL Aristide**
**1861** Banyuls-sur-Mer – **1944** Banyuls-sur-Mer
French sculptor. **1882** Moved to Paris. **1882–1886** Studied art at the Ecole des Beaux-Arts. **1889** Met Bourdelle. **1892** Contact with the Nabis, Bernard and Denis; greatly impressed by Gauguin. **1893** Set up his own tapestry weaving business in Banyuls-sur-Mer. **1895** First sculptures. **1896** Carved wooden sculptures. **1898** Began to work in terracotta. **1899** Moved to Villeneuve-Sainte-Georges, where he met Picasso. **1902** First solo-exhibition organised by Vollard in Paris. **1904/05** Participated in exhibitions at the Salon d'Automne. **1905** Friendships with Matisse and Harry Graf Kessler. **1908** Trip to Greece with his patrons Graf Kessler and Hugo von Hofmannsthal. **1910** Woodcuts and illustrations for *Daphnis and Chloe* and for Ovid's *Ars Amandi*. **1912** Worked on a monument to Cézanne, erected in **1929** in the Tuileries. Monument to soldiers killed in southwest France between **1919** and **1933**. Met Barlach on a trip to Germany. **1936** Tour of Italy. **1939** Resumed painting. Maillol's many sculptures of female figures in repose consciously continued the classical tradition and had a lasting influence, especially on German sculptors such as Georg Kolbe and Wilhelm Lehmbruck.
CATALOGUES RAISONNES: Guérin, M. (ed.): Catalogue raisonné de l'œuvre gravé et lithographié de A. M. 2 vols. Geneva 1965-

1967.– Rewald, J. (ed.): The Woodcuts of A. M. A Complete Catalogue. New York 1951
MONOGRAPHS, CATALOGUES: Appelbaum, S. (ed.): M. Woodcuts. 303 Great Book Illustrations by A. M. New York 1979.– Bassères, F.: M. mon ami. Paris 1979.– Berger, U. and J. Zutter (ed.): A. M. Georg-Kolbe-Museum, Berlin et al. Munich 1996 (cat.).– Borràs, L. (ed.): A. M. 1861-1944. Fundació Caixa de Pensiones. Barcelona 1979 (cat.).– Bouillée, M.: M. La Femme toujours recommencée. Paris 1989.– Busch, G.: A. M. als Illustrator. Neu-Isenburg 1970.– Cabanne, P. et al. (ed.): M. Galerie Dina Vierny. Paris 1987 (cat.).– Cassou, J. (ed.): Hommage à A. M. Musée National d'Art Moderne. Paris 1961 (cat.).– Chevalier, D.: M. Munich 1971.– Cladel, J.: A. M. Sa Vie, son œuvre, ses idées. Paris 1937.– George, W. and D. Vierny: A. M. Berlin 1964, New York 1965.– George, W.: A. M. et l'âme de la sculpture. Neuchâtel 1977.– Grand-Chastel, P.: A. M. Milan 1966.– Harsányi, Z.: M. Budapest 1979.– Linnenkamp, R.: A. M. Die großen Plastiken. Munich 1960.– Lorquin, B.: M. aux Tuileries. Paris 1991.– Lorquin, B.: A. M. Geneva 1994, London and New York 1995.– A. M. Musée Cantonal des Beaux-Arts. Lausanne. 1996 (cat.).– Monery, J.-P. (ed.): A. M. Musée de Saint-Tropez. Saint Tropez 1994 (cat.).– Peters, H. A. (ed.): M. Kunsthalle Baden-Baden. Baden-Baden 1978 (cat.).– Rewald, J.: M. London and New York 1939, Paris 1939.– Rewald, J. (ed.): A. M. 1861-1944. Solomon R. Guggenheim Museum. New York 1975 (cat.).– Rewald, J. and M. C. Valaison (ed.): M. au Palais des Rois de Majorque. Musée Hyacinthe Rigaud. Perpignan 1979 (cat.).– Rewald, J. et al. (ed.): A. M. Musée Départemental des Beaux-Arts, Yamanashi et al. Paris 1984 (cat.).– Slatkin, W.: A. M. in the 1890s. Ann Arbor (MI) 1982.– Uhde-Bernays, H.: A. M. Dresden 1957.– Vierny, D. (ed.): A. M. Haus der Kunst. Munich 1962 (cat.).– Vierny, D. et al. (ed.): M. La Méditerranée. Musée d'Orsay. Paris 1986 (cat.).– Waldemar, G.: M. Neuchâtel. 1977

**MALEVICH Kasimir**
**1878** Kiev – **1935** Leningrad
Russian painter. **1895** Began studies at the Kiev School of art, his first paintings being influenced by Impressionism. From **1900** lived in Moscow where he became friends with the Rayonists Larionov and Goncharova and encountered Fauvism. **1910** Studied and experimented with Symbolism, Cubism and Futurism and took part in the first exhibition of the artists' group Karo-Bube. **1913** Designed geometric, non-representational stage sets for the futuristic opera *Der Sieg über die Sonne*. **1915** Displayed Suprematist compositions at the last Futurist exhibition in Petrograd, among them his famous painting *Black Square on a White Field* (St. Petersburg, Russian State Museum). **1916** Called for the 'freeing of art from the burden of the object' in his article *From Cubism and Futurism to Suprema-*

tism. After the October Revolution in **1917**, taught at the State Art School in Moscow. From **1919** involved in the setting up of a school of modern art in Vitebsk, and from **1922** in a similar project in Petrograd. **1921** The new political system led to a crack down on his New Art. At the exhibition "15 years of Soviet Art" held in Moscow in **1932**, Malevich's works were hung in a separate room as a cautionary example of subversive revolutionary art.
WRITINGS: Andersen, T. (ed.): K. M. Essays on Art. 4 vols. Copenhagen 1966-1978.– K. M.: Die gegenstandslose Welt. Munich 1927, Mainz 1980.– K. M.: Über die neuen Systeme in der Kunst. Zurich 1988.– Nakov, A. B. (ed.): M. Ecrits. 4 vols. Paris 1975-1981
CATALOGUES RAISONNES: Karshan, D. (ed.): M. The Graphic Work 1912-1930. London and New York 1982.– Nakov, A. B. (ed.): K. M. Leben und Werk. Catalogue Raisonné. 3 vols. Landau 1992/93
MONOGRAPHS, CATALOGUES: Basner, E. B. and E. N. Petrova (ed.): K. M. Una retrospettiva. Palazzo Medici-Riccardi. Florence 1993 (cat.).– Beeren, W. A. L. (ed.): K. M. 1878-1935. Stedeljik Museum, Amsterdam et al. Amsterdam 1988 (cat.).– Crone, R. and D. Moos: K. M. The Climax of Disclosure. Chicago 1991.– Douglas, C.: M. Artist and Theoreticain. New York 1991.– Duborgel, B.: M. La Question de l'icône. Saint-Etienne 1997.– Fauchereau, S.: K. M. Paris 1991, Northford 1993.– Haftmann, W. (ed.): K. M. Suprematismus. Die gegenstandslose Welt. Cologne 1962, 1989.– Kowtun, J. (ed.): K. M. Werke aus sowjetischen Sammlungen. Städtische Kunsthalle Düsseldorf. Düsseldorf 1980 (cat.).– K. M. 1878-1935. Stedeljik Museum, Amsterdam 1988 (cat.).– Andrea, J. d' (ed.): K. M. 1878-1935. National Gallery of Art, Washington et al. Washington 1990 (cat.).– K. M. Artiste et théoricien. Avec la collab. de E. E. Petrova. Paris 1990.– Marcadé, J.-C.: M. Paris 1990.– Martin, J.-H. and P. Hulten (ed.): M. Centre Georges Pompidou. Paris 1978 (cat.).– Martineau, E.: M. et la philosophie. Lausanne 1977.– Milner, J.: K. M. and the Art of Geometry. New Haven (CT) and London 1996.– Nakov, A.: K. M. Leben und Werk. 3 vols. Landau 1992-1994.– Petrova, E. et al. (ed.): K. M. Artist and Theoretician. London 1990/K. M. Künstler und Theoretiker. Weingarten 1991.– Rubinger, K. (ed.): K. M. zum 100. Geburtstag. Galerie Gmurzynska. Cologne 1978 (cat.).– Sarab'janov, D. V. and A. S. Satskich.: K. M. Moscow 1993.– Shadova, L. A. (ed.): K. M. und sein Kreis. Dresden 1978, Munich 1982.– Simmons, W. S.: K. M.'s Black Square and the Genesis of Suprematism 1907-1915. New York 1981.– Stachelhaus, H.: K. M. Ein tragischer Konflikt. Düsseldorf 1989.– Steinmüller, G.: Die suprematistischen Bilder von K. M. Malerei über Malerei. Cologne 1991.– Susovski, M. (ed.): K. M: Retrospektiva djela iz fundusa Ruskog Drzavnog Muzeja iz Lenjingrada. Muzej Suvremene Umjetnosti. Zagreb 1989 (cat.).– Valabrègue, F.: K. M. J'ai découvert un monde nouveau. Marseille 1994.– Weiss, E. (ed.): K. M. Werk und Wirkung. Museum Ludwig. Cologne 1995 (cat.).– Zhadova, L. A.: M. Suprematism and Revolution in Russian Art 1910-1930. London and New York 1982

**MANESSIER Alfred**
**1911** St.-Ouen – **1993** Orléans
French painter. **1926–1933** Studied architecture at the Ecoles des Beaux-Arts in Amiens and Paris. Friendship with Jean Le Moal. **1932** Trip to Holland. **1933** Exhibited at the Salon des Indépendants in Paris. **1935** Became acquainted with Bertholle and had

contact with the group of artists around Bissière. **1938–1949** Participated in exhibitions at the Salon d'Automne, Salon de Mai and Salon de la Libération in Paris. **1943** First copperplate engravings. Retreated to the Trappist monastery of Soligny and turned to religion. **1948** Took up lithography and designs for stained-glass windows. **1953** Awards at the São Paulo Biennale and **1954** at the exhibition "Sacred Art in Vienna". **1955–1964** Participation in documenta 1–3 in Kassel. **1958** Won an award from the Institut International d'Art Liturgique and **1962** the main international painting prize at the Venice Biennale. Manessier, whose abstractions are rooted in Cubism and Fauvism, is a representative of the Ecole de Paris. Typically, he painted flat, warmly-coloured, grid-like compositions with religious motifs as the central theme
CATALOGUES RAISONNES: Langlois, A. (ed.): A. M. Les Vitraux. Catalogue Raisonné. Bern 1993.– Manessier, C. (ed.): A. M. Catalogue raisonné (in preparation)
MONOGRAPHS, CATALOGUES: Cayrol, J.: M. Paris 1955, 1966.– Füglister, R. and G. Pflug: M. à Fribourg. Fribourg 1989.– Hodin, P.: A. M. Neuchâtel 1972, Bath 1972.– A. M. Gemälde, Handzeichnungen, Wandteppiche, Entwürfe für Glasfenster. Kunsthalle Bremen. Bremen. 1970 (cat.).– A. M. Œuvre de 1935-1969. Musée des Beaux-Arts. Dijon 1970 (cat.).– A. M. Centre International du Vitrail. Chartres 1993 (cat.).– Manessier, C. et al. (ed.): A. M. Œuvre tissé. Tapisseries, vêtements liturgiques. Abbatiale, Musée de Payerne et al. (o. O) 1993 (cat.).– Stoullig, C. et al. (ed.): A. M. Grand Palais. Paris 1992 (cat.)

**MANET Edouard**
**1832** Paris – **1883** Paris
French painter. After studying law for a short time and attending a naval school, he studied painting from **1850–1856** in the studio Couture and at the Académie Suisse. **1858** Rejected by the Salon. **1861** Salon début with paintings in a realist Spanish style. Took up themes of modern life. Became friends with Degas. **1863** Scandal caused by his painting *Déjeuner sur l'Herbe*, hung in the Salon des Refusés. **1866** Became acquainted with Monet and Zola. **1867** Put on his own exhibition during the Paris World Fair. **1874** A visit to Monet

in Argenteuil led him to adopt a freer Impressionist approach in his *plein-air* painting. **1875** Visited Venice. **1878** Rejected by the Paris World Fair. **1881** Elected to the Legion of Honour. **1883** Last pastel drawings. Died in appalling pain after amputation of a leg.
WRITINGS: Bareau, J. W. (ed.): M. par lui-même. Evreux 1991.– Courthion, P. and P. Cailler (ed.): M. raconté par lui même et par ses amis. 2 vols. Geneva 1953.– E. M.: Lettres de jeunesse 1848-1849. Voyage à Rio. Paris 1928.– E. M.: Lettres du siège de Paris. 1849-1850. Paris 1996.– Moreau-Nélaton, E. (ed.): M. raconté par lui-même. 2 vols. Paris 1926.– Tabarant, A. (ed.): Une Correspondance inédite d'E. M.: Les lettres du siège de Paris (1870-1871). Paris 1935.– Wilson-Bareau, J.: M. by Himself. Correspondence and Conversation. Boston 1991
CATALOGUES RAISONNES: Fisher, J. M. (ed.): The Prints of E. M. Washington 1985.– Guérin, M. (ed.): L'œuvre gravé de M. Paris 1944.– Harris, J. C. (ed.): E. M. The Graphic Work. A Catalogue Raisonné. New York 1970, San Francisco 1991.– Jamot, P. et al. (ed.): M. 2 vols. Paris 1932.– Leiris, A. d. (ed.): The Drawings of E. M. Berkeley and Los Angeles 1969.– Orienti, S.: The Complete Paintings of M. New York 1967/Tout l'œuvre peint d'E. M. Paris 1970.– Pool, P. (ed.): The Complete Paintings of M. Harmondsworth 1985.– Rouart, D. and D. Wildenstein (ed.): E. M. Catalogue raisonné de l'œuvre peint. 2 vols. Lausanne and Paris 1975.– Tabarant, A. (ed.): M. et ses œuvres. Paris 1947

**MANGOLD Robert**
born **1937** North Tonawanda (NY)
American painter. Studied **1956–1959** at Cleveland Art Institute in Ohio and **1960–1962** at Yale University Graduate Art School, New Haven. Met Josef Albers. **1962** Moved to New York where, in **1963**, he began to teach at the School of Visual Arts and at Hunter College. **1964** First solo-exhibition at the Thibaut Gallery, displaying his *Wall* and *Area* paintings: coated plywood panels, evenly sprayed with paint. **1967** Exhibited *Circle paintings*, segments of painted masonite, at the Fischbach Gallery, New York. **1969** Guggenheim grant. Began a series of emblematic paintings. Between **1972** and **1982** participation in documenta 5–7 in Kassel. In the 70s, reverted to a more strictly geometric formal language, producing x-shaped paintings and illusionary frame pictures. *Brown Frame/Gray Ellipse*, painted in **1987**, marks a transition to two-coloured asymmetric diptychs and to a freer brush stroke. Mangold can be considered one of the pioneers of minimalist and fundamental painting.
MONOGRAPHS, CATALOGUES: Grevenstein, A. v. and S. Singer (ed.): R. M. Schilderijen 1964-1982. Stedelijk Museum. Amsterdam 1982 (cat.).– Heere, H. (ed.): R. M. Gemälde. Kunsthalle Bielefeld. Bielefeld 1980 (cat.).– Himmelreich, A. and S. Singer (ed.): R. M. Recente werken. Bonnefanten-

museum. Maastricht 1989 (cat.).– Kerber B. and H. Heere (ed.): R. M. Gemälde. Kunsthalle Bielefeld. Bielefeld 1980 (cat.).– Kertess, K. (ed.): R. M. The Attic Series. Pace Gallery. New York 1992 (cat.).– Lehmann, U.: R. M. Linie, Form, Farbe. Werkentwicklung von 1964-1994. Nuremberg 1995.– Raussmüller, U. and C. Sauer (ed.): R. M. Hallen für Neue Kunst, Schaffhausen et al. Schaffhausen 1993 (cat.).– Spector, N. (ed.): R. M. La Jolla Museum of Contemporary Art. La Jolla 1974 (cat.).– Stevens, M. (ed.): R. M. Painting 1971-1984. Akron Art Museum. Akron (OH) 1984 (cat.).– Waldman, D. (ed.): R. M. Solomon R. Guggenheim Museum. New York 1971 (cat.)

**MANGUIN Henri-Charles**
**1874** Paris – **1943** Saint-Tropez
French painter. Around **1894** entered the studio of Gustave Moreau. Friendships with Matisse, Marquet, Jean Puy and Henri Rouault. **1900** First solo-exhibition at the Berthe Weill gallery in Paris. **1902–1904** First joint-exhibitions at the Berthe Weill gallery in Paris with artists who later formed the Fauves. **1905** Participated in a joint-exhibition, officially billed as Fauvist, in the Salon d'Automne. **1906** Trip to Cavalaire. Became acquainted with H.-E. Cross and Theo van Rysselberghe. **1907–1910** Lived in Saint-Tropez. **1909** Trip with Marquet to Naples. In subsequent years, alternating sojourns in Switzerland, Paris and Provence. **1949** Settled in St.-Tropez. Manguin has the most subdued colour palette of all the Fauvists. His aim was to bring new life to landscape and nude painting.
CATALOGUE RAISONNE: Manguin, L. and C. (ed.): H. M. Catalogue raisonné de l'œuvre peint. Neuchâtel 1980
MONOGRAPHS, CATALOGUES: Cabanne, P.: H. M. Neuchatel 1964.– Diehl, G. et al. (ed.): H. M. 1874-1949. Musée Marmottan. Paris 1988 (cat.).– Gassier, P. et al. (ed.): H. M. parmi les Fauves. Fondation Pierre Gianadda. Martigny 1983 (cat.).– Goldmann. J. (ed.): H. M. 1874-1949. Erste deutsche Retrospektive. Ehemalige Galerie des XX. Jahrhunderts. Berlin 1970 (cat.).– H. M. Palais de la Méditerranée. Nice 1969 (cat.)/H. M. Erste deutsche Retrospektive. Städtische Kunsthalle Düsseldorf. Düsseldorf 1969.– H. M. Isetan Museum of Art, Tokyo et al. (o. O) 1980 (cat.).– Manguin, J.-P. (ed.): H. M. 1874-1949. Lumière du Midi. Musée Paul-Valery. Sète 1994 (cat.).– Mousseigne, A. (ed.): H. M. 1874-1949. Chapelle de la Miséricorde, Saint-Tropez. Cannes 1976 (cat.).– Steadman, W. E. and D. Sutton (ed.): H. M. in America. University of Arizona Museum of Art, Tucson et al. Tucson (AZ) 1974 (cat.)

**MANTZ Werner**
**1901** Cologne – **1983** Eijsden
German photographer. **1916** First shots with an amateur camera. **1920/21** Studied at the

Bavarian State School of Photography under Professor Spoerl. **1922** Opened a portrait studio in Cologne. **1926–1929** Worked mainly on architectural projects for the architects T. W. Riphahn and others. **1932** Opened a second studio in Maastricht. **1937/38** Photoseries on mines in Limburg, Holland. From **1938** lived in Maastricht where, from **1971** onwards, he did mainly portraits and pictures of children. **1977** Participation in documenta 6 in Kassel. MONOGRAPHS, CATALOGUES: Honnef, K. and G. Kierblewsky (ed.): W. M. Fotografien 1926-1938. Rheinisches Landesmuseum, Bonn. Cologne 1978 (cat.).– Mißelbeck, R. (ed.): W. M. Architekturphotographie in Köln. 1926-1932. Museum Ludwig. Cologne 1982 (cat.)

**MANZONI Piero**
**1933** Soncino – **1963** Milan
Italian artist. **1956** Co-editor of the Milan manifesto *Per la scoperta di una zona di immagini*. **1957** Solo-exhibition in the foyer of the Teatro delle Maschere in Milan. Met Yves Klein. Co-founder of Gruppo Nucleare. **1958** Contact with artists of the Zero Group in Düsseldorf. First *Achromes*, colourless compositions, and works on untreated canvas or on woollen textiles over canvas. Co-editor of the magazine *Il Gesto*. **1960** Began work on *Lines*, drawings on paper rolls stretching to lengths of 7,200 m. **1961** *Air bodies*, balloons inflated with the artist's breath, and the *Magic Plinth*. Exhibited *Merda d'artista* (cans of the artist's excrement) at the Galleria La Tartaruga in Rome. **1963** Contact with Arman and Tinguely. **1964** Participated in the Zero exhibition in Philadelphia. Took part in important exhibitions of monochrome painting. Manzoni aimed to create direct links between art, the artist and the individual. To this end, he acted provocatively and without reserve.
CATALOGUES RAISONNES: Battino, F. and L. Palazzoli (ed.): P. M. Catalogue raisonné. Milan 1992, Paris 1994.– Celant, G. (ed.): P. M. Catalogo generale. Milan 1975, 1990
MONOGRAPHS, CATALOGUES: Agnetti, V. et al.: P. M. Milan 1967.– Agnetti, V.: Gli achromes di P. M. Milan 1970.– Bucarelli, P. and P. Celant (ed.): P. M. Galleria Nazionale d'Arte Moderna. Roma 1991

(cat.).– Celant, G. (ed.): P. M. Städtische Galerie im Lenbachhaus. Munich et al. Munich 1973 (cat.).– Celant, G.: P. M. Milan 1975.– Celant, G. (ed.): P. M. Musée d'Art Moderne de la Ville de Paris et al. Paris 1991 (cat.)./ P. M. Castello di Rivoli, Museo d'Arte Contemporanea et al. Milan 1992 (cat.).– Fréchuret, M.: La Machine à peindre. Nîmes 1994.– Maggio, G. di et al. (ed.): P. M. Milano et mitologica. Milan 1997 (cat.).– P. M. 1933-1963. Kunstmuseum Basel et al. Basel 1973 (cat.).– P. M. Paintings, Reliefs and Objects. Tate Gallery. London 1974 (cat.).– P. M. Il suo e il nostro tempo. Palazzo Reale, Milan et al. Milan 1985 (cat.).– P. M. Museum of Contemporary Art. Los Angeles 1995 (cat.).– P. M. Serpentine Gallery. London 1998 (cat.).– P. M. Musée d'Art Moderne de la Ville de Paris 1991 (cat.).– Petersen, J.: P. M. The Life and the Works. Hamburg and Paris 1962

**MANZU Giacomo**
(Giacomo Manzoni)
**1908** Bergamo – **1991** Rome
Italian sculptor and painter. **1919–1921** Technical training as a decorator. **1923** Studied Greek and Roman sculpture and then turned to the works of Michelangelo. **1928** First sculpture. Visited Paris and moved to Milan. Influenced by Medardo Rosso. **1929** First flat reliefs. Contact with Sassù and Birolli. **1931** Exhibition at the Galleria Tre Arti in Milan with Sassù. **1933** Trip to Rome. Destroyed all works created prior to **1929**, in order to free himself from archaistic tendencies. **1936** On a trip to Paris went round the Musée Rodin, and later that year sculpted the first of his series of *Cardinals*. **1938** Participated at the Venice Biennale. **1941–1954** Appointed professor of Sculpture at the Accademia Brera in Milan. After the war, Manzù produced mainly portraits and religious works. **1959** and **1977** participation in documenta 2 and 6 in Kassel.
CATALOGUE RAISONNE: Ciranna, A. (ed.): G. M. Catologo dell' opera grafica 1929-1968. Milan 1968, 1974
MONOGRAPHS, CATALOGUES: Bogianckino, M. et al. (ed.): G. M. Villa di Poggio Imperiale. Florence 1986 (cat.).– Cremer, F.: G. M. Berlin 1979.– De Micheli, M.: G. M. Milan 1971, New York 1974.– Emmrich, J. et al. (ed.): G. M. Berlin 1979.– Filippo, E. d. (ed.): G. M. Album inedito. Roma 1977 (cat.).– Hüttinger, E.: G. M. Amriswil 1966.– Lenjasina, N. M.: G. M. Leningrad 1985.– G. M. The National Museum of Modern Art. Tokyo 1973 (cat.).– Manzu, I. (ed.): M. pittore. Bergamo 1988.– Parricchi, U. (ed.): M. 100 Works 1938 to 1980. A Retrospective Exhibition. Art Gallery of Hamilton, Toronto et al. Toronto 1980 (cat.).– Portoghesi, P. et al. (ed.): M. Palazzo Reale, Milan et al. Milan 1988 (cat.).– Rewald, J.: M. London and Greenwich (CT) 1967.– Rohrmoser, A. and E. Lack (ed.): M. Museum Carolino Augusteum. Salzburg 1974 (cat.).– Russoli, F. et al. (ed.): M. a Bergamo. Palazzo della

Ragione. Bergamo 1977 (cat.).– Siverio, R. (ed.): G. M. Galleria dell' Academia. Florence 1979 (cat.).– Velani, L. (ed.): M. Scottish National Gallery of Modern Art, Edinburgh et al. Milan 1987 (cat.)

**MAPPLETHORPE Robert**
**1946** New York – **1989** Boston
American photographer. Studied **1963–1968** at the Pratt Institute in Brooklyn, first commercial art, then graphics and painting. **1971** Visited the photographic archives of the Metropolitan Museum of Art in New York. First self-portraits. **1972** Friendship with Sam Wagstaff, his promoter. **1973** First solo-exhibition at the Light Gallery in New York. **1976** Sadomasochism became a central theme in his pictures. **1977** and **1982** exhibited at documenta 6 and 7 in Kassel. **1980** Began a photoseries on the world champion bodybuilder, Lisa Lyon. **1988** Retrospective at the Whitney Museum of American Art. Set up the Robert Mapplethorpe Foundation for the prevention of aids. Touring exhibition "The Perfect Moment". Mapplethorpe is best known for his highly aesthetic and often pornographic nude pictures, which provoked repeated scandals, censorship and his exclusion from exhibitions.
CATALOGUE RAISONNE: Danto, A. C. (ed.): M. New York and Munich 1992
MONOGRAPHS, CATALOGUES: Barents, E. (ed.): R. M. Stedelijk Museum, Amsterdam. Munich 1988 (cat.).– Celant, G.: M. versus Rodin. Milan 1992.– Celant, G. (ed.): R. M. Louisiana Museum, Humblebæk et al. Milan 1992 (cat.).– Conrad, P. (ed.): R. M. Portraits. National Portrait Gallery. London 1988 (cat.).– Danto, A. C.: M. New York 1992.– Danto, A. C.: Playing With The Edge. The Photographic Achievement of R. M. Berkeley et al. 1996.– Kardon, J. (ed.): R. M. The Perfect Moment. Institute of Contemporary Art, University of Pennsylvania. Philadelphia 1988 (cat.).– R. M. Centro per l'Arte Contemporanea. Prato 1993 (cat.).– R. M. Kunsthaus. Vienna 1994 (cat.).– Marshall, R. (ed.): R. M. London 1986, 1991.– Marshall, R. (ed.): R. M. Whitney Museum of American Art. New York 1988 (cat.).– Morgan, S. and A. Holinghurst (ed.): R. M. Institute of Contemporary Arts. London 1983 (cat.).– Morrisroe, P.: M. A Biography. New York 1993.– Takano, I.: R. M. Tokyo 1987

**MARC Franz**
**1880** Munich – **1916** (in action) at Verdun
German painter and graphic artist. **1899** Studied philosophy in Munich. **1900–1902** Studied at the Munich Academy. **1902** First trips to Paris and Italy. **1905** Long visit to the Bavarian Alps. Focused on animal motifs. **1907** Second trip to Paris. **1909** Moved to Sindelsdorf in Upper Bavaria. **1910** Met Kandinsky, Javlensky and Marianne von Verefkin and became friends with Macke. Painted his first *Blue Horses*, and, together with Kandinsky, organised both

exhibitions of the Blauer Reiter. **1911** Joined the Neue Künstlervereinigung (New Artists' Association) in Munich. **1912** Co-editor of the Blauer Reiter almanac. Participated at the exhibition of the Sonderbund in Cologne. Joined the New Secession in Berlin. Went with Macke to visit Delaunay in Paris. **1913** Long stay in Tyrol. **1914** Moved to Ried in Upper Bavaria, signed up for military service and was killed at Verdun. **1916** Memorial exhibition at the gallery Der Sturm in Berlin. Marc's expressive animal paintings, with their prismatic refraction of colour, form and movement, symbolise the unity of all creation.
WRITINGS: Lankheit, K. (ed.): F. M. Schriften. Cologne 1978.– Lankheit, K. (ed.): F. M. Briefe aus dem Felde. Munich 1982 / F. M. Letters from the War. New York 1992 / F. M.: Lettres du front. Paris 1996.– Macke, W. (ed.): A. M./ F. Marc: Briefwechsel. Cologne 1964.– F. M. and W. Kandinsky (ed.): Der Blaue Reiter. Munich 1912.– F. M.: Aufzeichnungen und Aphorismen. Munich 1946.– F. M.: Botschaften an den Prinzen Jussuf. Munich and Zurich 1987.– F. M.: Les cent aphorismes. La seconde vue. Paris 1996.– Meißner, G. (ed.): F. M. Briefe, Schriften und Aufzeichnungen. Leipzig 1989.– Semrau, J. (ed.): G. M. Briefwechsel 1933-1980. Leipzig 1995
CATALOGUE RAISONNE: Lankheit, K. (ed.): F. M. Katalog der Werke. Cologne 1970.– Lankheit, K.: F. M. Sein Leben und sein Kunst. Cologne 1976
MONOGRAPHS, CATALOGUES: Covre, J. N.: F. M. dal pensiero alla forma. Torino 1971.– Ehrhart, G.: F. M. oder Die abstrakte Kunst. Stuttgart 1949.– Franz, E. (ed.): F. M. Kräfte der Natur. Werke 1912-1915. Westfälisches Landesmuseum, Münster et al. Stuttgart 1994 (cat.).– Gollek, R. (ed.): F. M. 1880-1916. Städtische Galerie im Lenbachhaus. Munich 1980 (cat.).– Greilich, B.: Die Holzschnitte F. M. in Thematik und Formensprache. Göttingen 1987.– Hüneke, A.: F. M. Tierschicksale. Kunst als Heilsgeschichte. Frankfurt-on-Main 1994.– Lankheit, K.: F. M. im Urteil seiner Zeit. Cologne 1960.– Levine, S.: The Apocalyptic Vision. The Art of F. M. as German Expressionism. New York 1979.– F. M. Städtische Galerie im Lenbachhaus. Munich 1963 (cat.).– Martin, K.: F. M. Stuttgart 1959.– März, R.: F. M. Berlin 1984.– Moeller, M. M. (ed.): F. M. Zeichnungen und Aquarelle. Brücke-Museum, Berlin et al. Stuttgart 1989 (cat.).– Partsch, S.: F. M. 1880-1916. Cologne 1991.– Pese, C.: F. M. Leben und Werk. Stuttgart and Zurich 1989 / F. M. Life and Work. London 1990.– Platte, H. (ed.): F. M. Gemälde, Gouachen, Zeichnungen, Skulpturen. Hamburger Kunstverein. Hamburg 1964 (cat.).– Rosenthal, M. et al. (ed.): F. M. Pioneer of Spiritual Abstracion. University Art Museum. Berkeley CA) 1980 (cat.).– Rosenthal, M.: F. M. Munich 1992.– Schardt, A. J. (ed.): F. M. Leben und Werk. Berlin 1936.– Schuster, P.-K. (ed.): Der blaue Reiter präsentiert Euerer Hoheit sein Blaues Pferd. Haus der Kunst. Munich 1987 (cat.)

**MARCKS Gerhard**

**1889** Berlin – **1981** Burgbrohl
German sculptor. Worked from **1907** until his military service in **1912** in the studio of the sculptor Richard Scheibe. In the context of the Werkbund exhibition in Cologne designed a large-scale terracotta frieze for a Gropius building together with his teacher. **1914–1918** Military service and illness. **1918** Teaching position at the Berlin School of Arts and Crafts. **1919–1925** Teacher at the Bauhaus and director of the ceramic workshop. **1925–1933** Taught at the art school in Burg Giebichenstein near Halle. **1942** Worked on his giant *Maja*. **1946** Appointed Professor of Sculpture at the Hamburg School of Arts. **1950** Settled in Cologne where he taught at the School of Arts and Crafts. Commissions for monumental sculptures. **1955–1964** Participation in documenta 1–3 in Kassel. **1963** and **1976** Illustrations for the *Odyssey*. Marcks' early works have strong expressionist elements. After World War II he favoured mythological themes as expressions of human tragedy. WRITINGS: Frenzel, U. (ed.): G. M. 1889-1981. Briefe und Werke. Munich 1988.– Kath, R. R.: The Letters of G. M. and Marguerite Wildenhain 1970-1981. Ames (IO) 1991.– Semrau, J. (ed.): Durchs dunkle Deutschland: G. M. Briefwechsel 1933-1980. Leipzig 1995 CATALOGUES RAISONNES: Busch, G. and M. Rudloff (ed.): G. M. Das plastische Werk. Frankfurt-on-Main 1977.– Hanstein, H. R. (ed.): G. M. Das lithographische Werk. Cologne 1983.– Lammek, K. (ed.): G. M. Das druckgraphische Werk. Stuttgart 1990 MONOGRAPHS, CATALOGUES: Blaum, R. (ed.): G. M. und die Antike. Heidelberg 1993.– Geymüller, J. v.: G. M. und sein Holzschnittwerk. Bonn 1985.– Haftmann, W. (ed.): G. M. A Retrospective Exhibition. University of California Art Gallery. Los Angeles 1969 (cat.).– Hamer, D. G.: G. M. Bilder aus Niehagen. Rostock 1989.– Hoffmann, R. G. M. Berlin 1982.– Keller, J. J.: G. M. und Griechenland. Starnberg 1979.– Lubricht, R. and R. Blaum (ed.): G. M. und die Antike. G.-M.-Stiftung. Bremen. Bremen, Heidelberg 1993 (cat.).– G. M. Bildnisse und Landschaften, Skulpturen, Handzeichnungen und Aquarelle. Kunsthalle Bremen. Bremen 1969 (cat.).– Purrmann, H. H. Purrmann, G. M. Eine Künstlerfreundschaft in Briefen. Langenargen 1986.– Rieth, A.: G. M. Recklinghausen 1959.– Rudloff, M. (ed.): G. M. 1889-1981. Retrospektive. Josef-Haubrich-Kunsthalle, Cologne et al. Munich 1989 (cat.).– Rudloff, M. and C. Steckner: G. M. and C. Crodel. Eine Künstlerfreundschaft. Bremen 1992.– Rudloff, M.: G. M. und die Antike. Bremen and Heidelberg 1993

**MARCOUSSIS Louis**
(Ludwig Kasimir Ladislas Marcus)
**1883** Warsaw – **1941** Cusset
Polish-born French painter and graphic artist. **1901** Studied at the Cracow Academy of Art. **1903** Moved to Paris where he worked for a short time in the studio of Jules Lefèbvre. **1905** Exhibited Impressionist-style paintings at the Salon d'Automne and **1906** at the Salon des Indépendants, and worked on the side as a caricaturist. **1910** Friendships with Braque, Apollinaire and later Picasso led to experiments with Cubist painting techniques. **1912** Joined the artists' group Section d'Or **1913** Participation in the First German Autumn Salon at the gallery Der Sturm in Berlin. **1914–1918** Military service. **1921** Took part in another exhibition at the Sturm gallery in Berlin. **1925** First solo-exhibition at the Galerie Pierre in Paris. **1930** Trip to London where he met Helena Rubinstein, who later became his patroness. **1930–1937** Worked on book illustrations. **1933** Appointed Professor of Graphic Reproduction at the Académie Schlaefer in Pairs. **1934/35** Travelled around America. **1937** Retrospective at the Palais des Beaux-Arts in Brussels. **1940** Fled from Paris to Cusset near Vichy. Despite certain parallels between Marcoussis' works and Pittura metafisica and Surrealism, his style remained essentially Cubist to the very end. CATALOGUES RAISONNES: Lafranchis, J. (ed.): M. Sa Vie, son œuvre. Catalogue complet des peintures, aquarelles, dessins, gravures. Paris 1961.– Milet, S. (ed.): L. M. L'œuvre gravé. Catalogue raisonné. Skorping 1991.– Milet, S. (ed.): L. M. Catalogue raisonné de l'œuvre peint (in preparation) MONOGRAPHS, CATALOGUES: Cassou, J. (ed.): L. M. Musée National d'Art Moderne. Paris 1964 (cat.).– Cassou, J. (ed.): M. L'Ami des poètes. Bibliothèque Nationale. Paris 1972 (cat.).– Souvenir de M. Centre Georges Pompidou. Paris 1978 (cat.)

**MARDEN Brice**
born **1938** Bronxville (NY)
American painter. **1958–1961** Studied at Boston University School of Fine and Applied Arts and **1961–1963** at Yale University of Art in New Haven. **1964** First solo-exhibition of monochrome paintings in shades of grey at the Wilcox Gallery in Swarthmore. From **1965** used a mixture of oil paints, beeswax and turpentine to obtain rich colours and a matt surface. **1966** Solo-exhibition at the Bykert Gallery in New York of monochrome, landscape format paintings. Assistant to Rauschenberg. **1969–1974** Taught at the School of Visual Arts in New York. **1971** First trip to Greece leading, in **1973**, to the *Grove Group*, a series of grey-green painted panels inspired by olive groves. **1972** and **1977** participated at documenta 5 and 6 in Kassel. **1974** *Figure* series. In the late 70s he designed stained-glass windows for Basel cathedral and, in the early 80s he developed a free, gestural painting technique inspired by Far-Eastern calligraphy. **1989** Awarded the Skowhegan medal for painting. Marden's monochromes are a conscious attempt to supersede impersonal Color Field Painting and achieve a subjective, emotional charging of painted areas and surfaces. **1992** Participation in documenta 9 in Kassel. WRITINGS: B. M.: Suicide Notes. Lausanne 1974 CATALOGUE RAISONNE: Lewison, J. (ed.): B. M. Prints 1961-1991. A Catalogue Raisonné. Tate Gallery, London et al. London 1991 (cat.) MONOGRAPHS, CATALOGUES: Ashton, D. (ed.): B. M. Drawings 1963-1973. Contemporary Arts Museum, Houston et al. Houston 1974.– Bann, S. and R. Smith (ed.): B. M. Stedelijk Museum. Amsterdam 1981 (cat.).– Bois, Y.-A. and U. Loock (ed.): B. M. Kunsthalle Bern et al. Bern 1993 (cat.).– Dickhoff, W. (ed.): B. M. Galerie Michael Werner. Cologne 1989 (cat.).– Kern, H. (ed.): B. M. Zeichnungen 1964-1978. Kunstraum. Munich 1979 (cat.).– Kertesz, K. (ed.): B. M. Paintings and Drawings. New York 1992.– Koepplin, D. (ed.): B. M. Öffentliche Kunstsammlung, Museum für Gegenwartskunst. Basel 1993 (cat.).– B. M. Kunstraum. Munich 1979 (cat.).– B. M. Musée d'Art Moderne de la Ville de Paris. 1992 (cat.).– Richardson, B. (ed.): B. M. Cold Mountain. The Way to Cold Mountain. Dia Center for the Arts, New York et al. Houston 1992 (cat.).– Rimanelli, D. (ed.): B. M. Paintings and Drawings. Matthew Marks Gallery. New York 1995 (cat.).– Rose, B.: B. M. Drawings. New York 1995.– Schjeldahl, P. (ed.): B. M. Mary Bone Gallery. London 1988 (cat.).– Schwarz, D. and M. Semff (ed.): B. M. Work Books 1964-1996. Munich et al. Munich 1997 (cat.).– Shearer, L. (ed.): B. M. Solomon R. Guggenheim Museum. New York 1975 (cat.).– Yau, J. (ed.): B. M. Recent Paintings and Drawings. Anthony d'Offay Gallery. London 1988 (cat.).– Wilde, E. d. and D. Mignot (ed.): B. M. Schilderijen, tekeningen, etsen 1975-1980. Stedelijk Museum. Amsterdam 1981 (cat.).– Zimmer, W. (ed.): B. M. The Pace Gallery. New York 1984 (cat.)

**MARINI Marino**
**1901** Pistoia – **1980** Viareggio
Italian sculptor, painter and graphic artist. Studied at the art academy in Florence. **1928** Went to Paris, and came to know Braque, De Chirico, De Pisis, Laurens, Kandinsky, Maillol and Picasso. **1929–1940** Taught at the academy of art in Monza. **1935** Award at the Quadriennale in Rome. **1937** Participated in the Paris World Fair. **1940** Professorship at the Accademia Brera in Milan. **1941–1946** Lived in Ticino. Contact with Giacometti, Wotruba and Richier. **1946** Returned to Milan. **1950** Toured the USA. Solo-exhibition in New York. **1952** Important prize for sculpture at the Venice Biennale. **1955–1964** Participation in documenta 1–3 in Kassel. **1962** Major retrospective in Venice. Inspired by Etruscan art, the horse and rider constituted a central theme in Marini's œuvre. CATALOGUES RAISONNES: Guastalla, G. and G. (ed.): M. M. Catalogo rigionato dell' opere grafica 1919-1980 Roma 1990/M. M. Werkverzeichnis der Graphik. Langenhagen 1991/M. M. Catalogue Raisonné of the Graphic Work 1919-1980. Los Angeles 1993.– Pirovano, C. (ed.): M. M. scultore. Milan 1973.– Read, H. et al. (ed.): M. M. The Complete Works. New York 1970/M. M. L'œuvre complet. Paris 1970/M. M. Sämtliche Werke. Berlin 1971.– Schulz-Hoffmann, C. (ed.): M. M. Druckgraphik. Werkkatalog. Munich 1976.– Steingräber, E. (ed.): M. M. Malerei. Bad Homburg 1987/M. M. Pittore. Torino 1987.– Toninelli, L. F. (ed.): M. M. Opera grafica completa 1914-1976. Livorno and Milan 1970 MONOGRAPHS, CATALOGUES: Berger, D. and G. (ed.): M. M. Opera grafica. Palazzo Guasco, Alessandria. Milan 1989 (cat.).– Busignani, A.: M. M. Florence 1968.– Caradente, G.: M. M. Lithographs 1942-196. New York (n. d.).– Cooper, D.: M. M. Milan 1959.– De Micheli, M. (ed.): M. M. Sculture, pitture, disegni dal 1914 al 1977. Palazzo Grassi. Venice 1983 (cat.).– De Micheli, M.: M. pittore. Milan 1988.– Drot, J.-M. (ed.): M. M. Antologica 1919-1978. Roma 1991.– Fath, M. (ed.): M. M. Städtische Kunsthalle Mannheim. Mannheim 1984 (cat.).– Haftmann, W.: M. M. Bremen 1968.– Haftmann, W. (ed.): M. M. ritratti. Sculture, opere su carta. Galleria Pieter Coray, Lugano et al. Milan 1991 (cat.).– Hammacher, A. M.: M. M. Sculpture, Painting, Drawing. New York and London 1971/M. M. Skulptur, Malerei, Zeichnung. Bremen 1972.– Hofmann, W.: M. M. The Graphic Work. London 1960.– Hunter, S. and D. Finn: M. M. The Sculpture. New York 1993.– M. M. Mostra antologica. Palazzo Reale, Museo M. M. Milan 1989 (cat.).– Moutashar, M. (ed.): M. M. Musée Réattu & Espace Van Gogh, Arles et al. Arles 1995 (cat.).– Papi, L. (ed.): M. M. Pittore. Ivrea 1987/M. M. Malerei. Bad Homburg 1987/M. M. Paintings. Johannesburg 1989.– Pirovano, C. (ed.): M. pittore. Museo San Pancrazio, Florence. Milan 1988 (cat.).– Pirovano, C. (ed.): M. M. Mitografia. Sculture e dipinti 1939-1966. Galleria dello Scudo. Verona 1994 (cat.).– Ruggeri, G.: Io sono un etrusco. M. M. Bologna 1978.– Russoli, F.: M. M. Paintings and Drawings. New York 1963, London 1965.– Steingräber, E. (ed.): M. M. Zeichnungen aus dem Nachlaß. Staatsgalerie moderner Kunst, Munich. Milan 1987 (cat.).– Trier, E.: M. M. Neuchâtel 1961.– Trier, E.: The Sculpture of M. M. London and New York 1961.– Vallès-Bled, M. (ed.): M. M. Peintures. Musée des Beaux-Arts. Chartres 1993 (cat.).– Waldberg, P. et al.: M. M. Leben und Werk. Frankfurt-on-Main 1971

**MARIONI Joseph**
born **1941** Cincinnati (OH)
American painter. **1962–1966** Studied at Cincinnati Art Academy, and worked as a picture restorer at the Cincinnati Art Museum. **1966–1970** Continued his studies

at San Francisco Art Institute. **1972** Moved to New York. **1975** First solo-exhibition at the "Artists Space" in New York. **1988** Exhibition with the simple title *Painting* at the Museum Abteiberg in Mönchengladbach, Germany. **1993** Further exhibitions in Germany, Austria and Switzerland. In Marioni's radical approach, every painting is seen as a painted yet autonomous body of colour, running its own course and creating its own effects. The layers of acrylic paint applied to the vertical canvas with a roller are so fluid that they run down, forming patterns and structures without any intervention by the artist.
MONOGRAPHS, CATALOGUES: Kersting, H. (ed.): J. M. Painter. Städtisches Museum Mönchengladbach 1988 (cat.).– Poetter, J. et al. (ed.): J. M. Staatliche Kunsthalle Baden-Baden et al. Baden-Baden 1995 (cat.).

**MARK Mary Ellen**
born **1940** Philadelphia
American photographer. **1958–1962** Studied at Annenberg School of Communications. Studied art at Philadelphia University. **1964/65** Graduated in communications. One year scholarship to Turkey leading to a photoseries, her first piece of social criticism. **1965/66** Opened a photographic studio. Worked for *Magnum Photos* in New York and Paris. **1974** Publication of *Passport*, a book of photographs on social and political alienation in Asia and Northern Ireland. **1975** Grant from the National Foundation for Art Photography. First solo-exhibition at the Photopia Gallery in Philadelphia. **1979** Photoseries entitled *Ward 81* of women in a high security state psychiatric clinic in Oregon. **1980** Repeated trips to India leading to photographs of Mother Theresa in Calcutta. **1981** First prize in the Robert F. Kennedy contest for photojournalism
MONOGRAPHS, CATALOGUES: Fulton, M.: M. E. M. 25 Years. Boston 1992

**MARQUET Albert**
**1875** Bordeaux – **1947** Paris
French painter. **1890** Studied at the Ecole des Beaux-Arts in Paris. Beginning of a lifelong friendship with Matisse. **1897** Pupil of Gustave Moreau. **1900** Worked with

Matisse on decorations for the Grand Palais at the Paris World Fair. **1905** Exhibited with Matisse, Derain and Vlaminck at the Salon d'Automne. **1906–1945** Trips to France, Germany, Holland, North Africa, the Soviet Union and Scandinavia. **1945** Returned to Paris for good. Marquet is best known for his impressionist-style paintings of cities, ports and the bridges and quays of Paris. His aim was to document his travel experiences faithfully and realistically through his paintings. He applied his paints thinly with minimal accents and favoured subdued grey and green tones.
CATALOGUE RAISONNE: Wildenstein Institute (ed.): A. M. Catalogue raisonné (in preparation)
MONOGRAPHS, CATALOGUES: Cassou, J. and M. Sembat (ed.): Centenaire de la naissance d'A. M. Musée des Beaux-Arts de Bordeaux et al. Bordeaux 1975 (cat.).– Daulte, F. and M. Marquet: A. M. Lausanne 1953, Paris 1995.– German, M.: A. M. Moscow 1972.– Gollek, R. and G. Martin-Méry (ed.): A. M. 1875-1947. Städtische Galerie im Lenbachhaus. Munich 1976 (cat.).– Jourdain, E.: M. Paris 1959.– A. M. L'œuvre. Lausanne 1953.– A. M. Peintures, aquarelles, dessins. Musée Toulouse-Lautrec. Albi 1957 (cat.).– A. M. 1875-1947. The Baltimore Museum of Art et al. San Francisco 1958 (cat.).– A. M. 1875-1947. Wildenstein Gallery. London 1985 (cat.).– Marquet, M.: A. M. Paris 1951.– Marquet, M. et al. (ed.): A. M. 1875-1947. Fondation de l'Hermitage. Lausanne 1988 (cat.).– Martin-Méry, G. and M. Hoog (ed.): A. M. 1875-1947. Orangerie des Tuileries, Paris et al. Paris 1975 (cat.).– Platte, H.: A. M. Zeichnungen aus Hamburg. Hamburg 1964

**MARTENS Olaf**
born **1963** Halle (Saale)
German photographer. **1985** Worked for an engineering firm, after training as a constructional draughtsman. **1985–1990** Studied photography at the Leipzig School of Graphic Art and Design, attending master classes at this school **1990–1992**. **1990** Co-founder of the agency PUNCTUM in Leipzig. Worked as a freelance photographer for *FAZ-Magazin*, *Stern* and *Spiegel*.

**MARTIN Agnes**
**1912** Maklin (Canada) – **2004** Taos
Canadian-born American painter and writer. **1932** Moved to the USA. **1941–1954** Studied art history at Columbia University in New York. Taught at the University of New Mexico in Albuquerque and at Eastern Oregon College in Portland. First surrealist biomorphic paintings, influenced by early Abstract Expressionism. **1957** Contact with Kelly, Indiana, Jack Youngerman and Rosenquist in New York leading to incorporation of square, lattice-like structures and serial grids into her paintings. **1958** Solo-exhibition at the Betty Parson Gallery in New York. **1967** Moved to Cuba, New

Mexico where she concentrated on writing. **1973/74** Trip to Germany. Exhibitions at the Kunstraum Munich, the Kunsthalle Tübingen and the Kaiser Wilhelm Museum in Krefeld. In **1972** and **1977** participated in documenta 5 and 6 in Kassel. **1989** Elected to the American Academy and Institute of Art and Literature. **1991** Awarded the Javlensky Prize by the City of Wiesbaden. Martin's lightly lined and striped paintings of the 70s, on canvas or transparent plastic sheeting, anticipated fundamental painting.
WRITINGS: Schwarz, D. (ed.): Writings. Winterthur 1992/A. M. Schriften. Stuttgart 1995
MONOGRAPHS, CATALOGUES: Alloway, L. and S. Delchanty (ed.): A. M. Institute of Contemporary Art. Philadelphia 1973 (cat.).– Ashton, D. and A. Martin (ed.): A. M. Hayward Gallery, London et al. London 1977 (cat.).– Bloem, M. (ed.): A. M. Paintings and Drawings 1974-1990. Stedelijk Museum, Amsterdam et al. Amsterdam 1991 (cat.)/A. M. Peintures et dessins 1974-1990. Musée d'Art Moderne de la Ville de Paris. Paris 1991 (cat.)/A. M. Gemälde und Zeichnungen 1974-1990. Landesmuseum Wiesbaden. Wiesbaden 1991 (cat.).– Haskell, B. et al. (ed.): A. M. The Mind-Body Problem. Whitney Museum of American Art, New York et al. New York 1992 (cat.).– A. M.: A. M. Chicago 1981.– A. M. Waddington Galleries. London 1986 (cat.).– A. M. La Perfection inhérente à la vie. Paris 1993

**MASSON André**
**1896** Balagny-sur-Thérain (Oise) – **1987** Paris
French painter and graphic artist. First studied at the Brussels Academy then, in **1912**, took the course of Emile Verhaeren and went to Paris. **1914** Called up for military service, severely wounded and sent to a clinic for nervous disorders. **1922** Returned to Paris. **1924** Made contact with the Surrealists around Breton, remaining a member of the group up to **1929** and rejoining them in **1937**. **1934** Settled in Tossa, Catalonia. **1937** Returned to Paris from where, at the outbreak of World War II, he emigrated to America, arriving in New York and settling in Connecticut. **1945** Lived in Paris and Aix-en-Provence. **1954** Won the Grand Prix national des Arts. **1955–1964** Participation in documenta 1 – 3 in Kassel. **1964** Major retrospective at the Berlin Academy and the Stedelijk Museum in Amsterdam. **1972** Exhibited at the Venice Biennale. Masson, who illustrated numerous books and experimented with new techniques of graphic reproduction, developed his own method of automatic drawing, based on Surrealist principles, and applied this to his painting.
WRITINGS: Levaillant, F. (ed.): A. M. Les années surréalistes. Correspondance 1916-1942. Paris 1990.– A. M. Anatomie de mon univers. Marseille 1988.– Matthes, A. and H. Klewan (ed.): A. M. Gesammelte Schriften. Munich 1990.– Will-Levaillant, F. (ed.): A. M. Le rebelle du surréalisme. Ecrits. Paris 1994

CATALOGUES RAISONNES: A. M. Livres illustrés de gravures originales. Catalogue raisonné. Paris 1985.– Passeron, R. (ed.): A. M. Gravures 1924-1972. Fribourg 1973.– Passeron, R. (ed.): A. M. Catalogue général des Sculptures. Torino 1987/A. M. General Catalogue of the Sculptures. Torino 1988.– Saphire, L. (ed.): A. M. The Complete Graphic Work. Vol. 1: Surrealism 1924-1949. New York 1990.– Saphire, L. and P. Cramer (ed.): A. M. The Illustrated Books. Catalogue Raisonné. Geneva 1994
MONOGRAPHS, CATALOGUES: Ades, D.: A. M. New York 1994.– Barrault, J.-L. et al. (ed.): A. M. Rouen 1940.– Benincasa, C. (ed.): A. M. Parma 1981.– Charbonnier, G.: Entretiens avec A. M. Marseille 1985.– Clébert, J.-P.: Mythologie d'A. M. Geneva 1971.– Dimanche, A.: A. M. 1993.– Gualdoni, F. (ed.): A. M. Opere 1943-1971. Arte 92. Milan 1990 (cat.).– Hahn, O.: A. M. London and New York 1965, Stuttgart 1965.– Lahumière, A. (ed.): A. M. Kunstverein Villa Franck. Ludwigsburg 1985 (cat.).– Lanchner, C. and W. Rubin (ed.): A. M. The Museum of Modern Art. New York 1976 (cat.)/A. M. Centre Georges Pompidou. Paris 1977 (cat.).– Leiris, M. and G. Limbour: A. M. et son univers. Geneva and Paris 1947/A. M. and His Universe. London 1947.– Leiris, M. (ed.): A. M. Massacres et autres dessins. Paris 1971.– Leiris, M. (ed.): A. M. et le théâtre. Paris 1983.– Leiris, M. and M. Troche: A. M. en España. 1933-1943. Madrid 1993.– Levaillant, F.: A. M. Milan 1988.– Leymarie, J. and J.-M. Drot (ed.): M. Accademia di Francia. Roma 1989 (cat.).– A. M. Edgardo Acosta Gallery, Beverly Hills et al. Beverly Hills 1958 (cat.).– A. M. Dalla bestimmia all'invocazione: il cammino di A. M. Università di Parma. Parma 1985 (cat.).– Mèredieu, F. d.: A. M. Les Dessins automatiques. Paris 1988.– Noël, B.: A. M. La chair du regard. Paris 1993.– Passeron, R.: A. M. et les puissances du signe. Paris 1975.– Rahn, D.: A. M. Raumdarstellung und Zeitbezug in der Malerei. Tübingen 1978.– Sylvester, D. and J. Drew (ed.): A. M. Line Unleashed. Hayward Gallery. London 1987 (cat.).– Turenne, S. A. d. et al. (ed.): A. M. Musée des Beaux-Arts. Nîmes 1985 (cat.)

**MATHIEU Georges**
born **1921** Boulogne-sur-Mer (near Calais)
French painter and sculptor. Self-taught. **1942** After short courses in law, literature and philosophy, started to paint. **1947** Influenced by Wols, Pollock and De Kooning, he tended towards non-representational painting from the start. Exhibited that year in the Salon des Réalités Nouvelles and joined the poet and painter Camille Bryen in forming the group Non-figuration psychique, closely connected with automatic Tachisme. **1952** Trip to USA. **1953** Took part in the exhibition "Younger European Painters" at the Salomon Guggenheim Museum in New York. **1956** Monumental oil painting for the

Théâtre Sarah Bernhardt in Paris. **1959** Participation in documenta 2 in Kassel. From **1962** large sculptures and designs for furniture, tapestries and murals. **1967** Series of posters for Air France. **1974** Design for a new 10-franc piece. From **1975** member of the Paris Academy of Fine Arts. Mathieu, who is best known for his spontaneous public action paintings, is considered the most important exponent of French Tachisme and, after Malraux, the first of the Western calligraphers.
WRITINGS: G. M.: Analogie de la non-figuration. Paris 1949.– G. M.: Le Privilège d'être. Paris 1967.– G. M.: De la révolte à la renaissance. Au-delà du tachisme. Paris 1973.– G. M.: La Réponse de l'abstraction lyrique et quelques extrapolations d'ordre esthétique, éthique et métaphysique. Paris 1975.– G. M.: Désormais seul en face de Dieu. Lausanne 1998
MONOGRAPHS, CATALOGUES: Arnoud, R. (ed.): M. Quelques œuvres peintes de 1963 à 1978. Grand Palais. Paris 1978 (cat.).– Choay, F.: M. Madrid 1960.– Dane, M.-C. (ed.): M. Musée d'Art Moderne de la Ville de Paris. Paris 1963 (cat.).– Grainville, P. et G. Xuriguera: G. M. Paris 1993.– Haftmann, W. (ed.): M. Gemälde, Gouachen, Aquarelle, Collagen. Kölnischer Kunstverein. Cologne 1967 (cat.).– Mathey, F.: G. M. Paris and Milan 1969, Paris 1989.– Quignon-Fleuret, D. (ed.): M. Œuvres anciennes 1948-1960. Galerie Beaubourg. Paris 1974 (cat.).– Renzio, T. d. (ed.): G. M. Institute of Contemporary Arts. London 1956 (cat.).– Schehade, G. and F. Mathey (ed.): M. Galerie Charpentier. Paris 1965 (cat.).– Wable, A. (ed.): G. M. Château-Musée. Boulogne-sur Mer 1992 (cat.)

**MATISSE Henri**
**1869** Le Cateau-Cambrésis – **1954** Nice
French painter, sculptor and graphic artist. Abandoned law to study at the Académie des Beaux-Arts in Paris. Pupil of Gustave Moreau. **1896** First attempts at Impressionist painting. **1898** Trips to London and Corsica. From **1900** concentrated on autonomous painterly components: light, colour and form. **1904** First solo-exhibition in Paris. Went to stay with Signac in Saint-Tropez, where he began to experiment with pointillist painting techniques. **1905** Developed a new, Fauvist style with long brush storkes and large, heavily outlined colour fields. **1907** Completed his painting *Luxe, Calme et Volupté*, a key work of the Fauvist movement. **1908** Founded the Académie Matisse. **1909** Painted the large-scale works *La Danse* and *La Musique* (St. Petersburg, Ermitage) for the Russian collector Shchukin. **1910** Began to paint simpler forms and use more intense, contrasting and luminous colours. Painted vibrant, sensual works with a decorative, ornamental quality. **1913** Trip to Morocco. **1914-1917** Cubist influence. **1918** Moved to Nice. **1949** Interior design, murals and windows for the Chapel of the Rosary at Vence. First *papiers découpés*, arrangements of brightly coloured,

paper cut-outs. **1950** Prize for painting at the Venice Biennale. Running through Matisse's œuvre is a quest for perfection and harmony in paintings bursting with playfulness and joy.
WRITINGS: Bonnard, P. and H. M.: Correspondance. 1925-1946. Paris 1991.– Flam, J. D. (ed.): M. on Art. Berkeley 1995.– Fourcade, D. (ed.): H. M. Ecrits et propos sur l'art. Paris 1992.– H. M.: Über die Kunst. Zurich 1987.– H. M.: Ecrits et propos sur l'art. Paris 1989
CATALOGUES RAISONNES: Duthuit, C. and M. Duthuit-Matisse (ed.): H. M. Catalogue raisonné de l'œuvre gravé. 2 vols. Paris 1983.– Duthuit, C. and F. Gernaud (ed.): H. M. Catalogue raisonné des ouvrages illustrés. Paris 1988.– Duthuit, C. and F. Garnaud (ed.): H. M. Catalogue raisonné de l'œuvre sculpté. Paris 1997.– Elsen, A. E.: The Sculpture of H. M. New York 1971.– Monod-Fontaine, I.: The Sculpture of H. M. London 1984 (cat.)
MONOGRAPHS, CATALOGUES: Alpatov, M. V.: H. M. Dresden 1973.– Baumann, F. (ed.): H. M. Kunsthaus Zürich. Zurich 1982 (cat.).– Benjamin, R.: M.'s Notes of a Painter. Criticism, Theoryand Context 1891-1908. Ann Arbor (MI) 1987.– Billot, M. et al. (ed.): H. M. La Chapelle de Vence. Journal d'une création. Paris 1993.– Bois, Y.-A. and D. Fourcade (ed.): H. M. 1904-1917. Centre Georges Pompidou. Paris 1993 (cat.).– Clement, R. T.: H. M. A Bio-Bibliography. Westport 1993.– Cowart, J. et al. (ed.): H. M. Paper Cut-Outs. St. Louis Art Museum. St Louis 1977 (cat.).– Cowart, J. and D. Fourcade (ed.): H. M. The Early Years in Nice 1916-1930. National Gallery of Art. Washington 1986 (cat.).– Cowart, J. (ed.): M. in Marocco. The Paintings and Drawings. 1912-1913. National Gallery of Art, Washington et al. Washington 1990 (cat.).– Delectorskaya, L. et al. (ed.): H. M. Zeichnungen und Gouaches Découpées. Staatsgalerie Stuttgart. Stuttgart 1993 (cat.).– Delectorskaya, L.: H. M. Contre vents et marées. Peinture et livres illustrés de 1939 à 1943. Paris 1996.– Duthuit, G. (ed.): Ecrits sur M. Paris 1992.– Elderfield, J.: The Cut-Outs of H. M. London and New York 1978.– Elderfield, J. (ed.): The Drawings of H. M. The Museum of Modern Art. New York 1985 (cat.).– Elderfield, J. (ed.): H. M. A Retrospective. The Museum of Modern Art. New York 1992 (cat.).– Escholier, R.: M. A Portrait of the Artist and the Man. London 1960.– Flam, J. (ed.): H. M. The Man and His Art. London and Ithaca (NY) 1986.– Flam, J. (ed.): M. The Dance. National Gallery of Art. Washington 1993 (cat.).– Flam, J. (ed.): H. M. Cologne 1994.– Gauss, U. (ed.): H. M. Zeichnungen und Gouaches découpées. Staatsgalerie Stuttgart. Stuttgart 1993 (cat.).– Georgievskaja, E. B. (ed.): A. M. 1869-1954. Pushkin Museum, Moscow et al. Moscow 1993 (cat.).– Girard, X. et al. (ed.): H. M. Musée des Beaux-Arts, Nantes et al. Nice 1988 (cat.).– Girard, X. and S. Kuthy (ed.): H. M. 1869-1954. Skulpturen und Druckgraphik. Kunstmuseum. Bern 1992 (cat.).– Girard, X. (ed.): Les Chefs-d'œuvres du Musée Matisse. Musée des Beaux-Arts. Dijon 1991 (cat.)/H. M. Capolavori dal Museo M. di Nizza. Accademia di Francia, Romaa et al. Nice 1991 (cat.).– Girard, X.: H. M. La Chapelle du rosaire. 1948-1951. Paris 1992.– Girard, X. (ed.): M. La danse. La malmaison. Cannes 1993 (cat.).– Güse, E.-G. (ed.): H. M. Zeichnungen und Skulpturen. Saarland Museum, Saarbrücken. Munich 1991 (cat.).– Guillaud, J. and M.: M. Le Rythme et la ligne. Paris 1987.– Hahnloser-Ingold, M.: M. Fribourg et al. 1988.– Hahnloser-Ingold, M. (ed.): M. The Graphic Work. New York 1988.– Izerghina, A. (ed.): H. M. Paintings and

Sculptures in Soviet Museum. St. Petersburg 1978.– Lambert, S.: M. Lithographs. London 1972.– Ließegang, S.: H. M. Gegenstand und Bildrealität. Bergisch Gladbach and Cologne 1994.– H. M. Dessins et sculptures. Centre Georges Pompidou. Paris 1975 (cat.).– Monod-Fontaine, I. (ed.): H. M. Centre Georges Pompidou. Paris 1989, 1995 (cat.).– Néret, G.: M. Paris 1991.– Néret, G.: H. M. Cologne 1996.– Pagé, S. (ed.): Autour d'un chef-d'œuvre de Matisse. Les 3 versions de la Danse Barnes 1930-1933. Musé d'Art Moderne de la Ville de Paris. Paris 1993 (cat.).– Pleynet, M.: H. M. Lyon 1988, 1993.– Schneider, P. (ed.): M. Exposition du centenaire. Grand Palais. Paris 1970 (cat.).– Schneider, P. (ed.): H. M. M. et l'Italie. Ala Napoleonica e Museo Correr, Venice. Milan 1987 (cat.).– Schneider, P.: M. Paris 1984, New York 1984, Munich 1984.– Wappenschmidt, K.: H. M. Sein plastisches Werk. Kiel 1991

**MATTA Roberto**
(Roberto Sebastián Antonio Matta Euchaurren)
**1911** Santiago de Chile – **2002** Rom
Chilean painter. Qualified as an architect in Santiago de Chile before emigrating to Europe in **1932**. From **1934** worked in Paris for Le Corbusier. Met Picasso. Toured Europe and the Soviet Union. **1937** First surrealist-style paintings. **1939** Moved to New York and joined the Surrealists there. Went to Mexico with Motherwell, where he saw the eruption of the volcano Paricotin. This experience inspired the series *The Earth is a Man* of **1941**, in which natural forces are represented as flowing, biomorphic forms. **1948** Forced to break with the Surrealists after being "intellectually disqualified". Returned to Europe. **1949-1954** Lived in Rome. From **1954** alternated between Paris and Tarquinia in Italy. **1959-1977** Participation in documenta 2, 3 and 6 in Kassel. From **1960** actively involved in the peace movement. Visited Cuba. Painted monumental murals, including commissions for the University of Santiago de Chile and the UNESCO building in Paris. Matta's strictly abstract paintings with elements of psychic automatism had a powerful influence on Abstract Expressionism, particularly on the artists Gorky and Motherwell.
WRITINGS: Carrasco, E. (ed.): M. conversaciones. Santiago 1987
CATALOGUES RAISONNES: Ferrari, G. (ed.): M. Index dell'opera grafica dal 1969 al 1980. Roma 1980.– Ferrari, G. (ed.): Entretiens morphologiques. Notebook No. 1, 1936-1944. London, Paris and Tübingen 1986.– Sabatier, R. (ed.): M. Catalogue raisonné de l'œuvre gravé 1943-1974. Stockholm and Paris 1975
MONOGRAPHS, CATALOGUES: Bozo, D. et al. (ed.): M. Centre Georges Pompidou. Paris 1985 (cat.).– Ferrari, G. (ed.): M. etcetera. Geneva 1996.– Hiekisch-Picard, S. (ed.): M. Museum. Bochum 1991 (cat.).– Laureati, L.: R. M. Opere dal 1939 al 1975. Roma 1976.– M. Coigitum. Hayward

Gallery. London 1977 (cat.).– M. Dessins 1936-1989. Galerie de France. Paris 1990 (cat.).– R. M. Palazzo Reale. Milan 1990 (cat.).– Miller, N. (ed.): M. The First Decade. Rose Art Museum, Brandeis University. Waltham (MA) 1982 (cat.).– Otero, L.: Clave para M. Havanna 1984.– Rubin, W. (ed.): M. The Museum of Modern Art. New York 1957 (cat.).– Schmied, W. (ed.): Per il Chile con M. Kestner-Gesellschaft. Hanover 1974 (cat.).– Schmied, W. (ed.): M. Kunsthalle der Hypo-Kulturstiftung, Munich et al. Munich 1991 (cat.).– Schuster, J.: Développements sur l'infra-réalisme de M. Paris 1970

**MATTA-CLARK Gordon**
**1943** New York – **1978** New York
American artist. Son of the painter Roberto Matta. **1962-1968** Studied architecture at the Cornell School of Architecture in Ithaca. **1963** Spent one year at the Sorbonne in Paris. **1968** Completed the work *Rope Bridge*. **1969** Helped Dennis Oppenheim to set up the exhibition "Earth Art" at Cornell University. Met Robert Smithson. **1971** Refused to participate at the São Paulo Biennale in protest against the Brazilian military regime. **1972** Took part in documenta 5 in Kassel. **1973** Trip to Italy. **1975** Exhibited at the 9th Paris Biennale. **1977** Started the project *A Resource Center and Environmental Youth Program for Loisaida* in Chicago. Took part in documenta 6 in Kassel. **1978** Solo-exhibition at the Museum of Contemporary Art in Chicago. Married Jane Crawford. **1979** Solo-exhibition at the Kunstverein Karlsruhe and **1991** retrospective at the Castello di Rivoli in Turin. In spectacular actions, Matta-Clark broke off and removed large portions of masonry from buildings, especially derelict houses, and used them as sculptural elements. He is now considered a forerunner of Deconstructivism.
CATALOGUE RAISONNE: Breitwieser, S. (ed.): G. M.-C. Reorganizing Structure by Drawing Through It. Vienna and Cologne 1997
MONOGRAPHS, CATALOGUES: Breitwieser, S. (ed.): G. M.-C. White Cube/Black Box. Vienna 1996.– Diserens, C. et al. (ed.): G. M.-C. IVAM Centro Julio González, Valencia et al. Valencia 1993 (cat.).– Jacob, M. J. et al. (ed.): G. M.-C. A Retrospective. Museum of Contemporary Art. Chicago 1985 (cat.).– G. M.-C. International Cultureel-Centrum Amsterdam. 1977 (cat.).– G. M.-C. One for All – All for One. Städtische Kunsthalle Düsseldorf. Düsseldorf 1979 (cat.).– G. M.-C. Office Baroque und andere Arbeiten. Badischer Kunstverein. Karlsruhe 1979 (cat.)

**MATTHEUER Wolfgang**
**1927** Reichenbach – **2004** Leipzig
German painter and graphic artist. **1941-1944** Trained as a lithographer. **1944/1945** Military service. **1946/47** Travelled around West Germany. **1947-1951** Studied at the

Leipzig School of Graphic Art and Book Design. **1955** Saw exhibitions of Picasso and Beckmann in West Germany. Since **1957** taught at the Leipzig School of Graphic and Book Design. First solo-exhibition at the Kunsthandlung Engewald in Leipzig. **1965** Professor at the Leipzig School of Graphic and Book Design. **1966** Tour of the Soviet Union. **1973** Awarded the Art Prize of the German Democratic Republic. **1976** Participated in documenta 6 in Kassel. **1978** Elected to the East German Academy of Art in Berlin. **1981** Trip to Italy. **1984** Took part in the Venice Biennale. **1987** Solo-exhibition at the Museum of Fine Arts in Leipzig. Mattheuer is a key representative of critical realism. His paintings combine expressionist influences with elements of Neue Sachlichkeit and Magic Realism.
WRITINGS: W. M.: Äußerungen. Texte. Grafik. Leipzig 1989
CATALOGUE RAISONNE: Seyde, J. (ed.): W. M. Das druckgraphische Werk 1948-1986. Leipzig 1987
MONOGRAPHS, CATALOGUES: Fuhrmann, H. (ed.): W. M. Galerie Neue Meister. Dresden 1974 (cat.).– Gleisberg, D. (ed.): W. M. Das druckgrafische Werk. Lindenau-Museum. Altenburg 1977 (cat.).– Grubert-Thurow, B. (ed.): W. M. Vom Holz: die Holzstöcke und Holzschnitte. Städtisches Kunstmuseum Spendhaus. Reutlingen 1995 (cat.).– Hütt, W.: W. M. Dresden 1975.– Lang, L.: W. M. Berlin 1975.– Lüttner, P. (ed.): W. M. Sprengel Museum. Hanover 1990 (cat.).– Mattheuer-Neustädt, U.: Bilder als Botschaft – Die Botschaft der Bilder. Am Beispiel W. M. Leipzig 1997.– Romanus, P. (ed.): W. M. Sprengel Museum, Hanover. Halle 1985 (cat.).– Schneede, U. M. and H. Schönemann (ed.): W. M. Ein Künstler in der DDR. Hamnburger Kunstverein. Hamburg 1977 (cat.).– Schönemann, H.: W. M. Leipzig 1988.– Tschirner, M. et al. (ed.): Nähe und Horizont. W. M. Malerei. Grafik. Zeichnung. Plastik. Nationalgalerie der Staatlichen Museen, Altes Museum. Berlin 1988 (cat.)

**MEIDNER Ludwig**
**1884** Bernstadt – **1966** Darmstadt
German painter, graphic artist and writer.
**1901/02** Apprenticeship as a bricklayer.
**1903/04** Studied at the Royal School of Art

in Breslau. **1905** Moved to Berlin. **1906/07** Studied at the Académie Julian and the Académie Cormon in Paris. Friendship with Modigliani. **1907** Returned to Berlin **1911** Contributed to the magazine *Die Aktion*. **1912** Founded the group Die Pathetiker together with Janthur and Steinhardt. First joint-exhibition at the gallery Der Sturm in Berlin. **1913** Completed *Stadt in Flammen* (City in Flames), one of his most important works. **1914** Joined the Free Secession in Berlin. **1916–1918** Military service. **1924/25** Taught at the Studio School of Painting and Sculpture in Berlin. **1925–1932** Concentrated exclusively on literary works. **1935** Moved to Cologne. **1937** His works classified as "degenerate art" and confiscated. **1939–1953** Lived in exile in London. **1953** Returned to Germany. The central theme of Meidner's œuvre is city life. His works are shot through with expressionist anguish and are full of terrible visions.
WRITINGS: L. M.: Im Nacken das Sternenmeer. Leipzig and Munich 1918.– L. M.: Septemberschrei. Berlin 1920.– L. M.: Gang in die Stille. Berlin 1929.– L. M.: Hymnen und Lästerungen. Munich 1959
CATALOGUE RAISONNE: Grochowiak, T. (ed.): L. M. Recklinghausen 1966
MONOGRAPHS, CATALOGUES: Breuer, G. and I. Wagemann (ed.): L. M. Zeichner, Maler, Literat. 1884-1966. 2 vols. Mathildenhöhe, Darmstadt. Stuttgart 1991 (cat.).– Eliel, C. S. (ed.): The Apocalyptic Landscapes of L. M. Los Angeles County Museum of Art. Los Angeles 1989 (cat.)/L. M. Apokalyptische Landschaften. Berlinische Galerie, Berlin. Munich 1990 (cat.).– Flammann, W. (ed.): L. M. 1884-1966. Das druckgraphische Werk. Stadthalle Hofheim am Taunus. Hofheim 1991 (cat.).– Grochowiak, T.: L. M. Recklinghausen 1966.– Hodin, J. P.: L. M. Seine Kunst, seine Persönlichkeit, seine Zeit. Darmstadt 1973.– Hoffmann, K. (ed.): L. M. 1884-1966. Kunstverein Wolsburg. Wolfsburg 1985 (cat.).– Kunz, L. (ed.): L. M. Dichter, Maler und Cafés. Zurich 1973.– Scheid, E. (ed.): L. M. 1884-1966. Kneipe und Café. Stadtmuseum. Hofheim am Taunus 1994 (cat.)

**MEISTERMANN Georg**
**1911** Solingen – **1990** Cologne
German painter. **1929–1933** Studied at the Düsseldorf Academy under Heuser, Nauen and Mataré. **1937–1939** Trips to Holland, France and England. From **1937** worked on large stained-glass windows for churches. **1943** Developed a striking, angular painting style with zig-zag lines. **1950** Space-oriented painting with bent forms. **1953–1955** Professor at the Städelschule in Frankfurt. **1955–1960** Professor at the Düsseldorf Academy. Painted large-scale colour field compositions in minimalist style, entitled *Fastentücher* (Fasting Cloths). From **1960** professor at the Karlsruhe Academy. **1967–1972** President of the Deutscher Künstlerbund (German Artists Association). Meistermann was a leading exponent of abstraction in postwar Germany. His emblematic compo-

sitions, exploring the relationship of surface to space belong to the same abstract tradition as the works of Klee and Miró.
CATALOGUES RAISONNES: Knopper, H. (ed.): Werkverzeichnis der Papierarbeiten (in preparation).– Ruhrberg, K. und W. Schäfke (ed.): G. M. Monographie und Werkverzeichnis der Gemälde. Cologne 1991
MONOGRAPHS, CATALOGUES: Borger, H. (ed.): G. M. Rheinisches Landesmuseum, Bonn et al. Düsseldorf 1971 (cat.).– Calleen, J. M. (ed.): G. M. Galerie des alten Rathauses. Wittlich 1992 (cat.).– Hennemann, M. (ed.): G. M. Die Fenster in Profanbauten. Bonn 1985.– Heydt, H. (ed.): Die Schloßkirche zu Alt-Saarbrücken und die Glasfenster von G. M. Saarbrücken 1993.– Linfert, C.: G. M. Recklingkausen 1958.– Oellers, A. C. (ed.): G. M. Suermondt-Ludwig-Museum, Aachen et al. Aachen 1984 (cat.).– Pese, C. (ed.): G. M. Werke und Dokumente. Germanisches Nationalmuseum, Nuremberg et al. Klagenfurt 1981 (cat.).– Rosen, K.-H.: G. M. malt Willy Brandt. Bad Honnef 1993.– Ruhrberg, K. et al. (ed.): G. M. Die Kirchenfenster. Freiburg and Basel 1986.– Schäfke, W. (ed.): G. M. Josef-Haubrich-Kunsthalle, Cologne et al. Cologne 1991 (cat.).– Volkmann-Schluck, K. H. (ed.): G. M. Gemälde. Kunst- und Museumsverein Wuppertal et al. Recklinghausen 1959 (cat.)

**MERZ Mario**
born **1925** Turin
Italian artist. Medical studies interrupted by World War II, during which he joined an anti-fascist resistance group Justice and Freedom. **1946–1949** Visits to Rome and Paris. **1954** First solo-exhibition at the Galleria Bussola in Turin. **1962** Exhibition at the Galleria Notizia in Turin of spiral paintings in L'art informel style. **1966** Began combining natural materials (e.g. earth and branches) with synthetic materials or objects (e.g. glass and neon lights). **1968** First igloos. Participation in Prospekt '68 at the Kunsthalle Düsseldorf. **1969** Solo-exhibition at the Ileana Sonnabend Galerie in Paris. **1972** and **1982** participated in documenta 5 and 7 in Kassel and **1976** at the Venice Biennale. Resumed painting. Works with neon Fibonacci numerals. Merz's objects and installations combine concrete, physical aspects of art with the non-material aims of Concept Art. **1992** Participation in documenta 9 in Kassel.
WRITINGS: Merz, B. (ed.): M. M. Voglio fare subito un libro/Sofort will ich ein Buch machen. Frankfurt-on-Main and Salzburg 1985/M. M. Je veux faire un livre tout de suite. Le Nouveau Musée. Villeurbanne 1989 (cat.)
MONOGRAPHS, CATALOGUES: Ammann, J.-C. and S. Pagé (ed.): M. M. Musée d'Art Moderne de la Ville de Paris et al. Paris and Basel 1981 (cat.).– Barzel, A. (ed.): M. M. Je veux faire il curvo o dritto. Museo d'Arte Contemporaneo. Prato 1990 (cat.).– Celant, G. and Z. Felix (ed.): M. M.

Museum Folkwang, Essen et al. Essen 1979 (cat.).– Celant, G. and Z. Felix (ed.): M. M. Palazzo dei Congressi ed Espozioni, Republica di S. Marco. Milan 1983 (cat.).– Celant, G. (ed.): M. M. Solomon R. Guggenheim Museum. New York 1989 (cat.).– Eccher, D. (ed.): M. M. Gallerie Civica d'Arte Contemporaneo, Trento. Torino 1995 (cat.).– Granath, O. (ed.): M. M. Moderna Museet. Stockholm 1983 (cat.).– Haenlein, C. A. (ed.): M. M. Disegni. Arbeiten auf Papier. Kestner-Gesellschaft. Hanover 1982 (cat.).– M. M. Albright-Knox Art Gallery. Buffalo 1984 (cat.).– Mundici, C. (ed.): M. M. Terra elevata o la storia del disegno. Castello di Rivoli, Museo d'Arte Contemporanea. Milan 1990 (cat.).– Szeemann, H. et al. (ed.): M. M. 2 vols. Kunsthaus Zürich. Zurich 1985 (cat.)

**METZEL Olaf**
born **1952** Berlin
German sculptor. **1971–1977** Attended the Art Academy and University in Berlin. **1977/78** DAAD scholarship to Italy. **1982** Solo-exhibition at the Kunstraum in Munich. **1984** Participation in the exhibition "von hier aus" in Düsseldorf. **1986** Grant from the Kunstfond Bonn. Solo-exhibition at the Galerie Michael Schwarz in Braunschweig. Guest-professor at the Hamburg Academy. **1987** Won the Villa Massimo Prize in Rome. Took part in the Sculpture Boulevard along the Kurfürstendamm in Berlin. Participated in documenta 8 in Kassel. Since **1995** director of the Munich Academy of Art. **1996** Solo-exhibition at Lenbachhaus in Munich. Metzel's sculptures, often erected in public places, are assemblages of broken or demolished furnishings or everyday objects, put together like a collage.
MONOGRAPHS, CATALOGUES: Horn, L. (ed.): O. M. Skulptur. Kunstraum. Munich 1982 (cat.).– Horn, L. et al. (ed.): O. M. Zeichnungen 1985-1990. Westfälisches Landesmuseum, Münster et al. Münster 1990 (cat.).– Kurt-Eisner.-Kulturstiftung (ed.): O. M. Munich 1990.– O. M. Staatliche Kunsthalle Baden-Baden. Munich 1992 (cat.).– O. M. Hamburger Kunsthalle. Stuttgart 1992 (cat.).– Osterwold, T.: O. M. Institut für Auslandsbeziehungen. Stuttgart 1996 (cat.).– Wilmes, U. (ed.): O. M. Freizeitpark. Städtische Galerie im Lenbachhaus. Munich 1996 (cat.)

**METZINGER Jean**
**1883** Nantes – **1956** Paris
French painter. Around **1900** attended the Art Academy in Nantes. **1903** Moved to Paris and exhibited at the Salon des Indépendants. **1904** Presented his neo-impressionist-style paintings at the Salon d'Automne. **1906/07** Became acquainted with Delaunay, Gris, Braque and Picasso. **1910** Showed a strong interest in Cubism. **1911** Participated in the Salon des Indépendants. **1912** Joined the Section d'Or. Pub-

lished the article *Du Cubisme* with Gleizes. **1913** Participated in the First German Autumn Salon at the gallery Der Sturm in Berlin. **1914** One year of military service. **1915** Solo-exhibition at the Galerie L'Effort Moderne in Paris. **1922–1927** Wrote texts for the *Bulletin de l'Effort Moderne*. **1932** Solo-exhibitions in London. **1937** Painted the interior of the cinema of the Railway Palace for the Paris World Fair. **1947** Publication of a volume of poems *L'Ecluse*. **1953** Works displayed in the exhibition "Le Cubisme 1907–1914" at the Musée National d'Art Moderne in Paris. Since Metzinger's painting was somewhat dominated and overshadowed from the start by the influence of Gris and Picasso, his own sphere of influence remained limited.
WRITINGS: J. M. and A. Gleizes: Du cubisme. Paris 1912, Sisteron 1980 / Kubismus. Munich 1928, Mainz and Berlin 1980 CATALOGUE RAISONNE: Nikiel, B. and P. Cézanne (ed.): J. M. Catalogue raisonné (in preparation)
MONOGRAPHS, CATALOGUES: Hiscock, K.: J. M. His Role as Painter / Theorist in the Cubist Circle 1910-1915. Diss. Birmingham 1985.– J. M. Ecole Régionale des Beaux-Arts. Nantes 1985 (cat.).– Moser, J. and D. Robbins (ed.): J. M. in Retrospect. The University of Iowa Museum of Art. Iowa City 1985 (cat.)

**MEYER Adolf de**
(Adolf Edward Sigismund Meyer-Watson) **1869** Paris – **1949** Hollywood
French-American fashion photographer. **1895** Moved to London where he began to photograph. **1899** Entered London high society through his marriage to Olga Carraciolo and was introduced to the Royal Family. **1903** Solo-exhibition in London. **1906** and **1912** exhibitions in New York. Editor of the magazine *Camera Work*. **1914** Moved to New York and photographed for *Vogue* and *Vanity Fair*. **1919** Returned to Paris. From **1923** took photographs for *Harper's Bazaar*. **1939** Emigrated to America and settled in California. Meyer's photographs are a documentary of the mundane and fashion-conscious lifestyle of high society.
MONOGRAPHS, CATALOGUES: Brandauer, R. and P. Jullian: De M. New York 1976

**MICHALS Duane**
born **1932** Mc Keesport (PA)
American photographer. Studied at the University of Denver. **1958** Went to Russia where he took his first photographs. **1961** Moved to New York and made his name taking portraits of artists (T. Williams and Warhol). Photographed for *Vogue*, *Esquire* and *New York Times* Since **1964** contact to Magritte. **1966** First photo-story, entitled *Sequential Story*. From **1974** photographs with integrated text. **1977** Participation in documenta 6 in Kassel. **1982** Retrospective at the Musée d'Art Moderne de la Ville de Paris.
MONOGRAPHS, CATALOGUES: Gruber, F. L. et al. (ed.): D. M. Photographien 1958-1988. Hamburg 1988 (cat.).– D. M. Musée d'Art Moderne de la Ville de Paris. Paris 1982 (cat.)

**MICHAUX Henri**
**1899** Namur – **1984** Paris
Belgian-born French artist and writer. **1918–1921** Travelled all over the world as a sailor. Inspired by Lautréament's works, he took up writing himself in **1922**. **1924** Moved to Paris where, in **1925**, he saw the paintings of Klee, Ernst and de Chirico and decided to become an artist. **1927–1937** Travels in Asia and South America. **1937** First exhibition at the Galerie de la Pléiade in Paris. **1940–1945** Settled in Le Lavandou in the South of France. **1948** Worked on expressive watercolours. **1956** First experiments with hallucinogenic drugs, especially mescaline. **1959** and **1964** participation in documenta 2 and 3 in Kassel. **1960** Awarded the Einaudi Prize at the Venice Biennale. **1968** Use of acrylic paints. Michaux' drawing and painting style came closest to Surrealism. However, his compositions of the 50s were very much influenced by Tachisme. WRITINGS: Celan P. and K. Leonhard (ed.): H. M. Dichtungen und Schriften. 2 vols. Frankfurt-on-Main 1966 and 1971.– H. M.: Plume, précédé de Lointain. Intérieu. Paris 1938.– H. M.: Epreuves, Exorcismes 1940-1944. Paris 1945.– H. M.: L'infini turbulent. Paris 1957.– H. M.: Affrontements. Paris 1986.– H. M.: Darkness Moves. An H. M. Anthology. Berkeley 1993.– H. M.: Ecuador. Paris 1930, Graz 1994.– H. M.: Ideogramme in China. Graz 1994.– Schwerin, C. (ed.): In der Gesell-

schaft der Ungeheuer. Ausgewählte Dichtungen. Frankfurt-on-Main 1986
CATALOGUE RAISONNE: Mason, R. M. and C. Cherix (ed.): H. M. Les Estampes 1948-1984. Paris 1995
MONOGRAPHS, CATALOGUES: Angliviel, A. and A. Pacquement (ed.): H. M. Centre Georges Pompidou. Paris 1978 (cat.).– Baatsch, H.-A. (ed.): H. M. Peinture et poésie. Paris 1993.– Bonnefoi, G. (ed.): Hommage à M. Centre d'Art Contemporain de l'Abbaye de Beaulieu. 1985 (cat.).– Bowie, M.: H. M. A Study of His Literary Works. Oxford 1973.– Butor, M.: Improvisations sur H. M. Saint-Clément-de-Rivière. 1985.– Broome, P.: H. M. London 1977.– Edson, L.: H. M. and the Poetic of Movement. Saratoga 1985.– Elkan, L.: Les Voyages et les Propriétés d' H. M. New York 1988.– Hulten, P. et al. (ed.): H. M. Centre Georges Pompidou. Paris 1978 (cat.) / H. M. Solomon R. Guggenheim Museum, New York et al. New York 1978 (cat.).– Jahn, F. and M. Krüger (ed.): Bilder, Aquarelle, Zeichnungen, Gedichte, Aphorismen. 1942-1984. Munich 1987.– La Motte, M. d. (ed.): H. M. Berlin 1994.– Leonhard, K.: M. Stuttgart 1967.– Livingstone, M.: D. M. Photographs / Sequences / Texts 1968-1984. Museum of Modern Art. Oxford 1984 (cat.).– H. M. Stedelijk Museum. Amsterdam 1964 (cat.).– H. M. Kestner-Gesellschaft. Hanover 1972 (cat.).– H. M. Œuvres choisies 1927-1984. Musée Cantini, Marseilles et al. Marseille 1993-1994 (cat.).– Pacquement, A.: H. M. Peintures. Paris 1993.– Schmied, W. (ed.): H. M. St. Gallen 1973.– Schmied, W. (ed.): H. M. Das bildnerische Werk. Bayerische Akademie der Schönen Künste, Munich et al. Munich 1993 (cat.).– Stoullig, C. and N. Cendo (ed.): H. M. Œuvres choisies. 1927-1984. Musée Cantini, Marseille et al. Paris 1993 (cat.)

**MILLER Lee**
**1907** Poughkeepsie (NY) – **1977** Sussex
American photographer. **1926** Began to study art in New York. **1927** Discovered by Condé Nast as a photographic model. **1929** Became Man Ray's model and lover in Paris. **1930** Set up her own photographic studio in Paris. Separated from Man Ray and, in **1932**, returned to New York. **1934–1937** Lived in Egypt. **1937** Returned to Paris, but then moved with Roland Penrose to England. **1940** joined *Vogue*, working for them as a photojournalist during the war. Fashion photographs were juxtaposed with views of bomb damage in English cities. **1942–1945** War correspondent for the US in France, Belgium and Germany. **1947** Fashion designs with Peggy Riley in St. Moritz. **1954** Publication of her photographs in Roland Penrose's book *Picasso. His Life and Work*. **1973** Photographed Tàpies, whose biography Penrose was writing. **1977** Died of cancer.
MONOGRAPHS, CATALOGUES: Livingston, J. (ed.): L. M. Photographer. Washington et al. 1989 (cat.).– Penrose, A.: The Lives of L. M. New York 1985, 1988

**MIOTTE Jean**
born **1926** Paris
French painter. **1947** Studied under Othon Friesz and Ossip Zadkine in Paris. **1951/52** Met Arp, Severini and Francis. **1953** Participation in Salon des Réalités Nouvelles. **1957** First solo-exhibition at the Galerie Durand in Paris. Friendship with Serge Poliakoff and André Lanskoy. **1963** Exhibition "Art Contemporain" at the Grand Palais in Paris. **1968** Politically involved in the student unrest in Paris. **1980** Miotte was the first Western painter to be exhibited in Peking after Mao's death. **1994** Made the film *L'Eclatement d'un Grenade* based on a text by Fernando Arrabal. **1996** Retrospective at the Museum Mücsarnok, Budapest.
WRITINGS: J. M.: L'œuf, le couteau et la ficelle. Paris 1996
MONOGRAPHS, CATALOGUES: Chalumeau, J.-L.: M. L'Enjeu de la peinture n'est pas figurable. Paris 1990.– Cluny, C.-M.: M. Peintures et gouaches. Paris 1989.– Pleynet, M.: M. Œuvres sur papier 1950-1969. Paris 1987.– Pleynet, M.: J. M. Paris 1993

**MIRO Joan**
**1893** Montroig (near Barcelona) – **1983** Palma de Mallorca
Spanish painter, graphic artist and sculptor. Attended art classes at the Akademie La Lonja in Barcelona while still a teenager. **1912–1915** Studied at the Francisco Gali Art Academy. In-depth studies of Impressionist and Fauvist painting. **1917** Met Picabia in Barcelona. **1919** Trip to Paris where he met Picasso. **1919** Returned to Barcelona with Cubism and Dadaism. **1920** Moved to Paris. **1921/22** Painted paradisiacal landscapes in a poetic realist style. Gradual retraction of the picture's depth of field until his compositions became completely flat. **1924** Closer contact with Surrealist artists. Signed the Surrealist manifesto. **1925** Participated in the Surrealists' first joint-exhibition. **1926** Costume and stage designs, with Max Ernst for Sergei Diaghilev's Ballets Russes. **1928** Trip to Holland where he painted imaginary portraits after the Old Masters. First collages. **1937** Designed wall decorations for the Spanish pavilion at the Paris World Fair and posters for the Spanish Republic. **1942** Returned to Barcelona. **1944** First ceramic

works. **1956** Settled in Palma de Mallorca. Produced monumental ceramic murals for the UNESCO building in Paris and large-scale abstract paintings with colourful luminous signs, clearly influenced by modern trends in American painting. **1977–1983** Commissions for monumental sculptures in Madrid and Chicago.
WRITINGS: Rowell, M. (ed.): J. M. Selected Writings and Interviews. London and Boston 1986.– Schneidegger, E. (ed.): J. M. Gesammelte Schriften. Zurich 1957
CATALOGUES RAISONNES: Corredor-Matheos, J. (ed.): Los carteles de M. Barcelona 1980/M.'s Posters. Barcelona and Secaucus (NJ) 1980.– Cramer, P. (ed.): J. M. Catalogue raisonné des livres illustrés. Geneva 1989.– Dupin, J. and B. Videcoq (ed.): M. Graveur. 4 vols. Paris 1984-1994/M. The Engravings. 4 vols. New York 1989-1994.– Malet, R. M. (ed.): Obra de J. M. Fundació J. M. Barcelona 1988.– Mourlot, F. et al. (ed.): M. lithographies. 6 vols. Paris 1972-1992/M. Lithographs. 6 vols. Paris 1972-1992/M. Der Lithograph. 6 vols. Geneva 1972-1992
MONOGRAPHS, CATALOGUES: Altaió, V. (ed.): J. M. Memòria Any Miró, 1993. Barcelona 1994 (cat.).– Baumann, F. et al. (ed.): J. M. Kunsthaus, Zurich et al. Zurich 1986 (cat.).– Combalía, V. (ed.): El descubrimiento de M. J. M. y sus critico 1918-1929. Barcelona 1990.– Corbello, D.: Entendre M. Barcelona 1993.– Dupin, J.: J. M. La Vie et l'œuvre. Paris 1961, 1993/J. M. Leben und Werk. Cologne 1961/J. M. Life and Work. New York 1962, 1994.– Ebert-Schifferer, S. and H. Gaßner (ed.): M. Gemälde, Plastiken, Zeichnungen und Graphik. Werke aus den Kunstsammlungen des spanischen Staates. Schirn Kunsthalle, Frankfurt-on-Main. Munich 1988 (cat.).– Erben W.: J. M. 1893-1983. The Man and His Work. Cologne 1988.– Escudero, C. and T. Montaner (ed.): J. M. 1893-1993. Fundació Juan March, Barcelona. Madrid 1993 (cat.).– Fuchs, R. et al. (ed.): J. M. Viaggio delle figure. Museo d'Arte Contemporanea. Milan 1988 (cat.).– Gaßner, H.: J. M. Der magische Gärtner. Köln 1994.– Gaudieri, A. and P. Théberge (ed.): M. à Montreal. Musée des Beaux-Arts. Montreal 1986 (cat.).– Gimferrer, P.: Roots of M. New York 1993/J. M. Auf den Spuren seiner Kunst. Stuttgart 1993.– Greenberg, A.: J. M. New York 1969.– Haenlein, C. A. (ed.): J. M. Arbeiten auf Papier 1901-1977. Kestner-Gesellschaft. Hanover 1989 (cat.).– Jouffroy, A. and J. Teixidor: Les Sculptures de M. Paris 1973, 1980.– Lanchner, C. (ed.): J. M. The Museum of Modern Art. New York 1993 (cat.).– Leymarie, J. and J. Dupin (ed.): J. M. Grand Palais. Paris 1974 (cat.).– Lubar, R. S. et al. (ed.): J. M. A Retrospective. Solomon R. Guggenheim Museum. New York 1987 (cat.).– J. M. Sammlung der Fondation Maeght. Stadthalle Balingen. Munich 1994 (cat.).– Malet, R. M.: J. M. Stuttgart 1983.– Malet, R. M. (ed.): J. M. Fundació Joan Miró. Barcelona 1993, New York 1993 (cat.).– Maur, o. (ed.): J. M. escultor. Museo Nacional Centro de Arte Reina Sofía. Madrid 1986 (cat.)/M. Der Bildhauer. Cologne 1987 (cat.).– Penrose, R.: M. London and New York 1969.– Platschek, H.: J. M. Mit Selbstzeugnissen und Bilddokumenten dargestellt. Reinbek 1993.– Prat, J.-L. (ed.): J. M. Rétrospective de l'œuvre peint. Fondation Maeght. Saint-Paul 1990 (cat.).– Prat, J.-L. (ed.): J. M. Skulpturen. Kunsthalle der Hypo-Kulturstiftung. Munich 1990 (cat.).– Raillard, G.: M. Paris 1989.– Rose, B. (ed.): M. in America. Museum of Fine Arts. Houston 1982 (cat.).– Rowell, M.: M. New York 1971.– Rowell, M. (ed.): J. M. Campo de Estrellas. Museo Nacional Centro de Arte

Reina Sofía. Madrid 1993 (cat.).– Santos, R. T.: 35 años de J. M. Barcelona 1994.– Serra, P.: M. and Mallorca. New York 1986.– Soby, J. T. (ed.): J. M. The Museum of Modern Art, New York et al. New York 1959 (cat.).– Taillandier, Y.: Indelible M. New York 1972.– Weelen, G.: M. Cologne 1984, New York 1989

**MODERSOHN-BECKER Paula**
**1876** Dresden – **1907** Worpswede
German painter. **1888** Moved with her family to Bremen. **1892** Spent half a year in England. **1893–1895** Studied at a teach training college for women in Bremen. **1896–1898** Attended the School of Drawing and Painting founded by the Verein Berliner Artistinnen (Berlin Association of Female Artists). **1897** First visit to Worpswede where she took classes under the painter F. Mackensen. **1899** Exhibition at the Bremen Kunsthalle. **1900** Went to Paris to study at the Académie Colarossi and the Ecole des Beaux-Arts. Came to know Emil Nolde and Rainer Maria Rilke. **1901** Married Otto Modersohn. Moved to Worpswede. **1903** Second trip to Paris. Visited Rodin's studio. **1905** Spent more time in Paris, studying at the Académie Julian. February **1906** last visit to Paris. In spring **1907** returned to Worpswede. Modersohn-Becker, who died very young, shortly after the birth of her daughter Mathilde, is considered a forerunner of German Expressionism.
WRITINGS: Busch, G. and L. v. Reinken (ed.): P. M.-B. in Briefen und Tagebüchern. Frankfurt-on-Main 1979/P. M.-B. The Letters and Journals. Evanston 1990.– Radycki, D. (ed.): P. M.-B.: The Letters and Journals of P. M.-B. Metuchen 1980
CATALOGUES RAISONNES: Busch, G. and W. Werner (ed.): P. M.-B. Werkverzeichnis der Gemälde. Munich 1998.– Stoermer, C. (ed.): P. M.-B. Katalog ihrer Werke. Worpswede 1913.– Werner, W. (ed.): P. M.-B. Œuvreverzeichnis der Graphik. Bremen 1972
MONOGRAPHS, CATALOGUES: Bohlmann-Modersohn, M.: P. M.-B. Eine Biographie mit Briefen. Munich 1995.– Busch, G. et al. (ed.): P. M.-B. Zum hundertsten Geburtstag. Kunsthalle Bremen. Bremen 1976 (cat.).– Busch, G.: P. M.-B. Malerin, Zeichnerin. Frankfurt-on-Main 1981.– Friedel, H. (ed.): P. M.-B. Städtische Galerie im Lenbachhaus. Munich 1997 (cat.).– Harke, P. J.: Stilleben von P. M.-B. Worpswede. 1985.– Heise, C. G.: P. M.-B. Mutter und Kind. Stuttgart 1961.– Murken-Altrogge, C.: P. M.-B. Leben und Werk. Cologne 1980.– Perry, G.: P. M.-B. Her Life and Work. London 1979.– Reinken, L. v.: P. M.-B. in Selbstzeugnissen und Bilddokumenten. Reinbek 1983.– Schneede, U. M. (ed.): P. M.-B. Hamburger Kunstverein. Hamburg 1976 (cat.).– Stelzer, O.: P. M.-B. Berlin 1958.– Uhde-Stahl, B.: P. M.-B. Frau, Künstlerin, Mensch. Stuttgart, Zurich 1989.– Uhde-Stahl, B.: P. M.-B. London 1990

**MODIGLIANI Amedeo**
**1884** Livorno – **1920** Paris
Italian painter and sculptor. After short academic studies in Florence and Venice, he moved in **1906** to Paris where he met Picasso and became friends with Utrillo and Soutine. His unsettled, dissolute lifestyle with excessive alcohol and drug consumption took their toll on his health. **1908** Exhibition at the Salon des Indépendants. **1909** Encouraged by his neighbour, the sculptor Brancusi, to take up sculpture. Produced heads of women and caryatids, inspired by African masks and sculptures. **1915/16** Developed his own style characterised by rusty colours, mannered, elongated forms and oval heads on tube-like necks. His sensuous nudes are confined within firm contours. **1918** Solo-exhibition at Berthe Weill's gallery in Paris. **1918–1919** Visited Survage in Cannes and Nice. Painted landscapes reminiscent of early Cubist works. Modigliani died of tuberculosis. All the figures he portrayed were taken from real life. Through distortion of their natural shape and cubist deformations of pictorial space he reached a summit of expressiveness.
CATALOGUES RAISONNES: Ceroni, A. (ed.): A. M. 2 vols. Milan 1958-1965.– Ceroni, A. (ed.): Tout l'œuvre peint de M. Paris 1972.– Guastella, G. and G. (ed.): M. Catalogue raisonné. Peintures, dessins, aquarelles. 2 vols. Roma 1990-1992/M.'s Complete Paintings, Drawings and Watercolors. Catalogue Raisonné. 2 vols. San Francisco 1990.– Lanthemann, J. (ed.): M. 1884-1920. Catalogue raisonné. Sa Vie, son œuvre complet, son art. Barcelona 1970.– Patani, O. (ed.): A. M. Catalogo generale. 3 vols. Milan 1991-1994.– Pfannstiel, A.: M. et son œuvre. Etude critique et catalogue raisonné. Paris 1956.– Piccioni, L. (ed.): I dipinti di M. Milan 1970
MONOGRAPHS, CATALOGUES: Alexandre, N. (ed.): The Unknown M. New York 1993/Der unbekannte M. Museum Ludwig, Cologne. Munich 1993 (cat.).– Castieau-Barrielle, T.: La Vie et l'œuvre de A. M. Paris 1987.– Ceroni: A. M. Die Akte. Stuttgart, Berlin 1989.– Contensou, B. and D. Maréchessant (ed.): A. M. 1884-1920. Musée d'Art Moderne de la Ville de Paris. Paris 1981 (cat.).– Fifield, W.: M. The Biography. London 1978.– Hall, D.: M. Oxford 1984.– Iwasaki, Y. et al. (ed.): M. National Museum of Modern Art, Tokyo et al. Tokyo 1985 (cat.).– Kruszynski, A.: A. M. Akte und Porträts. Munich et al. 1996.– Lassaigne, J.: A. M. Frankfurt-on-Main et al. 1981.– Mann, C.: M. New York and Oxford 1980.– A. M. Palazzo Grassi. Venice 1993 (cat.).– Modigliani, J.: M. Men and Myth. London 1959.– Modigliani, J.: M. une biographie. Paris 1990.– Nicoïdski, C.: A. M. Paris 1989.– Nuzzo, P.: A. M. a Montparnasse negli anni 1916-1920. Galleria d'Arte Moderna e Contemporanea, Palazzo Forti, Verona. Milan 1988 (cat.).– Parisot, C.: M. Paris 1992, New York 1996.– Patani, O. and A. Grimani: M. Disegni giovanili 1896-1905. Roma 1990.– Piccione, L.: I dipinti di

M. Milan 1970.– Rose, J.: M. The Pure Bohemian. New York 1991/A. M. Sein Leben, sein Werk, seine Zeit. Bern et al. 1991.– Roy, C.: M. New York 1985, Geneva 1985.– Salmon, A.: A. M. Sein Leben und sein Schaffen. Zurich 1960.– Santini, A.: M. Maldetto dai livornesi. Livorno 1984.– Schmalenbach, W. (ed.): A. M. Malerei, Skulpturen, Zeichnungen. Kunstsammlung Nordrhein-Westfalen, Düsseldorf et al. Munich 1990 (cat.)/A. M. Paintings, Sculptures, Drawings. Munich 1990.– Schulmann D. et al. (ed.): M. J. B. Fondation Pierre Gianadda. Martigny 1990 (cat.).– Werner A.: A. M. New York 1966, Cologne 1968, 1991

**MOHOLY Lucia**
(née Schulz)
**1894** Karlín (Bohemia) – **1989** Zollikon (near Zurich)
Czech photographer. After training as an English teacher, studied history of art and philosophy. From **1915** worked as an editor for various magazines and publishers, and wrote a volume of expressionist poems under an assumed name. **1921** Married László Moholy-Nagy in Berlin. Joint photographic projects and theoretical treatises on art. **1923** On her husband's appointment to the Weimar Bauhaus, she took up an apprenticeship as a photographer and began studies at the Leipzig School of Arts and Crafts. **1924** Portraits of Bauhaus teachers and friends. **1926** Photoseries of the newly constructed Bauhaus in Dessau. **1929** Separation from Moholy-Nagy. Taught photography at the Itten School in Berlin. **1933** Emigrated to England, settling in London. **1939** Publication of her book *One Hundred Years of Photography*. **1945** Commissioned by UNESCO to photograph important cultural documents. **1959** Set herself up as an independent publicist in Zurich.
WRITINGS: L. M.: One Hundred Years of Photography. London 1939.– L. M.: Marginalien zu Moholy-Nagy. Dokumentarische Ungereimtheiten. Krefeld 1972
MONOGRAPHS, CATALOGUES: L. M. Fotos von der Bauhauszeit und der Emigration 1925-1940. Forum Böttcherstraße. Bremen (cat.).– Sachsse, R.: L. M. Bauhaus Fotografin. Düsseldorf 1985

**MOHOLY-NAGY László**
**1895** Bácsborsod – **1946** Chicago
Hungarian artist. **1914–1917** Military service. Did his first drawings while recovering from severe wounds in hospital. **1918** Completed law studies in Budapest and took up painting. **1919/20** Moved first to Vienna and then to Berlin. First photograms with Lucia Schulz. **1923** Appointed to the Weimar Bauhaus where he directed the metal workshop and later the preliminary course. **1926** Publication of his Bauhaus book *Painting, Photography, Film*. From **1928** designed stage sets, organised exhibitions and wrote articles on the

theory of art in Berlin. **1934/35** Emigrated to England via Amsterdam. Film productions and publication of books of documentary photographs. Exhibition of plexiglas sculptures. **1937** Offered a position at the New Bauhaus in Chicago which, however, closed in **1938** owing to financial problems. Opened his own School of Design, which he directed until he died. László Moholy-Nagy's artistic output encompassed painting, photography, film and stage design. In his experiments with photograms he pioneered the artistic use of light and laid the foundations for Kinetic Art.
WRITINGS: Kaplan, L. (ed.): L. M.-N. Biographical Writings. Durham 1995.– L. M.-N.: Malerei, Photographie, Film (Bauhausbücher 8). Munich 1925/Painting, Photograpy, Film. Cambridge (MA) and London 1969/Peinture, photographie, film et autres écrits sur la photographie. Nîmes 1993.– L. M.-N.: Von Material zu Architektur (Bauhausbücher 14). Munich 1929.– L. M.-N.: The New Vision. From Material to Architecture. New York 1932, London 1939.– L. M.-N.: Vision in Motion. Chicago 1947, 1961
MONOGRAPHS, CATALOGUES: Botar, O.: L. M.-N. From Budapest to Berlin 1914-1923. Newark 1995.– Caplan, L.: L. M.-N.: Biographical Writings. Diss. Chicago 1988.– Caton, J. H.: The Utopian Vision of M.-N. Diss. Princeton University. Ann Arbor (MI) 1984.– David, C. et al. (ed.): L. M.-N. IVAM Centro Julio González, Valencia et al. Valencia 1991 (cat.).– David, C. et al. (ed.): L. M.-N. Museum Fridericianum, Kassel et al. Stuttgart 1991 (cat.).– Engelbrecht, Lloyd C. (ed.): M.-N. A New Vision for Chicago. Champaign 1991.– Haus, A. (ed.): L. M.-N. Fotos und Fotogramme. Munich 1978/M.-N. Photos et photogrammes. Paris 1979/M.-N. Photographs and Photograms. London and New York 1980.– Herzogenrath, W. et al. (ed.): L. M.-N. Württembergischer Kunstverein, Stuttgart et al. Stuttgart 1974.– Hight, E. M.: L. M.-N. Picturing Modernism. M.-N. and Photography in Weimar. Cambridge 1994.– Jäger, G. and G. Wessing (ed.): L. M.-N. Ergebnisse aus dem Internationalen L. M.-N. Symposium, Bielefeld 1995 Bielefeld 1997.– Jánosi, I.: L. M.-N. His Early Life in Hungary 1895-1919. Diss. Bloomington (IN) 1979.– Kostelanetz (ed.): L. M.-N. New York 1970, London 1971.– Lusk, I.-C.: Montagen ins Blaue. L. M.-N. Fotomontagen und -collagen 1922-1943. Giessen 1980.– L. M.-N. Museum of Contemporary Art, Chicago et al. Chicago 1969 (cat.).– L. M.-N. Centre Georges Pompidou. Paris 1976 (cat.).– L. M.-N. Frühe Photographien. Berlin 1989 (cat.).– L. M.-N. Musée Cantini. Marseille 1991 (cat.).– L. M.-N. Les Fotogrammes. Centre Georges Pompidou. Paris 1995 (cat.)/Die Fotogramme. Museum Folkwang. Essen 1996 (cat.).– Moholy-Nagy, S.: M.-N. Experiment in Totality. New York 1950, 1969.– Newhall, B. (ed.): M.-N. Photographs, Photograms and Photomontages.

New York 1971.– Passuth, K.: M.-N. Paris 1984, London 1985, Weingarten 1986.– Rice, L. D. and D. W. Steadman (ed.): Photographs of M.-N. Claremont (CA) 1975.– Rondolino, G.: L. M.-N.: Pittura, fotografia, film. Torino 1975.– Seuphor, M.: P. M. Life and Work. New York 1956.– Soucek, L.: L. M.-N. Bratislava 1965.– Starr, S.: L. M.-N. Photography and Film. New York 1990.– Steckel, H.: L. M.-N. 1895-1946: Entwurf seiner Wahrnehmungslehre. 2 vols. Diss. Berlin 1974

**MONDRIAN Piet**
(Pieter Cornelis Mondriaan)
**1872** Amersfoort (near Utrecht) –
**1944** New York
Dutch painter. **1892–1897** Studied at the Rijksakademie in Amsterdam under A. Allebé. **1904/05** Lived in Brabant and Overijssel. Developed an abstract style early in his career. Up to **1906** painted landscapes in the style of the Impressionists from Amsterdam and The Hague. **1905/06** Did scientific drawings for Professor Calcan in Leiden. **1909** Exhibition at the Stedelijk Museum in Amsterdam. Vehement criticism of his free, Fauvist-style landscapes. **1911–1914** Lived in Paris. Cubist phase. **1914** Returned to Holland, living in Amsterdam, Laren, Blaricum, Scheveningen and Domburg. **1915** Met van Doesburg. **1917** Founded the artists' group De Stijl with van Doesburg, and published his series of articles on *The New Structuring of Painting* in the *De Stijl magazine*. **1917** First plus-minus compositions, paintings with rhythmic horizontal and vertical lines. **1918** Geometric grid paintings. **1919** Returned to Paris. **1920** Publication of his treatise *Le Neo Plasticisme*. Around **1920** abstract paintings of coloured rectangles outlined in black. **1921** Reduced his palette to three pure primary colours plus black, white and grey. **1930** Joined the group Cercle et Carré. **1931** Joined Abstraction-Création. **1938** Moved to London. **1940** Emigrated to America, settling in New York. Last change of style: framework of black lines replaced by coloured lines and rows of small colourful rectangles.
WRITINGS: Holtzman, H. and M. S. James (ed.): The New Art, the New Life. The Collected Writings of P. M. Boston 1986, London 1987, New York 1993.– P. M.: Neue Gestaltung. Berlin 1925, 1974.– P. M.: Plastic Art and Pure Plastic Art. New York 1945.– P. M.: Le Néo-plasticisme. Paris 1920, Amersfoort 1994.– P. M.: Natural Reality and Abstract Reality. New York 1995.– Schmidt, G.: Theorien und Ideen von P. M. Basel 1972
CATALOGUES RAISONNES: Blok, C. (ed.): P. M. Een catalogus van zijn werk in Nederlands bezit. Amsterdam 1974.– Joosten, J. and R. P. Welsh (ed.): P. M. Catalogue Raisonné. Ghent, New York and Munich 1997.– Ottolenghi, M. G. (ed.): Tout l'œuvre peint de P. M. Paris 1975
MONOGRAPHS, CATALOGUES: Apollonio, U.: M. und die Abstrakten. Munich

1973.– Blotkamp, C.: M. Destuctie als kunst. Zwolle 1994/M. The Art of Destruction. New York 1995.– Bois, Y.-A. et al. (ed.): P. M. 1872-1944. Haags Gemeentemuseum, The Hague et al. Milan 1994, Bern 1995.– Bois, Y.-A. (ed.): P. M. 1872-1944. National Gallery of Art, Washington et al. Boston 1995 (cat.).– Celant, G. and M. Govan (ed.): M. e De Stijl. Venice et al. Venice 1990 (cat.).– Champa, K. S.: Mondrian Studies. Chicago 1985.– Deicher, S.: P. M. Structures in Space. Cologne 1995.– Deicher, S.: P. M. Protestantismus und Modernität. Berlin 1995.– Elgar, F.: M. New York 1968.– Fauchereau, S.: M. et l'utopie néo-plastique. Paris 1995.– Henkels, H. (ed.): M. From Figuration to Abstraction. Seibu Museum of Art, Tokyo et al. The Hague 1987 (cat.).– Jaffé, H. L. C.: P. M. Paris 1970, 1991, Cologne 1971, 1982, New York 1970, 1985.– Lemoine, S.: M. et De Stijl. Paris 1987.– Lévy, B.-H.: P. M. Paris 1992.– Lewis, D.: M. 1872-1944. London 1957.– Meuris, J.: M. Paris 1991.– Milner, J.: M. London and New York 1992.– P. M. 1872-1944. Centennial Exhibition. Solomon R. Guggenheim Museum. New York 1971 (cat.).– M. and The Hague School. Whitworth Art Gallery. Manchester 1980 (cat.).– Rüdiger, R.: Der Begriff des Gegenstandes bei P. M. Berlin 1982.– Scheer, T. and A. Thomas-Netik: P. M. Komposition mit Rot, Gelb und Blau. Frankfurt-on-Main 1995.– Seuphor, M.: P. M. Life and Work. New York 1956/P. M. Sa Vie, son œuvre. Paris 1957/P. M. Leben und Werk. Cologne 1957.– Sweeney, J. J. (ed.): P. M. The Museum of Modern Art. New York 1948 (cat.).– Threlfall, T.: P. M. His Life's Work and Evolution. New York 1988.– Tomassoni, I. (ed.): P. M. Florence 1969.– Versteeg, C.: M. een leven in maat en ritme. The Hague 1988.– Welsh, R. P. (ed.): P. M. The Art Gallery of Toronto et al. Toronto 1966 (cat.).– Welsh, R. P.: M.'s Early Career, the Naturalistic Periods. New York and London 1977.– Wijsenbeek, L. J. F.: P. M. Recklinghausen 1968, Greenwich (CT) 1969

**MONET Claude**
**1840** Paris – **1926** Giverny
French painter. **1843** Moved from Paris to Le Havre. **1855** Friendship and collaboration with E. Boudin. Began painting *en plein air*. **1859** Studied at the Académie Suisse. Came to know Pissarro, Jongkind, Daubigny and Troyon. Admired Delacroix, Corot, Millet and Courbet. **1861** Military service in Algeria. Returned to Paris for health reasons. **1862** Entered the studio of Gleyre, where he met Bazille, Sisley and Renoir, and became very interested in Manet's work. **1865** First public success, **1869** Rejected by the Salon. **1870/71** Married Camille Doncieux. Moved to London at the outbreak of war, where he studied the paintings of Constable and Turner and met the art dealer Durand-Ruel, who helped to organize an exhibition for him. **1872–1877** Lived in Argenteuil

near Paris. Together with Sisley, Pissarro and Renoir founded the group Société des Artistes Indépendants, mockingly referred to by the critics as the Impressionists, a name suggested by Monet's painting *Impression, Sunrise* (1872). They held eight joint-exhibitions from **1874** to **1886**. **1879** Death of his wife. **1881** Moved to Poissy. **1883** Mediterranean cruise with Renoir. From **1883** lived in Giverny, where the celebrated waterlily gardens inspired his water-lily series. **1886** Took part in the Paris World Fair. Monet is regarded as the archetypal Impressionist who, together with Renoir, was chiefly responsible for developing the Impressionist style of painting.
WRITINGS: Brive, P. (ed.): G. Clemenceau: Lettres à une amie 1923-1929. Paris 1970.– Graber, H.: Camille Pissarro, Alfred Sisley, C. M. nach eigenen und fremden Zeugnissen. Basel 1943.– Kendall, R. (ed.): C. M. par lui-même: tableaux, dessins, pastels, correspondance. Evreux 1989.– Proietti, M. L.: Lettere di C. M. Assisi and Roma 1974
CATALOGUE RAISONNE: Wildenstein, D. (ed.): C. M. Catalogue raisonné. 4 vols. Cologne 1996
MONOGRAPHS, CATALOGUES: Adhémar, H. et al. (ed.): Hommage à C. M. Grand Palais. Paris 1981 (cat.).– Alphant, M.: C. M. Paris 1993.– Cogniat, R.: M. and His World. London 1966.– Cogniat, R. et al. (ed.): M. et ses amis. Musée Marmottan. Paris 1971 (cat.).– Decker, M. d.: C. M. Paris 1992.– Geelhaar, C. et al. (ed.): C. M. Nympheas. Kunstmuseum Basel. Zurich 1986 (cat.).– Gordon, R. and A. Forge: M. Cologne 1985, New York 1989.– Hamilton, G. H.: C. M.'s Paintings of the Rouen Cathedral. London 1966.– Hommage à C. M. Grand Palais. Paris 1980 (cat.).– Hoschedé, J.-P.: C. M. Ce mal connu. 2 vols. Geneva 1960.– House, J.: M. Oxford 1977.– House, J.: M. Nature into Art. New Haven (CT) and London 1986.– Isaacson, J.: M. Le Déjeuner sur l'herbe. New York 1972.– Isaacson, J.: C. M. Observations et réflexions. Neuchâtel 1978.– Joyces, C. et al.: Monet at Giverny. London 1975, 1988.– Keller, H.: C. M. Munich 1985.– Kendall, R. (ed.): M. by Himself. London 1989.– Lévêque, J.: M. Paris 1980.– Levine, S. Z.: M. and His Critics. New York and London 1976.– Moffet, C. S.: M.'s Water Lilies. New York 1978.– Mount, M.: M. New York 1966.– Reuterswärd, O.: M. Stockholm 1948.– Rewald, J. and F. Weitzenhoffer (ed.): Aspects of M. A Symposium on the Artist's Life and Time. New York 1984.– Reymond, N.: C. M. Paris 1992.– Rouart, D. et al. (ed.): M. Nymphéas ou les miroirs du temps. Paris 1972 (cat.).– Sagner-Düchting, K.: C. M. A Feast for the Eyes. Cologne 1990.– Seiberling, G.: M.'s Series. New York and London 1981.– Seitz, W. C.: C. M. Cologne 1960, 1990.– Seitz, W. C.: C. M. Seasons and Moments. New York 1970.– Spate, V.: The Life and Work of C. M. London and New York 1992.– Stucky, C. F. (ed.): M. A Retrospective. New York 1985.– Stucky, C. F.: C. M. Cologne 1994, London and New York 1995.– Stucky, C. F. and S. Shaw (ed.): C. M. 1840-1926. The Art Institute. Chicago 1995 (cat.).– Tucker, P. H.: M. at Argenteuil. New Haven (CT) and London 1982.– Tucker, P. H. (ed.): M. in the 90's. The Series Paintings. Museum of Fine Arts, Boston et al. New Haven (CT) and London 1989 (cat.).– Tucker, P. H.: C. M. Life and Art. New Haven (CT) et al. 1995.– Wildenstein, D. et al. (ed.): M.'s Years at Giverny: Beyond Impressionism. Metropolitan Museum of Art. New York 1978 (cat.)

## MONORY Jacques

born **1934** Paris
French painter and performance artist. **1955** First solo-exhibition at the Galerie Kléber in Paris. **1963** Exhibited at the 19th Salon de Mai in the Musée d'Art Moderne de la Ville de Paris. **1968** Produced the film *Ex* in monochrome blue. **1970** Publication of the book *Document Bleu*. **1971** Exhibition of paintings and objects at the Musée Galliéra in Paris. From **1972** developed the idea of the photo-novel. From **1975** designed book objects. From **1978** took part in his own video-performances. Monory is best known for his hyperrealist paintings in monochrome blue presenting garish, eye-catching pictures from magazines like a film sequence on canvas.
WRITINGS: J. M.: Eldorado. Paris 1991
MONOGRAPHS, CATALOGUES: Bailly, J.-C.: M. Paris 1979.– Gaudibert, P. and A. Jouffroy: M. Paris 1972.– Gaultier, B. (ed.): M. C. N. A. C. Paris 1974 (cat.).– Jouffroy, A. (ed.): M. Centre National d'Art Contemporain. Paris 1974 (cat.).– Lyotard, J.-F.: L'Assassinat de l'expérience put la peinture: M. Bègles 1984.– M. Toxique. Musée d'Art Moderne de la Ville de Paris. Paris 1984 (cat.).– Tilman, P.: M. Paris 1992

## MOORE Henry

**1898** Castleford (Yorkshire) – **1986** Much Hadham (Hertfordshire)
English sculptor and graphic artist. **1917** Military service. **1919–1921** Studied at the School of Arts in Leeds. **1923** Went to Paris. **1925** Scholarship to study in France and Italy. **1926–1939** Taught at the Royal College of Art and at the Chelsea School of Art in London. **1928** First solo-exhibition at the Warren Gallery in London. **1930** Joined the artists of the Seven and Five Society. **1933** Became a member of the One group. **1936** Participated in the international Surrealist exhibition in London. Tour of Spain including prehistoric caves in the Pyrenees. **1940** Moved to Much Hadham. Commissioned to do a series of drawings of air-raid shelters in London, with further public commissions for sculptures following after the war. **1946** Exhibition at the Museum of Modern Art in New York. **1948** Major prizes for sculpture at the Venice Biennale and **1953** at the São Paulo Biennale. Between **1955–1977** participated in documenta 1–3 and 6 in Kassel. Moore's sculpture developed from a post-Picassoesque style to pure abstraction. His favourite theme was the reclining figure, in which holes, hollows and concavities create an interplay between the figure and its surroundings between the material and immaterial.
WRITINGS: Hofmann, W. (ed.): H. M. Schriften und Skulpturen. Frankfurt-on-Main 1959.– James, P. (ed.): H. M. on Sculpture. London 1966, 1971, New York 1992 / H. M. über die Plastik. Munich 1972 / Notes sur la sculpture. Paris 1994.– H. M.: My Ideas, Inspiration and Life as an Artist. London 1986.– Webber, S. (ed.): H. M.

My Ideas, Inspiration and Life as an Artist. San Francisco 1986
CATALOGUES RAISONNES: Bowness, A. and H. Read (ed.): H. M. Complete Sculpture 1921-1986. 6 vols. London 1965-1988.– Cramer, G. et al. (ed.): H. M. The Graphic Work 1931-1984. 4 vols. Geneva 1973-1986.– Garrould, A. (ed.): H. M. Drawings 1916-1983. 6 vols. London 1992ff
MONOGRAPHS, CATALOGUES: Allemand-Cosneau, C. (ed.): H. M. From the Inside Out. Plasters, Carvings and Drawings. Städtische Kunsthalle Mannheim et al. Munich and Nantes 1996 (cat.).– Berthould, R.: The Life of H. M. London 1986, New York 1987.– Bott, G.: H. M. Maquetten, Bronzen, Handzeichnungen. Bonn 1979.– Clark, K.: H. M. Drawings. London 1974.– Compton, S. (ed.): H. M. Royal Academy of Arts. London 1988 (cat.).– Davis, A. (ed.): H. M. Bibliography. H. M. Foundation. 5 vols. London 1992.– Finn, D.: H. M. Sculpture and Environment. London and New York 1977.– Flemming, H. T.: H. M. Katakomben. Munich 1956.– Grohmann: W. H. M. Berlin 1960 / The Art of H. M. New York 1960.– Hall, D.: H. M. The Life and Work of a Great Sculptor. New York 1966.– Hedgecoe, J.: A Monumental Vision. The Sculpture of H. M. New York 1968.– Hodin, J. P.: H. M. Cologne 1956.– Jianou, I.: H. M. Paris 1968, New York 1968.– Melville, R.: H. M. Sculpture and Drawings 1921-1969. New York 1971.– Mitchinson, D.: H. M. Sculpture 1922-1980. London and New York 1981 / H. M. Plastiken 1922-1980. Stuttgart 1981.– Mitchinson, D. and J. Stallabrass: H. M. Paris 1992.– Mitchinson, D. (ed.): H. M. Fondation Pierre Gianadda. Martigny 1989 (cat.).– H. M. Sculptures et Dessins. Orangerie des Tuileries, Musée National d'Art Moderne. Paris 1977 (cat.).– Mostra di H. M. Forte di Belvedere. Florence 1972 (cat.).– Neumann, E.: Die archetypische Welt H. M.'s. Zurich and Stuttgart 1961 / The Archetypal World of H. M. Lawrenceville 1985.– Read, H.: H. M. A Study of His Life and Work. London 1965.– Read, H.: H. M. Portrait of the Artist. London and New York 1979.– Russel, J.: H. M. Harmondsworth 1973, 1980.– Russoli, F. (ed.): H. M. Plastiken 1922-1980. Stuttgart 1981.– Seldis, H.: H. M. in America. New York 1973.– Sylvester, D.: H. M. New York 1968.– Teague, E. H.: H. M. Bibliography and Reproductions Index. Jefferson (NC) 1981.– Walter, E.: H. M. Cologne 1956

## MORANDI Giorgio

**1890** Bologna – **1964** Bologna
Italian painter. **1907–1913** Studied at the Accademia di Belli Arti in Bologna. First still lifes and landscapes inspired by the works of Renoir, Monet and Cézanne. **1914** Met Boccioni and Carrà in Bologna and took part in the first Futurist exhibition at the Galleria Sprovieri in Rome. **1914–1930** Taught drawing at various schools in Bologna. **1918** Came to know Mario Broglio, founder of the magazine *Valori* *Plastici*, and began to paint metaphysical still lifes. **1919** Acquainted with De Chirico. **1920** Resumed a classical approach to still-life painting similar to that of Cézanne. **1921** Participated in the joint-exhibition "Valori Plastici". **1928** Exhibited at the Venice Biennale. **1930–1956** Professor of graphic techniques at the Accademia di Belli Arti in Bologna. **1939** Awarded second prize for painting at the Quadriennale d'Arte Nazionale in Rome, in **1948** the top prize for Italian painting at the Venice Biennale, in **1953** the graphics prize and, in **1957** the first prize for painting at the São Paulo Biennale. **1955–1964** Participation in documenta 1–3 in Kassel. Morandi clung faithfully to his main subject, the still life, up to the end of his career. He created a cosmic unity out of familiar objects, such as vessels, vases and bottles, through subtle combinations of colour and the interplay of shadow and light.
CATALOGUES RAISONNES: Cordaro, M. (ed.): M. Incisione. Catalogo generale. Milan 1991.– Cordaro, M. (ed.): M. Opera grafica. Catalogo generale. Milan 1991.– Pasquali, M. (ed.): M. Aquarelli. Catalogo generale. Milan 1992 / G. M. Die Aquarelle. Vienna 1995.– Pasquali, M. (ed.): M. Disegni. Catalogo generale. Milan 1994.– Tavoni, E. (ed.): M. Disegni. Catalogue raisonné. 2 vols. Bologna 1981-1984.– Valsecchi, M. et al. (ed.): M. Desegni. 2 vols. Bologna 1981-1984.– Vitali, L. (ed.): L'opera grafica di G. M. 2 vols. Torino 1964-1968.– Vitali, L. et al. (ed.): M. Dipinti, acquarelli, incisioni, disegni. Catalogo sistematico. 5 vols. Milan 1994
MONOGRAPHS, CATALOGUES: Arcangeli, F.: G. M. Torino 1981.– Argan, G. C. and F. Basile (ed.): M. Disegni. Sasso Marconi 1984.– Burger, A.: Die Stilleben des G. M. Eine koloritgeschichtliche Untersuchung. Hildesheim 1984.– Giuffré, G.: G. M. Lucerne 1970.– Güse, E.-G. and F. A. Morat (ed.): G. M. Gemälde, Aquarelle, Zeichnungen, Radierungen. Saarland Museum, Saarbrücken et al. Munich 1993 (cat.).– Jouvet, J. and W. Schmied (ed.): G. M. Zurich 1982.– G. M. 1890-1964. Sala de Exposiciones de la Caja de Pensiones. Madrid 1984 (cat.).– G. M. Fondation Dina Vierny, Musée Maillol. Paris 1996 (cat.).– Morat, F. A. (ed.): G. M. Haus der Kunst. Munich 1981 (cat.).– Pasquali, M. (ed.): G. M. 1890-1964. Caja de pensiones. Barcelona 1984 (cat.) / G. M. 1890-1964. Gemälde, Aquarelle, Zeichnungen, Radierungen. Kunsthalle Tübingen et al. Cologne 1989 (cat.).– Pasquali, M. et al. (ed.): G. M. 1890-1990. Galleria Communale d'Arte Moderna, Bologna. Milan 1990 (cat.).– Pasquali, M. (ed.): Museo M., Bologna. Il catalogo. Bologna 1993.– Pasquali, M. (ed.): G. M. L'immagine dell'assenza. Museo Mediceo, Palazzo Medici Ricardi, Florence. Milan 1994 (cat.).– Prisco, M. (ed.): Der unveröffentlichte M. Roma 1984.– Raimondi, G.: Jahre mit G. M. Frankfurt-on-Main 1990.– Riccomini, E. et al. (ed.): M. e il suo tempo. Galleria Coummunale d'Arte, Moderna. Bologna 1985 (cat.).– Solmi, F.: M. Storia e leggenda. Bologna 1978.– Solmi, F. et al.: G. M. New York 1988.– Wilkin, K.: G. M. New York 1996

## MOREAU Gustave

**1826** Paris – **1898** Paris
French painter. **1846–1849** Studied at the Ecole des Beaux-Arts under Chassériau. **1852** Exhibited his *Pietà* at the Paris Salon. **1858–1860** Lived in Italy, studying Renaissance painting. Came to know Edgar Degas and Puvis de Chavannes. **1864** Achieved success at the Salon with *Oedipus and the Sphinx*. **1874** Order of merit from the Legion of Honour. **1878** Took part in the Paris World Fair. **1881** Began watercolour illustrations of La Fontaine's *Fables*. **1885** Went to Holland to study the works of Rembrandt. **1888** Became a member and, in **1892**, professor at the Académie des Beaux-Arts in Paris, where his pupils included the Fauves, Matisse, Jean Puy and Rouault. Moreau's enchanted pictorial world, peopled with exotic mythological figures from diverse cultures, adorned in rich colours and filigree ornamentation, was later rediscovered by the Surrealists.
WRITINGS: G. M. L'Assembleur de rêves. Ecrits complets de G. M. Fontfroide 1984
CATALOGUES RAISONNES: Bittler, P. and P.-L. Mathieu (ed.): Catalogue des dessins de G. M. Paris 1983.– Mathieu, P.-L. (ed.): G. M. Sa Vie, son œuvre, catalogue raisonné de l'œuvre achevé. Paris 1976 / G. M. With a Catalogue of the Finished Paintings, Watercolors and Drawings. Boston 1976.– Mathieu, P.-L. (ed.): Tout l'œuvre peint de G. M. Paris 1991
MONOGRAPHS, CATALOGUES: Alexandrian, S.: L'univers de G. M. Paris 1975.– Hahlbrock, P.: G. M. oder Das Unbehagen in der Natur. Berlin 1976.– Hofstätter, H. H.: G. M. Leben und Werk. Cologne 1978.– Holten, R. v.: G. M. Symbolist. Stockholm 1965.– Kaplan, J.: G. M. Los Angeles County Museum of Art. Greenwich (CT) 1974 (cat.).– Kaplan, J.: The Art of G. M. Theory, Styleand Content. Ann Arbor (MI) 1982.– Lacambre, G. et al. (ed.): G. M. 1826-1898. Sala d'Arme di Palazzo Vecchio, Florence et al. Florence 1989 (cat.).– Lacambre, G. (ed.): Musée G. M. Peintures, cartons, aquarelles etc. Musée G. M. Paris 1990 (cat.).– Lacambre, G.: G. M. e l'Italia. Milan 1996.– Laan, A. v. de (ed.): G. M. Stadsgalerij Heerlen. Ghent 1991 (cat.).– Mantura, B. and G. Lacambre (ed.): G. M. L'elogio del poeta. Palazzo Racani Arroni, Spoleto. Roma 1992 (cat.).– Mathieu, P.-L.: G. M. Aquarelles. Fribourg 1984 / G. M. The Watercolors. New York 1985.– Mathieu, P.-L.: Le Musée G. M. Paris 1986.– Mathieu, P.-L.: G. M. Paris 1995, New York 1996.– Mezin, L. (ed.): L'Inde de G. M. Paris et al. Paris 1997 (cat.).– G. M. Los Angeles County Museum of Art. Los Angeles 1974 (cat.).– Paladilhe, J. and J. Pierre: G. M. New York 1972.– Segalen, V.: G. M. Maître imagier de l'Orphisme. Fontfroide 1984.– Selz, J.: G. M. Paris 1978, New York 1979.– Stooss, T. and P.-L. Mathieu (ed.): G. M. Symboliste. Kunsthaus Zürich. Zurich 1986 (cat.)

## MORELLET François

born **1926** Cholet
French painter. Self-taught. Professionally an industrialist. **1950** First solo-exhibition at the Galerie Creuze in Paris. **1950–1952** Visited Brazil and Spain. **1951** Intensive study of the works of Mondrian. **1952** Inspired by the decorative tiled floors in the Alhambra in Granada, displaying almost infinite variations of a single pattern, he

began to paint uniformly structured designs. **1954** Met Max Bill in Switzerland. **1960** Founded Groupe Recherche d'Art visuel together with Le Parc, Yvaral and Demarco. **1960–1962** Trips to the USA and India. **1963** and **1965** Participated in the Paris Biennale. Between **1963** and **1977** took part in documenta 3, 4 and 6 in Kassel. Exhibited **1970** and **1986** at the Venice Biennale. **1971** Solo-exhibition at the Kunstverein in Frankfurt am Main. **1977** Solo-exhibition at the Nationalgalerie in Berlin. **1986** Retrospective at the Musée National d'Art Moderne in Paris. **1989** Participated in Prospect '89. **1992** Solo-exhibition at the Sprengel Museum, Hanover. Morellet's paintings and kinetic pictorial objects are closely related to Op Art.
CATALOGUE RAISONNE: Anna, S. (ed.): F. M. Installations/Catalogue Raisonné seiner Installationen. Chemnitz 1994
MONOGRAPHS, CATALOGUES: Blistène, B. and C. Grenier (ed.): F. M. Centre Georges Pompidou, Paris et al. Paris 1986, Amsterdam 1986 (cat.).– Bußmann, K. et al. (ed.): F. M. Interventionen. Westfälisches Landesmuseum. Münster 1989 (cat.).– Friedel, H. (ed.): F. M. Neonly. Galerie im Lenbachhaus. Munich 1995 (cat.).– Gassiot Talabot, G.: F. M. Milan 1971.– Gässler, E. (ed.): F. M. Stadtmuseum. Oldenburg 1995 (cat.).– Güse, E.-G. (ed.): F. M. Grands formats. Saarland Museum. Saarbrücken 1991 (cat.).– Kotik, C. and J. v. d. Marck (ed.): F. M. Systems. Albright-Knox Art Gallery. Buffalo 1984 (cat.).– Lemoine, S.: F. M. Zurich 1986.– Lemoine, S. (ed.): F. M. Dessins. Musée de Grenoble et al. Grenoble 1991 (cat.)/F. M. Zeichnungen. Städtisches Kunstmuseum Spendhaus. Reutlingen 1991 (cat.).– Lemoine, S.: F. M. Paris 1996.– F. M. Nationalgalerie, Berlin et al. Bochum 1977 (cat.).– Oelschläger, P. (ed.): F. M. Sprengel Museum. Hanover 1992 (cat.)

**MORGNER Wilhelm**
**1891** Soest – **1917** killed in action at Langenmark
German painter. **1908/09** Taught to paint by Georg Tappert in Worpswede. Returned to Soest. **1911** Moved to Berlin and joined the New Secession there. **1912** Took part in the Sonderbund exhibition in Cologne. Contact with the Blauer Reiter group. Woodcut and linocut prints published in Herwarth Walden's magazine *Der Sturm*. **1913** Called up for military service. **1914–1917** Active service. In contrast to the geometric pictorial language of Expressionists such as Kandinsky and Marc, Morgner's paintings and graphic works are characterised by more lyrical expressive elements and vegetative or organic forms.
WRITINGS: Knupp-Uhlenhaut, C. (ed.): W. M. Briefe und Zeichnungen. Briefe an Georg Tappert, an die Mutter und an Wilhelm Wulff. Soest 1984
CATALOGUES RAISONNES: W. M. Das vollständige Holzschnittwerk. Cologne 1970.– Witte, A. (ed.): W. M. 1891-1917.

Graphik. Verzeichnis sämtlicher Holz- und Linolschnitte, Lithographien und Radierungen. Wilhelm-Morgner-Haus. Soest 1991 (cat.)
MONOGRAPHS, CATALOGUES: Bußmann, K. (ed.): W. M. 1891-1917. Gemälde, Zeichnungen, Druckgraphik. Westfälisches Landesmuseum, Münster et al. Stuttgart 1991 (cat.).– Güse, E.-G.: W. M. Westfälisches Landesmuseum. Münster 1983 (cat.).– Heckmanns, F. W. (ed.): W. M. Württembergischer Kunstverein, Stuttgart. Münster 1967 (cat.).– Nerowski-Fisch, L.: W. M. 1891-1917. Ein Beitrag zum deutschen Expressionismus. Soest 1984.– Richter, B. (ed.): W. M. zum hundertsten Geburtstag. Städtisches Gustav-Lübcke-Museum. Hamm (cat.).– Seiler, H.: W. M. Recklinghausen 1958

**MORLEY Malcom**
born **1931** London
English painter. **1952/1953** Studied at Camberwell School of Arts and Crafts in London. **1954–1956** Continued his studies at the Royal College of Art in London, where he later became a teacher. **1957** First solo-exhibition at the Kornblee Gallery in New York. **1958** Moved to New York. **1964/65** Friendship with Newman. Painted abstract compositions with horizontal strips of colour. **1967–1969** Taught at the School of Visual Arts in New York. Painted sea battles and ports in photorealist style, reproducing old black and white prints on canvas by means of a grid. In **1972** and **1977** participated in documenta 5 and 6 in Kassel. **1977** DAAD scholarship to Berlin. **1980** Lived in England. **1982** Participated in the exhibition "Zeitgeist" in Berlin. Visited Crete. Morley's photorealist paintings focus on topics such as racism and apartheid. He creates a tension in his works by highlighting the ambiguity of perception and painted reality.
MONOGRAPHS, CATALOGUES: Compton, M. (ed.): M. M. Paintings 1965-1982. Whitechappel Art Gallery, London et al. London 1983 (cat.).– Grenier, C. (ed.): M. M. Centre Georges Pompidou, Paris et al. Paris 1993 (cat.).– Levine, L. and K. Kerless: M. M. Paris 1993.– M. M. Paintings 1965-1982. The Brooklyn Museum. New York 1984 (cat.).– M. M. Watercolours. Bonnefantum Museum, Maastricht et al. Liverpool 1991 (cat.).– M. M. Retrospective 1954-1993. Centre Georges Pompidou. Paris 1993 (cat.).– M. M. Anthony d'Offay Gallery. London 1990 (cat.).– Sylvester, D. (ed.): M. M. Anthony d'Offay Gallery. London 1990 (cat.).– Yau, J. (ed.): M. M. Fabian Carlsson Gallery. Lobndon 1985 (cat.)

**MORRIS Robert**
born **1931** Kansas City
American artist. Studied **1948–1950** at the Art Institute in Kansas City, **1951** at the California School of Fine Arts in San Francisco. **1952** Military service in Korea. **1953-**

**1955** Studied at Reed College in Portland. **1961–1963** Studied art history at Hunter College in New York and wrote a thesis on Brancusi. **1963** First solo-exhibition at the Green Gallery in New York. Staged actions with Yvonne Rainer. Composed dance pieces. **1965-1970** Worked on large sculptures and experimented with film and performances. **1968** Solo-exhibition at the Ileana Sonnabend gallery in Paris. Between **1968** and **1987** participated in documenta 4, 6 and 8 in Kassel. Taught at Hunter College, New York. **1973** Did his blind-time drawings. After **1983** took up figurative painting. **1988** First etchings. **1989** Worked on encaustic paintings. **1990** Investigative drawings. Morris is one of the most versatile artists in America. His works range from abstractions through expressive or figurative paintings to sculptures and installations related to Earth Art and Minimal Art.
WRITINGS: R. M.: Continuous Project Altered Daily. The Writings of R. M. Cambridge (MA) 1993
MONOGRAPHS, CATALOGUES: Berger, M.: R. M. Minimalism and the 1960s. New York 1989.– Compton, M. and D. Sylvester (ed.): R. M. Tate Gallery. London 1971 (cat.).– Fry, E. F. and D. P. Kuspit (ed.): R. M. Works of the Eighties. Museum of Contemporary Art. Chicago 1986.– Kambartel, W.: R. M. Felt Piece. Stuttgart 1971.– Krauss, R. et al. (ed.): R. M. The Mind-Body Problem. Solomon R. Guggenheim Museum. New York 1994 (cat.).– Krauss, R. et al. (ed.): R. M. 1961-1964. Paris 1995 (cat.).– Mayo, M. (ed.): R. M. Selected Works. Contemporary Arts Museum. Houston 1981 (cat.).– R. M. Tate Gallery. London 1971 (cat.).– R. M. Het observatorium van R. M. in Ostelijk Flevoland. Stedelijk Museum. Amsterdam 1977.– R. M. Solomon R. Guggenheim Museum. New York 1994 (cat.).– Paice, K. (ed.): R. M. The Mind/Body Problem. Solomon R. Guggenheim Museum. New York 1994 (cat.).– Sultan, T.: Inability to Endure or Deny the World. Representation and Text in the Work of R. M. Corcoran Gallery of Art. Washington 1990 (cat.).– Tucker, M. (ed.): R. M. Whitney Museum of American Art. New York 1970 (cat.)

**MORTENSEN Richard**
**1910** Copenhagen – **1993** Copenhagen
Danish painter and theoretician. **1931/32** Studied at the Academy of Art in Copenhagen. **1932** Spent a year in Berlin. **1933** First public showing of his works at the Autumn exhibition in Copenhagen. **1934/35** Joint publisher of the magazine *linien*. **1937** Visited Paris. **1944** Did a large painting for the Museum of Decorative Arts in Copenhagen. **1947** Moved to Paris, then alternated between Normandy, the South of France and Corsica. Won the Edvard Munch Prize in **1946** and the Kandinsky Prize in **1950**. **1955–1964** Participation in documenta 1 – 3 in Kassel. **1960** Exhibited at the Venice Biennale. **1985** Solo-exhibition at the Aarhus Museum.

**1989** Took part in the exhibition "Bilderstreit" in Cologne. Originally influenced by the Surrealist works of Dalí and Tanguy, in the 50s Mortensen took up free gestural painting. The spontaneity and fantasy of these later works is reminiscent of the art of the Cobra group.
MONOGRAPHS, CATALOGUES: Frandsen, J. W.: R. M. Ungsomsårene 1930-1940. Statens Museum for Kunst, Copenhagen 1984 (cat.).– Holtmann, H. (ed.): R. M. Gemälde, Wandteppiche, Reliefs, Grafik. Kunsthalle Kiel. Kiel 1971 (cat.).– Hulten, P. et al. (ed.): R. M. Paintings 1929-1993. Statens Museum for Kunst, Copenhagen et al. Copenhagen 1994 (cat.).– Johansson, E.: R. M. Copenhagen 1962.– R. M. Aarhus Kunstmuseum. Aarhus 1985 (cat.)

**MOTHERWELL Robert**
**1915** Aberdeen (WA) – **1991** Provincetown (MA)
American painter and art critic. Starting in **1935**, he studied philosophy, art history, aesthetics and archaeology at Stanford University in California, at the California School of Fine Arts, Valencia, at Harvard and at Columbia University, New York. Worked as a painter, author, publisher of art journals and teacher. **1941** Together with Kurt Seligman, experimented with printing techniques. Wrote treatises on Automatism and theories of Surrealism. First automatic drawings. **1944** Publication of first *Documents of Modern Art*, a series of articles by modern artists. **1945** First printing experiments in Stanley William Hayter's Atelier 17. **1945–1951** Taught at the Black Mountain College in Beria (NC). **1948** Founded the avant-garde school of art Subjects of the Artists with Baziotes, Newman and Rothko. **1950–1959** Taught at Hunter College in New York. **1964** Participation in documenta 3 in Kassel. Lived from **1970** until he died in Greenwich (CT). **1977** Commission for a mural for the National Gallery of Art in Washington. Alongside Pollock and De Kooning, Motherwell is one of the principal exponents of Abstract Expressionism and Action Painting.
WRITINGS: Terenzio, S. (ed.): R. M. The Collected Writings of R. M. New York and Oxford 1992
CATALOGUES RAISONNES: Terenzio, S. and D. C. Belknap (ed.): The Prints of R.

M. A Catalogue Raisonné 1943-1990.
New York 1990
MONOGRAPHS, CATALOGUES:
Arnason, H. H.: R. M. New York 1977,
1982.– Ashton, D. et al. (ed.): R. M.
Albright-Knox Art Gallery. Buffalo 1983
(cat.).– Carmean, E. A. (ed.): R. M. The
Reconciliation Elegy. Geneva and New
York 1980.– Caws, M. A.: R. M. What Art
Holds. New York 1996.– Flam, J.: M.
Oxford and New York 1991, Paris 1991,
Recklinghausen 1992.– Harten, J. et al.
(ed.): R. M. Eine Retrospektive. Städtische
Kunsthalle Düsseldorf et al. Düsseldorf
1976 (cat.).– Mattison, R. S.: R. M. The
Formative Years. Ann Arbor (MI) 1986.–
R. M. Kunsthalle Kiel. Kiel 1971 (cat.).–
R. M. Kunstmuseum und Kunstforening.
Aarhus 1980 (cat.).– R. M. Fundació
Antoni Tàpies, Barcelona et al. Barcelona
1996 (cat.).– O'Hara, F. et al. (ed.): R. M.
A Retrospective. The Museum of Modern
Art, New York et al. New York 1965 (cat.).–
Pleynet, M.: R. M. Paris 1989.– Rosand, D.
(ed.): R. M. on Paper. Drawings, Prints,
Collages. New York et al. New York
1996.– Terenzio, S. (ed.): R. M. & Black.
William Benton Museum of Art. New
York 1980 (cat.)

**MUCHE Georg**
**1895** Querfurt – **1987** Lindau
German painter and craftsman. **1913**
Studied painting in Munich. **1914** Moved
to Berlin. **1915** First non-figurative paint-
ings inspired by the works of Kandinsky.
**1916–1919** Taught at the art school
attached to Der Sturm in Berlin. **1920–
1927** Head teacher of the wood sculpture
and weaving classes at the Bauhaus. **1927–
1931** Taught at Itten's art school in Berlin.
From **1931** teaching post at the Breslau
Academy. **1933** Dismissed. **1934** Trip to
Italy. **1937** His works displayed as part of
the exhibition of "degenerate art" in
Munich. **1939–1958** Directed his own
school of textile engineering in Krefeld.
**1944–1949** Painted frescoes for the Insti-
tute of Silk Industry in Krefeld. **1950** Partic-
ipated at documenta 1 in Kassel. **1960**
Moved to Lindau on Lake Constance. **1963**
Guest of honour at Villa Massimo in Rome.
Solo-exhibition at the Kunstverein in
Mannheim. **1974** Retrospective at the
Nationalgalerie Berlin. **1979** Awarded the
Lovis Corinth Prize by the City of Regens-
burg.
WRITINGS: Ackermann, U. (ed.): G. M.:
Der alte Maler. Briefe 1945-1984. Tübingen
1992.– G. M.: Buonfresco. Briefe aus
Italien über Handwerk und Stil der echten
Frescomalerei. Berlin 1938.– G. M.: Blick-
punkt Sturm, Dada, Bauhaus, Gegenwart.
Munich 1961, Tübingen 1965
CATALOGUES RAISONNÉS: Droste, M.
et al. (ed.): G. M. Das künstlerische Werk
1912-1927. Bauhaus-Archiv. Berlin 1980
(cat.).– Schiller, P. H. (ed.): G. M. Das
druckgraphische Werk. Darmstadt 1970
MONOGRAPHS, CATALOGUES:
Brüggemann, E. W. and U. Ackermann

(ed.): G. M. Sturm – Bauhaus – Spätwerk.
Retrospektive. Bad Homburg v. d. Höhe
1995 (cat.).– Busch, L.: G. M. Dokumente
zum malerischen Werk der Jahre 1915 bis
1920. Tübingen 1984.– Heinz, M. and A.
Burger (ed.): G. M. Leise sagen. Neue
Galerie, Staatliche und Städtische Kunst-
sammlungen. Kassel 1986 (cat.).– Linder,
G.: G. M. Friedrichshafen 1983.– G. M.
Gemälde, Zeichnungen, Graphik. Städti-
sche Galerie im Lenbachhaus. Munich
1965 (cat.).– G. M. Das malerische Werk
1928-1982. Bauhaus-Archiv. Berlin 1983
(cat.).– Richter, H.: G. M. Recklinghausen
1960.– Thiem, G. (ed.): G. M. Der Zeich-
ner. Staatsgalerie Stuttgart. Stuttgart 1977
(cat.)

**MUELLER Otto**
**1874** Liebau – **1930** Breslau
German painter and graphic artist. **1890–
1894** Trained as a lithographer in Görlitz.
**1894–1896** Studied at the Dresden
Academy and, after graduating, travelled
with Gerhard Hauptmann through
Switzerland and France. **1898/99** Studied
at the Munich Academy under Stuck.
Admired Böcklin, Hans von Marées and
Ludwig von Hofmann. Returned to
Dresden. **1908** Moved to Berlin. Came to
know Lehmbruck and Rilke. **1910** Joined
the Brücke group and helped to found
the New Secession. **1912** Took part in the
Sonderbund exhibition in Cologne. Trav-
elled with Kirchner to Bohemia. While
fighting in the war **1916–1918** he did many
sketches for later paintings. **1918** Returned
to Berlin. **1919** Member of the Arts Advi-
sory Council. Taught at the Breslau
Academy. **1920** and **1923** Spent the
summers with Heckel on the Baltic Sea.
**1924–1930** Numerous trips to Dalmatia,
Hungary, Romania and Bulgaria. Mueller's
favourite theme was gypsy life. His palette
was more subdued than that of most
Brücke painters.
WRITINGS: Pachnicke, G. (ed.): O. M.
Briefe an Lotte und Gerhart Hauptmann
in den Jahren 1897-1899. Nuremberg
1986
CATALOGUES RAISONNÉS: Buchheim,
L.-G.: O. M. Leben und Werk. Mit einem
Werkverzeichnis der Graphik. Feldafing
1963, 1968.– Karsch, F. (ed.): O. M. Das
graphische Gesamtwerk. Holzschnitte,
Radierungen, Lithographien, Farblithogra-
phien. Berlin 1974
MONOGRAPHS, CATALOGUES: Billeter,
F.: Der Plastiker O. M. Zurich 1983.–
Decker, M.: Gestaltungselemente im Bild-
werk von O. M. Dortmund 1992.– Lüt-
tichau, M.-A. v.: O. M. Ein Romantiker
unter den Expressionisten. Cologne 1993.–
Moeller, M. (ed.): O. M. Brücke-Museum,
Berlin et al. Berlin 1996 (cat.).– O. M. 1874-
1930. Kunsthalle Bremen. Bremen 1956
(cat.).– O. M. Gemälde, Zeichnungen und
Druckgraphik. Städtisches Museum
Mülheim/Ruhr 1974 (cat.).– Schmeller, A.:
O. M. Mädchenbilder und Zigeunerleben.
Munich 1959

**MUNCH Edvard**
**1863** Løten (Hedmark) – **1944** Ekely (near
Oslo)
Norwegian painter and graphic artist.
Tragic childhood: Both his mother and his
sister Sophie died of consumption, while
his father was melancholy and dementedly
pious. First attended technical college.
From **1881** studied at the Royal School of
Drawing in Oslo. Painted human figures
and naturalistic landscapes full of light,
under the supervision of Christian Krohg.
**1883** Attended the Thaulows Academy,
where classes were held in the open air.
**1885** First trip to Paris and development of
a highly personal and colourful, expressive
style. **1889** First solo-exhibition. State
scholarship. During his stay in Paris **1889–
1892** he studied Old Masters, Impression-
ism and the paintings of the Pont-Aven
School and Nabis, and began to paint
Pointillist landscapes. **1892** Trip to Berlin,
where his exhibition at the Verein der
bildenden Künstler (Artists' Union) caused
a scandal. Founded the Berlin Secession.
Contact with Strindberg, Meier-Graefe,
Przybyszewski, Botho-Graeff. **1893** Began
work on his *Frieze of Life*. From **1894** pub-
lication of graphic reproductions. In the
1890's made many long visits to France,
Italy and Germany. Around **1900** did
numerous illustrations. **1896–1898** Partici-
pated in the exhibitions at the Salon des
Indépendants in Oslo. **1916** Wall paintings
for the University of Oslo. Moved to Ekely
near Oslo. **1921/22** Design for the canteen
of the Freia Chocolate Factory in Oslo.
Munch, one of the founding fathers of
Expressionism, had a decisive influence on
the development of modern art, especially
in Germany.
WRITINGS: Schiefler, G. (ed.): E. M.
Briefwechsel. 2 vols. Hamburg 1987-1990.–
Torjusen, B. (ed.): Words and Images of
E. M. London 1989
CATALOGUE RAISONNÉ: Schiefler, G.
(ed.): Verzeichnis des graphischen Werks
E. M.'s. 2 vols. Berlin 1907-1928, Oslo 1974,
Cologne 1995
MONOGRAPHS, CATALOGUES:
Benesch, O.: E. M. London 1960.– Bjørn-
stad, K.: E. M. Oslo 1993, Frankfurt-on-
Main 1995.– Bock, H. and G. Busch: E. M.
Probleme, Forschungen, Thesen. Munich
1973.– Boulton Smith, J.: E. M. 1863-1944.
Berlin 1962.– Carlsson, A.: E. M. Leben
und Werk. Stuttgart and Zurich 1984.–
Deknatel, F.: E. M. New York 1950.–
Eggum, A.: E. M. malerier, skisser og
studier. Stockholm 1983/E. M. peintures,
esquisses, études. Paris 1983/E. M. Paint-
ings, Sketches and Studies. New York 1984/
E. M. Gemälde, Zeichnungen und
Studien. Stuttgart 1986.– Eggum, A.: M.
and Photography. New Haven (CT) 1989/
M. und die Photographie. Bern 1991.–
Eggum, A. and R. Repetti (ed.): M. et la
France. Musée d'Orsay. Paris 1992 (cat.).–
Eggum, A. et al. (ed.): M. und Deutsch-
land. Kunsthalle der Hypo-Kulturstiftung,
Munich et al. Stuttgart 1994 (cat.).– Fahr-
Becker-Sterner, G. (ed.): E. M. Museum

Villa Stuck. Munich 1987 (cat.).– Gauguin,
P.: E. M. Oslo 1946.– Gerlach, H. E.: E.
M. Sein Leben und sein Werk. Hamburg
1955.– Gierløff, C.: E. M. selv. Oslo 1953.–
Heller, R.: M. His Life and Work. Chicago
and London 1984/E. M. Leben und Werk.
Munich et al. 1993.– Hodin, J. P.: E. M.
Berlin and Mainz 1963, London and New
York 1972, Paris 1991.– Hougen, P. (ed.): E.
M. Haus der Kunst, Munich et al. Munich
1973 (cat.).– Keiner, M. (ed.): E. M. und
seine Modelle. Galerie der Stadt Stuttgart.
Stuttgart 1993 (cat.).– Kneher, J.: E. M. in
seinen Ausstellungen zwischen 1892 und
1912. Worms 1994.– Langaard, J. H.: E. M.
Modningsår. Oslo 1960.– Langaard, J. H.
and R. Revold: E. M. som tegner. Oslo
1958.– Langaard, J. H. and R. Revold: E.
M. fra år til år. Oslo 1961.– Langaard, J. H.
and R. Revold.: E. M. Mesterverker i
Munch-museet. Oslo 1963.– Mag-
naguagno, G. (ed.): E. M. 1863-1944.
Museum Folkwang, Essen et al. Bern 1987
(cat.).– Messer, T.: E. M. Cologne 1989.–
Moen, A.: E. M. 3 vols. Oslo 1956-1958.– E.
M. Liebe, Angst, Tod. Kunsthalle Bielefeld.
Bielefeld 1980 (cat.).– Rosenblum, R. et al.
(ed.): E. M. Symbols and Images. National
Gallery of Art. Washington 1978 (cat.).–
Sarvig, E.: E. M. Grafik. Copenhagen
1948.– Schneede, U. M. (ed.): E. M.
Höhepunkte des malerischen Werks im
20. Jahrhundert. Hamburger Kunstverein.
Hamburg 1984 (cat.).– Schneede, U. M.: E.
M. Die frühen Meisterwerke. Frankfurt-
on-Main 1992.– Schütz, M. B.: Farbe und
Licht bei E. M. Saarbrücken 1985.– Stang,
R.: E. M. The Man and His Art. New York
1979, 1988/E. M. Der Mensch und Künst-
ler. Königstein 1979.– Stenersen, R.: E. M.
Närbild av ett geni. Stockholm 1944, Oslo
1945, Zurich 1949.– Thiis, J.: E. M. og hans
samtid. Oslo 1933.– Timm, W.: E. M.
Graphik. Stuttgart 1969.– Væring, R. and J.
H. Langaard: E. M. selvportretter. Oslo
1947.– Willoch, S.: E. M. raderinger. Oslo
1950.– Wood, M.-H. (ed.): E. M. The
Frieze of Life. New York 1993

**MUNKACSI Martin**
**1896** Kolozsvar – **1963** New York
Hungarian painter and photographer. First
focused on painting. **1923** Discovered pho-
tography by chance and in a very short time
became one of the most sought-after pho-
tojournalists in Hungary. From **1927**
worked for the publishers Ullstein in Berlin
and for the newspaper *Berliner Illustrirte
Zeitung*. Commissions took him all over
the world. In the 30s he emigrated to
America, where, among other things, he
photographed for *Harper's Bazaar*. Mun-
kacsi not only broke through the strict con-
ventions of formal fashion photography but
also set a new trend in photojournalism
with his dynamic, spontaneous pictures and
unusual snapshots.
MONOGRAPHS, CATALOGUES: Hoghe,
R. (ed.): Retrospektive Fotografie. M. M.
Bielefeld and Düsseldorf 1980.– White, N.
and J. Esten (ed.): M. Photographs of the
'20s, '30s and '40s. New York 1979

**MÜNTER Gabriele**
**1877** Berlin – **1962** Murnau
German painter. **1898–1900** Spent two
years with her sister in the USA. **1902**
Studied painting at the Phalanx School
under Kandinsky. **1903** Became engaged to
Kandinsky although he was still married.
**1904–1908** Travelled with Kandinsky to
Italy, France, Switzerland, Holland and
Tunisia, and made many trips to Russia.
**1908** First stay in Murnau. **1909** Inherited a
house in Murnau and became friends with
Jawlensky and von Werefkin. Joined the

Neue Künstlervereinigung (New Artists' Association) in Munich. **1911/12** Exhibited with the Blauer Reiter group. **1911** Out of solidarity with Kandinsky broke away from the Neue Künstlervereinigung. On the outbreak of war in **1914**, moved to Switzerland with Kandinsky, but went back to Murnau when he travelled on to Russia. **1915** Last meeting with Kandinsky in Stockholm. **1916** Told by Kandinsky that he wanted a separation, she was unable to work for a whole year. **1917** Moved to Copenhagen. **1920** Returned to Murnau. **1927** Took up painting again. Trip to Paris. **1933–1945** Retired to her house in Murnau. **1957** Donated many of her own paintings as well as those of Kandinsky to the Städtische Galerie im Lenbachhaus in Munich WRITINGS: Hoberg, A. (ed.): Kandinsky, W. und G. M. in Murnau und Kochel 1902–1914. Briefe und Erinnerungen. Munich 1994 / Kandinsky, W. and G. M. Letters and Remniscences 1902–1914. Munich 1994
CATALOGUES RAISONNES: Helms, S. (ed.): G. M. Das druckgraphische Werk. Munich 1967.– Pfeiffer-Belli, E. (ed.): G. M. Zeichnungen und Aquarelle. Mit einem Katalog von S. Helms. Berlin 1979
MONOGRAPHS, CATALOGUES: Eichner, J.: Kandinsky und G. M. Vom Ursprung moderner Kunst. Munich 1957.– Gollek, R. (ed.): G. M. 1877-1962. Städtische Galerie im Lenbachhaus. Munich 1977 (cat.).– Gollek, R.: G. M. Hinterglasbilder. Munich and Zurich 1981.– Gollek, R. (ed.): Das Münter-Haus in Murnau. (n. p.) 1984.– Heller, R. (ed.): G. M. The years of Expressionism 1903-1920. Milwaukee Art Museum et al. Milwaukee 1997.– Hoberg, A. and H. Friedel (ed.): G. M. 1877-1962. Retrospektive. Städtische Galerie im Lenbachhaus, Munich et al. Munich 1992 (cat.).– Kleine, G.: G. M. und Wassily Kandinsky. Biographie eines Paares. Frankfurt-on-Main 1990.– Mochon, A.: G. M. Between Munich and Murnau. Cambridge (MA) 1980.– G. M. Schirn Kunsthalle. Frankfurt-on-Main 1992 (cat.).– Röthel, H. K.: G. M. Munich 1957.– Vester, E. (ed.): G. M. Kunstverein Hamburg et al. Hamburg 1988 (cat.).– Windecker, S.: G. M. Eine Künstlerin aus dem Kreis des Blauen Reiter. Berlin 1991

**NAUMAN Bruce**
born **1941** Fort Wayne (IN)
American artist. **1960–1964** Studied mathematics, physics and art at the University of Wisconsin, Madison. **1964–1966** Studied at the University of California, Davis. **1965** First solo-exhibition of fibreglass sculptures at the Nicholas Wilder Gallery, Los Angeles. Began in **1966** to do films and body performances. From **1966–1968** gave courses at the San Francisco Art Institute. **1967** Moved to Mill Valley, California. **1968** First solo-exhibition in the Leo Castelli Gallery, New York and in the Galerie Konrad Fischer in Düsseldorf. Between **1968** and **1982** participation in

documenta 4–7 in Kassel. **1969** Moved to Pasadena. Journey to Paris. **1970** Lectureship in sculpture at the University of California, Irvine. **1972/73** Installations like *Wall Sound Piece* or *Green Light Corridor*. **1979** Moved to Pecos, New Mexico. **1991** Received the Max Beckmann Prize from the City of Frankfurt. **1992** Participation in documenta 9 in Kassel. **1993–1996** Important touring retrospective at the Centro de Arte Reina Sofia, Madrid and the Kunsthaus, Zurich. Nauman's multimedia works revolve around two central aspects of art: body experience – which is why he is often called the pioneer of Body Art – and sensory perceptions and their distortion.
WRITINGS: B. N. Interviews 1967-1988. Newark (NJ) 1996.– Hoffmann, C. (ed.): B. N. Interviews 1967-1988. Dresden 1996
CATALOGUES RAISONNES: Benezra, N. et al. (ed.): B. N. Exhibition Catalogue and Catalogue Raisonné. Walker Art Center, Minneapolis et al. Minneapolis 1994 (cat.).– Bruggen, C. v. et al.: B. N. Zeichnungen. 1965-1986. Museum für Gegenwartskunst, Basel et al. Basel 1986 (cat.).– Cordes, C. (ed.): B. N. Prints 1970-1989. A Catalogue Raisonné. New York 1989.– Snyder, J. and I. Shaffner (ed.): B. N. Prints and Related Works 1985-1996. Ridgefield et al. Ridgefield 1997 (cat.)
MONOGRAPHS, CATALOGUES: Ammann, J.-C. et al. (ed.): B. N. Kunstmuseum Basel et al. Basel 1986 (cat.) / B. N. Musée d'Art Moderne de la Ville de Paris, Paris et al. Paris 1986 (cat.) / B. N. Whitechapel Art Gallery, London et al. London 1986 (cat.).– Bruggen, C. v.: B. N. New York 1988, Basel 1989.– Halbreich, K. (ed.): B. N. Museo Nacional Centro de Arte Reina Sofia, Madrid et al. Madrid 1993 (cat.).– Labaume, V. et al. (ed.): B. N. Image/Text 1966-1996. Kunstmuseum Wolfsburg. Stuttgart 1997 (cat.).– Livingstone, J. and M. Tucker: B. N. Works from 1965-1972. Los Angeles County Museum et al. Los Angeles 1972 (cat.).– B. N. The Museum of Modern Art, New York et al. New York 1995 (cat.).– Richardson, B. (ed.): B. N. Neons. The Baltimore Museum of Art. Baltimore 1982 (cat.).– Schmidt, K. et al. (ed.): B. N. 1972-1981. Rijkskunstmuseum Kröller-Müller, Otterlo et al. Amsterdam 1981 (cat.).– Simon, J. (ed.): B. N. Walker Art Center, Minneapolis et al. Minneapolis 1994 (cat.).– Zutter, J. and F. Meyer (ed.): B. N. Skulpturen und Installationen 1985-1990. Museum für Gegenwartskunst, Basel et al. Cologne 1990 (cat.).

**NAY Ernst Wilhelm**
**1902** Berlin – **1968** Cologne
German painter. **1925–1928** Studied at the Berlin Academy under Hofer, among other teachers. **1931** Awarded the Rome Prize by the Prussian Art Academy. Turned to Surrealism. **1933** First solo-exhibition at the Galerie Flechtheim in Berlin. **1936** Barred from exhibiting. **1937** His works shown in the exhibition of "degenerate art". Visited Lofoten in Norway, where the barren land-

scape inspired him to do abstractions, the so-called *Lofoten* paintings. **1945–1951** Lived in Hofheim near Frankfurt am Main. **1951** Moved to Cologne. Around **1955** first disk compositions in decorative, occasionally nervously shifting colours. **1955–1964** Participation in documenta 1–3 in Kassel. **1956** Received the first prize for painting from the state of North Rhine-Westphalia and became a member of the Berlin Academy. **1960** Awarded the Guggenheim prize. From **1963** his works show the influence of L'art informel. Nay is one of the most important transitional figures between the pre-war abstractionists, such as Kandinsky and Klee, and the post-war generation of abstract painters.
WRITINGS: E. W. N.: Vom Gestaltwert der Farbe: Fläche, Zahl, Rhythmus. Munich 1955
CATALOGUES RAISONNES: Gabler, K. (ed.): E. W. N. Die Druckgraphik 1923-1968. Stuttgart and Zurich 1975.– Gohr, S. and A. Scheibler (ed.): E. W. N. Werkverzeichnis der Ölgemälde 1922-1968. 2 vols. Cologne 1991.– Haftmann, W.: E. W. N. Cologne 1960, 1991
MONOGRAPHS, CATALOGUES: Cassou, J.: N. Cologne 1969.– Gallwitz, K. (ed.): E. W. N. Die Hofheimer Jahre 1945-1951. Städelsches Kunstinstitut und Städtische Galerie, Frankfurt-on-Main. Stuttgart 1994 (cat.).– Gohr, S. and W. Haftmann (ed.): E. W. N. Eine Retrospektive. Josef-Haubrich-Kunsthalle. Cologne 1990 (cat.).– Haftmann, W. and H. Fuchs (ed.): E. W. N. Akademie der Künste. Berlin 1967 (cat.).– Hofmann, W. (ed.): E. W. N. Museum des 20. Jahrhunderts. Vienna 1967 (cat.).– E. W. N. 1902-1968. Bilder und Dokumente. Germanisches Nationalmuseum, Nuremberg. Munich 1980 (cat.).– E. W. N. 1902-1968. Bilder kommen aus Bildern. Museum Haus Lange, Krefeld et al. Krefeld 1985 (cat.).– Nay, E.: Ein strahlendes Weiß. Meine Zeit mit E. W. N. Berlin 1984.– Usinger, F.: E. W. N. Recklinghausen. 1961

**NEUSÜSS Floris**
born **1937** Lennep
German photographer. Studied photography, painting, and graphic art in Wuppertal, Munich, and Berlin. **1958** Began experimental photography. **1960** Nudograms and Body photographs (Körperfo-

togramme). **1963** Went to Vienna and worked with St. Stephan gallery group. **1964** Studio of her in own in Munich. Chemical paintings on body photograms. From **1971** lectured in experimental photography at the Kassel Werkakademie. **1972** Founded the Fotoforum Kassel and organized art and photographic exhibitions. **1971–1975** Photographic syntax projects. From **1976** *Körperauflösungen* and photogram performances. **1982** First photogram portraits. **1984** Large-format photograms and first Nachtbilder (night pictures). **1989** ULO-photograms.
WRITINGS: F. N.: Fotografie als Kunst – Kunst als Fotografie. Cologne 1979.– F. N.: Fotogramme, die lichtreichen Schatten. Munich and Kassel 1983.– F. N.: Das Fotogramm in der Kunst des 20. Jahrhunderts. Cologne 1990
MONOGRAPHS, CATALOGUES: F. N. Fotogramme. Düsseldorf 1963.– F. N. Figuren und Maßstäbe. London 1976 (cat.).– F. N. Fotografie 1957-1977. Kunstverein Kassel. Kassel 1977 (cat.).– F. N. Nachtstücke. Fotogramme 1957-1997. Rheinisches Landesmuseum. Bonn 1997 (cat.)

**NEVELSON Louise**
**1900** Kiev – **1988** New York
Russian-born American sculptress and painter. **1905** Emigration to the USA. **1920** Moved to New York. **1929/30** Studied at the Art Students League, New York. **1931/32** European trip. Developed an enthusiasm for African sculpture, which she saw in Paris at the Musée de l'Homme, as well as for the artists Boccioni, Brancusi and Picasso. Studies under H. Hofmann in Munich. **1932** Collaboration with Rivera on murals in the US. **1933** First solo-exhibition in New York. **1941** First solo-exhibition in the Nierendorf Gallery, New York. **1957** Sculptures made from single pieces of wood. **1960** First European solo-exhibition in the Galerie Daniel Cordier, Paris. **1962** Exhibited in the American Pavilion at the Venice Biennale. In **1964** and **1968** Participation in documenta 3 and 4 in Kassel. **1969** Solo-exhibition in the Museum of Fine Arts, Houston, **1973** in Moderna Museet, Stockholm and **1974** in the Nationalgalerie, Berlin. **1977** Participation in the exhibition "Boîtes" in Paris. Nevelson became known at the end of the 50s for her wooden constructions, painted in single colours, in which ordinary wooden pieces (chair legs, panels, parts of banisters) were displayed like holy relics.
WRITINGS: MacKown, D. (ed.): L. N. Dawns and Dusks. Taped Conversations with D. MacKown. New York 1976
CATALOGUE RAISONNE: Baro, G. (ed.): L. N. The Prints. New York 1974
MONOGRAPHS, CATALOGUES: Albee, E. (ed.): L. N. Atmosphere and Environments. Whitney Museum of American Art. New York 1980 (cat.).– Bober, N.: L. N. Breaking Tradition: The Story of L. N. New York 1984.– Cain, M.: L. N. New York 1989.– Celant, G.: L. N. Milan and Munich 1973.–

Celant, G. (ed.): N. Palazzo delle Esposizioni, Roma. Milan 1994 (cat.).– Friedman, M. (ed.): N. Wood Sculptures. Walker Art Center, Minneapolis. New York 1973 (cat.).– Glimcher, A. B.: L. N. New York and London 1972, 1976.– Gordon, J. (ed.): L. N. Whitney Museum of American Art. New York 1967 (cat.).– Johnson, V. E. (ed.): L. V. Prints and Drawings 1953-1966. New York 1967.– Kramer, H. and J. Lipman (ed.): N's World. Whitney Museum of American Art. New York 1983 (cat.).– Lisle, L.: L. N. A Passionate Life. New York 1990.– L. N. Centre National d'Art Contemporain. Paris 1974 (cat.).– Roberts, C.: N. Paris 1964.– Wilson, L.: L. N. Iconography and Sources. New York 1981

## NEWMAN Barnett

**1905** New York – **1970** New York
American painter and sculptor. **1922**–**1930** Studied philosophy and ornithology, then art at the Art Students League in New York. Around **1930** became acquainted with Still, Pollock, Gottlieb and Avery. Worked from **1931**–**1939** as an art teacher in the New York high school system. After destroying of his early artworks, he published essays in **1947/48** in *Tiger's Eye* magazine (of which he was co-publisher), including his two most important treatises on painting: *The First Man was an Artist* and *The Sublime is Now*. **1948** Founded the art school Subject of the Artist with Baziotes, Motherwell and Rothko. **1959** Lectureship at the University of Saskatchewan in Saskatoon, Canada. **1959** and **1968** participation in documenta 1 and 4 in Kassel. **1962**–**1964** Lecturer at the University of Pennsylvania in Philadelphia. Not until the age of 43 did Newman discover his own painting style in mystical abstraction. With his variations on thin vertical colour stripes on a monochrome background, he became one of the most important exponents of Color Field Painting. WRITINGS: Heynen, J. (ed.): B. N. Texte zur Kunst. Hildesheim 1979.– O'Neill, J. P. (ed.): B. N. Selected Writings and Interviews 1925-1970. New York 1990, Berkeley 1992/ B. N. Schriften and Interviews 1925-1970. Bern and Berlin 1996 CATALOGUES RAISONNES: Richardson, B. (ed.): B. N. The Complete Drawings 1944-1969. Baltimore Museum of Art. Baltimore 1979 (cat.).– Schor, G. (ed.): The Prints of B. N. 1961-1969. New York 1997/ B. N. The Prints 1961-1969. Stuttgart 1997 MONOGRAPHS, CATALOGUES: Bois, Y.-A. (ed.): B. N. Paintings. Pace Gallery. New York 1988 (cat.).– Brockhaus, C. and B. Vogelsang (ed.): B. N. Das zeichnerische Werk. Museum Ludwig. Cologne 1981 (cat.).– Hess, T. B.: B. N. New York 1969.– Hess, T. B. (ed.): B. N. The Museum of Modern Art, New York et al. Greenwich (CT) 1971 (cat.).– Heynen, J.: B. N.'s Texte zur Kunst. Hildesheim 1979.– Hommage à B. N. Nationalgalerie. Berlin 1982 (cat.).– B. N. Stedelijk Museum, Amsterdam et al. 1972 (cat.).– B. N. Das druckgraphische

Werk. Städtisches Museum Abteiberg. Mönchengladbach 1986 (cat.).– B. N. Gemälde und Skulpturen. Kunstsammlung Nordrhein-Westfalen, Düsseldorf. Stuttgart 1997 (cat.).– Paskus, B.: The Theory, Art and Critical Reception of B. N. Diss. Chapel Hill 1974.– Quick, D. M.: Meaning in the Art of B. N. and Three of His Contemporaries. Ann Arbor (MI) 1983.– Richardson, B. (ed.): B. N. The Complete Drawings 1944-1969. Detroit Institute of Arts et al. Detroit 1979 (cat.).– Read, H.: B. . 2 vols. London 1948 and 1956.– Reid, N. (ed.): B. N. Tate Gallery. London 1969 (cat.).– Rosenberg, H.: B. N. Broken Obelisk and Other Sculptures. Seattle 1971.– Rosenberg, H.: B. N. New York 1978, 1994.– Russel, J.: B. N. New York 1969.– Stecker, R.: The Stations of the Cross Lema Sabachthani von B. N. Bochum 1993.– Strick, J. (ed.): The Sublime is Now. The Early Work of B. N. Paintings and Drawings 1944-1949. Pace Wildenstein Gallery, New York et al. New York 1994 (cat.).– Vall, R. v. d.: Een subliemgevoel van plaats. Een filosofische interpretatie van het werk van B. N. Groningen 1994.– Zweite, A. (ed.): B. N. Bilder, Skulpturen, Graphik. Kunstsammlung Nordrhein-Westfalen. Düsseldorf 1997 (cat.)

## NEWTON Helmut

**1920** Berlin – **2004** Los Angeles
German-born Australian photographer. **1936**–**1938** Apprenticed to the Berlin photographer Yva. Lived from **1938**–**1940** in Singapore. **1940**–**1944** Military service in the Australian army. **1956** Lived in London. **1957** Moved to Paris. **1975** First solo-exhibition in the Galerie Nikon, Paris. **1976** Art Directors Club Prize in Tokyo. Solo-exhibition in the Nicholas Wilder Gallery, Los Angeles. **1981** Moved to Monte Carlo. **1984/85** Retrospective in the Musée d'Art Moderne de la Ville de Paris. **1985** Participation in the "Shots of Style" exhibition in the Victoria und Albert Museum, London. **1989** Was made Chevalier des Arts et des Lettres by the French culture minister. Participation in the "The Art of Photography" exhibition at the Museum of Fine Arts, Houston. Received the World Image Award for the best portrait photo in **1991** in New York. **1992** Awarded the German Service Cross. **1994** Retrospective at the Deichtorhallen, Hamburg. MONOGRAPHS, CATALOGUES: Felix, Z. (ed.): H. N. Aus dem Photographischen Werk. Deichtorhallen, Hamburg. Munich 1993 (cat.).– Lagerfeld, K.: H. N. Munich 1982.– Lagerfeld, K. (ed.): H. N. Centre National de la Photographie. Paris 1986 (cat.).– Newton, J. (ed.): H. N. in Moskau. Pushkin Museum, Moscow. Munich 1989 (cat.)

## NICHOLSON Ben

**1894** Denham (Buckinghamshire) –
**1982** London
English painter and object artist. Studied at

the Gresham School in Holt and at the Slade School of Art in London. After a stay in Paris in **1921**, where he saw paintings by Braque, Matisse and Picasso for the first time, he developed, through Cubism, his own novel concept of the pictorial image as an autonomous object. **1933** First completely abstract reliefs: fibreboard pieces cut into geometric shapes, painted in different colours and glued in layers. Until **1937** member of Abstraction-Création. Moved back to Cornwall in **1940** with his second wife, the sculptress Barbara Hepworth, and, along with the sculptor Gabo, attracted a circle of artists who became known as the St. Ives Painters. After **1945** returned to using representational elements in his pictures; alongside severe geometric abstractions he produced landscapes and still lifes reduced to little more than a few sketched lines. Nicholson became the principal exponent of Concrete Art in England. **1955**–**1964** Participation in documenta 1 – 3 in Kassel. WRITINGS: B. N.: Appliance House. Chicago and Cambridge 1990 CATALOGUES RAISONNES: Browse, L.: B. N. London 1956.– Read, H. (ed.): B. N. Paintings, Reliefs, Drawings. 2 vols. London 1955-1956.– Russel, J. (ed.): B. N. Drawings, Paintings and Reliefs 1911-1968. Bern 1969 MONOGRAPHS, CATALOGUES: Aley, R.: B. N. London 1963.– Baxandall, D.: B. N. Art in Progress. London 1962.– Harrison, C. (ed.): B. N. Tate Gallery. London 1969 (cat.).– Hodin, J. P.: B. N. The Meaning of His Art. London 1957.– Lewison, J. (ed.): B. N. The Years of Experiment 1919-1939. Kettle's Yard. Cambridge 1983 (cat.).– Lewison, J.: B. N. London and New York 1991.– Lewison, J. (ed.): B. N. Fondation Pierre Gianadda. Martigny 1992 (cat.).– Lewison, J. (ed.): B. N. Tate Gallery, London et al. London 1993 (cat.).– Lynton, N.: B. N. London 1993, 1998, Paris 1993.– Nash, S. A. (ed.): B. N. Fifty Years of His Art. Albright-Knox Art Gallery, Buffalo et al. New York 1978 (cat.).– Read, H.: B. N. Paintings, Reliefs, Drawings. 2 vols. London 1955-1956.– Russel, J. et al. (ed.): B. N. Drawings, Paintings, Reliefs 1911-1968. London 1969/ B. N. Zeichnungen, Gemälde, Reliefs 1911-1968. Stuttgart 1969.– Summerson, J.: B. N. Harmondsworth 1948

## NITSCH Hermann

born **1938** Vienna
Austrian action artist. **1957** Created the idea of the Orgies-Mysteries Theatre. **1960**–**1966** Exhibitions and actions using naked people; several prison sentences. **1960** First solo-exhibition in the Loyality Club, Vienna, and **1961** at the Galerie Fuchs, Vienna. After **1969**, publication of articles on the theory of the Orgies-Mysteries Theatre. **1971** Appointed professor at the Frankfurt School of Art. Bought Prinzendorf Castle. **1972** Participation in documenta 5 in Kassel. **1973** Founded a benefit

organization for the Orgies-Mysteries Theatre. **1981** Participation in the "Westkunst" exhibition in Cologne. **1972** and **1982** participation in documenta 5 and 7 in Kassel. **1984** Three-day long performance of the 80th Action at Prinzendorf Castle. **1989** Termination of his professorship at the Städelschule in Frankfurt on the Main. Nitsch, one of the exponents of Vienna Actionism, tried to shake the complacency of bourgeois society through his happening-style ritualised performances (sacrificial rites such as animal slaughter). WRITINGS: H. N.: Orgien Mysterien Theater/Orgies Mysteries Theatre. Darmstadt 1969.– H. N.: Die Architektur des Orgien-Mysterien-Theaters. Munich 1987.– H. N.: Das Orgien-Mysterien-Theater. Manifeste, Aufsätze, Vorträge. Salzburg and Vienna 1990.– H. N.: Zur Theorie des Orgien Mysterien Theaters. Zweiter Versuch. Salzburg 1995 CATALOGUES RAISONNES: H. N. Das Orgien Mysterien Theater. Die Partituren aller ausgeführten Aktionen 1960-1979. Naples, Munich, Vienna 1979.– Rychlik, O. and C. Gargele (ed.): H. N. Das früheste Werk 1955-1960. Vienna 1986 MONOGRAPHS, CATALOGUES: Eccher, D. (ed.): H. N. Galleria Civica di Arte Contemporanea, Trento. Milan 1991 (cat.).– Fuchs, R. (ed.): H. N. Das Orgien Mysterien Theater 1960-1983. Stedelijk Van Abbe Museum. Eindhoven 1983 (cat.).– Hegyi, L. et al. (ed.): H. N. Das Orgien Mysterien Theater. Museum Moderner Kunst Stiftung Ludwig. Vienna 1996.– H. N. Das Orgien Mysterien Theater. Theoretische Schriften. Partiturentwurf des 6 Tage Spieles. Naples, Reggio Emilia. Munich 1976 (cat.).– H. N. Das Orgien Mysterien Theater. 80. Aktion in Prinzendorf. Vienna 1984.– H. N. Das rote Tuch: der Mensch das unappetitlichste Vieh. H. N. Das Orgien-Mysterien-Theater im Spiegel der Presse 1960-1988. Vienna 1988.– H. N. Museum Moderner Kunst. Passau 1996 (cat.).– Ronte, D. and A. Zweite (ed.): N. Das bildnerische Werk. Städtische Galerie im Lenbachhaus, Munich et al. Munich, Salzburg and Vienna 1988 (cat.).– Rychlik, O. (ed.): H. N. Das früheste Werk 1955-1960. Vienna 1986.– Weiermair, P. (ed.): H. N. Expo '92. Seville 1992 (cat.)

## NOLAN Sidney

**1917** Carlton (Victoria) – **1992** London
Australian painter. Studied under Charles Wheeler at the National Gallery Art School in Melbourne. Began to paint at the end of the 30s. During his military service **1942**–**1945**, he discovered the landscapes of northern Victoria. From **1945** he created the *Ned Kelly* series, the first of a set of picture sequences on the 19th century Australian bandit and folk hero. **1947/48** European trip. Series of paintings telling the story of *Mrs. Fraser*, who was shipwrecked and lived among the Australian aborigines. **1957** Travelled to England. **1959** Participation in documenta 2 in Kassel.

MONOGRAPHS, CATALOGUES: Adams, B.: S. N. Such Is Life. A Biography. London 1987.– Clark, K. and C. MacInnes (ed.): S. N. Catalogue of an Exhibition of Paintings from 1947-1957. Whitechappel Art Gallery. London 1957 (cat.).– Clark, J. (ed.): S. N. Landscapes and Legends. National Gallery of Victoria. Cambridge and New York 1987 (cat.).– Clark, K. et al. (ed.): S. N. London 1961.– Gilchrist, M.: N. at Lanyon. Canberra 1976, 1985.– Haese, R. et al. (ed.): S. N. The City and the Plain. National Gallery of Victoria. Melbourne 1983 (cat.).– Krimmel, B. and E. (ed.): S. N. Gemälde und Druckgraphik. Kunsthalle Darmstadt. Darmstadt 1971 (cat.).– Lynn, E.: S. N. Myth and Imagery. London and Melbourne 1967.– Lynn, E.: S. N. Australia. Sydney 1979.– Lynn, E. and B. Semler: S. N.'s Ned Kelly. Canberra 1985.– McInnes, C. and B. Robertson: S. N. London 1961.– Melville, R. (ed.): Ned Kelly. 27 Paintings by S. N. London 1964.– Missingham, H. (ed.): S. N. Retrospective Exhibition. Paintings from 1937-1967. Art Gallery of New South Wales. Sydney 1967 (cat.).– Sayers, A. (ed.): S. N. The Ned Kelly Story. Metropolitain Museum of Art. New York 1994 (cat.)

**NOLAND Kenneth**
born **1924** Asheville (NC)
American painter. **1946–1948** Studied at Black Mountain College in Beria (NC) and **1948/49** under Ossip Zadkine in Paris. Taught until **1956** at various institutes in Washington, including the Institute of Contemporary Art and the Catholic University. **1968** Participation in documenta 4 in Kassel. **1977** Made a member of the American Academy and Institute of Art and Letters. **1985** Became Milton Avery Professor at Bard College, Annandale-on-Hudson (NY). Worked with the architect I. M. Pei on the design of the Wiesner Building at the Massachusetts Institute of Technology. **1986/87** Guest-artist at the Pratt Institute in New York in the departments of computer and video art. **1992** Participation in documenta 9 in Kassel. Noland's works are representative of Hard-Edge- and Minimal Art. Along with Louis he developed Color Field Painting with thinned paints. At first he worked with disk-like colour fields, then gradually began to use horizontally laid colour bands in

soft, harmonious tones. In the mid-80s, he became involved in computer art.
MONOGRAPHS, CATALOGUES: Agee, W. C. (ed.): K. N. The Circle Paintings 1956-1963. Museum of Fine Arts. Houston 1993 (cat.).– Fenton, T. (ed.): K. N. An Important Exhibition of Paintings from 1958 through 1989. Salander-O'Reilly Galleries 1989. New York 1989 (cat.).– Goldman, J.: K. N. Handmade Papers. Bedford Village 1978.– Moffet, K.: K. N. New York 1977.– Waldman, D. (ed.): K. N. A Retrospective. Solomon R. Guggenheim Museum. New York 1977 (cat.).– Wilkin, K.: K. N. New York 1990, Paris 1994

**NOLDE Emil**
**1867** Nolde (near Tondern) – **1956** Seebüll (near Neukirchen)
German painter and graphic artist. **1884–1888** Apprenticeship as furniture designer and woodcarver. Later worked in furniture factories in Munich, Karlsruhe and Berlin. **1889** Teacher at the Karlsruhe School of Arts and Crafts. **1892–1897** Taught ornamental drawing and modelling in the Arts and Crafts School in St. Gallen. **1899** Attended Hoelzel's School in Dachau and the Académie Julian in Paris. **1906/07** Member of the Brücke; met Munch. Dedicated himself from **1909** to religious themes. **1910** Controversy with Liebermann. Co-founder of the New Secession. **1913/14** Travelled with a scientific expedition to New Guinea via Russia, China, and Japan. **1919–1921** Member of the Arbeitsrat für Kunst (Arts Advisory Council). **1926** Moved to Seebüll. From **1931** member of the Prussian Art Academy. **1937** As part of the Nazi "degenerate art" operation, 1,052 of his works were seized from German museums. **1941** Ejected from the Reichskunstkammer (National Arts Council) and banned from painting. **1944** His Berlin studio was destroyed in a bombing raid. **1946** Awarded a professor's title by the state of Schleswig-Holstein. **1956** Founding of the Seebüll Ada and Ernst Nolde Foundation. Nolde's painting, through its subject matter and style, belongs to the more sensual form of Expressionism.
WRITINGS: E. N.: Brief aus den Jahren 1894-1926. Berlin 1929.– E. N.: Jahre der Kämpfe. Berlin 1934.– E. N.: Welt und Heimat. Cologne 1965.– E. N.: Reisen – Ächtung – Befreiung. Cologne 1967.– E. N.: Mein Leben. Berlin 1931, Cologne 1976
CATALOGUES RAISONNES: Schiefler, G. and C. Mosel (ed.): E. N. Das graphische Werk. 2 vols. Berlin 1927, Cologne 1966-1967, 1995.– Urban, M. (ed.): E. N. Werkverzeichnis der Gemälde. 2 vols. Munich 1987-1990/ E. N. Catalogue Raisonné of the Oil-Paintings. 2 vols. London 1987-1991
MONOGRAPHS, CATALOGUES: Ackley, C. S. et al. (ed.): N. The Painter's Prints. Museum of Fine Arts, Boston et al. Boston 1995 (cat.).– Bradley, W. S.: The Art of E. N. in The Context of North German Painting and Volkish Ideology. Ann Arbor (MI) 1983.– Bradley, W. S.: E. N. and German

Expressionism. Ann Arbor (MI) 1986.– Brugger, I. and M. Reuther (ed.): E. N. Kunstforum Bank Austria. Vienna 1994 (cat.).– Busch, G.: E. N. Aquarelle. Munich and Zurich 1987.– Chiappini, R. (ed.): E. N. Museo d'arte Moderna, Lugano. Milan 1994 (cat.).– Fehr, H.: E. N. Ein Buch der Freundschaft. Cologne 1957.– Haftmann, W.: E. N. Cologne 1958, New York 1959.– Haftmann, W.: E. N. Ungemalte Bilder. Cologne 1963/ E. N. Unpainted Pictures. New York 1963.– Hoffmann, K. (ed.): E. N. Kunstverein Wolfsburg. Wolfsburg 1991 (cat.).– Holeczek, B. (ed.): E. N. Gemälde, Aquarelle und Druckgraphik. Verzeichnis der Bestände. Kunstmuseum Hannover mit Sammlung Sprengel. Hanover 1980.– E. N. Ungemalte Bilder 1938-1945. Seebüll 1981/ E. N. Unpainted Pictures. Neukirchen 1987.– Osten, C. v. de (ed.): E. N. Gemälde, Aquarelle, Zeichnungen und Druckgraphik. Josef-Haubrich-Kunsthalle. Cologne 1973 (cat.).– Osterwold, T. (ed.): E. N. Württembergischer Kunstverein. Stuttgart 1987 (cat.).– Pois, R.: E. N. Washington 1982.– Reuther, M.: Das Frühwerk E. N. Vom Kunstgewerbler zum Künstler. Cologne 1985.– Roters, E. and M. M. Möller (ed.): E. N. in Berlin. Brücke Museum. Berlin 1988 (cat.).– Selz, P. (ed.): E. N. The Museum of Modern Art. New York 1980 (cat.).– Urban, M. (ed.): E. N. Aquarelle und Handzeichnungen. Seebüll 1967, 1982.– Urban, M. (ed.): Die Stiftung Seebüll Ada und E. N. Neukirchen 1991.– Vergo, P. and S. Lunn (ed.): E. N. Whitechappel Art Gallery. London 1995 (cat.)

**NOTHHELFER Gabriele** and **Helmut**
born **1945** Berlin (Gabriele)
born **1945** Bonn (Helmut)
German photographers. **1967–1969** Studied at the Lette School in Berlin and **1969/70** at the Folkwangschule in Essen. They have lived in Berlin since **1970** and work as technical employees at the Technical University and the Free University in Berlin. **1977** Participation in documenta 6 in Kassel. Their photography centres on contemporary themes, often showing people in unusual situations.
MONOGRAPH, CATALOGUE: G. and H. N. Galerie Breiting. Berlin 1980 (cat.)

**O'KEEFFE Georgia**
**1887** Sun Prairie (WI) – **1986** Santa Fe (NM)
American painter. **1905/06** Studied at the Art Institute of Chicago under J. Vanderpoel and **1907/08** at the Art Students League, New York, under W. M. Chase. **1909–1911** Did advertising drawing in Chicago. **1912** Took a summer course in painting under A. Bement at the University of Virginia, Charlottesville. **1912–1914** Taught art in Amarillo (TX). **1914/15** Moved to New York; studying at Columbia University under Arthur Dove. **1916** Participation in a group exhibition in Stieglitz' 291

gallery, New York. **1917** First solo-exhibition in the 291 gallery. **1917/18** Taught in Canyon (TX). **1924** Married the photographer Stieglitz. Exhibited large-format floral paintings alongside photographs by Stieglitz at the Anderson Galleries in New York. **1927** Retrospective at the Brooklyn Museum, New York. From **1929** regular trips to New Mexico. **1932** Summer stay in Canada. **1943** Retrospective in the Art Institute of Chicago. **1946** Stieglitz died; she moved to New Mexico. **1950** First European trip. **1966** Retrospective at the Amon Carter Museum, Fort Worth (TX), and **1970** at the Whitney Museum, New York. O'Keeffe's painting is mostly concerned with nature motifs like landscapes and plants, and has elements of both realism and Surrealism.
WRITINGS: Giboire, C. (ed.): Lovingly Georgia. The Complete Correspondence of G. O'K. and Anita Pollitzer. New York 1990
MONOGRAPHS, CATALOGUES: Benke, B.: G. O'K. 1887-1986. Flowers in the Desert. Cologne 1995.– Bry, D. and N. Callaway (ed.): G. O'K. The New York Years. New York 1991/ G. O'K. Die New Yorker Jahre. Munich 1991.– Bry, D. and L. Goodrich (ed.): G. O'K. Whitney Museum of American Art. New York 1970 (cat.).– Callaway, N. (ed.): G. O'K. One Hundred Flowers. New York and London 1987.– Castro, J. G.: The Art and Life of G. O'K. London and New York 1986.– Cowart, J. et al. (ed.): G. O'K. Art and Letters. The Museum of Modern Art, New York et al. New York 1987 (cat.).– Cowart, J. et al.: G. O'K. Ihr Leben und Werk. Bern 1989.– Eldredge, C. C.: G. O'K. New York 1991.– Eldredge, C. C. (ed.): G. O'K. American and Modern. Hayward Gallery, London et al. London 1993 (cat.).– Goodrich, L.: G. O'K. Drawings. New York 1968.– Haskell, B. (ed.): G. O'K. Works on Paper. Museum of New Mexico. Santa Fe 1985.– Hassrick, P. H. (ed.): The G. O'K. Museum New York 1997.– Kastro, J. G.: The Art and Life of G. O'k. New York 1985.– Kristeva, J. et al. (ed.): G. O'K. Paris 1989.– Lisle, L.: Portrait of an Artist. A Biography of G. O'K. Albuquerque 1986/ G. O'K. Das Leben der großen amerikanischen Malerin. Munich 1989.– Merrill, C. (ed.): From the Faraway Nearby: G. O'K. as Icon. Reading (MA) 1990, Albuquerque (NM) 1998.– Messinger, L. M. (ed.): G. O'K. Metropolitan Museum of Art. New York 1988 (cat.).– Robinson, R.: G. O'K. A Life. New York and London 1989.– Whitaker Peter, S.: G. O'K. and Photography. Diss. New York 1987.– Whitaker Peter, S.: G. O'K. The Early Years. New York and London 1991.– Winter, J.: My Name is Georgia. San Diego 1998

**ODENBACH Marcel**
born **1953** Cologne
German video artist. **1974–1979** Studied history of art, architecture, and semiotics at Aachen Technical College. **1976** First solo-

exhibition in the Galerie Hinrichs, Lohmar. Began to work in video with installations and performances. **1981** One-man show at the Folkwang Museum, Essen. **1982** Awarded a Glockengasse grant in Cologne. **1983** Karl-Schmidt-Rottluff grant, Darmstadt. **1987** Participation in documenta 8 in Kassel. **1989** Took part in the "Video-Skulptur" exhibition in Cologne and **1993** in the Mediale at the Deichtorhallen in Hamburg. **1994** Solo-presentation at the Federal Art and Exhibition Centre in Bonn. In his installations, Odenbach uses video as means of creating collages dealing with social themes.
MONOGRAPHS, CATALOGUES: Damsch-Wiehager, R. (ed.): M. O. Video-Arbeiten, Installationen, Zeichnungen 1988-1993. Galerie der Stadt Esslingen. Stuttgart 1993 (cat.).– Dziewior, Y. and F. Malsch (ed.): M. O. Zeichnungen 1975-1977. Vaduz et al. Vaduz 1997 (cat.).– Felix, Z. (ed.): M. O. Videoarbeiten. Folkwang Museum, Essen et al. Essen 1981 (cat.).– M. O. Stehen ist nicht Umfallen. Badischer Kunstverein, Karlsruhe et al. Karlsruhe 1988 (cat.).– Sand, G. (ed.): M. O. Besenrein. Video-Installationen. Sprengel Museum. Hanover 1997 (cat.)

**OEHLEN Albert**
born **1954** Krefeld
German painter. Trained in publishing. **1978–1981** Studied at the Hamburg School of Fine Arts. Displayed a strong element of social criticism in his first large-format paintings. **1984** Participation in the "Wahrheit ist Arbeit" exhibition at the Folkwang Museum in Essen (with W. Büttner, G. Herold and Kippenberger) leading to international exhibitions: **1984** "Von hier aus", Düsseldorf; **1988** "German/American Art of the Late 80s", Düsseldorf and Boston; **1989** "Bilderstreit", Cologne; **1991** "Metropolis", Berlin. At the end of the 80s, he produced his first abstract paintings. **1991** First visit to Los Angeles, where he did abstract oil paintings, painted-over pictures with figurative themes, and computer-generated graphics. Further exhibitions: **1993** "Der zerbrochene Spiegel", Vienna and Hamburg; **1995** Wexner Center, Columbus (OH); **1994** retrospective at the Deichtorhallen, Hamburg.
WRITINGS: A. O. im Gespräch mit W. Dickhoff und M. Prinzhorn. Cologne 1991
CATALOGUE RAISONNE: A. O. Linolschnitte. Graz and Cologne 1989
MONOGRAPHS, CATALOGUES: Ammann, J.-C. (ed.): A. O. Abortion of the Cool. Gesellschaft für Gegenwartskunst. Augsburg 1995 (cat.).– A. O. Abräumung. Prokuristische Malerei 1982-1984. Cologne 1987.– A. O. Salzburger Kunstverein. Salzburg 1993 (cat.).– A. O. Malerei. Deichtorhallen. Hamburg 1994 (cat.).– A. O. and Christopher Williams. Wexner Center for the Arts. Columbus (OH) 1995 (cat.).– A. O. Kunsthalle Basel. Basel 1997 (cat.).– Riemschneider, B. (ed.): A. O. Cologne 1995.– Rivas, F. et al. (ed.): A. O.

Institut Valenciano de Arte Moderna. Valencia 1996 (cat.)

**OELZE Richard**
**1900** Magdeburg – **1980** Posteholz
German painter. **1921–1926** Studied under Johannes Itten at the Weimar Bauhaus. **1926–1929** Lived in Dresden. **1929** Exhibited with the Dresden Secession. **1930/31** Lived in Ascona, then moved to Berlin. **1933** Moved to Paris; contact with the Surrealist artists grouped around Breton. **1934** Took part in the Surrealist "Minotaure" exhibition. **1936** Participation in the "International Surrealist Exhibition" in London and "Fantastic Art, Dada, Surrealism" exhibition at the Museum of Modern Art in New York. Lived from **1936–1938** in Switzerland. **1940** Military service. **1945** Held by the Americans as a prisoner-of-war. **1946–1962** Lived in Worpswede. **1950** Solo-exhibition in the Moderne Galerie, Cologne, and **1952** at the Kunstkabinett in Bremen. **1959** Participation in documenta 2 in Kassel. **1962** Moved to Posteholz. **1964** Awarded the Karl Ernst Osthaus Prize by the City of Hagen. Participation in documenta 3. Solo-exhibition at the Kestner Society, Hanover. **1966** First prize in art given by the state of North Rhein-Westphalia. **1968** Participation at the Venice Biennale. **1973** Solo-exhibition at the Hamburg Kunsthalle. **1978** Max Beckmann Prize awarded by the City of Frankfurt.
CATALOGUE RAISONNE: Schmied, W. (ed.): R. O. 1900-1980. Gemälde und Zeichnungen. Werkverzeichnis. Berlin 1987
MONOGRAPHS, CATALOGUES: Damsch-Wiehager, R.: R. O. Ein alter Meister der Moderne. Munich and Lucerne 1989.– Damsch-Wiehager, R.: R. O. Erwartung. Die ungewisse Gegenwart des Kommenden. Frankfurt-on-Main 1993.– Jaguer, E. (ed.): R. O. Paris 1990.– Küster, B. (ed.): R. O. Landschaften. Kunsthalle Wilhelmshaven. Lilienthal 1994 (cat.).– R. O. Kraft der Stille. Galerie Brockstedt. Hamburg 1995 (cat.).– Schmied, W. (ed.): R. O. Gemälde und Zeichnungen 1925-1962. Kestner-Gesellschaft. Hanover 1964 (cat.).– Schmied, W.: R. O. Göttingen al. 1965.– Schmied, W.: R. O. 1900-1980. Akademie der Künste, Berlin et al. Berlin 1987 (cat.)

**OLDENBURG Claes**
born **1929** Stockholm
Swedish-American artist. **1936** Moved with his family to Chicago. **1946–1950** Studied art and literature at Yale University, New Haven (CT). **1950/51** Worked as a newspaper reporter. **1953/54** Studied at the Art Institute of Chicago. **1956** Moved to New York, where he painted compositions heavily influenced by Abstract Expressionism. Met Dine. **1958** Met Kaprow, Segal and R. Whitman. Took part in happenings. **1958/59** First assemblages and environments. **1959** First solo-exhibition at the Judson Gallery, New York. From **1965**

worked on colossal monuments. **1964** Solo-exhibition at the Ileana Sonnabend gallery, Paris. **1964** and **1968** participation at the Venice Biennale. **1968–1982** Took part in documenta 4, 6 and 7 in Kassel. **1969** One-man exhibition at the Museum of Modern Art, New York. **1970** Retrospective at the Stedelijk Museum, Amsterdam. **1972** Arranged the *Mouse Museum*. Starting in **1976** produced large-format projects with C. van Bruggen, whom he married in **1977**. Retrospective of drawings in Stockholm and Tübingen. **1979** Installation of the *Mouse-Museum/Ray Gun Wing* at the Museum Ludwig in Cologne. **1984/85** *The Course of the Knife* project at the Campo dell' Arsenale, Venice. **1996** Retrospective at the Federal Art and Exhibition Centre, Bonn. Oldenburg, one of the main exponents of American Pop Art, started by making models of edibles like hamburgers, ice cream cones, and cakes, before he began to reproduce hard objects like basins, telephones, and vacuum cleaners in soft materials (*Soft Objects*).
WRITINGS: C. O.: Store Days. New York 1967.– C. O.: Raw Notes. Documents and Scripts of the Performances. Halifax 1973.– C. O. and L. Bruggen: Large-Scale Projects 1977-1980. New York 1980
CATALOGUES RAISONNES: Axsom, R. et al. (ed.): Printed Stuff. Prints, Posters and Ephemery by C. O. A Catalogue Raisonné 1958-1996. New York 1997.– Baro, G. (ed.): C. O. Drawings and Prints. London and New York 1969.– Hentschel, M. (ed.): C. O. Multiples 1964-1990. Portikus, Frankfurt-on-Main et al. Frankfurt-on-Main 1992 (cat.).– Lawson, T. et al. (ed.): C. O. Multiples in Retrospect 1964-1990. New York 1991
MONOGRAPHS, CATALOGUES: Adriani, G. et al. (ed.): C. O. Zeichnungen. Kunsthalle Tübingen et al. Tübingen 1975 (cat.).– Bruggen, C. v. (ed.): C. O. Mouse Museum /Ray Gun Wing. Rijksmuseum Kröller-Müller, Otterlo et al. Otterlo 1979 (cat.).– Bruggen, C. v.: C. O. Nur ein anderer Raum. Frankfurt-on-Main 1991.– Celant, G. (ed.): A Bottle of Notes and Some Voyages. C. O., Coosje v. Bruggen. Northern Centre for Contemporary Art, Sunderland et al. London 1988 (cat.).– Celant, G. (ed.): C. O. and Coosje v. Bruggen. Large Scale Projects. London 1995.– Celant, G. et al. (ed.): C. O. An Anthology. National Gallery of Art, Washington et al. New York 1995 (cat.)/C. O. Eine Anthologie. Kunst- und Ausstellungshalle der Bundesrepublik Deutschland, Bonn et al. Stuttgart 1996 (cat.).– Friedman, M. (ed.): O.: Six Themes. Walker Art Center. Minneapolis 1975 (cat.).– Fuchs, R. (ed.): C. v. Bruggen and C. O. Large-Scale Projects 1977-1980. New York 1980.– Glimcher, A.: C. O. New York 1992.– Haskell, B. (ed.): C. O. Object into Monument. Pasadena Art Museum. Pasadena 1971 (cat.).– Johnson, E. H.: C. O. Harmondsworth and Baltimore 1971.– Koepplin, D. (ed.): C. O. Die frühen Zeichnungen. Kupferstichkabinett. Basel 1992 (cat.).– C. O. Proposals for Monu-

ments and Buildings 1965-1969. Chicago 1969.– C. O. Raw Notes. Documents and Scripts of the Performances. Nova Scotia College of Art and Design. Halifax 1973 (cat.).– C. O. Multiples. Musée d'Art Moderne de Saint-Etienne. Saint-Etienne 1993.– Rose, B. (ed.): C. O. The Museum of Modern Art. New York 1969 (cat.).– Rose, B.: C. O. New York 1970, Stuttgart 1976.– Rose, B. et al. (ed.): Large-Scale Projects. C. O. and Coosje van Bruggen. New York 1994.– Ruhrberg, K. (ed.): C. O. Städtische Kunsthalle Düsseldorf. Düsseldorf 1970 (cat.).– Solway, A. and T. Lawson (ed.): C. O. Multiples in Retrospect 1964-1990. New York 1991

**OLITSKI Jules**
born **1922** Snovsk
Russian-born American painter. **1924** Moved to the USA. **1939–1942** Studied at the National Academy of Design and at the Beaux-Arts Institute, New York. **1942** Became an American citizen. **1942–1945** Military service. **1949–1951** Studied in Paris, attending the Académie de la Grande Chaumière and the sculpture school under Zadkine. Early works were influenced by Dubuffet, Fautrier and de Staël. **1950** First solo-exhibition at the Galerie Huit, Paris. **1952–1955** Trained as an art teacher at New York University. **1956–1967** Teaching jobs in New York and at Bennington College (VT). Under the influence of Noland and Frankenthaler, took a new direction and, in **1959**, using bright, thinly laid-on colours and biomorphic forms, created his *stained paintings*. From **1964** produced large-format Color Field and spray paintings. **1966** Participation at the Venice Biennale and **1967** at the Tokyo Biennale. **1968** Participation in documenta 4 in Kassel. **1973** and **1977** Solo-exhibition at the Museum of Fine Arts, Boston. Olitski, one of the most important Color Field painters, works with minimal colour contrast and chromatic colour ranges.
CATALOGUE RAISONNE: Wilkin, K. and S. Long (ed.): The Prints of J. O. A Catalogue Raisonné 1954-1989. Associated American Artists. New York 1989
MONOGRAPHS, CATALOGUES: Geldzahler, H. et al. (ed.): J. O. Salander-O'Reilly Galleries. New York 1990 (cat.).– Fenton, T.: J. O. and the Tradition of Oil Painting. Edmonton Art Gallery. Edmonton 1979 (cat.).– Fried, M. (ed.): J. O. Paintings. Corcoran Gallery. Washington 1967 (cat.).– Krauss, R. E. (ed.): J. O. Recent Paintings. Philadelphia Institute of Contemporary Art. Philadelphia 1968 (cat.).– Moffet, K. (ed.): J. O. Museum of Fine Arts. Boston 1973 (cat.).– Moffett, K.: J. O. New York 1981

**OPALKA Roman**
born **1931** Hocquincourt (Abbéville)
Polish-born French painter. **1940** Family forcibly moved to Coburg. **1946** Returned to Poland. **1949/50** Studied at the Lodz Art

School. **1951–1956** Studied at the Warsaw Art Academy. **1962** First participation at the Venice Biennale. **1965** Started to incorporate sequences of numbers in his paintings. **1966** First solo-exhibition at the Artysty Plastyka gallery in Warsaw. **1973** Solo-exhibition at the Museum Folkwang, Essen. **1974** Solo-exhibition at the John Weber Gallery, New York. **1976/77** DAAD scholarship to Berlin. **1977** Participated in the documenta 6 in Kassel and moved to France. **1984** Became a French citizen. **1987** Participation at the São Paulo Biennale. **1993** Solo-exhibition at the Musée d'Art Moderne, Paris. As his work progresses, a biographical series of sequentially numbered paintings is being built up, which he supplements with photographic self-portraits.
WRITINGS: R. O.: Begegnung durch Trennung. Munich 1991
MONOGRAPHS, CATALOGUES: Kowalska, B.: R. O. Kraków 1976.– Mason, R. M. (ed.): R. O. Musée d'Art et d'Histoire. Geneva 1977 (cat.).– Noël, B. et al. (ed.): R. O. Paris 1996.– R. O. Museum Haus Lange. Krefeld 1977 (cat.).– R. O. Neue Nationalgalerie. Berlin 1994 (cat.).– R. O. Anti-Sisyphos. Mit einem kritischen Apparat von C. Schlatter. Stuttgart 1994.– Schlatter, C. (ed.): O. Paris 1992 (cat.).– Shapiro, D.: O. Paris 1986

**OPPENHEIM Dennis**
born **1938** Mason City (WA)
American artist. Until **1965** studied at the California College of Arts and Crafts and at Stanford University. **1969** Began to work as a land artist, whereby he frequently altered the surface of the earth or its structure (*Annual Rings*). **1970** Began to involve his own body as well as nature in his works; in *Reading Position for Second Degree Burn* he used sunshine. **1972** and **1977** Participation in documenta 5 and 6 in Kassel. **1979** One-man show at the Basel Kunsthalle, **1995** at the Munich Kunstbunker Tumulka. Oppenheim documents his Land Art and Body Art in photographics, film and video.
CATALOGUE RAISONNE: Celant, G. (ed.): D. O. La Biennale di Venezia. Venice 1997 (cat.)
MONOGRAPHS, CATALOGUES: Gandini, M. (ed.): D. O. New York 1996.– Heiss, A. (ed.): D. O. Selected Works 1967-

1990. Institute of Contemporary Art, P. S. 1 Museum. New York 1991 (cat.).– Joyaux, A. G.: D. O. Accelerator for Evils Thoughts. Ball State University Museum of Art. Muncie (IN) 1985 (cat.).– D. O. Stedelijk Museum Amsterdam 1974.– D. O. Palais des Beaux-Arts. Brussels 1975 (cat.).– D. O. Retrospective. Works 1967-1977. Musée d'Art Contemporain. Montreal 1978 (cat.).– D. O. Kunsthalle Basel. Basel 1979 (cat.).– D. O. Musée d'Art Moderne de la Communauté Urbaine de Lille. Villeneuve d'Ascq 1994 (cat.).– D. O. Mannheimer Kunstverein. Mannheim 1996 (cat.).– Pagé, S. and J.-M. Poinsot (ed.): D. O. Musée d'Art Moderne de la Ville de Paris. Paris 1979 (cat.).– Spooner, P. F.: D. O. Drawings and Selected Sculpture. Illinois State University Galleries. 1992

**OPPENHEIM Meret**
**1913** Berlin – **1985** Basel
Swiss painter and object artist. **1932** Moved to Paris, where she studied at the Académie de la Grande Chaumière. Acquaintance with Giacometti and Arp. **1936** First solo-exhibition at the Galerie Schulthess, Basel. Participation in the "Fantastic Art, Dada, Surrealism" exhibition at the Museum of Modern Art, New York. Her *Déjeuner en Fourrure* was a sensation and was bought by the Museum of Modern Art. **1937–1939** Attended the Basel School of Arts and Crafts. **1938** Tour of Italy. **1942** Participation in the "First papers of surrealism" exhibition in New York. **1952** Solo-exhibition at the Galerie d'Art Moderne, Basel, and **1956** at the A l'Etoile Scellée gallery in Paris. Began in **1958** to work in sculpture. **1959** At the international surrealist exhibition in Paris she showed her famous *Festmahl* (Banquet), on the body of a naked woman with a golden face. **1972** Participation at the "Artistes suisses contemporains" exhibition in the Grand Palais in Paris and the "Le Surréalisme" show at the Musée des Arts Décoratifs. **1975** Art prize of the City of Berne. **1982** First prize from the City of Berlin. Oppenheim was the leading female member of the Surrealist movement, transforming Surrealist ideas into art in a witty, dadaist way.
WRITINGS: Meyer-Thoss, C. (ed.): M. O. Aufzeichnungen 1928-1985. Träume. Bern and Berlin 1986.– M. O.: Poèmes et carnet 1928-1985. Paris 1993
CATALOGUES RAISONNES: Curiger, B. (ed.): M. O. Spuren durchstandener Freiheit. Zurich and Frankfurt-on-Main 1989 / M. O. Defiance in the Face of Freedom. Cambridge (MA) 1990
MONOGRAPHS, CATALOGUES: Burckhardt, J. et al. (ed.): M. O. Beyond the Teacup. Solomon R. Guggenheim Museum, New York et al. New York 1996 (cat.).– Burckhardt, J. et al. (ed.): M. O. Eine andere Retrospektive. Vienna 1997 (cat.).– Curiger, B.: M. O. Zurich 1982.– Gianelli, I. (ed.): M. O. Palazzo Bianco, Genoa et al. Florence 1983 (cat.).– Helfenstein, J. (ed.): M. O. Legat an das Kunst-

museum Bern. Bern 1987 (cat.).– Helfenstein, J.: M. O. und der Surrealismus. Stuttgart 1993.– Meyer-Thoss, C.: M. O. Buch der Ideen. Zurich 1996.– M. O. Kunsthalle Bern et al. Bern 1984 (cat.).– M. O. Musée d'Art Moderne de la Ville de Paris. Paris 1984 (cat.).– M. O. Institute of Contemporary Arts. London 1989 (cat.).– Reutersärd, C. F. et al. (ed.): M. O. Moderna Museet. Stockholm 1967 (cat.).– Schulz, I.: Edelfuchs und Morgenrot. Studien zum Werk von M. O. Munich 1993.– Tavel, H. C. v. and H. Heisenbüttel (ed.): M. O. Museum der Stadt Solothurn et al. Solothurn 1974 (cat.)

**OROZCO José Clemente**
**1883** Ciudat Guzmán – **1949** Mexico City
Mexican painter. As a boy, he was already fascinated by the pictures of the folk art printmaker J. G. Posada. **1897–1900** Trained at the Agricultural School in Mexico City. **1904–1908** Studied architecture. **1908–1914** Drawing courses at the San Carlos Art Academy in Mexico City. Strongly influenced by the folk art of the Indios and Mestizos. From **1911** he worked as a political cartoonist for the opposition; among others for *La Vanguardia* magazine. Loose contact with Rivera and Siqueiros. **1917/18** Trips to San Francisco and New York. From **1922** onwards did large murals. **1923** Founder member of the Union of Technical Workers, Painters, and Sculptors. **1927–1934** Lived in the USA, mostly in New York. **1932** European trip. **1934** Mural for the Palacio de Bellas Artes, Mexico City. **1940** Six panel paintings for the Museum of Modern Art, New York. **1946** Awarded the Mexican National Art Prize. **1947** Retrospective at the Palacio de Bellas Artes, Mexico City. Along with Rivera and Siqueiros, Orozco is considered as one of the founders, of contemporary Mexican painting, of which murals are the outstanding feature.
WRITINGS: J. C. O.: Textos de O. Mexico City 1955.– J. C. O.: An Autobiography. Austin 1962
CATALOGUES RAISONNES: Hopkins: J. H.: O. A Catalogue of His Graphic Work. (o. O) 1967.– Marrozini, L. (ed.): Catálogo completo de la obra gráfica de O. San Juan 1970
MONOGRAPHS, CATALOGUES: Cardoza y Aragón, L.: O. Mexico City 1986.– Cardoza y Aragón, L. et al. (ed.): J. C. O. Musée d'Art Moderne de la Ville de Paris. Paris 1979 (cat.).– Conde, T. del (ed.): J. C. O. Antología critica. Mexico City 1982.– Conde, T. del et al.: O. Una relectura. Mexico City 1983.– Elliott, D. (ed.): O. 1883-1949. Museum of Modern Art. Oxford 1980 (cat.).– Helm, M.: Man of Fire. J. C. O. An Interpretative Memoir. Institute of Contemporary Art. New York 1953, Westport (CT) 1971 (cat.).– Lynch, J.: J. C. O.: The Easel Paintings and the Graphic Art. Diss. Cambridge 1960.– Manrique, J. A.: O. Mural Paintings. (n. p.) 1991.– Münzberg, O. and M. Nungesser

(ed.): J. C. O. Berlin 1981.– Reed, A.: O. New York 1956, 1985.– Reed, A. and M. Valladares de Orozco: O. Dresden 1979.– Zuno, J. G.: O. y la ironía plástica. Mexico City 1953

**OURSLER Tony**
born **1957** New York
American artist. **1979** Finished his training at the California Institute of the Arts, Valencia, then taught at the Massachusetts College of Art in Boston. **1981** First solo-exhibition "Video Viewpoints" at the Museum of Modern Art in New York. **1986** "Spheres of Influence" exhibition at the Pompidou Centre in Paris. **1988/89** Video performances with Constance DeJong in Los Angeles, New York and Chicago. Participation at the World Wide Video Festival in The Hague. **1992** Participation in documenta 9 in Kassel. **1994** Participation at the Media Biennale in Leipzig. **1997** Took part in documenta 10 in Kassel. In his multimedia works, Oursler examines the effects of the modern media on the human body and psyche.
MONOGRAPHS, CATALOGUES: Balkenhol, B. (ed.): T. O. My Drawings. Kassel 1997 (cat.).– Malsch, F. (ed.): T. O. Portikus, Frankfurt-on-Main et al. Frankfurt-on-Main 1995 (cat.).– T. O. Sphères d'influence. Centre Georges Pompidou. Paris 1986 (cat.).– T. O. Judy. Salzburger Kunstverein. Salzburg 1994.– T. O. Kunstverein Hannover. Hanover 1998 (cat.)

**OZENFANT Amédée**
**1886** St. Quentin – **1966** Cannes
French painter. **1906** Moved to Paris. **1909 –1913** Trips to Russia, Italy, Belgium, and Holland. **1910/11** and **1914** Participation at the Salon d'Automne. **1915** Started the magazine *L'Elan*. **1918** With Le Corbusier, he invented Purism and published the Purist manifesto *Après le Cubisme*. **1920– 1925** Published magazine *L'Esprit nouveau* together with Le Corbusier. **1921** "Jeanneret and Ozenfant" exhibition at the Galerie Druet, Paris. **1924** Shared a studio with Léger in Paris. **1927** First solo-exhibition at the Galerie Barbazanges, Paris. **1928** Participation in the exhibition of contemporary French painting in Moscow. **1925** Started to work on murals for the Musée

d'Art Moderne, Paris. **1935-1938** Lived in London. **1938** Moved to New York, where he established the Ozenfant School of Fine Arts. **1954** Returned to France. Ozenfant, co-founder of Purism, hoped to protect synthetic Cubist painting from becoming merely decorative, but in his own clichéd painting style, he fell victim to a certain aestheticism.
WRITINGS: A. O. and Le Corbusier: Après le cubisme. Paris 1918.– A. O. and Le Corbusier: La Peinture moderne. Paris 1927.– A. O.: A foundation of Modern Art. London 1931.– A. O.: Memoires 1886-1962. Paris 1968
MONOGRAPHS, CATALOGUES: Ball, S. L.: O. and Purism. The Evolution of a Style 1915-1930. Ann Arbor (MI) 1978.– Debrée, C. and F. Ducrois (ed.): A. O. Musée Antoine Lécuyer, Saint Quentin et al. Saint Quentin 1985 (cat.).– Ducrois, F.: A. O. Dijon 1985.– Golding, J.: O. New York 1985

**PAIK Nam June**
born **1932** Seoul
Korean composer and artist. **1950** Moved to Hongkong, then to Japan. Until **1956** she studied music, art history and philosophy at the University of Tokyo. **1956/57** Studied music history in Munich; acquaintanceship with K. Stockhausen. **1957/58** Studied composition at the Musikhochschule in Freiburg. Friendship with Cage. Worked from **1958-1963** at the Studio for Electronic Music at WDR, the West German Radio station in Cologne. **1962** Took part in the *Fluxus* Festival, Wiesbaden. **1963** First solo-exhibition with television sets at the Galerie Parnass, Wuppertal. **1963/64** Lived in Japan; experimented with electromagnetic manipulation of television pictures. **1964** Moved to New York; began collaborating with Charlotte Moorman. **1965** Solo-exhibition at the Galleria Bonino, New York. **1966** First installations with TV monitors. **1969/70** Developed a video synthesizer along with S. Abe. **1971** Solo-exhibition at the Museum of Modern Art, New York. **1975** Took part in the São Paulo Biennale. **1977** Participation in documenta 6 in Kassel. **1979** Became professor at the Art Academy in Düsseldorf. **1982** Retrospective at the Whitney Museum, New York. **1977** and **1987** participation in documenta 6 and 8 in Kassel. **1991/92** Important travelling exhibition "Video Time – Video Space" in Düsseldorf, Basel, Zurich and Vienna. **1993** Representative at the German pavilion at the Venice Biennale. **1995** Retrospective at the Wolfsburg Kunstmuseum. Paik, who experiments with the artistic possibilities inherent in electronic media, is one of the pioneers of video art.
WRITINGS: Decker, E. (ed.): N. J. P. Niederschriften eines Kulturnomaden. Cologne 1992.– N. J. P.: Du cheval à Christo et autres écrits. Brussels 1993
MONOGRAPHS, CATALOGUES: Block, R. (ed.): Art for Twenty-Five Million

People. Daadgalerie. Berlin 1984 (cat.).– Bußmann, K. and F. Matzner (ed.): N. J. P. Eine Database. La Biennale di Venezia. Deutscher Pavillon. Stuttgart 1993 (cat.).– Decker, E.: P. Video. Cologne 1988.– Fargier, J.-P.: N. J. P. Paris 1989.– Hanhardt, J. G. (ed.): N. J. P. Whitney Museum of American Art. New York 1982 (cat.).– Herzogenrath, W. (ed.): N. J. P. Werke 1946-1976. Musik, Fluxus, Video. Kölnischer Kunstverein. Cologne 1976 (cat.).– Herzogenrath, W.: N. J. P. Fluxus – Video. Munich 1983.– Herzogenrath, W. (ed.): N. J. P. Video Works 1963-1988. Hayward Gallery. London 1988 (cat.).– Kellein, T. and T. Stoos (ed.): N. J. P. Video Time – Video Space. Kunsthalle Basel et al. Stuttgart 1991 (cat.).– Matzner, F. (ed.): N. J. P. Baroque Laser. Münster 1995.– Restany, P. (ed.): N. J. P. La Fée électronique. Musée d'Art Moderne de la Ville de Paris. Paris 1989 (cat.).– N. J. P. et al.: N. J. P. Eine Data Base. Stuttgart 1994.– Rosebush, I. (ed.): N. J. P.: Videa'n Video 1959-1973. Everson Museum of Art. Syracuse (NY) 1979 (cat.).– Sayag, A. (ed.): N. J. P. Tricolor Video. Centre Georges Pompidou. Paris 1982 (cat.)

**PALADINO Mimmo**
born **1948** Paduli (near Benevent)
Italian painter. Studied from **1964-1968** at the Liceo Artistico di Benevento. **1977** First solo-exhibition at the Galleria Lucio Amelio in Naples; a year later he covered its walls with a monumental pastel painting. **1978-1980** Monochrome paintings in primary colours with geometric elements and found objects attached. **1980** Technical experiments with printing; produced archetypal figures in acquatint, woodblock and linocut prints. **1982** Participation in documenta 7 in Kassel. **1982-1985** Trips to Brazil; the blend of African and Catholic culture fascinated him and afterwards found its way into his work. Along with Clemente, Chia and Cucchi, Paladino, who projects archetypes and symbols onto the canvas, belongs to the Transavanguardia group.
WRITINGS: M. P.: En De Re. Modena 1980.– M. P. Milan 1990
MONOGRAPHS, CATALOGUES: Braun, E. and N. Rosenthal: M. P. Milan 1993.– Crutchfield, M. A. and H. Risatti (ed.): M. P. Recent Painting and Sculpture 1982-1986. Virginia Museum of Fine Arts. Richmond 1986 (cat.).– Dorflès, G.: M. P. Milan 1984.– Eccher, D. (ed.): M. P. L'opera su carta 1970-1992. Galleria Civica di Arte Contemporanea, Trento. Milan 1992 (cat.).– Friedel, H. (ed.): M. P. Arbeiten von 1977-1985. Städtische Galerie im Lenbachhaus. Munich 1985 (cat.).– Koepplin, D. et al. (ed.): M. P. Zeichnungen 1976-1981. Kunstmuseum Basel et al. Basel 1981 (cat.).– Oliva, A. B. and N. Rosenthal (ed.): M. P. Forte Belvedere, Florence. Milan 1993 (cat.).– M. P. Kunsthalle Basel et al. Basel 1980 (cat.).– M. P. Arbeiten auf Papier. Works on Paper. 1973-

1987. Moderne Galerie, Salzburg et al. Salzburg 1987 (cat.).– Pohlen, A. (ed.): M. P. Bilder und Zeichnungen 1981-1982. Von der Heidt-Museum, Wuppertal et al. Wuppertal 1982 (cat.).– Raspail, T. et al. (ed.): M. P. Musée St. Pierre. Lyon 1984 (cat.).– Schwarz, A. et al. (ed.): M. P. Naples 1995 (cat.).– Schwarz, M. et al. (ed.): M. P. Badischer Kunstverein. Karlsruhe 1980 (cat.).– Tidholm, T.: M. P. Drawings. Stockholm 1991

**PALERMO Blinky**
(Peter Heisterkamp)
**1943** Leipzig – **1977** Sri Lanka
German painter. **1952** Moved to Munster. **1961** Studied at the Munich School of Arts and Crafts. **1962-1967** Studied at the Düsseldorf Art Academy under Bruno Goller and Beuys. From **1964**, he went under the name of Blinky Palermo. **1966** First solo-exhibition at the Friedrich Dahlem gallery in Munich. From **1968** shared a studio with Knoebel, then with Rückriem. **1970** Travelled to New York with Gerhard Richter. **1972** and **1977** participation in documenta 5 and 6 in Kassel. Moved in **1973** to New York with his second wife Kristin. **1974** Travelled around America with Knoebel. **1975** Participation in the São Paulo Biennale. **1976** Again set up a studio in Düsseldorf and exhibited in the German pavilion at the Venice Biennale. **1980** Retrospective at the Galerie-Verein in Munich. Palermo, who can be considered a Minimalist and Hard-Edge artist, invokes a new spatial experience by making subtle optical and sculptural changes to a room.
CATALOGUES RAISONNES: Jahn, F. (ed.): P. Die gesamte Grafik und alle Auflagenobjekte 1966-1975. Städtisches Museum Abteiberg, Mönchengladbach et al. Munich 1983 (cat.).– Moeller, T. (ed.): P. Bilder und Objekte, Zeichnungen. 2 vols. Stuttgart 1995.– Werner, K. (ed.): B. P. Leipziger Galerie für Zeitgenössische Kunst. Stuttgart 1993 (cat.)
MONOGRAPHS, CATALOGUES: Bürgi, B. and E. Franz (ed.): P. Werke 1963-1977. Kunstmuseum Winterthur et al. Winterthur 1981 (cat.).– Dahlem, F. et al. (ed.): B. P. 1964-1976. Staatsgalerie moderner Kunst. Munich 1980 (cat.).– Dahlem, F. et al. (ed.): B. P. 1943-1977. New York 1989.– Maas, E. and D. Greenidge (ed.): B. P. 1943-1977. New York 1989.– Moeller, T. (ed.): P. Städtisches Kunstmuseum Bonn. Bonn 1994 (cat.).– B. P. Kunstmuseum. Winterthur 1984 (cat.).– B. P. Centre Georges Pompidou. Paris 1985 (cat.).– B. P. Städtisches Kunstmuseum Bonn. Bonn 1994 (cat.).– Schwenk, B.: Gleichnisse des Unerklärlichen. Zur Malerei des B. P. Frankfurt-on-Main 1990.– Schwenk, B.: Studien zur Person und zum Werk des Malers B. P. Bonn 1991.– Stemmler, D. (ed.): P. Städtisches Kunstmuseum Bonn. Bonn 1981 (cat.).– Storck, G. (ed.): P. Stoffbilder 1966-1972. Museum Haus Lange. Krefeld 1977 (cat.)

**PANAMARENKO**
born **1940** Antwerp
Belgian artist. **1955-1960** Studied at the Art Academy in Antwerp. **1961/62** Military sevice. **1962-1964** Worked at the National Hoger Institute. **1963** First solo-exhibition at the Antwerp Art Academy. **1964/65** First happenings. Published the *Happening News* magazine. **1967** Built his first airplane. **1969** Solo-exhibition at the René Block gallery in Berlin and the Konrad Fischer gallery in Düsseldorf. **1972** and **1977** Participation in documenta 5 and 6 in Kassel. **1972/73** Tour exhibition at the Kunstmuseum in Lucerne, at the Düsseldorf Kunsthalle, and at the Württembergischer Kunstverein in Stuttgart. **1976** Took part in the Venice Biennale. **1981** Solo-exhibition at the Pompidou Centre, Paris. **1987** Participation in the "Brennpunkt Düsseldorf" exhibition at the Düsseldorf Kunstmuseum. **1989** Retrospective at the Museum van Hedendaagse Kunst, Antwerp. **1992** Took part in documenta 9 in Kassel. Panamerenko's technically perfectly constructed flying objects, which do not fly, are a parody on contemporary Icarian illusions of progress.
WRITINGS: P.: Der Mechanismus der Schwerkraft. Bielefeld 1975.– Theys, H.: P. Brussels 1992.– Theys, H. (ed.): P. Multiples 1966-1994. Galerie Jamar. Antwerp 1995 (cat.)
MONOGRAPHS, CATALOGUES: Baudson, M.: P. Paris 1996.– Bex, F. and L. Dewachter (ed.): P. Een overzicht 1965-1985. Museum van Hedendaagse Kunst. Antwerp 1989 (cat.).– Grisebach, L. and P. Hefting (ed.): P. Nationalgalerie, Berlin et al. Berlin 1978 (cat.).– Grisebach, L. and J. Hoet (ed.): P. Haus der Kunst, Munich et al. Munich 1982 (cat.).– P. Objekte. Städtisches Museum Abteiberg. Mönchengladbach 1973 (cat.).– P. Musée d'Art Moderne de la Ville de Paris. Paris 1973 (cat.).– P. Stedelijk Van Abbe Museum. Eindhoven 1974 (cat.).– P. The Aeromodeller. Centre Georges Pompidou. Paris 1981 (cat.).– P. Werke 1963-1977. Kunstmuseum Winterthur et al. Munich 1984 (cat.).– P. Kunstverein Hannover. Hanover 1991 (cat.).– Tittel, L. et al. (ed.): P. Arbeiten 1966-1985. Kunstverein Friedrichshafen. Friedrichshafen 1985 (cat.)

**PAOLINI Giulio**
born **1940** Genua
Italian artist. First worked on stage designs. **1964** First solo-exhibition at the Galleria La Salita, Rome. **1967** Took part in the Arte Povera exhibition at the Galleria La Bertesca, Genoa with works focusing on the relationship between the artist, his subject and the observer (*Young Man observes Lorenzo Lotto*). **1971** Took part in the Arte Povera exhibition at the Munich Kunstverein. Between **1972** and **1992** participation in documenta 5, 6, 8 and 9 in Kassel. **1975/76** Creation of *Mimesi*, two copies of a Roman copy of the Medici Venus, facing each other so that the gaze

into the past is met by a look into the future. **1981** DAAD scholarship to Berlin. **1984** Took part in the Venice Biennale. **1985** Solo-exhibition at the Guggenheim Museum, New York. **1986** Retrospective at the Stuttgart Staatsgalerie. **1991** Solo-exhibition at the Castello di Rivoli, Turin. Paolini has a special position in the Arte Povera movement. His works are visual essays on art which transcend language; with him, they define art as a place to think about art.
WRITINGS: G. P.: IDEM. Torino 1975.– G. P.: Hortus clausus. Werke und Schriften 1960-1980. Lucerne 1981.– G. P.: Suspense. Breve storia del vuoto in tredici stanze. Florence 1988
CATALOGUE RAISONNE: G. P. L'opera grafica 1967-1992. Torino 1992
MONOGRAPHS, CATALOGUES: Bandini, M. et al. (ed.): G. P. Tutto qui. Pinacoteca Communale. Ravenna 1985 (cat.).– Celant: G. P. New York and Paris 1972.– Cladders, J. (ed.): G. P. Städtisches Museum. Mönchengladbach 1977 (cat.).– Cousseau, H. C. et al. (ed.): G. P. Musée des Beaux-Arts. Nantes 1987 (cat.).– Fagiolo, M. and A. Carlo: G. P. Parma 1980.– Faust, W. M. and E. Franz (ed.): G. P. Del bello intelligibile. Kunsthalle Bielefeld et al. Bielefeld 1982 (cat.).– Inboden, G. et al. (ed.): G. P. 4 vols. Staatsgalerie Stuttgart. Stuttgart 1986 (cat.).– Isler, S.: Del bello intelligibile: semiotische Analyse zu sechs Werken von G. P. Zurich 1983.– Kunz, M. (ed.): G. P. Werke und Schriften 1960-1980. 2 vols. Kunstmuseum. Lucerne 1981.– Maubant, J.-L. and D. Soutif (ed.): P. Melanconia ermetica. Galerie Maeght-Lelong. Paris 1985 (cat.).– Monferini, A. et al. (ed.): G. P. Galleria Nazionale d'Arte Moderna, Roma. Milan 1988 (cat.).– G. P. 2 vols. Le Nouveau Musée. Villeurbanne 1984 (cat.).– Poli, F.: G. P. Torino 1990.– Szeemann, H. et al. (ed.): G. P. Stedelijk Museum, Amsterdam et al. Amsterdam 1980

**PAOLOZZI Eduardo**
born **1924** Leith (near Edinburgh)
English sculptor and graphic artist. **1943** Studied art at Edinburgh College of Art. **1944–1947** Studied at the Slade School of Fine Arts, London. **1947** First solo-exhibition at the Mayor Gallery, London. **1947–**

**1950** Lived in Paris. Met Arp, Brancusi, Giacometti, Dubuffet, T. Tzara. **1949–1955** Taught fabric design at the Central School of Arts and Crafts, London. **1952** Founded the Independent Group at the Institute of Contemporary Arts in London. **1955–1958** Lectureship in sculpture at St. Martins School of Arts, London. **1959–1977** Took part in documenta 2 – 4 and 6 in Kassel. **1960** Participation in the Venice Biennale. **1962** First silkscreen prints. **1964** Solo-exhibition at the Museum of Modern Art, New York. **1974** DAAD scholarship to Berlin. **1979** Honorary doctorate bestowed by the Royal College of Art, London. **1981–1989** Professor of sculpture at the Munich Art Academy. **1981** Took part in the "Westkunst" exhibition in Cologne. **1985** Solo-exhibition at Museum Ludwig, Cologne. **1989** Guest-professorship at the Royal College of Art, London.
WRITINGS: E. P.: Metafisikal Translations. London 1962
CATALOGUE RAISONNE: Miles, R. (ed.): The Complete Prints of E. P. Prints, Drawings, Collages 1944-1977. Victoria and Albert Museum. London 1977 (cat.)
MONOGRAPHS, CATALOGUES: Frayling, C. and M. McLeod (ed.): E. P. Lost Magic Kingdoms. Museum of Mankind. London 1985 (cat.).– Grisebach, L. and F. Whitford (ed.): E. P. Nationalgalerie Berlin et al. Berlin 1975 (cat.).– Kirkpatrick, D.: E. P. London 1970.– Kirkpatrick, D. (ed.): E. P. Musée Nationaux du Canada. 1976 (cat.).– Konnertz, W.: E. P. Cologne 1984.– Middleton, M.: E. P. London 1963.– E. P. Laing Art Gallery, Newcastle et al. London 1976 (cat.).– E. P. Kölnischer Kunstverein. Cologne 1979 (cat.).– Schneede, U. M.: P. Stuttgart 1970, London and New York 1971.– Spencer, R. et al. (ed.): E. P. Recurring Themes. Royal Scottish Academy, Edinburgh et al. Edinburgh 1984 (cat.)/E. P. Wiederkehr der Themen. Städtische Galerie im Lenbachhaus, Munich et al. Munich 1984 (cat.).– Whitford, F.: E. P. Tate Gallery. London 1971 (cat.).– Whitford, F. et al. (ed.): E. P. Sculpture, Drawings, Collages and Graphics. The Arts Council of Great Britain, London et al. London 1976

**PARKS Gordon**
(Alexander Buchanan)
born **1912** Fort Scott (KS)
American photographer, film director and writer. Self-taught. Worked in several fields before deciding to become a photographer in **1937**. First specialised in fashion photography. **1942/43** Took pictures for the project Farm Security Administration. **1943 –1945** War correspondent for the Office of War Information in Washington. **1948– 1961** While working for *Life* magazine as a photojournalist, did a photoseries on street-gangs in Harlem and the civil rights movement and, at the same time, composed music and wrote poetry. Thereafter became a freelance photographer. **1962–1971** Wrote scripts and directed various films, including

*Shaft* (1971). **1977** Participation in documenta 6 in Kassel. Published several books of his photographs, to which he wrote poems. Parks is one of the few successful black photographers.
MONOGRAPHS, CATALOGUES: Berry, S.: G. P. New York 1991.– Buchsteiner, T. and K. Steinorth (ed.): G. P. 40 Jahre Fotografie. Tübingen 1989 (cat.).– Donloe, D.: G. P. Photographer, Writer, Composer, Film Maker. Los Angeles 1993.– G. P. Half Past Autumn. A Retrospective. Boston 1997 (cat.)

**PASCIN Jules**
(Julius Pincas)
**1885** Vidin (Bulgaria) – **1930** Paris
Bulgarian painter and draughtsman, whose father was a Spanish Jew and whose mother was Italian. Moved to Vienna in **1900**. **1903** Worked as a cartoonist for *Simplicissimus* magazine in Munich. **1905** Lived in Paris. In **1914** he moved to London, and finally settled in New York, where he became an American citizen. **1916/17** Resided in Cuba. **1920** Returned to Paris. **1924** Travelled in Tunisia. **1927/28** Lived in New York. **1930** Committed suicide shortly before the opening of his solo-exhibition in the Galerie Georges Petit, Paris. Pascin, who was an extraordinary cartoonist, produced drawings of women ranging from the charming to the frivolous; inspired by Toulouse-Lautrec, they also show a Fauvist influence.
CATALOGUE RAISONNE: Hémin, Y. et al. (ed.): J. P. Catalogue raisonné. 4 vols. Paris 1984-1992
MONOGRAPHS, CATALOGUES: Bay, A. (ed.): P. Malerier, Tegninger, Grafikk. Nasjonalgalleriet. Oslo 1980 (cat.).– Diehl, G.: P. Haus der Kunst, Munich et al. Munich 1969.– Dubreuil, P. (ed.): P. Œuvre gravé. Paris 1981.– Fels, F.: Dessins de P. Paris 1966.– Freudenheim, T. (ed.): P. University Art Museum. Berkeley 1966 (cat.).– Kobry, Y. and E. Cohen (ed.): P. 1885-1930. Musée-Galerie de la Seita. Paris 1995 (cat.).– Lang, L. (ed.): J. P. Berlin 1981.– Leeper, J. P.: J. P.'s Carribean Sketchbook. Austin 1964.– Warnod, A.: P. Monte Carlo 1954.– Werner, A. (ed.): P. New York 1959, 1972, Hamburg 1963

**PASMORE Victor**
**1908** Chesham – **1998** Malta
English painter and sculptor. Self-taught. **1927–1938** Government clerk in London; evening classes in art at the Central School. Started by doing impressionist style landscapes, then turned to Cubism. **1933** Joined the London Group. **1934** Took part in the "Objective Abstraction" exhibition. **1937** Co-founder of the Euston Road School, where he worked as a teacher. **1947/48** Friendship with Nicholson. Gradually developed an individual abstract painting style. **1954–1961** Lectureship at Durham University. **1954** Solo-exhibition at the Institute of Contemporary Art, London.

**1956** Participation in the "This Is Tomorrow" exhibition at the Whitechapel Art Gallery, London. **1960** Honoured as a leading English artist at the Venice Biennale. **1962** Solo-exhibition at the Kestner Society, Hanover. **1964** Participation in documenta 3 in Kassel. **1965** Retrospective at the Tate Gallery, London. **1983** Appointed to the Royal Academy. Pasmore was originally a determined proponent of representational painting, but later became a pioneer, both in theory and practice, of abstract art in England.
CATALOGUE RAISONNE: Bowness, A. and L. Lambertini (ed.): V. P. A Catalogue Raisonné of the Paintings, Constructions and Graphics 1926-1979. London and New York 1979
MONOGRAPHS, CATALOGUES: Alley, R. (ed.): V. P. Retrospective Exhibition 1925-1965. Tate Gallery. London 1965 (cat.).– Bell, C.: V. P. Harmondsworth 1945.– Gowing, L. and L. Sjöberg (ed.): V. P. Yale Center for British Art. New Haven 1988 (cat.).– Grieve, A. (ed.): V. P. Royal Academy of Arts. London 1980 (cat.).– Lynton, N. (ed.): V. P. Paintings and Graphics 1980-1992. London 1992.– V. P. National Gallery. London 1990 (cat.).– Reichardt, J.: V. P. London 1962

**PEARLSTEIN Philip**
born **1924** Pittsburgh (PA)
American painter. **1946–1949** Studied at the Carnegie Institute of Technology, Pittsburgh. **1951–1955** Studied art history at the Institute of Fine Arts, New York. Began to work as a graphic designer. **1955** First solo-exhibition at the Tanager Gallery, New York. **1959–1963** Taught at the Pratt Institute, New York. **1963–1968** Taught at Brooklyn College, New York. **1970** Retrospective at the Georgia Museum of Art, Athens. **1972** Solo-exhibiton at the Hanover Kunstverein and at the Kupferstichkabinett, Berlin. **1974** Prizewinner at the Tokyo Biennale. Typical characteristics of Pearlstein's pictures are a photographic point of view combined with a photorealist style of representation. His figures and motifs, which are often cut off at the edges of the pictures, seem to have been captured there by chance. He frequently paints nudes, mostly in pairs.

CATALOGUE RAISONNE: Bowman, R. (ed.): P. P. The Complete Paintings. New York and London 1983
MONOGRAPHS, CATALOGUES: Boatright, K. (ed.): P. P. Paintings and Watercolours. The University of Iowa Museum of Art. Iowa City 1983 (cat.).– Dückers, A. (ed.): P. P. Zeichnungen und Aquarelle, die Druckgraphik. Berlin 1972.– Kramer, L. K. (ed.): The Graphic Works of P. P. 1978-1994. Springfield Art Museum. Springfield 1995 (cat.).– Landwehr, W. C. (ed.): The Lithographs and Etchings of P. P. Springfield Art Museum. Springfield 1978 (cat.).– Nochlin, L. (ed.): P. P. Gorgia Museum of Art. Athens 1970 (cat.).– Perreault, J. (ed.): P. P. Drawings and Watercolors. New York 1988.– Viola, J.: The Painting and Teaching of P. P. New York 1982

**PECHSTEIN Max**
**1881** Eckersbach – **1955** Berlin
German painter. **1896–1900** Apprenticeship in decorative painting in Zwickau. **1900–1902** Studied at the Dresden School of Arts and Crafts. **1902–1906** Studied at the Dresden Academy. **1906** Joined the Brücke artists. Prize for Painting from the State of Saxony. **1907** Summer visit to Kirchner in Goppeln. **1908** Moved to Berlin, where he became a member of the Berlin Secession. **1910** Co-founder of the New Secession. Visited the Moritzburger lakes with Kirchner and Heckel. **1911** Founded with Kirchner the MUIM Institute (Moderner Unterricht in Malerei – Modern Teaching of Painting). **1912** Left the Brücke group because of his involvement in the Secession exhibition in Berlin. **1914** Trip to the Palau islands. Developed a simpler, more primitive stye. **1915/16** Military service on the western front. **1918** Co-founder of the Arbeitsrat für Kunst (Arts Advisory Council). **1922** Member of the Prussian Academy of the Arts. **1933** Banned from painting or exhibiting. **1937** His art is classified as "degenerate" and 326 works confiscated from German museums. **1944** Destruction of his Berlin apartment and loss of the greater part of his works. **1945** Professorship at the School of Fine Arts in Berlin.
WRITINGS: M. P.: Gedichte und Aufzeichnungen aus Palau, Künstlerbekenntnisse. Potsdam 1921.– M. P.: Ruf an die Jugend. Lorch and Stuttgart 1946.– Reidemeister, L. (ed.): M. P. Erinnerungen. Wiesbaden 1960, Munich 1963, Stuttgart 1993
CATALOGUES RAISONNES: Fechter, P. (ed.): Das graphische Werk M. P.'s. Berlin 1921.– Krüger, G.: Das druckgraphische Werk M. P.'s. Tökendorf 1988
MONOGRAPHS, CATALOGUES: Dieterich G. et al. (ed.): M. P. Das ferne Paradies. Städtisches Kunstmuseum Spendhaus. Reutlingen 1995 (cat.).– Lemmer, K.: M. P. und der Beginn des Expressionismus. Berlin 1949.– Möller, M. (ed.): M. P. Brücke-Museum, Berlin et al. Berlin 1996 (cat.).– Möller, M. (ed.): M. P. Sein

malerisches Werk. Kunsthalle Tübingen et al. Tübingen 1997 (cat.).– Reidemeister, L. (ed.): M. P. 1881-1955. Zeichnungen und Aquarelle. Stationen seines Lebens. Brücke-Museum. Berlin 1981 (cat.).– Schilling, J. (ed.): M. P. Kunstverein Braunschweig et al. Brunswick 1982 (cat.).– Schilling, J. (ed.): M. P. Zeichnungen und Aquarelle. Kunstverein Wolfsburg et al. Hamburg 1987 (cat.).– Stilijanov-Nedo, I. (ed.): M. P. Druckgraphik. Ostdeutsche Galerie. Regensburg 1989 (cat.).– Timm, W. (ed.): M. P. Ostsee-Bilder. Ostdeutsche Galerie. Regensburg 1981 (cat.)

**PEDERSEN Carl-Henning**
born **1913** Copenhagen
Danish painter. Self-taught. **1933** Inspired by Miró and Klee, began to paint in abstract style. **1936** Exhibition at the Copenhagen Autumn Salon. **1939** Trip to Paris. **1940** Contact with the artists' group Host. Worked on the *Helhesten* magazine; in the first issue, he published essays by Klees. **1948** Founded the Cobra group, which included Jorn and Appel; worked on its magazine. **1959/60** Trips to Turkey, Ceylon, India, and Nepal. **1962** UNESCO Prize at the Venice Biennale. Worked on large mosaics in Copenhagen and Herning. **1963** Exhibition at the Galerie de France, Paris. **1968** Retrospective at the Carnegie Museum, Pittsburgh. **1976** Opening of the Carl-Henning Pedersen and Else-Alfelt Museum in Denmark. **1983** Designed stained-glass windows for the Museum of the Danish Resistance Movement in Copenhagen. **1986** Produced mosaics, frescoes, and stained-glass windows for the cathedral in Ribe, Denmark.
MONOGRAPHS, CATALOGUES: C.-H. P.: P. Milan 1985.– Andreasen, E. (ed.): C.-H. P. Copenhagen 1965.– Dotremont, C.: C.-H. P. Brussels 1950.– Ninka: Portraet af maleren C.-H. P. Copenhagen 1980.– Paquet, M.: C.-H. P. Paris 1986.– C.-H. P. Tegninger, Akvareller og Gouacher 1936-1983. Copenhagen 1983 (cat.).– Schade, V.: C.-H. P. Copenhagen 1966

**PENALBA Alicia**
born **1918** Buenos Aires
Argentinian sculptress. **1935** Began her studies at the Academy of Fine Arts in

Buenos Aires. **1943** Apprenticeship at E. Centurio's studio. **1947** Received a prize at the Salon Nacional. **1948** Grant to study in Paris and continuation of her training under Ossip Zadkine. **1952** Systematically destroyed her earlier works. In a period of withdrawal, she produced *Love Totems* and *Plant Liturgies*: narrow tubular sculptures which open out from the inside. **1956** In her sculpture entitled *The Spark*, she turned from figures reaching upwards to sawtooth and jagged forms. **1957** First solo-exhibition at the Galerie Du Dragon in Paris. **1961** Exhibition at the Charles Lienhard gallery in Zurich. **1964** Took part in documenta 3 in Kassel.
MONOGRAPHS, CATALOGUES: Alva Negri, T.: A. P. O de la cadencia musical en la escultura. Buenos Aires 1986.– A. P. Musée des Beaux-Arts. La Chaux-de-Fonds 1982 (cat.).– Joffroy, A. B. et al. (ed.): P. Musée d'Art Moderne de la Ville de Paris. Paris 1977 (cat.).– Seuphor, M.: A. P. Amriswil 1960.– Seuphor, M.: A. P. Otto Gerson Gallery. New York 1960 (cat.).– Waldberg, P.: P. Paris 1957.– Waldberg, P. (ed.): P. Schloß Morsbroich, Städtisches Museum. Leverkusen 1964 (cat.)

**PENCK A. R.**
(Ralf Winkler)
born **1935** Dresden
German painter. **1956** Apprenticeship as a draughtsman with an advertising agency in Dresden. Taught himself the fundamentals of painting at the same time. Constantly at odds with the East German regime, he managed to survive by working as a postman, stoker and nightwatchman. **1960/61** First paintings of Stick Figures, which from then on became his trademark. **1965** A preoccupation with mathematics, cybernetics, and information theory led to his *System- und Weltbildern* (Systems and World Pictures). **1966** First *Standart* pictures; from **1968** *Standart* models out of sticking plaster. Started using the pseudonym A. R. Penck out of fear of government repression (A. Penck, who lived from 1858 – 1949 was a geologist and ice age expert). **1970** Founded the Lücke artists' group. **1972–1992** Participation in documenta 5, 7 and 9 in Kassel. **1977** First wooden sculptures, which from **1982** were also cast in bronze. After leaving East Germany in **1980**, he first settled in the Rhineland, then moved to London in **1983**, and from there went on to Dublin and New York. **1982** Published the first issue of *Krater und Wolke* magazine. **1985/86** Small bronzes and marble statuary. **1988** Lectureship at the Düsseldorf Academy. Penck fills his large canvases with archaic characters, symbols, and stick figures, which has given him the reputation of being a modern cave painter.
WRITINGS: A. R. P.: Standart Making. Munich 1970.– A. R. P.: Was ist Standart. Cologne and Munich 1970.– A. R. P.: Ich – Standart Literatur. Paris 1971.– A. R. P.: Der Begriff Modell. Erinnerungen an 1973.

Cologne 1978.– A. R. P. (mit J. Immendorf): Immendorf besucht Y. Munich 1979.– A. R. P.: Ende im Osten. Berlin 1981.– A. R. P. im Gespräch mit W. Dickhoff. Cologne 1990
MONOGRAPHS, CATALOGUES: Beeren, W. A. L. et al. (ed.): A. R. P. Museum Boymans-van Beuningen. Rotterdam 1979 (cat.).– Calvocoressi, R. (ed.): A. R. P. Waddington Galleries. London 1982 (cat.).– Calvocoressi, R. (ed.): A. R. P. Tate Gallery. London 1984 (cat.).– Dalbajewa, B. (ed.): A. R. P. Analyse einer Situation. Gemäldegalerie Neue Meister. Dresden 1992 (cat.).– Fuchs, R. and M. J. Jitta (ed.): Tekeningen A. R. P. Haags Gemeentemuseum. The Hague 1988 (cat.).– Gachnang, J. and M. Schmidt-Miescher (ed.): A. R. P. Kunsthalle Bern. Bern 1981 (cat.).– Gohr, S. (ed.): A. R. P. Gemälde, Handzeichnungen. Josef-Haubrich-Kunsthalle. Cologne 1981 (cat.).– Grisebach, L. et al. (ed.): A. R. P. Nationalgalerie, Berlin et al. Munich 1988 (cat.).– Guidieri, R. and C. Haenlein (ed.): A. R. P. Skulpturen und Zeichnungen 1971-1987. Kestner-Gesellschaft, Hanover et al. Hanover 1988 (cat.).– Guidieri (ed.): A. R. P. Sculptures. Paris 1988 (cat.).– Koepplin, D. (ed.): A. R. P. Zeichnungen bis 1975. Kunstmuseum Basel. Basel 1978 (cat.).– Marcadé, B.: A. R. P. Paris 1988.– A. R. P. Musée d'Art Moderne de Saint-Etienne. Saint-Etienne 1985 (cat.).– A. R. P. Skulpturen. Cologne 1983.– A. R. P. Zeichnungen 1958-1985. Gachnang & Springer. Bern and Berlin 1986 (cat.).– A. R. P. Sculptures in Bronze. Waddington Galleries. London 1986 (cat.).– Schmidt, M. et al. (ed.): A. R. P. Kunsthalle Bern. Bern 1975 (cat.).– Yau, J: A. R. P. New York 1993

**PENN Irving**
born **1917** Plainfield (NJ)
American photographer. Studied at the Philadelphia Museum School of Industrial Art under A. Brodovitch. Worked at first as a painter and was art director of various magazines, including the *Junior League Magazine*. **1942** Travelled to Mexico. **1943** First jobs for *Vogue*. **1944** Worked for the *American Field Service*. Trips to Europe and India. **1953** Opened a photographic studio in New York. **1974** Appearance of *Worlds in a Small Room*, a book in which he puts together a series of portraits taken during his travels in Africa, Italy, New Guinea, and other countries. Penn was one of the leading fashion photographers of the 50s. He is well known for his portraits of celebrities as well as of anonymous contemporary characters.
MONOGRAPHS, CATALOGUES: Foresta, M. A. (ed.): I. P. Master Images. National Museum of American Art. Washington 1990 (cat.).– Geldzahler, H. (ed.): I. P. Street Material. Metropolitan Museum of Art. New York 1977 (cat.).– Krauss, R. (ed.): I. P. Earthly Bodies. Marlborough Gallery. New York 1980 (cat.).– Szarkowski, J. (ed.): I. P. Recent Works. The Museum

of Modern Art. New York 1975 (cat.).–
Szarkowski, J. (ed.): I. P. The Museum of
Modern Art. New York 1986 (cat.).–
Westerbeck, C. et al. (ed.): I. P. A Retro-
spectice. The Art Institute of Chicago et
al. Chicago 1997 / I. P. Eine Retrospektive.
Munich 1997 (cat.)

### PENONE Giuseppe
born **1942** Garessio Ponte
Italian artist. **1960–1968** Studied at the
Accademia delle Belle Arti in Turin with
Anselmo and Pistoletto. **1968** First solo-
exhibition at the Deposito d'Arte Presente
and **1969** at the Galleria Gian Enzo
Sperone in Turin. From **1970** he taught at
the Liceo Artistico, Turin. Began to experi-
ment with his own body (e.g. body prints).
**1972–1987** Participation in documenta 5, 7
and 8 in Kassel. **1977** Solo-exhibition at
the Lucerne Kunstmuseum. **1978** Solo-
exhibition at the Museum Folkwang,
Essen, and participation at the Venice
Biennale. **1984** Solo-exhibition at the
Museum of Contemporary Art, Chicago.
**1992** Retrospective at the Castello di Rivoli,
Turin. Penone, one of the Arte Povera
artists, frequently examines the relationship
between body and space in his art, for
example by projecting enlarged fingerprints
on the walls or by using mirroring contact
lenses which reflect the room as a image on
the artist's eye.
WRITINGS: G. P.: Rovesciare gli occhi.
Torino 1977
CATALOGUE RAISONNE: Recht, R. (ed.):
P. L'Espace de la main. Musée de la Ville
de Strasbourg. Strasbourg 1991 (cat.)
MONOGRAPHS, CATALOGUES:
Ammann, J. C. (ed.): G. P. Bäume, Augen,
Haare, Wände, Tongefässe. Kunstmuseum.
Lucerne 1977 (cat.).– Barilli, R. et al. (ed.):
G. P. Staatliche Kunstalle. Baden-Baden
1978 (cat.).– Bradley, J. (ed.): G. P.
National Gallery of Canada. Ottawa 1983
(cat.).– Celant, G. and Z. Felix (ed.): G. P.
Museum Folkwang. Essen 1978 (cat.).–
Celant, G. (ed.): G. P. Stedelijk Museum.
Amsterdam 1980 (cat.).– Celant, G. (ed.):
G. P. Arnolfini Gallery, Bristol et al. Milan
1989 (cat.).– Gianelli, I. and G. Verzotti
(ed.): P. Castello di Rivoli, Museo d'Arte
Contemporanea. Torino 1992 (cat.).– G.
P. Städtisches Museum Abteiberg,
Mönchengladbach. Cologne 1982 (cat.).–
G. P. Musée des Beaux-Arts. Nantes 1986
(cat.).– Peters, H. A. (ed.): G. P. Staat-
liche Kunsthalle Baden-Baden. Baden-
Baden 1978 (cat.).– Schreier, C. (ed.):
G. P. Die Adern des Steins. Städtisches
Kunstmuseum Bonn. Bonn 1997 (cat.).–
Torsato, G. (ed.): G. P. Nîmes et al. Nîmes
1997 (cat.).

### PERMEKE Constant
**1886** Antwerp – **1952** Oostende
Belgian painter and sculptor. **1903–1906**
Studied at the Academies in Bruges and
Ghent. Met the artists Servaes, van den
Berghe, and the de Smet brothers. **1909**

Moved into the artists' colony in Laethem-
Saint-Martin. From **1912** lived in Ostend,
where he painted numerous landscapes
showing the influence of Breugel. **1913**
Forms became simplified to sharp-edged
areas of colour. **1914** Wounded in the war
and evacuated to England. **1916** Moved
from London to Chardstock, Devonshire.
**1918** Returned to Ostend. **1925** Moved to
Jabbeke (near Bruges). **1920** Co-founder of
the art magazine *Sélection*. First exhibition
at the Cercle Royal Artistique et Littéraire,
Antwerp. From **1936** he took up sculpture.
**1945/46** Director of the Académie Royale
des Beaux-Arts, Antwerp. **1947** Retrospec-
tive at the Musée d'Art Moderne, Paris.
**1950** and **1952** participation at the Venice
Biennale. **1959** Retrospective at the
Museum voor Schone Kunsten, Antwer-
pen. In addition to landscapes, Permeke
produced monumental figure composi-
tions, whose tendency towards the geo-
metric reveals the influence of the Cubists
and Léger.
MONOGRAPHS, CATALOGUES: Aver-
maete, R.: P. Brussels 1958, 1970.–
Bussche, W. v. de (ed.): C. P. Provinciaal
Museum. Jabbeke 1972 (cat.).– Bussche,
W. v. de (ed.): P. Antwerp 1986.– Bussche, W.
v. de (ed.): C. P. 1886-1952. Kunstverein
Hannover. Brussels 1987 (cat.).– Fierens,
P.: P. Paris 1930.– Haesaerts, P.: P. ou la
volonté de grandeur. Antwerp 1938.–
Haessaerts, P.: P. sculpteur. Brussels
1939.– Langui, E.: C. P. Brussels 1947,
1952.– C. P. Rétrospective. Koninklijk
Museum voor Schone Kunsten. Antwerp
1959 (cat.).– C. P. Rétrospective. Provinci-
aal Museum voor Moderne Kunst. Oost-
ende 1986 (cat.).– Ridder, A. d.: C. P.
1886-1952. Brussels 1947, 1952.– Stubbe,
A.: C. P. Leuven 1931

### PETROV Alexander
born **1947** Kujbyschew
Russian painter. **1961–1966** Studied at the
Painting Academy Penzensk, **1967–1971**
at the Painting and Industry School in
Moscow. Lives in Moscow.

### PETRUSSOV Georgi
**1903** Rostov-on-Don – **1971** Moscow
Russian photographer. Self-taught.
Worked **1920–1924** for the Rostov Indus-
trial Bank, and from **1924** until he died as
a press photographer in Moscow: **1926–
1928** as a staff member for *Pravda*, **1928–
1930** as chief photographer for the Magni-
togorsk Foundries **1930–1941** on a pictor-
ial documentation of the new Russia, **1941
–1945** as a photographic war-correspon-
dent for the Soviet Information Bureau as
well as for the newspaper *Isvestia*, and **1957
–1971** as a photojournalist for the Novosty
Agency. One of the most important Soviet
press photographers of the 30s and 40s.
His emphasis was on industrial and war
photography.
MONOGRAPHS, CATALOGUES: Var-
tanov, A.: G. P. Moscow 1979

### PEVSNER Antoine
(Nathan Borisovic Pevsner)
**1886** Orel (Russia) – **1962** Paris
Russian artist and constructivist theoreti-
cian. **1902–1911** Studied at the Art Acade-
mies in Kiev and St. Petersburg. **1911**
Moved to Paris. **1913** Became acquainted
with Archipenko, Brancusi and Modigliani.
First abstract encaustic paintings. **1915–
1917** Lived in Oslo with his brother Gabo.
**1917** Moved to Moscow, where he worked
together with Malevich and Tatlin and
taught at the WChUTEMAS art school.
**1920** Published the *Realist Manifesto* with
Gabo. **1921** Moved to Germany. **1923**
Returned to Paris; took part in the Salon
des Réalités Nouvelles. **1924** Exhibition
with Gabo in the Percier gallery, Paris.
**1929/30** Member of the Cercle et Carré
group. Became a French citizen. **1937**
Acquaintanceship with Kandinsky. **1938**
Exhibition at the Le Niveau gallery, Paris.
**1946** Became a leading member of the
Salon des Réalités Nouvelles. **1947** Solo-
exhibition at the René Drouin gallery, Paris
and, **1957**, at the Musée National d'Art
Moderne, Paris. **1955** and **1959** participation
in documenta 1 and 2 in Kassel. **1962** Took
part in the Venice Biennale. **1970** Retro-
spective at the National d'Art Moderne,
Paris. Pevsner's multi-dimensional con-
structions, which deliberately use oxidation
processes as part of their visual effect, had a
stimulating influence on Kinetic Art and
light environments.
WRITINGS: Pradel, M.-N. (ed.): P. au
Musée National d'Art Moderne. Les écrits
de P. Paris 1964
MONOGRAPHS, CATALOGUES: Dorival,
B.: Le Dessin dans l'œuvre d'A. P. Paris
1965.– Giedion-Welcker, C. and P. Peissi:
A. P. Huldigung eines Freundes. Neuchâtel
1961 / A. P. Hommage d'un ami. Neuchâtel
1961.– Joray, M. (ed.): A. P. Neuchâtel
1961.– Massat, R. A. P. et le construc-
tivisme. Paris 1956.– A. P. Musée National
d'Art Moderne. Paris 1957 (cat.)

### PEZOLD Friederike
born **1945** Vienna
Austrian video and multimedia artist.
Studied at the Munich Academy. **1971** First
video works. From **1973** incorporated
video, photography and drawings in a new
female pictorial language, best represented

by her **1976** work *Die neue leibhaftige
Zeichensprache eines Geschlechts* (The new
incarnate Sign Language of a Sex). **1977**
Started an independent radio station *Radio
freies Utopia* in Munich. Participation in
documenta 6 in Kassel. **1978** Produced a
video film *Die schwarz-weiße Göttin* (The
Black and White Goddess) for WDR (West
German Broadcasting Station). **1980** Partic-
ipation at the Venice Biennale. From **1984**
use of collages. Through her multimedia
works and performances, Pezold aims to
create a new social awareness and provoke
her viewers into interacting more positively
with their environment.
MONOGRAPHS, CATALOGUES: Haber,
H. G. et al. (ed.): F. P. Städtische Galerie
im Lenbachhaus, Munich. Graz 1975
(cat.).– F. P. Die schwarz-weiße Göttin und
ihre leibhaftige Zeichensprache. Staatliche
Kunsthalle Baden-Baden. Baden-Baden
1977 (cat.)

### PHILLIPS Peter
born **1939** Birmingham
English painter. **1953–1955** Attended the
Moseley Road Secondary School of Art.
**1955–1959** Studied at the Birmingham
College of Art. **1959–1962** Continued his
studies at the Royal College of Art,
London. Contact with Kitaj, Jones and
Hockney. **1962/63** Lectured at Coventry
College of Art and Birmingham College of
Art. **1963** Participation at the Paris Bien-
nale. **1964** Took part in the Pop Art exhibi-
tion in The Hague, Vienna, and Berlin.
**1964–1966** Lived in New York. Toured
the USA with A. Jones. **1965** Solo-exhibi-
tion at the Kornblee Gallery, New York.
**1966** Created the *Hybrid Project*, a survey
set up to establish the ideal work of art.
**1968/69** Guest-professor at the Hamburg
School of Fine Arts. **1972** Retrospective at
the Westfälischer Kunstverein in Münster
and **1976** at the Tate Gallery in London.
**1981** Australian trip. Pop artist Phillips
quotes the modern culture of the mass
media and consumer goods in his picture
collages.
MONOGRAPHS, CATALOGUES:
Crispoli, E.: P. P. Works / Opere 1960-1974.
Milan 1977.– Finch, C. and K. Honnef
(ed.): P. P. Westfälischer Kunstverein.
Münster 1972 (cat.).– Livingstone, M. (ed.):
P. P. Retrovision. Paintings 1960-1982.
Walker Art Gallery, Liverpool et al. Liver-
pool 1982 (cat.)

### PICABIA Francis
**1879** Paris – **1953** Paris
French painter with a Spanish father. Until
**1908** painted in Impressionist style, then
fell under the spell of the Fauves and
Cubists. In his search for new modes of
expression, he became one of the forerun-
ners of abstract art with his work *Rubber*
(Paris, Musée National d'Art Moderne),
painted in **1909**. He continued on this
path from **1913-1915**, which he spent
mostly in the USA. Out of these sharp-

edged, abstract compostions grew a series of machine paintings, whose very lack of functionality challenges faith in technical progress. **1916** Moved back to Europe and joined the Dada group in Paris. He made collages out of buttons, matches, feathers and other materials. After **1927**, the second important phase in his work began: a series of transparent paintings, in which superimposed, linear images blend into each other. From **1931–1939** lived on a boat near Cannes, **1939–1945** in Golfe-Juan. After returning to Paris, took up Colour Field Painting. **1947** Took part in the "Le Surréalisme en 1947" exhibition. In his art, Picabia experimented with many styles: Impressionism, Cubism, Orphism, Dadaism, and Surrealism. Due to this artistic diversity, he found it hard at first to make an impact, however, his overall influence on the development of 20th century art has proved significant and long-lasting.

WRITINGS: Orth, E.: Das dichterische Werk von F. P. Frankfurt-on-Main 1994.– F. P.: Ecrits. Paris 1975-1978 / Schriften. 2 vols. Hamburg 1981.– F. P.: Lettres à Christine 1945-1951. Paris 1988
MONOGRAPHS, CATALOGUES: Armero, G. (ed.): F. P. 1879-1953. Salas Pablo Ruiz Picasso, Madrid et al. Madrid 1985 (cat.).– Arthaud, C. (ed.): P. et la Côte d'Azur. Musée d'Art Moderne et d'Art Contemporain. Nice 1991 (cat.).– Bois, Y.-A.: P. Paris 1975, 1985.– Borràs, M. L.: P. London and New York 1985, Nortford 1993.– Calvocoressi, R. et al. (ed.): P. 1879-1953. National Gallery of Scotland, Edinburgh et al. Edinburgh 1991 (cat.).– Camfield, W. A.: F. P. His Art, Life and Times. Princeton (NJ) 1979.– Christians, U.: Studien zu F. P. Diss. Berlin 1980.– Faggiolo, A.: P. Milan 1976.– Fauchereau, S.: P. Paris 1996.– Felix, Z. (ed.): F. P. Das Spätwerk 1933-1953. Deichtorhallen, Hamburg et al. Stuttgart 1997 (cat.).– Granath, O. and N. Öhmann (ed.): F. P. Moderna Museet. Stockholm 1984 (cat.).– Heinz, M. and O. Schuldt (ed.): F. P. Städtische Kunsthalle Düsseldorf et al. Düsseldorf 1983 (cat.).– Heinz, M. (ed.): F. P. 1879-1953. Galerie Neuendorf, Frankfurt-on-Main et al. Frankfurt-on-Main and Stuttgart 1988 (cat.).– Labia, P. et al. (ed.): F. P. Antology. Lisbon 1997 (cat.).– Le Bot, M.: F. P. et la crise des valeurs figuratives 1900-1925. Paris 1968.– Martin, J.-H. and H. Seckel (ed.): F. P. Grand Palais. Paris 1976 (cat.).– Mohler, O.: Album F. P. Torino 1975.– F. P. Solomon R. Guggenheim Museum. New York 1970 (cat.).– F. P. Kunsthaus Zürich. Zurich 1984 (cat.).– F. P. "Il n'y a pas d'idéal sans passion et la passion n'est pas un idéal objectif". Musée des Beaux-Arts. Nîmes 1986 (cat.).– F. P. Didier Imbert Fine Art. Paris 1990 (cat.).– F. P. Máquinas y Españolas. IVAM Centro Julio González, Valencia et al. Paris 1995 (cat.).– Sanouillet, M. (ed.): F. P. et "391". 2 vols. Paris 1960-1966.– Wilson, S.: F. P. Accomodations of Desire 1924-1932. Kent Gallery. New York 1991 (cat.)

## PICASSO Pablo
**1881** Málaga – **1973** Mougins (near Cannes) Spanish artist. **1891** Moved with his family to La Coruña. First painting lessons from his father. **1895** Attended the La Lonja art school in Barcelona. **1896** First studio in Barcelona. **1899** Frequented the intellectuals' café El Quatre Gats. **1900** First stay in Paris, where he painted scenes from variety shows and circus life. From **1901**, he signed his works *Picasso*, his mother's name. His paintings from this time tend to be an almost monochrome blue-green (his Blue Period). **1904** Moved to Paris and set up a studio in the Bateau-Lavoir district. Met Matisse, Derain and Gertrude Stein, who was his first collector. His palette changed to reddish tones (the Red Period). **1906** Intensive involvement in the works of Cézanne. **1907**, even before he met Braque and the dealer and writer Kahnweiler, his style took a dramatic, revolutionary turn: with his painting *Les Demoiselles d'Avignon*, he broke definitively with the formal and aesthetic mores of the 19th century and paved the way for Cubism. **1909** Development of Analytical Cubism together with Braque. **1912** Began three-dimensional "paintings", incorporating sheet metal and wire as construction elements, as well as his first *papiers collés*. **1917** Stage designs for Diaghilev's Ballets Russes. **1920–1924** Neo-classical period. **1930** Set up a sculpture studio at Boisgeloup castle. **1937** For the Spanish pavilion at the Paris World Fair, he painted the mighty *Guernica*, employing abstraction, deformation, and anatomical mutilation to protest against the bombing of the Basque city by the German Condor Legion. **1939** Completion of the *Suite Vollard* series of etchings. **1940** Returned to Paris, where he was forbidden to exhibit. **1944** Joined the French Communist Party. From **1946**, he lived on the Côte d'Azur. From **1950** became especially interested in ceramics. In the 50s he began to explore the Old Masters, and painted variations on works by Velázquez, Delacroix and Manet. In his impressive late period from **1960** until his death, Picasso fought strongly and angrily against the growing predominance of abstraction. He donated all the works belonging to his family to the Picasso Museum in Barcelona, which opened in **1970**. **1985** Opening of the Musée Picasso in Paris.
WRITINGS: Bernadac, M. L. and C. Piot (ed.): P. écrits. Paris 1989, Munich 1989
CATALOGUES RAISONNÉS: Bernard-Bernadac, M. L. et al. (ed.): Le Musée Picasso. Catalogue sommaire illustré des collections. 2 vols. Paris 1985-1987 / The Picasso Museum, Paris. 2 vols. London and New York 1986-1987 / Picasso-Museum Paris. Bestandskatalog. Munich 1985.– Bloch, G. (ed.): P. P. Katalog des graphischen Werkes 1904-1967 / Catalogue of the Printed Graphic Work 1904-1967 / Catalogue de l'œuvre gravé et lithographié. 4 vols. Bern 1968-1979.– Chip, H. B. (ed.): P. P. Catalogue Raisonné of His Works. Vol. 1-6. San Francisco 1995-1998.– Daix, P.

and G. Boudaille (ed.): P. 1900-1906. Catalogue raisonné de l'œuvre peint. Neuchâtel 1966 / P. The Blue and Rose Periods. A Catalogue Raisonné. of the Paintings 1900-1906. Greenwich (CT) 1967 / P. Blaue und Rosa Periode 1900-1906. Munich 1966.– Daix, P. and J. Rosselet (ed.): Le Cubisme de P. Catalogue raisonné de l'œuvre peint 1907-1916. Neuchâtel 1979 / The Cubist Years 1907-1916. A Catalogue Raisonné of the Paintings and Related Works. New York 1979.– Geiser, B. and B. Baer (ed.): P. Peintre-Graveur. Catalogue illustré de l'œuvre gravé et lithographié (et des monotypes). 1899-1965. 5 vols. Bern 1933-1992.– Glimcher, A. and M. (ed.): Je suis le cahier. Die Skizzenbücher P.'s. Reinbek 1986 / Je Suis le Cahier. The Sketchbooks of P. New York 1986.– Goeppert, S. et al. (ed.): P. P. Catalogue raisonné des livres illustrés. Geneva 1983 / P. P. The Illustrated Books. Geneva 1983.– Mourlot, F. (ed.): P. Lithographe. 4 vols. Monte Carlo 1949-1964 / P. Lithograph. 4 vols. Geneva 1970.– Museu Picasso. Catàleg de pintura i dibuix. Textos de M. A. Capmany et al. Barcelona 1985.– Palau i Fabre, J. (ed.): P. The Early Years. New York 1981 / P. Kindheit und Jugend eines Genies 1881-1907. Munich 1981.– Palau i Fabre, J. (ed.): P. Cubism 1907-1917. Barcelona and New York 1990.– Ramié, G. (ed.): Céramique de P. Paris 1974, 1984 / P. Keramik. Bern 1980 / P. Catalogue of the Edited Ceramic Works. Vallauris 1988.– Rau, B. (ed.): P. P. Die Lithographien. Stuttgart 1988, 1993.– Rodrigo, L. C. (ed.): P. in his Posters. Image and Work. 4 vols. Madrid 1992.– Spies, W. and C. Piot (ed.): P. Das plastische Werk. Werkverzeichnis der Skulpturen 1983 / Les Sculptures de P. Lausanne 1971 / P. Sculpture. London 1972.– Zervos, C. (ed.): P. P. 1895-1972. 33 vols. Paris 1932-1978

## PIENE Otto
born **1928** Laasphe (Westphalia) German painter and object artist. **1944** Military service. **1948–1950** Studied at the Munich Academy, and from **1950–1953** at the Düsseldorf Academy. **1953–1957** Studied philosophy at Cologne University. **1955** Began to work artistically with light. **1957** Founder member, with Mack, of the Zero group. **1959** Solo-exhibition at the Schmela gallery, Düsseldorf. **1964** Guest-professor at the University of Pennsylvania. Took part in documenta 3 in Kassel. **1965** Solo-exhibition at the Kestner Society, Hanover. From **1968** lectureship at Massachusetts Institute of Technology in Cambridge, where he became director of the Center for Advanced Visual Studies in **1974**. **1972** Created the *Olympia Regenbogen* (Olympia Rainbow) in Munich. Exterior decoration of a factory building with monumental frescoes (commissioned by Rosenthal). **1977** Took part in documenta 6 in Kassel. **1981–1983** Organisation of the Sky Art conferences in Cambridge (MA), Linz and Munich. Became known for his kinetic light works (especially the "light

ballet"), which represent an attempt to reconcile modern technology with nature.
WRITINGS: O. P. and H. Mack: Zero. 3 vols. Düsseldorf 1958-1961 / Zero. Cambridge (MA) 1973.– O. P.: More Sky I. Betrachtungen und Skizzen zum Environment. Cambridge (MA) 1970.– O. P.: Migrant Apparition. Cambridge (MA) 1971.– O. P.: Rainbows. Cambridge (MA) 1971.– O. P.: Piene-Texte. Munich and Frankfurt-on-Main 1961
CATALOGUE RAISONNÉ: Mahlow, D. et al. (ed.): O. P. Werkverzeichnis der Druckgraphik 1960-1976. Karlsruhe 1977
MONOGRAPHS, CATALOGUES: Alloway, L. (ed.): O. P. Massachusetts Institute of Technology. Cambridge (MA) 1975 (cat.).– Claus, J. and H. Stachelhaus (ed.): O. P. Galerie Heimeshoff. Essen 1983 (cat.).– Herzogenrath, W. (ed.): O. P. Kölnischer Kunstverein. Cologne 1993 (cat.).– O. P. Retrospektive. Kölnischer Kunstverein. Cologne 1974 (cat.).– O. P. and J. Wissmann (ed.): O. P. Arbeiten auf Papier. Galerie Löhrl. Mönchengladbach 1986 (cat.).– Seaman, B. (ed.): Sonderausstellung O. P. und das CAVS, 20 Jahre Arbeit am Center for Advanced Visual Studies des Massachusetts Institutes of Technology, Cambridge (MA) Badischer Kunstverein, Karlsruhe. Berlin 1988 (cat.).– Wiese, S. v. and S. Rennert (ed.): O. P. Retrospektive 1952-1996. Kunstmuseum und Kunstpalast. Cologne 1996 (cat.).– Wißmann, J.: O. P. Recklinghausen 1976

## PISTOLETTO Michelangelo
born **1933** Biella
Italian artist. Worked from **1947–1958** as an art restorer in his father's workshop. **1958** Enthusiastic discovery of the works of Francis Bacon. **1960** First solo-exhibition at the Galleria Galatea, Turin. **1961** First paintings with reflecting areas. **1964** Solo-exhibition at Ileana Sonnabend gallery in Paris. **1967** Major prize at the São Paulo-Biennale. **1968** Gave his exhibition space at the Venice Biennale to other artists. Participation in documenta 4 in Kassel and at the "Arte povera azioni povere" in Amalfi. **1968–1970** Actions with the Lo Zoo group. **1971** Took part in the Arte Povera exhibition at the Munich Kunstverein. **1977** Directed the opera *Neither* in Rome. **1978** DAAD scholarship to Berlin. **1980** Solo-exhibition at the Museum of Modern Art, San Francisco. **1981** Participation in the "Westkunst" exhibition in Cologne. Sculptures out of polyurethane foam. **1982** Took part in documenta 7 in Kassel. First marble sculptures. **1985** Began covering sculptures with cloth and then painting them. **1989** Solo-exhibition at the Museo Capodimonte, Naples. **1992** and **1997** participation in documenta 9 and 10 in Kassel. **1994** Retrospective at the National Museum of Contemporary Art, Seoul. **1996** Solo-exhibition at the Lenbachhaus, Munich. Pistoletto, a multi-media artist whose work includes painting, photography, sculpture, and action art,

emphasises creative cooperation with other artists.
WRITINGS: M. P.: A Minus Artist. Florence 1988
MONOGRAPHS, CATALOGUES: Boatto, A.: P. Roma 1960.– Boatto, A.; M. P. dentro-fuori lo specchio. Roma 1969.– Celant, G. (ed.): M. P. Forte di Belvedere, Florence. Milan 1984 (cat.).– Celant, G. and A. Heiss (ed.): P. Division and Multiplication of the Mirror. Institute of Contemporary Art, P. S. 1 Museum, New York. New York 1988 (cat.).– Celant, G.: P. New York 1989, Milan 1990.– Corà, B.: M. P. Lo spazio della riflessione nell'arte. Ravenna 1986.– Dercon, C. (ed.): M. P. e la fotografia. Fundación de Serralves, Porto et al. Porto 1993 (cat.).– Felix, Z. (ed.): M. P. Gli oggetti in meno, lo specchio, la gabbia. Deichtorhallen. Hamburg 1992 (cat.).– Garcia, A. et al. (ed.): M. P. Palacio de Cristal, Parque del retiro. Madrid 1983 (cat.).– Krimmel, B. (ed.): M. P. Mathildenhöhe. Darmstadt 1974 (cat.).– Monferini, A. et al. (ed.): M. P. Galleria Nazionale d'Arte Moderna, Roma. Milan 1990 (cat.).– M. P. Centre National d'Art Contemporain. Grenoble 1987 (cat.).– Poetter, J. and R. E. Pahlke (ed.): M. P. Staatliche Kunsthalle Baden-Baden. Baden-Baden 1988 (cat.).– Schmied, W. (ed.): M. P. Kestner-Gesellschaft. Hanover 1973 (cat.).– Schott, F. and M. Schibig (ed.): M. P. Oggetti in meno 1965-1966. Kunsthalle Bern et al. Bern 1989 (cat.)

**PLESSI Fabrizio**
born **1940** Reggio Emilia
Italian video artist and stage designer. Studied at the Venice Academy of Fine Arts, where he later held master classes in painting. From **1968** his obsession with water led to installations, films, videos and performances on that theme. **1980** Took part in the Venice Film Festival with his *Liquid movie*. Awarded the City of Milan Prize. From **1982** devised myriad variations on the various mechanical and electronic possibilities of reproducing the element water. **1987** Received the international prize for *L'immagine elettronica* in Bologna. Created an electronic stage set for E. Cosimi's ballet *Sciame* at the Rovereto Festival. Participation in documenta 8 in Kassel. **1989** Designed sets and costumes for the opera *The Fall of Icarus* at the National Opera in Brussels. **1990** Professorship at the Media Arts Academy in Cologne.
CATALOGUE RAISONNE: Koelen, D. v. de (ed.): F. P. Opus Video-Skulptur. Werkverzeichnis der Video-Skulpturen 1976-1997. Mainz 1998
MONOGRAPHS, CATALOGUES: Bartsch, I. (ed.): F. P. Retrospektive. Museum am Ostwall. Dortmund 1993 (cat.).– Fagone, V. et al. (ed.): P. Water Video Projects. Heidelberger Kunstverein. Heidelberg 1983 (cat.).– Fagone, V. et al. (ed.): F. P. Milan 1985.– Goddrow, G. A. (ed.): F. P. Progetti del Mondo. Cologne 1997.– Kubisch, C.: F. P.

Aachen 1979.– Oliva, A. B. and O. Calabrese (ed.): P. Civici Musei, Reggio Emilia. Treviso 1990 (cat.).– F. P. Kunsthalle Kiel. Kiel 1977 (cat.).– F. P. Bombay Bombay. Museum Ludwig. Cologne 1993 (cat.).– F. P. Zeichnungen. Neue Galerie. Linz 1994 (cat.).– Reitbauer, R. (ed.): P. Museum Moderner Kunst, Stiftung Ludwig. Vienna 1991 (cat.).– Schepers, J. (ed.): F. P. La Rocca Elettronica. Rocca Paolina. Perugia 1995 (cat.).– Zweite, A. (ed.): F. P. Aquabiographie. Städtische Galerie im Lenbachhaus. Munich 1974 (cat.)

**POIRIER Anne** and **Patrick**
born **1942** Marseille (Anne)
born **1942** Nantes (Patrick)
French artists. **1963-1966** Studied at the Académie des Arts Décoratifs in Paris. **1967 – 1971** Lived in Rome on Villa Medici grants. **1970** First solo-exhibition in Rome. **1972** Solo-exhibition at the Maenz gallery, Cologne. **1974** Took part in the "Spurensicherung" (Trace- and Clue-Finding Art) exhibition at the Kunstverein, Hamburg. **1976, 1980** and **1984** participants at the Venice Biennale. **1977** Took part in documenta 6 in Kassel. Solo-exhibition at the Neue Berliner Kunstverein. **1979/80** P.S.1 grants for New York. **1988** Solo-exhibition at the Lenbachhaus and at the Dany Keller gallery, Munich. **1977/78** DAAD scholarship to Berlin. **1973** Solo-exhibition at the Neue Galerie, Aachen. **1977** Participation in documenta 6 in Kassel. **1984** Solo-exhibition at the Brooklyn Museum, New York. **1988** Solo-presentation at the Kunstforum in the Lenbachhaus, Munich. **1994** Solo-exhibition at the Museum Moderner Kunst, Vienna. The Poiriers are proponents of trace- and clue-finding art and individual mythology.
WRITINGS: A. and P. P.: Domus Aurea, archéologie, fiction. Paris 1977
MONOGRAPHS, CATALOGUES: Barzel, A. (ed.): A. & P. P. Decouvertes et rapports. Villanova University. Villanova (PA) 1991 (cat.).– Lascaut, G. et al. (ed.): A. et P. P. Domus Aurea, fascination des ruines. Centre Georges Pompidou, Paris et al. Paris and Bonn 1978 (cat.).– Foray, J.-M. et al. (ed.): A. und P. P. Museum Moderner Kunst Stiftung Ludwig, Vienna et al. Milan 1994 (cat.).– Marchi, S. (ed.): A. and P. P. Architettura e mitologica. Chiesa di S. Carpoforo. Milan 1984 (cat.).– Metken, G. et al. (ed.): A. and P. P. Galerie der Stadt Esslingen. Esslingen 1987 (cat.).– A. and P. P. Ruines sur ruines. Musée des Beaux-Arts de Caen. Caen 1985 (cat.)

**POLIAKOFF Serge**
**1906** Moscow – **1969** Paris
Russian-born French painter. **1918** Fled the Russian Revolution and moved to Paris in **1923**. Studied music and first earned his living as a guitarist. **1929/30** Attended the Académie Frochot, the Académie Bilbul and the Grande Chaumière in Paris. **1935-1937** Studied at the Slade School of Art in

London, afterwards moving back to Paris, where he made friends with Kandinsky, Sonia and Robert Delaunay and Freundlich. **1946** Awarded the Kandinsky Prize and, in **1956**, the Lissone Prize. In the late 40s he created his first monumental compositions while, in the 50s, he painted primarily diptychs and triptychs. **1959** and **1964** participation in documenta 2 and 3 in Kassel. **1962** Took French citizenship. **1965** International Prize at the Tokyo Biennale, **1966** first prize at the Menton Biennale. Via the colour theories of the Orphists, he developed a form of synthetic Cubism: a patchwork structure of highly intense colour areas that becomes denser towards the middle.
WRITINGS: S. P.: Enluminures. St. Gallen 1972
CATALOGUES RAISONNES: Poliakoff, A. (ed.): S. P. Catalogue raisonné (in preparation).– Rivière, Y. (ed.): S. P. Les Estampes. Paris 1974
MONOGRAPHS, CATALOGUES: Brütsch, F.: S. P. 1900-1969. Neuchâtel 1993.– Cassou, J.: S. P. Amriswil 1963.– Durozoi, G. et al. (ed.): S. P. Eine Übersicht. Museum Würth. Künzelsau 1997 (cat.).– Lassaigne, J.: P. Gouaches. Paris 1957.– Marchiori, G.: S. P. Paris 1976.– S. P. Musée National d'Art Moderne de la Ville de Paris. Paris 1970 (cat.).– S. P. Les Estampes. Paris 1974.– S. P. Fondation Dina Vierny, Musée Maillol. Paris 1996 (cat.).– Ragon, M.: P. Paris 1956.– Vallier, D.: S. P. Paris 1959.– Vallier, D. (ed.): S. P. Rétrospective. Galerie Melki. Paris 1991 (cat.).– Vierny, D. et al. (ed.): S. P. Paris 1995 (cat.)

**POLKE Sigmar**
born **1941** Oels (Lower Silesia)
German painter. **1953** Moved to West Berlin, then to Düsseldorf. **1959/60** Apprenticeship as a glass painter. Studied from **1961-1967** under Götz, Hoehme and Beuys at the Düsseldorf Academy. **1963** With K. Fischer-Lueg and G. Richter developed, Kapitalistischer Realismus a highly polemical version of Pop Art. From **1965** detailed study of historical and contemporary art works: variations on paintings by Dürer and Kandinsky, imitations of Arte Povera and Concept Art works. **1970/71** and **1977** guest-professor at the Hamburg School of Fine Arts. **1972-1982**

Participation in documenta 5-7 in Kassel. **1974** Travelled to Pakistan and Afghanistan. **1978** Moved to Cologne. Began to incorporate cartoons and, in the early 80s, addressed political themes. **1982** Received the Will Grohmann Award, **1984** the Kurt Schwitters Award, **1986** first prize for painting at the Venice Biennale, **1987** the Lichtwark Award in Hamburg, and **1988** the Baden-Württemberg State Award. **1989** Appointed professor at the Hamburg School of Fine Arts. **1991** *Neue Bilder* (New Pictures) series. Again and again, Polke comments ironically on the effects of manipulation by the mass media. He adheres to a classical modernist style, but employs unusual techniques and materials taken partly from trival and sub-cultures.
WRITINGS: S. P.: Höheres Wesen befehlen. Berlin 1968.– S. P.: Bizarre. Heidelberg 1972
MONOGRAPHS, CATALOGUES: Beeren, W. et al. (ed.): S. P. Museum Boymans-van Beuningen, Rotterdam et al. Rotterdam 1983 (cat.)./ S. P. Städtisches Kunstmuseum Bonn et al. Bonn 1984 (cat.).– Beeren, W. (ed.): S. P. Stedelijk Museum. Amsterdam 1992 (cat.).– Belting, H. et al. (ed.): S. P. Die drei Lügen der Malerei. Kunst- und Ausstellungshalle der Bundesrepublik Deutschland, Bonn. Stuttgart 1997 (cat.).– Curiger, B. and H. Liberknecht (ed.): S. P. Musée d'Art Moderne de la Ville de Paris 1988 (cat.).– Erfle, A.: S. P. Der Traum des Menelaos. Cologne 1997.– Ferguson, R. (ed.): S. P. Photoworks. Museum of Contemporary Art, Los Angeles et al. Zurich, Berlin and New York 1995 (cat.).– Gachnang, J. (ed.): S. P. Zeichnungen 1963-1969. Bern and Berlin 1987 (cat.).– Gohr, S. et al. (ed.): S. P. Kunsthaus, Zurich et al. Zurich and Cologne 1984 (cat.).– Groot, E. d. (ed.): S. P. Museum Boymans-van Beiningen, Rotterdam et al. Rotterdam 1983.– Hentschel, M.: Die Ordnung des Heterogenen. S. P.'s Werk bis 1986. Darmstadt 1991.– Heubach, F. W. and B. H. D. Buchloh (ed.): S. P. Bilder, Tücher, Objekte. Werkauswahl 1962-1971. Kunsthalle Tübingen et al. Tübingen 1976 (cat.).– Lamarche-Vadel, B. et al. (ed.): S. P. Musée d'Art Moderne de la Ville de Paris. Paris 1988 (cat.).– Nesbit, J. (ed.): S. P. Join the Dots. Tate Gallery, Liverpool. London 1995 (cat.).– Poetter, J. (ed.): S. P. Fotografien. Staatliche Kunsthalle Baden-Baden. Stuttgart 1990 (cat.).– S. P. San Francisco Museum of Modern Art et al. San Francisco 1990 (cat.).– Schimmel, P. and M. Morris Hambourg (ed.): S. P. Photowork. Museum of Contemporary Art. Los Angeles 1995 (cat.).– Schjeldahl, P. (ed.): S. P. Mary Boone Gallery, New York 1986 (cat.).– Schmidt, K. (ed.): S. P. Zeichnungen, Aquarelle, Skizzenbücher 1962-1988. Städtisches Kunstmuseum Bonn. Bonn 1988 (cat.).– Schmidt, K. and G. Schweikhart (ed.): S. P. Städtisches Kunstmuseum Bonn. Bonn 1988 (cat.).– Schulz-Hoffmann, C. and U. Bischoff (ed.): S. P. Schleifenbilder. Stuttgart 1992.– Stemmler, D. (ed.): S. P. Neue Bilder. Städtisches Museum Abteiberg. Mönchengladbach 1992 (cat.).– Szeemann, H. and T. Stooss (ed.): S. P. Josef-Haubrich-Kunsthalle, Cologne et al. Cologne 1984 (cat.).– Thistlewood, D. (ed.): S. P. Back to Postmodernity. Liverpool 1996.– Tosatto, G. and B. Marcadé (ed.): S. P. Carré d'Art, Musée d'Art Contemporain, Nîmes et al. Paris 1994 (cat.)

**POLLOCK Jackson**
**1912** Cody (WY) – **1956** East Hampton (NY)
American painter. **1925-1929** Studied at the Manual Arts School in Los Angeles and

from **1929/30** at the Art Students League in New York under Benton, the most important representative of American Scene Painting, whom he assisted in painting murals. **1936–1943** Created murals as part of a government programme. **1939** During a period of treatment for alcoholism, he began to study the teaching of C. G. Jung, especially his theory of archetypes. From **1942** friendship with Motherwell, a leading Abstract Expressionist, and with the Surrealist Matta, who encouraged him to write Surrealist poems. At first, he painted non-representational pictures, whose stylised forms were borrowed from primitive art, especially Indian art. **1945** Married the artist L. Krasner. **1946** First *Drip Painting*, whereby paint from perforated paint cans was allowed to drip onto canvases laid on the floor; at the same time he was experimenting with a heavy impasto made of sand, glass fragments, and other materials, and used sticks, knives, and spatulas instead of brushes. **1950/51** Rebelled against the anti-abstract art policies of the Art Institute of Chicago. **1951** Underwent further therapy for alcoholism and, in **1955**, psychoanalysis. **1956** Died in an automobile accident. Pollock developed Action Painting out of the Surrealist technique of Automatism. This gestural approach later led to the happening.
CATALOGUE RAISONNE: O'Connor, F. V. et al. (ed.): J. P. A Catalogue Raisonné of Paintings, Drawings and Other Works. 4 vols. New Haven (CT) and London 1978
MONOGRAPHS, CATALOGUES: Abadie, D. et al. (ed.): J. P. Centre Georges Pompidou. Paris 1982 (cat.).– Bätschmann, O.: J. P. Lucerne 1971.– Busignani, A.: P. Florence, London and New York 1971.– Cernuschi, C. (ed.): J. P. Psychoanalytic Drawings. Duke University Museum of Art, Durham et al. Durham 1992 (cat.).– Cernuschi, C.: J. P. Meaning and Significance. New York 1992.– Clark, T. J.: J. P. Abstraktion und Figuration. Hamburg 1994.– Frank, E.: J. P. New York 1983, Munich 1984.– Frascina, F. (ed.): P. and After. The Critical Debate. New York 1985.– Friedman, B. H.: J. P. Energy Made Visible. New York 1972.– Fujieda, T.: J. P. Tokyo 1979.– Landau, E.: J. P. New York 1989.– Naifeh, S. and G. W. Smith: J. P. An American Saga. London and New York 1989, London 1992.– Namuth, H.: L'Atelier de J. P. Paris 1978.– O'Connor, F. V. (ed.): J. P. The Museum of Modern Art. New York 1967 (cat.).– O'Connor, F. V. (ed.): J. P. The Black Pourings 1951-1953. Institute for Contemporary Art. Boston 1980 (cat.).– O'Hara, F.: J. P. New York 1959.– J. P. Bilder. Städtische Galerie im Städelschen Kunstinstitut. Frankfurt-on-Main 1982 (cat.).– Potter, J.: To a Violent Grave. An Oral Biography of J. P. New York 1985.– Putz, E.: J. P. Theorie und Bild. Hildesheim 1975.– Ratcliff, C.: The Fate of a Gesture. J. P. and Postwar American Art. New York 1996.– Robertson, B.: J. P. New York 1960.– Rohn, M. L.: Visual Dynamics in J. P.'s Abstractions. Ann Arbor (MI)

**POMODORO Arnaldo**
born **1926** Morciano di Romagna
Italian sculptor. Brother of G. Pomodoro. First studied architecture and was then apprenticed to a goldsmith. **1954** Moved to Milan, where he had his first solo-exhibition in **1955**. **1957** Signatory of the *Manifesto Against Style*. **1959** Took part in documenta 2 in Kassel. From the 60s, he produced geometric, usually spherical metal sculptures, whose smooth surfaces are broken in places to reveal graceful, intricate interiors. **1965** Solo-exhibition at the Marlborough Gallery, Rome. **1965–1968** Design and production of the open-air sculpture *Grande Disco* in front of the theatre in Darmstadt. **1969** Solo-exhibition at the Boymans-van Beuningen Museum, Rotterdam, and at the Kunstverein in Cologne. Pomodoro set a new course for the plastic arts by taking the principles of L'art informel and applying them to sculpture.
MONOGRAPHS, CATALOGUES: Ballo, G.: A. e Gio Pomodoro. Milan 1962.– Hunter, S.: A. P. New York 1982.– Hunter, S.: A. P. Milan 1995.– Mussa, I. (ed.): Luoghi fondamentali. Sculture di A. P. Forte di Belvedere, Florence. Milan 1984 (cat.).– Krimmel, E. (ed.): A. P. Großplastiken. Freiräume und Foyers des Staatstheaters. Darmstadt 1972 (cat.).– A. P. Museum Boymans-van Beuningen, Rotterdam et al. Rotterdam and Cologne 1969 (cat.).– Quintavalle, A. C.: A. P. Opere dal 1956 al 1960. Milan 1990.– Rosenthal, M. (ed.): A. P. A Quarter Century. Columbus Museum of Art. Columbus (OH) 1983 (cat.)

**POONS Larry**
born **1937** Tokyo
American painter. **1955–1957** Studied in Boston at the New England Conservatory of Music, **1958** at the Museum School of Fine Arts. **1958/59** Returned to New York, where he had lived as a boy. Met Louis, Newman, Noland, Kelly and F. Stella. In the early 60s, he produced his first *Dot Pictures*: paintings with oval or round dots of colour in a regular pattern on a monochrome background. **1963** Solo-exhibition at the Green Gallery and, **1967**, at the Leo Castelli Gallery, New York. **1968** Took part in documenta 4 in Kassel. From the early 70s, used viscous paint, dripped or thrown onto the canvas. **1978/79** Exhibition with M. Steiner at the Wuppertal Kunstverein and at Amerika Haus in Berlin. **1981/82** Retrospective at the Museum of Fine Arts, Boston. **1986** Solo-exhibition at the André Emmerich Gallery, New York. Poon's meditative Color Field style is coupled with a

**POPOVA Lyubov**
**1889** Ivanovskoye – **1924** Moscow
Russian painter. **1907–1909** Studied painting in Moscow under Joukovski, Joun and Dudin. **1910** Travelled in Italy. **1912** Took part in the artists' meeting in the Basnia (Tower) gallery in Moscow; meeting with Tatlin. **1912/13** Lived in Paris, where she worked in the studios of Metzinger and Le Fauconnier and painted her first Cubist pictures. **1913** Returned to Moscow. **1916** Under the influence of Malevich, produced her first non-representational pictures, displayed in a joint exhibition with Tatlin and Malevich in Moscow. **1917** Co-founded *Supremus* magazine. **1918** Member of the leftist federation of the Union of Moscow Artists, which included Rodchenko and Stepanova. **1919** Took part in the national exhibition "Non-Representational Art and Suprematism", **1921** in the "5x5 = 25" exhibition in Moscow. **1920–1923** Taught at the WChUTEMAS art school; did stage set designs. **1922** Took part in the exhibition of Russian art at the van Diemen gallery, Berlin. **1924/25** Posthumous retrospective at the Stroganov Institute, Moscow. In her various creative phases, Popova showed the influences of Cubism, Suprematism, and Constructivism. Out of her close association with Tatlin and Malevich, she developed her own non-representational style, known as Painterly Architectonics.
MONOGRAPHS, CATALOGUES: Adaskina, N. and D. Sarabianov: L. P. Paris 1989.– Dabrowski, M. (ed.): L. P. The Museum of Modern Art, New York et al. New York 1991 (cat.).– Sarabianov, D. V. and N. L. Adaskina: L. P. New York 1990.– Weiss, E. (ed.): L. P. 1889-1924. Museum Ludwig, Cologne et al. Munich 1991 (cat.)

**PRAGER Heinz-Günther**
born **1944** Herne (Westphalia)
German sculptor. **1964–1968** Studied at the School of Arts and Crafts in Münster. Regular study trips to Paris. From **1967** experimented with forms in wood, bronze and iron. **1970** First sculptures out of steel and pig iron, exploring the relationship between the viewer and the object viewed. **1973** Won a Villa Romana scholarship to Florence. **1974** Developed an anthropometric theory of sculpture. **1975** First solo-exhibition at the Museum Folkwang, Essen. Experiments on the variability of cylinders and plates. **1977** Took part in documenta 6 in Kassel. **1982/83** Stayed at the Villa Massimo in Rome. **1983** Professor of Sculp-

gestural actionism, showing the influence of Pollock's Action Painting.
MONOGRAPHS, CATALOGUES: Fenton, T.: (ed.): L. P. Recent Paintings. Edmonton Aret Gallery. Alberta 1974 (cat.).– Moffet, K. and T. Fenton (ed.): L. P. Paintings 1971-1981. Museum of Fine Arts. Boston 1981 (cat.).– Steiner, M. (ed.): L. P. Skulpturen und Gemälde aus New York. Wuppertal 1978 (cat.)

ture at the Braunschweig School of Art. Many commissions for sculptures in public places.
MONOGRAPHS, CATALOGUES: Cladders, J.: H.-G. P. Skulpturen. Galerie Kunst & Architektur. Hamburg 1986 (cat.).– Mennekes, S. J. F. (ed.): H.-G. P. Skulpturen, Arbeiten auf Papier. Skulpturenmuseum Glaskasten. Marl 1990 (cat.).– Nowald, K. (ed.): H.-G. P. Skulpturen. Museum Folkwang. Essen 1975 (cat.).– Oelschlägel, P.: H.-G. P. Distanz und Nähe. Hanover 1995.– Peters, U. (ed.): H.-G. P. Bodenskulpturen.Germanisches Nationalmuseum. Nuremberg 1990 (cat.).– Schneckenburger, M.: P. Skulpturen. Palais Liechtenstein, Vienna et al. Stuttgart 1983 (cat.).– Schnell, W.: H.-G. P. Skulpturen 1967-1978. Städtisches Museum, Schloß Morsbroich. Leverkusen 1978 (cat.).– Schwarz, M. (ed.): H.-G. P. Skulpturen und Zeichnungen. Badischer Kunstverein. Karlsruhe 1974 (cat.).– Uelsberg, G.: H.-G. P. Skulpturen. Cologne 1996.– Wedewer, R.: H.-G. P. Zeichnungen und Skulpturen. Cologne 1977

**PRAMPOLINI Enrico**
**1894** Modena – **1956** Rome
Italian painter and stage designer. **1911** Studied at the Rome Art Academy. **1912/13** Rejected by the Academy, he joined the Futurist movement. **1913** Wrote the manifesto We Want to *Bomb the Academy* and *Atmosfera struttura*. **1914** Took part in the Futurist exhibition at the Galleria Sprovieri, Rome. **1916** Met T. Tzara; took part in the Dada exhibition in Zurich. **1917** Founded *Noi* magazine. **1922** Joined the Section d'Or. Contact with theBauhaus and De Stijl. **1923** Published his manifesto *Mechanical Art*. **1924** Took part in the Futurist Congress in Milan. **1925–1937** Long stays in Paris. Met Mondrian, Vantongerloo, and others. Worked on theatre sets. **1931** Member of Abstraction-Création. **1934** Published the *Stile futurista* magazine with Fillia. **1941** Moved to Rome for good. **1961** Posthumous retrospective at the Galleria Nazionale d'Arte Moderna, Rome. Prampolini's painting went through many changes over the years. His avant-garde style is part Futurist, part Cubist, but his compositions also display elements of Purism and Geometric Abstraction.

1987.– Rose, B. (ed.): J. P. Drawings into Paintings. The Museum of Modern Art. New York 1980 (cat.).– Solomon, D.: J. P. A Biography. New York 1987.– Tomassoni, I.: P. Florence, London and New York 1969.– Wayup, C. L. (ed.): J. P. Psychoanalytical Drawings. New York 1970

MONOGRAPHS, CATALOGUES: Ballo, G. (ed.): P. verso i polimaterici. Galleria Fonte d'Abisso. Modena 1989 (cat.).– Bucarelli, P. (ed.): E. P. Galleria Nazionale d'Arte Moderna. Roma 1961 (cat.).– Courthion, P.: E. P. Roma 1957.– Crispolito, E. and G. d. Marco (ed.): E. P. Galleria Civica, Modena. Florence 1991 (cat.).– Crispolito, E. et al. (ed.): P. Dal futurismo all' informale. Palazzo delle Esposizioni. Roma 1992 (cat.).– Lista, G. (ed.): E. P. Carteggio futurista. Roma 1992.– Menna, F.: E. P. Roma 1967.– Oliva, A. B. (ed.): P. 1913-1956. Galleria Fonte d'Abisso. Modena 1985 (cat.).– Oliva, A. B.: P. Opere dal 1913-1956. Bologna 1986.– Pfister, E.: E. P. Milan 1940.– Siligato, R. (ed.): P. Carteggio 1916-1956. Palazzo delle Esposizioni. Roma 1992 (cat.).– Sinisi, S.: "Varieté". P. e la scena. Torino 1974

**PRIGOV Dimitri**
born **1940** Moscow
Russian painter. **1967** Finished studying sculpture at the Stroganov Art Institute in Moscow. Wrote poetry, dramas, and essays after a course in visual and concrete poetry. Took part in music performances with jazz and rock musicians. **1989** First solo-exhibition at the Struve Gallery, Chicago, and at the St. Louis Gallery of Contemporary Art. **1990** DAAD scholarship to Berlin. Prigov attempts in his art to distance himself from the cultural mainstream. His critical view of stereotyped images is underlined by his deliberate use of Soviet clichés in visual and verbal combination.
MONOGRAPHS, CATALOGUES: D. P. Struve Gallery. Chicago 1989 (cat.).– D. P. Saint Louis Gallery of Contemporary Art. Saint Louis 1989 (cat.)

**PRINCE Richard**
born **1949** in the Panama Canal Zone
American painter and photographer. **1976** First solo-exhibition at the Ellen Sragrow Gallery in New York. **1980** Became known for his rephotographing of printed pictures like advertising photos and magazine illustrations, including the Malboro Cowboys. Solo-exhibitions at Artists Space gallery in New York and at the CEPA Gallery in Buffalo, to which he added short texts on horror films, sex and war. **1984** Created the

*Gangs*, images taken from special magazines for truckers, surfers, motorcyclists, etc. **1986** Reproductions, redrawing and manual transfers of cartoons and puns. **1988** Took part in the Venice Biennale and in the BiNationale in Boston and Düsseldorf. **1992** Participation in documenta 9 in Kassel.
WRITINGS: R. P. Why I Go to the Movies Alone. New York 1983, Cologne 1994
MONOGRAPHS, CATALOGUES: Diserens, C. and V. Todoli (ed.): R. P. Spiritual Americatur. IVAM Centro Julio González. Valencia 1989 (cat.).– Haenlein, C. (ed.): R. P. Photographien 1977-1993. Kestner-Gesellschaft. Hanover 1994 (cat.).– Linker, K. (ed.): R. P. Le Nouveau Musée. Lyon 1983 (cat.).– Phillips, L. (ed.): R. P. Whitney Museum of American Art, New York et al. New York 1992 (cat.).– R. P. Magasin-Centre National d'Art Contemporain. Grenoble 1988 (cat.).– R. P. IVAM Centre del Carme. Valencia 1989 (cat.).– R. P. Inside View. Kent Fine Art. New York 1989.– R. P. San Francisco Museum of Modern Art et al. San Francisco 1993 (cat.)

**PUNI Ivan**
(Jean Pougny)
**1892** Konokkala (Finnland) – **1956** Paris
French painter of Russian-Finnish extraction, also known as Jean Pougny. **1910**-**1912** Studied art at the Académie Julian, Paris. At the end of **1912** he returned to St. Petersburg, where he had contact with Burlyuk, Malevich and Tatlin. **1914** Took part in the Salon des Indépendants, Paris. **1915** Organized the "0,10" exhibition, in which Malevich and Tatlin were also involved. Signatory of the *Suprematist Manifesto*. **1917** Participation in the "Karo Bube" exhibition. **1918** Lectured at the SWOMAS. **1919** Moved to Finland, **1920** to Berlin. **1921** Solo-exhibition at the Sturm gallery in Berlin. From **1923** he lived in Paris. Contact with Léger, Ozenfant, Severini, etc. **1924** Took part in the Salon des Tuileries. **1940** Travelled with Delaunay to the South of France, settling in Antibes. **1942** Returned to Paris. **1946** Became a French citizen. Puni was at first influenced by the Cubists but became one of the most important Suprematist artists. In later years he developed a more sensitive, figurative, atmospheric style of painting.
CATALOGUE RAISONNE: Berninger, H. and J.-A. Cartier (ed.): J. P. 1892-1956. Catalogue de l'œuvre. 2 vols. Tübingen 1972-1992
MONOGRAPHS, CATALOGUES: Cartier, J. A.: I. P. Paris 1961.– Gindertael, R. V. (ed.): P. Geneva 1957.– Marcade, J.-C. et al. (ed.): I. P. 1892-1956. Musée d'Art Moderne de la Ville de Paris. Paris 1993 (cat.).– Merkert, J. et al. (ed.): I. P. 1892-1956. Berlinische Galerie, Berlin et al. Stuttgart 1993 (cat.).– I. P. 1894-1956. Stedelijk Museum. Amsterdam 1961 (cat.).– I. P. Kunsthaus Zürich. Zurich 1975 (cat.)

**PURRMANN Hans**
**1880** Speyer – **1966** Basel
German painter. Took lessons from his father. **1898**-**1900** Studied at the Karlsruhe School of Arts and Crafts. **1900**-**1905** Studied art at the Munich Academy under Franz von Stuck. **1906** Moved to Paris; met Matisse in Gertrude Stein's salon. **1908** Founded the Matisse School in Paris with Levy and Moll. **1916** Moved to Berlin. **1935** Became director of the Villa Romana in Florence. **1937** Works were banned as degenerate. Lived from **1943** in Montagnola, near Lugano. **1950** Was made an honorary citizen of the City of Speyer. **1960** Solo-exhibition at the Hanover Kunstverein. **1962** Solo-exhibition at the Haus der Kunst and **1976/77** at the Villa Stuck museum in Munich. Purrmann's bright, colourful painting, mostly of landscapes, is reminiscent of that of his French idol Matisse.
WRITINGS: Göpel, B. and E.: Leben und Meinungen des Malers H. P. Erzählungen, Schriften und Briefe. Wiesbaden 1961
CATALOGUE RAISONNE: Heilmann, A. (ed.): H. P. Das druckgraphische Werk. Gesamtverzeichnis. Langenargen 1981
MONOGRAPHS, CATALOGUES: Gerke, E. and H.-J. Imiela: H. P. Mainz 1966.– Hausen, E.: Der Maler H. P. Berlin 1950.– Heilmann, A. (ed.): H. P. Stilleben, Akte, Interieurs. Kunstverein Speyer et al. Heidelberg 1990 (cat.).– Hindelang, E. (ed.): H. P. zum 100. Geburtstag. Museum Langenargen. Langenargen 1980 (cat.).– Ludwig, H.-J. (ed.): H. P. Akademie der Künste der DDR. Berlin 1982 (cat.).– H. P. Landschaften. Saarland Museum, Saarbrücken et al. Saarbrücken 1996 (cat.).– Roland, B. (ed.): Der Maler H. P. Landesmuseum Mainz et al. Mainz 1987 (cat.).– Rudloff, M. (ed.): H. P. Im Licht der Farbe. Gerhard-Marx-Haus, Bremen. Heidelberg 1995 (cat.).– Schumacher, E. (ed.): H. P. Haus der Kunst. Munich 1962 (cat.).– Weber, W. (ed.): H. P. zum 100. Geburtstag. Pfalzgalerie, Kaiserlautern et al. Mainz 1982 (cat.)

**PUSENKOFF Georgi**
born **1953** Krasnopolie (White Russia)
Russian painter. **1968** Moved with his family to Moscow. **1976** Ended his studies at the College of Electronic Technology in

Moscow. **1983** Course of studies in graphic art at the Academy of Polygraphy in Moscow. Worked as a graphic artist for book publishers. From **1984** exhibitions in the USSR and abroad. **1987** Member of the Hermitage association and of the Artists' Union. Lives and works since **1990** in Moscow and Cologne. **1993** Solo-exhibition at the Hans Mayer gallery, Düsseldorf, and at the Tretyakov gallery in Moscow. **1995** Exhibition at the Russian State Museum in St. Petersburg.
MONOGRAPHS, CATALOGUES: G. P. Russian State Museum, St. Petersburg, and U.-Blickle-Stiftung, Kraichtal. Kraichtal 1995 (cat.)

**RÄDERSCHEIDT Anton**
**1892** Cologne – **1970** Cologne
German painter. **1910** Began his studies at the Cologne School of Arts and Crafts, **1911**-**1914** continued at the Düsseldorf Academy. Trained as a drawing teacher. **1914**-**1917** Military service. **1917**-**1919** Trainee teacher in Cologne, then worked as a freelance artist. **1919** Co-founder and member of the Stupid group in Cologne. **1925** Worked together with Hoerle and Seiwert in the Group of Progressive Artists. Took part in the "Neue Sachlichkeit" exhibition at the Mannheim Kunsthalle. **1934/35** Moved to Berlin. **1936** Fled to France. **1937** Participation in the Salon des Surindépendants. **1938** Took part in the exhibition "Freie Deutsche Kunst" mounted by the Freie Künstlerbund (FKB) at the Maison de la Culture in Paris, a counterpart to the National Socialist propaganda exhibition of "degenerate art". **1939**-**1942** Held prisoner in Toulon and Les Milles; his Paris studio was confiscated. **1942** Fled to Switzerland. **1949** Moved to Paris. **1949** Returned to Cologne. **1952** Retrospective at the Kunstverein in Cologne. **1960** Participation in the exhibition of the German Artists' Association at the Kunsthalle in Baden-Baden. **1962** Exhibition at the Cologne Kunstverein. Räderscheidt's early painting was closely related to Magic Realism, but in later years became more abstract.
MONOGRAPHS, CATALOGUES: Arand, W. (ed.): A. R. Niederrheinischer Kunstverein und Städtisches Museum Wedel. Cologne 1988 (cat.).– Eimert, D. (ed.): A. R. Das Spätwerk. Leopold-Hoesch-Museum. Düren 1978 (cat.).– Feldenkirchen, T. (ed.): A. R. Kölnischer Kunstverein. Cologne 1967 (cat.).– Herzog, G.: A. R. Cologne 1991.– Richter, H.: A. R. Recklinghausen 1972.– Schäfke, W. and M. Euler-Schmidt (ed.): A. R. 1892-1970. Josef-Haubrich-Kunsthalle. Cologne 1993 (cat.)

**RADZIWILL Franz**
**1895** Strohhausen – **1983** Varel-Dangast
German painter. **1909**-**1913** Apprenticeship as a bricklayer. Studied architecture at the Technical College, and did evening courses in commercial drawing and design at the

School of Arts and Crafts in Bremen. **1915 -1917** Military service. **1919** Returned from prisoner-of-war camp. **1920–1923** Lived in Berlin, where he was a member of the Free Secession and the Novembergruppe. **1923** Moved to Dangast. **1925** Travelled to Holland. First solo-exhibition in Oldenburg. **1927** Exhibition at the Paul Cassirer gallery in Berlin. **1927/28** Worked in Dix's studio in Dresden. **1929** Took part in the Neue Sachlichkeit exhibition at the Stedelijk Museum in Amsterdam. **1933** Succeeded Klee as professor at the Düsseldorf Academy. **1935** Was dismissed from his post and forbidden to work. Travelled to Africa and South America. **1937** Was among the artists labelled "degenerate" by the Third Reich. **1939–1945** Called up for military service. **1963** Was awarded the Prix de Rome and a scholarship to the Villa Massimo. Became known for his landscapes and paintings of harbours, which rekindled the mystical feeling towards nature of German Romanticism through Magic Realism.
WRITINGS: Wietek, G. (ed.): F. R. – Wilhelm Niemeyer. Dokumente einer Freundschaft. Oldenburg 1990
CATALOGUES RAISONNES: Firmenich, A. and R. W. Schulze (ed.): F. R. 1895-1983. Werkverzeichnis der Ölgemälde. Cologne 1995.– Presler, G. (ed.): F. R. Die Druckgraphik. Weingarten 1993
MONOGRAPHS, CATALOGUES: Adelsbach, K. (ed.): F. R. 1895-1983. Das größte Wunder ist die Wirklichkeit. Kunsthalle Emden. Cologne 1995 (cat.).– Augustiny, W.: F. R. Göttingen 1963.– Hoffmann, J. and B. Sonnenschein (ed.): F. R. Staatliche Kunsthalle Berlin et al. Berlin 1981 (cat.).– Keiser, H. W. and R. W. Schulze: F. R. Der Maler. Munich 1975.– Kinkel, H. et al. (ed.): F. R. Gemälde, Aquarelle, Handzeichnungen. Kunsthalle Bremen. Bremen 1970 (cat.).– Küster, B.: F. R. Oldenburg 1981.– Maaß-Radziwill, H. H.: F. R. im Dritten Reich: der andere Widerstand. Vol. 1. Bremen 1995.– März, R.: F. R. Berlin 1975.– Radziwill, K. and H. H. Maaß-Radziwill (ed.): F. R. Raum und Haus. F.-R.-Haus, Varel. Munich and Lucerne 1987 (cat.).– Soiné, K. (ed.): F. R. Bilder der Seefahrt. Bremen 1992 (cat.).– Wietek, G. (ed.): F. R. Aquarelle und Zeichnungen. Landesmuseum Oldenburg. Oldenburg 1975 (cat.).– Wietek, G.: F. R., Wilhelm Niemeyer. Dokumente einer Freundschaft. Oldenburg 1990

## RAINER Arnulf
born **1929** Baden (near Vienna) Austrian painter. Studied from **1947–1949** at the Villach School of Arts and Crafts. **1950** Left the School of Applied Arts after one day, and the Vienna Academy of Fine Arts after only three days. First drawings influenced by the Surrealists. **1951** After intensive involvement with Abstract Expressionism and Tachisme, began to paint pictures almost devoid of form or division into colour areas (*Atomisationen* and *Blind-*

*zeichnungen*). **1953** He developed the over-painting technique which formed the basis of his later work. **1964** Experimented with hallucinogenic drugs and was involved in studies in psychiatric clinics. Investigated his own psyche using Action and Body Art. **1969** He began to take pictures of his own face and body, which he then painted over; he used the same technique on the paintings of Old Masters as well as contemporary artists. **1972–1983** Participation in documenta 5 – 7 in Kassel. After **1977** he also painted over pictures of death masks and death portraits. **1978** Exhibited finger paintings and foot paintings at the Curtze gallery in Vienna and Düsseldorf. In the 80s he took up religious themes again; a series of crucifixions, martyrdoms, massacres and portrayals of angels. **1985** Overpainting of botanical and zoological drawings from 18th and 19th century textbooks. **1987** Overpainting of snake and plant pictures. Rainer, the inventor of overpainting, uses the formal techniques of Viennese Actionism as a form of exhibitionism and to break down the barriers between art and life.
WRITINGS: Breicha, O. (ed.): A. R. Hirndrang. Selbstkommentar und andere Texte zu Werk und Person. Salzburg 1980.– A. R.: Proportionsordnungen 1953/54. Vienna 1988
CATALOGUES RAISONNES: Breicha, O. (ed.): A. R. Überdeckungen. Werkkatalog sämtlicher Radierungen, Lithographien und Siebdrucke 1950-1971. Vienna 1972.– Catoir, B.: A. R. Übermalte Bücher. Munich 1989
MONOGRAPHS, CATALOGUES: Aigner, C. et al. (ed.): A. R. Abgrundtiefe. Perspektieve. Krems 1997 (cat.).– Bersswordt-Wallrabe, H.-L. A. v. (ed.): A. R. Malerei auf Kreuzen. Bochum 1988.– Breicha, O.: A. R. Überdeckung. Munich 1971.– Catoir, B. and A. Saura (ed.): A. R. Campus Stellae. Santiago 1996 (cat.).– Fuchs, R. et al. (ed.): A. R. Solomon R. Guggenheim Museum, New-York et al. Munich 1989 (cat.).– Güse, E.-G. (ed.): A. R. Saarland Museum, Saarbrücken et al. Stuttgart 1990 (cat.).– Haenlein, C.-A. (ed.): A. R. Retrospektive 1950-1977. Kestner-Gesellschaft. Hanover 1977 (cat.).– Hofmann, W. et al. (ed.): A. R. Museum des 20. Jahrhunderts. Vienna 1968 (cat.).– Hofmann, W. et al. (ed.): A. R. A. R. Mort et sacrifice. Centre Georges Pompidou. Paris 1984 (cat.).– Hofmann, W. and A. R.: A. R. Totenmasken. Salzburg 1985.– Honisch, D. (ed.): A. R. Nationalgalerie, Berlin et al. Berlin 1980 (cat.).– Heynen, J. (ed.): A. R. Werke der 50er bis 80er Jahre. Museen Haus Lange und Haus Ester, Krefeld et al. Krefeld 1988 (cat.).– Kussin, T. (ed.): A. R. Naturgeschichte – Fauna, Flora etc. Schloß Grafenegg. Vienna 1987 (cat.).– Mennekes, F. (ed.): A. R. Umkreisen und Durchdringen. Christusgesichter. Stuttgart 1986 (cat.).– Mennekes, F.: A. R. Weinkreuz. Frankfurt-on-Main 1993.– A. R. Stedelijk Van Abbe Museum. Eindhoven 1984 (cat.).– A. R. Centre National d'Art Con-

temporain. Grenoble 1987 (cat.).– A. R. Young Cross. The Menil Foundation. Houston 1992 (cat.).– Rodiek, T. and H. Schulz (ed.): A. R. Kunsthalle Dominikanerkirche, Osnabrück et al. Osnabrück 1993 (cat.).– Rychlik, O. (ed.): Raineriana. Aufsätze zum Werk von A. R. Vienna and Cologne 1989.– Rychlik, O. (ed.): Die Titenmaskenüberarbeitungen von A. R. Vienna 1991.– Sandner, O. (ed.): A. R. Enzyklopädie und Revolution. Bregenz 1990 (cat.).– Schmidt, H. M. (ed.): A. R. Arbeiten 1948-1975. Hessisches Landesmuseum, Darmstadt et al. Darmstadt 1975 (cat.).– Schmidt, H. M. et al. (ed.): A. R. Retrospektive 1950-1976. Städtische Galerie im Lenbachhaus, Munich et al. Bern and Munich 1977 (cat.).– Schütt, J.: A. R. Überarbeitungen. Berlin 1994.– Schwaiger, B.: A. R. Malstunde. Vienna and Hamburg 1980.– Ullrich, F. (ed.): A. R. Städtische Kunsthalle Recklinghausen. Recklinghausen 1994 (cat.).– Wedewer, R. et al. (ed.): A. R. Zeichnungen 1949-1985. Museum Morsbroich, Leverkusen et al. Munich 1988 (cat.).– Wimmer, G. (ed.): A. R. verdeckt – entdeckt. Vienna 1987 (cat.)

## RAMOS Mel
born **1935** Sacramento (CA) American painter. **1953–1958** Studied art and art history at Sacramento Junior College and at California State University under Thiebaud. **1958** Taught at Elk Grove High School and at California State University. **1961** Began to draw in comic strip style, at first imitating the the *Batman* series. **1963** Took part in the exhibition "Pop Goes the East" at the Contemporary Art Museum, Houston. **1964** First solo-exhibition at the Bianchini Gallery, New York. From **1965** began to draw single female figures; drew pin-up girls from advertising pictures and magazine ads. **1967** Solo-exhibition at the Museum of Modern Art, San Francisco. **1972** Exhibition at the Utah Museum of Fine Arts, Salt Lake City. **1974** Participation in the Pop Art exhibition at the Whitney Museum, New York. **1977** Retrospective at the Oakland Museum (CA). From **1980** taught at California State University, Hayward. Took up landscape painting and self-portraits. **1986** Awarded the Visual Artists Fellowship Grant from the National Endowment for the Arts. Ramos' poster-style Pop Art lays the marketing strategies of the advertising industry bare by quoting their images.
MONOGRAPHS, CATALOGUES: Belz, C. (ed.): M. R. A Twenty Year Survey. Rose Art Museum, Brandeis University. Waltham 1980 (cat.).– Claridge, E.: The Girls of M. R. London and Chicago 1975.– Claridge, L.: M. R. Gemälde, Zeichnungen und Projekte der Jahre 1965-1972. Darmstadt 1975.– M. R. Watercolours. Berkeley 1979.– M. R. The Artist's Studio. Louis K. Meisel Gallery. New York 1989 (cat.).– Rosenblum, R.: M. R. Pop Art Images. Cologne 1994.– Wember, P. (ed.): M. R. Museum Haus Lange. Krefeld 1975 (cat.)

## RAUSCHENBERG Robert
born **1925** Port Arthur (TX) American painter and object artist. **1947** Attended the Académie Julian in Paris. **1948/49** Studied at Black Mountain College in Beria (NC) under Albers, **1949/50** at the Art Students League in New York under Kline, Motherwell, and others. **1951** First solo-exhibition at the Betty Parsons's Gallery, New York. Period of *All-White Paintings* and *All-Black Paintings*. **1952/53** Travelled around Spain, North Africa, and Italy. Following his return to New York he put on happenings with Cage, Merce Cunningham and David Tudor and began work on *Combine Paintings* made up of the most varied materials and found objects and in which painted elements are combined with objects and fragments. Also did collages and assemblages. **1959–1977** Participation in documenta 2, 4 and 6 in Kassel, at the São Paulo Biennale and at the Biennale in Paris. **1960** Took part in the exhibition "Le Nouveau Réalisme à Paris et à New York". **1966** Along with Billy Klüver, an engineer, he founded the company Experiments in Art and Technology (E. A. T). From **1970** he preferred working with cardboard in Minimal Art style; in the 80s he created sculptures out of found metal parts and pictures made by etching with acid on metal plates. Since **1984** he has headed the *Rauschenberg Overseas Cultural Interchange* (ROCI) project, which supports cooperation between artists around the globe. He goes on tour with dance and theatre groups, for whom he designs sets. Rauschenberg is recognised as a pioneer of American Pop Art.
WRITINGS: Rose, B. (ed.): R. An Interview. New York 1987 / R. R. im Gespräch mit B. Rose. Cologne 1989
CATALOGUE RAISONNE: Foster, E. (ed.): R. R. Prints 1948-1970. Minneapolis Institute of Arts. Minneapolis 1970 (cat.)
MONOGRAPHS, CATALOGUES: Adriani, G. and W. N. Greiner (ed.): R. R. Zeichnungen, Gouachen, Collagen 1949-1979. Kunsthalle Tübingen. Munich 1979 (cat.).– Alloway, L. (ed.): R. R. National Collection of Fine Arts, Smithsonian Institution, Washington et al. Washington 1976 (cat.).– Alloway, L. et al. (ed.): R. R. Werke 1950-1980. Staatliche Kunsthalle Berlin et al. Berlin 1980 (cat.).– Carow, B. (ed.): R. R. Kunstverein Hannover. Hannover 1970 (cat.).– Cowart, J. et al. (ed.): ROCI – R. Overseas Culture Interchange. National Gallery of Art, Washington. Munich 1991 (cat.).– Craft, C.: R. R. Haywire. New York 1997.– Feinstein, R. (ed.): R. R. The Silkscreen Paintings 1962-1964. Whitney Museum of American Art. New York 1990 (cat.).– Feinstein, R.: Random Order: The First Fifteen Years of R. R. Diss. New York University. New York 1990.– Forge, A.: R. R. New York 1969.– Geldzahler, H. et al. (ed.): R. R. Paintings, Drawings and Combines 1949-1964. Whitechappel Art Gallery. London 1965 (cat.).– Hopps, W. (ed.): R. R. The Early 1950's. The Corcoran Gallery of Art, Washington et al. Houston 1991

(cat.).– Hopps, W. and S. Davidson (ed.): R. R. A Retrospective. Solomon R. Guggenheim Museum, New York et al. New York 1997.– Hulten, P.: R. R. Photographs. New York 1981.– Kotz, M. L.: R. Art and Life. New York 1990.– R. R. National Collection of Fine Arts, Smithsonian Institution. Washington 1976 (cat.).– R. R. Tate Gallery. London 1981 (cat.).– Rose, B.: R. New York 1987.– Smith, M. L.: Image and World in the Prints of R. R. 1951-1981. Diss. University of Texas. Austin 1992.– Tomkins, C.: Off the Wall. R. R. and the Art World of our Time. Garden City 1980.– Turrell, J. B. (ed.): R. Sculpture. Fort Worth Art Museum. Fort Worth 1995 (cat.).– Wissmann. R. R. Black Maket. Stuttgart 1970.– Yakush, M. (ed.): R. Overseas Culture Interchange. National Gallery of Art. Washington 1991 (cat.).– Zemter, W. R.: R. R. Untersuchungen zur Bildstruktur. Diss. Bochum 1974.– Zweite, A. (ed.): R. R. Kunstsammlung Nordrhein-Westfalen, Düsseldorf. Cologne 1994 (cat.)

**RAY Man**
(Emanuel Rudnitzky)
**1890** Philadelphia – **1976** Paris
American painter, photographer, and object artist. Was part of the avant-garde circles in New York, especially at Stieglitz' gallery. After meeting Duchamp and Picabia in **1915**, he took part in Dada events, participating between **1916**–**1921** in demonstrations and exhibitions in New York and working for *391* and New York Dada magazines. In Paris, where he followed Duchamp in **1921**, he joined the group around Tristan Tzara, André Breton and Picabia. He did experimental photography and film, created collages and produced objects. **1925** He joined the Surrealist movement, became its official photographer, and took up painting again. **1927** Exhibition of photographs in New York. **1926** and **1928** Film projects. **1930**–**1940** Maintained contacts to artists and writers. **1940**–**1951** Worked in Hollywood. **1951** Returned to Paris; concentrated on painting and drawing. As one of the most productive and imaginative figures between Dada and Surrealism, Man Ray could never decide on which of his myriad talents he should concentrate: sculpture, painting, photography, film, literature, or architecture.
WRITINGS: M. R.: Selfportrait. London and Boston 1963 / M. R. Selbstporträt. Eine illustrierte Autobiographie. Munich 1983.– M. R.: Objets de mon affection. Paris 1983
CATALOGUES RAISONNES: Anselmino, L. and B. Pilat (ed.): M. R. opera grafica. 2 vols. Florence 1973 / M. R.'s Graphic Work. Catalogue Raisonné. San Francisco 1984.– Foresta, M. et al. (ed.): M. R. 1890-1976. Sein Gesamtwerk. Schaffhausen et al. 1989, 1994.– Hermann, B. (ed.): M. R. Objets de mon affection. Paris 1989.– Martin, J. H. (ed.): Catalogue raisonné

des sculptures et des objets. Paris 1983.– M. R. 1890-1976. Sein Gesamtwerk. Kilchberg 1994.– Sers, P. (ed.): M. R. Sculptures et objets. Catalogue raisonné. Paris 1983
MONOGRAPHS, CATALOGUES: Argan, G. C. et al. (ed.): M. R. Università. Parma 1981 (cat.).– Arigoni, C. (ed.): M. R. Cent' anni di libertà. 1890-1990. Palazzo Fortuny, Venice. Paris 1990 (cat.).– Baldwin, N.: M. R. American Artist. New York and London 1988, 1991.– Baum, T.: M. R.'s Paris. Washington 1989.– Bourgeade, P.: Bonsoir, M. R. Paris 1972.– Bramly, S.: M. R. Paris 1980.– Bussmann, G. (ed.): M. R. Frankfurter Kunstverein. Frankfurt-on-Main 1979 (cat.).– Ceuleers, J. (ed.): M. R. 1890-1976. Galerie Ronny van de Velde, Antwerp. Ghent 1995 (cat.).– Esten, J. (ed.): M. R. Bazaar Years. New York 1988 / M. R. in Harper's Bazaar. Munich 1989.– Fagiolo, M. (ed.): M. R. Opere 1914-1973. Il Collezionista d'Arte Contemporanea. Roma 1973 (cat.).– Foresta, M. (ed.): Perpetual Motif. The Art of M. R. National Museum of American Art, Smithsonian Institution, Washington et al. New York 1988, 1994 (cat.).– Guadagnini, W. (ed.): M. R. L'età della luce. Galleria Civica, Modena. Bologna 1989 (cat.).– Hartshorn, W. and M. Foresta (ed.): M. R. in Fashion. International Center of Photography, New York et al. New York 1990 (cat.).– Jahn, A. et al. (ed.): M. R. Galerie der Stadt Stuttgart et al. Stuttgart 1998 (cat.).– Janus (ed.): M. R. L'immagine fotografica. Venice 1976 (cat.).– Janus (ed.): M. R. Photographien, Gemälde, Objekte. Munich 1991.– Leymarie, J. et al. (ed.): M. R. Musée National d'Art Moderne, Paris et al. Paris 1972 (cat.).– Martin, J.-H. (ed.): M. R. photographe. Centre Georges Pompidou. Paris 1982, London 1982, Munich 1982 (cat.).– Penrose, R.: M. R. London 1975.– Perl, J. (ed.): M. R. New York 1979.– Perlin, G. and D. Palazzoli (ed.): M. R. Rétrospective 1912-1976. Nice 1997 (cat.).– Sayag, A. (ed.): M. R. La photographie à l'envers. Grand Palais. Paris 1997 (cat.).– Schlüter, B. (ed.): M. R. Neues wie Vertrautes. Kunstmuseum Wolfsburg. Stuttgart 1994 (cat.).– Schwarz, A.: M. R. The Rigour of Imagination. London and New York 1977.– Schwarz, A.: M. R. Munich 1980.– Seta, C. d.: M. R. Udine 1989

**RAYSSE Martial**
born **1936** Golfe-Juan (near Nice)
French painter and object artist. **1957** First solo-exhibition at the Longchamp gallery, Nice. **1960** Signatory to the *Nouveau Réalisme* manifesto and took part in the activities of the group. **1961** Took part in the Biennale des Jeunes in Paris and in the exhibition "The Art of Assemblage" in New York. **1962** First use of neon. Solo-exhibition at the Iolas Gallery, New York. **1965** Retrospective at the Stedelijk Museum, Amsterdam. **1966** Awarded the David Bright Prize at the Venice Biennale. **1967** Stage design for the ballet *Paradis perdu* by Roland Petit. **1968** and **1977** participation in documenta 4 and 6 in Kassel. In the 70s, he worked with simple materials like tempera on cardboard and painted mythological themes in a style related to Tachisme. Later turned to film-making. **1981** Retrospective at the Pompidou Centre, Paris. **1992** Participation in documenta 9 in Kassel. Raysse stood out, especially in the 60s, with assemblages using varied materials and techniques that showed consumer society as if through a distorting mirror.
MONOGRAPHS, CATALOGUES: Hulten, P. (ed.): M. R. 1970-1980. Centre Georges Pompidou. Paris 1981 (cat.).– Jouffroy, A.: M. R. Paris 1996.– Petersen, A. (ed.): M. R. Stedelijk Museum. Amsterdam 1981 (cat.).– M. R. Národní Galerie. Prague 1969 (cat.).– M. R. Musée Picasso. Antibes 1982 (cat.).– Restany, P. (ed.): M. R. Maître et esclave de l'imagination. Stedelijk Museum. Amsterdam 1965 (cat.).– Semin, D. and V. Dabin (ed.): M. R. Rétrospective. Galerie National du Jeu de Paume, Paris et al. Paris 1992 (cat.).– Todoroff, U. et al. (ed.): M. R. Museum Moderner Kunst Stiftung Ludwig, Vienna et al. Vienna 1993 (cat.)

**REDON Odilon**
(Bertrand-Jean Redon)
**1840** Bordeaux – **1916** Paris
French painter and graphic artist. Largely self-taught. Studied in Bordeaux and Paris. **1867** Etchings displayed at the Salon. Admired E. Delacroix, and later became acquainted with C. Corot, G. Courbet, and H. Fantin-Latour. **1881** First exhibition at the gallery of *La Vie moderne* magazine. **1884** Co-founder of the Salon des Indépendants. Took part in **1886** in the VIII Impressionist exhibition. **1890** Friendship with Gauguin. **1891** Close contact to the poet Mallarmé, to the Nabis group and to Gauguin; began to work using symbols. **1899** Exhibition of Symbolist painters in his honour at the Durand-Ruel gallery. Began to do paintings and pastels again in loosely applied, strong colours. **1909**–**1916** Lived meditative and withdrawn in Bièvres near Paris.
WRITINGS: Levy, S. (ed.): Lettres inédites d'O. R. à Bonger, Jourdain, Vines. Paris 1987.– O. R.: Lettres d'O. R. Brussels and Paris 1923.– O. R.: A soi-même: Journal (1867-1915). Paris 1961, 1989.– O. R.: Selbstgespräch. Tagebücher und Aufzeichnungen 1867-1915. Munich 1971.– O. R.: Critiques d'Art. Bordeaux 1987.– O. R. and C. Terrasse: Conversations avec O. R. Paris 1993
CATALOGUES RAISONNES: Harisson, S. R. (ed.): The Etchings of O. R. A Catalogue Raisonné. New York 1986.– Mellerio, A. (ed.): O. R. Complete Illustrative Catalogue of Lithographs and Etchings. New York 1968.– Mellerio, A. (ed.): O. R. Peintre, dessinateur et graveur. Paris 1923.– Wildenstein, A. et al. (ed.): O. R. Cata-

logue raisonné de l'œuvre peint et dessiné. 3 vols. Paris 1992-1996
MONOGRAPHS, CATALOGUES: Bacou, R.: O. R. 2 vols. Geneva 1956.– Bacou, R. (ed.): O. R. Pastels. London and New York 1987 / O. R. Pastelle. Cologne 1988.– Berger, K.: O. R. Phantasie und Farbe. Cologne 1964 / O. R. Fantasy and Color. New York 1965.– Cassou, J. (ed.): O. R. Paris 1974, Munich 1974.– Christ, O.: O. R. Visionen eines Künstlerpoeten. Berlin 1994.– Coustet, R.: L'Univers d'O. R. Paris 1984.– Daulte, F. and J. Jones (ed.): O. R. Fondation de l'Hermitage. Lausanne 1992 (cat.).– Druick, D. W. (ed.): O. R. Prince of Dreams (1840-1916). The Art Institute of Chicago et al. New York and London 1994 (cat.).– Eisenman, S. F.: The Temptation of Saint R. Biography, Ideolgy and Style in the Noirs of O. R. Chicago 1992.– Gamboni, D.: La Plume et le pinceau. O. R. et la littérature. Paris 1989.– Gowing, L. (ed.): O. R. Collección Ian Woodner. Barcelona 1990 (cat.).– Hobbs, R.: O. R. London and Boston 1977.– Klockenbring, G.: O. R. Wege zum Tor der Sonne. Stuttgart 1986.– Koella, R. (ed.): O. R. Kunstmuseum Winterthur et al. Winterthur 1983 (cat.).– Martin-Méry, G. (ed.): O. R. 1840-1916. Galerie des Beaux-Arts. Bordeaux 1985 (cat.).– Mellerio, A.: O. R. Peintre, dessinateur et graveur. Paris 1923, New York 1968.– Motoé, K. and K. Takahashi (ed.): O. R. 1840-1916. The National Museum of Modern Art, Tokyo et al. Tokyo 1989 (cat.).– Piel, F. (ed.): O. R. Meisterwerke aus der Sammlung Ian Woodner. Museum Villa Stuck. Munich 1986 (cat.).– O. R. La Natura dell'invisible. Musée Cantonale d'Art, Lugano. Geneva 1996 (cat.).– Sandstrom, S.: Le Monde imaginaire d'O. R. Lund 1955.– Schatz, M.: Der Betrachter im Werk von O. R. Hamburg 1988.– Selz, J.: O. R. Paris 1971.– Vialla, J.: La Vie et l'œuvre d'O. R. Paris 1988.– Wilson, M.: Nature and Imagination. The Work of O. R. London 1978

**REED David**
born **1946** San Diego (CA)
American painter. **1966** Attended the Skowhegan School of Painting and Sculpture. **1966/67** Lived in New York. Studied at the New York Studio School and **1968** at Reed College in Portland. **1975** First solo-exhibition at the Susan Coldwell Gallery, New York. **1977**–**1995** Exhibited regularly at the Max Protech Gallery, New York. **1992** Solo-exhibition at the San Francisco Art Institute and **1995** at the Württembergischer Kunstverein, Stuttgart. **1997** Participation in documenta 10 in Kassel.
MONOGRAPHS, CATALOGUES: Hentschel, M. and U. Kittelmann (ed.): D. R. Kölnischer Kunstverein et al. Stuttgart 1995.– Holler-Schuster, G. and P. Weibel (ed.): D. R. Neue Malereien für den Spiegelsaal. Graz 1996 (cat.).– D. R. San Francisco Art Institute. San Francisco 1993 (cat.).– D. R. Kölnischer Kunstverein et al. Münster 1995 (cat.)

**REINHARDT Ad**
1913 Buffalo – 1967 New York
American painter. 1931–1937 Studied art history at Columbia University in New York under Meyer Schapiro and others. 1936 Began studying painting at the National Academy of Design and at the American Artists School. 1937–1947 Joined the American Abstract Artists group. During the war, worked as an art critic for a magazine in New York and photographed for the Marines. Continued his art history studies after the war at the Institute of Fine Arts in New York and specialised in Far Eastern art. From 1947 taught at Brooklyn College and other American schools and universities. 1952/53 First European trip. 1955 First exhibition of *Black Paintings*. From 1960 painted nothing else but black squares, all of the same size. 1965 Became active in the peace movement, protesting against the Vietnam War. 1967 Awarded a Guggenheim grant. 1968 Participation in documenta 4 in Kassel. In a logical continuation of Mondrian's abstract painting style and using a minimal palette, Reinhardt strove to achieve a purist, self-sufficient art. His black paintings are the product of this endeavour.
WRITINGS: Kellein, A. (ed.): A. R. Schriften und Gespräche. Munich 1984.– Rose, B. (ed.): Art as Art. The Selected Writings of A. R. New York 1975
MONOGRAPHS, CATALOGUES: Bois, Y.-A.: A. R. Los Angeles Museum of Contemporary Art et al. New York 1991 (cat.).– Heere, H.: A. R. und die Tradition der Moderne. Frankfurt-on-Main 1984.– Hess. R. (ed.): The Art Comics and Satire of A. R. Städtische Kunsthalle Düsseldorf. Düsseldorf 1975 (cat.).– Inboden, G. and A. Kellein (ed.): A. R. Staatsgalerie Stuttgart. Stuttgart 1985 (cat.)/A. R. New York 1987.– Jenderko, I. and M. Imdahl (ed.): Epitaphe für A. R. Staatliche Kunsthalle Baden-Baden. Baden-Baden 1977 (cat.).– Kosuth, J. and C. Kozlov: A. R. Education into Darkness. New York 1966.– Lippard, L.: A. R. New York 1981, Stuttgart 1984.– McConathy, D. (ed.): A. R. Städtische Kunsthalle Düsseldorf et al. Düsseldorf 1972 (cat.).– Rowell, M. (ed.): A. R. and Color. Solomon R. Guggenheim Museum. New York 1980 (cat.).– Schjeldahl, P. (ed.): A. R. Art Comics and Satires. Truman Gallery. New York 1976 (cat.)

**RENGER-PATZSCH Albert**
1897 Würzburg – 1966 Wamel
German photographer. 1916–1918 Military service, then studied chemistry at Dresden Technical College. 1922–1925 Press photographer for the *Chicago Tribune*. Worked together with E. Fuhrmann on the book series *The World of Plants*. 1924/25 Plant studies and essays for the *Deutsches Kamera Almanach*. 1925 Worked as a freelance photographer. First exhibitions. Member of the Deutsche Werkbund. 1928 Had his own studio in the Museum Folkwang in Essen. Book of photographs, *Die*

*Welt ist schön* (The World is Beautiful), published by K. Wolff. Worked as an industrial photographer and for advertising. After the destruction of his archives in the war, he moved to Wamel in 1944. Renger-Patzsch was one of the most outspoken proponents of Neue Photographie, a movement which insisted that photographs should speak for themselves.
MONOGRAPHS, CATALOGUES: Heise, C. G.: A. R.-P. der Photograph. Berlin 1942.– Honnef, K. and G. Kierblewsky (ed.): Industrielandschaften, Industriearchitektur, Industrieprodukt. Fotografien 1925-1960 von A. R.-P. Rheinisches Landesmuseum, Bonn. Cologne 1977 (cat.).– Kempe, F. (ed.): A. R.-P. Der Fotograf der Dinge. Ruhrland- und Heimatmuseum. Essen 1967 (cat.).– Kempe, F. and C. G. Heise (ed.): A. R.-P. 100 Photos. Centre Georges Pompidou, Paris et al. Paris 1979 (cat.).– Kuspit, D. (ed.): A. R.-P. Joy Before the Object. The J. Paul Getty Museum, Malibu. New York 1993 (cat.).– Pfingsten, C.: Aspekte zum fotografischen Werk A. R.-P. Witterschlick/Bonn 1992.– A. R.-P. Museum Ludwig. Cologne 1993 (cat.).– A. R.-P. Städtisches Kunstmuseum Bonn. Stuttgart 1996 (cat.).– A. R.-P. Meisterwerke. Haus der Kunst. Munich 1998 (cat.)

**RENOIR Pierre-Auguste**
1841 Limoges – 1919 Cagnes-sur-Mer (near Nice)
French painter. 1854–1858 Apprenticeship as a porcelain painter in Paris. 1860–1864 Studied at the Ecole des Beaux-Arts and entered the studio of Gleyre with Monet, Sisley and Bazille. 1863 Painted *en plein air* with these friends in the Barbizon district; met Pissarro and Cézanne. 1864/65 Exhibited at the Salon. In 1866 and 1867 his light and natural portraits were rejected by the Salon. 1868–1870 Shared a studio with Bazille; met Manet. 1869 Together with Monet in Bougival on the Seine, laid the foundations of the Impressionist style. 1872 Rejected again by the Salon, he insisted on the setting-up of a Salon des Refusés. Durand-Ruel exhibited one of his paintings for the first time in London. 1874, 1876 and 1877 Participation in Impressionist exhibitions. 1879 Solo-exhibition at the gallery at Charpentier's magazine *La Vie moderne*. 1882 Visited Cézanne in L'Estaque.

Durand-Ruel showed his paintings at the 7th Impressionist Exhibition and in London. 1889 Refused to take part in the Paris World Fair. 1890 Married Aline. Returned to using bright colours and loose brushstrokes and, over the following years, painted mostly nudes and landscapes. 1892 First purchase of one of his paintings by the French nation. 1900 Took part in the centennial show of French art at the Paris World Fair. 1902 His health began to fail and his hands became crippled by rheumatism. 1904 First participation in the Paris Autumn Salon. 1910 Retrospective at the 9th Venice Biennale. 1913 Began to produce sculpture, with the help of R. Guinos. 1919 Was made Commander of the Legion of Honour and one of his paintings was hung in the Louvre. Beside Monet one of the greatest Impressionists.
CATALOGUES RAISONNES: Dauberville, G.-P. and M. (ed.): Catalogue raisonné de l'œuvre de P.-A. R. (in preparation).– Daulte, F. (ed.): A. R. Catalogue raisonné de l'œuvre peint. Vol. 1: Figures 1860-1890. Vol. 2: Figures 1891-1905. 2 vols. Lausanne and Paris 1971-1996.– Fezzi, E. (ed.): Das gemalte Gesamtwerk von R. aus der impressionistischen Periode 1869-1883. Lucerne 1973/Tout l'œuvre peint de R. Periode impressionniste 1869-1883. Paris 1985.– Roger-Marx, C.: Les Lithographies de R. Monte Carlo 1951.– Stella, J. G. (ed.): The Graphic Work of R. Catalogue Raisonné. Bradford and London (n. d.).– Tancock: The Sculpture of R. Philadelphia 1976.– Vollard, A.: P.-A. R. Tableaux, pastels et dessins. Paris 1918, 1954/R.'s Paintings, Pastels and Drawings. Tableaux, pastels et dessins de P.-A. R. San Francisco 1989
MONOGRAPHS, CATALOGUES: Adriani, G. (ed.): R. Gemälde 1860-1917. Kunsthalle Tübingen. Cologne 1996 (cat.).– André, A.: L'Atelier de R. 2 vols. Paris 1931, San Francisco 1989.– Bacou, R.: P. R. 2 vols. Geneva 1956.– Bailes, C. B. et al. (ed.): R.'s Portraits. The Art Institute of Chicago. Chivago 1997 (cat.).– Bailey, C. et al. (ed.): R. Portraits. National Gallery of Canada, Ottawa. New Haven (CT) 1997 (cat.).– Barnes, A. C. and V. d. Mazia: The Art of R. Merion (PA) 1986.– Baudot, J.: R.: Ses amis, ses modèles. Paris 1949.– Daulte, F.: P.-A. R. Basel 1958.– Daulte, F.: P.-A. R. Watercolours, Pastels and Drawings in Colour. London 1959.– Daulte, F.: A. R. Paris 1974.– Distel, A. et al. (ed.): R. Grand Palais, Paris et al. Paris 1985 (cat.)/Hayward Gallery, London et al. London and New York 1985 (cat.).– Fezzi, E.: R. Paris 1972.– Fosca, F.: R. London and Paris 1961.– Gaunt, W.: R. Oxford 1982.– Gowing, L.: R. Paintings. London 1947.– Haesaerts, P.: R. sculpteur. Brussels 1947/R. Sculptor. New York 1947.– Hoog, M. and N. Wadley: R. Un peintre, une vie, une œuvre. Paris 1989.– Keller, H.: A. R. Munich 1987.– Monneret, S.: R. Cologne 1990.– Perruchot, H.: La Vie de R. Paris 1964.– Renoir, J.: R. My Father. Boston 1958/Mein Vater A. R. Munich 1962.– Rewald J. (ed.): R. Drawings. New York 1946.– Rouart, D.: R. Geneva 1954, London 1985.– White, B. E.: R. His Life, Art and Letters. New York 1984

**REUSCH Erich**
born 1925 Wittenberg (Elbe)
German sculptor and architect. 1947–1953 Studied at the School of Fine Arts in Berlin under R. Scheibe and Uhlmann. From 1953 worked as an architect in Düsseldorf. Designed housing estates in Düsseldorf, Hanover, and Frankfurt am Main. From 1964 worked as a freelance artist. 1966 Solo-exhibition at the Von der Heydt-

Museum, Wuppertal. 1971 Project for the Ruhr University in Bochum. 1975–1988 Professorship at the Düsseldorf Academy. 1976 Solo-exhibition at the Düsseldorf Kunsthalle. 1977 Took part in documenta 6 in Kassel. 1986/87 Exhibition at the City Museum in Lüdenscheid. 1998 Retrospective at the Kunstmuseum, Bonn. From the 60s, he designed kinetic objects using new materials and techniques.
MONOGRAPHS, CATALOGUES: Adolphs, V. et al. (ed.): E. R. Arbeiten 1954-1998. Kunstmuseum Bonn. Bonn 1998 (cat.).– Jensen, J. C. (ed.): E. R. Elektrostatische Objekte. Kunsthalle zu Kiel. Kiel 1973 (cat.).– Kerber, B. (ed.): Hommage à Mc Cready. E. R. Museum am Ostwall. Dortmund 1972 (cat.).– Schneckenburger, M. (H.): E. R. Kunstverein Arnsberg. Arnsberg 1993 (cat.).– Weyergraf, C. and M. Imdahl (ed.): E. R. Kunsthalle Düsseldorf. Düsseldorf 1976 (cat.).– Weyergraf, C. (ed.): E. R. Karl Ernst Osthaus-Museum. Hagen 1978 (cat.).– Wissmann, J. (ed.): E. R. Städtische Galerie Lüdenscheid. Lüdenscheid 1986 (cat.)

**RHEIMS Bettina**
born 1952 Paris
French photographer. Began to photograph while still at school. 1972/73 Worked as a fashion model in New York. 1975–1978 Ran a gallery of modern painting. 1978 Publication of her animal photographs in book form. From 1982 worked as a fashion photographer for J.-C. de Castelbajac. From 1984 numerous portraits of celebrities and important public figures. 1987 First exhibition devoted solely to her works put on by Espace Photographique de Paris.
MONOGRAPHS, CATALOGUES: Monteroso, J.-L.: B. R. Paris 1987.– B. R. and B. Lamarche-Vadel: Les Espionnes. Munich 1992

**RIBOUD Marc**
born 1923 Lyons
French photographer. Self-taught. 1943–1945 Was active in the French Resistance and the Free French Army. 1945–1948 Studied engineering at the Ecole Centrale in Lyons. 1948–1952 Industrial engineer in Lyons. From 1952 worked for the Magnum agency and as a freelance photographer and

photojournalist in Paris. **1957–1971** Several trips to China. **1958–1975** Vice-president of Magnum Photos in Paris, **1975/76** president in Paris and New York. Became known for his pictures of China and North Vietnam, in which he emphasised the contrast between the single figure and the group.
MONOGRAPHS, CATALOGUES: Daniel, J. (ed.): M. R. in China. New York 1997.– M. R. Photos choisies 1953-1985. Musée d'Art Moderne de la Ville. Paris 1985 (cat.).– M. R. Centre National de la Photographie. Paris 1993 (cat.)

## RICHIER Germaine

**1904** Arles – **1959** Montpellier
French sculptress. Started her studies at the Ecole des Beaux-Arts, Montpellier. **1925** Moved to Paris. **1925–1929** Student and assistant in E. Bourdelle's studio. **1934** Blumenthal prize. **1937** Awarded the Diplom d'Honneur de Sculpture at the Paris World Fair. **1939–1945** Lived in Switzerland. From **1940** came under the influence of Giacometti. **1946** Returned to Paris. **1948–1954** Regular participation at the Venice Biennale. **1950** Her Christ sculpture for the church in Assy caused a controversy. **1951** Sculpture prize at the São Paulo Biennale. From **1951** she worked together with the painters Vieira da Silva and Hartung. **1956** Retrospective at the Musée National d'Art Moderne, Paris. **1959** and **1964** participation in documenta 2 and 3 in Kassel. Richier's figures, whose limbs are often tied together with wire, are bizarre creatures somewhere between human and animal, and with references to apocalyptic symbolism and Surrealist fantasy.
CATALOGUE RAISONNE: Guiter, F. (ed.): G. R. Catalogue raisonné (in preparation)
MONOGRAPHS, CATALOGUES: Cassou, J.: G. R. Cologne and Berlin 1961.– Cassou, J. et al. (ed.): G. R. Sculpteur 1904-1959. Paris 1966.– Crispolti, E.: G. R. Milan 1968.– Lammert, A. and J. Merkert (ed.): G. R. Akademie der Künste. Berlin 1997 (cat.).– Paulhan, J.: G. R. Paris 1957.– Ponge, F.: G. R. Montrouge 1948.– Prat, J.-L. (ed.): G. R. Rétrospective. Fondation Maeght. Saint-Paul 1996 (cat.).– G. R. Musée National d'Art Moderne. Paris 1955 (cat.).– G. R. Kunsthalle Bern. Bern 1958 (cat.).– G. R. 1904-1959. Kunsthaus Zürich. Zurich 1963 (cat.).– G. R. Galerie Creuzevault. Paris 1966 (cat.).– G. R. 1904-1959. Retrospective. Gallery Gimpel Fis. London 1973 (cat.)

## RICHTER Gerhard

born **1932** Dresden
German painter. First worked as a stage designer and poster artist in Zittau. **1952–1955** Studied at the Dresden Academy and, after moving to West Germany in **1961**, at the Düsseldorf Academy. **1963** Satirical introduction of *Capitalist Realism into Art* together with K. Fischer-Lueg and Polke.

**1964** Painted his first pictures based on magazine photographs and snapshots. **1967** Awarded the *Junger Westen* art prize in Recklinghausen; guest-professorship at the Hamburg School of Fine Arts. **1968** Began a series of large-format abstract paintings with great intensity of colour. **1969** Worked as an art teacher. **1971** Professorship at the Düsseldorf Academy. **1972** Took part in the Venice Biennale with *48 Portraits*. **1972–1997** Participation in documenta 5 – 10 in Kassel. **1974** Exhibition of the *Graue Bilder* (Grey Pictures) at the Municipal Museum in Mönchengladbach. **1978** Guest-professor at Nova Scotia College of Art and Design in Halifax. **1981** Arnold Bode Prize, **1985** Kokoschka Prize. **1991** Important retrospective at the Tate Gallery, London, and **1993** at the Musée d'Art Moderne de la Ville de Paris. Richter painted out-of-focus paraphrases of famous paintings and historical portrait photos in monochrome grey tones, enlarging them considerably. The originals, either his own pictures or ones from other sources, were then collected in an *Atlas*. In addition to these works, which lie stylistically between photorealism and Pop Art, he did colourful landscapes and cloud formations, candlelit still lifes, crudely painted aerial views of cities, and paintings based on RAL-colour charts.
WRITINGS: G. R.: Text. Frankfurt-on-Main 1993.– Obrist, H.-U. (ed.): G. R. Text. Schriften und Interviews. Frankfurt-on-Main and Leipzig 1993
CATALOGUES RAISONNES: Buchloh, B. H. D. (ed.): G. R. Catalogue Raisonné 1965-1993. Stuttgart 1993.– Harten, J. and D. Elger (ed.): G. R. Gemälde 1962-1985. Städtische Kunsthalle Düsseldorf. Cologne 1986 (cat.).– G. R. Editionen 1965-1993. Kunsthalle Bremen. Munich 1993 (cat.)
MONOGRAPHS, CATALOGUES: Buchloh, B. H. D. (ed.): G. R. Centre Georges Pompidou. Paris 1977 (cat.).– Buchloh, B. H. D. and R. Fuchs (ed.): G. R. Stedelijk Van Abbe Museum, Eindhoven et al. Eindhoven 1978 (cat.).– Buchloh, B. H. D. et al. (ed.): G. R. Art Gallery of Ontario, Toronto et al. Toronto 1988 (cat.).– Butin, D.: Zu R.'s Oktober-Bildern. Cologne 1991.– Butin, D. (ed.): G. R. Editionen 1965-1993. Kunsthalle Bremen. Munich 1993 (cat.).– Ehrenfried, S.: Ohne Eigenschaften. Das Portrait bei G. R. Vienna 1997.– Friedel, H. and U. Wilmes (ed.): G. R. Atlas der Fotos, Collagen und Skizzen. Cologne 1997.– Honnef, K.: G. R. Recklinghausen 1976.– Jahn, F. (ed.): G. R. Atlas. Städtische Galerie im Lenbachhaus, Munich et al. Munich 1989 (cat.).– Loers, V. (ed.): G. R. Shapes and Positions. Kunsthalle Ritter, Klagenfurt et al. Klagenfurt 1992 (cat.).– Loock, U. (ed.): G. R. Aquarelle. Staatsgalerie Stuttgart. Stuttgart 1985 (cat.).– Loock, U. and D. Zacharopoulos: G. R. Munich 1985.– Nasgaard, R. (ed.): G. R. Paintings. Museum of Contemporary Art, Chicago et al. London 1988 (cat.).– Neff, T. A. et al. (ed.): G. R. Art Gallery of Ontario, Toronto. London 1988 (cat.).– Obrist, H.-U. (ed.): G. H. 100 Bilder. Stuttgart 1996.– Petzet, M. and A. Zweite (ed.): G. R. Städtische Galerie im Lenbachhaus. Munich 1973 (cat.).– Rainbird, S. and J. Severne (ed.): G. R. Tate Gallery. London 1991 (cat.).– G. R. Kunst- und Ausstellungshalle der Bundesrepublik Deutschland, Bonn. Stuttgart 1993, 1996 (cat.)/G. R. Musée d'Art Moderne de la Ville de Paris et al. Stuttgart 1993 (cat.).– Salzmann, S. (ed.): G. R. Editionen 1965-1993. Kunsthalle Bremen. Bremen 1993 (cat.).– Thomas-Netik, A.: G. R. Mögliche Aspekte eines postmodernen Bewusstseins. Essen 1986.– Tilroe, A. and B. H. D. Buchloh (ed.): G. R. Museum Boymans-van-Beuningen. Rotterdam 1989 (cat.)

## RICHTER Hans

**1888** Berlin – **1976** Locarno
German artist. **1906–1909** Studied architecture. Attended the Berlin Academy and the Weimar School of Art. **1912/13** Contact with the Sturm group in Berlin. **1916** Member of the Dada movement in Zurich. **1917** First abstract works. **1918** Took part in the Dada exhibition "Die neue Kunst" in Zurich. **1921** Contributed to *De Stijl* magazine. **1922** Was one of the organisers of the Dada Contructivists Congress in Weimar. **1923–1926** Along with Mies van der Rohe and W. Graeff, published the magazine *G*. **1931** Fled from the Nazis to Russia, then to France, Holland, and Switzerland. **1936** Took part in the exhibition "Cubism and Abstract Art" in New York. **1941** Moved to the USA; was director of the Film Institute at City College in New York. **1944–1947** Worked on the film *Dreams that Money Can Buy*. **1952** Solo-exhibition at the Stedelijk Museum, Amsterdam. **1954–1958** Made films such as *8x8* and *Dadascope*. From **1960** took up painting again and made collages. Richter attempted very early on to use film in art. With his abstract film experiments, he was the most important early practitioner of the art of film-making.
WRITINGS: Gray, C. (ed.): H. R. by H. R. London 1971.– H. R.: Dada Profile. Zurich 1961.– H. R.: Dada. Kunst und Antikunst. Cologne 1964.– H. R.: Dada. Art and Anti-Art. London and New York 1965.– H. R.: H. R. London 1971.– H. R.: Begegnungen von Dada bis heute. Cologne 1973.– H. R.: Der Kampf um den Film. Munich 1976
MONOGRAPHS, CATALOGUES: Fifield, C.: True Artist and True Friend. A Biography of H. R. New York 1993.– Hoffman, J. (ed.): H. R. Malerei und Film. Deutsches Filmmuseum. Frankfurt-on-Main 1989 (cat.).– Hoßmann, G.: H. R. 1888-1976. Das bildnerische Werk. Diss. Cologne 1985.– Read, H. (ed.): H. R. Neuchâtel 1965.– Read, H. (ed.): H. R. Painter and Film-maker. Goethe Institut. London 1978 (cat.).– Volkmann, B. and R.-F. Raddatz (ed.): H. R. 1888-1976. Dadaist, Filmpionier, Maler, Theoretiker. Akademie der Künste, Berlin et al. Berlin 1982 (cat.)

## RICKEY George

born **1907** South Bend (IN)
American sculptor. **1926–1929** Studied in Oxford, **1929/30** at the Academy Lhote in Paris. **1945** First mobile. From **1949** kinetic glass sculptures; later mobiles in bare steel. **1962** Solo-exhibition at the Düsseldorf Kunstverein. **1964–1977** Participation in documenta 3, 4 and 6 in Kassel. **1966** Exhibition at the Corcoran Gallery of Art, Washington. **1967** Published *Constructivism, Origins and Evolution*. **1971** Solo-exhibition at the Museum of Art, San Francisco. Exhibitions: **1973** at the Kestner Society, Hanover, **1976** at the Kunsthalle in Bielefeld and **1992** at the Berlinische Galerie. Rickey's kinetic sculptures and steel mobiles are mostly Minimalist in style, being reduced to a few right-angled, reflecting elements.
WRITINGS: G. R.: Constructivism, Origins and Evolution. New York 1967
CATALOGUE RAISONNE: Eggeling, U. (ed.): G. R. Kinetische Skulpturen. Werkeverzeichnis und Bibliographie. Galerie Utermann. Dortmund 1990 (cat.)
MONOGRAPHS, CATALOGUES: Buchholz, G. and K. Gallwitz (ed.): G. R. Kinetische Skulpturen. Städtische Galerie im Städelschen Kunstinstitut. Frankfurt-on-Main 1977 (cat.).– Merkert, J. (ed.): G. R. in Berlin. 1967-1992. Berlinische Galerie. Berlin 1992 (cat.).– G. R. Retrospective Exhibition. UCLA Art Council. Los Angeles 1971 (cat.).– G. R. Kestner-Gesellschaft. Hanover 1973 (cat.).– G. R. Artcurial. Paris 1990 (cat.).– Riedl, P. A.: G. R. Kinetische Objekte. Stuttgart 1970.– Rosenthal, M.: G. R. New York 1977.– Selz, P. (ed.): G. R. Sixteen Years of Kinetic Sculpture. Corcoran Gallery of Art. Washington 1966 (cat.).– G. R. Kinetische Skulpturen. Galerie Pels-Leusden, Villa Griesebach und Skulpturengarten. Berlin 1987 (cat.).– Weisner, U. (ed.): G. R. Kinetische Objekte. Kunsthalle Bielefeld. Bielefeld 1976 (cat.).– Zielske, H. (ed.): G. R. Sieben kinetische Skulpturen. Galerie Utermann. Dortmund 1994 (cat.)

## RILEY Bridget

born **1931** London
English painter. **1949–1952** Studied at Goldsmith's College of Art and **1952–1955** at the Royal College of Art, London. **1959–**

**1961** Taught at Hornsey College of Art. Around **1961** explored Seurat's pointillism. After **1961** taught at Croydon Art College. **1962** First solo-exhibition at Gallery One, London. **1965** Participation in the exhibition "Responsive Eye" at the Museum of Modern Art, New York. **1968** and **1977** Awarded first prize for painting at the Venice Biennale and participated in documenta 4 in Kassel. **1971** Retrospective at the Düsseldorf Kunsthalle and **1978** at the Albright-Knox Art Gallery, Buffalo. **1983** Design sketches for the Royal Liverpool Hospital and *Colour Movements* for Ballet Rambert, Edinburgh. **1985** Retrospective at the Goldsmith's College Gallery, London. Influenced by Vasarely, Riley's pictures explore the optically irritating effects of colour patterns which evoke the illusion of movement on the picture surface.
MONOGRAPHS, CATALOGUES: Carow, B. (ed.): B. R. Kunstverein Hanover et al. Hanover et al. 1970 (cat.).– Kudielka, R. (ed.): B. R. Works 1959-1978. The National Museum of Modern Art. Tokyo 1980 (cat.).– Kudielka, R. (ed.): B. R. Gemälde 1982-1992. Kunsthalle Nürnberg et al. Nuremberg 1992 (cat.).– B. R. Paintings and Drawings 1951-1971. Hayward Gallery. London 1971 (cat.).– B. R. The Arts Council of Great Britain. London 1973 (cat.).– B. R. Works 1959-1978. Albright-Knox Art Gallery. Buffalo 1978 (cat.).– B. R. The Artist's Eye. National Gallery. London 1989 (cat.).– B. R. Recent Works. Spacex Gallery. Exeter 1993 (cat.).– Sausmarez, M. d.: B. R. London 1970

**RINKE Klaus**
born **1939** Wattenscheid
German artist. **1954–1957** Apprenticeship as poster painter in Gelsenkirchen. **1957–1960** Studied painting at the Folkwangschule, Essen. **1965–1968** Polyester figures. From **1968** worked with water. **1968** Solo-exhibition at the Kunsthalle Bern. From **1969** body events, which he called *Primärdemonstrationen*. **1972** Participation in documenta 5 in Kassel and **1973** at the São Paulo Biennale. From **1974** professorship at the Düsseldorf Academy. **1977** Participation in documenta 6 in Kassel. **1978–1980** Lived in Australia. **1981** Retrospective of drawings at the Stuttgart Staatsgalerie and **1992** of his complete works at the Düsseldorf Kunsthalle. Rinke gave up painting early in order to dedicate himself to more natural modes of expression, such as water sculptures.
CATALOGUE RAISONNE: Schmidt, H.-W. (ed.): K. R. retro aktiv. 1954-1991. Werkverzeichnis der Malerei, Skulptur, Primärdemonstrationen, Fotografie und Zeichnungen ab 1980. Städtische Kunsthalle Düsseldorf 1992 (cat.).
MONOGRAPHS, CATALOGUES: Adriani, G. (ed.): K. R. Zeit/Time, Raum/Space, Körper/Body, Handlungen/Transformationen. Kunsthalle Tübingen. Cologne 1972 (cat.).– Gauss, U. and A. Rave (ed.): R. – Hand – Zeichner. Die autonomen Werke

von 1957-1980. Staatsgalerie Stuttgart et al. Stuttgart 1981 (cat.).– Hofmann, W. and H. R. Leppien (ed.): K. R. Meine Plastik ist Zeichnung. Hamburger Kunsthalle. Hamburg 1978 (cat.).– Leppien, H. R. (ed.): K. R. Meine Plastik ist Zeichnung. Hamburger Kunsthalle. Hamburg 1978 (cat.).– K. R. Musée d'Art Moderne de la Ville de Paris. Paris 1976 (cat.).– K. R. Palais du Tau. Rheims 1986 (cat.)

**RIOPELLE Jean-Paul**
born **1923** Montreal
Canadian painter. **1940–1942** Studied mathematics at the Polytechnic, Montreal. Inspired to take up painting by André Breton's essay *Surrealism and Painting*. **1946** Participation at the International Surrealist exhibitions in New York and Paris. European travels and acquaintanceship with Breton. **1947** Moved to Paris; contact with P. Waldberg, Soulages, Mathieu, Wols and others. **1949** Solo-exhibition at the Nina Dausset gallery, Paris. **1951** and **1955** participation at the São Paulo Biennale and, **1954**, at the Venice Biennale. **1959** and **1964** participation in documenta 2 and 3 in Kassel. **1962** Art prize awarded by UNESCO in Paris. **1972** Solo-exhibition at the Musée d'Art Moderne de la Ville de Paris. **1981** Retrospective at the Musée National d'Art Moderne, Paris. Riopelle's main influences were P.-E. Borduas and the Surrealists. The main body of his work can be placed between Abstract Expressionism and the Ecole de Paris.
CATALOGUE RAISONNE: Riopelle, Y. (ed.): J.-P. R. Catalogue raisonné (in preparation)
MONOGRAPHS, CATALOGUES: Billy, H. d.: R. Montreal 1996.– Bordier, R. et al. (ed.): R. Œuvres 1966-1977. Paris 1991 (cat.).– Erouart, G.: Entretiens avec J.-P. R. Montreal 1993.– Gagnon, D.: R. grandeur nature. Saint-Laurent 1988.– Prat, J.-L. (ed.): J.-P. R. "D'hier et d'aujourd'hui". Fondation Maeght. Saint-Paul 1990 (cat.).– Prat, J.-P. (ed.): J.-P. R. Museum of Fine Arts. Montreal 1991 (cat.).– J.-P. R. National Gallery of Canada. Ottawa 1962 (cat.).– R.-P. R. Autour d'une œuvre. Musée des Beaux-Arts de Rennes. Rennes 1988 (cat.).– Schneider, P.: R. Signes mêlés. Paris 1972.– Schneider, P. (ed.): J.-P. R. Musée d'Art et d'Industrie de Saint-Etienne. Saint-Etienne 1980 (cat.).– Schneider, P. (ed.): J.-P. R. Peinture 1946-1977. Centre Georges Pompidou, Paris et al. Paris 1981 (cat.).– Vigneault, G. et al. (ed.): J.-P. R. Montreal Museum of Fine Arts. Montreal 1991 (cat.)

**RIST Pipilotti**
born **1962** Rheintal (Switzerland)
Swiss video and computer artist. Studied commercial art, graphic illustration, and photography at the School of Applied Arts in Vienna and attended the class on audio-visual design at the Design School in Basel. Worked for Dig it, the Laboratory for

Image and Sound in Zurich, and was a member of the music ensemble Les Reines Prochaines. She works mostly with video installations, because, as she says, "everything fits in there, like in a compact handbag". Her tapes are often played at festivals and in museums, as well as being broadcast on television. **1988** Won the prize at the Feminale Cologne for her video *Japsen* (Gasping). **1989** Received and award from VIPER in Lucerne for her video installation *Die Tempodrosslerin saust* (The Speed Limiter is Racing). **1994** Awarded the video art prize of the Swiss Banking Federation. **1997** Received the Premio 2000 at the Venice Biennale.
CATALOGUE RAISONNE: P. R. Remake of the Weekend. Hamburger Bahnhof, Berlin et al. Cologne 1998 (cat.)
MONOGRAPHS, CATALOGUES: P. R. I Am Not the Girl Who Misses Much. Cologne 1994

**RIVERA Diego**
**1886** Guanajuato – **1957** Mexico City
Mexican painter. **1907** Grant to travel to Europe and study in Madrid and Paris. Inspired by the works of Cézanne and Picasso, began to paint in a Cubist style. After a stay of several months in Italy, during which he studied Renaissance frescoes, he returned to Mexico in **1921**, where he received commissions for large murals. The historical cycle that he produced for the Ministry of Education in Mexico City from **1923–1928** already bears the hallmarks of his personal style: simply-told monumental compositions depicting the lives and social conflicts of the Mexican people. **1927/28** Travelled to the Soviet Union. **1929–1935** Decorated the interior of the Mexican National Palace with a history of his country from the Indios and the Aztecs to modern times. **1933** A mural for the Rockefeller Center in New York, featuring a portrait of Lenin, caused a scandal. From **1951** decoration of exteriors. **1952** Mosaic for the Olympic Stadium in Mexico City. Rivera, who was married to the artist F. Kahlo, is one of the Big Three (along with Orozco and Siqueiros) of the Mexican mural movement.
WRITINGS: D. R. and G. March: My Art, My Life. New York 1960, 1990
CATALOGUES RAISONNES: Favela, R.

(ed.): Catalogue Raisonné of Works of D. R. (in preparation).– D. R. Catálogo general de obra de caballete. Mexico City 1989
MONOGRAPHS, CATALOGUES: Azuela, A.: D. R. en Detroit. Mexico City 1985.– Burrus, C. (ed.): D. R. & Frida Kahlo. Fondation Pierre Gianadda. Martigny 1990 (cat.).– Craven: D. R. As Epic Modernist. Thorndike 1997.– Downs, L. and E. Sharp (ed.): D. R. A Retrospective. Detroit Institute of Arts et al. New York 1986 (cat.).– Downs, L. and E. Sharp (ed.): D. R. Retrospectiva. Museo Nacional Centro de Arte Reina Sofia, Madrid et al. Madrid 1992 (cat.).– Eder, R. et al. (ed.): D. R. Exposición nacional de homenaje. Palacio de Bellas Artes. Mexico City 1977 (cat.).– Favela, R. (ed.): D. R. The Cubist Years. Phoenix Art Museum. Phoenix 1984 (cat.).– Gonzáles, D.: D. R. His Art, His Life. Springfield 1996.– Holland, G.: D. R. Chatham 1997.– Larrera, I. H. d. (ed.): D. R. Paradise Lost at Rockefeller Center. Mexico City 1987.– Larrera, I. H. d. (ed.): D. R.'s Murals at the Rockefeller Center. Mexico City 1990.– López Rangel, R.: D. R. y la arquitectura mexicana. Mexico City 1986.– Marín, G. R.: Encuentros con D. R. México 1993.– Münzberg, O. (ed.): D. R. Retrospektive. Detroit Institute of Arts, Detroit et al. Berlin 1987 (cat.).– Newman Helms, C. (ed.): D. R. A Retrospective. Detroit Institute of Arts, Detroit et al. New York 1986 (cat.).– O'Gorman, J.: La técnica de D. R. en la pintura mural. Mexico City 1954.– Paine, F. E.: D. R. North Stratford 1979.– Reyero, M.: D. R. Mexico City 1983.– Rosci, M.: Die Fresken von D. R. Herrsching 1989.– Secker, H. F.: D. R. Dresden 1957.– Tibbs, T. (ed.): J. de R. Retrospective Exhibition 1930-1971. La Jolla Museum of Contemporary Art. La Jolla 1972 (cat.).– Tibol, R. (ed.): Arte y politica: D. R. Mexico City 1979.– Tibol, R.: D. R. ilustrador. Mexico City 1986.– Wolfe, B.: The Fabulous Life of D. R. New York 1969, 1990/La Vie fabuleuse de D. R. Paris 1994

**RIVERS Larry**
**1923** New York – **2002** Long Island
American painter. **1944/45** Studied composition at the Juillard School of Music, New York. Earned his living at first as a jazz saxophonist. **1947/48** Studied art under Hofmann and **1948–1951** at New York University. Became enthusiastic about Bonnard and De Kooning. **1949** First solo-exhibition at the Jane Street Gallery, New York. **1950** Lived in Europe. **1964–1977** Participation in documenta 3, 4 and 6 in Kassel. **1966** Set design for Stravinsky's *Oedipus Rex*. **1967/68** Television production *Africa* with Gaisseau. **1968** Participation in documenta 4 in Kassel. **1970–1972** Production of the semi-documentary film *Tits*. **1970** Retrospective at the Art Institute of Chicago. **1975** Travelled through East Africa. **1980** Retrospective at the Kestner Society, Hanover. **1981** Exhibition at the Hirshhorn Museum, Washington. In the

60s, Rivers combined his Abstract Expressionist style with motifs from consumer society or from art history, which links him with the beginnings of Pop Art.
WRITINGS: L. R. and A. Weinstein: What Did I Do? The Unauthorized Autobiography. New York 1992
MONOGRAPHS, CATALOGUES: Brightman, C. (ed.): Drawings and Digressions by L. R. New York 1979.– Haenlein, C. (ed.): L. R. Retrospektive. Bilder und Skulpturen. Kestner-Gesellschaft. Hanover et al. Hanover 1980 (cat.).– Harrison, H. A.: L. R. New York 1977, 1984.– Hunter, S. (ed.): L. R. Rose Art Museum, Brandeis University. Waltham (MA) 1965 (cat.).– Hunter, S.: L. R. New York 1969, 1972.– Hunter, S.: L. R. New York 1989, Paris 1990.– Koriath, H.: L. R. Bildende Kunst in Beziehung zur Dichtung Frank O'Haras. Frankfurt-on-Main 1990.– Rosenzweig, P. (ed.): L. R. Hirshorn Museum. Washington 1981 (cat.).– Rouart, D.: L. R. New York 1985

**RODIN Auguste**
**1840** Paris – **1917** Meudon
French sculptor. Studied at the Ecole des Arts Décoratifs and later at the Ecole des Beaux-Arts in Paris. **1864** First independent sculptures. **1875** Created *The Age of Bronze*. **1876** Travelled to Florence and Rome; fell under the spell of Michelangelo. **1877** Visited French cathedrals, to study Gothic art. **1881** Visited London. **1883** Met Camille Claudel. **1884**–**1886** Worked on the *Burghers of Calais*. **1894** Moved to Meudon. Met G. Clemenceau, Cézanne, Monet. **1898** Broke off relations with Claudel. **1900** Had his own pavilion at the Paris World Fair. **1916** Set up the Rodin Museum at the Hôtel Biron, Paris. **1917** Married R. Beuret. Rodin's sculptures are habitually sketchy, even fragmentary. Rodin, who initiated the modern era in sculpture, tended to create only a torso and often carved his work out of the block using very few cuts. This was a reaction to the restrictive conformity of traditional sculpture and allowed his successors to explore new pathways.
WRITINGS: Beausire, A. and H. Pichet (ed.): Correspondance de R. 2 vols. Paris 1985-1992.– Gsell, P. (ed.): A. R. Die Kunst. Gespräche des Meisters. Leipzig 1913/R. on Art. New York 1971
CATALOGUES RAISONNES: Goldscheider, C.: A. R. Vie et œuvre. Catalogue raisonné de l'œuvre sculpté. Vol. 1: 1860-1886. Lausanne and Paris 1989.– Grappe, C. (ed.): Catalogue du Musée R. Paris 1944.– Judrin, C. (ed.): Musée Rodin. Inventaire des dessins. 6 vols. Paris 1984.– Tancock, J. L: The Sculpture of A. R. The Collection of the Rodin Museum, Philadelphia. Boston 1976, 1989.– Thorson, V. (ed.): R. Graphics. A Catalogue Raisonné of Drypoints and Book Illustrations. Fine Arts Museums of San Francisco. San Francisco 1975 (cat.)
MONOGRAPHS, CATALOGUES: Anders, G.: Obdachlose Skulptur. Über R. Munich 1994.– Barbier, N. (ed.): Marbres de R.

Collection du Musée Rodin. Paris 1987.– Barbier, N. (ed.): R. Sculpteur. Œuvres méconnues. Musée Rodin. Paris 1992 (cat.).– Beausire, A.: Quand R. exposait. Paris 1988.– Bonnet, A.-M. (ed.): A. R. Erotic Watercolors. New York 1995/Erotische Aquarelle. Munich 1995.– Bothner, R.: A. R. Die Bürger von Calais. Frankfurt-on-Main and Leipzig 1993.– Butler, R.: The Shape of Genius. New Haven (CT) and London 1993.– Butler, R. et al. (ed.): A. R. Eros und Leidenschaft. Tübingen 1996.– Caso, J. d. and P. B. Sanders (ed.): R.'s Sculpture. A Critical Study of the Spreckels Collection. The Fine Arts of San Francisco. Rutland 1977 (cat.).– Crone, R. and S. Salzmann. (ed.): R. Eros und Kreativität. Kunsthalle Bremen et al. Munich 1991 (cat.).– Daix, P. R. Paris 1988.– Descharnes, R. and J.-F. Chabrun: A. R. New York 1967.– Elsen, A. E. (ed.): R. The Museum of Modern Art. New York 1963 (cat.).– Elsen, A. and K. Varnedoe: The Drawings of R. New York 1971.– Elsen, A. E. (ed.): R. Rediscovered. National Gallery of Art. Washington 1981 (cat.).– Elsen, A. E.: R.'s Thinker and the Dilemmas of Modern Public Sculpture. New Haven (CT) 1985.– Grunfeld, F. V.: R A Biography. London and New York 1987.– Grunfeld, F. V.: Rodin. Berlin 1993.– Güse, E.-G. (ed.): A. R. Zeichnungen und Aquarelle. Westfälisches Landesmuseum, Münster et al. Stuttgart 1984 (cat.)/A. R. Drawings and Watercolors. Westfälisches Landesmuseum, Münster. New York 1984 (cat.).– Jarrassé, D.: R. La Passion du mouvement. Paris 1993/R. A Passion for Movement. New York 1995.– Jianou, I. and C. Goldscheider: A. R. Paris 1967.– Laurent, M.: R. Paris 1988, Cologne 1989.– Lavrillier, C.-M.: R. La Porte de l'enfer. Lausanne 1988.– Martinez, R.-M.: R. L'Artiste face à l'état. Paris 1993.– Miller Vita, J. and G. Marotta (ed.): R. Metropolitan Museum of Modern Art. New York 1986 (cat.).– Mirbeau, O.: Correspondance avec A. R. Tusson 1988.– Pinet, H. (ed.): Les Photographes de R. Paris 1986.– Schmoll gen. Eisenwerth, J. A.: R.-Studien. Persönlichkeit, Werke, Wirkung, Bibliographie. Munich 1983.– Schmoll gen. Eisenwerth, J. A.: R und Camille Claudel. Munich 1994.– Taillandier, Y.: R. Paris 1983 (cat.)

**RODCHENKO Alexander**
**1891** St. Petersburg – **1956** Moscow
Russian artist. **1911**–**1914** Trained at the art school in Kasan. **1914**–**1916** Studied at the Stroganoff Institute in Moscow. **1915** Founded the school of Non-objective Art. Contacts with Malevich and Tatlin. **1916** Participated in the exhibition "Magazin" in Moscow. **1918** Decorated the Moscow cabaret Café Pittoresque with Tatlin and G. Jakulov. **1920** Founder member of the Inkhuk cultural institute. Began to do photomontages and mobile-like hanging sculptures. **1921**–**1930** Professor at the School of Technological Art in Moscow. **1921** Period of monochrome pictures. Participation at

the exhibition "5 x 5". **1922** Participation in the Constructivist exhibition in Berlin. Gave up painting to dedicate himself to typographic work, poster and stage design. From **1924** concentrated on photography. **1925** Awarded special honours at the International Exhibition of Art and Industry in Paris. Worked from **1933** as a photojournalist, compiling a pictorial record of the new Russia. **1940**–**1944** Second non-representational phase. Among the successors to the Suprematists around Malevich, it was Rodchenko, the artist-engineer and production artist, who was chiefly responsible for the theoretical development and practical, artistic realisation of Constructivism.
WRITINGS: Khan-Magomedov, S. O. (ed.): A. R. Aufsätze, Erinnerungen, autobiographische Notizen, Briefe. Dresden 1993.– Lavrentiev, A. et al. (ed.): R.: Ecrits complets sur l'art, l'architecture et la révolution. Paris 1988
CATALOGUES RAISONNES: Elliot, D. and A. Lavrentiev (ed.): A. R. Works on Paper 1914-1920. London 1991.– Karginow, G.: R. Budapest 1979.– Khan-Magomedov, S. O. et al. (ed.): R. The Complete Work. London and Cambridge (MA) 1986/R. L'œuvre complet. Paris 1987
MONOGRAPHS, CATALOGUES: Elliott, D. (ed.): A. R. 1891-1956. Museum of Modern Art. Oxford 1979 (cat.).– Gallissaires, P. (ed.): A. R. Alles ist Experiment. Der Künstler-Ingenieur. Hamburg 1993.– Gaßner, H. (ed.): R. Fotografien. Munich 1982.– Gaßner, H.: A. R. Konstruktion 1920 oder die Kunst, das Leben zu organisieren. Frankfurt-on-Main 1984.– Karginov, G.: R. Paris 1977, London 1979.– Larentiev, A. (ed.): R. Grafico, designer, fotografo. Milan 1992 (cat.).– Larentiev, A. N. (ed.): A. R. Photography 1924-1954. New York 1995/A. R. Photographie 1924-1954. Cologne 1995.– Linhart, L.: A. R. Prague 1964.– Noever, P. (ed.): A. M. R., W. F. Spenanowa. Die Zukunft ist unser einziges Ziel. Munich 1991.– A. R. und W. Stepanowa. Wilhelm Lehmbruck Museum, Duisburg et al. Duisburg 1982 (cat.).– Unverfehrt, G. and T. Böttger (ed.): R. Fotograf. Münchner Stadtmuseum et al. Göttingen 1989 (cat.)/R. Der Fotograf. Städtische Galerie. Wolfsburg 1990 (cat.).– Volkov-Lannite, L.: A. R. Moscow 1968.– Weiss, E. (ed.): A. R. Fotografien 1920-1938. Cologne 1978

**ROHLFS Christian**
**1849** Niendorf – **1938** Hagen
German painter and graphic artist. **1864** Serious knee injury, which later led to the amputation of his leg. **1870** Began to study art in Weimar, continuing from **1874**–**1884**. Independently of the French Impressionists, he developed his own naturalistic style which was soon heavily criticised. **1895** Lived in Berlin. **1901** Appointed to teach at the Folkwang School in Hagen, which was being set up by K. E. Osthaus. Met Renoir, Signac, Seurat, Cézanne and van Gogh,

who influenced his painting for a short time. From **1900** member of the Berlin Secession. In the summers of **1905/06**, he painted in Soest and met Nolde. From **1910** he turned to Expressionism. **1911** Joined the New Secession; **1914** member of the Free Secession. **1924** Member of the Prussian Academy of Arts in Berlin. From **1927**–**1938** lived most of the year in Ascona for health reasons. **1937** Expelled from the Berlin Academy and his works confiscated.
CATALOGUES RAISONNES: Elger, D. and A. Meseure (ed.): C. R. Das druckgraphische Gesamtwerk. Museum am Ostwall, Dortmund et al. Dortmund (cat.).– Gädeke, T.: C. R. Bestandkatalog seiner Werke im Schleswig-Holsteinischen Landesmuseum. Schleswig 1990.– Utermann, W. (ed.): C. R. Das druckgraphische Werk. Dortmund 1987.– Vogt, P. (ed.): C. R. Œuvrekatalog der Druckgraphik. Göttingen 1950.– Vogt, P.: C. R. Aquarelle, Wassertempera, Zeichnungen (mit Werkverzeichnis). Recklinghausen 1958.– Vogt, P. (ed.): C. R. Das graphische Werk. Recklinghausen 1960.– Vogt, P. and U. Köcke (ed.): C. R. Œuvrekatalog der Gemälde. Recklinghausen 1978
MONOGRAPHS, CATALOGUES: Bußmann, K. et al. (ed.): C. R. Westfälisches Landesmuseum, Münster et al. Stuttgart 1989 (cat.).– Gleisberg, D.: C. R. Dresden 1978.– Happel, R. (ed.): C. R. Kunstverein Braunschweig et al. Brunswick 1992 (cat.).– C. R. Aquarelle und Zeichnungen. Westfälisches Landesmuseum. Münster 1993.– C. R. 1849-1938. Gemälde zwischen 1877 und 1935. Museum Folkwang. Essen 1978 (cat.).– Scheidig, W.: C. R. Dresden 1965.– Schmidt, K. J. and H.-G. Kerkhoff (ed.): C. R. 1849-1938. Lyrische Expressionen. Artforum, Düsseldorf et al. Düsseldorf 1995 (cat.).– Vogt, P.: C. R. Cologne 1953, 1967.– Vogt, P. (ed.): C. R. Das Spätwerk. Museum Folkwang. Essen 1967 (cat.).– Vogt, P. (ed.): C. R. Folkwang Museum, Essen et al. Recklinghausen 1988 (cat.).– Vogt, P.: C. R. 1849-1938. Aquarelle, Wassertemperablätter, Zeichnungen. Recklinghausen 1988

**ROSAI Ottone**
**1895** Florence – **1957** Ivrea
Italian painter. Studied at the Institute of Decorative Art and the Art Academy in Florence. **1913** First solo-exhibition in Florence. Met the Futurists Boccioni, Carrà and Severini while participating in an exhibition organised by *Lacerba* magazine. **1914**–**1916** Contributed to the Futurist magazine *Lacerba*. The Futurist influence was very much in evidence in his still lifes and collage-like mixtures of painting and *papiers collés* from this period. From **1920** he distanced himself from Futurism and turned to a warmly coloured, naturalist Neo-primitivism, painting popular themes with wit and naiveté. **1925**–**1930** Took part in the exhibition of the Novecento group and worked for *Il Selvaggio* magazine. In the early 40s he did paintings of the cruci-

fixion and war, displaying great expressive intensity.
WRITINGS: O. R.: Il libro del Teppista. Florence 1919.– O. R.: Via Toscanella. Florence 1930
CATALOGUE RAISONNE: O. R.: I disegni del "Bargello". Florence 1990
MONOGRAPHS, CATALOGUES: Cavallo, R.: O. R. Milan 1973.– Santini, P. C.: R. Florence 1960.– Santini, P. C. et al. (ed.): O. R. Opere dal 1911 al 1951. Galleria Nazionale d'Arte Moderna, Romaa et al. Florence 1983 (cat.)

**ROSENBACH Ulrike**
born **1949** Bad Salzdefurth
German video artist. **1964–1969** Studied at the Düsseldorf Academy under Beuys and others. **1972** First video works. Solo-exhibition at the Ernst gallery in Hanover. **1973** Produced the live video event *isolation is transparent*. **1973-1976** Lived in the USA, taught at California Institute of the Arts, Valencia. **1976** Started the School of Creative Feminism in Cologne. **1977** and **1987** participation in documenta 6 and 8 in Kassel. **1978** Solo-exhibition at the Kunstmuseum Düsseldorf. **1980** and **1984** Participation at the Venice Biennale. **1984** Took part in the exhibition "Von hier aus" (From Here) in Cologne. Received the Festival Prize at the Locarno Video Festival and a Western Front working grant for Vancouver. **1989** Took part in the exhibition "Video-Skulptur" in Cologne. From **1989** was professor for New Media at the Saarbrücken Art Academy. **1995** Retrospective at the Freiburg video-forum. Rosenbach pioneered video art in Germany. Her work focuses on feminist issues.
WRITINGS: U. R.: Video, Performance, Feministische Kunst und Foto. Cologne 1978
MONOGRAPHS, CATALOGUES: Hirner, R. (ed.): U. R. Last Call für Engel. Kunstmuseum Heidenheim et al. Heidenheim 1996 (cat.).– Lupri, C.: U. R. Video, Performance, Installation. Art Gallery of York University. Toronto 1989 (cat.).– Schulz, B. (ed.): U. R. Arbeiten der 80er Jahre: Video, Installation, Performance, Fotografie. Stadtgalerie. Saarbrücken 1990 (cat.).– U. R. (ed.): U. R. Videokunst, Foto, Aktion/ Performance, feministische Kunst. Cologne 1982.– U. R. Spuren des Heiligen in der Kunst heute. Neue Galerie, Sammlung Ludwig. Aachen 1986 (cat.)

**ROSENQUIST James**
born **1933** Grand Forks (ND)
American painter. **1952-1955** Studied at the University of Minnesota in Minneapolis and **1957-1959** in New York at the Art Students League, where he met George Grosz and Robert Indiana. At first he worked as a designer, poster artist, and shop window dresser before he set up his own studio in the neighbourhood of Indiana and Ellsworth Kelly and started to produce banners with billboard images in fluores-

cent colours. **1963** Commission for a mural for the New York State Pavilion. **1965** Gigantic mural *F III* (3 x 26 m), a spatially interlocking composition, portraying the interplay of the human, commercial and mechanized aspects of American society. **1968** and **1977** participation in documenta 4 and 6 in Kassel. **1969** Experiments with film techniques. **1970** First video works. In the 70s, he was active in the anti-war movement and for the rights of the artist in a democratic society. From **1983** the mechanical elements in his paintings were there to mock a naive faith in technology. Rosenquist, one of the leading representatives of American Pop Art, assembles his monumental canvases out of fragmentary images taken from everyday life and elements of commercial advertising.
CATALOGUE RAISONNE: Glenn, C. W. (ed.): J. R. Time Dust. The Complete Graphics 1962-1992. Walker Art Center, Minneapolis et al. New York 1993 (cat.)
MONOGRAPHS, CATALOGUES: Adcock, C. E. et al. (ed.): J. R. IVAM Centro Julio González. Valencia 1991 (cat.).– Brundage, S. (ed.): J. R. The Big Paintings. Leo Castelli Gallery. New York 1994 (cat.).– Damiani, R.: J. R. The Nineties. New York 1996.– Goldman, J. (ed.): J. R. Denver Art Museum et al. New York 1985 (cat.).– Goldman, J.: J. R. The Early Pictures 1961-1964. New York 1992.– J. R. Whitney Museum of American Art. New Yok 1986 (cat.).– Tucker, M. (ed.): J. R. Whitney Museum of American Art. New York 1972 (cat.).– Varian, E. H. (ed.): J. R. Graphics Restrospective. The John and Mabel Ringling Museum of Art. Sarasota (FL) 1979 (cat.).– Weiss, E. (ed.): J. R. Gemälde, Räume, Graphik. Josef-Haubrich-Kunsthalle. Cologne 1972 (cat.)

**ROSSO Medardo**
**1858** Turin – **1928** Milan
Italian sculptor. **1881** Moved to Milan. **1882** Studied sculpture at the Brera Academy in Milan. **1884** Worked in J. Dalous studio in Paris, and was influenced by Impressionism and the works of Rodin. **1885** Lived in Vienna. **1886** Exhibition at the Salon des Indépendants in Paris. **1986** Returned to Milan; began to work on cemetery statuary. From **1889** lived in Paris again, where he met Degas, Robin and the collector Rouart.

**1900** Took part in the Paris World Fair. **1904** Solo-exhibition at the Salon d'Automne in Paris; further solo-exhibitions in Vienna and Milan. **1929** Retrospective at the Salon d'Automne in Paris. **1950** Retrospective at the Venice Biennale. A characteristic of Rosso's work is the mobility of his figures, evoking an Impressionist sense of movement with a psychological dimension. Many of his sculptures are purposely left in the wax model stage.
WRITINGS: Fezzi, E. (ed.): M. R. Scritti e pensieri 1889-1927. Cremona 1994
MONOGRAPHS, CATALOGUES: Barbantini, N.: M. R. Venice 1950.– Barr, M. S. (ed.): M. R. The Museum of Modern Art. New York 1963 (cat.).– Barr, M. S.: M. R. New York 1972.– Borghi, M.: M. R. Milan 1950.– Caramel, L and Mola Kirchmayr, P. (ed.): Mostra di M. R. Palazzo della Permanente. Milan 1979 (cat.).– Caramel, L. (ed.): M. R. Impressions in Wax and Bronze. 1882-1906. Kent Fine Art, New York et al. New York and London 1988 (cat.).– Caramel, L. (ed.): M. R. Whitechappel Art Gallery. London 1994 (cat.).– Fagioli, M. and L. Minunno (ed.): M. R. 2 vols. Florence 1993 (cat.).– Lista, G (ed.): M. R. La Sculpture impressionniste. Paris 1994.– Lista, G.: M. R. Destin d'un sculpteur. 1858-1928. Paris 1994.– Marchiori, G.: M. R. Milan 1966.– Papini, G.: M. R. Milan 1945.– M. R. Whitechapel Art Gallery. London 1994 (cat.).– Sanna, J. d.: M. R. o la creazione dello spazio moderno. Milan 1985.– Weiermair, P. et al. (ed.): M. R. 1858-1928. Frankfurter Kunstverein. Frankfurt-on-Main 1984 (cat.)

**ROTELLA Mimmo**
born **1918** Catanzaro
Italian artist. **1945** Finished studies at the Art Academy in Naples. **1945** Moved to Rome. **1951** First solo-exhibition at the Galleria Chiurazzi, Rome. **1951/52** Studied in the USA on a scholarship from the University of Missouri, Kansas City. From **1954** produced decollages often including film and advertising posters. **1961** Joined the Nouveaux Réalistes. Met Jacques de la Villeglé and Raymond Hains. **1964** Moved to Paris. **1965** Took part in the exhibition "Hommage à Nicéphore Nièpce" at the Galerie J in Paris. **1972** Publication of his book *Autorotella*. **1975** Produced a record of his phonetic poems. **1980** Moved to Milan. **1985** Solo-exhibition at the Reckermann gallery in Cologne. **1986** Invited to lecture in Cuba. Rotella, with his torn-poster paintings, is a typical exponent of Nouveau Réalisme.
MONOGRAPHS, CATALOGUES: Appella, G.: Colloquio con R. Roma 1984.– Barilli, R. and T. Sicoli: R. Milan 1996 (cat.).– Fagiolo dell'Arco, M.: M. R. Milan 1977.– Hunter, S.: R. Décollages 1954-1964. Milan 1986.– Oliva, A. B. et al.: M. R. L'Amière. Milan 1989.– Restany, P.: R. Dal décollage alla nuova immagine. Milan 1963.– Restany, P. et al. (ed.): M. R. Württembergischer Kunstverein, Stuttgart et al.

Stuttgart 1998 (cat.).– M. R. Autorotella. Milan 1972, Paris 1990.– Trini, T.: R. Milan 1974

**ROTH Dieter**
**1930** Hanover – **1998** Basel
Also known as Diter Rot. German painter and action artist. **1943** Moved to Switzerland. **1947** Trained as a graphic artist. Lived from **1957-1964** in Reykjavik. Travelled to Amsterdam, Basel, New York, Paris. **1958** First solo-exhibition in Reykjavik. **1964** Solo-exhibition at the Museum School of Art, Philadelphia. Collaborated with A. Knowles, D. Higgins, Brecht, C. Moorman and Paik. **1967** Returned to Reykjavik. **1968** and **1977** took part in documenta 4 and 5 in Kassel. From **1968** taught at the Düsseldorf Academy. **1981** Participation in the "Westkunst" exhibition in Cologne and **1982** at the Venice Biennale. **1984** Solo-exhibition at the Museum of Contemporary Art, Chicago. **1985** Took part in the exhibition "Livres d'Artistes" at the Pompidou Centre, Paris. Lived from **1990** in Basel. **1998** Prize at the Art Multiple, Düsseldorf. Roth can be categorised under the Fluxus and Eat-Art movements. He is best known for his book works, displaying an individual style of typography, and for his chocolate and mould objects.
WRITINGS: D. R.: Scheisse. Providence 1966.– D. R.: Die blaue Flut. Stuttgart 1967.– D. R.: mundunculum. Cologne 1968.– D. R.: Gesammelte Werke. Bücher und Grafik. 2 vols. Stuttgart 1971-1979.– D. R.: Frühe Schriften und typische Scheiße. Stuttgart, London 1975.– D. R.: Ein Tagebuch aus dem Jahre 1982. Basel 1984
CATALOGUES RAISONNES: D. R. Werkverzeichnis Graphik und Bücher. 2 vols. Stuttgart et al. 1972-1979.– Oberhuber, K. et al. (ed.): D. R. Das druckgraphische Werk. Cologne 1998
MONOGRAPHS, CATALOGUES: Broos, K. (ed.): D. R. Centre Régional d'Art Contemporain Midi-Pyrénées, Labege. 1987 (cat.).– Goldstein, A. (ed.): D. R. Museum of Contemporary Art. Chicago 1984 (cat.).– Helms, D. (ed.): D. R. Arbeiten auf Papier. Herzog Anton Ulrich-Museum. Brunswick 1985 (cat.).– Hohl, H. and A. Kamber (ed.): D. R. Zeichnungen. Hamburger Kunsthalle et al. Hamburg 1987 (cat.).– D. R. Bücher. Kestner-Gesellschaft. Hanover 1974 (cat.).– D. R. Bonner Kunstverein. Bonn 1983 (cat.).– D. R. Bilder, Zeichnungen, Objekte. Basel 1989 (cat.).– D. R. Museum Moderner Kunst. Passau 1992 (cat.).– Schneede, U. M. (ed.): D. R. Originale 1946-1974. Hamburger Kunstverein. Hamburg 1974 (cat.).– Schwarz, D.: Auf der Bogen Bahn. Studien zum literarischen Werk von D. R. Zurich 1981

**ROTHENBERG Susan**
born **1945** Buffalo (NY)
American painter and draughtswoman. **1962-1967** Studied at the Fine Arts School at Cornell University. **1964** Graduate

studies at State University, New York. **1965** Lived in Greece. **1971** Married the sculptor Trakas. **1975** First solo-exhibition with *Three Large Paintings* at the gallery 112 Greene Street in New York. **1979** Participation at the Whitney Biennale, New York. Separation from Trakas. Travelled to Mexico. **1980** Participation at Venice Biennale. **1981** Solo-exhibition at the Basel Kunsthalle. **1982** Participation at the exhibition "Zeitgeist" in Berlin. Solo-exhibition at the Stedelijk Museum, Amsterdam. **1988** Travelled in China. **1989** Married Naumann. **1990** Retrospective at the Rooseum Centre of Contemporary Arts, Malmö, and **1992** at the Albright-Knox Art Gallery, Buffalo and participation in documenta 9 in Kassel. Besides paintings Rothenberg has produced some very fine drawings.
MONOGRAPHS, CATALOGUES: Auping, M. (ed.): S. R. Paintings and Drawings. Albright-Knox Art Gallery, Buffalo et al. New York 1992 (cat.).– Blum, P. (ed.): S. R. Kunsthalle Basel et al. Basel 1981 (cat.).– Grevenstein, A. v. (ed.): S. R. Recente Schilderijen. Stedelijk Museum. Amsterdam 1982.– Nittve, L. and R. Storr (ed.): S. R. 15 Years – A Survey. Malmö Konsthall. Malmö 1990 (cat.).– Rathbone, E. (ed.): S. R. The Phillips Collection, Washington et al. Washington 1985 (cat.).– Tuchman, M. (ed.): S. R. Los Angeles County Museum of Art et al. Los Angeles 1983 (cat.).– Simon, J.: S. R. New York 1991

**ROTHKO Mark**
(Markus Rothkowitz)
**1903** Dvinsk (Lithuania) – **1970** New York
Lithuanian-born American painter. **1910** Moved with his family to Oregon. **1921-1923** Studied at Yale University, New Haven, and **1924-1929** under M. Weber at the Art Students League in New York. **1935** Founded the Expressionist group with Adolf Gottlieb The Ten. **1938** Showed interest in Surrealism and studied Greek mythology, metaphysics, C. G. Jung's theory of archetypes, and primitive art. **1947** First paintings with floating forms. **1949** With Baziotes, Motherwell and Newman, started the Subject of the Artist School, which closed in **1950**. Taught at the successor to this school (Studio 35) until **1955**, and at Brooklyn College as an assis-

tant professor from **1951-1954**. **1959** Participation in documenta 2 in Kassel. From **1960** he began to use ever darker colours. **1964** He decorated a chapel designed by Philip Johnson for the De Menil family in Houston. **1970** Suicide. With his meditative paintings, Rothko is among the most important of the Color Field painters.
CATALOGUE RAISONNE: Sandler, I. and B. Clearwater (ed.): M. R. Catalogue Raisonné (in preparation)
MONOGRAPHS, CATALOGUES: Ashton, D.: About R. New York 1983, 1996.– Barnes, S.: The R. Chapel. An Act of Faith. Austin 1989.– Breslin, J. E. B.: M. R. A Biography. Chicago 1993 / M. R. Eine Biographie. Klagenfurt 1995.– Chave, A. c.: M. R. Subjects in Abstraction. New Haven (CT) and London 1989, 1991.– Clearwater, B. (ed.): M. R. Works on Paper. National Gallery of Art, Washingtonn. New York 1984 (cat.).– Clearwater, B. (ed.): M. R. Œuvres sur papier. Paris 1993.– Glimcher, M. (ed.): The Art of M. R. Into an Unknown World. New York and London 1991.– Kellein, T. (ed.): M. R. Kunsthalle Basel. Basel 1989 (cat.).– McKinney, D. et al. (ed.): M. R. Kunsthaus Zurich et al. Zurich 1971 (cat.).– Nodelman, S.: The R. Chapel Paintings. Form as Meaning in the American Abstract Sublime. Austin 1997.– Rosenblum, R. et al. (ed.): M. R. Tate Gallery. London 1987, 1996 (cat.).– Seldes, L.: The Legacy of M. R. New York 1978, 1996.– Waldman, D. and B. Malamud (ed.): M. R. 1903-1970. A Retrospective. Solomon R. Guggenheim Museum, New York et al. New York 1978 (cat.).– Waldman, D.: M. R. in New York. Solomon R. Guggenheim Museum. New York 1994.– Weis, J. (ed.): M. R. National Gallery of Art, Washington et al. Washington 1998 (cat.).– Weiss, E. (ed.): M. R. 1903-1970. Retrospektive der Gemälde. Museum Ludwig. Cologne 1988 (cat.)

**ROUAULT Georges**
**1871** Paris – **1958** Paris
French painter and engraver. During his apprenticeship in a stained-glass workshop, he restored some medieval windows. Later studied with G. Moreau, whose influence is visible in his works up to **1903**. After Moreau's death, H. Daumier and Toulouse-Lautrec encouraged him to portray scenes and characters from real life. Before gravitating towards Fauvism around **1905**, he painted in dark, heavy colours. He then began to use wild, strong brush slashes, presenting his figures – clowns, prostitutes, farmers, workers, judges – in sombre but vivid, glowing colours with darkly outlined faces. The contrast between the broad, black lines and the pulsing, luminous colours is reminiscent of the stained-glass techniques he knew. **1917-1927** Produced important series of engravings, including illustrations for C. Baudelaire's *Fleurs du Mal* and the *Miserere*. **1932** Devoted himself increasingly to religious art, a development culminating in **1945** in his

stained-glass windows for the church in Assy.
WRITINGS: G. R.: Souvenirs intimes. Paris 1926.– G. R.: Paysages légendaires. Paris 1929.– G. R.: Petite banlieue. Paris 1929.– G. R.: Divertissements. Paris 1943.– G. R.: Soliloques. Neuchâtel 1944.– G. R.: Miserere. Paris 1991
CATALOGUES RAISONNES: Chapon, F. and I. Rouault (ed.): G. R. Œuvre gravé. 2 vols. Monte Carlo 1978-1979 / R.'s Complete Graphic Work. San Francisco 1979.– Chapon, F. (ed.): Le Livre des livres de R. Monaco 1992 / R.'s Illustrated Books. Catalogue Raisonné. San Francisco 1993.– Courthion, P.: G. R. Paris 1962, New York 1962, Cologne 1962.– Dorival, B. and I. Rouault (ed.): G. R. L'œuvre peint. 2 vols. Monte Carlo 1988 / R.'s Complete Paintings. San Francisco 1988.– Molinari, D. (ed.): G. R. 1871-1958. Catalogue raisonné. Collections de la Ville de Paris. Paris 1983
MONOGRAPHS, CATALOGUES: Bellini, P.: G. R. Uomo e artista. Milan 1972.– Chiappini, R. (ed.): G. R. Museo d'Arte Moderna. Lugano 1997 (cat.).– Dorival, B. (ed.): G. R. Haus der Kunst, Munich et al. Munich 1974 (cat.).– Gohr, S. (ed.): G. R. Josef-Haubrich-Kunsthalle. Cologne 1983 (cat.).– Hergott, F.: R. Paris 1991.– Hergott, F. et al. (ed.): R. Première période 1903-1920. Centre Georges Pompidou. Paris 1992 (cat.) / G. R. The Early Years 1903-1920. Royal Academy. London 1993 (cat.).– Hopf, P. (ed.): G. R. 1871-1958. Kunstamt Wedding. Berlin 1988 (cat.).– Koja, S. (ed.): G. R. Malerei und Graphik. Landessammlungen Rupertinum, Salzburg. Munich 1993 (cat.).– Leymarie, J. and M. Hoog (ed.): G. R. Exposition du centenaire. Musée National d'Art Moderne. Paris 1971 (cat.).– Marcoulesco, I.: G. R. The Inner Light. Houston 1996

**ROUSSEAU Henri**
**1844** Laval – **1910** Paris
French painter. Self-taught. **1863/64** Military musician; claimed to have served in Mexico. **1869** Began to work for the Paris customs office, where he earned his nickname *The Customs Officer*. During the Franco-Prussian war, he was a low-ranking officer in the French army. **1880** First exhibition of paintings. **1885** Exhibited at the Salon des Champs-Elysées in Paris. **1896-1910** Regular participation in the Salon des Indépendants, from **1905** also at the Salon d'Automne. **1890** Met Toulouse-Lautrec, Gauguin, Redon, Seurat and Pissarro. First exotic paintings. **1906** Met Delaunay, Picasso and Apollinaire and, in **1907**, made friends with Wilhelm Uhde, who published the first monograph on him in **1911**. Rousseau's portraits, still lifes, landscapes, and fantasy scenes are the first examples of a style termed "naive". Naive, because their subject matter is portrayed in a highly individual manner, without realistic analysis or intellectual reflection.
CATALOGUES RAISONNES: Artieri, G. (ed.): L'opera completa di R. il Doganiere.

Milan 1969.– Bouret, J.: H. R. Neuchâtel 1961, Greenwich (CT) 1961, Herrsching 1974.– Certigny, H. (ed.): Le Douanier R. et son temps. Biographie et catalogue raisonné. 2 vols. Tokyo 1984-1989.– Vallier, D.: H. R. Paris 1961, Cologne 1961, New York and London 1964, Munich 1981.– Vallier, D. (ed.): Tout l'œuvre peint de H. R. Paris 1970
MONOGRAPHS, CATALOGUES: Abé, Y. (ed.): H. R. et l'univers des naïfs français. Grande Galerie, Odakyu. Tokyo 1981 (cat.).– Alley, R.: Portrait of a Primitive. The Art of H. R. Oxford 1978.– Bihalji-Marin, L. and O.: H. R. Leben und Werk. Cologne 1976.– Broadskaya, N.: H. R. New York 1983.– Certigny, H.: La Vérité sur le douanier R. Lausanne, Paris 1961, 1971.– Elgar, F.: R. Paris 1980.– Hoog, M. (ed.): Le Douanier R. Grand Palais, Paris et al. Paris 1984 (cat.).– Keay, C.: H. R. Le Douanier. London and New York 1976.– Le Pichon, Y.: Le Monde du douanier R. Paris 1981 / The World of H. R. New York 1982.– Perruchot, H.: H. R. Eine Biographie. Eßlingen a. N. 1957.– Plazy, G.: Le Douanier R. Un naïf dans la jungle. Paris 1992.– Rich, D. C.: H. R. Museum of Modern Art Publications in Reprint. New York 1969.– Schneede, M.: H. R. Dortmund 1994.– Shattuck, R. et al. (ed.): H. R. The Museum of Modern Art. New York 1985 (cat.).– Stabenow, C. (ed.): H. R. Die Dschungelbilder. Munich 1984.– Stabenow, C.: H. R. Cologne 1991.– Vallier, D.: H. R. Paris 1979, New York 1979.– Vitiello, R.: R. e l'alienazione. Roma 1981

**ROZANOVA Olga**
**1886** Malenkach – **1918** Moscow
Russian artist. **1904-1910** Studied applied arts in Moscow. **1911** Moved to St. Petersburg, where she attended the Svanseva art school, and took part in exhibitions given by the Young People's Union. **1912-1914** Cubist-Futurist period. **1913** Published her essay *Concerning the Principles of a New Art*. **1915** Joined the Suprematist movement and worked on their magazine. Took part in the exhibitions "Streetcar WITH", "Zero-Ten", "Magazin", and "Karo Bube". Did book illustrations for Futurist poets and wrote her own *Transcendancy Poems*. **1919** Posthumous retrospective in Moscow. Several of her works were shown in **1922** at the Russian art exhibition at the Diemen gallery in Berlin. Rozanova revolutionised the art of book printing by breaking away from traditional typesetting; through the integration of collage technique she created a new union of words and pictures.
MONOGRAPHS, CATALOGUES: Rubinger, K. et al. (ed.): Künstlerinnen der russischen Avantgarde. 1910-1930. Galerie Gmurzynska. Cologne 1979 (cat.)

**RÜCKRIEM Ulrich**
born **1938** Düsseldorf
German sculptor. **1957-1959** Apprenticeship as a stonemason in Düren. **1959-1961**

Worked as a mason at Cologne Cathedral. **1962** Travelled through southern Europe, Morocco, and Tunisia and, after his return, decided to become a sculptor. **1964** First solo-exhibition at the Leopold Hoesch Museum, Düren. From **1968** he developed his own working technique, in which the material and the working process itself are characterised by doubling, reducing, and slighthy changing to the raw materials. **1969** Moved to Mönchengladbach where he shared a studio with Palermo. **1970** Solo-exhibition at the Museum Haus Lange in Krefeld. **1972**-**1992** Participation in documenta 5, 7, 8 and 9 in Kassel. **1975**-**1984** Professor at the Hamburg Academy of Fine Arts. **1978** Participation at the Venice Biennale with four split Dolomite stones. **1981** Participation at the "Westkunst" exhibition in Cologne. **1984** Professor of sculpture at the Düsseldorf Academy and **1988** Professor at the Frankfurt Academy. Rückriem has made an important contribution to Process Art with his stone, iron, and wooden sculptural works which reflect the creative processes and his working methods.
CATALOGUE RAISONNE: Meschede, F. et al. (ed.): U. R. Multiples und Druckgraphik 1969-1985. Freiburg 1986 (cat.)
MONOGRAPHS, CATALOGUES: Barker, B. et al. (ed.): U. R. Arbeiten. Stuttgart 1994.– Bußmann, K. et al. (ed.): U. R. Skulpturen, Zeichnungen. Westfälisches Landesmuseum. Münster 1985 (cat.).– Deecke, T. (ed.): U. R. Skulpturen 1977/78. Westfälischer Kunstverein, Münster et al. Mannheim 1979 (cat.).– Erhardt, H. (ed.): U. R. Städtische Galerie im Lenbachhaus. Munich 1995 (cat.).– Fuchs, R. (ed.): U. R. Skulpturen 1968-1970. Stedelijk Van Abbe Museum, Eindhoven et al. Eindhoven 1977 (cat.).– Gallwitz, K. et al. (ed.): Biennale 78, Venice. Deutscher Pavillon – U. R. Stuttgart 1978 (cat.).– Goldwater, M. et al. (ed.): U. R. New Works. The Fort Worth Art Museum. Fort Worth 1981 (cat.).– Heubach, F. et al. (ed.): U. R. Sculptures. Centre Georges Pompidou. Paris 1983 (cat.).– Hohmeyer, J.: U. R. Munich 1988.– Kersting, H. and U. R. (ed.): U. R. Skulpturen. Städtische Galerie im Städel. Frankfurt-on-Main 1984 (cat.).– Kersting, H. (ed.): U. R. Kunstsammlung Nordrhein-Westfalen, Düsseldorf et al. Düsseldorf 1987 (cat.).– Meschede, F.: Der Stein drängt nach draußen. Untersuchungen zur Skulptur von U. R. und ihre Entwicklung als Kunst im öffentlichen Raum. Diss. Münster 1987.– Meschede, F. et al. (ed.): U. R. Skulpturen-Zeichnungen. Kunstsammlung Nordrhein-Westfalen, Düsseldorf et al. Düsseldorf 1987 (cat.).– U. R. Museum of Modern Art. Oxford 1976 (cat.).– Ulbricht, G.: U. R. Skulpturen 1968-1973. Cologne 1973

**RUETZ Michael**
born **1940** Berlin
German photographer. Came from a publishing family in Riga. Studied Chinese,
Japanese and journalism in Freiburg, Munich and Berlin. Doctoral thesis on a Chinese novelist. **1969** – **1973** Worked as an editor for *Stern* magazine in Hamburg and, since then, as a freelance photographer. **1975** Examen at the Folkwang Art School, Essen, under Steinert and W. Fleckhaus. Since **1983** contracted author with Little, Brown and Company in Boston. Professorship at an art academy in Braunschweig. Won the Otto Steinert Award for Photography and **1981** the Villa Massimo Prize in Rome. Spent several years in Italy, America and Australia.
WRITINGS: M. R.: Christo verpackt Monschau. Cologne 1971.– M. R.: Auf Goethes Spuren. Zurich 1978.– M. R.: Nekropolis. Munich 1978.– M. R.: APO Berlin 1966-1969. Frankfurt-on-Main 1980.– M. F.: Luna. Nördlingen 1986.– M. F.: Über Berlin. Munich 1991.– M. F.: Library for the Eye 1993-1996. Berlin 1993-1996.– M. F.: Bibliothek der Augen I, II. Göttingen 1997-1998
MONOGRAPHS, CATALOGUES: M. R. Fotograf der Revolte. Galerie Mikro. Berlin 1970 (cat.)

**RUFF Thomas**
born **1958** Zell am Harmersbach (Black Forest)
German photographer. **1977**-**1985** Studied photography at the Düsseldorf Academy under Becher. **1985** and **1987** Portraits of his parents, relatives, and friends, as well as a serie of large colour portraits of heads in a sober, documentary style. From **1987** he photographed new buildings built during the German economic miracle of the 50s, selecting individual buildings that interested him rather than particular styles or categories. **1988** Received a grant for young artists from the state of North Rhine-Westphalia. **1989** Black and white photos of the night sky using existing material from the European Southern Observatory. **1992** Took part in documenta 9 in Kassel and in the **1995** Venice Biennale. In the mid-90s, he began to produce synthetic portraits using computer manipulation.
MONOGRAPHS, CATALOGUES: Brauchitsch, B. v.: T. R. Frankfurt-on-Main 1992.– Durand, R. (ed.): T. R. Paris 1997 (cat.).– Levene, U. (ed.): T. R. Rooseum Center for Contemporary Art. Malmö 1996

(cat.).– T. R. Porträts. Museum Schloß Hardenberg, Velbert et al. Cologne 1988 (cat.).– T. R. Portretten, Huizen, Sterren, Stedelijk Museum, Amsterdam et al. Amsterdam and Grenoble 1989 (cat.).– T. R. Bonner Kunstverein. Bonn 1991 (cat.).– T. R. and A. Giese (ed.): T. R. andere Portraits + 3 D. Deutscher Pavillon, Biennale von Venedig. Stuttgart 1995 (cat.)

**RUSCHA Edward**
born **1937** Omaha (NE)
American painter. **1942** Moved to Oklahoma City. **1947** Began to draw comics. **1949** Travelled to California. **1955** Trip to Mexico. **1956**-**1960** Studied at the Chouinard Art Institute and at the school of the Walt Disney cartoonists in Los Angeles. **1963** Solo-exhibition at the Ferus Gallery, Los Angeles. **1963**-**1966** Publication of his books *Twenty-Six Gasoline Stations* and *Every Building on the Sunset Strip*. **1964** Participation at the exhibition "American Drawings" at the Guggenheim Museum, New York. **1967** Participation at the Saõ Paulo and Paris Biennale and **1970** at the Venice Biennale. **1972**-**1992** Took part in documenta 5 – 7 and 9 in Kassel. **1982** Exhibition entitled "I don't want no Retrospective – The Works of Edward Ruscha" at the San Francisco Museum of Modern Art. **1985** Mural for the Miami Dade public library. **1989** Retrospective at the Pompidou Centre, Paris. **1993** Soloexhibition at the Gagosian Gallery, New York. Ruscha's alphabetic works represent the complex relationship between text and typography. In the 70s, he used organic substances (like foodstuffs) in place of paints.
MONOGRAPHS, CATALOGUES: Bogle, A. (ed.): E. R. Graphic Works by E. R. City Art Gallery. Auckland 1978 (cat.).– Bois, Y.-A. (ed.): E. R. Romance with Liquids. Paintings 1966-1969. Gagosian Gallery. New York 1993 (cat.).– Bois, Y.-A.: E. R. The Word Paintings. New York 1993.– Cathcart, L. L. (ed.): E. R. Albright-Knox Art Gallery. Buffalo 1976 (cat.).– Clearwater, B. and C. Knight (ed.): E. R. Words Without Thoughts Never to Heaven Go. Lannan Museum, Lake Worth. New York 1988 (cat.).– Foster, E. A.: E. R. Minneapolis 1972.– Groot, E. d. (ed.): E. R. Paintings. Museum Beuymans-van Beuningen, Rotterdam et al. Rotterdam 1989 (cat.).– Hickey, D. et al. (ed.): The Works of E. R. San Francisco Museum of Modern Art et al. New York 1982 (cat.).– Hulten, P. and D. Cameron (ed.): E. R. Centre Georges Pompidou, Paris et al. Paris 1989 (cat.)

**RUSSOLO Luigi**
**1885** Pertogruaro – **1947** Cerro di Laveno
Italian painter and musician. Studied music. **1909** Encouraged by Bonzagni and Romani to take up painting. Friendship with Boccioni. **1910** Co-founder of the Futurist movement with Balla, Boccioni, Carrà and Severini. Took part between **1910**

–**1913** in Futurist exhibitions and signed the painting manifestos of the group. **1913** Issued the *Manifesto of Noise Art*, in which he coined the term Bruitism. Gave up painting in favour of music and together with U. Piatti constructed the *Intonarumori*, a musical instrument for producing noises. **1917** Wounded in the war. **1918** Moved to Paris. **1941** Took up figurative painting again.
WRITINGS: Maffina, G. F.: L. R. e l'arte dei rumori. Con tutti gli scritti musicali. Torino 1978.– L. R.: L'arte dei rumori. Milan 1916.– L. R.: Al di là della materia. Milan 1938
CATALOGUE RAISONNE: Maffina, G. F. (ed.): L'opera grafica di L. R. Varese 1977
MONOGRAPHS, CATALOGUES: Bartsch, I. (ed.): R. Die Geräuschkunst. 1913-1931. Museum. Bochum 1985 (cat.).– Zanovello Russolo, M. et al. (ed.): L. R. L'uomo, l'artista. Milan 1958

**RUTHENBECK Reiner**
born **1937** Velbert
German sculptor. Studied photography and from **1962** sculpture at the Düsseldorf Academy, as a student of Beuys. **1965** First sculptures, influenced by Surrealism, out of clay, iron, wire and wood. Towards the end of the 60s, he tried to imbue his sculptures and objects with a sense of stillness. His interest in a purely existential objectivity led finally to his famous *Aschehaufen* (Ashheap) of **1968/69** and the *Papierhaufen* (Pile of Paper) of **1970**, two works which link him with the Arte Povera movement. Since the mid-70s he has used fabrics to create environments out of rooms. **1972**–**1992** Participation in documenta 5 – 7 and 9 in Kassel. **1975** Taught at the Hamburg School of Fine Arts. **1976** Participation at the Venice Biennale. From **1980** professorship at the Düsseldorf Academy in the Department of Art Education, Münster. **1982** Table installations. Konrad von Soest Prize for the Plastic Arts, awarded by the Westphalen-Lippe landscape association. His works explore the diverse interrelationships of rigid, elastic and flexible materials and the tensions that emerge between object and space. He thereby bridges the gap between Material and Kinetic Art.
MONOGRAPHS, CATALOGUES: Bee, A. (ed.): R. R. Frankfurt-on-Main 1997

(cat.).– Blume, D. (ed.): R. R. Arbeiten 1965-1983. Kunstverein Braunschweig. Brunswick 1983 (cat.).– Grinten H. v. d. and J. Cladders (ed.): R. R. Städtisches Museum Abteiberg. Mönchengladbach 1972 (cat.).– Harten, J. (ed.): R. R. Objekte. Städtische Kunsthalle Düsseldorf. Düsseldorf 1974 (cat.).– Honnef, K. and J. Cladders (ed.): R. R. Westfälischer Kunstverein. Münster 1971 (cat.).– Potter, J. (ed.): R. R. Staatliche Kunsthalle Baden-Baden. Baden-Baden 1993 (cat.).– Wontorra, B. (ed.): R. R. Fotografie 1956-1976. Kunstverein für die Rheinlande und Westfalen, Düsseldorf. Stuttgart 1991 (cat.)

**RYMAN Robert**
born **1930** Nashville (TN)
American painter. **1948/49** Trained as a teacher at Tennessee Polytechnic Institute in Cookville and **1949/50** at George Peabody College for Teachers in Nashville. **1950-1952** Served in the American Army. **1952** Settled in New York, where he became interested in painting. Worked until **1960** as a museum warden at the Museum of Modern Art, where he met the artists Flavin and LeWitt, both proponents of Minimal Art. **1961** Married the art critic L. Lippard. Between **1972** and **1982** took part in documenta 5 – 7 in Kassel. **1993** Important retrospective at the Tate Gallery, London. Since the early 50s Ryman, the concept artist, has painted almost nothing but square format monochrome pictures, seeking a way to reveal the creative process itself and the gradual unfolding of a work. From the 60s he became interested in the visual effects created by fixing his canvases to the wall with hooks.
CATALOGUE RAISONNE: Baker Sandbock, A. (ed.): R. R. Prints 1969-1993. New York 1993
MONOGRAPHS, CATALOGUES: Bois, Y.-A. and C. Sauer (ed.): S. R. Centre Georges Pompidou, Paris et al. Paris 1981 (cat.).– Frémont, J.: R. R. Le paradoxe absolu. Caen 1991.– Huber, C. (ed.): R. R. Kunsthalle Basel. Basel 1975 (cat.).– R. R. Paintings and Reliefs. INK, Hallen für internationale neue Kunst. Zurich 1980 (cat.).– R. R. Espace d'Art Contemporain. Paris 1992 (cat.).– Sauer, C. and U. Raussmüller (ed.): R. R. Hallen für Neue Kunst. Schaffhausen 1991 (cat.).– Spector, N. (ed.): R. R. Stedelijk Museum. Amsterdam 1974 (cat.).– Spector, N. (ed.): R. R. Whitechapel Art Gallery. London 1977 (cat.).– Storr, R. (ed.): R. R. Tate Gallery, London et al. London and New York 1993 (cat.).– Waldman, D. (ed.): R. R. Solomon R. Guggenheim Museum. New York 1972 (cat.)

**SAINT PHALLE Niki de**
**1930** Neuilly-sur-Seine (near Paris) – **2002** San Diego
French sculptress and painter. **1933** Moved to New York. **1951** Returned to France. **1956** First assemblages. Solo-exhibition in St. Gallen. From **1961** staged happenings

with her husband Jean Tinguely, and did *Shot Paintings*. Contact with the Nouveaux Réalistes in Paris. Participated in the exhibition "The Art of Assemblage" at the Museum of Modern Art, New York. **1964** Began to model Nanas, voluptuous, garishly coloured female figures. **1966** Installation of the giant, walk-through Nana figure *Hon* at the Moderna Museet, Stockholm. Design of further *Sculptural Houses*. **1967** Solo-exhibition at the Stedelijk Museum, Amsterdam. **1968** Participated in the exhibition "Dada, Surrealism and their Heritage" at the Museum of Modern Art, New York. **1976** Solo-exhibition at the Boymans-van Beuningen Museum, Rotterdam. **1979** Began construction of a sculptural park *Giardino dei Tarocchi* (Tarot Garden) near Florence. **1982** Created *La Fontaine Strawinsky*, a fountain in Paris, with Tinguely. **1988** Participated at the Venice Biennale. **1993** Solo-exhibition at the Musée d'Art Moderne de la Ville de Paris. The spectacular, monumental and garish character of de Saint Phalle's sculptures has much in common with Pop Art.
MONOGRAPHS, CATALOGUES: Boulez, P. (ed.): J. Tinguely and N. de S. P. La Fontaine Igor Strawinsky über dem I. R. C. A. M. Centre Georges Pompidou. Bern 1983.– Bourdon, D. (ed.): N. at Nassau. Nassau County Museum of Fine Arts. Roslyn (NY) 1987 (cat.).– Chenivesse, D. (ed.): N. de S. P. Das graphische Werk 1968-1980. Figuren. Ulmer Museum. Ulm 1980 (cat.).– Hering, K.-H. (ed.): N. de S. P. Werke 1962-1968. Düsseldorfer Kunstverein. Düsseldorf 1969 (cat.).– Hulten, P. et al. (ed.): N. de S. P. Centre Georges Pompidou. Paris 1980 (cat.).– Hulten, P. et al. (ed.): N. de S. P. Kunst- und Ausstellungshalle der Bundesrepublik Deutschland, Bonn et al. Stuttgart 1992 (cat.).– Hulten, P. (ed.): N. de S.-P. Tableaux éclatés. Musée d'Art Moderne de la Ville de Paris. Paris 1993 (cat.).– N. de S. P. Stedelijk Museum. Amsterdam 1967 (cat.).– N. de S. P. Retrospektive 1954-1980. Wilhelm Lehmbruck Museum. Duisburg 1980 (cat.).– N. de S. P. Moderna Museet. Stockholm 1981 (cat.).– Schulz-Hoffmann, C. (ed.): N. de S. P. Bilder, Figuren, Phantastische Gärten. Kunsthalle der Hypo-Kulturstiftung. Munich 1987 (cat.)

**SALGADO Sebastião Ribeiro**
born **1944** Aimoóres (Minas Gerais)
Brazilian photographer. **1964-1967** Studied economics at the University of São Paulo, graduating with a Master's degree in **1968**. From **1969-1971** wrote his doctoral thesis in Paris. **1971-1973** Worked for a coffee import company in London. **1973** First pieces of photojournalism. From **1979** member of the photographic agency Magnum in Paris. Photographic documentation of the living conditions of immigrant workers in European countries.
MONOGRAPHS, CATALOGUES: Buarque de Hollanda, C.: Terra by S. S. New York 1997.– Galeano, E. and F.

Ritchin: S. S. An Uncertain Grace. New York 1990

**SALLE David**
born **1952** Norman (OK)
American painter. Studied until **1975** at the California Institute of the Arts, Valencia. **1975** First solo-exhibition as part of "Project" in Cambridge (MA) and at the Claire Copley Gallery, Los Angeles. **1976** Solo-exhibition in the Foundation Corps de Garde, Groningen. **1981** Participated in the "Westkunst" exhibition in Cologne. **1982** Took part in documenta 7 in Kassel and in the exhibition "Zeitgeist" in Berlin. **1985** Participated in the Nouvelle Biennale de Paris. **1986** Solo-exhibition at the Whitney Museum of American Art, New York. Participated in the exhibition "Europa/Amerika" at the Museum Ludwig, Cologne. **1988** Retrospective at the Staatsgalerie Moderner Kunst, Munich, and at the Tel Aviv Museum of Art. **1994** Solo-exhibition at the Mary Boone Gallery, New York.
WRITINGS: Schjeldahl, P.: S. An Interview with D. S. New York 1987
MONOGRAPHS, CATALOGUES: Beeren, W. A. L. (ed.): D. S. Museum Boymans-van Beuningen. Rotterdam 1983 (cat.).– Busche, E. A. (ed.): D. S. Arbeiten auf Papier. 1974-1986. Museum am Ostwall, Dortmund et al. Dortmund 1986 (cat.).– Kardon, J. and L. Phillips (ed.): D. S. Institute of Contemporary Art, University of Pennsylvania, Pittsburgh et al. Pittsburgh 1986 (cat.).– Kögel, R.: D. S. Malerei. Ein kunstwissenschaftlicher Meta-Ansatz Hamburg 199..– Liebmann, L. (ed.): D. S. 1979-1994. New York 1994.– Power, K. and C. Schulz-Hoffmann (ed.): D. S. Staatsgalerie moderner kunst, Munich et al. Munich and Madrid 1988 (cat.).– Rosenblum, R. (ed.): D. S. Zurich 1986.– D. S. Whitney Museum of American Art. New York 1986 (cat.).– Whitney, D. (ed.): D. S. New York 1994

**SALOMON Erich**
**1886** Berlin – **1944** Auschwitz
German photographer. First studied law. Was a prisoner of war in France. **1918-1925** Worked as a photojournalist for Ullstein Verlag. **1927-1933** Reportages for the

*Berliner Illustrirte Zeitung, Time* and the *New York Tribune.* **1934** Fled to Holland, but was later arrested by the Nazis. **1971** Posthumously awarded the Erich Salomon Prize – the first time the prize had gone to a photojournalist. **1981** Retrospective at the Stedelijk Museum, Amsterdam. With his photographic documentation of great political events, Salomon laid the foundations of modern photojournalism.
MONOGRAPHS, CATALOGUES: Barents, E. and W. H. Roobol (ed.): Dr. E. S. 1886-1944. Aus dem Leben eines Fotografen. Munich 1981.– Forberg, G.: Die unbestechliche Kamera des Dr. E. S. Düsseldorf 1976.– Frecot, J. (ed.): E. S. Berlinische Galerie. Berlin 1986 (cat.).– Hassner, R. (ed.): E. S. Fotografiska Museet. Stockholm 1974 (cat.).– E. S. Berlinische Galerie. Berlin 1983 (cat.).– Vries, H. d. and P. Hunter-Salomon (ed.): E. S. Portrait of an Age. New York 1967

**SAMARAS Lucas**
born **1936** Kastoria
Greek-born American artist. **1948** Moved to the USA. **1955-1959** Studied art history at Rutger's University (NJ), and at Columbia University, New York. **1955** First solo-exhibition at Rutger's University. **1966** Retrospective at the Pace Gallery, New York. **1968 – 1977** Participated in documenta 4 – 6 in Kassel. **1969** Taught at Yale University, New Haven, and **1970/71** at Brooklyn College, New York. Solo-exhibition at the gallery Der Spiegel in Cologne. **1971** Retrospective at the Museum of Contemporary Art, Chicago. **1978** Trips to England and Greece. **1980** Participated at the Venice Biennale and **1983** in the exhibition "New Art" at the Tate Gallery, London. **1984, 1985** and **1987** Solo-exhibition at the Pace Gallery. Samaras' early works, furniture-like objects covered with thousands of needles, are closely related to Fluxus. In his later environments he uses mirrors to evoke the illusion of unlimited space.
WRITINGS: L. S.: S. Album, Autointerview, Autobiography, Utopolaroid. New York 1971
MONOGRAPHS, CATALOGUES: Alloway, L. (ed.): L. S. Selected Works 1960-1966. Pace Gallery. New York 1966 (cat.).– Glenn, C. and A. Glimcher (ed.): L. S. Phototransformations. University Art Museum. Long Beach 1975 (cat.).– Glenn, C. (ed.): L. S. Sketches, Drawings, Doodles and Plates. New York 1987.– Glimcher, A.: L. S.'s Photo-Transformations. New York 1975.– Idiana, G. (ed.): L. S. Chairs and Drawings. Pace Gallery. New York 1987 (cat.).– Levin, K.: L. S. New York 1974.– Lifson, B.: The Photographs of L. S. New York 1987.– McEvilley, T. et al. (ed.): L. S. Objects and Subjects 1969-1986. Denver Art Museum et al. New York 1988 (cat.).– L. S. Whitney Museum of American Art. New York 1973 (cat.).– L. S. Self 1961-1991. Yokohama Museum of Art. Yokohama 1991 (cat.).– Schjedahl, P. (ed.): S. Pastels. Denver Art Museum. Denver 1981 (cat.)

## SANDER August

**1876** Herford – **1964** Cologne
German photographer. **1890–1896** As a boy, worked on the dump at the Herford mine. **1896** Employed by the photographer G. Jung in Trier. **1898–1900** Worked here and there as a photographic assistant. Attended the Dresden Academy of Painting. **1901** Employee at the Photographic Art Institute Greiff in Linz on the Danube which he took over in **1902** together with F. Stuckenberg. In **1904** awarded a gold medal and special honours at an exhibition at the Palais des Beaux-Arts in Paris. **1910** Moved to Cologne. **1914** Took part in the exhibition of the Deutsche Werkbund. **1920** Had the idea of compiling an artistic documentary register of different types of people. **1929** Publication of *Antlitz der Zeit* (Face of our Time), a preview of the complete work *Menschen des 20. Jahrhunderts* (People of the 20th Century) containing about 550 photographs. **1934** *Antlitz der Zeit* taken out of circulation by the Nazis and the printing blocks destroyed. **1939** Found a safe place for his photographs and moved to Kuchhausen. **1944** Cologne apartment destroyed in a bombing raid. **1950** Exhibited at the first Photokina in Cologne. **1954** Participated in the exhibition "Family of Man" at the Museum of Modern Art in New York. **1960/61** Received the Federal Service Cross and the Cultural Prize of the German Photographic Society. **1962** Publication of his book of photographs *Deutschenspiegel*.
MONOGRAPHS, CATALOGUES: Hartz, J. v.: A. S. Millerton 1977 / A. S. Paris 1977.– Kramer, R. (ed.): A. S. Photographs of an Epoch. New York 1980.– Lange, S. (ed.): A. S. Visages d'une époque. Centre National de la Photographie. Paris 1995 (cat.).– Sachse, R. (ed.): A. S. Köln wie es war. Cologne 1988.– A. S. V fotografijach net nejasnych tenej! Pushkin Museum. Moscow 1994 (cat.).– Sander, G.: A. S. Leipzig 1982.– Sander, G. (ed.): A. S. In der Photographie gibt es keine ungeklärten Schatten! August-Sander Archiv. Berlin 1994 (cat.).– Schreier, C. (ed.): A. S. National Portrait Gallery. London 1997 (cat.).– Wilde, A. et al. (ed.): A. S. Die Reise nach Sardinien. Sprengel Museum. Hanover 1995 (cat.)

## SANTOMASO Giuseppe

**1907** Venice – **1990** Venice
Italian painter. Studied at the Venice Art Academy. **1928** First public exhibition. **1937** Travelled to Holland. From **1940** solo-exhibitions at the Rive Gauche gallery in Paris and in the Hanover Gallery, London. **1945** Publication of 27 of his drawings in P. Eluard's Anthology *Grand Air* by the Milanese gallery Santa Radegonda. **1947** Founder member of the group Fronte Nuovo delle Arti. **1952** First purely abstract painting. **1953** Intensive study of the paintings of Hans Hartung. **1954** Won first prize for painting at the Venice Biennale. San-

tomaso achieved a form of abstraction that never completely betrays its relation to the object. The lyrical, somewhat hermetic elements that appear in his paintings of the 50s are evidence of Hartung's influence.
CATALOGUES RAISONNES: Alfieri (ed.): S. Catalogo ragionato 1931-1974. Venice 1975.– Calderoni, F. (ed.): S. Opera grafica 1938-1975. Roma 1975.– G. S. Catalogue raisonné 1931-1974. Venice 1975
MONOGRAPHS, CATALOGUES: Apollonio, U.: G. S. Amriswil 1959.– Ballo, G. (ed.): S. Opere 1939-1982. Museo Correr, Venice. Milan 1982 (cat.).– Daminato, L. (ed.): S. Opere 1939-1986. Palazzo Reale. Milan 1986 (cat.).– Francastel, P.: S. Cicale e cattedrali. Amriswil 1962.– Messer, T. (ed.): S. Opere 1939-1986. Palazzo Reale. Milan 1986 (cat.).– Ponente, N. (ed.): S. Pitture. Venice 1968.– Rasekhschaffe-Aras, A. and M. Bärmann (ed.): S. Ravensburg 1988 (cat.).– Steingräber, E. and C. Schulz-Hoffmann (ed.): S. Staatsgalerie moderner Kunst. Munich 1979 (cat.).– Steingräber, E.: S. Langenhagen 1992.– Venturi, L.: S. Roma 1955

## SAURA Antonio

born **1930** Huesca
Spanish painter. Self-taught. **1943–1947** Began to paint during a long period of illness. **1950** First solo-exhibition in the book shop Libros de Zaragoza in Madrid. **1953–1955** Lived in Paris and had contact with the Surrealists. **1956** Returned to Madrid. **1957** Founded the group El Paso with Tàpies, Millarès and Canogar in Madrid. **1958** First *Imaginary Portraits*. Participated at the Venice Biennale. **1957–1977** Took part in documenta 2, 3 and 6 in Kassel. **1960** Participated in the exhibition "Spanish Painting" at the Museum of Modern Art, New York. Won the Guggenheim Award and **1966** the main prize for graphic reproductions at the Lugano Biennale. **1967** Lived in Paris until his expulsion from France in **1977**. **1979** Touring retrospective, starting at the Stedelijk Museum, Amsterdam. **1983** Led the committee "Artists of the World against Apartheid". **1985** Taught at Circulo de Bellas Artes, Madrid. **1987** Painted the ceiling of the new town hall in Huesca. **1990** Retrospective at the Centro de Arte Reina Sofía, Madrid, and at Lenbachhaus in Munich.

WRITINGS: A. S.: Libreta 1958-1980. Madrid 1982
CATALOGUES RAISONNES: Galfetti, M. (ed.): A. S. L'œuvre gravé 1958-1984. Paris 1985 / A. S. La obra grafica. Paris 1990.– Galfetti, M. (ed.): A. S. L'œuvre imprimé 1958-1984. Geneva 1985
MONOGRAPHS, CATALOGUES: Ayllon, J.: A. S. Barcelona 1969.– Chiappini, R. (ed.): A. S. Museo d'Arte Moderna della Città di Lugano, Villa Malpensata. Milan 1994 (cat.).– Circi-Pellicier, A. (ed.): A. S. Fundació Joan Miró, Barcelona et al. Barcelona 1980 (cat.).– Cohen, M. and T. Llorens (ed.): A. S. Peintures 1956-1985. Musée Rath, Geneva et al. Geneva 1989.– Cortanze, G. d. (ed.): A. S. Paris 1994.– Köb, E. (ed.): A. S. La quinta del sordo. Secession. Vienna 1989 (cat.).– Mason, R. M. (ed.): A. S. Musée d'Art et d'Histoire, Geneva 1989 (cat.) / A. S. Städtische Galerie im Lenbachhaus, Munich 1990 (cat.).– Oliver, G.: S. in Cuenca. Copenhagen 1983.– Vázque de Parga, A. (ed.): S. Desenari 1890-1990. Barcelona 1991 (cat.).– Sarduy, S.: A. S. Barcelona 1987.– A. S. Desenari. 1980-1990. Palau de la Virreina. Barcelona 1991 (cat.).– Söderberg, L. (ed.): A. S. Imagina 1956-1997. Malmö Konsthall. Malmö 1997 (cat.)

## SCHAD Christian

**1894** Miesbach – **1982** Stuttgart
German painter and experimental photographer. **1913** Studied at the Munich Academy. **1915** Participated in an exhibition of the New Munich Secession. **1915–1920** Lived in Zurich and Geneva. Participated in Dada events. **1919** First photograms entitled *Schadographien*. **1920–1927** Lived in Italy. **1925** Moved to Vienna where, in **1927**, he had his first solo-exhibition at the Galerie Würthle. **1929** Took part in the exhibition "Neue Sachlichkeit" at the Stedelijk Museum, Amsterdam. **1936** Participated in the exhibition "Fantastic Art, Dada, Surrealism" at the Museum of Modern Art, New York. **1942** Moved to Aschaffenburg and, in **1962**, to Keilheim. **1968** Participated in the exhibition "Dada-Surrealism and their Heritage" at the Museum of Modern Art. Major retrospectives: **1972** at the Palazzo Reale in Milan, **1980** at the Kunsthalle Berlin and **1997** at Lenbachhaus, Munich. Schad is best known for his invention of Schadographie, by which images of objects are produced on light-sensitive plates without the use of a camera.
WRITINGS: C. S. Mein Lebensweg. Galerie Würthle. Vienna 1926 (cat.)
CATALOGUES RAISONNES: Richter, M.-L. and T. Helmert-Corvey (ed.): C. S. Druckgraphiken und Schadographien in Einzelblättern und Mappenwerken 1913-1981. Herford et al. 1997.– Testori, G. (ed.): C. S. Werkverzeichnis 1920-1930. Galleria del Levante. Milan and Munich 1970 (cat.)
MONOGRAPHS, CATALOGUES: Bezzola, T. (ed.): C. S. Kunsthaus Zurich et al. Zurich 1997 (cat.).– Eberle, M. and H.

Bergius (ed.): C. S. Staatliche Kunsthalle Berlin. Berlin 1980 (cat.).– Gravenkamp, C.: Das Gesicht des 20. Jahrhunderts im Werk des Malers C. S. Kassel 1959.– Hartl, C. (ed.): C. S. 1894-1982. Oberhausmuseum. Passau 1989 (cat.).– Heesemann-Wilson, A.: C. S. Expressionist, Dadist und Maler der Neuen Sachlichkeit. Göttingen 1978.– Laszlo, C.: C. S. Basel 1972.– Osborn, M.: Der Maler C. S. Berlin 1927.– Richter, G. A. (ed.): C. S. Zeichnungen und Legenden. Rottach-Egern 1990 (cat.).– Schad, B. et al. (ed.): C. S. Die späten Jahre. 1942-1982. Galerie der Stadt Aschaffenburg et al. Aschaffenburg 1994 (cat.).– R. S. Schadographien 1918-1975. Von der Heydt-Museum. Wuppertal 1975 (cat.).– Tassi, R. (ed.): C. S. Palazzo Reale. Milan 1972 (cat.).– Testori, G.: C. S. Werke von 1920 bis 1930. Milan and Munich 1970

## SCHAPIRO Miriam

born **1923** Toronto
Canadian-born American painter and collage artist. Studied **1943–1949** at the University of Iowa, where she later met her husband, the painter P. Brach. Her abstract gestural paintings of the 50s developed into Hard-Edge painting with calmer, more orderly forms. In the 70s, the artist combined found objects and materials from the world of a housewife into collages, assemblages and paintings, calling this procedure *femmage*. **1971–1975** Collaboration with J. Chicago, as director of the Department of Feminist Art at the California Institute of Art in Valencia. Her works became connected with decorative Pattern-Art. In the 80s she took up figurative acrylic painting on the theme of dance.
WRITINGS: M. S.: Women and the Creative Process. Manchester 1974
MONOGRAPHS, CATALOGUES: Goma-Peterson, T. (ed.): M. S A Retrospective. College of Wooster Art Museum. Wooster (OH) 1980 (cat.).– M. S. Femmages 1971-1985. Brentwood Gallery. St. Louis 1985 (cat.).– M. S. Bernice Steinbaum Gallery. New York 1986

## SCHIELE Egon

**1890** Tulln (Lower Austria) – **1918** Vienna
Austrian painter and draughtsman. **1906–1909** Studied at the Vienna Academy. **1909** Co-founder of the Neukunstgruppe (New Artists' Group). Collaboration with the Vienna workshops. **1907** Met Klimt. **1911** Joined the artists' association Sema in Munich. **1912** Took part in the exhibition of the Blauer Reiter. Given a three-day sentence for disseminating pornographic drawings. **1914** Participated in the exhibition of the Werkbund in Cologne. **1915** Called up for military service. **1918** Died of Spanish influenza. Schiele's career as an artist, cut short by his untimely death, falls squarely within the period of Viennese Jugendstil. However, his works have marked Expressionist traits. He contorts his figures and selects daring perspectives and glowing

colours: colour, for him, being the most potent medium of expression.
WRITINGS: E. S.: Ich ewiges Kind. Gedichte. Vienna and Munich 1985
CATALOGUES RAISONNES: Kallir, O. (ed.): E. S. The Complete Works. London, New York, Paris and Cologne 1990.– Kallir, O. (ed.): E. S. Das druckgraphische Werk. Vienna 1970.– Leopold, R. (ed.): E. S. Gemälde, Aquarelle, Zeichnungen. Salzburg 1972/E. S. Paintings, Watercolours, Drawings. London 1973.– Malafarina, G. (ed.): Tout l'œuvre peint de S. Paris 1983
MONOGRAPHS, CATALOGUES: Comini, A.: E. S. London 1976.– Comini, A.: Nudes. E. S. New York 1995.– Comini, A.: E. S.'s Portraits. Berkeley 1990.– Fischer, W. G.: E. S. 1890-1918. Desire and Decay. Cologne 1995.– Fournier, J.-F.: E. S. La Décadence de Vienne 1890-1918. Paris 1992.– Kallir, J. (ed.): E. S. National Gallery, Washington et al. New York 1994 (cat.).– Knafo, D.: E. S. A Self in Creation. Rutherford 1993.– Kuchling, H.: E. S. und sein Kreis. Ramerding 1982.– Mitsch: E. S. 1890-1918. Salzburg 1974.– Mitsch, E.: E. S. Salzburg and Vienna 1987.– Mitsch, E.: The Art of E. S. Oxford 1989, San Francisco 1995.– Mitsch, E. (ed.): E. S. in der Albertina. Vienna 1990 (cat.).– Müller-Tamm, P. (ed.): E. S. Inszenierung und Identität. Cologne 1995.– Nebehay, C. M.: E. S. 1890-1918. Leben, Briefe, Gedichte. Salzburg and Vienna 1979.– Nebehay, C. M.: E. S. Leben und Werk. Salzburg and Vienna 1980.– Nebehay, C. M.: E. S. Von der Skizze zum Bild. Die Skizzenbücher. Vienna and Munich 1989.– Sabarsky, S. (ed.): E. S. Pinacoteca Capitolina, Roma. Milan 1984 (cat.).– Sabarsky, S. (ed.): E. S. Hamburger Kunsthalle. Hamburg 1985 (cat.).– Sabarsky, S. (ed.): E. S. New York 1985.– Sabarsky, S. (ed.): E. S. 1890-1918. A Centennial Retrospective. Los Angeles County Museum of Art. Nassau 1990 (cat.).– Schröder, K. A. and H. Szeemann (ed.): E. S. und seine Zeit. Sammlung Leopold. Kunsthaus Zurich et al. Munich 1989.– Schröder, K. A.: E. S. Eros und Passion. Munich 1995.– Steiner, R.: E. S. 1890-1918. The Midnight Soul of the Artist. Cologne 1991.– Thomas, K. (ed.): E. S. Die Sammlung Leopold, Wien. Cologne 1995 (cat.).– Walrod, S. T.: E. S. A Psychobiography. Ann Arbor (MI) 1980.– Werkner, P. (ed.): E. S. Art, Sexuality and Viennese Modernism. Palo Alto 1994.– Whitford, F.: E. S. London 1981.– Wilson, S.: E. S. Ithaca (NY) 1980

**SCHLEMMER Oskar**
**1888** Stuttgart – **1943** Baden-Baden
German painter, sculptor and stage designer. After an apprenticeship in an intarsia workshop, studied **1905-1909** at the School of Arts and Crafts and the Art Academy in Stuttgart. **1910** Lived in Berlin. **1912** Master classes under Hoelzel in Stuttgart. **1920** Invited to the Bauhaus in Weimar by Walter Gropius and appointed director of the workshop for mural paint-

ings and later for wood and stone sculpture. Became famous for his Constructivist designs for his *Triadic Ballet*, first performed in **1922** in Stuttgart, in which figures in costumes made up of basic geometric forms represent people in space. **1923** Took over the theatre workshop at the Bauhaus and, after moving to Dessau, set up an experimental theatre there. **1928-1930** Painted murals for the Folkwang Museum in Essen. **1929** Took up an appointment at the Breslau Academy. **1932** Professorship at the American School in Berlin, terminated in **1933** by the Nazis. **1938/39** Camouflaged military installations. **1940** Worked with Baumeister and Muche at the Wuppertal Institute of Painting Materials. **1942** Series of small-scale *Fensterbilder* (Window Paintings). Throughout his career, in all his various works, Schlemmer explored the relationships and effects of space, form, colour, sound, movement and light.
WRITINGS: Bärmann, M. (ed.): J. Bissier und O. S. Briefwechsel. St. Gallen 1988.– Hüneke, A. (ed.): O. S. Idealist der Form. Briefe, Tagebücher, Schriften 1912-1943. Leipzig 1990.– O. S.: Die Bühne am Bauhaus. Bauhausbuch. Munich 1925/The Theatre of the Bauhaus. Middletown (CT) 1961/Théâtre et abstraction. Paris 1978.– O. S.: Briefe und Tagebücher. Munich 1958, Stuttgart 1977.– Schlemmer, T. (ed.): The Letters and Diaries of O. S. Middletown (CT) 1972
CATALOGUES RAISONNES: Grohmann, W. and T. Schlemmer (ed.): Zeichnungen und Graphik. Œuvrekatalog. Stuttgart 1965, San Francisco 1982.– Hildebrandt, H. (ed.): O. S. Munich 1952.– Maur, K. v. (ed.): O. S. Monographie und Œuvrekatalog der Gemälde, Aquarelle, Pastelle und Plastiken. 2 vols. Munich 1979.– Schlemmer, T. (ed.): O. S. Zeichnungen und Graphik. Œuvrekatalog. Stuttgart 1965
MONOGRAPHS, CATALOGUES: Bender, B. et al. (ed.): O. S. Wand – Bild. Bild – Wand. Städtische Kunsthalle Mannheim: Mannheim 1988 (cat.).– Gauss, U. (ed.): O. S. Aquarelle. Staatsgalerie Stuttgart. Stuttgart 1988 (cat.).– Grohmann, W. and T. Schlemmer: O. S. Zeichnungen und Graphiken. Stuttgart 1965.– Herzogenrath, W.: O. S. Die Wandgestaltung der neuen Architektur. Munich 1973.– Hohl, R. (ed.): O. S. Die Fensterbilder. Kunstmuseum Basel. Frankfurt-on-Main 1990.– Kahn-Rossi, M. (ed.): O. S. Les Noces. Museo Cantonale d'Arte, Lugano. Milan 1988 (cat.).– Lehman, A. L. and B. Richardson (ed.): O. S. The Baltimore Museum of Art et al. Baltimore 1986 (cat.).– Maur, K. v.: O. S. Munich 1979.– Maur, K. v. (ed.): O. S. Staatsgalerie Stuttgart. Munich 1977, 1982 (cat.).– Maur, K. v. (ed.): O. S. Der Folkwang-Zyklus. Malerei um 1930. Staatsgalerie Stuttgart et al. Stuttgart 1993 (cat.).– Meyer-Ellinger, H. (ed.): O. S. 1888-1943. Jahrhunderthalle, Hoechst et al. Frankfurt-on-Main 1984 (cat.).– Scheper, D.: O. S. Das triadische Ballett und die Bauhaus-bühne. Berlin 1988.– Schlemmer, C. R. and U. J. (ed.): O. S. Tanz, Theater, Bühne. Kunstsammlung Nordrhein-Westfalen, Düsseldorf et al. Stuttgart 1994 (cat.).– O. S. Staatsgalerie Stuttgart et al. Stuttgart 1977 (cat.).– Svestka, J. et al. (ed.): O. S. Das Lackkabinett. Düsseldorfer Kunstverein. Düsseldorf 1987 (cat.)

**SCHLICHTER Rudolf**
**1890** Calw – **1955** Munich
German painter. **1904** Apprenticeship as an enamel painter in a factory in Pforzheim. **1907-1910** Attended the Stuttgart School of Arts and Crafts. **1910** Began studies at the Karlsruhe Academy. **1916** Called up for

military service, but prematurely dismissed for staging a hunger strike. **1919** Co-founder of the group Rih in Karlsruhe. Moved to Berlin, where he joined the Novembergruppe. **1920** Participated in the First International DADA Trade Fair. Worked as an illustrator for various publishers. **1925** Participated in the "Neue Sachlichkeit" exhibition at the Kunsthalle Mannheim. **1927** Solo-exhibition at the Neumann-Nierendorf gallery in Berlin. **1929** Took part in the "Neue Sachlichkeit" exhibition at the Stedelijk Museum in Amsterdam. **1931** Publication of his novel *Zwischenwelt*. **1932/33** Moved to Rottenburg am Neckar. Publication of his autobiography in two volumes. **1939** Confiscation of his works, classified as "degenerate" by the Nazis. **1939** Moved to Munich. **1942** Loss of his studio through a bombing raid. **1949** Publication of an article entitled *Das Abenteuer der Kunst* (The Adventure of Art). **1998** Major retrospective at Lenbachhaus, Munich.
WRITINGS: Heißerer, D. (ed.): R. S. Das Abenteuer der Kunst. Hamburg 1949, 1998.– Heißerer, D. (ed.): R. S. Die Verteidigung des Panoptikums. Autobiographische, zeit- und kunstkritische Schriften sowie Briefe 1930-1955. Berlin 1995.– Heißerer, D. (ed.): R. S. Drohende Katastrophe. Gedichte 1931-1936. Warmbronn 1997.– Heißerer, D. (ed.): R. S. und Ernst Jünger. Briefwechsel. Stuttgart 1997.– R. S.: Autobiographie. 2 vols. Hamburg 1932-1933, Berlin 1991.– R. S.: Das Abenteuer der Kunst. Hamburg 1949
MONOGRAPHS, CATALOGUES: Adriani, G. (ed.): R. S. Gemälde, Aquarelle, Zeichnungen. Kunsthalle Tübingen et al. Munich 1997 (cat.).– Grützmacher, C. (ed.): R. S. Das widerspenstige Fleisch. Berlin 1991.– Grützmacher, C. (ed.): R. S. Tönerne Füße. Berlin 1992.– Horn, G. et al. (ed.): R. S. 1890-1955. Staatliche Kunsthalle Berlin 1984 (cat.).– Metken, G.: R. S. Blinde Macht. Frankfurt-on-Main 1990.– R. S. Von der Heydt-Museum, Wuppertal et al. Munich 1997 (cat.).– Testori, G. (ed.): R. S. 1890-1955. Galleria del Levante. Milan 1970 (cat.)

**SCHMIDT-ROTTLUFF Karl**
(Karl Schmidt)
**1884** Rottluff (near Chemnitz) –
**1976** Berlin
German painter and graphic artist. **1901** Friendship with Heckel. **1905** Began to study architecture at the technical college in Dresden. Together with Bleyl, Kirchner and Heckel, founded the Brücke group. **1906** Brought Nolde into the group. **1907-1912** Spent the summers in Dangast. **1910** Abandoned Impressionist Valeur painting and restricted himself to pure colours. **1911** His gradual simplification of form and structure led to Cubist-style figures. **1912** Moved to Berlin; friendship with Feininger. Participated in the "Sonderbund" exhibition in Cologne. Travelled to Italy, Paris and Dalmatia. **1913** Brücke disbanded. **1915**

-**1918** Fought in Lithuania and Russia. **1918**-**1921** Joined the Arbeitskreis für Kunst and worked for the magazine *Die Aktion*. **1918-1943** Lived in Berlin, spending summers on the Baltic Sea. **1931-1933** Member of the Prussian Academy of Arts. **1937** 608 of his works declared "degenerate" by the Nazis and confiscated from German museums. **1943** Moved to Rottluff after the loss of his Berlin studio. **1946** Returned to Berlin where, from **1947-1954**, he was professor at the School of Fine Arts. Responsible for the founding of the Brücke-Museum in Berlin in **1964**. Schmidt-Rottluff's extensive œuvre includes not only paintings but also graphic works, including many woodcuts.
CATALOGUES RAISONNES: Grohmann, W.: K. S.-R. (mit Werkverzeichnis der Gemälde 1905-1954). Stuttgart 1956.– Rathenau, E. (ed.): K. S.-R. Das graphische Werk seit 1923. New York and Berlin 1964.– Schapire, R. (ed.): K. S.-R.'s graphisches Werk bis 1923. 2 vols. Berlin 1924, 1970, New York 1987.– K. S.-R. Zum 100. Geburtstag. Schleswig-Holsteinisches Landesmuseum. Schleswig 1984 (cat.).– K. S.-R. Gemälde und Aquarelle. Ausstellung zum 100. Geburtstag des Künstlers. Brücke-Museum. Berlin 1984 (cat.).– K. S.-R. Der Maler. Städtische Kunstsammlungen. Chemnitz 1993 (cat.)
MONOGRAPHS, CATALOGUES: Anna, S. (ed.): K. S.-R. Malerei und Grafik. Bestandskatalog der Städtischen Kunstsammlungen Chemnitz. Stuttgart 1993.– Brix, K.: K. S.-R. Leipzig and Munich 1972.– Grohmann, W.: K. S.-R. Stuttgart 1956.– Moeller, M. M. (ed.): K. S.-R. Aquarelle. Brücke-Museum, Berlin et al. Munich 1991 (cat.).– Moeller, M. M. and H.-W. Schmidt (ed.): K. S.-R. Der Maler. Städtische Kunsthalle Düsseldorf et al. Stuttgart 1992 (cat.).– Moeller, M. M. (ed.): K. S.-R. Tuschepinselzeichnungen. Galerie Jahrhunderthalle, Hoechst et al. Munich 1995 (cat.).– Moeller, M. M. (ed.): K. S.-R. Kunsthalle der Hypo-Kulturstiftung, Munich et al. Munich 1997 (cat.).– Reidemeister, L. (ed.): K. S.-R. Brücke-Museum. Berlin 1984 (cat.).– Schilling, J. and D. Blume (ed.): K. S.-R. Werke 1905-1961. Kunstverein Braunschweig. Brunswick 1979 (cat.).– Thiem, G.: K. S.-R. Aquarelle und Zeichnungen. Munich 1963.– Thiem, G. and A. Zweite (ed.): K. S.-R. Retrospektive. Städtische Galerie im Lenbachhaus, Munich et al. Munich 1989 (cat.).– Wietek, G.: S.-R. Graphik. Munich 1971.– Wietek, G.: K. S.-R. in Hamburg und Schleswig-Holstein. Neumünster 1984.– Wietek, G.: S.-R. Oldenburger Jahre 1907-1912. Mainz 1995

**SCHNABEL Julian**
born **1951** New York
American painter. **1965** Moved with his family from New York to Texas, where he studied from **1969-1972** at the University of Houston. **1973/74** Took part in the Independent Study Program run by the

Whitney Museum in New York. **1978** Travelled to Spain, Italy and Germany, where he exhibited for the first time at the December gallery in Düsseldorf. **1979** Achieved recognition in the art world with his solo-exhibition at the Mary Boone Gallery in New York. **1980** Participated at the Venice Biennale, **1981** in the exhibition "A New Spirit in Painting" at the Royal Academy in London and in the "Westkunst" exhibition in Cologne. **1982** Major solo-exhibition at the Stedelijk Museum, Amsterdam. **1983** First sculptures made of heterogeneous materials. **1985** Represented at the Nouvelle Biennale in Paris. **1987** Major retrospective at the Pompidou Centre in Paris and at the Whitney Museum of American Art in New York. **1987/88** *Recognitions*, projections of the names of saints and religious or clerical symbols, the tarpaulin of military vehicles onto projections. In his mostly large-format paintings Schnabel combines unusual grounds with found objects such as broken pieces of china or antlers.
WRITINGS: J. S.: C. V. J. Nicknames of Maitre D's and Other Excerpts from Life. New York 1987
MONOGRAPHS, CATALOGUES:
Ammann, J.-C. and M. Suter (ed.): J. S. Kunsthalle Basel et al. Basel 1981 (cat.).– Barzel, A. (ed.): J. S. Museo d'Arte Contemporaneo. Prato 1989 (cat.).– Blistène, B. et al. (ed.): J. S. Centre Georges Pompidou. Paris 1987 (cat.).– Collings, M. et al. (ed.): J. S. Paintings 1975-1986. Whitechapel Art Gallery, London et al. London 1986 (cat.).– Eccher, D. and N. Rosenthal (ed.): J. S. Bologna 1996 (cat.).– Eccher, D.: J. S. New York 1997.– Francis, R. (ed.): J. S. Tate Gallery. London 1982 (cat.).– Grevenstein, R. and A. v. (ed.): J. S. Stedelijk Museum. Amsterdam 1982.– Kuspit, D. B. (ed.): J. S. Waddington Galleries. London 1985 (cat.).– Landau, S. and G. Politi (ed.): J. S. Israel Museum. Jerusalem 1988 (cat.).– McEvilley, T. (ed.): J. S. Paintings 1975-1986. Whitechapel Art Gallery. London 1986 (cat.).– Ricard, R. and A. v. Grevenstein (ed.): J. S. Stedelijk Museum. Amsterdam 1982 (cat.).– J. S. CVJ. New York 1988 (cat.).– J. S. Musée d'Art Contemporain de Bordeaux. Bordeaux 1989 (cat.).– J. S. Sculpture 1987-1989. New York 1990.– J. S. Works on Paper 1976-1992. Matthew Marks Gallery. New York 1994 (cat.).– J. S. Galleria d'Arte Moderna. Bologna 1996 (cat.).– Syring, M. L. (ed.): J. S. Bilder 1975-1986. Städtische Kunsthalle Düsseldorf. Düsseldorf 1987 (cat.).– Zutter, J. et al. (ed.): J. S. Arbeiten auf Papier 1975-1988. Museum für Gegenwartskunst, Basel et al. Munich 1989 (cat.)

**SCHNEIDER Gérard**
**1898** Sainte-Croix (Waadt) – **1986** Paris
Swiss-born French painter. **1916/17** Studied at the Ecole des Arts Décoratifs in Neuchâtel. **1918** Moved to Paris, where he entered Cormon's studio at the Ecole des Beaux-Arts. **1920** Moved back to Switzerland. First exhibition in Neuchâtel. From

**1922** lived in Paris again. **1926** Participated in the Salon d'Automne and, in **1936**, in the Salon des Surindépendants. **1944** Became an abstract painter. **1946** Exhibited at the Salon des Réalités Nouvelles. **1947** First solo-exhibition at the Lydia Conti gallery in Paris. **1948** Participated at the Venice Biennale. **1955** Exhibition at the Palais des Beaux-Arts, Brussels. **1955** and **1959** participation in documenta 1 and 2 in Kassel. **1957** Prix des la Peinture Abstraite in Lissone. **1959** Won a prize at the International Art Exhibition in Tokyo, **1966** major prize at the Venice Biennale. **1970** Retrospective at the Galleria Civica d'Arte, Turin. **1983** Solo-exhibition at the Musée des Beaux-Arts, Neuchâtel.
MONOGRAPHS, CATALOGUES:
Dunoyer, J.-M. (ed.): G. S. Musée d'Art et d'Histoire de Neuchâtel. Neuchâtel 1983 (cat.).– Gindertaël, R. v.: G. S. Galleria Lorenzelli, Bergamo. Venice 1967 (cat.).– Orizet, J.: S. Peintures. Paris 1984.– Pobé, M.: S. Paris 1959.– Ragon, M.: G. S. Amriswil 1961.– G. S. Städtische Kunsthalle Düsseldorf. Düsseldorf 1962 (cat.)

**SCHÖFFER Nicolas**
**1912** Kalocsa – **1992** Paris
Hungarian-born French sculptor and object artist. Studied at the Budapest School of Arts. **1936** Moved to Paris and continued his studies at the Ecole des Beaux-Arts. **1948** First exhibition at the Galerie Breteau. Developed the theoretical basis for his later kinetic sculptures involving audiovisual effects such as reflected light, movement, sound and music. **1950** First public exhibition of kinetic sculptures at the Galerie des Deux-Iles, Paris. **1954** Constructed sound installations, with the engineer J. Bureau and the composer P. Henry. **1956** and **1964** Created *Cysp I*, the first cybernetic sculpture. **1959** and **1964** participation in documenta 2 and 3 in Kassel. **1961** Built a 52 metre-high kinetic tower in La Boverie Park, Liège. In the same year, participated at the São Paulo Biennale and, in **1964**, in documenta 3 in Kassel. **1965** First major presentations in America as part of the exhibition "Kinetic and Optic Art Today" at the Albright-Knox Art Gallery, Buffalo. **1968** Designed a cybernetic stage set for the Hamburg Opera. Major prize at the Venice Biennale. **1973** Constructed the automobile sculpture *Scam*. **1986** Awarded the Leonardo Prize in San Francisco. Schöffer, a leading exponent of Kinetic Art, developed a new art form out of a combination of sculpture, projected light, movement and film.
WRITINGS: N. S.: La Ville cybernétique. Paris 1969.– N. S.: Le nouvel esprit artistique. Paris 1970.– N. S.: Perturbation et Chronocratie. Paris 1978
MONOGRAPHS, CATALOGUES: Aknai, T.: N. S. Budapest 1975.– Cassou, J. et al.: N. S. Neuchâtel 1963.– Haas, A.: N. S. Paris 1975.– Habasque, G. and J. Cassou: N. S. Neuchâtel 1963.– Hoornart, P.: N. S. Liège 1985.– N. S. Kinetische Plastik. Licht,

Raum, Bewegung. Städtische Kunsthalle Düsseldorf. Düsseldorf 1968.– N. S. Musée d'Art Moderne. Paris 1974 (cat.).– Sers, P.: Entretiens avec N. S. Paris 1971

**SCHOLZ Georg**
**1890** Wolfenbüttel – **1945** Waldkirch
German painter. **1908** Studied painting under H. Thoma and W. Trübner at the regional school of art in Karlsruhe. **1914**–**1918** Military service. **1919** Joined the Communist Party. Together with Hubbuch and Schlichter founded the group Rih, that merged with the Novembergruppe. From **1920** realist paintings in Berlin Dada style. Became acquainted with Dix, Grosz and Kanoldt. From **1923** taught at the regional school of art in Karlsruhe. **1925/26** Contributed to *Simplicissimus*. **1925** Participated in the "Neue Sachlichkeit" exhibition at the Kunsthalle Mannheim. **1933** Dismissed from his teaching post. **1937** Confiscation of his paintings, classified as "degenerate art". **1975** Retrospective at the Badische Kunstverein, Karlsruhe. Scholz was one of the most energetic proponents of Critical Realism in the early 20s.
CATALOGUE RAISONNE: Bessel, B. (ed.): G. S. Das druckgraphische Werk. Künstlerhaus-Galerie. Karlsruhe 1982 (cat.)
MONOGRAPHS, CATALOGUES:
Holsten, S.: G. S. Karlsruhe 1990.– Leibinger, R. (ed.): G. S. 1890-1945. Waldkirch (cat.).– Mück, H.-D. (ed.): G. S. 1890-1945. Malerei, Zeichnung, Druckgraphik. Stuttgart 1991.– G. S. Ein Beitrag zur Diskussion realistischer Kunst. Badischer Kunstverein. Karlsruhe 1975 (cat.)

**SCHOONHOVEN Jan**
born **1914** Delft
Dutch painter and sculptor. **1930**–**1934** Studied at the Academy of Arts in The Hague, and from **1946** worked for the postal service there. **1949** First solo-exhibition at the Arts Centre in The Hague. In the early 50s, made contact with the Cobra artists. **1955** Started to make reliefs out of *papier mâché*. **1958** Co-founder of the Nederlandse informele Groep. **1960** Founded the group Nul together with Armando, Henk and Peeters. **1967** Won a second prize at the São Paulo Biennale and took part in the World Fair in Montreal.

**1968** Exhibited at documenta 4 in Kassel. **1972/73** Major solo-exhibitions at Abteiberg Museum, Mönchengladbach and the Hamburg Kunsthalle. **1977** Participated in documenta 6 in Kassel and, in **1981**, in the "Westkunst" exhibition, Cologne. **1984** David Röell Award. **1989** Retrospective at the Stedelijk Museum, Amsterdam. Schoonhoven's conception of objectivity, as manifested in his series of *papier mâché* relief works, aligns him with artists of the Zero group.
MONOGRAPHS, CATALOGUES: Bool, F. et al. (ed.): J. S. Retrospectief. Haags Gemeentemuseum et al. The Hague 1984 (cat.).– Imdahl, M. et al. (ed.): J. S. Retrospektiv. Essen et al. Essen 1995 (cat.).– Lemoine, S. (ed.): J. S. Retrospektive. Institut Néederlandais, Paris et al. Paris 1988 (cat.).– J. S. Zeichnungen 1940-1975. Städtische Kunsthalle Düsseldorf et al. Düsseldorf 1975 (cat.).– J. S. Städtisches Museum, Schloß Morsbroich. Leverkusen 1981 (cat.).– J. S. A Retrospective. Ritter Art Gallery. Boca Raton 1987 (cat.).– Wesseling, J.: S. Beeldend kunstenaar. s'-Gravenhage 1990

**SCHRIMPF Georg**
**1889** Munich – **1938** Berlin
German painter. Self-taught. **1902** Apprenticeship as a baker. **1915** Military service. Early discharge owing to illness. **1915**–**1918** Lived in Berlin and began to work as a freelance artist. **1918** Moved to Munich. **1921** Joined the New Secession. **1922** Went to Italy where he came in contact with the group Valori plastici. **1924** Publication of a short article on Schrimpf by Carrà. **1925** Participated in the "Neue Sachlichkeit" exhibition at the Kunsthalle Mannheim. From **1927** professor at the Munich School of Decorative Arts. **1929** Participated in the "Neue Sachlichkeit" exhibition at the Stedelijk Museum in Amsterdam. **1932** Spent a year in Rome. **1933**–**1938** Professor at the Teacher Training College for the Arts in Berlin. **1933** Participated in the exhibition "Neue Deutsche Romantik" at the Kestner Society in Hanover. **1937** Resigned voluntarily from his professorship.
CATALOGUE RAISONNE: Storch, W. (ed.): G. S. und Maria Uhden. Leben und Werk. Mit einem Werkverzeichnis. Museum Villa Stuck, Munich et al. Munich and Berlin 1985 (cat.)
MONOGRAPHS, CATALOGUES: Hartleb, R.: G. S. Dresden 1984.– Pförtner, M. G. S. Berlin 1940

**SCHULTZE Bernard**
born **1919** Schneidemühl
German painter and object artist. **1934**–**1936** and **1938/39** Studied at the Teacher Training College for the Arts in Berlin. **1936**–**1938** Studied at the Düsseldorf Academy. **1939**–**1944** Military Service. **1945** After losing all his early works in the war, began to paint in a Surrealist style. Went to France. **1947**–**1968** Lived in Frankfurt am

Main. **1951** Experimented with Tachisme. **1952** Founder member of the group Quadriga. From **1956** made reliefs by sticking torn photographs to the canvas. **1959**–**1977** Participation in documenta 2, 3 and 6 in Kassel. From **1961** *Migof* constructions and *Zungen* (tongue)-collages: three-dimensional works in which the sculptural elements project out of the surface of the painting far into the surrounding space. From **1964** repeated trips to New York. **1966** Solo-exhibition at the Kestner Society in Hanover. **1968** Moved to Cologne. **1976** Large-format oil paintings, watercolours and drawings. **1980** Major solo-exhibition at the Kunsthalle Düsseldorf. **1986** Lovis Corinth Prize. In the late 50s, as his Expressionist and Surrealist periods drew to a close, he turned to abstraction and L'art informel, and applied the principles of this approach to his sprawling sculptures that seem to reach out and capture space.
WRITINGS: B. S.: Migof-Reden, Zeichnungen und Texte. Stierstadt 1971.– B. S.: Im Sieb die gelbroten Körner. Heidelberg 1972.– B. S.: Sperriger Zaun aus Zeit. Düsseldorf 1976
CATALOGUES RAISONNES: Heuer, E. and W. Zemter (ed.): B. S. Die Druckgrafik. Märkisches Museum. Witten 1990 (cat.)
MONOGRAPHS, CATALOGUES: Honnef, K. (ed.): B. S. Papier-Arbeiten. 1946-1983. Rheinisches Landesmuseum, Bonn et al. Bonn 1984 (cat.).– Leo, P. (ed.): B. S. Städtisches Museum. Bochum 1970 (cat.).– Leppien, H. R. (ed.): B. S. Zerbrochene Verstecke. Hamburger Kunsthalle. Hamburg 1980 (cat.).– Romain, L. and R. Wedewer: B. S. Munich 1991.– Schmied, W. (ed.): B. S. Kestner-Gesellschaft. Hanover 1966 (cat.).– Roters, E. and C. Schneegans (ed.): B. S. Im Labyrinth. Werke von 1947-1990. Gemäldegalerie. Dresden 1991 (cat.).– Volkmann, B. and R.-F. Raddatz (ed.): B. S. Im Labyrinth. Werke von 1940-1980. Städtische Kunsthalle Düsseldorf et al. Berlin 1980 (cat.).– Wedewer, R. and P. W. Jansen (ed.): B. S. Städtisches Museum Leverkusen, Schloß Morsbroich. Leverkusen 1966 (cat.).– Weis, E. (ed.): B. S. Das große Format. Arbeiten aus dem letzten Jahrzehnt. Museum Ludwig, Cologne et al. Munich 1994 (cat.)

## SCHUMACHER Emil

born **1912** Hagen (Westphalia)
German painter. **1932**–**1935** Taking his parents' advice, studied graphic art at the Dortmund School of Arts and Crafts. First worked as a painter and lithographer. **1939**–**1945** Employed as a technical draughtsman in an armaments factory. After the war, inspired by the paintings of Rohlfs, he began to paint Cubist landscapes. However, after going to Paris in **1951**, where he met Wols, he developed a graffiti-like pictorial language related to L'art informel. He treated his colours as autonomous raw materials, and gave them depth by applying

the paint so thickly that it almost formed a relief. **1958**–**1960** Professor at the Hamburg School of Fine Arts. **1959**–**1977** Participation in documenta 2, 3 and 6 in Kassel. **1966**–**1977** Professor at the Karlsruhe Academy and **1967/68** at the Minneapolis School of Art. Made several tours of the USA and, from **1971**, spent summer and winter holidays in Ibiza. On one trip to Morocco, in **1983**, he painted the series *Maroc*. **1987** Awarded the Jörg Ratgeb Prize and made an honorary citizen of the City of Hagen. By incorporating materials such as lead, asphalt, sisal and paper, and altering the painting surface through hammering, Schumacher produced works of art that are half-paintings, half-reliefs.
WRITINGS: E. S.: Ein Buch mit sieben Siegeln. Heidelberg 1972
MONOGRAPHS, CATALOGUES: Bretschneider, K. (ed.): E. S. und das Materialbild. Hamburger Kunsthalle et al. Hamburg 1998 (cat.).– Brunner, R.: E. S. Das informelle Werk. Gießen 1992.– Christian, J. C. (ed.): E. S. Werke 1989-1992. Kunstsammlung Nordrhein-Westfalen. Düsseldorf 1992 (cat.).– Fehr, M. (ed.): E. S. Zeichen und Farbe. Cologne 1987.– Franzke, A. et al. (ed.): E. S. 2 vols. Museo d'Arte Moderna della Città di Lugano. Lugano 1994 (cat.).– Gallwitz, K. and R. Fuchs (ed.): E. S. Malerei 1936-1991. Zum 80. Geburtstag. Städtische Galerie im Städel, Frankfurt-on-Main et al. Frankfurt-on-Main 1992 (cat.).– Gsell, R. (ed.): E. S. Arbeiten auf Papier. Augsburger Kunstverein. Augsburg 1985 (cat.).– Güse, E.-G.: E. S. Djerba. Stuttgart 1983.– Güse, E.-G.: E. S. Die Gouachen der 80er Jahre. Munich 1992.– Herrmann, M. (ed.): E. S. Späte Bilder. Nationalgalerie. Berlin 1988 (cat.).– Jensen, J. C. et al. (ed.): E. S. Arbeiten auf Papier. Museumsberg Flensburg. Flensburg 1997 (cat.).– Holeczek, B. (ed.): E. S. Arbeiten auf Papier 1957-1982. Kunstmuseum Hanover et al. Hanover 1982 (cat.).– Klant, M. and C. Zuschlag: E. S. im Gespräch. "Der Erde näher als den Sternen". Stuttgart 1992.– Meyer zu Eissen, A. (ed.): E. S. Kunsthalle Bremen et al. Bremen 1984 (cat.).– Ruhrberg, K.: E. S. Zeichen und Farbe. Cologne 1987.– Schilling, J. (ed.): E. S. Gemälde und Werke auf Papier. 1946-1990. Kunstverein Wolksburg. Wolfsburg 1990 (cat.).– Schmalenbach, W. (ed.): E. S. Kunstverein für die Rheinlande und Westfalen. Düsseldorf 1971 (cat.).– Schmalenbach W.: E. S. Cologne 1981.– E. S. Arbeiten auf Papier. Städtisches Museum, Mülheim et al. Mülheim 1987 (cat.).– E. S. Malerei 1936-1991. Museum der bildenden Künste. Leipzig 1993 (cat.).– E. S. Pinacoteca Comunale, Casa Rusca, Locarno. Lugano 1994 (cat.).– E. S. Retrospektive. Haus der Kunst, Munich et al. Munich 1998 (cat.).– Sylvanus, E.: E. S. Recklinghausen 1959.– Wißmann, M.: E. S. Documenta III. Formlos und doch Form. Cologne 1992.– Wißmann, J. (ed.): E S. Ein Künstler und seine Stadt. Karl-Ernst-Osthaus-Museum. Hagen 1997 (cat.).

## SCHÜTTE Thomas

born **1954** Oldenburg
German sculptor. **1973**–**1981** Studied under Gerhard Richter at the Düsseldorf Academy. **1977** Created the *Mauer* (Wall) at the Düsseldorf Academy. **1979** Solo-exhibitions at the gallery La Vitrine in Paris and at the Arno Kohnen gallery in Düsseldorf. **1981** Participated in the "Westkunst" exhibition, Cologne. Solo-exhibition at the Konrad Fischer gallery, Düsseldorf. **1986** Solo-exhibition at Museum Haus Lange, Krefeld and participation in the Jehnisch Park sculpture exhibition, Hamburg. **1987** and **1997** took part in documenta 8 and 10 in Kassel. **1990** Solo-exhibition at the Kunsthalle Bern and **1992** at the Raum für Kunst, Hamburg. **1994** Solo-exhibitions at the Hamburg Kunsthalle and at the Württembergische Kunstverein, Stuttgart. Schütte's approach to art is that of a concept artist, except that he emphasises the quality of experience evoked by his modified spaces. His best-known works are architectural models that appear monumental.
WRITINGS: T. S.: Aufzeichnungen aus der 2. Reihe. Düsseldorf 1991
MONOGRAPHS, CATALOGUES: Barth, F. (ed.): T. S. Figur. Hamburger Kunsthalle, Hamburg et al. Hamburg 1994 (cat.).– Bußmann, K. and U. Wilmes (ed.): T. S. Obst und Gemüse. Westfälisches Landesmuseum. Münster 1987 (cat.).– Dürr, B. et al. (ed.): Hier 88 – T. S. Staatliche Kunsthalle Baden-Baden. Baden-Baden 1988 (cat.).– Glozer, L. and U. Look (ed.): T. S. Pläne I-XXX. Produzentengalerie. Hamburg 1985 (cat.).– Heynen, J. et al. (ed.): T. S. London 1998 (cat.).– Loock, U. et al. (ed.): T. S. Sieben Felder. Kunsthalle Bern et al. Bern 1990 (cat.).– Osterwold, T. (ed.): T. S. Kassel 1996 (cat.).– T. S. Musée d'Art Moderne de la Ville de Paris. Paris 1990 (cat.).– T. S. Skizzen und Gedichte. Kunstraum, Munich et al. Düsseldorf 1995 (cat.).– Wilmes, U. and T. S.: T. S. Portikus. Frankfurt-on-Main 1989 (cat.)

## SCHWARZKOGLER Rudolf

**1940** Vienna – **1969** Vienna
Austrian action artist. **1957**–**1961** Studied applied graphics at the Lehr- und Versuchsanstalt in Vienna. **1958** Became acquainted with Hermann Nitsch. **1964** Participated in

Otto Muehl's happening *Luftballkonzert*, and afterwards worked with him on the adaptation of the text *Sanitäre Kunst*. **1965** Active participant in Nitsch aktions. **1966** Participated in the action-concert for Al Hansen at the gallery next to St. Stephan's church in Vienna. Self-wounding and maiming actions, aimed at freeing himself from taboos connected with the body. **1967/68** Made films with Günter and Anni Brus and Muehl. First depressions and health problems. **1969** Killed himself by jumping out of the window of his apartment.
MONOGRAPHS, CATALOGUES: Badura-Triska, E. and H. Klocker: R. S. Leben und Werk. Museum Moderner Kunst Stiftung Ludwig, Vienna et al. Klagenfurt 1992 (cat.).– Nitsch, H. (ed.): R. S. Galerie nächst St. Stephan. Vienna 1970 (cat.).– Weiermair, P. and H. Nitsch (ed.): R. S. Galerie Krinzinger. Innsbruck 1976 (cat.)

## SCHWITTERS Kurt

**1887** Hanover – **1948** Ambleside
German artist. **1909**–**1914** Studied at the Dresden Academy and **1914** in Berlin. **1915** Returned to Hanover. **1918** First public exhibition at the gallery Der Sturm in Berlin. Worked on the magazine of the same name. **1919** Labelled his dadaist works *MERZ*. **1920** Met Arp and T. Tzara. Exhibition at the Société Anonyme in New York. **1921** First meetings with Hausmann and Höch. **1922** Participated in the Dada congress in Weimar. Acquaintanceship and collaboration with Doesburg. **1923**–**1932** Published the magazine *MERZ*. **1923** Spent the summer with Arp on the Island of Rügen. **1924** Started work on his first Merz building in his house in Hanover. **1924** Première of *Ursonate*. Exhibition at the Kestner Society, Hanover. **1932** Joined the group Abstraction-Création. **1933** Emigrated to Norway and began his second Merz building. **1940** Escaped to England, where he began his last Merz building in Ambleside. Among the Dadaists, Schwitters stood apart, his goal being to develop a new synthetic art form combining painting, sculpture and architecture. For a long time he was not accepted by the other Berlin Dadaists. In his Merz buildings, collages and assemblages he gave found objects new value by incorporating them into pictures.
WRITINGS: Hausmann, R and K. S.: Pin. Gießen 1986.– Lach, F. (ed.): K. S. Das literarische Werk. 5 vols. Cologne 1973-1981, 1998.– Nundel, E. (ed.): K. S. Briefe aus fünf Jahrzehnten. Frankfurt-on-Main 1975.– Rothenberg, J. and P. Joris (ed.): K. S. Poems, Performances, Pieces, Proses, Plays, Poetics. Philadelphia 1993
CATALOGUE RAISONNE: Schwitters, E. and I. Bodesohn-Vogel (ed.): K. S. Werkverzeichnis der Collagen, Assemblagen, Ölbilder, Aquarelle, Plastiken. 2 vols. Freren 1991.– S.-Archiv der Stadtbibliothek Hannover. Bestandsverzeichnis. Hanover 1986
MONOGRAPHS, CATALOGUES: Bailly, C.: K. S. Paris 1993.– Bazzoli, F.: K. S.

L'Art m'amuse beaucoup. Marseille 1991.–
Büchner, J. and N. Nobis (ed.): K. S.
1887-1948. Sprengel Museum, Hanover.
Berlin 1986 (cat.).– Dietrich, D.: The Col-
lages of K. S. Tradition and Innovation.
Cambridge 1993.– Elderfield, J. (ed.): K.
S. The Museum of Modern Art. New York
and London 1985, Düsseldorf 1987 (cat.).–
Elger, D.: K. S. Der Merzbau. Cologne
1984.– Erfurth, E. (ed.): Kalter Hund oder
Der Skandal um K. S. Ursonate. Obern-
burg 1993.– Gohr, S. and D. Elger (ed.):
K. S. Die späten Werke. Museum Ludwig.
Cologne 1985 (cat.).– Homayr, R.: Montage
als Kunstform. Opladen 1991.– Lach, F.:
Der Merzkünstler K. S. Cologne 1971.–
Lemoine, S. nd D. Semin (ed.): K. S.
Centre Georges Pompidou, Paris et al.
Paris 1994 (cat.).– Nobis, B.: K. S. und
die romantische Ironie. Alfter 1993.–
Nobis, B. et al. (ed.): K. S. IVAM Centro
Julio González, Valencia 1995 (cat.).–
Nündel, E.: K. S. in Selbstzeugnissen und
Bilddokumenten. Reinbek 1981.– Ratte-
meyer, V. and D. Helms (ed.): "Typogra-
phie kann unter Umständen Kunst sein" –
K. S. Typographie und Werbegestaltung.
Landesmuseum Wiesbaden et al. Wies-
baden 1990 (cat.).– Remerson, S.: K. S.
in England 1940-1948. London 1958.–
Schaub, G. (ed.): K. S. "Bürger und Idiot".
Berlin 1993.– Schmalenbach, W.: K. S.
Cologne 1967, Munich 1984, New York
1967, 1984.– Schreck, J. (ed.): K. S. Anna
Blume und andere Literatur und Grafik.
Berlin 1985.– Stadtmüller, K. (ed.): K. S.
in Norwegen. Hanover 1997.– Steinitz, K.
T.: K. S. Erinnerungen aus den Jahren
1918-1930. Zurich 1963.– Steinitz, K. T.: K.
S. A Portrait from Life. Berkeley 1968.–
Themerson, S.: K. S. in England 1940-1948.
London 1958.– Webster, G.: Kurt Merz
Schwitters. A Biographical Study. Cardiff
1997

**SEAMAN Bill**
born **1956** Kennet (MS)
American video artist. **1975-1977** Studied
at the Rhode Island School of Design in
Providence. **1979** Bachelor of Fine Arts at
San Francisco Art Institute. **1985** Master of
Science in Visual Studies at Massachusetts
Institute of Technology, Cambridge (MA)
where, from **1987**, he also held classes in
film and video. Grant from the National
Endowment for the Arts, Washington. **1992**
and **1995** special awards for Interactive Art
at Ars Electronica, Linz. **1994/95** Guest-
artist at ZKM in Karlsruhe. **1995** Interna-
tional Video Art Prize from Southwest
German Radio in Baden-Baden and the
ZKM, Karlsruhe. **1996** Awards at the
Videonale and the Federal Art and Exhibi-
tion Centre in Bonn. From **1966** professor
at the Department of Arts at the University
of Maryland, Baltimore. Up until **1983**
Seaman worked mostly as a perfomance
artist, but after that began to make videos
as well. His interactive installations of the
90s combine texts, static images and film
sequences.

**SEGAL Arthur**
**1875** Jassy (Romania) – **1944** London
Romanian painter. **1892** First studied in
Berlin then, in **1896**, transferred to Munich
where he attended Hoelzel's classes.
**1902/03** Study trips to Paris and Italy.
**1904** Returned to Berlin and participated
in the exhibition of the Berlin Secession.
**1914-1920** Moved to Ascona. Became
acquainted with Arp and Javlensky. **1916**
Exhibited and took part in Cabaret
Voltaire. **1920** Returned to Berlin and
became a member of the Novembergruppe.
**1925** Refused the offer of a teaching posi-
tion at the Bauhaus. **1932** Exhibited with
the Novembergruppe and in the "Juryfreie
Kunstschau" (Art Show without a Jury).
**1933** Emigrated to Mallorca. **1936** Moved
to London. Segal was a key figure in the
Zurich Dada movement and one of the
main organisers of Cabaret Voltaire.
WRITINGS: A. S.: Über das Licht in der
Malerei. Berlin 1924
MONOGRAPHS, CATALOGUES: Exner,
H.: A. S. Dresden 1985.– Friedman, M.
and G. W. J. Beal (ed.): G. S. Walker Art
Center. Minneapolis 1978 (cat.).– Herzo-
genrath, W. and P. Liska (ed.): A. S. 1875-
1944. Kölnischer Kunstverein et al. Berlin
1987 (cat.).– Nathanson, R.: A Collection
of Woodcuts by A. S. London 1972

**SEGAL George**
born **1924** New York
American sculptor. **1940** Moved with his
family to South Brunswick (NJ). **1941/42**
Attended the Cooper Union of Art and
Architecture in New York. **1942-1946**
Trained as an art teacher and studied phi-
losophy and literature at Rutgers University
in New Brunswick (NJ). **1947-1949** Con-
tinued his studies at Pratt Institute of
Design in Brooklyn and New York Univer-

sity. **1953** Friendship with Kaprow. From
**1955** taught at Highland Park Community
Center. **1956** First solo-exhibition at the
Hansa Gallery, New York. **1957/58** Staged
happenings with Oldenburg and Kaprow.
**1960** Began work on plaster-casts of life-
size human figures and environments. **1963**
Solo-exhibition at the Galerie Sonnabend,
Paris. **1964** Taught at Hunter College. **1968**
and **1972** participated in documenta 4 and
5 in Kassel. Solo-exhibition at the Museum
of Contemporary Art, Chicago. **1971/72**
Retrospectives in European cities. **1978**
Major retrospective at the Walker Art
Center, Minneapolis. **1981/82** Tours and
exhibitions in China and Japan. **1988** Par-
ticipated at the Venice Biennale. Segal
places his anonymous white plaster figures
in realistic settings, giving the impression
that they have been turned to stone while
going about their daily business.
MONOGRAPHS, CATALOGUES: Barrio-
Garay, J. L. (ed.): G. S. Environments.
Philadelphia Institute of Contemporary
Art. Philadelphia 1976 (cat.).– Finkeldey,
B.: G. S. Situationen. Kunst und Alltag.
Frankfurt-on-Main 1990.– Friedman, M.
and G. W. J. Beal (ed.): G. S. Sculptures.
Walker Art Center. Minneapolis 1978
(cat.).– Hunter, S. and D. Hawthorne: G.
S. Paris 1988, New York 1988.– Kreyten-
berg, G.: G. S. Ruth in Her Kitchen. Stutt-
gart 1970.– Marck, J. v. d.: G. S. New York
1975, 1979.– Price, M. (ed.): G. S. Modern
Art Museum of Fort Worth. Fort Worth
1990 (cat.).– G. S. Kunsthaus Zürich.
Zurich 1971 (cat.).– G. S. Städtische Galerie
im Lenbachaus, Munich et al. Munich 1972
(cat.).– G. S. Museum Boymans-van
Beuningen. Rotterdam 1972 (cat.).– Seitz,
W. C.: S. London and New York 1972,
Stuttgart 1972.– Teuber, D.: G. S. Wege zur
Körperüberformung. Frankfurt-on-Main
and Bern 1987.– Tuchman, P.: G. S. New
York 1983, Munich 1984.– Viatte, G. (ed.):
G. S. Centre National d'Art Contemporain.
Paris 1972 (cat.)

**SEGALL Lasar**
**1889** Vilnius – **1957** São Paulo
Lithuanian painter. **1906-1909** Studied at
the Berlin School of Arts and the Dresden
Academy. **1909** Exhibited with the Berlin
Secession. **1910** Came to know Grosz, Dix
and Schwitters. **1911-1913** Trips to Holland
and Brazil. **1914** Internment in Meißen.
**1917** Went to Vilnius. **1919** Co-founder of
the Dresden Secession. **1920** Solo-exhibi-
tion at the Museum Folkwang in Hagen
and **1922** at the Kupferstichkabinett
attached to Leipzig Museum. **1923** Moved
to São Paulo. **1926** Exhibition at the Kunst-
kabinett Stuttgart. Lived **1931** in Paris, **1934**
in Rom and **1943** in New York. **1954** Major
Retrospective in São Paulo. Segall originally
tended to paint expressive figures, and
during World War II he did several paint-
ings depicting the persecution of the Jews.
In the course of his career he progressed
from Expressionism to geometric abstrac-
tion.

WRITINGS: L. S. Antologia de textos
nacionais sobre a obra e o artista. Rio de
Janeiro 1982
MONOGRAPHS, CATALOGUES: Bardi,
P. M.: L. S. Milan 1959.– Beccari, V. D'H.:
L. S. e o modernismo paulista. Sao Paulo
1984.– Fierens, P.: L. S. Paris 1938.– From-
mold, E.: L. S. Milan 1975.– Gullar, F. et al.
(ed.): L. S. Museu de Arte Moderna. Rio de
Janeiro 1967.– Horn, G. and V. d'Horta
Beccari (ed.): L. S. 1891-1957. Malerei,
Zeichnungen, Druckgrafik, Skulptur. Staat-
liche Kunsthalle Berlin. Berlin 1990 (cat.).–
Levi, L.: Os temas judáicos de L. S. São
Paulo 1979.– Naves, R. and M. Mattos
Araújo (ed.): O desenho de L. S. Museu
Lasar Segall. São Paulo 1991 (cat.)

**SEIWERT Franz Wilhelm**
**1894** Cologne – **1933** Cologne
German painter. **1910-1914** Attended the
Cologne School of Arts and Crafts. **1917**
Contributed to the magazine Die Aktion.
**1919** Participated in Dada events, but
never exhibited with the Dadaists. Joined
the artists' group Stupid. **1923** First major
solo-exhibition at the Kunstverein in
Cologne. **1924** Publication of his treatise
Technik, Produktionsorganisation, Kultur
and die neue Gesellschaft (Technology,
Production Management, Culture and the
New Society). **1929** Published the magazine
a–z for the Gruppe progressiver Künstler
(Group of Progressive Artists). Participated
in the exhibition "asb (architectuur,
schilderwerk, beeldhouwwerk)" at the
Stedelijk Museum, Amsterdam. **1930** Took
part in the exhibition "Socialistische kunst
heden" at the Stedelijk Museum. **1931/32**
Helped to set up the Kunstgewerbe-
museum (Museum of Arts and Crafts) in
Cologne. **1933** Glass mosaic representing
the life of the working classes destroyed by
the Nazis. Though formally influenced by
Cubism and Dada, Seiwert's paintings
mainly reflect his Marxist view of the
world, showing the relationships of workers
to operating systems and to each other in
an ideal, technological society.
WRITINGS: Bohnen, U. and D. Backes:
Der Schritt, der einmal getan wurde, wird
nicht zurückgenommen. F.-W. S. Schriften.
Berlin 1978
CATALOGUE RAISONNE: Bohnen, U.
(ed.): F.-W. S. 1894-1933. Leben und Werk.
Werkverzeichnis. Kölnischer Kunstverein.
Cologne 1978 (cat.)
MONOGRAPHS, CATALOGUES:
Bohnen, U. (ed.): F. W. S. 1894-1933.
Brunswick 1978.– Jatho, C. O.: F. W. S.
Recklinghausen 1964

**SEKINE Nobuo**
born **1942** Imiya
Japanese sculptor. **1964-1968** Studied
painting at the School of Arts in Tama, and
took additional courses in sculpture from
**1967** in Tokyo. **1965** First solo-exhibition at
the Tokyo Gallery. **1970** Participated at the
Venice Biennale. **1972** Commission for a

sculpture for the town hall in Saitama. **1976** Various works for the sculpture garden of the Louisiana Museum in Humlebæk, Denmark. From **1980** flat reliefs in steel. Since **1987** he has been working on *Phase Conceptions*, a series of works incorporating painterly and sculptural elements. Sekine combines natural materials such as sponges, water and mud with steel or sculpted paving stones, in an attempt to discover and reveal their material and structural properties.
MONOGRAPHS, CATALOGUES: Sculpture of Scenery. Works of N. S and Environment. Art Studio. Tokyo 1987.– N. S. Louisiana Museum. Humblebæk 1978 (cat.)

**SERAPHINE de Senlis**
(Séraphine Louis)
**1864** Assy – **1934** Senlis
French naïve painter. Spent her youth working as a shepherdess, and later entered domestic service in Senlis. **1912** Her artistic talent was discovered by Wilhelm Uhde. Throughout her hardworking but sheltered life, she painted flowers, leaves and fruits. These paintings in which human figures are linked to nature in a bizarre, surreal fashion are not representations of any particular natural order but rather the fantastic products of a heavenly dream. **1927** First exhibition at the Galerie Quatre Chemins in Paris. **1934** Died, mentally deranged, in a home for the aged in Senlis.
MONOGRAPHS, CATALOGUES: Gunther, T. M. (ed.): La Réalité intérieure. S. de Senlis et quelques peintres autodidactes. Musée d'Art et d'archéologie. Senlis 1989 (cat.).– S. L. Galerie de France. Paris 1945 (cat.).– S. L. Ancienne Abbaye Saint-Vincent. Senlis 1972 (cat.).– Vircondelet, A.: S. L. Paris 1986

**SERRA Richard**
born **1939** San Francisco
American sculptor. **1957–1961** Studied at the University of California in Berkeley and in Santa Barbara (CA). **1964** Completed his studies at Yale University, New Haven (CT) where he came in contact with Albers. **1964/65** Fulbright scholarship to Paris. Encountered Arte Povera. **1966**

Visited Florence. First solo-exhibition at the Galleria La Salita in Rome. Moved to New York. **1968** Produced his *Splashing Series*: examples of Process Art in which molten lead is flung into the corners of a room. Made 16 mm films of everyday occurences and encounters. **1969** Solo-exhibition at the Castelli Warehouse, New York. From the 70s onwards produced monumental open-air sculptures out of steel plates that seem to intersect their surroundings. **1972–1987** Participated in documenta 5 – 8 in Kassel. **1975** Awarded the Skowhegan Medal for Sculpture. **1980** Participated at the Venice Biennale and, **1982** and **1987**, in documenta 7 and 8 in Kassel. **1983** Major retrospective at the Pompidou Centre in Paris, **1986** at the Museum of Modern Art, New York and **1990** at the Stedelijk Van Abbe Museum, Eindhoven. In Serra's labile, precariously balanced sculptural configurations of steel, sheer weight – a basic material property – becomes the central binding element of the work.
WRITINGS: R. S.: Ecrits et entretiens 1970-1989. Paris 1990 / R. S.: The Hours of the Day. Schriften und Interviews 1970-1989. 2 vols. Kunsthaus Zürich. Bern 1990 (cat.).– R. S.: Writings, Interviews. Chicago 1994.– Weyergraf, C. (ed.): R. S. Interviews etc. 1970-1980. Hudson River Museum. Yonkers (NY) 1980 (cat.)
CATALOGUES RAISONNES: Breitenbach, S. (ed.): R. S. Das druckgraphische Werk 1972-1988. Berlin 1989.– Güse, E.-G. (ed.): R. S. Westfälisches Landesmuseum, Münster et al. Stuttgart 1987, New York 1988 (cat.).– Janssen, H. (ed.): R. S. Zeichnungen 1969-1990. Bern 1990
MONOGRAPHS, CATALOGUES: Berg, K. v. d.: Der leibhafte Raum. Das Terminal von R. S. in Bochum. Stuttgart 1995.– Bois, Y.-A. and R. E. Krauss (ed.): R. S. Centre Georges Pompidou. Paris 1983 (cat.).– Brockhaus, C. et al. (ed.): R. S. Props. Wilhelm Lehmbruck Museum. Duisburg 1994 (cat.).– Buskirk, M.: R. S. Intersection. New York 1996.– Galerie m (ed.): R. S. Neue Skulpturen in Europa 1977-1985. Bochum 1985.– Krauss, R. E. and L. Rosenstock (ed.): R. S. Sculpture. The Museum of Modern Art. New York 1986, 1988 (cat.).– Krempel, U. et al. (ed.): R. S. Running Arcs, Weight and Measure, Drawings. Kunstsammlung Nordrhein-Westfalen. Düsseldorf 1993 (cat.).– Pacquement, A.: R. S. Paris 1993.– Reinartz, D.: R. S. La Mormaire. New York 1996.– Rosenstock, L. (ed.): R. S. Sculpture. The Museum of Modern Art. New York 1986 (cat.).– Rouse, Y. (ed.): R. S. Museo Nacional Centro de Arte Reina Sofía. Madrid 1992 (cat.).– Schwandner, M. (ed.): R. S. Intersection Basel. Düsseldorf 1996.– R. S. Drawings 1969-1990. Bonnefantenmuseum. Maastricht 1990 (cat.).– R. S. Weight and Measure. Tate Gallery, London et al. London and Seattle 1992 (cat.).– Weyergraf, C. et al. (ed.): R. S. Arbeiten 66-77. Kunsthalle Tübingen et al. Tübingen 1978 (cat.).– Weyergraf-Serra, C. and M. Buskirk (ed.): The Destruction of Titled Arc. Cambridge (MA) 1991

**SERUSIER Paul**
**1864** Paris – **1927** Morlaix
French painter and theoretician. **1888** Assistant at the Académie Julian in Paris. Met Gauguin in Pont-Aven and learnt about Synthetism. Introduced Gauguin to Denis, Bonnard and Vuillard. **1889** Organised the group of Symbolist artists, the Nabis. Visited Gauguin and, like him, painted Breton peasant women and landscapes. **1891** Under the influence of J.

Verkade, a fellow-member of the Nabis, his ideas began to be permeated with elements of mysticism. **1892** Long stay in Pont-Aven. **1893** Went to Italy with Bernard. **1893–1896** Worked at the Lugné-Poe Theatre. **1897** Visited Verkade for the first time at the Benedictine monastery of Beuron in Germany. **1914–1927** Went back to work in Brittany. The influence of his role model Gauguin and his love of Japanese woodcuts find expression in Sérusier's blocks of colour and linear outlines.
WRITINGS: P. S.: ABC de la peinture. Suivi d'une correspondance inédite. Paris 1921,1950
CATALOGUE RAISONNE: Guicheteau, M. and P. H. Boutaric (ed.): P. S. 2 vols. Paris 1976-1989
MONOGRAPHS, CATALOGUES: Boyle-Turner, C.: P. S. Diss. Ann Arbor (MI) 1983.– Denis, M.: P. S. Sa Vie, son œuvre. Paris 1942.– Guicheteau, M.: P. S. Paris 1976.– Guicheteau, M.: P. S. Pontoise 1989.– Masson, H.: P. S. De Pont-Aven à Châteauneuf-du-Faou. Saint-Brieuc 1991.– P. S. Musée des Jacobins. Morlaix 1987 (cat.).– P. S. et la Bretagne. Musée de Pont-Aven. Pont-Aven 1991 (cat.)

**SERVRANCKX Victor**
**1897** Dieghem – **1965** Vilvorde
Belgian painter. **1912–1917** Studied at the Académie des Beaux-Arts in Brussels. **1917** First solo-exhibition at the Galerie Giroux in Brussels. From **1932** professor at the Ecole des Arts Industriels et Décoratifs in Bruxelles. **1920** Joined the group of Paris artists L'Effort moderne, promoted by L. Rosenberg. **1925** Influence of Mondrian and Moholy-Nagy on his work. **1926** Represented at the exhibition of the Société Anonyme in America. **1947** Retrospective at the Palais des Beaux-Arts, Brussels. Servranckx was one of Belgium's first abstract painters. Originally influenced by the Futurist machine aesthetic, he later tended toward Surrealism and finally practised strictly formal Abstraction.
MONOGRAPHS, CATALOGUES: Bilcke, M: S. Antwerp 1959, Brussels 1964.– Hommage à S. Galerie Contemporaine. Brussels 1957 (cat.).– V. S. Musée d'Ixelles. Brussels 1965 (cat.).– V. S. en de abstracte kunst. Koninklijke Musea voor Schone Kunsten van België. Brussels 1989 (cat.)

**SEURAT Georges**
**1859** Paris – **1891** Paris
French painter and theoretician. **1878/79** Studied at the Ecole des Beaux-Arts in Paris; read many treatises on colour theory. **1880** Military Service. **1883** First large work, an outdoor scene painted according to a new colour-splitting method termed Divisionism or Pointillism. **1884** Rejected by the official Salon. Came to know Signac and, together with him and other artists, founded the Société des Artistes Indépendants who held their own Salon. **1885** Painted works on the island of La Grande Jatte, in Paris and at Grancamp on the coast of Normandy. **1886** *La Grand Jatte* caused a sensation at the VIII Impressionist exhibition. Exhibited with Pissarro and Signac in Nantes. Met the theoretician and art critic C. Henry and made contact with the Symbolists and Anarchists. **1887** Participated in the exhibition of the Les XX group in Brussels. **1888** Painted at Port-en-Bessin, **1889** on the beach at Crotoy and **1890** in Gravelines, where he wrote down his theories of painting. Died of diphtheria. Seurat's colour theories and scientific approach to painting had a profound effect on modern painting and theoretical developments in 20th century art.
WRITINGS: Seurat, P.: Notes sur Delacroix. Caen 1987.– G. S.: Correspondance, témoignages, notes inédites, critiques. Paris 1991
CATALOGUES RAISONNES: Chastel, A. (ed.): L'opera completa di S. Milan 1972.– Dorra, H. and J. Rewald (ed.): S. L'œuvre peint, biographie et catalogue critique. Paris 1959.– Grenier, G. (ed.): S. Catalogo completo dei dipinti. Florence 1990.– Haucke, C.-M. d. (ed.): S. et son œuvre. 2 vols. Paris 1961.– Kahn, G. (ed.): Dessins. 2 vols. Paris 1920.– Minervino, F. (ed.): Das Gesamtwerk des S. Lucerne 1972 / Tout l'œuvre peint de S. Paris 1973.– Zimmermann, M. F.: S. Sein Werk und die kunsthistorische Debatte seiner Zeit. Weinheim 1991 / S. His Complete Works. San Francisco 1991

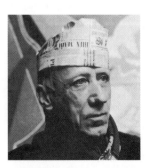

**SEVERINI Gino**
**1883** Cortona – **1966** Paris
Italian painter. **1899** Went to Rome, where he attended evening classes at the Villa

Medici. **1901** After meeting Balla and Boccioni he decided to devote himself to art. From **1906** lived in Paris, where he encountered the paintings of Seurat and met Modigliani. Signed the *Technical Manifesto of Painting* issued by the Futurists on 11 February **1910**. Produced his first paintings of dancers and cabarets during this period. **1912** Took part in Futurist exhibitions in Paris, London and Berlin and organised exhibitions for the Milan Futurists in Paris. **1915-1921** Cubist period: numerous still lifes with musical instruments. **1924-1935** Carried out several commissions for mosaics and murals. **1950** Important prize at the Venice Biennale. Severini combined divisionist principles of composition with a cubo-futurist approach. He was chiefly concerned with conveying a sense of movement and the connection between events, separated in time but linked in the mind.
WRITINGS: G. S.: Du cubisme au classicisme. Paris 1921.– G. S.: Tempo de "l'effort moderne". La vita di un pittore. Florence 1968.– G. S.: Dal cubismo al classicismo e altri saggi sulla divina proporzione e sul numero d'oro. Florence 1972.– G. S.: La vita di un pittore. Milan 1946, 1983/The Life of a Painter. The Autobiography of G. S. Princeton (NJ) 1995.– G. S.: Ecrits sur l'art. Paris 1987.– G. S.: Lezioni sul mosaico. Ravenna 1988
CATALOGUES RAISONNES: Fonti, D. (ed.): G. S. Catalogo ragionato. Milan 1988.– Meloni, F. (ed.): Tutta l' opera grafica. Reggio Emilia 1982
MONOGRAPHS, CATALOGUES: Barilli, R. (ed.): G. S. (1883-1966). Palazzo Pitti, Florence. Milan 1983 (cat.).– Benzi, F. (ed.): G. S. Affreschi, mosaici, decorazioni, monumentali 1921-1941. Galleria Arco Farnese. Roma 1992 (cat.).– Dorfles, G. and P. L. Siena, P. L. (ed.): G. S. Castel Mareccio, Bolzano. Milan 1987 (cat.).– Eco, U. et al. (ed.): G. S. dal 1916 al 1936. Palazzo Cuttica. Alessandria 1987 (cat.).– Fagiolo dell'Arco, M. (ed.): G. S. Prima e dopo l'opera. Documenti, opere ed imagini. Palazzo Casali, Cortona. Milan 1983 (cat.).– Hanson, A. C. (ed.): S. Futurista 1912-1917. New Haven (CT) et al. 1995 (cat.).– Mascherpa, G. (ed.): S. e il mosaico. Ravenna 1985 (cat.).– Pacini, P.: G. S. Florence 1966.– Pacini, P.: S. 1913. Prato 1977.– Ruggeri, G.: Il tempo di G. S. Bologna 1981.– G. S. Musée National d'Art Moderne. Paris 1967 (cat.).– Venturi, L.: G. S. Roma 1961.– Vescovo, M. (ed.): G. S. La regola, la maschera, il sacro. Bologna 1993

## SEYMOUR David

**1911** Warsaw – **1956** Suez Canal
Polish-born American photographer. From **1933** worked as a freelance photographer in Paris. **1936-1938** Documented the Spanish Civil War. **1939** Reportage on Spanish refugees being shipped to Mexico. Emigrated to the USA and volunteered for military service in the American army. Photoseries on postwar Germany and the founding of the State of Israel. **1947** Together with Capa, Cartier-Bresson and others, founded the photographic agency Magnum, and was ist president from **1954 -1956.** Seymour became famous for his moving pictures of neglected, starving and crippled children. He was killed while covering the Suez Canal crisis.
MONOGRAPHS, CATALOGUES: Capa, C. and B. Karia (ed.): D. S. Chim. 1911-1956. New York and London 1974.– Cartier-Bresson, H. et al. (ed.): D. S. 1911-1956. New York and London 1974.– Fárová, A. (ed.): D. S. New York 1967.– Friedberg, J.: D. S.-Chim. Prague 1966

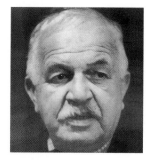

## SHAHN Ben

**1898** Kowno (Lithuania) – **1969** New York
Lithuanian-born American painter and photographer. **1906** Moved to New York. **1913-1917** Trained as a lithographer. **1919-1922** Studied biology. **1922** Attended the National Academy of Design, New York. **1924/25** and **1927-1929** Toured North Africa and Europe. **1929** Inspired through his friendship with Evans to take up photography. **1930** Solo-exhibition at the Downtown Gallery, New York. **1931/32** Completed the series *Sacco and Vanzetti*. **1932** Assisted Rivera with murals for the Rockefeller Center. Solo-exhibition at the Harvard Society for Contemporary Art in Cambridge (MA). **1947** Taught at the Museum of Fine Arts, Boston. Solo-exhibition at the Museum of Modern Art, New York. **1954** Participated at the Venice Biennale. **1956** Professorship at Harvard University. **1959** and **1964** participation in documenta 2 and 3 in Kassel. **1960** Retrospective at the Museum of Modern Art, New York, and **1962** at the Kunsthalle Baden-Baden. In that he used his art to speak out against social and political injustice, Shahn can be regarded as an exponent of social realism.
WRITINGS: Pohl, F. K.: B. S. with B. S.'s Writings. San Francisco 1993.– B. S.: The Biography of a Painting. Cambridge (MA) 1956, New York 1966.– B. S.: The Shape of Content. Cambridge (MA) 1957, 1963
CATALOGUES RAISONNES: Prescott, K. W. (ed.): The Complete Graphic Works of B. S. New York 1973.– Soby, J. T. (ed.): B. S. Catalogue Raisonné 2 vols. New York 1963
MONOGRAPHS, CATALOGUES: Bentivoglio, M.: B. S. Roma 1963.– Bryson Shahn, B.: B. S. New York 1972.– Morse, J. D. (ed.): B. S. London and New York 1972.– Pohl, F. K.: B. S. New Deal Artist in a Cold War Climate. 1947-1954. Austin 1989.– Pratt, D. (ed.): The Expanded Eye of B. S. Cambridge 1975.– Rodman, S.: Portrait of the Artist as an American: B. S. New York 1951.– Shan, B.: B. S. New York 1972.– B. S. Prefectural Museum of Arts. Hiroshima 1970 (cat.).– Soby, J. T. (ed.): B. S. His Graphic Art. New York 1963 / B. S. Grafik. Frankfurt-on-Main 1963.– Soby, J. T.: B. S. Malerei Frankfurt-on-Main 1964.– Weiss, M. R. (ed.): B. S. Photographer. An Album from the Thirties. New York 1973

## SHAIKHET Arkadi

**1898** Nikolajev – **1959** Moscow
Soviet photojournalist. **1918** Moved to Moscow. **1922** Worked as a retoucher for a portrait photographer. From **1924** worked as a photojournalist for *Rabotschaja* and *Oronek* and other organisations. Member of the Union of Russian Proletarian Photojournalists (ROPF). **1931** Together with M. Alpert and S. Tules produced the photodocumentary *24 Hours in the Life of the Filppov Family*, potraying a day in the life of a metal worker. **1928** Received a first

prize for works displayed at the exhibition "10 Years of Soviet Photography". During World War II, took photographs at the front. Co-founder of Soviet photojournalism.

## SHAW Jeffrey

born **1944** Melbourne
Australian action and multimedia artist. **1958-1964** Studied architecture and history of art at the University of Melbourne and **1965/66** sculpture at the Accademia di Brera in Milan and at St. Martin's School of Art in London. **1987** Presented the video-installation *Heavens Gate* at the Felix Meritis gallery in Amsterdam. **1989** Taught at the Academy in Rotterdam and **1990** at the Rietveld Academy in Amsterdam. From **1991** director of the Institute for Visual Media at ZKM in Karlsruhe. **1992** Presentation of his *Virtual Museum* at Ars Electronica in Linz. Until **1995** professor at the Karlsruhe School of Design. Shaw uses digital media such as computers and beam projectors in an attempt to involve the public in the creation and modification of a work. Their reactions then become a constituent part of the artwork.
MONOGRAPHS, CATALOGUES: J. S. Going to the Heart of the Center of the Garden of Delights. De Vleeshal. Middelburg 1986 (cat.).– Weibel, P. u. H. Klotz (ed.): J. S. A User's Manuel – Eine Gebrauchsanweisung. Vom Expanded Cinema zur Virtuellen Realität. ZKM Karlsruhe. Stuttgart 1997 (cat.)

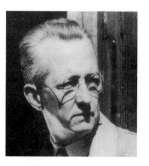

## SHEELER Charles

**1883** Philadelphia – **1965** Dobbs Ferry (NY)
American painter and photographer. **1902-1906** Studied at Pennsylvania Academy of Fine Arts in Philadelphia. **1904/05** Trip to Europe. **1907** First solo-exhibition in Philadelphia. **1908/09** Long stays in Italy and Paris. Came to know the Cubists and Fauves. **1912** First professional work as a photographer. **1913** Participated in the Armory Show in New York. **1918** Moved to New York. **1920** Worked on films with Strand. From **1923** photographed for *Vogue*. **1927** Photo-documentary of the Ford plants in Michigan. **1929** Photoseries of Chartres Cathedral. **1933** Moved to Connecticut. Participated at the Biennale of

American Art at the Whitney Museum, New York. **1939** Solo-exhibition at the Museum of Modern Art, New York. **1959** A stroke put an end to his artistic career. Sheeler's activities as a photographer and painter influenced and enhanced one another. Architecture was his central theme.
MONOGRAPHS, CATALOGUES: Dochterman, L.: The Stylistc Development of the Work of C. S. Diss. The University of Iowa. Iowa City 1963.– Fillin-Yeh, S.: C. S. and the Machine Age. Diss. New York 1981, Ann Arbor (MI) 1983.– Fillin-Yeh, S. (ed.): C. S. American Interiors. Yale University Art Gallery. New Haven (CT) 1987 (cat.).– Friedman, M. et al. (ed.): C. S. Smithsonian Institution. Washington 1968 (cat.).– Friedman, M. (ed.): C. S. Paintings, Drawings, Photographs. New York 1975.– Lucic, K.: C. S. and the Cult of the Machine. London and Cambridge (MA) 1991.– Rourke, C.: C. S. Artist in the American Tradition. New York 1938, 1969.– C. S. Smithsonian Institution, Washington et al. Washington 1962.– C. S. The Photographs. Museum of Fine Arts. Boston 1988 (cat.).– Troyen, C. and E. E. Hirshler (ed.): C. S. 2 vols. Museum of Fine Arts, Boston et al. New York 1987 (cat.)

## SHERMAN Cindy

born **1954** Glen Ridge (NJ)
American artist. **1972-1975** Studied art at the State University of New York, Buffalo. **1975** Photoseries *Cutouts*. **1976** First Solo-exhibition at the Hallwals Gallery. **1977** Moved with her friend Robert Longo to New York, where she made her first untitled film stills. **1980** Colour photographs with backscreen projections. Solo-exhibition at Metro-Pictures, New York. **1982** Solo-exhibition at the Stedelijk Museum in Amsterdam. Participated in documenta 7 in Kassel and at the Venice Biennale. **1983** Received a Guggenheim grant. **1984-1986** Touring retrospective organised by the Akron Art Museum (OH). **1989** Awarded the Skowhegan Medal for Photography. Participated in the exhibition "Bilderstreit" in Cologne. **1989/90** Worked on *History Portraits* in Rome. **1991** Solo-exhibition at the Kunsthalle Basel. **1997** Made her first film *Office Killer*. Most of Cindy Sherman's photographs are pictures of herself, transformed and integrated into typical styles and images of the mass media.
WRITINGS: C. S. im Gespräch mit W. Dickhoff. Cologne 1995
MONOGRAPHS, CATALOGUES: Barendt, E. (ed.): C. S. Stedelijk Museum, Amsterdam. Munich 1982 (cat.).– Barendt, E. and P. Schjeldahl (ed.): C. S. Whitney Museum of American Art. New York 1987, Munich 1987.– Cathcart, L. (ed.): C. S. Photographs. Contemporary Arts Museum. Houston 1985 (cat.).– Cruz, A. et al. (ed.): C. S. Museum of Contemporary Art, Chicago et al. Los Angeles and London 1997 (cat.).– Felix, Z. and M. Schwandner (ed.): C. S. Photoarbeiten 1975-1995. Deich-

torhallen. Hamburg 1995 (cat.).– Foster, H. et al. (ed.): C. S. Museum Boymans-van Beuningen, Rotterdam et al. Rotterdam 1996 (cat.).– Gravel, B. v.: C. S. New York 1996.– Kellein, T. (ed.): C. S. Kunsthalle Basel et al. Stuttgart 1991 (cat.).– Krauss, R. and N. Bryson (ed.): C. S. 1979-1993. New York 1993, Munich 1994.– Meneguzzo, M.: C. S. Milan 1990.– Schjedahl, P.: C. S. New York 1984.– Schjedahl, P. and L. Phillips (ed.): C. S. Whitney Museum of American Art. New York 1987 (cat.).– Schneider, C.: C. S. History Portraits. Die Wiedergeburt des Gemäldes nach dem Ende der Malerei. Munich 1995.– C. S. Staatliche Kunsthalle Baden-Baden. Baden-Baden 1997 (cat.)

## SIEVERDING Katharina
born **1945** Prague
German artist. **1949** Moved to Castrop-Rauxel. **1962** Studied at the Hamburg School of Fine Arts, and **1967–1974** at the Düsseldorf Academy under T. Otto. **1969** Masterclasses with Beuys. From **1969** concentrated on photography and film. **1972–1982** Participated in documenta 5 – 7 in Kassel. **1976** DAAD scholarship to New York. **1977** Solo-exhibition at the Museum Folkwang, Essen. From **1975** large-format photography. **1980** Solo-exhibition at the Mattildenhöhe exhibition centre in Darmstadt. Sieverding's photography focuses on social and political issues such as role conflicts between men and women and questions of identity.
MONOGRAPHS, CATALOGUES: Crone, R. et al. (ed.): S. Bonner Kunstverein. Bonn 1992 (cat.).– Fuchs, R. et al. (ed.): K. S. Kunstsammlung Nordrhein-Westfalen, Düsseldorf et al. Cologne 1997 (cat.).– Inboden, G. and R. Schmitz (ed.): K. S. Biennale di Venezia 1997. Venice 1997 (cat.).– Schneider, A. and K. S.: K. S. Kristallisationsbilder. Staatliche Museen, Neue Nationalgalerie. Berlin 1992 (cat.).– K. S. Städtisches Museum Abteiberg. Mönchengladbach 1984 (cat.).– K. S. Kunstverein Bonn et al. Stuttgart 1992 (cat.).– K. S. Städtische Galerie. Erlangen 1993 (cat.).– Solomon-Godeau, A. (ed.): K. S. Eine Installation. Museum Ostdeutsche Galerie. Regensburg 1993 (cat.)

## SIGNAC Paul
**1863** Paris – **1935** Paris
French painter. Studied for a short while at Bing's Académie libre. **1884** Co-founder of the Société des Artistes Indépendants. Became friends with Seurat, and adopted his divisionist method of painting. **1886** Participated in the VIII Impressionist exhibition. Represented by Durand-Ruel in New York and exhibited with Seurat and Pissarro in Nantes. **1887** Travelled with Seurat to Brussels and to the Mediterranean. **1889** Visited van Gogh in Arles. Illustrated the theoretical works of C. Henry and was politically aligned with the Anarchists. His harbour scenes and sea

paintings, in oils and watercolours, are like mosaics made up of tiny squares of pure, brilliant colour. **1893** Bought a house in Saint-Tropez that became the favourite seaside retreat of many modern painters. **1896** First trip to Holland. **1899** Published his theoretical treatise on Neo-impressionism, *D'Eugène Delacroix au néo-impressionnisme*. **1908** Elected president of the Indépendants. Like his friend Seurat, Signac was an artist whose method of painting and theoretical writings were fundamental to Neo-Impressionism.
WRITINGS: P. S.: D'Eugène Delacroix au néo-impressionnisme. Paris 1899, 1987.– P. S.: Jongkind. Paris 1927
CATALOGUES RAISONNES: Cachin, F. (ed.): P. S. Catalogue raisonné (in preparation).– Kornfeld, E. W. and P. A. Wick (ed.): Catalogue raisonné de l'œuvre gravé et lithographié de P. S. Bern 1974
MONOGRAPHS, CATALOGUES: Cachin, F. P. S. Milan 1970, Paris 1971, Greenwich (CT) 1971.– Lemoyne de Forges, M. T.: Catalogue de l'exposition du centenaire de P. S. Musée National du Louvre. Paris 1963 (cat.).– Monery, J.-P. (ed.): S. et Saint-Tropez. Musée de l'Annonciade, Saint-Tropez et al. Saint-Tropez 1992 (cat.).– Ratcliff, F.: P. S. and Color in Neo-Impressionism. New York 1992.– P. S. Musée National d'Art Moderne. Paris 1951 (cat.).– P. S. und die Befreiung der Farbe in Europa. Westfälisches Landesmuseum, Münster et al. Münster 1996 (cat.).– P. S. La Libération des couleurs. Musée de Grenoble. Paris 1997 (cat.)

## ŠIMA Josef
**1891** Jaroměř – **1971** Paris
Czech painter. **1911–1914** Studied at the Academy of Art in Prague under J. Preisler, and later at the Vienna Academy. **1921** Moved to Paris. Member of the group Devětsil and founder-member, together with Lecomte, Daumal and Reneville, of Group du Grand Jeu. **1923** First solo-exhibition at the gallery Topič in Prague. From **1925** paintings influenced by Surrealism and geometric abstraction. Around **1930** became interested in mythological themes. **1959** Participation in documenta 2 in Kassel. **1968** Retrospective at the Musée d'Art Moderne in Paris, **1974** at the Kunstverein Bochum and **1992** at the Musée

d'Art Moderne, Paris. Sima experimented with a variety of painting styles in the course of his career. In Czechoslovakia he was celebrated as the "Painter of Things Imaginary". His late works from the mid-50s onwards are mostly geometric compositions with pronounced light-dark contrasts.
MONOGRAPHS, CATALOGUES: Leymarie, J. et al. (ed.): S. Musée National d'Art Moderne. Paris 1968 (cat.).– Linhartová, V.: J., ses amis, ses contemporains. Brussels 1974.– Machalick_, J.: J. S. Prague 1991.– Munck, J. (ed.): S. Le grand jeu. Musée d'Art Moderne. Paris 1992 (cat.).– Peyré, Y.: Les Leçons de la lumière. Caen 1992.– S. et Le Grand Jeu. Musée d'Art Moderne de la Ville de Paris et al. Paris 1992 (cat.).– Smejkal, F. J. S. Prague 1988, Paris 1992.– Spielmann, P. (ed.): J. S. Neue Galerie am Landesmuseum Joanneum, Graz. Bochum 1974 (cat.).– Starobinski, J. (ed.): S. œuvres récentes. Galerie le Point cardinal. Paris 1971 (cat.)

## SIMONDS Charles
born **1945** New York
American object artist. **1963–1969** Studied at the University of California in Berkeley and Rutgers University in New Brunswick (NJ). **1969–1971** Employed as a teacher. From **1970** sculptural works on walls of buildings on Lower East Side, New York. **1971** *Landscape Body Dwelling*: an example of Body Art, in which the naked, mud-covered body of the artist is presented as a derelict landscape. This action led on to a series of portable models of ruins that became his *Pompeii Complex*. **1970–1974** Worked on various film projects and carried out actions. **1976** Publication of his book *Three Peoples*. **1977** Participation in documenta 6 in Kassel. **1994** Exhibition at the Fundació la Caixa in Barcelona. Simond's attempts to symbolically visualize cultural and historical developments and social decline are in some respects related the works of the Spurensicherer (trace- and clue-finding artists).
WRITINGS: C.S. Three Peoples. Genoa 1975
MONOGRAPHS, CATALOGUES: Abadie, D. and G. Celant (ed.): C. S. Galerie Nationale du Jeu de Paume, Paris et al. Paris 1994 (cat.).– Neff, J. H. (ed.): C. S. Circles and Towers Growing. Museum of Contemporary Art, Chicago et al. Chicago 1982 (cat.).– Lascaut, G.: S. Paris, New York and Zurich 1986.– Molderings, H. (ed.): C. S. Schwebende Städte und andere Architekturen. Westfälischer Kunstverein. Münster 1978 (cat.).– Sauquet, S. (ed.): C. S. Fundació Caixa de Pensiones. Barcelona 1994 (cat.).– C. S. Albright-Knox Art Gallery. Buffalo 1977 (cat.).– C. S. Circles and Towers Growing. Museum Ludwig, Cologne et al. Cologne 1979.– C. S. Galerie Maegt Lelong. Paris 1986 (cat.)

## SINGIER Gustave
**1909** Warneton – **1984** Paris
Belgian-born French painter. **1919** Moved

to Paris where he trained as an interior decorator. **1936** His meeting with C. Walch stimulated him to take up abstract painting. **1945** Founded the Salon de Mai. **1946** Joint-exhibition with Le Moal and Manessier at the Galerie Drouin, Paris. First tapestry design. **1949** Solo-exhibition at the Galerie Billiet-Caputo, Paris. **1951–1954** Taught at the Académie Ranson. **1955** and **1959** participation in documenta 1 and 2 in Kassel. **1957** Solo-exhibition at the Kestner Society, Hanover. From **1967** professor at the Ecole Nationale des Beaux-Arts, Paris. **1973** Solo-exhibition at the Musée des Beaux-Arts in Caen. **1992** Retrospective at the Centre Noiroit in Arras. Singier's simplified abstract forms and warm, glowing colours have strong similarities to Manessier's paintings.
CATALOGUE RAISONNE: Schmücking, R. (ed.): G. S. Das graphische Werk. Brunswick 1958
MONOGRAPHS, CATALOGUES: Charbonier, G.: S. Paris 1957.– Lescure, J. (ed.): S. Musée des Beaux-Arts. Caen 1973 (cat.).– Lescure, J.: G. S. Paris 1988.– G. S. Städtisches Museum. Wuppertal 1957 (cat.)

## SIQUEIROS David Alfaro
**1886** San Rosalía de Camargo – **1974** Mexico City
Mexican painter. **1911–1913** Studied at the San Carlos Art Academy in Mexico City. **1919** Received a scholarship enabling him to work in Paris and Barcelona for three years. Friendship with Rivera. **1924** Painted frescoes in the Escuela Nacional Preparatoria. **1930** Banished to Tasco for political reasons and in **1932** officially exiled. Designed a mural for the Plaza Art Center in Los Angeles. **1934** Spent a year in New York. **1935** Organised a workshop, with pupils including Pollock. **1937** Took part in the Spanish Civil War. **1944** Founded the Centro Realista de Arte Moderna. **1950** Frescoes for the Palacio de Bellas Artes. **1955** Visits to Poland and the Soviet Union. **1962** Sentenced to eight years' imprisonment but granted a reprieve in **1964**. From **1964–1969** worked on a monumental fresco entitled *The March of Humanity*, for which he was awarded the Mexican National Prize for Art. Along with Rivera and Orozco, Siqueiros is regarded as one of the great Mexican fresco painters.

WRITINGS: D. A. S.: Esculto-pintura: Cuarta etapa del muralismo en México. New York 1968.– D. A. S.: L'Art et la révolution. Paris 1973 / Art and Revolution. London 1975.– D. A. S.: Me llamaban el Coronelazo. Mexico City 1977 / Man nannte mich den "Großen Oberst". Erinnerungen. Berlin 1988.– Tibol, R. (ed.): Textos de D. A. S. Mexico City 1974 / D. A. S. Der neue mexikanische Realismus. Reden und Schriften zur Kunst. Dresden 1975
MONOGRAPHS, CATALOGUES: Arenal de Siqueiros et al. (ed.): Vida y obra de d. A. S.: Juicios criticos. Mexico City 1975.– De Micheli, M.: S. New York 1968.– Folgarait, L.: So Far from Heaven. D. A. S.'s "The March of Humanity" and Mexican Revolutionary Politics. Cambridge (MA) 1987.– Grigulevic, I. R.: S. Moscow 1980.– Rochfort, D.: The Development of a Revolutionary Public Mural Art in the Work of D. A. S. Diss. London 1986.– Rodríguez, A.: S. Mexico City 1974.– Semenov, O. S.: D. A. S. Moscow 1980.– Stein, P.: S. His Life and Works. New York 1994.– Tibol, R.: S.: Introductor de realidades. Mexico City 1961 / D. A. S. Dresden 1966.– White, D. A.: S. Encino 1990

**SIRONI Mario**
**1885** Sassari (Sardinia) – **1961** Milan
Italian painter. **1900** Moved to Rome. **1905** Began to study mathematics but stopped after one year. Came to know Severini and Boccioni, and entered the studio of Balla. **1914** Participated in the international Futurist exhibition in Rome. **1915** Became an official member of the Futurists. **1915**–**1918** Signed up for military service. **1918** Settled in Milan where he worked as an art critic. Sironi's paintings display a close affinity to Pittura metafisica. **1919** Participated in the Futurist exhibition at the Palazzo Cova, Milan. **1922** Founder-member of the Novecento Italiano group. **1926** and **1929** organised two Novecento exhibitions. **1935**–**1940** Worked on murals for the Turin Triennale and for the University of Rome. After World War II, designed stage sets and took up easel painting again. **1956** Honorary membership of the Accademia di San Luca. Sironi's paintings bridge three of the great art movements of his time, Futurism, Pittura metafisica and Neo-Classicism.
WRITINGS: Camesasca, E. (ed.): M. S. Scritti editi e inediti. Milan 1980
CATALOGUES RAISONNES: Bellonzi, F. (ed.): Catalogue raisonné de l'œuvre gravé. Milan 1985.– Benzi, F. and A. S. (ed.): S. illustratore. Catalogo ragionato. Roma 1988
MONOGRAPHS, CATALOGUES: Bartolini, S.: M. S. Reggio Emilia 1976.– Bellonzi, F.: S. Milan 1985.– Benzi, F. (ed.): M. S. Astrazione e materia. Galleria Arco Farnese. Roma 1989 (cat.).– Benzi, F. (ed.): M. S. 1885-1961. Galleria Nazionale d'Arte Moderna, Roma. Milan 1993 (cat.).– Bucci, M. and C. Bartoletti (ed.): M. S. per il teatro. Gabinetto Disegni e Stampe degli

Uffizi. Florence 1991 (cat.).– Gian Ferrari, C. (ed.): S. 1885-1961. Palazzo Reale. Milan 1985 (cat.).– Harten, J. and J. Poetter (ed.): M. S. 1885-1961. Städtische Kunsthalle Düsseldorf et al. Cologne 1988 (cat.).– Penelope, M. (ed.): S. Opere 1902-1960. Padiglione dell'Artigianato Sardo. Sassari 1985 (cat.).– Penelope, M.: S. Dal Futurismo al Dopoguerra. Roma 1990.– Pica, A.: M. S. pittore. Milan 1955, 1962 / M. S. Painter. London 1955.– Sartoris, A.: M. S. Il mito dell' architettura. Padiglione d'Arte Contemporanea. Milan 1990 (cat.).– Traversi, G.: M. S. Disegni. Milan 1968

**SLEVOGT Max**
**1868** Landshut – **1932** Neukastel
German painter and graphic artist. **1884**–**1890** Studied at the Munich Academy of Fine Arts under J. Herterich and W. Diez. Strongly influenced by W. Leibl and W. Trübner. **1889** Went to Paris and studied French Impressionism at the Académie Julian. **1890** Study trip to Italy. **1893** Joined the Munich Secession and the Freie Vereinigung (Association of Free Painters). From **1896** contributed to the magazine *Simplizissimus*. **1900** Went to Paris for the World Fair. **1901** Stayed in Frankfurt am Main, where he did his 200 paintings. From **1901** lived in Berlin and concentrated on portrait painting. Directed a master class at the Academy. **1914** Travelled to Egypt and painted landscapes in a new light, under the blazing sun. **1915** Did war paintings in Belgium, and in **1918** moved to Neukastel in the Palatinate. In the 20s he took up religious themes again, producing the graphic series *Passion*. Did over 500 illustrations for Goethe's *Faust*. **1924** Painted a mural for the music room at Neukastel, another in Berlin and a third **1927** in Bremen. His last work, completed in **1932**, was a fresco of *Golgotha* in the Friedenskirche at Ludwigshafen. Along with Liebermann and Corinth, Slevogt is one of the leading exponents of German Impressionism.
CATALOGUES RAISONNES: Sievers, J. and E. Waldmann (ed.): M. S. Das druckgraphische Werk 1890-1914. Heidelberg and Berlin 1962 / M. S. The Graphic Work 1890-1914. San Francisco 1991
MONOGRAPHS, CATALOGUES: Blinn, H.: M. S. und seine Wandmalereien. Landau 1983.– Dieckmann, F. (ed.): W. A. Mozart: Die Zauberflöte. M. S. Randzeichnungen zu Mozarts Handschrift. Berlin 1984.– Esser, K.-H. (ed.): M. S. Nachlaß aus Neukastel. Mainz 1972.– Imiela, H.-J.: M. S. Karlsruhe 1968.– Imiela, H.-J. and B. Roland: S. und Mozart. M.-S.-Galerie, Schloß "Villa Ludwigshöhe" et al. Mainz 1991 (cat.).– Güse, E.-G. et al. (ed.): M. S. Gemälde, Aquarelle, Zeichnungen. Saarland Museum, Saarbrücken et al. Stuttgart 1992 (cat.).– Heffels, M.: Die Buchillustrationen von M. S. Bonn 1952.– Mosel, C.: M. S. Graphik und Handzeichnungen. Hanover 1965.– Passarge, W.: S. Wand- und Deckengemälde auf Neukastel. Hei-

delberg and Berlin 1961.– Roland, B.: M. S. Der Nachlass auf Schloß "Villa Ludwigshöhe". Dortmund 1982.– Roland, B. (ed.): M. S. Ägyptenreise 1914. Landesmuseum, Mainz et al. Mainz 1989 (cat.).– Roland, B.: S.-Graphik. 3 vols. Edenkoben 1990.– Roland, B.: M. S. Pfälzische Landschaften. Max-Slevogt-Galerie, Schloß Ludwigshöhe. Munich 1991 (cat.).– Weber, W.: Die religiösen Werke von M. S. Kaiserslautern 1966

**SMET Gustave de**
**1877** Ghent – **1943** Deurle-sur-Lys
Belgian painter. First apprenticed to his father, a decorative painter. **1888**–**1895** Studied at the Art Academy in Ghent. **1901** Moved to Laethem-Saint-Martin, where Permeke, Berghe, Servaes and his brother Léon were working, and adopted a Neo-Impressionist style. **1914** Emigrated with Berghe to Holland. Influenced by Le Fauconnier, he took up Expressionist painting. **1918** Returned to Laethem and, together with P.-G. Hecke and A. de Ridder, set up the studio Sélection. **1927** Moved to Deurle. Co-founder of the Flemish Expressionist movement.
CATALOGUE RAISONNE: Hecke, P.-G. v. and E. Langui (ed.): G. de S. Sa Vie et son œuvre. Brussels 1945
MONOGRAPHS, CATALOGUES: Boysen, P.: G. d. s. Antwerp 1989.– Langui, E.: G. d. S. De mensch en zijn werk. Brussels 1945.– Puyvelde, L. v.: G. d. S. Antwerp 1949.– G. de S. Exposition rétrospective. Koninklijk Museum voor Schone Kunsten. Antwerp 1961 (cat.).– G. d. S. Rétrospective. Provinciaal Museum voor Moderne Kunst. Oostende 1989 (cat.)

**SMITH David**
**1906** Decatur (IN) – **1965** Albany (NY)
American sculptor. Worked originally as a welder and solderer at the Studebaker automotive plant in South Bend (IN). There he learned various basic techniques that he later applied in his sculptures. **1926**–**1931** Studied at the Art Students League in New York. **1930** Met J. Graham. **1932** First wood sculptures. **1933/34** Began to work in steel. **1937** Exhibition at the Willard Gallery, New York. **1941** Moved to Bolton Landing where he set up his own workshop Terminal

Iron Works. **1950/51** Received a Guggenheim grant. Participated **1951** at the São Paulo Biennale and **1954** at the Venice Biennale. **1957** Solo-exhibition at the Museum of Modern Art, New York. **1958** Exhibited again at the Venice Biennale. **1959**–**1977** Took part in documenta 2–4 and 6 in Kassel. **1962** Worked on 27 sculptures for the "Festival of Both Worlds in Spoleto". **1986** Major retrospective at the Kunsthalle, Düsseldorf. Though there are many parallels between Smith's works and those of Calder and González, especially in terms of style and motif, his mastery of industrial manufacturing techniques sets him apart and introduces an important new material element to his sculpture.
WRITINGS: Gray, C. (ed.): D. S. by D. S. Sculpture and Writings. New York and London 1968, 1972
CATALOGUES RAISONNES: Krauss, R. E. (ed.): Terminal Iron Work / The Sculpture of D. S. Cambridge (MA) 1971, New York and London 1977.– Schwartz, A. and P. Cummings (ed.): D. S. The Prints. New York 1987
MONOGRAPHS, CATALOGUES: Carmean, E. A. (ed.): D. S. National Gallery of Art. Washington 1982 (cat.).– Cone, J. H. and M. Paul (ed.): D. S. 1906-1965. A Retrospective Exhibition. Fogg Art Museum. Cambridge et al. Cambridge (MA) 1966 (cat.).– Cummings, P. (ed.): D. S. The Drawings. Whitney Museum of American Art. New York 1979 (cat.).– Fry, E. F. (ed.): D. S. Solomon R. Guggenheim Museum. New York 1969 (cat.).– Fry, E. F. (ed.): D. S. Painter, Sculptor, Draftsman. Hirshhorn Museum and Sculpture Garden, Washington. New York 1982 (cat.).– Gimenez, C. (ed.): D. S. 1906-1965. IVAM Centro Julio González, Valencia et al. Valencia 1996 (cat.).– Lewison, J. et al. (ed.): D. S. Medals for Dishonor. 1937-1940. Imperial War Museum, London et al. Leeds 1991 (cat.).– McCoy, G. (ed.): D. S. From Life of the Artist. New York, Washington and London 1973.– Marcus, S. E.: The Working Methods of D. S. Diss. Columbia University. New York 1972.– Marcus, S. E.: D. S. The Sculptor and His Work. Ithaca (NY) and London 1983.– Merkert, J. (ed.): D. S. Skulpturen, Zeichnungen. Kunstsammlung Nordrhein-Westfalen, Düsseldorf et al. Munich 1986 (cat.).– D. S. Sculptures, Drawings. Whitechappel Art Gallery. London 1987 (cat.).– Rikhoff, J.: D. S. I Remember. Glenns Falls (NY) 1984.– D. S. Solomon R. Guggenheim Museum. New York 1969 (cat.).– D. S. Zeichnungen. Staatsgalerie Stuttgart et al. Stuttgart 1976 (cat.).– D. S. Medals for Dishonor. Columbus Museum of Art. Columbus (OH) 1996 (cat.).– D. S.: D. S. in Italy. New York 1996.– Wilkin, K.: D. S. New York 1984

**SMITH Kiki**
born **1954** Nuremberg
American sculptress, painter and installation artist. **1976** Went to New York where she met the film producer C. Ahearn who

introduced her to the artists' group Collaborative. **1979** First paintings in the series Severed Limbs. Began to use Gray's Anatomy as source material. **1980–1983** Involved in various projects, including books and videos. Trips to Europe. **1985** Trained as an emergency medical technician. **1987** First paper sculptures, taking the body as her central theme. **1991** Participated at the Whitney Biennale in New York. **1993** Invited to the Whitney and the Venice Biennale. **1997** Took part in documenta 10 in Kassel.
MONOGRAPHS, CATALOGUES: Ackley, C. et al. (ed.): K. S. The Unique Print 70s into 90s. Museum of Fine Arts. Boston 1990 (cat.).– Brown, E. A. (ed.): K. S. Sojourn in Santa Barbara. University Art Museum. University of California. Santa Barbara 1995 (cat.).– Bradley, J. (ed.): K. S. The Power Plant. Toronto 1994 (cat.).– Colombo, P. et al. (ed.): K. S. Institute of Contemporary Art. Amsterdam 1990 (cat.).– Fuchs, A. (ed.): K. S. Lousiana Museum of Modern Art. Humblebæk 1995 (cat.).– Isaak, A.(ed.): K. S. Whitechapel Gallery. London 1995 (cat.).– Landau, S. (ed.): K. S. The Israel Museum. Jerusalem 1994 (cat.).– Morin, F. and M. Vignelli (ed.): K. S. The Interrupted Life. New Museum of Contemporary Art. New York 1991 (cat.).– Noever, P. (ed.): K. S. Silent Works. MAK – Museum für angewandte Kunst. Graz 1992 (cat.).– Shearer, L. and C. Gould (ed.): K. S. Williams College Museum, Williamstown et al. Williamstown 1992 (cat.).– K. S. New York. Pace Wildenstein. New York 1995 (cat.).– K. S. Whitechappel Art Gallery. London 1995 (cat.).– K. S. Montreal Museum of Fine Arts et al. Montreal 1996 (cat.).– Spapen, M. (ed.): K. S. Prints and Multiples 1985-1993. Barbara Krakow Gallery. Boston 1994 (cat.).– Stoops, S. L. (ed.): K. S. Unfolding the Body. Rose Art Museum. Brandeis University 1992 (cat.).– Théberge, P. (ed.): K. S. The Montreal Museum of Fine Arts. Montreal 1996 (cat.)

**SMITH Tony**
**1912** South Orange (NJ) – **1980** New York American sculptor, painter and architect. **1933–1936** Studied at the Art Students League, Chicago. **1937/38** Continued his studies at the New Bauhaus in Chicago. **1938/39** Assistant to F. L. Wright. Became friends with Newman, Rothko, Pollock and Still. **1953–1955** Spent two years in Germany. **1950–1953** and **1957/58** taught at the Pratt Institute, New York. **1960** First minimalist sculptures. **1966** First solo-exhibition in Hartford (CT). **1968** Participated in documenta 4 in Kassel. **1969** Taught at the University of Hawaii in Honolulu. **1974** Solo-exhibition at the University of Maryland Art Gallery. **1988** Retrospective at the Westfälische Landesmuseum, Münster, and at Museum Abteiberg in Mönchengladbach. His simple geometric sculptures of almost architectonic dimensions can be termed site-specific sculptures, since their

design is very much determined by the place at which they are destined to stand.
MONOGRAPHS, CATALOGUES: Lippard, L. R.: T. S. New York 1971/ T. S. Stuttgart 1971.– McShine, K. (ed.): T. S. The Museum of Modern Art. New York 1971 (cat.).– Meschede, F. (ed.): T. S. Skulpturen und Zeichnungen. 1961-1969. Westfälisches Landesmuseum, Münster et al. Münster et al. 1988 (cat.).– T. S. Ten Elements and Throwback. Pace Gallery. New Yok 1979 (cat.).– T. S. Paintings and Sculpture. The Pace Gallery. New York 1983 (cat.).– Wagstaff, S. (ed.): T. S. Two Exhibitions of Sculpture. Wadsworth Antheneum, Hartford (CT), Philadelphia Institute of Contemporary Art. Philadelphia 1966 (cat.)

**SMITH William Eugene**
**1918** Wichita (KS) – **1979** Tucson (AZ) American photographer. **1936/37** Studied photography at the University of Notre Dame, Indiana. First photographs for newspapers in Wichita and **1937/38** for *Newsweek*, New York. From **1938** worked as a freelance photographer for *Life* magazine, *Harper's Bazaar* and the *New York Times*. **1944/45** and **1947–1954** employed again by *Life* magazine as a war correspondent. **1949** Elected president of the Photo League. **1954** Joined the agency Magnum. **1959** Honorary award from the American Society of Magazine Photographers. **1966–1969** Taught photography at the New School for Social Research in New York, and subsequently at the School of Visual Arts, New York, and the University of Arizona, Tuscon. **1971** National Endowment for the Arts Award. Smith specialized in human interest photography: reportages on social issues.
WRITINGS: Lamb, C. and A. Stark (ed.): W. E. S. Papers. Tucson (AZ) 1983
MONOGRAPHS, CATALOGUES: Bunnell, P. C. and L. K. (ed.): W. E. S. His Photographs and Notes. New York 1969, 1993.– Hansen, H.: Myth and Vision. On the Walk to Paradise Garden and the Photography of W. E. S. Lund 1987.– Hughes, J.: W. E. S. Shadow and Substance. New York 1989.– Johnson, W. S. (ed.): W. E. S. Early Work. Tucson (AZ) 1980.– Johnson, W. S.: W. E. S. Master of the Photographic Essay. Millerton (NY) 1981, London 1990.– Kirstein, L.: W. E. S. His Photographs and Notes. New York 1993.– Maddow, B. et al. (ed.): Let Truth Be The Prejustice. W. E. S. His Life and Photographs. Philadelphia Museum of Art. New York 1985 (cat.).– W. E. S. Milan 1983.– Willumson, G. G.: W. E. S. and the Photograhic Essay. Cambridge (MA) 1992

**SMITHSON Robert**
**1938** Passaic (NJ) – **1973** near Tecovas Lake (TX)
American artist. **1953–1956** Studied at the Art Students League, New York, and **1956** at Brooklyn Museum School. **1957** Travelled through the USA and Meciko. First

paintings in Abstract Expressionist style. **1959** First solo-exhibition at the Artist's Gallery, New York. **1960** Came to know LeWitt. **1961** First solo-exhibition at the Galleria George Lester, Rome. In the mid-60s took up "Minimal Art". Close contact with other minimal artists. **1966** Participated in the exhibition "Primary Structures" at the Jewish Museum, New York, and soon afterwards produced his first Land Art projects, some in collaboration with Heizer. **1968** Participated in the Minimal Art exhibition at the Gemeentemuseum in The Hague. **1970** Created *Spiral Jetty* in the Great Salt Lake at Utah: earthworks forming an enormous spiral, turning the landscape into a huge geometric figure. **1972** and **1977** participated in documenta 5 and 6 in Kassel. **1973** Guggenheim grant. Killed in a plane crash while surveying his work *Amarillo Ramp* near Tecovas Lake. **1974** Solo-exhibition at the New York Cultural Center. **1993** Retrospective at the Centro Julio González, Valencia. In his best-known works Smithson used natural landscapes to form geometric figures.
WRITINGS: Holt, N. (ed.): The Writings of R. S. New York 1979, Berkeley 1996.– Tsai, E. (ed.): R. S. Unearthed. Drawings, Collages, Writings. Wallach Gallery at Columbia University. New York 1991 (cat.)
MONOGRAPHS, CATALOGUES: Boulan, M.-S. (ed.): R. S. Une rétrospective. IVAM Centro Julio González, Valencia et al. Valencia 1993 (cat.).– Casanova, M. et al. (ed.): R. S. El paisaje entrópico. Una retrospectiva 1960-1973. IVAM Centro Julio González, Valencia et al. Valencia 1993 (cat.).– Halley, P. (ed.): R. S. The Early Works 1959-1962. Diana Brown Gallery. New York 1985 (cat.).– Hobbs, R. et al. (ed.): R. S. Sculpture. Ithaca (NY) and London 1981.– Hobbs, R. et al. (ed.): R. S. Retrospective. Musée d'Art Moderne de la Ville de Paris, Paris et al. Paris 1982 (cat.)/ R. S. A Retrospektive. Wilhelm Lehmbruck Museum. Duisburg 1983 (cat.).– Meschede, F. and B. Kalthoff (ed.): R. S. Zeichnungen aus dem Nachlaß. Westfälisches Landemuseum, Münster et al. Münster 1989 (cat.).– Schmidt, E.: Zwischen Kino, Landschaft und Museum: Erfahrung und Fiktion im Werk von R. S. Frankfurt-on-Main 1995.– Shapiro, G: Earthwards. R. S. and Art After Babel. Berkeley 1995, 1998.– R. S. Das Frühwerk 1959-1962. Kunstmuseum. Lucerne 1988 (cat.).– R. S. Une Rétrospective. Le Paysage entropique 1960-1973. Palais des Beaux-Arts, Brussels et al. Brussels 1994 (cat.).– Sobieszek, R. et al.: R. S. Photo Works. Los Angeles County Museum of Art. Albuquerque 1993 (cat.)

**SNELSON Kenneth**
born **1927** Pendleton (OR)
American sculptor. **1946/47** Studied at the University of Oregon in Eugene, **1947/48** at Black Mountain College in Beria (NC) under Albers and De Kooning, and **1949** at the Académie Montmartre under Léger.

**1960** Moved to New York. **1962** First solo-exhibition at the Pratt Institute, Brooklyn. Taught at the Cooper Union and the School of Visual Arts in New York and also at Yale University in New Haven (CT). **1966** Exhibition at the Dwan Gallery in New York. **1974** Received a grant from the National Endowment for the Arts, and in **1975**, a DAAD scholarship to Berlin. **1977** Participation in documenta 6 in Kassel. **1987** Honorary award from the American Institute of Architects and Letters. With his forceful, dynamic constructions of metal piping and taut ropes, Snelson can be regarded as one of the leading abstract sculptors in America during the 60s and 70s.
MONOGRAPHS, CATALOGUES: Fox, H. N. (ed.): K. S. Hirshhorn Museum, Washington et al. Washington 1981 (cat.).– Glozer, L. (ed.): K. S. Struktur und Spannung. Kunstverein Hannover. Hanover 1971 (cat.).– Schneider, A. and K. S. (ed.): K. S. Skulpturen. Nationalgalerie. Berlin 1977 (cat.).– Weider, L.: Full Circle. Panoramas by K. S. New York 1990

**SOLANO Susana**
born **1946** Barcelona
Spanish sculptress. Painted up to the end of the 70s, and then took up abstract sculpture, first working with curved iron plates. **1980** First solo-exhibition at the Fundació Joan Miró, Barcelona. **1983** Solo-exhibition at the Galeria Ciento, Barcelona. **1987** Participated in documenta 8 in Kassel and at the São Paulo Biennale. Solo-exhibition at the Musée d'Art Contemporain, Bordeaux. **1988** and **1993** Participated at the Venice Biennale. **1989** Solo-presentations at the Abteiberg Museum, Mönchengladbach, and at the Hirshhorn Museum, Washington. **1992** Participated in documenta 9 in Kassel and had a solo-exhibition at the Whitechapel Art Gallery, London. Solano's works are mostly installations in steel, reminiscent of enclosures or cages.
MONOGRAPHS, CATALOGUES: Blanch, T. and D. Stemmler (ed.): S. S. Städtisches Museum Abteiberg. Mönchengladbach 1989 (cat.).– Blanch, T. et al. (ed.): S. S. Museo Nacional Centro de Arte Reina Sofía, Madrid et al. Madrid 1992 (cat.).– Froment, J.-L. and J.-M. Poinsot: S. S. Sculptures de 1981 à 1987. Musée d'Art

Contemporain. Bordeaux 1987.– García, A. and A. Himmelreich (ed.): S. S. Bonnefantenmuseum. Maastricht 1988 (cat.).– García, A. et al. (ed.): S. S. Skulpturen und Fotografien. Neuer Berliner Kunstverein et al. Wechmar 1996 (cat.).– Logrono, M.: El templo escultórico de S. S. Madrid 1987.– Martínez-Garrido, S. (ed.): S. S. Museo Nacional Centro de Arte Reina Sofía. Madrid 1991 (cat.).– Navarro, J. R. (ed.): S. S. Fundació Joan Miró. Barcelona 1980 (cat.).– Poinsot, J.-M. (ed.): S. S. Musée d'Art Contemporain de Bordeaux. Bordeaux 1987 (cat.).– Poinsot, J.-M. (ed.): S. S. Museum of Modern Art, San Francisco et al. San Francisco 1991 (cat.).– Queralt, R. (ed.): S. S. Galleria Giorgio Persano. Torino 1987 (cat.).– S. S. Centre National d'Art Contemporain. Grenoble 1993 (cat.).

**SOLDATI Atanasio**
**1896** Parma – **1953** Milan
Italian painter. Studied architecture up until **1922**. First solo-exhibition in Parma. **1925** Moved to Milan. Developed a strictly geometric abstract painting style, closely related to that of Mondrian. **1930** Moved closer to Pittura metafisica. **1933** Solo-exhibition at the Galleria Il Milione, Milan. After World War II, joined Dorfles, Monnet and Munari in founding the movement Movimento Arte Concreta. **1954** Posthumous retrospective at the Galleria Bergamini, Milan. **1969** Solo-exhibition at the Galleria Civica d'Arte Moderna, Turin. Soldati aimed to achieve a synthesis of metaphysics and abstraction through his painting.
MONOGRAPHS, CATALOGUES: Bianchino, G. (ed.): A. S. Università di Parma. Parma 1993 (cat.).– Garau, A. (ed.): A. S. Milan 1990.– Mallé, L. and N. Ponente (ed.): A. S. Galleria Civica d'Arte Moderna. Torino 1970 (cat.).– Santini, P. C. (ed.): A. S. Centro Cult. Olivetti. Ivrea 1965 (cat.)

**SONDERBORG K. R. H.**
(Kurt Rudolf Hoffmann)
born **1923** Sonderborg
German painter. **1939–1941** Business studies. **1941/42** Interned in the concentration camp Fuhlsbüttel. **1947–1949** Studied at the Hamburg School of Art. **1951** Trip to

Italy. **1953** Worked in Hayter's graphic studio Atelier 17 in Paris. Member of the Zen 49 group. **1955** Karl-Ernst Osthaus Prize from the City of Hagen. **1956** Joint-exhibition with Götz at the Kestner Society, Hanover. **1957** Went to England. **1958** Participated at the Venice Biennale in **1959** and **1964** in documenta 2 and 3 in Kassel. **1960** Prize for graphic art at the Tokyo Biennale and **1963** major prize for drawing at the São Paulo Biennale. **1965** Solo-exhibition at the Stedelijk Museum, Eindhoven. **1966** Taught at the Stuttgart Academy. **1970** Participated at the Venice Biennale. **1985** Scholarship to the Villa Massimo, Rome. **1988** Retrospective at the City Gallery in Stuttgart. Sonderborg's spontaneous, expressive style of painting is closely related to French Tachisme, although his mode of expression is often quite graphic, being limited to black-and-white contrasts.
MONOGRAPHS, CATALOGUES: Gauss, U. (ed.): K. R. H. S. Arbeiten auf Papier. Staatsgalerie Stuttgart. Stuttgart 1985 (cat.).– Hahn, O.: K. R. H. S. Stuttgart 1964, London 1964.– Költzsch, G.-W. (ed.): K. R. H. S. Werke 1948-1986. Moderne Galerie des Saarland Museums. Saarbrücken 1987 (cat.).– Labarthe, A. S.: S. Tuer un rat. Paris 1974.– Meyer, W. and T. Osterwold (ed.): K. R. H. S. Württembergischer Kunstverein. Stuttgart 1993 (cat.).– Motte, M. d. la (ed.): K. R. H. S. Galerie Georg Nothelfer. Berlin 1991 (cat.).– Nusser, U. et al. (ed.): K. R. H. S. Württembergischer Kunstverein. Stuttgart 1993 (cat.).– Poetter, J. (ed.): K. R. H. S. Staatliche Kunsthalle Baden-Baden. Baden-Baden 1993 (cat.).– Reinhardt, B. (ed.): K. R. H. S. Galerie der Stadt Stuttgart 1988 (cat.).– K. R. H. S. Kölnischer Kunstverein. Cologne 1965 (cat.)

**SONNIER Keith**
born **1941** Mamou (LA)
American artist. **1959–1963** Studied at the University of Southwestern Louisana in Lafayette. **1963/64** Lived in France. **1964–1966** Studied at Rutgers University, New Brunswick (NJ). Began to work in glass and neon. **1968** Solo-exhibition at the Ricke gallery in Cologne. From **1970** film and video installations. **1970** Solo-exhibition at the Steledijk Museum, Eindhoven, and at the Leo Castelli Gallery, New York. **1972** Participated in documenta 5 in Kassel and at the Venice Biennale. **1974** Guggenheim grant and first prize at the Tokyo Graphic Biennale. **1977** Participation in documenta 6 in Kassel. **1979** Solo-presentation at the Pompidou Centre, Paris. **1987** Retrospective at the Alexandria Museum of Art (LA). **1989** Solo-exhibition at the Hirshhorn Museum, Washington, and at the Douglas Hyde Gallery, Dublin. Since the mid-60s, most of Sonnier's best-known works have been objects constructed out of neon and glass. They are examples of Material Art.
MONOGRAPHS, CATALOGUES: Elger, D. (ed.): K. S. Sprengel Museum, Hanover

et al. Stuttgart 1993 (cat.).– Kuspit, D. (ed.): K. S. Hyde Gallery. Dublin 1989 (cat.).– O'Brien, G. (ed.): K. S. Leo Castelli Gallery. New York 1992 (cat.).– Puvogel, R. (ed.): K. S. Projekt Flughafen Munich 1989-1992. Stuttgart 1992.– Raben, H. et al. (ed.): K. S. Lichtweg/Lightway. Stuttgart 1992.– K. S. Stedelijk Van Abbe Museum. Eindhoven 1970 (cat.).– K. S. Argon-und-Neon-Arbeiten. Museum Haus Lange. Krefeld 1979 (cat.).– K. S. Kunsthalle. Nuremberg 1994 (cat.).– Zilczer, J. (ed.): K. S. Hirshhorn Museum and Sculpture Garden. Washington 1989 (cat.)

**SOTO Jesús Rafael**
born **1923** Ciudad Bolivar
Venezualen painter and sculptor. **1942-1947** Studied at the Art Academy in Caracas. **1947-1950** Director of the Maracaibo Academy. **1950** Moved to Paris where he exhibited at the Salon des Réalités Nouvelles and met Tinguely and Agam. **1956** Solo-exhibition at the Galerie Denise René, Paris. **1958** Participated at the Venice Biennale. **1963** Received the Premio Wolf prize at the São Paulo Biennale and exhibited at the Museum Haus Lange in Krefeld. **1964** Awarded the David Bright Prize at the Venice Biennale and participation in documenta 3 in Kassel. **1968** Solo-exhibition at the Kunsthalle Bern and **1971** at the Museum of Contemporary Art, Chicago. **1981** Participated in the "Westkunst" exhibition, Cologne. **1990** Won the UNESCO Picasso Medal. **1992** Retrospective at the Museo de Bellas Artes, Caracas. **1993** Nominated Commandeur des Arts et Lettres in France. Soto uses optical illusions, reminiscent of Vasarely's Op Art, but also explores the possibilities of technologically produced vibrations.
WRITINGS: S. Textos. Madrid 1990
MONOGRAPHS, CATALOGUES: Balza, J.: J. R. S. Caracas 1981.– Boulton, A.: S. Caracas 1973.– Boulton, A. et al. (ed.): S. Palacio de Velázquez, Parque del Retiro. Madrid 1982 (cat.).– Boulton, A. and M. Homma (ed.): J. R. S. Museum of Modern Art. Kamakura 1990.– Butor, M. et al. (ed.): J. R. S. Galerie Nationale du Jeu de Paume. Paris 1996 (cat.).– Clay, J. (ed.): S. Musée d'Art Moderne de la Ville de Paris. Paris 1969 (cat.).– Joray, M.: J. R. S. Neuchâtel 1984.– Lemaire, G.-G.: J.-R. S. Paris 1997.– Renard, C.-L. (ed.): S. A Retrospective Exhibition. Solomon R. Guggenheim Museum. New York 1974 (cat.).– Renard, C.-L.: S. Œuvres actuelles. Centre Georges Pompidou. Paris 1979 (cat.).– Somaini, L.: S. Milan 1991.– S. Cuarenta años de creación 1943-1983. Museo de Arte Contemporáneo. Caracas 1983.– S. Space Art. Center for the Fine Arts and the Hispanic Heritage Festival Committee. Miami 1985 (cat.)

**SOULAGES Pierre**
born **1919** Rodez (Aveyron)
French painter. **1938** Went to Paris to study

at the Ecole des Beaux-Arts but returned home after a short time without completing the course. **1943** Discovered abstract art, and came to know Sonia Delaunay. **1946** Moved to Courbevoie. **1947** Set up his own studio in Paris. Became acquainted with Picabia, Hartung and Léger. First works exhibited at the Salon des Surindépendants. **1949** First solo-exhibition at the Galerie Lydia Conti, Paris. **1949–1951** Stage and costume designs. **1953** Prize for Painting at the São Paulo Biennale. **1955** and **1964** participation in documenta 1 and 2 in Kassel. **1960/61** First retrospective at the Kestner Society, Hanover, the Folkwang Museum, Essen, and the Gemeentemuseum in The Hague. **1967** Retrospective at the Musée d'Art et d'Industrie, Saint-Etienne. From **1979** painted mostly in dark colours. **1987** Designed a monumental tapestry for the new Ministry of Finance in Paris. Awarded a major national prize for painting in Paris. **1993** Retrospective in Seoul. **1995** Completed a series of stained-glass windows for the Abbey of Conques in France. In many of Soulage's paintings, broad swaths of black or dark brown hover over a pale or lightly washed ground.
CATALOGUES RAISONNES: Daix, P. and J. J. Sweeney (ed.): P. S. L'œuvre 1947-1990. Neuchâtel 1991.– Encrevé, P. (ed.): S. L'œuvre complet. Peintures. 3 vols. 1946-1996. Paris 1994-1998.– Rivière, Y. (ed.): S. Eaux-fortes, litographies 1952-1973. Paris 1974
MONOGRAPHS, CATALOGUES: Ceysson, B.: P. S. Paris 1979.– Ceysson, B. (ed.): P. S. 40 Jahre Malerei. Stuttgart 1989.– Duby, S. et al. (ed.): P. S. Musée Saint-Pierre, Lyon et al. Lyon 1987, Reutlingen 1987 (cat.).– Heck, C. et al. (ed.): Conques. Les vitraux de S. Paris 1994.– Juliet, C.: Entretien avec P. S. Caen 1990.– Labbaye, C.: S. Eaux-fortes, lithographies 1952-1973. Paris 1974.– Loers, V. (ed.): S. 40 Jahre Malerei. Museum Fridericianum, Kassel et al. Kassel 1989 (cat.).– Pacquement, A. et al. (ed.): S. Peintures récentes. Centre Georges Pompidou. Paris 1979 (cat.).– Ragon, M.: Les Ateliers de S. Paris 1990.– Rivière, Y. (ed.): S. Eaux-fortes, lithographies 1952-1973. Paris 1974.– P. S. Musée d'Art Moderne de la Ville de Paris. Paris 1996 (cat.).– Sweeney, J. J.: P. S. Neuchâtel 1972, Greewich 1972, London 1973

**SOUTINE Chaïm**
**1893** Smilovitchy (near Minsk) – **1943** Paris
Lithuanian-born French painter. **1910–1913** Studied at the Art Academy in Vilnius, and then went to Paris. **1916** Took a studio at the artists' colony La Ruche where he lived with Modigliani and Chagall. Introduced by Modigliani to the art dealer Zborowski who in **1919** persuaded him to go to Céret to paint landscapes. His numerous landscapes, painted there over the next three years in a thick impasto and garish colours, betray a tortured and restless spirit. **1923** Returned to Paris and sold all the paintings in his studio to the American art collector

A. Barnes. His newly acquired affluence calmed Soutine's vehemence somewhat, but did not prevent a second triumph: paintings of animal carcasses in which he pays homage to Rembrandt. People in uniform were another favourite theme of his. **1937** Came to know Gerda Groth, who was trying to escape from the Germans. Lived with her in Civry-sur-Serein near Auxerre and in Paris, until she was deported to a concentration camp. **1940** Met the former wife of Ernst, who hid him from the Nazis in Paris. **1943** Died from internal bleeding caused by a stomach ulcer. Became famous in the mid-20s for his paintings of slaughtered oxen. In the early 30s, after a short lyrical period, his paintings once again became powerfully expressive, as he portrayed the suffering of uprooted, homeless people.
CATALOGUES RAISONNES: Lanthemann, J. (ed.): S. Catalogue raisonné de l'œuvre dessinée. Paris 1981.– Tuchman, M., E. Dunow and K. Perls (ed.): C. S. (1893-1943). Catalogue Raisonné. Werkverzeichnis. 2 vols. Cologne 1993
MONOGRAPHS, CATALOGUES: Chiappini, R. (ed.): C. S. Museo d'Arte Moderna della Città di Lugano. Milan 1995 (cat.).– Cogniat, R.: S. Paris 1979, New York 1984.– Courthion, P.: S. Peintre du déchirant. Lausanne 1972.– Güse, E.-G. (ed.): C. S. 1893-1943. Westfälisches Landesmuseum, Münster et al. Stuttgart 1981 (cat.).– Lassaigne, J.: S. Paris 1954.– Michaelis, G.: Mes années avec S. Paris 1973.– Nicoïdski, C. (ed.): S. ou la Profanation. 1993, l'année Soutine. Orangerie des Tuileries. Paris 1993 (cat.).– Szittya, E.: S. et son temps. Paris 1955.– Tuchman, M. (ed.): C. S. Los Angeles County Museum. Los Angeles 1968 (cat.).– Vallès-Bled, M. (ed.): S. Musée. Chartres 1989 (cat.).– Werner, A.: C. S. New York 1985, Paris 1986.– Wheeler, M.: S. New York 1950, 1967

**SOUTTER Louis**
**1871** Morges (Waadt) – **1942** Ballaigues (Waadt)
Swiss painter. **1888–1890** Studied natural sciences and engineering in Lausanne. **1892–1894** Studied music at the Conservatoire in Brussels. **1895** Took painting lessons, first in Lausanne and Geneva and then in Paris. **1897** Moved to the USA. **1898**

Directed the art department at Colorado College in Colorado Springs. **1904** Returned to Morges. **1906** Admitted to a psychiatric clinic for the first time. **1923** Permanently committed to a mental asylum. **1936** First solo-exhibition at the Wadsworth Atheneum in Hartford (CT). **1937** Solo-exhibition at the Paul Vallotton gallery, Lausanne. **1939** Solo-exhibition at the Weyhe Gallery, New York. Soutter painted and drew in a desperate attempt to earn money and usually used the simplest materials (chalk and school notebooks). The themes of his expressive drawings were often taken from the Bible.
CATALOGUE RAISONNE: Thévoz, M. (ed.): L. S. Catalogue de l'œuvre. Lausanne and Zurich 1976
MONOGRAPHS, CATALOGUES: Bader, A.: L. S. Eine pathologische Studie. Stuttgart 1968.– Berger, R. and E. Manganel: L. S. Lausanne 1961.– Hachmeister, H. (ed.): L. S. Zeichnungen und Fingermalereien. Hachmeister Galerie. Münster 1991 (cat.).– Kuenzi, A. and A. Ferrari (ed.): L. S. Fondation Pierre Gianadda. Martigny 1990 (cat.).– Morax, R. (ed.): L. S. Illustrationen zum Tell. Bern 1994.– L. S. Rétrospective. Musée Cantonal des Beaux-Arts, Lausanne et al. Lausanne 1974.– Thévoz, M.: L. S. Lausanne 1970.– Thévoz, M.: L. S. ou l'écriture du désir. Lausanne and Zurich 1974.– Thévoz, M.: Détournement d'écriture. Paris 1989.– Zweite, A. (ed.): L. S. (1871-1942). Zeichnungen, Bücher, Fingermalereien. Städtische Galerie im Lenbachhaus, Munich et al. Munich 1985 (cat.)

**SPENCER Stanley**
**1891** Cookham – **1959** Cookham
English painter. **1908–1912** Studied under Tonks at the Slade School of Art in London. **1912** Participated in the second Post-Impressionist exhibition in London. **1914–1918** Military service. **1922** Lived in Yugoslavia. **1926–1932** Worked on murals for the Burghclere Chapel. **1927** First solo-exhibition at the Goupil Gallery, London. **1932** Moved to Cookham. **1932** and **1939** participated at the Venice Biennale. **1932–1935** Elected to the Royal Academy but resigned when two of his works were rejected. **1933–1936** Spent two years in Switzerland. **1939–1945** Engaged as an official war artist. **1946** Took part in the competition *The Temptation of St. Anthony*. **1950** Elected to the Royal Academy. **1954** Trip to China. **1955** Retrospective at the Tate Gallery and **1980** at the Royal Academy, London. Spencer's striking but finely executed figurative paintings were usually based on religious themes. His later works depict sexual tensions and problems associated with old age or illness.
WRITINGS: Rothenstein, J. (ed.): S. S. The Man. Correspondence and Reminiscences. London 1979
CATALOGUE RAISONNE: Bell, K. (ed.): S. S. A Complete Catalogue of the Paintings. London and New York 1992
MONOGRAPHS, CATALOGUES: Alison,

J. (ed.): S. S. The Apotheosis of Love. Barbican Art Gallery. London 1991 (cat.).– Bell, K. (ed.): S. S. Royal Academy of Arts. London 1980 (cat.).– Carline, R.: S. S. at War. London 1978.– Collis, M.: S. S. A Biography. London 1962.– Collis, M.: A private View on S. S. London 1972.– Nesbitt, J. (ed.): S. S. A Sort of Heaven. Tate Gallery, London. Liverpool 1992 (cat.).– Pople, K.: S. S. A Biography. London 1991, New York 1997.– Robinson, D.: S. S. Visions from a Berkshire Village. Oxford 1979.– Robinson, D.: S. S. San Francisco 1993.– Spencer, G.: S. S. London 1961.– S. S. War Artist on Clydeside. Scottish Arts Council. Edinburgh 1975 (cat.).– S. S. 1891-1959. The Arts Council of Great Britain. London 1976 (cat.)

**SPERO Nancy**
born **1926** Cleveland (OH)
American painter. **1945–1949** Studied at the Art Institute of Chicago. **1949/50** Went to Paris and attended the Ecole des Beaux-Arts. **1951** Married Leon Golub. Worked in New York, Chicago, Ischia, Florence and Paris on compositions with reduced forms. **1962** First solo-exhibition in Paris. **1964** Moved to New York. **1966–1970** Inspired by the horror of the Vietnam War and the fixation of the New York art scene on Pop and Minimal Art to produce her *War Series*. Actively engaged in artistic and political activities of the Art Workers Coalition. **1969** Joined the group Women Artists in Revolution. **1971** Founder-member of the New York Artists in Residence Gallery. From **1974** concentrated on the subject of women, producing feminist works portraying the torture of femal political prisoners. After **1978** Spero created large-scale murals, installations and designs of whole rooms, using stamps rather than traditional methods of painting. **1997** Participation in documenta 10 in Kassel.
MONOGRAPHS, CATALOGUES: Bird, J. and L. Tickner (ed.): N. S. Institute of Contemporary Arts. London 1987 (cat.).– Bird, J. et al. (ed.): N. S. London 1996 (cat.).– King, E. A. (ed.): N. S. The Black Paris Paintings 1959-1966. Carnegie-Mellon University Art Gallery. Pittsburgh 1985 (cat.).– Pohlen, A. (ed.): N. S. Bilder 1958-1990. Haus am Waldsee, Berlin et al. Berlin 1990 (cat.).– N. S. Rebirth of Venus. Kyoto 1989.– Storr, R.: N. S. Works Since 1950. Everson Museum of Art, Syracuse (NY) et al. New York 1987 (cat.).– Tickner, L.: N. S. Inscribing Woman Between The Lines. Institute of Contemporary Arts. London 1987 (cat.).– Vierneisel, K. et al. (ed.): N. S. Women Breathing. Ulmer Museum. Stuttgart 1992.– Weskott, H. et al. (ed.): N. S. in der Glyptothek. Arbeiten auf Papier. Glyptothek am Königsplatz. Munich 1991

**SPOERRI Daniel**
(Daniel Isaak Feinstein)
born **1930** Galati (Romania)

Romanian object artist. **1942** Moved to Switzerland. **1950–1954** Trained as a dancer. **1955–1957** Danced at the Bern Opera. **1957** Assistant to K. Bremer at the theatre in Darmstadt. Wrote articles on experimental theatre. **1959** Moved to Paris. **1960** Founder-member of the Nouveaux Réalistes. Began his *Trap Pictures*, in which random arrangements of objects are affixed to their chance support, for instance a table, tipped into a vertical position and declared a work of art. Contact with the Fluxus movement in New York. **1961** First solo-exhibition at the Galleria Schwarz, Milan. Participated in the exhibition "The Art of Assemblage" at the Museum of Modern Art, New York. **1968** Opened his Eat-Art-Restaurant in Düsseldorf and issued the magazine *Eat-Art-Edition*. **1972** Retrospective at the Centre National d'Art Contemporain, Paris. Participated **1976** at the Venice Biennale, **1977** in documenta 6 in Kassel and **1981** in the "Westkunst" exhibition in Cologne. **1983** Professorship at the Munich Academy. **1990** Solo-exhibition at the Musée d'Art Moderne de la Ville de Paris and the Museum Moderner Kunst, Vienna, and **1994** at the Musée de l'Assistance publique, Paris. Spoerri is one of the leading exponents of Nouveau Réalisme. As he put it himself, he "shapes life into a work of art", and thereby bridges the gap, often with a touch of irony, between art and trivial, day-to-day culture.
WRITINGS: D. S.: Topographie anecdotée du hasard. Paris 1962, 1990 / Anekdoten zu einer Topographie des Zufalls. Neuwied and Berlin 1968.– D. S.: "Ja, Mama, das machen wir". Egnach 1992.– D. S.: L'optique moderne. Paris 1963.– D. S.: Gastronomisches Tagebuch. Neuwied and Berlin 1970.– D. S.: The Mythological Travels of a Modern Sir Mandeville. New York 1970
MONOGRAPHS, CATALOGUES: Bremer, C. et al. (ed.): D. S. Zürcher Kunstgesellschaft. Zurich 1972 (cat.).– Dufrêne F. and D. S. (ed.): D. S. Centre National d'Art Contemporain. Paris 1972 (cat.).– Hahn, O.: D. S. Paris 1990.– Huber-Greub, B. and S. Andreae (ed.): D. S. Musée sentimental de Bâle. Basel and Bern 1989 (cat.).– Kamber, A. (ed.): D. S. Kosta Theos: "Dogma I am god". Kunstmuseum Solothurn. Dieterswil, Brussels 1987 (cat.).– Kamber, A. et al. (ed.): Petit lexique sentimental autour de D. S. Centre Georges Pompidou, Paris et al. Paris and Solothurn 1990 (cat.).– Schmidt, P.: Salute. D. S. Freunde und Studenten, Munich 1983-1989. Künstlerwerkstatt Lothringerstraße. Munich 1990 (cat.).– D. S. Hommage à Isaac Feinstein. Stedelijk Museum. Amsterdam 1971 (cat.).– D. S. Städtisches Kunstmuseum Spendhaus. Reutlingen 1985 (cat.)

**STAEL Nicolas de**
**1914** St. Petersburg – **1955** Antibes (Côte d'Azur)
Russian-born French painter. Became a page-boy at the royal court in St. Peters-

burg at the age of two. After the revolution in **1919** fled with his family to Poland, and from there to exile in Belgium. **1933–1936** Studied at the Académie des Beaux-Arts in Brussels. First worked as a stage designer. From **1938** lived in Paris, where he was a pupil of Léger. **1942** Painted his first abstract compositions that were hung **1944** beside the paintings of Kandinsky, Domela and Magnelli in the exhibition "Peintures Abstraites" at the Galerie L'Esquisse in Paris. From **1950** clearly recognisable, figurative forms appear in his paintings. **1955** Committed suicide. De Staël began by painting still lifes and portraits, but destroyed most of these early works. After a long period of experimenting with ideas related to Tachisme and L'art informel, he took to painting abstract Color Field compositions.
WRITINGS: N. de S.: Lettres à Pierre Lecuire. Paris 1966.– N. de S.: Lettres à Jacques Dubourg. London 1981
CATALOGUE RAISONNE: Chastel, A. et al. (ed.): N. de S. Catalogue raisonné de l'œuvre peint. Neuchâtel 1996
MONOGRAPHS, CATALOGUES: Cassou, J. (ed.): Musée National d'Art Moderne. Paris 1956 (cat.).– Cooper, D.: N. de S. London 1961.– Dobbels, D.: S. Paris 1994.– Dumur, G.: N. de S. Paris 1975, New York 1985.– Granville, P. and D. Sutton (ed.): N. de S. Grand Palais, Paris et al. Paris 1981 (cat.).– Jouffroy, J. P.: La Mesure de N. de S. Neuchâtel 1981.– Lévy, D. A. et al. (ed.): N. de S. Fondazione Magnani Rocca, Parma. Milan 1994 (cat.).– Mansar, A.: N. de S. Paris 1990.– Messer, T. M. (ed.): N. de S. Retrospektive. Schirn Kunsthalle, Frankfurt-on-Main. Stuttgart 1994 (cat.).– Monod-Fontaine, I. (ed.): N. de S. Centre Georges Pompidou. Paris 1981 (cat.).– Prat, J.-L. (ed.): N. de S. Rétrospective de l'œuvre peint. Fondation Maeght. Saint-Paul 1991 (cat.).– Prat, J.-L. (ed.): N. de S. Fondation Pierre Gianadda. Martigny 1995 (cat.).– Rathbone, E. E. (ed.): N. de S. in America. The Phillips Collection, Washington et al. Washington 1990 (cat.).– N. de S. Galleria Civica. Torino 1960 (cat.).– N. de S. Fondation Maeght. Saint-Paul 1972 (cat.).– Sutton, D. (ed.): N. de S. Whitechappel Art Gallery. London 1956 (cat.).– Tudal, A.: N. de S. Paris 1951

**STAMOS Theodoros**
born **1922** New York
Greek-born American painter. **1936–1939** Studied sculpture at the American Artists School, New York. **1943** First solo-exhibition at the Wakefield Gallery, New York. **1948/49** Trips to France, Italy and Greece. **1948** Participated at the Venice Biennale. **1950** Taught at Black Mountain College in Beria (NC). **1955** Participated in the exhibition "Cinquante ans d'Art aux Etats Unis" at the Musée d'Art Moderne, Paris. **1959** Participated in documenta 2 in Kassel. **1970** Took part in the exhibition "Trends in 20s Century Art" at the Santa Barbara

Museum (CA) and **1978** in the exhibition "Abstract Expressionism: The Formative Years" at the Whitney Museum, New York. In contrast to most Abstract Expressionist works, Stamos' paintings often prompt associations in the viewer and have an atmospheric quality, reminiscent of landscapes.
MONOGRAPHS, CATALOGUES: Cavaliere, B. and T. F. Wolff (ed.): T. S. Werke 1945-1984. Galerie Knoedler. Zurich 1984 (cat.).– Pomeroy, R.: S. New York 1974.– Ronte, D. (ed.): S. Kouros Gallery. New York 1989 (cat.).– Sawyer, K. B.: S. Paris 1960.– Schneidler, H. (ed.): T. S. Malerei 1947-1987. Schloß Morsbroich. Leverkusen 1987 (cat.).– N. S. Corcoran Gallery of Art. Washington 1958 (cat.)

**STAZEWSKI Henryk**
**1894** Warsaw – **1988** Warsaw
Polish painter. **1913–1919** Studied at the Academy of Fine Arts in Warsaw. **1924** A founder-member of the Constructivist, Suprematist and Cubist group Blok, and editor of their magazine. Friendships with M. Seuphor and Mondrian. After an early Cubist and Purist phase, he adopted the geometric abstract style of Mondrian. **1926** Collaborated with the avant-garde group Praesens. Interior decorations and book designs in a Neo-Plastic style. **1929** Member of the a. r.group. Joined Cercle et Carré in **1932** and Abstraction-Création in **1930**. From **1929–1933** experimental phase, in which he tried to combine the styles of Neo-Plasticism and Unism. After World War II, resumed geometric abstract painting. **1959–1964** Series of white metal reliefs: systematic variations on a square. **1974** Developed the idea of a series of white paintings with arrangements of black lines. **1980** Set up an artists' exchange programme between Poland and America.
MONOGRAPHS, CATALOGUES: Kowalska, B.: H. S. Warsaw 1985.– Piga, S. (ed.): H. S. 1894-1988. Rilievi e dipinti. Roma 1991 (cat.).– Stanislawski, R. and J. Ladnowska (ed.): H. S. Muzeum Sztuki. Lodz 1969 (cat.).– Stanislawski, R. (ed.): H. S. Pionero polaco del arte concreto. Centro Atlántico de Arte Moderno. Las Palmas de Gran Canaria 1990 (cat.)

**STEICHEN Edward**
**1879** Luxemburg – **1973** West Wedding (CT)
American photographer, originally from Luxemburg. **1881** Moved to Hancock (MI). **1894–1898** Trained as a lithographer in Milwaukee. **1899** Participated in the second Philadelphia Photographic Salon. **1900** Came to know Stieglitz in New York. Visited the Paris World Fair. **1901** So impressed by Rodin that he offered to take portraits of him. **1902** First solo-exhibition of photographs and paintings at the Maison des Artistes, Paris. Joined the Photo Secession. Returned to New York. **1904** First prize at the international exhibition in La Haye. **1905** Opened Gallery 291 in New York with Stieglitz. **1906** Second stay in Paris. **1908** First colour photographs. **1913** Issues 42/43 of the journal *Camera Work* dedicated to him. **1917** Leading American war photographer in France. In the 20s and 30s was chief photographer for *Vogue and Vanity Fair*. **1936** Solo-exhibition at the Museum of Modern Art, New York. From **1947** director of photography at the Museum of Modern Art, New York. **1952–1955** Organised the exhibition "The Family of Man". **1961** Major retrospective at the Museum of Modern Art, New York.
WRITINGS: E. S.: A Life in Photography. New York 1963/Ein Leben für die Fotografie. Düsseldorf 1965
MONOGRAPHS, CATALOGUES: Kelton, R.: E. S. New York 1978, Munich 1978.– Liberman, A. et al. (ed.): S. the Photographer. The Museum of Modern Art. New York 1961 (cat.).– Longwell, D. (ed.): S. The Master Prints. 1895-1914. The Symbolist Period. The Museum of Modern Art. New York 1978 (cat.)/S. Meisterphotographien 1895-1914. Die symbolistische Periode. New York and Tübingen 1978.– Mayer, G. (ed.): E. S. The Photographer. New York 1961 (cat.).– Phillips, C.: S. at War. New York 1981.– Sandburg, C.: S. the Photographer. New York 1929.– Shoenfeld, A. (ed.): The Paintings of E. S. The Heckscher Museum. Huntington 1985 (cat.)

**STEINBACH Haim**
born **1944** Rechovott (Israel)
American sculptor of Israeli origins. **1962** Took American citizenship. **1962–1968**

Studied at the Pratt Institute in Brooklyn and **1971–1973** at Yale University, New Haven (CT). **1969** First solo-exhibition at the Panoras Gallery, New York. **1988** Solo-exhibition at the Musée d'Art Contemporain, Bordeaux. Participated in the group exhibition "Schlaf der Vernunft" (The Deadening of Reason), Kassel. **1991** Took part in the exhibition "Metropolis" in Berlin. **1992** Participated in documenta 9 in Kassel. Steinbach places objects of various origins in surprising combinations on shelf-like stands. A form of wordless theatre with material objects as players, presented with biting irony.
MONOGRAPHS, CATALOGUES: Celant, G. et al. (ed.): H. S. Œuvres récentes. Musée d'Art Contemporain de Bordeaux. Bordeaux 1986 (cat.).– Dubost, P. et al. (ed.): H. S. Kärtner Landesgalerie. Klagenfurt 1994 (cat.).– Hegyi, L. et al. (ed.): H. S. Vienna et al. Vienna 1997 (cat.).– No Rocks Allowed: A Book for an Exhibition by H. S. Rotterdam 1992

**STEINERT Otto**
**1915** Saarbrücken – **1978** Essen
German photographer. Self-taught. **1934–1939** Studied medicine, and worked until **1948** as a doctor. **1948–1951** Head of the department of photography at the Saarbrücken School of Arts and Crafts. **1949** Founded the group fotoform to which Keetman and Hajek-Halke belonged. **1951** Organised the first of three programmatic exhibitions of photography entitled Subjektive *Fotografie*, developing the principles set down in the Bauhaus publication *Neue Fotografie* and providing an important stimulus to photography in Germany. **1952–1959** Director of the School of Arts and Crafts in Saarbrücken. Specialised in artistic portraits and live-photography. **1959–1978** As director of the Folkwang School in Essen, set up a department of photography and organised numerous exhibitions. **1974** Awarded the National Service Cross. Steinert was one of the most influential teachers of photography in the postwar era.
WRITINGS: O. S.: Subjektive Fotografie. Bonn 1952, Munich 1955.– O. S.: Teaching Methods. Essen 1965.– O. S.: das Technische Bild- und Dokumentationsmittel Fotografie. Essen 1973
MONOGRAPHS, CATALOGUES: Eskildsen, U. and R. Knodt (ed.): Sammlung O. S. Folkwang Museum. Essen 1981.– Eskildsen, U. and T. Koenig (ed.): O. S. und Schüler. Fotografie und Ausbildung 1948-1978. Folkwang Museum. Essen 1990 (cat.).– Kempe, F. and H. Schardt: O. S. und seine Schüler. Essen 1965.– Kempe, F. (ed.): O. S., der Initiator einer fotografischen Bewegung. Folkwang Museum, Essen et al. Essen 1976 (cat.).– Koenig, T.: O. S.'s Konzept "Subjektive Fotografie" 1951-1953. Munich 1988.– Plunien, E. (ed.): O. S. und Schüler. Essen 1967 (cat.).– Schmoll gen. Eisenwerth, J. A. (ed.): O. S. Der Initiator einer fotografischen Bewegung. Museum Folkwang. Essen 1959

(cat.).– Tamms, F.: Gestaltung des Bildteils. O. S. Düsseldorf 1966

**STELARC**
born **1948** Victoria
Australian performance, multimedia and Internet artist. From **1968** first appearances as an artist. From **1970** *Amplified Body Events*, from **1976** *The Third Hand Project*, **1992** *Virtual Arm Project* and **1995** *Ping Body*. He uses robots and medical systems in his works to reinforce his effects. **1994** Presented *Bodies and Machines* in the exhibition "Mutations d'Image" in Paris and at the Charleroi Dance Biennale. In his performances he interacts with a third hand, a virtual arm, a virtual body and a magnetic sculpture.

**STELLA Frank**
born **1936** Malden
American painter. **1950–1954** Visited the Attended Phillips Academy, Andover (MA). Came to know Carl Andre. **1954–1958** Studied art and art history under S. Greene and W. C. Seitz at Princeton University (NJ). Came to know Jasper Johns. **1959** While living in New York, he began his strictly geometric series of black pinstripe paintings. **1961** Trip to Europe. Around **1966** first works in copper and aluminium paints, and compositions in which a tension is set up between the compact inner pattern and the surrounding frame. In his *Shaped Canvases* he cut the painted form out of the canvas. **1968** and **1977** participation in documenta 4 and 6 in Kassel. Around **1975** he abandoned this stringently geometric approach and produced multi-coloured montages made up of curved shapes cut out of sheets of aluminium and painted in bright colours. **1983** Guest-professor at Harvard University. **1990** Produced his first three-dimensional works and, in **1992**, his first architectural designs, including plans for a museum of modern art in Dresden. Major retrospectives: **1987** at the Museum of Modern Art, New York, and **1996** at the Haus der Kunst, Munich. Stella set out to develop a style of Color Field Painting free of any trace of expressiveness. To avoid creating any artificial impressions or evoking emotional associations, he used the paints, brushes and tools

of an ordinary house-painter and usually confined his art to symmetrical patterns.
WRITINGS: F. S.: Working Space. The Charles Norton Eliot Lectures 1983-1984. Cambridge (MA) and London 1986
CATALOGUES RAISONNES.– Axsom, R. H. (ed.): The Prints of F. S. A Catalogue Raisonné 1967-1982. New York 1983.– Rubin, L. and R. Rosenblum (ed.): F. S. Paintings 1958-1965. A Catalogue Raisonné. New York 1986
MONOGRAPHS, CATALOGUES: Boehm, G. et al. (ed.): F. S. Werke 1958-1976. Kunsthalle Bielefeld. Bielefeld 1977 (cat.).– Geelhaar, C. (ed.): F. S. Zeichnungen 1956-1970. Kunstmuseum Basel. Basel 1980 (cat.).– Goldman, J. et al. (ed.): F. S. Museo Nacional Centro de Arte Reina Sofía. Madrid 1995 (cat.).– Goldman, J. et al. (ed.): F. S. Haus der Kunst, Munich et al. Munich 1996 (cat.).– Guberman, S.: F. S. An Illustrated Biography. New York 1995.– Imdahl, M.: F. S. Sanbornville II. Stuttgart 1970.– Inboden, G. (ed.): F. S. Black Paintings 1958-1960. Staatsgalerie Stuttgart. Stuttgart 1988 (cat.).– Leider, P. (ed.): F. S. Since 1970. Fort Worth Art Museum. Fort Worth 1978 (cat.).– Meier, R.: Shards by F. S. London and New York 1983.– Pacquement, A.: F. S. La création contemporaine. Paris 1988.– Reinhardt, B. (ed.): F. S. Moby Dick Series. Stuttgart 1993.– Rosenblum, R.: F. S. Harmondsworth and Baltimore 1971.– Rubin, W. S. (ed.): F. S. The Museum of Modern Art. New York 1970 (cat.).– Rubin, W. (ed.): F. S. 1970-1987. The Museum of Modern Art, New York et al. New York 1987 (cat.)/F. S. 1970-1987. Centre Georges Pompidou. Paris 1987 (cat.).– F. S. Working Space. Cambridge 1986

**STELLA Joseph**
**1877** Muro Lucano – **1946** New York
Italian-born American painter. **1896** Emigrated with his brother to the USA and settled in New York, where he studied medicine for one year. **1898–1901** Studied at the New York School of Arts under William M. Chase. **1907/08** Worked for the magazine *Survey*. First industrial townscapes. **1909/10** Returned to Italy and made contact with the Futurists. **1911/12** Went to Paris where he met Modigliani and Matisse. **1912** Saw the Futurist exhibition and exhibited his own works at the Salon des Indépendants in Paris. **1913** Returned to New York and took part in the Armory Show. **1915** Met Duchamp and Picabia. **1920** First solo-exhibition at the Montross Gallery in New York. Joined the Société Anonyme and participated in their exhibition. **1923** Painted his most famous work entitled *New York Interpreted*. **1930–1934** Second stay in Paris. **1940** Trip to India. **1939** Retrospective at the Newark Museum (NJ). **1963** Retrospective at the Whitney Museum of American Art, New York. Many of Stella's paintings show the industrial and urban face of America.
MONOGRAPHS, CATALOGUES: Baur, J.

I. H.: J. S. New York et al. 1971, 1991.– Gerdts, W. H. (ed.): Drawings of J. S. Newark (NJ) 1962.– Haskell, B. (ed.): J. S. Whitney Museum of American Art. New York 1994 (cat.).– Jaffe, I. B.: J. S. Cambridge (MA) 1970.– Jaffe, I. B.: J. S.'s Symbolism. San Francisco 1994.– Moser, J. (ed.): Visual Poetry. The Drawings of J. S. National Museum of American Art, Washington et al. Washington 1990 (cat.).– J. S. Whitney Museum of American Art. New York 1963 (cat.).– Zilczer, J. (ed.): J. S. Hirshhorn Museum and Sculpture Garden Collection. Washington 1983 (cat.)

**STEPANOVA Varvara**
**1884** Kowno (Lithuania) – **1958** Moscow
Russian artist. **1910–1913** Attended art school in Kasan. Met Rodchenko, her later professional partner and husband. Took private lessons from I. Maschkov. **1913/14** Studied at the Stroganov School of Art in Moscow. **1914–1917** Worked for the leftist Federation of Artists and in the department of fine arts of NARKOMPROS in Moscow. **1918** Co-founder of the Constructivist movement. **1921–1925** Taught at the College of Social Education in Moscow, and from **1924/25** also in the textile department of WChUTEMAS. **1922** Stage design for the comedy *The Death of Tarelkin* by A. Suchowo-Kobylin. Did fabric designs, designed magazine and book covers and, together with her husband, produced picture books.
WRITINGS: Lavrentiev, A. (ed.): S. Moscow 1994
CATALOGUES RAISONNES: Lavrentiev, A. N. (ed.): V. S. The Complete Work. Cambridge 1988 / W. S. Ein Leben für den Konstruktivismus. Weingarten 1988
MONOGRAPHS, CATALOGUES: Holsten, S. et al. (ed.): Alexander Rodtschenko und W. S. Wilhelm-Lehmbruck-Museum. Duisburg 1982 (cat.).– Noever, P. (ed.): Alexander M. Rodtschenko und W. S. Die Zukunft ist unser einziges Ziel. Munich 1991.– Quilici, V. (ed.): Rodcenko e S. Alle origini del costruttivismo. Palazzo dei Priori e Palazzo Cesaroni, Perugia. Milan 1984 (cat.)

**STIEGLITZ Alfred**
**1864** Hoboken (NJ) – **1946** New York
German-born American photographer and gallery owner. **1871** Moved to New York. **1881** Moved to Berlin. **1882–1890** Studied mechanical enginering and photochemistry at the College of Technology in Berlin. **1883** Took up photography. **1890** Returned to New York. **1890** Published the magazine *American Amateur Photographer*. **1896** First night exposures. **1897–1902** Founded and published the journal *Camera Notes*. **1899** First solo-exhibition at the Camera Club, New York. **1902** Together with Coburn and Steichen founded the Photo-Secession. **1903** Founded and published the magazine *Camera Work*. **1904** Met the photographer Kühn. **1907** Trip to Germany.

**1905** Ran Gallery 291, where in **1908** he exhibited drawings by Rodin. **1916** Published the Dada-oriented magazine *291*, to which Picabia, Duchamp and Man Ray contributed. **1917** Stopped working for *Camera Work* and *291*. **1924** Married Georgia O'Keeffe. **1925** Organised the exhibition "Seven Americans", and opened The Intimate Gallery and in **1929** its successor An American Place. After **1937** gave up photography owing to severe illness. **1942** Solo-exhibition at the Museum of Modern Art, New York, and **1944** at the Philadelphia Museum of Art. As a representative of Art Photography Stieglitz was one of the most important champions of photography as an art form and of the avant-garde in America in the early 20th century.
WRITINGS: Seligmann, H. J.: A. S. Talking. Notes from Some Conversations 1925-1931. New Haven (CT) 1966.– A. S.: Photo-Secessions and ist Opponent. Five Letters. New York 1910
MONOGRAPHS, CATALOGUES: America and A. S. A Collective Portrait. Millerton 1979.– Arrowsmith, A. and B. Rathbone (ed.): Georgia O'Keeffe and A. S. Two Lives. The Phillips Collection, Washington et al. London 1992 (cat.).– Bunnell, P. C.: A. S. Photographs from the Collection of Georgia O'Keeffe. Santa Fe 1993.– Bry, D.: A. S. Photographer. Essay. New York 1965, 1996.– Doty, R.: Photo-Secession. S. and the Fine-Art Movement in Photography. New York 1978.– Dufek, A.: A. S. Prague 1990.– Gee, H. (ed.): S. and the Photo-Secession. Pictorialism to Modernisme 1902-1917. New Jersey State Museum. Trenton 1978 (cat.).– Greenough, S. and J. Hamilton (ed.): A. S. Photographs and Writings. Metropolitan Museum of Art, New York et al. New York 1983 (cat.).– Greenough, S.: A. S.'s Photographs of Clouds. Diss. Albuquerque 1984.– Frank, W. et al. (ed.): America and A. S. A Collective Portrait. New York 1934.– Haines, R. E.: The Inner Eye of A. S. Washington 1982.– Homer, W. I.: A. S. and the American Avant-garde. Boston 1977.– Homer, W. I.: A. S. and the Photo-Secession. Boston 1983.– Kiefer, G. W. A. S. New York 1991.– Lowe, S. D.: S. A Memoir/Biography. New York 1989.– Lynes, B. B.: O'Keeffe, S. and the Critics 1916-1929. Ann Arbor (MI) 1989.– Norman, D. (ed.): A. S. Introduction to an American Seer. New York 1960, 1973.– Peterson, C. (ed.): A. S.'s Camera Notes. New York 1996.– Porter, A. (ed.): Camera Work: A. S. Zurich 1985.– Seligman, H. J.: A. S. Talking. Notes on Some of His Conversations. 1925.-1931. New Haven (CT) 1966.– Szarkowski, J.: A. S. at Lake George. New York 1995.– Weber, E.: A. S. New York 1994.– Whelan, R.: A. S. A Biography. Boston 1995

**STILL Clyfford**
**1904** Grandin (ND) – **1980** New York
American painter. Studied **1926/27** and **1931–1933** at Spokane University in Washington, where he later became an art

teacher himself. His pupils at colleges and universities in California, Virginia and New York included Tobey and Rothko and many other Abstract Expressionist painters. **1943** First solo-exhibition at the San Francisco Museum of Art. In the 30s, inspired by the works of Cézanne and van Gogh, he painted abstract figures and landscapes, while his works of the 40s are more Surrealist in character, being based on mythological themes and the workings of the subconscious. Around **1947** he developed his last painting style: large canvases, usually covered in a thick, monochrome-black layer of paint and framed by bright contrasting colours. **1959** Participated in documenta 2 in Kassel and in the exhibition at the Albright-Knox Art Gallery in Buffalo (NY). **1979** Retrospective at the Metropolitan Museum of Modern Art, New York, and **1992** at the Kunsthalle Basel. Out of the principles of Abstract Expressionism Still created works of a calm, meditative character.
MONOGRAPHS, CATALOGUES: Anfam, D.: C. S. Diss. London 1984.– Jonas-Edel, J.: C. S.'s Bild vom Selbst und vom Absoluten. Studien zur Intention und Entwicklung seiner Malerei. Cologne 1995.– Kellein, T. (ed.): C. S. Albright-Knox Art Gallery, Buffalo et al. Munich 1992 (cat.)/C. S. Kunsthalle Basel. Munich 1992 (cat.).– Kellein, T. (ed.): C. S. New York 1995.– O'Neill, J. P. O. and K. Kuh (ed.): C. S. Metropolitan Museum of Art. New York 1979 (cat.).– C. S. Thirty-Three Paintings in the Albright-Knox Art Gallery. Buffalo 1966 (cat.).– C. S. Marlborough-Gerson Gallery Inc. New York 1969 (cat.).– C. S. San Francisco Museum of Contemporary Art. San Francico 1976 (cat.)

**STÖHRER Walter**
born **1937** Stuttgart
German painter. **1957–1959** Studied at the Karlsruhe Academy under HAP Grieshaber. **1959** Moved to Berlin. Participated at the Young Artists Biennale in Paris. **1961** First solo-exhibition at the Kellergalerie in Schloß Darmstadt. **1964** Critics Award from the City of Berlin. **1965** Solo-exhibition at the Galerie St. Stefan, Vienna. **1973** Studied at the Cité des Arts, Paris. **1977** Villa Romana Award, Florence. **1979** Solo-exhibition at the DAAD gallery in Berlin,

and **1980** at the Württembergische Kunstverein, Stuttgart. **1981/82** Guest-professor at the Berlin School of Arts. **1984** Retrospective at the Kunsthalle in Düsseldorf and at the Saarland Museum, Saarbrücken. From **1986** professor at the Berlin School of Arts. **1989** Solo-exhibition at the Berlinische Galerie. Stöhrer's paintings, executed with an impulsive, passionate brush stroke, are reminiscent of Ecriture automatique (automatic writing) and the spontaneity of L'art informel.
CATALOGUE RAISONNE: Bose, G. (ed.): W. S. Werkverzeichnis der Druckgraphik. Radierungen 1960-1966. Berlin 1994
MONOGRAPHS, CATALOGUES: Bose, G. (ed.): W. S. Bilder 1961-1988. Museum für moderne Kunst, Photographie und Architektur. Berlin 1989 (cat.).– Jensen, J. C. (ed.): W. S. Neue Bilder. Kunsthalle Kiel. Kiel 1990 (cat.).– Jensen, J. C. et al. (ed.): W. S. Kunstverein Hannover. Hannover 1998 (cat.).– Meyer zu Eissen, A. (ed.): W. S. Arbeiten 1962-1983. Kunsthalle Bremen et al. Bremen 1983 (cat.).– Motte, M. d. la (ed.): W. S. Weissglut. Galerie Nothelfer. Berlin 1993 (cat.).– Reising, G. (ed.): W. S. Werke auf Papier 1959-1995. Staatliche Kunsthalle. Karlsruhe 1995 (cat.).– Schaart, J. (ed.): W. S. Bilder 1961-1988. Berlinische Galerie. Berlin 1989 (cat.).– Schmidt, J.-K. (ed.): W. S. Stuttgart 1995 (cat.).– W. S. Arbeiten 1962-1983. Kunstmuseum. Düsseldorf 1984 (cat.).– W. S. Frühe Druckgrafik. Kunsthalle Bremen. Bremen 1994 (cat.).– W. S. Neue Arbeiten. Kunstverein Augsburg et al. Augsburg 1994 (cat.)

**STRAND Paul**
**1890** New York – **1976** Paris
American photographer. **1904–1909** Studied at the Ethical Culture School in New York under Hine. **1909** Joined the Camera Club in New York. **1911** Trip to Europe. **1912** Set up his own studio, specialising first of all in portraits, street scenes and architecture. **1915** Documentary series on the Southern States of America. **1916** Photoseries on depressed areas of New York. Experiments with abstract compositions. First solo-exhibition at the 291 gallery and first photographs published in *Camera Work*. **1919–1921** Collaborated with Sheeler on the film *Manahatta*. **1922** Made further expeimental films and wrote articles on photography. Taught at the C. H. White's School of Photography. **1935** Travelled to Russia where he met Sergei M. Eisenstein. **1943/44** Photomontages on the election campaign of F. D. Roosevelt. **1945** Retrospective at the Museum of Modern Art, New York. **1950** Moved to Paris. Photoseries in various countries, including a series of portraits of contemporary artists in France. **1971** Retrospective at the Philadelphia Museum of Art. Strand, whose abstract photography is an attempt to reveal the underlying structure of the viewed object, can be considered the first modern photographer in America.
MONOGRAPHS, CATALOGUES: Butor, M. et al. (ed.): P. S. Centre Georges Pompidou. Paris 1977 (cat.).– Duncan, C.: P. S. The World on My Doorstep, the Years 1850 to 1976. New York 1994/P. S. Die Welt vor meiner Tür. Museum Folkwang, Essen. New York and Frankfurt-on-Main 1994 (cat.)/P. S. Le Monde à ma porte. Paris 1994.– Greenough, S. (ed.): P. S. An American Vision. National Gallery of Art, Washington et al. New York 1990 (cat.).– Hoffman, H. and M. E. Hofman: P. S. A Retrospective Monograph. 2 vols. New York 1972.– Lloyd, V. (ed.): P. S. A Retrospective Exhibition of His Photographs 1915-1968. National Portrait Gallery.

London 1976 (cat.).– Newhall, N. (ed.): P. S. Photographs 1915-1945. The Museum of Modern Art. New York 1945 (cat.).– Peters, G. P.: P. S. An Extraordinary Vision. Santa Fe 1994.– Rosenblum, N.: P. S. The Early Years. Diss. New York. Ann Arbor (MI) 1983.– Stange, M. et al. (ed.): P. S. Essays on His Life and Work. New York 1990

**STRELOW Liselotte**
**1908** Redel (near Polzin) – **1981** Hamburg
German photographer. **1924–1929** Agricultural work. From **1930** studied photography at the Lette School in Berlin, and then entered the studio of S. Byk. **1938** Employed as a photographer by Kodak in Berlin. **1945** Opened a new photographic studio in Detmold. **1950** Moved to Düsseldorf, where she made her name taking portraits of artists, actors and theatre celebrities. **1957** Received a prize for photography at the Venice Biennale. **1961** Publication of her book on portrait photography entitled *Das manipulierte Menschenbild* (Manipulation of the Human Image). **1977** Retrospective at the Rheinisches Landesmuseum, Bonn, and participation in documenta 6 in Kassel.
WRITINGS: L. S.: Das manipulierte Menschenbildnis. Düsseldorf and Vienna 1961.– L. S.: Photogenic Portrait Management. London 1966
MONOGRAPHS, CATALOGUES: Honnef, K. et al. (ed.): L. S. Porträts 1933-1972. Rheinisches Landesmuseum, Bonn. Cologne 1977 (cat.)

**STRUTH Thomas**
born **1954** Geldern (Lower Rhineland)
German photographer. **1973–1980** Studied painting under Gerhard Richter and photography under Becker at the Düsseldorf Academy. From **1976** large-scale documentary series in black-and-white of architecture and municipal buildings in their cultural and social context, a favourite theme being empty streets, deserted inner-city areas and derelict factories. **1978** Scholarship from the Düsseldorf Academy to New York, where his first solo-exhibition was held. **1980–1982** Community service in a citizens' advice bureau. **1982** Took up professional photography, with a special focus on urban life and city centres in metropo-

lises as varied as Naples, Tokyo, Chicago and Berlin. International exhibitions in Munich, Cologne, Brussels, Amsterdam, Paris, Washington and New York. **1993** Professor at Karlsruhe School of Design.
MONOGRAPHS, CATALOGUES: Belting, H. (ed.): T. S. Museum Photographs. Hamburger Kunsthalle. Munich 1993 (cat.).– Buchloh, B. H. D. (ed.): T. S. Photographs. Chicago 1990 (cat.).– Buchholz, B. et al. (ed.): T. S. Portraits. Hanover 1997 (cat.).– Lingwood, J. and M. Teitelbaum (ed.): T. S. Strangers and Friends. Photographs 1986-1992. Institute of Contemporary Arts, London. Cambridge 1994.– T. S. Unbewußte Orte. Kunsthalle Bern et al. Cologne 1987 (cat.).– T. S. Portraits. Krefelder Kunstmuseum, Museum Haus Lange. Krefeld 1992 (cat.).– T. S. Stranger and Friends. Photographs 1986-1992. Institute of Contemporary Arts, Boston et al. Munich 1994.– T. S. Straßen. Fotografie 1976-1995. Städtisches Kunstmuseum Bonn. Cologne 1995 (cat.)

**STRZEMINSKI Vladislav**
**1893** Minsk – **1952** Lodz
Polish painter and theoretician. **1918/19** Studied at WChUTEMAS in Moscow. **1922** Moved to Poland. Joined the artists' groups Blok a. r. and Praesens. **1924–1927** Together with his wife Kobro, developed the theory of Unism, with the aim of achieving an absolute pictorial balance, i.e. perfect homogeneity of all the constituent parts of a composition. **1930–1933** Unistic compositions devoid of all forms of colour contrast. **1945–1950** Taught at the School of Applied Arts in Lodz. **1958** Posthumous publication of his treatise *Learning by Seeing*. Strzemiński's ideas are a logical extension of Malevich's theories of Suprematism. Unism was chiefly manifested in white paintings, divided up into minute fields that produce a vibrating effect.
WRITINGS: W. S.: Unizm w malarstwie. Warsaw 1928.– W. S.: Teoria widzenia. Kraków 1958.– W. S.: Pisma. Warsaw 1975.– W. S. and K. Kobro: L'Espace uniste. Ecrits du constructivisme polonais. Lausanne 1977
MONOGRAPHS, CATALOGUES: Adolphs, V. et al. (ed.): W. S. 1893-1952. Städtisches Kunstmuseum Bonn. Cologne 1994 (cat.).– Baranowicz, Z.: W. S. Warsaw 1984.– Turowski, A. (ed.): W. S. Städtische Kunsthalle Düsseldorf. Düsseldorf 1980 (cat.).– Zagrodzkiego, J. (ed.): W. S. In Memoriam. Lodz 1988

**SUGAI Koumi**
born **1919** Kobe
Japanese painter and graphic artist. **1933–1937** Studied at the Art Academy in Osaka. Worked from **1937** as a poster designer. **1947** Took painting lessions from T. Nakamura. **1948/49** Became especially interested first in Surrealism and then in the works of Pollock and Calder. **1952** Moved to Paris. **1953** First solo-exhibition at the Craven

gallery in Paris. **1956** Participated in the Salon des Réalités Nouvelles and **1957** in the Salon de Mai in Paris. **1959** Prize for graphic art at the Ljubljana Biennale. Participated in documenta 2 in Kassel. **1960** Retrospective at the Art Museum in Leverkusen. **1961** Prize for painting at the Tokyo Biennale, **1962** David Bright Prize at the Venice Biennale and **1965** prize for painting at the São Paulo Biennale. **1963** Solo-exhibition at the Kestner Society, Hanover. **1964** Participated in documenta 3 in Kassel. **1969** Retrospective at the National Museum of Modern Art, Kyoto. **1981** Solo-exhibition at the Satani Gallery, Tokyo. Sugai's lyrical form of Abstract Expressionism is closely related to the painting style of the Ecole de Paris, but is also threaded through with traces of traditional Japanese calligraphy.
MONOGRAPHS, CATALOGUES: Chalumeau, J.-L.: K. S. Paris 1995.– Lambert, J.-C.: S. Paris 1990, Geneva 1992.– K. S. Städtisches Museum, Schloß Morsbroich. Leverkusen 1960 (cat.).– K. S. Retrospektive 1952-1963. Kestner-Gesellschaft. Hanover 1963 (cat.).– Mandiargues, A. P. d. et al. (ed.): K. S. Seibu Museum of Art. Tokyo 1983 (cat.)

**SURVAGE Léopold**
(Leopoldij Sturzwasgh)
**1879** Willmanstrand – **1968** Paris
French painter of Finnish and Danish origins. **1901** Studied at the Moscow Art Academy. **1908** Went to Paris to study under Matisse. Came to know Cézanne, under whose influence he adopted a Cubist approach to painting. **1911** Contact with Archipenko. Participated in the Salon d'Automne, and **1912** in the Salon des Indépendants. **1917** First solo-exhibition in Paris at Galerie Bongard. **1919** Founder-member of Section d'Or. **1920** Solo-exhibition at the gallery of Léonce Rosenberg. **1922** Stage design for Diaghilev's production of the I. Stravinsky ballet *Mavra* in Paris. **1927** Took French citizenship. From **1933** numerous stage designs, wall decorations and tapestries. **1937** Monumental murals for the Paris World Fair. **1960** Guggenheim Award. **1965** Illustrations for books by J. Cocteau and H. de Balzac. **1966** Retrospective at the Musée Galliéra, Paris and **1993** at the Musée d'Art Moderne, Troyes. Survage's

large, decorative paintings display elements of Cubism but have a poetic style of their own.
WRITINGS: Seyres, H. (ed.): L. S. Ecrits sur la peinture. Paris 1992
CATALOGUE RAISONNE: Brosset, E. (ed.): L. S. Catalogue raisonné (in preparation)
MONOGRAPHS, CATALOGUES: Abadie, D. (ed.): S. Les Années héroïques. Musée d'Art Moderne, Troyes et al. Arcueil 1993 (cat.).– Fournet, C. (ed.): S. Rythmes colorés. Musée d'Art et d'Industrie. Saint-Etienne 1973 (cat.).– Gauthier, M.: S. Paris 1953.– Putnam, S.: The Glistening Bridge. L. S. and the Spatial Problem in Painting. New York 1929.– L. S. Musée des Beaux-Arts. Lyon 1968 (cat.).– L. S. Musée d'Art Moderne et d'Art Contemporain. Nice 1975 (cat.).– Warnod, J.: L. S. Brussels 1983

**SUTHERLAND Graham**
**1903** London – **1980** London
English painter. **1921–1926** Studied graphic art at Goldsmith's College, London, and then worked as a book illustrator and poster designer. From **1926** taught at Chelsea School of Art in London. Towards the mid-30s he took up oil painting and, influenced by Surrealism, painted semi-abstract landscapes with a weird, haunting quality. **1941–1945** Worked as an official war painter, depicting bomb damage in London and towns in southern England. **1944** Commission for a *Crucifixion* for St. Matthew's church in Northampton, completed after the war, when he embarked on a series of religious paintings. **1947** Visited the Côte d'Azur, where he painted more landscapes. **1952** Represented England at the Venice Biennale. **1955–1964** Participation in documenta 1 – 3 in Kassel. In the late 50s he painted portraits of famous politicians including W. Churchill and K. Adenauer. In his fantastic, sombre landscape paintings Sutherland was aiming to portray the brutality of nature and the dark forces underlying all beauty. With Bacon, he is one of the main representatives of surrealist-visionary painting in England.
CATALOGUES RAISONNES: Man, F. H. (ed.): G. S. Das graphische Werk 1922-1970. Munich 1970/G. S. The Graphic Work. 1922-1970. San Francisco 1970.– Tassi, R. (ed.): G. S. Complete Graphic Work. London and New York 1978/G. S. Tout l'œuvre gravé (1922-1978). Paris 1980
MONOGRAPHS, CATALOGUES: Alley, R. (ed.): G. S. Tate Gallery, London et al. London 1982 (cat.).– Arcangeli, F.: G. S. New York 1975.– Berthoud, R.: G. S. A Biography. London 1982.– Bruno, G. (ed.): G. S. Storia segreta 1922-1979. Museo dell'Accademia Ligustica di Belle Arti. Genoa 1991 (cat.).– Chiappini, R. (ed.): S. Pinacoteca comunale, Casa Rusca, Locarno. Milan 1988 (cat.).– Cooke, G.: G. S. Early Etchings. Brookfield 1993.– Cooper, D.: The Work of G. S. London and New York 1961, Oxford 1980.– Cooper, D. (ed.): G. S. Haus der Kunst, Munich et al. Munich

1967 (cat.).– Hayes, J. (ed.): Portraits by G. S. National Portrait Gallery. London 1977 (cat.).– Hayes, J.: The Art of G. S. Oxford and New York 1980.– Krimmel, B. (ed.): G. S. Mathildenhöhe. Darmstadt 1982 (cat.).– Melville, R. (ed.): G. S. London 1950.– Nicholls, P. et al. (ed.): Bestiari di G. S. Milan 1985 (cat.).– Sanesi, R. (ed.): G. S. Palazzo dell Albere. Trento 1981 (cat.).– G. S. Galleria Civica d'Arte Moderna. Torino 1965 (cat.).– Tassi, R. (ed.): S. Disegni di guerra. Milan 1979 (cat.).– Thuillier, R.: G. S. Inspirations. Guildford, Surrey 1982

**TAAFFE Philip**
born **1955** Elisabeth (NJ)
American painter. **1977** Finished his studies at the Cooper Union, New York. In the early 80s he incorporated elements of Op Art from the works of artists like Riley in his novel pictorial constructions. Besides Op Art techniques, he was particularly interested in the works of Newman. **1988–1992** Lived in Naples, studying ornamental designs from various cultures. In the late 80s he experimented with colour printing techniques and produced increasingly abstract acrylic paintings with sections of collage. **1982** Regular exhibitions in galleries throughout Europe and America, including "German and American Art of the Late 80s", Düsseldorf and Boston (1988), "Post Abstract Abstraction", Aldrich (1987), "Doubletake", Vienna and London (1992), "ARS 95", Helsinki (1995). **1987, 1991** and **1995** invitations to the Whitney Biennale in New York.
MONOGRAPHS, CATALOGUES: Adams, B. (ed.): P. T. Wiener Secession. Vienna 1996 (cat.).– P. T. Mary Boone Gallery. New York 1981 (cat.).– P. T. Gagosian Gallery. New York 1991 (cat.).– P. T. Center for the Fine Arts. Miami 1993 (cat.).– P. T. Thomas Ammann Fine Art. Zurich 1998 (cat.)

**TAEUBER-ARP Sophie**
**1889** Davos – **1943** Zurich
Swiss painter and sculptress. **1908–1910** Attended the St. Gallen School of Arts and Crafts. **1911–1913** Studied at the Debschitz College of Education and Research in Munich. **1915** Met Arp. **1916–1928** Taught at the School of Arts and Crafts in Zurich.

**1916–1920** Took part in Dada events in Zurich, primarily as a dancer. **1921** Married Arp. **1926–1928** Interior decoration of the Aubette restaurant in Strasbourg with Arp and Doesburg. **1928** Moved to Meudon, near Paris. **1930** Joined Cercle et Carré and then Abstraction-Création. **1936** Participated in the exhibition "Fantastic Art, Dada and Surrealism" at the Museum of Modern Art, New York. **1937** Founded the magazine *Plastique* and joined the Swiss Alliance group. **1941–1943** Lived in Grasse, near Nice, along with Arp, Magnelli and Sonia Delaunay. **1943** Returned to Zurich; close contact with Bill. Taeuber-Arp's abstract art combines geometric elements in rhythmic formation with the expressive force of pure colour. She had a considerable influence on Arp.
CATALOGUE RAISONNE: Schmidt, G. and H. Weber (ed.): S. T.-A. Basel 1948
MONOGRAPHS, CATALOGUES: Fauve, J. L. et al. (ed.): S. T.-A. Musée d'Art Moderne. Strasbourg 1977 (cat.).– Gohr, S. (ed.): S. T.-A. 1889-1943. Bahnhof Rolandseck. Stuttgart 1993 (cat.).– Lanchner, C. (ed.): S. T.-A. The Museum of Modern Art. New York 1981 (cat.).– Pagé, S. et al. (ed.): S. T.-A. Musée d'Art Moderne de la Ville de Paris et al. Paris 1989 (cat.).– Seuphor, M.: Mission spirituelle de l'art. A propos de l'œuvre de S. T.-A. Paris and Liège 1953.– Staber, M.: S. T.-A. Lausanne 1970.– S. T.-A. Musée National d'Art Moderne. Paris 1964 (cat.).– S. T.-A. Kunstmuseum Winterthur. Winterthur 1977 (cat.).– S. T.-A. zum 100. Geburtstag. Aarauer Kunsthaus et al. Aarau 1989 (cat.).– S. T.-A. Kunsthalle Bern et al. Stuttgart 1993 (cat.).– Wasmuth, J. (ed.): Hans Arp und S. T.-A. Ein Künstlerpaar der Moderne. Stuttgart 1996 (cat.)

**TAKIS**
(Takis Vassilakis)
born **1925** Athens
Greek-born French sculptor. Self-taught. **1946** First sculptural works. **1953/54** Lived in London. **1954** Moved to Paris. **1955** First solo-exhibition at the Furstenberg gallery, Paris. **1958/59** Began to work with magnetic fields. **1960** Solo-exhibition at the Iolas Gallery, New York. **1966/67** Lived in London. **1968** Took part in documenta 4 in Kassel. **1969** Took part in the exhibition "The Machine as Seen at the End of the Mechanical Age" at the Museum of Modern Art, New York. **1972** Solo-exhibition at the Centre National d'Art Contemporain, Paris, and **1974** at the Hanover Kunstverein. **1977** Took part in documenta 6 in Kassel. **1981, 1984** and **1985** projects at the Pompidou Centre, Paris. **1988** Grand Prix de sculpture in Paris. **1993** Retrospective at the Galerie Nationale du Jeu de Paume, Paris. Takis's kinetic sculptures, combining mechanical movement with the optical illusions of Op Art, reached their peak with his *Firework sculptures*.
WRITINGS: V. T.: Estafilades. Paris 1961.– V. T.: Musique Magnétique. Paris 1975
MONOGRAPHS, CATALOGUES: Calas,

H. and N.: T. Monographies. Paris 1984.–
Lebel, J. J. et al. (ed.): T. Centre National
d'Art Contemporain. Paris 1972 (cat.).– Pac-
quement, A. (ed.): T. Galerie Nationale du
Jeu de Paume, Paris et al. Paris 1993 (cat.).–
T. Les Magnétrons de T. Galerie Alexandre
Iolas. Paris 1966 (cat.).– T. Städtisches
Museum. Leverkusen 1970 (cat.).– T. Trois
totems. Espace musical. Centre Georges
Pompidou. Paris 1981 (cat.).– Vieville, D.:
T. Paris 1993

### TAL-COAT Pierre
(Pierre Jacob)
**1905** Clohars-Carnoët – **1985** Saint-Pierre
de Bailleul
French painter. Self-taught. Lived in Paris
**1924-1926**. **1925** Did designs for the
Henriot porcelain factory in Quimper.
**1927** First solo-exhibition at the A. G.
Fabre gallery, Paris. **1930** Studied at the
Scandinavian Academy. **1931** Moved to
Paris. **1935/36** Exhibited with the group
Forces Nouvelles as well as Nouvelle
Génération in Paris. **1936-1939** Worked on
the series *Massacre*: paintings inspired by
the Spanish Civil War. **1940-1944** Lived in
Aix-en-Provence. **1947** Masson introduced
him to Chinese landscape painting. **1954**
Solo-exhibition at the Galerie Maeght. **1955**
and **1959** took part in documenta 1 and 2 in
Kassel. **1968** Grand Prix National des arts.
**1976** Solo-exhibition at the Grand Palais,
Paris. **1980** Took part in the exhibition
"Forces nouvelles" at the Musée d'Art
Moderne de la Ville de Paris. The central
theme of Tal-Coat's art is the countryside,
however, he transforms his landscapes into
abstract, lyrical colour visions.
WRITINGS: P. T.-C.: Libre regard. Paris
1991
MONOGRAPHS, CATALOGUES: Blot-
tière, S. (ed.): T.-C. Rétrospective des
dessins et œuvres sur papier. Musée des
Beaux-Arts. Rennes 1988 (cat.).– Greff, J.-P.
(ed.): T.-C. Musée Matisse. Le Cateau-
Cambrésis 1991 (cat.).– Leymarie, J.: T.-C.
Geneva 1992.– Maldiney, H. and R. J.
Moulin (ed.): T. C. Grand Palais. Paris 1976
(cat.).– Mason, R. M. (ed.): T-C. Gravures
1970-1984. Musée d'Art et d'Histoire.
Geneva 1985 (cat.).– Schneider, J.-C. et al.:
T. C. Lavis et aquarelles. Paris 1991

### TAMAYO Rufino
**1899** Oaxaca – **1991** Mexico City
Mexican painter. **1917/18** Studied at the
Academy in Mexico City. **1921** Director of
the Department of Ethnological Drawing
at the Museum of Anthropology. **1926-**
**1928** Lived in New York. **1929/30** Taught at
the Art Academy in Mexico City and **1938**
at the Dalton School, New York. **1943**
Worked on frescoes for Smith College,
Northampton. **1948** Retrospective at the
Instituto Nacional de Bellas Artes, Mexico
City. **1949** Took part in the Venice Bien-
nale. **1951** Retrospective at the Palais des
Beaux-Arts in Brussels. **1953** First Prize at
the São Paulo Biennale. **1958** Frescoes for

the UNESCO building in Paris. **1979** Solo-
exhibition at the Guggenheim Museum,
New York. **1981** Opening of the Tamayo
Museums in Mexico City. **1987** Retrospec-
tive at the art museum and at the Tamayo
Museum in Mexico City and **1990** at the
Berlin Kunsthalle. Tamayo was not one of
the great revolutionaries of Mexican mural
painting, but found his inspiration in pre-
Columbian folk art, which he combined
with elements of Cubism and Surrealism.
WRITINGS: R. T.: Antología crítica.
Mexico City 1987.– Tibol, R. (ed.): Textos
de R. T. Mexico City 1987
MONOGRAPHS, CATALOGUES:
Cardoza y Aragón, L. et al. (ed.): R. T. Pin-
turas. Museo Nacional Centro de Arte
Reina Sofía. Madrid 1988 (cat.).– Conde, T.
del et al. (ed.): R. T. 70 años de creación.
Museo de Arte Contemporáneo Interna-
cional Rufino Tamayo. Mexico City 1987
(cat.).– Corredor-Matheos, J.: T. Barcelona
1982, 1991.– Genauer, E.: R. T. New York
1974.– Goldwater, R.: R. T. New York
1947.– Lynch, J. B. (ed.): T. Phoenix Art
Museum. Phoenix 1968 (cat.).– Lynch, J.
B. (ed.): R. T. Fifty Years of His Painting.
Phillips Collection. Washington 1978
(cat.).– Moyssén, X. (ed.): R. T. Mexico
City 1980.– Paz, O.: T. en la pintura mexi-
cana. Mexico City 1959.– Paz, O. (ed.): R.
T. Peintures 1960-1974. Musée d'Art
Moderne de la Ville de Paris. Paris 1974
(cat.).– Paz, O. (ed.): R. T. Myth and
Magic. Solomon R. Guggenheim Museum.
New York 1979 (cat.).– Paz, O. and J. Las-
saigne: R. T. New York 1983, Paris 1983,
Munich 1986.– Ruckhaberle, D. and E.
Coldewey (ed.): R. T. Staatliche Kunsthalle
Berlin. Berlin 1990 (cat.).– Westheim, P.: T.
Mexico City 1957

### TANGUY Yves
**1900** Paris – **1955** Woodbury (CT)
American painter of French origin. Self-
taught. Joined the French merchant marine
and between **1918-1920** sailed on a
freighter to England, Spain, Portugal, and
South America. **1920-1923** Military
service. He decided to become a painter in
**1923** after seeing a painting by De Chirico
in a window at the Galerie Paul Guillaume
in Paris. In his first pictures he extended De
Chirico's spatial confinement into an unend-
ing vista: eliminating facades, architecture,

faces, and monuments and taking up his
favourite subject, the infinite panorama of
the sea. **1925** Met André Breton and the
Surrealist painters, and showed his fantastic
landscapes peopled with amorphous,
unidentifiable object and weird sculptural
constructions in their exhibitions. **1939**
Emigrated, along with many of the Surreal-
ists, to America and settled in Woodbury,
where he lived on a farm. **1942** Took part in
the exhibition "Artists in Exile" at the Pierre
Matisse Gallery, New York, and in the Sur-
realist exhibition organised by Breton and
Duchamp at the Reid Mansion. **1948**
Became an American citizen. **1982** Impor-
tant retrospectives at the Baden-Baden
Kunsthalle and at the Pompidou Centre,
Paris.
WRITINGS: Y. T.: Lettres de loin.
Adressées à Marcel Jean. Paris 1993
CATALOGUES RAISONNÉS: Sage, K. et
al. (ed.): Y. T. Un Recueil de ses œuvres. A
Summary of His Works. New York 1963.–
Wittrock, W. (ed.): Y. T. Das druckgraphi-
sche Werk. Staatsgalerie Stuttgart. Düssel-
dorf 1976 (cat.)
MONOGRAPHS, CATALOGUES:
Marchesseau, D.: Y. T. Paris 1973.–
Penrose, R. et al. (ed.): Y. T. Centre
Georges Pompidou. Paris 1982 (cat.).– Sage,
K.: Y. T. A Summary of His Works. New
York 1963.– Schmidt, K. (ed.): Y. T. Staatli-
che Kunsthalle Baden-Baden et al. Munich
1982 (cat.).– Soby, J. T. (ed.): Y. T. The
Museum of Modern Art. New York 1972
(cat.).– Tanguy, G.-M.: Y. T. Druide sur-
réaliste. Paris 1995.– Y. T. A Retrospective.
Solomon R. Guggenheim Museum. New
York 1983 (cat.).– Waldberg, P.: Y. T. Brus-
sels 1977

### TAPIES Antoni
born **1923** Barcelona
Spanish painter, graphic and object artist.
Self-taught. **1943-1946** Studied law in
Barcelona and attended the Academy for
just two months. **1948** Co-founder of the
Dau al Set group and of their magazine.
**1951** Visited Picasso. **1952** First abstractions.
**1956** Travelled in Italy, and studied
Vedanta, Taoism and Zen Buddhism. **1959**
**-1977** Participation in documenta 2, 3 and
6 in Kassel. **1966** Arrested and convicted
for holding illegal meetings in a monastery
near Barcelona. **1970** Retreats with Miró to
Montserrat Cloister out of solidarity with
those who had not betrayed Catalan leftists
and communists on trial. First sculptural
objects. **1981** Awarded the Gold Medal for
Fine Arts by King Juan Carlos and received
an honorary doctorate from the Royal
College of Art in London. Important retro-
spectives: **1993** at the Schirn art museum,
Frankfurt am Main, **1994** at the Galerie
Nationale du Jeu de Paume and **1995** at the
Guggenheim Museum, New York. Involved
himself very early with the work of the Sur-
realists, and was inspired by Picasso, Miró
and Klee. He quickly moved into abstraction
and began to produce collages out of a
never-ending variety of materials. His late

works are characterised by mythological
and philosophical themes. The runes and
symbols that appear, scratched onto or in
his paintings, have a magical, cosmic
meaning.
WRITINGS: Catoir, B. (ed.): Gespräche
mit A. T. Munich 1987, 1998 / Conversa-
tions avec A. T. Paris 1988 / Conversations
with A. T. Munich 1991.– A. T.: La pratique
de l'art. Paris 1974 / Die Praxis der Kunst. St.
Gallen 1976.– A. T.: L'Art contre l'esthé-
tique. Paris 1978 / Kunst kontra Ästhetik. St.
Gallen 1983.– A. T.: Mémoire. Autobiogra-
phie. Paris 1981 / Erinnerungen. Fragment
einer Autobiographie. St. Gallen 1988.–
A. T.: La Réalité comme art. Paris 1989
CATALOGUES RAISONNÉS: Agustí, A.
et al. (ed.): T. Obra completa. 4 vols.
Barcelona 1988-1997 / T. Catalogue
raisonné. 4 vols. Paris 1988-1997 / A. T. The
Complete Works. 4 vols. New York 1988-
1997.– Galfetti, M. (ed.): T. Das graphische
Werk 1947-1978. 2 vols. Sankt Gallen 1974-
1984 / T. L'œuvre gravé 1947-1978. 2 vols.
Paris 1974-1984 / T. The Graphic Work 1947-
1978. 2 vols. San Francisco 1984
MONOGRAPHS, CATALOGUES: Abadie,
D. (ed.): T. ouvrage collectif. Galerie
Nationale du Jeu de Paume. Paris 1994
(cat.).– Ballo, G. (ed.): T. Milano 1985.–
Bärmann, M. and G. Fischer (ed.):
T. El libre. Das Buch. Stadtmuseum, Sieg-
burg et al. Siegburg 1994 (cat.).– Borja, M.
J.: A. T. The Matter Paintings. Ann Arbor
(MI) 1990.– Borja-Villel, M. J. (ed.): T.
Comunicació sobre el mur. Fundació
Antoni Tàpies, Barcelona et al. Valencia
1992 (cat.).– Cirici, A.: T. Zeuge des
Schweigens. Düsseldorf 1971 / T. Witness of
Silence. New York 1972.– Cirlot, J.-E.: T.
Barcelona 1960.– Cirlot, J.-E.: T. Signifi-
cación de la pintura de T. Barcelona 1962.–
Combalia Dexeux, V.: T. Paris 1984,
Brunswick 1990.– Dauber, G. (ed.): A. T.
Kunsthalle Bremen. Bremen 1977 (cat.).–
Davvetas, D.: A. T. Paris 1994.– Franzke, A.
and M. Schwarz (ed.): A. T. Werk und Zeit.
Stuttgart 1979 (cat.).– Franzke, A.: T.
Munich 1992, Paris 1993, New York 1995.–
García, J.-M. (ed.): T. und die Bücher.
Schirn Kunsthalle, Frankfurt-on-Main.
Barcelona 1991 (cat.).– Gatt, G.: A. T.
Bologna 1967.– Giménez, C. and D.
Ashton (ed.): T. Solomon R. Guggenheim
Museum, New York et al. New York and
Paris 1995 (cat.).– Gimferrer, P.: A. T. i
l'esprit català. Barcelona 1974 / A. T. and the
Catalan Spirit. New York 1975 / A. T. und
der Geist Kataloniens. Frankfurt-on-Main
and Berlin 1976.– Malet, R. M.: Los carte-
les de T. Barcelona 1984 / T. affiches. Paris
1988.– Messer, T. M. (ed.): T. Eine Retro-
spektive. Schirn Kunsthalle. Frankfurt-on-
Main 1993 (cat.).– Moure, G.: T. Objets du
temps. Paris 1994 / T. Objects of Time.
Cologne 1995.– Penrose, R.: A. T. London
1978, New York 1993.– Permanyer, L.: T.
and the New Culture. New York 1986 / T. et
la nouvelle culture. Paris 1986.– Raillard,
G.: T. Paris 1976.– Raillard, G.: La Syllabe
noire de T. Marseille 1994.– Schmalenbach,
W.: A. T. Zeichen und Strukturen. Frank-
furt-on-Main and Berlin 1974.– Schmalen-
bach, W. (ed.): T. Die achtziger Jahre.
Kunstsammlung Nordrhein-Westfalen,
Düsseldorf 1989 (cat.).– Wye, D. (ed.): A.
T. in Print. The Museum of Modern Art.
New York 1992 (cat.)

### TATLIN Vladimir
**1885** Moscow – **1958** Norodevichi
Russian artist. **1902/03** and **1909-1911**
Studied at the School of Painting, Sculp-
ture, and Architecture in Moscow. **1907/08**
Lessons from Larionov. **1912** Took part in
the "Donkey Tail" exhibition in Moscow.
**1913** Travelled to North Africa, Berlin, and

Retrospective at the Musée d'Art Moderne de la Ville de Paris. Telemaque's geometrically composed pictures integrate elements of Pop Art and Nouveau Réalisme such as comics and commonplace objects.
MONOGRAPHS, CATALOGUES: Gassiot-Talabot, G. (ed.): H. T. Galleria Arte Borgogna. Milan 1973 (cat.).– Noël, B. (ed.): H. T. Musée d'Art Moderne de la Ville de Paris. Paris 1976 (cat.).– Noël, B. and C. Thieck (ed.): H. T. Galerie Adrien Maeght. Paris 1981 (cat.).– H. T. Dérive graphique. Musée de Maubeuge 1993 (cat.).– H. T. Espace Electra. Paris 1995 (cat.)

Paris. Became acquainted with the work of the Fauves and the Cubists. Met Picasso. **1915** Took part in the exhibitions "Streetcar 5" and "0.10" in St. Petersburg. **1916** Took part in the exhibition "Magazin" in Moscow. **1917** Designed the interior of the Café Pittoresque in Moscow with Rodchenko and Jakulov. **1918/19** Director of the IZO NARKOMPROS in Moscow. **1919/20** Tower model construction for the Monument to the Third International. **1921–1925** Taught at the GINChUK in Leningrad. **1922** Took part in the Russian Art exhibition in Berlin. **1923** Stage design for Chlebnikov's play *Zangezi*. **1925–1927** Professor at the Art Institute in Kiev. **1927–1933** Taught at UTEMAS in Moscow. **1929–1932** Construction of the experimental flying machine *Letatlin*. **1934** Returned to classic painting and worked as a stage set designer. **1937** Assisted with the ceremonial decorations in Moscow for the 20th anniversary of the October Revolution. **1948** Officially declared an "Enemy of the People" by the Communist Party. **1993** Retrospective at the Kunsthalle Düsseldorf. Tatlin was one of the most important members of the Eastern European avant-garde. With his counter-reliefs, the new icons of a functional social order, he laid the cornerstone of Constructivism.
CATALOGUE RAISONNE: Andersen T. et al. (ed.): W. T. 1885-1953. Moderna Museet, Stockholm et al. Stockholm 1968 (cat.)
MONOGRAPHS, CATALOGUES: Davenport, G.: T. New York 1974.– Harten, J. and A. Strigalev (ed.): V. T. Retrospektive. Städtische Kunsthalle Düsseldorf et al. Cologne 1993 (cat.).– Harten, J. (ed.): W. T. Leben, Werk, Wirkung. Ein internationales Symposium. Cologne 1993.– Körner, E.: T. Outlines Of a Career in the Context of Contemporary Russian Avant-Garde Art as Related to Eastern and Western Tendencies. Budapest 1985.– Milner, J.: V. T. and the Russian Avant-Garde. New Haven (CT) and London 1983.– Ray, M.: T. e la cultura del Vchutemas. 1885-1953, 1920-1930. Roma 1992.– Rowell, M.: V. T. Form, Faktura. Cambridge (MA) 1978.– Shadova, L. A. (ed.): T. Budapest 1980, Dresden 1984, Weingarten 1987, London and New York 1988.– W. T. Moderna Museet. Stockholm 1968 (cat.).

**TELEMAQUE Hervé**
born **1937** Port-au-Prince (Haiti)
Haitian-born French painter. **1957–1960** Studied at the Art Students League, New York and, during this time, was strongly influenced by Gorky and De Kooning. **1962** Moved to Paris and participated in the Salon Latino-Américain. **1964** Solo-exhibition at the Matthias Fels gallery in Paris. **1964** Joint-exhibition with Geissler at the Hanover Gallery, London. **1964** and **1968** took part in documenta 3 and 4 in Kassel. **1968** Was represented at the exhibition "Painting in France 1900–1967" at the Metropolitan Museum of Art, New York. Took part in documenta 4 in Kassel. **1976**

**THEK Paul**
**1933** Brooklyn (NY) – **1988** New York
American object artist. **1951–1954** Studied at the Cooper Union, the Art Students League and at the Pratt Institute in New York. Lived from **1955–1962** in Florida and Italy and **1962–1968** in New York, before going to Europe again. **1964** Solo-exhibition at the Stable Gallery, New York, and **1966** at the Pace Gallery, New York. **1968** Took part in documenta 4 in Kassel. **1972** Solo-exhibition at the Moderna Museet, Stockholm, and at the Lucerne Kunstmuseum. **1976** and **1980** took part in the Venice Biennale. **1981** Participated in the "Westkunst" exhibition in Cologne. **1984** Solo-exhibition at the Barbara Gladstone Gallery, New York. **1986** Took part in the Chambre d'Amis exhibition in Ghent. **1991** Retrospective of drawings at the Brooke Alexander Gallery, New York. Thek's early works are provocative environments with a neo-Dadaist anti-aesthetic, which is evident especially in his selection of unusual materials. His mythical environments of the 70s are manifestations of his form of Individual Mythology.
MONOGRAPHS, CATALOGUES: Franke, M.: "Work in Progress – Art is Liturgy". Das historische-prozessuale und betrachterbezogene Ausstellungskonzept von P. T. Frankfurt-on-Main and Berlin 1993.– P. T. Kunstmuseum. Lucerne 1973 (cat.).– P. T. Procession. Institute of Contemporary Art, University of Pennsylvania. Philadelphia 1977 (cat.).– Wilson, A. et al. (ed.): P. T. Snap! Pop! Was! Touch me not! Witte de With Center for Contemporary Art, Rotterdam et al. Rotterdam 1995, Berlin 1996 (cat.).

**THIEBAUD Wayne**
born **1920** Mesa (AZ)
American painter. First worked as a sign painter, caricaturist, and designer. **1942–1945** Served in the US Air Force and designed murals for the US Army. **1949–1953** Studied at San José State University (CA) and at California State University in Sacramento. **1951** First solo-exhibition at the Crocker Art Gallery, Sacramento. **1951–1961** Taught at Sacramento City College. **1954–1957** Produced educational films. Travelled around Mexico and Europe. **1961** Awarded the Scholastic Art prize. **1960–**

**1976** Taught at the University of California in Davis. **1965** Solo-exhibition at the Galleria Schwarz, Milan. **1967** Took part in the São Paulo Biennale. **1972** Took part in documenta 5 in Kassel. **1981** Solo-exhibition at the Walker Art Center in Minneapolis and **1985** at the San Francisco Museum of Modern Art. Thiebaud made his name with his ironically exaggerated paintings of commonplace objects like lipstick and pies. In his individual form of Pop Art, he uses heavy impasto and garish colours and emphasises the painting process.
MONOGRAPHS, CATALOGUES: Berkson, B.: Vision and Revision: Hand Colored Prints by W. T. The Fine Art Museum. San Francisco 1991 (cat.).– Cooper, G. (ed.): W. T. Survey 1947-1976. Art Museum. Phoenix 1976 (cat.).– Coplans, J. (ed.): W. T. Pasadena Art Museum. Pasadena 1968 (cat.).– Glenn, C. and J. (ed.): W. T. Private Drawings. The Artist's Sketchbook. New York 1987.– Tsujimoto, K. (ed.): W. T. San Francisco Museum of Modern Art. San Francisco 1985 (cat.)

**THIELER Fred**
born **1916** Königsberg
German painter. Member of the Zen 49 group and the Neue Gruppe. **1937–1941** Studied medicine. **1946–1948** Studied at the Munich Art Academy under K. Caspars. **1951/52** Lived in Paris. **1951** First solo-exhibition at the Le Canard gallery, Amsterdam. **1952** Returned to Munich. **1959** and **1964** took part in documenta 2 and 3 in Kassel. **1960–1981** Taught at the Berlin Art Academy. **1983** Solo-exhibition at the Nothelfer gallery, Berlin, and **1986** at the Saarland Museum, Saarbrücken and the Berlin Academy. **1988** Took part in the exhibition "Stationen der Moderne" at the Berlinische Galerie. **1989** Designed the ceiling of the Residenz theatre in Munich. **1991** Retrospective at the Emden Kunsthalle. Thieler is a proponent of abstract Neo-Expressionism.
CATALOGUE RAISONNE: Firmenich, A. and J. Merkert (ed.): F. T. Monographie und Werkverzeichnis. Bilder von 1942-1993. Cologne 1994
MONOGRAPHS, CATALOGUES: Firmenich, A. (ed.): F. T. Dialog mit der Farbe.

Kunsthalle Emden et al. Emden 1991 (cat.).– Motte, M. d. la (ed.): F. T. Städtische Kunstsammlungen. Bonn 1968.– Motte, M. d. la (ed.): F. T. Galerie Nothelfer. Berlin 1983 (cat.).– Orff, H. (ed.): F. T. Haus am Walsee, Berlin et al. Berlin 1962 (cat.).– Roters, E. et al. (ed.): F. T. Akademie der Künste, Berlin et al. Berlin 1986 (cat.).– Volkmann, B. and R.-F. Raddatz (ed.): F. T. Arbeiten 1940-1986. Akademie der Künste, Berlin et al. Berlin 1986 (cat.)

**THORN-PRIKKER Jan**
**1868** The Hague – **1932** Cologne
Dutch painter and stained-glass artist. **1883–1887** Studied at the Academy in The Hague. **1910** First stained-glass window for the train station in Hagen, Westphalia. **1913–1918** Taught at the Essen School of Arts and Crafts, and worked on mosaics, glass paintings, murals, furniture design and tapestries. **1920–1923** Took over a professorship at the School of Arts and Crafts in Munich. **1923–1926** Taught in Düsseldorf at the Art Academy and from **1926–1932** at the Cologne School of Arts and Crafts. He was a leading exponent of Dutch Jugendstil, but was also influenced by Pointillism and Symbolism. The greater part of his work was in the crafts: stained-glass, ceramics and batik, at which he excelled.
WRITINGS: J. T. P.: Die Brieven van J. T. P. aan Henri Borel en anderen. Nieuwkoop 1980
MONOGRAPHS, CATALOGUES: Heynen, J. (ed.): J. T. P. Kaiser Wilhelm Museum. Krefeld 1982 (cat.).– Hoff, A.: J. T. P. Recklinghausen 1958.– J. T.-P. Stedelijk Museum. Amsterdam 1968 (cat.).– Wember, P. (ed.): J. T. P. Glasfenster, Wandbilder, Ornamente 1891-1932. Kaiser Wilhelm Museum. Krefeld 1966 (cat.).– Wex, J. L.: J. T. P. Abstraktion und Konkretion in freier und angewandter Kunst. Bochum 1984

**THURSZ Frederic**
born **1930** Casablanca
Moroccan-born American painter. **1953–1957** Studied in New York and Paris. **1992** Participation in documenta 9 in Kassel. Professorship at City University in New York. With his paintings based on the color field tradition of Rothko and Newman, and

emphasising colour effects, Thursz is representative of the new radical painting movement. Multi-layered, semi-transparent overpainting of the ground using pigment and metallic colours intensify the sheen and illumination effects of the picture surface.
MONOGRAPHS, CATALOGUES: F. M. T. University of Kentucky Gallery of Art. Lexington 1965 (cat.).– F. M. T. Musée d'Art Moderne. St. Etienne 1989 (cat.).– Wahl, K. (ed.): F. M. T. Galerie Lelong. Paris and New York 1991 (cat.)

**TILLMANS Wolfgang**
born **1968** Remscheid
German photographer. **1987–1990** Lived in Hamburg. **1988** Exhibited his graphic works, produced with a Canon laser copier and entitled *Approaches*, at the Fabrik-Foto-Forum in Hamburg. **1990–1992** Studied photography at the Bournemouth & Poole College of Art and Design in England. Produced photo diptychs which were exhibited at the PPS Galerie F. C. Gundlach in Hamburg. **1992–1994** Worked in London, and **1994/95** in New York. Focused on the themes of young people and subcultures. Photographed for the young fashion magazine *i-D. Interview* und *Spex*. **1995** Solo-exhibition at the Zurich Kunsthalle and **1996** exhibition of his *Faltenwürfe* at the Daniel Buchholz gallery in Cologne. Tillmans is an important representative of close-to-life photography in Germany.
MONOGRAPHS, CATALOGUES: Lütgens, A. et al. (ed.): W. T. Stuttgart 1996 (cat.).– Riemschneider, B. (ed.): W. T. Cologne 1995.– W. T. Portikus. Frankfurt-on-Main 1995 (cat.).– W. T. Kunsthalle Zürich. Zurich 1995 (cat.).– W. T. Concorde. Cologne 1997

**TILSON Joe**
born **1928** London
English painter. Worked at first as a carpenter. **1946–1949** Worked for the Royal Air Force. **1949–1952** Studied at St. Martin's School of Art and **1952–1955** at the Royal College of Art. **1955–1957** Lived in Italy. **1958–1963** Taught at St. Martin's School of Art, London. **1960** Received a Gulbenkian Foundation grant. **1962** Solo-exhibition at the Marlborough Fine Art Gallery, London.

**1964**, **1976** and **1988** took part in the Venice Biennale. **1965** and **1983** awarded the Graphic Prize in Ljubljana. **1968** Participation in documenta 4 in Kassel. **1971/72** Guest-professor at the Hamburg School of Fine Arts. **1972** Moved to Wiltshire. **1973** Retrospective at the Boymans-van Beuningen museum, Rotterdam. **1976** DAAD grant to Berlin. **1985** Appointed a member of the Royal Academy of Arts, London. **1992** Retrospective at Waddington Graphics, London. Tilson, whose work stems from the Pop Art movement, achieved a remarkable synthesis of image and typography in his *Combination Pictures*.
WRITINGS: J. T.: A-Z Box. Fragments of an Oneiric Alphabet. London 1970.– J. T.: Alchera 1970-1976. London 1976
MONOGRAPHS, CATALOGUES: Compton, M. and M. Livingstone: T. Milan 1993.– Gilmour, P. (ed.): J. T. Graphics. Vancouver Art Gallery. Vancouver 1979 (cat.).– Hammacher-v. d. Brande, R. (ed.): J. T. Museum Boymans-van Beuningen. Rotterdam 1973 (cat.).– Quintavalle, A. C.: J. T. Milan 1977.– J. T. Pages. Marlborough Fine Art Ltd. London 1970 (cat.)

**TINGUELY Jean**
**1925** Fribourg – **1991** Bern
Swiss sculptor. **1940–1945** Studied at the Basel School of Arts and Crafts. **1944** Began to experiment with moving objects. **1951** Moved to Paris. **1954** Solo-exhibition at the Arnaud gallery and participation in the Salon des Réalités Nouvelles in Paris. Joined the group Le Mouvement. **1955** Began his *Métamatics*, a series of kinetic sculptures. **1959** Took part in the Paris Biennale. Contact with the group Zero. **1961** Collaboration with Niki de Saint Phalle. **1964–1977** Took part in documenta 3, 4 and 6 in Kassel. **1966** Together with Saint Phalle installed the kinetic female figure *Hon* in the Moderna Museet, Stockholm. Took part in the exhibition "The Machine" at the Museum of Modern Art, New York. **1967** Took part in Expo' 67 in Montreal and **1968** in the exhibition "Dada, Surrealism and their Heritage" at the Museum of Modern Art, New York. Retrospective at the Museum of Contemporary Art, Chicago. **1972/73** Touring retrospective, starting at the Kunsthalle in Basel. **1980/81** Together with Saint Phalle, designed the fountain *La Fontaine Stravinsky* in Paris. **1988** and **1997** Retrospective at the Pompidou Centre, Paris. Tinguely's constructions work like machines but have no meaningful function and can therefore be seen as satirical comments on technological society.
WRITINGS: Hahnloser, M. (ed.): Briefe von J. T. an Maja Sacher. Bern 1992.– Hahnloser, M. (ed.): J. T. Briefe an Paul Sacher und gemeinsame Freunde. Bern 1996
CATALOGUES RAISONNES: Bischofberger, C. (ed.): J. T. Werkkatalog Skulpturen und Reliefs 1954-1985. 2 vols. Zurich 1982-1990

MONOGRAPHS, CATALOGUES: Althaus, P. F. (ed.): J. T. Kunsthalle Basel. Basel 1972 (cat.).– Bezzola, L.: J. T. Zurich 1974.– Bezzola, L. and M. Hahnloser-Ingold (ed.): J. T. Fribourg – Moscou – Fribourg. Zurich 1992.– Botta, M. et al. (ed.): J. T. Die Sammlung. The Collection. Bern 1997.– Calvocoressi, R. (ed.): J. T. Kunsthaus Zurich et al. Zurich 1982 (cat.).– Conil Lacoste, M.: T. L'énergétique de l'insolence. Paris 1989.– Hulten, P. (ed.): J. T. Méta. Frankfurt-on-Main and Vienna 1972, Boston 1972, 1975, Paris 1973.– Hulten, P.: J. T. A Magic Stronger than Death. Milan 1987 / J. T. Une magie plus forte que la mort. Paris 1987.– Hulten, P. (ed.): J. T. Centre Georges Pompidou. Paris 1988 (cat.).– Keller, J.-P.: T. et le mystère de la roue manquante. Carouge 1992.– Lacoste, M.: T. L'énergetique de l'insolence. 2 vols. Paris 1989.– Michaud, E.: J. T. Chronologie, expositions, bibliographie. Paris 1970.– Museum Jean Tinguely (ed.): Museum J. T., Basel. Die Sammlung. Bern 1996.– Poley, S. and S. Salzmann (ed.): J. T. Meta-Maschinen. Wilhelm-Lembruck-Museum. Duisburg 1979 (cat.).– Poley, S. and C. Schulz-Hoffmann (ed.): J. T. Kunsthalle der Hypo-Kulturstiftung. Munich 1985 (cat.).– Schmied, W. and P. F. Althans (ed.): J. T. Kestner-Gesellschaft. Hanover 1972 (cat.).– Schulz-Hoffmann, C. (ed.): J. T. Nachtschattengewächse. Kunsthaus Wien. Munich 1991 (cat.).– Stumm, R. and K. Wyss: J. T. Basel 1985.– J. T. Machines de T. Centre National d'Art Contemporain. Paris 1971 (cat.).– J. T. Stedelijk Museum. Amsterdam 1973 (cat.).– J. T. Centre Georges Pompidou. Paris 1997 (cat.).– Violand-Hobi, H. E.: J. T. Biographie und Werk. Munich 1995

**TOBEY Mark**
**1890** Centerville – **1976** Basel
American painter. **1906–1908** Studied at the Art Institute of Chicago. First worked as a draughtsman in a fashion studio. **1917** First solo-exhibition of portrait drawings at the Knoedler Gallery in New York. **1922** Became interested in Chinese calligraphy and East Asian philosophies, especially the religion of Baha'i. **1922–1925** Taught art in Seattle and **1930–1937** at Dartington Hall in Devonshire. Travelled through Europe, the Orient and the Far East, staying in **1935** in a Zen monastery in Japan, where he studied calligraphy. **1938** Composed his own music. **1959** and **1964** participation in documenta 2 and 3 in Kassel. **1960** Moved to Basel, and felt at home with the humanist tradition there, but continued his travels around the USA. Retrospectives **1974** at the Smithsonian Institution, Washington, **1984** in the National Gallery, Washington, and **1990** "A Centennial Exhibition" at the Beyeler gallery, Basel. Tobey's *White Writings*, networks of fine calligraphic figures, were originally quite easy to interpret but became increasingly abstract and unintelligible, reflecting his introverted, contemplative way of life.

WRITINGS: M. T.: The World of Market. Seattle et al. 1981
CATALOGUE RAISONNE: Heidenheim, H. H. (ed.): M. T. Das druckgraphische Werk. Radierungen und Serigraphien 1970-1975. Düsseldorf 1975
MONOGRAPHS, CATALOGUES: Bärmann, M. et al. (ed.): M. T. Werke 1935-1975. Museum Folkwang. Essen 1989 (cat.).– Bärmann, M. (ed.): M. T. Between Worlds. Museo d'Arte, Mendrisio et al. Mendrisio 1989 (cat.).– Bärmann, M. et al. (ed.): M. T. Museo Nacional Centro de Arte Reina Sofia. Madrid 1997 (cat.).– Choay, F.: M. T. Paris 1961.– Cummings, P. (ed.): M. T. Paintings 1920-1960. Yoshii Gallery. New York 1994 (cat.).– Dahl, A. L. et al. (ed.): M. T. Art and Belief. Oxford and St. Petersburg (FL) 1984.– Ixmeier, E.: M. T. Bochum 1981.– Rathbone, E. E. (ed.): M. T. City Paintings. National Gallery of Art. Washington 1984 (cat.).– Roberts, C.: M. T. New York 1959, Paris 1959.– Schmied, W.: T. Stuttgart 1966, London and New York 1966.– Seitz, W. C. (ed.): M. T. The Museum of Modern Art. New York 1962 (cat.).– Taylor, J. C. (ed.): M. T. Tribute to M. T. National Collection of Fine Arts, Smithsonian Institution. Washington 1974 (cat.).– Thomas, E. B. (ed.): M. T. A Retrospective Exhibition from Northwest Collections. Seattle Art Museum. Seattle 1959 (cat.).– M. T.'s 80. A Retrospective. Seattle Art Museum. Seattle 1970 (cat.).– M. T. Between Worlds. Opere 1935-1975. Museo d'Arte. Mendrisio 1989 (cat.).– M. T. A Centennial Exhibition. Galerie Beyeler. Basel 1990 (cat.).– Yao, M.-C.: The Influence of Chinese and Japanese Calligraphy on M. T. San Francisco 1983

**TOMLIN Bradley Walker**
**1899** Syracuse (NY) – **1953** New York
American painter. **1917–1921** Studied at the College of Fine Arts at Syracuse University, New York. **1921** Moved to New York. **1922** First solo-exhibition put on by Skaneateles and Cazenovia, New York. **1923/24** Studied at the Académie Colarossi and at the Académie de la Grande Chaumière in Paris. **1924** Returned to New York. **1932–1941** Taught at Sarah Lawrence College. **1941** Came to know Gottlieb and was highly impressed by Abstract Expressionism. **1948** Became friends with Motherwell, Pollock and Gorky. **1952** Took part in the exhibition "Fifteen Americans" at the Museum of Modern Art, New York. **1957** Retrospective at the Whitney Museum of American Art, New York. **1959** Posthumous participation in documenta 2 in Kassel. **1975** Retrospective at the Albright-Knox Art Gallery, Buffalo. Tomlin was a leading exponent of Action Painting in America. His most important works were created in the last few years of his life.
MONOGRAPHS, CATALOGUES: Baur, J. I. H. (ed.): B. W. T. Whitney Museum of American Art. New York 1957 (cat.).– Chenault, J. (ed.): B. W. T. A Retrospective

View. The Emily Lowe Gallery, Hofstra University, Hempstedt et al. Buffalo 1975 (cat.)

## TORRES-GARCIA Joaquín
**1874** Montevideo – **1949** Montevideo
Uruguayan painter of Spanish origins. **1891** Emigrated to Spain. **1894–1908** Studied at the Art Academy in Barcelona. Worked on Gaudí's cathedral the *Sagrada Familia*. **1920/21** Lived in New York and came to know Duchamp and Joseph Stella. **1922** First solo-exhibition at the Hanfstengel Gallery, New York. **1924** Moved to Paris. Friendly relations with Mondrian, Doesburg and Vantongerloo. **1926** Solo-exhibition at the Fabre gallery in Paris. **1928** First participation in the Salon des Indépendants. **1930** Exhibited with Cercle et Carré and helped with the publication of their magazine. **1933** Returned to Montevideo. From **1936** published and edited the journal *Círculo y Cuadrado*. **1935** Co-founder of the Asociación de Arte Constructivo. **1944** Publication of his article *Universalismo Constructivo*, which had a profound influence on other artists and the South American art scene as a whole. Torres-Garcia was an artist who bridged the gap between the pre-Columbian culture of South America and modern European art movements, especially Cubism and Neo-Plasticism.
WRITINGS: Fló, J. (ed.): T.-G. Escritos. Montevideo 1974.– J. T.-G.: Historia de mi vida. Barcelona 1939, 1990.– J. T.-G.: Universalismo constructivo. 2 vols. Buenos Aires 1944, 1984
CATALOGUE RAISONNE: Jardí, E.: T.-G. Barcelona 1974
MONOGRAPHS, CATALOGUES: Brandao, L. (ed.): J. T.-G. Museo de Monterrey. Monterrey 1981 (cat.).– Buzio de Torres, C. et al. (ed.): T.-G. Grid-Pattern-Sign. Paris-Montevideo. Hayward Gallery. London 1985 (cat.).– Buzio de Torres, C. et al. (ed.): T.-G. IVAM Centro Julio Gónzales, Valencia et al. Valencia 1991 (cat.).– Cassou, J.: T.-G. Paris 1955.– Gradowcyk, M. H.: J. T.-G. Buenos Aires 1985.– Jardí, E.: T.-G. New York 1973.– Kalenberg, A. and J. Lassaigne (ed.): T.-G.: Construction et symboles. Musée d'Art Moderne de la Ville de Paris. Paris 1975 (cat.).– Llorens, T. (ed.): J. T.-G. Museo Nacional Centro de Arte Reina Sofia. Madrid 1991 (cat.).– Pereda, R.: T. G. Montevideo 1991.– Robbins, D.: J. T.-G. 1874-1949. Museum of Art, Rhode Island School of Design et al. Providence 1970 (cat.).– Toys, A. (ed.): Les Joguines de T.-G. IVAM Centro Julio González. Valencia 1997 (cat.)

## TOULOUSE-LAUTREC Henri de
**1864** Albi – **1901** Chateau Malromé (Gironde)
French painter and graphic artist. **1882–1886** Trained in the studio of Cormon, where he came to know Bernard and van Gogh. Frequented theatres, music-halls,

cafés and the haunts of the Paris demimonde. **1886** First publication of drawings in magazines. **1889** Exhibited for the first time at the Salon des Indépendants. **1890** Travelled with Signac to Brussels to the exhibition of the Les XX group and to Spain. **1891** Began to design stylised posters with strong outlines and large areas of colour, for restaurants, cabarets, and publishers. **1892** Travelled to Brussels and London. **1893** First important solo-exhibition at Goupil. Lived from time to time in a bordello, where he drew and painted. **1894–1897** Travels to Belgium, Holland, Spain, London, Lisbon. Exhibition at the Salon of the Libre Esthétique group in Brussels. Contact with the Nabis and contributions to *La Revue Blanche*. **1899** After suffering a nervous breakdown, he was committed to the sanatorium in Neuilly. **1901** Became partially paralysed and died in his mother's castle. Toulouse-Lautrec, whose lithographs and posters are still reprinted today, was equally talented in drawing and painting. This double talent allowed him to create a unique style, combining elements of Impressionism, Symbolism and Japanese colour prints.
WRITINGS: Goldschmidt, L. and H. Schimmel (ed.): Unpublished Correspondance of H. de T.-L. London 1969.– Goldschmidt, L. and H. Schimmel (ed.): T.-L. Lettres 1871-1901. Paris 1972 /.– Schimmel, H. D. (ed.): The Letters of H. de T.-L. Oxford 1991.– Schimmel, H. D. (ed.): Die Briefe von H. de T.-L. Munich 1994
CATALOGUES RAISONNES: Adhémar, J. (ed.): T.-L. Lithographies. Paris 1965 /T.-L. His Complete Lithographs and Drypoints. New York 1965.– Adriani, G. (ed.): T.-L. Das gesamte graphische Werk. Sammlung Gerstenberg. Cologne 1986 /T.-L. The Complete Graphic Works. Gerstenberg Collection. London 1988.– Dortu, M.-G. (ed.): T.-L. et son œuvre. 6 vols. Paris and New York 1971.– Julien, E. (ed.): Les Affiches de T.-L. Catalogue complet et raisonné. Paris 1992.– Mourlot, F. (ed.): Les Affiches de T.-L. Paris 1992.– Sugana, G. M. and G. Caproni (ed.): The Complete Paintings of T.-L. London 1973 /Tout l'œuvre peint de T.-L. Paris 1986.– Wittrock, W. (ed.): T.-L. The Complete Prints. 2 vols. London 1985 /T.-L. Catalogue raisonné des estampes. 2 vols. Paris 1985

## TOYEN
(Marie Germínová)
**1902** Prague – **1980** Paris
Czech painter. **1918** Studied at the Prague Art Academy. **1920** Founder-member of the Devetsil group in Prague. **1923** Exhibited with the Modern Art Bazar group. Took the pseudonym Toyen. **1925** Moved to Paris. **1929** Returned to Prague. **1934** Together with Nezval, Styrsky and Teige founded the Surrealist movement in Prague. **1935** At the Prague Surrealist exhibition, he met André Breton and Paul Eluard, who were also taking part. Travelled to Paris where he met other Surrealists. **1947** Emigrated to

France. **1968** Retrospective in Aquila, Italy. In the mid-30s, after periods devoted to naive and Cubist styles of painting, Toyen became an enthusiastic proponent of Surrealism.
MONOGRAPHS, CATALOGUES: Bischof, R.: T. 1902-1980. Eigenschaften ohne Frau. Frankfurt-on-Main 1987.– Breton, A. et al.: T. Paris 1953.– Breton, A. et al. (ed.): T. Das malerische Werk. Frankfurt-on-Main 1987.– Holten, R. v.: T. En surrealistik visionär. Köping 1984.– Ivsic, R.: T. Paris 1974.– Péret, B.: T. Paris 1953

## TRAKAS George
born **1944** Quebec
Canadian sculptor and installation artist. After **1972** installed bridges and corridors through landscapes and gallery spaces. **1977** Exhibited his work *Union Pass* at documenta 6 in Kassel, in which two model bridges, a modern one of steel and an old-style one of wood, were installed facing each other and then melted together into a single new construction through an explosion. **1987** Participation in documenta 8 in Kassel.

## TRIER Hann
born **1915** Düsseldorf
German painter. Member of the Zen 49 group. **1934–1938** Studied at the Düsseldorf Art Academy. **1952–1955** Lived and travelled for long periods in South America. **1955/56** Guest-professorship at the Hamburg School of Fine Arts. **1955** Participation in documenta 1 in Kassel. **1957–1980** Taught at the Berlin School of Fine Arts.

**1958** Solo-exhibition at the Cologne Kunstverein and **1959** at the Kestner Society, Hanover. **1959** and **1964** took part in documenta 2 and 3 in Kassel. Retrospectives: **1972** at the Rheinische Landesmuseum in Bonn, **1985** at the Saarland Museum, Saarbrücken, **1990** at the Von der Heydt-Museum, Wuppertal, and again at the Rheinische Landesmuseum in Bonn. Trier's early paintings are Neo-Expressionist in character. After his travels in South America, he developed a linear compositional style which culminated in his *Vibration* paintings.
WRITINGS: H. T.: Wie ich ein Bild male. Berlin 1963.– H. T.: Ut poesis pictura? Einige Betrachtungen zur Malerei der griechischen Antike. Heidelberg 1985
CATALOGUES RAISONNES: Euler-Schmidt, M. (ed.): H. T. Werkverzeichnis der Gemälde 1990-1995. Cologne 1995.– Fehlemann, S. (ed.): H. T. Monographie und Werkverzeichnis der Gemälde bis 1989. Cologne 1990.– Gerlach-Laxner, U. (ed.): H. T. Druckgraphik. Werkverzeichnis und Monographie. Cologne 1994 (cat.)
MONOGRAPHS, CATALOGUES: Fehlemann, S. (ed.): H. T. Retrospetektive. Bilder 1949-1989. Von der Heydt-Museum, Wuppertal. Cologne 1990 (cat.).– Költzsch, G.-W. (ed.): H. T. Tatort Malerei. Moderne Galerie des Saarland Museums, Saarbrücken et al. Saarbrücken 1985 (cat.).– Költzsch, G.-W. (ed.): H. T. Archimedes. Folkwang Museum. Essen 1990 (cat.).– Motte, M. d. la (ed.): Dokumentation H. T. Bonn 1980.– Osterodt, H.: H. T. Zur Genese des Malens mit beiden Händen im künstlerischen Werk 1947-1959. Bramsche 1994.– Roters, E.: H. T. Die Deckengemälde in Berlin, Heidelberg and Cologne. Berlin 1981.– Schmalenbach, W. (ed.): H. T. Kestner-Gesellschaft. Hanover 1959 (cat.).– Schmidt, H. M. (ed.): H. T. Im Handumdrehen. Rheinisches Landesmuseum, Bonn et al. Cologne 1990 (cat.).– Schwinzer, E. et al. (ed.): H. T. Metamorphose der Farbe. Gustav-Lübke-Museum, Hamm et al. Hamm 1995 (cat.).– H. T. Gemälde, Zeichnungen, Graphiken 1951-1972. Rheinisches Landesmuseum, Bonn. Bonn 1972 (cat.).– H. T. Gemälde, Zeichnungen, Graphiken, Retrospektive. Kölnischer Kunstverein. Cologne 1979 (cat.)

## TROCKEL Rosemarie
born **1952** Schwerte (Westphalia)
German artist. First studied mathematics and theology. **1974–1978** Studied painting at the School of Industrial Arts in Cologne. **1983** First solo-exhibition at the Monika Sprüth gallery, Cologne. **1984** Solo-exhibitions at the Stampa gallery in Basel and at the Ascan Crone gallery in Hamburg. **1985** Solo-exhibition at the Rheinische Landesmuseum in Bonn. **1988** Took part in the BiNationale exhibition in Düsseldorf and Boston. Exhibitions at the Institute of Contemporary Arts, London, and at the Basel Kunsthalle. **1991** Exhibition at the Institute

of Contemporary Art, Boston, and **1992** at the Ludwig Museum, Cologne. **1997** Participation in documenta 10 in Kassel. Trockel is difficult to categorise. She uses a broad range of techniques and styles. Often her work makes reflective or ironic statements about the role of women in contemporary society and about styles of presentation in museums.
CATALOGUE RAISONNE: Theewen, G. (ed.): R. T. Herde. Werkverzeichnis. Cologne 1997
MONOGRAPHS, CATALOGUES: Ammann, J.-C. et al. (ed.): R. T. Kunsthalle Basel et al. Basel 1988 (cat.).– Ammann, J.-C. und U. Panhans-Bühler: R. T. White Carrot. Frankfurt-on-Main 1997.– Burke, G. (ed.): R. T. City Gallery. Wellington 1993 (cat.).– Dickhoff, W. (ed.): R. T. Bilder, Skulpturen, Zeichnungen. Rheinisches Landesmuseum, Bonn. Cologne 1985 (cat.).– Dickhoff, W. (ed.): R. T. Kunsthalle Basel et al. Basel and London 1988 (cat.).– Dickhoff, W.: R. T. Eine Einführung in ihr Werk und Schaffen. Frankfurt-on-Main 1992.– Koepplin, D. (ed.): R. T. Papierarbeiten. Museum für Gegenwartskunst, Basel et al. Basel and Stuttgart 1991 (cat.).– Noever, P. (ed.): R. T. Anima. Österreichisches Museum für Angewandte Kunst, Vienna. Stuttgart 1994 (cat.).– Stich, S. (ed.): R. T. The Insitute of Contemporary Art, Boston et al. Munich 1991 (cat.).– R. T. The Museum of Modern Art. New York 1988 (cat.).– R. T. Museo Nacional Centro de Arte Reina Sofia, Madrid et al. Madrid 1992 (cat.).– R. T. Museum of Contemporary Art. Sydney 1994 (cat.)

**TÜBKE Werner**
1929 Schönebeck – 2004 Leipzig
German painter. **1948–1953** After serving an apprenticeship as a painter and graduating from the Master School of German Craftsmanship in Magdeburg, he studied at the Leipzig School of Graphic Art and Book Design. Did yet another course of studies, this time in art education and psychology at the University of Greifswald. From **1954**, he worked as a painter in Leipzig. **1964** Became a lecturer, and in **1972** professor at the Leipzig School of Graphic Art and Book Design, and stayed on as rector for a number of years. As a State Artist of the GDR, he exhibited in **1977** in documenta and 6 in Kassel. At the beginning of the 70s, he was allowed to travel to Italy; this contact with the classic Italian masters was to become an important influence in his work. **1984** He taught at the Summer Academy in Salzburg. From **1983–1989** he and his assistants created the Peasants' War Panorama in Bad Frankenhausen, whose 1,722 square metres of painted surface make it the largest oil painting in the world. With his monumental paintings and murals dealing with historical themes in a classic style, Tübke made an inspiring contribution to socialist history painting.

CATALOGUE RAISONNE: Meißner, G. (ed.): W. T. Gemälde, Aquarelle, Druckgraphik (mit Werkverzeichnis). Gemäldegalerie Neue Meister, Dresden et al. Dresden 1976 (cat.).– Tübke, B. (ed.): W. T. Das graphische Werk. 1950-1990. Düsseldorf 1991
MONOGRAPHS, CATALOGUES: Beaucamp, E.: W. T. Arbeiterklasse und Intelligenz. Frankfurt-on-Main 1985.– Betthausen, P. and C. Bube (ed.): W. T. Nationalgalerie der Staatlichen Museen. Berlin 1989 (cat.).– Emmrich, I.: W. T. Schöpfertum und Erbe. Berlin 1976.– Kober, K. M.: Reformation, Revolution. Panorama Frankenhausen. Monumentalbild von W. T. Dresden 1988.– Kober, K. M.: W. T. Monumentalbild Frankenhausen. Dresden 1989.– Lindner, G. and M. Wollenheit (ed.): W. T. Handzeichnungen und Aquarelle. Panorama, Bad Frankenhausen. Leipzig 1992 (cat.).– Meißner, G.: W. T. Leben und Werk. Leipzig 1989.– Raum, W. (ed.): W. T. Malerei, Grafik, Zeichnung. Staatliche Galerie Moritzburg, Halle et al. Halle 1979 (cat.)

**TUCKER William**
born **1935** Cairo
English sculptor. **1955–1958** Studied history at Oxford University. **1959/60** Attended the Central School of Art and Design and St. Martin's School of Art, London. **1962** First solo-exhibition at the Grabowski Gallery, London. **1968** Took part in documenta 4 in Kassel. **1974** Published the theoretical paper *The Condition of Sculpture*. **1976** Professorship at the University of Western Ontario. **1978–1982** Taught at Columbia University and **1978–1980** at the New York Studio School of Painting and Sculpture. **1980** Guggenheim grant for sculpture. **1987** Exhibition at the Tate Gallery, London. With his abstract, colourful rod constructions in steel, fibreglass and wood, Tucker belongs, along with King and I. Witkin, to those sculptors of the British avant-garde who have freed sculpture of its representational function and concentrated on materials and structures.
WRITINGS: W. T.: The Language of Sculpture. London and New York 1974
MONOGRAPHS, CATALOGUES: Ashton, D. (ed.): W. T. Gods. Five Recent Sculptures. Tate Gallery. London 1987 (cat.).– Forge, A. (ed.): W. T. Sculpture 1970-1973. Serpentine Gallery. London 1973 (cat.)

**TUTTLE Richard**
born **1941** Rahway (NJ)
American sculptor and painter. **1959–1963** Studied at Trinity College, Hartford (CT), and **1963/64** at the Cooper Union in New York. **1963** First paper constructions. **1965** First solo-exhibition at the Betty Parsons Gallery, New York. **1967** Began to produce monochrome dyed polygonal linen cloths, which could be turned, hung, or laid at will. **1968** Travelled to Japan. **1970** Solo-exhibition at the Albright-Knox Art Gallery, Buffalo, and **1972** at the Museum of

Modern Art, New York. **1972–1982** Participation in documenta 5–7 in Kassel. **1975** Retrospective at the Whitney Museum of American Art, New York. **1979** Solo-exhibition at the Stedelijk Museum, Amsterdam. Tuttle's works are made mostly of a few simple materials – paper, wood, or cloth. With this minimal range of materials, he explores the boundaries between painting and sculpture.
MONOGRAPHS, CATALOGUES: Elger, D. (ed.): R. T. Sprengel Museum. Hanover 1990 (cat.).– Harris, S. et al. (ed.): R. T. Institute of Contemporary Art. Amsterdam 1991 (cat.).– Harris, S. et al. (ed.): The Poetry of Form. R. T. Drawings from the Vogel Collection. Indianapolis Museum of Art. Indianapolis 1994 (cat.).– Hutchinson, J. et al. (ed.): R. T. London et al. London 1996 (cat.).– Johnen, J.: Poetische Punkte. Der Zufall als Erkennungsprinzip im Werk von R. T. Cologne 1982.– Poetter, J. (ed.): R. T. Chaos, die Form/The Form. Staatliche Kunsthalle Baden-Baden. Stuttgart 1993 (cat.).– Smith, H. (ed.): R. T. From 210 Collage-Drawings. Pasadena Institute of Technology. Pasadena 1989 (cat.).– Stemmler, D. et al. (ed.): R. T. Städtisches Museum Abteiberg. Mönchengladbach 1985 (cat.).– Tucker, M. (ed.): R. T. Whitney Museum of American Art, New York et al. New York 1975 (cat.).– R. T. Stedelijk Museum. Amsterdam 1979 (cat.).– R. T. Musée des Beaux-Arts. Calais 1982 (cat.).– R. T. Two Pinwheel Works 1964-1985. Institute of Contemporary Arts. London 1985 (cat.).– R. T. Musée d'Art Contemporain de Bordeaux. Bordeaux 1986 (cat.).– R. T. Oxyderood/Red Oxide. Museum Boymans-van Beuningen. Rotterdam 1994 (cat.).– Verna, G. and A. (ed.): List of Drawing Material of R. T. Zurich 1979

**TUYMANS Luc**
born **1958** Mortsel
Belgian painter. **1976–1979** Studied painting at the Sint Lukas Institute in Brussels. **1979/80** at the Ecole Nationale Supérieure des Arts Visuels de la Cambre in Brussels and **1980–1982** at the Académie Royale des Beaux Arts in Antwerp. **1982–1986** Studied history of art at the Free University in Brussels. **1989** First solo-exhibition in Antwerp. **1992** Participation in documenta 9 in

Kassel. **1993** Represented at an exhibition of contemporary art at the Hamburg Deichtorhallen and **1994** at the Hayward Gallery at the "Unbound" exhibition. Tuymans combines traditional painting with frames taken from post-war films and amateur snapshots. The unobtrusive, mostly monochrome colours contrast effectively with the brutality of his subject matter.
MONOGRAPHS, CATALOGUES: Busche, W. v. d. et al. (ed.): L. T. Provinciaal Museum voor Moderne Kunst. Oostende 1990 (cat.).– Helfenstein, J. et al. (ed.): L. T. Premonition. Kunstmuseum Bern et al. Bern 1997 (cat.).– Loock, U. (ed.): L. T. Kunsthalle Bern. Bern 1992 (cat.).– Loock, U. (ed.): L. T. London 1996.– Salzman, G. et al. (ed.): L. T. Chicago et al. 1995 (cat.).– L. T. Museum Haus Lange. Krefeld 1993 (cat.)

**TWOMBLY Cy**
born **1929** Lexington (VA)
American painter. **1948/49** Studied at the Boston School of Fine Art and **1950–1952** at the Art Students League, New York, and at Black Mountain College in Beria (NC), where he attended courses given by Kline and Motherwell. Travelled with Rauschenberg to Italy, Spain, and North Africa. **1953** After his first solo-exhibition at the Kootz Gallery in New York he exhibited for the first time in Europe at the Galeria d'Arte Contemporanea in Florence. In subsequent years he commuted between Europe and America. **1955/56** Taught in the Art Department of Southern Seminary Junior College, Buena Vista (VA). **1957** Settled in Rome. **1977** and **1982** participation in documenta 6 and 7 in Kassel. Important retrospectives: at the Pompidou Centre, Paris in **1988**, and **1994** at the Museum of Modern Art, New York; the latter was also shown at the Nationalgalerie in Berlin. Most of Twombly's paintings have been produced in series and he likes to group his paintings into cycles. Out of Abstract Expressionism he has developed his own complex and script-like pictorial language. His faint allusive signs and marks are dispersed over a more or less monochrome background, with smudging and delicate hints of colour.
CATALOGUES RAISONNES: Bastian, H. (ed.): C. T. Zeichnungen 1953-1973. Frankfurt-on-Main, Berlin and Vienna 1973.– Bastian, H. (ed.): C. T. Das graphische Werk 1953-1984. Munich 1984/C. T. A Catalogue Raisonné of the Printed Graphic Work. New York 1984.– Bastian, H. (ed.): C. T. Catalogue Raisonné der Gemälde. 4 vols. Munich 1992-1996.– Lambert, Y. (ed.): C. T. Catalogue raisonné des œuvres sur papier. 1973-1982. 2 vols. Milan 1979-1992.– Roscio, N. del (ed.): C. T. Catalogue Raisonné of Sculpture. Vol. 1: 1946-1997. New York and Munich 1997
MONOGRAPHS, CATALOGUES: Barthes, R.: C. T. Berlin 1983.– Bastian, H.: C. T. Bilder 1952-1976. Frankfurt-on-Main, Berlin and Vienna 1978.– Blistène, B. and

H. Szeemann (ed.). C. T. Centre Georges Pompidou. Paris 1988 (cat.).– Busse, K.-P.: Erzählung, Landschaft und Text im Werk von C. T. Cologne 1997.– Göricke, J.: C. T. Spurensuche. Munich 1994.– Heyden, T.: Zu sehen und zu lesen. Anmerkungen zum Verständnis des Geschriebenen bei C. T. Nuremberg 1986.– Schmidt, K. (ed.): C. T. Malerei, Arbeiten auf Papier 1955-1983. Staatliche Kunsthalle Baden-Baden. Baden-Baden 1984 (cat.).– Schmidt, K. and G. Boehm (ed.): C. T. Serien auf Papier 1957-1987. Städtisches Kunstmuseum Bonn et al. Bonn 1987 (cat.).– Schmidt, K. (ed.): C. T. The Menil Collection. Houston 1989 (cat.).– Szeemann, H. et al. (ed.): C. T. Paintings, Works on Paper, Sculpture. Whitechapel Art Gallery. London 1987 (cat.)/C. T. Bilder, Arbeiten auf Papier, Skulpturen. Kunsthaus Zurich et al. unich 1987 (cat.).– C. T. Paintings and Drawings. Whitney Museum of American Art. New York 1979 (cat.).– C. T. Souvenirs of d'Arros and Gaeta. Thomas Ammann Fine Art. Zurich 1992 (cat.).– Varnedoe, K. (ed.): C. T. A Retrospective. The Museum of Modern Art, New York et al. New York 1994 (cat.)/C. T. Eine Retrospektive. Nationalgalerie, Berlin et al. Munich 1995 (cat.)

**TWORKOV Jack**
**1900** Biala (Poland) – **1982** Provincetown (MA)
Polish-American painter. **1913** Moved to the USA. **1920–1923** Studied at Columbia University, New York and **1923–1925** at the Art Students League in New York. **1928** Took American citizenship. Worked from **1936–1941** as part of the Works Progress Administration Federal Art Project. **1940** First solo-exhibition at the A. C. A. Gallery, New York. **1946** His painting became influenced by De Kooning and the Abstract Expressionists. **1948–1955** Taught at Queens College, New York. **1948–1953** Shared a studio with De Kooning. From **1954** he painted in an abstract style. **1959** Took part in documenta 2 in Kassel. **1963–1969** Taught at Yale University, New Haven (CT). **1964** Retrospective at the Whitney Museum of American Art, New York. After **1969** many of his compostions have a grid-like structure. Retrospectives: **1982** at the Guggenheim Museum, New York, and **1987** at the Pennsylvania Academy of the Fine Arts, Philadelphia. Proponent of Abstract Expressionism and Action Painting. His lyric abstractions are imbued with a strongly atmospheric character, calling up associations with landscapes.
MONOGRAPHS, CATALOGUES: Armstrong, R. and C. Baker (ed.): J. T. Paintings 1928-1982. Pennsylvania Academy of the Fine Arts, Philadelphia et al. Philadelphia 1987 (cat.).– Bryant, E. (ed.): J. T. Whitney Museum New York 1964 (cat.).– Demarco, R. et al. (ed.): J. T. Paintings 1950-1978. Third Eye Centre. Glasgow 1979 (cat.).– Forge, A. (ed.): J. T. Fifteen Years

**UECKER Günther**
born **1930** Wendorf
German artist. **1949–1953** Studied in Wismar and at the Academy of Arts in East Berlin. **1953–1957** Continued his training at the Düsseldorf Academy. **1957** First nail-works. **1958** Joint-exhibitions with Mack and Piene. Created spirals out of nails, called *Clouages*. **1959** First solo-exhibition at the Azimuth gallery, Milan. First turning discs. **1960** Joined the Zero group. **1962** Took part in the exhibition "nul" at the Stedelijk Museum, Amsterdam, and at "ZERO-Festival" in Düsseldorf. The Zero group tied with the group "N" for first prize at the San Marino Biennale. **1964** Award from the state of North Rhine-Westphalia. **1964–1977** Participation in documenta 3, 4 and 7 in Kassel. **1967** Zero group disbanded. **1970** Participated at the Venice Biennale. **1971** Retrospective at the Moderna Museet, Stockholm. Participation at the São Paulo Biennale. **1972** Made the film *Schwarzraum-Weißraum*. **1974** Stage design for Beethoven's opera *Fidelio* in Bremen. From **1976** professor at the Düsseldorf Academy. **1983** Solo-exhibition at the Kunsthalle Düsseldorf. **1984** Travelled on the Trans-Siberian Express. **1987** Retrospective at the Wilhelm-Hack-Museum, Ludwigshafen, and **1992** at the Museum des 20. Jahrhunderts in Vienna. The rhythmic effects created by the highly differentiated play of light and shade in Uecker's *Great Spiral* works, align him closely with Kinetic Art. The painstaking work of setting the thousands of nails in place one by one was, for the artist, a form of Zen-Buddhist meditation.
WRITINGS: G. U.: Kölnisch – Klause – (Phobien). Cologne 1983.– Wiese, S. v. (ed.): G. U. Schriften. St. Gallen 1979
CATALOGUES RAISONNES: Helms, D. (ed.): G. U. Recklinghausen 1970.– Honisch, D. (ed.): U. Mit einem Werkverzeichnis von M. Haedecke (1955-1980). Stuttgart 1982, New York 1986
MONOGRAPHS, CATALOGUES: Gassen, R. W. and B. Holeczek: U. Heidelberg 1987 (cat.).– Helms, D.: G. U. Recklinghausen 1970.– Holeczek, B. et al. (ed.): G. U. Retrospektive. Wilhelm-Hack-Museum, Ludwigshafen. Heidelberg 1987 (cat.).– Honisch, D.: M. Skulpturen. Düsseldorf and Vienna 1986.– Honisch, D. (ed.): G. U. eine Retrospektive. Kunsthalle der Hypo-Kulturstiftung. Munich 1993 (cat.).– Jocks, N. (ed.): G. U. Archäologie des Reisens. Cologne 1997.– Schmied, W. (ed.): G. U. Kestner-Gesellschaft, Hanover et al. St. Gallen 1972 (cat.).– Sharp, W.: G. U. New York 1966.– Storms, W. (ed.): U. in Wien. Museum Moderner Kunst, Stiftung Ludwig, Vienna. Stuttgart 1992 (cat.).– Strelow, H. G. U. Cologne 1955.– G. U. Bild-Objekte 1957-1970. Moderna Museet. Stockholm 1971 (cat.).– G. U. Staatsgalerie Stuttgart. Stuttgart 1976 (cat.).– G. U.

**UHLMANN Hans**
**1900** Berlin – **1975** Berlin
German sculptor. **1919–1924** Studied at the Technical College in Berlin. **1925** First sculptures. **1926–1933** Taught at the Berlin Academy of Fine Arts. **1929** Visit to France. **1930** First solo-exhibition at the Gurlitt gallery, Berlin. **1933–1935** Imprisoned for "conspiracy". Until **1945** worked as an engineer. **1947** Berlin Art Award. **1950** Taught again at the Berlin Academy. **1952** Prize for drawing at the São Paulo Biennale. **1954** Participation at the Venice Biennale and completion of the sculpture *Concerto* for the foyer of the Berlin Music Academy. Between **1955** and **1977** took part in documenta 1 – 3 and 6 in Kassel. **1968** Retrospective at the Berlin Academy, Berlin. **1975** Solo-exhibition of drawings at the Nationalgalerie, Berlin. Uhlmann's early sculptures, slender, abstract constructions of wire or steel, are reminiscent of the works of the Russian Constructivists such as Gabo. After World War II, his three-dimensional works acquired more elasticity and lightness. The fixed, static sculptures were replaced by free forms articulating space.
CATALOGUES RAISONNES: Brockhaus, C. and J. Merkert (ed.): H. U. 1900-1975. Die Aquarelle und Zeichnungen. Wilhelm-Lehmbruck-Museum, Duisburg et al. Duisburg 1990 (cat.).– Haftmann, W.: H. U. Leben und Werk. Mit einem Werkverzeichnis der Skulpturen von U. Lehmann-Brockhaus. Berlin 1975
MONOGRAPHS, CATALOGUES: Baumgart, F. (ed.): U. Handzeichnungen. Frankfurt-on-Main 1960.– Fuchs, H. (ed.): H. U. Plastik und Zeichnungen. Städtische Kunsthalle Mannheim. Mannheim 1978 (cat.).– Killy, H. E. (ed.): H. U. Akademie der Künste. Berlin 1968 (cat.)

**ULLMAN Micha**
born **1939** Tel Aviv
Israeli sculptor and object artist. **1960–1964** Studied art at the Bezalel Academy of Art in Tel Aviv. **1973** Participated at the

Kunstverein Braunschweig. Brunswick 1979 (cat.).– Wolleh, L.: G. U. Eine Dokumentation. Cologne 1971

São Paulo Biennale and **1987** in documenta 8 in Kassel. **1988** Exhibition at the Israel Museum in Jerusalem and **1990** at the Nationalgalerie, Berlin. **1992** Took part again in the documenta in Kassel.
MONOGRAPHS, CATALOGUES: Barzel, A. and J. Sartorius (ed.): M. U. National-galerie. Berlin 1990 (cat.).– Scheps, M. and S. Breitenberg-Semel (ed.): M. U. The Surface. Drawings 1970-1980. Tel Aviv Museum. Tel Aviv 1980 (cat.).– Zamona, Y. and A. Ofek (ed.): M. U. Israel Museum. Jerusalem 1988 (cat.)

**UMBO**
(Otto Umbehr)
**1902** Düsseldorf – **1980** Hanover
German photographer. Self-taught. **1921–1923** Studied at the Bauhaus in Weimar under Itten, Gropius, Kandinsky and Klee. **1924** Took the pseudonym Umbo. Worked as clown, camera man and whitewasher. Co-founder of the Deutscher Fotodienst (German Photographic Service). **1938–1943** Worked for the Ullstein Verlag, Berlin. He was one of the most important photojournalists worldwide in the 20s. **1965–1974** Taught at the Hanover School of Arts and Crafts. Umbo had an avant-garde approach to photography and experimented a great deal. He also made montages.
CATALOGUE RAISONNE: Molderings, H.: U. 1902-1980. Düsseldorf 1996
MONOGRAPHS, CATALOGUES: Holeczek, B. and G. Reinhard (ed.): U. Photographien 1925-1933. Spectrum-Photogalerie im Kunstmuseum Hannover. Hanover 1979 (cat.).– Molderings, H. (ed.): U. Vom Bauhaus zum Bildjournalismus. Kunstverein für die Rheinlande und Westfalen, Düsseldorf et al. Düsseldorf 1995 (cat.)/U. Vom Bauhaus zum Bildjournalismus. Kunstmuseum Bern. Bern 1997 (cat.).– Molderings, H. (ed.): U. Centre National de la Photographie. Paris 1996 (cat.).– U. Kunsthalle Darmstadt. Darmstadt 1981 (cat.)

**URSULA**
(Ursula Schultze-Bluhm)
born **1921** Mittenwalde (Mark Brandenburg)
German painter and object artist. **1938** Wrote her first prose before moving to

Berlin. **1945–1953** Worked for the American Cultural Institute in Berlin. **1950** Took up painting and wrote accompanying texts. **1954** Dubuffet discovered her work and exhibited her paintings in his Musée de l'art brut. First solo-exhibition at the Zimmer gallery in Frankfurt am Main. **1955** Married the painter Bernhard Schultze. **1960** Neo-Dadaist assemblage of *objets trouvés*. Exhibitions **1974** at the Kunsthalle Düsseldorf. **1977** Participation in documenta 6 in Kassel. **1979** at the Museum Bochum and **1992** at the Von der Heydt-Museum, Wuppertal.
MONOGRAPHS, CATALOGUES: Fehlemann, S. et al. (ed.): U. Retrospektive. Werke 1951-1992. Von der Heydt-Museum, Wuppertal. Munich 1992 (cat.).– U. Musée des Arts Décoratifs. Paris 1972 (cat.).– U. Städtische Kunsthalle Düsseldorf. Düsseldorf 1974 (cat.).– U. Bilder, Objekte, Zeichnungen. Museum Bochum 1979 (cat.).– U. Kunsthalle Bremen. Bremen 1992 (cat.)

**UTRILLO Maurice**
(Maurice Valadon)
**1883** Paris – **1955** Dax (Landes)
French painter. Illegitimate son of the painter Suzanne Valadon. He lived a dissolute life and was an alcoholic. **1902** A doctor advised his mother to encourage him to take up painting. Though this did not cure his drinking problem, it at least unearthed his natural talent as a painter. Despite continual interruptions for treatment, he was soon able to sell his paintings of picturesque places such as Montmartre in Paris. From **1909** onwards he seldom painted from nature but used postcards as his starting material. **1924** Attempted suicide and then moved in to his mother's apartment in Chateau St.-Bertin (Ain). Encouraged by his publisher, Frapier, took up graphic work. In the 30s Utrillo began to overcome his alcoholism. He married and organised numerous exhibitionn, but his new-found success only tempted him to produce more paintings in the same vein as his popular city scenes. **1983** Exhibition "Centenaire de la naissance de M. U." at the Musée Jacquemart-André in Paris.
CATALOGUE RAISONNE: Pétridès, P. (ed.): L'œuvre complet de M. U. 5 vols. Paris 1959-1974
MONOGRAPHS, CATALOGUES: Basler, A.: M. U. Paris 1931.– Carco, F.: U. Paris 1956 / M. U. Legende und Wirklichkeit. Zurich 1958.– Coquiot, G.: M. U. Berlin 1925.– Courthion, P.: U. e Montmartre. Milan 1969.– Crespello, J.-P.: U. La bohème et l'ivresse à Montmartre. Paris 1970.– Fabris, J.: U. Sa Vie, son œuvre. Paris 1982.– Fabris, J. (ed.): L'Exposition rétrospective de M. U. Odakyu Grande Galerie, Tokyo et al. Tokyo 1985 (cat.).– Fabris, J.: M. U. Paris 1992.– Mac Orlan, P.: U. Paris 1952.– Valore, L.: M. U. mon mari. Paris 1956.– Warnod, J.: U. Paris 1983, New York 1984, Munich 1984.– Werner, A.: M. U. New York 1981

**VALLOTTON Félix**
**1865** Lausanne – **1925** Paris
Swiss painter and graphic artist. Came to Paris at the age of 17 to study at the Académie Julian and was fascinated by the paintings of van Gogh, Gauguin and the Symbolists. **1885** Exhibited for the first time at the Salon des Artistes français in Paris. **1894** Worked as a graphic artist for *La Revue Blanche* and *Rire*. **1902** Participation at the exhibition of the group création at the Salon d'Automne, and exhibited there every year from **1919** to **1925**. **1921–1924** Painted southern landscapes. **1925** Retrospective at the Museum Arlaud, Lausanne. **1929** Organised an exhibition entitled "Vallotton inconnu" at the Drouet gallery in Paris **1992** Exhibitions at the Musée Cantonal des Beaux-Arts, Lausanne and **1995** at the Kunsthalle der Hypo-Kulturstiftung, Munich. An important principle in Vallotton's approach to painting was to avoid merely "copying" nature. His works contain elements of Symbolism and Art Nouveau. The realist style of his paintings anticipates Neue Sachlichkeit.
CATALOGUES RAISONNES: Vallotton, M. and C. Goerg (ed.): F. V. Catalogue raisonné de l'œuvre gravé et lithographié. Geneva 1972 / F. V. Catalogue Raisonné of the Printed Graphic Work. Geneva 1972
MONOGRAPHS, CATALOGUES: Brodskaia, N.: F. V. Le Nabi étranger. Bornemouth 1996.– Busch, G. et al. (ed.): F. V. Leben und Werk. Frauenfeld 1982 / V. Vie et œuvre. Lausanne 1985.– Ducrey, M.: F. V. La Vie, la technique, l'œuvre peint. Lausanne 1989 / V. His Life, His Technique, His Paintings. Lausanne 1989.– Ducrey, M. et al. (ed.): F. V. Kunsthalle der Hypo-Kulturstiftung, Munich et al. Munich 1995 (cat.).– Friedrich, J.: F. V. Zurich 1979.– Guisan, G. and D. Jakubec (ed.): F. V. Documents pour une biographie et pour l'histoire d'une œuvre. 3 vols. Paris 1973-1975.– Hahnloser-Bühler, H.: F. V. et ses amis. Paris 1936.– Horn, U. (ed.): F. V. Berlin 1987.– Jourdain, F.: F. V. Geneva 1953.– Jover, M. (ed.): F. V. Gravures sur bois. Monaco 1993.– Koella, R.: Das Bild der Landschaft im Schaffen von F. V. Zurich 1970.– Koella, R. (ed.): F. V. Bilder, Zeichnungen, Graphik. Kunstmuseum Winterthur et al. Winterthur 1978 (cat.).– Koella, R. (ed.): F. V. Kunsthalle der Hypo-Kulturstiftung, Munich et al. Munich 1995 (cat.).– Monnier, J.: F. V. Lausanne 1970.– Newman, S. M. (ed.): F. V. A Retrospective. Yale University Art Gallery, New Haven et al. New Haven (CT) 1991 (cat.).– Newman, S. M. et al.: F. V. New York 1992, Paris 1992.– Saint-James, A.: V. Dessinateur de presse. Paris 1979.– Schultze, J. et al. (ed.): F. V. Das druckgraphische Werk. Kunsthalle Bremen. Bremen 1981 (cat.) / F. V. Das druckgraphische Werk. Rupertinum. Salzburg 1987 (cat.).– F. V. Musée Cantonal des Beaux-Arts. Lausanne 1992 (cat.).– Vierney, D. et al. (ed.): Le nu dans l'œuvre de F. V. Musée Maillol. Paris 1997 (cat.)

**VALMIER Georges**
**1885** Valmier – **1937** Paris
French painter. **1905** Studied at the Académie des Beaux-Arts in Paris. **1913/14** Participated in the Salon des Indépendants in Paris. **1914** Military service. **1919** First solo-exhibition at the Galerie de l'Effort Moderne run by the art dealer Rosenberg in Paris. **1920** Exhibited with the Section d'Or. **1921** Designed the front cover of the journal *Bulletin de l'Effort Moderne*. **1922/23** Stage designs for M. Jacob, Marinetti and others. **1925** Took part in the exhibition "L'Art d'Aujourd'hui" in Paris. **1926** Participated in the exhibition of the Société Anonyme at the Brooklyn Museum, New York. **1929/30** Participated in the Salon des Surindépendants and **1935** in the Abstraction-Création exhibition in Paris. **1937** Decorations for the Paris World Fair. Valmier's style has close links to Cubist painting, his fragmented images becoming increasingly abstract in the course of his career.
CATALOGUE RAISONNE: Bazetoux, D. (ed.): G. V. Catalogue raisonné. Paris 1991
MONOGRAPHS, CATALOGUES: Bettex-Cailler, N.: G. V. Geneva 1956.– Pillement, G. (ed.): G. V. Œuvres de 1917 à 1935. Galerie Melki. Paris 1973 (cat.)

**VANTONGERLOO Georges**
**1886** Antwerp – **1965** Paris
Belgian painter, sculptor and architect. Studied at the Antwerp and Brussels Academies of Art. **1914–1917** Military service. **1916** Went to Holland and met Mondrian and van Doesburg. **1917** Founder-member of the group De Stijl, and until **1920** contributor to the journal of the same name. **1923** Took part in the De Stijl exhibition at the Galerie de l'Effort Moderne in Paris and **1926** in the exhibition of the Société Anonyme at the Brooklyn Museum, New York. **1924** Publication of his article *L'art et son avenir*. **1927** Moved to Paris. **1931–1937** Founder-member and vice-president of the group Abstraction-Création. **1936** Participated in the exhibition "Cubism and Abstract Art" at the Museum of Modern Art, New York. **1943** Solo-exhibition at the Galerie de Berri, Paris. Participated **1946** in the first Salon des Réalités Nouvelles in Paris, **1949** in a joint-exhibition with Bill and Pevsner at the Kunsthaus Zurich and **1952** in the De Stijl exhibition at the Museum of Modern Art, New York. Retrospectives: **1962** at the Marlborough Gallery, London and **1981** at the Kunsthaus Zurich and at the Musées Royaux des Beaux-Arts de Belgique, Brussels. His plastic, mathematically constructed works are an attempt to apply scientific thinking to art. In his abstract sculpture, Vantongerloo extends the formal theories developed by Mondrian to three dimensions, anticipating the Bauhaus approach to architecture. However, after **1937** Vantongerloo introduced rhythmic curving lines, rejecting Mondrian's idea that only rectangular constructions reflect the harmony of the universe.

WRITINGS: G. V.: L'Art et son avenir. Antwerp 1924
MONOGRAPHS, CATALOGUES: Bill, M. (ed.): G. V. Paintings, Sculptures, Reflections. Marlborough Fine Arts Ltd. New York 1948 (cat.).– Ceuleers, J. v. (ed.): G. V. Antwerp et al. Antwerp 1996 (cat.).– Livingston, J. (ed.): G. V. Corcoran Gallery of Art, Washington et al. Washington and Brussels 1980 (cat.).– Thomas, A.: Denkbilder. Materialien zur Entwicklung von G. V. bis 1921. Düsseldorf 1987.– G. V. Musées Royaux des Beaux-Arts de Belgique. Brussels 1981 (cat.).– G. V. Kunsthaus Zürich. Zurich 1981 (cat.).– G. V. Akademie der Künste, Berlin et al. Berlin 1986 (cat.)

**VASARELY Victor**
(Gyözö Vásárhelyi)
**1908** Pécs (Hungary) – **1997** Paris
Hungarian-born French painter and graphic artist. **1928–1930** Entered Sandor Bortnyik's private school of graphic art where he encountered the works of the Russian Constructivists. **1930** Settled in Paris, doing mostly graphic work. From **1944** devoted himself to painting again and from his systematic observations of optical illusions developed a method of geometric abstraction in which an impression of movement is created through visual ambiguity. **1951** First kinetic paintings. From **1955** he designed murals and reliefs in ceramic, aluminium and other metals, mostly for buildings in France. **1955–1968** Participation in documenta 1–4 in Kassel. From **1961** lived in Annet-sur-Marne. **1970** Opening of a museum dedicated to his works in Gardes (Vaucluse). There are two further Vasarely museums in Pécs and Budapest. **1976** Inauguration of the Fondation Vasarely in Aix-en-Provence, which provided the financial backing for the Institute of Contemporary Design and Architecture, opened in **1981**. **1982** Opening of the Vasarely Centre in Oslo. Vasarely is the most creative representative of Op Art. The different hues and arrangements of his brightly coloured geometric shapes create an impression of perpetual movement.
WRITINGS: Ferrier, J.-L.: Entretiens avec V. V. Paris 1969 / Gespräche mit V. V. Cologne 1971.– V. V.: Plasticité. Paris 1969.– V. V.: Notes brutes. Paris 1972.– V. V.: Gea. Budapest 1986
CATALOGUE RAISONNE: Joray, M. et al. (ed.): V. V. 4 vols. Neuchâtel 1965-1980
MONOGRAPHS, CATALOGUES: Blomstedt, J.: V. Helsinki 1960.– Brück, A.: V.-Analysen. Hamburg 1970.– Dahhan, B.: V. ou La connaissance d'un art moléculaire. Paris 1979.– Diehl, G.: V. V. Paris 1973, Bindlach 1993.– Joray, M. (ed.): V. 3 vols. Neuchâtel 1969-1974.– Knierim, R.: V. und der Konstruktivismus. Diss. Bochum 1978.– Motte, M. d. la and A. Tolnay (ed.). V. Werke aus sechs Jahrzehnten. Stuttgart 1986 (cat.).– Schmied, W.: V. V. Wegebereiter zur Modernen Kunst. Hanover 1967.– Schröder, K. A. (ed.): V. V. Kunst-

forum Wien der Bank Austria, Vienna. Munich 1992 (cat.).– Spies, W.: V. V. Cologne 1958.– Spies, W.: V. Teuffen 1969, New York 1971.– V. V. inconnu/The Unknown V./Der unbekannte V. Neuchâtel 1977.– Weikert, H.: V. V. Begegnung mit Kunstwerken. Munich 1971

**VASULKA Steina** and **Woody**
born **1940** Reykjavik (Steina)
born **1937** Brno (Woody)
Steina Vasulka: Icelandic musician and video artist. **1959** Scholarship from the Czechoslovakian Ministry of Culture to study at the Conservatory of Music in Prague. **1964** Married Woody Vasulka and, for a short time, played with the Iceland Symphony Orchestra. **1965** Moved with Woody to New York, where she worked as a freelance musician. From **1969** made videos with Woody. **1973**–**1975** Began the project *Machine Vision*, an on-going exploration of spatial effects created with mechanical systems and electronic imaging techniques. **1979** Faculty member at the Center for Media Study, State University of New York, Buffalo. **1980** Moved to Santa Fe. **1992** Together with Woody, won the American Film Institute Maya Deren Award and **1995** the Siemens Prize for Media Art from the ZKM in Karlsruhe.
Woody Vasulka: Czechoslovakian media artist. Studied engineering in Brno. **1964** Diploma in film production and direction from the School of Performing Arts in Prague. **1965** Founded the electronic media theatre The Kitchen with A. Mannik. **1973**–**1979** Lived in Buffalo, teaching at the Center for Media Study. From **1993** professor at the Polytechnic in Brno.
MONOGRAPHS, CATALOGUES: Sturken, M. (ed.): S. and W. V. Machine Media. San Francisco Museum of Modern Art. San Francisco 1996 (cat.).– Willoughby, D. (ed.): S. and W. V. Vidéastes 1969-1984. Ciné-MBXA/Cinédoc. Paris 1984 (cat.).– Youngblood, G. (ed.): Video by S. and W. V. Denver Art Museum. Denver 1992 (cat.)

**VEDOVA Emilio**
born **1919** Venice
Italian painter. Self-taught. **1937**–**1940** Lived in Rome and Florence. **1942** Joined the artists' group Corrente. First solo-exhibition at the Galleria Spiga in Milan. **1943**–**1945** Active in the resistance movement. **1946** Joined the group Fronte Nuovo delle Arti. **1947** Participation at the Venice Biennale. **1951** Solo-exhibition at the Catherine Viviano Gallery, New York. **1954** Trip to Brazil. **1955**–**1982** Took part in documenta 1–3 and 7 in Kassel. **1957** Guggenheim Award, and **1960** major prize at the Venice Biennale. **1961** Stage design for L. Nono's Opera *Intolleranza* in Venice. **1964/65** Visited Berlin and the USA. From **1975** taught at the Accademia di Belle Arti in Venice. **1984** Retrospective at the Museo Correr, Venice, and **1986** at the Staatsgalerie Moderner Kunst, Munich. **1993** Solo-exhibition at the Museo d'Arte Moderna, Lugano. Many of Vedova's paintings depict violent political upheavals and were intended as protests against injustice and repression. Since the 60s he has been regarded as the leading exponent of L'art informel in Italy.
WRITINGS: Haftmann, W. (ed.): E. V. Blätter aus dem Tagebuch. Munich 1960 MONOGRAPHS, CATALOGUES: Argan, G. C. and M. Calvesi: V. Comprenze 1946-1981. Milan 1981.– Cela, C. J. et al.: La pintura de V. Palma de Mallorca 1962.– Celant, G.: V. 1935-1984. Museo Correr, Venice. Milan 1984 (cat.).– Chiappini, R. (ed.): E. V. Museo d'Arte Moderna, Lugano. Milan 1993 (cat.).– Eccher, D. (ed.): E. V. Gallerie Civica d'Arte Contemporaneo. Trento 1996 (cat.).– Haftmann, W.: E. V. Munich 1960.– Mahlow, D. et al. (ed.): E. V. Staatliche Kunsthalle Baden-Baden. Baden-Baden 1965 (cat.).– Marchiori, G.: E. V. Venice 1951.– Schilling, J. Brunswick 1981 (cat.).– Schmied, W. (ed.): V. und Salzburg. Salzburg 1988.– Schulz-Hoffmann, C. et al. (ed.): E. V. Staatsgalerie moderner Kunst, Munich et al. Munich 1986 (cat.).– E. V. Malerei. Wiener Sezession. Vienna 1987 (cat.)

**VELDE Bram van**
**1892** Zoeterwoude – **1981** Grimaud
Dutch painter. **1907**–**1914** Apprenticed to a decorator in The Hague. **1922/23** Moved to the artists' colony in Worpswede where he began to do paintings. **1924** Went to Paris where he encountered Impressionism and contemporary art. **1932** Moved to Mallorca, but returned to Paris in **1936**, at the outbreak of the Spanish Civil War. **1937** Friendship with S. Beckett. **1946** First solo-exhibition at the Galerie de Mai von Pierre Loeb in Paris. **1952** Solo-exhibition at the Galerie Maeght, Paris. **1964** Participation in documenta 3 in Kassel. **1958** Retrospective at the Kunsthalle Bern. **1959** Moved to Geneva. Retrospectives **1960** at the Stedelijk Museum in Amsterdam, **1966** at the Wallraf-Richartz Museum in Cologne, **1989** at the Musée National d'Art Moderne in Paris and **1996** at the Musée Rath, Geneva. Velde developed a highly individual pictorial language with some Expressionist and Fauvist elements but also close affinities to L'art informel.
CATALOGUES RAISONNES: Mason, R. M. and J. Putman (ed.): B. v. V. Les Lithographies 1923-1981. 3 vols. Paris and Geneva 1973-1984.– Putman, J. and C. Juliet (ed.): B. v. V. Catalogue raisonné de l'œuvre peint 1907-1960. Paris 1975
MONOGRAPHS, CATALOGUES: Beckett, S. et al. (ed.): B. v. V. Paris 1958, New York 1960.– Becket, S. and F. Meyer (ed.): B. v. V. Albright-Knox Art Gallery. Buffalo 1968 (cat.).– Greshoff, J. et al (ed.): B. v. V. 1895-1981. Bonnefantenmuseum, Maastricht et al. The Hague 1989 (cat.).– Gribaudo, E. (ed.): B. v. V. Torino 1970.– Juliet, C.: Rencontres avec B. v. V. Saint-Clement-de-Rivière 1995/Begegnungen mit B. v. V. Tübingen 1989.– Mason, R. M. (ed.): B. v. V. 1895-1981. Retrospective du centenaire. Musée Rath, Geneva 1996 (cat.).– Peyré, Y.: D'un accès de vision. B. v. V. Paris 1994.– Slagter, E.: B. v. V. Een hommage. Leyden 1994.– Stoullig, C. et al. (ed.): B. v. V. Centre Georges Pompidou, Paris et al. Paris 1989 (cat.).– B. v. V. Musée National d'Art Moderne. Paris 1970 (cat.).– B. v. V. Fondation Maeght. Saint-Paul 1973 (cat.).– B. v. V. Musée d'Art et d'Industrie de Saint-Etienne. Saint-Etienne 1985 (cat.)

**VEREFKIN Marianne von**
**1860** Tula (Russia) – **1938** Ascona
Russian painter. **1883** Began to study at the Moscow School of Art. **1886** Moved with her family to St. Petersburg where she took private lessons from Repin. **1888** Shot herself in the right hand while hunting and never recovered the use of it. **1891** Came to know Javlensky with whom she moved to Munich in **1896**. Gave up her own painting for nine years. **1906** Met Franz von Lenbach and Franz von Stuck. **1908** Painted with Kandinsky, Münter and Javlensky in Murnau. **1909**–**1912** Joined the Neue Künstlervereinigung in Munich. **1912** Exhibited with the Blauer Reiter. **1913** Participated in the First German Autumn Salon in Berlin. **1914** Moved with Javlensky to Switzerland and **1919** to Ascona. **1921** Separated from Javlensky. **1924** Founded the artists' group Der Große Bär, organising a group exhibition in **1928** with Schmidt-Rottluff and Rohlfs at the Berlin gallery Nierendorf. Verefkin was originally influenced by the Nabis and Fauves, but over the years moved closer to German Expressionism.
WRITINGS: Weiler, C. (ed.): M. v. W. Briefe an einen Unbekannten 1901-1905. Cologne 1960
MONOGRAPHS, CATALOGUES: Brögmann, N. (ed.): M. v. W. Œuvres peintes 1907-1936. Fondation Neumann. Gingis 1996 (cat.).– Fäthke, B.: M. v. W. Leben und Werk 1860-1938. Munich 1988.– Federer, K. (ed.): M. v. W. Zeugnis und Bild. Zurich 1975.– Hahl-Koch, J.: M. v. W. und der russische Symbolismus. Munich 1967.– Russ, S. et al. (ed.): M. v.

W. Gemälde und Skizzen. Landesmuseum Wiesbaden. Wiesbaden 1980 (cat.)

**VIEIRA DA SILVA Maria Elena**
**1908** Lisbon – **1992** Paris
Portuguese painter. Originally wanted to be a sculptress and took lessons from E. Bourdelle and C. Despiau in Paris. First worked as an industrial designer and illustrator. **1928/29** Entered the studios of Friesz and Léger, and **1932** studied at the Académie Ranson under Bissière. **1933** First solo-exhibition at the Jeanne Bucher gallery in Paris. **1936** Took part in the exhibition "Ecole de Paris". **1940**–**1947** Moved to Portugal, then on to Brazil, returning to Paris after the war. **1954** Participated at the Venice Biennale and, between **1955** and **1964**, in documenta 1–3 in Kassel. Major retrospectives in Paris and Lisbon. Vieira da Silva's sophisticated networks of subtle, grey-toned lines are like labyrinthine urban visions. In her later works, her structures and tones became more lyrical.
CATALOGUES RAISONNES: Duval, V. et al. (ed.): M. E. V. d. S. Monographie und Catalogue raisonné. 2 vols. Geneva 1993-1994.– Weelen, G.: V. D. S. Les Estampes 1929-1976. Paris 1977.– Weelen, G. and J.-F. Jaeger: V. D. S. Catalogue raisonné. Geneva 1994
MONOGRAPHS, CATALOGUES: Brouwer, C. d. and A. Mommens (ed.): V. d. S. dans les collections portugaises. Musée d'Art Moderne, Brussels. Tervuren 1991 (cat.).– Butor, M.: V. d. S. Peintures. Paris 1983.– Cesariny, M.: V. d. S. Lisbon 1984.– Descargues, P.: V. d. S. Paris 1950.– Esteban, C. (ed.): V. d. S. Peintures 1935-1969. Musée National d'Art Moderne, Paris et al. Paris 1969 (cat.).– Grynpas N. A. (ed.): V. d. S. Fundação Calouste Gulbenkian, Lisbon et al. Paris and Geneva 1988 (cat.).– Jaeger, J.-F. (ed.): V. d. S. La Densité de la transparence. Galerie J. Bucher. Paris 1986 (cat.).– Lassaigne, J. (ed.): V. d. S. Musée de Peinture et de Sculpture, Grenoble et al. Grenoble 1980 (cat.).– Lassaigne, J. and G. Weelen: V. d. S. Paris 1987, 1992, New York 1979.– Luís, A. B.: Longos dias têm cem anos presença de V. d. S. Lisbon 1982.– Terrasse, A.: L'Univers de V. d. S. Paris 1977.– Vallier, D.: V. d. S. Paris 1971.– Vallier, D.: Chemins d'approche. V. d. S. Paris 1982.– V. d. S. Fundação Calouste Gulbenkian. Lisbon 1977 (cat.).– Weelen, G.: V. d. S. Œuvres sur papier. Paris 1983

**VILLEGLE Jacques de la**
born **1926** Quimper (Brittany)
French artist. **1944**–**1946** Studied at the Ecole des Beaux-Arts in Rennes. **1945** Came to know Raymond Hains and worked with him until **1950**. From **1947**–**1949** studied architecture in Nantes. **1949** Moved to Paris. From **1950** carried out various film projects. **1953** Published the book *Hépérile éclaté* with Hains. **1957** Organised the exhibition "Affiches

lacérées", displaying torn posters. **1959** First solo-exhibition at the studio of François Dufrêne in Paris. Participation at the Biennale des Jeunes in Paris. **1960** Co-founder of the group Nouveaux Réalistes. Solo-exhibitions **1965** at the Museum Haus Lange, Krefeld, **1971** at the Moderna Museet, Stockholm, and **1977** at the Pompidou Centre, Paris. **1986** Took part in the exhibition "1960 les Nouveaux Réalistes" at the Musée d'Art Moderne de la Ville de Paris. Villeglé is an affichist or "poster ripper" and a representative of Nouveau Réalisme.
WRITINGS: J. d. la V.: Les Volantes du ravisseur. La Louvière 1974.– J. d la V.: L'Innocence du choix. Nice 1982
CATALOGUE RAISONNE: Fornet, C. et al. (ed.): J. d. la V. Catalogue thématique des affiches lacérées de V. 14 vols. Paris 1988ff.
MONOGRAPHS, CATALOGUES: Hahn, O. and J. d. la Villeglé (ed.): V. retrospektivt 1949-1971. Moderna Museet. Stockholm 1971 (cat.).– Lamarche-Vadel, B.: V. La Présentation en jugement. Paris 1990.– Restany, P. (ed.): V. Temoin de notre temps. Galerie Beaubourg. Paris 1974 (cat.).– J. d. la V. Lacéré anonyme. Centre Georges Pompidou. Paris 1977 (cat.).– J. d. la V. Le Retour de l'hourloupe. Maison de la Culture. Rennes 1985 (cat.).– J. d. la V. Galerie du Génie. Paris 1988 (cat.)

**VILLON Jacques**
(Gaston Duchamp)
**1875** Damville – **1963** Puteaux
French painter. Brother of Marcel Duchamp and Raymond Duchamp-Villon. **1894** Moved to Paris and trained at the Atelier Cormon. **1905** Joint-exhibition with Duchamp-Villon in Rouen. **1911/12** Founder-member of Section d'Or with Picabia, Léger and Metzinger. **1914–1918** Military service. **1919** Took up abstract painting. From **1920** worked mainly as a graphic artist. **1922** Exhibited with the Société Anonyme in New York. From **1931** resumed abstract painting. **1935** Went to the USA. **1939** Participated in the first Salon des Réalités Nouvelles in Paris. **1950** Carnegie Award. **1951** Retrospective at the Musée National d'Art Moderne, Paris. **1955** **-1964** Participation in documenta 1 – 3 in Kassel. **1956** Major prize at the Venice

Biennale. Retrospectives **1960** at the Moderna Museet, Stockholm, **1963** at the Kunsthaus Zurich and **1975** at the Musée des Beaux-Arts, Rouen. Villon's painting is rooted in Cubism, but developed into an individual style with bright colours and simplified forms.
WRITINGS: J. V.: Couleurs et construction. Caen 1985
CATALOGUES RAISONNES: Auberty, J. and C. Perusseaux (ed.): J. V. Œuvre gravé. Paris 1954.– Ginestet, C. d. and C. Pouillon (ed.): V. Les Estampes et les illustrations. Paris 1979
MONOGRAPHS, CATALOGUES: Groot, I. M. d. (ed.): J. V. Grafiek uit een particuliere verzameling. Rijksmuseum. Amsterdam 1984 (cat.).– Lassaigne, J.: J. V. Paris 1950.– Lassalle, H. and O. Popovitch (ed.): J. V. Musée des Beaux-Arts, Rouen et al. Paris 1975 (cat.).– Mellquist, J.: Les Caricatures de J. V. ou la marge de l'indulgence. Geneva 1960.– Pressat, R. et al. (ed.): J. V. L'œuvre gravé. Musée du Dessin et de l'Estampe originale. Gravelines 1989 (cat.).– Robbins, D. (ed.): J. V. Fogg Art Museum, Cambridge (MA). Boston 1976 (cat.).– J. V. Kunsthaus Zürich. Zurich 1963 (cat.).– J. V. Musée Campredon. L'Isle-sur-la-Sorgue 1992 (cat.).– Wick, P. A. (ed.): J. V. Master of Graphic Art 1875-1963. Museum of Fine Arts, Boston. New York 1964 (cat.)

**VIOLA Bill**
born **1951** Flushing (NY)
American video artist. Up to **1973** studied at the College of Visual and Performing Arts at Syracuse University in New York. **1973–1980** Collaborated with M. Cunningham D. Tudor on the work *Rainforest*. **1974** First solo-presentation of video installations at The Kitchen, New York. **1974– 1976** Technical director of Art/Tapes/22 in Florence. **1976–1980** Artist-in-residence at the TV station WNET, New York. **1977** Took part in documenta 6 in Kassel. **1980/81** Visited Japan. **1981** Moved to Long Beach (CA). **1983** Solo-exhibition at the Musée d'Art Moderne de la Ville de Paris. **1987** Retrospective at the Museum of Modern Art, New York, and **1992** at the Kunsthalle Düsseldorf. Took part in documenta 9 in Kassel. **1995** Participation at the Venice Biennale. Viola exploits the technical possibilities of modern media with a high degree of perfection, but uses technology purely to serve his artistic ends and put across the central theme of his works: the basic human experiences of birth and death.
WRITINGS: Violette, R. and B. V. (ed.): B. V. Reasons for Knocking at an Empty House. Writings 1973-1994. Cambridge (MA) 1994, London 1995
CATALOGUE RAISONNE: Pühringer, A. (ed.): B. V. Salzburger Kunstverein. Klagenfurt 1994 (cat.)
MONOGRAPHS, CATALOGUES: Boyle, D. et al. (ed.): B. V. Musée d'Art Moderne de la Ville de Paris. Paris 1983 (cat.).– Boyle, D. et al. (ed.): B. V. Survey of a Decade.

Contemporary Arts Museum. Houston 1988 (cat.).– Brown, J. (ed.): B. V. Museum of Contemporary Art. Los Angeles 1985 (cat.).– Hentschel, M. and H. Paflik-Huber (ed.): B. V. Stations. Württembergischer Kunstverein. Stuttgart 1996 (cat.).– London, B. et al. (ed.): B. V. Installations and Video-tapes. The Museum of Modern Art. New York 1987 (cat.).– Mayes, C. S. (ed.): B. V. The City of Man. Brockton Art Museum. Brockton 1989 (cat.).– Ross, D. et al. (ed.): B. V. Los Angeles County Museum of Art, Los Angeles et al. New York 1997.– Syring, M. L. (ed.): B. V. Nie gesehene Bilder. Städtische Kunsthalle Düsseldorf et al. Düsseldorf 1992 (cat.).– Vierny, D. et al.: V. Paris 1979.– B. V. Slowly Turning Narrative. Institute of Contemporary Art, Philadelphia et al. Philadelphia 1992 (cat.).– B. V. Solomon R. Guggenheim Museum (Soho). New York 1997 (cat.).– B. V. Mas allas de la mirada. Museo Nacional Centro de Arte Reina Sofía. Madrid 1993 (cat.).– Wallace, I. (ed.): B. V. Institute of Contemporary Arts, London et al. London 1984.– Zeitlin, M. A. (ed.): B. V. Buried Secrets. The United States Pavillion 46th Venice Biennale, Venice/Arizona State University Art Museum, Tempe. Tempe 1995 (cat.).– Zutter, J. (ed.): B. V. Museum für Gegenwartskunst. Basel 1987 (cat.)

**VIRNICH Thomas**
born **1957** Eschweiler (near Aachen)
German painter and object artist. **1978– 1981** Studied at the Technical College in Aachen under J. Bandau. **1981–1985** Studied painting at the Düsseldorf Academy under A. Hüppi and E. Gomringer. **1983** First solo-exhibition at the Rosenthal gallery in Selb. Travel grant and award from the City of Aachen. Given a special promotion stand at the art fair Art Cologne in Cologne. **1985** Grant from the state of North Rhine-Westphalia and exhibition at the Museum Abteiberg, Mönchengladbach. **1987** Took part in documenta 8 in Kassel.
MONOGRAPHS, CATALOGUES: Gercke, H. et al. (ed.): T. V. Kunstverein Bonn et al. Bonn 1988 (cat.).– Tacke, C. (ed.): T. V. Kunstraum. Munich 1986 (cat.).– T. V. Kunstverein Braunschweig. Brunswick 1966 (cat.)

**VISSER Carel**
born **1928** Papendrecht
Dutch sculptor. **1948/49** Studied architecture at the Technical College in Delft. **1949 -1951** Studied art at the Royal Academy of Fine Arts in The Hague. **1952** Moved to Amsterdam. **1954** First solo-exhibition at the art dealer's Martinet in Amsterdam. **1958–1962** Taught at the Royal Academy in The Hague. **1962** Guest-professor at the University of Washington. From **1966** taught at Atelier '63 in Haarlem. **1968** Represented the Netherlands at the Venice Biennale and took part in documenta 4 in

Kassel. **1972** Awarded the Dutch national prize for architecture and sculpture and, in **1992**, the art prize from the City of Amsterdam. **1985** Retrospective at the Boymans-van Beuningen Museum, Rotterdam, and **1990** at the Sprengel Museum, Hanover.
MONOGRAPHS, CATALOGUES: Blees, F. (ed.): C. V. Van Reekum Museum. Apeldoorn 1992 (cat.).– Blok, C.: C. V. Amsterdam 1968.– Blotkamp, C.: C. V. Utrecht and Antwerp 1989.– Elger, D. (ed.): C. V. Sprengel Museum. Hanover 1990 (cat.).– Fuchs, R. (ed.): C. V. Beelden, tekeningen, collages. Stedelijk Van Abbe Museum. Amsterdam 1975 (cat.).– Sculptor's Work by C. V. Whitechappel Art Gallery. London 1978 (cat.).– C. V. Neuere Skulpturen und Zeichnungen. Städtische Kunsthalle Düsseldorf. Düsseldorf 1977 (cat.).– C. V. Werken 1975-1985. Museum Boymans-van Beuningen. Rotterdam 1985 (cat.).– C. V. Gemeentemuseum. The Hague 1994 (cat.)

**VIVIN Louis**
**1861** Hadol – **1936** Paris
French painter. Self-taught. **1879–1922** Worked for the post office. **1889** Exhibited at the Salon of the Postal Ministry. **1898** Moved to Paris. After his retirement in **1922**, he devoted himself entirely to painting until paralysis of his right arm prevented him from working anymore. Around **1925** met the art historian Wilhelm Uhde, who recognised his talent and promoted him. **1955** Posthume participation in documenta 1 in Kassel. The naive painter Vivin specialised in hunting scenes, still lifes with flowers and, above all, street scenes and paintings of buildings, which he faithfully reconstructed on paper in minute detail. He often used postcards as his starting material, but gave the pictures a strange, somewhat bleak atmosphere.
MONOGRAPHS, CATALOGUES: Hommage à L. V. Musée du Vieux-Château. Laval 1985 (cat.).– Jakovsky, A.: L. V. Peintre de Paris. Paris 1953.– V. His Paris. Perls Gallery. New York 1971 (cat.)

**VLAMINCK Maurice de**
**1876** Paris – **1958** Rueil-la-Gadelière (Eure-et-Loir)
Flemish-born French painter. **1892** Left home and went to live on the island of

Chatou on the Seine. Was a racing cyclist for a time, and earned his living playing violin in a provincial orchestra. Around **1900** he began to paint, sharing a studio in Chatou, near Paris, with Derain. After seeing the **1901** van Gogh exhibition in Paris he became intoxicated with colour. Up to **1907** applied pure unmixed paints with violent brush strokes. Works exhibited by Vollard in Paris. His style was even bolder than that of the other Fauves. **1908** The Fauves began to disband, and Vlaminck aligned himself more with Cézanne and the Cubists. Following Derain's example, he began to paint sombre, dramatic compositions in a romantic realist style. After **1918** he retired to the country and became something of a recluse. **1943** Publication of his highly controversial book *Portraits avant décès*, drawing the attention of the German occupying forces to several other artists. **1944** Acquitted by a special French court.
WRITINGS: Sauvage, M. (ed.): M. de V. Mein Testament. Gespräche und Bekenntnisse. Zurich 1959.– M. de V.: Tournant dangereux. Souvenirs de ma vie. Paris 1929.– M. de V.: Les Pensées et la voix. Paris 1983
CATALOGUES RAISONNES: Walterskirchen, K. v. (ed.): M. d. V. Verzeichnis des graphischen Werkes. Bern 1974.– Wildenstein Institute (ed.): M. de V. Catalogue raisonné (in preparation)
MONOGRAPHS, CATALOGUES: Carco, F.: M. d. V. Paris 1925.– Crespelle, J.-P.: V. Fauve de la peinture. Paris 1958.– Genevoix, M.: M. V. l'homme. Paris 1954.– MacOrlan, P.: V. Peintures 1900-1945. Paris 1945, New York 1958.– Perls, K.: G. V. New York 1941.– Pollag, S.: Mes souvenirs sur V. Geneva 1968.– Rey, R.: M. d. V. Munich 1956.– Sauvage, M.: V. Sa Vie et son message. Geneva 1956.– Selz, J.: V. Paris 1963.– Vallès-Bled, M. and M.-L. Imhoff (ed.): V. Il pittore e la critica. Milan 1988 (cat.).– M. V. Kunstmuseum Bern. Bern 1961 (cat.)

**VORDEMBERGE-GILDEWART Friedrich**
**1899** Osnabrück – **1962** Ulm
German painter. First apprenticed to a joiner. **1919** Attended the School of Arts and Crafts, then studied architecture and sculpture at the Technical College in Hanover. First abstract paintings. **1922-1924** Entered the studio of Vierthaler. **1923** Studied at the Weimar Bauhaus. **1924** Trip to London. Co-founder of the group "k". Came to know Arp, Schwitters and Doesburg, and subsequently joined the De Stijl group. **1926** Exhibited with the Société Anonyme at the Museum of Modern Art, New York. **1927** Co-founder of the group die abstrakten hannover. **1929** First solo-exhibition at the Povolozky gallery, Paris. **1930** Contact with the Cercle et Carré artists in Paris. **1936/37** Long stays in Berlin and Zurich. **1937** Moved to Amsterdam. **1939** Participation in the exhibition "Réalités Nouvelles" in Paris. **1941** Came to know Beckmann. **1942** Director of Edition Duwaer in Amsterdam. From **1954** taught at the Ulm School of Design. **1955** and **1959** participation in documenta 1 and 2 in Kassel. Retrospectives: **1974** at the Juda Gallery, London, and **1985** at the Wilhelm-Hack-Museum, Ludwigshafen. With his abstract compositions reduced to the most elementary forms, Vordemberge-Gildewart is representative of the Constructivist movement initiated by Doesburg.
WRITINGS: Helms, D. (ed.): F. V.-G.: Schriften und Vorträge. St. Gallen 1976.– F. V.-G.: Millimeter und Geraden. Amsterdam 1940.– F. V.-G.: "abstract-concrett-absolut". Amsterdam 1946.– F. V.-G.: Pro domo. Baden-Baden 1954
CATALOGUE RAISONNE: Helms, D. and A. Valstar-Verhoff (ed.): F. V.-G. The Complete Works. Munich 1990
MONOGRAPHS, CATALOGUES: Helms, D.: V.-G. Göttingen 1972.– Helms, D. (ed.): V.-G. Baugestaltung. Landesmuseum Wiesbaden. Wiesbaden 1993 (cat.).– Jaffé, H. L. C.: V.-G. Mensch und Werk. Cologne 1971.– Lohse, R. P. (ed.): V.-G. Eine Bild-Biografie. Teufen 1959.– Partsch, S. (ed.): F. V.-G. 1899-1962. Wilhelm-Hack-Museum, Ludwigshafen. Münsterschwarzach 1985 (cat.).– Rattemeyer, V. et al. (ed.): Typographie kann unter Umständen Kunst sein. V.-G. Typographie und Werbegestaltung. Landesmuseum Wiesbaden et al. Wiesbaden 1990 (cat.).– Rotzler, W.: V.-G. St. Gallen 1979.– Schäfer, J.: F. V.-G. Studien zu einer beschreibenden Werkanalyse. Frankfurt-on-Main et al. 1984.– F. V.-G. Städtische Kunsthalle Mannheim. Mannheim 1970 (cat.).– F. V.-G. Remembered. Annely Juda Fine Art. London 1974 (cat.).– Wijsenbeek, L. J. F. et al. (ed.): V.-G. Haags Gemeentemuseum et al. The Hague 1966 (cat.)

**VOSTELL Wolf**
**1932** Leverkusen – **1998** Berlin
German artist. **1950-1953** Trained as a lithographer. **1954/55** Studied art at the Wuppertal School of Arts and Crafts and at the Ecole des Beaux-Arts in Paris. Described his work as "décollage", a term he discovered in an article about a plane crash in the French newspaper *Figaro*. Met the composer Karl-Heinz Stockhausen. **1957/58** Studied at the Düsseldorf Academy. **1962-1969** Published the magazine *Dé-coll/age*. **1962** As a co-founder of Fluxus, helped to organise Fluxus events in Wiesbaden, Copenhagen and Paris, followed by New York in **1963** and Berlin and Ulm in **1964**. **1965** Publication of the review *Happening, Fluxus, Pop Art, Neuer Realismus*. **1966** Retrospective at the Kunstverein in Cologne. **1968** Participation at the Venice Biennale. **1969** First covering of cars with concrete, in Cologne. **1971** Moved to Berlin. Made the film *Désastres*. **1974** Retrospective at the Musée d'Art Moderne de la Ville de Paris. **1976** Founded the Museo Vostell Malpartida de Cáseres in Spain. **1977** Took part in documenta 6 in Kassel. **1981** Took his Fluxus train, a mobile museum, to 15 different cities. **1985** Retrospective at the Musée d'Art Moderne, Strasbourg. **1990** Participation at the Venice Biennale. **1992** Retrospectives in Cologne, Bonn and Mannheim. **1997** Hannah Höch Prize for his complete works. After establishing Video Art, Vostell found happenings the most effective way of expressing his political views. With his torn-poster works and smudged, over-painted photo-montages he can also be regarded as a Nouveau Réaliste.
WRITINGS: W. V. and J. Becker (ed.): Happenings: Fluxus, Pop Art, Nouveau Réalisme. Reinbek 1965.– W. V.: Miss Vietnam and Texts of Other Happenings. San Francisco 1969.– W. V.: dé-coll/agen 1954-1969. Berlin 1969.– W. V.: Happening & Leben. Neuwied and Berlin 1970.– W. V.: Aktionen. Reinbek 1970
CATALOGUES RAISONNES: W. V. Œuvre-Verzeichnis. Galerie René Block. Berlin 1970.– Schilling, J. (ed.): W. V. Das plastische Werk 1953-1987. Milan 1987
MONOGRAPHS, CATALOGUES: Domínguez, A. F. (ed.): Museo V. Malpartida de Cáceres 1994.– Gottberg, D. (ed.): V. Fluxus-Zug. Das mobile Museum. Berlin 1981 (cat.).– Lehni, N. et al. (ed.): W. V. Environnement, vidéo, peintures, dessins 1977-1985. Musée d'Art Moderne. Strasbourg 1985 (cat.).– Merkert, J. (ed.): V. Retrospektive. Berlin 1974. Neue Nationalgalerie. Berlin 1975 (cat.).– Rüdiger, U. (ed.): V. Leben = Kunst = Leben. Kunstgalerie Gera. Leipzig 1993 (cat.).– Schilling, J. (ed.): W. V. Dé-coll/agen. Verwischungen, Schichtenbilder, Bleibilder, Objektbilder 1955-1979. Kunstverein Braunschweig. Brunswick 1980 (cat.).– Schmied, W. et al. (ed.): V. Retrospektive 1958-1974. Neue Nationalgalerie. Berlin 1975 (cat.).– Schmied, W. et al. (ed.): V. und Berlin. Leben und Werk 1971-1981. Daadgalerie. Berlin 1982 (cat.).– Schmied, W.: Die fünf Hämmer des W. V. Berlin 1992.– Simon, S.: W. V.'s Aktions-Bildsprache. Eine Dokumentation 1954-1969. Berlin 1969.– W. V. Kestner-Gesellschaft. Hanover 1977 (cat.).– W. V. Museum am Ostwall, Dortmund et al. Dortmund 1977 (cat.).– V. Leben = Kunst = Leben. Orangerie. Gera 1993 (cat.).– Wedewer, R. et al. (ed.): W. V. Rheinisches Landesmuseum, Bonn et al. Heidelberg 1992 (cat.).– Wick, R.: V. soziologisch. Bonn 1969

**VUILLARD Edouard**
**1868** Cuiseaux (Saône) – **1940** La Baule (Loire-Atlantique)
French painter. **1886-1889** Studied at the Paris Ecole des Beaux-Arts under Gérôme. **1888** Attended the Académie Julian, where he made friends with Bonnard, Denis and Sérusier. **1889** First and only exhibition of his works at the Salon. **1890** Co-founder of the Symbolist group, the Nabis. Shared a studio with Bonnard and Denis. **1891** Contact with Toulouse-Lautrec. Inspired by Japanese colour woodcuts, he began to

paint intimate interiors. **1892** First of a series of decorative scenes as wall paintings. **1893** Stage designs for the Théâtre de l'Œuvre, run by his old school friend Lugné-Poe. **1900** Trip to Switzerland with Vallotton. Exhibited for the first time with the Berlin Secession and **1901** with the Unabhängigen. **1903** Co-founder of the Deutsche Herbstsalon. **1909** Taught for a short time at the Académie Ranson. **1914-1916** Worked as a military painter. In the 20s and 30s he painted numerous traditional-style portraits, interiors and cityscapes. **1937** Was killed fleeing from German troops. **1990** Retrospective at the Musée des Beaux-Arts in Lyon. Alongside Bonnard and Sérusier, Vuillard is regarded as one of the leading members of the Nabis. He uses sensitive patterning and planes of colour to convey his mystical and religious meaning.
WRITINGS: E. V.: Sous la dir. Paris 1990
CATALOGUES RAISONNES: Chastel, A. et al. (ed.): V. Catalogue des œuvres. Paris 1990.– Roger-Marx, C. (ed.): E. V. L'œuvre gravé. Monte Carlo 1948, Paris 1984 / The Graphic Work of E. V. San Francisco 1990
MONOGRAPHS, CATALOGUES: Dumas, A. and G. Cogeval (ed.): V. Musée des Beaux-Arts, Lyon et al. Paris 1990 (cat.).– Easton, E. W. (ed.): The Intimate Interiors of E. V. The Museum of Fine Arts, Houston et al. Washington 1989 (cat.).– Groom, G. L.: E. V. Painter-Decorator. London and New Haven (CT) 1994.– Preston, S.: E. V. New York 1972, 1984.– Ritchie, A. C. (ed.): E. V. The Museum of Modern Art. New York 1954, 1969 (cat.).– Roger-Marx, C.: V. Paris 1945, London 1946.– Russell, J. (ed.): V. 1868-1940. Art Gallery of Toronto et al. Greenwich (CT) 1971 (cat.).– Salomon, J.: Auprès de V. Paris 1953, 1968.– Schweicher, C.: Die Bildraumgestaltung, das Dekorative und das Ornamentale im Werk von E. V. Trever 1949.– Thomson, B.: V. Oxford and New York 1988, Paris 1988.– Thomson, B. (ed.): E. V. South Bank Center, London et al. London 1991 (cat.).– Warnod, J.: V. Paris 1988

**WAGEMAKER Jaap**
(Adriaan Barend)
**1906** Haarlem – **1972** Amsterdam
Dutch painter. **1919-1925** Studied at the

Haarlem School of Arts and Crafts. **1926** Joined the group of Haarlem artists known as Kunst Zij Ons Doel. First works influenced by Permeke. **1930–1934** Painted numerous still lifes with flowers in the style of Redon. **1946** Moved to Amsterdam. Inspired by Picasso's works. From **1956/57** material paintings incorporating sacking, slate, sand, wood and found objects. **1972** Retrospective at the Kunsthalle in Bremen. The materials Wagemaker used often give the surface of the canvas the appearance of a fissured landscape.
MONOGRAPHS, CATALOGUES: Doelman, C.: De informele kunst van J. W. Amsterdam 1962.– Heyer, S. d. and M. v. d. Knaap: J. W. Zwolle 1995.– Schultze, J. (ed.): J. W. Kunsthalle Bremen. Bremen 1972 (cat.).– Wagemaker-v. d. Mer, D. et al.: J. W. Amsterdam 1978.– J. W. Stedelijk Museum. Amsterdam 1967 (cat.).– J. W. Aarde in verf. Göttingen 1995 (cat.)

**WALL Jeff**
born **1946** Vancouver
Canadian photo-artist. **1964–1970** Studied art history at the Department of Fine Arts at the University of British Columbia. Took part in several group exhibitions of Conceptual Art. **1970–1973** Research at the Courtauld Institute of Art in London and wrote his doctoral thesis in art history. **1976** After holding various teaching posts he obtained a professorship at the Center of the Arts at the Simon Fraser University in Vancouver. **1982–1997** took part in documenta 7, 8 and 10 in Kassel. From **1987** Professor of Fine Arts at the University of British Columbia. **1995** Major retrospective in Chicago, Paris, Helsinki and London and **1997** at the Museum of Contemporary Art, Los Angeles. Wall's photographic works reveal his thorough knowledge of the classical genres (landscapes, portraits etc.). His large-format Cibachrome pictures presented in light boxes illuminated with fluorescent lighting are references to key works in the history of art.
WRITINGS: Stemmrich, G. (ed.): J. W. Szenarien im Bildraum der Wirklichkeit. Essays and Interviews. Dresden 1997.– J. W.: Landscape Manual. Vancouver 1970.– J. W. Transparencies. Mit einem Gespräch zwischen Els Barents und J. W. Munich 1986
MONOGRAPHS, CATALOGUES: Ammann, J.-C. (ed.): J. W. The Storyteller. Frankfurt-on-Main 1992.– Barents E. and F. Migayrou (ed.): J. W. Le Nouveau Musée. Villeurbanne 1988 (cat.).– Brougher, K. (ed.): J. W. Museum of Contemporary Art. Los Angeles 1997 (cat.).– Dufour, G. (ed.): J. W. Vancouver Art Gallery. Vancouver 1990 (cat.).– Duve, T. d. and B. Groys (ed.): J. W. London 1996.– Linsley, R. and V. Auffermann: J. W. The Storyteller. Frankfurt-on-Main 1992.– Schwander, M. and J. W. (ed.): J. W. Dead Troops Talk. Kunstmuseum Luzern. Basel 1993 (cat.).– Thielmann, A. and J. W.: J. W. Westfälischer Kunstverein. Münster 1988 (cat.).–

Tuyl, G. v. et al. (ed.): J. W. Landscapes and Other Pictures. Kunstmuseum Wolfsburg. Wolfsburg 1996 (cat.).– J. W. Musée d'Art Moderne de la Ville de Paris 1988 (cat.).– J. W. Städtische Kunsthalle Düsseldorf. Düsseldorf 1994 (cat.).– J. W. Galerie Nationale du Jeu de Paume, Paris et al. Paris 1995 (cat.).– J. W. Kunstbau des Lenbachhauses. Munich 1996 (cat.)

**WALTHER Franz Erhard**
born **1939** Fulda
German artist. **1957–1959** Studied at the Offenbach School of Arts and Crafts, **1959–1961** at the Städelschule in Frankfurt am Main and **1962–1964** at the Düsseldorf Academy under Götz. **1963–1969** Produced *1. Werksatz*, action objects with textiles. **1967** Solo-exhibition at the H. Friedrich gallery in Munich. Moved to New York. **1969–1972** *2. Werksatz*: walk-through metal objects. **1969** Solo-exhibitions at the Museum Haus Lange in Krefeld and at the Kunsthalle Düsseldorf, **1970** at the Museum of Modern Art, New York. **1971** Returned to Germany and was appointed professor of sculpture at the Hamburg School of Fine Arts. **1972** and **1977** participation in documenta 5 and 6 in Kassel. **1977** Solo-exhibition at Museum Ludwig in Cologne. **1981** Participated in the "Westkunst" exhibition in Cologne. **1982** and **1987** took part in documenta 7 and 8 in Kassel. **1984/85** Professor at the Städelschule in Frankfurt am Main. **1985** Günter Fruhtrunk Prize from the Munich Academy. **1992** Solo-exhibition at the Kunstmuseum in Lucerne. Walther's objects and working constructions, that have no function but still force the viewer to try to work out how they operate, are representative of Process Art.
WRITINGS: König, K. (ed.): F. E. W. Objekte benutzen. Cologne and New York 1968.– F. E. W.: Prozeßmaterial. Cologne 1970.– F. E. W.: Tagebuch. Cologne 1971.– F. E. W.: Organon. Klagenfurt 1983.– F. E. W.: Wortwerke. 1974-1986. Klagenfurt 1987.– F. E. W.: Das Haus in dem ich wohne. Klasgenfurt 1990.– F. E. W.: Denkraum, Werkraum. Über Akademie und Lehre. Regensburg 1993
MONOGRAPHS, CATALOGUES: Adriani, G.: F. E. W. Arbeiten 1955-1963. Material zum 1. Werksatz 1963-1969. Cologne 1972.– Adriani, G. and K. Vogel (ed.): F. E. W. Arbeiten 1969-1976. Tübigen and Hamburg 1977.– Bojescul, W. (ed.): F. E. W. Ich bin die Skulptur. Wandformationen 1978-1985. Kunstverein Braunschweig. Brunswick 1986 (cat.).– Damsch-Wiehager, A. (ed.): F. E. W. Antwort der Körper. Galerie Villa Merkel, Esslingen. Stuttgart 1993 (cat.).– Dückers, A. et al. (ed.): F. E. W. Zeichnungen-Werkzeichnungen 1957-1984. Staatliche Museen, Kupferstichkabinett. Berlin 1989 (cat.).– Lange, S.: Der 1. Werksatz 1963-1969 von F. E. W. Frankfurt-on-Main 1991.– Lingner, M. (ed.): Das Haus in dem ich wohne. Die Theorie zum Werkentwurf von F. E. W. Klagenfurt 1990.– Pauseback,

W. (ed.): F. E. W. Handlung Werk. Nationalgalerie. Berlin 1981 (cat.).– Stemmler, D. and G. Seng (ed.): F. E. W. Arbeiten 1959-1963. Städtisches Kunstmuseum Bonn. Bonn 1980 (cat.).– F. E. W. and H. Kern (ed.): F. E. W. Diagramme zum 1. Werksatz. Kunstraum. Munich 1976 (cat.).– F. E. W. and M. Pauseback (ed.): F. E. W. Handlung. Werk. Nationalgalerie. Berlin 1981 (cat.).– F. E. W. Gelenke im Raum. Deichtorhallen. Hamburg 1998 (cat.)

**WANG Cheng**
born **1965** Wuhu (Province of Anhui)
Chinese painter. Up to **1991** Studied art at the Jiangsu College of Education. Painted over photographs and texts from newspapers, making pictures that are part-collage and part-painting.

**WARHOL Andy**
(Andrej Warhola)
**1928** Pittsburgh (PA) – **1987** New York
American artist born to Czech immigrant parents. **1945–1949** Studied graphic design at the Carnegie Institute of Technology in Pittsburgh. On graduating, went to New York where he worked as an illustrator and commercial artist. Invented the blotted line technique, a precursor of reproduction methods such as the serigraph technique. From **1960** did paintings based on images from comic strips, or using icons of American advertising and consumerism, like Coca-Cola bottles, dollar bills, Campbell's soup cans, as his motifs. From **1962** he and his team at his New York studio The Factory produced a steady stream of portraits of celebrities, often consisting of rows of repeated images, as well as photographic works, films and music. Brought out the celebrity magazine *Interview* and organised TV shows and multimedia concerts with the pop group Velvet Underground. **1968** Travelled to Stockholm for his first European exhibition and participated in documenta 4 in Kassel. In the same year, the man-hater and feminist writer V. Solanas forced her way into the Factory, fired three revolver shots at Warhol and hit him twice. He was hospitalized for two months. In his later years he often took the works of Old Masters such as Leonardo's *Last Supper* as starting material. **1989** Major retrospective

at the Museum of Modern Art, New York, and at the Museum Ludwig, Cologne. Warhol was and remains the most famous and controversial figure in Pop Art. The mass-production of works through his Factory radically diminished the importance placed on original works in conventional art circles.
WRITINGS: Hackett, P. (ed.): The A. W. Diaries. London 1989/A. W. Das Tagebuch. Munich 1989.– A. W.: Ladies and Gentlemen. Milan 1975.– A. W.: The Philosophy of A. W. (A to B and Back Again). New York 1975.– A. W. and P. Hackett: POPism: The Warhol Sixties. New York 1980
CATALOGUES RAISONNES: Ammann, T. E. (ed.): A. W. Werkverzeichnis. Band I: Gemalte Bilder und erste Siebdrucke 1960-1962. Munich 1992.– Crone, R. (ed.): A. W. Catalogue Raisonné. New York and Washington 1970, Berlin 1976.– Feldman, F. and J. Schellmann (ed.): A. W. Prints. A Catalogue Raisonné 1962-1987. New York and Munich 1997.– Wünsche, H. (ed.): A. W. Das graphische Werk 1962-1980. Bonn 1981
MONOGRAPHS, CATALOGUES: Angell, C. et al. (ed.): The Inaugural Publication. The A. W. Museum. Pittsburgh 1994/The A. W. Museum. Stuttgart 1994.– Baudrillard, J.: A. W. Paintings 1960-1986. New York 1996.– Billeter, E. et al. (ed.): A. W. Kunsthaus Zürich. Bern 1978 (cat.).– Blistène, B. and J.-M. Bouhours (ed.): A. W. Cinema. Centre Georges Pompidou. Paris 1990 (cat.).– Bockris, V.: The Life and Death of A. W. New York 1989/A. W. Düsseldorf 1989/A. W. Paris 1990.– Bourdon, D.: W. New York 1989, Paris 1989, Cologne 1989.– Cagle, V. M.: Reconstructing Pop/Subculture, Art, Rock and A. W. Thousand Oaks 1995.– Colacello, B.: Holy Terror. A. W. Close-up. New York 1990.– Coplans, J. A. W. Paasadena Art Museum. New York 1970 (cat.).– Coplans, J. and J. Baudrillard: A. W. Silkscreens from the Sixties. Munich 1990.– Crone, R.: A. W. Düsseldorf 1970, New York 1970.– Crone, R. and W. Wiegand: Die revolutionäre Ästhetik A. W.'s. Darmstadt 1972.– Crone, R.: Das bildnerische Werk A. W. Berlin 1976.– Crone, R.: A. W. Die frühen Werke. Stuttgart 1987.– Crone, R. (ed.): A. W. A Picture Show by the Artist. New York 1987.– Felix, Z. (ed.): A. W. Retrospektive. Deichtorhallen, Hamburg. Stuttgart 1993 (cat.).– Francis, M. et al. (ed.): The W. Lok. Glamour, Style, Fashion. Whitney Museum of American Art, New York et al. New York 1997 (cat.).– Garrels, G. (ed.): The Work of A. W. Seattle 1989.– Geldzahler, H.: A. W. Portraits of the Seventies and Eighties. London 1993.– Gidal, R. (ed.): A. W. Films and Paintings. London and New York 1971.– Guiles, F. L.: A. W. Voyeur des Lebens. Munich 1989.– Haenlein, C. A. (ed.): A. W. Bilder 1961-1981. Städtische Galerie im Lenbachhaus, Munich et al. Hanover 1981 (cat.).– Kornbluth, J.: Pre-Pop W. New York 1988.– Lüthy: A. W. Thirty Are Better Than One. Frankfurt-on-Main 1995.– MacCabe, C. (ed.): Who is A. W.? Bloomington (IN) 1998.– McShine, K. (ed.): A. W. A Retrospective. The Museum of Modern Art, New York et al. New York 1989 (cat.).– A. W. Retrospektive. Museum Ludwig, Cologne et al. Munich 1989 (cat.).– Nochlin, L.: A. W. Nudes. New York 1996.– O'Connor, J. and B. Liu (ed.): Unseen W. New York 1996.– O'Pray, M. (ed.): A. W. Film Factory. London 1989.– Pratt, A. R. (ed.): The Critical Response to A. W. Westport 1997.– Ratcliff, C.: A. W. New York 1983, Munich and Lucerne 1983.– Romain, L.: A. W. Munich 1993.–

Rosenblum, R. (ed.): A. W. Portraits of the 70's. Whitney Museum of American Art. New York 1979 (cat.).– Sabin, S.: A. W. Mit Selbstzeugnissen und Bilddokumenten. Reinbek 1992.– Schellmann, J. (ed.): A. W. Art from Art. Cologne, Munich 1994 (cat.).– Schwander, M. (ed.): A. W. Paintings 1960-1986. Kunstmuseum Luzern. Stuttgart 1995 (cat.).– Smith, P. S.: A. W.'s Art and Films. Ann Arbor (MI) 1986.– Smith, P. S.: W. Conversations about the Artist. Ann Arbor (MI) 1988.– Spies, W.: A. W. Cars. Die letzten Bilder. Kunstmuseum Bern. Stuttgart 1990 (cat.).– Stucky, C. (ed.): A. W. Heaven and Hell are Just One Breath Away. Late Paintings and Related Works 1984-1986. New York 1992.– A. W.'s Exposure. New York 1979.– A. W. Wilhelm-Hack-Museum. Ludwigshafen 1996 (cat.).– Wilcock, J.: The Autobiography and Sex Life of A. W. New York 1971

**WEEGEE**
(Arthur Fellig)
**1866** Zloczew (Poland) – **1968** New York
Polish-born American photographer. **1876** Moved to New York. **1915–1935** Worked as an assistant in a photographic laboratory. From **1935** photographed for the police force, taking some sensational pictures of accidents and scenes of crime. **1945** Publication of *Naked City*. First exhibition at the Museum of Modern Art, New York. From **1947** worked for *Vogue, Harper's Bazaar, Life* and other magazines. **1977** Posthume participation in documenta 6 in Kassel. Weegee means Famous One, and Arthur Fellig did indeed become notorious for his photographs of the dark side of New York, night scenes of sex and violence, exposed and captured in the glare of his flash.
WRITINGS: W. by W. An Autobiography. New York 1961, 1975
MONOGRAPHS, CATALOGUES: Coplans, J. and C. Capa (ed.): W. the Famous. Center of Photography. New York 1977 (cat.).– Coplans, J. (ed.): W.: Täter und Opfer. Munich 1978.– Nothhelfer, G. and H.: Bildinterpretationen zu Fotografien von W. Berlin 1978.– Porter, D. (ed.): W. 1899-1968. Zurich 1991.– Stettner, L.: W. The Famous. New York 1977.– Talmey, A. and M. Israel (ed.): W. New York and London 1978

**WEGMAN William**
born **1942** Holyoke (MA)
American photo and video artist. **1961– 1967** Studied at Massachusetts College of Art in Boston and at the University of Illinois in Urbana. **1967–1971** Taught at various universities in the USA. **1971** First solo-exhibition of video tapes at the Pomona College Art Gallery and at the Sonnabend gallery in Paris. **1975** Guggenheim-Fellowship and **1975–1977** National Endowment for the Arts Grant. Many of Wegman's works are parodies centering around his dog Man Ray.
MONOGRAPHS, CATALOGUES: Kunz,

M. (ed.): W. W. Malerei, Zeichnung, Fotografie, Video. Kunstmuseum Luzern et al. Cologne 1990 (cat.)/W. W. Paintings, Drawings, Photographs, Videotapes. New York 1990 (cat.).– Paul, F. (ed.): W. W. L'œuvre photographique. Fonds Régional d'Art Contemporain Limousin. Limoges . 1991 (cat.).– Paul, F. (ed.): W. W. Drawings 1973-1997. Limoges 1997 (cat.).– Lyons, L. and K. Levin (ed.): W.'s World. Corcoran Gallery, Washington et al. Washington 1983 (cat.)

**WEI Guangqing**
born **1963** Huangshi (Province of Hubei) Chinese painter. Up to **1985** studied oil painting at the Academy of Art in Zhejiang. Since **1995** he has taught oil painting at the Art Academy in Wuhan. Wei 's aim is to bridge the gap between the traditional and the modern through art.

**WEIBEL Peter**
born **1944** Odessa
Austrian video artist. **1946** Moved with his parents to Vienna. **1964** Studied literature at the Sorbonne in Paris. **1965** Made linguistic films. **1966** Wrote articles on conceptual photography and criticisms of theories of ideology. **1967** Actions, plays, texts and audible objects. **1968** Put together action films with Muehl, Brus and Valie Export and carried out actions and film projects in collaboration with Export. Alongside these activities he continued to study logic and wrote a doctoral thesis on mathematical logic. **1970** Took part in the first International Underground Festival in

London, and afterwards produced several linguistic video works. **1977** Took part in documenta 6 in Kassel and **1979** in "Videowochen" at the Museum Folkwang in Essen. **1981** Guest-professorship in Halifax, Canada. **1982** Professor of Design at the Vienna School of Applied Arts. Weibel is an exponent of Expanded Cinema.
WRITINGS: P. W.: Die Beschleunigung der Bilder in der Chronokratie. Bern 1987.– P. W.: Das Ich und die Dinge. Frankfurt-on-Main 1991
MONOGRAPHS, CATALOGUES: Breicha, O. (ed.): P. W. Mediendichtung. Vienna 1982.– Fleck, R. (ed.): P. W. Zur Rechtfertigung der hypothetischen Natur der Kunst und der Nicht-Identität in der Objektwelt. Galerie Tanja Grunert. Cologne 1992 (cat.).– Noever, P. (ed.): P. W. Inszenierte Kunstgeschichte. Österreichisches Museum für angewandte Kunst. Vienna 1988 (cat.).– Schuler, R. (ed.): P. W. Bildwelten 1982-1996. Vienna 1996.– Steinle, C. (ed.): P. W. Malerei zwischen Anarchie und Forschung. Neue Galerie am Landesmuseum Joanneum. Graz 1992 (cat.)

**WESSELMANN Tom**
**1931** Cincinnati (OH) – **2004** New York
American painter. **1951–1955** Studied psychology at the Cincinnati University and then attended the Art Academy of Cincinnati and the Cooper Union in New York. **1959** Made small abstract collages, combining the contrasting influences of Matisse and De Kooning. **1960** Painted still lifes and landscapes. **1961** First solo-exhibition at the Tanager Gallery in New York. **1963** Took part in the exhibition "Pop Goes the East" at the Contemporary Arts Museum, Houston, and **1965** in the exhibition "Young America 1965" at the Whitney Museum of American Art, New York. **1967** Participated in the São Paulo Biennale and, **1968** and **1977**, in documenta 4 and 6 in Kassel. In the 70s Wesselmann produced free-standing canvases, incorporating elements of collage and actual objects to create a third dimension. From **1983** painted enlargements of spontaneous sketches in garish colours on aluminium and steel. Wesselmann is one of the leading figures in American Pop Art. He became famous in the early 60s for his series *Great American Nudes*.
MONOGRAPHS, CATALOGUES: Buchsteiner, T. and O. Letze (ed.): T. W. Kunsthalle Tübingen et al. Stuttgart 1994 (cat.).– Glenn, C. W. (ed.): T. W. The Early Years, Collages 1959-1962. California State University Art Galleries. Long Beach 1974 (cat.).– Hunter, S.: T. W. New York 1994.– Livingstone, M. (ed.): T. W. A Retrospective Survey 1959-1992. Tokyo et al. Tokyo 1993 (cat.).– McEwen, J. (ed.): T. W. Paintings 1962-1986. The Mayor Gallery, Mayor Rowan Gallery. London 1988 (cat.).– Stealingworth, S.: T. W. New York 1980.– Ward, M.: T. W. Studie zur Matisse-Rezeption in Amerika. Hamburg 1992.– T. W. Galerie de France. Paris 1987 (cat.)

**WESTON Edward**
**1886** Highland Park (IL) – **1958** Carmel (CA)
American photographer. Studied at Illinois College of Photography. **1911** Opened a portrait studio in California and produced his first abstract photographs. **1923** Set up a studio in Mexico City with his son Brett. Came to know Rivera. **1927** Returned to the USA. **1932** Founded the group f/64 with Ansel Adams. **1937** Guggenheim Award. From **1947** suffered from Parkinson's disease. **1948** Photoseries of Point Lobos. **1950** Solo-exhibition at the Museum of Modern Art, New York. **1956** Retrospective at the Stedelijk Museum, Amsterdam. Through his own technical mastery and the influence of Stieglitz, Sheeler and Strand, Weston became a key representative of photographic realism.
WRITINGS: Bunnell, P. (ed.): E. W. on Photography. Salt Lake City 1983.– Newhall, N. (ed.): The Daybooks of E. W. 2 vols. New York 1990, 1996
MONOGRAPHS, CATALOGUES: Armitage, M. (ed.): The Art of E. W. New York 1932.– Baldinger, W. (ed.): The Heritage of E. W. University of Oregon. Eugene 1965 (cat.).– Bunnell, P. C. (ed.): Centennial Essays in Honor of E. W. Carmel 1986.– Conger, A.: E. W. in Mexico. Albuquerque 1983.– Conger, A. (ed.): E. W. Photographs from the Collection of the Center for Creative Photography. Tucson (AZ) 1992.– Danly, S. (ed.): E. W. in Los Angeles. Huntington Library. San Marino 1986 (cat.).– Green, E. (ed.): Washington Gallery of Modern Art. Washington 1966 (cat.).– Maddow, B.: E. W. His Life and Photographs. New York 1979.– Mora, G.: E. W. Form of Passion. New York 1995/Mora, G.: E. W. Formes de la passion. Paris 1995.– Newhall, N. (ed.): E. W. Photographer. The Flame of Recognition His Photographs. Accompanied by Excerpts from the Daybooks and Letters. New York 1965, 1993.– Newhall, B. (ed.): Supreme Instants: The Photography of E. W. Boston 1986.– Stebbins, E. (ed.): E. W.' Portraits and Nudes. Museum of Fine Arts, Boston et al. Boston 1989 (cat.)

**WILSON Robert**
born **1941** Waco (TX)
American artist. Took lessons from the

American painter G. McNeil in Paris before studying interior design, **1962–1965,** at the Pratt Institute in New York. **1966** Joint projects with the architect P. Soleri in Scottesdale (AZ). Staged public performances in the 70s, combining written texts, music, dance and design and breaking away from the conventional concept of a work as a narrative unfolding in a linear sequence from beginning to end. **1976** Staging at the Avignon Festival of his best-known work, the opera *Einstein on the Beach,* now considered a crowning example of Minimal music. **1984** Wrote a twelve-hour opera entitled *The CIVIL wars,* intending to involve performers from all over the world assembled for the Olympic Games in Los Angeles. However, the piece was never performed.
WRITINGS: R. W. (ed.): R. W. RWWM. Zurich 1997
MONOGRAPHS, CATALOGUES: Ambasz, E.: R. W. Paris 1991.– Bertoni, F. et al. (ed.): R. W. Stuttgart 1997.– Birnie Danzker, J.-A. (ed.): R. W. Steel Velvet. Museum Villa Stuck. Munich 1998 (cat.).– Fairbrother, T. (ed.): R. W.'s Vision. Museum of Fine Arts, Boston et al. Boston, New York 1991 (cat.).– Graff, B.: Das Geheimnis der Oberfläche. Der Raum der Postmoderne und die Bühnenkunst von R. W. Tübingen 199.– Haenlein, C. A. (ed.): R. W. Monuments. Kestner-Gesellschaft. Hanover 1991 (cat.).– Holmberg, A.: The Theatre of R. W. New York 1997.– Lehmann, H.-T.: Collaboration R. W. Zurich 1988.– Reinhardt, B. (ed.): R. W. Erinnerungen an eine Revolution. Environment. Stuttgart 1987 (cat.).– Rockwell, J. and R. Stearns (ed.): R. W. From a Theater of Images. Contemporary Arts Center. Cincinnati 1980 (cat.).– Wachsmann, M. and G. Lohnert (ed.): R. W. Die goldenen Fenster. Städtische Galerie im Lenbachhaus, Munich et al. Munich 1982 (cat.).– R. W. Mr. Bojangles' Memory. Centre Georges Pompidou. Paris 1991 (cat.)

**WINTER Fritz**
**1905** Altenbögge – **1976** Dießen-St. Georgen
German painter. Originally worked as a miner. **1927–1930** Studied at the Bauhaus in Dessau under Klee, Kandinsky and Schlemmer. **1930–1933** Lived in Berlin where he met Gabo. **1933** Moved to Dießen on the Ammersee. During the Third Reich his paintings were classified as "degenerate art" and banned. **1939–1949** Military service. Fought and was taken prisoner in Russia. **1944** Produced his 40-part worked *Triebkräfte der Erde* (Driving Forces of the Earth) while convalescing. **1953** Guest-lecturer at the Hamburg School of Art. From **1955** taught at the Academy of Arts and Crafts in Kassel. **1955** and **1959** participation in documenta 1 and 2 in Kassel. Painted on lighter grounds. From **1961** modulations of space through colour effects. Inspired by the ideas of the

Blauer Reiter movement, Winter saw art as a direct expression of the elementary forces of nature. From the 30s onwards he gradually abandoned figurative painting and after the war became more closely aligned with the Ecole de Paris.
WRITINGS: Haftmann, W. (ed.): F. W. Aus Briefen und Tagebüchern. 1932-1950. Bern 1951
CATALOGUES RAISONNES: Gabler, K. (ed.): Das graphische Werk von F. W. Frankfurter Kunstkabinett. Frankfurt-on-Main 1968 (cat.).– Lohberg, G.: F. W. Leben und Werk. Mit einem Werkverzeichnis der Gemälde. Munich 1986.– Tutsch C. (ed.): F. W. 1905-1976. Verzeichnis sämtlicher Werke F. W. im Besitz der Staatlichen Museen Kassel. Kassel 1992
MONOGRAPHS, CATALOGUES: Boess, C. and C. Schulz-Hoffmann (ed.): F. W. Munich 1988.– Büchner, J.: F. W. Recklinghausen 1963.– Gabler, K.-H.: Das graphische Werk von F. W. Frankfurt-on-Main 1968.– Gausling, H. (ed.): F. W. Städtisches Gustav-Lübcke-Museum, Hamm et al. Ahlen 1985 (cat.).– Haftmann, W.: F. W. Triebkräfte der Erde. Munich 1957.– Keller, H.: F. W. Munich 1976.– Kricke-Güse, S. and E.-G. Güse (ed.): F. W. Triebkräfte der Erde. Westfälisches Landesmuseum. Münster 1981 (cat.).– Schmidt, J.-K. et al. (ed.): F. W. Galerie der Stadt. Stuttgart 1990 (cat.).– Steingräber, E. (ed.): F. W. Staatsgalerie moderner Kunst und Galerie-Verein, Munich et al. Munich 1976 (cat.).– F. W. Kunstverein für die Rheinlande und Westfalen. Düsseldorf 1966 (cat.).– F. W. Neue Galerie. Kassel 1992 (cat.)

**WINTERS Terry**
born **1949** Brooklyn (NY)
American artist. Studied art at Pratt Institute, New York, graduating in **1971** with a Bachelor of Fine Arts degree. **1982** First solo-exhibition at the Ileana Sonnabend Gallery in New York. Major solo-exhibitions: **1985** Kunstmuseum, Lucerne, **1986** Tate Gallery, London, **1987** Saint Louis Art Museum and Walker Art Center, Minneapolis, **1991** Museum of Contemporary Art, Los Angeles, and Whitney Museum of American Art, New York, and **1998** at the IVAM Centro Julio González, Valencia.
WRITINGS: T. W. and R. Smith: Schema. New York 1987
MONOGRAPHS, CATALOGUES: Kane, M. L. (ed.): T. W. Currents 33. The St. Louis Art Museum. St. Louis 1987 (cat.).– Kertess, K. and M. Kunz (ed.): T. W. Kunstmuseum. Lucerne 1985 (cat.).– Lewison, J. (ed.): T. W. Tate Gallery. London 1986 (cat.).– Phillips, E. and K. Kertess (ed.): T. W. Museum of Contemporary Art, Los Angeles et al. New York 1991 (cat.).– Plous, P. and C. Knight (ed.): T. W. Painting and Drawing. University Art Museum, Santa Barbara et al. Seattle 1987 (cat.).– T. W. IVAM Centro Julio González, Valencia 1998 (cat.)

**WITKIEWICZ Stanislaw**
**1885** Warsaw – **1939** Jeziory
Polish painter, theoretician and writer. **1904** Trip to Italy. **1905/06** Studied art at the Cracow Academy. **1907** Took private painting lessons from W. Slewinski. **1908** Encountered avant-garde art movements in Paris, but his painting style was chiefly influenced by Jugendstil and Expressionism. **1910** Began writing his novel *The 622 Downfalls of Bungo, or The Demonic Woman.* **1914** Went on a scientific expedition to New Guinea. Signed up at the outbreak of war. From **1917** painted again in an abstract style retaining elements of Symbolism. **1918** Returned to Zakopane and wrote a theoretical treatise and the first of thirty plays. Invited to join the Cracow artists' group The Formalists. **1925** Concentrated on portrait painting. First successful stage designs. **1931** Published numerous articles on his philosophical theories and gradually abandoned painting.
WRITINGS: I. S. W.: Pisma filozoficzne i estetyczne. Warsaw 1974.– I. S. W.: Les Formes nouvelles en peinture et les malentendus qui en découlent. Lausanne 1979
CATALOGUE RAISONNE: Micinska, A.: S. I. W. Life and Work. Warsaw 1990
MONOGRAPHS, CATALOGUES: Crugten, A. (ed.): W. et la peinture. Lausanne 1979.– Hommage à S. I. W. Städtische Kunsthalle Düsseldorf. Düsseldorf 1980 (cat.).– Jakimowicz, I.: W. Warsaw 1985.– Jakimowicz, I. (ed.): S. I. W. Muzeum Narodowe. Warsaw 1990 (cat.).– Lingwood, J. (ed.): S. I. W. Photographs 1899-1939. Third Eye Centre. Glasgow 1989 (cat.).– Manthey, E. and B. v. Schleyer (ed.): S. I. W. 1885-1939. Neue Gesellschaft für Bildende Kunst, Berlin et al. Berlin 1990 (cat.).– Micinska, A.: S. I. W. Warsaw 1991.– Piasecki, Z.: S.W. Warsaw 1983.– Piotrowski, P.: Metafizika obrazu. O teorii sztuki i postawie artystycznej S. I. W. (Metaphysics of Picture. On the Theory of Art and Artistic Attitude of S. I. W.). Poznan 1985.– Piotrowski, P.: S. I. W. Warsaw 1989.– Schmidt, A.: Form und Deformation: zum kunsttheoretischen und dramatischen Werk von S. I. W. Munich 1992.– Sztaba, W.: S. I. W. Warsaw 1985.– S. I. W. Génie multiple de Pologne. Lausanne 1981

**WÖLFLI Adolf**
**1864** Bern – **1930** Waldau
Swiss painter. Was originally a goatherd and farm-labourer in Emmental. **1890** Imprisoned for two years for molesting children. **1895** Arrested again for raping a young girl. Kept for the rest of his life under high security at the psychiatric hospital in Waldau near Bern. **1899** First drawings. Drew with wax crayons and wrote prose and poetry. **1922** Completed his most famous work *Große Wandschirm* (Large Screen) **1976/77** Retrospectives in the Kunstverein in Bern and in Cologne. Over the years, Wölfli's compositions, which were first confused and chaotic, became

clearer and more disciplined. The rampant, intensely coloured images of his disturbed fantasy were seen as exemplary by the Surrealists and taken as examples of Art Brut, a term coined by Dubuffet for the art of outcasts from society.
WRITINGS: A. W.: Von der Wiege bis zum Grab. Schriften 1908-1912. Kunstmuseum Bern. 2 vols. Frankfurt-on-Main 1985
MONOGRAPHS, CATALOGUES: Hunger, B. (ed.): Porträt eines produktiven Unfalls. A. W. Basel and Frankfurt-on-Main 1993.– Longhauser, E. et al. (ed.): The Other Side of the Moon. The World of A. W. Moore Collection of Art and Design, Philadelphia et al. Philadelphia 1988 (cat.).– Morgenthaler, W.: Ein Geisteskranker als Künstler. A. W. Vienna and Berlin 1985/Madness and Art. The Life and Works of A. W. Lincoln 1992.– Spoerri, E. and J. Glaesemer (ed.): A. W. Zeichnungen 1904-1906. Kunstmuseum Bern et al. Bern 1976 (cat.).– Spoerri, E. (ed.): Der Engel des Herrn im Küchenschurz. Über A. W. A. W. Städtische Galerie im Städelschen Kunstinstitut, Frankfurt-on-Main. Stuttgart 1987 (cat.).– Spoerri, E. et al. (ed.): A. W. Dessinateur, compositeur. Lausanne 1991/A. W. Draftsman, Writer, Poet, Composer. Ithaca (NY) 1997.– A. W. Rupertinum. Salzburg 1996 (cat.).– A. W. Schreiber, Dichter, Zeichner. Ed. by Adolf-Wölfli-Stiftung, Kunstmuseum Bern. Basel 1997

**WOLS**
(Alfred Otto Wolfgang Schulze)
**1913** Berlin – **1951** Paris
German painter and photographer. **1919** Moved with his family to Dresden. **1932** Went to Berlin to apply to study at the Bauhaus. However, Moholy-Nagy advised him to go to Paris. There he wrote, painted and worked as a portrait photographer, becoming friends with Ernst, Léger, Domela, Arp, Giacometti, and Ozenfant. **1937** First major commission as official photographer at the Paris World Fair. **1939** Interned at the outbreak of war. **1940** Escaped and went into hiding in Cassis near Marseille, where he did drawings and watercolours. **1942** Fled from the Germans to Montélimar and met the writer H.-P. Roché, who promoted him. **1945** A first

exhibition of his watercolours at the Galerie Drouin was a failure. Returned to Paris one year later, and in **1947** had sensational success with an exhibition in the same gallery. Came to know Jean-Paul Sartre and Simone de Beauvoir, who promised to help him. Shared many artistic ideas with Giacometti and Mathieu. **1955-1964** Participation in documenta 1–3 in Kassel. Inspired by Surrealist theories of psychic automatism, Wols produced many of his early drawings, watercolours and oil paintings under the influence of drugs and alcohol. Later, he used thick brush strokes and heavy impasto to create paintings with a relief structure, and sometimes inscribed lines and shapes into the paint.
WRITINGS: W.: Aphorisms. Amiens 1989
MONOGRAPHS, CATALOGUES: Damme, C. v.: Kunst als catharsis en psychogenese … W. Ghent 1985.– Glozer, L. (ed.): W. Photograph. Kestner-Gesellschaft, Hanover. Munich 1978 (cat.).– Götze, G. (ed.): W. sa vie … Goethe-Institut, Paris et al. Paris 1986 (cat.).– Inch, P. (ed.): Circus W. The Life and Work of W. S. Todmorden 1978.– Haftmann, W. et al. (ed.): W. Aufzeichnungen, Aquarelle, Aphorismen, Zeichnungen. Cologne 1963/ W. en personne. Paris 1963.– Haftmann, W. (ed.): W. Stedelijk Van Abbe Museum. Eindhoven 1966 (cat.).– Haftmann, W. (ed.): W. Gemälde, Aquarelle, Zeichnungen. Nationalgalerie. Berlin 1973 (cat.).– Karabelnik-Matta, M. and T. Abt (ed.): W. Bilder, Aquarelle, Zeichnungen, Photographien. Kunsthaus, Zurich et al. Zurich 1989 (cat.).– Osterwold, T. and T. Knubben (ed.): W. Aquarelle 1937-1951. Ravensburg 1997 (cat.).– Petersen, H. J.: W. Leben und Werk im Spiegel gewandelter Wahrnehmung. Frankfurt-on-Main and Berlin 1994.– Rathke, E. and S. (ed.): W. Bilder, Aquarelle, Zeichnungen, Photographien, Druckgraphik. Kunstsammlung Nordrhein-Westfalen. Düsseldorf 1989 (cat.).– Rathke, E. (ed.): W. Fotografias, acuarellas y grabados. Sala Parpalló/Palau des Scala. Valencia 1993 (cat.).– Salden, H. A. F.: W.'s Bildkonzept. Thesis. Giessen 1991.– W. Musée d'Art Moderne de la Ville de Paris. Paris 1973 (cat.).– W. Kunsthaus Zurich et al. Bern 1989 (cat.).– Wols photographe. Centre Georges Pompidou. Paris 1980 (cat.)

**WOOD Grant**
**1892** Anamosa (IA) – **1942** Iowa City (IA) American painter. **1910/11** Studied at the Minneapolis School of Design and Handicraft. **1913-1916** Went to evening classes at the Art Institute in Chicago. From **1913** worked as a designer. **1914-1916** Helped to run the silver workshop of C. Haga in Chicago. **1920** Trip to Paris. **1923/24** Attended the Académie Julian in Paris. **1926** Exhibition at the Carmine gallery, Paris. **1928** Visited Munich. Founded the Little Gallery in Cedar Rapid. **1932** Opening of the Stone City Colony and Art School (IA).

**1934-1941** Taught at the University of Iowa, Ames. **1942** Received special honours at the Annual American Exhibition at the Art Institute of Chicago. **1959** Major posthumous retrospective at the University of Kansas, Kansas City. Wood's early paintings have strong Impressionist elements. However, a combined interest in German Renaissance art and Neue Sachlichkeit led him to develop a strictly veristic style. His landscapes and true-to-life portraits of farmers and ordinary people in mid-West America make him an important exponent of American realism and regionalism.
WRITINGS: G. W.: Revolt Against the City. Iowa City 1935
CATALOGUE RAISONNÉ: Cole, S. (ed.): G. W. The Lithographs. A Catalogue Raisonné. New York 1984
MONOGRAPHS, CATALOGUES: Corn, W. M. (ed.): G. W. The Regionalist Vision. Whitney Museum of American Art, New York et al. New Haven (CT) 1983 (cat.).– Dennis, J. M.: G. W. A Study in American Art and Culture. New York 1975.– Dennis, J. M. (ed.): G. W. Still Lives as Decorative Abstractions. Elvehjem Museum of Art. Madison 1985 (cat.).– Garwood, D.: Artist in Iowa. A Life of G. W. New York 1944.– Liffring-Zug, J. (ed.): Ths is G. W. Country. Davenport Municipal Art Gallery. Davenport (IA) 1977

**WOODROW Bill**
born **1948** Henley (Oxfordshire) English sculptor. **1967/68** Went to Winchester School of Art. **1968-1971** Studied at St. Martin's School of Art and **1971/72** at Chelsea School of Art in London. **1972** First solo-exhibition at the Whitechapel Art Gallery in London. He made his name in the early 80s as a representative of the New British Sculpture with his assemblages of found objects, used materials and bits of rubbish. In the 90s he began to cast his works in steel and bronze, giving his *objets trouvés* an unusual elegance reminiscent of the ideal aesthetics of classical sculpture. **1987** Participation in documenta 8 in Kassel. **1996** Retrospective at the Tate Gallery in London.
MONOGRAPHS, CATALOGUES: Cooke, L.: B. W. Sculpture 1980-1986. Fruitmarket Gallery. Edinburgh 1986 (cat.).– Roberts, J. (ed.): B. W. Fool's Gold. Tate Gallery, London et al. London 1996 (cat.).– B. W. Positive Earth – Negative Earth. Münchner Kunstverein. Munich 1987 (cat.).– B. W. An American Master Revealea. Davenport Museum of Art. Davenport 1995 (cat.)

**WOOL Christopher**
born **1955** Chicago
American painter. **1984** First solo-exhibition at the Cable Gallery, New York. **1989** Solo-exhibition at the San Francisco Museum of Modern Art. **1991** at the Boyman van Beuningen Museum, Rotter-

dam, and at the Kunsthalle Bern. **1991** Took part in the exhibition "Metropolis" at the Martin-Gropius-Bau in Berlin. **1992** Participation in documenta 9 in Kassel.
MONOGRAPHS, CATALOGUES: New Work: C. W. San Francisco Museum of Modern Art. San Francisco 1989 (cat.).– O'Brien, G. (ed.): C. W. Cats in Bag – Bags in River. Museum Boymans-van Beuningen, Rotterdam et al. Rotterdam 1991 (cat.)

**WOTRUBA Fritz**
**1907** Vienna – **1976** Vienna
Austrian sculptor. **1921-1924** Trained as an engraver. **1926-1929** Studied sculpture at the Vienna School of Arts and Crafts. **1928** First *Torso*. **1930** Trip to Germany. Came to know Lehmbruck and Maillol. **1931** Solo-exhibition at the Museum Folkwang, Essen. **1932** Solo-exhibition at the Würthle gallery, Vienna. **1934** and **1948** participation at the Venice Biennale. **1938** Emigrated to Switzerland, settling in Zug. **1945** Returned to Austria and was appointed professor at the Vienna Academy. **1947** Met Giacometti, Daniel-Henri Kahnweiler and Zadkine in Paris. **1955/56** Touring exhibition starting at the Institute of Contemporary Art, Boston. **1959** and **1964** took part in documenta 2 and 3 in Kassel. **1967** Retrospective at the Haus der Kunst, Munich. **1977** Took part in documenta 6 in Kassel. **1980** Opening of the Fritz-Wotruba-Haus in Vienna. **1992** Retrospective at the Kunsthaus in Zug. After World War II, Wotruba abandoned the classical naturalistic style of his early works and moved towards abstraction, producing simple block-like structures with a rough surface. His works had a formative influence on various art movements of the 50s.
WRITINGS: Breicha, O. (ed.): Um W. Schriften zum Werk. Vienna 1968.– F. W.: Überlegungen. Gedanken zur Kunst. Oprecht and Zurich 1945
MONOGRAPHS, CATALOGUES: Besset, M. (ed.): F. W. Palais des Beaux-Arts. Brussels 1951 (cat.).– Breicha, O. (ed.): Um W. Schriften zum Werk. Vienna 1968.– Breicha, O.: F. W. Figur als Widerstand. Salzburg 1977, 1995.– Breicha, O. et al. (ed.): F. W. St. Gallen 1993.– Canetti, E.: F. W. Vienna 1955.– Demus, K.: F. W.

Vienna 1955.– Feuchtmüller, R. et al. (ed.): F. W. Die Kirche in Wien-Mauer. Vienna et al. 1977.– Heer, F.: F. W. Neuchâtel 1961, St. Gallen 1977.– Hofmann, W. (ed.): F. W. Museum des 20. Jahrhunderts. Vienna 1963 (cat.).– Hofmann, W. (ed.): F. W. St. Gallen 1984.– Mitsch, E. (ed.): F. W. Druckgraphik 1950-1975. Graphische Sammlung Albertina. Vienna 1989 (cat.).– Peichl, G. (ed.): W. Hommage à W. Akademie der Bildenden Künste. Vienna 1985 (cat.).– Rudloff, M. (ed.): F. W. Der Bildhauer als Bühnenbildner. Gerhard-Marcks-Haus, Bremen. Vienna and Bremen 1992 (cat.).– Salis, J. R.: F. W. Zurich 1948.– F. W. Forte di Belvedere. Florence 1976 (cat.)

**WYETH Andrew**
born **1917** Chadds Ford (PA)
American painter. Was taught to paint by his father, the illustrator N. C. Wyeth. **1937** Illustrated *Robin Hood*. From **1939**, with almost photographic accuracy, he painted landscapes, mainly in Pennsylvania and Maine where he spent most summers. He used tempera paints, depicting desolate scenes with the odd lonely figure. **1955** Made an Honorary Doctor of Fine Arts by Harvard University in Cambridge (MA). **1966** Retrospective at the Pennsylvania Academy of the Fine Arts, Philadelphia. **1971-1985** Series of 200 portraits entitled the *Helga Picture*. **1976** Retrospective at the Metropolitan Museum of Art, New York. Wyeth takes his motifs from his immediate surroundings. His works, which display many elements of Magic Realism, are full of veristic detail.
WRITINGS: A. W.: Autobiography. Boston 1995
CATALOGUE RAISONNE: Allen, D. and D. Jr. (ed.): W. The Collected Paintings, Illustrations and Murals. New York 1972
MONOGRAPHS, CATALOGUES: Corn, W. M. et al. (ed.): The Art of A. W. De Young Memorial Museum. San Francisco 1973 (cat.).– Dempsey, B. H. (ed.): A. W. Sozheastern Collections. Jacksonville Art Museum. Jacksonville 1992 (cat.).– Duff, J. H.: An American Vision. Three Generations of Wyeth Art. New York 1989.– Jur'eva, T. S.: A. W. Moscow 1986.– McCord, D. (ed.): A. W. Museum of Fine Arts, Boston. Greenwich (CT) 1970.– Meryman, R.: A. W. A Secret Life. New York 1996.– Richardson, E. P. (ed.): A. W. Temperas, Watercolors, Dry Brush Drawings. 1938-1966. The Pennsylvania Academy of Fine Arts, Philadelphia et al. Philadelphia 1966 (cat.).– Wilmerding, J. (ed.): A. W. The Helga Pictures. New York 1987.– A. W. Albright-Knox Art Gallery. Buffalo 1962 (cat.).– A. W. Two Worlds of A. W. Kuerners and Olsons. Metropolitan Museum of Art. New York 1976 (cat.).– A. W. Royal Academy of Arts. London 1980 (cat.).– A. W. Temperas, aquarelles, drybrush, dessins. Galerie C. Bernard. Paris 1980 (cat.).– Wyeth, B. J.: W. at Kuerners. Boston 1976

## ZADKINE Ossip

**1890** Smolensk – **1967** Paris
Russian-born French sculptor. **1905** Moved to England and from **1907** studied in London. **1909** Met Chagall in Vitebsk. Moved to Paris where, from **1911**, he studied at the Ecole des Beaux-Arts and exhibited for the first time at the Salon des Indépendants and the Salon d'Automne. **1912** Joined the Cubists and met Apollinaire, Archipenko, Picasso and Survage. **1913** Friendship with Modigliani. **1914–1917** Fought in the war and was poisoned by nerve gas. War drawings. **1921** Solo-exhibition at the Galerie Barbazanges. **1931** Trip to Greece. **1938** Long stay in New York. **1941** Moved to New York. **1945** Returned to Paris and taught at the Académie de la Grande Chaumière. **1949** Retrospective at the Musée National d'Art Moderne, Paris. **1950** Awarded a major prize for sculpture at the Venice Biennale. **1953** Memorial to the destruction of the City of Rotterdam. **1959** Participation in documenta 2 in Kassel. **1992** Exhibition at the Musée Réattu, Arles. Zadkine was one of the first artists to apply the principles of Cubism to sculpture.
WRITINGS: O. Z.: Comment je suis devenu sculpteur. Brussels 1951.– O. Z.: Le Maillet et le ciseau. Souvenirs de ma vie. Paris 1968
CATALOGUES RAISONNES: Czwiklitzer, C. (ed.): O. Z. Le Sculpteur-graveur de 1919 à 1967. Paris 1967.– Jianou, I. (ed.): O. Z. Catalogue raisonné des sculptures. Paris 1979.– Lecombre, S. (ed.): O. Z. L'œuvre sculpté. Paris 1994
MONOGRAPHS, CATALOGUES: Beranová, J. and J. Postma: Z. Rotterdam 1985.– Buchanan, D.: The Secret World of Z. Paris 1966.– Cassou, J.: O. Z. Amriswil 1962.– Cogniat, R.: O. Z. Paris 1958.– Gertz, U.: Z. Duiburg 1965.– Hammacher, A. M.: O. Z. Munich 1958, London and New York 1958.– Jianou, I.: Z. Paris 1964, 1979.– Lecombre, S. (ed.): Catalogue Musée Z. Sculptures. Paris 1989.– Lichtenstern, C.: O. Z. 1890-1967. Der Bildhauer und seine Ikonographie. Berlin 1980.– Marchal, G.-L. and S. Lecombre (ed.): O. Z. La Sculpture … toute une vie. Rodez 1992.– Moutashar, M. (ed.): Z. Bois et pierres. Musée Réattu, Arles et al. Arles 1992 (cat.).– Prax, V.: Avec Z. Souvenirs de notre vie. Lausanne, Paris 1973

## ZAO WOU-KI

born **1921** Peking
Chinese-born French painter. **1935–1941** Studied at the Academy of Art in Hangzhou. **1940** Detailed analysis of the works of Klee, Matisse and Picasso. **1941–1947** Professor at the Academy of Art in Hangzhou. **1941** First solo-exhibition at the Sino-Soviet Society in Tongking. **1948** Moved to Paris. **1950** Solo-exhibition at the Galerie Pierre, Paris. Met Michaux and P. Loeb. **1953** Stage design for the ballet *La Perle* by R. Petit. **1955** Received the Carnegie Award in Pittsburgh. **1957/58** Tour of the USA. **1965** Retrospective at the Museum Folkwang, Essen, and at the Albertina, Vienna. **1971–1975** Lived in China. **1981** Exhibition at the Grand Palais, Paris. **1990** Solo-exhibition at the Musée des Beaux-Arts, Tours. Zao Wou-ki is a representative of the Ecole de Paris, combining elements of Far Eastern calligraphy and lyrical landscape painting with Tachisme.
CATALOGUES RAISONNES: Agerup, J. (ed.): Z. W.-K. The Graphic Work. A Catalogue Raisonné 1937-1995. Skorping 1995.– Jacometti, N.: Catalogue raisonné de l'œuvre gravée et lithographiée de Z. W.-K. 1949-1954. Berne 1955.– Leymarie, J. and F. Marquet (ed.): Z. W.-K. Catalogue raisonné des peintures. Paris 1978-1986.– Marquet, F. and R. Callois (ed.): Z. W.-K. Les Estampes 1937-1974. Paris 1975
MONOGRAPHS, CATALOGUES: Daix, P. (ed.): Z. W.-K. L'œuvre 1935-1993. Neuchâtel 1994.– Join-Lambert, S. (ed.): Z. W.-K. Musée des Beaux-Arts. Tours 1990 (cat.).– Laude, J.: Z. W.-K. Brussels 1974.– Leymarie, J.: Z. W.-K. New York 1979.– Ragon, M.: Z. W.-K. Madrid 1962.– Roy, C.: Z. W.-K. Paris 1992.– Schneider, P. (ed.): Z. W.-K. Centre d'Art plastique contemporain. Paris 1988 (cat.).– Z. W.-K. and F. Marquet: Autoportrait. Paris 1988

## ZENIUK Jerry

born **1945** Hamburg
German-born American painter. **1950** Moved to the USA. **1969** Graduated from the University of Boulder (CO), and then began to paint with pigments mixed with hot wax and graphite powder. **1971** First solo-exhibition in New York. **1973/74** Went to Hamburg and exhibited his encaustic wax paintings in a number of German cities. **1976** Stopped using wax and began to paint exclusively with natural pigments applied to the canvas in several layers to achieve contrasts of form and colour. **1977** Participation in documenta 6 in Kassel. **1977/78** DAAD scholarship to Berlin. **1981** Fellowship for painting from the National Endowment for the Arts. **1996** Retrospective at the Kunsthalle Karlsruhe.
MONOGRAPHS, CATALOGUES: Salzmann, S. (ed.): J. Z. 1971-1989. Kunsthalle Bremen et al. Bremen 1990 (cat.).– J. Z. Palmenhaus. Städtische Galerie Villa Zanders. Bergisch-Gladbach 1994 (cat.).– J. Z. Staatliche Kunsthalle Karlsruhe. Karlsruhe 1996 (cat.)

## ZHANG Xiaogang

born **1958** Kunming (Province of Yunnan)
Chinese painter. **1982** Completed his course in oil painting at the Academy of Fine Arts in Sichuan. **1986** Founder-member of the Society for Research into Western Art. Taught at the Academy of Fine Arts in Sichuan, Chongqing.

## ZORIO Gilberto

born **1944** Adorno Micca
Italian Arte Povera artist. **1963–1970** Studied sculpture and painting at the Accademia Albertina di Belle Arti, Turin. **1967** First solo-exhibition at the Galleria Sperone, Turin. Took part in the exhibition "Arte Povera" at the University of Genoa. **1968** Participated in the exhibition "Prospect '68" at the Kunsthalle Düsseldorf. **1969** Solo-exhibition at the Sonnabend gallery, Paris. **1971** Took part in the Arte Povera exhibition at the Kunstverein Munich and **1972** in documenta 5 in Kassel. **1976** Solo-exhibition at the Kunstmuseum in Lucerne and **1985** at the Württembergische Kunstverein, Stuttgart. **1986** Participation at the Venice Biennale and solo-exhibition at the Pompidou Centre, Paris. **1987** Solo-exhibition at the Stedelijk Van Abbe Museum, Eindhoven. Zorio uses many different materials in all sorts of combinations. His sculptures, that seem to shatter space, are as dynamic as his performances.
MONOGRAPHS, CATALOGUES: Ammann, J. C. et al. (ed.): G. Z. Kunstmuseum. Lucerne 1976 (cat.).– Ammann, J. C. (ed.): G. Z. Stedelijk Museum. Amsterdam 1979 (cat.).– Ammann, J. C. et al. (ed.): G. Z. Opere 1967 al 1984. Galleria Civica. Modena 1985 (cat.).– Celant, G. (ed.): G. Z. Galleria Christian Stein. Torino 1987 (cat.).– Celant, G. and R. H. Fuchs (ed.): G. Z. Stedelijk Van Abbe Museum. Eindhoven 1987 (cat.).– Celant, G. (ed.): G. Z. IVAM Centro del Carme. Valencia 1991 (cat.).– Celant, G. (ed.): G. Z. Florence 1992 (cat.).– David, C. et al. (ed.): G. Z. Centre Georges Pompidou. Paris 1986 (cat.).– Dimitrijevic, N. and M. Bertoni (ed.): G. Z. Institute of Contemporary Arts, Amsterdam et al. Amsterdam 1991 (cat.).– Merz, B. and D. Zaccharopoulos (ed.): G. Z. Pinacoteca Comunale. Ravenna 1982 (cat.).– Merz, B. et al. (ed.): G. Z. Au fond de la cour à droite. Galerie Pietro Sparta. Chagny 1984 (cat.).– G. Z. Württembergischer Kunstverein, Stuttgart et al. Stuttgart 1985 (cat.).–

# Acknowledgments, copyrights, credits

The editor, the authors and the publisher wish to thank the artists, museums and public collections, galleries and private collectors, archives, photographers and all other institutions and individuals who have helped us in compiling this publication over a period of three years. The editor and the publisher have made every effort to ensure that all copyrights were respected for the works illustrated and that the necessary permission was obtained from the artists, their heirs, representatives or estates. Given the large number of artists involved, this was not possible in every case, in spite of intensive research. Should any claims remain outstanding, the copyright holders or their representatives are requested to contact the publisher.

© VG BILD-KUNST, BONN 2005: Abakanovicz-Kosmowska, Abramovic, Adler, Agam, Alechinsky, Alfaro, Andre, Antes, Anuszkiewicz, Archipenko, Arman, Arp, Arroyo, Artschwager, Atlan, Balla, Balthus, Baranov-Rossiné, Barceló, Basquiat, Bauchant, Baumeister, Bazaine, Beckmann, Belling, Bellmer, Bernard, Beuys, Beverloo, Bill, Bissier, Bissière, Blake, Blume, Blumenfeld, Boltanski, Bombois, Bonnard, Brancusi, Braque, Brauner, Broodthaers, Brüning, Buchheister, Buffet, Bulatov, Buren, Bury, Calder, Campendonk, Campigli, Capogrossi, Carrà, Casorati, Caulfield, César, Chagall, Chaissac, Chamberlain, Charchoune, Chia, Chillida, Claasen, Crotti, Cruz-Diez, Csáky, D'Arcangelo, Davis D., Davis S., De Chirico, Denis, Depero, Derain, de Smet, Dewasne, Diller, Dix, Djuric, Doesburg, Domela, Dominguez, Dongen, Dorazio, Dubuffet, Dufy, Ensor, Erfurth, Ernst, Erró, Estève, Export, Fahlström, Fautrier, Feininger L., Felixmüller, Fetting, Fischer, Francis, Friesz, Fruhtrunk, Gargallo, Garouste, Gerz, Giacometti, Girke, Gleizes, Goncharova, González, Gorky, Götz, Gromaire, Grosz, Gruber, Guttuso, Haacke, Hains, Hamilton, Hartung H., Hausmann, Heiliger, Heisig, Held, Hélion, Helnwein, Herbin, Hérold, Hirshfield, Höch, Hödicke, Hoehme, Hoerle, Holzer, Horn, Ignatovich, Itten, Jacob, Jacobsen, Jacquet, Janco, Javlensky, Jensen, Johns, Kabakov, Kandinsky, Kanovitz, Kisling, Klapheck, Klauke, Klee, Klein Y., Kline, Kokoschka, Kosuth, Kramer, Kudo, Kupka, Lakner, Lam, Lanskoy, Lapicque, Lardera, Larionov, Laurencin, Laurens, Lavier, Laysiepen, Léger, Le Moal, Lempicka, Le Parc, Leroy, Levine, LeWitt, Lhote, Lichtenstein, Liebermann, Lindner, Lissitzky, Lohse, Mack, Magnelli, Magritte, Maillol, Manessier, Mangold, Manguin, Manzoni, Marcoussis, Marden, Marini, Marquet, Masson, Matta, Mattheuer, Meistermann, Metzel, Metzinger, Michaux, Miotte, Moholy-Nagy, Monory, Morandi, Morellet, Morris, Mortensen, Münter, Nauman, Nevelson, Newman, Nicholson, Nieuwenhuys, Nitsch, Noland, Nothhelfer G., Nothhelfer H., O'Keeffe, Odenbach, Olitski, Opalka, Oppenheim M., Orozco, Ozenfant, Palermo, Paolozzi, Pascin, Permeke, Pevsner, Picabia, Piene, Poirier A., Poirier P., Poliakoff, Poons, Prager, Puni, Purrmann, Räderscheidt, Radziwill, Ramos, Raysse, Reinhardt, Richier, Rickey, Riopelle, Rivers, Rodchenko, Rohlfs, Rosenbach, Rosenquist, Rotella, Rouault, Ruff, Ruthenbeck, Saint Phalle, Salle, Saura, Schmidt-Rottluff, Schneider, Schöffer, Schoonhoven, Schulze, Schumacher, Schütte, Schwitters, Serra, Servranckx, Severini, Shahn, Signac, Simonds, Singier, Sironi, Slevogt, Smith D., Solano, Sonnier, Soto, Soulages, Spencer, Spoerri, Staël, Stella F., Stöhrer, Survage, Taeuber-Arp, Tanguy, Tatlin, Telemaque, Thieler, Tilson, Tinguely, Tobey, Torres-García, Trier, Trockel, Tübke, Uhlmann, Ulay, Utrillo, Valmier, van der Leck, Vantongerloo, van Velde, Vasarely, Vassilakis, Vieira da Silva, Villeglé, Villon, Virnich, Visser, Vivin, Vlaminck, Vostell, Vuillard, Walther, Wesselmann, Winter, Zadkine, Zao Wou-ki.

Albers (© The Josef and Anni Albers Foundation/ VG Bild-Kunst, Bonn 2005), Appel (© K. Appel Foundation/VG Bild-Kunst, Bonn 2005), Auerbach (© Marlborough Fine Art Ltd., London), Bacon (© The Estate of Francis Bacon/ VG Bild-Kunst, Bonn 2005), Barlach (© Ernst und Hans Barlach Lizenzverwaltung, Ratzeburg), Beaton (© Cecil Beaton Archive, courtesy of Sotheby's, London), Benton (© T. H. Benton and R. P. Benton Testamentary Trusts/VG Bild-Kunst, Bonn 2005), Boeckl (© Oskar Boeckl, Fuschel am Berg), Borofsky (© Paula Cooper Gallery, New York), Brandt (© Bill Brandt Archive Ltd., London), Buchholz (© Nachlass Buchholz, Königstein), Burri (© Fondazione Palazzo Albizzini, Città di Castello, Perugia), Byars (© Estate James Lee Byars), Cornell (© The Joseph and Robert Cornell Memorial Foundation/ VG Bild-Kunst, Bonn 2005), Dalí (© Salvador Dalí. Foundation Gala-Salvador Dalí/ VG Bild-Kunst, Bonn 2005), Davringhausen (© Galerie Wildbrand, Cologne), De Kooning (© The Willem de Kooning Foundation/ VG Bild-Kunst, Bonn 2005), Delaunay, Delaunay-Terk (© L&M Services B.V., Amsterdam), Delvaux (© Fond. P. Delvaux S. Idesbald, Belgien/VG Bild-Kunst, Bonn 2005), Dexel (© Bernhard Dexel, Hamburg), Dine (© Pace Wildenstein Gallery, New York), Di Suvero (© Oil&Steel Gallery, Long Island City), Doisneau (© The Estate of Robert Doisneau/Rapho agence de presse photographique, Paris), Drtikol (© Ervina Boková-Drtikolová, Podebrady), Duchamp (© Succession Marcel Duchamp/VG Bild-Kunst, Bonn 2005), Evans (© Estate of Walker Evans, The Metropolitan Museum of Art, New York), Flavin (© Estate of Dan Flavin/VG Bild-Kunst, Bonn 2005), Fontana (© Fondazione Fontana, Milan), Freundlich (© Les amis de Jeanne et Otto Freundlich, Pontoise), Gabo (© Nina and Abraham Williams, Biddenden), Gidal (© Pia Gidal, Jerusalem), Glarner (© Fritz Glarner Estate, Locarno), Gormley (© Jay Joplin/White Cube Gallery, London), Gottlieb (© Adolph and Esther Gottlieb Foundation/VG Bild-Kunst, Bonn 2005), Graeser (© Camille Graeser-Stiftung, Zurich), Graves (© Nancy Graves Foundation/VG Bild-Kunst, Bonn 2005), Gursky (© Courtesy: Monika Sprüth Galerie, Köln/ VG Bild-Kunst, Bonn 2005), Haas (© Tony Stone/ Getty Communication, London), Hanson (© Wesla Hanson, Davie, FL.), Haring (© Keith Haring Estate, New York), Heartfield (© The Heartfield Community of Heirs/VG Bild-Kunst, Bonn 2005), Heckel (© Nachlass Erich Heckel, Hemmenhofen), Heizer (© Xavier Fourcade Inc., New York), Henri (© Galleria Martini e Rocchetti, Genoa), Hesse (© The Estate of Eva Hesse, New York), Hirst (© Jay Joplin/White Cube Gallery, London), Hockney (© The David Hockney No. 1 U. S. Trust, Los Angeles), Hofer (© Nachlass Hofer, c/o Kunsthandlung Köhrmann, Cologne), Hofmann (© The Estate of Hans Hofmann, Courtesy Andre Emmerich Gallery, New York), Horst (© Richard J. Horst, New York), Hundertwasser (© Joram Harel Management, Vienna), Immendorf, Kirkeby, Lüpertz, Penck (© Galerie Michael Werner, Cologne and New York), Jorn (© fam.Jorn/ VG Bild-Kunst, Bonn 2005), Judd (© Art Judd Foundation. Licensed by VAGA, NY/ VG Bild-Kunst, Bonn 2005), Kanoldt (© Staatl. Graphische Sammlung, München/ VG Bild- Kunst, Bonn 2005), Kertész (© Ministère de la Culture, France), Kienholz (© Estate of Edward Kienholz, Nancy), Kippenberger (© Galerie Gisela Capitain, Cologne), Kirchner (© Ingeborg und Dr. Wolfgang Henze-Ketterer, Wich-

trach/Berne), Kitaj (© Marlborough Fine Art, London), Kobro (© Muzeum Sztuki, Lodz), Kricke (© Sabine Kricke-Güse, Saarbrücken), Krull (© Germaine-Krull-Stiftung, Braunfels), Kühn (© Kühn-Nachlass, Birgitz), Kushner (© D.C. Moore Gallery, New York), Lange (© The Estate of Dorothea Lange, Oakland, CA), Le Corbusier (© FLC/VG Bild-Kunst, Bonn 2005), Lipchitz (© The Estate of Jacques Lipchitz, courtesy Marlborough Gallery, New York), Louis (© Estate of Morris Louis, Washington), McLean (© Anthony d'Offay Gallery, London), Mantz (© Grete Mantz-Schmidt, Maastricht), Manzù (© Inge Manzù, Rome), Marcks (© Brigitte Marcks-Geck, Hamburg), Matisse (© Succession H. Matisse/VG Bild-Kunst, Bonn 2005), Matta-Clark (© Courtesy Holly Solomon Gallery, New York), Meidner (© Ludwig Meidner-Archiv, Jüdisches Museum der Stadt Frankfurt/Main), Merz (© Archivio Mario Merz, Torino), Miró (© Successió Miró / VG Bild-Kunst, Bonn 2005), Mondrian (© Mondrian/ Holtzman Trust, c/o hcr@hcrinternational.com 2005), Moore (© The Henry Moore Foundation, Much Hadham, Hertfordshire), Morley (© Mary Boone Gallery, New York), Motherwell (© Dedalus Foundation Inc./VG Bild-Kunst, Bonn 2005), Munch (© The Munch Museum/ The Munch Ellingsen Group/VG Bild-Kunst, Bonn 2005), Munkacsi (© Joan Munkacsi, Woodstock, NY), Nay (© Nachlass Ernst Wilhelm Nay, Frau Elisabeth Nay-Scheibler, Cologne), Newton (© Helmut Newton/Galerie Rudolf Kicken, Cologne), Nolde (© Stiftung Seebüll Ada und Emil Nolde, Neukirchen-Seebüll), Oelze (© Richard Oelze Archiv, Aerzen), Oursler (© Metro Pictures, New York), Pechstein (© Max Pechstein Urheberrechtsgemeinschaft, Hamburg), Penn (courtesy Vogue, © by The Condé Nast Publications Inc., New York), Picasso (© Succession Picasso/VG Bild-Kunst, Bonn 2005), Polke (© Sigmar Polke/Galerie Klein, Bad Münstereifel), Pollock (© Pollock-Krasner Foundation/ VG Bild-Kunst, Bonn 2005), Pomodoro (© Arnoldo Pomodoro, courtesy Marlborough Gallery, New York), Rauschenberg (© Robert Rauschenberg/ VG Bild-Kunst, Bonn 2005), Ray (© Man Ray Trust, Paris/VG Bild-Kunst, Bonn 2005), Renger-Patzsch (© Albert-Renger-Patzsch-Archiv/Ann and Jürgen Wilde/VG Bild-Kunst, Bonn 2005), Rheims (© Gina Kehayoff Verlag, Munich), Rosai (© Ottone Rosai, Prato), Rothko (© Kate Rothko-Prizel & Christopher Rothko/VG Bild-Kunst, Bonn 2005), Ryman (© John Weber Gallery, New York), Salomon (© Peter Hunter, Den Haag), Sander (© Photograph. Sammlung/SK Stiftung Kultur-A. Sander Archiv, Köln/VG Bild-Kunst, Bonn 2005), Schad (© Christian Schad Stiftung Aschaffenburg/ VG Bild-Kunst, Bonn 2005), Schlemmer (© C. Ramon Schlemmer, Oggebbio), Schlichter (© Viola Roehr-v. Alvensleben, Munich), Schrimpf (© Nachlass Georg Schrimpf, Munich), Segal (© The George and Helen Segal Foundation/VG Bild-Kunst, Bonn 2005), Seymour (© David Seymour Estate, Washington), Steichen (© Steichen Carousel, New York), Steinert (© Stefan Steinert, Essen/ Museum Folkwang, Essen), Stieglitz (© The Georgia O'Keeffe Foundation, Albiquiu, NM), Still (© Mrs Clyfford Still, New Windsor, MD), Strand (© Aperture Foundation Inc., Paul Strand Archive, Millerton, NY), Strelow (© Gesellschaft Photo-Archiv/VG Bild-Kunst, Bonn 2005), Tàpies (© Fondation Antoni Tàpies Barcelona/VG Bild-Kunst, Bonn 2005), Tuymans (© Zeno X Gallery, Antwerp), Twombly (© Cy Twombly Archives of Painting and Drawings, Heiner Bastian, Berlin), Vordemberge-Gildewart (© Stiftung Vordemberge-Gildewart, Lachen), Wall (© Marian Goodman Gallery, New York), Warhol (© Andy Warhol Foundation for the Visual Arts/ARS, New York), Weegee (Arthur Fellig) (© reproduced with permission of the International Photography, New York), Weston (© Center for Creative Photography, Tucson, AZ), Wood (© VAGA Inc., New York).

© 1998 THE ARTISTS: Acconci, Albright, Almy, Anderson, Anselmo, Arakawa, Arcangelo, Armajani, Armitage, Aycock, Baj, Baldessari, Bar-Am, Baselitz, Baziotes, Becher, Berghe, Berlewi, Birnbaum, Blais, Bleckner, Blume, Botero, Brecht, Brisley, Bruch, Brus, Bruskin, Burden, Campus, Caro, Chadwick, Chaldei, Charlton, Christo & Jeanne-Claude, Clemente, Close, Coburn, Colville, Constant, Corneille, Corpora, Cottingham, Cragg, Cucchi, Dado, Dai Guangyu, Darboven, Davie, De Maria, Duncan, Eddy, Emshwiller, Estes, Etienne-Martin, Fabro, Fischl, Flanagan, Förg, Frank, Frankenthaler, Freud, Freund, Frize, Garouste, Garrin, Geiger, Gertsch, Gilbert & George, Gober, Goings, Goldin, Golub, Götz, Graubner, Green, Grützke, Gundlach, Günther, Hajek, Halley, Hantaï, Heerich, Hegedüs, Helnwein, Hill, Holzer, Hoover, Indiana, Jenney, Jetelová, Jochims, Jonas, Jones, Kahn, Kantor, Kaprow, Karavan, Kawamata, Kawara, Keetman, Kelley, Kelly, Kiefer, King, Klauke, Klein W., Knoebel, Koons, Kossoff, Kounellis, Krims, Kruger, Kubota, Lafontaine, Lang, Lasker, Lassnig, Lebeck, Leibowitz, Liu Wei, Long, Longo, Luginbühl, McBride, McCollum, Marioni, Martens, Martin, Mathieu, Michals, Nesüss, Oehlen, Oldenburg, Oppenheim D., Paik, Paladino, Panamarenko, Paolini, Parks, Pearlstein, Pedersen, Penone, Petrov, Pezold, Phillips, Piene, Pistoletto, Plessi, Prigov, Prince, Pusenkoff, Rainer, Reed, Reusch, Riboud, Richter G., Riley, Rinke, Rist, Rivera, Roth, Rothenberg, Rückriem, Ruetz, Ruscha, Salgado, Samaras, Schapiro, Schnabel, Schultze, Seaman, Sekine, Shaw, Sherman, Sieverding, Smith K., Smithson, Snelson, Sonderborg, Soutine, Spero, Stamos, Steinbach, Stelarc, Stepanova, Struth, Sugaï, Sutherland, Taaffe, Takis, Tal-Coat, Télémaque, Thek, Thiebaud, Thursz, Tillmans, Trakas, Tucker, Tuttle, Uecker, Ullman, Umbo, Ursula, Vasulka, Vedova, Viola, Wang Cheng, Weibel, Wei Guangqing, Wegman, Wilson, Winters, Wols, Woodrow, Wool, Wyeth, Zeniuk, Zhang Xiaogang, Zorio.

© 1998 THE HEIRS OF THE ARTISTS OR THEIR ESTATES: Afro, Albright, Arbus, Armagnac, Baertling, Baziotes, Berghe, Berlewi, Birolli, Butler, Calderara, Cornell, Crippa, Demuth, Diebenkorn, Disler, Dove, Epstein, Exter, Filatov, Filliou, Fleischmann, Fruhtrunk, Gnoli, Goller, Grandma Moses, Grossberg, Guston, Hartley, Hartung K., Hausner, Heiliger, Hepworth, Hine, Hoelzel, Hubbuch, Huszár, Ignatovich, Kassák, Kemény, Kliun, Kudoyarov, Leck, Macdonald-Wright, Maciunas, Malevich, Meyer, Miller, Muche, Nolan, Orozco, Pasmore, Penalba, Petrussov, Prampolini, Richter H., Russolo, Santomaso, Schwarzkogler, Segal A., Segall, Seiwert, Séraphine, Shaikhet, Sheeler, Šima, Siqueiros, Sironi, Smet, Smith T., Soldati, Soutter, Stazewski, Strzemiński, Tamayo, Thorn-Prikker, Tomlin, Toyen, Tworkov, Velde, Verefkin, Wagemaker, Witkiewicz, Wölfli, Wotruba.

PHOTO CREDITS: The locations and owners of the works illustrated are noted in the respective captions unless these wished to remain anonymous or were not known to the editor. The archives, photographers and copyright holders who gave us their support are listed overleaf. We wish to thank them for their kind assistance. The editor and the publisher would be grateful for notification of any omissions or errors in this respect. The numbers refer to the book pages.

Abbreviations: t = top, tr = top right, tl = top left, c = centre, b = bottom, bl = bottom left, br = bottom right. Aachen: Ludwig Forum für Internationale Kunst 396 t (Photo: Anne Gold), 514 (Photo: Anne Gold), 563 t, 566 t; Sammlung Niescher 413 t.– Ahlen: Fritz-Winter-Haus 236.– Amsterdam: Heiting Collection 642 br, 648, 660 t, 660 b, 661 t, 661 b, 662 t, 665 t, 669 b, 675 t, 676 tr, 678 b.– Archives of the authors: 20, 26 t, 183 t, 248 t, 257 tl, 263 br, 379 bl, 382 bl, 438 t, 445, 446 b, 474 b, 478 tl, 483 t, 497 t, 499, 502 t, 504 t, 506 t, 512 b, 523 t, 528 t, 530 t, 532 t, 535 t, 537 t, 538 br, 559 t, 562 t, 562 bl, 566 b, 569 t, 572 t.– Archives of the artists: 238 t, 240 b, 247 tl, 263 bl, 264 t, 264 bl, 264 br, 265 tl, 265 tr, 296 b (Photo: Octavian Stacescu), 297, 307 t, 336, 340 t, 342 t, 342 b, 343 t, 354 b, 366 t, 367 b (Photo: Joachim Rosse), 372 t, 375 t, 381 b, 395 br, 475 tr, 475 br, 490 tr, 493 b, 495 t, 502 b, 503, 530 b, 538 bl, 545, 548 t, 548 c, 548 b, 552 b, 553 t, 564 t, 564 b, 567 t, 567 b, 570 t, 570 c, 591 t, 597 t, 597 c, 601 t (Photo: Werner Schulz), 602 t, 602 b, 603 b, 604, 605 br (Photo: Ilja Schnorr), 608 r, 609 t, 609 b (Photo: Lothar Schnepf), 610 b, 613 t, 615 l, 616 b, 617 t, 662 b, 679 t, 679 b, 680 tl, 680 tr.– Bad Münstereifel: Courtesy Galerie Klein 388, 678 tr.– Basel: Courtesy Galerie Beyeler 351 b; Courtesy Galerie Buchmann 363; Öffentliche Kunstsammlung Basel (Photo: Martin Bühler) 465 b, 556 t.– Belen (NM): Donald Woodman 551.– Berlin: Archiv für Kunst und Geschichte (AKG) 2, 10, 27, 35, 38, 41 t, 45, 46 bl, 47 t, 49, 57, 62, 64 t (Photo: Erich Lessing), 65 c, 69, 77 t, 80 t, 82, 90 t, 91 b, 93, 100, 111 tl, 111 tr (Photo: Erich Lessing), 115, 118, 121 b, 125 (Photo: David Heald), 128 t, 138, 143, 150 b, 156 tl, 156 tr, 160 (Photo: Erich Lessing), 163 tl, 163 tr (Photo: Erich Lessing), 163 b, 164 tr, 165 tr, 165 b, 169, 174 tl, 178 t, 178 b, 181 r, 200 b, 202 tr, 204 tr, 208 tl, 210, 215, 216/217, 230 tr, 247 tr (Photo: Erich Lessing), 249, 270, 275, 276 tl, 291, 292 bl, 303 b, 311 t, 312 t, 313 b, 320 t, 321 b, 324 t, 325, 341 b, 345, 352 t; Brücke-Museum 360 t (Photo: R. Friedrich) 424 l; Courtesy Galerie Busche Galerie 359 b; Courtesy Galerie Brusberg 367 t, 368 b; Courtesy Galerie Max Hetzler 360, 375 b, 391 b, 392 t, 392 b, 393 tr; Courtesy Ladengalerie 367 tl; Fine Art Rafael Vostell 584.– Bochum: c Bochum Kunstvermittlung 542 t, 542 l, 542 r (Photo: Gerd Geyer), 606.– Bonn: Kunst- und Ausstellungshalle der Bundesrepublik Deutschland (Photo: P. Oszwald) 597 b, 599 br, 614 t; Rheinisches Landesmuseum 637 b, 640 t, 642 tl, 642 tr, 652, 658, 659 t, 659 b, 670 tr, 674 b; Stiftung für Kunst und Kultur und Kunstmuseum (Photo: Norbert Faehling) 398, 399.– Boston: C. O. White 590 bl.– Cologne: 235 Media 601 bl, 613 c, 613 b, 617 b (Photo: Seaman); Courtesy Galerie Reckermann 328 br; Courtesy Galerie Ricke 393 tl, 394 t; Courtesy Jablonka Galerie 394 br; Elisabeth Jappe 602 br, 603 c; Elisabeth Nay-Scheibler 237; Friedrich Rosenstiel 596, 602 bl; Internationale Kunstmesse (Photo: Elmar Thomas) 608 bl; Klemens Gasser und Tanja Grunert GmbH 618; Michael Konze 416 tr; Rheinisches Bildarchiv 54, 110 tl, 207 t, 251, 255, 261 t, 299, 301 t, 308 br, 310 t, 314, 315, 316/317, 319 t, 323 b, 339 b, 340 br, 361 t, 361 b, 362 t, 369 b, 370 t, 370 b, 371 t, 371 b, 412 b, 436 br, 441 b, 462, 464 t, 481, 485 b, 492 b, 511 t, 512 t, 518, 520, 523 b, 527 br, 528 b, 530 tr, 536 b, 536 br, 537 b, 612 t, 620, 622 t, 623, 624, 625, 626, 627, 629, 630 t, 630 b, 631 t, 631 b, 632 t, 632 bl, 632 br, 633 t, 633 b, 634, 635, 636 t, 636 b, 637 t, 637 c, 638 t, 638 bl, 638 br, 639, 640 tr, 640 b, 641 t, 641 bl, 643 t, 643 b, 644, 645 tl, 645 tr, 645 b, 646 b, 647, 649, 650 b, 651 t, 651 b, 653, 654, 655 t, 655 b, 656 t, 656 c, 656 b, 657, 663 l, 663 r, 664 t, 664 b, 665 b, 666 t, 666 c, 666 b, 667 t, 667 b, 668 t, 668 b, 669 t, 670 bl, 670 br, 671 t, 671 b, 672 t, 672 b, 673 t, 673 bl, 673 br, 674 t, 675 b, 676 b; Westdeutscher Rundfunk (WDR) 595.– Darmstadt: Hessisches Landesmuseum (Photo: S. Althöfer) 554.– Duisburg: Wilhelm Lehmbruck Museum 414 t, 418, 496 t, 557 bl.– Düren: Sammlung Renker 539 t.– Düsseldorf: Courtesy Galerie Gmyrek 375 bl; Courtesy Galerie Hans Mayer 386 t; Courtesy Galerie Karin Fesel 180 tr, 366 b; Courtesy Galerie Konrad Fischer 552 tl; Kunstsammlung Nordrhein-Westfalen (Photo: Walter Klein), 262, 326; Monika Baumgartl (photo) 540 tr, 600; Walter Vogel (photo) 577; Wolfgang Volz 330, 549, 550.– Emden: Kunsthalle in Emden 397 tl, 397 tr.– Esslingen: Fingerle 113 t.– Frankfurt-on-Main: Lufthistorische Gesellschaft am Flughafen Frankfurt am Main 446 t.– Fuschel am Berg: Oskar Boeckl 246 b.– Haigerloch: Sammlung Sabine Schwenk 391 t.– Hamburg: Barlach Haus 413 b.– Hamburger Kunsthalle (Photo: Elke Walford) 475 tr, 575 t; Sammlung F. C. Gundlach 677 tr.– Hanover: Ponton European Media Art LAB 617 c; Sprengel Museum Hannover 461, 468.– Heidelberg: Edition Staeck (Photo: Giancarlo Pancaldi) 605 bl.– Hempstead (NY): Eric Politzer 552 tr.– Herrsching: Ehemaliges Archiv Schuler 94 b, 157 b.– Humblebæk: Louisiana Museum of Modern Art 199 c, 453, 473, 483 b, 489, 490 t, 540 bl, 558 t.– Kassel: Documenta-Archiv 533 b (Photo: Dirk Bleicher), 560, 611 tr; Frank Mihm 544 t, 563 b, 565, 598 t; Georg Memec 541; Neue Galerie Kassel 590 br.– Künsacht: Walther Bechtler-Stiftung 506 b.– Lódz: Muzeum Sztuki 449.– London: Courtesy Annely Juda Fine Art 355 t, 355 b, 447 b, 531 t; Kasmin Ltd. 531 br, 532 b; Lund Humpries 89; Marlborough International Fine Art 332, 333, 379 bl; Saatchi Collection 572 c, 573 br; Tate Gallery 435, 491 bl (Photo: F. L. Kenett); Time Life 310 b.– Lucerne: Courtesy Galerie Rosengart 218 t.– Mannheim: Städtische Kunsthalle Mannheim 415 t, 443 t.– Mexico City: Rafael Doniz 205 tl, 206 b.– Much Hadham, Hertfordshire: Henry Moore Foundation 402, 476.– Milan: Collection Panza di Biumo 535 c, 535 b, 598 b; Edizione Beatrice d'Este 40 b; Fabbri 78 tl, 78 bl, 87 t, 88 tl, 88 tr, 88 br, 98 t, 122 t, 123 t, 145 b, 154 tr, 174 tr, 184 b, 239 tl, 439 t, 467 b; Galleria Schwarz 459; Le Arti 417.– Mulhouse: Braun 47 br.– Munich: Archiv Alexander Koch 43 b, 53, 60, 96, 112 tl, 113 b, 116, 182, 188, 190 l, 196 b; Archiv Bruckmann 79 tl, 226 bl; Archiv KML 30; Courtesy Barbara Gross Galerie 383 b; Courtesy Galerie Walser 356 b; Courtesy Sammlung Goetz 362 b, 390, 395 bl, 614 b, 676 tl (Photo: Raimund Koch); Galerie Heiner Friedrich 547 b; Marc Weis & Martin De Mattia 573 bl.– Münster: Westfälisches Landesmuseum für Kunst und Kulturgeschichte 559 b; Napa (CA): Hess Collection 158 bl, 222 tl, 223 tr, 240 t, 288 b, 292 br, 340 bl, 343 t, 364, 376 t, 381 t, 456 b, 538 t.– Neuchâtel: Ides et Calendes 212.– Neukirchen-Seebüll: Stiftung Seebüll Ada und Emil Nolde 51 b.– Neuss-Selikum: Gerhard Hoehme Archiv (Photo: Olaf Bergmann) 266 b.– New York: Courtesy Barbara Gladstone Gallery 611 tl; Courtesy Blum Helman Gallery 544 bl; Courtesy Byard Hoffman Foundation 612 bl; Courtesy D. C. Moore Gallery 353 t; Courtesy Lelong Gallery 393 b; Courtesy Leo Castelli Gallery 385 bl, 605 t; Courtesy Pace Wildenstein 574 t; Courtesy Sperone Westwater 557 br; Harry Shunk 575 t, 580 c, 581 t; New York Graphic Society 107, 203 t; Performing Art Services 583 t; Perls Galleries 431 l; Silvermann Collection (Photo: Rolf Jährling) 588 c, 588 b; The Museum of Modern Art 438 l.– Otterlo: Rijksmuseum Kröller-Müller 516.– Paris: Collection Ninon Robelin 522 b; Courtesy Galerie Denise René 171 br; Courtesy Galerie Louise Leiris 218 b; Courtesy Galerie Marianne et Pierre Nahon, Galerie Beaubourg 576; Galerie de France 470 b, 471 b; Galerie Durand-Dessert (Photo: Adam Rzepka) 570 b; Galerie Flinker 495 b; Marc Vaux 440; Musée National d'Art Moderne, Centre Georges Pompidou 444, 466; Musée Rodin (Photo: Bruno Jarret) 408.– Remscheid: Sammlung Feelisch 583 (Photo: Robert R. McElroy), 587 l, 589 t, 589 b.– Rovereto: Museo Fortunato Depero 436 bl.– Saint-Paul-de-Vence: Fondation Maeght 505 b.– Seattle: Charles Adler 497 b.– Stuttgart: Archiv Kohlhammer 150 t; Sammlung Südwest LB 353 b; Staatsgalerie Stuttgart 423 t, 587 r (Archiv Sohm), 587 b (Archiv Sohm).– Torini: Galleria Galatea 64 b; Paolo Mussat Sartor 557 l.– Venice: Peggy Guggenheim Collection 493 tr.– Vienna: Jaffé 47 bl, 129, 205 b; Museum moderner Kunst 521, 522 tr, 586 b, 599 t; L. Hoffenreich 585 t.– Winterthur: Sammlung Oskar Reinhart 412 t.– Zurich: Alesco AG 559 b, 572 b, 574 b, 601 br; Courtesy Galerie Bruno Bischofberger 324 b, 377 b, 378 b, 384 t, 387 t, 507, 508; Courtesy Galerie Thomas Ammann 276 tr, 285, 378 t, 380 b, 382 tl, 394 bl; Kunsthaus Zurich, Alberto Giacometti Stiftung 488 b. The remaining illustrations belong to the editor's archive and the archive of Benedikt Taschen Verlag, Cologne.

PORTRAITS: Adams, Ansel: Weston.– Adelmann, Marianne: Armitage, César, Hajek, Kricke, Lardera, Penalba, Pomodoro, Schöffer.– Akademie der Kunst, Berlin: Heartfield.– Annely Juda Fine Art, London: Green.– Araiy, JuanVictor: Orozco.– Archiv Sohm, Stuttgart: Maciunas.– Archives of American Art: Benton, Louis, Flanagan, Hopper.– Archivio Storico delle Arti Contemporanee della Biennale di Venezia: Boccioni, Morandi, Severini.– Arendt, Karl: Buchholz.– Armstrong, David: Goldin.– Arthur, John: Pearlstein.– Artists: Antes, Bruch, Burden, Campus, D. Davis, Dorazio, Duncan, Export, Filliou, Fischer, Frize, Garrin, Gertsch, Gerz, Girke (Archiv Brandstetter & Wyss, Zurich); Graubner, Gundlach, Hanson, Heerich, Hegedüs, Karavan, Kippenberger, Klapheck, Klauke, Lichtenstein, Lohse, Luginbühl, Mack, Meistermann, Miotte, Morellet, Prager, Räderscheidt, Rist, Roth, Schultze, Schütte (Photo: Hans Strube), Shaw, Snelson, Stelarc, Tübke, Ursula, Vasulka, Wagemaker, Winters, Wool.– ATP Bilderdienst, Zurich: Bill.– August Sander Archiv, Cologne: Seiwert.– Barbara Gross Galerie, Munich: Spero.– Barcellona, Marianne: Graves, Nauman.– Bauer, Karlheinz: Bellmer.– Baumgartl, Monika: Rinke.– BBC Hulton Picture Library: Epstein, O'Keeffe, Spencer, Stieglitz.– Bellon, Denise: Duchamp.– Benson, Bob: De Maria.– Bercholt: Le Moal.– Bergmann, Olaf: Hoehme.– Bettex, Ivan: Crotti.– Bezzola, Leonardo: Saint Phalle.– Boelhouwer, H. C.: Schoonhoven.– Boubat, Edouard: Hantaï.– Bravo, Manuel Alvarez: Rivera.– Buchholz, Daniel: Tillmans.– Burckhardt, Rudolph: Diller.– Cartier-Bresson, Henri: Matta.– Chevalier, Yvonne: Magnelli.– Cooper, Martha: Fischl.– Crespelle, J.-P.: Gris.– Culer, Ara: Alechinsky.– D'Alessandro, R.: Arcangelo.– Darrow, A.: Gabo.– Deutsche Fotothek, Dresden: Barlach.– documenta 2 (catalogue): Afro, Appel, Bacon, Baumeister, Bazaine, Bissière, Braque, Brauner, Buchheister, Burri, Capogrossi, De Kooning, Dubuffet, Ernst, Fautrier, Fontana, Geiger, Goller, Gorky, Götz, Guston, Jorn, Kantor, Kemény, Lam, Manessier, Marcks, Masson, Mathieu, Matisse, Mortensen, Motherwell, Nay, Nicholson, Pasmore, Poliakoff, Pollock, Santomaso, Saura, Šima, Soulages, Staël, Sugaï, Sutherland, Tamayo, Tàpies, Thieler, Tobey, Trier, Vasarely, Vedova, Villon.– documenta 8: Anderson, Aycock, Cage, Günther, Jetelová, Kaprow, Kiefer, Morris, Paik, Penone, Rosenbach, Trakas, Wall.– Eurich, Crispin: Moore.– Feininger, Lotte: Salomon.– Felb, Vhris: Wood.– Felver, Chris: Woodrow.– Film Publishers Inc., New York: Laurens.– Frajndlich, Abe: Eisenstaedt, Frank, Horst, Riboud.– Frank, Stephen: Arbus.– Fricke, Karsten: Claasen, Lebeck, Michaels, Newton, Umbo.– Friters-Drucker, M.: Jacobsen.– Fritz Glarner Estate, Locarno: Glarner.– Füermann, Klaus: Leibowitz.– Galerie Bischofberger, Zurich: Barceló (Photo: Mário Cabrita Gil), Basquiat.– Galerie Gmyrek, Düsseldorf: McLean (Photo: Bernd Janssen).– Galerie Inge Baecker, Cologne: Kabakov.– Galerie Karin Fesel, Düsseldorf: Calderara, Jochims (Photo: Dietmar Schneider, Cologne).– Galerie Konrad Fischer: Long.– Galerie Louis Carré & Cie, Paris: Estève.– Galerie Maeght, Paris: Giacometti.– Galerie Maeght Lelong, Paris: Velde.– Galerie Nothelfer, Berlin: Lakner (Photo: E. Kiessling).– Galerie Ricke, Cologne: Marioni (Photo: Nicholas Walster), Reed (Photo: Pamela Reed).– Galerie Rupert Walser, Munich: Zeniuk.– Galerie Yvon Lambert, Paris: Blais.– Galvin, Guglielmo: Caulfield.– Giacomelli: Ruscha.– Gnilka, Ewald: Uhlmann.– Goldblatt, John: King.– Gorgoni, Gianfranco: Andre, Paladino, Smithson, Sonnier.– Grab, Richard de: Tal-Coat.– Greenfield-Sanders, Timothy: Halley.– Greer, Fergus: K. Smith.– Grethe, Arnold: Hoyningen-Huene.– Griffin, Steve: Artschwager.– Grotz, Paul: Evans.– Haas, Marianne: Garouste.– Halsband, Michael: Kanovitz.– Hauert, Roger: Picasso.– Hervochon, Yves: Agam.– Hess: Beckmann.– Higgins, Dick: Brecht.– Hoyningen-Huene, George: Cartier-Bresson.– Hyde, Jacqueline: Survage.– Institut Belge d'Information et de Documentation: Magritte.– Katz, Benjamin: Baselitz, Beuys, Boltanski, Buren, Byars, Chia, Clemente, Cucchi, Fabro, Förg, Gilbert & George, Grützke, Haacke, Haring, Hödicke, Horn, Immendorff, Kelley, Kirkeby, Knoebel, Kramer, Lasker, Le Parc, Leroy, Lüpertz, Marden, Nenüss, Odenbach, Oehlen, Penck, Plessi, Polke, G. Richter, Rückriem, Salle, Schnabel, Sherman, Steinbach, Struth, Trockel, Villeglé, Virnich.– Keystone: Siqueiros.– Kiesling, G.: Vostell.– Klemm, Barbara: Ruetz.– Krolow, Wolfgang: Chaldei.– Kunsthalle in Emden: Bruskin, Filatov.– Kunsthalle Mannheim: Bissier.– Lacombe, Brigitte: Rothenberg.– Larionov, Mme: Larionov.– Lazarus, Marvin P.: Gottlieb.– Lloyd, Gilbert: Diebenkorn.– Lortz, Helmut: Berlevi.– Mapplethorpe, Robert: Kushner.– Marlborough Fine Arts, London: Auerbach.– Mayr, Walter: Schumacher.– McDarrah, Fred W.: Chamberlain, Hesse, Judd, Still.– Mihm, Frank: Hoover, Kawamata, Lafontaine, Lang, Metzel, Solano.– Miller, W.: Brancusi.– Moholy, Lucia: Henri.– Moholy-Nagy, László: Moholy.– Morgenbaum, Carl: Mantz.– Müller, Grégoire: Jacquet.– Musée Léger, Biot: Léger.– Muzeum Sztuki, Lódz: Kobro.– Namuth, Hans: Cornell, Jensen, Kline.– Natanson, Alfred: Vallotton.– Newhall, Beaumont: Adams, Halsman.– Nguyen, Michel: Thursz.– Norman, Dorothy: Demuth.– Ohlbaum, Isolde: Brus.– Orgel-Köhne, L. and A.: Höch.– Parks, Gordon Jr.: Parks.– Pevsner, Mme: Pevsner.– Pfaffe, Wolfgang: Abramovic, Acconci, Jonas, Kounellis, Levine, Matta-Clark, Poirier.– Pflaum, Barbara: Lassnig.– Phocas, Suzanne: Metzinger.– Pinsard, Laurent: Etienne-Martin.– Price, Penelope: Oursler.– Ramos, Mrs.: Ramos.– Ramson, Sidsel: Pedersen.– Rautert, Timm: Walther.– Reiser: Fruhtrunk.– Riess: Archipenko.– Rowan, Richard: Haas.– Schmied, Erika: Oelze, Uecker.– Schuh: Doesburg.– Schwartz, Marvin W.: Heizer, Flavin.– Schwitters, Ernst: Schwitters.– Self-portrait: Brandt, Close, Coburn, Drtikol, Baranov-Rossiné, Becher, Blumenfeld, Bourke-White, Doisneau, A. Feininger, Freund, Gidal, Kassák, Keetman, Krims, Krull, Mapplethorpe, McBride, Meyer, Opalka, Prince, Ruff, Sieverding, W. E. Smith, Steichen, Thiebaud, Weegee, Wegman, Wilson.– Seng, Walther: Piene.– Seuphor, Michel: Russolo, Vantongerloo.– Shunk, Harry: Y. Klein.– Steichen, Edward: Sheeler.– Stieglitz, Alfred: Dove, Hartley.– Stiftung für Kunst und Kultur und Kunstmuseum, Bonn: Liu Wei, Wang Cheng, Wei Guangqing, Zhang Xiaogang.– Stocchi, Gabriele: Twombly.– Strelow, Lieselotte: Heiliger.– Sunami, Soichi: Miró.– The British Council, London: Freud.– The Pace Gallery, New York: Morley, Reinhardt.– Trewyn Studio, St. Ives: Hepworth.– Tyler Graphics: Frankenthaler, Tworkov.– Vandercan, Serge: Fleischmann.– Vita, Wolfgang: Christo & Jeanne-Claude.– Votava, F.: Wotruba.– Wadenoyen, Hugo van: Chadwick.– Waller, Baine: Estès.– Weill, Etienne: Arp.– Weiss, Gerhard: Belling.– Wienstraht, Leonore: Helnwein.– Wiklund, Lars: Fahlström.– Wilkinson, Kirk C.: Wyeth.– Wolff, Martha: Kandinsky.

# Index of Names

Bold numbers indicate illustrations.
Names mentioned in the lexicon of artists are not included in the index of names.